MASTERWORKS OF AMERICAN PAINTING AT THE DE YOUNG

MASTERWORKS OF AMERICAN PAINTING AT THE DE YOUNG

Timothy Anglin Burgard, General Editor

Daniell Cornell

Isabel Breskin

Amanda Glesmann

Elizabeth Leavy

Kevin Muller

FINE ARTS MUSEUMS OF SAN FRANCISCO

Published on the occasion of the reopening of the de Young
in Golden Gate Park, San Francisco, California, October 2005

© 2005 Fine Arts Museums of San Francisco

Published with the assistance of the Ednah Root Foundation
and the Luce Fund for American Scholarship

ISBN 0–88401–116–x (cloth) ISBN 0–88401–117–8 (paper)
Library of Congress Control Number: 2005927825

Page ii: Willem de Kooning (1904–1997), *Untitled XX*, 1977
Oil on canvas, 80 × 70 in. (203.2 × 177.8 cm)
Museum purchase, gift of Nan Tucker McEvoy, 2002.1
(See cat. no. 115)

Printed in Hong Kong

CONTENTS

Foreword and Acknowledgments

HARRY S. PARKER III VII

The Evolving Collection

TIMOTHY ANGLIN BURGARD XI

Essays on the Paintings 1

Notes 473

Index 561

HARRY S. PARKER III

FOREWORD AND ACKNOWLEDGMENTS

It is with great pleasure that I present this elegant book on the occasion of the opening of the new de Young museum in Golden Gate Park. Beautifully illustrated, it features a selection of masterworks from the permanent collection of American art in the Fine Arts Museums of San Francisco, illuminated by scholarship that emphasizes cultural context and lively, new interpretations. The lead for this impressive volume was taken by Timothy Anglin Burgard, Ednah Root Curator of American Art and Curator-in-Charge of American Art, who served as the general editor, and Daniell Cornell, Curator of American Art and Director of Contemporary Art Projects. They were joined in this collaboration by outside professional scholars Isabel Breskin, Amanda Glesmann, Elizabeth Leavy, and Kevin Muller. They have produced a collection of intriguing essays that offer both compelling analysis for scholars and a useful introduction to the collection for the museum's public. Additional help was provided by research interns Elizabeth Benjamin and Emily Doman, and Jane Glover, Coordinator of the American Art Study Center, gave invaluable support.

In 1972, when the M. H. de Young Memorial Museum and the California Palace of the Legion of Honor were united to form the Fine Arts Museums of San Francisco, the American art collection was divided between them. In 1971 a landmark exhibition, *Three Centuries of American*

[Facing] Jess (1923–2004), *The Enamored Mage, Translation #6*, 1965. Oil on canvas mounted on wood, 24½ × 30 in. (62.2 × 76.2 cm). Gift of a grateful Board of Trustees in honor of Harry S. Parker III, Director of the Fine Arts Museums of San Francisco, 1987–2005, 2005.87

Painting, had brought together paintings from the separate institutions, making it immediately apparent that the different strengths in their holdings created a general survey of American paintings of considerable significance. With the merger, the collections were reorganized, placing the entire American collection at the de Young. The collection has since grown into a survey that ranks among the finest in the world.

Central to the growth in its prestige was the remarkable gift of the private collection of American art assembled by John D. Rockefeller 3rd and Blanchette Hooker Rockefeller. Begun in 1979 as a gift and completed as a bequest in 1993, the Rockefeller collection, principally comprising works from the colonial period to the nineteenth century, served as the catalyst for the growth of a survey of American paintings unrivaled in the western United States. Of the 117 essays on works selected for this book, forty-five discuss paintings that came from the Rockefellers. During my tenure as director, a personal goal has been to build on that strength by extending the depth and quality of the collection with paintings from the twentieth and twenty-first centuries. The success of that effort is evident in the large number of works acquired within the past eighteen years by notable modern and contemporary artists, including key figures such as Georgia O'Keeffe, Arthur Dove, Charles Demuth, Chiura Obata, Aaron Douglas, Mark Rothko, David Smith, Willem de Kooning, Jess, Richard Diebenkorn, Wayne Thiebaud, and Ed Ruscha, to name some of those represented in this volume.

Upon the opening of the new de Young, designed by architects Jacques Herzog and Pierre de Meuron, this expanded collection will be beautifully installed in a

contemporary building with galleries sensitive to their aesthetic requirements. The scholarly efforts evident in this book offer extensive insights into paintings in the permanent collection that may only be hinted at in the brief label descriptions in the galleries.

We are grateful to the Ednah Root Foundation for continued support of the department of American art, and most particularly for the generous funding of this publication. A grant from the Luce Fund for American Scholarship provided important support as well. The book was produced under the guidance of Ann Karlstrom, Director of Publications and Graphic Design, and Elisa Urbanelli, Managing Editor, working with Christine Taylor and her staff at Wilsted & Taylor Publishing Services. The handsome design is by Jeff Clark. The book's manuscript editor, Fronia W. Simpson, aided by Melody Lacina, shaped the authors' prose with accuracy and finesse. Suzy Peterson of the Fine Arts Museums performed the important task of gathering illustrations from outside sources and clearing picture permissions, and Sue Grinols, Manager of Photo Services, arranged for new photography by museum photographer Joseph McDonald, as well as assisted with manuscript preparation.

This collection catalogue will serve as a potent reminder of the visual experience of visitors to the museum and provide a wealth of information to enhance their pleasure when returning to view these masterful paintings.

[Facing] Trompe l'oeil paintings in an American art gallery of the new de Young. © Nic Lehoux Photography

TIMOTHY ANGLIN BURGARD

THE EVOLVING COLLECTION

Since its inception in the Fine Arts Building at the California Midwinter Exposition of 1894 in Golden Gate Park, its subsequent institutionalization in the M. H. de Young Memorial Museum in 1924, and its rebirth in the new de Young in 2005, the permanent collection has evolved exponentially. In the museum's first century, its component collections have been augmented or diminished by directors, curators, and donors through purchase, gift, and refinement. The de Young has been transformed from a city museum that housed treasures ranging from armaments to art, to a museum of national stature whose fine art collections are international in scope.

This catalogue, published to coincide with the opening of the new de Young museum in Golden Gate Park, includes 117 scholarly essays on paintings that span in date from 1670 to 2001, and that represent approximately one-tenth of the de Young's permanent collection of American paintings. It is a measure of the museum's aspirations and achievements that one-fourth of these works were acquired since the publication of two earlier books that document the origins and expansion of the permanent collection of American paintings at the de Young, *American Canvas: Paintings from the Collection of The Fine Arts Museums of San Francisco* (1989) and *The Rockefeller Collection of American Art at The Fine Arts Museums of San Francisco* (1994).

[Facing] Chiura Obata (1885–1975), *Mother Earth*, 1912/1922/1928. Ink and color on silk, 87¾ × 58⅝ in. (222.9 × 148.9 cm). Gift of the Obata Family, 2000.71.2 (See cat. 74)

The paintings in this catalogue were selected primarily for their perceived importance within the history of American art, and many are textbook examples by famous artists. However, some of the more recent acquisitions reveal both subtle and significant shifts in the scholarly redefinition of American art, and a parallel shift in the de Young's collection policies, which are increasingly more representative of America's historical diversity. The authors of this catalogue approach cultural history with a contemporary methodology that is contextual, viewing objects as bearers of meaning that reflect both personal visions and collective concerns, as well as the time, place, and culture of their creation. While the paintings in this catalogue are products of their historical contexts, a brief survey of several works reveals that contemporary curatorial considerations have influenced their acquisition by the de Young.

The acquisition in 1995 of Joshua Johnson's *Letitia Grace McCurdy* (pl. 11) has expanded the cultural diversity of the de Young's collection. Although Johnson today enjoys great prominence as the first African American painter with an identified art practice, during his lifetime he was a self-taught Baltimore portrait painter whose reputation did not extend beyond his local patrons. However, Johnson's African American identity, combined with a resurgence of African American populist pride and academic scholarship, has contributed to an increase in the auction prices for his paintings from $250 in 1961 to a record $660,000 in 1988, outpacing the prices for comparable portraits by Euro-American artists. Although multiculturalism is a historically documented fact of American art, it has been provocative for some museum visitors because it seems to

contradict generations of scholarship that ignored such evidence in favor of American art's European roots. Recognizing that art museums play a significant role in the validation of culture, other museum visitors increasingly expect to see their own cultural histories and identities reflected in museums. The premium placed on Johnson's African American identity is indicative of the shifting definitions of American culture, in which diversity is not new, but is newly relevant.

Charles Christian Nahl's *Peter Quivey and the Mountain Lion* (pl. 25), acquired in 1998, is a quintessential portrait from California's gold rush era. Similar portraits of prominent San Francisco Bay Area pioneers accounted for a substantial percentage of the original de Young museum's collections. However, such "regional" works consistently have been viewed as provincial—and therefore secondary—by critics and scholars who promoted the primacy of works by East Coast artists. Nahl's portrait is undeniably grounded in local history, as Peter Quivey was a founder of the Bay Area city of San Jose. However, Quivey's fringed buckskin jacket, Bowie knife, and Colt revolver inevitably evoke America's national Manifest Destiny to settle the trans-Mississippi West. Nahl's image of Quivey, as both a rugged California pioneer in the western mode and a cultured art patron in the eastern mode, reveals subtle regional facets of national issues such as Manifest Destiny that are often presented as monolithic. The acquisition of Nahl's portrait of Peter Quivey demonstrates a renewed commitment by the de Young to preserve a distinctive regional identity that will distinguish this California institution from other museums that exclusively emulate the models provided by major New York museums.

Chiura Obata is little known outside the San Francisco Bay Area and is one of the artists in the de Young's collection most deserving of a national reputation. Obata's large-scale *Mother Earth* (pl. 74 and p. x) and *Lake Basin in the High Sierra* (pl. 75), both acquired in 2000, have the potential to be the greatest revelations of the new de Young's American art collection. As a prominent public lecturer, Obata provided thousands of people with their introduction to traditional *sumi-e* (brush-and-ink painting), Asian art and aesthetics, and Buddhist philosophies regarding nature. Given his teaching position at the University of California at Berkeley, Obata was never compelled to earn a living exclusively through the sale of his works, and his family has respected his perception of art as a spiritual, rather

than a commercial, calling. This philosophy has had unintended consequences, as the art market rarely validates artworks that it cannot sell in quantities sufficient to establish their value as commodities. Museums apply different standards of value; the inclusion of two works by Obata in this catalogue and their prominent placement in the new de Young galleries constitute a conscious attempt to foster a critical appraisal of Obata's cultural contributions.

Jack Levine's *Birmingham '63* (pl. 111), acquired in 1999, exemplifies the de Young's ongoing interest in acquiring works of historical significance in a broad range of artistic styles, irrespective of transitory art-world trends. As a Social Realist who first gained renown in the 1930s, Levine has observed that he was famous at the age of twenty and forgotten by the age of thirty, as the ascendancy of Abstract Expressionism in the post–World War II era increasingly marginalized artists of Levine's generation who continued to work in representational styles. This marginalization has been compounded in many modern art museums, which have privileged works that are perceived to extend the main lines of avant-garde modernism. Conversely, the Fine Arts Museums of San Francisco, whose Legion of Honor museum houses works by Levine's artistic heroes El Greco, Rembrandt van Rijn, Peter Paul Rubens, and Honoré Daumier, have a different perspective on Levine's position in the history of art. Inspired by the civil rights protests in Birmingham, Alabama, in 1963, Levine's painting captures the power of art to shape public opinion and to transform temporal events into timeless truths. Although some critics continue to argue that Social Realism is an outdated style, Levine's themes of racism and the abuse of power remain relevant, reminding viewers that truly resonant art speaks to the human condition, regardless of the artwork's stylistic vocabulary or date of origin.

Ed Ruscha's *A Particular Kind of Heaven* (pl. 116), acquired in 2001, epitomizes the de Young's renewed commitment to modern and contemporary art. For most of its first century, the de Young exhibited contemporary art but acquired mostly older American art. However, in 1988 the museum formally decided to expand the collection into the twentieth century and up to the present day. Some traditionalists have questioned this evolving collection policy, arguing that the de Young should collect historical works and abdicate responsibility for contemporary works to modern art museums or contemporary art venues. Such a course of action—or inaction—would severely diminish

the exhibition opportunities for living artists and their au-diences and would also have the effect of further severing contemporary works from their historical foundations, a perennial problem in museums that enshrine avant-garde modernism at the expense of other art movements. Viewed within the context of a modern art museum, Ruscha's *A Particular Kind of Heaven* might resonate with works on view by the Dada artist Marcel Duchamp or the European Surrealists. At the de Young, Ruscha's contemporary California landscape may be perceived as having even older roots in the western landscapes of Hudson River School artists such as Albert Bierstadt, whose *California Spring* (pl. 33) helped to shape the paradigm of the gold rush state as an earthly Eden or El Dorado. Such revealing juxtapositions suggest that modern and historical art museums are not mutually exclusive venues but rather can share a symbiotic relationship that greatly expands the viewer's experience.

The old and new acquisitions described in the essays that follow eloquently demonstrate the cultural fluidity of art objects and their contexts. Changing perceptions of the same objects by new generations of scholars and viewers with different frames of reference make it possible to see the de Young's permanent collection of objects as a collection of ideas that are continually reinterpreted. As a component of this evolutionary process, the installation of art at the new de Young provides an unparalleled opportunity to reconsider all of the museum's collections, which are increasingly multicultural, interdisciplinary, and global, bridging ancestral and American identities; transforming the traditional taxonomies applied to cultures and objects; striking a balance between the local, the national, and the international; and fostering a dialogue between the art of the past and the art of the present. The new de Young aspires to provide a cultural common ground—a fertile gathering place for art, people, and ideas that has roots in history but that will continue to grow in the future, thus sustaining the resonance and relevance of its evolving collections.

MASTERWORKS OF AMERICAN PAINTING AT THE DE YOUNG

EDITORIAL NOTE: The 117 essays in this book discuss paintings selected from the permanent collection of the Fine Arts Museums of San Francisco. The essays are arranged in chronological order by date of execution of the featured paintings. Where an artist is represented in the book by more than one painting, those essays appear in sequence following the earliest dated work by the artist.

Each essay is signed with its author's initials.

Isabel Breskin [IB] *Timothy Anglin Burgard* [TAB]
Daniell Cornell [DC] *Amanda Glesmann* [AG]
Elizabeth Leavy [EL] *Kevin Muller* [KM]

Notes to the essays appear in the back of this volume.

1. FREAKE-GIBBS LIMNER, *David, Joanna, and Abigail Mason*

CHANGING TERMS OF VALUE

In 1973 John D. Rockefeller 3rd—who was later to donate his collection of American paintings to the Fine Arts Museums of San Francisco—considered purchasing *David, Joanna, and Abigail Mason* (1670) by an unidentified artist.[1] The price was high; *David, Joanna, and Abigail Mason* was the first American painting offered for sale at $1 million.[2] That price could be justified in part by the portrait's rarity; fewer than three dozen seventeenth-century American paintings from Massachusetts survived, and this was the only known one to include more than two people. The painting shows three of the children of Arthur and Joanna Mason formally posed in a dark, interior space. The children are depicted with charming detail: David's (1661–1724) small smile, the delicate lace edging his collar; Joanna's (1664–before 1725) bright, direct gaze, the loop of ribbon over her finger; the gentle way little Abigail (b. 1666) holds her sprig of flowers. Yet it was outmoded even for its own time, painted in a flat, linear style that emphasized pattern rather than fully rounded forms in a convincing perspectival space. That style, while still practiced in the British provinces, had been replaced at the British court with an interest in the baroque dynamism and naturalism of Dutch portraiture. Were an American provenance and a winning subject enough to justify a seven-figure price for what was essentially a provincial British work of art? Rockefeller hesitated.

For Arthur and Joanna Mason, the value of the painting lay not only in its representation of their children but also in the opportunity it provided for them to demonstrate their financial success and cultural refinement. Arthur Mason was one of half a dozen bakers in Boston at a time when the city's population was about 4,500. While most members of his profession struggled to turn a decent profit under the laws regulating bread prices, Mason prospered.[3] The painting's stylistic similarity to provincial English portraits is a striking visual reminder of the profound cultural, emotional, and psychological connections between Britain and its distant colonies and the effort of colonial artists and their patrons to re-create familiar British cultural forms in a new land.[4]

Each of the Mason children holds an attribute that is symbolic of his or her position in the family: a gentleman's silver-topped walking stick for the male heir; a fan and coral beads for a daughter of wealthy parents; a rose for an innocent child.[5] Joanna carefully holds her skirt with her forefinger and thumb, in the manner prescribed by contemporary dance and etiquette manuals.[6] The inclusion of these attributes and gestures demonstrates the family's knowledge of elite cultural forms and manners. Meanwhile, the children's expensive clothes declare the family's financial success. The colonies' Puritan governors enacted sumptuary laws aimed at trimming excesses in dress. Double-slashed sleeves were not permitted; single-slashed sleeves were. Yet, as the portrait of the Mason children shows, while the colonists adhered to the laws, in their "pride" they went "as farr as they may."[7] All three children wear single-slashed sleeves, the white linen worn underneath standing out handsomely from the dark material of the sleeves. The swag of gold-trimmed green drapery in the upper right corner of the painting defines not just the setting but also the Masons' wealth: all fabric was costly, especially such a generous length as this.

To our eyes, the children's clothes may seem rather adult for ones so young. However, at this time, clothing was used

2

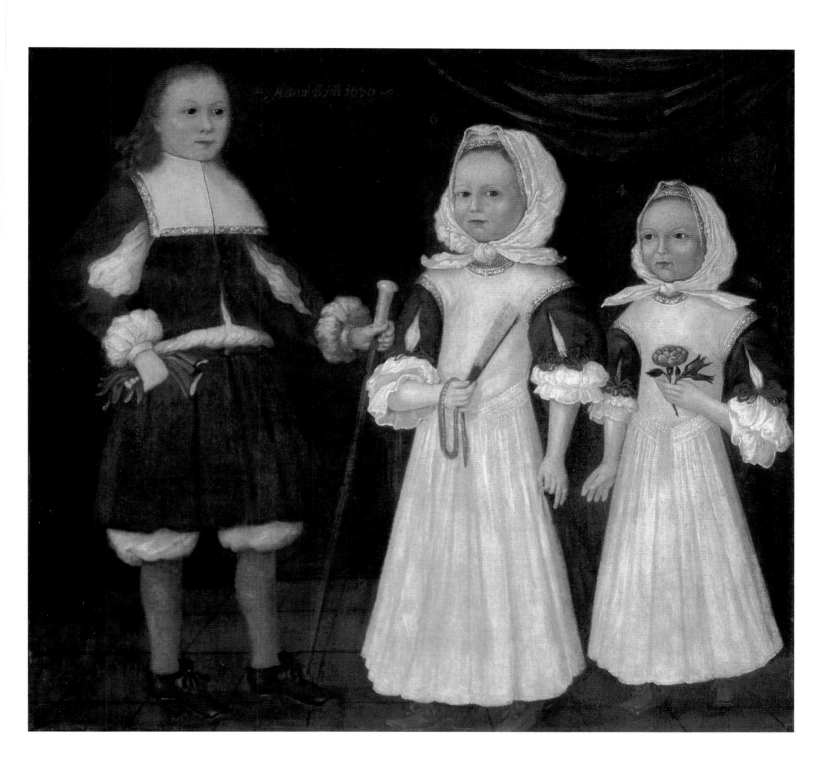

1. Attributed to the Freake-Gibbs Limner (active
ca. 1670), *David, Joanna, and Abigail Mason*, 1670
Oil on canvas, 39 × 42½ in. (99.1 × 108 cm)
Gift of Mr. and Mrs. John D. Rockefeller 3rd, 1979.7.3

to demonstrate clear differences in class and, after infancy, gender, but age to a lesser degree.[8] It would be fitting, therefore, for David Mason, eight and old enough to be considered a "gentleman-in-training," to wear a suit and starched collar and to adopt a formal posture, and for the girls to be shown in the kinds of petticoats and pinafores they would wear throughout their adult lives. Additionally, certain elements of the children's costumes, which are harder for us to identify and read today, would have strongly signaled the children's youth to contemporary audiences. For instance, the two girls wear coral-bead necklaces. The artist has carefully delineated the strands, picking out the highlights of the reflective beads with dots of white paint. Superstitious parents often put coral necklaces on their children to ward off "fascination," defined in one seventeenth-century text as "a binding which comes from the spirit of the Witch, through the eyes of him that is bewitched, entering to his heart."[9] In a period of high child mortality, some parents commissioned a postmortem portrait to help preserve the memory of a child who had died. To the left of each of the Mason children, the artist painted a number corresponding to his or her age: 8, 6, 4.[10] Those strange, floating numbers seem to be a proud statement that *these* three children are vibrantly alive. The painting thus can be seen as a celebration of a growing family, a testament to God's blessing, and a harbinger of a prosperous future.

Indeed, in addition to capturing the children's likenesses, the painting also recorded each one's position and responsibility in the family as a bearer of a family name, as a future heir, or as a potential progenitor. The law of primogeniture, which gave the firstborn male superior legal and hereditary rights, held sway in this era, and the artist has used a number of devices to signal David's privileged position in the family. He stands at a slight remove from his younger sisters, a separation that is emphasized by the strong line of his walking stick. Significantly taller than they, he stands against a plain, dark ground while they are sheltered by that swag of drapery. David's body is inflected to his left while Joanna and Abigail turn to their right, or at least their feet do. Even though the law provided Joanna with no special privileges, she bears her mother's name and so marks the continuation of the maternal line of descent in tandem with the paternal. Little Abigail's flowers are another indicator of the children's relative status at a time when flowers were used to symbolize youth. In 1669 Anne Bradstreet employed a flower metaphor in a memorial

poem that lamented the death of three of her grandchildren, one of whom was an infant: "No sooner come, but gone, and fal'n asleep / Acquaintance short, yet parting caus'd us weep, / Three flowers, two scarcely blown, the last i'th'bud."[11] The painter makes a similar comparison between the three Mason children and Abigail's flowers. The full, tightly petalled rose, farthest to the left on the sprig and matching David's position on the canvas, suggests that David is a blossom "scarcely blown." Indeed, David's "graduation" to breeches may have been the motivation for commissioning the portrait.[12] The two buds can be seen as representing Joanna and Abigail. The middle bud is plumper and more upright than the other, suggesting that six-year-old Joanna is closer to blossoming than four-year-old Abigail. A visitor to the colonies some fifteen years later was to refer to Joanna as "the very flower of Boston."[13]

The painting stayed with the descendants of Arthur and Joanna Mason, passing from their son David through nine succeeding generations. In that journey, the terms of the painting's value gradually shifted. As the relevance of the specific emblems in the painting faded (what was the cost of slashed sleeves? what was the meaning of a rose held by a young girl?), the painting itself gradually became emblematic of the family's historical pedigree and genealogical longevity.

Rockefeller, who had already built a formidable collection of Asian art, later explained his decision to begin collecting American works, "We suddenly realized that we had nothing that represented our own country, our own culture, our own heritage. . . . Therefore, we decided to acquire just a few American paintings."[14] In 1949 Rockefeller had taken over the leadership of the Colonial Williamsburg Foundation, started by his father, and he practiced an active brand of Americanism there, seeking to teach what he saw as the virtues of American society to visitors to the restored and re-created town.[15] When *David, Joanna, and Abigail Mason* was offered for sale in 1973, the bicentennial was approaching and the three-hundred-year-old portrait—no longer a familial artifact—could take on new value as a national artifact, reflecting pride in American aesthetic and cultural achievement. The Mason children, in turn, could be read as retroactive symbols of a young land that had grown into adult independence. The painting had been transformed from British family portrait to American national symbol. The terms of value had shifted again. Rockefeller bought the painting. [IB]

2. JOHN SMIBERT, *John Nelson*

CLAIMING STATUS

In the top left corner of his 1732 portrait of John Nelson (1654–1734), John Smibert (1688–1751) has included a coat of arms. A cross patonce surmounted with a helmet and crest, Nelson's coat of arms is sometimes "said to be that of the Temple family" by art historians.[1] In making that attribution, scholars explicitly link Nelson with his titled maternal grandfather, Sir John Temple of Stantonbury and, by extension, to a legacy of privilege, power, and nobility.

Some eighteenth-century American artists, often itinerant ones, designed coats of arms. As they made their designs, artists at times referred to books on heraldry to find elements of a coat of arms from a family having a similar name as their client, whether the client was actually related to the family or not.[2] The resulting design was not technically legitimate—only those who could prove descent from a family who had received a Grant of Arms from the College of Heralds in England or who could prove that their family had borne the arms for one hundred years were entitled to have a coat of arms.[3] Yet even a fabricated arms could confer the appearance of familial longevity and distinction and endow gravitas on its bearer.

It is perhaps odd to focus first on a marginal detail like the coat of arms when discussing such an imposing portrait.[4] And certainly Smibert has arranged the composition so that Nelson's serious, well-lived face draws our attention, not the coat of arms. That distinguished visage is framed by a full wig. The crisp, white line of Nelson's Steenkirk tie contrasts with his dark butterscotch coat and vibrant red cape and directs our gaze up to Nelson's head and down to his hands.[5] Nelson elegantly holds a fold of cloth with one hand, a long finger pointing to the other hand, which rests solidly on two books. Our eyes pass from one hand to the

other and travel up Nelson's right arm to return, once again, to his face. The coat of arms does not figure in this visual journey but rather floats somewhat disconcertingly on the picture plane, an odd counterpoint to the impression of recession through the window to Nelson's left. Yet, despite its somewhat awkward inclusion and faint appearance, the coat of arms is a powerful indicator of the ways this elderly gentleman and the artist who painted him were able to negotiate changes in their status and, in the process, achieve personal and professional success.

The London diarist George Vertue (1689–1756) explained Smibert's motives for migrating to the American colonies. He wrote, "[Smibert] was not contented here, to be on a level with some of the best painters. but desired to be were [*sic*] he might in the present, be lookt on as at the top."[6] And indeed Smibert had exhibited from very early in his career an ambitious nature and a keen sense of professional direction. He was born in Scotland. Despite his modest background—he came from a family of artisans and was apprenticed to a housepainter—Smibert was able to piece together the elements of an education that transformed him from housepainter to successful artist. The first step in that transformation was a move to London, where he worked decorating carriages. He then spent several years copying paintings for art dealers while studying at a makeshift academy.[7] In 1716 he returned briefly to Scotland, where he made some of his first portraits before embarking for Italy, where he studied for three years. There, Smibert met Dean George Berkeley (1685–1753), who later invited Smibert to accompany him to the colonies and help establish a university. The university never received its promised funding, and Berkeley returned to England, but Smibert stayed.

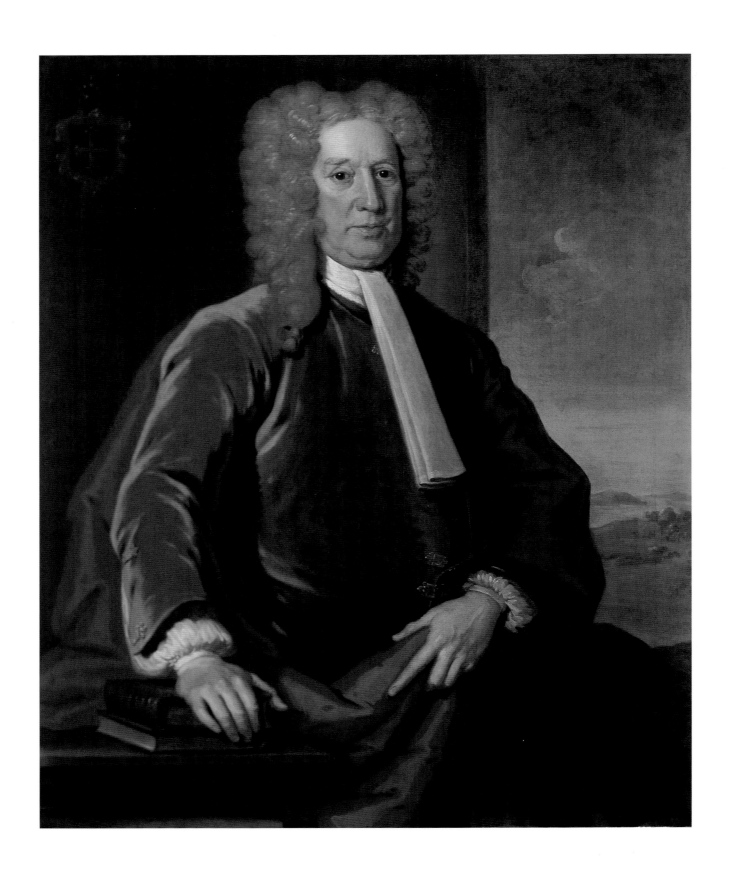

2. John Smibert (1688–1751), *John Nelson*, 1732
 Oil on canvas, 44⅜ × 36 in. (112.7 × 91.4 cm)
 Gift of Mr. and Mrs. John D. Rockefeller 3rd, 1979.7.93

Smibert's social and professional ascent continued after his move to Boston about 1729. He married Mary Williams, who came from a wealthy family with extensive social connections. He worshiped at Old South Church beside Boston's most powerful Congregationalists. These personal associations would provide Smibert with access to those people most likely to commission portraits. His marriage and his church membership allowed Smibert to present himself to them as an equal, a gentleman who understood the customs and concerns of the elite and would represent them appropriately. The impressive list of names that Smibert recorded in a notebook are evidence of his success in finding sitters: 241 paintings, including almost 100 in the first five years. John Nelson paid the substantial sum of forty guineas for his portrait, as did all of Smibert's subjects who chose the same size and format.[8] As a British artist who had trained and worked in London and who had traveled and studied in Italy, Smibert did indeed find himself "lookt on as at the top."

Yet, in the colonies, Smibert's education as an artist effectively stopped. Practically the only contemporary artworks he had to study were those he made himself or the prints and copies that he had brought with him. Portraits that he made shortly after his arrival, including that of John Nelson, show the sensitivity and vigor that made Smibert one of London's best, but as the years passed and his health faltered, his production became more formulaic. And, despite his prodigious output, Smibert found that he needed an additional source of income. In 1734 he opened a shop selling artists' colors. As proprietor, Smibert catered to young artists, hobbyists, and members of his earliest profession—housepainters.[9] In addition to the color shop, Smibert opened a gallery containing copies of Italian masterpieces, casts of sculptures, and engravings from his own collection. The gallery remained intact for thirty years after his death and was an important site of study and inspiration for young American artists. In 1777 a young man named John Trumbull (1756–1843), who was to become a celebrated history painter, went to Boston to pursue his studies. He later wrote in his autobiography:

> There I hired the room which had been built by Mr. Smibert, the patriarch of painting in America, and found in it several copies by him from celebrated pictures in Europe, which were very useful to me. . . . Mr. Copley was gone to Europe, and there remained in Boston no artist from whom I could gain oral instruction; but these copies supplied the place, and I made some progress.[10]

Even as he remained a sought-after portraitist and served as a model and guide for future generations, Smibert was also a shopkeeper. At times he provided patrons with renditions of coats of arms, associating himself with those less accomplished artists who traveled the countryside seeking work and recalling his own early days as a decorator of carriages.[11]

Nelson sat for his portrait close to the end of his long, adventurous life. Like Smibert, Nelson emigrated to the colonies from Britain and worked as a merchant. Among his exploits, he participated in an uprising against an unpopular governor, was captured by the French during the French and Indian War, discovered a plot by the French to invade Maine and New Hampshire, and, when his attempt to pass the information on to the Americans was discovered, was imprisoned for two years.[12] Painted at the end of this colorful and illustrious career, Nelson's portrait could remind his descendants of his achievements and serve as a statement of his values.

The coat of arms was an important component in this project. Even though Nelson had lived in the colonies for many years and had made his reputation and fortune there, it was still important to him to employ in his portrait a marker of status officially sanctioned and recorded (at least, supposedly) in Britain.[13] Indeed, the physical distance from England may have increased the motivation to include the coat of arms if Nelson wanted to assert his continuing allegiance to, and identification with, his far-off homeland. And yet Nelson had once famously defied the king. While he was a French captive he was allowed to make a trip to London, with a French gentleman paying his bond of 20,000 pounds. King William forbade Nelson to return to his French jail. Nelson asked if the king intended to pay his bond for him, and, on hearing that the king did not, answered, "Please God I live, I'll go." And he did, suffering the king's wrath for his defiance after his release.[14] Nelson's decision, many years later, to include a coat of arms in his portrait may have been an effort to present himself as his king's loyal subject and to supplant his reputation as a man who had refused to obey the crown. A coat of arms allows the bearer to acknowledge the larger authority that grants the right to it while simultaneously displaying symbols and mottoes that resonate with personal significance and celebrate individual accomplishment. In choosing to include the coat of arms in his portrait, Nelson asserts both his Britishness and his personal independence. [1B]

3. DE PEYSTER PAINTER, *Maria Maytilda Winkler*

LIKENESS AND SAMENESS

In her portrait made about 1735, Maria Maytilda Winkler[1] is an attractive young woman in a vibrant red dress. Her head is turned slightly—we can see just one of her dangling earrings—but she meets our gaze with steady, dark brown eyes. Her face, a perfect oval, is smooth and unlined and her expression is one of serene self-control. The low neckline of her dress reveals plump, rounded shoulders and an expanse of creamy skin. A tendril of hair curls alluringly over one shoulder and a double string of pearls encircles her neck. Her right hand bends back to expose the delicate skin on the inside of her wrist. As a counterbalance to the sensuous elements in the portrait, a lamb, symbol of innocence, nestles in the crook of her left arm. The garland of flowers in her lap refers to feminine beauty, even as it warns of beauty's transitory nature.

While the large, pink flower in the garland is recognizable as some kind of rose, and the red flower in the middle appears to be a variety of poppy, the artist—who is unknown to us—has sufficiently stylized the other blooms that they cannot be identified.[2] A comparison of Winkler's portrait with a companion portrait of her sister, Jacomina (private collection), suggests that the artist has stylized his sitters' likenesses in a manner similar to the flowers.[3] Clothing, setting, posture, facial features: all are alike in the portraits, from the style of their sleeves to their drop earrings, from strong, straight noses to dark eyes, from high foreheads to oval faces. Jacomina had died in childhood, and perhaps the artist used her surviving sister as his model for the post-mortem painting. However, the portraits of the Winkler sisters also resemble those of other, unrelated women. These women, including Phila Franks (fig. 3.1), share the Winkler sisters' oval faces and direct gazes, they are similarly posed

with one arm crossing in front of their bodies and the other out to the side, and all are positioned against a wall that opens onto a wooded, parklike setting. The artist has indeed stylized his subjects, using conventional settings, costumes, poses, and even features.

The women in these portraits were all members of wealthy families of Dutch descent who lived in New York City and the Hudson River Valley. The patronage of these families helped cultivate early American painting, particularly portraiture. Why were these families willing to have their daughters' appearance molded or conventionalized? Did they care little for accurate likeness?

A young beauty, Maria Maytilda Winkler had probably recently come of age—that may have been the reason for the portrait commission—and thus was newly available for marriage. The painting presents her in accordance with contemporary ideas about feminine comeliness, desirable attributes, and appropriate deportment. The docility of the lamb, the delicacy and attractiveness of the flowers, and the placidity of the wooded scene are qualities that also adhere to Winkler. That she holds herself so elegantly suggests she possesses both the composure and the training expected of a lady of her class. The painting artfully employs these common attributes and metaphors to deliver its central message: Maria Maytilda would make an excellent wife.

The artist has borrowed many of the attributes and metaphors in Winkler's portrait from another work of art. Lacking access to art schools, art collections, or even many paintings (other than their own) to study, colonial painters turned to mezzotints of British portraits by established, academically trained artists for instruction and guidance. The De Peyster Painter has used a mezzotint by John Smith

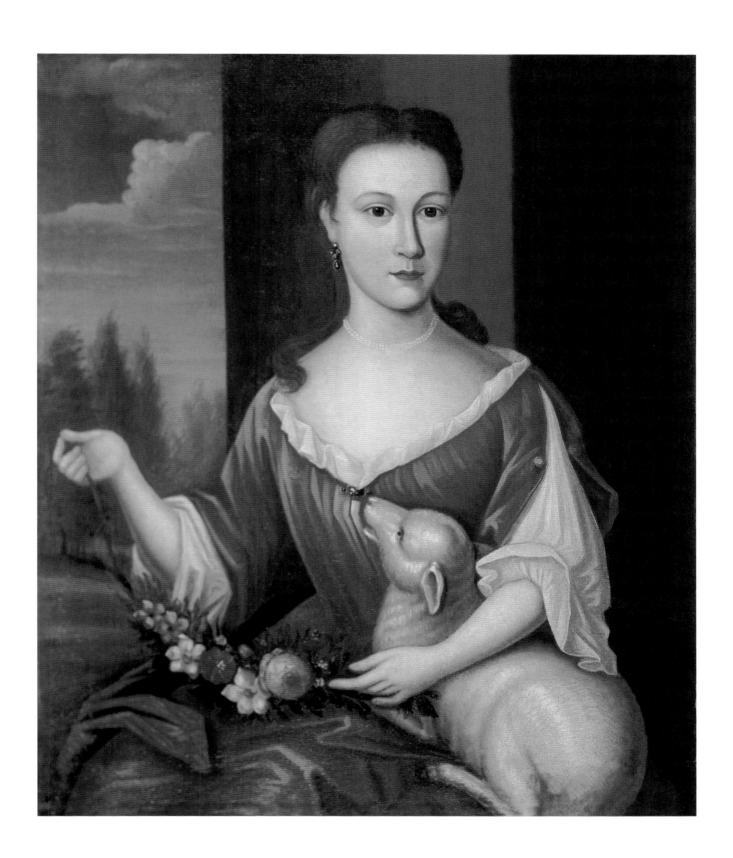

3. Attributed to the De Peyster Painter (active
 ca. 1735), *Maria Maytilda Winkler*, ca. 1735
 Oil on canvas, 30⅛ × 25⅛ in. (76.5 × 63.8 cm)
 Gift of Mr. and Mrs. John D. Rockefeller 3rd, 1979.7.34

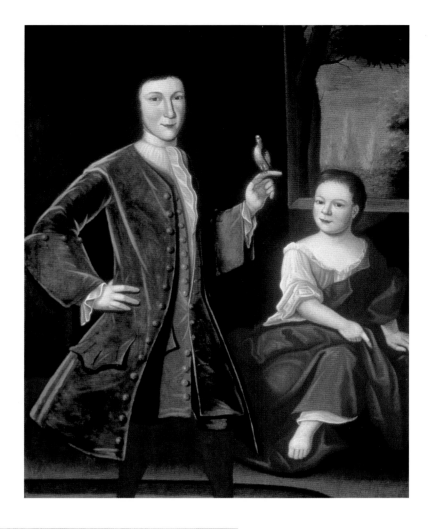

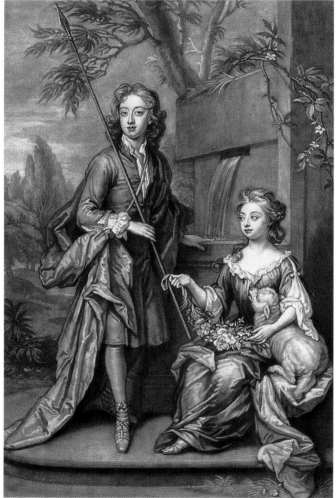

Fig. 3.1 [above]. Unknown, *David and Phila Franks*, ca. 1735. Oil on canvas. American Jewish Historical Society, Newton Centre, Massachusetts, and New York, New York

Fig 3.2 [left]. John Smith after Godfrey Kneller, *Portraits of Lord Villiers and Lady Mary Villiers*, 1715–25. Mezzotint. Courtesy Winterthur Museum. Gift of Mrs. Waldron Phoenix Belknap, 1967.0982A

after Godfrey Kneller's *Portraits of Lord Villiers and Lady Mary Villiers* (fig. 3.2) to help him in painting *Maria Maytilda Winkler*. In that print we see the template for the lamb, the flowers, the pleated drapery, and even the tendril of hair. In the mezzotint, the De Peyster Painter found a guide for his uncertain hand as well as the appropriate visual vocabulary to convey his message about Winkler.

But there is more to the borrowing than that. The British took over the Dutch colony of New Netherland in 1664, but they immediately recognized that severing ties with the great Amsterdam trading companies would be tantamount to killing the goose that would soon lay a golden egg. Thus the takeover was not an eviction of one culture in favor of another, but rather a cohabitation.[4] New Amsterdam in the seventeenth century already possessed one of the chief characteristics of its future incarnation, New York City: it was home to an unprecedented mix of religions, nationalities, races, and ethnicities. The British takeover did little to change that. In the next three decades, as the two great mercantile powers battled each other and negotiated the division of territorial spoils, the island of Manhattan and surrounding lands changed hands five times, a kind of colonial volleyball that culminated in the Glorious Revolution of 1688–89, in which the Dutch Willem of Orange was crowned king of England. For the next hundred years Dutch culture and traditions remained strong in New York even as British manners, style, and taste exerted a profound influence. Thus, the descendants of Dutch settlers might turn to British prints as sources for their portraits, for British culture had been absorbed and thoroughly mixed into their own. Yet the similarities between the Dutch portraits also suggest the flourishing connections among the Dutch neighbors: the sameness of the features in their portraits creating familial resemblances among the various Dutch clans; the common portrait conventions of pose, setting, and dress indicating a shared visual language; the decision by Dutch families to commission portraits from the same artist serving as a means to cement social ties.

In the mezzotint process the image is created with an array of small dots, producing an unusually soft line. This fact helps explain Winkler's rather flaccid left arm and hand, which seem to lack bone and muscle, and the uninterrupted smoothness of her shoulders where her collarbone should have been: the print's technique has led the painter astray. The black-and-white mezzotint process also gave the artist little guidance in how to use color to represent drapery convincingly. In Winkler's portrait, the artist has struggled to represent the fabric of the dress, using bald white lines to delineate its folds and gathers. While the lack of visible bone structure in the portrait could be seen as a virtue—softness and gentleness being preferred in a woman over strength and firmness—the schematic depiction of drapery is a deficiency in Winkler's portrait.

The De Peyster Painter has chosen to deviate from his mezzotint model in some important ways. The prints are necessarily in shades of black and white, while the De Peyster Painter has embraced a simple, but brilliant, palette for his portrait of Winkler. He has used the same rich orange-red of her dress for the garland's ribbon and for her lips. In the print, Lady Mary Villiers turns her head, averting her gaze and allowing the viewer to study her unchallenged. Winkler, however, looks at us directly. While Lady Villiers is presented in full-length, the portrait of Winkler is three-quarter-length; she is much closer to the picture plane, and therefore to the viewer.

These few but significant changes have a profound effect on the portrait. For, even as we acknowledge its conventional aspects, the painting imparts a charged vitality. Eye to eye with a proximate woman in a fiery dress, we have a profound, direct sense of a real person. While the most obvious purpose of portraiture is to capture the likeness of the sitter, at different periods portraiture has served other purposes as well, purposes that may be better achieved if fidelity to the sitter is combined with a certain level of stylization. Thus the use of the mezzotint could aid the artist in providing guidance, could aid the painting in asserting Maria Maytilda's marriageability, and could aid the family in acknowledging both British traditions and Dutch connections. This is not a portrait of a provincial girl jealously aping a stylish noblewoman. Rather, it is a colonial woman seeking a balance between conformity and individuality, aspiration and an acknowledgment of communal ties, sameness and likeness. [IB]

4. ROBERT FEKE, *Mrs. Charles Apthorp*

MOTHER AND DAUGHTERS

Imagine for a moment an eighteenth-century portrait hung not against the pristine wall of a museum, positioned by curators so that it can engage productively with the variety of other colonial objects surrounding it, but instead in its original setting, in a home surrounded by the utilitarian possessions and personal treasures that belonged to the family that lived there. Imagine the dialogue that might develop among those assorted household items as they shared a room. In the case of this portrait of Grizzell Eastwick Apthorp (1709–1796) we can do just that: through our imaginings, restore the painting to the room in which it originally hung and eavesdrop on those conversations.

In 1758 Charles Ward Apthorp, husband to Grizzell Apthorp and father to fifteen surviving children, suddenly died.[1] Although he was an elderly man of substantial property, he left no will. Accordingly, a "true and perfect inventory of all ye Goods, Chattels, Rights and Credits" that belonged to him was ordered by the Court of Probate in Suffolk County, Massachusetts, to be delivered by 28 February 1759. On 7 January 1759 the inventory of the contents of Apthorp's main residence—a handsome, three-story brick mansion on King Street in Cambridge—was filed with the court. According to the estate inventory, Apthorp's "Best Parlour" contained:

1 Large looking glass &			
a Chimney glass &			
2 pr brass branches	£15	3	4
6 Family Pictures	32	10	5
10 Mahogany Chairs			
yellow bottoms	16	—	—

a Sett of crimson & sett of			
yellow damask Window			
Curtains & Cushions	25	—	—
3 Glaz'd pictures & a Tea Chest	—	18	0
2 Mahagony tables & 1 japannd			
tea table	5	4	0
3 Window Shades & fire			
Screen & 3 Carpets	6	9	0
1 pr Andirons Shovell Tongs			
& fender	3	0	0
An Earthen Soop dish			
& Copper Cooler	2	—	—
a Parcell of China Delph			
and Glass Ware	15	2	8[2]

Using the estate inventory, we can imagine what the "Best Parlour" must have looked like: the rich crimson and yellow of the curtains and cushions, the flickering light from the brass candleholders (the "branches" on the list) reflected in the two mirrors, the patterned carpets and fire screen, the warm browns of the mahogany tables and chairs, the bright glints of the glassware, and, looking down on it all, the familiar presences in those six family pictures. As a group, the six pictures formed the costliest item in the room, but individually they were each valued at about the same amount as the japanned and mahogany tables.[3] While they are each worth significantly more than the three "glazed pictures" —probably prints—which are listed along with a tea chest at just eighteen shillings, the Apthorps undoubtedly paid more than five pounds to commission each of the portraits and have them framed.[4] The portraits' valuation

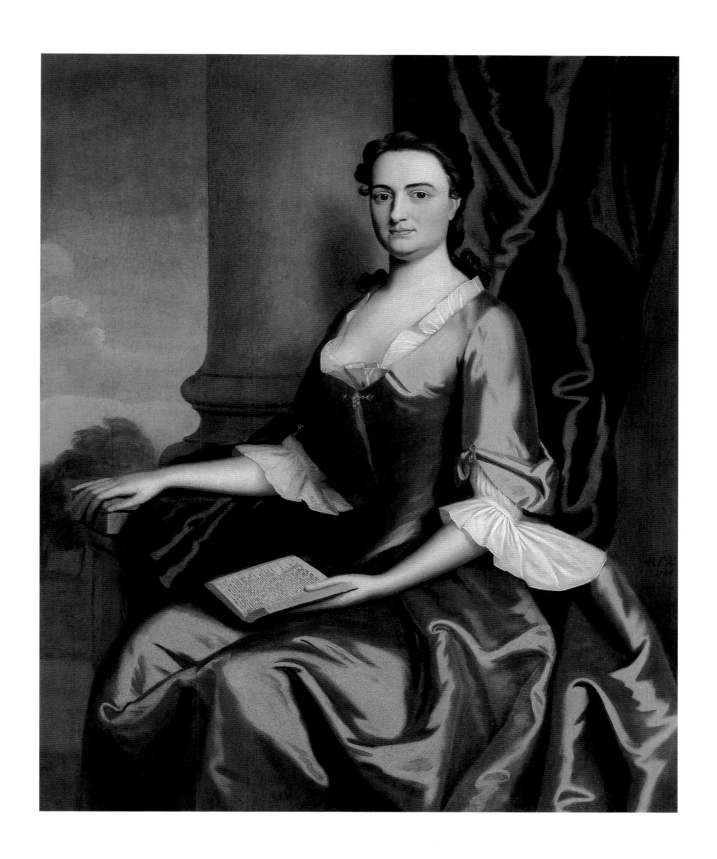

4. Robert Feke (ca. 1707–ca. 1752), *Mrs. Charles Apthorp*
 (Grizzell Eastwick Apthorp), 1748. Oil on canvas,
 49⅝ × 39¾ in. (124.4 × 99.5 cm). Gift of Mr. and
 Mrs. John D. Rockefeller 3rd, 1979.7.42

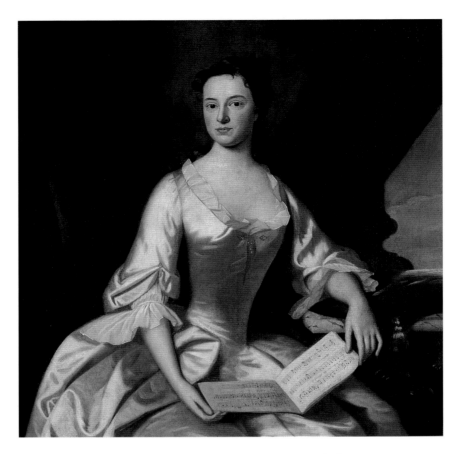

Fig. 4.1. Robert Feke (ca. 1707–ca. 1752), *Mrs. Barlow Trecothick*,
ca. 1748. Oil on canvas, 40⅞ × 40⅜ in. (103.8 × 102.4 cm).
The Roland P. Murdock Collection, Wichita Art Museum, M78.49

demonstrates the almost purely personal or familial worth of the paintings at this time, as there was no secondary market for portraits.[5] The inventory does not identify the "six family pictures" further, but they were almost certainly three portraits by Robert Feke (ca. 1707–ca. 1752) of Charles, Grizzell, and their second daughter, also named Grizzell, from 1748; and three portraits by Joseph Blackburn (active 1752–ca. 1778) of Charles and Grizzell from 1758, and of their eldest daughter, Susan, from 1757.[5] At roughly forty by fifty inches each (except for that of the younger Grizzell, which is a forty-inch square), the six paintings would have convincingly populated the room.[7]

Feke was one of the first American-born portraitists. Yet to identify him as an American painter is somewhat misleading; like many artists in the colonies at this time he turned to European mezzotints for poses, costumes, and settings for his portraits.[8] What training he had probably came from studying the portraits by British artists

that government officials brought with them.[9] His three portraits of the Apthorps are steeped, therefore, in British artistic styles and traditions. Like many painters in the American colonies, Blackburn was from Britain, coming to Newport, Rhode Island, via Bermuda in 1754; he returned to England in 1763.

Apthorp's wealth had allowed him to indulge his taste for fine furniture from England.[10] In fact, Apthorp's connections to Britain remained strong throughout his life. He sent several of his children there, returned a number of times himself, and made much of his fortune as the paymaster and commissary of the British army and navy in America. Even the sorrowful marble cherub who mourns on his funerary monument in Boston's King's Chapel was designed by a London artist, Henry Cheere.[11] Given their propensity for things British, therefore, it is not surprising that the Apthorps selected Blackburn for the portrait of Susan and for the second pair of portraits of themselves. (Indeed,

they had little choice, as there were few other accomplished portraitists: Feke was dead by this time, as was John Smibert.) It was not common to have more than one portrait of the same person painted. The Apthorps may commissioned the second pair of portraits because they wished to memorialize their old age, or perhaps because they desired paintings by a "real" English artist.

In her portrait by Feke, Mrs. Apthorp wears a dress with the sheen and rich color of copper. An opening to her left reveals a lawn, a tree, and an expanse of sky, which provides a coloristic counterpoint to the tumble of blue drapery behind her. Feke has worked to situate Mrs. Apthorp persuasively in the imaginary setting. The shadow of her head grazes the column next to her, her left arm and hand rest on the plinth supporting the column, and the landscape in the background is touched with the same coppery hue as her dress. Mrs. Apthorp holds a copy of John Milton's epic poem *Paradise Lost* on her lap. Colonial Americans had high regard for *Paradise Lost*, and the works of Milton were specifically recommended by contemporary conduct books as appropriate reading for young ladies.[12] Mrs. Apthorp apparently pauses as she reads Adam's panegyric of Eve:

> O fairest of Creation, last and best
> Of all God's Works, Creature in whom excell'd
> Whatever can to sight or thought be form'd
> Holy, divine, good, amiable, or sweet!
> . . . with thee
> Certain my resolution is to Die;
> How can I live without thee, how forgo
> Thy sweet converse and Love so dearly join'd
> To live again in these wild Woods forlorn?
> . . . no no, I feel
> The Link of Nature draw me: Flesh of Flesh,
> Bone of my Bone thou art, and from thy State
> Mine shall never be parted, bliss or woe.

By including the text in the portrait, Feke associates Eve's qualities with Mrs. Apthorp.[13]

In their four portraits, the three women adopt markedly similar postures: seated, one arm resting on a table, plinth, or other support, the other arm crossing the body with the hand in the lap, the torso turned slightly so one shoulder is out of view. In the case of the Feke portraits the resemblance between mother and daughter is particularly strong (fig. 4.1). Their matching steady, dark gazes and strong brows contribute to that resemblance, as do their dresses, which are virtually identical in design. They both hold books in their hands—daughter Grizzell's is a songbook; perhaps the "spinnett" that the inventory lists in the "great Parlour" was her instrument. When Mrs. Apthorp entered the Best Parlour she would have had the disorienting experience of seeing herself doubled six times—in the portraits by Blackburn and Feke, in the two mirrors, and, at one step removed, in the two portraits of her daughters: a dizzying visual replication. For the daughters—both either recently married or soon to be married at the time their respective portraits were painted—any identification with their "virtuous and amiable," not to mention astonishingly reproductively successful, mother would have been appropriate, indeed welcome.[14] With this striking intergenerational identification, Mrs. Apthorp again becomes Eve: a first mother who through her daughters and her daughters' daughters will populate the world, or at least the American colonies.

Tracing a family line through male descendants is a relatively easy task: the common last name forms the links of a chain that cinches the generations neatly together. Those men's sisters and daughters tend to scatter, however, as they marry, change their names, and become incorporated in their husbands' family lines. The three women in these portraits began life named Eastwick, Apthorp, and Apthorp, and ended it Apthorp, Trecothick, and Bulfinch. Yet by "returning" the portraits to the room in which they originally hung, we can gather some of the scattered links of the Apthorp family chain and appreciate the resemblances and identifications between mother and daughters that might otherwise go unnoticed. Although Grizzell and Susan left home and married, their portraits did not leave with them but stayed in their mother's possession until the end of her life. She died in 1796, age eighty-eight. [IB]

5. JOHN SINGLETON COPLEY, *Mrs. Daniel Sargent*

EASE PERSONIFIED, EFFORT EVINCED

Many years after Mary Sargent (1743–1813) sat for John Singleton Copley (1738–1815), one of her sons, Henry Sargent (1770–1845), recalled the stories she had told him about the experience.

> [Copley] painted a very beautiful head of my mother, who told me that she sat for him fifteen or sixteen times! Six hours at a time!! And that once she had been sitting to him for many hours, when he left the room for a few minutes, but requested that she would not move from her seat during his absence. She had the curiosity, however, to peep at the picture, and, to her astonishment, she found it all rubbed out.[1]

Henry Sargent was himself an accomplished artist, and his peppering of exclamation points makes clear that he considered excessive, even obsessive, the many hours Copley required to produce a portrait. Yet as Sargent's unauthorized discovery reveals, Copley was a perfectionist who needed a long time to work and rework his canvas, struggling through trial and error to achieve the precise result he wanted.

It is easy to imagine Sargent's tedium as she passed nearly one hundred hours in Copley's studio in 1763. Less easy to conjure fully, perhaps, is the physical difficulty of posing. Sargent was constrained in her posture both by the extensive, explicit rules of deportment for a lady of her class and by her corset stays and hoop, items of dress designed to help the wearer assume correct posture and appearance, but not intended for comfort. That posture was defined by the eighteenth-century dancing master P. Rameau: "The head must be held erect, without any suggestion of stiffness, the shoulders pressed well back.... The arms should hang at the sides ... the waist steady, the legs straight and the feet turned outwards."[2] Yet even as a lady donned the appropriate attire and managed her head, torso, and limbs correctly, it was essential that she exhibit no effort in the attainment of her perfect posture. "I hope that in guarding against defects no one will be so stupid as to appear stiff or awkward," Rameau cautioned.[3] An air of ease was as essential an element of correct attire as a tightly laced corset. However Sargent's clothes cut or chafed, however weary she became during those interminable hours in Copley's studio, there is no sense of discomfort or fatigue in the painting of her. Another eighteenth-century author writing about posture urged his readers, "Let us imagine ourselves as so many living Pictures drawn by the most excellent Masters, exquisitely designed to afford the utmost Pleasure to the beholders."[4] Sargent provides her beholders with exactly that: she has perfectly mastered an air of ease.

Copley painted Sargent in the year of her marriage to her cousin Daniel Sargent. She stands in front of a masonry wall, next to a fountain, a sliver of sky visible above her head. With her left hand she delicately gathers the skirt of her dress, perhaps to keep it from splashes of water from the fountain. With her right she holds a scallop shell under the water. The shell was a conventional attribute of Venus, goddess of love and beauty, and the fall of water was symbolic of purity and fertility. Turned at an angle to the viewer, Sargent gazes softly off to her right, her expression pleasant, relaxed, and unemotional. It is Sargent's dress that steals the show. Of a richly elaborated blue satin-weave silk, the dress (called a sack) indicated her new marital status.[5] With daubs, strokes, and dots of white, gray, and light blue paint,

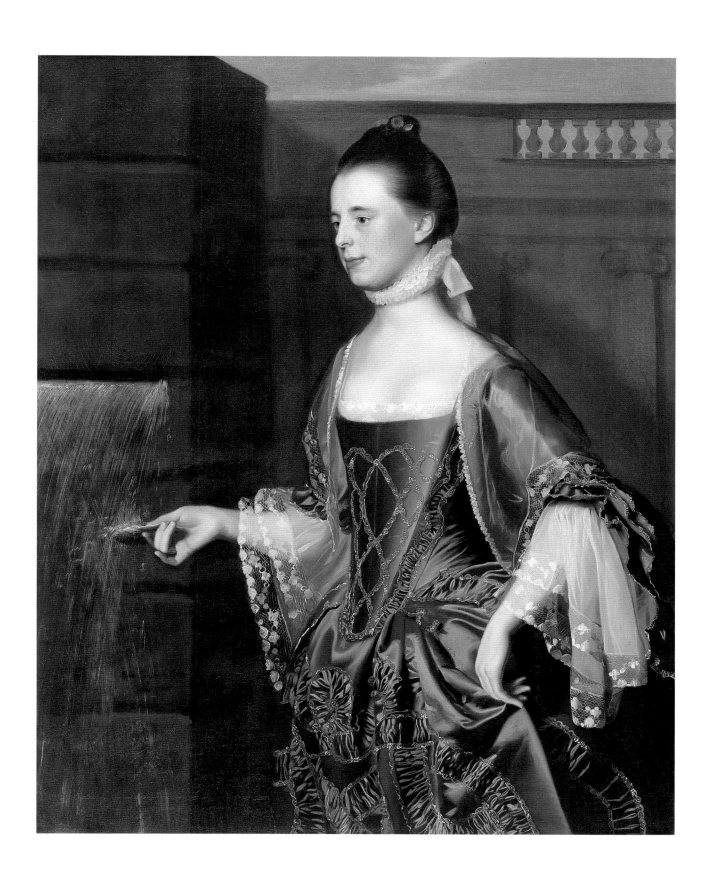

5. John Singleton Copley (1738–1815), *Mrs. Daniel Sargent*
(*Mary Turner*), 1763. Oil on canvas, 49½ × 39¼ in. (126 × 100 cm)
Gift of Mr. and Mrs. John D. Rockefeller 3rd, 1979.7.31

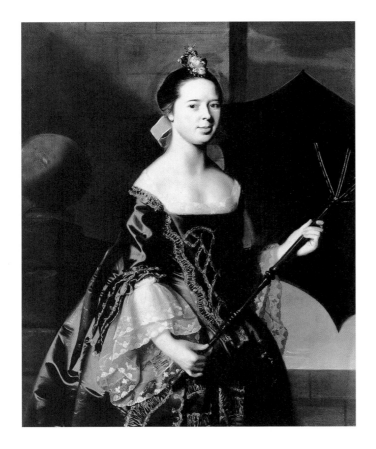

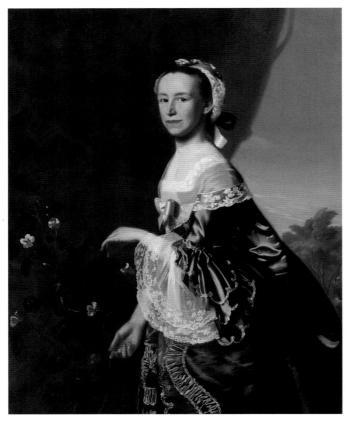

Copley has painstakingly delineated the folds and tucks of the ruching on her skirt and the intricacies of the French lace on her stomacher and sleeves.

Although he was able to capture Sargent's easy refinement, Copley was himself criticized for the obvious labor that went into his paintings. Benjamin West (1738–1820), an American artist who had immigrated to England and quickly became conversant in the British style of portraiture, wrote to Copley in 1766 with advice for improving his painting.[6] West counseled,

> At first sight the Picture struck the Eye as being to liney, which was judgd to have arose from there being so much neetness in the lines ... I very well know from endevouring at great Correctness in ones out line it is apt to Produce a Poverty in the look of ones work ... when ever great Desition [decision] is attended to they lines are apt to be to fine and edgey.[7]

By British standards, Copley's paint lacked the fluidity and softness necessary to create an appealing picture; his lines were too hard and decisive, his struggle to achieve "great Correctness" too apparent. Copley *was* a laborious painter. Copley himself wrote, "I find ... that [my portraits] are almost allways good in proportion to the time I give them provided I have a subject that is picturesk."[8] Numerous anecdotes recount sitters clamoring for overdue portraits and models complaining of long hours.[9] An observer reported that Copley used his palette knife to match a tone of paint with every part of the face, "whether in light, shadow, or reflection."[10]

Yet even after he received West's advice, Copley kept painting with "great Desition." His depiction of his American subjects and their finery satisfied his subjects, for they continued to commission portraits and recommend him to relatives and friends.[11] While on a trip to New York Copley reported, "It takes up much time to finish all the parts of a Picture when it is to be well finishd, and the Gentry of this

Fig. 5.1 [above left]. John Singleton Copley (1738–1815), *Mrs. Benjamin Pickman (Mary Toppan)*, 1763. Oil on canvas, 50 × 40 in. (127 × 101.6 cm). Yale University Art Gallery. Bequest of Edith Malvina K. Wetmore, 1966.79.3

Fig. 5.2 [left]. John Singleton Copley (1738–1815), *Mrs. James Warren (Mercy Otis)*, ca. 1763. Oil on canvas, 49⅝ × 39½ in. (126.1 × 100.3 cm). Museum of Fine Arts, Boston. Bequest of Winslow Warren, 31.212

place distinguish very well, so I must slight nothing."[12] The audience for Copley's portrait was—like the artist himself—highly attuned to nuances of costume and pose. The choice of a certain style of dress or the quality of lace edging a sleeve could have symbolic, cultural, social, or even political significance. Textiles and lace were markers of economic achievement; indicators of rank, age, and marital status; vital trade goods; signals of class and prerogative; and, during the Revolution, potent political symbols and the subject of boycotts.[13]

Copley's determination to "slight nothing" is evident in two other portraits from 1763. Both *Mrs. Benjamin Pickman* (fig. 5.1) and *Mrs. James Warren* (fig. 5.2) show signs of Copley's effort to get the portrait just right. Pickman's head is surrounded by a halo of reworked paint; beneath Warren's nasturtiums the painted-over blooms of a rose bush are still visible. These two portraits also reveal some of the complicated associations of fabric and dress in the colonial era: in these two portraits the women are wearing the same dress that Sargent wears in hers. Copley may have seen the dress in a print and, as he and other artists had done on many other occasions, decided in consultation with the sitter to copy it for the painting.[14] But the blue silk sack is shown from a different angle in each portrait, precluding the possibility that it was simply copied from an existing picture. British artists kept a wardrobe of dresses in their studios for their sitters to wear in their portraits; perhaps the dress was a studio prop of Copley's. Yet the dress, specifically the lace on the dress, would have been extremely expensive—well

beyond the means of a twenty-five-year-old artist.[15] One convincing explanation for these women's decision to be portrayed in the same dress is the connecting lines of residential proximity, shared political action, university attendance, friendship, and distant kinship that existed between these women, their husbands, and their extended families.[16] The dress could have been given or lent as a marker of these affinities and connections, a statement of affection and respect. The appearance of the dress in the three portraits made these connections visible for those who visited the women's homes.

As we read the complaints of Copley's impatient sitters or study the evidence in his portraits, we can appreciate the effort that went into the production of the paintings. We see the beautifully rendered silks and laces and marvel at the artist's skill and work. But there are other elements that Copley wove into the portrait that are harder to identify from our temporal perch precisely because he has included them in the paintings with such ease and with such an apparent lack of effort: literary references, the acknowledgment of certain cultural and social tropes, the inclusion of the forms of deference and propriety, and—as in the case of Sargent, Pickman, and Warren—the nuanced connections between individuals and families. Just as Sargent is able to adopt an air of ease despite her discomfort in posing, Copley's ease in seamlessly combining the disparate elements of the portrait hides the complexities of the portrait-making project and reveals him to be an even more skillful artist than we imagined.[17] [IB]

6. JOHN SINGLETON COPLEY, *William Vassall and His Son Leonard*

PATERNAL EDUCATION

In September 1765 John Singleton Copley (1738–1815) sent a package to London. The package contained a painting he had made of his half brother Henry Pelham with a pet flying squirrel (fig. 6.1). Copley was a young but highly accomplished artist, and he was anxious to learn how his work would fare under the scrutiny of England's finest portraitists. Like all colonial American artists, he had had to piece together his artistic training—there were no art schools to provide instruction and few artists to pass on knowledge. But he was more fortunate than many: when he was ten, his widowed mother married Peter Pelham (1695–1751), an engraver and teacher. In the few years before he died, Pelham taught his young stepson the art of making mezzotints.

In August 1766 news of *Boy with a Squirrel* finally came. Sir Joshua Reynolds (1723–1792) declared that "it was a very wonderfull Performance."[1] More helpful to Copley, although less flattering, was the constructive criticism he received from Benjamin West (1738–1820), a Philadelphia artist who had immigrated to London. In his letter, West urged Copley to come to Europe for three or four years of study of the great masters and to send another painting showing "two in one Piece," that is, with two figures in it.[2]

Copley's eagerness to learn is palpable in his response. His letter is a tumble of questions: What does West think of the use of pastels? How does West interpret Count Algarotti's text on painting? What is the present state of painting in Italy? Despite his enthusiasm, Copley begged off sending a two-figure painting—the days were short and cold, he complained, and he was distracted by other projects.[3] To paint two figures in convincing physical and psychological relation is an artistic task significantly harder than painting

a single figure, and Copley, never a fast worker, realized he did not have enough time to meet the challenge.

A few years later, however, he did create such a painting, this portrait of William Vassall (1715–1800) and his son Leonard (1764–1860). Vassall is seated, legs crossed, right hand tucked into his waistcoat, left arm resting on the back of a chair. He wears a simple brown suit. Leonard stands to his father's left, gesturing to an open page in the book he is holding. He gazes up at his father, who, instead of meeting his son's eye, looks at the viewer. Copley has placed the two figures in an interior space defined by a plain, dark cloth that hangs behind Vassall. He has carefully delineated such details as the polished circles of Leonard's metal buttons, the smooth silk of Vassall's stockings, and the dusting of wig powder on his shoulders.

Copley has picked out the reflection of Vassall's hand and shirt cuff in Leonard's shiny buttons, yet the two figures' spatial relationship remains confusing. Vassall's left hand is too bright, which makes it appear to project in front of Leonard who should, by the logic of the painting, be standing in front of it. "Two in one Piece" was hard indeed. Copley was notorious for the number of sittings he required, and it has been hypothesized that Vassall and Leonard posed separately.[4] Separate sittings would help explain the lack of any convincing sense of personal connection between the father and son. Indeed, the painting may originally have been conceived as a portrait of Vassall alone.[5]

The uncluttered setting of the portrait and Vassall's somber suit may have surprised contemporaneous viewers: Vassall, whose wealth came from his family's Jamaican plantations, was known for his elegant lifestyle. He lived in

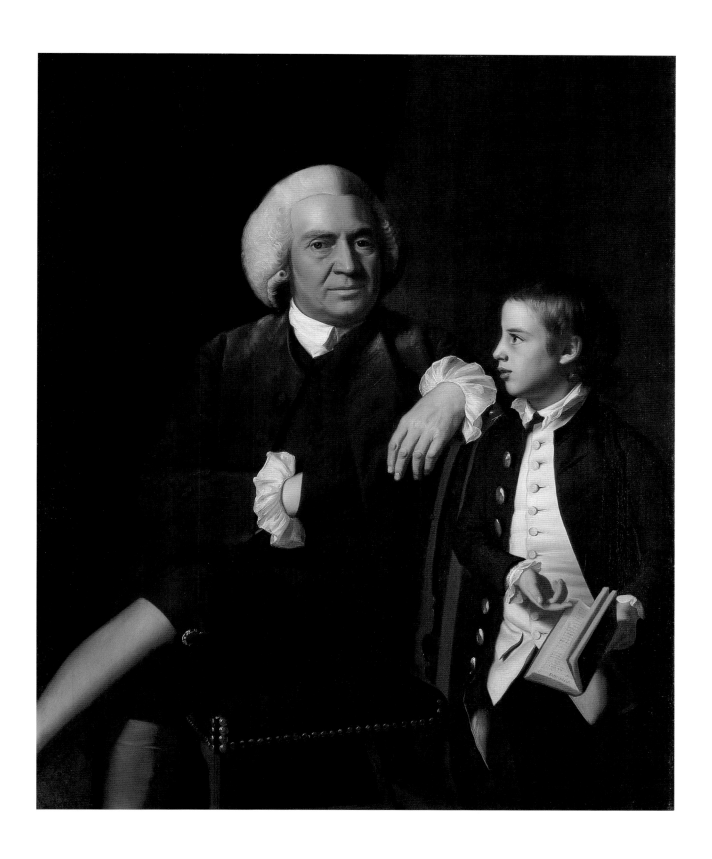

6. John Singleton Copley (1738–1815), *William
Vassall and His Son Leonard*, ca. 1770–72
Oil on canvas, 49⅛ × 40⅜ in. (126.4 × 102.6 cm)
Gift of Mr. and Mrs. John D. Rockefeller 3rd, 1979.7.30

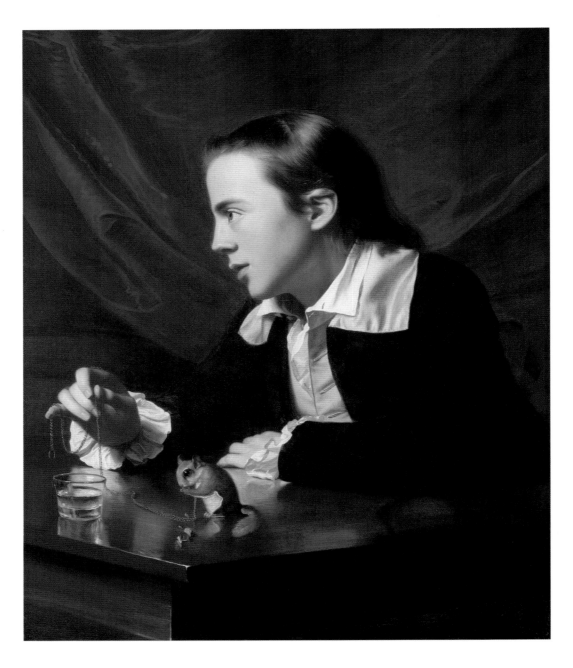

a mansion with terraced gardens and owned one of Boston's few carriages, emblazoned with his coat of arms. In addition to having expensive tastes, Vassall was a gambler. He had no occupation and shirked public service. He was quick to bring any grievance, no matter how slight, before the courts.

Vassal was not universally disliked: John Adams described him as "a man of letters and virtues, without one vice that I ever knew or suspected, except garrulity."[6] Yet as the political climate grew more charged and talk of rebellion filled the air, Vassall's courtly tastes may have inclined the Sons of Liberty against him. Vassall later strenuously (and self-servingly) claimed that he was neutral during the revolution, yet at the time his wealth, equipage, love of cards, and failure to pursue a career associated him with the luxuries and frivolities of monarchy. In 1774 he and his family fled Boston for Rhode Island, and in 1775 they sailed for London. As was his wont, Vassall began a long and ultimately unsuccessful legal battle to have his confiscated property returned to him.

Did William Vassall have a premonition of these events when he sat for Copley sometime between 1770 and 1772?

Did he sniff the political winds, decide to bolster his reputation, and choose portraiture as the means to accomplish that goal?[7] About 1770 Copley was painting the likenesses of some very prominent Whigs, among them Paul Revere, Samuel Adams, and John Hancock. Perhaps Vassall hoped to associate himself with them through his choice of portraitist. Yet Copley was also painting high Tories, including General Thomas Gage, who was commander of the British forces in North America when he sat, and James Gambier, a captain in the Royal Navy.[8] The simple attire Vassall chose for his portrait can be seen as an attempt to downplay his fancy airs and appear steadier, more serious. Or he may have been following the prevailing trend among men in the early 1770s in choosing darker, more sober garb and settings for their portraits.

One element in the portrait strongly suggests that Vassall was indeed trying to improve his standing in the increasingly fractured community: his son. As already noted, Leonard's inclusion is awkward; the portrait would be complete and balanced without him. He functions not as an individual but as an attribute of his father.[9] His position on the canvas, his appeal for his father's attention, and the fact that he presents his profile to the viewer—limiting both the legibility and the impact of his likeness—all contribute to that function. Yet with the inclusion of Leonard, Vassall is able to present himself as benevolently paternal.[10]

John Locke's *Some Thoughts Concerning Education* (1693) was enormously influential in both England and the American colonies in the eighteenth century. According to Locke, the role of parents is to provide the education and experiences necessary to shape their children's character. A growing understanding of childhood as a distinctive stage of life helped foster a more egalitarian relationship between parents and children and an increasing appreciation for the importance of the transition into adulthood. Indeed, parents' prime responsibility, according to the new theories of child rearing, was to raise their children to become morally self-sufficient and independent. Those ideas were seized on by American revolutionaries who insisted that the colonists as a people had come of age and therefore, by necessity, should be allowed to advance into full adulthood, independent of Mother England.[11]

In his portrait, Vassall presents himself as a Lockean parent.[12] Leonard seeks his father's help with a book he is studying, allowing Vassall to demonstrate his concern for his child's education and therefore for the development of his character. He is preparing Leonard for his independence. Vassall's outward gaze undermines this narrative somewhat, however, as we feel he is eyeing us to make sure we get the point. While Vassall may not have gone so far as to claim with the rebels that the colonies should be freed from an unnaturally protracted adolescence, the portrait does not in any way foreclose that interpretation. It is a portrait of a quietly serious, caring parent, not Billy Vassall, dandified gambler. It is a portrait of professed, if not felt, neutrality.

Copley himself struggled to maintain a neutral stance during the early 1770s. He complained in a letter to Benjamin West, "The Party spirit is so high, that what ever compliments the leaders of either party is looked on as a tassit disppropriation of those of the other. . . . I am desirous of avoiding every imputation of party spirit."[13] As one who repeatedly complimented both Tories and Whigs in his depictions of them, Copley's position was difficult indeed. Meanwhile, Copley's father-in-law, Richard Clarke, the Massachusetts consignee for the British East India Company, was coming under attack for profiting from trade with Britain at the expense of the colonists: it was his tea that was dumped into the harbor during the Boston Tea Party. In 1774 Copley sailed for London, followed in 1775 by his family. It might appear that Copley, his own father and stepfather dead, was now treading the political path laid by his father-in-law. But in going to London Copley was not declaring himself a loyalist; rather, he was at last following his decade-old dream. Copley went to England, not to demonstrate allegiance to the crown, but to learn from his artistic forefathers. [IB]

Fig. 6.1 [facing]. John Singleton Copley (1738–1815), *Henry Pelham (Boy with a Squirrel)*, 1765. Oil on canvas, 30⅜ × 25⅛ in. (77.2 × 63.8 cm). Museum of Fine Arts, Boston. Gift of the artist's great-granddaughter, 1978.297

7. CHARLES WILLSON PEALE, *Mordecai Gist*

CAPTAIN OF HIS FATE

*Though it be allowed that elaborate harmony of colouring, a brilliancy of tints,
a soft and gradual transition from one to another, present to the eye, what an
harmonious concert of musick does to the ear, it must be remembered, that painting
is not merely gratification of the sight.* SIR JOSHUA REYNOLDS, from *Discourse IV*[1]

More than any other artist in colonial America, Charles Willson Peale (1741–1827) represented the eighteenth-century spirit of the Enlightenment, with its interest in scientific inquiry, rational philosophy, objective description, pragmatic skills, and artistic expression.[2] He was a scientist, inventor, soldier, politician, artist, and founder of the country's first natural history museum in 1786 and its first art school, the Pennsylvania Academy of the Fine Arts, in 1805.[3] Just one consequence of his many creative talents was the invention of porcelain dentures.[4] He has been called "a kind of down-home American Leonardo."[5] The father of eleven surviving children and primary provider for many nieces and nephews, Peale founded a hundred-year dynasty of artists and museum professionals in Philadelphia that remains extraordinary in American art.[6]

Peale initially apprenticed with John Singleton Copley (1738–1815) in Boston, and earlier art historians often confused the work of the two artists.[7] He grew up in Maryland, and a group of prominent Baltimore citizens, recognizing his artistic talent and hoping to cultivate it so that they would have a skilled artist to paint their portraits, sent Peale to London to study from 1767 to 1769 at the newly formed Royal Academy of Arts with America's most influential painter at the time, the expatriate Benjamin West (1738–1820). *Mordecai Gist* (ca. 1774) was painted shortly after Peale's return from London and reflects his training there.[8] Under the influence of Sir Joshua Reynolds (1723–1792), the Royal Academy's first president, English portraiture emphasized the grand effect associated with history painting

over the psychological makeup of the sitter.[9] Nevertheless, Peale registers the character of Gist in the luminous tones of his face, which stands out from a canvas that is organized as an arrangement of brown hues. Consistent with his prominent place in society as the son of Thomas Gist, a wealthy sea captain from a well-established Baltimore family, the sitter's direct, assured gaze and self-confident pose reinforce the viewer's impression that the man represented here is exactly who he was meant to be.[10] The jaunty angle of his ornate and fashionable three-cornered hat suggests a personality that is slightly playful yet sensibly sincere, as befits a dashing, thirty-one-year-old colonial businessman.[11]

Mordecai Gist demonstrates the strong impact of Reynolds in Peale's training. From his early study of antiquity and Renaissance art in Rome, Reynolds advocated a return to classical models, developing a style of painting known as the "grand manner" in a series of famous theoretical *Discourses*, which he delivered as lectures at the Academy.[12] In Reynolds's formulation, painting in the grand manner elevates history painting by rendering heroic figures within idealized settings and subordinating specific elements to the "effect of grandeur" attained by the uniformity of the whole: "perfect form is produced by leaving out particularities, and retaining only general ideas."[13]

Applying these principles to portraiture, Reynolds raised it to the status of history painting, becoming the greatest portraitist in residence at the Academy. He used classical themes and props to establish his sitters within the context of a noble and illustrious past, as in his portrait *Admiral*

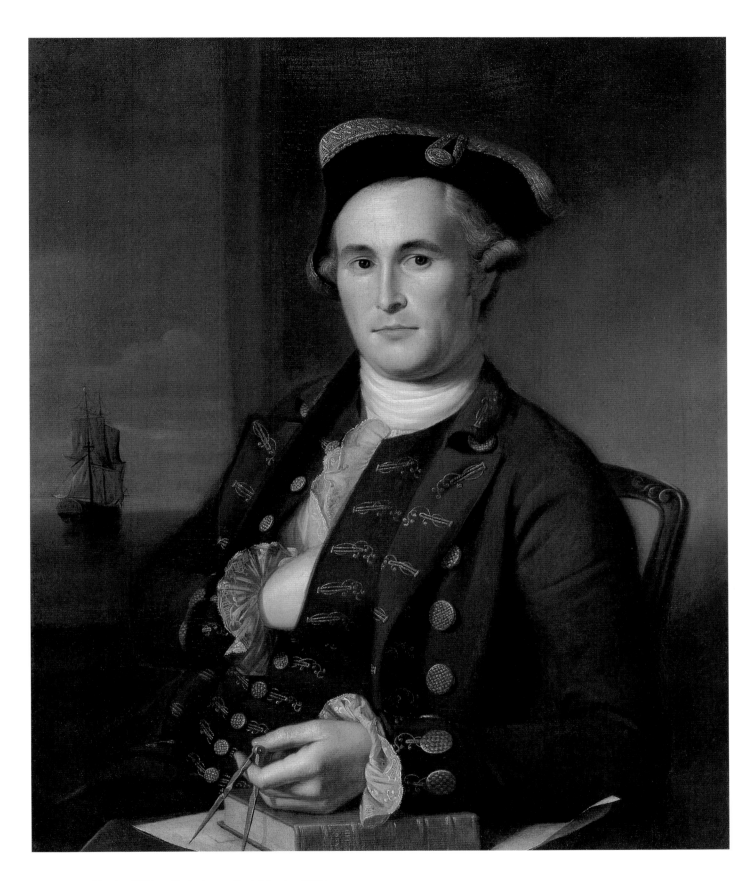

7. Charles Willson Peale (1741–1827), *Mordecai Gist,*
 ca. 1774. Oil on canvas, 29¾ × 24¾ in. (75.6 × 62.9 cm)
 Gift of Mr. and Mrs. John D. Rockefeller 3rd, 1979.7.79

Fig. 7.1. Sir Joshua Reynolds (1723–1792), *Admiral Sir Robert Kingsmill*, 1764 or 1766. Oil on canvas, 29½ × 24½ in. (74.9 × 62.2 cm). Tate Gallery, London

Sir Robert Kingsmill (fig. 7.1). Reynolds locates his subject within a long line of seafaring heroes through the military costume and the battleship under sail in the background. In addition, his debt to the techniques of Renaissance old masters is evident in the use of chiaroscuro to highlight Sir Robert's face and of underpainting to create an impression of dimensionality.

Mordecai Gist illustrates Peale's adoption of Reynolds's technique for building up the figure in the classical man-ner, especially apparent today in the green underpainting, used to create the lifelike modeling of flesh, that shows through the skin tones.[14] The composition, too, appears in-debted to Reynolds's principles of the generalized ideal, as seen in *Admiral Sir Robert Kingsmill*. Each painting pre-sents its sitter in a three-quarter pose in front of a view to the distance with its symbolic vessel. The faces in both portraits are rendered convincingly, but their recognizable costumes convey a formal dignity and lofty purpose that transcend

the accurate rendering of their features. By appropriating these conventions of aristocratic portraiture from Reynolds, Peale ingeniously links Gist's membership in Baltimore's mercantile and entrepreneurial elite to the privileged status of England's titled class.[15]

Peale loads the painting with the signs of Gist's commercial venture: dividers, chart, and a copy of Euclid's *Geometry*. His hand rests on the book and holds the dividers with an easy elegance, suggesting a comfortable acquaintance with these tools as well as the cultivated grace of aristocratic portraiture. Similarly, Gist's hat, coat, and vest, with their ornate buttons and abundant accents of embroidery, provide a refined pattern of reflective gold that not so subtly signals Gist's riches without placing him in an ostentatious setting that might carry the negative association of unmerited wealth. Referencing his mercantile prosperity as a function of hard work lends his economic status the appearance of inevitability, supporting the belief that his class privilege is a natural fact. Gold thus serves several interlocking metaphoric purposes as a sign of Gist's status. It signals his mastery on the seas and its financial rewards; it links him to depictions of English aristocracy; and it alludes to his suitability as a subject worthy of portraiture by calling attention to the effects of paint on the material surface of the canvas.

Although Gist is seated indoors at his writing desk, the props indicate that his true calling is not the bourgeois activities of his business but the more heroic adventures that beckon him as captain of the ship waiting in the distance. Consistent with Reynolds's teaching, Peale also references Renaissance portraits in these objects, which were used to signify the valiant travels of European explorers and the role of science in discovering and mapping out a new understanding of the world. Drawing the viewer's gaze out the window into the larger world of commerce, where Gist's tools have their practical uses, his vessel appears to be sailing into a rosy light. Viewers would have perceived in this painting the popular metaphor of the ship of state, which links Gist's own fortunes to those of the nation more generally. The painting offers Gist as objective evidence for the Jeffersonian notion of "meritocracy," which disguised class privilege by holding that those who deserved to lead the country would rise to do so on the strength of their talents and abilities.

Peale returned from London on the eve of the American Revolution just as Copley, a loyalist, was departing to live the remainder of his life in England. The thirty-three-year-old Peale thus found himself the leading portrait painter of the emerging nation, and his name quickly became nearly synonymous with Philadelphia, the capital of revolutionary political events.[16] He was commissioned to paint the first portrait of General George Washington, which came to serve as the icon to represent the new Republic during diplomatic negotiations, and went on to produce an entire portrait series of Revolutionary War leaders that he called "The Gallery of Great Men."[17] Peale installed these portraits in his Philadelphia Museum, where science, technology, and the arts were presented in a thematic and rational scheme meant to educate.[18] It included his famous display of a nearly complete mastodon skeleton, whose exhumation he had directed in 1805.[19]

The portrait of Mordecai Gist, one of two the artist is known to have painted, anticipates Peale's interest in military leaders.[20] At the time of this portrait, Gist was a member of the Baltimore Independent Cadets, a voluntary military group preparing for the approaching war for independence.[21] He would become a general, earning fame as an officer in the Maryland Regiment, usually considered one of the two best in Washington's Revolutionary army,[22] and serving in the key campaigns of Trenton, Princeton, and Valley Forge. After the war he settled near Charleston, South Carolina. [DC]

8. CHARLES WILLSON PEALE, *Self-Portrait*

WITH AN EYE ON LEGACY

When Charles Willson Peale (1741–1827) decided to try his hand at painting in 1764, he looked through his window and in the mirror to find his first subjects. Neither the surrounding landscape nor the reflected sitter will protest the tedium of posing for an inexperienced, uncertain painter, and the painter is spared any embarrassment if the picture proves unsuccessful. With a confidence and gusto that would characterize most of his endeavors, Peale quickly moved from the landscape to his self-portrait, to a painting of his wife, then to likenesses of his siblings, next to a portrait of a friend named Isaac Harris, until one Captain Maybury paid him ten pounds "to draw his and his Lady's portraits."[1]

In that first self-portrait, the pieces of a disassembled clock are scattered in front of Peale, a reference to one of the many other careers (coach building, saddlery, silversmithing, and clock making among them) that he was considering before he turned to painting. Peale's fascination for mechanical things, for invention and experiment continued throughout his life. In addition to becoming an accomplished portraitist, he was a natural scientist, a taxidermist, a dentist, and a farmer. Most significantly, he founded and ran one of America's first museums, the most important one of its era. The museum exhibits included portraits of notable men, specimens of preserved animals displayed against painted backdrops showing their natural habitats, Native American artifacts, and the skeleton of an ancient mastodon, which he had exhumed from a field in New York.

Peale painted nearly twenty self-portraits during his long career. One small self-portrait (1765, unlocated)—which he made because he found himself with nothing to do—proved an excellent advertisement of his services. As he described in his autobiography, "This [self-portrait] being

seen got him the portraits of three children of a wealthy merchant to paint."[2] On another occasion Peale had prepared a loaded palette for a sitter who did not arrive. With colors at the ready and time on his hands, he painted a portrait of himself instead and "in less than two hours made a striking likeness."[3] However, while the making of these two portraits simply served to fill some idle hours, in many of Peale's other self-portraits there is a palpable sense that he was thinking specifically of his legacy and future reputation as he painted them.

A small image, just six by five and a half inches, shows the artist in a brown militiaman's uniform with a captain's gold braid on his hat (1777–78, American Philosophical Society, Philadelphia). Peale, an ardent Whig who was proud of his military service with General George Washington, probably wished to memorialize his participation in the Revolutionary War. Perhaps he also imagined painting a larger work from the little canvas after the war was over to better commemorate his service.[4] In a self-portrait with his young daughter Angelica from the early 1780s (The Museum of Fine Arts, Houston), Peale demonstrated a gentler, sweeter side of this desire to establish his legacy. In it, he sits with paintbrush in hand before an unfinished portrait of his wife. Angelica grasps the handle of the brush while smiling mischievously at the viewer. Peale seems to be taking delight in this impish little girl's artistic skill—when she was grown she was said to be a good painter—as she literally and figuratively takes over his brush.[5]

But Peale's interest in his legacy is clearest in the self-portraits that he made at the end of his life. In 1821 his third wife died of yellow fever. He too was stricken and, although he recovered, Peale began to make preparations for the end

8. Charles Willson Peale (1741–1827), *Self-Portrait*, 1822
 Oil on canvas, 29¼ × 24⅛ in. (74.3 × 61.3 cm)
 Gift of Mr. and Mrs. John D. Rockefeller 3rd, 1993.35.22

of his life: he distributed family portraits that he had in his possession; he worked to finalize the incorporation of his museum; and, over the next several years, he made six self-portraits and wrote his autobiography.[6] It might be expected that the self-portraits of a man at the end of his life would document the creeping ravages of time—in both depiction and execution there would be evidence of slipping faculties and eroded skill. But Peale's portraits suggest no such declension. He appears vigorous, even youthful. One biographer remarked that because Peale was "always young in countenance and conservative in dress, the dating of [the self-portraits] becomes little more than study of the recession of the hair line."[7] Rather than encroaching death, the subject of these portraits is undiminished strength. In particular, Peale celebrates his power of sight: the sharpness of his scientific eye, the sensitivity of his artistic eye, and his continuing ability to deceive the eyes of others.

In 1822 Peale painted this portrait of himself for his daughter Sophie.[8] The portrait shows the artist, palette and brushes in hand, against a plain ground. Peale's halo of silver hair, the fluttering white collar of his shirt, and his thumb protruding through the hole in the palette stand out strongly from the dark background and his black coat. The red, yellow, and blue daubs and the spectrum of mixed paint on the palette provide the portrait's only bright notes of color. With the palette Peale is able both to introduce a witty trompe-l'oeil element and to reference chromatics and the art of color mixing. The mixed paint ranges from forest green to dark brownish red. There is a dab of the same red paint on the edge of the palette, as if Peale had wiped the excess paint off his brush when he had finished mixing. The dab puts a period on the end of the mixed-color sentence: "There, *that* is how it's done." Meanwhile, the reduction of color to the three primaries on the palette suggests that the portrait itself reduces the artist to his essential character. Peale depicts himself without ostentation, beyond affectation, a good old Whig of the Benjamin Franklin ilk. At the same time, his gaze is a little unnerving in its intensity. The impression by turns is one of skepticism and possible disapproval (created by the slight arch of his eyebrows and pinch of his lips) and one of frankness and objectivity, the gaze of the scientist appraising his subject.

Peale made another version of the portrait with his body inflected the opposite way for his son Rubens and exhibited both of them at the Pennsylvania Academy of the Fine Arts.[9] The paintings were described in the accompanying catalogue, at a time when life expectancy hovered around forty, as "painted by the artist in his 81st year of his age without spectacles, 1822."[10] About 1804 Peale had painted a portrait of himself with a pair of glasses pushed up on his forehead (Pennsylvania Academy of the Fine Arts), perhaps to demonstrate that, despite his advancing age, he could paint without them.[11] Some twenty years later, in these two paintings for his children, Peale makes a more pointed reference to the acuity of his vision and, in the sharp discernment of his gaze as depicted in the paintings, to the acuity of his mind also.

Certainly Peale's most obvious attempt to commemorate his legacy is *The Artist in His Museum* (1822, Pennnsylvania Academy of the Fine Arts), which shows him theatrically lifting a curtain on the exhibits he created. This portrait counters the unpretentious impression that Peale had created in the portraits for Sophie and Rubens. Peale looms large—the canvas is more than eight feet tall and he positioned himself in the foreground, an impressive presence. He gestures with one hand while he raises the curtain, inviting the viewer to study the exhibits and thus see through his eyes as he rationalized nature's profusion.

One of Peale's last self-portraits shows him walking down a staircase, a reference to his advanced age and approaching death.[12] At the top, his painting room is visible with a portrait of his wife and daughter from 1771 visible on an easel. The painting was powerfully illusionistic, and Peale was delighted when viewers were fooled into thinking that the staircase was real. Peale measured the success of a portrait by how accurately it captured its subject. "If a painter . . . paints a portrait in such perfection as to produce a perfect illusion of sight," he declared in his autobiography, "in such perfection that the spectator believes the real person is there, that happy Painter will deserve to be carressed by the greatest mortal beings."[13] To deceive the eye, to fool the rational observer, was the portraitist's greatest accomplishment. In the *Staircase Self-Portrait*, Peale demonstrated his unwavering power to do so.

A desire to memorialize his achievements, sentiment, an interest in displaying his skill and vigor, a wish to commemorate his place in American culture, the satisfaction of exerting his powers of illusion: all persuaded Peale to look in the mirror and pick up his brush at different times in his life. Peale's legacy—that is, how others would see him and his accomplishments—became bound up with how Peale saw the world, particularly in the late self-portraits. His painting for Sophie suggests he saw with a particularly discerning and intelligent eye. [IB]

9. JOSEPH WRIGHT, *John Coats Browne*

INTERNATIONAL SOURCES FOR AN IMAGE OF AMERICAN BOYHOOD

John Coats Browne (1774–1832) regards us tentatively from Joseph Wright's portrait (ca. 1784). The boy's wide-set eyes and slightly pinched mouth give him an uncertain air. The rest of the portrait, however, belies any impression of timidity. Browne stands with jaunty confidence—hip casually thrust out, arm akimbo, feet positioned at a rakish angle. Behind him a large column rises from a hefty plinth. A length of drapery—raspberry colored and fringed in gold—falls and twists behind him, creating a dynamic diagonal and providing competing coloristic sizzle for Browne's orange coat and a contrasting note to the vertical of his blue suit. The complementary colors of the coat and suit further enliven the coloration of the painting.[1] Browne's dark hair and eyes and his black kerchief, hat, and shoes fall into an alternating rhythm with his white collar, cuffs, and stockings, the white feather on his hat, and the reflective silver buckles on his shoes.

Joseph Wright (1756–1793) was unusually well traveled for an eighteenth-century American. Born in Bordentown, New Jersey, he was educated in Philadelphia. His mother, Patience Wright (1725–1786), was an artist who made wax portraits. She moved to England and Joseph followed her there in 1773, becoming the first American artist to enroll at the Royal Academy of Arts, in London. Patience Wright was an ardent and outspoken supporter of the American Revolution and a sometime spy for the cause, yet was able to achieve great success with her art in London, counting King George III and Queen Charlotte among her clients.[2] In 1781 Joseph Wright journeyed to Paris to capture Benjamin Franklin's likeness, anticipating the great demand

there would be for his image in America. In 1783, the war over, Wright returned to Philadelphia and then followed the new United States government as it moved between that city and New York. He went to Mount Vernon to paint George Washington and make a life mask. Wright also made a plaster relief of Washington, showing him in profile, crowned with a laurel wreath.[3]

Wright painted Browne shortly after returning to the United States from France. Browne wears the breeches, vest, and long jacket of a schoolboy from a well-to-do family.[4] Browne's father was a prosperous ironmonger who had rejected his Quaker upbringing in order to bear arms during the American Revolution. Browne followed in his father's profession and later became the first president of Kensington Bank.[5] While Browne's attire identifies him as a late-eighteenth-century student—a common sight on the streets of Philadelphia—both his posture and the portrait's setting connect him with far-removed people and places.

Wright borrowed Browne's self-assured pose from *Blue Boy* (1770, fig. 9.1) by the British painter Thomas Gainsborough (1727–1788). Gainsborough sought to educate himself about art by studying the works of the Flemish artist Anthony Van Dyck (1599–1641) that he found in public and private British collections. *Blue Boy*'s pose and costume are an homage to Van Dyck; similar poses can be seen, for instance, in Van Dyck's painting of the Villiers brothers (1635, Windsor Castle, Royal Collection), who stand in a similar, easy contrapposto.[6] Even though *Blue Boy* was not exhibited while Wright was in London and was not engraved until 1821, Wright could have seen the painting when he was

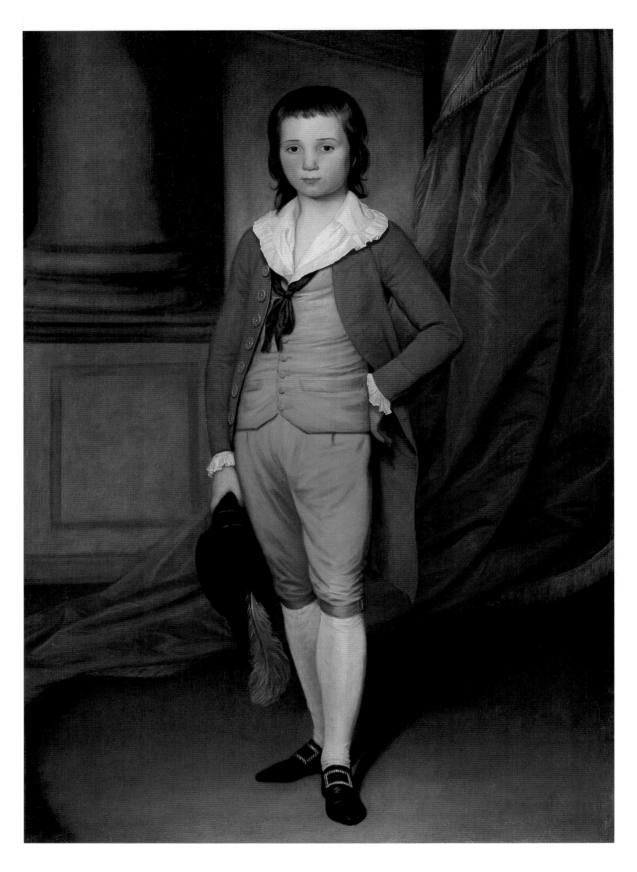

9. Joseph Wright (1756–1793), *John Coats Browne*, ca. 1784
Oil on canvas, 61⅜ × 42⅞ in. (155.9 × 108.9 cm)
Gift of Mr. and Mrs. John D. Rockefeller 3rd, 1979.7.107

in England. The model for *Blue Boy* was another iron-monger's son, Jonathan Buttall, and the Buttalls' home was close to Patience Wright's. That proximity may have helped Joseph to secure an invitation to see the painting which had won Gainsborough much praise in the Royal Academy exhibition in 1770.[7]

When Wright received the commission to paint John Coats Browne, he may have kept mum about his source, "stealing" the pose and composition of *Blue Boy* to enhance his own work. Or he may have described the famous London portrait to Browne's father and suggested that the portrait of his son would benefit from the visual quotation. There was, after all, a long tradition of American artists garnering postures, props, costumes, and settings from British portraits. Such borrowings had made architectural elements like the large column in *John Coats Browne* commonplace in American portraiture, even though they were rare in actual American homes. These architectural elements provided fitting settings for distinguished gentlemen such as John Nelson (pl. 2), formidable women such as Mrs. Charles Apthorp (pl. 4), or brides clad in sumptuous finery like Mrs. Daniel Sargent (pl. 5). Young John Browne is neither distinguished nor formidable, and his schoolboy suit makes it clear he is no artistocrat. Yet, with his jaunty pose, he confidently inhabits his surroundings.

Indeed, Wright has chosen a very different setting for his ironmonger's son than Gainsborough chose for his. With that change in setting, as well as alterations to the boy's costume, Wright tailored the portrait for an American sensibility. Jonathan Buttall stands in a natural setting on uneven ground, a thicket of trees behind him, and a glowering sky above. His suit of clothes, while blue like Browne's vest and breeches, is of shiny silk, edged with silver. Gainsborough's depiction of its soft sheen adds notes of small drama to an already striking image. The color contrast in the Gainsborough portrait comes from the dull orangish brown of the background setting off the shimmering blue figure of the boy.

The differences in Wright's portrait—the dignified, interior space; the simpler clothes; the quieter tone—can be attributed in part to the influence of neoclassical art with its high-minded seriousness, sober rationality, and noble, often heroic, figures. Wright was acquainted with the American artist Benjamin West (1738–1820) who lived in London, and he may have seen some of West's numerous paintings depicting events from classical history and myth.[8] In the measured language of Neoclassicism, resonant as it

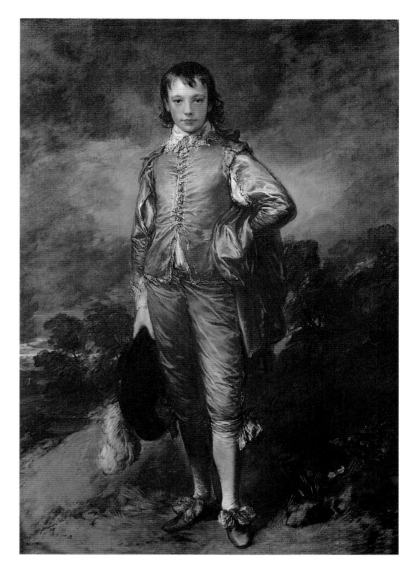

Fig. 9.1. Thomas Gainsborough (1727–1788), *Jonathan Buttall*, known as *Blue Boy*, ca. 1770. Oil on canvas, 70 × 48 in. (177.8 × 122 cm). Henry E. Huntington Art Gallery, San Marino, California

was with references to ancient Greece and Rome, many Americans found an appropriate style for a burgeoning democracy. Thomas Jefferson designed his home, Monticello, in a neoclassical style, and it became the dominant architectural language for the nation's new capital. Wright himself included a classical symbol of victory, the laurel wreath, in his plaster relief of Washington. Wright also may have had the chance to see neoclassical paintings in Paris. In the early 1780s the French were on the verge of their own uprising against monarchy and, later, in the hands of Jacques-Louis David (1748–1825), Neoclassicism became a powerful means to communicate political ideals.

John Coats Browne is a painting of an American boy, adopting a posture from a British painting, itself inspired by the work of a Flemish artist, and depicted with classically derived elements. In the period before the American Revolution, each person's identity as American, British, or both was open and shifting. Yet in this portrait we can sense a dawning consciousness of the self as specifically American. Possibly at the urging of his forceful and patriotic mother, Wright sought out the founders of the new American nation to portray and was perhaps particularly aware of the national aspect of his art making. Wright took what seemed most appropriate from the sources around him—*Blue Boy*'s graceful confidence, Neoclassicism's high-minded seriousness—and, adding his own spirited use of color, defined a language appropriate to his subject: a new, and still quite young, American. [IB]

10. BENJAMIN WEST, *Genius Calling Forth the Fine Arts to Adorn Manufactures and Commerce*

AN AMERICAN ARTIST IN KING GEORGE III'S COURT

In 1826 Benjamin West Jr. and his brother, Raphael, wrote a letter to J. W. Taylor, speaker of the House of Representatives. Their purpose in writing was to offer for purchase to the United States Government 150 paintings by their father, Benjamin West (1738–1820). Moved by "the conviction that the works of their father should find their final place of destiny in his native country," the two men envisioned the paintings forming the foundation of an art academy and a "truly National Gallery." They concluded their letter, "[The paintings] are productions of American-born genius, and let them be deposited in whatever quarter of the globe destiny may place them, the honor of having produced them belongs to the United States of America."[1]

The sons' fervent belief in the value of West's work to the United States was offset by the biography and list of paintings accompanying the letter. While indeed American-born, West had passed the majority of his life in England. He had created all of his mature work there, much of it for King George III. Included on the list of paintings were such works as *Landscape View of Windsor Castle, with the Royal Hunt; Procession of Queen Elizabeth to St. Paul's*; and *Design for a Monument to Lord Nelson*. Such paintings would have been awkward inclusions in that "truly [American] National Gallery."

West was born outside Philadephia. His "extraordinary love" of the fine arts induced him to leave the colonies for Italy in 1760 so he could study the works of the old masters. West aspired to history painting—large-scale work depict-

ing events from history, mythology, and the Bible characterized by nobility of deed and intensity of emotion. He was later to expand the scope of history painting to include contemporary heroic scenes, but as a young man in Philadelphia he probably recognized that there would be little chance to produce work other than portraits in America. After four years in Italy, he moved to England and soon attracted the attention of King George, who provided him with a generous annual stipend and commissioned work depicting events from British history and the Bible for the embellishment of Windsor Castle. West became a founding member and the second president of the Royal Academy of Arts, and he was the Surveyor of the King's Pictures until his death. West also became a mentor and teacher to many young American artists who, in the decades after his emigration, also made the journey to Europe in search of an artistic education—among them John Singleton Copley (1743–1818), Gilbert Stuart (1755–1828), and Matthew Pratt (1734–1805).

One of the items that Raphael and Benjamin Jr. offered the American government was *Genius Calling Forth the Fine Arts to Adorn Manufactures and Commerce*, an oil sketch for the central panel in a decorative ceiling. The ceiling was installed in 1788 in a drawing room at the Queen's Lodge, the primary residence of the royal family, which stood on the South Terrace of Windsor Castle. A man named Haas transferred West's design to the ceiling, mixing colored marble dust with fixative in the Italian technique of

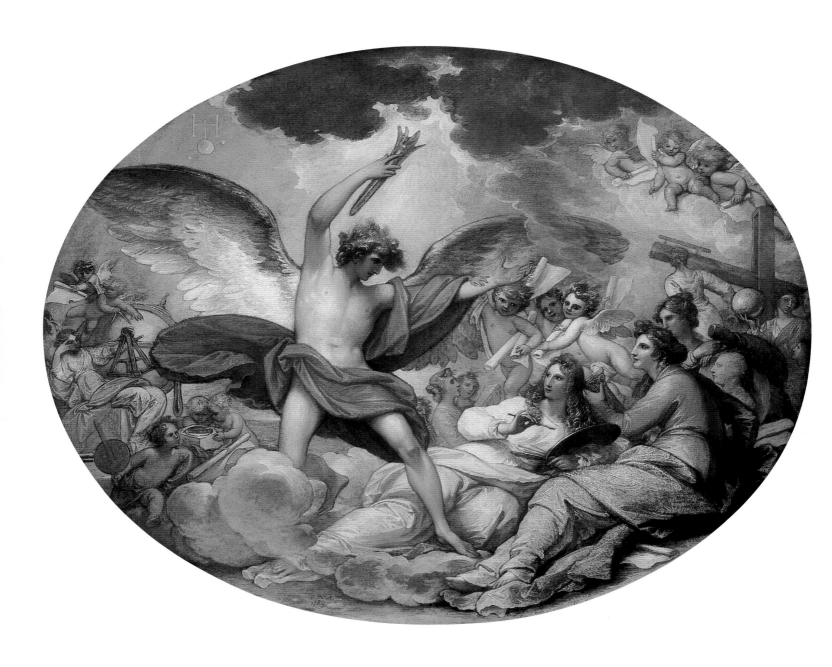

10. Benjamin West (1738–1820), *Genius Calling Forth
the Fine Arts to Adorn Manufactures and Commerce,*
1789. Oil on paperboard (mounted on canvas),
19⅜ × 24⅝ in. (49.2 × 62.5 cm). Gift of Mr.
and Mrs. John D. Rockefeller 3rd, 1979.7.104

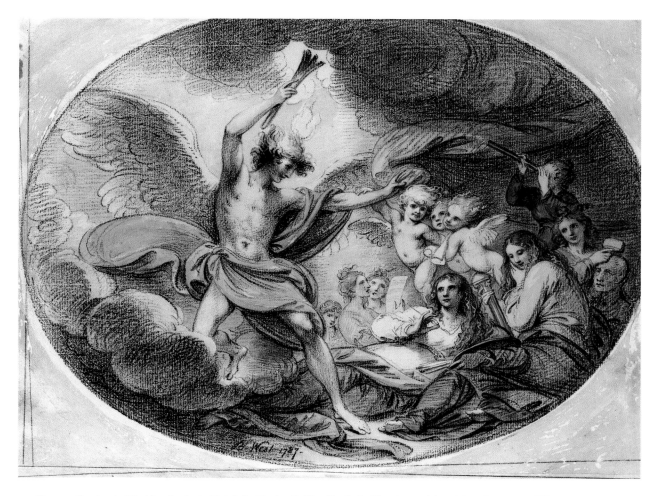

Fig. 10.1. Benjamin West (1738–1820), *Sketch for Genius Calling Forth the Fine Arts to Adorn Manufactures and Commerce*, 1787. Black chalk and watercolor, 13¾ × 18½ in. (34.9 × 47 cm). Cincinnati Art Museum. Gift of Sallie J. McCall, 1915.13

marmotinto. The ceiling was destroyed when George IV ordered the Queen's Lodge demolished in 1823, and there are now a number of conflicting descriptions of it. Probably the most reliable source is a guide to Windsor Castle first published in 1792.[2] According to that description, *Genius Calling Forth the Fine Arts* formed the central oval of the ceiling. Scenes representing agriculture, manufacturing, commerce, and riches were placed at each corner of the ceiling, bracketing the central oval.[3] The four panels in between these scenes were horizontal compositions painted in imitation bas-relief showing allegories of astronomy and navigation, botany and chemistry, fortification and gunnery, and electricity and geography.

West was probably influenced in his design by a nine-panel ceiling, similarly populated with allegorical and classical figures and itself derived from Italianate models, painted by Peter Paul Rubens (1577–1640) at Whitehall

Palace. Despite its traditional, Renaissance-inspired form, West's ceiling is strikingly modern in subject, depicting the activities and requirements of a prosperous, technologically advanced nation rather than simply lauding the royal family.[4] In the central painting, the winged, nude figure of Genius, bearing a torch of enlightenment, is surrounded by putti and classically robed figures. The figures on the right who hold brushes and a palette, an Ionic column, and a mallet represent Painting, Architecture, and Sculpture. Sculpture leans on a bust of George III. Two smaller figures in the background singing, accompanied by another figure playing a recorder, represent Music. In addition to these traditional, allegorical figures there appear instruments of modern navigation, geography, and astronomy: a calipers, compass, sextant, and, most significantly, a large telescope trained on a small disk, topped with an *H*, which floats at the painting's upper left. The telescope was designed by Sir

William Herschel (1738–1822), astronomer to George III, who discovered the planet Uranus (symbolized by the disk) in 1781. The two smaller circles next to the disk probably represent the two moons of Uranus, which Herschel discovered in 1787.[5]

In many ways, Herschel's and West's positions were similar: they were two highly skilled, talented men whose work was sanctioned and supported by the king. That support, while assuredly welcome, meant they were also required to perform tasks that made apparent their subservience. A day's entertainment for one group of visitors to the royal court included a tour of the castle followed by a visit to the chapel, where West displayed his design for a stained-glass window of the Resurrection. Dinner began at four o'clock, followed by a concert. "But that which rendered the entertainment superior to what any other sovereign in Europe of the world could give," one visitor recalled, "was the introduction of Dr. Herschel and his grand telescope. . . . That illustrious astonomer exhibited the various heavenly bodies to the great delight and astonishment of the august party."[6] In another instance, West was called on to create "transparent and watercolor pictures to adorn the Marble Gallery at a great evening entertainment in the Castle given by their Majesties to the nobility," in effect, to provide party decor.[7] In both instances, the significant scientific and artistic achievements of Herschel and West become entertainments, objects of admiration, and indicators of the king's wealth and power, not unlike the costly furniture on view during the tour of the palace or the sumptuous meal served at the banquet.

Genius Calling Forth the Fine Arts differs in some significant ways from a drawing showing the same composition (fig. 10.1). In the drawing, there are no figures to the left of Genius, nor are there any putti in the clouds to the right. The grouping of robed figures and putti at the lower right is largely the same as in the oil painting, but instead of Herschel's large telescope and the woman holding the sphere, the drawing shows a man looking through a small, hand-held telescope. The symbol for Uranus is also missing. The drawing is dated 1787, the same year Herschel discovered the two moons of Uranus. Perhaps West added the specific references to Herschel in the oil sketch—which is dated two years after Herschel's discovery and one year after the installation of the ceiling—to acknowledge Herschel's latest discovery. Or perhaps he added those references as he was preparing the painting for exhibition at the Royal Academy.[8] It is surprising that a work that was distinctly not about the glorification of the royal house would so clearly celebrate the achievements of a commoner, even one under the patronage of the king. West may have chosen to include the symbols of Herschel's discoveries for the wider audience at the Royal Academy, knowing the inclusion would inspire pride in a fellow Englishman's accomplishments. In the painting, West subtly points to his own achievements along with Herschel's by positioning the figure representing Painting in the center foreground, a reference to the value of his own profession to a modern nation.

Raphael and Benjamin West Jr. were unsuccessful in persuading the United States government to purchase their father's works, perhaps because the stamp of monarchy was evident on so many of the paintings. George III's presence in *Genius Calling Forth the Fine Arts* is limited to the small depiction of a bust in one corner, and it is the achievements of art and science, not of the king, that are celebrated. Nonetheless, the painting's allegorical subject matter and traditional forms link it decisively with European taste and production. While West's work did not become the foundation for a national academy of art, the sons' assertion of their father's relevance to American art was, ultimately, borne out. West was a guide and inspiration to many young American artists, and paintings like *Genius Calling Forth the Fine Arts* now make their home in collections of American art. [IB]

11. JOSHUA JOHNSON, *Letitia Grace McCurdy*

REFINING THE FOLK PORTRAIT

"A nebulous figure, a Negro painter of considerable ability and with a style peculiarly his own, was a limner of portraits in Baltimore during the last decade of the eighteenth century and the first quarter of the nineteenth. As far as can be learned, Joshua Johnston, or Johnson, was the first individual in the United States with Negro blood to win for himself a place as a portrait painter." So wrote the Baltimore genealogist and art historian J. Hall Pleasants in 1942, and so began more than sixty years of scholarly debate and speculation about Johnson and his heritage.[1]

Today Joshua Johnson (1761/63–after ca. 1825), who worked in Baltimore from 1794/95 to about 1825, is regarded as the earliest known black American artist for whom a body of extant work survives. His biography remains largely unknown, and until the discovery of his manumission papers in 1994 the effort to establish his racial identity was the impetus for numerous studies and exhibitions of his work.[2] Pleasants, who reintroduced Johnson in an essay in the *Walpole Society Notebook for 1939* and in a more widely cited article published three years later in the *Maryland Historical Magazine*, was a retired physician who had become a nationally recognized expert on early Maryland painting. He identified Johnson as African American on the basis of oral traditions passed down in families whose ancestors the artist had painted and corroborated these family histories with period sources such as city directories and census records.[3]

The results of Pleasants's research were inconsistent and contradictory, but the idea that Johnson was black went largely unchallenged. Johnson's designation as African American was both popular and controversial. In the 1970s, as his assumed African American heritage became more widely known—and prices for his works escalated—some scholars demanded further documentary evidence of Johnson's race. Ironically, his racial identity only became more nebulous as scholars continued to study him.[4] The four different oral traditions originally introduced by Pleasants established that Johnson was either a slave, a slave apprenticed as a blacksmith, a consumptive black servant (who was probably a slave), or an immigrant from the West Indies. Carolyn J. Weekley, in the most comprehensive study of Johnson to date, brought additional family histories to the record, yet the question of Johnson's race remained unresolved. One of the accounts Weekley uncovered suggested that Johnson was a "red man," adding further ambiguity to his racial status.[5] Until the emergence of Johnson's manumission records, the only evidence of his race that did not rely on oral tradition was the Baltimore city directory of 1817–18, cited by Pleasants, in which Johnson is listed among "Free Householders of Colour." In the federal census reports of 1790 and 1800, however, Johnson is listed as a free white head of household.[6]

A widely cited advertisement for Johnson's services as a portraitist, published in the *Baltimore Intelligencer* on 19 December 1798, though frequently cited, did little to clarify Johnson's racial identity and raised further questions about his artistic training. In the advertisement, Johnson describes himself as a "self-taught genius," who "by dint of industrious application" and "having experienced many insuperable obstacles in the pursuit of his studies" has come to receive "liberal encouragement" for his portrait painting.[7] Scholars advocated close attention to the words "insuperable obstacles," suggesting that they be read as a reference to Johnson's early life as a slave. Johnson's claim

11. Joshua Johnson (1761/63–after ca. 1825), *Letitia Grace McCurdy*, ca. 1800–2
Oil on canvas, 41 × 34½ in. (104.1 × 87.6 cm). Acquired by public subscription
on the occasion of the centennial of the M. H. de Young Memorial Museum
with major contributions from the Fine Arts Museum Auxiliary, Bernard
and Barbro Osher, the Thad Brown Memorial Fund, and the Volunteer
Council of the Fine Arts Museums of San Francisco, 1995.22

that he was self-taught received little attention. Instead, his work was repeatedly examined for the influence of the Peale family: Charles Willson Peale, his sons Rembrandt and Raphael, and his nephew Charles Peale Polk, all of whom worked as portraitists in Baltimore around the time Johnson is known to have been active there.[8] Weekley's study of Johnson states the case for his association with the Peales most strongly. Incorporating elements of the many oral traditions surrounding Johnson, Weekley concludes that he was the French-speaking "Negro boy" who had been brought to Baltimore from the West Indies in 1777 by Bobby Polk (1744–1777) and later served as a valet to Charles Willson Peale, Polk's brother-in-law.[9]

As Weekley's theory suggests, Johnson's celebrated position as the first significant Afro-American painter has tended to eclipse the historical dimensions of his place in early American society. His status as one of many folk artists working in Baltimore at the turn of the nineteenth century has repeatedly been discounted. Yet the most common points of comparison between Johnson's work and that of the Peales—poses, costumes, accessories—are best interpreted not in terms of influence but as part of a vocabulary of artistic conventions common to practitioners of the nonacademic folk tradition of American painting. In fact, Johnson's work has less in common with the work of Charles Willson Peale than with that of his nephew, Charles Peale Polk, who did not share Peale's academic training and painted in a less sophisticated style.[10]

The discovery of Johnson's manumission papers, which surfaced six years after Weekley's study was published, allows many of the previous theories about the artist to be dismissed. The papers conclusively establish that Johnson was a mulatto, the son of George Johnson of Baltimore County, Maryland, and a slave mother owned by the small-time farmer William Wheeler Sr. A bill of sale indicates that Wheeler sold Joshua to his father in 1782, and that Johnson in turn arranged to free Joshua after he completed an apprenticeship to the Baltimore blacksmith William Forepaugh, or when he turned twenty-one, whichever came first. Johnson's whereabouts and activities between the time he completed his apprenticeship and the beginning of his career as a portraitist in Baltimore (which can only be documented after 1794/95) are unknown.[11]

Joshua Johnson was never a "slave artist," nor a slave or apprentice to the Peales. The fact that multiple, romanticized, historically inaccurate versions of Johnson's life story persisted in oral histories and historical scholarship before

Fig. 11.1. Joshua Johnson (1761/63–after ca. 1825), *Grace Allison McCurdy (Mrs. Hugh McCurdy) and Her Daughters, Mary Jane and Letitia Grace*, ca. 1806. Oil on canvas, 44 × 38¾ in. (111.8 × 98.4 cm). The Corcoran Gallery of Art, Washington, D.C. Museum purchase through the gifts of William Wilson Corcoran, Elizabeth Donner Norment, Francis Biddle, Erich Cohn, Hardinge Scholle, and the William A. Clark Fund, 1983.87

the manumission papers were discovered suggests the degree to which an evolving cultural and political climate has shaped the understanding and reception of Johnson's career. His gradual ascent from obscurity to prominence parallels the larger effort to recover the contributions of African Americans that accompanied the civil rights movement and the more recent academic emphasis on multiculturalism. Popular interest in Johnson's presumed African American identity notably affected the commercial value of his work. Whereas in 1961 one of his portraits brought $250, by 1988 a picture by Johnson was sold at auction for $666,000, an increase that outpaced both inflation and prices for comparable works by artists with more conventional histories.[12]

Johnson received commissions from many of Maryland's leading civic, military, and mercantile families, and over half of his known subjects are young children.[13] His portrait of Letitia Grace McCurdy (1797–1875) was one of the thirteen portraits originally attributed to the artist in the influential study published by Pleasants in 1942.[14] It is the earliest of two known portraits Johnson painted for the McCurdys; the second, a group portrait of Letitia, her mother, and her younger sister, was completed some five years later (fig. 11.1). Letitia was the daughter of Hugh McCurdy (ca. 1765–1805), a wealthy Baltimore merchant, and Grace Allison McCurdy (1781–1829), of Philadelphia.[15] While in the family portrait the fashionably dressed McCurdys—seated on a stylish, horsehair-covered sofa—present a unified picture of refinement, Letitia's portrait demonstrates the artist's skill at representing the status and sophistication of a family through the portrayal of a single privileged child.

In this full-length portrait, Letitia is roughly four years old. She stands facing the viewer on a luxurious marbleized floor. Behind her, a red curtain has been pulled aside to reveal a pale green backdrop and a glimpse of a fenced and tree-lined walkway at the far right; both the curtain and this play of interior and exterior settings were common portrait conventions. Letitia is fashionably dressed in a thin, white muslin frock with a high, gathered waistline, low neck, and short, turned-back sleeves. This style of children's dress first appeared in France in the 1790s and was popular in America from 1800 to 1810, the decade the portrait was painted.[16] Letitia's pointed red shoes, known as straights, are made of red morocco leather and ornamented with gold buckles. Such elegant footwear, along with her necklace and stylish hair—cut short around the face and brushed forward, with soft curls in the back—complete her image as a fashionable young girl of the early nineteenth century.[17]

Yet another symbol of Letitia's—and by extension, her family's—class status and refinement is the small white dog at her left, who sits obediently as she offers him a biscuit. The strange, foxy face, long hair, and bushy tail of the dog in the McCurdy portrait distinguish it from animals painted by Johnson's contemporaries. Similar dogs appear in Johnson's portraits of Mary Buchanan Smith (1797–1798), Eliza White O'Donnell (1802–3), and Charles John Stricker Wilmans (1803–5), making it likely that the dog

serves a symbolic, rather than documentary, function. Its features suggest that it was a Pomeranian puppy, one of the most popular—and prestigious—dogs in early America. The breed was popularized by Queen Charlotte, who first imported a Pomeranian (from Iceland, by way of Germany) during the reign of her husband, King George III, who ruled Great Britain from 1760 to 1820.[18]

In the seventeenth century, the British royalty led a shift in Anglo-American attitudes toward dogs; they came to be valued as pets, not simply as working animals. By the eighteenth century, purebred dogs had become objects to be collected and were used by an increasingly affluent middle class to express their status. Subsequently, dogs began to appear in portraits, especially in England and colonial America.[19] With the publication of works such as Francis Coventry's *The History of Pompey the Little: or, the Life and Adventures of a Lap Dog* (1751), the pet dog became a popular literary figure. In the late eighteenth century, American newspapers were filled with elegies for deceased dogs, notices offering generous rewards for missing pets, discussions of breeding, and declarations of the rights of dogs under the law.[20]

Yet dogs were more than just status symbols. As research on the noted society portraitist John Singleton Copley (1738–1815) has shown, the pairing of animals and children in portraiture reflected shifting beliefs about the moral development of children.[21] In the late eighteenth century, under the influence of European Enlightenment philosophies and cultural changes prompted by the American Revolution, traditional Puritan beliefs about children's innate depravity began to give way to a more sympathetic appreciation of childhood and the innocence of children. Childhood came to be seen as an important formative period, and this led to increased attention to early childhood development and education. Many portraitists began painting children in the company of young animals, emphasizing their mutual youth and receptivity to training.[22] In Johnson's painting, Letitia appears to have paused to greet the viewer before offering a biscuit to the obedient puppy sitting expectantly at her side. For the McCurdys and their contemporaries, the well-behaved dog and the fashionable young girl created a coveted image of innocence, virtue, and good breeding. [AG]

12. JOHN VANDERLYN, *Caius Marius Amid the Ruins of Carthage*

GRAND DESIGNS AND
TRAGIC AMBITIONS

*Alas! how miserably have my fond anticipations been realised, and
how ill has my zeal and exertions been rewarded.* JOHN VANDERLYN[1]

Like his patron Aaron Burr, John Vanderlyn (1775–1852) was resolute to the point of stubbornness, grandiose in his schemes for glory, and considered a failure at the end of his life. Early in his career, the gold medal that he received at the 1808 Paris Salon for *Caius Marius Amid the Ruins of Carthage* (1807) guaranteed Vanderlyn an exhibition record unrivaled by any American artist up to that time. Yet his biographies report he would die so poor that near the end of his life he needed to borrow a dollar for transportation.[2] In *Caius Marius*, Vanderlyn staked his reputation on the French model of neoclassical history painting, which referenced antiquity, at a time when Americans were almost all following the British model of grand manner depictions favored by Benjamin West (1738–1820) and the Royal Academy of Arts in London, which often included a focus on contemporary events. Such a resolve reflects Vanderlyn's ambition and self-confidence but also reveals his refusal to acknowledge the pragmatic constraints of American political and cultural fashions, which led to a lifetime of frustration, bitterness, and anger. It makes his famous early painting of the vanquished Roman general Caius Marius seem an eerily apt metaphor for the artist's own personal history.

Born in Kingston, New York, of the region's Dutch ancestry, the artist was still using the old-world spelling of John Vander Lyn in his drawing book of 1792.[3] Demonstrating an early talent for drawing, he was sent in 1795 by his parents to apprentice in the studio of Gilbert Stuart (1755–1828).[4] The young Vanderlyn so impressed Aaron Burr (1756–1836), the United States senator from New York,

that the famous politician made the artist his protégé.[5] A committed francophile, Burr sent Vanderlyn to study from 1796 to 1800 with François André Vincent in Paris. There Vanderlyn adopted the French academic method of the atelier, copying from old master painters and drawing from live, nude models, which is evident in the keen sculptural lines, close attention to anatomy, and smooth surface of his monumental portrait of Caius Marius. After a brief return to New York in 1800, Vanderlyn again traveled to Europe, building a solid reputation there from 1802 to 1815 as a history painter, especially of neoclassical figures.

In his first major canvas, *The Death of Jane McCrea* (1804, Wadsworth Atheneum, Hartford, Conn.), Vanderlyn recounts a recent event on the American frontier, putting the muscular bodies of American Indians on display in a harrowing scene of slaughter with racist overtones. In his choice of subject, Vanderlyn is emulating Benjamin West, the expatriate artist living in London and the most renowned American painter of the day. In *The Death of General Wolfe* (1770, National Gallery of Canada, Ottawa), based on the French and Indian Wars, West had altered the tradition of history painting by depicting recent episodes in a heroic manner instead of representing events from antiquity. However, West, who had become president of London's Royal Academy after Sir Joshua Reynolds (1723–1792), also continued to follow the more traditional conventions of history painting, which took their subjects from literary sources, including mythological and biblical texts. Desiring to be acknowledged on the world stage, West submitted his

12. John Vanderlyn (1775–1852), *Caius Marius Amid the Ruins of Carthage*, 1807. Oil on canvas, 87 × 68½ in. (221 × 174 cm) Gift of M. H. de Young, 49835

Fig. 12.1. Benjamin West (1738–1820), *Death on the Pale Horse*, 1796. Oil on canvas, 23½ × 50½ in. (59.7 × 128.3 cm). The Detroit Institute of Arts. Founders Society Purchase, Robert H. Tannahill Foundation Fund, 79.33

monumental painting, *Death on the Pale Horse* (fig. 12.1), to the Paris Salon of 1802, where he was greatly honored by the French. A poem read at the celebration hosted by the Paris museums compared West to Jacques-Louis David's teacher, Joseph-Marie Vien (1716–1809), the acknowledged master of French history painting.[6] In reviewing the works on display, Napoleon Bonaparte admired West's entry and invited him to join the cortege as the general continued to tour the rest of the exhibition.[7]

Although the French honored West at the 1802 Salon, he was not the first American artist to have a work exhibited by that body. In 1800 Vanderlyn had gained that distinction when his self-portrait of that same year was accepted.[8] In his self-portrait, Vanderlyn adopts both fashion and techniques from the French tradition, signaling his desire as an American artist to wear the mantle of legitimate heir to the traditions of Europe. That ambition was given its greatest encouragement at the Paris Salon of 1808, where his *Caius Marius* was a remarkable success. Painted while he was living in Rome, the painting was awarded a gold medal by the jurors, which Napoleon ceremoniously confirmed on Vanderlyn.[9]

Decidedly Continental in his tastes, Vanderlyn preferred the painting traditions of France and Italy to those of England favored by most of his fellow citizens. American sentiment toward France had reached its zenith when the Paris Peace Treaty of 1783 brought a formal end to the War for Independence between the United States and England, but this attitude shifted considerably at the end of the eighteenth century as the revolutions in the two countries diverged. Soon the excesses of the French Revolution came to embody (often literally in political caricatures) the fears of conservative Americans rather than their democratic ideals. Irrespective of politics, West's association with London's Royal Academy also was an important factor in the choice of England as the usual European destination for aspiring American painters. By contrast, Vanderlyn's patron, the anti-British, pro-republican politician Aaron Burr, sponsored the artist's studies in Paris. Not surprisingly, given his French training, Vanderlyn sympathized with the heritage of France, where Jacques-Louis David (1748–1825), the official painter of the French Revolution, developed a tradition of history painting in support of the new republic's moral values (fig. 12.2). These works rooted psychological drama in the display and gestures of the human body, encoding powerful political messages in the language of aesthetic ideals.

Following this lead, Vanderlyn drew inspiration from Plutarch's account of Greeks and Romans in *Parallel Lives*, finding in the story of Marius a narrative to dramatize his own understanding of the relationship between individual character and national fortune. Marius had been a military

Fig. 12.2 [top]. Jacques-Louis David (1748–1825), *The Death of Socrates*, 1787. Oil on canvas, 51 × 77¼ in. (129.5 × 196.2 cm). The Metropolitan Museum of Art, New York. Catharine Lorillard Wolfe Collection, Wolfe Fund, 1931.31.45

Fig. 12.3 [bottom]. Jacques-Louis David (1748–1825), *Leonidas at Thermopylae* [detail], 1814. Oil on canvas, 155½ × 209 in. (395 × 530.9 cm). Musée du Louvre, Paris, INV.3690

leader and member of the Roman consulate who fell from power during the political turbulence of the Roman republic during the second century B.C. In hopes of gathering an army that would conquer Rome, he fled to Carthage in North Africa, where his life was threatened and he was denied asylum. Using the symbolic vocabulary of French painting, Vanderlyn paints the famous general seated as a military hero, yet defeated in his ambitions. The ruins of Carthage mirror Marius's own ruin and suggest that, in failing to recognize a noble leader, the city is doomed to fall. In protoromantic fashion, the ruins of the city are symbols of both its decay and its former grandeur. The animal running across the rubble symbolizes the jackal of the Egyptian god Anubus, who presides over tombs and weighs the hearts of the deceased in the scales of justice. Vanderlyn connects the moral meaning of this tableau to America by transforming the animal into a fox.[10]

All these associations suggest that Vanderlyn may have meant for the painting to be an allegorical portrait of his patron Aaron Burr, whose fortunes were reversed after becoming vice president under Thomas Jefferson in 1800 and whose features resembled those of Vanderlyn's Marius. Burr was frustrated at his ineffectual role under Jefferson, which led him to conspire in an impossibly grandiose scheme. With an Irish expatriate named Harman Blennerhassett and the governor of the recently acquired Louisiana Territory, James Wilkinson, Burr attempted to take over the land west of the Mississippi, secede from the United States, use his new power base to invade Mexico, and set himself up as head of a new political empire.[11] The ill-conceived plot was discovered, and, although he was acquitted in a trial for treason, Burr's fortunes never recovered. His life took an even more desperate turn in 1804 when, having earned the enmity of Alexander Hamilton, his principal rival in New York politics, Burr became a refugee from the law after fatally wounding Hamilton in a duel. He died isolated and embittered.

Burr and Marius shared parallel stories of virtuous character and public service undone by overweening hubris and investment in self-destroying schemes. Vanderlyn followed the French tradition of using classical scenarios to reference contemporary events. In many ways, Vanderlyn's life followed a similar trajectory, albeit with different circumstances. His character strengths and flaws mirrored those of Burr and Marius, as did his rise to fame and eventual fall into despair over unfulfilled aspirations.

While the context of the painting conveys this morality tale to the viewer, it is the physicality of Marius's body that commands attention. More than a symbolic icon, his body metaphorically articulates the power of the individual relative to the power of the state. Specifically, Marius reinforces an image of independent, confident, virile, and active masculinity, despite his obviously defeated circumstances. Jacques-Louis David deploys almost exactly the same gendered vocabulary to similar effect in his *Leonidas at Thermopylae* (fig. 12.3), which depicts the three hundred doomed Spartan soliders under Leonidas's command as they are defeated at the Thermopylae pass.[12] Most notably, Leonidas commands the center, seated stoically, staring resolutely out of the picture, his body's smooth musculature on display, sword raised, defiant to the end in his perfect, idealized manhood.[13]

Similarly, Marius sits in a relaxed yet upright posture, firmly grasping the scabbard of his sword, gazing intently forward, though not directly at the viewer. His look is meditative and intellectually concentrated. Some critics have suggested that the image indicates a brooding Marius plotting his revenge, "a pensive figure whose hidden thoughts are the true subject in the painting."[14] But this ignores the body for the face. Contradicting the deep psychological trouble legible in his countenance, the open drapery and towering placement of his more-than-life-size torso emphasize Marius's firm, well-defined, muscular male form as an ideal of honest resolve. The cloak and tunic have fallen away to reveal his bare upper torso and a large, strong leg, exposing his powerful physique in a manner that suggests both the heroic athlete of classical Greece and Rome and David's representation of sexual potency as aesthetic ideal.[15]

This image of the masculine ideal was part of a highly coded visual vocabulary that defined men and women according to the gendered assumptions inherent in European cultures in the nineteenth century. It was a way of seeing based on a system of related oppositions, in which male and female bodies were invested with visual signs that compelled viewers to identify sexual differences as cultural norms. In contemporary critical discussions, sexual difference has been explained as a function of spectatorship, or the relationship between the painted image and the viewer. Most simply, men and women are positioned respectively as active and passive, a dynamic mirrored in social, political, and cultural relations that make these roles appear natural. The nude body offers an especially potent site for gendered construction because its appeal to aesthetic values removes it from any other context, turning the cultural differences within our visual perceptions into apparently natural facts.[16]

Vanderlyn's painting conveys the moral lessons implicit in the gendered society found in classical narratives. It was followed by another major achievement, *Ariadne Asleep on the Island of Naxos* (1812, Pennsylvania Academy of the Fine Arts, Philadelphia), which he conceived as a feminine pendant to his masculine *Caius Marius*.[17] The painting won Vanderlyn the same acclaim from France's Salon establishment that had greeted his *Caius Marius*. However, renown in Europe did not translate into success in the United States, where Vanderlyn returned in 1815 with a mission to educate American sensibilities in an appreciation for French and Italian models of history painting and simultaneously to establish his fame.[18] The spirit of this Continental style ran counter to the country's popular taste, which had never been comfortable with the exposed bodies in the grand statements of history painting.[19]

Vanderlyn spent the remainder of his life attempting to realize his dream of prosperity and prominence through an ambitious project to construct an elaborate rotunda in New York City for exhibiting his *Panoramic View of the Palace and Gardens of Versailles* (1818–19).[20] Although panoramas were favored entertainment spectacles at the time and usually profitable, Vanderlyn's project failed as a financial venture. His own devotion to the high academic ideals of French art led him to choose a subject many in the United States found uncongenial. He was criticized for ignoring his own American heritage by electing to extol the splendors of Europe, and especially the French monarchy that Versailles represented.[21]

After nine years of failed panoramic exhibitions in the rotunda, the City of New York refused to renew Vanderlyn's lease, depriving him of the primary scheme by which he had expected to earn a living while advancing the cause of classical history painting in the United States. He remained distracted by his idea, devoting his final years to soliciting public and financial support for a circular panorama building in Washington, D.C., as a way to advance the arts nationally. He was to be disappointed as artistic sensibilities at midcentury turned to landscape painting, rendering his proposal antiquated. In the end, Vanderlyn's own life had replaced his patron Burr's as the modern counterpoint to his tragic, historical portrayal of Caius Marius. [DC]

13. JOHN WESLEY JARVIS, *Philip Hone*

THE BOON COMPANION AND
THE MAYOR OF NEW YORK

By all accounts—and there are many—John Wesley Jarvis (1780–1840) was a flamboyant, eccentric man. Biographical sketches invariably include accounts of his outrageous dress, his chaotic studio, his drunken adventures, his saucy mistreatment of venerable sitters, and his uproarious storytelling. Jarvis was born in England and raised there until he was brought to Philadelphia as a five-year-old.[1] At sixteen, he was apprenticed to the portrait painter and engraver Edward Savage (1761–1817). In 1800 Savage moved to New York City, and Jarvis moved with him. Jarvis lived an itinerant life, frequently traveling to Baltimore and New Orleans, where he found eager sitters and ran through his earnings like water. Jarvis—the sought-after portraitist and consummate storyteller—suffered a stroke in 1834 that affected both his painting arm and his speech. He died in 1840, penniless.

While Jarvis's dissolute habits may have hastened his death, in his heyday they also brought the artist attention and, with it, clients. Washington Irving reported seeing Jarvis in Baltimore in 1811: "The gentlemen have all voted him a rare wag and a most brilliant wit; and the ladies pronounce him one of the queerest, ugliest, more agreeable creatures in the world. . . . He is overwhelmed with business and pleasure, his pictures admired and extolled to the skies, and his jokes industriously repeated and laughed at."[2] Jarvis's ability to spin a hilarious yarn, to mimic and amuse, was an essential part of his appeal and has become an integral part of his biography. Yet the oft-repeated stories of Jarvis's antics threaten to obscure recognition of his artistic accomplishments. As one writer put it, "his independent habits . . . have, in a manner, caused the artist to disappear

in the boon-companion."[3] For despite his many eccentricities, Jarvis was known as one of the great portraitists of his day. At a time when having a painting hung in New York's City Hall was a mark of distinction for an American artist, Jarvis had six full-length portraits of naval heroes from the War of 1812 exhibited there.[4]

Before those successes, however, Jarvis worked to establish his reputation in New York. In June 1809 he advertised his services as a portraitist in the *Long Island Star*.[5] According to the advertisement, a half-length portrait that included the hands, like this one of Philip Hone (1809), would cost sixty dollars. In his portrait, Hone (1780–1851) pauses in his reading, one finger marking his place in the small volume he holds. Seated with his left arm resting on the back of his chair, he turns slightly toward the viewer. The drapery that hangs behind him is lifted on the left to reveal a landscape with trees. It is, in some ways, a conservative portrait, painted in a style widely practiced at the time, now defined by some as Romantic Realism, in which vivid likeness is softened by small measures of idealism and generalization.[6] In an entirely conventional setting, Hone's body forms a sturdy, conventional triangle. Yet the painting also conveys a feeling of great energy. The alertness of Hone's gaze and the swirl of curls around his head suggest the liveliness of the sitter's curiosity and intellect. The slight twist in Hone's torso gives a note of convincing spontaneity to the familiar portrait trope of the interrupted reader. Jarvis's quick, painterly treatment of Hone's hands, the landscape, and the drapery help to redirect attention continually to Hone's face, where the brushwork is tighter and the detail finer. The viewer is thus forced to meet

13. John Wesley Jarvis (1780–1840), *Philip Hone*, 1809
Oil on wood panel, 34 × 26¾ in. (86.4 × 67.9 cm)
Gift of Mr. and Mrs. John D. Rockefeller 3rd, 1986.84

repeatedly the slight challenge in the sitter's eyes. His strong, handsome features are framed dramatically by the trio of crisp white, dark black, and dull red of shirt, jacket, and drapery. The cursory treatment of the drapery and the puzzling topography of its folds show Jarvis's need for a talented assistant like Henry Inman (1801–1846), who would later serve as his apprentice and paint portrait backgrounds and drapery for him.[7]

At the time Jarvis made this portrait, Hone was a young man. He later traveled throughout Europe and built an impressive art collection and library that he installed in a mansion on lower Broadway. He became active in Whig politics as a speaker and organizer and became the friend and associate of many prominent men. As the mayor of New York in 1825, he presided over the opening of the Erie Canal. Also in the future lay the twenty-eight-volume diary that Hone kept between 1828 and 1851, amounting at his death to two million words. In the pages of his diary, he proved a sharply opinionated art critic. In May 1833, for instance, he visited the spring exhibition of the National Academy of Design and remarked: "[Samuel F. B. Morse] is an excellent fellow and is well acquainted with the principles of his art; but he has no imagination. He makes good portraits, strong likenesses . . . but he cannot design. There is no poetry about his paintings, and his prose consists of straight lines, which look as if they had been stretched to their utmost tension to form clothes-lines."[8] In 1809, however, Hone was still building his fortune at the auction house he ran with his brother, and it is only the book in Hone's hands and the distinct impression of a quick mind that provide hints of the life that lay ahead.

Part of the reason for the success of this portrait may be that Jarvis and Hone understood each other, recognizing that they shared similar passions. Jarvis was reported, in an apocryphal but not uncharacteristic account, to have strolled the New Orleans waterfront carrying a silk umbrella and a cage full of birds, magnolia blossoms and a baby alligator sprouting from the pocket of his pink waistcoat, all the while singing Scottish ditties in perfect dialect.[9] A friend's eulogy of Hone, in contrast, paints a picture of dedication, intelligent service, and professional direction.[10] Yet the two men had much in common. Both were great storytellers: Jarvis with his tall tales, Hone in his diary. Both were passionate about the theater: Jarvis an instinctive performer, Hone the patron to actors, playwrights, directors. The two men were even neighbors for a while when Jarvis lived on Murray Street, just off Broadway.

In addition, both men were active participants in the web of formal and informal clubs and other associations that were becoming an integral part of New York society, business, and politics. Hone belonged to a number of clubs—groups of men who would gather for a meal and conversation on a regular basis—and founded one of his own called the Hone Club, which became known for the high quality of its repasts and the civility of its conversation.[11] The clubs provided important occasions for the exchange of information, the forming and cementing of social and business connections, and for political planning. At one gathering for Whigs, Hone stood between Henry Clay and Daniel Webster and asked the assembled guests to swear to make one of them president.[12]

Artists also had their clubs, and, while the increasing numbers of trained artists in the United States brought more competition, that competition was ameliorated in part by the camaraderie of the clubs and by collegial exchanges of knowledge.[13] Jarvis took advantage of these opportunities to learn from other artists—among them one of his fellow apprentices under Savage and the miniaturist Edward Greene Malbone (1777–1807) who happened into his studio one day. Jarvis took on Henry Inman as his apprentice and then, when the time came, Inman took Jarvis's son as his own apprentice. These relationships and encounters—social, coincidental, familial, contractual—demonstrate the growing richness of artistic life in the United States.

In addition to being a striking image, John Wesley Jarvis's portrait of Philip Hone represents an important moment in American art making and in the life of the young nation. At the time the painting was made, New York City was on its way to becoming, in the words of the maligned Samuel F. B. Morse (1791–1872), "the capital of the country"—not just economically but also culturally. The opening of the Erie Canal was a coronation of sorts; with it New York became "the queen of American cities."[14] Boston and Philadelphia largely dominated eighteenth-century American art making, but increasingly in the pages ahead our attention will be on New York. The United States in general was becoming more culturally sophisticated, with a greater complement of artists, associations to train them, collectors—like Philip Hone—to support them, and, at places like City Hall, new sources of commissions and venues for public exhibition. Even as Jarvis the idiosyncratic boon companion amuses with his antics, he also provides insight into the changing practices of art education, art making, and art patronage in early-nineteenth-century America. [IB]

14. ROBERT SALMON, *British Merchantman in the River Mersey off Liverpool*

ACCURACY IN THE SERVICE OF IDEALISM

After seeing *British Merchantman in the River Mersey off Liverpool* (1809) by Robert Salmon (1775–bet. 1848 and 1851) hanging at the Fine Arts Museums of San Francisco, a number of museum visitors have written to complain that the title is incorrect.[1] Some of those visitors simply note the cannons bristling from the gun ports that run the length of the ship and along the poop deck: this is no merchant vessel, they argue, but rather a man-of-war. Others with more expert knowledge of British naval history agree, citing the presence of the Red Ensign waving at the stern. The Red Ensign, they assert, could only be flown by a man-of-war, according to contemporaneous regulations, not by a merchantman. And in fact, when John D. Rockefeller 3rd first donated the painting in 1979, it was listed as *British Warship in Liverpool Harbor*—a title that would probably have satisfied both groups of museum visitors.

Salmon's painting indisputably shows a precisely rendered view of a twenty-eight-gun, three-masted ship under sail on a brisk day off the British city of Liverpool. The sails billow and luff while the crew makes busy. Skeins of lines and rigging crisscross the sky between the masts. A tall figure, probably the captain, gesturing authoritatively, stands silhouetted on the poop deck. A small boat is being raised or lowered from the stern. Marine painters often offered three views of the same vessel in a single work. In this painting, the large vessel to the right of the central ship seems to be another view of the central ship, and the ship to the left—slightly harder to descry—may also offer another perspective of it.[2] Other craft dot the choppy waters, including, in the foreground, a small dory with five men aboard. The sun breaks through clouds at the upper right,

casting broad areas of shadow. The brick buildings and distinctive spires of Liverpool hug the horizon. The painting shows the influence of both Dutch and Italian traditions on British marine painting: the former in its pyramidal arrangement of the ships, low horizon, and expansive sky; the latter in its detailed topographical drawing, clear coloring, and cool lighting.[3]

The high level of detail in the painting allowed nautical experts to identify positively the type of ship and its location. Those experts reported that such an impressive, aggressive array of gunnery on a merchant ship was standard, indeed necessary, at the time the painting was made. In the early nineteenth century, both the man-of-war and the merchantman flew the Red Ensign. It was actually a commissioning pennant—missing from this vessel—that would differentiate the two kinds of ships. Liverpool does not have a harbor proper but rather sits on the Mersey River, which is a mile wide at this point and more like an arm of the sea than a river.[4]

Salmon painted *British Merchantman* while living in Liverpool between 1806 and 1811. It was there that he could have seen paintings by Willem van de Velde the Younger (1633–1707) and Canaletto (1697–1768) who helped bring Dutch and Italian influences respectively to Britain. Salmon averaged about twenty pictures a year during his first stay in Liverpool. Between 1811 and 1822 he worked chiefly in Scotland, particularly in the coastal city of Greenock, creating some 250 paintings. He was again in Liverpool between 1822 and 1825 and then traveled extensively around the British Isles during the next few years before moving to Boston in 1828. He stayed there until 1842,

14. Robert Salmon (1775–bet. 1848 and 1851), *British Merchantman in the River
Mersey off Liverpool*, 1809. Oil on canvas, 27⅞ × 50⅜ in. (70.8 × 128 cm)
Gift of Mr. and Mrs. John D. Rockefeller 3rd, 1979.7.89

creating more than 400 works, and was justly celebrated as America's leading marine painter.[5] Salmon painted many images of individual ships—ship portraits—but his oeuvre also includes general harbor scenes; romantic pictures of moonlit voyages, pirates, and shipwrecks; landscapes; and even a small number of portraits.

Perhaps the museum visitors who objected to the apparent error in the painting's title did so in part because this is a painting that presents itself as being highly accurate—the "mistake" in this context was especially grating. Salmon observed his subjects minutely. In Boston he lived on the waterfront above a boatbuilder's shop and outfitted his studio with a bay window so that he could look up- and downstream.[6] Later he traded paintings for a boat and sails, and we can imagine him darting about in the harbor amid the larger ships, sketching assiduously.[7] He made careful pencil sketches, often using a ruler to proportion distances and a quadrant system to establish scale, a discipline that produced meticulous, highly detailed paintings.[8] In *British Merchantman* we can see the trails of water dripping from the dory's oars in the foreground and the shadows cast by the masts and yards on the central vessel's sails, and perhaps most important in establishing the painting's accuracy, we can trace the intricacies of the ship's rigging and feel certain the artist knew the position and purpose of every rope.

The attention to delineation and accuracy extends also to the buildings along Liverpool's waterfront. Salmon has depicted landmarks that would have been significant to city dwellers and to arriving seamen alike: the Townsend Mill (under the tip of the bowsprit), the dome of St. Paul's Church (over the figurehead), the dome of the town hall (in front of the foremast), the spire of St. George's Church (above the fourth gun), the spire of St. Nicholas's Church (just to the right), and the spire of St. Thomas's Church (forward of the main mast). Salmon has been so careful in his representation that, if needed, we could date the painting using the structures as guides: the low, tan-colored building just ahead of the figurehead is the old fort, which disappeared within ten years of the painting's creation as the docks spread northward. The St. Nicholas spire shown here collapsed in 1810.[9] By including these landmarks, Salmon has created a "geographical label" legible to both locals and seafaring people.[10]

And also legible to patrons. As the more detailed records that Salmon kept during his years in Boston show, many of the people who purchased his paintings were connected with the sea—for livelihood and for love. Thomas Handasyd Perkins, for instance, bought a number of works, as did his son, two nephews, and his son-in-law. They were merchants, traders, and yachtsmen. One of Perkins's nephews was a sea captain for a time; his son-in-law was the president of the Port Society of Boston. Accuracy would undoubtedly have been important to these men, and to others who knew shipping well.

Yet in addition to the high level of accuracy in Salmon's ship portraits there is a large dose of idealism. The low horizon of *British Merchantman* allows Salmon to position the boat with its sails standing out against the sky, raked with beams of light that burst from behind a cloud. The small dory obscured in the shadowy foreground provides a measure of scale, but also a powerful contrast: the hunched backs of the cramped men laboring over their oars serve as counterpoint to the sunlit sails billowing with wind and the colors snapping in the stiff breeze. Like many portraits of people, a ship portrait balances truth to actual likeness with a desire to present the subject in the most favorable light. *British Merchantman in the River Mersey off Liverpool* is certainly an image of what the ship looked like, but it also conveys what the ship meant: the riches and glory it might bring its owners and crew, the power that enabled it to sail freely about the world unafraid of attack, the technological advancements of its design, the implicit connection to empire that accompanied any British overseas trading mission in the nineteenth century.[11]

At their best, Salmon's marine paintings provide their viewers with a welter of absorbing detail and an elevated sense of drama to accompany the visual spectacle of seeing a magnificent ship under sail. Salmon was well aware of the power of dramatic effects. Shortly after his arrival in the United States he painted a number of enormous canvases —three that showed the city of Boston and three that formed a panorama of Algiers. One of the paintings of Boston was used as a backdrop by the Federal Theater. One of the Algerian paintings depicted a nocturnal battle with the Algerian fleet on fire. It was semitransparent, allowing lanterns and candles to be shone through it to make evocative visual effects. Even in *British Merchantman in the River Mersey off Liverpool*, a much earlier painting, Salmon demonstrated how light and shadow and an impression of surging movement could create a compelling image. One elderly man, reminiscing about his youthful visits to Salmon's Boston studio, recalled, "Salmon was not an idealist; his pictures were faithful transcripts of what he saw and felt."[12] If that is so, then Salmon felt that ships were grand, beautiful, inspiring things. [IB]

15. THOMAS BIRCH, *The Narrows, New York Bay*

REVOLUTIONARY PASTORAL

When Thomas Birch (1779–1851) died, a friend eulogized him in the *Philadelphia Art Union Reporter*, writing, "Mr. Birch was not a complainer, but was rather disposed to look on the bright side of the world." He went on, "In evenness and cheerfulness of disposition, and amenity and quietness of manners, he was remarkable. . . . The easy gait observed in the horses of his sleigh scenes, may symbolize the steady, even tenor his life. . . . Caring little for the out-door bustle of the world, he sought and found serene happiness in the circle of home, and at his easel."[1] The broad outlines of the biography suggest the eulogizer knew his subject well: Birch spent a contented life close to home and family. He migrated to the United States from England with his family when he was fifteen. That significant move aside, he never ventured far or for long from his adopted home of Philadelphia. He learned his art from his father, an engraver and painter of enamel miniatures. Father and son collaborated on a series of prints of Philadelphia that they published in 1800.

This serene painting, *The Narrows, New York Bay* (1812), seems a fitting production of such a man. It shows a curving shoreline, a bay expanding toward a low horizon, distant hills, an expansive sky. A number of large ships navigate the calm, bluish gray water. Four smaller boats are pulled up on the beach, and four people are gathered nearby. In the foreground, cows doze and swish flies in a patch of sun; the recumbent cow making a nice visual parallel with the largest beached boat. An ancient tree stands on the left, its broken top a jagged spire, its lower boughs in full leaf. The visual trope of the blasted tree was to become a signature element in the landscape paintings of Thomas Cole (1801–1848) and other Hudson River School artists.

In this painting, half marine view and half bucolic landscape, Birch combines artistic conventions of the sublime and the picturesque to present a quietly inspiring vision of America's future. The breeze that gently fills the sails of those ships of commerce also clears the dark clouds gathered at the upper left, revealing a softly glowing sky of pale blue, pink, and yellow. Using the metaphor of the brightening sky, Birch subtly suggests the optimistic spirit of the ships' journeys, the possibilities for riches and glory that come with trade and expansion. The cows, meanwhile, represent the agrarian foundation of the nation's prosperity. Birch has organized the painting in alternating bands of light and shadow: the dark strip in the foreground, the cows' patch of sun, the swath of dark foliage behind them, the bright line of the beach, a patch of darker water, the silvery horizon.[2] These bands, regularly spaced and falling into a lulling rhythm, lead the viewer's eye easily into the distance and symbolically toward a prosperous future.

It is possible that Birch made the painting from Staten Island looking north toward the steeples of Manhattan with Brooklyn at the far right. More plausible, perhaps, is the theory that the view looks toward the ocean from Brooklyn with Staten Island on the right, Manhattan out of sight.[3] By the time the painting entered the art market in 1973, after remaining in the collection of one family for more than a century, it had acquired the title *The Narrows, New York Bay*. Birch did work at times in the area around New York City—indeed almost all his harbor scenes are of New York and Philadelphia. Yet there is no documentation to prove that Birch named the painting *The Narrows, New York Bay*. In 1812, the year he made this picture, Birch exhibited ten paintings at Philadelphia's Pennsylvania Academy of the

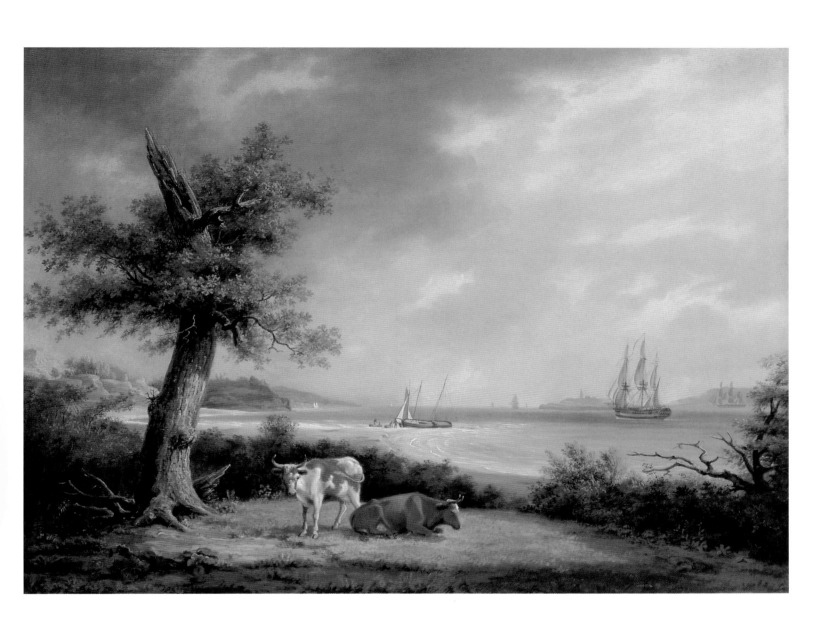

15. Thomas Birch (1779–1851), *The Narrows, New York Bay*, 1812
Oil on wood panel, 19⅞ × 26¾ in. (50.5 × 67.9 cm)
Gift of Mr. and Mrs. John D. Rockefeller 3rd, 1979.7.17

Fine Arts. Among them was a work entitled *View of a Bay*, which might be this painting.

Birch's father had a small art collection, and the younger man would have had ample opportunity to study the Dutch works in it. Certainly the pattern of dark and light, the stately tree, the cows, and the depiction of water and sky in this painting suggest a Dutch influence.[4] The specificity with which he has depicted the old tree and the cows suggests that Birch also made close observations of nature. And indeed he was praised by his contemporaries for his "remarkable fidelity to nature" and "adherence to facts."[5] The painting, therefore, possesses both a general similarity to a type of landscape (a "generic" Dutch landscape) and a sense of representing an actual place. Thus, while the title is uncertain and the exact location hard to pin down, the view itself is somehow familiar: we feel we do know this place, this land, this water and sky. It is accessible in a way that makes it also feel recognizable. That feeling of familiarity and recognizability may be the source for the work's title more than any actual evidence of where it was painted, and it may be part of the reason why the title has remained attached to the picture over the years.

And yet, this serene, familiar painting with its somnolent cows, drifting boats, and placid water is, in a way, revolutionary. For Birch was one of the first painters in the United States to turn from the highly remunerative, established field of portraiture to the more uncertain one of landscape. He had, for a while, painted profile portraits on Bristol board, which were in great demand in the early nineteenth century, and he probably earned a decent living at it. But already by 1811, the first year he exhibited at the Pennsylvania Academy of the Fine Arts, there are no portraits among the eleven works Birch showed. In *View of Lemon Hill, the Seat of Henry Pratt, Esq.*, there is a kind of pictorial segue between portraits and landscapes: a likeness, not of a man, but of his property. The rest of his offerings for this year and the following one consist of marine paintings, landscapes, winter scenes, views in and around Philadelphia, and a couple of genre pictures. In turning to landscape, Birch blazed an important trail. There had been little demand for landscape painting in America up to this time, and typically it had been confined to the views in the backgrounds of portrait subjects. In the ensuing decades, however, American landscape painting would develop and eventually flourish, finding public and private patrons and becoming an essential element in shaping how the nation understood itself.

Yet it was not, ultimately, in landscape that Birch made his name as an artist, but rather in the surprisingly bellicose tradition of naval battle scenes. Inspired by his adopted homeland's victories against his native land's navy in the War of 1812, Birch painted a series of twelve naval engagements, five of which he displayed at the Academy of Fine Arts in Philadelphia in 1813.[6] Birch touched a patriotic nerve; the popularity of these battle scenes led him to make additional versions (critics called them "repetitions") of a number of them, and he also produced a set of engravings of them. He continued to work in this vein (while also producing landscapes and other views) through the 1820s. Many of his later marine paintings are romantic views of shipwrecks and storms, journeys of the imagination to exotic or forbidding places. With the mythic struggle of man and nature a theme in many of them, these works provide a striking contrast to the committed localism and diligent harmony of his harbor scenes, made at the same time.

In this painting there is no conflict, naval or otherwise. Ships, cows, men go about their business in peace. That the artist would very shortly begin to paint scenes of violence, action, and heroism, that the painting represents a dramatic turn in the development of art in the United States—these surprising facts are hidden in the familiar contours of that reassuringly accessible place, be it the Narrows of New York Bay, or elsewhere. [IB]

CHANGING TASTE IN AMERICAN STILL LIFE

Raphaelle Peale (1774–1825) was one of the first American painters to specialize in still life. His father, Charles Willson Peale, was a prominent artist, author, inventor, and museologist who was instrumental in founding the Pennsylvania Academy of the Fine Arts and amassed one of the nation's leading natural history collections. Peale's Museum, established in 1784, encouraged the union of art and science through its innovative display of portraits, exotic artifacts, minerals, plants, and carefully preserved animals that were prepared using a taxidermy method Peale himself developed. As the eldest child, Raphaelle was frequently called on to assist his father with museum work. He painted backgrounds for habitat displays and helped with the gathering and preservation of specimens, assuming the post of chief taxidermist in 1798.[1]

Raphaelle was encouraged to explore both art and science, and his duties at the museum did not prevent him from producing portraits, miniatures, and still lifes. Artistic ambition was actively encouraged in the Peale family. Beginning with Raphaelle in 1774, Charles Willson Peale named seven children after famous artists; four of them became painters.[2] Raphaelle was the only one who chose to focus on still life, which at that time was the least valued genre of painting and was widely considered to be lacking in intellectual and moral substance.[3] Nevertheless, Raphaelle's still lifes were more successful with buyers and critics than his portraiture had been. In 1813, after viewing several of his "fruit pieces" at the Pennsylvania Academy's annual exhibition, a writer for *Port Folio* declared, "Raphaelle Peale has demonstrated talents so transcendent in subjects of still life, that with proper attention and encouragement, he will, in our opinion, rival the first artists, ancient or modern, in that department of painting."[4]

Exhibition records from the Pennsylvania Academy remain the primary source of information on Raphaelle's paintings. Unlike his father and his brother Rembrandt, he did not leave behind other sources such as journals and letters that might help to document his artistic production. Between the time he turned to the genre in 1811 and his death in 1825, he completed an estimated one hundred fifty still lifes, but only eighty-two appear in academy records, and today roughly fifty are extant. Although he did not abandon portraiture entirely, it became an increasingly less significant aspect of his work; exhibition records indicate that Raphaelle showed only nine portraits and six miniatures at the academy during these years.[5]

Raphaelle's most prolific period of still-life painting may have been encouraged by the development of new exhibition opportunities in Philadelphia and the changes such venues brought to the early-nineteenth-century art market. While portraits and miniatures had to be commissioned in advance, still life and other modern subjects like it had a wider appeal and could essentially be painted on speculation. The large number of still lifes Raphaelle exhibited suggests that he was aware of the marketing potential of academy exhibitions. Although he occasionally showed works that had already been sold, many of the paintings on view at the academy were available for purchase, and their appearance in exhibitions may have encouraged new buyers.[6]

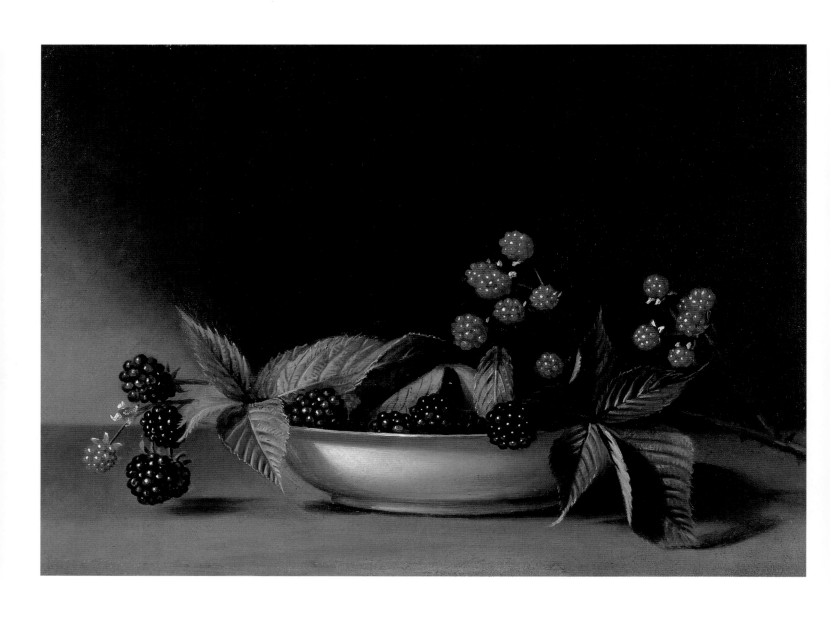

16. Raphaelle Peale (1774–1825), *Blackberries*, ca. 1813
 Oil on wood panel, 7¼ × 10¼ in. (18.4 × 26 cm)
 Gift of Mr. and Mrs. John D. Rockefeller 3rd, 1993.35.23

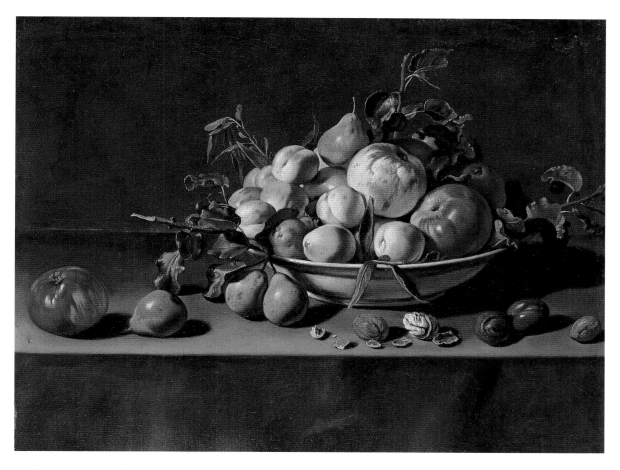

Fig. 16.1. Unidentified artist, *Fruit Still Life*, seventeenth century. Oil on canvas, 22½ × 29 in. (57.2 × 73.7 cm). Fine Arts Museums of San Francisco. Gift of the de Young Museum Society, 58.48.2

Although it was unusual for American artists to paint still lifes in the late eighteenth and early nineteenth centuries, examples of the genre were widely available. Dutch still lifes were exhibited in Philadelphia as early as 1796, and many prints after Dutch and Flemish paintings were in circulation in the city.[7] Most Dutch and Flemish still lifes known in America focused on flowers or lavish displays of dead game—subjects Raphaelle never painted—presented in richly furnished interiors. It has been suggested that the austerity, lack of elaborate setting, dramatic lighting, and stark isolation of objects in Raphaelle's still lifes had far more in common with the work of seventeenth-century Spanish artists such as Francisco de Zurbarán and, especially, Juan Sánchez Cotán, whose work was shown at the academy in 1818.[8] Yet Raphaelle was likely influenced by Dutch and Flemish still lifes as well. As *Fruit Still Life* (fig. 16.1) suggests, not all Dutch and Flemish works featured sumptuous banquet scenes. Although the display of fruit in *Fruit Still Life* is more bountiful than those painted by Raphaelle, it is dramatically lit and arranged in an unornamented setting not unlike that of *Blackberries* and many of his other works.

Dutch and Flemish examples seem to have been particularly influential in the work of Raphaelle's uncle, James Peale, who turned from miniatures to still-life painting in the 1820s, nearly ten years after Raphaelle did. The two seem to have occasionally shared props and were likely aware of similar European precedents, though the presentation of fruit and vegetables in each artist's work clearly differs. While James's paintings tend to share the typical scale of European still lifes, close to the 22½ by 29 inches of *Fruit Still Life*, Raphaelle's pictures tend to be considerably reduced. *Blackberries*, his smallest composition, measures only 7¼ by 10¼ inches. Both artists focus on edible

subjects such as fruit and vegetables, but James consistently evokes a sense of transience that is not always present in Raphaelle's work, including signs of aging and decay such as spots, wormholes, and discoloration. Although Raphaelle occasionally includes such details, his subjects are more often presented—as is the case in *Blackberries*—in a state of timeless, freshly picked perfection.[9]

Raphaelle's careful renderings of flawless fruit and vegetables link many of his paintings to botanical prints, which in the late eighteenth and early nineteenth centuries were extremely popular in Philadelphia. Since the 1750s, when the Philadelphian Benjamin Franklin achieved international renown for the discovery of electricity and his famous experiments with lightning, the city had been recognized as a scientific center. Even after New York became the economic capital of the country, Philadelphia remained an important source of advancements in engineering, agriculture, economics, medicine, and especially botany. Peale's Museum further contributed to the city's status as a leader in the sciences through its impressive collection of specimens.[10] Given his family's interest in natural history and his work as taxidermist at the museum, Raphaelle was probably well versed in the representational conventions that botanical illustrations employed.[11] In the case of *Blackberries*, similarity with such illustrations is particularly strong. Like the prints, which picture plants and flowers at various stages of development, the painting features a branch of berries ranging from young and red to black and fully ripe.[12] Also notable is the shallow, Chinese-export porcelain saucer in which the berries rest. Such pieces were common in representations of fruit and vegetables of the period; this example resembles one of the containers featured in *Twelve Months of Fruit,* a popular series of plates first published by the British nurseryman Robert Furber in 1738.[13]

By specializing in still lifes instead of more traditional—and prestigious—subjects such as the portraits and history paintings favored by his father and his brother Rembrandt, Raphaelle confounded expectations. *Blackberries* was a further defiance of convention. Rather than emphasizing a connection to Dutch and Flemish still-life traditions, the painting's composition seems equally indebted to botanical prints. Yet in choosing the blackberry as his subject, Raphaelle departs from that body of imagery as well. No record exists of contemporary reaction to the painting, but viewers likely found it surprising, even for an artist who consistently tested boundaries. Although Raphaelle had always avoided

the exotic and expensive fruit typically pictured in still lifes in favor of seasonal, locally grown subjects such as apples, fox grapes, corn, peaches, and strawberries—all popular produce—blackberries were considered no better than a common weed in 1813, the year the picture was likely painted.

Early American settlers domesticated wild strawberries and took pains to import the luxurious raspberry and cultivate it in American gardens, but the wild blackberry, according to nineteenth-century bush-berry expert Fred Wallace Card, "was to them much what the blackberry of England had been—simply a wild bramble, to be destroyed when possible and replaced by something better, and whose fruit was to be gathered at will." While raspberries and strawberries were frequently discussed in eighteenth- and nineteenth-century horticultural literature and appeared in a variety of botanical prints, blackberries were largely overlooked.[14] Their presence as a wild fruit is mentioned in surveys of Philadelphia agriculture published in 1685 and 1785, but discussion of their cultivation does not appear until the 1830s, and the process was not perfected until 1875.[15] Notably, blackberries are ignored in the *American Gardener's Calendar,* the first treatise devoted specifically to American gardening. Written by the Philadelphia nurseryman Bernard M'Mahon, the work appeared in eleven editions between 1806 and 1857. Although M'Mahon discusses strawberries and raspberries extensively, blackberries are not mentioned in the first edition nor in the edition published in 1819, five years after *Blackberries* was first exhibited at the academy.[16]

Writing in 1898, after blackberries had become a popular cultivated fruit considered "a luscious addition to the dessert of mid-summer," L. H. Bailey speculated that they had previously been neglected by horticulturists due to the difficulty of harvesting and preserving them. In his *Evolution of Our Native Fruits,* Bailey noted, "There is no berry fruit grown which sooner deteriorates after picking, and few which are necessarily picked in such unfit condition. The blackberry is not ripe simply because it is black; it must be soft, and it must drop into the hand when the cluster is shaken."[17] Artistic and horticultural conventions aside, the delicate and temperamental quality of the fruit likely presented an appealing challenge for Raphaelle, who by this time was an experienced taxidermist at his father's museum. In *Blackberries* he captures the characteristic—if fleeting—energy of a trailing blackberry branch, endowing the fruit

with an exuberance and animation often thought to be missing in his portraits.[18] The visually striking work demonstrates Raphaelle's mastery of representational painting and suggests a broader triumph as well: Here the notoriously difficult wild blackberry has been tamed, yet it has lost none of its spirit.

Capturing the accurate likeness of his subjects was a challenge Raphaelle encountered both as a portraitist and as a taxidermist, and on some level he seems to have associated the two occupations with one another. In an advertisement for his portraits that appeared in *Poulson's American Daily Advertiser* in October 1801, he promoted the portrait likeness as consolation in the event of a loved one's death. The ad began, "DEATH Deprives us of our Friends, and then we regret having neglected an opportunity of obtaining their Likenesses."[19] Charles Coleman Sellers, Raphaelle's great-nephew and one of his earliest biographers, noted that on another occasion the artist ran an advertisement offering "painting from the corpse," a service he listed—perhaps humorously—under the heading "Still Life."[20]

Raphaelle may have considered his lively paintings of fruit and vegetables to be another sort of likeness, which preserved and in some cases amplified the vivacity of his subjects, fixing them in an unblemished state that endured long after stock and stem had withered. Such artful manipulation of nature was related to his work at Peale's Museum. A writer for *Poulson's* described the collection in 1828 as "animal scenery of wood and wild, blended and intermingled with insect, bird and beast, all seemingly alive, but preserving at the same time, the stillness and silence of death."[21] In his representations of vegetables and fruit Raphaelle countered this stillness. *Blackberries* is a dynamic likeness that captures a vitality impossible to preserve in other facets of his work and testifies to the "transcendent" talents noted in the *Port Folio* review of his earliest still-life paintings. [AG]

17. GILBERT STUART, *William Rufus Gray*

QUIETING THE BACKGROUND PARADE

Gilbert Stuart (1755–1828) often infuriated the people whose portraits he painted. He refused to paint them when they arrived at his studio neatly coiffed and in their finest clothes, preferring to wait until their appearance had returned to more natural disarray. He did not deliver promised works. When he did produce the finished portraits he refused to comply with their requests for alterations or a higher degree of flattery. Stuart's disregard for his sitters' wishes can be attributed in part to his boorish, irascible nature. He was also constantly hounded by creditors. Thus, he started more portraits at once (collecting half the fee up front) than he could possibly finish in a timely fashion.

But a large measure of Stuart's indifference to his sitters' wishes came from his artistic principles. He disliked elaborate poses and refused to labor over details of dress, attributes, or backgrounds. He mocked Jacques-Louis David's (1748–1825) painting *Le Sacre de Napoléon Ier* when it was exhibited in Boston in 1827. "How delicately the lace is drawn!" he exclaimed. "Did one ever see richer satin? The ermine is wonderful in its finish. And, by Jove, the thing has a head!"[1] About backgrounds in paintings Stuart declared, "Backgrounds point to dates and circumstances of employment or profession, but the person should be so portrayed as to be read like the Bible without notes, which in books are likened unto background in painting. Too much parade in the background [is] like notes with a book to it, and as very apt to fatigue by the constant shifting of attention."[2] Stuart's lack of interest in what surrounded his sitters makes for some awkward moments in his paintings, for when he did add drapery and props, he did so carelessly. John Jay is menaced by a seemingly malevolent pile of drapery; General Henry Knox rests his hand on the sketchiest of cannons

(ca. 1805, Museum of Fine Arts, Boston); a tornado of paint forms the landscape outside Thomas Jefferson's window (1805–7, Bowdoin College Museum of Art, Brunswick, Maine); and the building that stands behind Josiah Quincy looks no more substantial than the architectural plans that Quincy holds in hands (1824, Museum of Fine Arts, Boston). When Stuart, after an impoverished childhood, finally received artistic instruction after literally begging a place in Benjamin West's (1738–1820) London studio, he refused to learn drawing ("All studies [are] to be made with brush in hand," he declared) or the greater complexities of composition.[3] Rumors that he "could not paint below the fifth button" induced him to exhibit a full-length portrait of William Grant skating at the 1782 Royal Academy of Arts exhibition in London—a portrait that made his reputation (1782, National Gallery of Art, Washington, D.C.). But that triumph aside, he was always most assured when he was painting single-figure bust or half-length portraits.[4]

For all the "faults" in his portraits, Stuart could, in the words of West, "nail the face to the canvas."[5] When he painted a face, Stuart first blocked in the shape on the canvas with opaque color and then covered it with a quickly applied layer of semitransparent paint. The result was skin with all the freshness and translucency of actual flesh.[6] Moreover, Stuart was able expertly to capture likeness—not the deplorable background parade declaring accomplishment and profession—but that more elusive aspect of likeness: the sitter's character. And, as the prominence of the sitters mentioned above shows, Stuart was among the most highly regarded portrait painters of his time, despite his bad manners and refusal to flatter.

William Rufus Gray (1783–1831), however, was not a

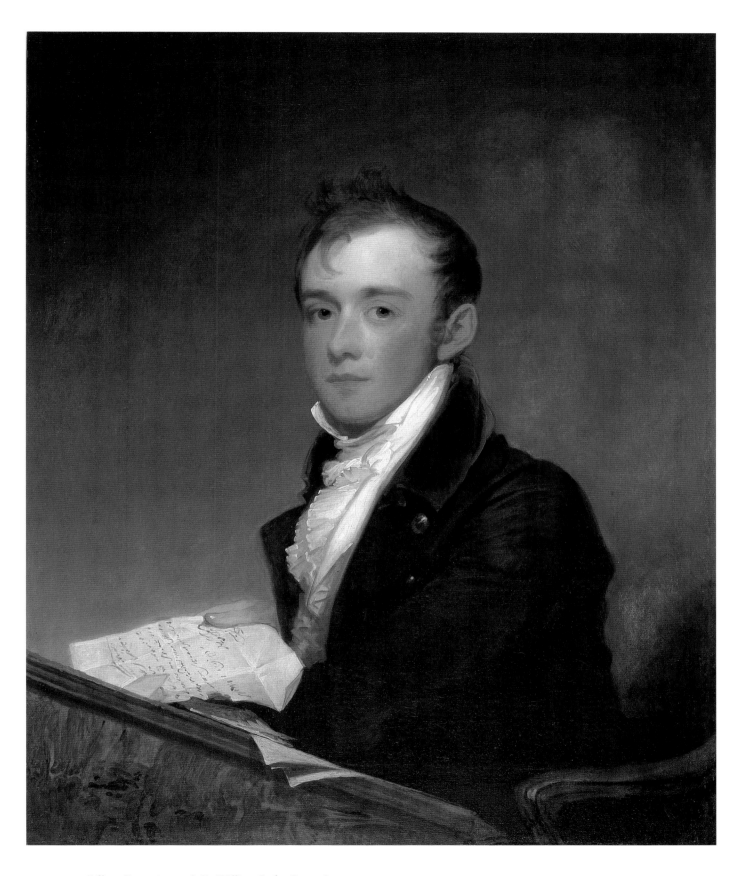

17. Gilbert Stuart (1755–1828), *William Rufus Gray*, 1807
 Oil on canvas mounted on hardboard panel, 33¼ × 27 in. (84.5 × 68.6 cm)
 Gift of Osgood Hooker, 1964.114

prominent man when Gilbert Stuart painted him in 1807. He was just twenty-four, the eldest son of William Gray of Salem, for whom he worked. In the portrait he is seated at a desk. He holds a letter in his right hand; other papers curl over the edge of the desk to nice trompe-l'oeil effect. Gray turns his head and meets the viewer's gaze. The youthfulness of his pink complexion, unwrinkled countenance, and the insouciant curl on his forehead are countered somewhat by the high, confining collar of his shirt, the soberness of his dark jacket, and the press of business before him. The background, not surprisingly, is unembellished. The brighter parts of the portrait—the white of the letter, the shirt, and the sheen of light on Gray's forehead—stand out handsomely against the dark ground. Stuart's characteristic lack of interest in depicting details of dress is apparent in his treatment of Gray's shirt ruff, which disintegrates on close looking into a hasty swirl of white paint. As Stuart asserted, by removing the detail of a finely delineated shirt ruff—a potential part of the distracting "parade"—the viewer's attention lingers longer on Gray's young face.

In the same year he painted the portrait of William Rufus Gray, Stuart also painted Gray's father and mother. Unlike his son, who had not yet had the opportunity to make his mark on the world, William Gray, fifty-seven years old and a millionaire three times over, had a long list of accomplishments. His portrait may have been commissioned to celebrate his latest: he had just been elected the federalist senator for Essex County, Massachusetts. He would also serve as the lieutenant governor for Massachusetts and for six years was president of the Boston branch of the Bank of the United States. In the meantime, he kept busy by running his trading company, one of the first from New England to trade with Russia, India, and China and which, at its height, employed three hundred seamen.[7] Like his son, the elder Gray is depicted sitting at a desk, papers before him. Similarly clad and posed, he too turns to look at the viewer. When hung together, the two portraits, mirrors of each other but for the age of the sitters, would have fallen into the ancient dialogue between youth and seniority, hopeful promise and proven experience.

If we are, as Stuart suggests, to read these portraits as "Bible[s] without notes," what can we learn about father and son from looking at them? William Gray's rugged face, well lined from years of hard work, is warmed by a slight smile. His gaze is direct, kind, steady, and perhaps a little tired. His hair falls limply on his forehead and his collar is not as high as his son's: this is no man of fashion. The portrait gives the impression of a disciplined, industrious, generous man of simple tastes, an impression supported by the elder Gray's biography. The younger Gray's expression lacks his father's steadiness. There is a slight arrogance in his gaze mixed with a contrasting dose of uncertainty. He seems to belong to that group of Stuart sitters whom a nineteenth-century critic deplored for their "painful, constrained desire to be elegant or mild, correct and well mannered . . . as if the sitter did not feel quite assured of himself and his position, and were doing his best to look brave and fine for posterity."[8] He leans into the slanted top of his desk, the letter in his hand held close to his body, his right arm folded tightly against his side. This cramped posture suggests the tension of someone, new to a task, who leans in close to his work, his whole body coiled at the effort. His father, meanwhile, long accustomed to hours at a desk, leans back in his chair. The younger Gray's expression is guarded, as if he were conscious of being judged and trying to make his own assessments, too. It is hard not to feel a little sorry for Rufus Gray, despite that tinge of arrogance. He had a long road ahead of him if he was to match his father's accomplishments, and, given the mirrored portraits of father and son, expectations for him to do so were high.

When the painter John Trumbull (1756–1843) was an elderly man, he acquired a portrait that Stuart had made of him when Trumbull was in his youth. He gazed at the painting intently and declared, "Stuart was indeed a great painter. I may not be a judge of this likeness,—they say no one is of his own,—but this I know, that face looks exactly as I felt then."[9] In addition to capturing what William Rufus Gray looked like (he had his father's nose and large chin), Stuart's portrait seems to capture what William Rufus Gray felt like: a young man hoping so much to make an impression on the viewer but not yet sure how, a young man feeling the benevolent but sizable presence of his father. William Rufus Gray died when he was forty-eight. The biographical dictionaries do not list him alongside his father; his accomplishments were not so notable after all. But a man who worked for him chose to name his son William Rufus Gray Bates after him, and we can take that as a sign that this uncertain young man was well-liked, and perhaps at least matched his father in kindness and generosity.[10] [IB]

18. THOMAS COLE, *View near the Village of Catskill*

AMERICAN ARCADIA

Thomas Cole (1801–1848) was acknowledged as the preeminent founder of the Hudson River School of landscape painting, which sought to establish an American tradition independent from that of Europe. The philosophical foundations of the movement may be traced to romantic concepts of the sublime, the beautiful, and the picturesque, which were codified in the writings of the influential European aestheticians Edmund Burke, William Gilpin, Sir Uvedale Price, and Archibald Alison. Drawing inspiration from earlier artists ranging from Claude Lorrain and Salvator Rosa to his countrymen J. M. W. Turner and John Constable, Cole emulated European ideals of landscape painting as a synthesis of observed nature, the artist's imagination, and moral content. Cole struggled to establish a tradition of literary, historical, allegorical, and religious painting in America through ambitious series such as *The Course of Empire* (1832–36) and *The Voyage of Life* (1839–40). His critical reputation, however, was based on his American scenes, which gave pictorial form to a vision of the American landscape as a stage and as a metaphor for the new nation.[1]

Thomas Cole was born in the textile center of Bolton-le-Moors, Lancashire, England, and worked as an engraver in Chorley and Liverpool before immigrating to the United States with his family in 1818. Financial necessity compelled the young artist to work as an itinerant art teacher, portraitist, and decorative painter in Ohio frontier towns, as well as in Philadelphia and Pittsburgh. Cole learned the rudiments of painting from the itinerant portrait painter John Stein in 1821 and obtained permission to draw from the plaster cast collection at the Pennsylvania Academy of the Fine Arts in 1824, but he was essentially a self-taught artist.[2]

In 1825 Cole moved to New York City and made his first sketching trip up the Hudson River to the Catskill Mountains, an event that is often cited as marking the founding of the Hudson River School. He later traveled extensively throughout the mountains of New York and New England and also made two influential trips (1829–32, 1841–42) to Europe. Cole was a founding member of New York's National Academy of Design (1826) and was the teacher of Frederic Edwin Church (1826–1900), who later assumed Cole's position as America's greatest landscape painter.

Cole's art and life were inextricably linked with the region surrounding the Catskill Mountains. During his first trip up the Hudson River in 1825, he visited the Hudson Highlands and West Point, the confluence of the Hudson and Mohawk Rivers north of Albany, the Hudson River village of Catskill, and Kaaterskill Falls and the Pine Orchard House hotel in the Catskill Mountains.[3] When three of the paintings inspired by this trip (including two Catskill Mountain views) were purchased and publicized by the prominent artists John Trumbull, Asher B. Durand, and William Dunlap, Cole's reputation as a landscape painter was secured.[4] Cole returned to the Catskills in 1826 and visited the region frequently until 1836, when he married Maria Bartow and settled just north of the village of Catskill. Cole's loyalty to his adopted country and favored landscape impressed his friend George Washington Greene, who recalled, "Many a time I have seen him turn from a long and earnest gaze at the grand mountain scenery of Rome, exclaiming, 'Beautiful! grand! — but after all I love the Catskills.'"[5]

Cole's trail to the Catskill Mountains had been blazed earlier by the Knickerbocker writers William Cullen

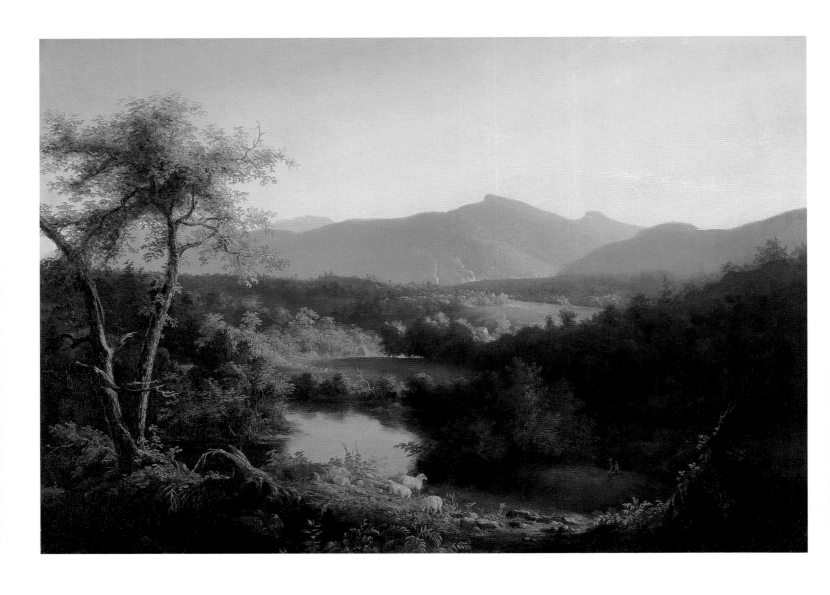

18. Thomas Cole (1801–1848), *View near the Village of Catskill*, 1827
Oil on wood panel, 24½ × 35 in. (62.2 × 88.9 cm)
Gift of Mr. and Mrs. John D. Rockefeller 3rd, 1993.35.7

Bryant, James Fenimore Cooper, and Washington Irving, who sought to establish an American literary tradition by endowing the new nation's landscape with historical and legendary associations comparable to those of Europe. Washington Irving set "Rip Van Winkle" (1819), a nostalgic ode to the passing of the Hudson River Valley's Dutch colonial heritage, in the mythical village of Sleepy Hollow and the surrounding "Kaatskill" Mountains.[6] James Fenimore Cooper's *The Pioneers* (1823) included a section in which the frontier woodsman hero Natty Bumppo ("Leatherstocking") described the Catskills' spectacular Kaaterskill Falls as resembling "flakes of driven snow" and the view from the Pine Orchard cliff ledge as encompassing all of "Creation!"[7]

Cole's 1825 trip up the Hudson River coincided with the growth of tourism and trade in the Catskills, which were facilitated by expanded steamboat service and new tourist lodgings.[8] One year earlier, the Pine Orchard House (later renamed the Catskill Mountain House) was constructed to serve a largely urban clientele with the time, means, and inclination to indulge in mountain sightseeing.[9] The Catskills soon joined Niagara Falls and Saratoga Springs on the itinerary for the American equivalent of the European grand tour.[10] Manufactured in Cole's native England, Enoch Wood's plate (fig. 18.1) depicting the Catskill Mountain House is an example of a souvenir that had cultural currency on both sides of the Atlantic Ocean. In Cole's *View near the Village of Catskill* (1827), the lodge appears on a distant ridge (fig. 18.2).

Cole's paintings of American mountain scenery both reflected this new interest in the Catskills and shaped its evolution.[11] His panoramic *Landscape with Figures: A Scene from "The Last of the Mohicans"* (fig. 18.3) of 1826, inspired by Cooper's best-selling novel, was commissioned for installation in the Hudson River steamship *Albany*.[12] Cole's romantic painting of the Lake George region blurred the distinction between fact and fiction and preconditioned the perceptions of the steamboat's passengers before they disembarked for mountain sightseeing. The symbiotic relationship between Cole's Catskill paintings and the tourist industry is reflected in James Kirke Paulding's *The New Mirror for Travellers; and Guide to the Springs* (1828), which urged "the picturesque tourist" to buy Cole's Catskill paintings to adorn the home, while Andrew T. Goodrich's *North American Tourist* (1839) described Kaaterskill Falls and other sites that "the magic touches of Cole the artist have brought to the public imagination."[13]

Fig. 18.1 [top]. Enoch Wood (1759–1840), *Plate "Pine Orchard House, Catskill Mountains,"* after 1831. Dark blue transfer-printed earthenware, 10¼ in. (26 cm) diameter. Albany Institute of History and Art. Bequest of James Ten Eyck, 1911.5.50

Fig. 18.2 [bottom]. Thomas Cole, *View near the Village of Catskill* [detail]

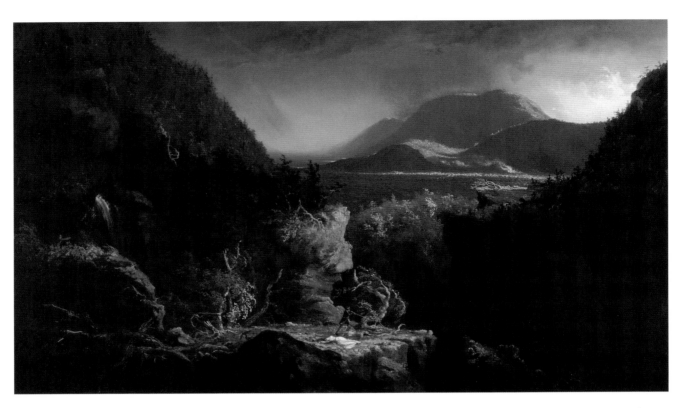

Fig. 18.3. Thomas Cole (1801–1848), *Landscape with Figures: A Scene from "The Last of the Mohicans,"* 1826. Oil on wood panel, image: 26⅛ × 43⅟16 in. (66.4 × 109.4 cm). Daniel J. Terra Collection, Terra Foundation for American Art, Chicago, 1993.2

Cole's *View near the Village of Catskill*, which looks west from the village of Catskill toward the Catskill Mountains, is the first of at least ten paintings depicting his favorite subject.[14] He sketched the scene during his first trip to the area in the summer of 1825, returned again in 1826 while boarding in the village for several months, and continued to make drawings and paintings from near this spot into the 1840s.[15] The stagelike composition, with its foreground framing trees, central body of water, distant mountains, and luminous atmosphere, reveals the influence of Cole's greatest art historical mentor, the seventeenth-century landscapist Claude Lorrain.[16] The foreground ridge demarcates the wilderness from the pastoral cultivated valley below, and Cole's signature on the foreground rock ("T. Cole 1827") explicitly identifies the artist as a mediator between these two realms. Cole's perspective from an elevated promontory participates in the eighteenth-century topographic view tradition, but his treatment of the subject is informed by his European-influenced aesthetic philosophy, which endowed landscapes with symbolic significance.

The contrast between the intertwined living and dead trees at the left and the gnarled stumps to the right embodies the cyclical forces of nature described by Cole in his "Essay on American Scenery" (1836): "In the American forest we find trees in every state of vegetable life and decay—the slender sapling rises in the shadow of the lofty tree, and the giant in his prime stands by the hoary patriarch of the wood—on the ground lie prostrate decaying ranks that once waved their verdant heads in the sun and wind."[17] Implementing this analogy, Cole frequently filled his otherwise sparsely populated landscapes with trees that bear "a resemblance to the human form. . . . There is an expression of affection in intertwining branches,—of despondency in the drooping willow."[18] Cole extended his anthropomorphic vision to bodies of water, writing, "Like the eye in the human countenance, it is a most expressive feature: in the unrippled lake, which mirrors all surrounding objects, we have the expression of tranquillity and peace."[19]

The triangular, notched mountain peaks of Kaaterskill High Peak and Round Top, which form the backdrop to this bucolic landscape, recall the artist's poetic description of the Catskills, in which "the green hills gently rising from the flood, recede like steps by which we may ascend to a great temple, whose pillars are those everlasting hills, and

whose dome is the blue boundless vault of heaven."[20] Cole's architectonic and arboreal metaphors not only suggest that nature has a divine architect but also more subtly imply that this landscape is ideally fit for human habitation.[21] His juxtaposition of the farmhouses nestled in the fertile valley with the gleaming white Catskill Mountain House in the notch of South Mountain at the upper right also suggests that the agrarian and tourist inhabitants coexist in perfect harmony.[22]

Cole observed as well that although the presence of God and the products of creation were perhaps more apparent in the wilderness, "the cultivated must not be forgotten, for it is still more important to man in his social capacity— ... and, though devoid of the stern sublimity of the wild, its quieter spirit steals tenderly into our bosoms mingled with a thousand domestic affections and heart-touching associations—human hands have wrought, and human deeds hallowed all around."[23] Cole's pastoral image of peace and plenty, complete with a strolling couple and grazing sheep, projects his perception of the Catskill Mountain landscape as a New World Eden that reveals both the stamp of God's creation and a prophecy of America's future.[24] In contrast with the rich historical resonance of European landscapes, Cole observed,

American associations are not so much of the past as of the present and the future. Seated on a pleasant knoll, look down into the bosom of that secluded valley, begirt with wooded hills—through those enameled meadows and wide waving fields of grain, a silver stream winds lingeringly along—here, seeking the green shade of trees —there glancing in the sunshine: on its banks are rural dwellings shaded by elms and garlanded by flowers— from yonder dark mass of foliage the village spire beams like a star. You see no ruined tower to tell of outrage — no gorgeous temple to speak of ostentation; but freedom's offspring—peace, security, and happiness, dwell there, the spirits of the scene.[25]

[TAB]

THE LANDSCAPE OF
AMERICA'S MYTHIC HISTORY

I always admired greatly the sky of that picture, deeming it the finest morning effect I ever saw painted. FREDERIC EDWIN CHURCH[1]

According to Thomas Cole's great-granddaughter, Edith Cole Silberstein, Prometheus held a special significance for the artist, not only as the giver of light and wisdom to humanity but also as an emblematic moral figure whose determination to provide instruction left him solitary and tortured.[2] Cole (1801–1848) took the narrative for his painting from *Prometheus Unbound*, the classical Greek and Roman tragedy.[3] Prometheus was a Titan, a race of immortal giants who inhabited the earth prior to humanity. Jupiter (Zeus in Greek mythology) charged him to create human beings, whom he fashioned out of mud and water in the image of the gods.[4] Taking pity on people because they seemed so defenseless within the created order, Prometheus stole fire from the realm of the gods to aid human civilization. The theft greatly angered Jupiter, who had the Titan chained to a rock on Mount Caucasus in Scythia, exposed to all the extremes of temperature and the elements. Even more gruesome, he was condemned to have his liver devoured by a vulture each day, only to have it renewed and then devoured again the next.

The story of Prometheus was particularly appealing to literary and visual artists of the romantic period because his defiance of Jupiter provided a moral lesson in the virtues of independence, rebellion, physical courage, and uncompromising sacrifice. Cole's rendition of the myth encapsulates the narrative in a monumental scene of pathos and grandeur that references the struggle between the Titan and Jupiter, who is signaled in the single star that occupies the vast expanse of purple sky. In a statement he prepared to accompany the painting, Cole makes this symbolism

evident: "The Artist has supposed the time to be the dawn of day. Jupiter the Morning Star."[5]

Cole had built a career out of moralizing, allegorical landscapes, the most famous of which is his five-canvas epic *The Course of Empire* (1834–36), which was painted for his patron, Luman Reed.[6] Opportunely painted around the time of the opening of the Wabash and Erie Canal extension from Fort Wayne to Largo, Indiana, these works, using imagery from the natural countryside of upper New York State, offered a symbolic warning against the hubris of civilization and promoted the enduring virtue of wilderness.[7] These beliefs characterize the aristocratic values of the conservative Federalist Party, to which Reed, as a self-made merchant, aspired but could never fully belong.[8] In 1836 Cole castigated the Catskill and Canajoharie Railroad for "cutting all the trees down in the beautiful valley on which I have looked so often with a loving eye."[9] Cole's monumental sequence illustrates the rise and fall of an ancient civilization in a beautiful environment: *The Savage State, The Pastoral or Arcadian State, The Consummation of Empire, Destruction,* and *Desolation.* He represents the civilization at its height as a random arrangement of neoclassical structures and pompous monuments that provide the setting for aggrandizing ceremonies (fig. 19.1).[10] Yet, at the conclusion of the cycle, nature reclaims the scene, leaving the ruins of civilization as tragic markers in the original landscape. Within Cole's conservative moral universe, human accomplishments are transient and cyclical whereas nature is enduring and a source of renewal.[11]

Cole was a member of the Freemasons, a social orga-

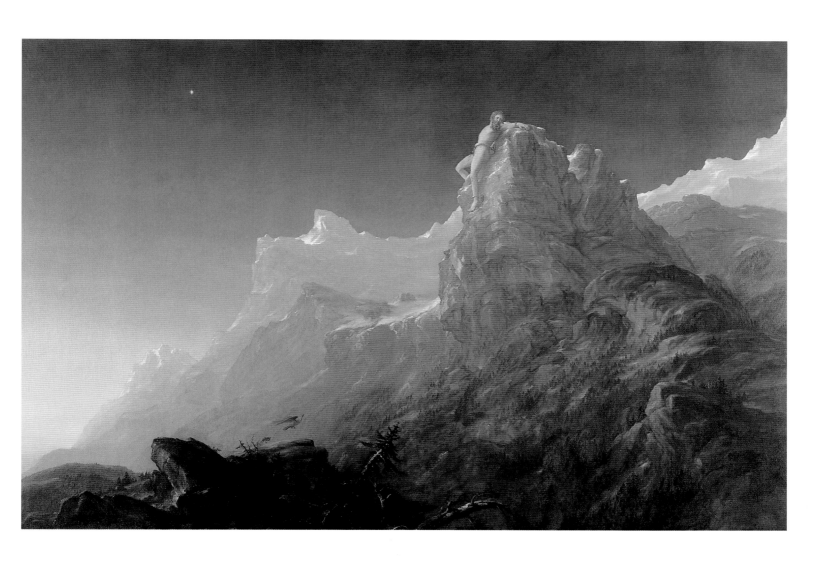

19. Thomas Cole (1801–1848), *Prometheus Bound*, 1847
Oil on canvas, 64 × 96 in. (162.6 × 243.8 cm)
Gift of Mr. and Mrs. Steven MacGregor Read
and the Estate of Joyce I. Swader, 1997.28

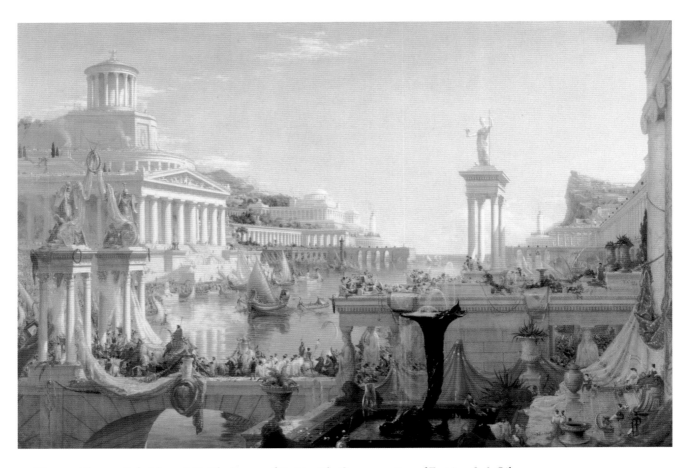

Fig. 19.1. Thomas Cole (1801–1848), *The Course of Empire: The Consummation of Empire*, 1836. Oil on canvas, 51¼ × 76 in. (130.2 × 193 cm). Collection of The New-York Historical Society, New York, 1858.3

nization with benign, secret rituals and strong ties to the Federalist Party during the colonial and nationalist periods of American history.[12] As a Freemason, he accepted the group's belief that a connection could be drawn between the achievements of Greece and Rome and those of places in the Hebrew scriptures, especially Jerusalem and Solomon's Temple. Within Masonic tenets, stone buildings offer a rationale for the moral principles underlying a virtuous society by linking classical and Hebrew ethics to Christian values through an interpretative strategy of allegorical symbols. Cole's devout Protestantism and his Freemasonry conjoin in many of his moralizing visual narratives, beginning with the warning against pride and decadence in *The Course of Empire*, which invokes the stories of fallen cities in both pagan antiquity and the Bible.

In *Prometheus Bound* (1847), Cole again conflates classical and Christian references through the logic of Freemasonry to create an allegorical canvas. While Prometheus is

drawn from classical mythology, the figure is chained to the vertical face of a mountain peak in a manner that recalls Christ's Crucifixion. That Cole intended this association is clear from his handwritten description for the exhibition of the painting at London's Westminster Hall in 1847: "Prometheus is left attached to the mountain in the manner of one crucified."[13] Patricia Junker raises an intriguing possibility in her discussion of Cole's motives for sending this painting to London for the competition to decorate the new Houses of Parliament, noting that Prometheus was a powerful icon of moral and social reform for many influential abolitionist intellectuals and writers.[14] Therefore, the manacles can be seen as a reference to slavery, which dominated national debates over the moral course of America in the 1840s, providing another context in which classical iconography and religious values were joined through symbolic association.[15]

Additionally, although Cole's subject is a tumultuous

wilderness, the artist probably is relying—as in *The Course of Empire*—on the connections that Freemasonry draws among Christian, Hebrew, and classical beliefs through the symbolism of buildings. In this case, the rugged mountain rocks function metaphorically as an image of an individual's rough, natural state, which must be fashioned into the "living stones" that are the figurative building blocks of the Christian church, according to its teachings. Such a reading is also consistent with Cole's increasing preoccupation with evangelical Christianity during this later period of his life, evident in his series *The Voyage of Life* (1839–40) and his commitment to a final monumental painting series titled *The Cross and the World* (unfinished).

However, it is not only through iconography that Cole shifts the emphasis of his painting from the heroic potential of Prometheus to the moral meaning implicit in the landscape. Cole's canvas stages this spectacle as an encounter between the viewer and a monumental and vertiginous panorama. Although he prepared a sketch of the nude Prometheus, Cole seems almost indifferent to the figure's anatomy.[16] It has been observed that for a time the figure was even painted out so as not to detract from the depiction of the landscape.[17] Prometheus is presented nude to signal the work's status as a historical painting with a moral message, the highest category of painting in the academic hierarchy and salon competitions. But even the vulture beginning its morning ascent in the foreground is painted with more finesse than Prometheus, who functions merely as a cipher for the narrative. The figure's awkward handling contrasts starkly with the bravura treatment of the landscape, the true subject of Cole's painting. In shifting the visual focus from the nude to the landscape, Cole was helping to forge a new category of painting called "historical landscape."[18] The artist's own formulation, a "higher style of landscape," was more explicit in its ambition to align his idealized and allegorical depictions of nature with enduring moral and religious meaning.[19]

Cole's gambit, consistent with the sensibility of Romanticism, emphasizes the ethical values of powerful emotional experiences available both in the natural world and in art, twin routes to moral understanding. Combining nature and art in landscape painting afforded a new and elevated significance because it could lead viewers into a heightened state of awareness, even transcendence, through an emphasis on the sublime. The English philosopher Edmund Burke, in his *Philosophical Enquiry into the Origins of Our Ideas of the Sublime and Beautiful* (1757),

defines the sublime as an experience of emotional excitement that suspends its spectator in a state of terror and dread.[20] According to Burke, this effect unsettles the soul by creating impressions of chaos, disparity, and anxiety. It is antithetical to an experience of the beautiful, which is identified with the classical tradition of order, balance, and harmony.

Prometheus Bound directly engages viewers with an experience of the sublime. Its monumental scale overwhelms the eye and makes it impossible to take in the entire image all at once. The setting itself is a landscape of grand proportions, signaled by the diminutive size of the vulture in the lower foreground and the ice-covered, craggy peaks that sweep into the distance. Even the giant Prometheus appears small and insignificant, easily overlooked at first glance. A deep chasm opens at the bottom right of the painting, positioning the viewer over its plunging abyss. The mountains are painted as if they were turbulent waves about to crash over the spectator, with Prometheus chained to the leading edge of the nearest crest. The strong diagonal organization of the scene and the apparent rushing movement of the landscape from right to left create a sense of the terrible force of nature that characterizes the sublime.

At the same time, an inverse triangular space occupies most of the upper portion of the painting, recording a vast and empty sky that stretches far into the distant night. At the lower left edge of the work, the rising sun signals daybreak, created with subtle tonalities that convey a quiescent radiance. Frederic Church called it "the finest morning effect I ever saw painted."[21] The sky's deep stillness and quiet luminosity contrast dramatically with the tempestuous terrain. Jupiter, a lone star, emphasizes the expansive emptiness.

The painting orchestrates a symphony of opposites: it is all agitation and yet still, at once earth and air, fiery and chilly, near and distant. It suspends the spectator between the emotional extremes represented by the calm of the empty sky and the turmoil of the jutting ridges.[22] The spectator is made to feel the dislocations in this landscape by its scale and by the emotional anxiety of sublime perceptions. In the language of Edmund Burke, *Prometheus Bound* demonstrates the moral possibilities of terror. More than merely the depiction of a tragic story, the painting enacts a disarming spectacle of competing visual signs. Although set far away from the actual American topography, the work expresses Cole's conservative moral vision through an allegorical landscape that becomes the principal character in the artist's own mythical history.[23] [DC]

20. GUSTAV GRUNEWALD, *Niagara Falls Diptych*

SUBLIME THEOLOGY

We must have new combinations of language to describe the Falls of Niagara. THOMAS MOORE[1]

Few sites in North America maintain as strong a hold on the popular imagination as Niagara Falls. It was a favorite tourist destination even before the building of the Erie Canal made it easily accessible in 1825, and afterward thousands visited it each year.[2] As an archetype of the natural grandeur associated with the American landscape, it served as an emblem of the republican virtues that appeared to be intrinsic to the continent. Nature and nation were indelibly linked in an imaginative scenario that implied it was the country's destiny not only to be shaped by but also to shape the seemingly untamable power of wilderness. Much has been written about the significance of Niagara Falls as a symbol of America's ambitions. Elizabeth McKinsey traces its ever-evolving associations as "an American icon" and writes that although it "never received official recognition as America's preeminent natural wonder, it was an obvious unofficial emblem of the new nation."[3] Indeed, Niagara Falls often served as an analogy for the country's most famous political voices, beginning with George Washington and continuing through Andrew Jackson, Daniel Webster, John Calhoun, and even extending to spiritual leaders such as Ralph Waldo Emerson.[4]

Moreover, Niagara Falls would play a pivotal role in the development of the Hudson River School painters in the first half of the nineteenth century. Their scenes of the terrain around New York and New England shifted the subject of American painting to the landscape, reflecting the wedding of nationalist sentiments to pride of place.[5] In his pendant paintings of Niagara Falls, Gustav Grunewald (1805–1878) created a work that expresses these symbolic correspondences, uniting American painting, history, and

identity. The paintings, *Niagara River at the Cataract* and *Horseshoe Falls from below the High Bank* (both ca. 1832), are monumental, each measuring seven by five feet. They offer an early example of the use of landscape to establish national identity through the visual language of the sublime, a pictorial vocabulary that emphasizes the viewer's felt experience over strict visual accuracy.[6] Rather than objectively describing a scene, Grunewald participates in the practice of Hudson River School painters in rendering the specifics of flora and fauna and the details of place with accuracy but organizing the composition with more of an eye to effect than accurate transcription.

Ironically, the viewer's encounter with the sublime in landscape painting was hardly a distinctly American experience; rather, it can be traced to a European discourse on the opposition between the beautiful and the sublime in the seventeenth century.[7] This debate was rooted in the opposition of visual styles represented by Claude Lorrain's classically formal, pastoral views and Salvator Rosa's tumultuous, often violent wilderness scenes. The sublime's central role in nineteenth-century landscape painting was further buttressed by Edmund Burke's treatise, *A Philosophical Enquiry into the Origin of Our Ideas of the Sublime and Beautiful* (1757). In Burke's formulation, the sublime is an aesthetic experience in which the object overpowers reason so that the pleasurable contemplation of its beauty is replaced by the frightening anticipation of its dangers, which he called "a sort of delightful horror, a sort of tranquility tinged with terror."[8] In his 1801 travel account, Heriot George describes Niagara Falls in just these terms: "Casting the eye from the Table Rock into the basin beneath, the

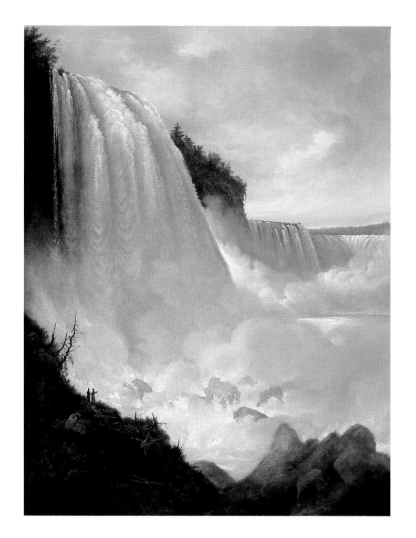 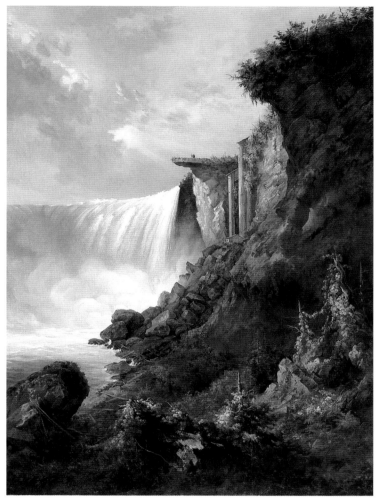

20A. Attributed to Gustav Grunewald (1805–1878), *Niagara River at
 the Cataract*, ca. 1832. Oil on canvas, 84 × 60 in. (213.4 × 152.4 cm)
 Gift of John Davis Hatch V, in memory of John Davis
 Hatch IV, A.I.A., architect of San Francisco, 1996.52.1

20B. Attributed to Gustav Grunewald (1805–1878), *Horseshoe Falls
 from below the High Bank*, ca. 1832. Oil on canvas, 84 × 60 in.
 (213.4 × 152.4 cm). Gift of John Davis Hatch V, in memory of
 John Davis Hatch IV, A.I.A., architect of San Francisco, 1996.52.2

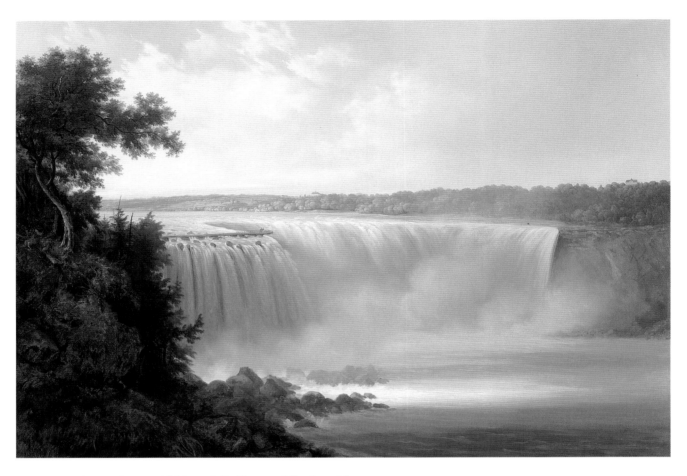

Fig. 20.1. Gustav Grunewald (1805–1878), *Niagara Falls*, 1834. Oil on canvas,
38 × 54 in. (96.5 × 137.2 cm). Allentown Art Museum, Pennsylvania, 86.07

effect is awfully grand, magnificent, and sublime. No object intervening between the spectator and that profound abyss, he appears suspended in the atmosphere."[9]

Drawing on the rhetoric of the sublime to depict Niagara Falls, Grunewald emphasizes the awesome spectacle of this natural phenomenon through the monumental size of the canvases and the diminutive scale of the figures inserted into both scenes. The tiny men at the base of the Horseshoe Falls (pl. 20A), as well as the even smaller trio standing in the distance on Table Rock (pl. 20B), reinforce the insignificance of humans in the presence of these powerful cascades. And yet, signs of tourism point to the central role of human participation in this natural wonder: the stairways along the cliffs, the viewing station, and the precarious lookout bridge extending eight feet beyond the precipice.

In addition, Grunewald incorporates the viewer into the drama by the seven-foot height of the paintings. This strategy accentuates the experience of the monumental falls by heightening the physical encounter with the painting as an object and visually aligning the viewer with the diminutive tourists in the scene. Traditional western landscapes are usually presented in a lateral format, emphasizing the significance of the horizon.[10] A vertical format is most often used in portraits, an orientation based on the upright position of the human body and the elongated oval of the face. One could argue that Grunewald has painted a double "portrait" of the falls, as if the site embodied its own distinct personality and psychology.[11] However, these paintings actually reference the psychological experience of spectators and their responses before representations of a sublime natural wonder.

Grunewald mobilizes the aesthetic experience of the sublime further through a subtle visual ploy that dramatically manipulates the viewer's perception. Although at first glance the paintings appear to be a single view divided between two equal canvases, the spectator's point of view

shifts significantly from one painting to the other. The unequal distances become evident when one compares the section of the falls included in both images. Horseshoe Falls appears in both scenes, but in *Niagara River at the Cataract* (pl. 20A) the viewer is positioned much farther downstream, closer to the large cascade on the American side, with Horseshoe Falls in the distance. The gap between the paintings does more than break the scene in half; it forces spectators to jump radically within the imaginary space of the scene, disturbing their equilibrium and engaging their senses in a visceral experience of the sublime.

As a prominent landscape historian writes, the sublime, "with its emphasis on obscurity, vacuity and indeterminacy, destabilizes and disorientates: in terms of landscape art it seeks to represent less the objects that strike the viewer than the sensations experienced by the viewer."[12] Grunewald's pendant paintings re-create these conditions on canvas even as he represents the natural scene with realistic precision, heightening the depicted illusion through his characteristic rendering of close tonal values, especially evident in the foliage, mist, and billows of foam.[13] More significantly, Grunewald captures the gap in the spectator's experience, the indeterminacy that frustrates a unified comprehension of the falls. He renders literal the gulf between human beings and the natural world that fascinated his teacher Caspar David Friedrich and underlies the sublime's radically subjective aesthetic.[14]

Niagara appears to have held a special resonance for Grunewald, who migrated from the Moravian religious community of Gnadau, Germany, to join the sect's settlement at Bethlehem, Pennsylvania, in 1831. One of his first sketching trips was to Niagara Falls in 1832, and from 1841 to 1854 he painted and exhibited the subject at least eleven times (fig. 20.1).[15] For the Moravians, an evangelical religious denomination, nature and its attendant phenomena were not so much a symbol of national destiny as evidence of God, "the Great Artist himself."[16] Most suggestively, the radical subjectivity of Friedrich's teachings on sublime painting as the catalyst for emotionally charged feelings within the viewer bears a remarkable resemblance to the Moravian doctrine of the "theology of the heart," which charged the believer to look for experiential evidence of God within.[17]

Given Moravian beliefs, Niagara Falls would have carried a double significance for Grunewald as the visible proof of God's marvelous handiwork and as a site to test the sensory actions of God's spirit within one's heart. The avalanche of jumbled boulders testifies to the power of the falls over solid rock and reveals even the most seemingly secure footing to be treacherous, a metaphor for the believer's precarious position on earth. Similarly, littered throughout the foreground of both paintings are logs and ruined tree stumps in the shape of crosses, reminders of God's presence as creator and destroyer. The light breaking through the clouds shines on the group of onlookers that occupy Table Rock, signaling the congruence of physical and spiritual experience. The effects of industrialism, which by the 1830s would have been evident in the buildings along the shoreline of the falls, have been eliminated in favor of a pristine wilderness.[18] Consistent with Moravian theology, the falls do not offer a challenge for human progress but a personal encounter with the divine. As the professor of drawing and painting at the Moravian Seminary for Young Ladies from 1836 to 1866, Grunewald would have been able to use Niagara Falls to instruct his charges on this relationship between nineteenth-century notions of natural philosophy and evangelical theology.[19] [DC]

FINDING A PARTICULARLY AMERICAN IDEAL

Let the . . . artist go to some of the grandest recesses in nature, such as is found in her mountains. . . . let him go to her wild forests . . . or to her cultivated valleys . . . let him view the angry, dashing and foaming waters . . . let no toil, impede his progress to these recesses of nature and let him view them with an unprejudiced eye.[1]

With these words Jasper Francis Cropsey (1823–1900) exhorted his fellow artists to experience nature firsthand, observe it closely, and depict it faithfully. For American landscape painters of the Hudson River School like Cropsey, the sketching jaunt was the center of their practice. During the summer months when the weather was kind, these artists left their urban studios and traveled in search of unspoiled vistas and inspiring scenery to sketch. Winter would find the artists back indoors, transforming their summer harvest into finished paintings.

Cropsey made his first such jaunt in 1843, shortly after he had completed his five-year apprenticeship in an architectural office. He spent two weeks in "the Jerseys," capturing the beauties of local sights such as Greenwood Lake. The resulting painting won him election as an associate of the National Academy of Design when he exhibited it there a year later. The painting was praised for being "a careful representation of nature [which] has the appearance . . . of having been painted on the spot; . . . the foreground is carefully painted and full of truth."[2] Cropsey returned to the area around Greenwood Lake again and again, painting more than twenty-five views between 1843 and 1897. The Fine Arts Museums' *View of Greenwood Lake, New Jersey* is the earliest located one.

In the first half of the nineteenth century, Americans ascribed meanings to their natural landscape that gave special resonance to the idea of "painting on the spot." No longer considered a dark and forbidding wilderness, American

nature became associated with both progress and divinity. This new appreciation for the symbolic richness of nature allowed landscape painting to flourish in America. It also meant that its practitioners bore heavy responsibilities.

One of those responsibilities was to preserve the sights of the wilderness before they were destroyed. "The axe of civilization is busy with our old forests," one author warned. "It behooves our artists to rescue . . . the little [wilderness] that is left, before it is for ever too late."[3] Yet, there was little desire to halt the relentless progress of civilization, that is, urbanization, industrialization, and territorial expansion. And indeed, another of the artists' responsibilities was to depict the newly cleared, fertile fields and the vast stores of natural resources that fueled America's rising power. In their paintings, landscape artists often contrasted tangled wilderness with a peaceful, spreading pastoral scene. While the prospect of loss tinted some of these paintings with a nostalgic glow, in others the horizon shone with a shimmering light, promise of a bright future. Additionally, landscape artists sought to express the connection between the American landscape and the divine. American nature was creation untouched. Contact with it, some believed, was as close as man could come to God.

As is perhaps obvious, there were contradictions inherent in these responsibilities: how to pay homage to both God and economic development, how to pay tribute to the direct experience of nature and to the idea of nature, how to convey moral messages and the results of semi-scientific

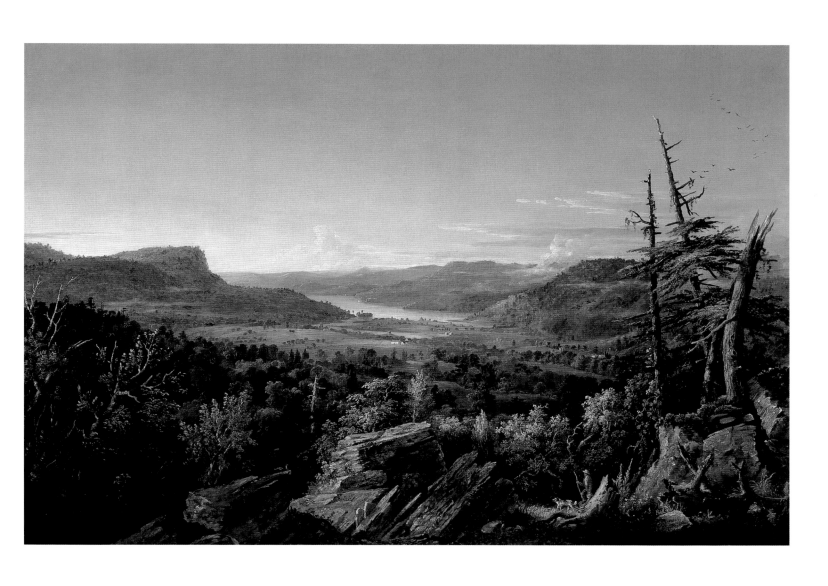

21. Jasper Francis Cropsey (1823–1900), *View of Greenwood Lake, New Jersey*, 1845. Oil on canvas, 30¾ × 40¾ in. (78.1 × 103.5 cm). Gift of Gustav Epstein, 45.24

Fig. 21.1. Jasper Francis Cropsey, *View from Bald Mountain, Orange County, New York, October 3, 1843.*
Pen and ink, sepia wash. Cleveland Museum of Art. Gift of J. L. W. Jones, 1933.401

observation? Thomas Cole (1801–1848) advocated turning to nature for inspiration, making careful studies of it, but then waiting before turning those studies into a finished work so that time might "draw a veil over the common details" and let the symbolic meanings resonate.[4] The second generation of Hudson River School painters under the artistic leadership of Asher B. Durand (1796–1886) put less stock in the powers of the imagination and more in the powers of observation, advocating precisely detailed representations of nature. Like many others, Cropsey straddled these two approaches of idealism and naturalism.[5]

To further complicate matters, ideas about the American landscape were colored with more than a tinge of cultural chauvinism. Americans were anxious to achieve cultural independence from England to match their political liberation. Writers minimized the artistic importance of the European landscape while celebrating the unique beauties and divine lessons of American scenery ("one is man's nature, the other—God's") and decried the steady stream of artists, Cropsey among them, who traveled, stud-

ied, and painted in Europe.[6] Europeans, meanwhile, asserted their condescending belief that the artistic "children" of "a new country" must take the opportunity "of studying art as well as nature in the old countries" if they hoped to improve.[7] Cropsey made his first trip to Europe in 1847, liking it so much he returned to England in 1856 for a seven-year stay. While there he painted English scenery but also many large landscapes of American subjects, using his old sketches. Known for his brilliant colors, he often painted autumnal scenes showing the rich reds and oranges of New England foliage. Visitors to his London studio greeted his exhibition of the vividly hued *Autumn—On the Hudson River* (1860, National Gallery of Art, Washington, D.C.) with skepticism, so Cropsey had some autumn leaves sent from America and tacked them up next to the painting, a masterful publicity trick and another opportunity to assert the importance of accuracy.

Cropsey painted this view of Greenwood Lake early in his career, and it shows his engagement with these ideas. The painting is probably a smaller version of an unlocated

1844 work that Cropsey displayed at the National Academy of Design; it is very closely related to the drawing for that missing painting.[8] When Cropsey made his sketch of Greenwood Lake in 1843, it was the middle ground and the shapes and massing of the mountains that captured his attention (fig. 21.1). He depicted the foreground as a quick, generalized band of bushes, trees, and rocks. For the painting, however, he created a foreground with splintered and overturned stumps and tree trunks, patches of wildflowers, tufts of shaggy flowers, and striated boulders. This detailed, dense foreground gives way to a view into a wide and peaceful valley, sprinkled with habitations and enclosed by well-worn purple mountains that stretch to the horizon. The sky, deep blue at the top of the painting, lightens to lavender and a touch of white at the horizon. The landscape is painted in rich, loamy greens and browns, enlivened in places with orange. In the center is Greenwood Lake, extending into the distance between the low mountains, a serene sheet of water.

Cropsey uses the elements in the foreground to do much of his symbolic heavy lifting. He probably based the foreground in part on sketches he had made in other locales and in part on his imagination. The landscape beyond, however, is full of the topographical particularities of an actual place: this red-roofed farmhouse here, the shape of this mountain just so, the curve of the water's edge like this.[9] Combining the imagined or synthesized with the observed in this way, Cropsey balances the ideal and the actual, the abstract and the local. The jumbled foreground is a contrasting frame for the expansive view beyond and enhances the sense of deep recession as the eye jumps over the rocks and undergrowth to reach the lake in the distance. A small, intrepid figure hiking through the wilderness at the lower right augurs the taming of this swath of wilderness. He carries a picnic basket, filled presumably with the bounty of the farms below, and travels with his trusty dog, a species once wild and now domesticated. Their arrival startles a bird from its roost on a wedge of rock. They are precursors of the many who will eventually survey, clear, inhabit, and farm these woods. With its upthrust angles and clearly visible strata, the wedge of rock is representative of the powerful forces that shaped the earth. In the decades before the publication of Charles Darwin's *On the Origin of Species* (1859), geologists, theologians, and naturalists advanced competing theories about the earth's formation while striving to make those theories compatible with belief in divine creation.[10] With the prominent placement of the rock, Cropsey is fulfilling his artistic obligation to represent faithfully the signs and results of these mysterious and awesome forces.

Cropsey was not alone at Greenwood Lake, as the sailboats dotting the surface of the lake suggest. As the century progressed and modes of travel improved, the new industry of tourism burgeoned in the United States, the New World's answer to the European grand tour. With no ancient ruins or soaring cathedrals to visit, Americans sought out sites of natural beauty and splendor. Guidebooks providing travelers with information and itineraries also told them how to look at and think about the landscapes they were seeing. Those descriptions are infused with the same ideas that Cropsey depicted in his view of Greenwood Lake. One 1857 guidebook explains how to get to Greenwood Lake and then adds appreciatively, "This varied hill and lake neighborhood presents in its general air an admirable blending of the wild ruggedness of the great mountain ranges and the pastoral sweetness of the fertile valley lands."[11] Just as Cropsey had painted it. [IB]

"A LITTLE PRESENT FOR FRIENDS & FRIENDLY PEOPLE"

The wolf also shall lie down with the lamb, and the leopard shall lie down with the kid; and the calf and the young lion and the fatling together; and a little child shall lead them.

And the cow and the bear shall feed; their young ones shall lie down together; and the lion shall eat straw like the ox.

And the sucking child shall play on the hole of the asp, and the weaned child shall put his hand on the cockatrice's den.

They shall not hurt nor destroy in all my holy mountain; for the earth shall be full of the knowledge of the Lord, as the waters cover the sea. ISAIAH 11:6–9

These verses were at the heart of a sermon delivered by Edward Hicks (1780–1849) to the Goose Creek Meeting of Loudon County, Virginia, in February 1837.[1] He was not a minister, for the Religious Society of Friends, or Quakers, do not have professional clergy. They believe, rather, that any individual can be a conduit of divine truth. Some, such as Hicks, became renowned for their gifts in this regard and spent much time traveling to meetings to speak. Hicks's Goose Creek sermon was considered so inspired that it was soon published as *A Little Present for Friends & Friendly People; in the Form of a Miscellaneous Discourse, by a Poor Illiterate Mechanic*.[2] The scriptural passage on which he expounded that wintry day in Virginia, prophesying the establishment of God's kingdom on earth, was a subject close to his heart, and one he knew well, for he had been depicting it on canvas for almost twenty years. By the time of his death in 1849, Hicks had painted at least sixty of his so-called Peaceable Kingdoms, most of which were given, bartered, or sold to other Quakers.[3] Hicks created these paintings expecting them to stay within his religious community; his faith and its practice are therefore essential to the study of his art.

Edward Hicks was born in 1780 to an Anglican family,

but he was raised by a Quaker couple after his mother died soon thereafter.[4] He did not become a Friend himself, however, until after a rowdy adolescence spent as an apprentice to the coach builders William and Henry Tomlinson. From them Hicks learned every aspect of constructing a coach, particularly enjoying the decorative ornamentation. Having discovered a profound love of painting, following his apprenticeship he established his own business creating signs and adorning coaches and other everyday objects.[5] Soon thereafter Hicks joined Quaker Meeting and gained a reputation for giving "compelling, spontaneous utterance to the 'inner light.'"[6] At this time he also became deeply involved in a controversy then polarizing the religion. Elias Hicks, Edward's older second cousin, and his partisans believed the Friends had deviated too far from the doctrine of "quietism," which held that it was necessary to empty one's mind of all outward concerns so as to be receptive to the inner light. Advocates of quietism believed in the silent meeting and personal simplicity, and they held that the Bible was a collection of "divinely inspired allegories—that the Scriptures were symbolic rather than literal in meaning."[7] Elias's efforts to return American Quakerism to this more austere and personal practice were extremely divisive, and

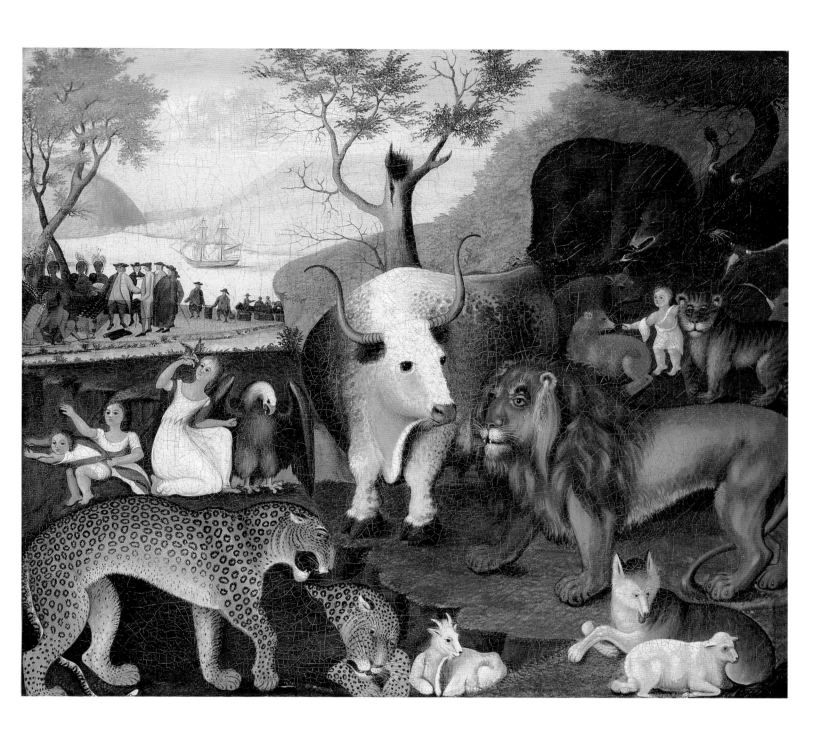

22. Edward Hicks (1780–1849), *The Peaceable Kingdom*, ca. 1846

Oil on canvas, 25 × 28½ in. (63.5 × 72.4 cm)

Gift of Mr. and Mrs. John D. Rockefeller 3rd, 1993.35.14

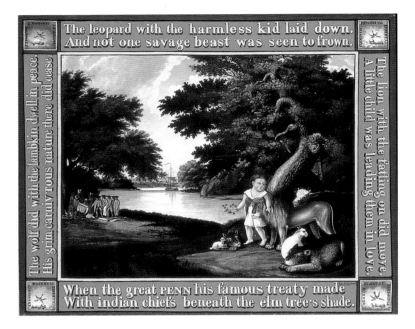

The leopard with the harmless kid laid down,
And not one savage beast was seen to frown.

The wolf did with the lambkin dwell in peace.
His grim carniv'rous nature there did cease.

The lion with the fatling on did move,
A little child was leading them in love.

When the great PENN his famous treaty made
With indian chiefs beneath the elm tree's shade.

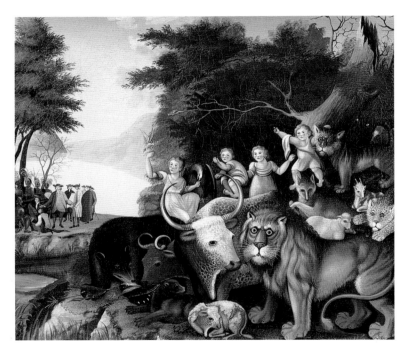

Fig. 22.1 [top]. Edward Hicks (1780–1849), *Peaceable Kingdom (with Rhymed Borders)*, 1826–27. Oil on canvas, 29¼ × 35¼ in. (74.3 × 89.5 cm). Abby Aldrich Rockefeller Folk Art Museum, Colonial Williamsburg Foundation, Williamsburg, Virginia, 1933.101.1

Fig. 22.2 [bottom]. Edward Hicks (1780–1849), *Peaceable Kingdom*, ca. 1830–35. Oil on canvas, 30⅛ × 34½ in. (76.5 x 87.6 cm). Fenimore Art Museum, Cooperstown, New York, N-38.61

two factions—the Orthodox and the Hicksite—spent years struggling for dominance. In 1827 a formal Separation was agreed on, though the two sects remained hostile for decades.[8] Three years after the Separation, Elias wrote a letter that would prove to be his last; its central theme was the Peaceable Kingdom of Isaiah, which his young cousin had been painting for the past decade. The letter was widely published as the final dispatch of a great leader, and Edward's images came to have a new currency among Hicksite Quakers.[9]

Though certain elements vary among Hicks's dozens of *Peaceable Kingdoms*, the paintings are more alike than different. The de Young's example is typical of those painted during the 1840s. The animal pairings of Isaiah are all present—wolf and lamb, leopard and kid, bear and cow, lion and ox—some with their mates, and the little child stands toga-clad in their midst. As Hicks's sermon explained, the wild animals represent man's baser nature, the domesticated ones the potential man has to transcend his nature if he will only open himself to the inner light.[10] The animals are stylized and iconographic rather than veristic, a hallmark of Hicks's style. To the left of the creatures appear three figures in vaguely classical dress. The largest has been variously identified as Peace, Liberty, and the goddess Hebe; she holds the dove of peace and is accompanied by the bald eagle of the United States.[11] This trio might signal Hicks's hope for peace on a national level. At her side are two children, whose gestures are at first difficult to comprehend. A closer look reveals one hand of the larger child to be covering a hole in the embankment; she must be the "weaned child," with her hand on the hole of the cockatrice (a mythical serpent). The smaller child must therefore be the "sucking child," and the rock on which he or she is perched the well-camouflaged home of the asp. In the background, separated from the main scene by a chasm and a river, is Hicks's interpretation of Benjamin West's famous *Penn's Treaty with the Indians* (1771–72, Pennsylvania Academy of the Fine Arts, Philadelphia). Penn, a Quaker, was included as an exemplar of quietist principles.[12] A tree rises from behind the massive ox at the middle of the composition. The trunk appears to have been struck by lightning, the upper portion broken off. From either side of the trunk a branch grows, one bearing the green leaves of spring and the other, dead, brown leaves. This tree represents the Society of Friends; formerly a single entity, it has split into two. In Hicks's conception, the branch of the Hicksites is alive and growing, while that of the Orthodoxy is in decline.

Even as Hicks's faith provided the subjects and impetus for his paintings, it presented a conundrum with which he would struggle for years. Simplicity was a key value for Quakers, especially Hicksites, who dressed in neutral tones and eschewed adornment of their persons or homes, an aesthetic incompatible with painting. Indeed, the fine arts were proscribed as a "worldly indulgence," although a grudging dispensation was made for artisans who created or decorated practical items for non-Quaker clients.[13] While Hicks's sign painting fell into this category, the easel paintings that he began to produce about 1820, such as the *Peaceable Kingdom*s, assuredly did not.[14] He was torn between his dearly held Quaker principles and a heartfelt belief that his impulse to paint came from God. In his *Memoirs* Hicks confessed, "My constitutional nature has presented formidable obstacles to the attainment of that truly desirable character, a consistent and exemplary member of the Religious Society of Friends; one of which is an excessive fondness for painting"[15] Hicks found many eager recipients for his works, however, and his production of *Peaceable Kingdom*s only increased with time. Evidently his paintings were considered exempt from the prohibition on painting, due to their religious subject and didactic function. John Comly, a Hicksite who vehemently rejected fine art, wrote in his journal in 1830, "My mind was opened to behold the operations of Divine Goodness in making use of outward things to arrest the attention and thus conveying deep instruction to the teachable mind. . . . let [children's] susceptible and innocent minds become familiarized with the pictures and representations of filial affection, of parental tenderness, of brotherly kindness, of innocence and peace, of images of God in the works of nature, or of the visible creation."[16] Complex ideas can be understood if they are presented in a simple manner, and at this Hicks excelled, drawing on his experience as a sign painter to produce easily legible visual sermons.[17]

Folk. Naïve. Primitive. All of these terms have been applied to artists whose work reflects artisan sources and a limited understanding of academic art.[18] Edward Hicks has often been considered the archetypal American folk artist, but the central role of faith in his life and in his painting sets him apart. The "folk" appearance of his art may result from a decision to adopt a "deliberately artless" style as a mechanism for satisfying his impulse to paint without compromising the tenets of his religion.[19] By applying the direct, iconographic technique of his sign painting to his easel paintings, Hicks distanced himself from "fine art"; the highly legible style is also appropriate for didactic images. He had no desire to create elite art, to command high prices, or to be enshrined on a museum wall.[20] Edward Hicks painted because he felt that his brush was an agent of the inner light, conveying God's message of peace on earth. [EL]

PADDLE WHEELS OF COMMERCE

George Caleb Bingham's *Boatmen on the Missouri* (1846) depicts an occurrence familiar to mid-nineteenth-century travelers in the West: men on a flatboat drifting silently downstream with a load of fuelwood. At the time, nearly all steamboats burned wood in their fireboxes to create the steam that turned their paddle wheels. According to one historian, a single steamboat making the round trip journey between Louisville, Kentucky, and New Orleans, Louisiana, in the 1840s burned on average 504 cords of wood (a single cord measures four feet high by four feet deep by eight feet long).[1] Steamboats carried only a limited amount of fuelwood, usually enough to last about twelve hours of running time, because boat owners wished to devote as much space as possible to paying passengers and freight.[2]

To meet the demand for fuelwood en route, men called "woodhawks" sold chopped and corded wood from stations along the riverbank. Some entrepreneurial individuals established woodyards where steamboats could tie up, while others, such as those Bingham represented in this painting, floated chopped wood out to passing steamboats.[3] A German traveling on the upper Mississippi River in the 1850s witnessed this refueling method firsthand:

[The woodhawks] have built small crude ships or flat-boats which are kept constantly in full load. Up front it is posted what the load of wood costs. The captain takes his telescope and reads the figure. If it suits him, he calls over to the shore "Cast off!" and immediately the wood-man springs onto his flatboat and secures it to the side of ours. We proceed with him in tow for a couple of miles

and the wood is unloaded. Then the man pushes off with his boat lightened but his pocketbook pleasantly enhanced, for the return to his wood place.[4]

Given the high volume of river traffic, where hundreds of steamboats making dozens of trips each year made the major western rivers the equivalent of present-day interstate highways, as well as the relatively easy access to timber along all the major rivers, many men found selling fuelwood to steamboats a lucrative business. Some even claimed it was more profitable than the other primary occupation of the area, farming.[5] Bingham, a longtime resident of Missouri, undoubtedly witnessed these men and their refueling operations during his frequent travels aboard steamboats in the West.

George Caleb Bingham (1811–1879) was born in Augusta County, Virginia, and at the age of eight moved with his family to Franklin, Missouri. He was initially inspired to become a painter by Chester Harding, who briefly visited Franklin in 1822 to complete his portrait of the region's most famous resident, Daniel Boone.[6] Eventually, Bingham became a successful portraitist, to the degree that portrait commissions provided him with a stable source of income for the rest of his life, but his letters tell us he longed to create more ambitious works.[7] Therefore, in 1838 he traveled to Philadelphia, Baltimore, and possibly New York, where, in an effort to improve his skills, he examined paintings in public collections, purchased drawings, engravings, and plaster casts, and perhaps even enrolled in anatomy classes.[8]

For the next six years Bingham complemented his portrait practice with genre and landscape subjects, but he

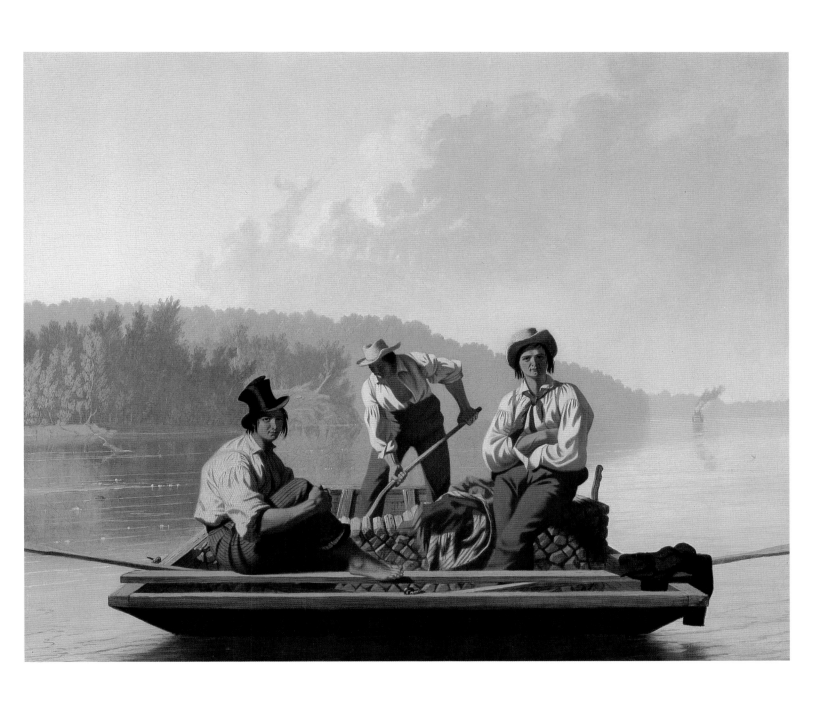

23. George Caleb Bingham (1811–1879), *Boatmen on the Missouri*, 1846

Oil on canvas, 25⅛ × 30¼ in. (63.8 × 76.8 cm)

Gift of Mr. and Mrs. John D. Rockefeller 3rd, 1979.7.15

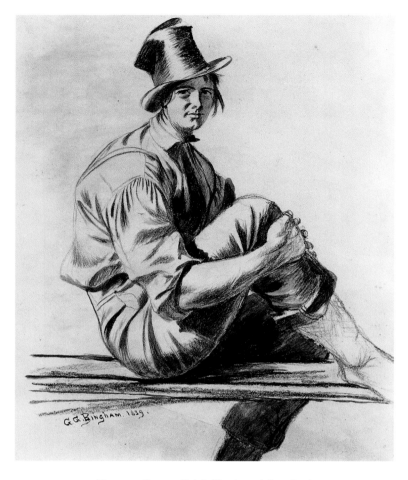

Fig. 23.1. George Caleb Bingham (1811–1879), *Boatman: Study for "Boatmen on the Missouri,"* 1839. Graphite and gray and black washes on wove paper, 9⅝ × 8⅛ in. (24.5 × 20.5 cm). Private collection

could find no patron consistently interested in these pictures. That changed, however, in 1845, when the American Art-Union, a New York–based organization devoted to stimulating public support for American artists, purchased two genre scenes and two landscapes from him.[9] The next year the same group purchased four more paintings from him, including *Boatmen on the Missouri*. For this one painting he was paid $100—the most money he had received for a genre painting to date.[10] Bingham had finally found an institutional patron willing to pay handsomely for this kind of painting, and over the next six years he developed a repertoire of works depicting life in the West for this organization. As a result, by 1849 he was known locally and nationally as "the Missouri Artist."[11]

Boatmen on the Missouri may represent a familiar aspect of life on the Missouri River, but the painting is not a transcription of reality. Western travelers generally found actual woodmen to be unsavory characters. One traveler termed them "outcasts," while another described them as "generally tall, lanky, unwashed men, with clay-coloured faces, looking for all the world as though they had been made out of the same mud that dyes the Mississippi waters."[12] Boatmen as a class also had a poor reputation.[13] In preparation for his painting, Bingham did not sketch real woodmen or boatmen. Instead, he asked his acquaintances to dress in the appropriate costume and posed them in emulation of figures he found in engravings after Renaissance paintings (fig. 23.1).[14] As a result, the men in his paintings appear clean, respectably dressed, and perhaps even a bit genteel, in contrast to the threatening and dirty ruffians his contemporaries described in their travel accounts and diaries.

The artist then used these sketches as the basis for his painting, placing each figure in a rigorously structured composition. The three boatmen and their flatboat form a pyramid and thus appear as a self-contained unit. However, the artist's placement of the figures on the boat also connects them to their surroundings. The man on the far left sits on a thick plank resting across the two gunwales at the front of the craft. Dressed in striped trousers, a loose-fitting shirt, and a hat with a broken crown, he faces to the right while clasping his knee with his hands and looking out at the viewer. The figure to the far right, wearing brownish red pants, a shirt tied at the neck with a red kerchief, and a cream-colored hat, perches on the load of chopped wood stacked across the midsection of the boat. He too looks out toward us. To the rear of the boat is a man dressed in mauve

pants, loose-fitting shirt, and a cream-colored hat who tenses his stooped frame to scoop a shovelful of bark chips overboard. By positioning each figure farther back on the boat, Bingham subtly leads our eye to the thickly wooded riverbank on the shore behind them. In addition, by posing the men so that the head of the man on the left is lowest in the composition, that of the stooping man slightly higher, and the head of the man leaning against the woodpile the highest, Bingham encourages us to read the composition from left to right, thereby establishing a momentum that connects these woodhawks to the steamboat visible at the far right. We are therefore able to see them as much-needed middlemen who, by transforming the forest into fuelwood, advance the machinery of commerce, the steamboat.

Although it is carefully composed, *Boatmen on the Missouri* nonetheless appears "real." Most paintings representing shipping take as their vantage point a riverbank or shoreline. Bingham, by contrast, positions his viewer hovering five or six feet above the water in front of the boat. He also has two of the men look out toward us. In so doing they seem to acknowledge our presence. Or do they? Their expressionless faces also suggest that they are simply looking at the scenery downriver behind us, and if this is so, then we do not exist for them. We are thus encouraged to believe we are witness to life along the river as it cannot be seen from the river's edge, and therefore what we see appears authentic.

Bingham's painting ultimately contributes to the mythification of the American West. By identifying the men in the painting's title as "boatmen" and not as "woodhawks," and by representing two of the men relaxing, we all overlook the labor they had previously expended. Woodmen typically spent the winter cutting, chopping, hauling, and stacking wood in anticipation of steamboat traffic that began after the spring thaw. Such work must have been laborious, dangerous, and dirty, to say nothing of the mosquitoes that swarmed during the warmer months. Moreover, woodmen did not usually load wood onto a passing steamboat; instead, this job fell to the boat's crew.[15] Woodmen therefore must have often appeared as boatmen to travelers like Bingham who only saw them as they rowed a load of fuelwood out to a steamboat, waited for it to be loaded, and then drifted back downstream. *Boatmen on the Missouri* would have us believe the American West was a place where easy profits come from nature's abundance, not the physical labor required to transform nature into a saleable commodity.[16] [KM]

24. GEORGE CALEB BINGHAM, *Country Politician*

TALKING POLITICS

George Caleb Bingham (1811–1879) was not only a successful painter, he was also an active politician.[1] He first entered political life in 1840, when he was named a delegate to the Missouri state Whig convention. At the same time, he was commissioned to paint processional banners for Whig candidates.[2] The Whig Party had formed a few years earlier from a coalition of smaller parties united in their opposition to the policies of Andrew Jackson and his followers, whom many saw as disregarding and undermining the principles of the Constitution.[3] Whigs believed themselves the true inheritors of the democratic principles established by the American Revolution and accordingly took as their name the word applied in the eighteenth century to the colonists who resisted the tyranny of the English monarchy.

Bingham probably came to identify himself as a Whig in 1837, when he was adversely affected by banking policies enacted by President Martin Van Buren, a Democrat.[4] In 1844 Bingham once again served as a delegate to the Whig state convention and painted political banners for Whig candidates. Then in 1846, at the urging of his friends, he ran for state representative from Saline County. Although he won the election, the results were contested by the Democratic candidate, and Bingham held the office for only three months, at which time the legislature controlled by Democrats ruled against him. He swore he would never again enter politics, but in 1848 he ran for state representative again, this time defeating the Democratic incumbent.[5]

Despite his busy political schedule, Bingham continued to paint portraits and genre scenes, and in the spring of 1849, only months after he had begun his term as state representative, he completed his painting *Country Politician*. Bingham carefully planned and executed this painting,

making detailed drawings of each figure, some of which reveal he considered different poses and physiognomies (fig. 24.1).[6] His attention to the subtleties of facial structure was part of the more general interest in the pseudo-science of phrenology, which claimed that the shape of a person's face and head revealed his or her true character.[7] By rendering the figures with distinct physiognomies, Bingham no doubt expected his contemporaries to "read" the figures' faces.

Once he completed his preparatory drawings, the artist positioned each figure within a highly structured composition.[8] The gentleman who sits on an overturned crate draws us into the composition by looking at us and, because no one is seated across from him, we are able to imagine ourselves joining the discussion. The orthogonals created by the floorboards and rafters of the room focus our attention on the talking politician to the right. His posture, gesture, and gaze in turn direct us to the old man hunched on the chair opposite him. He leans toward the politician and looks at him intently, thus encouraging us to look back at the politician and at the gentleman beside him. Taking a slow pull on his pipe, he appears to ruminate on the politician's point. Looking us in the eye, he seem to be asking, "Well, what do *you* think?" To the left stands a young man with his back turned to the stove. Although he may be listening to the politician, he appears more intent on reading the notices posted on the wall, including the large poster for the Mabie Circus, which locates the scene somewhere in rural Missouri.[9]

No symbols appear anywhere in the painting to suggest the subject of the politician's discourse, and therefore the painting appears to depict a slice of everyday life: three men listening to a politician. However, for the artist and his

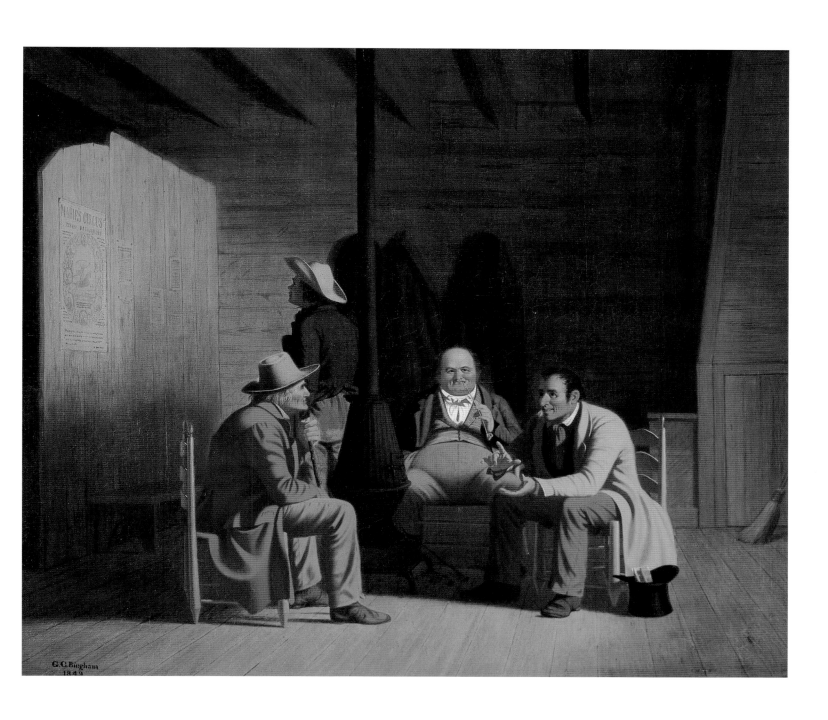

24. George Caleb Bingham (1811–1879), *Country Politician*, 1849
 Oil on canvas, 20 × 24 in. (50.8 × 61 cm)
 Gift of Mr. and Mrs. John D. Rockefeller 3rd, 1979.7.16

Fig. 24.1. George Caleb Bingham (1811–1879),
Citizen, 1849. Black india ink, wash, and pencil
on rag paper, 9⅜ × 8¾ in. (24.5 × 22.2 cm).
The Nelson-Atkins Museum of Art, Kansas City,
Missouri. Lent by the People of Missouri, 8-1977/52

fellow Missourians, the painting was a response to a highly charged political debate currently raging throughout the state. Bingham exhibited *Country Politician* in St. Louis shortly after he completed it. In a brief article published in the local *Daily Missouri Republican*, a reporter described it as "a scene in a bar-room, in which the group is most perfect life-like. The jolly old landlord, smoking his pipe; a politician, most earnestly discussing to a very indifferent looking farmer the Wilmot Proviso; whilst a boy, with his coat-tail turned up to the stove, is reading a show-bill."[10] The reporter, perhaps reading each figure's physiognomy, identified the men as specific types—a politician, a land-lord, and a farmer. More significantly, he saw them dis-cussing a specific piece of legislation, the Wilmot Proviso.

The Wilmot Proviso had been authored by a Pennsylva-nia representative to Congress as an amendment to an 1846 bill authorizing federal funds to purchase territories from Mexico.[11] The amendment sought to prohibit the intro-duction of slavery into any new territories. Although the Wilmot Proviso never came up for a vote in the Senate, and therefore never became law, the House of Representatives did vote on it twice, in 1846 and again in 1847. Each time, the vote was divided along sectional lines, with Northern representatives voting for it and Southern representatives voting against it, thereby vividly underscoring the deep dif-ferences between North and South on the question of slav-ery. The Wilmot Proviso injected the issue of slavery into political discussions throughout the country, but especially in Southern states like Missouri, where slavery was legal.

In January 1849 the Missouri State Senate passed what came to be called the Jackson Resolutions—named after the Democratic Missouri senator Claiborne Jackson.[12] These resolutions responded to the Wilmot Proviso by as-serting that it was unconstitutional for Congress to enact any legislation on the subject of slavery. If Congress did at-tempt to pass such laws, the Jackson Resolutions stated Mis-souri would cooperate with other slaveholding states "in such measures [as] may be deemed necessary for our mu-tual protection against the encroachments of Northern fa-naticism."[13] Jackson and other Southern slaveholders saw the Wilmot Proviso as an attack on the South by the North, so in response he and like-minded Southerners responded by threatening to dissolve the Union altogether. The Sen-ate resolutions then went to the Missouri House of Repre-sentatives, where it was referred to a committee on which Bingham sat, the Committee on Federal Relations. This

committee proposed a more moderate set of resolutions, known as the Bingham Resolutions, which acknowledged that Congress did have the authority to limit slavery in new territories, but recommended that Congress defer to the citizens and politicians of each state to decide the issue on their own. These more moderate resolutions did not call for the abolition of slavery, nor did they threaten secession. The Jackson Resolutions eventually carried the day and were adopted by the Missouri State Senate and the House.

Writing some forty years later, one Missouri historian noted that the debate on the Wilmot Proviso "occasioned very great excitement, threatening not only the accustomed repose and fellowship of the people, but the disruption of political parties."[14] Given the fact that Bingham painted *Country Politician* about the time he was engaged in formulating a more moderate response to the Jackson Resolutions, it seems likely the painting represents his solution to the debate engendered by the Wilmot Proviso: namely, that it was the responsibility, not of Congress, but of the down-home sort of people Bingham depicted in his painting to debate and resolve for themselves the issue of slavery within their respective states.[15] Thus, the gentleman who looks out from the painting might be more pointedly asking us, "Well, what do you think about *slavery?*"

Curiously, once Bingham's painting traveled back East it lost these connotations. In the summer of 1849 Bingham took *Country Politician* to New York, where it was purchased by the American Art-Union (AA-U) for $200.[16] The AA-U sought to promote American art to ordinary citizens, and therefore its selection committee preferred works that would have broad appeal throughout the country. *Country Politician* may have invoked the emotional debate over slavery and states' rights for the artist and his peers in Missouri, but the AA-U saw it in decidedly neutral terms and thus described the subject of the painting as "Three men are seated around a stove, one of whom is arguing some knotty point with an old traveler. Behind the stove a man is standing warming his back with his coat-skirts lifted."[17] Of course, Bingham's painting could seen in such terms because it avoids overt, and even covert, political symbolism. It may have appealed to the AA-U because it depicted a community activity understood at the time to be characteristically American. "To take part in the government of the society and to talk about it is the greatest business and as it were the only pleasure that an American knows," wrote the Frenchman Alexis de Tocqueville in his *Democracy in America* (1835).[18] Bingham thus negotiated the regional and national by subsuming a specific regional debate over the future of slavery within an artistic rendering of the national activity of discussing politics.[19] [KM]

25. CHARLES CHRISTIAN NAHL, *Peter Quivey and the Mountain Lion*

FROM THE PRAIRIE TO THE PARLOR

Charles Christian Nahl's personal experience of California frontier life endowed his work with an aura of authenticity that earned him a reputation as the best of the gold rush–era artists. He deserves the principal credit for establishing the pictorial image of the forty-niner as a uniquely American archetype, comparable to such legendary predecessors in the American West as the frontiersman and the river boatman. Nahl's paintings and illustrations also recorded the complex convergence of Native American, Spanish, Euro-American, and Asian cultures that helped to forge the identity of a new character type—the Californian.

Karl (Charles) Heinrich Christian Nahl (1818–1878) was born in Kassel, Germany, into a family composed of several generations of painters, sculptors, engravers, and craftsmen. He studied art first with his cousin Wilhelm, and then with Justin Heinrich Zusch at the Kassel Academy. In 1846 Nahl moved to Paris, augmenting his training with the history painters Horace Vernet and Paul Delaroche with human anatomy studies at the School of Medicine and the city morgue. In 1849 Nahl immigrated to New York City and established a reputation as a history and genre painter through the American Art-Union (1839–52).[1] Nahl's unique synthesis of European Realism and Romanticism, along with his skills as a history, genre, portrait, and animal painter, ideally suited him for his subsequent career in California.

Lured by visions of gold rush fortunes, in 1851 Nahl and fellow artist Frederick Augustus Wenderoth sailed for California, where they made an unsuccessful attempt at mining in the Yuba River town of Rough and Ready, near Nevada City. When the aspiring Argonauts realized they had been sold a "salted" (artificially enriched) mining claim, Nahl reverted to his original calling, creating twelve-dollar portraits that the miners could send to their families.[2] After his Sacramento studio was destroyed by fire in 1852, Nahl settled permanently in San Francisco, establishing an art and photography studio in partnership with his brother Arthur and Wenderoth.

In the three years before Nahl arrived in San Francisco, the non-native population had grown exponentially from less than one thousand to approximately forty thousand. Cognizant of their role in the national drama of America's Manifest Destiny to settle the trans-Mississippi West, newly wealthy patrons with social and cultural aspirations commissioned artworks that documented their contributions to California's evolving history. Nahl created oil and daguerreotype portraits for these private patrons, lithographs for the print market, and drawings for wood engravings that were published in books and periodicals.[3] Portraiture—of both the living and the dead—constituted the bulk of their commissions, and Arthur Nahl wrote in 1858: "We are working like a factory; Carl [Charles] paints the heads and I paint the garments."[4]

Among Nahl's portrait patrons was Peter Quivey (1807–1869), a prominent pioneer, forty-niner, farmer, livestock rancher, landholder, hotelier, and hunter who settled in San Jose, fifty miles south of San Francisco. Quivey's travels as a pioneer mirrored the expansion of the American frontier. Born in Syracuse, New York, he moved to Kentucky in 1825, Indiana in 1836, Missouri in 1839, and California in 1846. En route to California, Quivey and his family initially joined the infamous Donner Party, but by traveling ahead of the main group, avoided its fate of starvation, death, and cannibalism in the Sierra Nevada. On his arrival, Quivey learned of the outbreak of the

94

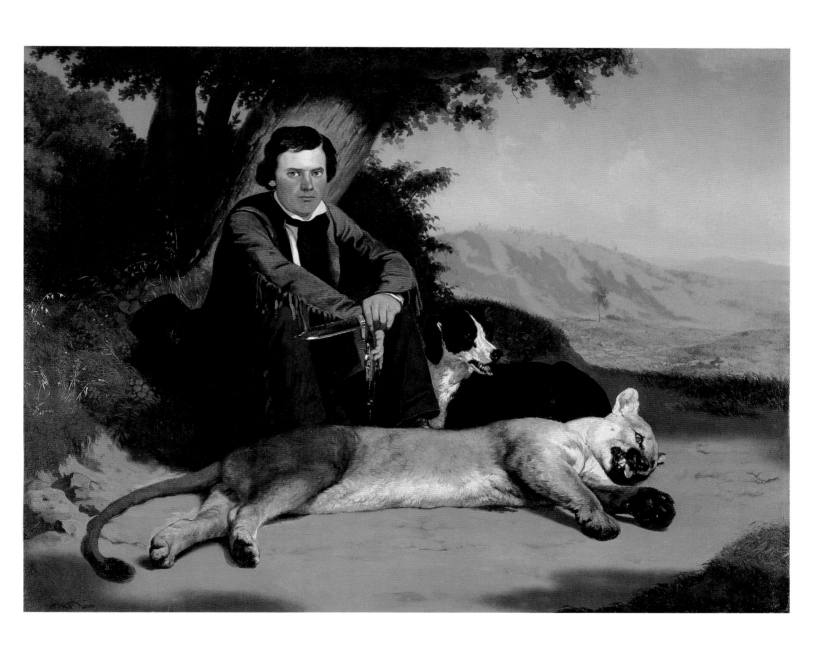

25. Charles Christian Nahl (1818–1878), *Peter Quivey and the Mountain Lion*, 1857. Oil on canvas, 26 × 34 in. (66 × 86.4 cm). Museum purchase, James E. Harrold Jr. Bequest and gift of an anonymous donor, 1998.32

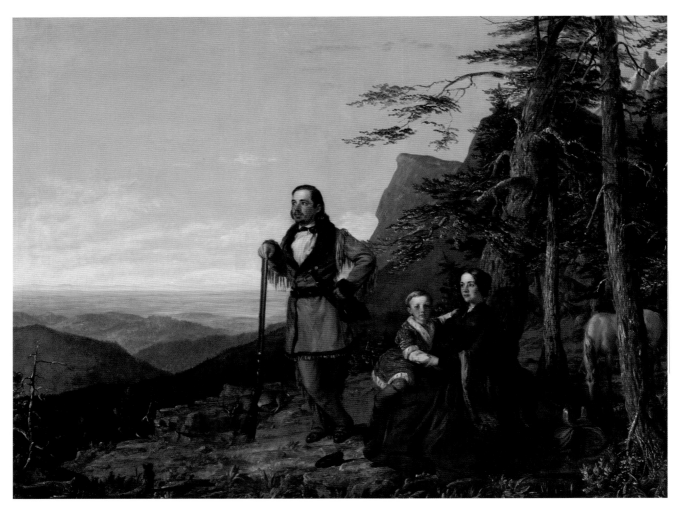

Fig. 25.1. William Smith Jewett (1812–1873), *The Promised Land—the Grayson Family*, 1850. Oil on canvas, 50¾ × 64 in. (128.9 × 162.6 cm). Daniel J. Terra Collection, courtesy of Terra Museum of American Art, Chicago, 5.1994

Mexican-American War and joined Colonel John C. Frémont in liberating California from Mexican rule. In 1847 Quivey settled permanently in San Jose, where he built both the first frame house and the first hotel—the Miners' Home.[5]

Nahl's *Peter Quivey and the Mountain Lion* (1857), which depicts Quivey in the self-conscious pose of a heroic, two-fisted frontiersman and hunter, was described in the newspaper *Daily Alta California*:

> Mr. Quivey has a picture by Nahl, representing him sitting at the foot of a tree, with a revolver and a bowie knife in his hands, and a dead panther lying stretched out before him. It was taken from a photograph which was itself taken from nature. The panther was one which Mr. Quivey killed with his revolver after it had been driven into a tree by his dog.

He went up under the tree and killed the brute. The picture is done in Nahl's best style, and would do no discredit to any gallery. . . . Mr. Quivey has promised to send this picture to the Agricultural Fair of the District.[6]

Nahl's use of a now-lost photograph "taken from nature" as the basis for his painted portrait of Peter Quivey reflected a common practice among contemporary portraitists, referenced in an editorial published in the art periodical *The Crayon* in 1855: "The apprehension once entertained that this art would, to a certain extent, thrust the artist and his vocation aside, are now no longer indulged; but, on the contrary, it is seen that Photography, so far from being a rival, is in truth a most important auxiliary to the resources of the artist."[7] In another article published in *The Crayon*

in 1857, the renowned portraitist Rembrandt Peale observed that "it has become necessary for the portrait painter to make his portraits not only *as* true, but expressively *more* true than the daguerreotypes, with which but few, at present, are 'content.'"[8]

The influence of photography—and the photography studio—is readily apparent in Nahl's stagelike setting, in which the human and animal protagonists are rendered with a clarity of focus while the Santa Clara Mountains provide a scenic backdrop softened by atmospheric perspective. Responding to Nahl's photographic aesthetic, the art critic Benjamin P. Avery observed: "He is distinguished for excellence of drawing, richness of finish, accuracy of detail, and brilliancy of color. Nothing that enters into his works is slightingly treated; indeed, the only objection to this fine artist is, that he is too exquisitely mechanical in some of his pieces."[9] Despite Avery's critique, the authenticity of Nahl's portrait is enhanced by such exquisitely rendered details as Quivey's face (which is suntanned only below the area shaded by his hat), the soft fur of the animals, and the gleaming steel weapons.[10]

Quivey's weapons of choice are a bloodstained Bowie knife, of the type made famous by the frontiersman Jim Bowie, and a .44 caliber Colt Model Dragoon revolver manufactured by the Hartford, Connecticut, firm of Samuel Colt.[11] These legendary weapons, which played key roles in the American West, are linked visually to the eyes and mouth of their mountain lion victim by their glistening highlights. Quivey's fringed buckskin coat and pants consciously recall the trademark attire of Daniel Boone and Davy Crockett, America's most famous frontiersmen. Quivey's carefully cultivated backwoods persona is somewhat belied by his stylish, starched white shirt, silk foulard, and hat, which identify him as a gentleman hunter. Quivey's role as a mediator between the frontier and civilization is emphasized by the contrast between the wild mountain lion and the trained hunting dog, and between the primitive knife and the technologically sophisticated re-volver. Quivey's dual identities as an experienced frontiersman and as a nascent art patron, equally adept on the prairie or in the parlor, are emblematic of the seemingly competing agendas that coexisted in gold rush–era California.

Nahl's photographic and painted portraits of Quivey were both almost certainly influenced by William Smith Jewett's painting *The Promised Land—the Grayson Family* of 1850 (fig. 25.1). Both portraits depict pioneering Californians who wear buckskin attire with a white shirt and black cravat while carrying a gun and a Bowie knife. Similarly, both paintings incorporate recognizable California landscape settings and a dead game animal.[12] Peter Quivey had traveled with the Graysons for at least part of his westward journey to California in 1846, and *The Promised Land—the Grayson Family* was renowned in San Francisco art circles even before its first public display in 1857, the same year Nahl dated Quivey's portrait. Significantly, the Graysons' instructions to Jewett stated that their portrait should represent the "success of pioneers."[13] This broader theme is made explicit in Jewett's title, *The Promised Land*, but it is also implicit in Nahl's portrait of Peter Quivey, which is almost certainly the painting exhibited at the California State Fair in San Jose in 1856 with the more generic title *The Hunter*.[14]

Nahl's *Peter Quivey and the Mountain Lion* is a product of the complex political, social, economic, and cultural forces that lured both the artist and his subject to California during the gold rush. The painting may be viewed as a trophy that commemorates the hunting prowess and the cultural sophistication of its patron. In addition, Nahl's proficiency with the language of European history painting enabled him to transform this provincial California genre scene into an American history subject that reflected national aspirations. *Peter Quivey and the Mountain Lion*, a visual metaphor for the intersection of nature and culture, reflects America's perceived Manifest Destiny to settle and to domesticate the trans-Mississippi West, a national vision that was realized in gold rush California. [TAB]

CULTIVATING NOSTALGIA

For many viewers, George Henry Durrie's (1820–1863) *Winter in the Country* (1857) looks familiar even if the artist's name is not. Was *Winter in the Country* the picture for January on the calendar that came from the insurance company? Perhaps it was on a card, bordered in red and with "Season's Greetings" written in gold script underneath it. Or perhaps that sense of familiarity has a less tangible source, for the painting conforms perfectly to a shared American idea of a once-common but now-lost way of life that was lived in New England in the mid–nineteenth century.[1] As such, it serves as a vivid illustration of the myths the nation tells itself about its rural past.

The scene is a simple one: a farmyard in winter, a barn, an inn, distant mountains, a small stream. Visitors arrive and depart. Animals pull a sledge with a load of firewood. Each element in the scene is highly evocative of that lost way of life. Durrie shows us glittering icicles, a curl of blue smoke, friends meeting on a porch, chickens scratching on the snowy ground, wary but not unfriendly dogs sizing each other up. These details and others conjure the smell of a wood fire, the ring of voices and the jingle of a harness in the brisk air, the cracking sound of ice, the crunch of snow, and the swish of sled runners, bracing cold and the promise of warmth indoors. The pink, yellow, and lavender sky rhymes with the pale yellow of the inn, the grayish purple of the mountains, and the pinkish tinge of the shadows thrown on the snow, unifying the scene and casting it all in a comforting glow.

Durrie was one of the originators of the American winter landscape as a subgenre and certainly its most consistent and prolific practitioner.[2] He received little formal education and not much artistic education either. He studied with Nathaniel Jocelyn (1796–1881) between 1839 and 1841,

but probably only intermittently as he was also working as an itinerant portraitist at the time. He produced his first winter landscape in the mid-1840s and was established as a landscape painter by 1850. But for one year, he spent his adult life in New Haven, Connecticut, and many of the elements that appear in his paintings are drawn from the surrounding countryside.[3] Years after his death, his daughter recalled how, as a young girl, she had watched him paint: "Sometimes I would linger [in his studio], watch him put brush on canvas, starting a winter scene, and see what appeared: the roof of an old tavern, or the top of a farmhouse, or some barns, a cow enclosure; on my next visit a road, a sleigh, a load of wood going by, drawn by oxen, a little dog following—always a dog was a feature of his winter scenes—perhaps the driver stopping to chat with a friend on the road."[4] As Mary Clarissa's memory suggests, Durrie returned repeatedly to favorite motifs: the curving road, the welcoming inn, the barns and animals in the farmyard, the vignettes of rural companionship and sociability. Durrie did paint other seasons, sometimes referred to as his "foliaged" landscapes, but what little measure of fame he achieved during his life was due to his paintings of winter. The lithographers Currier & Ives purchased ten of his paintings, many of them snow scenes, and published prints of them between 1861 and 1867. Some of those prints then appeared on calendars for the Traveler's Insurance Company. Widely disseminated by Currier & Ives, Durrie's images became well known. But art world connoisseurs, critics, and historians quickly forgot him after his death—if they ever knew him at all.

A large part of the reason why Durrie has been substantially overlooked until quite recently is that he worked outside the established, celebrated landscape convention of the Hudson River School. The Hudson River School artists,

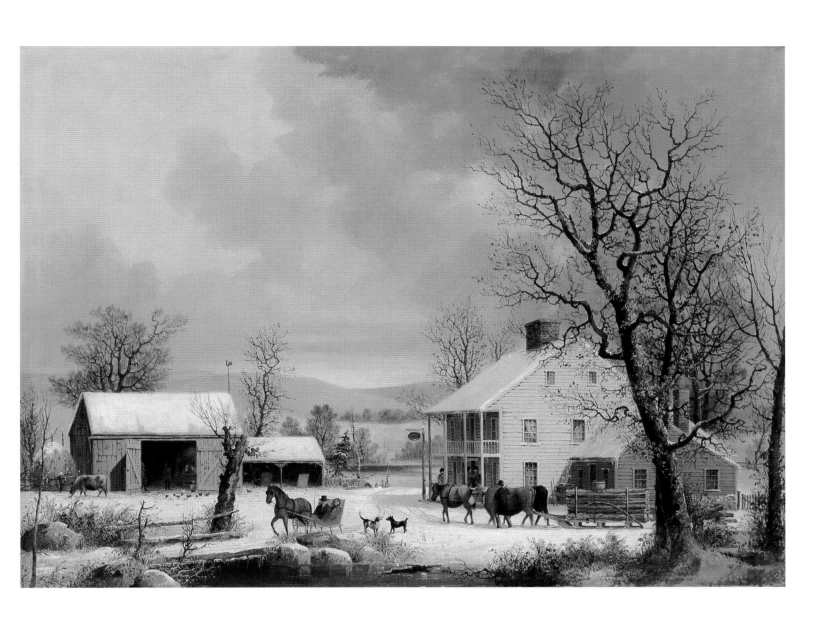

26. George Henry Durrie (1820–1863), *Winter in the Country*, 1857
Oil on canvas, 18 × 24 in. (45.7 × 61 cm). Museum purchase,
Roscoe and Margaret Oakes Income Fund, 1985.47

many of whom had received European training, typically minimized the human presence in the landscape, focusing instead on natural elements to capture the profundity of the American landscape. It fell to them, in part, to redefine the nation's relationship to its diminishing wilderness in the face of expanding cities, growing industry, and tourism. While the Hudson River School artists depicted God's work, Durrie depicted man's work. He lacked training in European landscape conventions, and his sensibilities were more akin to those of the Dutch genre painters. Rather than trying to capture the immensity and symbolic meaning of the American landscape, Durrie made it primarily a setting for human activity, infusing it with anecdote and charming incident. He also chose a subject—the landscape in winter—that was unpopular with Hudson River School painters.[5]

Durrie was aware of the kind of landscape painting that was being practiced by the Hudson River School. He was a lifelong admirer of the work of Thomas Cole (1801–1848), the progenitor of the Hudson River School tradition. In an advertisement for a sale of his winter scenes he wrote that he was offering them to "the admirers of the fine arts and all who would adorn their parlors with pictures that will stand for ages as an evidence of a cultivated and refined taste."[6] He understood what the watchwords were, appealing to potential purchasers' elevated sensibilities. Durrie even tried living in New York in an apparent attempt to enter the national art scene. In 1857 he opened a studio on Broadway but returned to New Haven a year later—his work was out of keeping with current metropolitan ideas of fine art.[7]

Yet both the painters of the Hudson River School and Durrie trafficked in loss and longing. From an early-twenty-first-century perspective and for urban and suburban dwellers as so many of us are, *Winter in the Country* appears coated with a sugary layer of nostalgia—sweet or saccharine depending on personal taste. But even at the time of its making, the painting evoked a way of life that many remembered, but fewer and fewer lived. The painting offered an idealized depiction of rural existence, glossing over poverty, toil, and hardships. Durrie's paintings promised neighborliness rather than isolation; time free for sleigh rides, skating, and visiting; sleds fully laden with wood; and plenty of hay for every animal.[8] While the Hudson River School painters might avoid winter scenes, the snow-blanketed farm became a popular literary and pictorial trope after the Civil War, most notably in James Greenleaf Whittier's book-length poem, *Snow-Bound* (1866). The poem concludes,

Dreaming in throngful city ways
Of Winter joys his boyhood knew;
And dear and early friends—the few
Who yet remain—shall pause to view
These Flemish pictures of old days;
Sit with me by the homestead hearth.
And stretch the hands of memory forth
To warm them at the wood-fire's blaze![9]

The mention of paintings from the Low Countries reveals the common source for the poem and Durrie's paintings, which also offered warm memories of childhood winter pleasures to urban dwellers.

Whittier was an abolitionist, and *Snow-Bound* celebrates the traditional New England virtues of hard work and moral fortitude, virtues that stood in implicit contrast to the degeneracy of the South, corrupted by slavery. Durrie emerges in the pages of his diary as a genial, sociable man whose idea of a "fine day in every respect" was to spend some time working, have tea with a friend, and go for a long walk.[10] He recounts sleigh rides, recalling "the trees sparkling with icy limbs" and how the snowy ground "glittering in the sun looked beautiful," but not finding any greater meaning in the experience than the pleasures of the excursion.[11] Yet in the saltbox house at the right in *Winter in the Country*, Durrie makes reference to the first New England settlers, yeoman farmers who had built the small dwelling, and cleared and tended the land. Prospering through labor and discipline, their descendants were able to build the house next to it with its second floor and porch. In the juxtaposition of the two houses, Durrie describes a narrative of economic and social progress based on those New England virtues. Durrie's artistic vision was retrospective, but not apolitical.

Popularity can be treacherous for artists. The Currier & Ives prints, affordable and widely available, convinced critics that Durrie was a popular rather than a fine artist. The prints were translations of his paintings rather than replicas of them, but the deficiencies of the prints led some to dismiss Durrie's skill. Other historians used Durrie's paintings as social documents, gleaning information about rural life, but overlooking their aesthetic value. Today, we recognize Durrie as an artist with a profound commitment to his chosen subject, as well as the ability to develop independently. He possessed the tenacity and confidence to diverge from the dominant artistic philosophies of his day. He saw the artistic possibilities of a New England farm under a perfect blanket of snow. [IB]

27. JAMES BARD, *The Steamship "Syracuse"*

BUILDING A STEAMBOAT

It is the end of the day. The sky is awash with pink, purple, and orange. The water, ruffled by small waves, is a deep blue in the fading light. Sailboats tack close to shore. Suddenly, the noise of a steam engine rumbles through the quiet and a magnificent boat comes into view. Painted a crisp white, it glows in the gathering dusk. Its flags stream in the evening breeze, its walking beam rocks steadily and efficiently, and its paddle wheel churns up a fine, frothy spray. But a few passengers are on deck—solitary, dark-clad men who stand or sit in silence. The window of the wheelhouse provides a glimpse of the captain's profile. The name on the side of the boat identifies it as the *Syracuse*, named after the Erie Canal boomtown in upstate New York, and the sidewheel is decorated with a painting of Syracuse's mills and factories. But the name is hardly required to identify this boat. Even in dimming light every detail of decking, decoration, and machinery stands out with sharp precision. The boat moves powerfully through the dark water. The tall smokestack leaves a bruise of exhaust in the purple sky, a lingering reminder of the boat's presence even after it has moved downriver and out of sight.

Such is the scene in James Bard's (1815–1897) 1857 painting *The Steamship "Syracuse."* Bard depicted his first steamboat with his twin brother, John, when they were just twelve years old and living in lower Manhattan. An 1824 Supreme Court decision had broken the monopoly on steamboat commerce in New York, and 1825 had seen the opening of the Erie Canal.[1] The waters around New York City—and the Hudson River in particular—were filled with these marvelous new vessels. The brothers made watercolors of steamships and the occasional sloop or schooner until the mid-1840s before trying their hands at oil painting, signing their work "J. and J. Bard." In 1849 their partnership abruptly ended, and paintings from the following years bear only James's name. John's whereabouts are unknown for the next several years, and he died in an almshouse in 1856.[2] James continued painting steamboat portraits for forty more years, completing, by one probably overly generous count, four thousand images before his death.[3] At last tally, there were about four hundred Bard paintings extant and another one hundred known through photographs, notes, or tracings.[4]

Bard's approach to portraying steam vessels was formulaic and precise. He often used a thirty-by-fifty-two-inch canvas. He nearly always showed the boats in profile, from their port side, steaming toward the left. They are large on the canvas, particularly in relation to the background sailboats and houses on the shore. Except for one painting, the verdure of spring or summer always covers the background hills. Bard indicated the speed of the ships by showing waving flags and a spray of white water at the bow, the paddle wheel, and behind the stern. He depicted the ships with a high level of graphic detail executed with a minute precision that reinforces the sense of complete accuracy. Indeed, one commentator remarked, "they could lay down plans for a boat from one of his pictures, so correct were their proportions."[5]

Bard began his paintings at the shipyard, clambering over the boat with a yardstick, taking careful measurements.[6] He then turned to his sketchbook, drawing the hull and dividing its length into equal parts corresponding to ten-foot sections of the boat. He divided each of the parts again into foot-long increments. Using these divisions as a guide, he then drew in the decks, machinery, pilot house, pipes, and so on.[7] As he worked, he used the tools of the

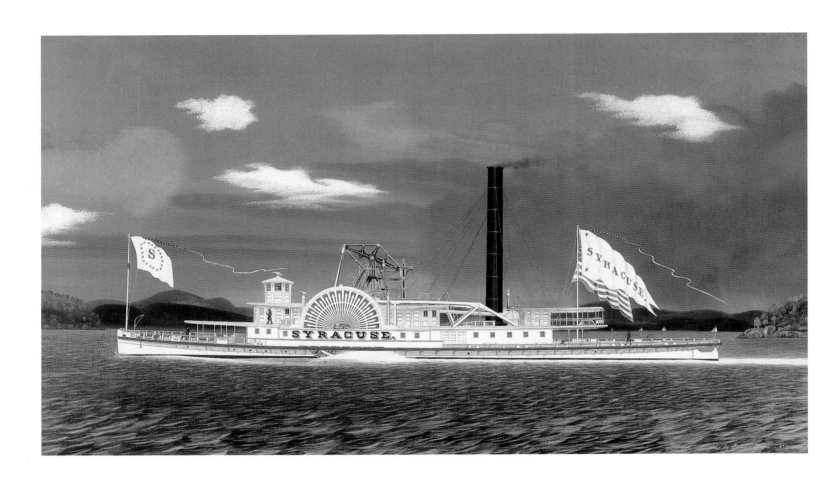

27. James Bard (1815–1897), *The Steamship "Syracuse,"* 1857
 Oil on canvas, 30 × 52 in. (76.2 × 132.1 cm)
 Gift of Mr. and Mrs. J. Burgess Jamieson, 1996.6

Fig. 27.1. James Bard (1815–1897), *The Steamship "Jay Gould,"* ca. 1868. Drawing. Mariners Museum, Newport News, Virginia

naval architect—the T square and triangle, splines and ducks for drawing curves—creating, in a kind of reverse process, the plans for the ship. The completed drawings are artworks in their own right, the firmness and clarity of Bard's lines creating an image at once lucid, rational, and beautiful. No wonder James Bard signed his paintings "Drawn & Painted by James Bard"; surely he was proud of these renderings.[8] Bard returned to the shipyard with his finished sketch to make relentless corrections and to add copious notes on color. The clear lines of the drawings are often veiled by a contrasting scrim of scrawled comments and reminders. As he checked his drawing, Bard probably also conferred with his patrons, who were shipowners and operators and who would have been quick to notice any errors or irregularities. So his drawing of the *Jay Gould* (fig. 27.1) included the note, "The smoke pipe is not in the right place as it is 24 ft from its center to the center of the Beam Frame the other parts of the draft of Cabin stair house is [*sic*] right and so is the steam pipe and wistle [*sic*] also right." On his drawing of the *James Stevens* (ca. 1857, Mariners Museum, Newport News, Va.) he jotted, "narrower beam than this is," "no window here," "no pole here." Bard reconstructed the steamboats on canvas, even building up the paint with gesso in places to create three-dimensionality.[9]

In his paintings, Bard was paying homage to these swift, gleaming boats and the men who made them. He was also effectively denying or obscuring the darker, more dangerous aspects of steamboat travel. Steam engines are liable to explode if they are not tended carefully. There was little

official oversight of the passenger steamboat business for many years, and there was ample incentive to win fame and riders by being the fastest boat on the route. So steamboats would race each other to establish supremacy. Perhaps most infamous was the race between the *Henry Clay* and the *Armenia* in 1852. The *Henry Clay* surged ahead after trailing for much of the race, but burst into flames. Some eighty people died. In one well-known contest in 1847, the captains of the *Cornelius Vanderbilt* and the *Oregon* bet $1,000 on who could get from the Battery in lower Manhattan to Sing Sing, about forty miles up the Hudson, and back first. The *Oregon* edged ahead but was running out of coal. The owner ordered that an anvil be tied onto the boiler's safety valve and commanded the crew to chop up the fine furniture and interiors (for which he had paid some $30,000) for fuel. The *Oregon* ultimately won the Pyrrhic victory. Opulent decor such as that on the *Oregon* earned the steamboats the nickname of "floating palaces" but perhaps also contributed to an atmosphere of licentiousness. Newspapers warned that they "swarmed with vile women."[10]

Bard never painted the steamship interiors. He did not depict the disasters. He acknowledged the rivalries between ships and owners by placing competitors in the backgrounds of some of his portraits, but his paintings of the races celebrate speed and the exhilaration of bracing contest rather than the irresponsible behavior of the owners of the *Henry Clay* and the *Oregon*. Bard's painting of the *C. Vanderbilt–Oregon* race (1847, private collection) actually shows the former and ultimately losing ship ahead, its passengers

studiously checking their watches or calmly glancing toward the stern, where the bow of the *Oregon* can just be seen. There is no belching smoke, shaking engine, frantic captain, or cluster of anxious passengers. Bard was often commissioned to paint boats when they were first launched or when they had been refitted or sold.[11] Thus, the boats in his paintings look fresh, nimble, and finely tuned. A photograph from the 1880s shows the partners who owned the *Kaaterskill* posed formally around Bard's magnificent painting of the ship. Bard's vision was shared by these serious men; it is hard to imagine any of them doing anything as pecuniarily rash as burning furniture or as morally reprehensible as racing to the death.

Yet the romance of the steamships was not lost on Bard. His skies are often richly hued and dramatic. The dwarfed sailboats in the background seem a mocking editorial comment. The exuberant flags express what cannot be conveyed in the precise delineation of fittings and machinery. Bard's passion is perhaps best revealed by the volume of his output, his unfaltering commitment to his subject over decades of work, and his unfailing memory for the details of the boats he had painted.[12]

Bard never received any artistic training, instead learning as he worked. The similarities of his depictions are perhaps the result of both the narrow focus of his subject matter and his untutored background: he lacked the ability to paint the ships from trickier perspectives and his categorical approach to his subject required a consistent compositional formula. And indeed, flipping through reproductions of his work, one is caught short by any deviation from his usual formula.[13] Yet Bard found in these steamboats richness and variety; details of color, the size of a steam pipe, the positioning of a window made every boat unique, a valuable addition to his lifelong catalogue. [IB]

28. FREDERIC EDWIN CHURCH, *Twilight*

DARKNESS COMING

. . . we are undergoing a virulent epidemic of sunsets. JAMES JACKSON JARVES[1]

Twilight (1858) is a remarkably quiet painting of intimate scale and poetic intensity by an artist better known for his grand panoramas and sublime theatricality.[2] Coming at the end of Church's early career, it represents his transition from the influence of his teacher, Thomas Cole (1801–1848), with whom he studied from 1844 to 1846. Church, the only student that the famous founder of American landscape painting ever agreed to teach, lived in Cole's house and shared his studio. Cole's landscapes of the Hudson River Valley had looked to the past, remaining wedded to historical and mythological subjects even while depicting local flora and fauna (see cat. 19). Church, however, was more interested in the future; he depicted a landscape that reflected the American continent rather than recalled a European topographical rhetoric.[3] He also moved away from Cole's painterly technique, developing the meticulously detailed realism that came to characterize the Hudson River School painters of whom he was the most celebrated. As E. P. Richardson, a defining historian of American art, wrote, "*Twilight*, an early work, shows how far he [Church] already surpassed his teacher Cole in luminosity and in resonance of tone."[4]

Frederic Edwin Church (1826–1900) was born and grew up in Hartford, Connecticut, an eighth-generation descendant of the town's original Puritan founders.[5] He began exhibiting at the National Academy of Design when only nineteen years of age, becoming its youngest associate member in 1849 at the age of twenty-three.[6] Putting aside the romantic vocabulary of Cole for the detailed visual accuracy advocated by the English theorist and critic John Ruskin (1819–1900) in his multivolume *Modern Painters* (1843–56), Church brought a scientific observation to his

depictions of the Northeast's natural phenomena that signaled the shift to representational realism.[7] At the same time, influenced by the theoretical writings of the German naturalist Alexander von Humboldt (1769–1859) in his book *Cosmos*, Church altered the tradition of landscape painting, rejecting specific locales in favor of idealized scenes that relied on details synthesized from many sites.[8]

His artistic colleagues were traveling to Europe for study, principally at the Düsseldorf Academy, and for sketching trips in the Alps. However, Church's interest in wilderness, further inspired by Humboldt's enthusiastic descriptions of the exotic beauty to be found in the tropical climates of South America, led the painter in a different direction.[9] In 1853 he set out for Colombia and Ecuador, becoming the first artist from the United States to sketch on location in the Andes Mountains. Throughout his life, Church's peripatetic nature led him to undertake numerous additional sketching trips, to South America again in 1857, to Labrador in 1859, to Jamaica in 1865, and to Greece, Syria, and Palestine in 1867–68. In contrast to his colleagues who went to Europe to study paintings in famous museums and galleries, Church traveled for the purpose of seeing the places themselves. After 1872 Church lived at Olana, the palatial home and studio that he built on a hilltop overlooking the Hudson River and whose design was based on the Islamic structures he encountered during his visit to the Near East.[10]

Niagara (fig. 28.1), the artist's first great triumph, dramatically altered the point of view of previous American landscape paintings, suspending spectators within the scene rather than allowing them to remain comfortably outside it as observers. Church also enveloped viewers by

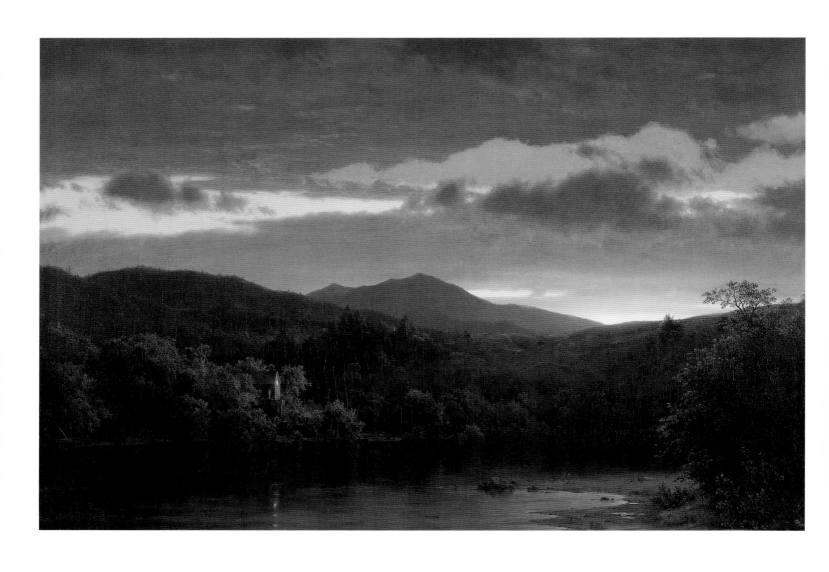

28. Frederic Edwin Church (1826–1900), *Twilight*, 1858
 Oil on canvas mounted on hardboard panel, 23⅞ × 35⅞ in. (60.6 × 91.1 cm)
 Gift of Mr. and Mrs. John D. Rockefeller 3rd, 1993.35.6

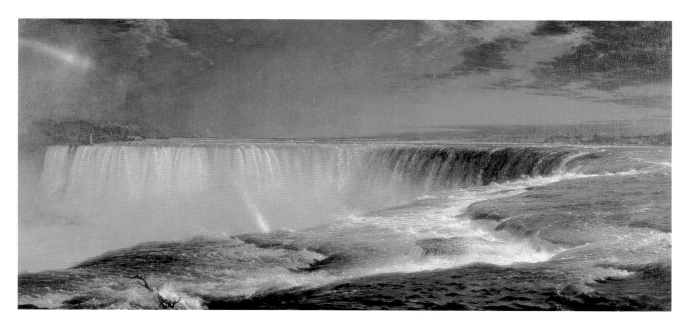

Fig. 28.1. Frederic Edwin Church (1826–1900), *Niagara*, 1857. Oil on canvas, 42½ × 90½ in. (108 × 229.9 cm). The Corcoran Museum of Art, Washington, D.C. Museum purchase, Gallery Fund, 76.15

significantly widening the horizontal sweep of the canvas, extending its physical breadth. At both the popular and professional levels, in both acclaim and financial gain, *Niagara* was one of the foremost paintings in the United Sates during the nineteenth century. In this work Church demonstrated his genius as a commercial producer, initiating the "great picture," a painting "conceived specifically to be shown alone, usually accompanied by carefully managed publicity."[11] His status as the most successful artist of the 1850s and 1860s was largely the result of this entrepreneurial ability.

Church quickly understood that by transforming sketches and studies done while on voyages to unusual locations—often perceived as dangerous and exotic—into enormous canvases of illusionist precision, he could produce highly marketable staged events that rivaled concerts or operas. In fact, guidebooks that accompanied the display of these prodigious canvases encouraged spectators to view them through opera glasses. After returning to New York from South America, Church turned his studies into large-scale compositions of mysterious tropical scenes that captured the imagination of the public and critics alike. He secured his position as the country's leading painter with just such a work, the monumentally staged *Heart of the Andes* (fig. 28.2), which "was one of the great cultural events of its day as well as a resounding financial success."[12] In the

first three weeks the painting earned more than $3,000 in admissions and collected an additional $6,000 in subscriptions for future engraving. When New York manufacturer William T. Blodgett bought the painting for $10,000 in 1859, it was the highest price for a landscape painting ever paid to a living American artist.[13]

Twilight was painted in 1858, the first year of Church's residence at the prestigious Tenth Street Studio Building, where *Heart of the Andes* would first go on display the following year.[14] The setting sun was one of his favorite subjects. It afforded him the opportunity to depict the glowing, light-suffused effects of clouds and atmosphere that give the appearance of illuminating the canvas from within rather than relying on light striking the canvas.[15] Mysterious and evocative, *Twilight*, ostensibly a scene of the Hudson River Valley, creates an impression that is simultaneously serene and ominous.[16] In part, this mood is due to new pigments introduced in the 1850s that provided the effulgent tonalities evident in the painting, especially the vivid reds and oranges that play off the rich, dark hues and heighten the work's visual contrasts.

Church's vision of nature depends less on the topography of the Hudson River Valley than on the flamboyant spectacle of its ever-changing, cloud-filled skies. Combining fact and fiction, he is following the lead of other American and English romantic artists who were using Luke

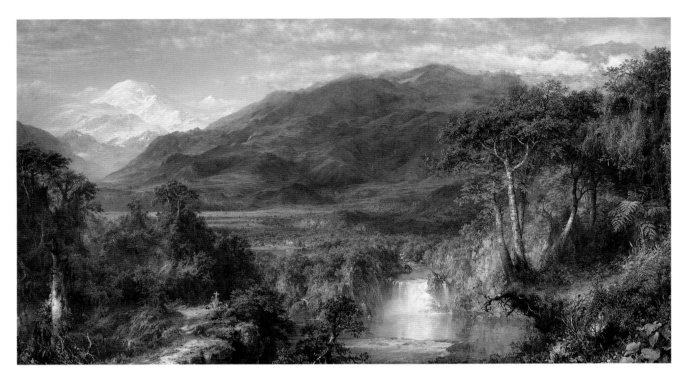

Fig. 28.2. Frederic Edwin Church (1826–1900), *Heart of the Andes*, 1859. Oil on canvas, 66⅛ × 119¼ in. (168 × 302.9 cm). The Metropolitan Museum of Art, New York. Bequest of Margaret E. Dows, 1909.09.95

Howard's first taxonomy of clouds in his *Climate of London* (1818–20) to create a vocabulary of visual effects that combined scientific knowledge and poetic truth.[17] In spite of its relatively small scale, Church's *Twilight* reveals an understanding of America's wilderness that is closer to the sublime representation of nature seen in Cole's grand symbolic allegories than a vision of the landscape as a benign handmaiden to progress.[18] In place of a natural paradise that reflects a divinely ordained harmony between individuals and the land, Church's painting interjects the philosophical vocabulary of the sublime to shift the psychological effect on his viewers toward an uncertain and ambiguous encounter with the natural world.[19]

Such a construct of nature understands it as wilderness and lies at the opposite pole from the pastoral notion of landscape that characterized the work of many of Church's fellow realist painters in the Hudson River School (for example, see Jasper Francis Cropsey, *View of Greenwood Lake, New Jersey*, cat. 21). The discourse of wilderness relies on the language of exploration, the heroic and personal conquest, with its vocabulary of natural adversity. It also encourages an understanding of nature as the foil to civilization. To be sure, the painting's atmospheric effects and the

lone dwelling create a poetic mood in keeping with the contemplative tone of a benign pastoral environment. However, rather than evoking a harmonious calm, *Twilight* seems to present dusk as a foreboding prospect. The window and the surface of the pond reflect the light disappearing over the horizon, a final echo before darkness envelops the scene entirely. The encroaching darkness heightens the solitary character of the building and emphasizes its vulnerability within the wilderness.[20]

Wilderness was the fundamental articulation of the nineteenth-century American sublime, the "delightful horror" in the face of potential danger produced by a sense of physical and psychological loss of boundaries. However, the opening of the Erie Canal in 1825 had largely turned the wilderness of the Hudson River Valley and the Catskills into a site for rural tourism. In *Twilight*, Church reaches back to an earlier era, depicting a densely wooded scene prior to the changes brought about by the canal and industrial progress. He replaces the terror of wilderness associated with an actual place with its depiction as a sign, using the emotional tenor in the language of the sublime to reference the political realities of the 1850s. It seems likely that Church's twilight reflects a civilized threat far

more dangerous than the hazards of untamed nature: the increasingly ominous sectional divisions that will erupt into the Civil War three years later.

According to the landscape theorist Malcolm Andrews, the sublime operates when viewers experience "the threat to self-preservation experienced at a safe distance," which ties it to an aesthetic disturbance more than a specific type of terrain.[21] In *Niagara*, Church captured the sublime in the image of a natural phenomenon closely identified with the United States, a force that symbolized the irreversible and raging social, political, and economic currents of the country. In the face of the prodigious wonder represented by Niagara Falls, the artist found a way to depict the unspeakable headlong rush of events that was leading the country over a momentous cultural precipice. Similarly, in the uncharted, tropical region depicted in *Heart of the Andes*, he found a vision of nature that swallowed up the human presence in its untrammeled power and grandeur. Both paintings displaced the fears about a divided country and civil combat into the aesthetic register of sublime landscape painting.

Between these two canvases of impressive scale lies the more modestly sized *Twilight*, which also employs the vocabulary of sublime landscape to reference the country's troubled times. But rather than setting the work at the site of a natural wonder or in an exotic location, Church locates the emotional tension of *Twilight* in the familiar terrain of upstate New York. He records a landscape that would have been perceived to represent the United States early in the nineteenth century before the impact of industrialism, an era irrecoverably in the country's past and already incorporated into its mythic history. However, its reassuring evocation of nostalgia for a simpler time is coupled with a reminder of the more immediate sense of anxiety that darkness brings to the wilderness. Viewers experience foreboding because the painting's familiar scenery elides the "safe distance" that usually characterizes the sublime, making palpable the apprehension that accompanies an imminent loss of visibility. More than a metaphor for the darkness of the coming civil strife, *Twilight* offers an objective correlative for the tenuous purchase of civilization in the face of forces, whether natural or cultural, that have the power to overwhelm it. Its metaphoric aptness in expressing the nation's wartime anxiety epitomizes what James Jackson Jarves called the era's "virulent epidemic of sunsets." [DC]

29. FREDERIC EDWIN CHURCH, *Rainy Season in the Tropics*

A VISION OF UNITY IN DISUNITED TIMES

When the nineteenth-century art critic and biographer Henry Tuckerman saw *Rainy Season in the Tropics* in 1866, he fell into a rhetorical swoon, matching the soaring peaks of the painting with equally high-flown language. "Athwart a mountain-bounded valley and gorge," he gushed, "floats one of those frequent showers which so often drench the traveler and freshen vegetation in those regions, while a bit of clear, deep blue sky smiles from the fleecy clouds that overlay the firmament, and the sunshine, beaming across the vapory vail, forms thereon a rainbow, which seems to clasp the whole with a prismatic bridge."[1] The artist responsible was Frederic Edwin Church (1826–1900), perhaps the most celebrated American artist of the mid–nineteenth century. But by 1900, the year of Church's death, a small exhibit of his work at the Metropolitan Museum of Art in New York brought backhanded compliments ("These views are valuable ethnographic data") and biting criticism ("It is a very easy trick to surround a mountain with enveloping steam from a teakettle") that pop the balloon of Tuckerman's praise.[2]

By 1900, as well, *Rainy Season in the Tropics* had passed from the estate of Marshall O. Roberts, who had commissioned the painting in the early 1860s, to Henry P. Sturges, another great patron of American art. The painting hung first in Sturges's New York City home and then at his family's rambling country residence in Connecticut, where it was found in 1965 by J. Wilhelm Middendorf II.[3] Stories of its rediscovery vary slightly. Some place the cast-off painting in a dark shed, others a barn, still others in an unused greenhouse. It was unquestionably in bad shape, filthy and torn from just above the waterfall to the top right corner. Yet, as the story goes, even by the light of a single candle

Middendorf recognized the worth of the damaged painting and wrote a check on the spot.[4]

Today the painting is meticulously restored. The rainbow once again arcs seamlessly over a mist-filled gorge, from worn and craggy peaks to humid, green jungle. In the middle distance lies a placid lake. Glints of light on the far bank suggest a human settlement, but it is subsumed in the hazy expanse of the plateau beyond. The passing shower sweeps to the left; on the right, the clouds open to reveal infinite blue. Church has not provided his viewers with ground to stand on: we are held in vertiginous suspension. But he has provided a path for us to walk visually, easing our entry into the scene. Two men, diminutive but impossible to miss in red and striped ponchos, pause on that path to secure a load on one of their pack mules, oblivious to nature's awe-inspiring display. The painting is a study in opposites: the pale browns, yellows, and oranges of the rock and the verdant foliage of the jungle; the dark clouds and the clearing sky; the quiet lake and the thundering waterfall; sublime scenery and quotidian detail.

Looking at the painting today, we can appreciate Tuckerman's fulsome response and imagine Middendorf's delight at his discovery, but we can also understand the reservations of the teakettle critic. We see at once the stunning achievement of the painting and yet also how dated it is. Like the critic we feel we have to "bear in mind . . . the general taste of the country at that time [when Church formed his style]."[5] However, more than matters of taste and style place the painting so securely in a past era.

Before we define what precisely separates us from the painting, consider what Church saw as he worked on the canvas. He stood under the nodding branches of a palm

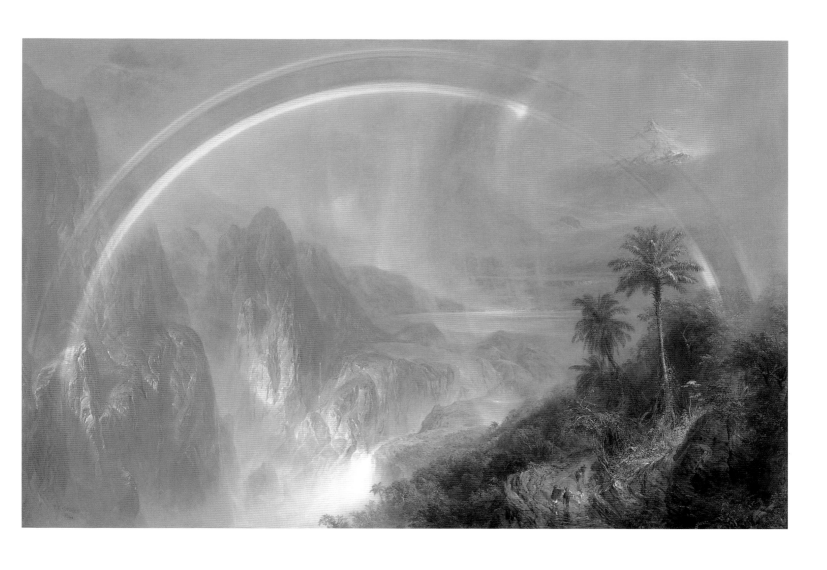

29. Frederic Edwin Church (1826–1900), *Rainy Season in the Tropics*, 1866. Oil on canvas, 56¼ × 84¼ in. (142.9 × 214 cm) Mildred Anna Williams Collection, 1970.9

tree, rainbow-hued birds and gemlike butterflies about him. He was, in fact, in his studio on Tenth Street in New York City. The flora and preserved fauna were souvenirs of his travels, reminders to visitors—as if they needed them—of the epic series of South American canvases he had begun with the phenomenally successful *Heart of the Andes* (Metropolitan Museum of Art) in 1859.[6] As he painted, he looked at sketches he had made on those travels. Church and his wife had gone to Jamaica in April 1865, seeking a change of scene that might ease their grief after the sudden death of their two children. In Jamaica, he sketched feathery fronds of palms, wild philodendrons, and trumpet trees.[7] On his return, he transplanted these exotic plants into an Andean landscape. He also may have been looking at meteorological texts. The scrupulous delineation of the double rainbow, with the strip of sky between the two arcs—technically known as Alexander's band—shown darker than the rest, suggests he had a scientific treatise at hand.

It is no surprise to learn that this painting was a studio production. For one thing, the working method of the Hudson River School of painters is well known: the journey into nature to make detailed, carefully observed sketches, the return to the studio to synthesize those bits of landscape into a grand image. Even more telling, *Rainy Season in the Tropics* clearly represents a fantastic place, with diverse ecosystems in improbable proximity, arranged with overt theatricality for the benefit of the viewer. The painting is a construction, not a record.

The writings of the famed German naturalist Alexander von Humboldt (1769–1859) had first inspired Church to travel south. Church followed Humboldt's footsteps in South America—even staying in the same house near Quito where Humboldt had stayed sixty years earlier. Church also followed in his philosophical footsteps.[8] Humboldt's scientific works are infused with a profound optimism, deeply moving in their vision of the world. He wrote, "Nature is a unity in diversity of phenomena; a harmony, blending together all created things, however dissimilar in form and attributes; one great whole animated by the breath of life."[9] *Rainy Season in the Tropics* can be read as Church's paean to Humboldt's ideas. Those divergent ecosystems are indeed neighbors, conjoined in a larger whole, a circle of life represented by the perfect, overarching geometry of the rainbow. Church originally included a church at the base of the rainbow on the left.[10] Perhaps he painted it out because he did not want to overemphasize the already clear Christian symbolism of the rainbow, allowing instead a broader (but not atheistic) interpretation: rainbow as animating "breath of life."

No wonder, then, that critics have seen this lavishly joyful painting as a celebration of the Civil War's end and the nation's unified future.[11] It is suffused with ideas of union, but a union more lofty than the political shape of a single country. And no wonder also that historians have read in it a lifting of the veil of grief as Church and his wife anticipated the birth of another child.[12] The painting resonates with a deeply held Humboldtian optimism.

Humboldt wrote that he viewed nature with scientific objectivity but also "as the reflection of the image impressed by the senses upon the inner man, that is upon his ideas and feelings."[13] This prominent consideration given to nature's impact on man—aesthetic, moral, sensual— shapes *Rainy Season in the Tropics*. And here lies the source of the painting's datedness, the quaintness despite the grandeur: in Church's elaborate image-making (with an emphasis on *making*) and his extravagant celebration of man's apprehension of nature.

In 1859 Alexander von Humboldt died and Charles Darwin's *On the Origin of Species* was published. Darwin's work fundamentally changed how people viewed the world around them.[14] Where Humboldt had seen unity and harmony in nature, Darwin revealed struggle, conflict, and randomness. Darwin wrote, "We do not see, or we forget, that the birds which are idly singing around us mostly live on insects or seeds, and are thus constantly destroying life; or we forget how largely these songsters, or their eggs, or their nestlings, are destroyed by birds and beasts of prey."[15] After Darwin, this destruction became increasingly difficult to forget. And as the century progressed, Humboldt's theories and Church's paintings fell out of favor.

Today Darwin's hard lessons have thoroughly infiltrated our culture. Our own relationship with nature is often adversarial, as we struggle to manage our growth and control our destructive impulses. We are too knowing to think that nature's array is for our benefit. Yet Church's painting can stir us still. Although unity on a Humboldtian scale is out of reach, we do know how interconnected life is, how the loss or introduction of one species in an ecosystem can upend its balance. While that interconnectedness is not proof of universal harmony, knowledge of it at least allows each creature its place. So we may smile cynically at the unabashed glory of that double rainbow, but we can yet find comfort in the yellow butterflies, precisely depicted, that flit through the jungle canopy. [IB]

30. ALBERT BIERSTADT, *Roman Fish Market, Arch of Octavius*

"IN ROME EVEN THE DIRT
BECOMES PICTURESQUE"[1]

Rome's *Porticus Octaviae*, or Portico of Octavia, was one of the many ambitious building projects undertaken by the emperor Augustus. He named it for his sister Octavia, the wife whom Antony had abandoned for Cleopatra.[2] Erected in 23 B.C. near the Tiber River on the site of the former Portico of Metellus, it was an enormous rectangular colonnade surrounding an open-air precinct in which two earlier temples were located.[3] Nearly three hundred columns marked the perimeter, which was interrupted by elaborate pedimented entry pavilions on two sides.[4] Following the sack of Rome in the fifth century, the portico, like so much of Imperial Rome, fell into disrepair. Throughout the Middle Ages ancient monuments were stripped of their valuable marble or dismantled stone by stone for building materials.[5] Small, vernacular medieval buildings absorbed the Portico of Octavia with the exception of one entryway, which had been appropriated as the atrium of the Church of Sant'Angelo during the eighth century. Sometime in the twelfth century the city's central fish market was established around the atrium, and in 1556 a four-block area adjacent to the portico's remains was designated the Ghetto, where Rome's Jewish population was required to live until 1870.[6]

Both the fish market and the Ghetto were still thriving when Albert Bierstadt (1830–1902) lived in Rome during the winter of 1857–58.[7] He had spent the previous several years studying in Düsseldorf and was on an extended tour of Switzerland and Italy before returning to the United States. At that time, the area around the ruins of the portico was decidedly shabby, fetid with the stench of fish and neighboring the insalubrious Ghetto. John Murray, the author of the popular *Handbook of Rome and Its Environs*, refers to the neighborhood as "one of the filthiest quarters in Rome."[8] Visitors to Rome from the United States were routinely shocked by the condition of the Eternal City and blamed what they perceived to be corrupt and authoritarian papal rule. Americans considered themselves the heirs of the ancients, reviving their democratic ideals, imitating their architecture, and industriously advancing civilization. In contrast, modern Italians were thought degraded by their undemocratic government and to have had "superstition, poverty, and indolence" thrust on them by the Catholic Church.[9] These poor yet picturesque people were to be the subject to Bierstadt's first painting on returning from Europe.[10]

Roman Fish Market, Arch of Octavius—the error in titling the monument appears to have been Bierstadt's own—was the artist's sole foray into genre painting and was a great success. The Boston Athenaeum not only exhibited the painting shortly after its completion in 1858 but also bought it for four hundred dollars the same year, Bierstadt's first sale to an American museum.[11] A portion of the fish market is laid out as if on a stage, the brick archway standing in as a proscenium. A pair of vignettes is brightly lit in the foreground. A woman holding an infant converses with two men at the left, as a cat surreptitiously stalks a dead fish. At the right a long marble slab is supported by a debased Corinthian capital, both surely pilfered from the portico long before, to form a counter for the preparation and vending of seafood. Near the end of the counter, a woman is industriously engaged with a distaff and spindle, while

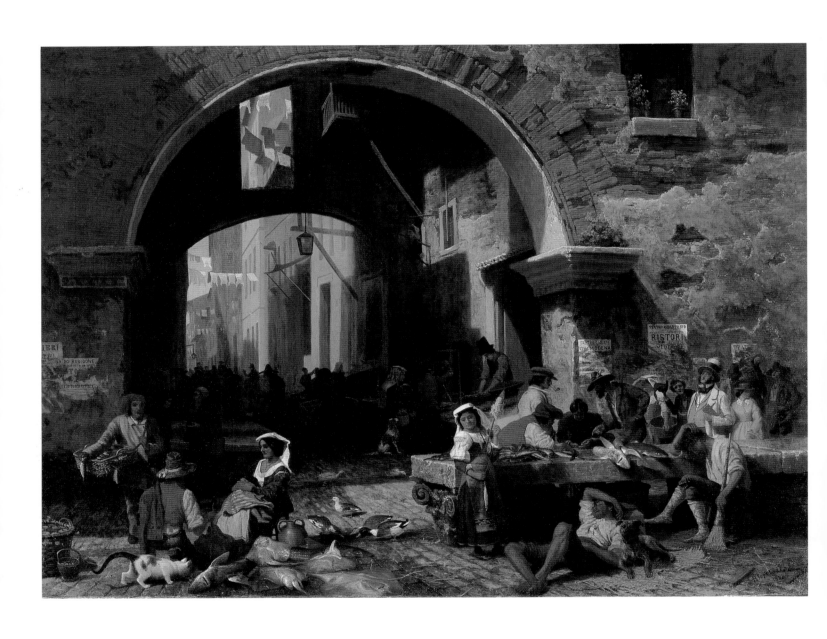

30. Albert Bierstadt (1830–1902), *Roman Fish Market, Arch of
Octavius*, 1858. Oil on canvas, 27⅜ × 37⅜ in. (70.2 × 95 cm)
Gift of Mr. and Mrs. John D. Rockefeller 3rd, 1979.7.12

Fig 30.1. Giovanni Battista Piranesi (1720–1778), *The Portico of Octavia: The Entrance Porch, Interior (Vedute interna dell'Atrio del portico de Ottavia)*, 1760. Etching, plate: 22 × 28 in. (55.9 × 71.1 cm). The Metropolitan Museum of Art, New York. Gift of Mrs. Alfred J. Marrow, 64.521.2

behind her a group of men gamble at *morra*. A young man with a broom sits in front of the counter, asleep with his head propped up on his arm; at his feet a second man is also enjoying a nap, sprawled on the ground by his faithful dog.[12] Entering the scene at the right is a pair of tourists, probably American; the well-dressed and bespectacled gentleman has his guidebook at the ready, while his diminutive wife follows apprehensively in his wake.[13] Behind this tableau, through the brick remnant of the portico, more workaday Romans can be seen within and beyond the shadows of the archway. It is a busy, disorderly, earthy scene.[14]

The painting is a study in contrasts, leaving no doubt as to its message: the values and accomplishments of ancient Rome are lost to modern Romans just as the beautiful marble, intricate carving, and lofty inscriptions have been taken from the Portico of Octavia.[15] Performing the nineteenth-century ritual of following a guidebook itinerary around Rome, the tourists probably came in search of edifying, romantic ruins of classical architecture, finding instead crumbling brick underpinnings robbed of their marble skin; the ornamental elements of the portico have been recycled in the service of fishmongers. Formerly the gleaming white of classical antiquity, the structures are now gray with soot and grime. Like many others before them, the visitors discovered that most Roman ruins "do not stand apart in solitary grandeur, forming a shrine for memory and thought. . . . They are often in unfavorable positions, and

bear the shadow of disenchanting proximities . . . and we can nowhere escape from the debasing associations of actual life."[16] Massachusetts politician George Hillard might have had the Portico of Octavia in mind as he wrote that passage in 1853.

Bierstadt emphasizes the disarray and degeneration of the market not only by what he has depicted but also by what he has left out. An entire entry pavilion of the original portico survived as the atrium of Sant'Angelo. These portals were rectangular; the large sides were open colonnades of four columns twenty-eight feet tall, but the short ends were solid walls each pierced by a single large archway. One of these lateral walls of the entryway-turned-atrium forms the backdrop in Bierstadt's painting. What remains unseen is the rest of the atrium. Off to the right is the facade of Sant'Angelo, into which several of the marble columns and portions of the pediment of the portico have been incorporated. To the left is the largely intact inner facade of the entry pavilion. As noted above, two of the columns were replaced by a large archway in the second century A.D., but the entablature, pediment, and remaining columns still stand.[17] On the other side of this added archway is the Piazza di Pescheria. Behind the viewer is a second arch, almost identical to the one pictured. Bierstadt therefore had available numerous views of the portico and fish market that would have included ruins more in keeping with nineteenth-century expectations.

Fig. 30.2. Michael Neher (1798–1876), *The Fish Market at the Porticus Octaviae*, ca. 1825. Watercolor. Staatliche Graphische Sammlung, Munich, 1908:20

Classical ruins were not a new subject for artists but had not always carried Bierstadt's message of degradation. In 1760 Giovanni Battista Piranesi published an etching of the portico ruins (fig. 30.1).[18] His view shows the same arch and alley but includes much more of Sant'Angelo's atrium as well, including the tall columns and massive pediments on the left and right, and a third-century arch—now partially walled in—at the left.[19] Figures are few and tiny, the space vast and open. Though the area is definitely run-down, the ruins still possess some of their grandeur, and the mood is romantic and nostalgic. The foliage growing from the crumbling classical remains implies that the march of time and the processes of nature, not the indifference or predations of the Romans, have led to this state of affairs. As in Bierstadt's painting, tourists are in the atrium to view the ruins, but this group does not seem disoriented or disappointed as they listen to their guide. Several decades later, about 1825, the German artist Michael Neher made a watercolor of the fish market (fig. 30.2). This time the vantage point is outside the atrium, in the piazza.[20] The market is active and crowded, but the mood is festive rather than oppressive thanks to the bright colors and animated postures. For Neher the ruins are a picturesque background for a charming genre painting.[21]

Bierstadt went to pains to emphasize the crowds, chaos, and churlishness of everyday life at the Portico of Octavia, but there is another side to his "indolent" Romans. The two men set apart in front of the marble counter reference classical sculptures of sleeping figures. On the ground lies a rather more modest incarnation of the *Barberini Faun*, while a modern *Sleeping Endymion* slumps at the table.[22] These visual quotations would have been easily legible to Bierstadt's audience, as both statues were well known and well represented in museum cast collections. These classical echoes were likely intended to heighten the contrast between the Romans of the nineteenth century and their august forebears. Another possible reading should be considered, however. Perhaps the poses of these napping workmen are meant to remind the viewer that these coarse people are still the descendants of the Romans of old, and that only their ill fortune to live in an undemocratic, unenlightened society debases them. *Roman Fish Market, Arch of Octavius* is undoubtedly a meditation on the decline and fall of an ancient civilization, but it can also be regarded as an image of latter-day Romans living with the past and making it their own. [EL]

TRANQUILITY AND REPOSE
IN TURBULENT TIMES

Bierstadt's title invites us to think morally, sentimentally, and symbolically
about light, time, transience, God, and nature. ANDREAS BLÜHM in *Light!*[1]

When Albert Bierstadt (1830–1902) exhibited *Sunlight and Shadow* (1862), first at the Brooklyn Art Association and then at the newly opened Fine Arts Academy in Buffalo, New York, the painting was instantly proclaimed a masterful depiction of light and shade effects, and its critical success initiated the artist's fame.[2] Although Bierstadt listed the work as for sale from its first exhibition, he refused $1,500 and then $3,500 for it, then a remarkable sum for an American painting.[3] So popular was the work that in 1864 the artist produced a chromolithograph of the painting that was received with equal enthusiasm.[4] In fact, Bierstadt was one of the first artists who understood and exploited the potential of color lithography to expand the market for his work by offering high-quality reproductions on canvas that resembled original paintings.[5] The subtle atmospheric effects of *Sunlight and Shadow* made it an ideal candidate to introduce the artistic possibilities of this new technological medium, which put artworks within the financial reaches of the middle class.[6]

The painting is based on an earlier oil sketch that Bierstadt completed in 1855 during his years of study (1853–57) in Düsseldorf, Germany.[7] The National Academy of Design and earlier the American Art-Union, the most influential art institutions of the time in the United States, encouraged American artists to adopt the style of rational and tightly painted illusionism that was the hallmark of the Düsseldorf Academy in order to produce politically motivated history paintings and genre scenes. Bierstadt, as most of his American peers who wished to be taken seriously,

traveled to Düsseldorf for professional training in European methods of perspective, composition, drawing, and anatomy in close association with the German-born painter Emanuel Leutze (1816–1868) and the circle of painters gathered around him.[8] Central to this training was an emphasis on oil sketches from nature that would be used to compose major, large-scale paintings in the studio.[9] It was a method that Bierstadt embraced wholeheartedly, and it remained a defining mark of his work throughout his long career. Bierstadt's three expeditions to the American West—first in 1858 to Wyoming, and then in 1863 and 1871–73 to California, where he set up a studio in San Francisco—made him one of the most important inventors of the nation's view of the region.

The sketch painted on site that is the basis for *Sunlight and Shadow* demonstrates the spontaneity of Bierstadt's preliminary studies and suggests that he was interested in the atmospheric effects of this scene from the beginning (fig. 31.1). The subject of the sketch and painting is identifiable as the Gothic Revival chapel of the Löwenburg royal castle near Kassel.[10] But a comparison of the two works reveals the way in which his apparently realistic depictions were actually invented fictions designed to convey symbolic and ideological meaning. Most noticeable in comparing the sketch and the painting, which was made seven years later, is the addition of the large oak tree that dominates the foreground of the finished composition. Scholars have noted that there is no evidence that a tree ever existed at this site, confirming that Bierstadt's realism is

31. Albert Bierstadt (1830–1902), *Sunlight and Shadow*, 1862
Oil on canvas, 39 × 32½ in. (99.1 × 82.6 cm)
Gift of Mr. and Mrs. John D. Rockefeller 3rd, 1979.7.10

rooted in illusionistic detail but not necessarily in accurate description.[11] This is the same strategy that would lead him to adopt the visual language of Husdon River School painting, which celebrated the sublime effects of American topography.

The influence of the Düsseldorf Academy, with its interest in genre scenes, is also evident in the painting's emphasis on incident. It is precisely these genre elements, absent from the earlier sketch, that Bierstadt adds to the painting: the mother and child huddled on the steps at the gate, the specific figure of the praying saint rendered in the chapel's interior stained-glass window, and most notably the commanding oak tree that dominates the foreground. These features turn the painting into a scene ripe with narrative possibilities and associations, which are suggested through a series of parallels and contrasts.

The impoverished mother and child transform the painting from a picturesque architectural view of a quaint chapel to a poignant morality tale, referencing the debilitating effects of social unrest caused by Germany's regional wars that was bound to resonate powerfully with Americans during their own Civil War. In light of the social and political upheavals in Germany following the 1848 revolutions against state and church, the painting contrasts a romanticized German past, represented by this Gothic Revival chapel (ca. 1800), with the reality of the present. During the first half of the nineteenth century, the industrial revolution had sharply divided the economic interests of the bourgeoisie and the urban proletariat, creating a new class of worker that formed an alliance with the peasantry to call for a unified, democratic, national state organized to serve their needs. The abject pose of the woman cradling her child, nearly invisible in the shadows, contrasts with the church's open door and the warmth of the stained glass inside, its rich red hues aligning and identifying the impoverished human figures with the life of the depicted saint.

Similar pairings are suggested by the medieval-inspired statuary. The figure on the balustrade, whose hand is raised in benediction, is paralleled by the trunk of the oak, and together they frame the sunlit Virgin in her pointed-arch niche. Bierstadt's scene emphatically embraces religious orthodoxy, which is signaled by his isolating three columns in the balustrade, in all probability a reference to the Trinity that supports the Virgin. One scholar has argued that Bierstadt loads his painting with an iconography of such signs rather than symbols in order to affirm the orthodoxy of traditional Lutheran faith over more contemporary

Fig. 31.1. Albert Bierstadt (1830–1902), *Sunlight and Shadow* [architectural detail], ca. 1853–55. Oil on paper, 19 × 13 in. (48.3 × 33 cm). The Newark Museum, New Jersey. Gift of J. Ackerman Coles, 1920, 20.1209

pre-Raphaelite views.[12] The most obvious pairing is the statue of the Madonna and Child over the doorway with the mother and child directly below it. In addition to these emblems of a more innocent past now lost, the winged angel head in the center of the tympanum underscores Bierstadt's lament.

However, it is the introduction of the oak tree into the scene that most clearly demonstrates Bierstadt's inventive conflation of literal, symbolic, and moral signs. The oak, a symbol originally central to the Druids, ties this romanticized medieval scene and its Christian references to pagan mythology. For the Druids, the sturdy strength of an oak tree made it a sign of endurance, which Christian theologians translated into strength and virtue, often referencing the Virgin Mary.[13] Bierstadt represents the oak ripping up through the tessellated stone courtyard, suggesting that the fifty-year-old chapel is much older and more venerable, as if it and the gnarled old tree were rooted in the medieval era, with its greater assurance and tranquility. The oak also provides Bierstadt an occasion to create the subtle effects of soft light and dappled shadow that lend this scene its aura of poetic nostalgia. The dark leaves of the ivy crawling up the tree trunk connote age and stand out from the lighter oak leaves of their host. His rendering of suffused yet luminous light gives the surface a quality that has been called dramatic in its "love of the ephemeral and unpredictable."[14] The title *Sunlight and Shadow* provides the organizing rubric underlying all the other contrasts the artist has worked into his painting. The tree and religion, representing two distinguished histories, one natural and one cultural, are aligned in their contrast with the harsh economic and social conditions from which the woman and child seek refuge.

The strategy Bierstadt deployed in creating this highly illusionist rendering of an invented scene would become the mainstay of his career as he brought back sketches to New York from his travels to the American West and translated them onto canvas. Adding imaginary narrative incident to grand landscape vistas, he participated with other Hudson River School painters in a reinterpretation of history painting, attaching the ideological myths of the nation to its terrain. Although his landscape imagery was keyed to natural topography rather than to the religious traditions he explored in *Sunlight and Shadow*, this painting pointed the way to his use of light effects in the search for transcendent meaning. At the height of the Civil War, Bierstadt painted a poetic image of tranquility to demonstrate the power of the past during times of profound unrest. It is a symbolic vision with a moral purpose. [DC]

32. ALBERT BIERSTADT, *View of Donner Lake, California*

MOVING MOUNTAINS

In the spring of 1846, some fifteen hundred emigrants set out for California—then still part of Mexico—inspired and encouraged by the recent publication of *The Emigrants' Guide to Oregon and California*, by Lansford Hastings.[1] A large wagon train reached Fort Laramie in late June, including Andrew Jackson Grayson, a young merchant accompanied by his wife and young son, and the brothers George and Jacob Donner with their families.[2] There the train broke into smaller groups. At Fort Bridger, the Donner party opted not to follow the established route as the Graysons and others had but to take the new Hastings' Cutoff, touted in the *Guide*, which proved extremely difficult going.[3] As a result, they were far behind the other emigrants when they reached the Sierra Nevada in late October. Just past Truckee Lake they camped for the night one thousand feet below the summit; by morning the pass was under five feet of snow. The rest of the story is well known: five feet of snow became twenty, and before being rescued long months later, some of the party were compelled to eat the flesh of their dead companions in order to survive.[4]

The Graysons had a less eventful overland journey and settled in San Francisco, population four hundred.[5] Establishing himself as a merchant, Grayson made a fortune a few years later when the gold rush brought tens of thousands to his door in need of supplies. In 1850 he commissioned William Smith Jewett, California's preeminent portraitist, to depict the family at the very spot where they had first spied the Sacramento Valley. For his two-thousand-dollar fee the artist had to fulfill a laundry list of requirements; he had to go to the location to make studies, and the painting must include "success of pioneers; threatening mountains; smiling valley, three full-length portraits,

Grayson in buckskin outfit."[6] The finished painting is a celebration of success, both in conquering the Sierra Nevada and in seizing the opportunity proffered by California (see fig. 25.1). Grayson stands in the center, the golden valley to the left and the mountains he has theoretically just traversed at the right. He leans on his long rifle, the butt of which bisects the prone form of a dead deer some distance away, no doubt the victim of Grayson's unerring aim. His buckskin suit marks him a hardy pioneer who overcame the rigors of the overland journey; its natty fur collar and the formal shirt and tie he wears underneath show him to be utterly civilized. Frances Grayson sits behind her husband, perfectly composed at the base of a tree. Young Ned is perched rather precariously on the edge of her lap, presumably so that her handsome costume will be visible. Like his father, he wears buckskin leggings, along with a regal, ermine-trimmed red robe. He is the prince of this royal family of California, heir to its promise.

Twenty years later another artist ventured into the mountains to make studies for a painting commemorating a Sierra crossing. Albert Bierstadt (1830–1902) was at the height of his fame when Collis P. Huntington commissioned one of his signature sweeping landscapes, specifically a view looking east from the summit to Truckee Lake, which was now known as Donner Lake as a perpetual memorial.[7] Bierstadt and his wife set out in July 1871 for San Francisco, their home for the next two years. En route, they traversed the summit of the Sierra a mere four hundred feet north of the wagon road that the Donner party had failed to reach in time. The Bierstadts, however, passed not over the mountain but through it, via their patron's Central Pacific Railroad (CPRR) Summit Tunnel.[8] Huntington was

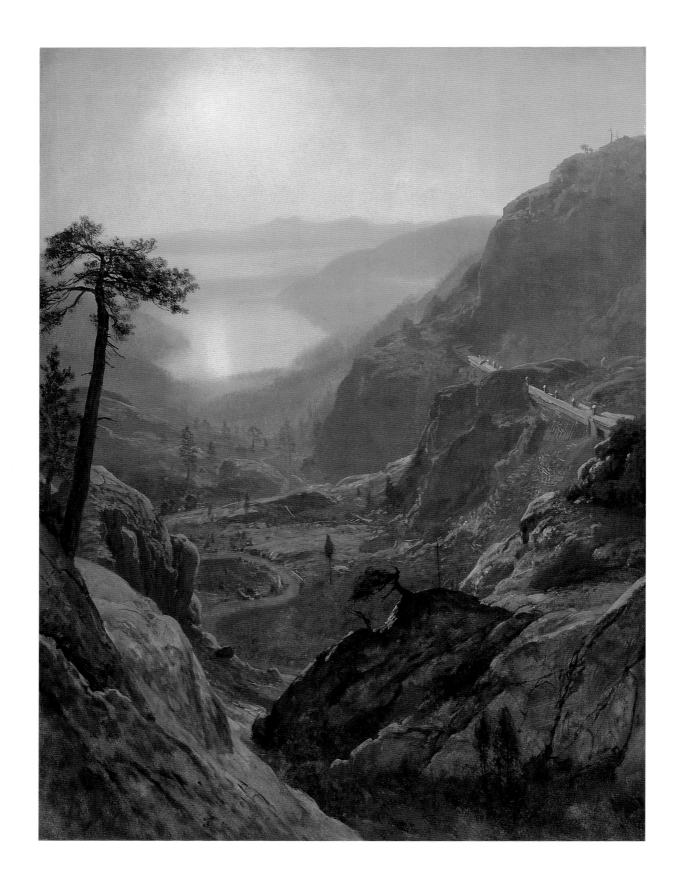

32. Albert Bierstadt (1830–1902), *View of Donner Lake, California*, 1871 or 1872
 Oil on paper mounted on canvas, 29¼ × 21⅞ in. (74.3 × 55.5 cm)
 Gift of Anna Bennett and Jessie Jonas in memory of August F. Jonas Jr., 1984.54

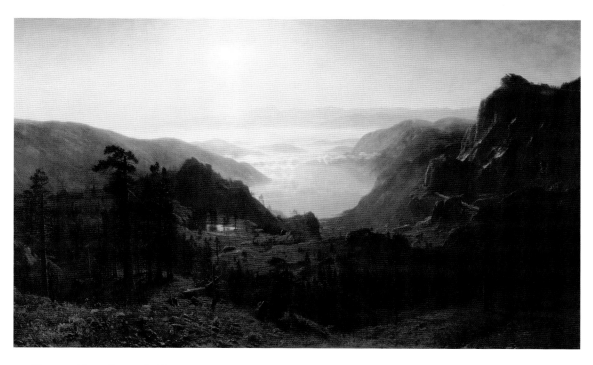

Fig. 32.1. Albert Bierstadt (1830–1902), *Donner Lake from the Summit*, 1873. Oil on canvas, 72⅛ × 120³⁄₁₆ in. (183.2 × 305.3 cm). Collection of The New-York Historical Society, 1909.16

one of the "Big Four" who had pushed the transcontinental railroad over the Sierra Nevada, overcoming fearsome topography, harsh weather, and a labor shortage to realize a technological and financial coup.[9] A monumental painting was a fitting celebration of this epochal achievement, would demonstrate Huntington's status as one of the cultural elite, and when exhibited would serve as an advertisement for the CPRR.[10] He knew exactly which portion of the route it should depict: the stretch lying between Donner Lake and the summit. This section of track had necessitated tunnels, trestles, stone retaining walls, and the famous snowsheds.[11] Huntington was a savvy promoter and recognized the threefold potential of this particular vista: not only was the lake celebrated for its beauty, but "right here were overcome the greatest physical difficulties in the construction of the road, while the immediate vicinity was the scene of the most pathetic tragedy in the experience of our pioneer immigration. . . . The two associations of the spot are, therefore, sharply and suggestively antithetical: so much slowness and hardship in the early days, so much rapidity and ease now." The *Overland Monthly* critic who penned this review of the finished painting understood its message precisely as Huntington had expected.[12]

Bierstadt was in San Francisco for four days before he retraced his journey back up to Donner Pass with Huntington to be shown the desired view.[13] He remained in the area for more than a week making preliminary studies, apparently rising early each morning to capture the effect of sunrise.[14] Sometime before exhibiting *Donner Lake from the Summit* (fig. 32.1) more than a year later, he made the highly finished study known as *View of Donner Lake, California*.[15] Less than three feet high and two feet wide, the study depicts a small but pivotal portion of the final exhibition-size (six by ten feet) painting. The sun has just risen beyond the distant Washoe Mountains, casting an ethereal yellow glow over the shining surface of Donner Lake. Meandering through the middle ground is the old emigrant wagon road, which disappears behind a rocky scarp as it makes its way over the pass. Hewn into the mountainside above the road is the railroad, though we see neither train nor tracks, only the Summit Tunnel and some of the thirty-seven miles of snowsheds, the innovation that made rail travel possible through winter's heavy snows.[16] In the foreground, precipitously slanting rock faces create a vertiginous feeling, as the eye descends two thousand feet from vantage point to lake.[17] One outcropping is deep in shadow; on it a tall, thin cross stands memorializing the Donner group.[18] The study differs from the final composition Bierstadt eventually sent to Huntington in New York.[19] The study's vertical format, emphasizing the pitch and ruggedness of the terrain, is replaced by a

Fig. 32.2. William Keith (1838–1911), *Donner Lake*, ca. 1878. Oil on canvas, 24 × 15 in. (61 × 38.1 cm). Collection of the Hearst Art Gallery, Saint Mary's College of California. Gift of Agnes M. Egan

horizontal Sierra vista far more typical of Bierstadt's oeuvre. The wagon road and railroad that are the focus of the study are reduced to minute features of the finished composition, the contrast between the two modes of travel no longer stressed. Bierstadt demonstrates that the advent of the railroad did not diminish the natural beauty of California's mountains; rather, it enabled anyone to cross them in comfort and safety.

Bierstadt's *View of Donner Lake, California* and William Smith Jewett's *The Promised Land—the Grayson Family* both commemorate the triumph of man over nature, but by completely different means. Jewett's Andrew Jackson Grayson lords over the landscape, his upper body breaking the horizon line, a wild creature dead at his feet. The rigors of the Sierra crossing are hinted at by the towering white peak at the upper right, but for the most part the mountains are screened by trees so as not to detract from Grayson's dominance. In keeping with his reputation as a painter of sublime paeans to nature, Bierstadt adopts another approach. The human presence, in the form of the before-and-after comparison of wagon road and railroad, is unified with the landscape by the rosy light of dawn tinting the lower two-thirds of the painting. Rather than conquering nature, man has remade the environment in order to temper its perils without compromising its beauty. The mood of the romantic sublime, the presence of the wagon road, and the tragic resonance of the Donner name remind us of the power of the Sierra to render humans utterly helpless and hopeless. The ribbon of snowsheds and the promise implicit in the golden sunrise assure us that we are now safe from such a fate, thanks to the engineering miracle of Collis P. Huntington's railroad.[20]

A few years later, William Keith took Huntington's railroad to the summit of the Sierra and painted Donner Lake from much the same vantage point that Bierstadt had (fig. 32.2). His view is far more intimate, the mountains curving in to cradle a bright blue Donner Lake in the distance. Gone is the sheer drop-off, precipitous descent, and sharp, rocky angles; Keith provides the viewer with a place to stand, and the mountainside slopes gently downward. Gone, too, is the railroad, tucked away out of sight. This image of the Sierra is benign, though no less beautiful. The triumph of the railroad depicted by Bierstadt had made possible a new relationship between mountains and man. [EL]

33. ALBERT BIERSTADT, *California Spring*

ANOTHER CHANCE FOR EDEN

*Visual images build relationships between people and the places where
they live; they transform land into landscape.* HEATH SCHENKER[1]

In 1876 Albert Bierstadt (1830–1902) submitted *California Spring* (1875),[2] one of four paintings he had exhibited for sale at the National Academy of Design in 1875, to the Centennial International Exhibition in Philadelphia.[3] Just three years previously, he had been hailed as the country's preeminent painter of national landscape with his monumental *Donner Lake from the Summit* (see fig. 32.1), exhibited at the 1873 Vienna Exposition.[4] The *San Francisco Chronicle* had called that work "a sublime painting of a sublime landscape," and the *California Art Gallery* proclaimed it the "latest and most agreeable art-sensation of our city."[5] Bierstadt's reputation was to decline dramatically as the Hudson River School style he brought to his scenes of the American West came to seem outmoded in light of later-nineteenth-century urban realism and impressionist painting techniques.[6] However, *California Spring* represents the artist at the height of his career and powers.

Beginning in the 1820s, surveyors, accompanied by journalists and (later) photographers, reported on the United States territories west of the Mississippi, fueling a national interest in Manifest Destiny.[7] This ideology supported the romantic belief that the United States was a country destined by natural forces and the character of its people to subdue the North American continent from the Atlantic to the Pacific coasts. The rhetoric of Manifest Destiny served the interests of those of European heritage, principally English, Dutch, and German, refusing to acknowledge the established communities of other nations and cultures living between the Missouri River and Pacific Ocean.[8] It was a language of empire perfectly suited to the discovery of gold in California in 1848, which set off a westward migration that was unprecedented in American settlement.

Bierstadt made three sketching trips to the American West, during which he took stereographs, collected Indian artifacts, and produced a large body of drawings and plein-air oil studies to be used later in composing studio paintings.[9] As other Hudson River School painters had, Bierstadt followed the method in which he had been trained during study in Düsseldorf from 1853 to 1857, seeking an American equivalent to the conventions of European alpine painting.[10] In April 1859 he first traveled west with Frederick W. Lander's survey expedition party from Missouri to the Rocky Mountains, comparing them favorably with the Bernese Alps in Switzerland, which were central to the romantic vocabulary of the sublime.[11] In long letters sent back to and published in New York, Bierstadt proved himself an enterprising self-promoter with descriptive tales of his adventures that whetted the appetite of Easterners for his future paintings.[12] That fall he moved into the Tenth Street Studio Building in New York City, the most illustrious address for an artist at the time and home to the other great Hudson River School painter of his generation, Frederic Edwin Church (1826–1900). Many of Bierstadt's close friends also worked out of studios in the building, including Sanford Robinson Gifford (1823–1880) with whom he had traveled on sketching trips in Italy, and colleagues from Düsseldorf, including Worthington Whittredge (1820–1910) and William Stanley Haseltine (1835–1900).[13]

By his second journey west in 1863, Bierstadt had established himself as one of the country's preeminent painters. *Sunlight and Shadow* (pl. 31), his European-influenced painting of poetic realism that was shown at the National Academy of Design in 1862, had brought him national acclaim. It was followed in 1863 by the phenomenal success

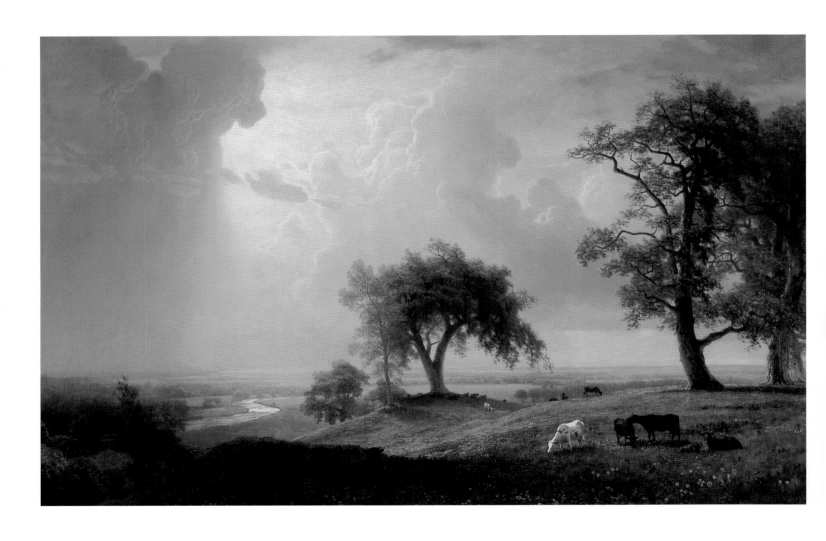

33. Albert Bierstadt (1830–1902), *California Spring*, 1875
Oil on canvas, 54¼ × 84¼ in. (137.8 × 214 cm)
Presented to the City and County of
San Francisco by Gordon Blanding, 1941.6

of *The Rocky Mountains, Lander's Peak* (1863), a large-scale studio work composed from sketches made during his initial western trip.[14] During this second trip, Bierstadt traveled to San Francisco, Yosemite, Mariposa, and the Pacific Northwest with one of New York's most flamboyant literary figures, Fitz Hugh Ludlow (1836–1870), who had become infamous for his memoir based on his experiences as a drug addict, *The Hasheesh Eater* (1857). Ludlow enticed Easterners to anticipate eagerly Bierstadt's future paintings in a series of descriptive sketches for the *Atlantic Monthly* and his dramatic letters recounting the journey, which were published in the *New York Evening Post*.[15]

California Spring is painted from studies made during Bierstadt's third western sojourn, from 1871 to 1873. The artist and his wife, Rosalie, traveled on the recently completed transcontinental railroad, and, upon reaching San Francisco, remained for two years while Bierstadt made short sketching trips into the countryside. In place of the panoramic scenes of the Rocky Mountains and Yosemite that Bierstadt produced in the 1860s, here he painted the flat, wide plain of the Sacramento River Valley. After the physical and psychological devastation of the Civil War, Bierstadt's highly detailed yet romantic depictions of towering peaks and open plains offered these natural splendors as evidence of the nation's unlimited potential, becoming synonymous in the minds of many people with the promise of a new start. As a scholar of the American West writes, "Bierstadt offered a war-torn nation images of a landscape unbloodied and full of promise."[16] His paintings reinforced a transcendental vision that looked to nature and the language of the sublime for proof that America was indeed the new promised land and a divine blessing; both ideas supported the doctrine of Manifest Destiny.

California Spring connects that promise explicitly with California, combining the monumental scale and operatic spectacle of the sublime landscape with the idyllic and serene poetry of a pastoral scene that is more characteristic of picturesque views. The bucolic landscape offers an ideal—and predominantly idealized—vocabulary of place that associates the Sacramento River Valley's identifiable topography with the beauty of the natural world. The pastoral's visual language of peace, harmony, and abundance is meant to reflect the humanizing influence that civilization introduces into the wildness of nature. At the same time, Bierstadt evokes the sublime by representing the viewer's dramatic encounter with nature as an experience of inspiring power and awe. His representational ideal

synthesizes the grandeur of a sweeping, yet serene, vista and the turbulent movement of an expansive, storm-filled sky.

In the painting, cows graze in the foreground amid a colorful array of meticulously detailed wildflowers. Bierstadt follows the standard model for pastoral paintings established by Claude Lorrain (1600–1682): silhouetted trees framing the scene in the foreground, water reflecting in middle ground, and mountains defining the distance—although his are mountains of clouds rather than craggy peaks. Behind the cattle, a broad expanse of fertile fields, open and waiting to be settled, spreads across the canvas. In the words of a present-day environmentalist, Bierstadt "did not depict the harsh realities of life in the Central Valley that were even then becoming apparent—the struggle for water, recurrent droughts, a landscape impoverished by overgrazing."[17] Rather, he conjures the benevolent largesse of a new Eden.

Drawing on the tradition of seventeenth-century Dutch landscapes, Bierstadt drops the horizon by inventing a high vantage point, which magnifies the panorama, the spatial depth, and the vast expanse of sky.[18] This strategy, used by painters such as Jacob van Ruisdael (1628/29–1682), throws the emotional drama of the scene into the sky, displacing the narrative stimulus onto the natural elements (fig. 33.1). A thunderstorm has just passed through the valley, evident in the shadowed foreground and the bank of dark cumulus clouds at the left. The sun is breaking through, its golden light coloring the sky and glinting on the river. As in its Dutch counterparts, Bierstadt's painting is suffused with an atmospheric light that seems to suggest divine intervention, reinforced by the elevated viewpoint that takes in the entire valley at a glance. The dark foreground places the viewer under the shadow of the storm, but the bright valley anticipates its clearing as the rain and thunderclouds draw aside on the left like a curtain opening on a new act.

The lofty California oak trees provide the visual link between the physical and ideological realms. The monumental trees framing the scene on the right reach from the foreground space occupied by the cows into the sky at the top of the canvas. Their brown and green coloration ties them to the meadow and livestock, while the rounded shape of limbs and leaves rhymes the billowing mountains of storm clouds. Earlier art historians have also noted the similarity between this composition and Rembrandt's famous etching *The Three Trees* (fig. 33.2).[19] As in that work, the oak trees provide a strong diagonal, countering the horizontal flatness of the vista and leading viewers through the

Fig. 33.1 [top]. Jacob Isaacksz van Ruisdael (1628/29–1682), *A Burst of Sunshine*, ca. 1660. Oil on canvas, 32½ × 39 in. (82.6 × 99.1 cm). The Louvre, INV.1820

Fig. 33.2 [bottom]. Rembrandt Harmensz van Rijn (1606–1669), *The Three Trees*, 1643. Etching, 8⅟₁₆ × 10⅞ in. (20.5 × 27.7 cm). Courtesy of the Fogg Art Museum, Harvard University Art Museums. Gift of William Gray from the Collection of Francis Calley Gray, 63264

pictorial space from foreground to horizon. Additionally, they connect the scene to the rhetoric of spiritual transformation through the symbolic allusions to the Crucifixion and Resurrection on which Rembrandt's image relies in its typological reference to the three crosses on Golgotha.

These California oak trees are a double symbol, alluding to both specific place and moral redemption. Bierstadt renders California's Sacramento Valley as another chance for Eden and hope for the future, signified by the glinting gold dome of the recently completed state capital building, which the artist depicts as a barely visible mark on the distant horizon. As the painting's early viewers well knew, the gold on that dome had been discovered a generation earlier in the Sierra Nevada, not far from Sacramento.

The city was also the terminus of the Central Pacific Railroad, which had joined with the Union Pacific Railroad to create the first transcontinental rail line in 1869. Bierstadt's grand canvas *Donner Lake from the Summit* celebrates that achievement, depicting the highest point in the Sierra Nevada through which the train passes before descending to the Sacramento Valley. The railroad magnate Collis P. Huntington commissioned that painting as a testament to the power of commerce and industry, and especially his railroad, in establishing the United States as an American empire.[20] *California Spring* provides the pendant fertile valley to that rugged mountain pass and its associations with the railroad and gold. It metaphorically promises that the dark storm of sectionalism and its turbulence will fade in the golden luster of California's opportunity.[21] [DC]

34. JOHN FREDERICK KENSETT,

Sunrise among the Rocks of Paradise at Newport

SOUVENIR OF A PLACE NOT SEEN

In his landscape paintings, John Frederick Kensett (1816–1872) eschewed the grandiose and the sensational, depicting instead the secluded, the calm, touched with the small, subtle dramas of changing light, moving water, and the silent growth of nature. In *Sunrise among the Rocks of Paradise at Newport* (1859) dawn is breaking over a marsh bounded by rocks and edged with reeds. The sky is pale at the horizon, still shaded with the purples of night at its upper reaches. The first rays of the sun brush the clouds with red. In the dim light, the rocks are reddish brown, mottled, and indistinct. The water reflects them and a streak of yellow sky. In the distance, ducks fly in formation, and others float in the rocks' shadows or begin their flapping ascent, feet skimming the water. It is a painting of sonic and psychic quiet.

How surprising, then, to realize that the Rocks of Paradise of this painting lie just a short distance from the fashionable, and crowded, heart of the resort town of Newport, Rhode Island.[1] In 1847 steamships began carrying overnight travelers to Newport from New York City. During the following decades, Newport changed from a somnolent, coastal town into an exclusive and well-appointed resort. By the late 1850s developers had built several large hotels, an increasing number of cottages were available for rent, and urban residents were constructing summer homes. An illustration by Winslow Homer entitled *The Bathe at Newport* (1858), which appeared in *Harper's Weekly*, shows the waters of Town Beach jammed with swimmers, floaters, and waders, and the shore similarly crowded with watchers and walkers. Newport does not seem a particularly restful summer retreat.

Kensett first visited Newport in the early 1850s, before it

had been discovered by many vacationers and when artists were making their summer jaunts to the White Mountains in New Hampshire and other inland destinations instead. Benjamin Champney, an artist friend who was summering in the mountains, wrote to Kensett in Newport urging him to join his companionable group: "Now do come and leave those Old rocks and water scapes and try us here for a little while. I know you will come back to the stern mountains with pleasure after getting tired of the monotony of the ocean."[2] But Kensett did not tire of the ocean, returning to Newport and other coastal sites for many summers to come.

Kensett's father was an English engraver. When he died in 1829, Kensett studied that art with his uncle, Alfred Daggett (1799–1872). He worked as an engraver in New York and New Haven until 1840, when he traveled to Europe for what would be a seven-year stay. He first supported himself by engraving, but in 1843 turned full time to painting. While he was in Europe, he regularly sent paintings to the National Academy of Design and the American Art-Union for exhibition. Thus, when he returned to the United States in late 1847, his was already a familiar name among art collectors and critics and he was quickly able to establish his reputation in New York City. Kensett's paintings were purchased by some of the most notable collectors of the day.[3] Known as a particularly amiable man, Kensett would have had the chance to socialize with patrons and potential patrons during his sojourns in Newport.[4] Other artists began to join him in Newport in the later 1850s, but it was Kensett who established the strongest affiliation with Newport; it became, in a sense, his subject.[5]

While other artists tended to paint the most recognizable

34. John Frederick Kensett (1816–1872), *Sunrise among the Rocks of Paradise at Newport*, 1859
Oil on canvas, 18 × 30 in. (45.7 × 76.2 cm)
Gift of Mr. and Mrs. John D. Rockefeller 3rd, 1979.7.69

places and popular destinations around the resort town, Kensett increasingly sought out the lesser-known, less frequented sites farther up the coast. When he did paint a popular beach or landmark, Kensett often arranged his composition so that its most familiar feature was not included in the painting. He was able to capture the essence of a place through his careful observations of vegetation and rock, the quality of light, the shape of shoreline. In this way he could paint Newport, really capture the place, without showing its most familiar historic, natural, or popular features.[6] In painting the modest aspects of the landscape—the marshy ground, the weathered rocks, the common waterfowl—he was actually painting its most salient features. As one nineteenth-century critic wrote, "Never invoking the assistance of a great or sensational subject, but sedulously seeking for the simplest material, he has by his skill and feeling as a painter, taught us the beauty and the poetry of subjects that have been called meagre and devoid of interest."[7]

Kensett's landscapes of Newport, when hung on the walls of homes in the city, could serve as reminders of summer idylls. Yet, because Kensett chose to depict out-of-the-way sites and not the most familiar Newport landmarks, the paintings are not just simple souvenirs, resonant with happy memories of sun, fresh air, and leisure. Few people saw the Rocks of Paradise as Kensett painted them.[8] The site of the painting is a short distance from the road that connected Newport to Middletown and that led to some of Newport's most famous historic spots.[9] That road carried a veritable parade of phaetons and barouches on summer afternoons, as tourists, tired out from mornings spent swimming, took long drives along this and other roads to enjoy the scenery, thus following the established daily itinerary for fashionable visitors. Few people would alight from their carriages, however, and those who did probably did not brave the swampy ground around these rocks. Fewer still would have made the journey at daybreak. Henry James described the Rocks of Paradise nearly twenty years after Kensett painted *Sunrise among the Rocks*:

> The place itself will be familiar only to those rare pedestrians who, not contented with enjoying the scenery from the seat of a barouche, have strolled at will among the lovely meadows, where in the most primeval solitude it is possible to get far-reaching views of the sea, or to find fascinating little nooks among hills and valleys whose very existence is hardly known to the ordinary summer visitor.[10]

Kensett, certainly, was no ordinary summer visitor; he was indeed that rare pedestrian who sought out such secluded sites. But we cannot automatically ascribe those traits to other Newport visitors. If this painting was a souvenir for an urban collector, it was possibly a souvenir of a place not seen.[11]

Kensett's landscapes assumed a viewer who would be able to recognize the subject by feel, as it were, rather than by obvious features. They also assumed a viewer who would have the education and sensibility for looking at paintings, the ability to appreciate the "poetry" in a "meagre" scene, to quote James. That viewer would be able to savor both the landscape in nature and its depiction. A Kensett painting, therefore, was not only a reminder of a place visited, it was also an assertion of the viewer's refinement.[12] In *Sunrise among the Rocks* and other Newport paintings, that assertion became even more pronounced because Newport itself carried connotations of superior quality and discernment. One writer observed, "The class of people who make Newport their summer residence, is different from that at any other resort in the country. There is but very little of the shoddy aristocracy and none of the low sporting fraternity. Long Branch and Saratoga are the resorts of these classes, while the substantial and higher classes of society make this their resort for health and pleasure."[13] The viewer who knew Newport and knew that he was looking at a fine painting of Newport would have the satisfaction of seeing the measure of his or her refinement doubly confirmed.

But this painting is more than just a salve to cultured egos. Viewers who did possess that refined sensibility may indeed have particularly treasured this painting as a memento of a summer spent and a way of life lived, but the painting is also an expression of a profound experience of landscape. Without bombast or moralizing, without reading human messages or history into the landscape, the painting celebrates the quiet beauty of early morning over a marsh. It records an experience of nature that requires getting up early and tramping over soggy ground, shunning human fellowship and watching closely the colors in the sky and the birds on the water. The painting could have been a souvenir, and it might have offered a therapeutic retreat from urban life as well as playing a role in claiming a level of refinement and gentility. But in addition to and in spite of all this, *Sunrise among the Rocks of Paradise at Newport* is also a meditative observation of the way dawn breaks over a solitary sliver of Rhode Island coast. [IB]

35. SANFORD ROBINSON GIFFORD, *Windsor Castle*

THE LANDSCAPE OF
AMERICAN ANGLOPHILIA

Sanford Robinson Gifford (1823–1880) completed his final painting of Windsor Castle in 1860, three years after returning from an extensive tour of Europe. He produced his first sketches of the castle on a visit to Windsor in July 1855 and returned to the subject at least six times, reworking it in a series of oil sketches and paintings.[1] Gifford's abiding interest in the site was not merely aesthetic; by the mid–nineteenth century Windsor Castle had become a popular destination for American tourists and was considered emblematic of England's noble history and culture.

At the time Gifford embarked for Europe in 1855, the practice of making a grand tour of European monuments and cultural sites was common among privileged young Americans and had come to be seen as an important component of a well-rounded education. Many American artists received training in Europe, and foreign art collections attracted students and general travelers alike.[2] By the 1850s numerous guidebooks and narrative accounts of European travel were available, and articles on foreign attractions and scenery were frequently featured in newspapers and magazines. Such writings provided models for travelers and offered a glimpse of the sites and scenery of Europe to those who could not make the trip themselves.[3]

As a result of a common language and strong cultural ties dating from the colonial past, many nineteenth-century Americans were particularly fascinated with England. In spite of contemporary differences between the two nations, travel to England was often characterized as a homecoming or cultural pilgrimage, and narrative accounts typically stressed a shared Anglo-American history.

Having been raised on English literature, legends, nursery rhymes, and schoolbooks, American visitors often found English landmarks deeply familiar.[4] An article published in the *North American Review* in 1861 suggests that the American tourist in England "feels that he knows many who have lived and died here better than he knows his next-door neighbor at home. He cannot believe he has never before lived in those scenes."[5]

The familiarity of English literary and historical landmarks enhanced their popularity as tourist attractions. There seems to have been something appealing about the hazy sense of déjà vu inspired by visiting sites that were recognizable from history lessons and literature, yet carried the mystique of a foreign culture. Americans were especially interested in those aspects of British life that could not be found at home, such as castles, cathedrals, and the lives and manners of the English aristocracy and royal family. In *Pencillings by the Way* (1836), Nathaniel Parker Willis likened the English aristocracy to a similarly familiar yet enigmatic group from the United States, declaring: "a North American Indian, in his more dignified phase, approached nearer to the manner of an English nobleman than any other person."[6] While in England in 1849, Ralph Waldo Emerson was likewise impressed by the calm and self-possession of the aristocracy, describing them in his journal as "a model class for manners and speech. . . . They are like castles compared with our men."[7]

Indeed, the castle, a distinctively European building form, was often invoked as a representative of the character and sensibilities of the nobleman or monarch who

35. Sanford Robinson Gifford (1823–1880), *Windsor Castle*, 1860

Oil on canvas, 17¾ × 29⅞ in. (45.1 × 75.9 cm)

Gift of Mr. and Mrs. John D. Rockefeller 3rd, 1979.7.44

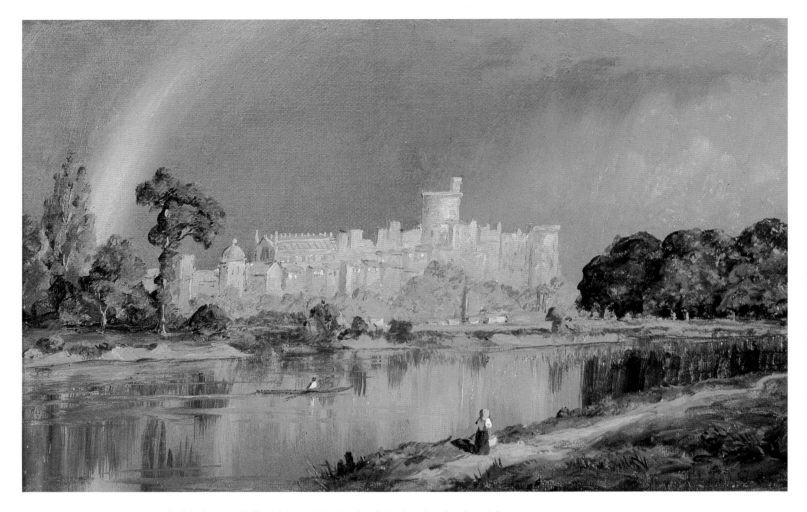

Fig. 35.1. Sanford Robinson Gifford (1823–1880), *Study of Windsor Castle*, 1855. Oil on canvas,
6⅜ × 9⅝ in. (16.2 × 24.5 cm). Collection of Edward T. Wilson, Fund for Fine Arts, Bethesda, Maryland

occupied it. Writing of a day trip to Windsor in *England* (1837), James Fenimore Cooper used a comparison of Windsor Castle and the French palace Versailles, as a means of emphasizing differences between England and France. He asserted that Versailles "leaves an impression of a monarch who deems a kingdom erected for his use, who forces nature and triumphs over difficulties to attain the magnificent; the other, of a head of state, profiting by accident to attain an abode in which his comforts are blinded with a long chain of historical images."[8] In contrast to the pomp and posturing of Versailles, Windsor Castle appeared natural and unself-conscious, its long history lending British rule an air of innate righteousness.

Unlike the relatively young Versailles, built between 1661 and 1687, Windsor Castle's history spanned centuries. Construction of the castle began about 1080 with a motte and bailey (an artificial hill with a fenced area on top) built by William the Conqueror. By 1272 the castle had assumed what is essentially its current form, with a prominent round tower and two wards with walls and towers around them. It remains the world's oldest and largest occupied castle and was a popular tourist destination throughout the nineteenth century, especially after 1849, when a rail line from London was extended to Windsor. The castle fell in and out of favor with the royal family over the centuries, but Queen Victoria (1819–1901) made it her official residence when she ascended the throne in 1837, and all state visits during her reign took place there. When Gifford visited the castle in 1855 it was one of three residences shared by the queen and her husband, Prince Albert, who divided their time between Windsor and their private homes: Osborne, on the Isle of Wight, and Balmoral, in Scotland.[9]

American interest in the British monarchy reached new extremes during Victoria's reign; shortly after her coronation American newspapers were filled with reports on her appearance, dress, and daily activities, leading some writers to complain of "Regina mania" and "Victoria Fever." In the late 1830s shops in Philadelphia and New York offered items inspired by the queen, such as hairbrushes, clocks, soap, bonnets, shawls, hats, lace, sheet music, gloves, and even Victoria bean soup and Victoria mint juleps. In 1860, the year Gifford painted *Windsor Castle*, a visit to America by her son, the eighteen-year-old Prince of Wales, caused a sensation, with crowds of more than thirty thousand people assembling at each of his stops, and lavish balls, parades, and state dinners organized in his honor in major American cities.[10] In response to the prince's visit to New York, *Frank Leslie's Illustrated Newspaper* remarked: "we do not remember any turn out of the people in any way comparable with this."[11]

Gifford kept a detailed journal while in Europe, written in the form of letters to his father that he asked be kept together as a record of the trip. Although it is not clear that Gifford was caught up in "Victoria Fever" as were so many of his contemporaries, his travels in England nevertheless seem to have been given shape by his knowledge of English history and literature. His entries focus on descriptions of the sites he visits, interspersed with references to literary history and the books he is reading as he travels. His tour of the English countryside included visits to Shakespeare's (1564–1616) birthplace, William Wordsworth's (1770–1850) cottage, and Thomas Gray's (1716–1771) tomb, and in the account of his stop at Windsor Castle Gifford frequently adopts the tone of a guidebook or local history.[12]

It was a sketch of the river from the Thames, made following an afternoon rainstorm on Gifford's second day at Windsor (fig. 35.1), that served loosely as the basis for many subsequent oil sketches and paintings, including his *Windsor Castle* of 1860. Although in his journal Gifford described several of the castle's most notable features, such as the Great Park and the noted prospect from the battlements of the Round Tower (which he described as "a very beautiful and panoramic view of an extensive and lovely landscape"), he chose to develop a more mysterious scene, presenting the castle in strong, shadowy silhouette, rising above the bank of the Thames at sunset.[13]

In contrast to earlier sketches made from the riverbank, such as *Study of Windsor Castle*, the castle in the painting of 1860 appears elevated and contrasts sharply with the gold and pink tones of the evening sky. Whereas the sketch suggests motion, with masses of passing storm clouds, a rower on the river, and a sturdy figure moving across the foreground, the painting projects near perfect stillness. The surface of the river is completely smooth, and the trees along its bank are engulfed in shadow. A woman draped in a red shawl walks along the water in the foreground, holding the hand of a young child as they approach an indistinct collection of figures gathered farther along the riverbank. A flagpole is faintly visible on the Round Tower, but the flag appears to have already been lowered for the night.[14] The air is still, the sky broken only by a low bank of pink clouds along the horizon and a curving trail of wispy pink clouds that seems to encircle and highlight the castle, as if even nature were emphasizing the structure's central, authoritative presence.

Whether or not Gifford shared the prevailing American enchantment with the monarchy, he seems to have relished the challenge of creating an iconic view that could support the legendary qualities the English aristocracy and their castles embodied. In the sketches and paintings preceding *Windsor Castle*, indications of weather and specific details of activity along the river were increasingly filtered from the composition, resulting in a painting that projects the composed grace and strength the castle represents without tying it to a particular moment. The painting was purchased by Henry Wade Rogers (1806–1880), a prominent lawyer in Buffalo, New York. A nineteenth-century history of Buffalo noted that Rogers's parents "were from England, and of English puritan descent." Like early Puritan settlers, his ancestors had "emigrated" to New York State "while that region was yet called 'the West,' and, like most of its early settlers, they had little capital, save their stalwart frames and the stern virtues of their race — industry, economy, the love of independence and the fear of God."[15] In 1860, when America was on the brink of civil war, reflections on English character and strength — qualities presumably shared by New England Puritans and their descendants — allowed for hope that the power of an honorable past could secure a proud future. English history, represented in monuments like Windsor Castle, suggested that a nation whose citizens were endowed with the innate virtues of their castlelike English ancestors could find the strength to endure the challenging times ahead. [AG]

NORTH SHORE SUBLIME

Martin Johnson Heade (1819–1904) was touched with wanderlust, moving his base of operations from town to town many times in his career as well as striking out on countless transitory journeys. In 1837, at the age of eighteen, he was sent by his father—suitably affluent and indulgent to nurture his son's artistic ambitions—to apprentice with the painter Edward Hicks.[1] This fifteen-mile journey through the Pennsylvania countryside was just the beginning, for the very next year found him studying art in Europe, living for more than two years in Italy, England, and France. During the 1840s and 1850s Heade worked as an itinerant portraitist, periodically submitting paintings to exhibitions in Philadelphia and New York. Between 1845 and 1858 he set up shop in Brooklyn, Philadelphia, St. Louis, Chicago, Trenton, and Providence, as well as spending two years in Rome. Heade rented a studio in New York's Tenth Street Studio Building in 1859, where Frederic Edwin Church and Albert Bierstadt painted their renowned landscapes, but even such illustrious company held him for only two years before he moved on to Boston.

During his New York sojourn Heade had begun making frequent visits to coastal resort areas up and down the New England seaboard. These trips provided the raw material—in the form of impressions, memories, and sketches—for approximately thirty luminist seascapes painted between 1859 and 1863.[2] Fully half are dated 1863, when Heade was working furiously to raise funds for his first trip to South America, later that year.[3] One of the paintings that emerged from his Boston studio during this period of intense activity was *Singing Beach, Manchester*, a stunning Atlantic seascape. Characteristic of Heade's shore paintings, it captures a distinct moment at a marginal time of day, which has previously been described as sunset, due in all likelihood to the intensity of color at the horizon.[4] However, Sarah Cash has demonstrated that the prospect shown in the painting is almost due east. As the brightly illuminated undersides of the clouds confirm the sun's presence just below the horizon line, it now seems likely that the painting depicts dawn, which perhaps alters its perceived mood but in no way detracts from its beauty or appeal.[5]

The sun lurking behind the large double-humped rock offshore tints the sky with bands of color ranging from fiery orange to a deep blue-gray. Another island is visible on the horizon, as is what appears to be the curve of the shore in the left distance.[6] A rocky bluff, also at left, is closer to the viewer's position on the rock- and seaweed-strewn beach. Foam-edged sheets of glassy water overlap as they spread up the shore; the next wave is depicted as if frozen, just as it begins to break at the right, and others swell up behind as they move inland. Heade's brushwork is invisible, his use of color intense, his most minute detail highly finished. Although artists were turning out seascapes literally by the thousands during this period, virtuosity such as that exhibited here distinguishes Heade's as exceptional.

Heade almost never recorded the location of his views on the paintings, leaving the viewer to wonder how, and when, *Singing Beach, Manchester* came by its site-specific title.[7] His paintings from the 1860s bore titles when they were exhibited or sold, but no real evidence exists of who christened them. In a letter to his dealer at the time, Seth Vose of Providence, Heade wrote, "I have just sent by early express two pictures that I happened to have finished. . . . The small one that I send you may call *Sunset on Lake Champlain* and the other—nothing."[8] The phrasing "you

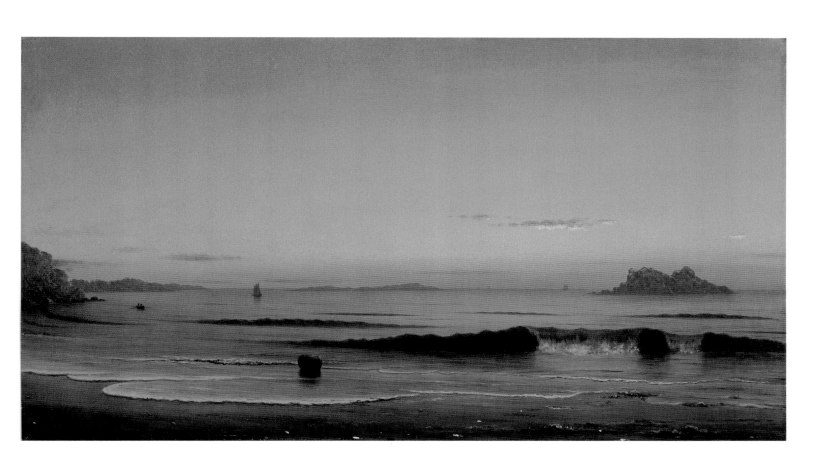

36. Martin Johnson Heade (1819–1904), *Singing Beach,
 Manchester*, 1863. Oil on canvas, 20 × 36 in. (50.8 × 91.4 cm)
 Gift of Mr. and Mrs. John D. Rockefeller 3rd, 1993.35.12

may call" as opposed to "I call" implies that titles were not significant to Heade and that at least some of the time he left the naming up to his dealers. Complicating matters is the fact that after Heade's death in 1904 his reputation diminished, and many paintings lost any association with historical records as they changed hands time and time again. By the turn of the twentieth century, the de Young painting had long disappeared from view, taking with it any title Heade may have given it.

The whereabouts of the painting during its first century are unknown, though it appears to have remained on the East Coast. In 1965 it was offered for sale by the Vose Galleries—the same family dealership that Heade had almost certainly entrusted with the painting in 1863—with the title *Breaking Waves, Newport*.[9] Theodore E. Stebbins Jr., the leading expert on Heade, included the painting in an exhibition of the artist's work in 1969, giving it the title *Twilight, Spouting Rock Beach*. Since Spouting Rock Beach is in Newport, the location had not changed but simply became more specific.[10] Newport was an excellent candidate as a site, for Heade definitely visited the area on many occasions and exhibited numerous paintings with Rhode Island titles in the 1850s and 1860s.[11] An 1857 lithograph of Spouting Rock, however, does not resemble *Twilight*'s beach, and no offshore islands are visible there, rendering this attribution far from certain.[12]

While conducting research for a 1994 Heade exhibition, Sarah Cash made two important discoveries about the painting then known as *Twilight, Spouting Rock Beach*.[13] Through careful sleuthing she determined the location in fact to be a coastal resort, but one some seventy-five miles north of Newport: Manchester, Massachusetts. Given Heade's peripatetic nature, his love of the seashore, and his intermittent residence in Boston from 1861 to 1863, it is not surprising that he would find his way to Manchester, a popular and easily accessible destination on Massachusetts's North Shore.[14] With the help of an 1861 Heade sketch of "Eagle Cliff" and a contemporary Manchester photographer, Cash was able to determine Heade's precise location as Singing Beach, so called because the sand emits a distinct squeaking sound when walked across.[15] The view from Singing Beach, however, still was not a perfect match for that in the painting, leading Cash to her second discovery—Heade had taken liberties with the landscape. At the far left of the painting is Eagle Head Bluff, Kettle Island lies in the center distance, and the outcropping offshore at the right is unmistakably a landmark known as Rock Dundy.[16] Seeing these three features at the same time is, however, impossible. If Heade had looked out to sea with Eagle Head at his left and Kettle Island dead ahead, Rock Dundy would have been well out of his line of vision. Instead, the rather less interesting profile of Great Egg Rock would have been before him. Back in the studio, Heade must have substituted the more picturesque formation, creating a composite image.[17]

Ultimately, it does not matter whether Heade shifted the coastal topography of Manchester around in *Singing Beach, Manchester*, or even that the painting depicts that particular beach. Names are specific, but what Heade depicted is universal—the power of the ocean and humankind's inconsequentiality before it. Whatever the location of this luminous seashore, the mood of the painting is introspective and ethereal. The beach is deserted save the viewer, leisure and commercial undertakings stilled. The fringe of white foam at the water's edge, all but invisible in the harsh glare of midday, glows under the low, crepuscular light. Another splash of white draws attention to the wave poised as it begins to break, taut with arrested, yet inevitable, motion. So still is the rest of the scene that imagining the rhythmic roar of the surf is easy. Other people are beyond the range of hearing; two men are visible in the small rowboat, and crews must be aboard the sailboat in the middle distance and the tiny ships on the very horizon. This series of increasingly minute boats, as well as Heade's use of an extended horizontal format, parallel stepped-back planes, and a low horizon line, creates the impression of limitless space.[18] The vast sweep of sky and water dwarfs the vessels; indeed, the smallness of man within nature's expanse is a major theme of the painting.

A vestige of human activity remains on the deserted beach: a single wooden barrel, washed up on the shore. Each wave that rushes in would rock it gently back and forth. No clues to the barrel's origin are visible, and one imagines a host of scenarios: did it fall overboard, was it cast away intentionally, could it even be the product of a distant wreck? Wherever and however the barrel embarked, it was carried to this beach as a passive passenger on the tides, a man-made artifact at the mercy of the sea and moon. As such, it stands proxy for humankind, vulnerable in the face of inexorable natural forces. Heade thus subtly communicates the sublimity of a powerful ocean currently in repose, a marked departure from the dramatic, crashing seas of the romantic painters earlier in the century but one that intensifies the seascape's emotional impact.[19] [EL]

37. MARTIN JOHNSON HEADE, *The Great Swamp*

LOSS AND LIFE IN THE MARSH

A salt marsh farmer wanting to gather a crop of hay had to watch the water closely, waiting for that handful of days when the tides ran particularly low. That was his chance to cut the black grass (*Spartina patens*) that carpeted the higher marsh, two feet tall. Some of it he would load onto a hayrack and cart away. But the rest he would rake and cock into conical haystacks twenty feet high. He built the stacks on staddles—circles of stakes set into the marsh—so the hay would stay dry when the tides rose again. The stacks might stand for months. Come winter the farmer would haul them away over the ice.

American genre painters such as William Sidney Mount (1807–1868) and Eastman Johnson (1824–1906) found pictorial opportunities in haying, tired workers relaxing, or celebrations of cleared fields and filled barns. But salt haying in a marsh presents a very different scene and setting, one that was the almost exclusive purview of Martin Johnson Heade (1819–1904). Between 1859 and 1904 Heade painted 120 marsh landscapes, many of which include elements of haying. The marsh paintings ultimately made up a fifth of Heade's oeuvre, which also included seascapes, tropical landscapes (he traveled three times to Latin America), still lifes of flowers, and paintings of hummingbirds. The marsh paintings were not duplicative—Heade worked carefully on each one to achieve balance between the various elements in the image. Many of the marsh paintings show evidence of his alterations and erasures. An examination of *The Great Swamp* (1868) under ultraviolet and infrared light revealed that the haystack on the far left was originally significantly larger and that Heade had reduced it.[1]

Perhaps none of Heade's marsh landscapes is as evocative and atmospheric as *The Great Swamp*.[2] From a closely detailed foreground of flowers, grasses, and rock, the marsh spreads away into a hazy distance toward an encircling band of low hills. The sun burns a white hole into the gray-purple atmosphere and casts an eerie yellow light on the haystacks below. It is a flood tide, and a man steers his small boat between the large, looming stacks. A child, dressed in red, is his passenger. In the right foreground the stakes of an unused staddle poke out of the water. It is a preternaturally quiet scene. The companionable presence of the man and child, probably father and son, is comforting, the red shirt a vibrant, lively note amid the grays and browns. Red appears too in the flowers in the lower left, and as we look more closely we notice blue blooms there as well, tucked between the green and yellow grasses. And so we are drawn into the beauties of the marsh, despite the presence of those haystacks, so bulbous and alien, and the strangeness of the sky. The marsh offers a rich bounty—as evidenced by those stacks—to those patient and hardworking enough to gather it.

In December 1675 Rhode Island's Great Swamp was the site of an attack on the Narragansett tribe by members of the Connecticut, Massachusetts, and Plymouth militias. The attack was the result of months of tension and escalating acts of retaliation by both sides for broken promises, trampled crops, slaughtered livestock, and murdered informants. In a letter dated 21 December 1675 Joseph Dudley described the attack:

> Our men, with great courage, entered the swamp . . . ; within the cedar swamp we found some hundreds of wigwams, forted in with a breastwork and flankered, and many small blockhouses . . . ; they entertained us with a

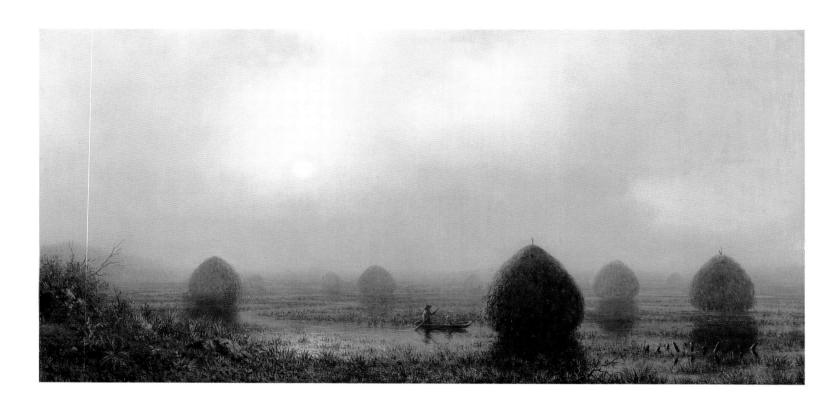

37. Martin Johnson Heade (1819–1904), *The Great Swamp*, 1868
 Oil on canvas, 14⅞ × 30⅛ in. (37.8 × 76.5 cm)
 Gift of Mr. and Mrs. John D. Rockefeller 3rd, 1993.35.11

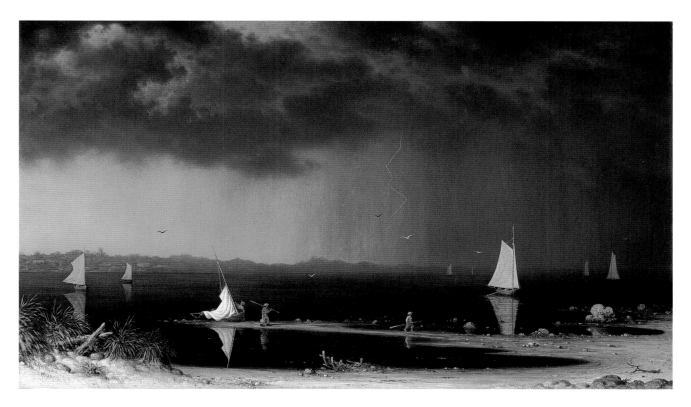

Fig. 37.1. Martin Johnson Heade (1819–1904), *Thunder Storm on Narragansett Bay*, 1868.
Oil on canvas, 32⅛ × 54¾ in. (81.6 × 139.1 cm). Amon Carter Museum, Fort Worth, Texas, 1977.17

fierce fight, and many thousand shot, for about an hour, when our men valiantly scaled the fort, beat them thence, and from the blockhouses. . . . The Indians fell on again, recarried and beat us out of the fort, but by the great resolution and courage of the General and Major, we reinforced, and very hardly entered the fort again, and fired the wigwams, with many living and dead persons in them. . . .[3]

Dudley reports that two hundred Narragansett warriors were slain but makes no mention of the scores of children, women, and elderly people who must have died in the blaze. Once we know the story of this raid on the Narragansetts in the Great Swamp it becomes possible to find references to those events in the painting: the way the shape of the haystacks recalls wigwams, the flame-red color of the boy's shirt, the sky hazy and gray as if filled with smoke.[4]

His paintings aside, Heade left a meager record of his life. There are a few scattered letters, some receipts from his assorted and inevitably ill-fated business speculations, and the squibs, short articles, and letters that he published in a variety of journals and newspapers. We do not know why specifically he was drawn to marshes as a subject, or what he thought of the Great Swamp in particular, or if he knew of its bloody past. But Heade was a hunter and a sportsman (he contributed often to the magazine *Forest and Stream* under the pseudonym Didymus), and he seemed to have a deep appreciation for the productive relationship between man and land. He must have drawn profound pleasure from the rich, natural offerings of the marsh ecosystem. His marsh landscapes are often inhabited by pairs of figures, most commonly a man with a child, representative of the future generation that will benefit from the carefully tended land and the wise use of resources.

Yet Heade also expressed a darker aspect of nature in his paintings. In the contemporaneous and geographically proximate painting *Thunder Storm on Narragansett Bay*, a fissure of lightning cracks the dark sky, the water a spill of black ink (fig. 37.1). A half dozen small sailboats make for shore, but their limp sails hang useless in the sullen air. It appears certain that the boats in the distance will not reach land before the storm hits; their ghostly sails foreshadow

tragedy. This is no paean to the grandeur of nature: it is a painting about the vulnerability of man in the face of nature's arbitrary, unfeeling force.

Heade was a hard man to know. Although he worked for a number of years in the Tenth Street Studio Building—home to many prominent New York artists during the second half of the nineteenth century—his neighbors in the building do not recall him in their memoirs or reminiscences. He made enough enemies to be refused membership in the National Academy of Design and the Century Association. His writing suggests a prickly, acerbic man who would not suffer fools, nor barely anyone else gladly. He lived a nomadic life, only settling down once (in Florida) and marrying when he was in his sixties. Such a man may have felt an emotional kinship with the bleak landscape of the Great Swamp and the deep gloom that heralds a thunderstorm.[5]

Heade is one of a number of American artists who have been grouped together as "luminists." While these artists never worked as a school—indeed they did not necessarily even know each other—their work shares a number of formal characteristics: pronounced horizontal format, absence of visible brushstrokes, and a close attention to the qualities and effects of light. Some scholars have sought to link the practitioners of Luminism with Emersonian philosophy; other, later art historians have rejected that connection while continuing to note the similarities among the artists' work. *The Great Swamp* demonstrates the dangers in too easily grouping so-called luminist paintings together. The motivations and philosophies that charged their creation cannot be reduced to a single source. Indeed, perhaps Heade was drawn to marshes precisely because they did not have any established iconography, allowing meanings to float and shift like a ground fog.[6] *The Great Swamp* can be read, by turns, as a record of a way of life, a record of the weather and atmosphere on a given day, a memorial to a tragedy, and a reflection of the artist's state of mind. [IB]

38. MARTIN JOHNSON HEADE, *Orchid and Hummingbird*

A NATURAL SELECTION

Martin Johnson Heade (1819–1904) departed on a much-anticipated trip to South America shortly after painting *Singing Beach, Manchester* in 1863 (pl. 36). His destination was Brazil, his quarry, native hummingbirds. The North American variety of these tiny, iridescent creatures had fascinated him since childhood, and he proposed to paint a series of twenty hummingbird "portraits" depicting the creatures mating, nesting, and raising their young; the paintings would then be published as chromolithographs in an opulent volume to be titled *Gems of Brazil*.[1] Twelve of the paintings were completed by March 1864 and were exhibited in Rio de Janeiro, so impressing the emperor Dom Pedro II that he awarded Heade the Order of the Rose.[2] Flush with his Brazilian success and carrying sketchbooks full of studies of tropical flora and fauna—as well as a selection of hummingbird skins—Heade traveled to London to oversee the production of his book.[3] While he was there, however, the project disintegrated, possibly because he was dissatisfied with the quality of the lithographs made from his paintings or owing to lack of funds.[4] Heade returned to the United States in 1865, only to embark on a brief trip to Nicaragua the following year.[5]

Although *Gems of Brazil* never saw publication, the introduction that Heade composed for the volume has survived.[6] Its detailed descriptions of the physiology and behavior of hummingbirds attest to his extensive ornithological study and firsthand experience with the creatures.[7] In one passage regarding their feeding habits, Heade noted that the bills of certain species appear designed specifically to fit into the cup-shaped orchids from which they obtain sustenance. This statement, the first instance in which he is known to have linked hummingbirds and orchids, situates him within the greatest natural history debate of the nineteenth century; indeed, the argument is still topical today. In 1859 Charles Darwin had published his epochal *On the Origin of Species by Means of Natural Selection*, challenging the dominant Linnaean view of a fixed and divinely ordained natural order. Instead, Darwin proposed that living organisms exist in a state of constant change, evolving through a process of natural selection.[8]

Heade, with his long-standing interest in natural history, would almost certainly have been captivated by these revolutionary ideas.[9] His observation that hummingbirds are *adapted* to their environment—those that feed on cup-shaped orchids have curved bills, those who rely on other food sources do not—indicates not simply awareness but adoption and promotion of Darwin's ideas. As a long-term subscriber (and later contributor) to *Forest and Stream*, a periodical that published articles expressing evolutionary views, Heade most likely was also familiar with Darwin's lesser-known publications. One, *On the Various Contrivances by Which British and Foreign Orchids Are Fertilised by Insects* (1862), addresses the physiology of orchids as well as the relationships between the flower and its surroundings.[10] Darwin notes the "endless diversity of beautiful adaptations" of orchids to their environment, dovetailing neatly with Heade's subsequent observation regarding the adaptation of hummingbirds to the very same flowers.[11] Indeed, as Ella Foshay has demonstrated, Darwinian theories are at the heart of an exquisite series of beautiful, enigmatic, and sensuous paintings that Heade produced during the last three decades of the nineteenth century.[12]

Heade made his third and last tropical voyage in 1870, this time visiting Colombia, Panama, and Jamaica.[13] After

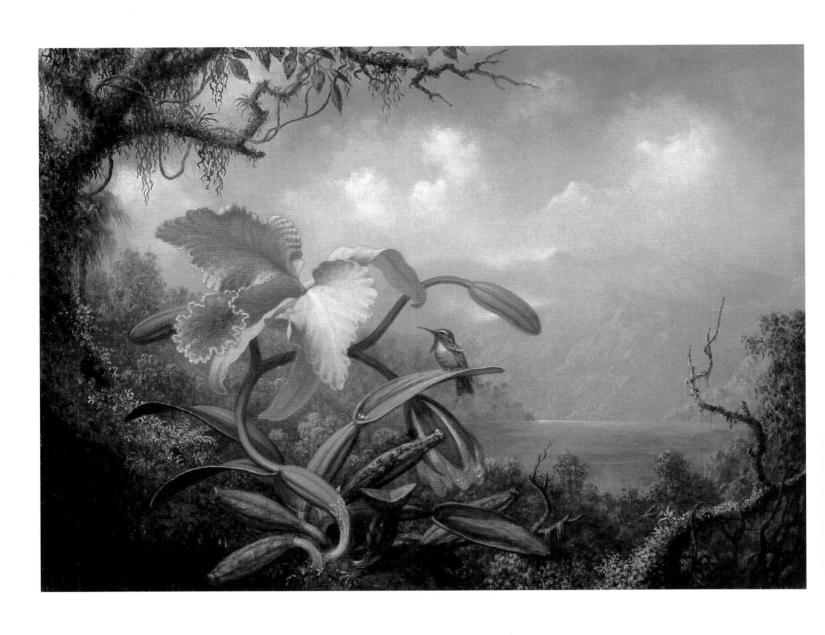

38. Martin Johnson Heade (1819–1904), *Orchid and Hummingbird*,
ca. 1885. Oil on canvas, 15 × 20⅛ in. (38.1 × 51.1 cm)
Gift of Mr. and Mrs. John D. Rockefeller 3rd, 1979.7.49

his return, he began to paint in an unprecedented new format: a lush South American landscape background, botanically accurate orchids, and the hummingbirds that he had continued to depict after the failure of *Gems of Brazil*.[14] These idiosyncratic works—not still life, not landscape, not scientific illustration—were a long-term enterprise for the artist, who produced at least twenty-five paintings of this type between 1871 and 1901, never significantly altering his basic formula.[15] The number and type of blooms and birds vary from canvas to canvas, but all are unfailingly rendered with such accuracy that individual species can be identified.

A cattleya orchid and a single Heliodore's wood star hummingbird are the specimens in the de Young's *Orchid and Hummingbird*, life-size, positioned front and center, and brightly lit.[16] So close are they to the picture plane that they appear to grow out of the canvas, stretching toward the viewer. At the painting's center the brilliant green and fuchsia hummingbird perches on a leaf of the orchid, itself a starburst of cotton-candy pink surrounding a throat aglow with the colors of sunrise. The orchid is rooted onto the branch of a tree that, almost overgrown with moss and vines, extends back and around to frame the bird and flower from the unobtrusive middle distance. A fully realized landscape of a mountain lake under a stormy sky lies beyond, evincing the influence of the mammoth landscapes of Frederic Edwin Church (1826–1900), Heade's neighbor in New York's Tenth Street Studio Building. Reminiscent of Church's *Rainy Season in the Tropics* (pl. 29), dense foliage and a hazy atmosphere convey the sultry, humid climate of the South American jungle, the natural habitat of both orchid and hummingbird.[17]

According to Foshay, "The active, physiological processes of nature and their interrelationships with the surrounding environment formed the core of the Darwinian evolutionary view of nature."[18] Heade's artistic innovations mirrored these new scientific ideas. His paintings of orchids and hummingbirds depart from convention by depicting them in an ecologically appropriate setting, as he had seen them on his travels.[19] Moreover, his orchid is actually *growing*, rooted in the bark of a tree, as it would be in the wild, fully integrated into its surroundings. "Physiological processes" are portrayed as well. The growth and change that Darwin considered the sine qua non of all life are explicit in the multiple stages of development seen on the single orchid plant, and implicit in the sinuosity of its stems, which almost appear to be moving and growing before our eyes. Procreation, central to evolutionary theory, is represented in the form of the hummingbird, an orchid pollinator.[20] Other paintings from the series more obviously reference reproduction by including two hummingbirds, either a male-female mating pair or a male-male pair fighting as part of the mating process—the "survival of the fittest" in action.[21]

Despite the undeniable, brilliant beauty of Heade's paintings of orchids and hummingbirds, they received only a few oblique critical references even though they were widely exhibited.[22] They were, literally, unmentionable. At the time, orchids carried sexual overtones that effectively rendered them invisible. Though a horticultural "orchid mania" had blossomed in the 1830s and the flowers could be found in countless greenhouses, they were absent from the many popular handbooks of floral symbolism.[23] Orchids were strictly a botanical concern, the only common flower without any recognized meaning. Their impropriety had several sources, beginning with the very name; orchid derives from *orchis*, the Greek word for testicle. In antiquity, orchids were considered a potent aphrodisiac, a belief reiterated by Linnaeus in the eighteenth century.[24] Victorian sensibilities were also certain to be offended by the appearance of orchids, both the blatant resemblance of the flower's orifice to the female genitalia and the more concealed phallic shaft within.[25] Hummingbirds had a somewhat scandalous reputation as well, due to their polygamous and aggressive mating behaviors.[26] The orchid and hummingbird made excellent exemplars of Darwinian theories of adaptation and natural selection that evidently influenced Heade. By selecting a forbidden flower and its promiscuous pollinator as subjects, however, he placed his paintings outside nineteenth-century cultural discourse, consigning them to obscurity until evolving mores would permit their scientific sensuality to be appreciated. [EL]

FINDING A FUTURE IN THE PAST

*As language keeps alive the fire of nationality, so should painting embalm
the genius of a country by preserving memory of familiar scenes, or by
transmitting to posterity reminiscences of actions, deeds, or manners.*
Cosmopolitan Art Journal, June 1857[1]

Eastman Johnson's *Sugaring Off* (1861–65)[2] was painted only a few years after his *Negro Life at the South* (fig. 39.1), popularly known as *Old Kentucky Home*, was exhibited to wide critical acclaim at the National Academy of Design's spring 1859 exhibition. He sent six paintings to the exhibition, but it was *Negro Life at the South*, supposedly depicting the domestic lives of slaves in Washington, D.C., that immediately elevated Johnson (1824–1906) to the status of "the premier painter of African American life"[3] and firmly established his reputation. Based on this work and others similar to it, Johnson is usually considered the finest American genre artist of the mid–nineteenth century.[4]

However, modern assessments of Johnson's portrayal of African Americans are divided; some see in his depictions "sympathy, dignity, and great inner strength," while others point to his reliance on conservative and stereotypical assumptions in creating sentimental genre paintings with wide popular appeal.[5] *Negro Life at the South*, for instance, painted on the eve of the Civil War, has been criticized for depicting well-fed, happy slaves engaged in leisure activities, reinforcing beliefs about African Americans as natural musicians, caretakers, and carefree idlers.[6] Nevertheless, his best genre paintings rise above mere anecdotal incident in a way that captures the essence of narrative events. Certainly this is true of his late great masterpiece, *The Cranberry Harvest* (1880), which shares with the early *Sugaring Off* the elements that epitomize Johnson's finest works: common people in scenes of everyday life that he elevates through the dramatic resonance of human character and

emotional mood. These paintings demonstrate Johnson's strength at capturing local landscape peopled with convincing subjects, especially in the rural communities of his home state of Maine.[7]

Born in Lovell, Maine, in 1824, Johnson grew up in Fryeburg and began his artistic training in 1839 as an apprentice to a Boston lithographer. In 1844 his father, Philip Johnson, Maine's secretary of state under Democratic governor John Fairfield, moved the family to Washington, D.C., when Fairfield was elected to the United States Senate in 1843.[8] Through his father's political connections, Eastman Johnson began doing crayon portraits of influential statesmen and their families.[9] In a makeshift studio in a Senate committee meeting room, Johnson made likenesses of national political figures such as Dolley Madison (1846), John Quincy Adams (1846), and Mrs. Alexander Hamilton (1846).[10] The success of those portraits led in 1846 to an invitation to paint the literary and intellectual elite in Cambridge, Massachusetts, including Henry Wadsworth Longfellow (1846), Ralph Waldo Emerson (1846), and Nathaniel Hawthorne (1846).[11]

As most artists of his generation, Johnson went abroad to study painting. He entered the Düsseldorf Academy in 1849, where he was trained in the detailed illusionist realism for which the school was renowned, and then the studio of Düsseldorf's most prominent American painter, Emanuel Leutze (1816–1868), in 1851. Johnson's skill earned him the opportunity to paint the small-scale replica of his teacher's famous *Washington Crossing the Delaware* (1851) that

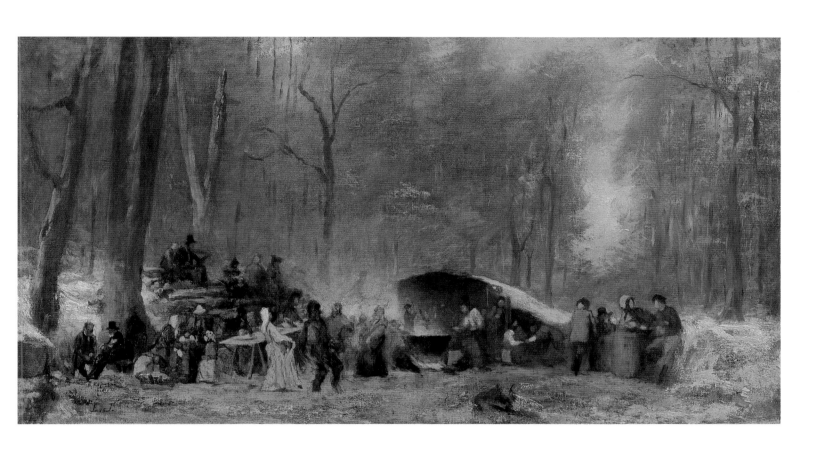

39. Eastman Johnson (1824–1906), *Sugaring Off*, ca. 1865
 Oil on canvas, 16⅞ × 32 in. (42.9 × 81.3 cm)
 Gift of Mr. and Mrs. John D. Rockefeller 3rd, 1979.7.63

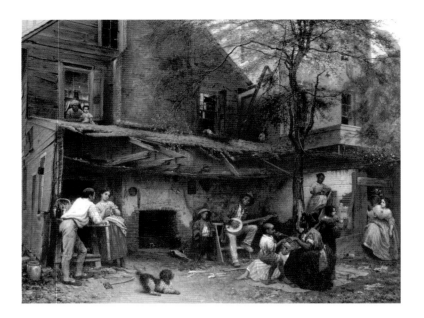

Fig. 39.1. Eastman Johnson (1824–1906), *Negro Life at the South*, 1859. Oil on canvas, 36 × 45¼ in. (91.4 × 114.9 cm). Collection of The New-York Historical Society, S-225

was used to produce the mass-market engravings of the work.[12] In 1852 Johnson moved to the Netherlands to study seventeenth-century Dutch realist masters firsthand, soon winning a reputation as the "American Rembrandt."[13] While in The Hague Johnson undoubtedly developed his appreciation for the genre paintings that would become the focus of his early career. Intending to increase his understanding of color by studying with Thomas Couture (1815–1879), Johnson went to Paris in 1855. Although he returned to the United States after only a few months following his mother's death, Johnson's mature work strongly reflects Couture's liberating influence from the tight stylistic manner of Düsseldorf, especially in the use of granular surfaces, saturated colors, dark outlines, and rich, red-brown undercoats to create the warm grounds for his light effects.[14]

Sugaring Off is one of the major, multifigured landscape canvases Johnson painted as part of a campaign that included many preliminary vignettes and group subjects begun shortly after his return from Europe and the phenomenal reception of his genre paintings at the National Academy of Design. From 1861 to 1865 Johnson painted approximately twenty-five pictures meant to culminate in a large-scale work depicting the quintessential spring event of rural New England life, the raucous party in the woods celebrating the year's first batch of sap that is boiled to produce

maple sugar.[15] Clearly a tribute to his Yankee upbringing, with its ideological values of social harmony rooted in self-reliance and ingenuity, Johnson's maple sugar paintings offer a more complex interpretation of the region's cultural legacy than the nostalgia for a timeless continuity that these representations appear to suggest. While using his skill as a genre painter to represent with near documentary detail the process of maple sugar production from the era of his childhood, Johnson infused his scene with the current economic, political, and social effects of industrialism and the Civil War that were irrevocably transforming the nation.

Sugaring Off presents the artist's vision of America through an ambitious genre study, integrating several intimate groups into a panoramic tableau. Johnson exploits the psychological drama inherent in genre painting to provide insight into the experience of rural life. At this festive celebration there are people dancing to a fiddler; women and children listening to a storyteller; men whittling, playing cards, and conversing; a couple flirting; and a man sneaking a drink of whiskey. These vignettes are organized around a kettle tender, who oversees the boiling maple sap, near the center of the composition.

As a recent exhibition of his maple sugar paintings has demonstrated, Johnson also explored many of these genre scenes as their own separate preliminary works, detailing the labor-intensive methods of preindustrial production that had been replaced with innovative technologies.[16] By the 1860s, cranes were being used to lift the kettles, replacing the heavy, green logs, metal troughs had replaced the crafted barrels for catching and storing the syrup, and narrow boiling pans had replaced the heavy kettle for boiling the sap.[17] Johnson also used these works to explore how industrialism had turned the interrelated cycle of work and leisure into a relationship with a clearly defined boundary, one based largely on the distinction between rural and urban patterns of life.[18]

At the same time, *Sugaring Off* is a hybrid painting that marries the traditions of genre to landscape. Johnson captures the local countryside of the Maine woods with accurate attention to its maples, birches, and snow-covered, rocky terrain. Using the techniques he learned in Europe, he employs a reddish ground and dark outlines to emphasize the central role of the fire and glowing black kettle of sap at the heart of the painting. The saturated reds, oranges, and yellows contribute to the painting's tonal warmth and serve as a sign of the easy camaraderie among the revelers and their close-knit community. In contrast, the

bright whites of the snow and sky surround this circle of intimate friendships, creating a crisp atmosphere that emphasizes the harsh winter conditions they have endured together in this deep woodland. The fiery kettle operates as both sign and source of the springtime thaw, resonating with the forest leaves and floor that echo its vibrant heat.

In contrast to the picturesque and sublime landscapes of the dominant Hudson River School, Johnson's intimate scene paints a more meditative mood. However, his tonal registers carry an ambiguity that introduces the era's cultural tensions into the painting. The setting is early spring when the natural conditions are right for collecting maple sap, with temperatures above freezing during the day and below at night. The warm color scheme points to the moderating climate that signals the end of winter and the sense of renewal and hope the new season augurs. However, this red, yellow, and brown palette also creates a visual impression of the changing hues of autumn foliage. Such an association suggests the fall season's sense of ending and invests the scene with a rosy ambience that connotes nostalgia. In this way, Johnson elicits the viewer's experience of both spring and fall, simultaneously referencing times of anticipation and longing, of change and reminiscence.

By introducing the visual vocabulary of nostalgia into the painting, Johnson calls attention to historical conditions that no longer exist and implicitly critiques what has been lost. Although not overtly political, Johnson's maple sugar paintings, created from 1861 to 1865, coincided with America's most wrenching political trauma, the Civil War. Coming from a political family with strong abolitionist ties and identifying with the Unionists, Johnson could be expected to address the nation's most important political crisis.[19] Ironically, when he won his reputation as a painter with *Negro Life at the South*, white Southerners praised his depiction of the backstreet living conditions of urban slaves in Washington, D.C.[20] However, with the advent of the Civil War, Johnson did not put forward a broad, obvious critique of slavery.[21] Rather, he turned to the gentler brush of nostalgia, relying on its contemplative mood to carry his admonition. Countering the ethical assumptions of the Confederacy, Johnson turns to the New England of his childhood to remind viewers of a cultural and intellectual heritage far different from the values driving slavery.

Sugaring Off directly challenges the Southern way of life with a Northeastern model—the innocence he portrays and the coherence of the community he celebrates providing a foil for the moral culpability and forced cohesion of those living together in a slave economy. Ingeniously collapsing the visual cues of spring and autumn in the painting, Johnson laments the New England of his childhood. In his study on Johnson's maple sugar paintings, Brian Allen points out that as early as 1792 Benjamin Rush, the nation's most highly regarded physician and a well-known abolitionist, saw the importance of the contrast between maple sugar and cane sugar. Rush wrote, "I cannot help contemplating a maple sugar tree without a species of veneration, for I behold in it a happy means of rendering commerce and slavery of African brethren in sugar islands as unnecessary."[22] Astutely teasing out the implications of maple sugar as a political metaphor, Allen builds a case for Johnson's paintings on this subject as a highly charged abolitionist statement.[23]

Through the double register of nostalgia for previous values and hope for regeneration, Johnson paints a future vision of the United States in the language of rural genre scenes and landscape more pastoral than sublime. However, these were terms that carried no metaphoric currency in the highly charged social and political atmosphere of industrialism and the Civil War. It is not surprising that Johnson never secured a patron, even among Northern sympathizers, who would financially support turning his campaign of perceptive sketches into a major, finished canvas. [DC]

40. EASTMAN JOHNSON, *Portraits (The Brown Family)*

A GILDED-AGE MORALITY PLAY

His Portraits *are portraits of mirrors, curtains,
carpet, mantel-piece, and upholstery in general.*
Appleton's Journal, 1869[1]

By the time Eastman Johnson (1824–1906) painted *Portraits (The Brown Family)* (1869), he had established himself as the premier painter in North America, known for the local incident, national subjects, and universal humanity that he captured in his genre scenes of contemporary life. His brand of illusionist realism, adopted from German and Dutch models during his European training, undoubtedly prepared the way for Winslow Homer (1836–1910) and Thomas Eakins (1844–1916), whose works have come to overshadow Johnson's even though they mine the territory he pioneered.[2] This vocabulary was the foundation for Johnson's rapid rise to preeminence, which began with depictions of African Americans as fully realized personalities even when placed within conventional settings.[3] The expressive power of these images gave them the feeling of portraits, and just as he created a hybrid between landscape and genre in his scenes of maple sugaring (pl. 39), Johnson also united portraiture and genre, producing a synthesis of painting styles that captured the social and economic conditions of the United States in the mid–nineteenth century.

The combination of portraiture and genre was not Johnson's invention.[4] He borrowed it from eighteenth-century British portraits known as conversation pieces, which referred to pictures commissioned by families or friends that portrayed them informally, often in domestic settings or sharing common upper-class activities such as hunts, musical parties, and sumptuous meals. The British developed this approach to portraiture, usually attributed to William Hogarth (1697–1764), by appropriating seventeenth-century Flemish court paintings and Dutch group portraits

and domestic genre scenes, which they married to their own emphasis on sumptuous display (fig. 40.1).[5] Thomas Gainsborough (1727–1788), in particular, was known for presenting his sitters in what was called "van Dyck dress," portraying them in dramatic clothing that had the opulent look of the fancy dress worn by Anthony van Dyck's (1599–1641) aristocratic sitters (fig. 40.2).[6]

At the same time, drawing on everyday scenes that were the hallmark of bourgeois life in seventeenth-century Holland, British conversation pieces are organized around informal events and commonplace interactions, emphasizing group narratives over the aristocratic grand manner of individual poses and gestures.[7] The conversation piece thus transforms assumptions about portraiture as a mode of self-presentation, elevating the middle-class ethic of sensibility and benevolence above aristocratic privilege and excess by celebrating the placid and tranquil joys of domestic bliss that are the foundations of a bourgeois society.[8]

Portraits (The Brown Family) partakes of this tradition but translates it into the American entrepreneurial class that comprised the elites of the Gilded Age, so called after Mark Twain and Charles Dudley Warner's satiric lampoon of the times published in 1873.[9] In the years following the Civil War, the conversation piece enjoyed immense popularity. As the term *Gilded Age* implies, these were highly prosperous years in the United States, and Americans eager to put the divisions of the war behind them looked for reassurances of order and stability in their lives. Informal portraits "at home" were designed to flatter financially successful families by aligning their personal identities with

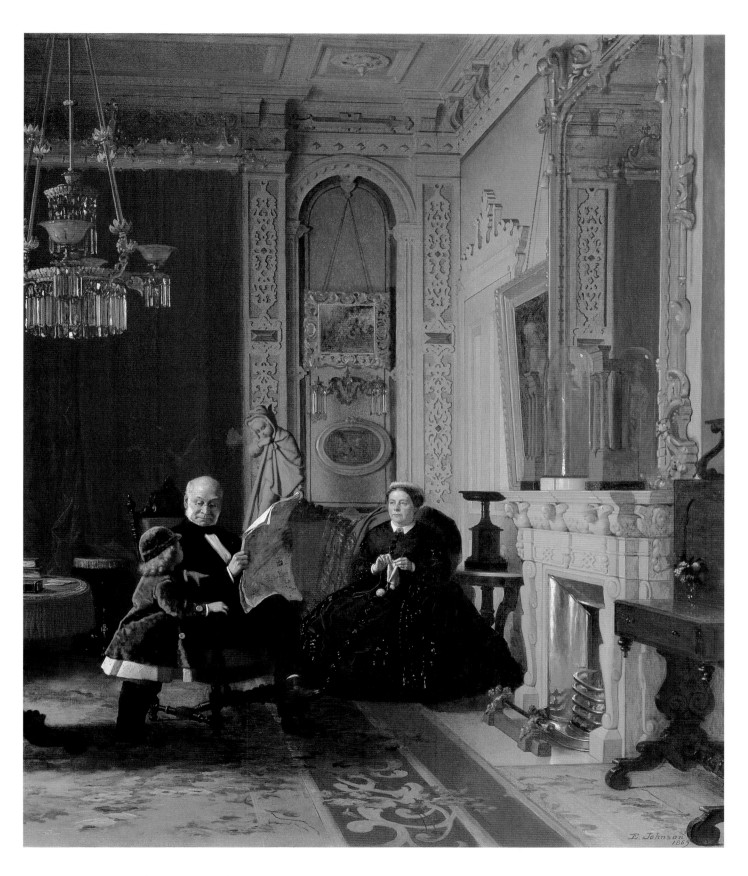

40. Eastman Johnson (1824–1906), *Portraits (The Brown Family)*, 1869
 Oil on canvas, 38½ × 32⅜ in. (97.8 × 82.2 cm)
 Gift of Mr. and Mrs. John D. Rockefeller 3rd, 1979.7.67

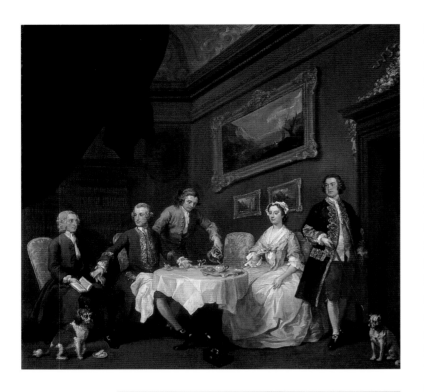

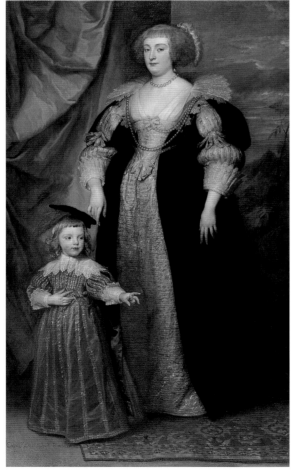

the material commodities that adorned their residences. There is an irony, of course, in the exhibitionism of putting one's private spaces on public display as a virtuous act, but the era's moral logic of entrepreneurship suggested that private values translated into public prosperity.

The scene represents James and Eliza Brown with their grandson, William Adams Brown, in their elaborately designed parlor. James Brown (1791–1877), a wealthy financier of influential industrialists, had founded the New York branch of Brown Brothers and Company, his family's international banking firm, in 1825, the year the Erie Canal opened.[10] The young boy, William (1865–1943), seeks a moment of attention from his grandparents, who pause in their pursuits to indulge his interruption. James Brown, dressed in formal attire and still holding the newspaper that he was reading moments before, looks down as William tugs on his arm. Eliza Marie Coe Brown (1803–1890), wearing a dress richly embroidered with jet that glitters from the firelight, looks up from her knitting.[11] Both seem fondly amused by William, who is dressed for the outdoors rather than the stuffy confines of this grand parlor.

The affable demeanor of the three participants in this domestic narrative reinforces the supposed honesty of the depiction and creates a feeling that everything is as it should be. A contemporary account describes the scene, commenting, "nothing could be more natural than the action of the little child, laying its hand on grandpapa's arm to attract his attention from the newspaper."[12] The quotidian activities of reading and knitting further suggest the industry that results in prosperity, which the room is meant to exhibit. At the same time, these commonplace activities indicate the gendered ordering of society that was considered necessary for tranquil social harmony because it was understood that "the parlor mediated between the home and the outside world."[13] Eliza pursues a task within the home for the home, which is her proper sphere, and James reads about the world outside the home, linking him to the realm of business and commerce that is his domain.[14]

Fig. 40.1 [above left]. William Hogarth (1697–1764), *The Strode Family*, 1738. Oil on canvas, 34¼ × 36 in. (87 × 91.5 cm). Tate Gallery, London

Fig. 40.2 [left]. Anthony van Dyck (1599–1641), *Marie Claire de Croy, Duchesse d'Havré, and Child*, 1634. Oil on canvas, 82¼ × 48⅞ in. (208.9 × 124.1 cm). Fine Arts Museums of San Francisco. Roscoe and Margaret Oakes Collection, 58.43

Fig. 40.3. Attributed to Mathew Brady (1822–1896), *James and Eliza Brown in Their New York City Parlor*, ca. 1868. Retouched photograph. Courtesy of John Davis

The parlor provides the nexus for both worlds, which are joined by the child, symbol of the legacy such roles ensure and guarantor that the family business, founded before the Civil War, will be successfully carried on by the generations born after it. One historian sees the painting as representative of a national postwar psychological phenomenon, as "Americans looked for reassurance to the innocence of children, untainted by the fratricide practiced by their elders. When these children were pictured with their parents or, even better, their grandparents, viewers were presented with an optimistic picture of the preservation and integrity of the familial unit."[15] Tellingly absent is the couple's son and boy's father, John Crosby Brown (1838–1909), who

managed the company throughout the Civil War, turning the conflict to the business advantages that greatly enlarged the family fortune.[16]

Ironically, nothing about the parlor itself supports the narrative's assumptions that the commonplace is important in establishing an ethical and stable social order. The room was the product of America's most prestigious interior designer and cabinetmaker of the time, the Frenchman Léon Marcotte.[17] John Crosby Brown commissioned the painting to commemorate the house at 21 University Place, in which he had grown up, as his parents, the elder Browns, prepared to move uptown to a new home on the recently vogue Park Avenue.[18] When the extravagant parlor was

originally built in 1846, Marcotte designed it in the height of fashion for that time, transforming the house's drawing room from its previous Greek Revival style, which had been popular earlier in the century, to its present French Renaissance Revival style. However, in the changing climate after the Civil War, the antebellum connotations of the room were out of step with the ideals of a nation that was seeking to put behind it the tensions that had led to that devastating conflict. Critics were especially hard on the decor, at times even attempting to distance Johnson from the painting by blaming the artist's patrons for commissioning the work. A critic for the *New-York Daily Tribune* wrote: "Is it possible that an artist could have invested or chosen this dreadful room? We cannot believe that Mr. Johnson would do either."[19]

Interestingly, the prevailing style of the Gilded Age, appropriating the Beaux-Arts design of public buildings for the grand houses of wealthy industrialists, was as excessive as the earlier Renaissance Revival style evident in *Portraits (The Brown Family)*. The decor in the painting may be out of date but it still registers as opulent, giving the sitters an air of elitist noblesse oblige. However, the impression of entitlement is set firmly within an American ethic of middle-class prosperity rather than the aristocratic ethic of birth associated with European wealth and privilege. The painting insinuates that James and Eliza Brown have earned their luxury by the force of character and therefore have not just the right but almost a moral duty to enjoy the fruits of their respectability.

The realistic painterly techniques that Johnson uses to depict this family morality play also derive from seventeenth-century Dutch modes. Realist methods, with their virtuosity of detailed rendering, were ideally suited to portraying the commercial values of the rising Dutch merchant classes, and that same spirit equally served the newly prosperous economy of America's Gilded Age.[20] Johnson employs this illusionist vocabulary to turn the ordinariness of the scene into an elaborate display for the spectator.

Nearly every surface is overwrought with ornamentation. Everything in the painting seems designed to heighten the sense of contrast. The color scheme is a study in the opposition of red and green hues. The monumental scale of the mantel, towering overmantel and mirror, oriental carpet, draperies, and chandelier contrasts with the more intimate scale of the cozy fire, floral bouquet, and books and letters on the table. Such disparity displaces the difference between the viewer and the Brown family onto the representation of their domestic lives.

There was also a self-referential aspect to the conversation piece, since such paintings were often the very decor exhibited in the rooms they represented. The focus, in fact, was as much on the inventory of stylish furnishings as on the sitters. This was certainly the case with the parlor in *Portraits (The Brown Family)*, which most commentators have remarked more rightly represents a portrait of a room than a setting for its sitters. In fact, the Browns' regard for this particular parlor caused them to move it with them, in part or in whole, to three different locations. In 1868 they commissioned the celebrated photographer Mathew Brady to record it, an image Johnson clearly used in creating his painting (fig. 40.3).[21]

When Johnson submitted the painting to the National Academy of Design, he entered it under the title *Portraits*, leading to an ambiguity of reference: the sitters do not engage the viewer, as is common in formal portraits, but each other. It is the ostentatious display of the parlor that seems to demand the viewer's attention, confirmed by the exacting attention to detail with which Johnson renders it, adding to speculation that it is a "portrait" of a parlor that can be characterized by its furnishings. In the language of visual culture, the parlor serves as "a constructed 'portrait' of the taste, morals, and character of the family who created it."[22] The painting, thus, represents the strange conflations of a cultural sensibility that painted the everyday virtues of bourgeois morality with the brush of prosperity and consumption. [DC]

41. WINSLOW HOMER, *The Bright Side*

TRUTH AND HUMOR

Of the three paintings Winslow Homer (1836–1910) exhibited at the National Academy of Design's *Fortieth Annual Exhibition* in New York in 1865, critics found *The Bright Side* his strongest, noting the merit of both its execution and its subject matter.[1] The critic for *The Evening Post* wrote:

> In the works of Winslow Homer we have a direct style and faithful observation of nature. The best example of Mr. Homer's talent is that called "Bright Side," a picture … representing a group of negro mule-drivers dozing on the sunny side of an army-tent. There is in this work a dry, latent humor, and vigorous emphasis of character; and the episode of camp-life is told in a manly way.[2]

Praise for Homer's ability to render a scene truthfully strikes a familiar chord today because of Homer's reputation as one of the great American realist painters. The critic's observation of the "latent humor" in *The Bright Side* is perhaps more puzzling, as we rarely think of Homer as an artist who depicted humorous subjects. And yet in 1865 this critic was not the only one who saw humor in the painting.[3] Keeping in mind that these critics were all white men, what exactly did white Americans living in New York in 1865 find humorous about *The Bright Side?*

Winslow Homer was born into a wealthy Boston family who encouraged and supported his artistic interests.[4] Between 1855 and 1857 he apprenticed to a lithographer in Boston, creating images for commercial publications such as sheet music. Although he later claimed that he loathed this work, by the time his apprenticeship had ended he was a confident and accomplished draftsman. Indeed, the year his apprenticeship ended, he began contributing illustra-

tions of contemporary life to popular magazines and soon was regularly freelancing for one of the nation's premier publications, *Harper's Weekly*. In 1859 Homer moved to New York City to be closer to the main office of *Harper's* as well as to take advantage of the many opportunities available there to study art. He enrolled in life class at the National Academy of Design and apprenticed himself to a local painter. When the Civil War began in April 1861, *Harper's* appointed him an "artist-correspondent" to the Army of the Potomac, and over the next few years Homer witnessed life in the Union Army firsthand. Many of the sketches he made served as the basis for illustrations published in *Harper's*, but toward the end of the war Homer also used them for his own paintings, including *The Bright Side*, which occupies an important place in Homer's career, as it marks his transition from illustrator to professional painter. The painting's subject and relatively small size suggest it is something akin to a painted illustration, but in terms of style, it points to Homer's future as one of the great realist painters of the nineteenth century.[5]

In 1865 critics could have seen *The Bright Side* as a "faithful observation of nature" in part because Homer's subject corresponded to familiar aspects of army life. During the Civil War both free blacks from the North and escaped slaves from the South (known as "contrabands") served as mule drivers in the Union Army quartermaster's corps, which was responsible for moving the army's supplies, including all the materiel needed to set up camp.[6] Significantly, Homer represented these men not as they drive their wagons through enemy gunfire but as they rest while awaiting orders to move camp elsewhere. Soldiers of all rank, position, and ethnicity who served in both the Union and

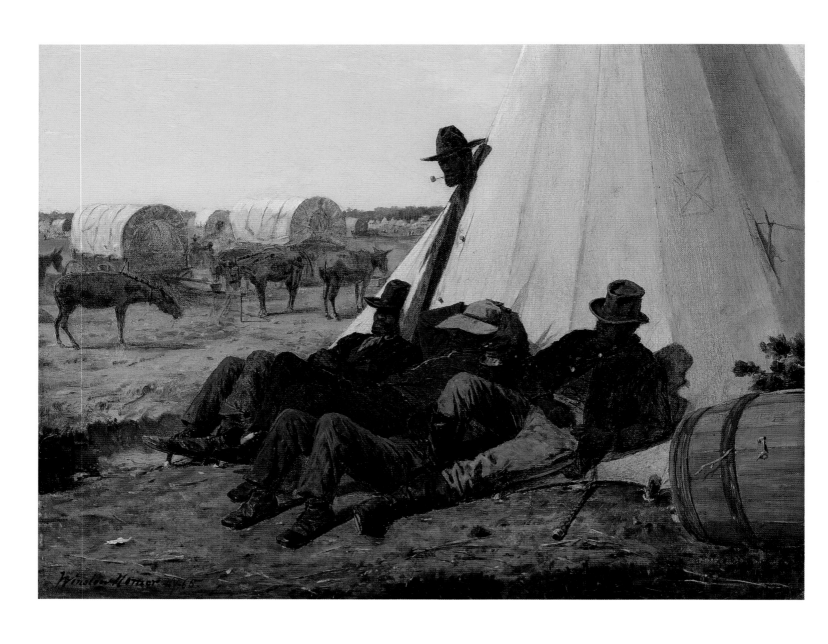

41. Winslow Homer (1836–1910), *The Bright Side*, 1865
 Oil on canvas, 12¾ × 17 in. (32.4 × 43.2 cm)
 Gift of Mr. and Mrs. John D. Rockefeller 3rd, 1979.7.56

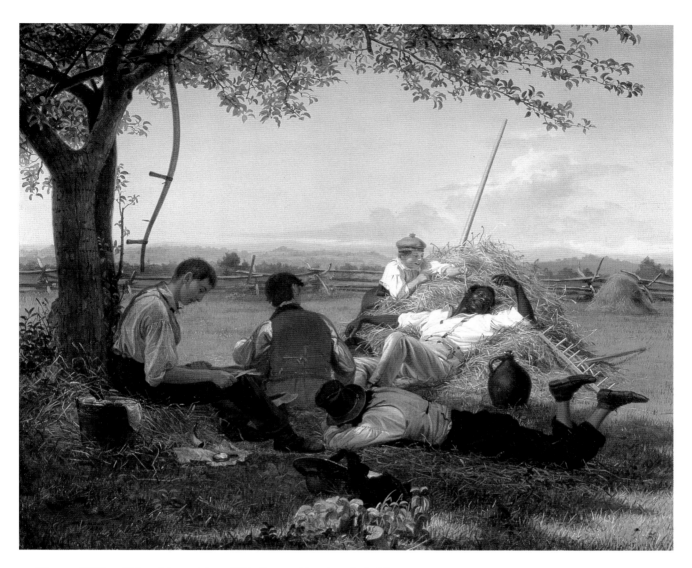

Fig. 41.1. William Sidney Mount (1807–1868), *Farmers Nooning*, 1836. Oil on canvas,
20 × 24 in. (50.8 × 61 cm). The Long Island Museum of American Art, History,
and Carriages, Stony Brook, New York. Gift of Frederick Sturges Jr., 1954

Confederate armies spent much of their time idle, waiting for something to happen. At the beginning of the war one Union soldier complained: "We left home full of fight. . . . For two months we drilled steadily, patiently waiting the expected orders which never came but to be countermanded. We have now come to the conclusion that we will have no chance, and we are waiting in sullen silence and impatience for the expiration of our time."[7] This soldier's frustration may have stemmed in part from the fact that his experience contradicted the images of warfare he had seen, such as in traditional history paintings, which celebrated war as a grand and heroic affair. In contrast, Homer's *The*

Bright Side would have seemed "real" precisely because it was a genre scene and thus corresponded more closely with the reality of warfare described by soldiers in their letters home.

The veracity in Homer's subject is also conveyed by the way in which Homer rendered it. He executed the work in a linear rather than painterly style, reinforcing its reportorial nature. This style in turn enabled him to represent each man with a distinct physiognomy, suggesting Homer carefully observed specific African American individuals in preparation for this painting.[8] Homer then arranged the composition so that the viewer seems to share the camp

with these men. By placing the dozing men and their tent in the foreground and tilting the ground plane up behind them, it feels as if we are standing only a few feet from this resting group. Then, as we stand observing the scene before us, one of the mule drivers pokes his head out of the tent flap and stares at us. His glare makes us feel like intruders, potentially disrupting his and his friends' rest. But it is precisely his penetrating gaze that acknowledges our presence and further connects us to the scene.

Although *The Bright Side* appears to be an accurate portrayal of camp life, the critics who attributed humor to it did so because they saw it as representing a nineteenth-century stereotype about black Americans. One critic stated, "The lazy sunlight, the lazy, nodding donkeys, the lazy, lolling negroes, make a humorously conceived and truthfully executed picture."[9] In his analysis of representations of black Americans by white artists, the art historian Michael Harris reminds us, "Despite the real-world impact of the construction of a black racial identity and its derogatory imagery, it is important to recognize it as what it is: a construction, an invention."[10] Thus, when white critics saw the resting teamsters in Homer's painting as behaving humorously, they were responding to a construction, a white invention of black identity, which in this case had been created and reified through artistic conventions.

The representation of black men at rest in the sun in *The Bright Side* calls to mind William Sidney Mount's 1836 *Farmers Nooning* (fig. 41.1), a painting that also depicts a black man relaxing in the sun. Mount's painting shows four farmers and a boy taking a break on a sunny afternoon. Even though the subject is rendered in a naturalistic style, this genre scene is a fiction; the figures represent stereotypes, their identity made visible by their contrasting behavior. The white farmer to the left spends his free time preparing for the future by sanding a scythe sharpener. In contrast, the black farmer sleeps on top of a haycock. In the context of abolitionist debates raging at the time Mount executed his

painting, some Northern viewers would have interpreted this black figure's behavior as suggesting that even if blacks had the same opportunities as whites—that is, even if they were free—they would choose not to work because they were inherently lazy.[11] Nearly thirty years later, critics who saw *The Bright Side* recognized this established pictorial convention and interpreted it as referencing a stereotype of black male behavior. Although neither Homer nor Mount had sinister intentions, their paintings did have implications for the real world because, as Harris notes, the ultimate power of such paintings is that "they naturalized a social order with black subjects ... exhibiting stereotypical behavior so as to emphasize their social and political inferiority."[12]

Yet the title Homer gave to this painting, *The Bright Side*, suggests he might have been calling into question the truthfulness of this stereotype. The title suggests an awkward pun on the fact that these black men rest on the bright (sunny) side of the tent. However, dressed in their dark blue uniforms, which absorbed the heat, they must have been uncomfortable, especially if it were a hot, muggy day in Virginia, and thus perhaps they are not experiencing unmitigated, lazy pleasure. Homer and his peers would have known that black soldiers fought as courageously as white soldiers, as the history of the Massachusetts Fifty-fourth Regiment, for example, famously attested. Traveling with the Army of the Potomac, Homer would have also known that labor performed by mule drivers was essential for the success of the Union Army. Moreover, black soldiers were often assigned more onerous duties than their white counterparts, for which they were paid less.[13] Executed at the end of the Civil War, when the antebellum social order was about to be transformed, *The Bright Side* perhaps accurately encodes the uncertainty and ambivalence many white Americans felt about the prospects for an integrated society.

[KM]

CLUES TO AN ART HISTORICAL MYSTERY

As a young boy in England, John George Brown (1831–1913) received little encouragement from his parents regarding his artistic interests. But he was stubborn, apprenticing himself at a glass factory in Newcastle upon Tyne and attending drawing classes in the evenings. His seven-year apprenticeship complete, he worked and studied in Newcastle, London, and Edinburgh, earning a prize from the Royal Academy in Edinburgh. Brown later told a journalist, "Emigrant songs were the rage in London that season; everybody was singing them, and they fired me with the idea to try my fortune in America." And so, on his twenty-second birthday, John George Brown arrived in New York City and quickly found work at a glass company in Brooklyn.[1] Brown married his employer's daughter and found his new father-in-law supportive of his pursuit of an artistic career. All was well. But then, in 1856, Brown's father-in-law suddenly died and the next year the glass company failed. On his own and with a family to support, Brown painted portraits whenever he could. But it was his paintings of young children that caught the public's eye. By 1860 he was able to rent space in New York's famed Tenth Street Studio Building, home at one time or another to some of the city's most important artists. He worked there for the next fifty-three years, first producing lighthearted images of country children and later urban street urchins. Those paintings of children made him one of the most successful, famous American artists of his day.

On the Hudson (1867) is a marked diversion from those oversweetened images. There are no mischievous boys with hearts of gold beneath their grubby exteriors here, nor are there any pretty but pert and bossy girls. Instead, we see a stately view of the Hudson River on a magnificent autumn day. The foliage is ablaze with reds and oranges. Where the sun falls on them, the Palisades are a golden brown; where in shade, a deep chocolate. The waters of the Hudson spread wide across the foreground and stretch into the deep distance on the right. The river is ruffled by a faint breeze, and the reflections of the Palisades and the sky are blurred and refracted. Against this gently broken and richly hued surface the white steamboat *Thomas E. Hulse* stands out sharply. In the patch of sun that brightens the dock, people await the steamboat's arrival at Burdett's Landing at Fort Lee, New Jersey. The old buildings of the town cluster in the shade. Other steamboats, most visibly the *Cayuga*, and sailing vessels ply the waters of the river upstream.

If at first financial need and presumably a genuine interest in the subject and then the momentum of his established reputation led Brown to paint his pictures of children, what led him to paint this landscape? As is so often the case, the artist's motivations are not clear. Perhaps it was a wish to add some variety to his painting routine, or the desire to capture an arresting scene he had witnessed. Perhaps he sought to challenge himself with a new subject, or to show critics and colleagues the breadth of his ability. Perhaps it was business after all, a commission from someone who either did not know or did not care that Brown had made his name with a completely different type of subject matter, someone who wished to have one of the city's most prominent artists create a similarly prominent painting. This last explanation, in this case, seems the most plausible one because of the painting's size.[2] At close to three and a half feet tall by six feet wide, it is too large to be the expression of a personal whim: such a painting would be costly in both time and materials. And if it was painted to

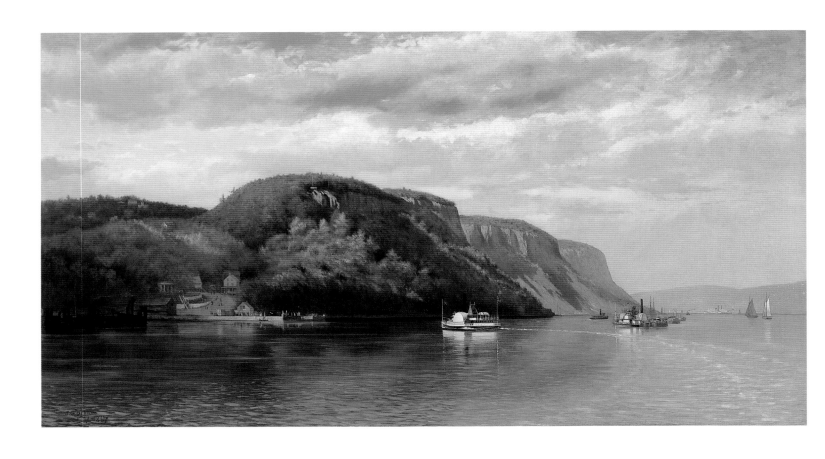

42. John George Brown (1831–1913), *On the Hudson*, 1867
Oil on canvas, 39 × 72 in. (99.1 × 182.9 cm)
Gift of Mr. and Mrs. John D. Rockefeller 3rd, 1979.7.19

prove a point to contemporaries, surely it would have been exhibited in at least one prominent venue. Brown regularly showed paintings at the National Academy of Design, but this was not one of them. In the mid-1860s Brown had two commissions for large group portraits in landscape settings, so he was certainly taking on similar projects.[3] If we accept that *On the Hudson* was a commissioned work, the questions become who commissioned it and why.

We will not secure a definitive answer to those questions, but we may, by starting with the painting's setting, piece together some clues.[4] Fort Lee was the site of revolutionary conflict, and an outnumbered George Washington, according to some, had wept as his soldiers were forced to retreat from the area. A Stephen Bourdette is named in accounts of the wartime events, sometimes as a neutral party, willing to aid whichever side seemed most likely to help him in return, and at others as a diehard supporter of the revolutionaries. Bourdette built a large house in Fort Lee and oversaw the landing used by local farmers when conveying their produce to markets in New York. By the 1860s the architectural remnants of that bellicose era had become overgrown with vines, victims of the elements rather than the British, and picnickers from New York City provided a balance of trade for the New Jersey fruits and vegetables. City residents could easily reach Fort Lee by boarding the steamboats at docks at Spring and Christopher Streets, and many people came to enjoy the calm and color.

Stephen Bourdette's house and landing were eventually purchased by Robert Annett. Born in Ireland, he had been apprenticed to a ship's carpenter, had owned a small freight-carrying sloop, and had run a ferry from New York to Hoboken before he opened a store in New York in 1806. In 1824 he moved to Fort Lee, eventually owning most of the property on the bluffs above the town as well as the landing. Over the years, a number of ferries carrying parties of day-trippers made the journey between Fort Lee and New York, among them one named the *Robert Annett*. Later the *Thomas E. Hulse* made the trip with Robert Annett's son George as captain.[5]

With the name "Annett" figuring so prominently in this very brief history, a member of that family becomes a prime "suspect" as we investigate who may have commissioned

On the Hudson. Robert Annett was a longtime resident of the area, and as the owner of the landing and hotel and a likely owner of steamboats that brought visitors there, he would have had a number of good reasons for wishing to have the landscape painted. John George Brown lived in New Jersey between 1863 and 1869, and a newspaper account has him sketching near Fort Lee in September 1865. There would have been ample opportunity for Brown and Annett to meet. Perhaps Annett planned to hang the painting in some public place, envisioning it as a kind of advertisement for Fort Lee's spectacular scenery and the quiet refuge it offered to city dwellers. Elements in the painting support this idea. With its large scale and rich colors, it is an eye-catching, arresting painting. At the same time, its composition is a restful balance of sky, land, and water; the activity and crowds on the landing, reduced to tiny detail, reinforce the sense of a retreat. The *Thomas E. Hulse*, positioned roughly at the center of the canvas, is a focal point for the painting. The boat's wide, curving wake draws the eye toward it. The prominence of the name on its side ensures that viewers will know the name of the steamboat that can carry them to Fort Lee.

Or perhaps this theory is wrong. Maybe it was George W. Annett who commissioned the painting, or the owner of the *Thomas E. Hulse*. Robert Annett would have been seventy-nine when Brown completed this painting; perhaps it is a fond, nostalgic record of his home and life, untainted by old business concerns. We do not know. We have found no record of the commission, no mention of the painting hanging in a steamboat or above a mantel, no letter from Annett describing his plans. Those silences, so common in the historic record, can be frustrating. Yet by pursuing the question of why Brown painted *On the Hudson* we learn more about what is depicted and have a glimpse of the people to whom this place mattered. At the end of his life, Brown told a reporter, "When J. G. Brown is no more . . . those who come after me will be rummaging about this studio and they will discover scores of canvases which will show, I hope, that I was not a painter of one idea."[6] Among the things that were found in his studio was a study for *On the Hudson*. [IB]

43. WORTHINGTON WHITTREDGE,

On the Cache la Poudre River, Colorado

FINDING ARCADIA ON
THE AMERICAN PLAINS

A traveler aboard the slow-moving train between Omaha, Nebraska, and Pueblo, Colorado, should expect, according to one journalist who made the trip in 1876, a view "heartbreaking in its sear and yellow uniformity."[1] Mile after mile, hour after hour, the plains stretched to the horizon, bleak and undifferentiated. At last, however, the mountains appeared—Pike's Peak, Long's Peak, and Gray's Peak among them—a drink of icy water for parched eyes. The journalist reported, "A thrill of vivid pleasure passes through us as we gaze for the first time upon these famous mountains." But that thrill soon vanished as, the writer continued, "the inexpressibly arid blank of the plains mitigates our transports, and leaves an impression of disappointment which is not soon or easily overcome."[2] The mountains, named and recognizable, provided drama and sublime beauty in an otherwise anonymous, wearisome landscape.

Yet not every traveler who passed through the western plains found them as tedious as the journalist had. Worthington Whittredge (1820–1910), a celebrated American landscape painter, made three journeys through the western territories. In 1866 he journeyed by horseback, accompanying General John Pope on a tour of inspection, which took him from Fort Leavenworth in Kansas to Santa Fe and back. Four years later he returned in the company of fellow artists John Frederick Kensett (1816–1872) and Sanford Gifford (1823–1880). A year later he made a brief, final trip to Colorado. It was not the Rocky Mountains that enticed him to return. Rather, it was those supposedly dreary, apparently monotonous plains. As Whittredge recalled years later in his autobiography, "I had never seen the plains or anything like them. They impressed me deeply. I cared more for them than for the mountains." He continued,

> Often on reaching an elevation we had a remarkable view of the great plains. Due to the curvature of the earth, no definite horizon was visible, the whole line melting away, even in that clear atmosphere, into mere air. I had never seen any effect like it, and it was another proof of the vastness and impressiveness of the plains. Nothing could be more like an Arcadian landscape than was here presented to our view ... the earth covered with soft grass waving in the wind, with innumerable flowers often covering acres with a single color as if they had been planted there.[3]

Where others had found tedium, Whittredge found a rare beauty, as capable as the mountains of inspiring awe.

Whittredge's aversion to mountains and preference for humbler subjects long preceded his journeys to Colorado. Born in rural Ohio, he received little education. At seventeen, filled with wanderlust and an inexplicable craving to be an artist, he moved to Cincinnati and apprenticed himself to a sign painter. Gradually he taught himself how to paint but, in 1849, still feeling the deficits of his schooling, went to Europe to study, sketch, and travel. He stayed ten years, receiving instruction at the Düsseldorf Academy when it was at its prime. In 1854 he traveled through

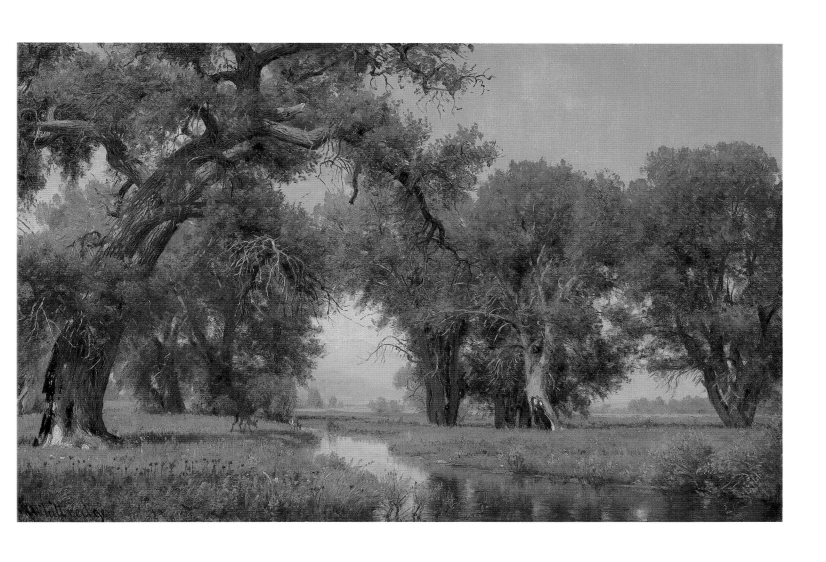

43. Worthington Whittredge (1820–1910), *On the Cache la Poudre
River, Colorado*, 1871. Oil on canvas, 15⅜ × 23⅛ in. (39.1 × 58.7 cm)
Museum purchase, Roscoe and Margaret Oakes Income Fund, 1986.39

Switzerland with Albert Bierstadt (1830–1902), but Whittredge did not find the alpine scenery to his liking. "My thoughts ran more upon simple scenes and simple subjects," he wrote, "Or it may be I never got into the way of measuring all grandeur in a perpendicular line."[4] We can imagine the pair—Bierstadt, who would become famous for his operatic views of western American mountain scenes, and Whittredge, the lover of plains—painting side by side, the one in ecstasies before the famous Swiss peaks, the other disconcerted.

When Whittredge returned to the United States after his decade abroad, however, it was the American landscape that he found unsettling. Shortly after his arrival, he saw a "truly American landscape" painting by Asher B. Durand (1796–1886) that moved him to tears.[5] Yet Whittredge could not adjust his eyes to his new surroundings. He restlessly searched for a landscape he could paint, traveling first to Newport, where he spent his time "looking at the sky and endeavoring to find out what was the matter with it," moving from there to New York City, where he was overcome by noise and loneliness, and finally escaping to the Catskill Mountains. He later wrote, "But how different was the scene before me from anything I had been looking at for many years! The forest was a mass of decaying logs and tangled brush wood, no peasants to pick up every vestige of fallen sticks to burn in their miserable huts, no well-ordered forests, nothing but the primitive woods with their solemn silence reigning everywhere."[6] Gradually, however, Whittredge repatriated his vision. That dense and chaotic forest became the subject of many paintings over the next decade.

Whittredge was drawn to the light and space of the western plains as well as to the Catskill woods' enveloping quiet. In May 1871 Whittredge wrote a letter to the *Greeley (Colo.) Tribune* in which he recalled fondly the "many gorgeous sunsets" he had seen there. He added, "Those who have claimed so much for the atmosphere of Italy, never saw the atmosphere of our plains near the mountains. . . . We need age, historical associations, and great poets and painters to make our land as renowned as the ash heaps of the Old World; but we need nothing of this kind to enjoy its beautiful scenery when it is before our eyes, if we will but strip ourselves of old prejudices, and use our common senses."[7] Whittredge had not forgotten the sights and sensations of Europe, but the plains offered landscapes to rival them.

In the groves of cottonwood trees that dot the plains,

Whittredge found an echo of the New England forest interiors he had come to love. A particular group of cottonwood trees on the Cache la Poudre River, which Whittredge saw on his first journey west, made a profound impression on him. When part of a painting made after that trip failed to satisfy him, he returned to Colorado to find that same group of trees so he might insert them in the painting. A year later, in 1871, a reporter for the *Greeley (Colo.) Tribune* noted that the artist was again in town, making studies of cottonwood trees. It was then that Whittredge painted *On the Cache la Poudre River, Colorado*.[8]

Whittredge seems to have made virtually the whole painting in one sitting in the field, applying the paint wet into wet. Small holes around the edge of the canvas indicate that he had tacked it onto a drawing board, a common plein-air technique. When the canvas was stretched later, the edges of it would have to be folded over the sides of the stretcher, resulting in the loss of part of the image. To avoid this problem, Whittredge lined the canvas with a larger piece of fabric (it was apparently his handiwork) and then extended the composition onto the lining.[9] He later enlarged *On the Cache la Poudre River*, creating a monumental canvas fitting for these commanding trees.[10] Yet this smaller painting, with its free handling and lighter palette, is fresh and immediate.

In the painting, the river ambles beneath a stately group of cottonwoods. A large tree fills the upper left quadrant, its spreading branches pushing against the edges of the canvas. Other trees, equally impressive in age and size, line the middle distance, creating a richly patterned wall of foliage and branches. That wall is broken on the right by a window of blue sky and in the center by a graceful doorway arching over the river. Through these apertures we have a glimpse of the melting yellow plains, here and there other trees, and, finally, mountains in the far distance. A carpet of green grass and pink and purple wildflowers spreads under the trees. Two deer graze on the left riverbank. Walls, windows, doors, carpets: the painting conveys a profound feeling of enclosure and shelter. It is a vision of the plains much more akin to Whittredge's forested landscapes than to the searing expanse the sour journalist saw from the train. It is the vision of a man who had found the serenity and simplicity of Arcadia in his own country and who felt, at last, at home there. [IB]

44. WILLIAM MORRIS HUNT, *Governor's Creek, Florida*

A PICTURE "TO WONDER
AT IF NOT TO PAINT"

Reflecting on his artistic career in 1910, Elihu Vedder (1836–1923) recalled that his friend and fellow artist William Morris Hunt (1824–1879) "was so identified in my mind with Boston that to say 'Hunt' was to me the same as saying 'Boston.'"[1] During the second half of the nineteenth century, few would have disagreed. Hunt was Boston's leading painter in the 1860s and 1870s and took an active role in the art community as a teacher, collector, and member of the city's cultural elite. Ironically, it is Hunt's contact with regions beyond Boston's borders—as a European-trained artist, a proponent of modern French painting, and a painter of exotic and regional landscapes—that have formed his strongest legacy. Although in his own time Hunt was recognized primarily for his portraits and figure subjects, he is best known today for the landscapes he painted during the final years of his life.[2] Hunt's earliest works from this period are the haunting Florida landscapes he completed in the early 1870s, a decade before the region became a popular subject for artists. In paintings such as *Governor's Creek, Florida*, Hunt renders the dreamy exoticism of the far Southeast in a fresh way, capturing haunting impressions rather than the lighthearted, Edenic scenery sought by northern tourists.

Florida's mystique was not a nineteenth-century development. From the time of earliest European contact, when legend associated Ponce de Leon's quest for the Fountain of Youth with the region's discovery, Florida possessed an aura of romance and exoticism. The difficulties of traveling there tightened Florida's grip on the American imagination, yet it remained a legendary paradise rather than a

carefully explored and documented territory. Florida was purchased from Spain in 1821 and admitted to the union in 1845. Yet it was not until the expansion of the railroads after the Civil War that access to the Southeast improved, and many areas remained almost totally unreachable until the 1890s.[3] Artists were particularly slow to travel to the region. In 1853 *Harper's New Monthly Magazine* published an article lamenting the lack of painted landscapes of the South, and illustrated travel accounts began to appear only in the 1870s.[4]

Perhaps because their work required less actual knowledge of the region than visual representations of it would, novelists, such as Harriet Beecher Stowe, moved more quickly to explore Florida's potential. In 1856 Stowe followed her best-selling first novel, *Uncle Tom's Cabin*, with *Dred: A Tale of the Dismal Swamp*, the story of an escaped slave in the swamplands. A decade later, in search of the more healthful, temperate climate that drew many travelers to the region, Stowe herself went to Florida. With the hopes of rehabilitating her chronically ill son, she leased a cotton plantation south of Jacksonville for him to operate. A few years later Stowe settled there as well, purchasing a cottage and grove at Mandarin.[5] She published her own firsthand account of Florida in 1873. *Palmetto Leaves* describes the landscape, weather, and sights of the region, but it is not a typical travel narrative. Instead of presenting an idealized picture of the lush vegetation, tropical climate, and exotic wildlife common in other depictions, Stowe warns those who would travel to Florida: "don't hope for too much. Because you hear that roses and callas blossom in the

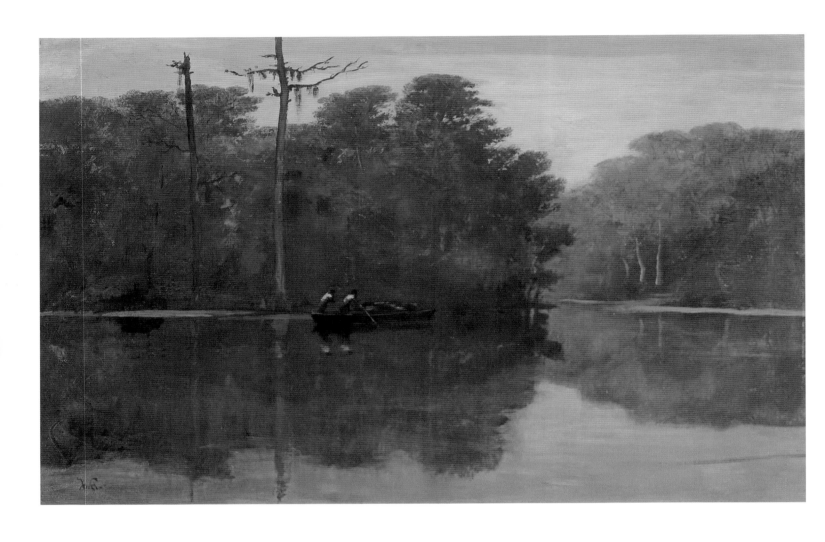

44. William Morris Hunt (1824–1879), *Governor's Creek,*
 Florida, 1874. Oil on canvas, 25 × 39 in. (63.5 × 99.1 cm)
 Gift of Mr. and Mrs. John D. Rockefeller 3rd, 1993.35.18

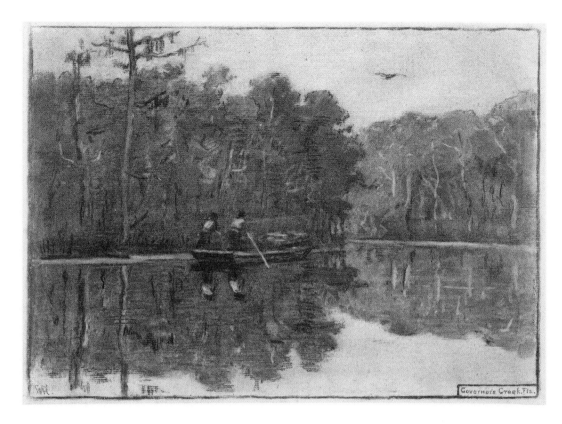

Fig. 44.1. William Morris Hunt (1824–1879), *Governor's Creek, Florida*, 1873. Charcoal on paper, 8⅛ × 11⅛ in. (21.3 × 28.3 cm). Museum of Fine Arts, Boston. Gift of L. Aaron Lebowich, 50.732

open air all winter, and flowers abound in the woods, don't expect to find an eternal summer." She describes a resident's "sort of tumble-down, wild, picnicky kind of life— this general happy-go-luckiness which Florida inculcates."[6] There was no place for this Florida alongside the idealized image put forth in travel literature, advertising, and the region's longtime status as a mythic, earthly paradise. Stowe complained: "If we painted her, we should not represent her as a neat, trim damsel, with stretched linen cuffs and collar: she would be a brunette, dark but comely, with gorgeous tissues, a general disarray and dazzle, and with a sort of jolly untidiness, free, easy, and joyous."[7] She advocated celebration of the true, complicated, dynamic Florida which had yet to be represented.

William Morris Hunt made his first trip to Florida in the winter of 1872–73, while *Palmetto Leaves* was still in progress. That November, months after a final separation from his wife and children, Hunt had lost his studio and its contents—including much of his own work and a closet full of paintings by Jean-François Millet, Narcisse Virgile Diaz de la Peña, and other French artists—when the great Boston

fire destroyed sixty-five acres at the center of the city.[8] Depressed and unable to work, he traveled with his close friend the Boston financier John Murray Forbes (1813–1898) to Forbes's home in Magnolia Springs, Florida, an inland resort on the St. John's River. The pair spent the winter exploring the river and its tributaries, including Governor's Creek, and Hunt began to work again, creating numerous charcoal sketches, many of which later formed the basis for oil paintings. Although they visited St. Augustine and several of the popular tourist sites along the river, it was the calm, uninhabited, wintry landscapes of St. John's less-traveled branches that captured Hunt's attention.[9] A year before Stowe's book was published, Hunt too was drawn to the strange, off-season landscape she described.

Shortly before returning to Boston the following spring, he wrote his own account of the unfamiliar scenery, noting, "foliage now so dense that the novelty of it is passed; also that lovely contrast of the brown masses of trees with the bright, tender green. All this, with an occasional gigantic cypress reflected in the perfectly still water of the creeks, makes pictures to wonder at if not to paint."[10] Hunt, like Stowe, was

no starry-eyed tourist. He had not been commissioned to create typical, idyllic views of Florida, nor did he seek them out. He marveled at the strange, wild scenery he encountered, seeking to capture—through sketches and related paintings—his impressions of what Stowe called the "peculiar, desolate untidiness" of the winter landscape,[11] rather than striving for monumental views of an eternal summer.

While Hunt's choice of Florida subjects would prove influential for later artists working there such as Winslow Homer (1836–1910) and Martin Johnson Heade (1819–1904), his practice of outdoor sketching, which first became central in his Florida works, was even more revolutionary and established his place in a national movement toward greater breadth and spontaneity in painting. After returning from Florida in 1873, he moved away from portraiture, turning almost exclusively to landscapes, which he began—as he had in Florida—by sketching out of doors.[12] His sketching practice allowed him to capture his true impression of his subjects—a goal he had always stressed in his teaching. In developing these impressions in oil paintings, he was careful to retain the sketchlike character of his original charcoal drawings, adopting lively brushwork and composing his pictures of generalized forms delineated by color and light.[13] His unelaborated, evocative paintings were often compared unfavorably with the highly finished, documentary or theatrical landscapes painted by an older generation of American artists such as Thomas Cole (1801–1848) and Asher B. Durand (1796–1886). Hunt's work was also at odds with that of contemporary landscapists such as Frederic Edwin Church (1826–1900) and George Inness (1825–1894). Unlike those artists, Hunt seldom painted panoramic views, choosing instead a more narrowly focused engagement with his subject.

Hunt's divergence from the artistic practices of many of his American contemporaries was controversial and often attributed to his French training and his friendship with Barbizon landscape artists such as Millet. Yet the landscapes he painted in the 1870s, during the last five years of his life, are among the most original paintings of his career. His Florida works were not his first attempt at landscapes; he had experimented with landscape subjects at Barbizon, and again from time to time in Newport and on trips to the Azores and Brittany in the late 1850s and 1860s, and at various times in the Boston area. These infrequent departures from figure painting were, for the most part, imitative in composition, color, and subject of rural scenes by Millet and other French artists.[14]

It was in painting the swamplands in Florida—an area without parallels in the French landscape or in more familiar northern scenery—that Hunt began to formulate a new approach. Among his first Florida works was a charcoal drawing of Governor's Creek made in 1873 (fig. 44.1), which he later used as the basis for *Governor's Creek, Florida* and another, smaller painting of the same subject that remained in the family of his friend John Forbes.[15] In *Governor's Creek, Florida* Hunt captures the stillness of an early winter morning on the St. John's River. The nearly seamless transition between the trees along the banks and their reflection on the water's surface is disrupted only by a few striking patches of green algae and the presence of two figures poling a skiff toward a bend in the river, who, if not for their bent, laboring posture, would seem as fixed and unmoving as the scenery around them. In both the drawing and the painting of Governor's Creek, Hunt portrays the moss-draped cypress trees and their reflections as flat masses, with occasional vertical strokes signifying tree trunks. The lone bird flying in the upper right corner of the drawing has been omitted from the painted composition, and the figures in the skiff have been rendered smaller in relation to the landscape around them, which has been stretched laterally in the painting to reveal a broader, less exacting sweep of shoreline. As in the drawing, the painted composition is dominated by the reflective expanse of water and dense stand of trees, with only a narrow stretch of pink- and peach-toned morning sky visible at the top of the canvas. The painting gives no hint as to what may be around the bend in the river, nor to what may lie beyond the roughly painted foliage. Hunt presents instead a fixed moment of heavy, humid morning; the Florida winter few could appreciate or expect, full of disarray and dazzle, a picture "to wonder at if not to paint." [AG]

45. THOMAS EAKINS, *The Courtship*

AN ARTISTIC SPIN

*If America is to produce great painters and if young art students wish to assume
a place in the history of their country, their first desire should be to remain
in America, to peer deeper into the heart of American life.* THOMAS EAKINS[1]

Thomas Eakins's life was marked by public controversy, and he painted *The Courtship* (ca. 1878) early in his career during the first of several pivotal episodes. Just two years before Eakins's now famous painting *The Gross Clinic* (1876) was rejected by the Centennial International Exhibition in Philadelphia as an unsuitable subject for the art pavilion and relegated to the United States Army Post Hospital.[2] A monumental portrait of Dr. Samuel David Gross, who gave surgical instruction at Jefferson Medical College, the painting caused an uproar due to its subject matter, which offended Victorian morals with its frank depiction of medical procedures and human flesh.

In contrast to *The Gross Clinic*, in which Eakins demonstrates his modern interest in science and an objective understanding of the body, *The Courtship* participates in the Victorian era's preference for decorum and restraint associated with an earlier time. It is consistent with the tenor of Eakins's first exhibition in 1878 with the newly formed Society of American Artists in New York, where he showed his paintings *William Rush Carving His Allegorical Figure of the Schuylkill River* (1876–77) and *In Grandmother's Time* (1876).[3] Like *The Courtship*, these works are historical genre paintings that appealed to the vogue for early American subjects that were popular as part of the period's vogue for the Colonial Revival. In *The Courtship* Eakins signals the anxiety felt by late-nineteenth-century Americans as they negotiated the social, political, and economic changes brought about by modernity.

Born in 1844 as the son of a Pennsylvania teacher, whose tenant-farming family changed its name from Akens,

Thomas Eakins (1844–1916) showed an early aptitude for study in science and mathematics, giving the "scientific address" at his graduating ceremonies from the academically esteemed Central High School in Philadelphia.[4] Eakins completed course work at the prestigious Pennsylvania Academy of the Fine Arts from 1862 to 1866, while also attending anatomy lectures as part of his training at the leading medical school in Philadelphia, Jefferson Medical College. In 1866 Eakins was accepted for study in the prestigious atelier of Jean-Léon Gérôme (1824–1904) at the Ecole des Beaux-Arts in Paris, where he received classical instruction in drawing and painting from nude models (fig. 45.1).[5] At the conclusion of his studies, in 1869–70 he traveled to Spain, where he recorded the impact on him of paintings at the Museo del Prado in Madrid, especially the old master works of baroque realism.

After returning from Europe and setting up a studio in Philadelphia in 1874, Eakins registered at Jefferson Medical College and began assisting as a volunteer with surgical demonstrations and anatomy lectures.[6] In 1878 he took a highly influential teaching position as Christian Schussele's assistant at the Pennsylvania Academy of the Fine Arts. When Schussele died the following year, Eakins was appointed to his former teacher's position as professor of drawing and painting, eventually becoming director of the school.[7] From this point his career flourished as one of the country's leading artists. He became a talented sculptor, and his first sculpture commissions in 1882 on the subjects of spinning and knitting reflect the success of his colonial genre paintings such as *The Courtship*.[8] Also in the

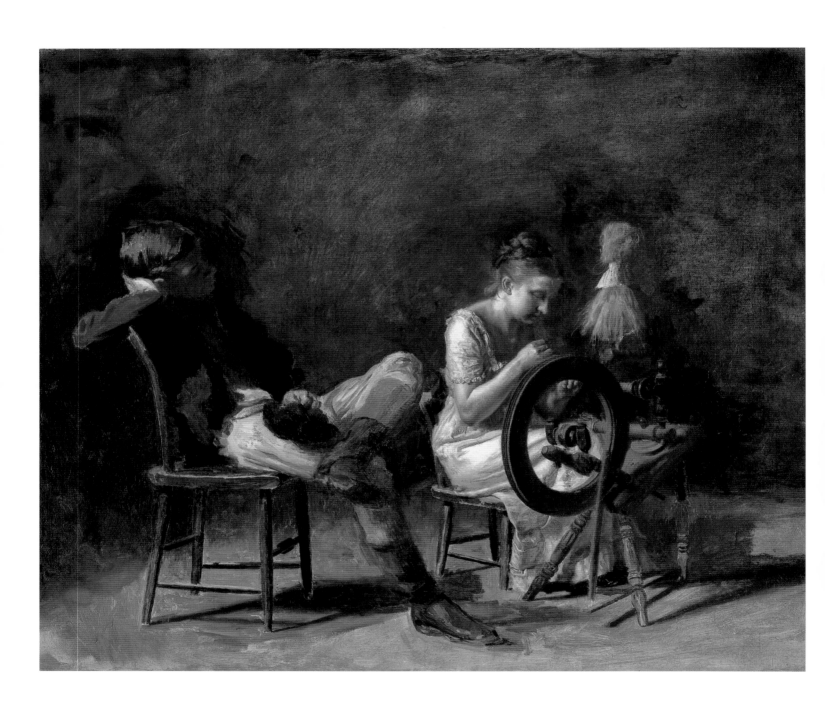

45. Thomas Eakins (1844–1916), *The Courtship*,
ca. 1878. Oil on canvas, 20 × 24 in. (50.8 × 61 cm)
Museum purchase, gift of Mrs. Herbert Fleishhacker,
M. H. de Young, John McLaughlin, J. S. Morgan and
Sons, and Miss Keith Wakeman by exchange, 72.7

1880s, his interest in scientific knowledge led Eakins to the developing field of photography, which would play a major role in his work as an artistic tool in place of preparatory sketches.[9] Today, Eakins's photographs are esteemed as highly accomplished works of art in their own right.[10]

At the height of his success in 1886, a serious scandal broke out over Eakins's use of nude models in his drawing classes. All biographers of Eakins see this event as the defining moment in the artist's life and have recounted the deleterious effect it had on his contemporary reputation, his career, his work, his family, and his emotional well-being.[11] Put simply, the incident involved his removal of a loincloth covering the genitals of a male model during a coeducational drawing session.[12] The situation was aggravated, no doubt, by Eakins's radically innovative use of students as models for each other, which especially alarmed their parents.

The conservative board members, who represented the repressive values of Victorian Philadelphia, seemed perpetually shocked by the aggressive anatomical naturalism and emotional realism of Eakins's artistry as well as his progressive teaching methods, including dissection and the use of nude photographic studies.[13] Their prudish scruples would not tolerate such intrusions, and, incited by the loincloth episode, they asked Eakins to resign.[14] When he refused, he was fired for insubordination amid ridiculously escalating charges of flirtatious behavior, suggestive language, incest, and, finally, bestiality.[15] Only with his turn to portraiture in the 1890s would Eakins regain a measure of the stature and prestige that he lost when he was forced to leave the Pennsylvania Academy.[16]

In spite of his unconventional attitudes toward teaching and embrace of modern science, Eakins was also drawn to a poetic nostalgia for the past, especially as a metaphor for his artistry. *The Courtship* is one of a group of works that Eakins painted from 1877 to 1883 on the historical subject of women spinning.[17] In this endeavor, Eakins was participating in the rage for all things colonial at the time.[18] The 1876 Centennial Exhibition, which celebrated the country's colonial heritage, had an enormous influence on the decorative arts, fine arts, and architecture. As a native of Philadelphia, Eakins would have been familiar with the fair's exhibits, such as the New England kitchen that housed a colonial spinning wheel. A certain irony is implicit in the very notion of the Philadelphia Centennial, which advocated a progressive future by celebrating the past. In *The Courtship*, Eakins used the subject of spinning

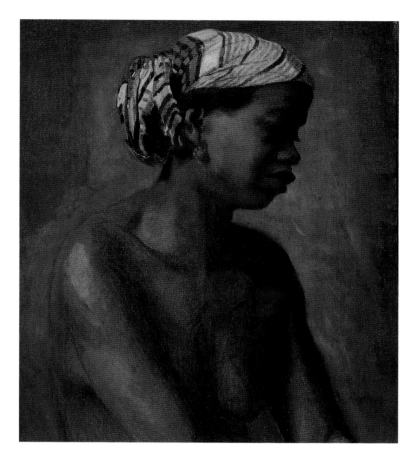

Fig. 45.1. Thomas Eakins (1844–1916), *Figure Model*, ca. 1867–69. Oil on canvas, 23 × 19¾ in. (58.4 × 50.2 cm). Mildred Anna Williams Collection, 1966.41

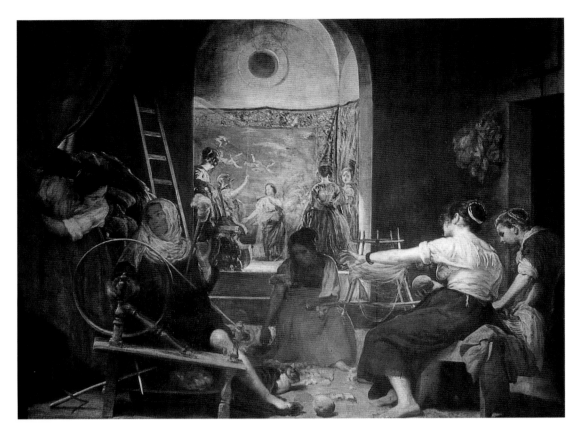

Fig. 45.2. Diego Rodríguez de Silva y Velázquez (1599–1660), *The Fable of Arachne (The Spinners)*,
1657. Oil on canvas, 86½ × 113¾ in. (219.7 × 288.9 cm). Museo del Prado, Madrid

to turn this understanding of the past into a complex metaphor for artistic realism.

Two years after the jury at the Philadelphia Centennial rejected *The Gross Clinic* for being too explicit, Eakins took up a subject in *The Courtship* that directly references the exhibition. Although he isolates his depiction of the young couple within the confines of an indistinctly articulated room, the clothing and the type of spinning wheel clearly locate the scene in the colonial era. A young suitor rests, gazing uninterruptedly at the object of his affection while she attends to work that clearly predates industrialism and the economic and social changes of Eakins's modern world represented by the anatomy lessons of Dr. Gross. Nevertheless, a parallel exists between the two paintings; Eakins depicts the woman's proficient handiwork in a manner that resembles his treatment of the doctor's deftly trained hands and the work of surgery. Both colonial spinner and modern doctor are linked across the divide of industrialism by a skillful attention to their respective crafts. Not incidentally, an appreciative audience watches both spinner and doctor.

In *The Courtship*, Eakins renders the young man through bravura brushstrokes of strong painterly effect that imply rather than describe. His costume is summary, the pants bold swashes of golden paint and his jacket mere patches of color. His face is shadowed and blurred, as Eakins relies on a slumping cross-legged pose rather than any expressive facial features to indicate the suitor's casual but genuine attention. In depicting the female figure, Eakins effaces the evidence of his brushstrokes, creating a more finished surface that clearly renders her simple muslin dress with its decorative trim along the sleeve and neckline. In contrast to the suitor's hands and face, her features are completed with care and eloquently modeled to give the impression of smooth and supple skin. Her right arm is shapely in its classically drawn proportion, showing evidence of the anatomical structure that supports her activity. As viewers of the painting follow her attention on spinning, they are made to notice that the wheel is depicted with all the specificity necessary to identify its individual parts. Eakins provides enough visual evidence to build a functionally

working model. The only missing parts are the spokes of the wheel, rendered invisible by the act of spinning.

In terms of the narrative implied in *The Courtship*, Eakins aligns the viewer with the suitor's gaze and the privilege of looking that both the scene and the painted surface encourage as a natural activity. In this alignment, the gender roles are significant: the male figure, who embodies (both visually and literally in his painterly form) the work of the artist, gazes directly at the female figure, whose attention is diverted to her own work of spinning. Through this combination of narrative incident and changing painterly effects, Eakins establishes a hierarchy of gazes that moves the viewer's look from male suitor, to female worker, to spinning wheel. Attendant to that movement, the visual detail becomes increasingly specific.

Eakins's painterly strategy and his thematizing of an appreciative audience tie the subject to his own work as a painter. It serves as a metaphor of his artistry and expertly trained craft that is both traditional and modern. In *The Courtship*, much of the image is rendered through obvious brushstrokes that call attention to this work as the product of painting. The space of the walls and the floor, especially, evinces an obvious delight in the various effects that can be used to depict a single surface. Eakins scumbles, hatches, daubs, and smudges the paint. He uses short, long, stubbed, and flowing brushstrokes. He paints the canvas with gestures that include spreading, scratching, streaking, rubbing, smoothing, and even drawing. These are the traditional lessons he learned from Velázquez, Ribera, and the other great Spanish baroque realists.

According to his earliest biographer, "Eakins was one of the first American artists to experience Spanish art in Spain."[19] Diego Velázquez (1599–1660), in particular, captured Eakins's attention when he visited the Prado in 1870 at the conclusion of his European studies. In his journals, Eakins specifically comments on *The Fable of Arachne (The Spinners)* (1657), calling it "the finest piece of painting I have ever seen" (fig. 45.2).[20] Eakins's close attention to the technique of this work reveals the importance of its impact on him, and it seems reasonable that he would have carried from Spain a desire to pay homage to the master of realism that the American artist considered his greatest predecessor.

In Velázquez's painting, the goddess Minerva, the inventor of the loom, is shown in the foreground with Arachne, whose work was considered unsurpassed, not only in its finished state but also in her very act of weaving it. The women are engaged in a spinning contest prompted by Minerva's anger at Arachne's pride over her artistic fame. The scene in the background shows Arachne's beautiful tapestry depicting Titian's *Rape of Europa* (1559–62) and Minerva turning Arachne into a spider as punishment for her insolence. The irony, of course, is that as a spider, Arachne is condemned to spend the remainder of her life weaving webs out of her own bitter entrails. As the fable relates, within classical lore spinning is a metaphor for invention, skillful execution, hubris, and the cost exacted by artistic creation. Eakins's painting draws on this symbolism in its use of spinning as a metaphor linking artist and artwork.

Velázquez's painting also illustrates how spinning offers an analogy for narrative and history even as it relates the tale from Ovid. The turning of raw materials into thread has been a staple of imagery for the turning of events into stories since classical antiquity. It underlies the personification of history as Clio, one of the female muses who presided over song and prompted memory.[21] An entire constellation of tropes has evolved based on this metaphoric symbol: we look for the central thread of a story, talk about weaving events into a recognizable pattern, and even of spinning a good yarn. These tropes all share an awareness of the importance of the individual details in constructing an interconnected totality. To lose a single stitch is to risk unraveling the whole.

A similar understanding underlies the assumptions that support the conventions of realist representation advocated by Eakins. It is the precision of the details that grant an image its illusionary force. The visual rhetoric of realism relies on an apparent objectivity to produce a convincingly unified composition, which is the measure of the painting's success. In *The Courtship*, Eakins has created a meditation in paint that unites the skills of spinner, storyteller, and artist into a complex, interdependent image. Eakins courts his viewers through a web of metaphoric conceits that are simultaneously traditional and modern, reflecting the vocabulary of realism that he would continue to champion throughout his life. [DC]

46. THOMAS EAKINS, *Frank Jay St. John*

A MEMBER OF A PERSONAL ACADEMY

In 1886 Thomas Eakins (1844–1916) was forced to resign from the Pennsylvania Academy of the Fine Arts because he had removed the loincloth from a male model who was posing for a class that included female and male students. A scientist by nature as well as an artist, Eakins had studied anatomy as a young man, attending autopsies, dissections, and surgeries. To drape the body and therefore inhibit the study of it for reasons as inconsequential (to him) as decorum was offensive. The loss of his position was a great blow.[1] Eakins withdrew into a small circle of friends, painting little. When he did pick up his brush, it was to execute portraits of two professors at the University of Pennsylvania. Like most of the 247 portraits that Eakins painted during his career, these two paintings were not commissioned. Rather, Eakins sought out sitters who provided him with a visual or intellectual challenge, offering the finished painting as a form of payment for the time spent posing. Between his de facto dismissal from the Pennsylvania Academy and his death, Eakins painted, beginning with these two portraits, a veritable procession of learned, accomplished men: scientists, teachers, doctors, priests. He created, in the process, his own, alternative "academy," where his commitment to scientific truth was understood and welcomed.[2]

In many of these later portraits, Eakins includes the tools and instruments the scientists had invented, his depictions of these machines taking on the character of portraits themselves. For his portrait of Professor Henry A. Rowland (fig. 46.1), for instance, Eakins traveled from Philadelphia to Baltimore to study a machine of Rowland's devising that allowed for remarkably precise measurements of the solar spectrum. He wrote to Rowland after seeing it, "The directness and simplicity of that engine has affected me and

I shall be a better mechanic and a better artist."[3] For Eakins science and art were inextricably linked, a line of inquiry in one fostering advances in the other.

Frank Jay St. John was another member of Eakins's alternative academy. While some of Eakins's portraits are grand in scale, depicting the subject life size, the painting of St. John (1900), a coal merchant, is much more modest. This modesty is perhaps appropriate, for St. John's contribution to science was nothing so grand as measuring the spectrum. He had patented a better fire-grate bar for use in steam boilers. While it might not alter the course of physics, St. John's invention did produce a clean fire, did not warp when overheated, and, when rocked, would efficiently break down clinkers.[4] Regardless of whether St. John commissioned the portrait or Eakins asked him to sit, it is an admiring and sympathetic view of the man, celebrating the spirit of his accomplishment and the mind that conceived it.

Eakins shows St. John nearly in profile, seated in an armchair. His expression is serious, his gaze steady behind his pince-nez. He wears a black overcoat, a smudge of red cravat visible at his throat. He holds his hat on his lap. Leaning against a piece of furniture on the left are two fire grates. There is an oriental carpet on the floor, a map on the wall. The map's columnar legend bears a resemblance to the openings on the fire grate, linking the two visually. Both the map and the strong light that falls from an unseen window onto St. John's face are reminiscent of Dutch portraiture, as is the quiet solemnity of the scene.[5] Eakins carefully describes textures and materials: the dull sheen of the thick wool of the overcoat, the bright glint of St. John's wedding band, the sliver of white light caught on the lens of his

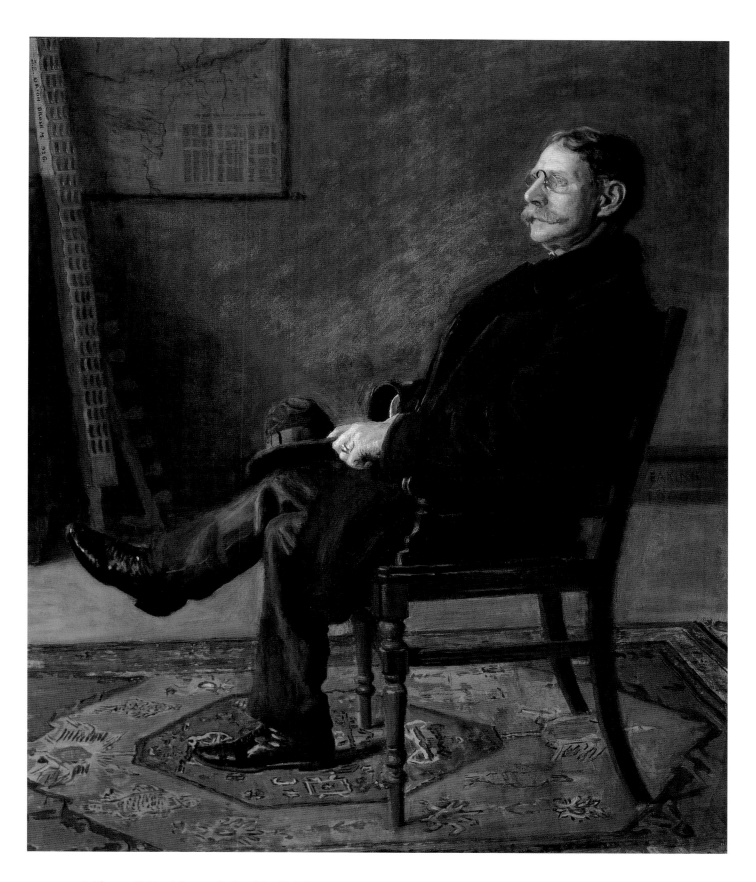

46. Thomas Eakins (1844–1916), *Frank Jay St. John*, 1900
Oil on canvas, 23⅞ × 19⅞ in. (60.6 × 50.5 cm)
Gift of Mr. and Mrs. John D. Rockefeller 3rd, 1979.7.37

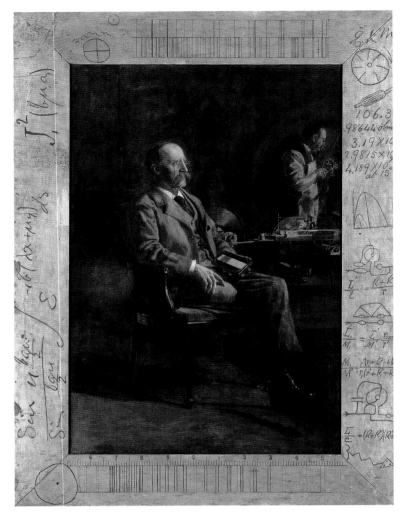

Fig. 46.1. Thomas Eakins (1844–1916), *Professor Henry A. Rowland*, 1897. Oil on canvas, 80¼ × 54 in. (203.8 × 137.2 cm). Addison Gallery of American Art, Phillips Academy, Andover, Massachusetts. Gift of Stephen C. Clark, 1931.5

glasses, the shine of his polished shoes. Using these details, Eakins conjures St. John's physical presence.[6] Using St. John's eye, he conjures his psychological presence. St. John looks through the lens of his pince-nez, yet we can see the eye behind it. The eye, watery blue, a little reddened in the white, is focused on something beyond the edge of the canvas, possibly beyond the room altogether. The right eye is not visible, although Eakins shows the right lens of the spectacles. The brown blankness behind the lens is unsettling, the void making the other, glittering eye that much more arresting.

There are other unsettling moments in the painting. At first glance, St. John's right hand appears to be missing—his black coat sleeve gapes tunnel-like, empty but for the white shirt cuff. On closer study, a flick of pink paint just above the left hand reassures that the right one is not missing after all but is tucked behind the crossed left leg. Even once the missing hand is found, however, the odd passage in the painting does not fully resolve. Another unsettling moment occurs in the background. The baseboard on the wall behind St. John does not remain at a continuous level but jumps up on the right. A man wearing his overcoat in a room slightly askew, caught in a posture that renders him with one eye and one hand: the combined result of these small incongruities is a painting infused with subtle, restless tension.

Hat at the ready, coat on, feet pointed toward the source of light: St. John seems to be on the verge of leaving. Yet he leans back in the chair and wears an expression suggestive of someone settled in for a long, patient wait.[7] Eakins sometimes insisted that his subjects wear old, familiar clothing when they sat for their portraits, seeing in the garments an expression of the wearers' taste and character.[8] Perhaps Eakins was struck by the figure that St. John cut when he arrived at the studio in his coat and hat, and asked him to pose so attired. Perhaps St. John was an impatient man, a man of action, always on the go.

A photograph probably taken by Eakins's protégé Samuel Murray shows Eakins working on St. John's portrait (fig. 46.2). Like St. John, Eakins is seated with his legs crossed. In a neat flip-flop, in the photograph it is St. John we see full face while Eakins is in profile. As the photograph shows, Eakins placed his sitters directly in front of him as he painted. He taught his students to construct the central, vertical axis of their paintings before anything else, and he unfailingly followed his own advice. He then positioned his

subjects at the intersection of the vertical and horizontal axes, arranging them asymmetrically.

In the portrait of St. John, the vertical axis divides the painting into two contrasting halves. On the right, St. John's light-bathed face; the solid, dark form of his torso; the simple sweep of the back legs of the chair. On the left, St. John's hand, ready hat, crossed legs, the map and fire grate. The right half is a painting of thought—a mind engaged, a man lost to his surroundings as he pursues an idea. The light illuminating the man is the light of modern revelation, not religious in nature but scientific. It suggests a dawning Eureka. The left half is a painting of action and movement, hands that build and legs that walk, a fire grate that helps propel machines, a map that shows the path.

Eakins's "academy" painting of Rowland shows a similar bifurcation. The professor sits in a posture not unlike St. John's—legs crossed, the face almost in profile, one hand obscured. They even share pince-nez and fulsome mustaches. They also share expressions of deep thought. In the background of Rowland's portrait, his assistant, sleeves rolled and apron smudged, works at a lathe. Rowland personifies thought, the assistant labor.[9] The spectrum-measuring instrument, the outcome of their dual endeavors, links them visually. Eakins was celebrated for his ability to portray "mere thinking without the aid of gesture of attitude."[10] In these two paintings, Eakins presents compelling, dignified portraits of men absorbed in thought.

For Eakins thought was not an end in itself. After all, he was not a philosopher but a painter and a scientist. The useful application of thought was as valuable, if not more so, than the thinking. Rowland was able to achieve his groundbreaking measurements because he built finer instruments than his colleagues did. St. John noticed the weakness of existing fire grates and then constructed a better one. Just as Rowland's machine extends from his arm, St. John's grate extends from his foot. So, despite the passive, seated posture, St. John is indeed a man of action: he experiments and he manufactures. And while he is momentarily lost in thought, he will leave soon, ready to apply the fruits of his musings. [IB]

Fig. 46.2. *Thomas Eakins Painting a Portrait of Frank Jay St. John*, 1900. Silver gelatin print, 5 5/16 × 6¾ in. (13.5 × 17.2 cm). Samuel Murray Archival Collection, Hirshhorn Museum and Sculpture Garden, Smithsonian Institution, Washington, D.C., HMSG EM 32

47. JAMES MCNEILL WHISTLER,

The Gold Scab: Eruption in Frilthy Lucre (The Creditor)

ACRIMONY IN BLUE AND GOLD

James McNeill Whistler (1834–1903) once remarked, "Yes, I have many friends and I am grateful to them; but those whom most I love are my enemies—not in a biblical sense; oh no! But because they keep one always busy, always up to the mark, either fighting them or proving them to be idiots."[1] In *The Gold Scab* (1879), Whistler's former friend and first significant patron, Frederick Richards Leyland (1831–1892), is revealed to be one such enemy.

At the time Whistler completed the painting, legal fees from a notorious libel suit against the art critic John Ruskin and the expense of building the White House, his new home and studio in London, had left him deeply in debt. Leyland was one of three creditors appointed to carry out the terms of the bankruptcy petition Whistler filed in 1879 and oversee the liquidation of his assets; *The Gold Scab* marks Leyland's irredeemable shift from patron to creditor.[2]

The painting was one of three satirical works Whistler created for display at the White House in anticipation of the official inspection of the property by his creditors.[3] Of those retaliatory paintings *The Gold Scab* most directly addresses the contentious turn the relationship between the artist and his former patron had taken. It is a brutal caricature, with Leyland portrayed as a monstrous, reptilian peacock seated improbably at a piano. His face—the last recognizably human feature of his body—wears a menacing expression, and he turns toward the viewer as though startled, his rough, buckled claws hovering over the keyboard. He sits atop a model of the White House as if it were an egg he hoped to hatch, his mangy tail feathers splayed across it in a gesture of possession. As his contorted body curls horribly

toward the piano, one long, scaly leg extends toward the viewer, foregrounding his vicious spur and threatening, talonlike foot.[4]

Contemporary critics did not identify the work as a caricature of Leyland; one of the earliest commentators on the painting described its subject as "a demon sitting on the ridge of a Gothic house playing the piano." In 1882 the architect E. W. Godwin likewise observed the creature's demonic appearance, describing the painting as a portrait of the devil "in the form of a peacock-man."[5] For viewers familiar with the relationship between the artist and his patron, however, there could be no mistaking this horrible creature's identity. In reference to the frilled clothing Leyland often wore, Whistler used the form of ornamental, gathered fabric as a motif throughout the painting. The starched frills of the creature's shirtfront and the cuffs of his sleeves provide the stylized form for the ridiculous comb of feathers crowning his head. Frill-like slashes of paint accent the sheet music propped on the piano, highlighting the single musical note (F) and a few of the letters in its punning title: "The 'Gold Scab': Eruption in FRiLthy Lucre." The selective capitalization in "FRiLthy" emphasizes Leyland's initials, and the word itself is a mocking reference to his signature style.[6]

Although scathing caricature was a staple in satirical weeklies, such a virulently bitter image was unexpected from Whistler, who was perhaps the most self-consciously cultivated aesthetic artist of his generation. As one contemporary newspaper account remarked: "to the uninitiated in art the sarcasm seems a great deal better than the

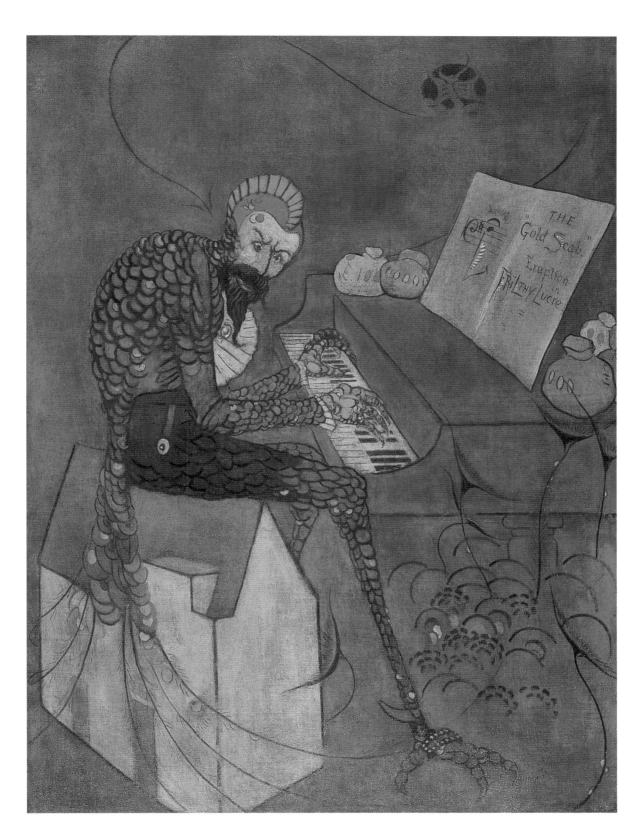

47. James McNeill Whistler (1834–1903), *The Gold Scab:*
 Eruption in Frilthy Lucre (The Creditor), 1879
 Oil on canvas, 73½ × 55 in. (186.7 × 139.7 cm)
 Gift of Mrs. Alma de Bretteville Spreckels
 through the Patrons of Art and Music, 1977.11

Fig. 47.1. James McNeill Whistler (1834–1903), south wall of *Harmony in Blue and Gold: The Peacock Room*, 1876–77. Oil paint and metal leaf on canvas, leather, and wood, 13 ft. 10⅛ in. × 20 ft. 1½ in. Freer Gallery of Art, Smithsonian Institution, Washington, D.C., Gift of Charles Lang Freer, F1904.61

painting, but, if the work be Mr. Whistler's, it is puzzling to understand how he should have chosen such a subject."[7] The painting's dull, murky palette and hideous subject were deeply at odds with the artist's usual harmonious, atmospheric compositions. Equally startling was the vindictive streak the painting made evident. Whistler had long been outspoken on questions of aesthetics and taste, but it was only following his highly publicized trial against Ruskin that the sharpness of his convictions—and his wit—was thrust before the public.

A peacock afflicted by a pestilent eruption of coin was a meaningful image for Whistler and Leyland. Money had been the source of conflict between them since a dispute two years earlier over Leyland's dining room (now known as the Peacock Room and installed at the Freer Gallery of Art, Smithsonian Institution, Washington, D.C.). The room was remodeled by the architect Thomas Jeckyll to

house Leyland's extensive collection of blue-and-white porcelain, and Whistler was asked to oversee its decoration, which was to include two of his paintings, *La Princesse du pays de la porcelaine* (1864–65) and *The Three Girls* (commissioned by Leyland in 1867 but never delivered). Whistler drastically altered the room, remaking it in a striking color scheme of turquoise, blue, and gold. He created painted screens covered with peacocks and designs drawn from their feathers and ultimately extended his decorative scheme by painting over the antique Spanish leather on the walls. When Leyland refused to pay Whistler what the artist thought his treatment of the room was worth, Whistler immortalized their disagreement in a mural along the south wall (fig. 47.1).[8]

The mural, originally titled *Art and Money*, features two fighting peacocks. One stands proudly, its wings spread, a large plume of feathers fanned behind it. There are silver

coins amid the feathers of its chest and wings and scattered around its feet. Along its throat is a line of silver feathers resembling the ruffled shirtfront in *The Gold Scab*, and a frill-like comb of gold feathers crowns its head. It faces a second peacock, who seems to back away in retreat, its tail feathers low to the ground. This peacock's wings are extended, but it obviously is no match for its opponent. It has a tall silver crest feather, reminiscent of Whistler's distinctive white forelock.[9] In *Art and Money*, the richly ornamented peacock clearly has the advantage. It seems certain that money will triumph, and by the time *The Gold Scab* was painted, it had. Yet art—and Whistler—would have the last laugh.

Whistler painted *Art and Money* in the space reserved for *The Three Girls*. Having decided that the painting would never be surrendered to Leyland, he used its frame to house *The Gold Scab* instead, providing Leyland with a clear reminder of their previous conflict. Whistler designed and painted the frame in 1872 to complement *The Three Girls*, a large, horizontal composition in which three women admire an arrangement of flowers against a Japanesque backdrop of screens and drapery.[10] Like many of Whistler's frames from the early 1870s, it has alternating reeded and flat moldings and was gilded without gesso, allowing the grain of the wood to show through. The flat of the frame is painted with small blue flowers, possibly in reference to blue-and-white Chinese porcelain—like that Leyland intended to display in the Peacock Room—which was typically decorated with hawthorn blossoms.[11]

Among the flowers on one edge of the frame Whistler included his butterfly signature, enclosed in a circle as he did on other works he completed in the 1870s. Along another edge of the frame he painted the opening notes from the third of Schubert's *Moments Musicaux*.[12] The reorientation of the frame required to accommodate the vertical format of *The Gold Scab* changed the prominence of both symbols. Whistler's signature now holds a central place on the top, while the musical notes—which would originally have appeared below *The Three Girls*, at the center of the composition, now occupy a relatively inconspicuous place on the left side of the frame. While the musical inscription may initially have been conceived as a benign reference to Leyland's interest in the piano, it takes on a different tone in relation to *The Gold Scab*, a deeply unflattering portrait of the amateur musician.[13]

There is nothing elegant or refined in the perverse ostentation of this frilled figure at the piano. The musical score he plays is surrounded by large bags of money, and the

Fig. 47.2. William Holman Hunt (1827–1910), *The Awakening Conscience*, 1853. Oil on canvas, 30 × 22 in. (76.2 × 55.9 cm). Presented by Sir Colin and Lady Anderson through the Friends of the Tate Gallery, London, 1976, T02075

scaly feathers covering his body are mottled with blisterlike gold coins. Leyland recognized this unflattering caricature for the personal attack that it was and took legal action to prevent its inclusion in the initial liquidation sale of Whistler's assets. Nevertheless, the painting was included at a subsequent auction of Whistler's work held at Sotheby's in 1880. It changed hands twice before passing to the ownership of the artist George P. Jacomb-Hood, who famously refused to part with it even when offered eight hundred pounds in 1892, the year of Leyland's death.[14]

The strangeness of the picture would have been compounded for nineteenth-century audiences by the incongruity of its primary subject: a man at the piano. Although most professional musicians and composers were male, amateur piano students were almost exclusively female, and the instrument was distinctly feminized.[15] Learning to play was central to the education of middle-class girls, as the piano was linked with a woman's proper role in domestic life.[16] The woman at the piano was such a pervasive figure that she became a frequent subject for nineteenth-century artists. She appeared in paintings, as well as in popular prints illustrating sheet music, ads, novels, and magazines. By the late nineteenth century piano-playing women were so common in visual culture that the motif could be used as a cliché by cartoonists who wished to attack social pretension and musical mediocrity.[17]

Piano-playing men remained virtually invisible. Men were sometimes depicted watching admiringly as women played the piano; they did not play themselves. William Holman Hunt's *The Awakening Conscience* (fig. 47.2) is a well-known variation on both the woman-at-the-piano motif and its variant, the love scene at the piano. The painting was controversial when it was shown at the Royal Academy in 1854 and gained widespread notoriety through reviews and reproductions published in the popular press. As one of the most famous nineteenth-century piano scenes, it likely influenced Whistler as he devised *The Gold Scab*, which also modified the woman-at-the-piano motif, though to different ends. In Hunt's picture, a man is seated in front of a piano, but the low height and backward angle of his chair—both making it impossible for him to reach the keyboard—suggest that he never intended to play. His attention is occupied by the young woman who has risen from his lap and turned toward the viewer. She was identified in a well-known review by Ruskin as a fallen woman, awakened to the error of her ways.[18]

The Gold Scab presents a revelation of a different sort. Whistler exposes Leyland as a miserly, inhuman beast, whose very skin has been transformed to scaly feathers by selfishness and greed. His lack of discernment is revealed by the title of the song he plays—"FRiLthy Lucre" surely lies far beyond the province of art. His remarkable presence at the piano—for no greater purpose than to gloat over his fortune—signals an even deeper breach of taste. He is surrounded in a noxious fog of turquoise, blue, and gold—the colors of the Peacock Room—and patterns inspired by peacock feathers crowd the space around his feet. Above the piano is Whistler's signature, in the form of a deadly butterfly, its improbably long, barbed tail extending toward the back of Leyland's neck—an imminent attack of which he seems unaware.

The evolution of Whistler's signature, a stylized butterfly monogram, illustrates the progression by which the artist's dual identities—artistic genius and hostile provocateur—became inseparable aspects of his public persona. His use of the butterfly began in 1869 when, influenced by the signatures and seals on Japanese woodblock prints, he developed the design based on his initials, JW. At first, as on *The Gold Scab*'s frame, the butterfly was isolated in a compact circle. After the trial against Ruskin in 1879, a stinger was added to the butterfly's tail, and it took on a more expressive role in Whistler's works. In 1890, when Whistler published *The Gentle Art of Making Enemies*, a discussion of the Ruskin trial accompanied by a collection of poison pen letters written to dissident critics, venomous butterflies were used throughout the text to amplify his arguments.[19] The inclusion of a particularly ominous butterfly in *The Gold Scab* marks the painting as one of the first and most pointed public declarations of his discontent.

In this scabrous and unflattering portrait of Leyland, the union of artful butterfly and vengeful scorpion is complete. After Whistler's death, a fellow artist remarked: "he once spoke of himself as a 'soiled butterfly.' Surely this is the first recorded instance of a butterfly being an aggressive and vindictive insect."[20] Yet Whistler's butterfly, armed with a malignant barbed tail, was often vindictive, particularly when the artist thought his work was underappreciated or threatened. Facing such circumstances Whistler marshaled any and all of the weapons at his command, twisting and attacking artistic conventions—and even his subject—to assert the primacy of his art. [AG]

DESOLATE LANDSCAPES OF THE MIND

When Elihu Vedder (1836–1923) was profiled in the *Atlantic Monthly* in 1887, he was already well known as an illustrator and painter of haunting, symbolist pictures set in imaginative landscapes. As the *Atlantic* article noted: "[Vedder] dreams, but seldom forgets himself. There is calculation and method in his loftiest flights. The mysteries of life, the unknown and the preternatural, symbols and allegories, themes grand and terrible, allure him, and he undertakes to translate into intelligible form and color the unsubstantial pictures of the mind."[1] Although Vedder's visionary works were few in number compared to the more marketable landscapes and figure paintings he painted throughout his career, it was through his unsettling and enigmatic "pictures of the mind" that he made his mark. Unable to capture the weird, haunting subjects and effects of such pictures in more conventional terms, critics took to describing them as "Vedderesque."[2] Such "Vedderesque" paintings as *The Questioner of the Sphinx* (1863), *The Lair of the Sea Serpent* (1864, Museum of Fine Arts, Boston), and *The Sphinx of the Seashore* (1879) are today among Vedder's best-known works.

Vedder began his artistic career in New York in 1861, after studying briefly with the genre and history painter Tompkins H. Matteson and completing his training in Paris and Italy. From the beginning he was drawn to mythological and literary subjects and was especially fascinated by the lore surrounding both ancient Egypt and the sea.[3] *The Questioner of the Sphinx*, completed two years after Vedder established his New York studio (fig. 48.1), was the first of several paintings featuring a sphinx, a subject that would preoccupy him for the rest of his career. The painting—and its allegorical subject—quickly came to be associated with

the artist. When *The Questioner of the Sphinx* was mentioned in a review in 1868, five years after it was painted, it was considered unnecessary to explain the strange image: "Vedder's odd subject the 'Sphynx' [*sic*] is too well known to the readers of the *Art Journal* to need a description here."[4]

Vedder's interest in Egyptian monuments and culture was not unique; in the nineteenth century, Europe and America were gripped with a craze for all things Egyptian. This "Egyptomania," kindled in part by the comprehensive accounts of Egyptian culture produced during Napoleon's military campaign to Egypt at the end of the eighteenth century, grew as the nineteenth century progressed. The deciphering of Egyptian hieroglyphs in 1822, the opening of the Suez Canal in 1869, and the excavation of major sites such as Luxor and Giza spurred Western interest in Egyptian history and culture and provided models for the decorative arts and design.[5] Egyptian architecture was particularly influential. Obelisks (such as the Washington Monument, designed in 1845) were constructed in various American cities, and in the 1830s municipal buildings based on Egyptian funerary monuments, such as the New York courthouse and prison popularly called the Tombs (1835–38), began to appear in eastern cities. As a New Yorker, Vedder would have been familiar with the Tombs, but it is also likely that he saw such structures as a child in Cuba—where Egyptian-style prisons were popular—when visiting his father, who had a dental practice there.[6]

Vedder had not yet been to Egypt in the 1860s; he, as many Americans did, formed a notion of what it looked like based on photographs, drawings, and travel narratives such as John Gardner Wilkinson's *A Handbook for Egypt* (1847) and William Henry Bartlett's *The Nile Boat* (1850).[7] The

48. Elihu Vedder (1836–1923), *The Sphinx of the Seashore*, 1879
 Oil on canvas, 16 × 27⅞ in. (40.6 × 70.8 cm)
 Gift of Mr. and Mrs. John D. Rockefeller 3rd, 1979.7.102

sphinx was one of the most evocative and widespread symbols of Egyptian culture in the West and was featured prominently in both visual and written accounts of the region. The most famous Egyptian sphinx—and the one represented in *The Questioner of the Sphinx*—was the one at Chephren's funerary complex at Giza. Excavation of the Giza sphinx began in 1817 and continued sporadically until the 1920s. The first photographs of the sphinx were published in 1852, and in the following decades there was a ready market for prints of the monument.[8]

At the time the sphinx was discovered, only its massive head—measuring thirty feet high—was visible above the sand. The primary aim of the early excavations was to clear the lower portions of the monument—a task frustrated by frequent desert sandstorms.[9] In *The Questioner of the Sphinx* Vedder paints the monument in the early stages of excavation, when only its head could be seen. A single figure kneels beside its mouth, as though waiting for an answer. This exchange between questioner and sphinx is framed by a vast expanse of sand, punctuated by stone columns and slabs that suggest ruins. In the foreground, a human skull—perhaps belonging to a previous questioner—seems to sink into the sand beneath it.

The painting draws on an idea of the sphinx that would have been familiar to nineteenth-century viewers from Greek mythology. The Egyptian sphinx was the living image of the sun god, who guarded the approach to the palaces of the dead. The Greeks related the Egyptian word "sphinx" to their verb "sphingein," to strangle, constrict, bind tight, or throttle. In Greek myth, the winged creature—who was half-woman, half-lion—stopped travelers on the road to Thebes and demanded that they answer her riddle. Those who failed (as they all did with the exception of Oedipus) were strangled.[10] Through the interweaving of the Egyptian and Greek traditions, the sphinx came to be understood as a dangerous guardian of the secrets of life, often associated with powerful natural forces.

It was the metaphysical significance of the sphinx—rather than an interest in Egyptian history—that prompted Vedder's interest in the subject. Years after completing the painting he explained in a letter, "my idea in the sphinx was the haplessness of man before the immutable laws of nature."[11] In all of Vedder's work, he explored imaginative interpretations of reality that allowed him to investigate deeper meanings in his life and his art. Even after traveling in Egypt in 1889–90, he insisted that "a knowledge of the difference between the cartouches of Thotmes the Third

and Seti the First is not necessary to enable one to feel the size and grandeur of Egyptian architecture." Far more important is

> a certain inherent grandeur of conception which finally satisfies both the eye and the mind, belonging to the things themselves and totally independent of a knowledge of their history or meanings. It is their unwritten meaning, their poetic meaning, far more eloquent than words can express; and it sometimes seemed to me that this impression would only be dulled or lessened by a greater unveiling of their mysteries, and that to me Isis unveiled would be Isis dead.[12]

Vedder's writings during his trip to Egypt make it clear that for him, the poetic meaning of Egyptian monuments was found in the desolation they evoked. Describing a visit to the tombs at Luxor in a letter home, he wrote, "such desolation I never saw but it was <u>exactly</u> the kind of thing I have always been trying to paint."[13] He later recalled his impressions of the desert and "the lesson of the futility of human hopes one gets there."[14] W. H. Bishop, in a profile of Vedder published in the *American Art Review*, recognized this undertone in the artist's work, observing "a deep pensiveness mingled with a feeling for the desolate, weird, and mysterious. It is not a gentle, but a morbid melancholy. It is questioning, impatient, and a little desperate."[15]

Even without the Egyptian desert setting Vedder found so evocative, *The Sphinx of the Seashore* carries forward his exploration of the dark and desolate. Here Vedder's sphinx is a living creature rather than a figure in stone. Like the sphinx of Greek mythology, she has the head and breasts of a woman and the lower body of a lion. She reclines with one front paw stretched before her while the other rests on a human skull. Other skulls and bones surround her, some partially submerged in the muddy sand. The beach is littered with shells, strange, curving driftwood, and traces of a recent shipwreck such as cable rings, anchor flukes, wooden debris, and a scattering of the treasures once on board.

Writing in 1880, Bishop suggested that the scene "seems to epitomize the problem of ruin. It asks why ships go down, why the hard earnings of toil are scattered to the winds, why sailors drown and leave their bones to whiten on alien shores. It points the old, baffling inquiry as to the need in the economy of things of the wholesale devastation, involving guilty and innocent alike, which we observe in continual progress."[16] The progress of devastation continues with the thin, shallow waves in the foreground, which seem

Fig. 48.1. Elihu Vedder (1836–1923), *The Questioner of the Sphinx*, 1863. Oil on canvas, 36¼ × 42¼ in. (92.1 × 108 cm). Museum of Fine Arts, Boston. Bequest of Mrs. Martin Brimmer, 06.2430

poised to pull the litter on the beach—jewels and debris alike—out to sea. More ancient ruins are visible in the background, and the sphinx watches over it all, bathed in shadowy, reddish light under a dark, cloud-filled sky.

While *The Questioner of the Sphinx* engaged directly with Greek mythology surrounding the creature, in *The Sphinx of the Seashore* Vedder returns to the sphinx in a more symbolist mood, casting the creature as a universal power beyond the confines of Egypt. She retains the form of the Greek sphinx but here Vedder brings her to life, casting her as a powerful force on the human landscape

rather than a sentinel of a lost civilization. Critics noted the differences in approach between the two works. Frank Davis Millet, whose essay on Vedder mentioned both paintings, called *The Questioner of the Sphinx* "an intense and powerful suggestion of the great and lasting mystery that surrounds Egyptian history," while characterizing *The Sphinx of the Seashore* as "a good example of one of the vagaries of imaginative painting, to which it seems as if a certain element of the awful and the weird was as necessary as salt is to food."[17]

Although Vedder seems to have drawn on shared myth-

ologies of dangerous, female creatures such as sirens, mermaids, and other femmes fatales, his vibrant sea sphinx is also certainly a product of his own imagination.[18] A review of *The Sphinx of the Seashore* in the *Boston Evening Transcript* saw it as "one of those pictorial nightmares characteristic of the artist," which "successfully blends psychological truths with concrete forms of beauty and ornament."[19] Vedder's decision to represent the sphinx in such a charged watery setting was likely inspired in part by the annual inundation of the Nile, which was frequently pictured in travel accounts and guidebooks to Egypt.[20] The river, which covered the valley and delta in August and September of each year, could cause destruction but also provided necessary fertilization for the land, enabling farming. In Egyptian mythology the Nile was considered a moral force; its role as both giver and destroyer of life lent the river an air of ambiguity that would have appealed to the artist.

Recent studies of the painting have suggested that it may in fact have been inspired by a feverish nightmare the artist had as a young man, after returning from a fishing trip while recovering from a gunshot wound to his arm.[21] Whatever his inspiration, Vedder revisited the theme of sphinx as guardian of destruction in a drawing for Edward FitzGerald's *The Rubáiyát of Omar Khayyám* (1884), his most famous illustration project. In a plate titled *The Inevitable Fate*, Vedder depicted a sphinx lying atop a pile of bones and parts of machinery. In a manuscript note, he explained: "This figure of an all-devouring sphinx stretched over the remains of Creation typifies the destructive side of Nature."[22] *The Sphinx of the Seashore*, too, features a sphinx presiding over the wreckage of civilization. Both images depart from the conception of the sphinx as a reticent stone monument that Vedder explored in *The Questioner of the Sphinx* and other paintings set in Egypt.

The Sphinx of the Seashore and *The Inevitable Fate* engage Vedder's evolving understanding of the sphinx as keeper of destructive forces. In *The Sphinx of the Seashore*, the dark waters of the sea that are merely hinted at on the horizon in *The Questioner of the Sphinx* encroach ominously on the desolate shore. By the time Vedder drew *The Inevitable Fate*, the destructive forces of nature had been further distilled into the figure of the sphinx herself, who, even without the approaching tide, was mistress of the barren landscape. No longer the mysterious remnant of a lost culture, Vedder's dynamic, living sphinx emerges as an exotic, sexualized creature who presides over the unraveling of civilization. Vedder imaginatively combines actual knowledge and the associations carried by the sphinx with his own haunting vision, as he did in his most compelling works. When asked to explain his enigmatic pictures, Vedder replied: "I have intended to hold the mirror up to nature, only in this case nature is the little world of my imagination in which I wander sometimes and I have tried to give my impression on first meeting these strange beings in my wandering there. So I must use my painting as a mirror and only reflect without explaining. If the scene appears extraordinary, all I can say is that it would be stranger if it were not."[23] [AG]

187

49. FRANK DUVENECK, *Study for "Guard of the Harem"*

"TALENT OF THE BRUSH"

Frank Duveneck (1848–1919) had a long and successful career as an exhibiting artist and teacher in Cincinnati, Ohio, yet he is best remembered for the paintings he produced as a young man, while working and traveling extensively in Europe. Whether painting landscapes, still lifes, or the portrait heads for which he was best known by his contemporaries, Duveneck distinguished himself through his direct and spontaneous handling of paint. His mastery of this painterly technique, which he adopted as an art student in Munich, led John Singer Sargent (1856–1925) famously to declare: "After all's said, Frank Duveneck is the greatest talent of the brush of this generation."[1]

Born in Covington, Kentucky, across the Ohio River from Cincinnati, Duveneck began his artistic career as an apprentice in an altar-making shop, where he painted altarpieces and decorations for Catholic churches.[2] In 1870, at the age of twenty-two, Duveneck went to Germany to study at the Munich Art Academy. Americans who went abroad to study art in the 1870s chose between Paris and Munich. At that time, the differences in curriculum at the two academies were striking. Whereas training at the French Academy emphasized figure study and scrupulous drawing, training in Munich favored direct drawing on the canvas with a heavily loaded paintbrush. This brushy technique defined form as a series of blended planes and colors and lent the finished paintings an air of spontaneity that works based on firm, linear drawing and the measured application of paint did not share.[3]

It has been suggested that the understanding of German language and culture fostered by Duveneck's upbringing in a German immigrant community in Kentucky influenced his decision to study in Munich. Whatever the reason,

Duveneck's choice shaped his future direction as an artist. Wilhelm Diez, a professor in Munich, persuaded Duveneck not to continue with church decorating and introduced him to the teachings of Wilhelm Leibl, an influential German artist who had adapted the innovative realist style of the French painter Gustave Courbet.[4] Leibl was the greatest advocate of the *alla prima* (or "all at once") method of painting for which the Munich Academy became known. He insisted that works be finished in one session, painted wet into wet, without the usual final step of overpainting or glazing to unify the elements of the picture.[5]

Duveneck was a star student at the Munich Academy. He adopted Liebl's rapid, direct technique, with its emphasis on thick layers of paint applied with broad, visible brushstrokes, as well as the method of straightforward observation and unsentimental rendering of everyday life promoted by his teachers. In 1872, two years after entering the academy, he won a prize for composition and was granted the use of a studio and expenses for models. Many of the works Duveneck completed during this time were head studies or paintings of single figures. Such formats were popular among students in the Munich Academy because they required little studio space and few props.[6] Yet even after completing his training, Duveneck continued to paint portrait heads and isolated figure studies. In 1875, after he returned to the United States, several such works were shown to great acclaim at the Boston Art Club.

Reviews of the Boston Art Club exhibition formed the basis of Duveneck's reputation and set a pattern for future discussions of the artist's work, which invariably center on his mastery of technique and unidealized representation of his subjects. One of the artist's most notable early critics was

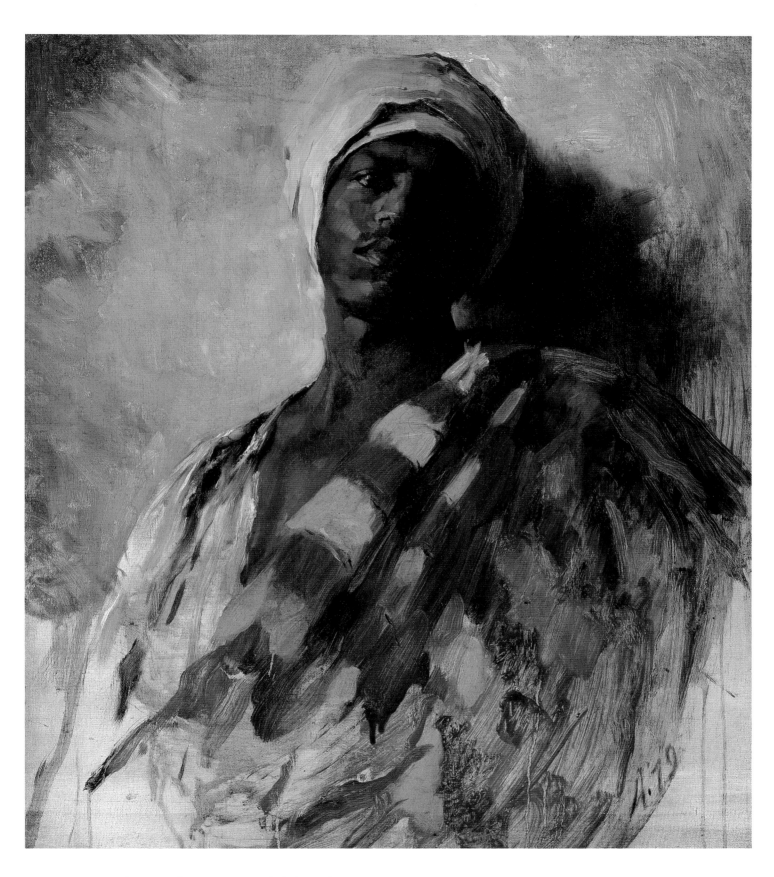

49. Frank Duveneck (1848–1919), *Study for "Guard of the Harem,"* 1879. Oil on canvas, 30 × 26 in. (76.2 × 66 cm). Gift of Peter McBean, 1990.11

Fig. 49.1. Frank Duveneck (1848–1919), *The Turkish Page*, 1876. Oil on canvas, 42 × 58¼ in. (106.7 × 148 cm). Pennsylvania Academy of the Fine Arts, Philadelphia. Joseph E. Temple Fund, 1894.1

Henry James, who introduced his review in the *Nation* with the auspicious words: "The discovery of an unexpected man of genius is always an interesting event, and nowhere perhaps could such an event excite higher relish than in the aesthetic city of Boston." James was impressed by Duveneck's technique, but the primary focus of his review was the artist's striking naturalism. He noted: "Mr. Duveneck is a painter of the rigidly natural school; unadorned reality is as yet his exclusive theme."[7] In describing several of the portraits in the exhibition, James observed: "Mr. Duveneck's models happen to have been very ill-favored persons, and he has reproduced them without a hint of compromise or arrangement."[8]

Despite the enthusiastic notice Duveneck received in Boston and his success as a teacher at the Ohio Mechanics Institute, it remained difficult for him to find buyers for his work. Not long after the exhibition at the Boston Art Club, he returned to Munich to establish a studio. He discovered that the new star at the Munich Academy was William Merritt Chase (1894–1916), a fellow midwesterner. Chase and Duveneck became friends, later renting a studio in Venice in 1876–77. During that time they shared supplies, props, and finances, often painting each other when they could not afford models.[9] Chase ultimately became a successful painter and teacher in New York, noted for his dramatic and exotically furnished studio. He encouraged Duveneck to experiment with the "orientalist" subjects drawn from Near Eastern cultures—such as harems, North African street markets, and views of Egypt—then popular among French academic artists.[10]

Often, Chase and Duveneck painted the same subjects; in 1876, shortly before they moved to Venice, both completed paintings titled *The Turkish Page*, using the same model and arrangement of props. In Duveneck's version of the painting (fig. 49.1), a shirtless young boy draped in luxurious fabric and wearing a red fez is seated on a leopard skin rug. A large, brass Moroccan water pitcher is to his left, and in his lap he holds a metal bowl filled with fruit. A white cockatoo, wings outstretched, balances on the bowl's rim, eyeing the cluster of grapes trailing over its side. As critics were quick to note when the work was shown at the National Academy of Design in New York in 1877, it was not a successful narrative painting, let alone an appealing orientalist work. A reviewer in the *Atlantic Monthly* complained:

It has, properly speaking, no local color, no locality. The boy is quite as much Jewish as Turkish. With the

exception of his fez, his costume . . . is not that of a Turkish page. . . . There is something annoying and even exasperating in this uncertainty in which we are left in regard to the meaning of the scene before us, which, added to the boy's painful emaciation and the uninteresting, if not positively disagreeable character of his face, detracts greatly from the pleasure we might otherwise have in the technical qualities of the painting.[11]

Other reviewers also noted Duveneck's strong technique and the lack of convincing anecdote in the picture. A critic for *Scribner's* called it "a gorgeous painting of still-life, of which the attenuated 'Turkish Page' is a mere accessory."[12]

George McLaughlin, commenting on the painting in a profile of Duveneck published in the *American Art Review* in 1881, had a similar reaction, characterizing the painting not as an orientalist work but as a study in technique: "The picture is in reality made up of studies. There is no serious attempt to make it conform to the title it bears, the tanned hands of the page presenting a marked contrast to the other portions of the body, precisely as it would appear on the arms of an academy model."[13] Duveneck did not arrange or idealize his subject as would have been necessary to produce a convincing image of a Turkish page; instead, he painted the model and the studio props just as he saw them.

The technique and straightforward observation Duveneck had learned in Munich, so effective in rendering portrait heads, did not serve the aesthetics of narrative painting—especially when it came to orientalist subjects, which were expected to follow conventions established in travel accounts, literature, and popular illustrations of exotic Eastern cultures.[14] Aside from the painting's title, Duveneck gave little clear indication that the work was set in Turkey, and he provided no sense of the daily life and activities of a Turkish page. These were not deficiencies for some. McLaughlin concluded, "Nothing can excel his *technique*. It is a model of strength, a *résumé* of all the qualities that go to make up manual skill, based, it may be said in this case, upon powers of observation of the first order."[15]

After returning from Venice in 1878, Chase left Munich to pursue a teaching career in New York City. Duveneck stayed behind and established an art school of his own. By the late 1870s Munich had become a favorite place for Americans to pursue their artistic training, and it was increasingly difficult for students to gain access to instructors at the academy.[16] Duveneck's school offered an alternative. It began as an informal group referred to as the Duveneck

Fig. 49.2. Frank Duveneck (1848–1919), *Guard of the Harem*, ca. 1880. Oil on canvas, 66 × 41¹⁄₁₆ in. (167.6 × 104.1 cm). Cincinnati Art Museum. Gift of the artist, 1915.115

Boys and included young Americans such as John White Alexander, Otto Bacher, and Joseph DeCamp. After teaching for one year in Munich and offering classes the following summer in the Bavarian village of Polling, Duveneck moved his school to Florence in October 1879. For the next two years he and his students spent winters in Florence and summers in Venice.[17]

After moving to Italy, Duveneck's palette grew brighter and more colorful, and he painted fewer of the gritty studies of peasants and street types, which had become his specialty in Munich.[18] One of his first Italian pictures was another orientalist subject: *Guard of the Harem* (ca. 1880). The study for the painting, dated 1879, may have been one of the first works he completed after settling in Florence. Both the study and the subsequent painting, which remains unfinished (fig. 49.2), depict a dark-skinned man—likely a North African model—leaning against a wall.[19] His turbaned head is turned to his left, and he looks off to the side, his chin slightly raised. In the painting, there is a patterned curtain or screen to his right, perhaps meant to mark the harem entrance. While the guard's head and torso are carefully painted, the rest of his body is barely suggested in boldly brushed areas of dark paint. Toward the bottom of the canvas the forms dissolve further into loose shading and faintly painted lines.

The study is focused on the most resolved areas of the painting—the guard's head and torso, which fill the canvas. Here the guard's gaze is less sidelong than in the painting, and he seems to look toward the viewer, half of his face darkened by shadow. In format the study resembles the portraits by the seventeenth-century Spanish and Dutch artists Diego Velázquez and Frans Hals whom Duveneck emulated as an art student, as well as the heads he sketched in teaching demonstrations.[20] Elizabeth Boott, who became

Duveneck's student in Munich—and later his wife—described such a demonstration in a letter to friends in Boston: "He sketched a head for me today. It is wonderful to see him sling the paint. . . . The dragging of dry color done so much in the French school, he does not seem to practice at all. Everything is moist, he paints in a puddle in fact. . . . The paint seems to squirm round at his bidding in the most extraordinary manner and model itself."[21] This effect can clearly be seen in the study, particularly around the guard's chest and shoulders, where the paint has been allowed to drip and run.

Although *Guard of the Harem* was never finished or exhibited, its large size suggests that it may have been intended for exhibition, perhaps in answer to critics who had dismissed *The Turkish Page* two years earlier. *Study for "Guard of the Harem"* illuminates the differences between the two works. Here, rather than a "series of studies"—as some critics described *The Turkish Page*—the artist presents a study of a single figure, in this case a convincingly Arab model with appropriate costume and props. Yet the distance between the two paintings is in fact not so great. While the later work's tight focus on an Arab guard—a sort of type—would have been in keeping with the taxonomic approach common to orientalist imagery, this image, too, departs from the expected conventions of Orientalism. Details of costume and setting are virtually absent—especially in the study—and the painting lacks the arrangement of figures and objects that might suggest a narrative. Instead, the emphasis is on the guard's intense and soulful expression—captured masterfully in broad and spontaneous slashes of paint. Like *The Turkish Page*, both the *Study for "Guard of the Harem"* and the later painting subordinate the mysteries of the East to the "talent of the brush." [AG]

IMAGING NORTHERN EXPLORATION

At a time when American fascination with exploring exotic, uncharted territories was at its height, William Bradford (1823–1892) was one of many artists who traveled to distant places in search of grand landscape subjects. Arctic scenery became his specialty. In 1876 the *San Francisco Daily Evening Bulletin* declared: "Bradford as an artist has taken possession of the Arctic region. The country all up around the North Pole belongs to him by right of artistic possession."[1] Bradford had at that point been painting coastal scenes for more than twenty years, specializing in Arctic landscapes since his first expedition to Labrador in 1861. During the series of extensively documented trips he made to the region in the following decade, Bradford produced photographs, sketches, and studies on which he based his paintings for the rest of his career. He became known as a painter, photographer, and explorer, presenting stereopticon slide lectures about his travels to audiences in the United States and England, and in 1873 published a lavish volume entitled *The Arctic Regions, Illustrated with Photographs Taken on an Art Expedition to Greenland*. Bradford spoke of "a revelation of a new world," filled with "wonderful manifestations of beauty and sublimity."[2] It was this world he made available through his art.

It may have been inevitable that Bradford, who grew up near the whaling center of New Bedford, Massachusetts, would be drawn to maritime painting. He was already in his early thirties when—after the failure of his merchant tailor business—he began to paint. He had spent his entire life by the sea and from the beginning was attracted by local subjects.[3] His first works were ships' portraits; under the tutelage of Albert Van Beest, a Dutch marine painter with whom he shared studio space in exchange for art instruction, he began to take on more elaborate compositions. He gradually extended his range to include coastal and harbor scenes around New Bedford, and over time his search for subject matter drew him farther and farther north.[4] His quest for grand landscape subjects was likely inspired by the successes of the acclaimed western painter Albert Bierstadt (1830–1902), a fellow New Bedford resident with whom Bradford maintained an acquaintance throughout his career, and also the renowned landscape painter Frederic Edwin Church (1826–1900).[5] In 1861, the same year that Church's *The Icebergs*, a monumental painting of the Newfoundland coast, began an acclaimed multi-city tour, Bradford made his first Arctic expedition. While Church's picture no doubt encouraged Bradford to pursue his own artistic exploration of the northern Atlantic, it is likely that the exhibition of *The Icebergs* was especially influential in securing financing for his voyages north.[6]

During the mid–nineteenth century the American shipping and whaling industries grew rapidly, and the United States was soon second only to England in maritime power.[7] As the sea became increasingly important to national identity, marine subjects grew ever more popular in American art and literature, capturing the imagination of such writers as Herman Melville and Edgar Allan Poe. Melville's work, like Bradford's, was influenced by direct experience of the whaling industry. Before writing *Typee* (1846) and *Omoo* (1847), his first tales of seafaring adventure, Melville was a crew member on the *Acushnet*, a whale ship under the direction of Bradford, Fuller, and Co., a venture owned by Bradford's father and uncle. Melville deserted the ship in the Marquesas Islands, later writing *Moby-Dick* (1851), the story of a whaling expedition that sails from New Bedford.

50. William Bradford (1823–1892), *Scene in the Arctic*,
ca. 1880. Oil on canvas, 29⅝ × 47¼ in. (75.2 × 120 cm)
Gift of Agnes van Eck Reed, 1991.39

Fig. 50.1. John Dunmore and George Critcherson, *The Steamer "Panther" Moored to the Ice in Melville Bay*, 1869. Albumen print, 11⅝ × 15⅛ in. (29.5 × 38.4 cm). New York State Office of Parks, Recreation and Historic Preservation, Olana State Historic Site, OL.1992.4

American fascination with the ocean and its frontiers was not limited to adventures in the South Seas and dramatic stories of whaling off the New England coast.[8] The expansionist impulse and scientific interests that had driven exploration of unknown territories such as South America and the Far West soon gave rise to widespread interest in the unfamiliar landscape of the Far North.[9] Expeditions to the Arctic were avidly followed in the press, and by the early 1850s several influential and popular accounts of the North Atlantic had been published. *The Open Polar Sea* by Dr. Isaac Hayes—who was a friend and drawing student of Church and later accompanied Bradford to the Arctic as a scientific adviser—quickly passed through seven consecutive reprintings after it appeared in 1855. Bradford himself is known to have read Elisha Kent Kane's *Arctic Exploration in the Years* 1853, 54, 55, an equally popular book published the following year. The artistic illustrations that accompanied such accounts helped fuel their popularity. Kane's text

was notable for its dramatic wood and metal engravings of the Arctic landscape by the marine painter James Hamilton.[10] By the early 1860s artistic representations of the region held equal weight with the scientific findings produced by the earliest Arctic explorations. With the publication of Louis L. Noble's *After Icebergs with a Painter: A Summer Voyage to Labrador and Around Newfoundland*, in 1862, the artistic perspective on the region moved to the fore. Noble had accompanied his friend and neighbor Frederic Church to Labrador and Newfoundland in 1859; his book introduced readers to the unique perspective of the artist-explorer. Although Church was never referred to by name, he was easily recognizable to many readers in the wake of the highly publicized exhibition of *The Icebergs*.[11]

A copy of Noble's *After Icebergs* was on board during Bradford's third northern expedition in 1864, and comments he made in his writings and interviews suggest that he too believed in the artist-explorer's unique perspective

on the unfamiliar polar landscape.[12] Many nineteenth-century landscape painters were knowledgeable about things scientific, and Bradford's commitment to science becomes particularly clear in accounts of his expeditions. He was kept abreast of both the artistic and scientific discoveries presented by Arctic exploration, and he bridged these interests by becoming one of the first artists to champion—and rely heavily on—the use of photography. Professional photographers were aboard to assist Bradford in documenting Arctic scenery on every expedition from 1863 forward, and the tipped-in photographs that illustrate *Arctic Regions*, a visual and narrative record of his culminating voyage to Greenland in 1869, distinguish it from previous accounts.[13] As a result of his open—and well-publicized—use of photography in the early days of the medium, Bradford's depictions of the Arctic were considered especially accurate. In 1873 the *Art Journal* declared, "Mr. Bradford's are the only works which profess incontrovertible truth in the representation of the northern regions."[14] A decade later, a writer for the *Philadelphia Photographer*, who perhaps held fewer illusions about the straightforward documentary nature of photography, added, "He is what may be called a *truthful* painter, following nature conscientiously, adorning her, or changing her but little, except where her arrangements do not suit the limits of his canvas."[15]

Bradford acknowledged his dependence on the photographs taken during his expeditions of the 1860s; they, along with his more conventional sketches and artistic studies, provided him with subject matter for the remainder of his career. Yet he viewed photographs not as art in their own right but as incomplete documents to aid in the creation of the more "truthful" pictures his critics praised. The primary failing of photographic studies was that they lacked color. As Bradford explained, the "wild, rugged shapes [of the icebergs], indescribable and ever-changing, baffle all description, and nothing can do justice but the sun-given power of the camera. And even that must fail, for until retouched by hand the glorious phases of color remain unexposed."[16] By the mid-1870s, when Bradford began a seven-year stay in Albert Bierstadt's former studio in San Francisco, he was focused almost exclusively on evoking in paint the rich and strange contrasts of color that his photographs could not capture. In addition to photography, he consulted the wash drawings, oil and charcoal sketches, and copious notes about color and light effects he had accumulated during a decade of summer journeys to the North Atlantic.[17] The

paintings he produced, including *Scene in the Arctic* (ca. 1880), are the result of numerous combinations and reworkings of this source material, arranged for dramatic effect. He frequently reused successful formats, and many of the compositions of these years revisit familiar incidents from his final voyage in 1869, such as the exciting moments when the *Panther*, the Scottish auxiliary steam bark Bradford hired for the expedition, was halted in the ice floes of Melville Bay for three days before retreating.[18]

Scene in the Arctic exemplifies the composite nature of Bradford's late work. A single ship among the icebergs became his best-known subject in the late 1870s and 1880s, and this is one of several paintings by this title that Bradford completed during those years. Here we see a three-masted ship with its sails lowered, silhouetted against two towering icebergs as it cuts its way through a ragged sheet of ice bounded by smaller floes. Two small figures stand at the bow, one of them pointing to the terrain ahead. The subject seems closely related to the albumen print *The Steamer "Panther" Moored to the Ice in Melville Bay* (fig. 50.1), although the position of the ship's bow has been reversed on the canvas, and two of the figures present in the photograph have been omitted. The painted composition has been extended laterally, and the image is bathed in the cool, dramatic palette of blues, greens, and whites typical of Bradford's work. The most significant difference between the two ships may also be the least apparent: although the ship in the painting resembles the *Panther*, it lacks the steam bark's smokestack between the main and after masts—a detail Bradford usually included in his paintings, such as *The Panther among the Icebergs in Melville Bay* (1874).[19] *Scene in the Arctic* does not convey the sense of danger and tension present in many of Bradford's scenes of Arctic adventure, nor does it offer an accurate portrait of the ship that conveyed Bradford and his crew along the coast of Greenland. The emphasis here is not on documentary or historical narrative, but rather on the exploration of color and light effects that fascinated Bradford even as he meticulously documented the polar region with colorless photography. Photographs may have lent credibility to Bradford's claims of truthful representation of nature, but as an artist-explorer he was devoted to the pursuit of a higher truth, one he achieved in paintings like *Scene in the Arctic* by recasting a heavily documented region as dramatic landscape through the combination of art, science, and imagination.

[AG]

COMMON HEROES

It is not a "pretty" picture, this depiction of a group of half-naked men clustered outside the grim walls of the rolling-mill, washing up preparatory to lunch, and at the present day the painter himself does not set much store upon it, but at the time it was painted it marked a departure in American art. FRANCIS J. ZIEGLER[1]

Born in Kentucky, Thomas Pollock Anshutz (1851–1912) moved with his family in 1863 to Wheeling, West Virginia, where he spent his teenage years growing up amid the region's urban factories that dominated the banks of the Ohio River. As Anshutz scholars regularly point out, the artist's family had a long association with iron manufacturing.[2] Within this context, for instance, one writer notes that the "remarkably straightforward and unmelodramatic" representation of *The Ironworkers' Noontime* (1880) is a bold revision of the traditional renderings that present "the ironworker as a Vulcan-at-the-forge figure," which mythologized the working class rather than focusing on individual human characters.[3] Such paintings were usually based on literary scenes that bolstered class and immigrant stereotypes by creating picturesque visual tableaux of factory workers or inspiring machinery.[4] Anshutz's painting may even have been a direct response to John George Brown's anecdotal *Longshoremen's Noon* (1879), the period's most well-known depiction of this theme (fig. 51.1). These images constructed the laborer as a timeless archetype of the exotic worlds associated with fantasy, the supernatural, and even the demonic, which was reinforced by the all-male context and romanticized setting.[5]

The Ironworkers' Noontime is often cited as the first painting in America to depict "labor" because it portrays working-class subjects defined by the organizational relationships of industrial capitalism.[6] Yet, the discussions that follow such a declaration almost always generalize about the conditions of modernity spawned by the industrial revolution with little reference to the specific social, political,

and economic context that Anshutz encoded in this scene.[7] Most descriptions merely treat the painting as a transparent description of the change in these conditions brought about by the factory system, which reduced workers from craftspeople to laborers.[8] Astonishingly, during a special exhibition at the Metropolitan Museum of Art in New York during the 1939 World's Fair, the painting was exhibited to celebrate the relations between American employers and laborers, ignoring the historical grounds of the work altogether.[9] Even those more recent discussions that focus on the social context of the painting usually point to generalities, such as the prevalence of child labor in late-nineteenth-century American industry.[10] However, Anshutz not only signaled the consequences of the industrial revolution, he structured *The Ironworkers' Noontime* through mixed visual codes that reference modernity's specific effects on a particular place.

As the principal professor of life-drawing classes at the Pennsylvania Academy of the Fine Arts in Philadelphia and later the school's director, Anshutz headed one of the country's most significant institutions for training in the art of representing the figure.[11] First attending the academy in 1878, Anshutz became chief demonstrator in the life-class dissections in 1880 and assistant professor in painting and drawing to Thomas Eakins (1844–1916) when he joined the faculty in 1881. Eakins was one of the country's strongest proponents of anatomy in life-drawing instruction. However, the use of nude male models in his life-drawing classes when female students were in attendance erupted in a scandal, which Anshutz helped to create by bringing up

51. Thomas Pollock Anshutz (1851–1912), *The Ironworkers'*
 Noontime, 1880. Oil on canvas, 17 × 23⅞ in. (43.2 × 60.6 cm)
 Gift of Mr. and Mrs. John D. Rockefeller 3rd, 1979.7.4

questions about Eakins's ethical judgment with the board, and Eakins was forced to resign. After the resignation, Anshutz, along with James P. Kelly, was given charge of teaching the anatomy and life classes. In 1909 he became director of the academy following William Merritt Chase's resignation.

In spite of its Victorian-era prudery, the Pennsylvania Academy was one of the leading institutions of progressive art in America. Anshutz was passionate about modern art movements, a forward-thinking instructor who promoted the new color theory of American avant-garde artists and even produced his own Fauve-inspired works after a trip to Europe in 1911.[12] In subject matter, *The Ironworkers' Noontime* anticipates the work of a group of artists commonly known as the Ashcan School, many of whom Anshutz mentored at the Pennsylvania Academy.[13] These artists are generally acknowledged as the first in America to record the gritty, real-life experiences of the immigrant and working classes in the city.[14] They were closely aligned, as was Anshutz, with socialism and its optimistic belief in the role that the urban proletariat could play in the march of industrial progress.[15]

Anshutz began preparatory drawings for the painting during one of his yearly visits to his mother and his wife's family, who lived in his boyhood town of Wheeling, West Virginia.[16] He did not depict the current conditions of 1880 in his painting of an iron foundry. Rather, the scene is more typical of that of a foundry during his childhood in the 1860s. Nevertheless, Anshutz resists the sentimentality of the nostalgic perspective that usually accompanies early memories. Instead, he chooses to present these workers through the synthesis of unvarnished realism and classical allusion that was the hallmark of the Pennsylvania Academy and the instruction of Eakins.

Through a vocabulary rooted in academic life drawing, Anshtuz places the heroic male body on display by depicting these workers, many of whom are stripped to the waist, in classical poses that show off their muscular bodies. The delineation of anatomical detail creates the illusion of an objective and naturalistic scene, and yet the workers are invested with epic perfection. The men stretch and bend as if they were the idealized, youthful athletes represented in Greek and Roman sculpture, spread across a commemorative frieze (fig. 51.2).[17] Consistent with the visual codes of classical masculinity, there is a register of voyeuristic pleasure in the focus on strong, virile, muscular bodies in the painting.[18] Anshutz's idealist visual language contrasts dramatically with the more gestural, turbulent, and emotive

Fig. 51.1 [top]. John George Brown (1831–1913), *Longshoremen's Noon*, 1879. Oil on canvas, 33¼ × 50¼ in. (89.5 × 127.6 cm). The Corcoran Gallery of Art, Washington, D.C. Museum purchase, Gallery Fund, 00.4

Fig. 51.2 [bottom]. J. Liberty Tadd, *Large Antique Class (#3)*, 1901. Albumen print. The Pennsylvania Academy of the Fine Arts, Philadelphia. Archive Collection

mode of expression that characterized the Ashcan School painters he inspired, whose realism was often directed toward explicit social criticism.

The nostalgia motivating Anshutz's account is for a kind of labor that by 1880 was already passing away due to the increasing mechanization of factory processes that turned workers into mere attendants on equipment. These men (and boys) are "puddlers," the highly skilled laborers who produced the sheets of metal that were cut into nails.[19] The temperatures had to be calculated exactly; otherwise the sheets would not be soft enough to punch out the nails or hard enough to make them durable. Extreme precision and dexterity were necessary in handling the molds. Such exacting work demanded strength, agility, and endurance, qualities associated with a rugged manliness often felt to be lacking in professional men whose jobs were largely confined to pencil and paper. In the Victorian period, images of working-class virility were welcomed as an antidote to the perceived feminizing influences on society, especially the increased demand for mental rather than physical labor among the middle and upper classes. By recalling the bodies of laboring workers from his childhood, Anshutz seems to be expressing his own longings for an earlier definition of masculinity that was clearer and more traditional.

But while Anshutz enlists the ironworkers to reflect nostalgia for an earlier, seemingly less complicated social order, the canvas is organized to reflect the social fabric of the moment. The painting is divided into two competing spatial terrains. The ironworkers are displayed across a shallow foreground plane. The foundry, by contrast, is represented in a way that gives viewers a feeling of deep space. It appears to stretch from the foreground into the background as far as can be seen by means of a sharply angled perspective that vanishes almost exactly at the left edge of the painting. This dynamic arrangement contrasts with the more static presentation of the workers. The sense of movement is reinforced by a visual pun: the boxlike buildings topped by smokestacks create the impression of a railroad train, and a set of parallel ruts recalling railroad tracks extends from the foreground toward the same vanishing point. A preliminary oil study of the factory demonstrates that Anshutz has purposely altered the building's depiction in order to emphasize the analogy with a train.[20]

Such associations would have had widespread cultural resonance in 1880. At the 1876 Centennial International Exhibition in Philadelphia, the railroad was celebrated as America's most significant hope for the future, yet the country's most violent railroad strike to date took place the following year.[21] The most potent symbol of industrialization at the time, the railroad was showcased at the centennial as a sign of material progress and growth, exemplified by the newly completed transcontinental railroad. The high visibility of union activity in the railroad industry, however, bespoke a growing threat to those who feared that organized labor would be used by political radicals to attack capitalism and bourgeois values more generally. Especially significant to viewers of Anshutz's painting would have been the support by Pittsburgh's ironworkers for the railroad workers during the 1877 strike, still a vivid memory in 1880.

Within such a context, the ominous form of the darkly shadowed factory building and the gray bleeding of water from the trough, which spreads throughout the foreground like a stain, are reminders of both the auspicious power and the anarchic potential of the new industrial classes in emerging urban centers. It converts the individual figures from their classicizing heroism to an ominous threat by aligning them with the era's troubling social and economic realities. At the same time, the carefully constructed monumentality of the forms belies the modest scale of the 17-by-23-inch canvas, giving it the presence of a work with the much larger size of a traditional history painting. In effect, Anshutz has succeeded in an ambitious gambit, transforming a genre painting of modest scale into a history painting of immense portent through his use of a classical composition, idealized figures, and the encoded signifiers of contemporary events. [DC]

THE TRUTH ABOUT HISTORY

Thomas Hovenden built his reputation on works that depicted the domestic lives of average Americans. His *Breaking Home Ties* (1890), which shows a young man leaving his country home to seek his fortune in the city, was voted the most popular painting exhibited at the World's Columbian Exposition in Chicago in 1893.[1] In an era of rapid industrialization and urbanization, Hovenden's nostalgic images of traditional rural families preserved their disappearing lifestyles and values in the realm of art and seemed to provide a comforting corrective to the excesses of the Gilded Age.

Thomas Hovenden (1840–1895) was born in Dunmanaway, Ireland, and later apprenticed to a carver and gilder before commencing his formal studies at the Cork School of Design. In 1863, at the height of the American Civil War, he immigrated to New York, where he worked as a frame maker and attended night classes at the National Academy of Design. In 1874 Hovenden went to France, studied with Alexandre Cabanel at the Ecole des Beaux-Arts in Paris (1874–75), and joined the art colony in the Breton town of Pont-Aven. Hovenden returned to New York in 1880, and in 1886 he succeeded his friend Thomas Eakins (1844–1916) as Director of Instruction at Philadelphia's Pennsylvania Academy of the Fine Arts. Hovenden's French academic training and his use of photographic studies shaped a style of anecdotal, romantic realism that was perceived as *retardataire* by art critics but was embraced by the public for its accessible narrative content.

Hovenden's *The Last Moments of John Brown* (ca. 1884) depicts the legendary abolitionist martyr being taken to his hanging in Charles Town, Virginia (now West Virginia), on 2 December 1859.[2] On 16 October 1859 Brown and twenty-one followers had seized the federal arsenal at Harper's Ferry, Virginia (now West Virginia), hoping to inspire a general rebellion among enslaved African Americans. As the raid unraveled, Brown and six survivors were captured on 18 October by U.S. troops commanded by Colonel Robert E. Lee. Following a weeklong trial, Brown was convicted of "treason to the Commonwealth" and "conspiring with slaves to commit treason and murder," and was sentenced on 2 November to death by hanging.[3]

Hovenden's first (fig. 52.1) and second (pl. 52) versions of the subject both depict the condemned man descending the stairs of the Charles Town jail, with a noose around his neck and his arms pinioned at his sides.[4] The symbolism of John Brown in bondage, like the enslaved African Americans he sought to free, would have been immediately apparent to viewers.[5] Behind Brown is Sheriff James W. Campbell, who holds the death warrant, and the jailer John Avis, whose gray suit foreshadows the gray uniforms later worn by the Confederate army. Brown's African American sympathizers are kept at bay by armed Jefferson Guards, the Virginia National Guard unit responsible for escorting the prisoner between jail, courthouse, and site of his execution.[6] Pausing on the stairs, Brown leans over the staircase railing to kiss an African American baby held up by its mother, who is also a caregiver for the young white girl clinging protectively to her skirt.

Brown's position on the stairs, surrounded by hostile captors, recalls traditional depictions of Christ presented to the people.[7] Hovenden makes the Christ analogy explicit by giving Brown's upper body a cross-shaped backdrop formed by the vertical barrel of a gun and John Avis's horizontal belt on one side and a dark red brick on the other.

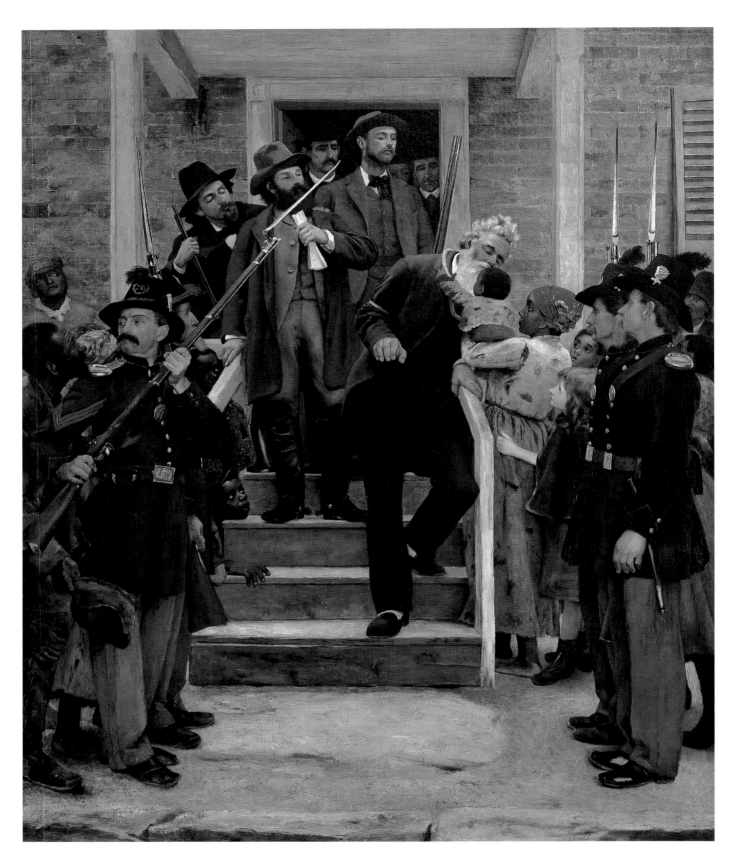

52. Thomas Hovenden (1840–1895), *The Last Moments of John Brown*,
ca. 1884. Oil on canvas, 46⅛ × 38⅛ in. (117.2 × 96.8 cm)
Gift of Mr. and Mrs. John D. Rockefeller 3rd, 1979.7.60

Brown's supporters frequently likened him to a biblical prophet and martyr, a modern Moses who attempted to lead enslaved African Americans to freedom. Comparing Brown's forthcoming execution to Christ's Crucifixion, Ralph Waldo Emerson wrote of "the new Saint whose fate yet hangs in suspense but whose martyrdom, if it shall be perfected, will make the gallows as glorious as the cross."[8] Emerson's friend Henry David Thoreau wrote, "Some eighteen hundred years ago, Christ was crucified; this morning, perchance, Captain Brown was hung."[9]

Hovenden's first version of the subject was commissioned by the manufacturer, art collector, and bibliophile Robbins Battell, of Norfolk, Connecticut.[10] Drawing on his French academic training, which often equated research with reality, Hovenden conducted extensive research on John Brown in Harper's Ferry and Charles Town.[11] The subject was not entirely original, as Louis Ransom's *John Brown on His Way to Execution* of 1860 (painting formerly at Oberlin College) and Thomas Satterwhite Noble's *John Brown's Blessing* of 1867 (fig. 52.2) both depicted Brown blessing (but not kissing) an African American baby.[12] In a letter to Hovenden dated 10 June 1882 Battell described his vision of the subject, emphasizing John Brown's kissing of the African American baby.[13] This legendary kiss was first described in a *New-York Daily Tribune* article published three days after Brown's execution:

> As he stepped out of the door, a black woman, with her little child in arms stood near his way. The twain were of the despised race, for whose emancipation and elevation to the dignity of children of God, he was about to lay down his life. His thoughts at that moment none can know except as his acts interpret them. He stopped for a moment in his course, stooped over, and, with the tenderness of one whose love is as broad as the brotherhood of man, kissed it affectionately. "That mother will be proud of that mark of distinction for her offspring, and

Fig. 52.1 [top right]. Thomas Hovenden (1840–1895), *The Last Moments of John Brown*, ca. 1884. Oil on canvas, 77⅜ × 66¼ in. (196.5 × 168.3 cm). The Metropolitan Museum of Art, Gift of Mr. and Mrs. Carl Stoeckel, 1897. 97.5

Fig. 52.2 [bottom right]. Thomas Satterwhite Noble (1835–1907), *John Brown's Blessing Just before His Execution*, 1867. Oil on canvas, 84¼ × 60¼ in. (214 × 153 cm). Collection of the New-York Historical Society, 1939.250

some day when, over the ashes of John Brown the temple of Virginia liberty is reared, she may join in the joyful song of praise which on that soil will do justice to his memory."[14]

The *Daily Tribune* article in turn provided the inspiration for the Quaker poet and abolitionist John Greenleaf Whittier's famous poem, "Brown of Ossawatomie" (1859), which included the following stanzas:

John Brown of Ossawatomie spake on his dying day:
"I will not have to shrive my soul a priest in Slavery's pay.
But let some poor slave-mother whom I have striven to free,
With her children, from the gallows-stair put up a prayer for me!"
John Brown of Ossawatomie, they led him out to die;
And lo! a poor slave-mother with her little child, pressed nigh.
Then the bold blue eye grew tender, and the old harsh face grew mild,
As he stooped between the jeering ranks and kissed the negro's child![15]

These reportorial and poetic visions of Brown's tender, grandfatherly action humanized a controversial figure who was, at the very least, culpable for murders both in "Bleeding Kansas" and in Harper's Ferry.[16] As both authors suggested, Brown's seemingly prosaic act of kissing the African American baby is prophetic for what it portends for this future generation—freedom.

In reality, the baby-kissing incident never occurred, as Hovenden knew from his extensive research, which included an interview with Brown's jailer.[17] Governor Henry A. Wise of Virginia, concerned that sympathizers would attempt to free Brown, had deployed 1,500 troops with orders to keep civilians away from the abolitionist and the hanging site, and to ensure that women and children in particular remained indoors.[18] John Wilkes Booth, the future assassin of President Abraham Lincoln, had to join the Richmond Grays militia in order to observe Brown's hanging.[19] For defeated Southerners who resented John Brown's mission and his mythic status, the baby-kissing story was demonstrably untrue. For victorious Northerners who revered Brown as an abolitionist martyr, the baby-kissing story was too good not to be true.[20]

Hovenden's first version of *The Last Moments of John Brown* was exhibited at Earle's Galleries in Philadelphia, at Knoedler's in New York, and at the Union League in Chicago, as well as in the American section of the 1889 Exposition Universelle in Paris, and earned the artist a national reputation.[21] Capitalizing on the painting's popularity, Hovenden created the second, two-thirds-scale version of *The Last Moments of John Brown*, painted with a tighter technique that would have facilitated its reproduction as a print.[22]

Hovenden's image of a benevolent John Brown's Christlike blessing of an African American child would have reassured Reconstruction-era viewers that the abolitionist's vision of freedom for enslaved African Americans had been redeemed by his martyrdom, which seemed to prefigure the horrific sacrifices of the Civil War.[23] Indeed, many Americans believed that the deaths of John Brown, Abraham Lincoln, and some 620,000 Civil War soldiers had cleansed the nation of the hypocrisy of the slavery system, which had undermined the principles of liberty and equality proclaimed in the Declaration of Independence, the Constitution, and the Bill of Rights.[24] This idealistic view was contradicted by the resurgent racism of the Reconstruction era, particularly the proliferation of Jim Crow laws that institutionalized prejudice. Between 1882 and 1884, as Hovenden completed his first John Brown painting, 153 African Americans were lynched. In 1883 the U.S. Supreme Court ruled that the Civil Rights Act of 1875 was unconstitutional. These historical realities suggest that John Brown's kissing of the African American baby was not the only fiction that is perpetuated in Hovenden's *The Last Moments of John Brown*. [TAB]

CONSPICUOUS BEAUTY

But portrait painting, don't you know, is very close quarters—a dangerous thing. JOHN SINGER SARGENT[1]

The outstanding portrait painter of his generation, John Singer Sargent (1856–1925) painted Caroline de Bassano (1847–1938) during the early years of his career, and this portrait reflects both his training and residency in Paris from 1874 to 1886.[2] Sargent initially enrolled in the official art school of Paris, the Ecole des Beaux-Arts, noted for its instruction in classical techniques, and then studied at the atelier of Carolus-Duran (1837–1917), an academic Impressionist and popular portraitist.[3] Sargent's Paris years, beginning when he was only eighteen years of age, are notable for his rapid rise and acclaim in the state-sponsored Salon, whose annual Paris exhibition, which defined the nineteenth-century French art scene, launched his career as a society portraitist.[4] Commissions that were unusual for a young foreigner came as Sargent shrewdly exploited his European upbringing and apprenticeship with Carolus-Duran, which provided an introduction into French society and allowed him to move easily in fashionable circles.[5]

In 1877, after only three years of study with Carolus-Duran, the Paris Salon accepted a portrait by Sargent, and two years later that precocious success was confirmed when Sargent's portrait of his teacher was awarded an honorable mention.[6] This portrait became the cover of the 17 January 1880 issue of *L'Illustration*, the conservative periodical of the Third Republic's new social hierarchy, and it assured that Sargent would gain the attention of Paris's fashionable beau monde because Carolus-Duran was the favorite portraitist of the elite society.[7] Sargent embraced his mentor's fluid working method, which he called *au premier coup*, achieved by applying paint directly on the canvas, without elaborate sketching or glazes, and pushing one color into another without waiting for the canvas to dry.[8] At his teacher's urging, Sargent traveled to Spain in 1879–80 to study the works of Diego Velázquez (1599–1660), which engendered in him a lifelong fascination with the European masters. That experience helped to create in Sargent's work a tension that conjoined traditional subjects and stylistic conventions with modern pictorial experiments in technique, spatial organization, and psychology.[9] It was a style perfectly suited to the tastes of a conservative social class that desired to appear au courant.[10]

Sargent's portrait of Caroline de Bassano was painted in 1884, the same year that his infamous portrait of Madame Pierre Gautreau, *Madame X* (1884), caused a scandal at the Paris Salon (fig. 53.1). From 1874 to 1884 Sargent had built a solid reputation at the Salon by introducing a psychological twist to standard subjects that tinged his works with just enough of the flamboyant decadence associated with the Aesthetic Movement to make them exciting and novel without threatening the conservative tastes and sensibilities of Parisian high society.[11] However, Sargent's notorious portrait of Gautreau stepped beyond acceptable boundaries.

Born Virginie Avegno in Louisiana, Gautreau was the American wife of a Parisian businessman. She exaggerated her beauty through theatrical displays that challenged social norms in the manner of the Aesthetes, often wearing revealing dresses and exotic cosmetics, dyeing her hair with henna, and highlighting her skin with lavender powder.[12] According to Albert Boime, Sargent's *Madame X* "is a testament to a compact between two cocky Americans to thumb their noses at envious foreign hosts."[13] The debate at the Salon centered on the diamond strap of her gown,

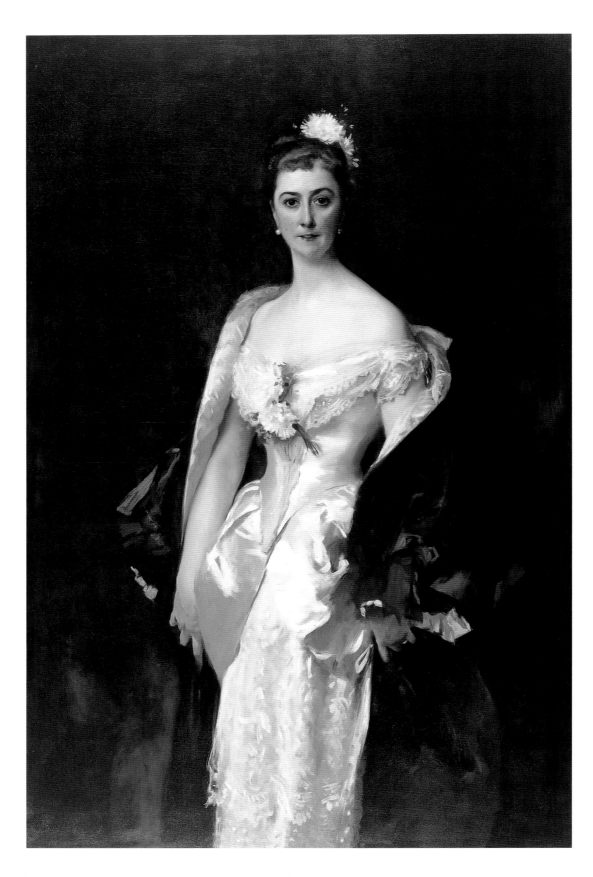

53. John Singer Sargent (1856–1925), *Caroline de Bassano, Marquise d'Espeuilles*, 1884. Oil on canvas, 62⅞ × 41⅜ in. (159.7 × 105.1 cm) Gift of Mr. and Mrs. John D. Rockefeller 3rd, 1979.7.90

which Sargent had painted as if it were sliding seductively off her shoulder, implying that her breast remained covered due only to the torqued position of her body.[14]

Although painted the same year, the portraits of these two prominent women in French society could not be farther apart in tenor and sensibility. Madame Gautreau is represented with the self-conscious affectation and elaborate artifice that "is a prime example of the Aesthetic Movement's love of the exaggerated posture and transformation of the body into a decorative object."[15] By contrast, Sargent's portrait of Caroline de Bassano relies on the traditions of grand manner painting, an aristocratic mode of self-presentation popularized in both London and Paris in the eighteenth century. A portrait in the grand manner stressed recognizable traits through a life-size, full-length likeness in a pose referred to as a "swagger."[16] The subject's face was painted with a smooth finish, designed to create a realistic depiction that suggested a readable, albeit idealized, personality. Such portraits borrowed postures, gestures, settings, and accessories principally from the baroque English court portraiture of Peter Paul Rubens and Anthony van Dyck, giving these painted indicators of social and political status the symbolic patina of intellectual and cultural history.

Auguste Rodin called Sargent the "van Dyck of our times," a moniker demonstrated in his glittering portrait of Caroline de Bassano.[17] The portrait is designed to convey her position in society as a titled aristocrat through the conventions of decorum and taste even as it records the ostentatious extravagance of her class-based privilege in the details of her swagger pose. However, in place of the imposing setting usually referenced in grand manner portraiture, Sargent isolates the marquise in a space meant to render her beauty as timeless. The weight of her status and position, registered by her expression, is reiterated by the opulence of her clothing and accessories. She stands in regal display, her luxurious satin wrap neither on nor off but rather slipping down to expose the full expanse of her pale shoulders and accentuating her long, graceful arm and slender neck. Ironically, Sargent manages to reveal a broad expanse of bodice and shoulder similar to that in his scandalous portrait of Madame Gautreau. Nevertheless, the swagger conventions of grand manner portraiture, which lend themselves to an aristocratic station, provide an air of respectability that the public found lacking in Sargent's portrait of an American-born socialite known for her decadence and sensationalism.

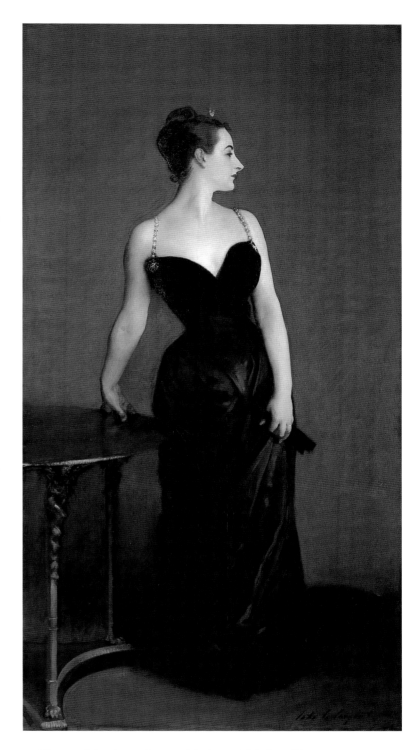

Fig. 53.1. John Singer Sargent (1856–1925), *Madame X (Madame Pierre Gautreau)*, 1884. Oil on canvas, 82¼ × 43¼ in. (208.6 × 109.9 cm). The Metropolitan Museum of Art. Arthur Hoppcock Hearn Fund, 16.53

Another major difference is the contrast between Caroline de Bassano's self-conscious and confidently direct gaze, which is customary in grand manner portraiture, and Madame Gautreau's affected, disinterested profile. Caroline de Bassano's face is fully realized through imperceptible brushstrokes that result in her sharply focused, frontal countenance. The impression, emphasized by her arched eyebrow, is meant to portray a powerful personality that is fully in control of her own display, assured and somewhat amused. Her gown, by contrast, is depicted with broad, visible brushstrokes that produce a highly tactile surface. Sargent's bravura expression in paint evokes a sensuality that the viewer translates into the textures of costly fabrics. Interestingly, flowers rather than jewelry set off her décolletage and head, as if the marquise herself were the jewel that crowns this ensemble of lace, satin, and flesh.

Sargent has deployed this tactile sensuality of the painted surface to represent a woman of seductive appeal whose image remains firmly within the conventions of decorous propriety prized by the upper class. At the same time, he discloses the sexual allure encoded in the conventions of the society portrait by emphasizing Caroline de Bassano's bold gaze. Erotic metaphor links wealth, class status, and female sexuality by representing the marquise as an exquisite physical object. However, in spite of the provocative possibilities she conjures, it is her tightly set mouth, pinched expression, and the wintry, ivory hues of her skin color and dress that remind viewers of the social boundaries she represents. A contemporary of Sargent writing about his portraits of such society women calls them "tense, 'prickly,' and complex," a judgment that could easily apply to this portrait of an aristocratic presence that remains cool and untouchably grand.[18] [DC]

OPULENT IMPRESSIONS

*Sargent is, by turns, very French, very British, and very watchful, which
is to say, very much an American kid raised abroad.* ADAM GOPNIK[1]

The American painter John Singer Sargent (1856–1925) was born in Florence, Italy, and grew up in the major cities of Europe, thanks to the peripatetic life of his parents, Dr. FitzWilliam Sargent and Mary Newbold Singer. In spite of his successful career as a surgeon in Philadelphia, Dr. Sargent was convinced by his wife to give up his practice so they could live a nomadic, expatriate existence, residing in Mediterranean pension houses in the winter and northern resorts in Switzerland, Germany, and France during the summer.[2] Such wanderings may be reflected in John Singer Sargent's early interest in painting Gypsies and other seemingly vagabond subjects in the Mediterranean countries of southern Europe and North Africa.[3] Exposed to European art and culture from birth, Sargent attended art schools wherever he was living and developed into a consummate cosmopolitan, evident in his portrait commissions of social elites, first in Paris and then in England and America.

Beginning in 1874, Sargent studied under the Parisian social portraitist Carolus-Duran (1837–1917) and matriculated at the Ecole des Beaux-Arts, developing his characteristic style of loose, fluid brushstrokes, rich coloration, and lustrous whites. Such effulgence is so clearly evident in his painterly vocabulary that Adam Gopnik has written, "In every portrait of Sargent's that works, there is a large, beautifully painted patch of white: … he achieved the shimmering complementary white that was an Impressionist dream object."[4] With visits to England in the 1880s, Sargent broke away from his Salon-oriented training, becoming more impressionistic in his techniques.

Although associated with European Impressionism in France and England, Sargent remained a United States citizen his entire life and often resided in America while working on portrait and mural commissions.[5] Later in his life, he gave up society portraiture for landscape painting based on sketches from his travels in the Alps and Italy (see cat. 55). He also hoped that public projects would help him to secure a permanent place in art history, his most famous being the murals for the new Boston Public Library (1890–1919), designed by the architects Stanford White and Charles McKim, and the Museum of Fine Arts, Boston (1916–25).[6] But throughout his adult life England remained Sargent's primary home, and his allegiance was rewarded in 1897 by his election to the British Royal Academy of Arts.[7]

Le verre de porto (1884) was painted the same year as Sargent's controversial Paris Salon portrait of Madame Pierre Gautreau, the infamous painting *Madame X* (see fig. 53.1), for which he was chastised by the French social elite because of the impropriety of his sitter's seductive pose and his acquiescence in her apparent class aspirations.[8] In spite of its original French title, *Le verre de porto* reflects a turning toward England that would lead him to settle there permanently in 1886.[9] Although still closely affiliated with the conservative Salon, Sargent was already challenging its dictates at the time of this painting. He was well aware of the eight independent Impressionist exhibitions that coincided with his years in Paris, was solicited for an exhibition by Berthe Morisot (1841–1895), and exhibited with Edgar Degas (1834–1917), Claude Monet (1840–1926), and Pierre-Auguste Renoir (1841–1919) at the Cercle des arts libéraux in 1882.[10] As *Le verre de porto* illustrates, his work was influenced by the Impressionists' nonacademic, modernist experiments, called "the new painting," evinced in the

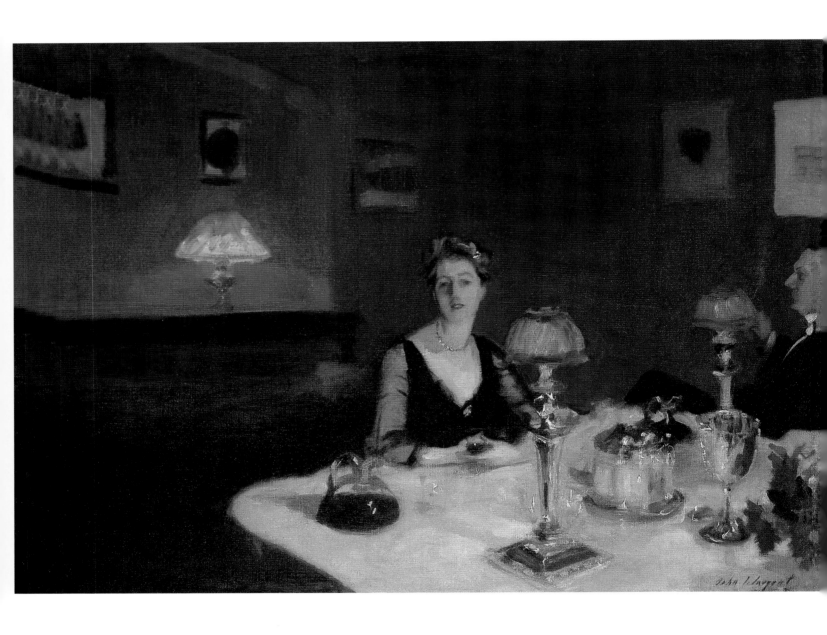

54. John Singer Sargent (1856–1925), *Le verre de porto (A Dinner Table
at Night)*, 1884. Oil on canvas, 20¼ × 26¼ in. (51.4 × 66.7 cm)
Gift of the Atholl McBean Foundation, 73.12

juxtapositions of light and dark to suggest a fleeting moment, the cameralike cropping of space, the unusual canted angles, and the domestic subject matter. Marc Simpson points out that Sargent must have believed the painting "to be French in feeling" because he borrowed it in 1885 to show in the avant-garde venue of Galerie Georges Petit's Exposition Internationale alongside works by Monet and Renoir.[11] From 1886 Sargent exhibited regularly at the New English Art Club, England's institutional center for impressionist painters.[12] It is ironic that Sargent's "Impressionist experiments are essentially an English phenomenon," although Albert Boime finds that the English Aesthetic Movement shared important affinities with Impressionism, especially the emphasis on decorative effect and stylized artifice.[13]

Sargent was able to enter English society largely through the efforts of another American expatriate, the writer Henry James (1843–1916), and their mutual friend Margaret Stuyvesant White, wife of a high-ranking United States Embassy official in London, both avid supporters of the Aesthetic Movement.[14] One of his earliest English subjects, *Le verre de porto* is an informal portrait of Mr. and Mrs. Albert Vickers in the dining room of their Sussex house, Beechwood, in Lavington, near Petworth.[15] Edith Vickers (Lady Gibbs) was the second wife of Albert, director and later chairman of Vickers Ltd., a Sheffield engineering firm. The work was probably painted around the same time as Sargent's formal, full-length society portrait *Mrs. Albert Vickers* (fig. 54.1), which relied on the more conservative elements of his Parisian style.[16]

By contrast, *Le verre de porto* represents one of Sargent's most impressionist works. It records a momentary perception through the diffusion of light effects and emphasizes vivid surfaces over depth of emotion, which are hallmarks of the style. In spite of the seeming intimacy represented by the Vickerses' dining room, the composition suggests a psychological tension between the sitters. Mrs. Vickers occupies the center of the painting as if she were a single figure, replacing the usual narrative interactions that characterize the style of portrait known as a conversation piece, on which this composition is drawn. Mr. Vickers sits to her left, his profile barely included in the scene; although close, he is marginalized, quite literally, at the right edge of the painting as an observer rather than a participant.

The painting is organized around the disconcerting interval that divides its subjects. Mrs. Vickers looks directly at the viewer, who is implicated in the scene by the cut of the frame and angle of the table that positions the spectator as a third person at this elegant dinner party. Although they

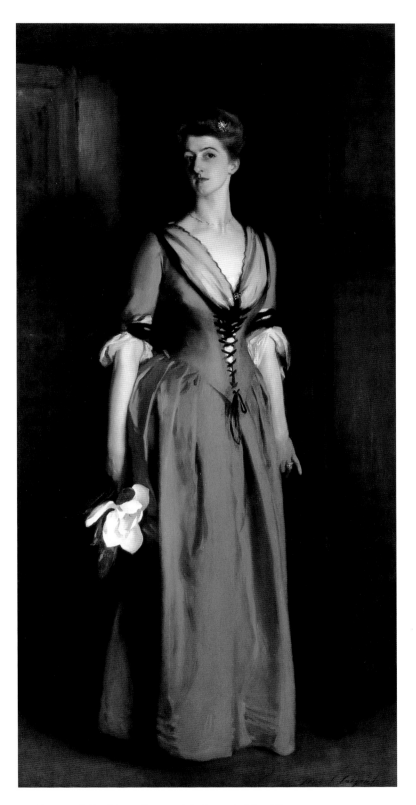

Fig. 54.1. John Singer Sargent (1856–1925), *Mrs. Albert Vickers*, 1884. Oil on canvas, 82¾ × 39³⁄₁₆ in. (210.2 × 101.1 cm). Virginia Museum of Fine Arts, Richmond. The Adolph D. and Wilkins C. Williams Fund, 92.152

share a table, Mr. and Mrs. Vickers appear isolated in their mutual estrangement, which the intensely red palette of the room magnifies. The work reflects a popular theme of the time, most famously expressed by Sir William Quiller Orchardson's *Mariage de Convenance* (1883, Kelvingrove Art Gallery and Museum, Glasgow), which was shown in 1884 at the Royal Academy of Arts in London and became one of the most frequently discussed paintings of the era.[17]

Sargent gives his version of the scene an added psychological charge, creating near-theatrical light and dark effects through strongly contrasting tonalities cast by the room's lamps. Conspicuous shadows play across Mrs. Vickers's face and produce the deeply darkened eye that reinforces her weary gaze. She cradles her glass of after-dinner port and looks to the unseen viewer, whom she hopes to engage in an effort to animate her fashionable yet apparently lonely and tiresome life. Mr. Vickers seems completely uninterested in his wife, facing her but, as one critic writes,

"decidedly not interested in looking at her, his thoughts drifting off like the smoke from his cigar."[18]

At the same time, these light effects draw attention to the elegant silver and crystal on the table by infusing them with spectacular brilliance. Their glittering surfaces reflect a life of luxury and pleasure often celebrated in impressionist paintings.[19] However, these objects dominate the spatial terrain of the canvas between Edith and Albert Vickers, dramatizing the degree to which they are separated by their opulence rather than comfortably surrounded by it.

It has been noted that Sargent never completely adopted Impressionism, but paintings such as this "brought him as close as he would ever come to Monet's defenselessness before the effects of light."[20] Its modern compositional elements and impressionist effects create a disturbing, informal portrait of a type that recalls the café scenes of Edgar Degas.[21] [DC]

55. JOHN SINGER SARGENT, *Trout Stream in the Tyrol*

WATCHING THE WATER

In 1885 John Singer Sargent (1856–1925) went with a group of American and British painters to paint the English landscape around Broadway in the Cotswolds. While the other artists carefully selected their scenes, Sargent chose his indiscriminately, stopping abruptly in the middle of a field, behind a barn, or facing a wall, setting up his easel and beginning that day's canvas. One observer remarked, "The process was like that in the game of musical chairs where the player has to stop dead, wherever he may happen to be, directly the piano stops playing."[1] But Sargent was not playing a game: he was training his eye. Sargent had spent the summer in Giverny with Claude Monet (1840–1926) and now, he explained, "in his half-inarticulate way," that "his object was to acquire the habit of reproducing precisely whatever met his vision without the slightest previous 'arrangement' of detail, the painter's business being, not to pick and choose, but to render the effect before him, whatever it may be."[2] After leaving Giverny, Sargent continued to write to Monet as he sought to master impressionist technique. Sargent requested information about the use of yellow and green and pressed Monet to visit London so he could advise Sargent on landscape.[3]

Some twenty years later, Sargent—with a profound sense of liberation—declared he was finished painting the society portraits that had made his name and turned his full attention to commissioned mural projects and landscapes. Scholars tend to overlook the landscapes. The knowledge that they were made while Sargent traveled with friends has marked them as diversions, especially when compared with the "serious" work of the large-scale, carefully researched, allegorical murals.[4] Yet these late landscapes—and there are hundreds of them—were neither hasty nor frivolous.

And while they depict the sights and scenery of exotic vacation spots and show friends luxuriating in the emptiness of somnolent afternoons, they also demonstrate Sargent's unfaltering dedication to looking closely at what is before him and vividly rendering what he saw.

Indeed, a great deal of labor was involved in producing these landscapes, a good part of it in just reaching the desired spot. Sargent set out for his painting day accompanied by his valet and sometime model Nicolo d'Inverno, who was loaded down with canvases, easels, as many as three umbrellas (against sun and wind), and props that might include dresses and a stuffed gazelle. While d'Inverno did the heavy lifting, Sargent followed an industrious painting regimen that found him at work every day, with the possible exception of Sundays, morning and afternoon. He was intrepid in reaching sites he wanted to paint. Adrian Stokes (1854–1935), who accompanied Sargent on three trips to the Alps and the Austrian Tyrol, described Sargent's precarious position as he painted an alpine stream: "I saw him working on a steep mountain side, the branch of a torrent rushing between his feet, one of which was set on stones piled up in the water."[5]

Perhaps that was Sargent's perch as he painted *Trout Stream in the Tyrol* (1914). In it, a stream pours through a forested landscape, its waters a froth of white, lavender, blue, green, and brown. Boulders are strewn along the watercourse, the stream surging over them in places. Little can be seen of the surrounding landscape. Evergreens edge the streambed, their spreading branches making an effective fence against sky and mountains. At the right, an angler prowls the bank, fishing satchel over his shoulder, rods in hand.[6] He watches the water intently. The bank is narrow

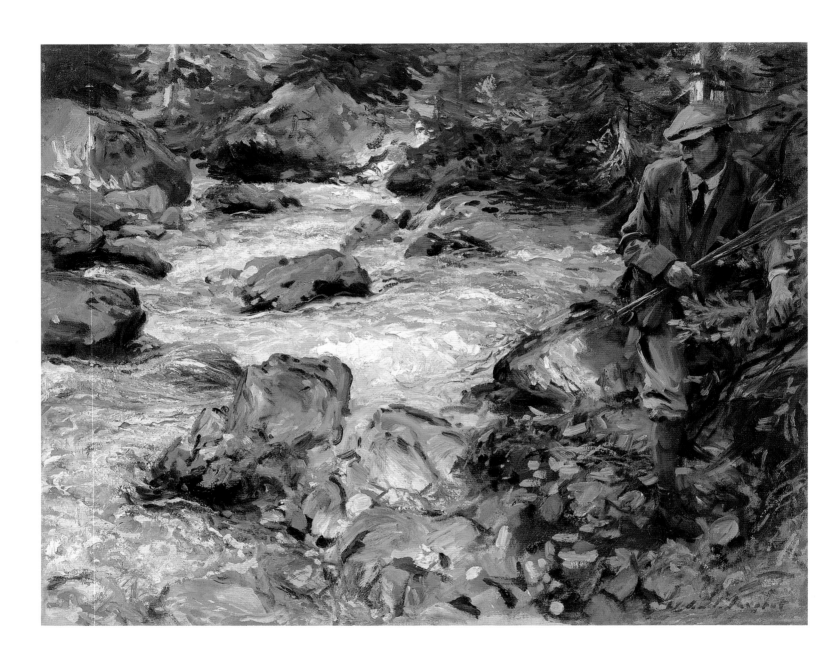

55. John Singer Sargent (1856–1925), *Trout Stream in the
Tyrol*, 1914. Oil on canvas, 22 × 28 in. (55.9 × 71.1 cm)
Gift of Isabella M. Cowell Estate, 1951.14

and the trees push in close. He holds a branch, steadying his balance even as he searches for a good place to drop his line. The stream is in shade but for scattered bright patches. A dapple of light catches the angler's cap and right lapel.

The painting contains all the hallmarks of Sargent's mature landscape style: high horizon; steep, disorienting perspective; foreground objects suggested with broad strokes rather than clearly delineated.[7] In *Trout Stream in the Tyrol*, the horizon is obscured completely. We look down on the man and the foreground boulders, yet the stream seems to flow from up above us. The water and rocks break down in the foreground into quick jabs and swipes of yellow, brown, black, and purple, here scalloped to show quick-moving ripples, there drawn in a thin line to depict a smooth flow, and underneath, layered in short swaths of yellow and orange to suggest stones.

Sargent professed the lack of ability for, and the lack of interest in, capturing sweeping panoramas of dramatic scenery. "I can paint objects; I can't paint *vedutas* [views]," he groused. And declared, "Enormous views and huge skies do not tempt me."[8] In his late paintings, Sargent repeatedly favored close, cropped landscapes. This tight perspective serves to disassociate the scenes from their familiar and often grand surroundings, allowing the play of color and pattern to communicate the particularity of the setting. At times Sargent's landscapes were so divorced from their surroundings as to become abstracted compositions. In *Trout Stream in the Tyrol*, the figure of the fisherman helps orient us in the landscape and remind us that these swirls of rich paint are meant to represent water, rock, and leaves. Again Sargent was following Monet, who, in the first decade of the twentieth century, painted forty-eight paintings of water lilies, erasing the horizon line and concentrating on the decorative effect of the flowers strewn across the blue-green surface of the water.[9] Sargent's interest in surface pattern can be seen throughout *Trout Stream in the Tyrol*: in the sprinkle of blue-green leaves at the angler's feet; in the placement of the bulky gray rocks amid the spray of whitewater; in the gently curving, feathery branches of the trees.

Sargent had just arrived in the Tyrol with Stokes and the rest of their party in 1914 when Austria declared war on Serbia, followed by Britain and France's declaration against Germany and Austria in return. Traveling without passports, the party was trapped in Austria. One British member attempted to make his way back to England and was arrested. As an American, Sargent was relatively safe, but his painting equipment was confiscated and taken to Innsbruck for inspection. Although his equipment was eventually returned, it was months before Sargent could gather the necessary documents to go home. In the meantime, he painted.

Stokes reports that Sargent was unfazed by wartime events, appeared to have little interest in the newspapers, and was unflappable throughout, continuing to work assiduously with whatever materials he had to hand. It is true that Sargent was highly productive during his five months in the Tyrol. Yet his contemplative paintings of Tyrolean churchyards and cemeteries belie Stokes's interpretation of Sargent's behavior as war erupted around them.[10] Sargent, shy, never demonstrative, knowing that his family in England would be deeply concerned about him and that friends in France were in danger, may have used the familiar routine of work as a bulwark against a rising flood of fear and worry. And indeed, there is a sense in the landscapes he made during that late summer and fall of 1914 that the tipped-up perspective and lack of horizon are efforts to shut the rest of the world out and preserve his idyll.[11] However, the landscapes also exude the contrary sense of a man destabilized by events, trapped in a prison from which there is no escape. Perhaps Sargent himself was like the fisherman on the stream bank, watching the water closely, observing its patterns, even as he tried to negotiate a tricky stretch of terrain.

[IB]

56. DENNIS MILLER BUNKER, *A Bohemian*

PERFORMING THE ARTISTIC LIFE

In an article published in the *Quarterly Illustrator* in 1894, the art critic Alfred Trumble declared: "The artist of to-day no longer rests under the popular stigma of chronic pauperism; he is no longer regarded as a mere visionary, incapable of caring for himself. Even that portion of the public which cannot understand his art is compelled to respect him with his summer home and winter studio, his faculty for enjoying his holiday without ceasing to enjoy his work."[1] Trumble's words evoked a new type of artist, one who was modern, enterprising, disciplined, and successful. The eccentric, dreamy, impoverished genius whose bohemian lifestyle had frequently been chronicled in novels and the popular press in the preceding decades was giving way to something new. By the last quarter of the nineteenth century many artists had begun to cultivate an air of competence and sophistication through their elaborate dress, cosmopolitan manners, and lavishly decorated studios. Yet the allure of bohemia lingered. When Dennis Miller Bunker (1861–1890) painted *A Bohemian* in 1885, it was this earlier, less opulent existence he chose to represent, drawing on romantic notions of aesthetic poverty that persisted well into the twentieth century.

Bunker, who died in 1890 at the age of twenty-nine, did not live to see two of the best-known dramatizations of bohemian life—George de Maurier's novel, *Trilby* (1894), and Giacomo Puccini's opera *La Bohème* (1895)—but by the 1880s a popular notion of bohemianism was already well established. The imagined country of bohemia and the creative bohemian life—as opposed to the actual region known as Bohemia, now the Czech Republic—developed in France. The French word, *bohémien*, was first applied to the Gypsies—thought to have come from Bohemia—who

entered France in large numbers in the early nineteenth century. By the 1830s the term came to be used in French literature to describe adventurous artistic and literary figures, especially those believed to have unconventional habits, questionable tastes, or loose morals. The concept of bohemianism became particularly well known through the writings of Henri Murger, whose sketches of bohemian life—first published in a small Parisian newspaper in the 1840s—were collected in the popular volume *Scènes de la vie de bohème* (1851), which was translated into twenty languages in the decade after it was published and repeatedly adapted for the stage.[2]

Linked with the Gypsy culture that gave rise to their name, bohemians represented escape from conventional life. They were typically impoverished, living without both the comforts and the trappings of middle-class society, and this lifestyle endowed them with an ennobling spirituality that they expressed in their art. Bohemianism was essentially related to youth and was often depicted in the media as a transitory stage, which would give way to professionalism and good sense. In both literary accounts and popular illustrations, bohemian artists were seen through a lens of sentimentality and nostalgia, their youth, freedom, and theatricality contrasted with the diligence and responsibility represented by the new breed of artists Alfred Trumble described in 1894.[3]

Although well-known artists such as James McNeill Whistler (1834–1903) and William Merritt Chase presented themselves as eccentric geniuses who enjoyed bohemian lives in spite of their professional success, popular conceptions of bohemianism focused on the early years of an artist's career.[4] Whistler, Chase, and other artists who

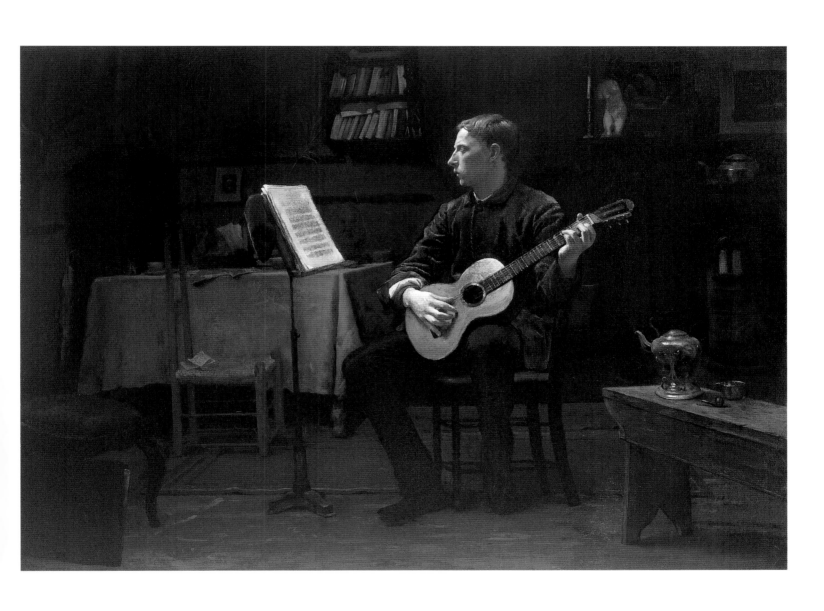

56. Dennis Miller Bunker (1861–1890), *A Bohemian*, 1885
Oil on canvas, 25¾ × 36 in. (65.4 × 91.4 cm)
Gift of Mr. and Mrs. John D. Rockefeller 3rd, 1993.35.1

Fig. 56.1. William Merritt Chase (1849–1916), *Tenth Street Studio*, ca. 1880–81/ca. 1910. Oil on canvas, 46⅞ × 66 in. (119.1 × 167.6 cm). Carnegie Museum of Art, Pittsburgh. Museum purchase, 17.22

fashioned themselves as flamboyant nonconformists in their later careers practiced a sort of genteel bohemianism, retaining a sense of freedom and theatricality even as their successes allowed them to live and work in increasingly luxurious surroundings.[5] Chase in particular was famous for the lavish and exotic furnishings of his studio, which was periodically opened to the public and depicted in his paintings and in illustrated magazines.[6]

Among the most celebrated of Chase's studio pictures was *Tenth Street Studio* (fig. 56.1), a large painting that the artist worked on intermittently for many years. A preliminary drawing for the work was included in a profile of Chase published in 1881, offering one of the first public glimpses

of his acclaimed studio. As the recollections of Chase's former student Gifford Beal suggest, the artful arrangement of Chase's studio furnishings created a powerful aesthetic effect:

In the large central studio the ceiling was lofty, and dust had been allowed to accumulate on all objects on the side walls and those suspended from the ceilings, such as hanging lamps, etc. so that the local color on the bottoms of these objects melted gradually in the dust collected in their tops. In contrast to this the floor was highly polished, and all around the studio to a height of about seven feet were numerous articles of glistening

brass, copper pots, with outsides of dead black and insides of flaming brilliance. Spanish furniture, superb hangings, and on the wall a huge white swan suspended on a piece of maroon-colored velvet. . . . The effect was beautiful and extraordinary.[7]

In the painting Chase re-creates this lavish environment, including three visitors—a woman seated at a table, perhaps sketching, and a couple examining a painting on the wall—who enjoy the "beautiful and extraordinary" atmosphere his display has created. Bunker created a far different effect in *A Bohemian*, one more closely allied with the bohemian lifestyle celebrated in popular prints and literature.

Bunker's departure from the model of artistic life embodied by Chase and the Tenth Street Studio was likely encouraged by his experience as an art student in Paris. He began his studies there in 1882, under Antoine Hébert at the Académie Julian, before continuing his training in the atelier of Jean-Léon Gérôme at the Ecole des Beaux-Arts.[8] Bunker returned to New York in December 1884 and occupied a studio there until the following October, when he moved to Boston to begin teaching at Cowles Art School. He painted *A Bohemian* shortly after returning to New York and exhibited it in April 1885 at the National Academy of Design, where it won the third-place Hallgarten Prize ($100). Before going to Paris, Bunker had studied with Chase at the Art Students League, and may have had the opportunity to experience his teacher's studio firsthand.[9] Yet in his own rendering of an artist's workspace Bunker chose to make the art atmosphere prized by Chase secondary; *A Bohemian* evokes not the genteel bohemianism of Chase's studio but rather the paintings and creative life Bunker encountered as an art student in Paris.

Beginning in the 1860s, subjects identified with Spanish culture—such as Gypsy life, guitar playing, flamenco performances, and bullfights—appeared frequently in French

Fig. 56.2 [top right]. Edouard Manet (1832–1883), *The Spanish Singer*, 1860. Oil on canvas, 58 × 45 in. (147.3 × 114.3 cm). The Metropolitan Museum of Art, New York. Purchase, gift of William Church Osborn, 49.58.2

Fig. 56.3 [bottom right]. Charles Sprague Pearce (1851–1914), *Prelude!* 1882. Oil on canvas, 60 × 48 in. (152.4 × 121.9 cm). Private collection. Photo courtesy of Mary Lublin Fine Arts, Inc.

painting. The popularity of Spanish subjects was still strong in Paris when Bunker arrived there in September 1882. At the Paris Salon earlier that year, John Singer Sargent (1856–1925), a prominent American painter whom Bunker would later befriend and travel with, exhibited a massive 8-by-11-foot painting of a flamenco performance, titled *El Jaleo* (1880, Isabella Stewart Gardner Museum, Boston). The painting, which included four guitar players in the background and two Spanish guitars hanging on the wall, was purchased by Thomas Jefferson Coolidge of Boston, the cousin of Bunker's friend and patron Isabella Stewart Gardner, who would later introduce Bunker to Sargent. Sargent was just one of many artists who achieved critical success with a Spanish-themed picture at the Paris Salons in the late nineteenth century. Bunker, a young, ambitious art student, naturally looked to such successful pictures as inspiration for his own work.[10]

It is likely that Bunker's subject for *A Bohemian*—a solitary figure playing a Spanish guitar in a modestly furnished studio—was influenced by Edouard Manet's famous painting *The Spanish Singer* (fig. 56.2), which Bunker could have seen in January 1884 at an exhibition of Manet's work held at the Ecole Nationale des Beaux-Arts. The painting had been a popular and critical success when first shown at the Salon of 1861, and in the following decades it continued to be exhibited and was repeatedly published as an etching. Bunker was probably also aware of another successful guitar painting—this one with an equally romantic Spanish subject—*Prelude!* (fig. 56.3), by the American painter Charles Sprague Pearce. This image of a young woman playing a guitar earned Pearce a third-class medal at the Paris Salon of 1883.[11]

Pearce's female guitar player was in keeping with musical subjects by American artists, which tended to focus on women rather than men. Paintings featuring guitars, harps, and cellos were becoming common in the late nineteenth century, increasingly supplanting the long-established motif of women at the piano. In an article published in *Scribner's Monthly* in 1881, the art critic Clarence Cook praised the old-fashioned guitar as a more "off-hand," "spontaneous" alternative to its "clumsy successor" the pianoforte, reserving special praise for the "picturesque charm of the instrument," which made it a particularly effective formal element in paintings. Cook noted that while "it is very hard for the performer on the piano to play a picturesque or even graceful part," the guitar and other string instruments, he continued, "lend themselves to the movements of grace

and beauty. . . . Great painters have seen their opportunity in the harmony between the shape of these instruments and the forms of the body."[12]

Although any painting including a guitar may have elicited comparison with paintings of women and guitars, *A Bohemian* has far more in common with Manet's *The Spanish Singer* and even Pearce's *Prelude!* in which a young woman plays the guitar, rather than simply posing with it. In both the Pearce and Manet paintings, the guitar player sits facing left, though in *The Spanish Singer* the musician turns his head to face the viewer. He is left-handed and holds the guitar oriented in that direction, seated on a crude wooden bench in an awkward position that would make it difficult to play the instrument. The spare interior—decorated only by the bench and a rough clay jug at the musician's feet—evokes the transitory atmosphere of Spanish Gypsy life and the modest trappings of bohemia. Such humble furnishings bear a clear relation to the props featured in *A Bohemian*—and especially the plank bench pictured at the right—yet the pose and mood of Bunker's musician share greater similarities with the guitar-playing woman in *Prelude!* Whereas Manet's musician balances precariously on a bench, turning to the viewer in midsong, the guitar players in the Bunker and Pearce paintings are relatively still and focused, absorbed in the music and perhaps lost in thought.

A Bohemian is set in a far more detailed interior than those suggested in *The Spanish Singer* or *Prelude!* Although the young guitar player and his music, which rests on a stand, are at the center of the composition and receive the most careful highlighting, many specifics of the studio furnishings can be discerned. A portfolio is propped against a chair in the foreground at the left, and a brass teakettle on stand rests beside a cup and pipe on the wooden bench at the right. Another kettle sits on the stove in the background, and bookshelves and pictures hang along the back wall. A small plaster cast of a classical Venus rests on a mantel behind the musician, next to a tall metal candlestick, and the table is littered with books, papers, and dishes. The chairs in the room are of mismatched styles, and the worn floor rug refuses to lie flat. The space lacks the careful eclecticism of Chase's studio. This incongruous collection of objects appears casual and unstudied; the emphasis here is on the artist, not the environment he has created.

The musician is painted with great care, the folds of his clothing and the tones of his reddish hair and mustache carefully rendered. His instrument is clearly recognizable

as a six-string Spanish guitar, a popular model at the time, which was manufactured both in Europe and by the Martin guitar company in New York.[13] The musician's fingers are carefully positioned along the fingerboard and the strings, suggesting his musical skill and training. In contrast to the particularity with which he is painted, the sketchy treatment of the studio furnishings becomes especially clear. The notes on the sheet music are an indecipherable blur, and none of the books or pictures on the wall can be identified. The space is animated by the guitar player's music, but its furnishing depends to a large degree on the viewer's notions of bohemian life.

The painting's setting is ambiguous enough that it has not always been identified as a studio. When A Bohemian was shown at the National Academy of Design in April 1885, one critic described it as a picture of "the odds and ends of the bachelor apartment."[14] By the time Bunker was profiled in Century Magazine in 1891, the painting was described as "a figure of a young man in a studio playing a guitar, and was called 'Bohemia.'"[15] More recently the picture has also been known as The Guitar Player, and some studies have suggested that it is a self-portrait set in Bunker's own studio, intended as an affirmation of the bohemian lifestyle he enjoyed during his brief, ten-year career.[16] Comparison with photographs of Bunker suggests otherwise. The figure in the painting lacks Bunker's dark, curly hair, strong brow, and long, heavily squared jawline. The emphasis here is less autobiographical than universal. The painting is far different from the studio pictures by Chase, which extend into various spaces of the studio and include a range of figures and activities. Instead, Bunker's picture, while suggesting the character of his studio furnishings, is more like the famous paintings of guitar performances by Manet and Pearce, which place the musician at the center of the composition and focus their narratives around the performance of a song. Although Bunker's musician is framed by a backdrop of studio props in a sort of stage performance, he nevertheless seems to be playing for himself—and the sake of his art alone—a gesture that reinforces the solitary nature of bohemianism and of all artistic life.

The similarity between A Bohemian and well-known Salon works with Spanish subjects is likely intentional; it is natural that as a young artist returning from Paris Bunker would have looked to successful guitar pictures by Manet and Pearce when devising ambitious works of his own. His relatively detailed rendering of a sparsely furnished studio was a similarly savvy move, as it enhanced the appeal of the painting for the many Americans who were captivated by the romance of bohemian life in the late nineteenth century. Bunker did indeed live an ascetic bohemian life, but he was not content with poverty—even at the threshold of his career. After settling in Boston in the winter of 1885, he wrote to his friend Joe Evans: "I suppose a man gets used to being poor after a number of years, but all the same its a great bore in our youth."[17] Five years later, in August 1890, he wrote to Isabella Stewart Gardner: "It is a mistake to have only one life. As for me, I am only rehearsing in this one—I might be a painter if I could live again and begin afresh. We ought to be given three tries, like the baseball men."[18] At the time of his death four months later, Bunker's own true performance had yet to begin. [AG]

221

TESTING THE LIMITS OF ILLUSION

In the late 1880s an anonymous article published in the *New York World* described the exceptional illusionism of William Michael Harnett's famous painting *After the Hunt* (1885):

> The spectator may place himself at any point of observation, remote or near, and he will find it difficult, if not impossible, to convince himself that he is not looking at real objects. . . . By dint of long study of the picture he at length admits that it is *all painting*; but the illusion even then persists, and he at last turns away, generally with the exclamation: "Marvelous! The most remarkable thing I ever saw!"[1]

After the Hunt was the artist's largest and most ambitious work. Painted in Paris in 1885 shortly before he returned from a lengthy stay in Europe, it reflects Harnett's artistic skill and aspirations, and his engagement with late-nineteenth-century collecting culture.[2]

Harnett (1848–1892) was one year old when his family left Ireland and immigrated to Philadelphia. At the age of seventeen he began training as a metal engraver, and two years later he enrolled in night classes at the Pennsylvania Academy of the Fine Arts. In 1871 he moved to New York City, where he spent his days working for jewelry firms and his nights taking classes at the National Academy of Design and the Cooper Union. Five years later he returned to Philadelphia, opened a studio, and resumed his studies at the Pennsylvania Academy. Harnett painted still lifes from the beginning, initially limiting himself to the fruit and flower subjects common in seventeenth-century Dutch still-life painting. In 1876, perhaps influenced by the lavish displays of exotic foreign objects, art, and antiques at the Philadelphia Centennial Exhibition, he began to paint man-made items as well, including elements such as musical instruments, books, beer mugs, and pipes.[3]

The Centennial Exhibition is often credited with introducing Americans to the ideals of the Aesthetic Movement—which originated in England and stressed notions of artistic quality and design—and with spurring a craze for collecting assorted antiques and artistic objects commonly described as "bric-a-brac."[4] In the years following the Civil War, collecting art and bric-a-brac became an increasingly popular pastime. A strong postwar economy and improvements in transportation enabled wealthy Americans to build their collections in markets and shops both at home and abroad, and soon a range of inexpensive, mass-produced decorative goods was available as well.[5] A writer for *The Aldine* declared in 1878: "If, heretofore, we have lacked those objects of *virtu* so essential for a certain class of still-life pictures, such is no longer the case. . . . The taste for bric-a-brac, fine porcelain, gold, silver, and glass vessels, has recently been remarkably developed in this country. . . . Even artists are beginning to gather objects of art, since they prove to be indispensable accessories in many pictures."[6]

Harnett began collecting as early as 1874, expanding his holdings dramatically during his travels in Europe and in the years following his return to America in 1885.[7] The lure of European bazaars and antique shops was likely one of his primary motivations to go abroad. He began saving for the trip in 1876 and embarked in 1880, spending nearly a year in England and Frankfurt before settling in Munich for four years. Unlike other artists who traveled to Munich in the nineteenth century to continue their studies, Harnett

57. William Michael Harnett (1848–1892), *After the Hunt*, 1885
 Oil on canvas, 71½ × 48½ in. (181.6 × 123.2 cm)
 Mildred Anna Williams Collection, 1940.93

Fig. 57.1. David Neal, *After the Hunt*, 1870.
Oil on canvas, 62⅜ × 46¾ in. (158.5 × 118.7 cm).
Los Angeles County Museum of Art. Gift of
Mr. and Mrs. Will Richeson Jr., M.72.103.1

did not enroll in the Royal Academy.[8] He showed his paintings at the local *Kunstverein* exhibitions and sold several of them to Europeans and Americans who passed through the city.[9]

By 1880 Harnett was already a mature painter with a definite style of his own, and although he may have taken private lessons in Munich, that style changed little during his time there, if anything becoming more precise and minute rather than approaching the broad, painterly brushwork favored by students at the Royal Academy.[10] The most notable development in Harnett's work during his Munich years was the inclusion of new elements such as armor, exotic textiles, and European decorative objects, drawn both from his own growing collection and from the Dutch masterpieces and German pictures he saw in local museums.

The study of old masters—great European painters who worked prior to the nineteenth century—was a significant aspect of artistic training in Munich. Instructors at the Royal Academy encouraged their students to visit works of art in person, and Harnett too seems to have taken advantage of the rich local art collections, which included many examples of Dutch still-life painting.[11] Still-life painting did not have a strong artistic tradition in Germany and was not part of regular instruction at the academy. Few well-known still-life painters worked in Munich in the late nineteenth century; two of the most prominent were Ludwig Eibl (1842–1918) and David Neal (1838–1915). Both artists drew on Dutch examples in their work, painting lavish displays of objects and large-scale still lifes of dead game that were similar in composition to *pronkstilleven* from Holland and Flanders and to seventeenth-century Dutch game pieces.[12]

David Neal was one of the first Americans to make a name for himself in the Munich art world. He specialized in portraits, still lifes, and history paintings and was a favorite student of Karl von Piloty, a prominent instructor at the Royal Academy.[13] Neal's *After the Hunt* (fig. 57.1) includes many elements that Harnett would later use in his own gaming pictures but creates a far different effect. While Harnett's *After the Hunt*, like Neal's, features an impressive display of hunt-related objects including a game bag, circular brass horn, richly ornamented rifle, and an assortment of dead animals such as birds and a rabbit, Neal's composition extends beyond the still life to create a detailed interior setting and a narrative. Neal's painting includes a man seated at the table, perhaps celebrating a successful hunt. His head is turned to look at the woman standing behind him, who has just refilled the glass he holds in his outstretched hand.

Two living dogs sit in the foreground of the picture beside the dead game, one of them—a hunting dog—presiding over a dead bird, while the other peeks out from between the legs of a wooden chair.

Harnett painted four versions of *After the Hunt*, beginning in 1883. He seems to have been influenced primarily by photographic still lifes and American gaming prints, rather than the seventeenth-century Dutch works emulated by Neal. The shallow composition and highly illusionistic rendering of objects in Harnett's *After the Hunt* series have led many scholars to suggest that he was influenced by the photographs of the Alsatian photographer Adolphe Braun (1811–1877), who began making stereographs of dead game in the 1860s.[14] Braun's *Hare and Ducks* (fig. 57.2) exhibits several of the strategies Harnett would later utilize in his own gaming series, such as the overlapping of objects and animals against a flat, wooden background and the use of directional, raking light. Both techniques emphasized the volume of each element in the composition and contributed to a sense of depth. The large scale of the photographs likewise enhanced their illusionistic quality and may have encouraged the exceptional size of the works in Harnett's *After the Hunt* series.[15]

In the mid–nineteenth century many French and British photographers specialized in gaming pictures, and the American firm Currier & Ives published a popular series of prints based on game-piece still lifes painted by Arthur Fitzwilliam Tait. In the mid-1870s L. Prang and Co. of Boston produced several "dining room pictures," many of which were game pieces featuring dead birds and other animals hanging against a neutral background.[16] Braun, and later Harnett, adopted this relatively simple aesthetic of hanging game compositions.

The isolated presentation of dead game against a stark background was a composition used by such eighteenth-century French artists as Jean-Siméon Chardin and Jean-Baptiste Oudry, and in the 1860s it began to make an occasional reappearance in contemporary realist paintings by artists such as Claude Monet, Frédéric Bazille, and Alfred Sisley. Braun's choice of this format was a direct response to current tastes. The photography company Braun, founded in 1855, was the largest manufacturer of art reproductions in the world, and in 1866 it began producing photographic inventories of noted European art collections.[17] As a result of such projects Braun possessed a unique understanding of the contemporary art market. In turning to Braun's photographs as a source for his own series of game

Fig 57.2. Adolphe Braun, *Hare and Ducks*, ca. 1865. Carbon print, 30⅜ × 21½ in. (77.2 × 54.5 cm). The Metropolitan Museum of Art, David Hunter McAlpin Fund, 47.149.52

pieces, Harnett allied himself with a successful and established figure in the art world.

Harnett completed the first two versions of his *After the Hunt* in 1883, followed by a third in 1884. When these pictures were met with harsh criticism in Munich, he went to Paris and set to work on the fourth and final painting in the series, with the goal of determining whether his work "had or had not artistic merit."[18] Each work in Harnett's *After the Hunt* series was larger and more elaborate than the last, and all used the vertical, hanging format seen here in the fourth version. Nearly six feet high and four feet wide, this painting was the largest of the four, measuring ten inches wider and more than fourteen inches higher than the first. Every version features assorted dead game and selected pieces of European hunting equipment from Harnett's personal collection, presented against a wooden door.[19]

The key included just above the ornate lock at the left of the canvas in the fourth version does not appear in any of the earlier paintings in the series. It may be taken as a symbol of Harnett's ambitions for the picture, which he hoped would open the door to fame and success.[20] Although the work was accepted at the Paris Salon of 1885, it did not receive the awards or critical attention he had hoped for. Nevertheless, this final version of *After the Hunt* was an important statement of his skill and aspirations; it helped secure his fame in America and inspired numerous followers. The painting was purchased by Theodore Stewart, who added it to the impressive collection of art and antiques on display at his extraordinarily luxurious New York saloons.[21]

Although Harnett's final version of *After the Hunt* did not bring him the immediate acclaim he desired, it remains one of his most compelling works. Here the tightly layered cluster of game and European hunting gear depicted in earlier versions is spread out against the background, and the alpenstock, sword, and rifle float unaccountably in space, creating a tension that prevents the image from being seen *only* as illusionistic. Harnett defies the laws of gravity, daring the viewer to challenge the illusion put forth by the painting. It is Harnett's creative force within the world of the canvas that holds the weapons aloft, reminding us of his ability to create illusions, and his power to disrupt them.

[AG]

58. MARY CASSATT, *Mrs. Robert S. Cassatt, the Artist's Mother*

A MOTHER'S TOUCH

Anyone who had the privilege of knowing Mary Cassatt's mother would know at once that it could be from her and her only that she and her brother, A. J. Cassatt, inherited their ability. LOUISINE HAVEMEYER[1]

When Mary Cassatt (1844–1926) died she was celebrated as an American national treasure, even though she had spent most of her life as an expatriate living in France and her impressionist style was by then considered passé.[2] As has been noted often, she was the sole American, male or female, invited to participate in any of the eight independent exhibitions from 1874 to 1886 organized by the Société Anonyme, the official name given to the group commonly called the Impressionists.[3] Her influence and prestige in the United States extend from her commission to paint a mural for the World's Columbian Exposition in Chicago (1893) to serving as personal art advisor to the New York philanthropists Henry O. and Louisine W. Havemeyer for a collection of artworks that now forms the core of the Metropolitan Museum of Art's world-renowned impressionist holdings.[4] Cassatt has remained one of the country's most well known and acclaimed artists of the nineteenth century, represented by major exhibitions every decade, beginning with a 1927 memorial retrospective at the Philadelphia Museum of Art. In 1946, when the National Gallery of Art sent *Two Hundred Years of American Painting* to the Tate Gallery in London, British critics ranked Cassatt's artistry in that exhibition second only to that of James McNeill Whistler (1834–1903).[5]

Cassatt's painting *Mrs. Robert S. Cassatt, the Artist's Mother* (ca. 1889) is as much a tribute to her upbringing and strong family ties as it is a modern portrait of her mother's powerful, female presence. Cassatt was born in 1844 to affluent, upper-class parents, whose families had come to the Pittsburgh region of Pennsylvania as investors and merchants, establishing themselves as economically and socially prominent members of the community.[6] When Cassatt was five years of age, her family began traveling, first to Philadelphia and then from 1850 to 1855 throughout Europe, especially to Paris, Heidelberg, and Darmstadt, where she attended local schools, learning to speak French and German fluently.[7] With the death from bone cancer of Cassatt's brother, Robert, the family returned to Philadelphia, the fourth largest city in the world at that time.[8] This cosmopolitan and socially prominent upbringing led to an interest in culture and the arts that Cassatt's mother encouraged, and by age fifteen Mary had decided to become an artist, enrolling in 1860 at the Pennsylvania Academy of the Fine Arts.[9]

In December 1865 Cassatt traveled to Paris, where she worked as a copyist in the Louvre, producing paintings for tourists to purchase as souvenirs.[10] Because women were not allowed to enroll in the official French academy school, the Ecole des Beaux-Arts, she applied to and was accepted by Jean-Léon Gérôme (1824–1904) to take private lessons in his atelier.[11] By 1867 Cassatt's dissatisfaction with conservative academic painting led her to study with Charles Chaplin and then to reside in the more independent art colonies at Courances and Ecouen, located outside Paris near the Fontainebleau Forest, where painters of the Barbizon School were paying homage to peasant life.[12] There Cassatt painted her first work accepted by the Salon, *The Mandolin* (1868), which marries an interest in the figure to the anecdotal character of genre painting.[13] After this success, she studied with the nonconformist painter Thomas Couture (1815–1879), the famous teacher of Edouard Manet (1832–1883), and then briefly with Charles Bellay in Rome, where Cassatt's mother was again a supportive presence, meeting

58. Mary Cassatt (1844–1926), *Mrs. Robert S. Cassatt, the Artist's
Mother*, ca. 1889. Oil on canvas, 38 × 27 in. (96.5 × 68.6 cm)
Museum purchase, William H. Noble Bequest Fund, 1979.35

and traveling with her throughout Italy in 1870. Cassatt's artistic education in Europe was interrupted by the Franco-Prussian War, which forced her in August of that year to return to Philadelphia, where she set up a studio. However, after little more than a year in Philadelphia and a brief sojourn in Chicago, Cassatt returned to Europe in 1871 to copy works in Parma by Antonio Allegri Correggio (ca. 1494–1534) on a commission from the bishop of Pittsburgh for his cathedral.[14] After traveling throughout Italy, Spain, Belgium, Holland, and France, Cassatt returned to Paris in 1874, finally settling in that city and living in its environs for the remainder of her life.[15]

A series of Salon refusals between 1874 and 1877 led Cassatt to accept an invitation by Edgar Degas (1834–1917) to participate in the Impressionists' Independent exhibition, securing her place as the only American artist to join the group, exhibiting with them in 1879, 1880, 1881, and 1886.[16] As a letter from her father attests, her debut was phenomenally successful among the French, although Americans, who were still hostile to Impressionism, dismissed her.[17] From this point on, Cassatt's career as an Impressionist flourished, through both the group's continuing Independent exhibitions and the influence of the famous Parisian art dealer Paul Durand-Ruel, who introduced Impressionism to an American audience.[18] About this time Cassatt increasingly became the central axis around which her family's life revolved, especially that of her parents, who had moved overseas to join their expatriated daughter in 1877.

Mary Cassatt had burst onto the scene in the 1879 Impressionist exhibition with paintings of women perceived to be modern, especially young women at the theater. *Woman in a Loge*, actually a portrait of her sister, Lydia, was repeatedly singled out by the critics as evidence of a remarkable new talent (fig. 58.1).[19] The artist introduced the mother-and-child theme that has become synonymous with her name in the sixth Impressionist exhibition of 1881, showing two works that signaled her dual concerns: modern pictorial representation and family life. One is a daringly executed mother and baby whose faces are pressed together in an abstract composition, turning and collapsing their profiles in a manner that hides their features. The other is a family portrait of Cassatt's mother, who is shown reading to three of her grandchildren by the artist's brother, Alexander.

Never marrying, Cassatt shared an especially close relationship with her mother, who lived near or with the artist

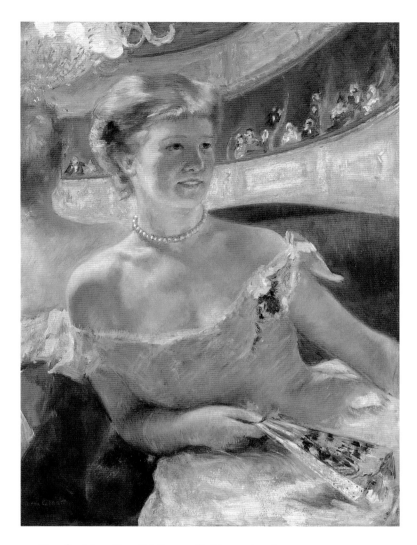

Fig. 58.1. Mary Cassatt (1844–1926), *Woman in a Loge (Lydia in a Loge, Wearing a Pearl Necklace)*, 1879. Oil on canvas, 31⅝ × 23 in. (80.3 × 58.4 cm). Philadelphia Museum of Art. Bequest of Charlotte Dorrance Wright, 1978.1.5

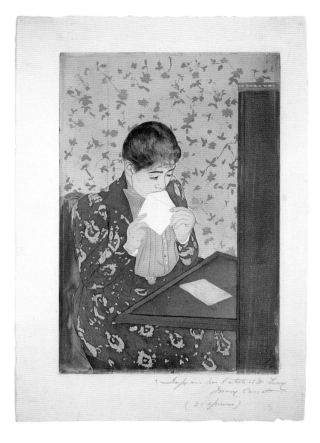

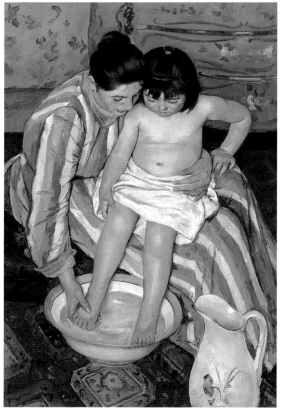

from 1877 until her death in 1895. In 1888 the mother-and-child subject emerged as Cassatt's dominant theme while she was restricted to her home owing to a horseback riding accident.[20] The relationship between mother and child also became especially poignant during this period because Cassatt needed to care for her increasingly fragile mother throughout the remaining years of her life.

Mrs. Robert S. Cassatt, the Artist's Mother is the final of a number of portraits that Cassatt painted of the family's matriarch.[21] In this painting she uses the vocabulary of Impressionism to draw viewers into the psychological character of her seventy-three-year-old mother. In spite of her obvious age, Mrs. Cassatt's gaze is clear and commanding, with an apparent calm repose that suggests she is content to be alone with her thoughts. Her face is rendered in meticulous detail with a delicate brush and lifelike modeling that reflects Cassatt's study of old masters and suggests depth and dimension of character. As Griselda Pollock has written, "The pose, the simple colouration and the use of the painting behind the head of Mrs. Cassatt recall above all the model of seventeenth-century Dutch portraits and one is tempted to compare this work to the late painting of Frans Hals."[22] Conversely, the highly visible and sketchy brushstrokes of colorful paint that define the background wall, bouquet, mirror (or painting) behind the sitter, chair, and shawl contrast with the more realistic depiction of the face and amplify the artist's description of her subject as a vital, vigorous, and intelligent woman.

However, the very ambiguity of the object on the wall behind Mrs. Cassatt serves as a reflecting trope, demonstrating the tension between expression and reflection in visual representation that was central to the Impressionists. And, as did other artists of that group, Cassatt introduced elements of Japanese art into her work that contributed to this optical investigation into pictorial space, including "decorative pattern, asymmetrical composition, lack of traditional Western perspective, strong contours, flattened

Fig. 58.2 [left top]. Mary Cassatt (1844–1926), *The Letter*, 1890–91. Drypoint and aquatint on cream laid paper, 13⅝ × 8⁵⁄₁₆ in. (34.5 × 21.1 cm). The Art Institute of Chicago. Martin A. Ryerson Collection, 1932.1282

Fig 58.3 [left bottom]. Mary Cassatt (1844–1926), *The Child's Bath*, 1893. Oil on canvas, 39½ × 26 in. (100.3 × 66 cm). The Art Institute of Chicago. The Robert A Waller Fund, 1910.2

shapes, and bold coloration."[23] In 1889 Cassatt was poised to embark on her own series of Japanese-influenced prints, which explore the spatial possibilities inherent in the dualities of line and color, perspective and pattern, illusion and surface (fig. 58.2).[24] In her portrait of her mother, Cassatt heightens these effects through her use of black. The large area of the canvas that is given over to Mrs. Cassatt's black dress flattens the image and tilts her body toward the picture plane, yet the same black mass operates as visual weight that anchors her within the shallow space of the indistinct scene.

This use of black both to organize and give symbolic weight to the depiction of Cassatt's mother recalls James Abbott McNeill Whistler's similar strategy in his famous painting *Arrangement in Gray and Black, No. 1: Portrait of the Painter's Mother* (1871).[25] First exhibited at the Royal Academy of Arts in London in 1871, Whistler's painting debuted in America in 1881 as the most prominent work in *American Artists at Home and in Europe*, an exhibition organized by the Pennsylvania Academy of the Fine Arts to celebrate expatriate artists working in Paris, Munich, and London.[26] Surprisingly, Cassatt was not included in the exhibition, but she would have been aware of the reception for Whistler's painting through her brother Alexander, one of Philadelphia's most prominent private collectors and art patrons.[27] Both artists look back to the old masters, especially Frans Hals and Diego Velázquez, translating the realism of baroque portraiture into the modern language of Impressionism. However, Whistler, a leading spokesperson for the Aesthetic Movement, emphasized the decorative surface and formal elements through his composition and title, subordinating his mother as a subject to the status of austere icon of moral piety in a painting that has often been compared to Hals's seventeenth-century group portrait of the Regentesses.[28] Conversely, Cassatt created a fully realized character through her exploration of the relationship between surface and depth, finding in the contrast between compositional devices and psychological penetration a key to her mother's strength and endurance.

Nevertheless, it is Mrs. Cassatt's hands, painted with a solidity and attention to realistic detail similar to that of her face, that situate this portrait within Cassatt's well-known mother-and-child subjects. As an artist, Cassatt would have a special interest in hands, and in many of her portraits it is the tender and capable hands of the mother attending to her child that give the impression of a loving bond (fig. 58.3).[29] In this way the hands in Cassatt's intimate scenes become a symbol of the familial bond between generations.

The role of hands in the portrait of her mother is especially meaningful because Cassatt's own artistry lies in her manual skill. In depicting the strength of her mother's hands, Cassatt figuratively addresses the talent passed to her from her mother. As a metaphor, these hands suggest that women of creative talent have the capacity to bring culture and intelligence to the bourgeois family, shaping it according to the strengths of their gender. It is this subtle articulation that allows feminists to claim for Cassatt's seemingly traditional scenarios a space of empowerment for women.[30] As one gender theorist has written: "In contrast to her male colleagues, [whose] subjects are largely those of bourgeois leisure and recreation, and private and domestic activities familiar in middle-class households[, Cassatt's] represent the social and pictorial 'spaces of femininity.'"[31]

Mrs. Robert S. Cassatt definitively counters Edgar Richardson's condescending and chauvinist assessment of Cassatt: "tea, clothes and nursery; nursery, clothes and tea."[32] It shows the artist to be a keen observer of modern life, her realism expressed through the manipulation of space, strong, contrasting colors, and an overtly worked surface. Cassatt's portrait pursues the theme of mother and child to adulthood, the mother represented by the painting's subject and the apparently absent child present in Cassatt's artistry, inflected by her modern, avant-garde handling. [DC]

AN APPEALING STILL LIFE UNWRAPPED

At first glance, *Oranges in Tissue Paper* (ca. 1890) seems like such a simple thing: oranges lying on a glossy tabletop before a blue curtain. Even as we admire the virtuosity of William McCloskey's execution, a voice—perhaps cynical, perhaps merely confused—pipes up from the museum visitor standing beside us: "But it's just some oranges!" Such consternation is understandable. Despite the undeniable beauty of the painting, can citrus be a sufficiently lofty subject to merit wall space in a museum? In the words of Rudyard Kipling, "It's pretty, but is it art?"[1] Still-life paintings such as this one can be surprisingly difficult for the twenty-first-century viewer to comprehend. In an age of crystal-clear color photography, agribusiness, and overnight shipping, *Oranges in Tissue Paper* might appear to provide nothing of greater interest or value than can be found in a glossy magazine ad or the produce department of any supermarket. There is more to these oranges, however, and indeed to any still life, than may meet the modern eye. Layers of interest and significance hide beneath the deceptively straightforward surface, much as the juicy flesh of the oranges themselves lies beneath the tough peels.

In the summer of 1925 Alice Van Natta, a reporter for the Portland *Oregonian*, referred to William J. McCloskey (1859–1941) as "one of the foremost portrait artists in this country."[2] In keeping with this designation, Van Natta's article, a review of McCloskey's paintings then on display at his daughter Alice's rustic automobile bivouac camp—Siskiyou Camp—discusses only the portraits that were McCloskey's bread and butter during his long and successful career and for which he was justly famous. It is surprising, then, to note that nearly half of the paintings visible in a contemporary photograph of the camp's main building are still lifes.[3] Despite the fact that either McCloskey or Van Natta deemed these paintings secondary to the portraits in 1925, today McCloskey is lauded specifically as a painter of still lifes in the American trompe l'oeil tradition of William Michael Harnett (1848–1892) and John Frederick Peto (1854–1907). Between 1888 and 1912 he executed a series of still lifes of oranges; in each at least one fruit is wrapped in white tissue paper. Two early examples were accepted for the National Academy of Design's sixty-third annual exhibition in 1888; the art critic Charles Kurtz opined, "These oranges, some of which show through their tissue paper wrappings—are painted with wonderful realism."[4] Though early in his career McCloskey exhibited a few still lifes, which included fruits such as plums, pomegranates, and peaches, he quickly settled on citrus as his particular subject.

William McCloskey enrolled in the Pennsylvania Academy of the Fine Arts in 1877, at the age of eighteen.[5] Perhaps he had been motivated by the Art Gallery the previous year at the Centennial Exposition, which boasted what the *Art Journal* considered "the best exhibition [of American paintings] that has ever to our knowledge been got together," including five by Thomas Eakins (1844–1916).[6] He may also have been inspired by the legacy of Philadelphia's famed Peale family.[7] At the Pennsylvania Academy McCloskey took Drapery Class with Christian Schussele, who believed that students would "benefit greatly from the study of grouped objects"; McCloskey's interest in still life may well have germinated under Schussele's guidance.[8] In 1879, following Schussele's death, McCloskey began studying portraiture with Eakins and produced his earliest known work, *Portrait of a Lady*. McCloskey's abilities in still

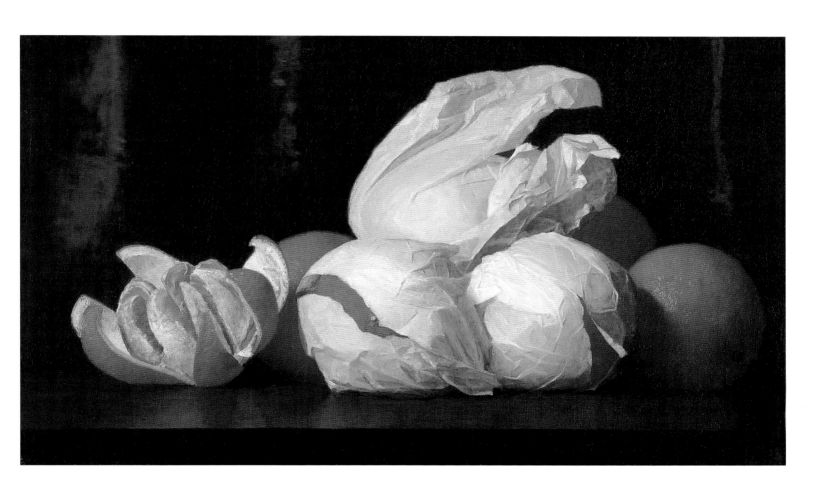

59. William J. McCloskey (1859–1941), *Oranges in Tissue Paper*, ca. 1890. Oil on canvas, 10 × 17 in. (25.4 × 43.2 cm) Gift of Mr. and Mrs. John D. Rockefeller 3rd, 1993.35.21

Fig. 59.1. Unidentified artist, *Albion Brand Valencias*, ca. 1915. Color lithograph, 9⅞ × 10⅞ in. (25.1 × 27.6 cm). Collection of Timothy Anglin Burgard

life would have developed as well, for Eakins offered informal classes in still life to his students. Of particular interest in light of McCloskey's subsequent oeuvre is this statement by Eakins, recorded by his student Charles Bregler:

> Paint a little still life, paint hard. . . .
>
> Paint an orange. After you have it done paint a white thing, or an egg.
>
> Take an egg or an orange, a piece of black cloth, and a piece of white paper and try to get the light and color.
>
> Paint an egg, it teaches you to paint well. . . .
>
> These simple studies make a strong painter.[9]

Eakins may have influenced not only McCloskey's portraits, as one would expect, but the "wrapped orange" series as well.

Six of the oranges visible in *Oranges in Tissue Paper* lie on a highly polished wooden tabletop, in which their reflection is dimly visible, while a seventh orange balances atop the arrangement. A Prussian blue curtain hangs close behind. The viewer's eye is positioned quite close to the fruit and at tabletop level, creating an intimate, circumscribed space. McCloskey's palette is limited to orange and its chromatic complement blue, white (the product of orange and blue light), and, to a lesser degree, brown.[10] Two fruits are partially obscured behind the others, and, along with the one at the far right, are shown with their brilliant orange peels intact. The leftmost orange has already been opened, its peel spread like the petals of a flower, displaying the translucent, parted wedges of fruit within as well as the creamy white albedo lining the inner surface of the peel. In

front, just before our eyes, two oranges rest in their tissue wrappings; both papers are rent to reveal a glimpse of bright peel within, in stark contrast to the white paper, through which a hint of color glows. The tissue of the final, crowning orange is intact, but seems almost to be unwrapping itself as we watch, the crumpled corners where it had been twisted around the sphere of the orange arcing off to the right like the crest of a wave. The painting is a study of contrasts: in the multiple surface textures—crinkly paper, smooth wood, rough peels, yielding orange flesh—in their relative translucency and opaqueness, and in the manner in which they absorb or reflect the bright white light illuminating the scene from the left.

The passage of time is suggested by the various states in which the oranges lie—wrapped and unwrapped, unpeeled and peeled—a virtual timeline of the path of the orange from shipment to consumption. Belying the label "still life," there is a palpable sense of drama and action as the oranges seem to rip and unwrap their papers of their own accord. The tissue of the upper fruit appears to be unwinding before our eyes, the orange to the left to be spreading its segments for us; the image is taut with the anticipation of further disclosures and, eventually, delectation. The viewer's senses are stimulated. Not only do we see these oranges, but so naturalistic and immediate is their depiction that we could swear we hear the rustle as they emerge from their tissue cocoons, feel the waxy roughness of their skins, smell their sweet aroma, and ultimately taste their juicy flesh.

The artistic rewards of wrapping the oranges in white tissue squares are manifold, but McCloskey cannot claim credit for the notion. That belongs to the "ingenious Florida fruit grower[s]," who developed the practice of stem-cutting oranges, wrapping them in tissue paper, and packing them into crates for shipment across the nation and beyond.[11] Rapidly adopted by other citrus-producing regions (fig. 59.1), this technique was an American innovation. To McCloskey, an orange was more than a wonderful fruit to paint, offering multiple textures and tonalities in its various states of disclosure; oranges were a symbol of American ingenuity by virtue of their very availability, indicated by the presence of the packing tissues.[12] Though obscured for modern viewers, the significance of the paper was easily comprehensible to a contemporary audience. No longer a rare prize, the modern American orange was a symbol of abundance, agriculture, technology, and transportation.[13] A far richer and more complex image than a first glance might indicate, *Oranges in Tissue Paper* ultimately complicates the very notion of a hierarchy of genres, as it is not too far-fetched to consider this still life to function almost as a portrait—a portrait of oranges, revealing their precise appearance, fundamental nature, cultural meaning, and dynamic presence at a specific moment in time. [EL]

60. JEFFERSON DAVID CHALFANT,

Bouguereau's Atelier at the Académie Julian, Paris

THE REFINEMENT OF A "REALISTIC" PAINTER

Jefferson David Chalfant (1856–1931) was already an established trompe l'oeil painter when he enrolled at the Académie Julian in Paris in 1890. Although at thirty-four years of age he was older than many of his fellow art students, his decision to study in Paris was not unusual. Just three years earlier, in an article about the expatriate painter John Singer Sargent (1856–1925), Henry James had declared, "It sounds like a paradox, but it is a very simple truth, that when to-day we look for 'American art' we find it mainly in Paris. When we find it out of Paris, we at least find a great deal of Paris in it."[1]

By the late nineteenth century, French art and models of artistic training had come to greatly influence American art. The popularity of French paintings prompted the United States government to impose a stiff tariff on foreign works of art in 1883, and in 1886 the French government launched an investigation of the extensive American market for French painting.[2] The demand for French art did not go unnoticed by American artists. Ambitious art students increasingly pursued training in Paris, eager to learn the academic, Barbizon, and impressionist styles popular with American collectors of French painting.[3]

Chalfant received his first formal artistic training at the Académie Julian. His early career had been spent working as a cabinetmaker with his father, painting and finishing parlor cars for railroad companies in Wilmington, Delaware, and Philadelphia. He began making informal sketches and painting landscapes and still lifes, completing his first trompe l'oeil picture in 1886. The illusionism of his work was so convincing that he was arrested later that year on suspicion of counterfeiting paper money and instructed to no longer include bank notes in his compositions.[4] Chalfant's studies in Paris were sponsored by Alfred Corning Clark, a wealthy art patron from Brooklyn, New York, who admired his trompe l'oeil paintings.[5] His early work had focused on objects, making good use of his skills as a craftsman. He did not begin to paint images of people—such as genre scenes and portraits—until after his studies in Paris, where he received training in life drawing.

The Académie Julian was a private art school founded in 1868 by Rodolphe Julian, a former wrestler and circus manager turned amateur artist. Students could draw or paint from a live model with little formal instruction while preparing for the admissions examination at the government-sponsored Ecole Nationale des Beaux-Arts.[6] Admission requirements at the Académie were extremely flexible. Anyone who could pay the tuition was permitted to attend classes, and enrollment could be arranged for a term as short as one month, beginning at any time.[7] Students chose their instructors and courses at their own convenience. Unlike the Ecole, the Académie operated year-round, providing night courses for students who worked during the day and offering practical instruction in marketable skills such as illustration, watercolor, and miniature painting.[8]

The Académie attracted large numbers of students, and by the late nineteenth century it had become so popular that it rivaled the Ecole des Beaux-Arts. Most of the

60. Jefferson David Chalfant (1856–1931), *Bouguereau's Atelier at the Académie Julian, Paris*, 1891
Oil on wood panel, 11⅛ × 14⅝ in. (28.2 × 37.2 cm)
Gift of Mr. and Mrs. John D. Rockefeller 3rd, 1979.7.26

Fig. 60.1. Jefferson David Chalfant (1856–1931), *Study for "Bouguereau's Atelier at the Académie Julian, Paris"* [detail], 1891. Graphite on laid paper, 17⅜ × 14¼ in. (44.2 × 36.2 cm). Fine Arts Museums of San Francisco, Achenbach Foundation for Graphic Arts. Gift of Mr. and Mrs. John D. Rockefeller 3rd, 1979.7.27

instructors at the Académie had themselves been students at the Ecole, and many of them were contributors to and jurors at the Paris Salons and had received numerous official prizes and public and private commissions.[9] Instructors worked in teams of two, making studio visits in alternate months to critique their students' progress. The rest of the time classes were run by *massiers* — advanced students elected by their peers to oversee details such as hiring models, purchasing supplies, and arbitrating student disputes.[10] The most popular teams of instructors at the time Chalfant attended the Académie were Gustave Boulanger and Jules-Joseph Lefebvre; and William-Adolphe Bouguereau and Tony Robert-Fleury. In both their own work and their teaching these artists emphasized figure drawing and careful study of live models as preparation for painting.[11] The Académie focused exclusively on technical training and did not offer courses in anatomy, perspective, art history, or aesthetics. As one student noted in 1893, "Construction is the main thing insisted upon at this school. No matter how good a study may be in color, if the drawing is bad it is cut to pieces."[12]

Instruction at the Académie was divided into nine ate-liers, four for women and five for men.[13] Chalfant studied in the atelier of Bouguereau and Robert-Fleury. While Bouguereau was known for his popular paintings of women and children — presented variously as peasant mother and child or in allegorical pairings such as Charity and her dependents, Venus and Cupid, or the Virgin Mary and baby Jesus — Robert-Fleury made a name for himself as a historical genre painter.[14] Due to his popular success and meticulous teaching style, Bouguereau attracted many students and was a well-known figure in the art world.[15]

In painting *Bouguereau's Atelier at the Académie Julian, Paris*, Chalfant declared his allegiance to Bouguereau's method and created a detailed record of one of the most prominent Parisian art schools of the late nineteenth century. Before attending the Académie, Chalfant painted his still lifes and trompe l'oeil pieces directly from studio props. Each of the genre paintings he completed after returning from Paris, however, has at least one corresponding pencil study and often one or more studies in oil, suggesting that Chalfant absorbed the Académie's teachings about the importance of preparatory drawings.[16] *Bouguereau's Atelier* was preceded by an exacting pencil study, identical in composition and very close in size to the painting (fig. 60.1). Rather than using studies to explore alternative compositional arrangements, Chalfant typically made them the direct basis for his paintings, placing charcoal or carbon paper on the back of a study and tracing over it to transfer the image to the canvas or panel. When he began to paint portraits in the 1890s, he often used photographs of his subjects in the same manner.[17] Large amounts of charcoal on the back of the study for *Bouguereau's Atelier* suggest that in this case Chalfant used a charcoal transfer.[18]

Bouguereau's Atelier features an industrious group of male art students in a life-drawing class. Two nude models, one male and the other female, are posed on wooden platforms, the easels arranged around them filling the cavernous, sunlit room. Bouguereau himself does not appear to be present, but the students nevertheless work quietly, some drawing the models in charcoal while others use oil. The scene is relatively sedate compared to the studio atmosphere described in some contemporary accounts. Edmund Wuerpel, an American who studied with Bouguereau in the 1890s, described the studio as "a barn of a place, an ancient warehouse from which, on the second and top floor all partitions had been knocked out and large sky-lights had been let into the north slope of the roof. It was enormous and light filled, with a howling, noisy milling mass of boys

and young men."[19] Cecilia Beaux, who entered the Académie in 1888 to study in a women's class with Bouguereau, recalled that the studio had been so crowded she had been forced to abandon painting: "I made one or two attempts at painting, and found that, without space and power to move, I got nowhere. I could neither see nor feel, and I felt smothered among the canvases about me. I decided to give up painting in the class, and devoted all my time to drawing."[20]

In Chalfant's painting the studio is crowded but not unmanageable, and the students are calm and diligent. The walls are covered with paintings and figure studies, as was typical at the Académie. While some of the work on the walls may have been selected by instructors to serve as models or inspiration for the class, one contemporary report suggests that at least some of them were comical portraits and caricatures of students, "painted in secret and secretly placed on the walls, the author being often unknown."[21] The light streaming in through the skylights is dimmed by cigarette smoke, which gathers in a hazy cloud, particularly toward the back of the room. This smoky environment was typical. Henry Ossawa Tanner, who studied at the Académie in the nearby studio of Jean-Joseph Benjamin-Constant and Jean-Paul Laurens, recalled in 1909: "I had often seen rooms full of tobacco smoke, but not as here in a room never ventilated—and when I say never, I mean not rarely but never, during the five or six months of cold weather. Never were the windows opened. They were nailed fast at the beginning of the cold season. Fifty or sixty men smoking in such a room for two or three hours would make it so the back rows could hardly see the model."[22]

Each atelier typically had two models, one male and one female, who were selected each day by a vote of the students. The models posed for eight hours at a stretch, with the exception of one ten-minute break each hour and one hour of rest at noon.[23] In an article published in 1895, after Chalfant returned to Delaware, a critic discussing figure paintings Chalfant had produced while in Paris noted, "The models in the academies are not as finely formed as those who go to private studios, as they are not so well paid, and only good models can command high prices; but the work that Mr. Chalfant has done from even poor subjects is fine in modeling and excellent as to flesh tint."[24] In *Bouguereau's Atelier* neither model is particularly shapely or

muscular, yet this fact is less a reflection of the physique of Académie Julian models than a testament to the artist's unwillingness to idealize them. As another critic declared in 1890, before Chalfant left for France: "He is a realistic rather than ideal painter."[25] While Chalfant's technical practice changed in Paris, his general approach to his subjects did not. His figure paintings retain the unflinching precision of his earlier works, which focused on arrangements of objects and musical instruments.[26]

Chalfant presents the scene not from the back of the room but from a position behind the first row of easels to the left of the female model, who is clearly visible in profile. Two palettes, spare brushes, and a small, spouted metal container and a tall glass bottle—perhaps holding materials used for cleaning brushes or thinning paint—are arranged at the edges of the platform on which the model stands. Chalfant has included himself among the students in the class; he sits at the far right of the composition, his hands folded in his lap, perhaps pausing to check the model's position before continuing with his drawing. While the student to his right, seated one row farther back, turns to look at the viewer, Chalfant himself stares straight ahead, his profile framed by a blank canvas beside him.[27]

Bouguereau's Atelier was one of Chalfant's few works inspired by his time in Europe. After he returned to Wilmington in 1892 the painting was displayed in his studio amid an arrangement of props and artifacts he had purchased while abroad. Photographs of the studio published in the late 1890s reveal that the walls were filled with several studies Chalfant made in Paris, along with drawings and etchings by other artists, including Lefebvre, an instructor at the Académie, and Severin Roesen, a prominent still-life painter.[28] Chalfant typically completed two to four paintings per year and was careful to choose popular subjects that would be easy to sell. The genre scenes he painted after returning from Paris focused on sentimental themes, such as craftsmen in dying trades, street children, and solitary musicians.[29] Chalfant apparently never attempted to sell *Bouguereau's Atelier*. Displayed in his studio, the painting reminded collectors and fellow artists of Chalfant's Parisian training and marked him as both a "realistic painter" and a skilled, academically trained artist. [AG]

61. JOHN FREDERICK PETO, *Job Lot Cheap*

PASSING TIME

Here he [Peto] sets Harnett's books in an architectural setting worthy of Josef Albers or any other geometric-abstract painter of recent years, and gives the whole the tragic tone which is uniquely his. ALFRED FRANKENSTEIN[1]

Job Lot Cheap (1892) is a poignant image of neglected and unwanted books that has an ironic parallel in John Frederick Peto himself (1854–1907), who spent years banished from the pages of art history books. Because he was so reclusive, preferring the relative quiet and obscurity of the seaside town of Island Heights, New Jersey, it was not until 1949 that most of Peto's paintings were discovered, hidden behind forged signatures of William M. Harnett (1848–1892).[2] Alfred Frankenstein, art critic for the *San Francisco Chronicle*, discovered Peto's work when he visited the little-known artist's studio during his research on the more famous Harnett, widely acknowledged as the central figure in American still-life painting.[3] Frankenstein discovered objects in Peto's studio that appeared in many of the paintings believed to be by Harnett, especially those painted in a looser, brushier style.[4] It quickly became evident that previous attributions to Harnett, based on the assumption he painted in two distinct styles, were mistaken, and that the signatures in most of Peto's works had been altered in order to pass them off as compositions by Harnett, Peto's friend and mentor.

The two artists knew each other well at the Pennsylvania Academy of the Fine Arts, where both were enrolled in the 1870s during the height of Thomas Eakins's (1844–1916) tenure.[5] Founded in 1805 by Charles Willson Peale, the Pennsylvania Academy was the nation's first art museum and school of fine arts. As home to the academy and the Peale family of painters, Philadelphia had led the nation in still-life painting during the late eighteenth and early

nineteenth centuries. James, Raphaelle, Rubens, Margaretta, and Sarah Miriam Peale, especially, built their reputations on realistic still lifes whose detailed and accurate renderings created the impression of tangible and often sensuous objects, evident in Raphaelle Peale's *Blackberries* (ca. 1813, pl. 16). Often they achieved effects so precise that viewers would be tempted to mistake the paintings for three-dimensional tableaux, what Charles Willson Peale termed "a deception in toto," in works such as his *"Staircase Group": Raphaelle and Titian Ramsay Peale* (1795) and Raphaelle Peale's *Venus Rising from the Sea—A Deception* (fig. 61.1).[6] Growing up in Philadelphia, Peto would have been well aware of this tradition, known as trompe l'oeil, or "fool the eye," painting, which was supported by the academy's instruction in academic realism.

Harnett's first major painting of this type was also titled *Job Lot Cheap*, painted at the academy in 1878, the year Peto arrived (fig. 61.2). Because Peto painted his version of the subject in 1892, the year Harnett died, it is likely that the work is a tribute to his good friend and mentor.[7] Both paintings depict a disheveled arrangement of books on a narrow ledge accompanied by painted signs and labels, including the title's reference to "Job Lot Cheap." However, Peto created a work with more compositional compression and symbolic weight than Harnett's mildly nostalgic depiction of old, worn books. John Wilmerding notes that the artist's "impulses toward density and compression create the feeling of impending instability."[8] In this way, Peto provided a visual analog for the anxieties and uncertainties of the

240

61. John Frederick Peto (1854–1907), *Job Lot Cheap*, 1892
 Oil on canvas, 29⅝ × 39¾ in. (75.3 × 101 cm)
 Gift of Mr. and Mrs. John D. Rockefeller 3rd, 1979.7.81

Fig. 61.1 [right]. Raphaelle Peale (1774–1825), *Venus Rising from the Sea—A Deception (After the Bath)*, ca. 1822. Oil on canvas, 29¼ × 24⅛ in. (74.3 × 61.3 cm). Nelson-Atkins Museum of Art, Kansas City, Missouri. Purchase, Nelson Trust, 34-147

Fig. 61.2 [below]. William Michael Harnett (1848–1892), *Job Lot Cheap*, 1878. Oil on canvas, 18 × 36 in. (45.7 × 91.4 cm). Reynolda House, Museum of American Art, Winston-Salem, North Carolina, 1966.2.10

artist's life, as well as for the fears of many who believed that the conditions of modernity were eliminating the social coherence of a simpler way of life.[9]

Peto sets his jumble of used, worn, and torn books within a tight architectural framework that provides numerous opportunities for trompe l'oeil illusionism. The objects are organized in a single, shallow space, which allows the artist to align them with the flat verticality of the picture plane, thereby heightening the deceptive effect by conflating depicted image and painted surface. The shuttered window is open to the street, suggesting a sidewalk stall, although a second shelf just visible above hints at more books for sale inside the indistinctly articulated room. The handmade signs, the torn scraps and residue of previous notices, the rusted nails and hardware, and the weathered and battered wood all add to the feeling of neglect and decay. That these well-worn elements are portrayed with exacting and deceptive illusion, all brushwork hidden by a smooth handling of paint, merely strengthens the impression of abjection by making viewers confront the relationship between reality and representation, between an actual object and an image.

Peto's use of text anticipates the use of linguistic fragments by the Cubists and Surrealists. Viewers must complete words and letters, actively engaging with the discursive context of the imaginary space. The puzzles are not difficult, but they raise the issue of ambiguity and the need to construct meaning based on visual clues. They are reminders of everyday life and what gives it significance. These books function as Peto's reflection on the past, symbols of what has been abandoned. In their battered, soiled, and rejected condition, they may even serve metaphorically as stand-ins for the lives of those who wrote or read them and no longer have any currency. The contemporary poet John Ashbery has compared them to Ezra Pound's characterization of our "botched civilization" as "a few thousand battered books."[10] The derelict quality of the neglected books stands in marked contrast to the aesthetic pleasures of antiquarian books, objects valued for their rarity and elegance as well as for the cultivated sensibility of the words they embody. Rather, these books and, by association, the humble peddler who has amassed them are both symbolic tropes for wisdom hidden beneath an inauspicious exterior, and both represent a way of life that was disappearing at the end of the nineteenth century.[11]

Peto was an avid reader, and his studio functioned as a library as much as a painting studio. John Wilmerding writes poetically of Peto's affection for old books: "A shelf of worn volumes bespoke the pleasures of constant reading— the old masters made familiar. Within these broken bindings and frayed pages reposed the muse of literature."[12] His studio-library contained a trompe l'oeil frieze, consisting of a shelf filled with books arranged with the haphazardness of this painting.[13] Books, therefore, appear to have played an important symbolic role in Peto's understanding of time passing, both as discarded objects and as the carriers of words no longer adequate to the present reality. They are "treasured repositories of solace and cultural wisdom," which suggest a fading way of life.[14] Although the whole lot may be going cheap, the books in this common scene are transformed through the alchemy of art into an elegiac reminder of human achievement and loss. [DC]

62. JOHN FREDERICK PETO, *The Cup We All Race 4*

A THIRST FOR AUTHENTICITY

One wonders why more attention has not been given to the extraordinary purity with which Peto kept expressing the "idea" or the archetype of the humble objects he had around him.[1] REGINA SORIA

Painted toward the end of his life, John Frederick Peto's *The Cup We All Race 4* (ca. 1900) offers a profile of the artist's personal experience and career through its symbolic references and pictorial concerns. As Alfred Frankenstein, the biographer who essentially discovered the artist's oeuvre during his research on William Michael Harnett (1848–1892), notes, "It does not take a Freudian psychologist to perceive that Peto's concern with used-up, discarded, and rejected things parallels his own life."[2] The spare simplicity of Peto's painting focuses the viewer's attention on the illusionary aspects of the work at the same time that it loads the few objects represented with an abundance of meanings. Viewers are required to search for personal meanings in Peto's subject matter, which ironically is unconventional by virtue of being extremely commonplace.

Born in 1854, Peto (1854–1907) was in his early twenties when he enrolled at the Pennsylvania Academy of the Fine Arts in 1877. A close associate of Harnett, Peto worked in Philadelphia as a still-life painter in the trompe l'oeil tradition from 1880 until his move to the relative isolation of Island Heights, New Jersey, in 1889.[3] Peto left only enigmatic indicators about his decision to withdraw from the cultured and sophisticated world of Philadelphia for the reclusive life of Island Heights, a coastal community near the Toms River. Although near fashionable seaside resorts such as Seaside Heights, frequented by wealthy Philadelphians, Island Heights was a strait-laced Methodist town.[4] The conservative religious morality of the town gives Peto's frequent use of wine bottles, beer mugs, pipes, and playing cards in his compositions an ironic cast.[5] Yet Peto must have felt comfortable with the pietistic strictures of his neighbors

because he often played the cornet at the area's numerous camp meeting revivals.[6]

The ethical conservatism of Methodism was one of the principal responses to the anxiety and social confusion brought about by modern industrial life in late Victorian America. At a time when many people feared that secularized visions of society were undermining the religious foundations of traditional republican moralism, both liturgical and nonliturgical Protestants were seeking new symbols that embodied ethical antidotes to the changing social conditions abetted by modernity.[7] Within such a cultural climate, the past carried a strong, nostalgic appeal, which Peto conjures through common, preindustrial objects that evoke both a simpler time and a more concrete reality.

The realism of the still life heightens Peto's claims for the authenticity of his subject matter. As a genre expressing spiritual and material values, still life gained prominence during the baroque era, especially in seventeenth-century Dutch painting with its vocabulary of wealth, abundance, and order that celebrated the values of a newly rising mercantile society.[8] Exotic fruits and flowers, expensive containers, and other opulent household objects testified to economic success and its pleasures, metaphorically paying tribute to the role of possessions in defining identity (fig. 62.1). The illusionistic representation in these displays emphasized the materiality of the objects depicted. The visual rendering of tangible detail aligned such images with the language of objective observation and gave them the status of physical truth, an effect enhanced by the elimination of brushstrokes in the smoothly painted surfaces.

Further, seventeenth-century Dutch still life had

62. John Frederick Peto (1854–1907), *The Cup We
 All Race 4*, ca. 1900. Oil on canvas and wood boards
 with brass plate, 25½ × 21½ in. (64.8 × 54.6 cm)
 Gift of Mr. and Mrs. John D. Rockefeller 3rd, 1979.7.80

Fig. 62.1. Willem van Aelst (1627–1683), *Flowers in a Silver Vase*, 1663. Oil on canvas, 26½ × 21½ in. (67.3 × 54.6 cm). Fine Arts Museums of San Francisco. Gift of Dr. and Mrs. Hermann Schuelein, 51.21

resonance for nineteenth-century Americans because "the cultures of the two countries in these respective centuries shared similar values. Both were nations grounded in Protestantism, giving rise to moralizing impulses; in commerce and mercantilism, investing value in material well-being; and in scientific exploration, finding expression in adventurous pioneering and technical ingenuity.[9] However, in spite of relying on the visual language of traditional still life, Peto's image could not be more at odds with the celebration of material progress and bourgeois ideals such painting promotes. His image provides a metaphor for rural rather than urban values and is more consistent with the tenor if not the substance of Thorstein Veblen's famous satirical critique of America's Gilded Age prosperity and "conspicuous consumption," *The Theory of the Leisure Class* (1899).

Everything about the painting is designed to suggest that it is a relic of a distant time and place, its melancholy tone countering the assumptions of optimism and progress that supported the image of America as a modern, industrial power.[10] The painting presents battered and splintered wooden boards within a wide, rustic wooden frame. A dented cup hangs on a crude metal hook. The painting's title, "the cup we all race 4," appears to be rudely incised into the boards. At the top of the framing boards, a skewed nameplate identifies the work as by "John F. Peto." Near the top of the board frame at the right edge, nails hold down the four corners of a card that otherwise seems to have been torn away. The representation of something apparently made with primitive tools and materials points to the harsh conditions of survival and hard work that symbolized for many Americans the virtues of the lost frontier, which Frederick Jackson Turner lamented in his famous "frontier thesis," delivered in a speech at the World's Columbian Exposition in 1893.

Within this context, the humble but pragmatic drinking cup promises a thirst-quenching drink as reward enough for the challenges of rural life. However, the historical account implied by this image is told emblematically. Peto uses a language of ambiguity, amplified by the conventions of trompe l'oeil, or "fool-the-eye," painting, a specialized form of still life popular in America at the end of the nineteenth century. Works in this style are designed to be elaborate visual deceptions that viewers will mistake for actual three-dimensional tableaux. It is a realist vocabulary that goes beyond mere convincingness into the realm of illusion.[11]

In *The Cup We All Race 4*, Peto creates a visual rebus that transcends representation to question the very relationship between reality and illusion. The central boards—with their hook and nails, tin cup, and incised letters—are painted on the center canvas. But the frame is made of actual wooden boards, painted to match the canvas's representational boards, creating confusion about what is canvas and what is board or frame. The incised letters, card corners, and nails are painted onto the actual boards, continuing the illusion of three-dimensionality. In a final reversal, the nameplate is an actual metal plate nailed into the top framing board. The play is made even more convincing by ensuring that the scale of all these objects is consistent with expectations of their actual size.

The celebration of deception over realistic representation reflects the Victorian era's concern for authenticity at a moment when many Americans believed that what was most genuine in the culture was vanishing before the advance of a new economic and social order, "a feeling that life had become not only overcivilized but also curiously unreal."[12] Given the ability of still life to link individuals to cultural assumptions, its popular resurgence at the end of the nineteenth century suggests the significance of the artificial as a national trope.

Peto's painting creates a tangle of equivocal visual artifice that doubles the ambiguity of the meaning in the image itself, posing a number of indecipherable interpretations, all centered on the tin cup and its verbal referent. The word *cup* occupies the same central section as the visual cup hanging above it, drawing attention to the question of representation and the relationship between image and language through their juxtaposition on a trompe l'oeil wooden board.[13] The use of painted versus actual graffito scratched into the framing boards accomplishes a clever sleight of hand, raising a crude mark associated with defacing property and an insistent indicator of physical presence to the level of fine art.[14]

However, the everyday nature of the imagery in Peto's painting reflects the artist's personal interests as much as the fin-de-siècle unease of the Victorian era. Its melancholic nostalgia is consistent with Peto's own disappointments and sense of loss. He appears to be gently satirizing his artistic aspirations, which were largely unrealized during his lifetime, leading viewers to ask what illusions they themselves pursue.[15] As John Yau has written, "what we race for—fame, love, money—is an illusion. Instead of glorifying the race, Peto uses *trompe l'oeil* to trick us into reaching for something we can never grasp."[16]

From his house along the Toms River, Peto would have seen the regular sailing meets that were sponsored by the local yacht club, and his humble cup may be an ironic reference to those events.[17] However, such a reference also serves a metaphoric purpose through the association of a sporting competition with a life lived in the pursuit of spiritual goals. Evangelical Methodists were fond of quoting the apostle Paul's admonition to "run with patience the race that is set before us" and to "press toward the mark for the prize of the high calling."[18] Such language gave religion a vigorous cast that made it seem more concrete and thus more real in an age of increasing spiritual uncertainty.

The single cup centered, framed, and isolated also resembles an altarpiece icon translated into an ordinary object. It speaks to the sacramental character of a way of life that was associated with rural values that now appeared to be obsolete—the plain, well-used cup discarded by a sophisticated urban age. It functions as an analog to Peto's own body, suffering at this time from Bright's disease, the painful kidney ailment that would eventually cause his death. That pain—coupled with Peto's nostalgia for a more authentic mode of life rooted in the rigors of earlier times rather than the ambiguities of Victorian modernity—creates the melancholic tone of his later work, as seen in this painting.[19] In this sense the painting is a still-life *vanitas*, a reminder of the illusory nature of both art and life. Or, as John Wilmerding wrote, "What we learn is that Peto's art was his life, that his still-life arrangements were indexes of his autobiography, and that his work was about the mysterious struggle of creation."[20] [DC]

63. THOMAS WILMER DEWING, *Elizabeth Platt Jencks*

MODERNITY AND AESTHETICIZATION

Each summer between 1890 and about 1905, a group of artists gathered in Cornish, New Hampshire, for conversation, fresh air, companionship, and art making. One contemporaneous writer described the advantages of Cornish's location: "[It is] 'far from the madding crowd,' in an atmosphere of modern antiquity, yet not dangerously distant from the intellectual Boston, nor more than a day's ride from commercial New York. . . . Essentially the atmosphere of Cornish is one of culture and hard work."[1] As the nineteenth century progressed, American artists—who had customarily gone to Europe for their educations—were able to find art schools and academies, new exhibition venues, and educated patrons in their homeland. In addition, at the Tenth Street Studio Building in New York City, on sketching jaunts in the Catskills or at Greenwood Lake, New Jersey, as members of the Century Association, in groups such as the Ten, and at colonies like Cornish, artists could talk, argue, learn, complain, and collaborate with each other.

Among the summer visitors at Cornish were Maria Richards Oakey (1845–1927), Augustus Saint-Gaudens (1848–1907), Abbott Handerson Thayer (1849–1921), Frederick MacMonnies (1863–1937), and Willard Metcalf (1853–1925). Perhaps inevitably, their strong personalities and creative spirits tended to bump and scrape against each other. That cultured, hardworking atmosphere was often suffused with the tension emanating from one of the founders of the colony, Thomas Wilmer Dewing (1851–1938). The other artists feared his scathing wit, and he was the center of many of the feuds and intrigues that percolated in the group. Additionally, Dewing, who was married to Oakey, conducted a long affair with Annie Lazarus, who was also at the colony. A photograph taken in the garden at

Cornish shows Oakey, hand on hip, and Lazarus, with her face scratched out.[2]

It was at Cornish in 1895 that Dewing painted this portrait of Elizabeth Platt Jencks (1867–1953). Jencks often joined her brother, the landscape architect Charles Platt (1861–1933), at Cornish in the summers. In August 1895 Dewing wrote to his patron Charles Lang Freer, "I am painting the portrait of Platt's sister." A month later he wrote again, "I have been painting a portrait of a lady up here that I want to show you."[3] When he began the painting, Dewing had just returned from a sojourn in Europe. While there he had toured galleries and shared a London studio with the American expatriate artist James McNeill Whistler (1834–1903). Whistler's tonalist influence is evident in the portrait of Jencks. In a technique similar to Whistler's, Dewing used fluid brushstrokes to apply thin swatches of white, gray, pink, and purple paint to the finely woven canvas. The muted tonality of the painting is set off handsomely by the richly detailed, gilded frame, designed by Dewing's friend the architect Stanford White (1853–1906).

Jencks stands against a mottled gray ground. The dress she wears was probably a studio prop of Dewing's, as one very like it appears in two other paintings by him.[4] Her right hand, sheathed in a long, brown glove, is on her hip. Her other arm, bare, hangs at her side. Dewing used a similar pose in two earlier portraits of children—young Robert Walton Goelet (1886, private collection) and DeLancey Iselin Kane (1887, Museum of the City of New York). Kane's portrait in particular recalls Thomas Gainsborough's *Blue Boy* (see fig. 9.1).[5] It is an assertive, confident posture—one elbow thrust out, the other arm casually hanging down—made even more so by a direct, steady

63. Thomas Wilmer Dewing (1851–1938), *Elizabeth Platt Jencks*, 1895
 Oil on canvas, 23¼ × 16¾ in. (59.1 × 42.5 cm)
 Gift of the Atholl McBean Foundation, 1987.40

Fig. 63.1. Thomas Wilmer Dewing, *The Lute*, 1900–4. Freer Gallery of Art,
Smithsonian Institution, Washington, D.C. Gift of Charles Lang Freer, F1913.34

gaze. Yet Jencks does not meet our eye as young Robert, De-
Lancey, and the Blue Boy do. Her heavy-lidded eyes are fo-
cused slightly to the left. She does not challenge us; rather,
she appears to be thinking of something else altogether.
The assertiveness of the posture is further softened in
Jencks's portrait by the shadows that graze her face, neck,
left shoulder, and arm. We have the sense of someone cau-
tiously emerging from or withdrawing into the shade. The
light that casts this shadow falls most strongly on Jencks's
chest, and the glowing triangle of skin seems exposed and
vulnerable.

The artist Dennis Miller Bunker (1861–1890) painted
Jencks in 1890, before her marriage. He wrote about the ex-
perience in a letter, commenting, "I have been painting all
the morning on a portrait that I've just started of Lizzie
Platt. I think I can make an effective thing of it. She [is]
rather a pretty girl and uncommonly nice. I think she's en-
gaged but they don't say a thing about it yet."[6] In Bunker's
letter Jencks is sweet "Lizzie Platt," watched over by a pro-
tective family (the "they" who are not revealing the en-
gagement). When the marriage did take place later that
year, Lizzie became Mrs. Francis Jencks, married to a suc-

cessful lawyer twenty years her senior, and a society doyenne who entertained lavishly in her stylish Baltimore home. Yet she retained the kindness Bunker had noticed. When her four children were older, she founded the Women's Civic League of Baltimore and became involved in many philanthropic activities. The independent spirit suggested by that hand-on-hip posture in Dewing's portrait led her to support Franklin Delano Roosevelt's first campaign for president, to the irritation of her wealthy Baltimore neighbors.[7] Dewing has made a striking likeness of his sitter's character, capturing both her kindness and confidence.

Jencks's portrait was Dewing's last society portrait. While he would continue to paint women—indeed, he devoted his career to doing so—his subjects after 1905 were models. His purpose in the later paintings was not to capture likeness or suggest character but to use the models to express ideas and create aesthetic effects. The women appear cloistered in windowless interiors or, in a group of paintings he made at Cornish that he called "decorative landscapes," artfully posed in lush, emerald green meadows (fig. 63.1). While not all beautiful, these women possess a rarefied elegance. Thin and long-limbed, trapped in thick, airless atmospheres, they seem like an exotic species of ancient insect preserved in amber. Yet one contemporaneous writer found in them something elusively up-to-date. He wrote, "[The women] all seem to live in a Pre-Raphaelite atmosphere, in mysterious gardens, on wide, lonesome lawns, or in spacious empty interiors. . . . They all have a dreamlike tendency, and, though absolutely modern, are something quite different from what we generally understand by modern women."[8]

The portrait of Jencks possesses a similar, elusive impression of modernity. Jencks and the models have been dressed, positioned, and framed by the artist, but there is something about them that defies control or knowledge. The models appear lost in thought or engaged in rites beyond our ken. White designed the gilded frames encircling these images to provide a transition between the works of art and the settings in which they were placed, which gives us an idea of the kind of elaborate interiors for which these paintings were intended.[9] Yet the women in the paintings do not occupy such interiors but instead some otherworldly place, far from the squabbles and petty dramas unfolding at Cornish, a place where neither work, nor men, nor cares disturb them. While the other women simply ignore us, Jencks both wards us off with her spiky elbow and retreats into shadow. All, however, possess a certain independence of both spirit and thought, aestheticized but hardly subjugated. [IB]

CRITICAL RESPONSES TO BEAUTY

The young woman in Edmund C. Tarbell's (1862–1938) painting *The Blue Veil* (1898) casts her eyes downward and turns away from the viewer. Presented with her profile, it is hard for us to determine her mood—shy, sad, pensive, sulky? Similarly, the painting—with its close-cropped composition—declines to tell us where she is. The background is a thick, abstract swirl of lavender, blue, white, gray, and yellow. But, as the title makes clear, Tarbell's painting is not really about the woman at all. Rather, it is a painting of her veil, which has been caught by a breeze and flows around her face and shoulders in sheer folds and waves the color of lapis. Or, to be more precise, the painting is about how that transparent blue veil changes the color of the woman's skin and hair, dress and hat, how it billows and twists in the wind, and how its hue deepens as the fabric turns and doubles. The painting was exhibited seven times in the fourteen years after Tarbell painted it, and it is easy to see why. It is a lovely image.

Yet the loveliness of Tarbell's paintings—this is just one of many that could be so described—led some contemporaneous critics to question the value of his art. Throughout his life, as the artistic winds shifted, Tarbell was disparaged and praised for his single-minded commitment to beauty. Some critics charged he lacked imagination. Others complained that he failed to record the great achievements of the age in which he lived. Others dismissed him as a pure technician, "a man without ideas or ideals."[1] His champions, however, found a possibility for renewal in his paintings. One writer compared Tarbell's paintings to the flowers carefully coaxed to bloom by a gardener who assiduously works a small urban plot: "Does [the garden] not cleanse his spirit of the moil of life, refresh and strengthen him? . . . If

he thinks at all about the matter, will he not divine that the import of these flowers is that they are a tiny concrete expression of the immeasurable conception of beauty? And so divining, he will not seek to measure the influence upon his life of that portion of beauty. It is enough that his spirit is cleansed, refreshed, and fortified."[2] When pressed to enunciate his philosophy of art, Tarbell only replied, "There is little to be said . . . I am simply trying to make things like." He did assert, however, "Art should try to render the beauty of the thing seen."[3] So, according to Tarbell, paintings should resemble perfectly that which they depict, and they should also draw out or capture inherent beauty.

As a young man Tarbell studied in Paris. He returned to his native Boston in 1886 strongly influenced by the Impressionists' goal of capturing the changing effects of light. His credo "to make things like" has a distinctly impressionist fragrance to it. But Impressionism was not his only influence. The Arts and Crafts Movement, with its belief in the moral value of hard work and skilled craftsmanship and its rejection of industrialized mass-production, also shaped his work.[4] Followers of the Arts and Crafts Movement believed that beautifully wrought, well-made things could indeed satisfy the soul. The movement stressed education and Tarbell was a lifelong teacher, guiding students at the Museum School in Boston and, later in his life, at the Corcoran School of Art in Washington, D.C. The sturdy yet beautiful objects of the colonial era inspired many Arts and Crafts artisans. Boston, once home to Paul Revere and John Singleton Copley (1738–1815) and Tarbell's home for much of his life, became a center for the American branch of the movement. Tarbell, like many other late-nineteenth-century American artists, was also influenced by Asian art.

64. Edmund C. Tarbell (1862–1938), *The Blue Veil*, 1898
 Oil on canvas, 29 × 24 in. (73.7 × 61 cm)
 Mildred Anna Williams Collection, 1942.6

He included examples of it in his paintings of interiors and imitated the asymmetrically balanced compositions of Japanese prints.

While Tarbell assimilated these ideas, he was not so wedded to idealized notions about the preindustrial past that he ignored his own times. He might include a fine eighteenth-century desk in a painting of a New England interior, but the woman who sits at it clearly belongs to the artist's day.[5] Art critics often compared his mature work to that of the Dutch master Jan Vermeer (1632–1675), yet they were also quick to note that the women who quietly sewed or read in Tarbell's paintings were his contemporaries.[6] Indeed, Tarbell was celebrated as a painter of a healthy, positive vision of modern, American life.[7] Never abandoning the fundamentals of draftsmanship or composition and maintaining his commitment to craft, Tarbell avoided much of the scandalized criticism that was leveled at avant-garde art: that it used tricks and subterfuges to create its effects, that it was careless in execution, and, most seriously, that it was downright dissolute. Balancing the traditional and the new, Tarbell strove to create art that expressed his belief in the moral benefit of work and the spiritual benefit of beauty.

More recent critics of Tarbell's work have asserted that his paintings "contain subtle antifeminist propaganda because they perpetuate traditional feminine ideals of passivity, spirituality, and domesticity, while ignoring the activities of the modern Boston New Woman."[8] Tarbell has placed the women in his paintings in spare, quiet rooms, regarding them as aesthetic objects, much like the vases or screens around them. The woman in *The Blue Veil* is merely the wearer of the veil: she is provided with no other identity or agency and is erased completely from the title. It is discomfiting to learn that Tarbell kept his own daughters out of school so they could pose for him.[9] (His only son appears much less frequently in his paintings.) If Tarbell often named his children and his wife in the titles of the paintings in which they appeared, those paintings also demonstrate his control over his family as he arranges and aestheticizes them.[10]

There is, then, a distinctly conservative aspect of Tarbell's art for which, like his commitment to beauty, he was either warmly congratulated or chided. One critic wrote approvingly, "Here is work essentially conservative, based on the soundest and sanest painting of the past, yet of the quality that assured the enthusiasm of brother artists and the appreciation and the financial backing of intelligent collectors."[11] While another, writing an obituary and probably endeavoring to be respectful, remarked, "His life covered three-quarters of a century in which the course of art was marked by bitter struggle, revolt and reaction. . . . Yet, because he chose to cast his considerable talents with the side that sought to preserve the status quo, there is little of this turmoil evident in his canvases."[12] Both commentators are right. Tarbell had been a founding member of the Ten—a group of artists who seceded from the established Society of American Artists—a fact that might suggest a revolutionary bent. But Tarbell determined his artistic mission to "make things like" and to embrace beauty early in his life, and he was undeterred from it by the various artistic struggles and revolts of his time. And so, in this painting, we see a woman subsumed in the simple, fleeting beauty of her veil caught by a breeze. [IB]

BEYOND THE HUNT

In one of the earliest accounts of *The Wild Swan*, published in the *Boston Sunday Post* two years after the painting was completed, a critic marveled: "If a person wishes to be startled out of his ordinary complacency and to almost believe the days of sorcery have returned, he has but to visit Alexander Pope's studio in this city and to look at a recent painting titled 'The Wild Swan.'"[1] The monumental picture of a dead swan hanging by its feet against a green paneled backdrop was striking not only for its trompe l'oeil illusionism but also because it marked a departure from the familiar compositional and stylistic conventions governing trompe l'oeil and animal painting at the turn of the twentieth century.

Alexander Pope (1849–1924) began making sketches and carvings of animals as a young boy, and although he later studied anatomy and perspective drawing with the Boston painter and sculptor William Rimmer, he claimed to be self-taught. His first professional works were lifelike wooden sculptures of animals, which he carved and painted while working at his family's lumber business in Boston. On the basis of these sculptures—two of which were reputedly sold to the czar of Russia, Alexander III—and the illustrations he provided for two volumes of lithographs, *Upland Game Birds and Waterfowl of the United States* (1878) and *Celebrated Dogs of America* (1882), Pope became known for sympathetic portrayals of animals. After turning to oil painting in 1882, he specialized in sentimental animal portraits, occasionally attempting more ambitious narratives and historical themes in paintings of the animal world.[2]

Images of animals—whether as cherished pets or objects of sport—were highly prized in turn-of-the-century America, and Pope's work elicited a range of favorable comparisons. In the early years of his career, critics repeatedly likened him to the popular English artist Sir Edwin Landseer, whose emotion-laden and moralistic animal paintings were widely reproduced as prints in both England and America and were often copied by amateur artists.[3] Contemporary viewers of Pope's work would also likely have related it to the hunting pictures of Arthur Fitzwilliam Tait, many of which were reproduced as chromolithographs by the New York firm Currier & Ives.[4] As Pope's career progressed, however, he distinguished his work from the sentimental, narrative works of his fellow animal painters by becoming known for a more careful, exacting interest in the specific features and habits of the animals he painted. One critic noted: "Pope's paintings are not of the conventional chromo type one is wont to note in animal pictures. They are careful studies, absolutely faithful to his subjects, full of life, spirit, and character."[5]

A writer for the *Boston Globe* made a similar observation, attributing the unusual fidelity of Pope's pictures to the character of his particular interest in the natural world: "Primarily [Pope] is a sportsman, although at heart he is a naturalist, as well as a painter. He likes to paint the things he loves and the things with which he is most familiar. So did Audubon in his day."[6] This comparison to the famous naturalist John James Audubon, whose illustrated surveys of American wildlife such as *The Birds of America* (1827–38) were widely known, suggests a scientist's close, direct observation and a sportsman's obsessive and single-minded focus on one creature—both of which were considered hallmarks of Pope's work.

As Frank T. Robinson observed in 1891, Pope's "compositions, if ever faulty, are made so by his desire to exalt his

65. Alexander Pope (1849–1924), *The Wild Swan*, 1900
 Oil on canvas, 57 × 44½ in. (144.8 × 113 cm)
 Purchased through gifts from members of the Boards
 of Trustees, the de Young Museum Society and the
 Patrons of Art and Music, friends of the Museums,
 and, by exchange, Sir Joseph Duveen, 72.28

subject; and so earnestly and surely does he keep the eye centered on the figures, that accessories are of little consequence."[7] Given the strength of Pope's interest in the animals themselves—rather than in narrative, setting, and other "accessories"—it is not surprising that he began to create trompe l'oeil still lifes. He completed his first trompe l'oeil image in 1887, yet such works remain relatively few in proportion to his more typical animal paintings. Pope referred to his trompe l'oeil works as "characteristic pieces," not because they are representative of his artistic production (in fact he is thought to have completed only about a dozen such pictures) but because they faithfully represent the closely observed, typical features of his subjects.[8]

Despite Pope's interest in fashioning his trompe l'oeil still lifes as characteristic representations of his subjects, these works do not resemble the documentary style of Audubon's drawings. Whereas Audubon's work emphasizes the lifelike quality of his subjects through narrative compositions centered on each animal's typical behaviors, Pope's usual paintings tend to follow late-nineteenth-century American trompe l'oeil conventions. Many of them are composed of groupings of objects and dead animals hanging on a door—meant to represent trophies of a hunt—a format that would have been familiar to viewers from famous trompe l'oeil paintings such as William Michael Harnett's *After the Hunt* (pl. 57).[9] Among such works, Pope's *Wild Swan*, its subject isolated starkly against a green, paneled background, is a notable exception.

Critics, impressed by the illusionistic realism of the painting, were nevertheless puzzled by Pope's intentions. Howard Cave complained, "there is nothing to lend attractiveness to the picture save the beauty of the outline and the delicacy of the white plumage. No background could be more commonplace or uninteresting." Equally troubling was the painting's lack of typical trompe l'oeil cues—such as the inclusion of an errant calling card or newspaper clipping—that would mark the image as an artful illusion: "there are no telltale witnesses of deception," Cave remarked, "yet at close range the average spectator would cheat himself into believing that a real bird hung before him."[10]

Cave's objections aside, it is clear that Pope had great ambitions for *The Wild Swan*. A year after it was completed he added the inscription "copyrighted 1901" to the lower left edge of the canvas, suggesting his belief that it would become a widely circulated image. In a letter dated 1910 Pope referred to the painting as "my best known picture." He

Fig. 65.1. John James Audubon, *Trumpeter Swan (Cygnus Buccinator)*, plate 406 in *The Birds of America* (1827–38), published by Macmillan in 1937. Photo courtesy of Stanford University Libraries, Department of Special Collections

noted that it "was exhibited in a great many places and is pretty well known in the principal cities of the country," and he repeated a proud assertion he had made a few years earlier: "as an example of realistic painting it is not equaled on either side of the water."[11]

The notoriety *The Wild Swan* achieved was in equal proportion to Pope's deviations from usual trompe l'oeil compositions. Trumpeter swans were an unusual subject for trompe l'oeil, and it was rare to depict any animal in isolation from other animals or objects. If the goal was to create a striking image, however, the trumpeter swan—the largest swan in the world—was a good choice. Its wings, which fill Pope's canvas, often spanned ten feet, and its long neck, also emphasized in the painting, could measure six feet in length when fully extended in flight.[12] The green wooden paneling from which Pope's trussed swan hangs was also remarkable. While many still lifes were set against a door with intricate locks and hinges, or at least a weathered wooden backdrop with various textures for the artist to explore, the paneled background in *The Wild Swan* is relatively smooth and uniform, with the exception of regular recesses. The absence of metal hardware suggests that the panels are not part of a door at all but rather make up an imposing wall.

In *The Wild Swan*, the viewer is left without the usual interpretative cues. The setting is unclear, and the animal is not presented as a hunting trophy, surrounded by objects that might suggest a valorizing narrative. Instead, the swan is framed in bold silhouette against a dark backdrop, its

form suggestive of crucifixion or sacrifice. Pope gives us, simply, a dead bird, its massive, lifeless body revealing little more than a whisper of the powers involved in its execution and capture.[13] Dead animals—as a subject of both artistic and scientific study—were not in themselves remarkable at the turn of the century, but such stark acknowledgment of their condition was rare.

As the proliferation of nineteenth-century manuals such as William T. Hornaday's *Taxidermy and Zoological Collecting* (1894) and the *Ladies' Manual of Art* (1890)—which included a lengthy guide for parlor taxidermists—suggests, dead animals were common household elements, and indeed considered by many to be part of a well-furnished home.[14] Even Audubon, after completing field research, based his illustrations on stuffed birds—many of which he shot himself—which were posed on wire armatures in his studio.[15] Yet the goal of both the taxidermist and the naturalist was to artfully return these creatures to their living form, complete with realistic expressions and poses, and, when possible, a replication of their natural environment. Audubon's trumpeter swan in *Birds of America* is a study of vitality and motion, the length and muscularity of its neck—a feature he commented on at length in his *Ornithological Biography* (1831–39)—is emphasized as it turns back in pursuit of a moth that skims the water's surface (fig. 65.1).[16] Pope, an accomplished animal portraitist, could surely have provided his swan with similar animation if he so chose. Yet this bird, with its subtly shaded layers of white feathers, is foremost a model of painterly skill, an icon stripped of the active posture and narrative details that would return it to life. It is, emphatically, a corpse; a hunting trophy without its props.

The Wild Swan was owned for many years by the Massachusetts Society for the Prevention of Cruelty to Animals. In the early twentieth century it came to be known as *The Trumpeter Swan*, perhaps in response to the suggestion that the painting was intended as a warning of the imperiled status of trumpeter swans, who were close to extinction at the turn of the century.[17] Along with draining of marshes and other disruptions of the swans' natural habitat, hunting was a primary cause of their diminishing numbers; due to their impressive size, trumpeter swans were coveted hunting trophies well into the twentieth century. Yet it was not hunting for sport but rather commercial hunting that posed the biggest threat. Swan skins were sought as a source of down and ornament for women's hats and clothing.[18] Swan products were particularly popular in Europe; during the nineteenth century, the Hudson's Bay Company of Canada exported 94,326 swan skins.[19] If any critique is implied in Pope's painting, it is likely directed at this fashion craze for swan skin rather than at the activity of sportsmen such as himself.

Pope's interest in hunting was a primary element of his artistic persona. In a profile published in *New England Magazine* in 1891, his studio was described as full of "the paraphernalia of the sportsman.... the walls being decorated with a grand variety of fishing rods, baskets, nets, and huntsman's outfits. These are grouped in an artistic manner for ornamentation as well as ready use. There is no attempt at color riot, no fussy collection of fabrics, antiques, armor, or curios."[20] This last remark was likely a dig at the highly theatrical and lavishly decorated New York studio of the painter William Merritt Chase, a space worlds apart from Pope's humble workplace.[21] *The Wild Swan*, produced in this sportsman's shrine, suggests both artistic ambition and a sportsman's love of the hunt. Pope's careful rendering of the fallen swan's subtly shaded white feathers is a bravura performance, a testament to his technical skill and his mastery over a once powerful wild creature. The painting is a hunting trophy without need of the props this usually implies, just as Pope was, in the words of the *Boston Globe*, "primarily . . . a sportsman, although at heart he is a naturalist, as well as a painter." [AG]

MAKING AMERICANS
UNDER THE MAYPOLE

William Glackens established his artistic reputation at the turn of the twentieth century with uncompromising modern depictions of New York City's middle class. Despite his well-known association with New York, William James Glackens (1870–1938) was born, raised, and for the early part of his life worked in Philadelphia.[1] He attended Central High School, where he studied drawing in a curriculum established in the 1840s by the painter Rembrandt Peale. After graduation, Glackens continued his artistic education by enrolling in night classes at the Pennsylvania Academy of the Fine Arts, while working days as an artist-reporter for a local newspaper.[2] When Everett Shinn, George Luks, and John Sloan were also hired as artist-reporters for the same paper, the four men immediately became friends, forming an informal artists' club. The seriousness of their commitment to painting deepened in the early 1890s when they were introduced to Robert Henri (1865–1929), a young and charismatic American artist who had just returned from Europe and was teaching in Philadelphia. Henri quickly established himself as the group's mentor by encouraging Glackens and the others to become professional artists and, more important, to paint modern subjects in a modern style.[3] Thanks to Henri's inspiration, all four men today rank among America's best-known turn-of-the-century artists and, together with Henri, are identified as members of the Eight, popularly known as the Ashcan School.[4]

Henri taught Glackens and the others to reject the prevailing academic approach to painting, which was founded on the ability to render the human body accurately, which in turn enabled the artist to paint traditional history, genre, and mythological subjects. Conservative academicians also held that brushstrokes should be invisible, giving a painting a smooth finish. By contrast, Henri championed a gestural painterly technique, one he felt allowed artists to respond more directly, actively, and truthfully to the ebb and flow of contemporary life. Summing up his approach in 1910, Henri said, "A thing that is finished is dead. . . . A thing that has the greatest expression of life itself, however roughly it may be expressed, is in reality the most finished work of art. A finished technique without relation to life is a piece of mechanics, it is not a work of art."[5]

Henri's strong personality and progressive ideas exerted a powerful influence over Glackens. The two briefly shared a painting studio in Philadelphia, and in 1895–96 Glackens accompanied Henri to Europe, where Henri encouraged him to study works by artists who painted in a "rough" painterly technique, including Frans Hals, Diego Velázquez, Edgar Degas, and Edouard Manet.[6] Glackens responded positively to these artistic stimuli, especially to the work of Manet, whom he emulated by painting urban parks, as had Manet more than thirty years earlier. On Glackens's return to the United States, he moved to New York City, where he became one of the nation's premier commercial illustrators, a profession that provided him the stable income that enabled him to pursue painting.[7]

Glackens distinguished himself from his artistic peers such as Henri, Shinn, and Sloan by specializing in scenes of middle-class leisure. Indeed, when early-twentieth-century critics appraised Glackens's work, they often

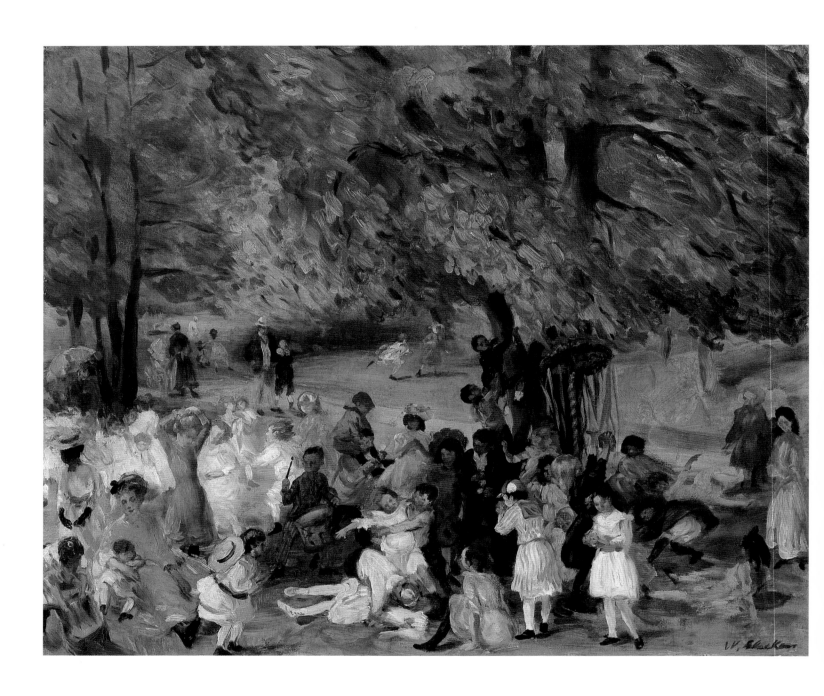

66. William Glackens (1870–1938), *May Day in Central Park*,
ca. 1905. Oil on canvas, 25⅛ × 30¼ in. (63.8 × 76.8 cm)
Gift of the Charles E. Merrill Trust with matching
funds of the de Young Museum Society, 70.11

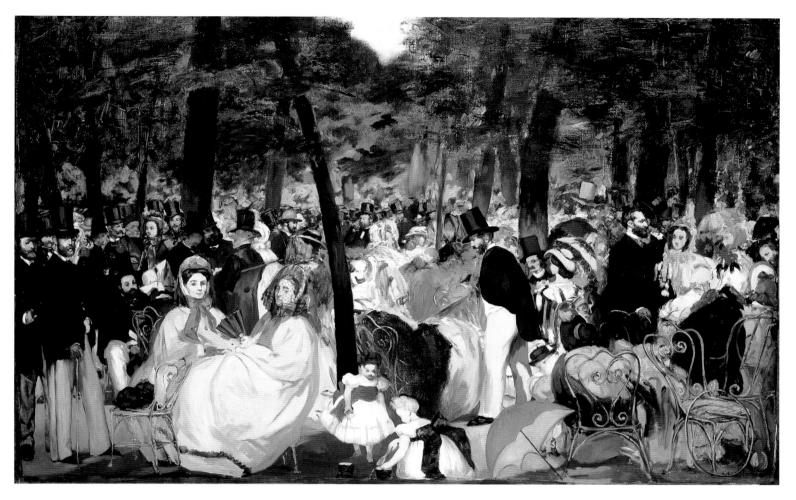

Fig. 66.1. Edouard Manet (1832–1883), *Music in the Tuileries Gardens*, 1860–62. Oil on canvas, 30 × 46½ in. (76.2 × 118.1 cm). The National Gallery, London. NG 3260. The Lane Bequest

compared him to Manet, both for his brushwork and for the fact that Manet was known as a painter of the modern middle class. The art writer Walter Pach wrote in 1910, "As Edouard Manet saw the life of the Parisian café of his time, or of the French capital, represented in the 'Music of the Tuilleries', so William J. Glackens has given us documents of American life in his significant series of pictures, [including] the 'May-Day.'"[8] The critic Margaret Anderson similarly observed, "Such things as his 'May Day in Central Park' are distinctly French. They might have been done by Manet. . . . These resemblances, however, only emphasize the originality of the American landscape."[9] Edouard Manet (1832–1883), considered at the time, and ever since, to be the principal founder of modern art for his direct and honest representations of real people at their leisure, worked in a bold, painterly, and abstracted style.[10] By comparing

Glackens to Manet, these critics asserted *May Day in Central Park* (ca. 1905) was as original as Manet's European modernism. But they also argued that it was perhaps even fresher, as both critics were careful to note that the painting was unequivocally American.

If we compare *May Day in Central Park* to Manet's earlier *Music in the Tuileries Gardens* (fig. 66.1), we see that both paintings use a brushy, painterly visual language to evoke the transient nature of modern middle-class life in the city. In Manet's painting, middle-class men wear black frock coats and top hats. In Glackens's picture, the children are recognizable as from the same social stratum because they are clean, well-dressed, wear light colors, and are supervised by the nursemaids characteristically employed by middle-class New Yorkers. In both Europe and the United States, the middle class was strongly associated

with modern life after their increasing economic, political, and social power in the eighteenth and nineteenth centuries enabled them to displace the previous long-standing aristocratic social order. Thus the very existence of the middle class was a primary condition of modernity.

Furthermore, while Manet was himself familiar with the Tuileries, and Glackens, a New Yorker, would no doubt have witnessed May Day celebrations in Central Park, both of their paintings nonetheless lack a certain specificity. Manet's painting has no clear narrative and instead conveys the undirected bustle of men and women socializing in the Tuileries Gardens. Glackens's *May Day in Central Park*, too, is less a rendering of a specific May Day event than a colorful, sweeping, celebratory evocation of middle-class children at play following a Maypole dance (notice the pole leaning against the tree). Thin washes of green-yellow pigment for the grass—applied with broad strokes of his brush —provide a neutral backdrop for the choppy, darkly outlined foliage above and the candy-colored foreground figures below. These figures he painted with thinner-tipped brushes, varying his handwork to capture the fleeting appearance of sunlight and shadow on clothing and bodies moving rapidly through space. Using quick strokes of color Glackens effectively evokes the jerky movements and shrieks, laughs, and screams of young children at vigorous play on a warm spring afternoon.

The subject of *May Day in Central Park* is distinctly American, just as critics noted. Most obviously, Glackens's children are loud and exuberant, two qualities that were often ascribed to Americans and that distinguished them from their more genteel and cosmopolitan Parisian counterparts. More subtly, the celebration Glackens depicted was about making Americans. At the end of the nineteenth century, social reformers believed that industrialization, urbanization, and immigration were eroding the foundation of American identity.[11] Reformers perceived that the tens of thousands of European immigrants who settled in the United States each year posed a threat to American values. First, immigrants who continued to practice the folk traditions associated with their home country were seen by many native-born Americans as unwilling to assimilate and thus posed a threat to the core Anglo-American values on which the country was believed to have been built. Second, most immigrants were of the working class. They thus constituted the growing number of men and women who observed May Day as an international labor holiday, established in 1886, by striking against their middle- and upper-class employers who in turn considered such activities un-American.[12] To combat these perceived threats to the American way of life, reformers sought to institute a new type of organized play that would instill healthy America values in young minds and bodies.

Reformers looked into the Anglo-American past for model forms of play and found in Elizabethan England a great flowering of folk traditions, among them Maypole dances.[13] These dances were consciously revived in an effort to provide much-needed exercise for American youth and to maintain what reformers believed to be a proper American identity.[14] When performed by children of Anglo-American heritage, usually of the middle class, Maypole dances were thought to bolster a sense of their own heritage. More important, when performed by immigrant children, who were usually among the urban poor, Maypole dances would help to "Americanize" them by substituting a truly American folk tradition for one that their parents may have brought from Europe. In addition, children's celebrations of May Day with Maypole dances would potentially counteract May Day labor strikes. Thus when Glackens painted this work, May Day celebrations in Central Park were associated with modern urban life in America and were understood to be part of the process of making modern citizens ever more *American*. By rendering such a modern subject in a distinctly modern style, Glackens invested his playful child subjects with an energy and vigor that seemed to ensure America's future prosperity. [KM]

67. MAURICE PRENDERGAST, *The Holiday*

PAINTING THE FABRIC OF URBAN LIFE

In 1910 the Boston painter and printmaker Charles Hovey Pepper assessed the work of his friend Maurice Brazil Prendergast (1859–1924) in an article titled "Is Drawing to Disappear in Artistic Individuality?" An editor's note below Pepper's byline asserted: "this sketch by Mr. Pepper is particularly significant because of the pronounced difference in style between his own work, with its careful drawing, and the highly impressionistic painting of Mr. Prendergast."[1] Echoing the lyrical, lighthearted tone commonly used in descriptions of Prendergast's work, Pepper offered the following appraisal of his fellow artist: "Prendergast. What does that name bring to mind? Pictures gay, joyous. Trees and silver skies. Deep blue sea and orange rocks. People in movement, holiday folk in their saffron, violet, white, pearl, tan. Quaint design. Color powerful, but not crude. Canvasses built up with overpainting—color dragged on color. A paint quality as delicious as old tapestry."[2]

In the months before Pepper's article was published, he visited Prendergast's Boston studio and photographed ten of his paintings, including *The Holiday* (ca. 1908–9). Although it was not among the four reproduced in his article, Pepper clearly had the painting in mind as he characterized Prendergast's typical subject matter and style; his discussion of the artist's "holiday folk" could easily serve as a description of *The Holiday* itself. Even without an illustration, *The Holiday*—and Prendergast's many other paintings of coastal leisure—would have been well known to Pepper's readers. In 1924 Duncan Phillips, one of Prendergast's earliest major collectors, noted "the inexhaustible variations in the Prendergast repetitions of approximately the same theme, beach parties or picnics in the park," and described such "midsummer daydreams" as the artist's "favorite fantasy."[3]

With the establishment of the Boston Common in 1634, Boston demonstrated a commitment to preserving open space that would intensify in the face of rapid urbanization in the nineteenth century. In 1837 Boston became home to the nation's first botanical garden, and the subsequent development of the city's Emerald Necklace of parks, developed by the landscape architect Frederick Law Olmsted in the 1870s, secured its place at the forefront of the public parks movement.[4] This enthusiasm for urban public spaces did not necessarily extend to public beaches and seaside resorts. As the expansion of public transportation in the Northeast—and especially the extension of the railroads—made formerly exclusive oceanside parks and resort areas accessible to a wider range of visitors, many Bostonians became anxious. The growth of popular amusement parks was particularly troubling in light of the "pernicious developments" at Coney Island, a site known for such "objectionable features" as vaudeville theaters and dance halls. An article published in *Cosmopolitan Magazine* in 1902 warned that if such debauchery was possible along the New York coast, it was an even greater danger in Boston, "the only great American city that ranks as a summer capital for large sections of the country."[5]

While most artists who painted beach scenes at the turn of the century focused on elite beachgoers, Prendergast preferred more crowded, public sites such as Revere Beach, a working-class resort, and Salem Willows, a coastal amusement park. He was the first artist to paint the new public leisure sites around Boston, and the attention his work received was initially enhanced by the controversial nature of such sites.[6] Prendergast's own feelings about new forms of public recreation are unclear, yet his Roman Catholic, working-class background and his repeated trips to public

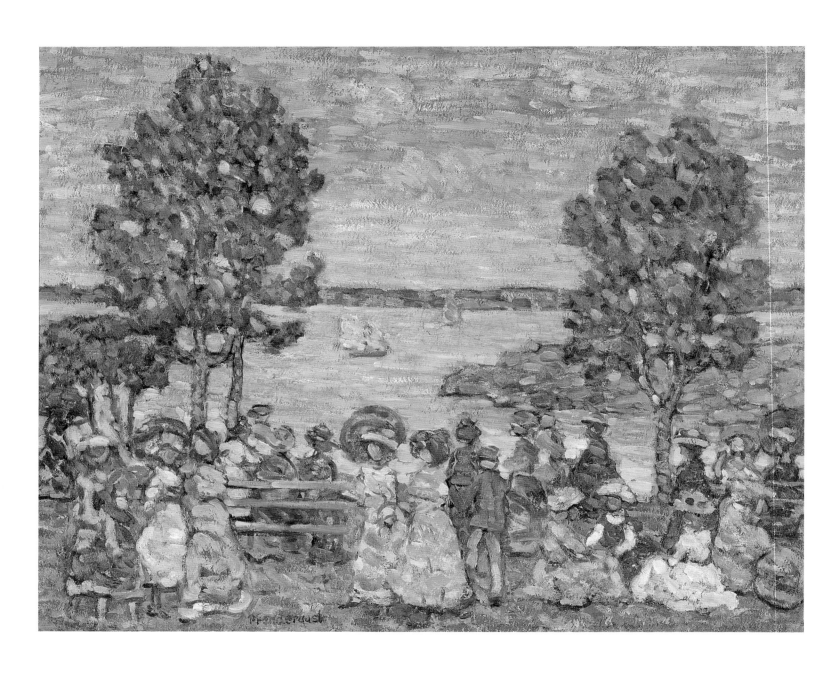

67. Maurice Prendergast (1859–1924), *The Holiday*,
 ca. 1908–9. Oil on canvas, 27 × 34⅜ in. (68.6 × 87.3 cm)
 Gift of the Charles E. Merrill Trust with matching
 funds from the de Young Museum Society, 68.14

parks and beaches suggest he was not troubled by the democratic mixing of crowds fostered by such spaces.[7] Prendergast painted these crowds repeatedly, but he emphasized formal concerns rather than narrative specificity. At the beach, along the coast, or in a park, his crowds are friezelike groupings of color and gesture. While their dress and postures are distinctive, their physical features are not.

In *The Holiday*, as in many of Prendergast's works, the crowd is primarily female, and he has taken care to suggest the elements of each woman's fashionable clothing—the figures form a bold line of sweeping skirts, cinched waists, full sleeves, and elegantly trimmed and beribboned hats. They are clustered in groups, talking with each other or looking out to sea, many of them holding brightly colored Japanese parasols.[8] Two boats pass in the distance, and several of the women are grouped on park benches, looking out to sea.[9] Prendergast's focus is on color and form, and he has painted the scene with a thick layering of overlapping brushstrokes.

This use of heavy impasto was present in his work from the time he began painting in oil in 1904 and likely relates to the layering of discrete washes typical in watercolor, his usual medium in the early decades of his career. Such layering of oil distinguishes Prendergast's work from the direct painting, wet-into-wet, favored by many other artists of the period, who felt that this method preserved spontaneity.[10] In Prendergast's earlier oils, various brushstrokes were used to define specific objects. A parasol might be painted with the twirl of a full brush, while a female figure would be formed from a few broad strokes within a contour line. By the time Prendergast painted *The Holiday*, his brushstroke had become more decorative and less varied, creating an allover pattern of equally emphatic strokes. To compensate for this effect, Prendergast began using contour lines of contrasting colors to differentiate between figure and ground, as he does here.[11]

Perhaps because of Prendergast's distinctive technique, contemporary critics tended to focus on the style and color harmonies of his work and his relationship to European artists, rather than addressing the implications of his leisure subjects. While some Boston reviewers identified the sites he painted and remarked on the veracity of his work, discussion of the decorative effect of his paintings was far more common, particularly after the development of his more systemic, patterned style about 1907.[12] Beginning in 1906 his work was compared to a range of media, including mosaics, samplers, wallpapers, rag carpets, and, most often,

tapestry.[13] The art critic for the *New York Evening Post*, Charles de Kay, authored some of the most extensive discussions of Prendergast's richly textured works. De Kay referred to the artist in 1908 as "an extreme decorationist" and complained that his "idea of painting seems the jotting down of salient colors and the edges of forms for later use in samplers or tapestries."[14] Elsewhere de Kay asserted that the "dream of decorative combinations of colors to which he [Prendergast] subjects the groups of city folks" degraded the artist's urban genre subjects, giving his figural compositions the appearance of "old faded samplers or wallpapers."[15]

The language of textiles present in many contemporary reviews also inflects art historical scholarship on the artist. Comparisons to tapestry and brocade continue to haunt discussions of his work, as do references to the visible flatness and friezelike quality of his compositions.[16] Yet the relationship between textiles and Prendergast's work has tended to remain descriptive, and when the actual tactile quality of his paintings is acknowledged it is generally discussed in the context of his modernism. The search for the sources and influences behind his early modernist, post-impressionist style has focused on his relationship to European artists, rarely taking into account the impact that design movements and developments in the decorative arts—including contemporary textiles—may have had on his work. Yet Prendergast had a serious interest in decorative art and design, as the tapestry-like character of his compositions and paint handling—so often noted in discussions of his work—attest.

The sources most commonly attributed to Prendergast include the aesthetic paintings of James McNeill Whistler (1834–1903), Japanese prints, the color explorations of Paul Cézanne, the large-scale paintings and murals of the French artist Pierre Puvis de Chavannes—which were influenced by fourteenth- and fifteenth-century Florentine murals—and the design principles espoused by the Nabis, a group of painters working in Paris at the turn of the century.[17] The Nabis, who drew their name from the Hebrew word *Nebiim*, "prophets," hoped to break away from the confines of the canvas and reestablish painting as a decorative art, making it accessible as a part of everyday life. While they identified themselves primarily as painters and were interested in murals and other forms of wall ornamentation, they also designed fans, screens, mosaics, stained-glass windows, and tapestries. Prendergast is typically linked to the Nabis as a result of their mutual interest in book illustration

and graphic design, but it seems that Nabi tapestries were also an important influence in the development of the abstracted, tapestry-like patterning that came to characterize his later oil paintings.[18]

In nineteenth-century France, tapestry was a subactivity of painting. Both paintings and tapestries tended to follow similar compositional conventions, and popular painted works were frequently reproduced as tapestries.[19] Yet weavers were careful to preserve the specific limitations of their medium. In the 1820s the chemist Eugène Chevreul, who directed the laboratory that produced dyes for the Gobelin tapestry works in Paris, wrote: "tapestry must not try to outdo painting by seeking to reproduce details and effects for which it is not designed; its corded structure and the fact that its colors are threads makes this impossible."[20] Sensitivity to the particular character of the woven surface persisted in the early twentieth century, when Prendergast was cultivating his tapestry effects. George Leland Hunter, author of *Decorative Textiles* (1918), the first comprehensive book on the subject, wrote: "The main text of my book is of course Texture. . . . It is of textiles the most distinctive quality, and when applied to other materials such as wood, marble and brick, iron, bronze and gold, paint, paper and cement, is merely a borrowed and imitative term."[21]

Artists who were interested in tapestry at the turn of the century seemed to appreciate the unique qualities of the medium even as they sought to incorporate it into their work in new ways. The Nabis explored tapestry as a form of mural decoration; they had no desire to use it to reproduce paintings, but instead created designs meant specifically for weaving.[22] Prendergast in turn imported the distinctive texture of tapestry to the painted surface. While the sources of this borrowing remain unclear, its presence in his work is unmistakable. In recent years, Prendergast's exceptionally close relationship and collaboration with his younger brother Charles, a successful frame maker who also specialized in decorative painting, has led to a reexamination of Prendergast's relationship to the British Aesthetic Movement and Arts and Crafts design reforms, along with a new appreciation of his interest in contemporary decorative arts. Maurice and Charles shared a collection of design sources that included materials such as antique fragments, pre-Columbian pottery, novelties from Chinatown, and demitasses from Woolworth's.[23] They also collected frames, and Charles often made frames specifically for his brother's paintings, as was the case for *The Holiday*. The "paint quality as delicious as old tapestry"—present in *The Holiday* and noted by critics in so many of Prendergast's paintings—suggests that his interests as an "extreme decorationist" significantly affected the development of his work, inspiring the conception of an adventurous new style. [AG]

68. ROCKWELL KENT, *Afternoon on the Sea, Monhegan*

ROCKWELL KENT DISCOVERS
MONHEGAN ISLAND

Many Americans know the art of Rockwell Kent (1882–1971), although they may not recognize the name. His 280 dramatic illustrations for a 1930 edition of *Moby-Dick*, still available today, are considered by many to be the definitive visual representation of Herman Melville's classic tale of a man, the sea, and obsession. A painter and graphic artist (as well as author and activist), Kent brought more than his printmaking skills and artist's eye to the project. Not unlike Captain Ahab, he was a man driven by inner forces who spent his life on a mission that took him to extreme environments. Rather than chasing a white whale, Kent pursued solitude, simplicity, and communion with nature. Understanding Kent the man is fundamental to appreciating his art. As reported in a *Philadelphia Record* article based on a long interview with the artist on Monhegan Island, "[Kent] considers it vastly more important to be regarded as a man than as an artist, and art, at best, he deems only an incident in any man's life. Moreover, he thinks it absolutely essential that a man's art be thoroughly consistent with his life and not apart from it, as it often happens to be."[1]

Rockwell Kent began his artistic career as a summer student of William Merritt Chase in Shinnecock, Long Island.[2] There he became an advocate of Chase's emphasis on the "big picture" and the ability to lay down the essentials of a composition in a few strong brushstrokes. Later, in his autobiography, Kent recalls his state of mind while with Chase: "Truly I loved this world of ours. I wanted to arrest its transient moods, to hold them, to capture them. And to that end, and that alone, I painted."[3] After his second summer, Chase offered him a scholarship to the New York

School of Art, which Kent declined under family pressure, instead enrolling at Columbia to study architecture in 1900. Three years later, unable to suppress his desire to paint, he spent the summer recess with Abbott Handerson Thayer in New Hampshire.[4] Back in New York he enrolled in evening classes at the New York School of Art with the dynamic, progressive Robert Henri (1865–1929) and dropped out of Columbia to study with him full-time the following year. Kent's painting never showed much stylistic evidence of Henri's tutelage, but his teacher was responsible for sending him to the artists' colony on Monhegan Island in 1905, a trip that would have profound implications for Kent's life and art.[5]

Artists, drawn by the dramatic crags and crashing sea, had been congregating in the summer on Monhegan, ten miles off the Maine coast, for many years before Kent arrived there at the age of twenty-three. He appears to have been the first, however, who felt a powerful camaraderie not with his fellow artists but with the small community of fishermen who lived on the island year-round.[6] Most of the summer visitors probably felt pity for the locals: isolated on a rocky island far at sea, dependent on the fickle sea and unforgiving elements for their survival, performing hard physical labor day in and day out. Kent felt envy. "I envied their strength, their knowledge of their work, their skill in it. . . . God how I envied them their power to row! To pull their heavy traps! I'd see my own thin wrists, my artist's hands. As though for the first time I saw my work in true perspective and felt its triviality."[7] When the other artists went home in August, Kent stayed, working at land-based jobs such as

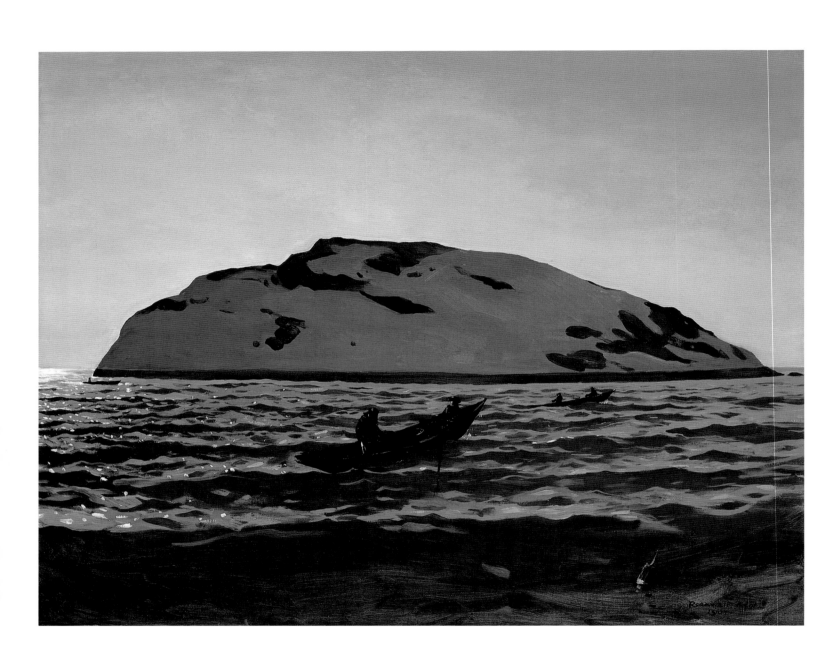

68. Rockwell Kent (1882–1971), *Afternoon on the Sea,
Monhegan*, 1907. Oil on canvas, 33 × 44 in. (83.9 × 111.8 cm)
Museum purchase, Richard B. Gump Trust Fund, Bequest
of Katherine Hayes Trust, Art Trust Fund, and Unrestricted
Art Acquisition Endowment Income, and partial gift in
memory of Mr. and Mrs. Langdon W. Post, 1994.107

Fig. 68.1. Winslow Homer (1836–1910), *The Fog Warning*, 1885. Oil on canvas,
30¼ × 48½ in. (76.8 × 123.2 cm). Museum of Fine Arts, Boston. Otis Norcross Fund, 94.72

house painting, privy cleaning (at ten dollars per), and most frequently as a well digger—punishing work on an island made of stone. Through the demanding physical challenges, and by supporting himself financially for the first time, Kent felt that he truly had a place in the world, and that he had *earned* it.

At year's end Kent returned to the mainland, his parents, and a job as an architectural draftsman, all of which he found stifling. He fled back to Monhegan in April and became a true islander—buying property, becoming a lobsterman, and building the house in which he would live for several years.[8] Despite the rigors of his new lifestyle, Kent never stopped painting. "There on Monhegan Island, between and after days of work with maul and drill, with hammer and nails or at the oars, on days it blew too hard at sea, on Sundays, I was painting: painting with a fervor born . . . of my close contact with the sea and sail, and deepened by the reverence that the whole universe imposed."[9] *Afternoon on the Sea, Monhegan* (1907) is characteristic of these paintings in its balanced composition, large abstract forms described by fluid brushstrokes, and strong contrast between light and dark in a palette restricted almost exclusively to shades of blue. Kent once wrote, "What in the world has happened to mankind that *soft*—soft lines, soft colors, soft effects—means excellence?"[10] Paintings such as this are his response to the softness he so disdained. The simplicity and

physicality that Kent thrived on are made manifest in his monumental images, in accordance with his assertion that "Art is an expression of a live personality."[11]

In April 1907 he exhibited fourteen of his island paintings, including *Afternoon on the Sea*, at the William Clausen Galleries in New York to raves from critics and his peers. Size and power are recurring themes in their reviews: "Splendid big thoughts. . . . I'd like to buy some of them" (John Sloan); "[Kent's paintings are] expressions of powerful ideas" (George Bellows); "Broad, realistic, powerful representations of weltering seas, men laboring in boats, rude rocky headlands. . . . The paint is laid on by an athlete of the brush. . . . [Kent's subjects] are rendered with a fidelity that tells of a big grip on essentials" (James Huneker, art critic for the *New York Sun*). Despite the enthusiasm with which the show was met—the catalogue sold out quickly—none of the canvases found a buyer. Financially, the exhibition represented a loss for Kent, but it firmly established his reputation as a leading artist.[12]

Kent's Monhegan paintings reminded many viewers of another artist of the Maine coast. "One young man, Rockwell Kent, is already doing shorescapes and marines that are being favorably compared with the paintings of Winslow Homer, our greatest living delineator of the life of the open."[13] Kent was indeed a disciple of Homer, then still working at Prout's Neck, some fifty miles southwest of

Fig. 68.2. Rockwell Kent (1882–1971), *The End*, 1927. Wood engraving, 4⅞ × 7 in. (12.3 × 17.8 cm) (image); 7¾ × 9⅞ in. (19.6 × 25.1 cm) (sheet). Fine Arts Museums of San Francisco. California State Library long loan

Monhegan. They shared a fascination with the elemental power of nature, and both chose to live for a time side by side with workingmen and -women in communities where life was inextricably linked with the sea. Kent's fishermen are brothers to those Homer painted in the 1880s, and his powerful, abstracted waves emulate his exemplar's later nonfigural seascapes. Both artists returned again and again to depictions of men confronting nature, in the face of which they are small, vulnerable, and perhaps even doomed. Kent often deemphasized the narrative sense of drama and peril that famously threatens Homer's fisherfolk, leaving the theme implicit in elements such as the small scale of the boats and the looming shadow of the island that falls over the fishermen in *Afternoon on the Sea*.[14] The fading light behind the monolith is a reminder that night is approaching and the fishermen must soon return to the safety of port, their lives at the mercy of nature's timetable. Homer's legacy is most apparent in the visual quotations Kent employs, such as the steeply pitched dory of *The Fog Warning* (fig. 68.1) repeated in disparate media and at all stages of his career (fig. 68.2).

The same desire for solitude and closeness to the landscape that led Homer to the crags of Prout's Neck drove Kent to seek out some of the most desolate spots in the world.[15] The call of the wild was his lifelong siren song, beckoning him to the next adventure, promising spiritual fulfillment through physical effort and communion with nature.[16] Several months after his marriage in 1908, he moved his primary residence from Monhegan to Connecticut, though he continued to summer on the island for a few years. Thereafter Kent followed a predictable pattern: some months in "civilization" (New York, primarily), visiting his family and tending to the business end of being an artist, followed by a period of adventurous travel. He would find remote settlements and settle in to live as one of the community, painting on the side. When he returned to New York it would be with paintings and studies in hand, ready to work up, exhibit, and market. Over the years his peregrinations took him as close to the ends of the earth as he could manage; he spent extended periods in Newfoundland (1914–15, with his family); Fox Island, twelve miles off the Alaskan coast (1918); Tierra del Fuego (1922); and Greenland (1929, 1931, 1934–35). This wanderlust—the impetus behind Kent's art—was sparked on Monhegan Island, where a well-educated young artist, dependent on familial largesse, decided that he could not paint what he had not lived. [EL]

THE CHARACTER AND MEANING OF MOUNTAINS

I mind how we lay in June, such a transparent summer morning;
You settled your head athwart my hips and gently turned over upon me,
And parted the shirt from my bosom-bone, and plunged your tongue to my barestript heart,
And reached till you felt my beard, and reached till you held my feet.
WALT WHITMAN, *Leaves of Grass*

In a letter to his friend Norma Berger, Marsden Hartley (1877–1943) wrote that Albrecht Dürer's Christ-like portrait of 1500 was "all around the best portrait that has ever been done by anyone at any time."[1] But then he goes on, curiously it seems, to say: "I would like to make a painting of a mountain and have it have all that this portrait has."[2] Reading Hartley's autobiographical memoir, *Somehow a Past*, provides additional insight into this strange affinity between his own modern expression and the Renaissance classicism of Dürer's portrait. Hartley's discussions of Renaissance masters, especially the frescoes of Masaccio and Piero della Francesca, illustrate his belief that in finding their subject matter, great painters engage in a form of self-portraiture.[3] For Hartley, it would appear that subject was the mountains of Maine.

Hartley is known preeminently for his masterful abstractions that used emblematic and iconic signs to reference his stay in imperial Berlin during 1912–15 and his homoerotic fascination with its pervasive male culture.[4] The best known of the group is his *Portrait of a German Officer* (see fig. 70.1), which is a tribute to the German officer Karl von Freyburg, with whom Hartley shared a discreet yet passionate affair.[5] However, Hartley began and ended his career principally as a landscape painter. His introduction in 1903 to the work of the Swiss-born, Italian Art Nouveau painter Giovanni Segantini (1858–1899), which

he saw in the European art journal *Jugend*, provided Hartley with the technique that he adapted for his own modernist visual experiments.[6] Essentially a proponent of Divisionism, Segantini developed a characteristic painterly "stitch," consisting of small, overlapping brushstrokes that interweave in a decoratively patterned surface while retaining the impression of solidity of the objects represented.[7] Hartley enthusiastically adapted this technique, refining it over the next four years for his series of mountain landscapes near North Lovell, Maine, which includes *The Summer Camp, Blue Mountain* (ca. 1909).

Hartley writes in his autobiography that Segantini appealed to him because the artist, who lived in the Alps, had invented a visual language that captured the mystical nature of the landscape, demonstrating that he "understood the character and the meaning of the mountains."[8] Hartley shared Segantini's appreciation for the connections between mountains and mysticism. Hartley began his art education in 1898 at the Cleveland School of Art, where he first encountered the Transcendentalism of Ralph Waldo Emerson and Henry David Thoreau that was to be a profound influence on his life and work.[9] He appropriated their concept of correspondences, that is, the metaphoric use of natural symbols to describe the sensations that connected spiritual values and emotional experiences.

Hartley moved to New York in 1899, studying first at the

69. Marsden Hartley (1877–1943), *The Summer Camp, Blue Mountain*, ca. 1909. Oil on canvas, 30 × 34 in. (76.2 × 86.4 cm)
Gift of Mr. and Mrs. John D. Rockefeller 3rd, 1979.7.47

New York School of Art, run by William Merritt Chase, and then at the National Academy of Design. During these years, Walt Whitman's publisher, Horace Traubel, became Hartley's friend and supporter, introducing him to the poet. Hartley's earliest extant painting is of the facade of Whitman's Camden, New Jersey, home, an unusual subject that suggests a pilgrimage to the site and probably an homage to the poet in whom Hartley recognized a kindred spirit in the pursuit of male desire and sexual intimacy.[10] Hartley, also a published poet and critic, appreciated the transcendental understanding that allowed Whitman to explore his homosexuality through a mystical experience of the natural world. As in Whitman's poetry, Hartley found that his paintings provided the means to express the ardor of his gay longings openly but encoded in the imagery of a spiritual sensibility.

The Summer Camp, Blue Mountain captures Hartley's ecstatic love of the landscape, but it is also a portrait of his transcendental experience and the ineffable connection to the mystical oversoul, the universal intelligence uniting all living things, which he encountered in the writings of Emerson and Whitman. The painting is one of ten works in this style executed during 1908–9, all of which depict the seasonal changes of a group of mountains near his residence in North Lovell, Maine. At the urging of Maurice Prendergast (1859–1924) in April 1909, Hartley showed these works to Alfred Stieglitz, who was so impressed that he exhibited them at his Gallery 291 in New York City the very next month; it was Hartley's first significant one-person exhibition.[11]

Although the title of this painting refers to the site's use in the summer as a camp, the scene seems more likely to be late fall with its evidence of snow and the brilliant reds, oranges, mauves, and pinks of the foliage. The brilliant blue mountain fills the picture plane, reducing the sky to a tiny sliver at the top of the canvas and collapsing the foreground trees into the mountain's solid bulk through the Segantini stitch technique. Although a palette of intense blues and icy whites dominates the painting, the atmosphere of chilly immobility it creates is countered by the frenzied staccato of warm tonalities that are woven into the textured topography.

The agitated paint handling sets up an emotional correspondence that suggests the mystical experience of nature the transcendentalists believed would align individuals with the spiritual realm. In the summer of 1907, Hartley lived and worked at Green Acre farm, a utopian community in Eliot, Maine, that had been founded by the transcendentalist Sarah Farmer.[12] The community drew together artists, theologians, and mystics attracted to the religious teachings of spiritualism and theosophy.[13] Theosophy posits a theory of perception that inspired many modern painters, most notably Wassily Kandinsky and Piet Mondrian but also American artists known to Hartley such as Arthur Wesley Dow and Max Weber, both of whom spent time at Green Acre. According to theosophical teachings, dynamic arrangements of music and color act as abstract languages that can express inner perceptions and emotions otherwise unavailable to the rational mind. In Hartley's case, a theosophical approach permitted him to create a self-portrait of the ecstasies that drove his inner life.

The enlivened canvas that results from the jabbing marks of Hartley's technique is simultaneously an image of the energy found in nature and an expression of the artist's response to it. In the spiritual language of theosophy, it is an equivalent, the evocation of similar subjective sensations mobilized by seemingly unrelated objects.[14] It brings cognitive understanding through the power of images rather than relying on an intellectual apprehension of their meaning. Hartley's equivalent strategy is revealed in the fringe of clouds ringing the ridge of the mountains at the top of the canvas. Although he is painting storm clouds building behind the mountain, it also appears that the mountain may be on fire, its solid, cold presence bursting into fiery heat. An earlier critic of this painting wrote perceptively that the clouds represent "an icy conflagration charged with brooding energy, each of Hartley's prominent strokes of paint standing upright as if it too carried a bolt of electricity."[15] The sexually loaded language of the description accurately relays Hartley's own nervous, masculine eroticism, a driving force that, while visible, only hints at the powerful presence still hidden. Through the mystical associations within a transcendental understanding of nature, Hartley found an equivalent for the open closet of his own eroticism. It is a symbolic portrait that both conceals and reveals, expressing his creative identity and pent desires without having to name his homosexuality. [DC]

A ROOM OF HIS OWN

Symbolism can never quite be evaded in any work of art because every form and movement that we make symbolizes a condition in ourselves. MARSDEN HARTLEY[1]

Marsden Hartley's thoroughly modern sensibility made him a friend and guest of some of the most advanced artists and patrons of his day. In 1909 he showed his paintings to Maurice and Charles Prendergast, who, favorably impressed, introduced him to New York's leading group of artists, the Eight.[2] Shortly thereafter Hartley (1877–1943) received a warm reception from Alfred Stieglitz, who gave him his first major solo exhibition, establishing him as a member of America's most progressive art circle and providing access to Europe's leading figures of avant-garde art and culture. Throughout his career Hartley was befriended and championed by Gertrude Stein, Mabel Dodge Luhan, Albert Barnes, and Paul Strand.[3] He was also a close friend of some of the era's most significant writers, including Djuna Barnes, Hart Crane, Marianne Moore, Robert McAlmon, Ezra Pound, and William Carlos Williams.[4] As its first secretary, he participated in the Société Anonyme with Marcel Duchamp, Katherine Dreier, and Man Ray.[5] And he was proud to be in the company of fellow artists Charles Demuth (1883–1935), John Marin (1870–1953), and Preston Dickinson (1891–1930), whose works were part of a private collection that formed the defining nucleus of the Columbus Museum of Art.[6]

Stieglitz had exhibited Hartley's work in 1909 immediately after seeing the artist's landscape paintings of the mountains near his residence in North Lovell, Maine (see pl. 69). Hartley was exposed to the heady circle around Stieglitz, who was the first to show Henri Matisse, Paul Cézanne, and Pablo Picasso in the United States.[7] His second exhibition at Gallery 291 in February 1912 featured still lifes painted under the influence of these defining figures

of modern art. During this period his work moved away from the post-impressionist "Segantini stitch" style, which had established his reputation, toward the structured abstraction of flattened forms that would characterize the rest of his career.[8] An art historian of Hartley's still lifes has written that this work fuses "the compositional and structural approach of Cézanne with the glowing colorism and decorative emphasis of Matisse."[9]

A Bermuda Window in a Semi-Tropic Character (1917) vividly demonstrates Hartley's stylistic internalization of these modern French masters. In it Hartley adopts Matisse's use of the window as an organizing device.[10] The bright primary palette of blue, red, and yellow is also reminiscent of Matisse, as are the sinuous line and color that Hartley employs to simplify forms, flatten space, and establish tonal contrasts. The spare geometry and tilted, multiple perspectives testify to the continuing influence of Cézanne. With economy, Hartley organizes his composition into a series of structural relationships. The walls and the drapery form strong verticals that occupy two-thirds of the canvas, compressing the view out the window into a narrow shaft of landscape. This verticality is rhymed in the tall vase with a single flower, which unites the exterior scene with the tabletop in the foreground. The dark plane of the tabletop isolates the forms of the fruit scattered across it, much as Cézanne often used a white tablecloth to similar effect.

Shortly after Stieglitz exhibited Hartley's work in April 1912, he traveled to Europe for a firsthand look at how the School of Paris was transforming modern art.[11] He lived in Europe for more than three years, settling for a time in Berlin beginning in May 1913. In Wassily Kandinsky and

70. Marsden Hartley (1877–1943), *A Bermuda
Window in a Semi-Tropic Character*, 1917
Oil on canvas, 31¾ × 26 in. (80.7 × 66 cm)
Memorial gift of Dr. T. Edward and Tullah
Hanley, Bradford, Pennsylvania, 69.30.94

Fig. 70.1. Marsden Hartley (1877–1943), *Portrait of a German Officer*, 1914. Oil on canvas, 68¼ × 41⅜ in. (173.4 × 105.1 cm). The Metropolitan Museum of Art, New York. Alfred Stieglitz Collection, 1949 (49.70.42)

other members of Der Blaue Reiter (The Blue Rider) group, Hartley found artistic compatriots who shared his aesthetic vision, especially in their emphasis on the mystical relationship between form and intuitive creativity.[12]

Often Hartley's mysticism was expressed in visual analogies for internal states of being, as when he finds himself overwhelmed by the glittering pageantry of German soldiers on horseback, which becomes a trope for his own inability to apprehend the stimulating revelations of modern life:

> those gleaming blinding medieval breast plates of silver and brass—making the eye go black when the sun glanced like a spear as the bodies moved. . . . [T]he huge year in Paris with the revelations of the Louvre and the new modern masters. The coming face to face with so much life and art all at once—was all but blinding.[13]

Using the rhetorical image of "blinding" to explain being dazzled beyond an ability to comprehend, Hartley transforms his obsession with the cult of military masculinity that characterized imperial Berlin into the realm of mystical spirituality. In his autobiography, Hartley not only reveals how much he is impressed by such scenes, but he recounts his experience with language drawn from terms used to describe male sexual response: "the whole scene was fairly bursting with organized energy and the tension was terrific and somehow most voluptuous in the feeling of power—a sexual immensity even in it—when passion rises to the full and something must happen to quiet it."[14]

At the Restaurant Thomas, where the members of Der Blaue Reiter regularly gathered, Hartley also found in Lieutenant Karl von Freyburg a person to embody the passionate desires for male affection accompanying his homosexuality that were too uncomfortable for him to live openly, especially in America. Hartley's love affair with von Freyburg led to his best-known and frequently discussed series of paintings, memorial "portraits" of von Freyburg rendered through abstract symbols and coded ciphers that reference the couple's relationship without revealing its details (fig. 70.1). The historian Peter Gay argues that Hartley strategically deployed such semi-abstraction because it teases viewers: "It at once offers and withholds a message." Patricia McDonnell writes similarly about these Berlin portraits: Hartley, working within the sexual and social restrictions of the era, "turned to the art of the code and invented cryptic ciphers which would signal homosexuality to a

knowing viewer, while concealing it from the average passerby."[15] Hartley used this coded visual language to express both his love for von Freyburg and his grief when the soldier was killed during one of the first battles of World War I.[16] As has often been pointed out, the resulting series of German military paintings represented one of the most significant assimilations in America of the lessons of European avant-garde abstraction in the early modern period.[17]

Returning to the United States in December 1915, Hartley found a public hostile to the overt signs of German militarism in his paintings. The following summer he retreated to a community of artists, writers, and actors gathered around the radical journalists John Reed and Louise Bryant. There he developed deep friendships with fellow Stieglitz circle artists Demuth and Carl Sprinchorn that would continue throughout his life. The art historian Marc Simpson has written that in this supportive atmosphere, "Hartley, deprived of his German subject matter, developed radically simplified abstract works related to European Synthetic Cubism—works as advanced as any in Europe and more daring than any American would attempt for another decade."[18] When he decided to spend the winter of 1916–17 in Bermuda with Demuth, Hartley applied his newly forged vocabulary of Synthetic Cubism to a more representational mode that reflected a retreat to his earlier interest in Matisse and Cézanne.

In a series of still lifes set before an open window, Hartley developed a coded symbolism that is more transparent than that in his German military paintings. Even contemporary commentaries noted the overtly sexualized nature of these window compositions, evident in the anatomical cloud, erect flower, and phallic fruits.[19] However, simply identifying Freudian shapes, even if they are principally male, does not indicate how Hartley was using such symbols. It is more telling to observe how he doubles these masculine forms, suggesting the erotic pairing of two men in an intimate, domestic setting: two walls, two curtains, two tiebacks, two plums, two pears, two buildings, the double cloud, double sails, and even the pairing of yellow fruits —banana and lemon. Only the vase with its solitary flower stands alone, but even it offers a pair of leaves.

Yet for all the doubles in this still life, there is little entwining. The fruits especially are insistently separate, and the flat bands of color representing the walls and drapery resolutely flank each side of the scene. When one considers that the central flower resembles a gardenia, which is what Hartley regularly wore in his lapel, the possibility that he has created a symbolic depiction of his own sexual isolation becomes compelling.[20] The claustrophobic interior, with its window limiting the view of the outside world, contrasts with the spacious background scene, where the double pink sails of the cheerfully buoyant boat represent the elusiveness of coupling. In the symbolic vocabulary of the still life, with its references to the fleeting nature of sensual pleasures, such happiness was something that Hartley could entertain only in the privacy of his own room. [DC]

THE REFLECTED SPECTACLE
OF VAUDEVILLE

In the introduction to *Vaudeville* (1914), one of the first book-length studies of popular theater, Caroline Caffin declares: "watch the audience trooping into a New York vaudeville house. There is no more democratic crowd to be seen anywhere."[1] The inclusive mixing of men and women from a range of ethnic and social backgrounds, which was fostered in vaudeville audiences, contributed to the popularity of theatrical subjects among American Realist artists at the turn of the century. Everett Shinn (1876–1953), an illustrator, painter, and decorator who was a prominent member of the progressive group of artists called the Eight, was particularly stagestruck.[2] In the first decade of the twentieth century he produced dozens of drawings, pastels, and paintings of theatrical subjects, which today are among his best-known works.

A trip to England and France during the summer of 1900 affirmed Shinn's interest in depicting the theater. While abroad he was exposed to the work of Edgar Degas, Jean-Louis Forain, and Walter Sickert. Degas's *cafés-chantants* and theatrical subjects and Sickert's images of cockney music halls inspired numerous sketches, many of which Shinn drew on in paintings and drawings for more than a decade.[3] In January 1901, just three months after returning from Europe, Shinn showed eighty-five pastels—nearly a third of them inspired by European theater—at a gallery in New York.[4] Three years later, Shinn had become even more closely associated with theatrical subjects than with the representations of urban street life on which his early artistic success had been based, prompting a critic for the *New York Times* to observe: "his great haunt is the open-air stage, the café chantant, or the small Parisian theatre."[5]

The art critic Albert E. Gallatin, acknowledging that "Shinn has been greatly influenced by Degas," insisted that he "has only gone to Degas for inspiration, for ideas, not slavishly and unintelligently to copy him. He has learnt to see things from Degas's point of view; he too now sees the artistic possibilities of the gas-lighted music hall."[6] Such references to Degas were common in reviews of Shinn's work, and Shinn himself made no secret of his admiration for the French artist. While in Paris, he rented a studio across the street from Degas's apartment, and he later referred to the artist as "the greatest painter France has ever turned out."[7]

The urge to compare the two artists is understandable. In addition to Shinn's known affinity for Degas and their shared interest in theatrical subjects, their works include clear compositional similarities. Both make use of dramatic cropping, oblique angles, fragmented viewpoints, strong contrasts of light and shadow, and sharp caricature of urban types in their depictions of performers and audiences. Yet Gallatin was right to note the divergence between their work, which employs shared formal strategies to different ends. While Degas's interest in the voyeuristic and colorful theater crowds remains primarily formal, each scene rendered as a frozen arrangement of daring and provocative compositional elements, Shinn emphasizes interaction between the audiences and performers in his pictures. Through a network of interwoven gazes and unexpected juxtapositions of form, he draws the viewer into an experience of collective spectatorship.

71. Everett Shinn (1876–1953), *Outdoor Theatre*, ca. 1910
Oil on canvas, 24¾ × 21½ in. (62.9 × 54.6 cm)
Memorial gift from Dr. T. Edward and Tullah
Hanley, Bradford, Pennsylvania, 69.30.190

The community of spectatorship created in Shinn's work was one of the characteristic features of vaudeville, the most popular form of theatrical entertainment in America at the turn of the century. Vaudeville performances were a string of unrelated acts, including everything from singing, dancing, and comedy routines to animal acts, bicycle stunts, juggling, puppetry, magic shows, and acrobatics.[8] Performers played directly to the audience, and the success of an act depended on this interaction. The best seats for a vaudeville show were in the front, closer to the stage than generally preferred in dramatic theater, and performers often stood as close to the edge of the stage as possible, to maximize their contact with the audience.[9] If the crowd did not respond positively to an act, it would be pulled from the next performance.[10]

In 1914 Caroline Caffin, who marveled at the democratic blending of classes and ethnicities in the New York vaudeville audience, noted that usually "more than half" of the typical audience is male: "[M]en of all degrees come trooping in; some alone, some in batches, and some accompanied by women, or more often by one woman, wherein again is a difference from the theatre-going party."[11] Indeed, vaudeville was one of the few types of theatrical performance that still attracted large numbers of men.

Although dramatic theater had been attended primarily by men in the early decades of the nineteenth century, constraints imposed on theater audiences in the 1850s—such as prohibition of prostitution, smoking, spitting, whistling, stomping feet, and wearing hats—were enforced to increase the respectability of the theater and make it an appropriate family entertainment. Acts were revised to appeal to women and children, and all performances had to meet a standard of decency determined by theater producers.[12]

Outdoor Theatre (ca. 1910), one of several paintings inspired by the sketches Shinn made in Paris, combines elements of the American vaudeville experience with the artist's memories of French theatrical performances. The painting was completed nearly a decade after Shinn returned to New York. Like many of Degas's depictions of outdoor theaters, Shinn's picture features a performer on stage, viewed from a lowered perspective in the audience. Bare branches at the top of the canvas—whether actual or the result of elaborate stage dressing—suggest the outdoor setting noted in the painting's title.

The figure on stage, a vocalist in a long white gown, cuts a dramatic silhouette against a backdrop of highly saturated yellows and greens. The bold highlights on her dress and the wall of rich, bright colors behind her suggest an intensity of stage lighting quite different from that in Degas's work, which has the diffused quality common to the gaslight and electric carbon lighting typically used in late-nineteenth-century French theaters.[13] By the turn of the century, when Shinn was painting vaudeville, American theaters had begun to use incandescent electrical lighting systems, which created a much stronger, crisper light. Shinn's attention to the dramatic effects of electrical lighting was likely influenced by David Belasco, an innovator in lighting technology who commissioned Shinn to paint eighteen murals for his Stuyvesant Theatre, which opened in 1907. Belasco made a point of designing the lighting for his productions before allowing the actors to rehearse, ensuring that from the start, lighting would set the tone for the performance.[14] Shinn explored the effects of electric lighting in many of his vaudeville paintings, including *Girl in Red on Stage* (ca. 1905),[15] in which two women—this time seated in the gallery—are silhouetted against a brightly lit stage, one of them looking over her shoulder at the viewer in a pose similar to that of the woman in *Outdoor Theatre*.

Outdoor Theatre also features a pairing of women, yet in this case their relationship to one another—and the viewer of the picture—is unclear, creating an animating tension in the image. Here a vocalist, captured in mid-song, has turned to her left, her right arm stretched across her body, tracing her movement away from the viewer. She is mirrored by a fashionably dressed woman in the audience, whose body is turned in the opposite direction, looking out of the painting as if waiting for the viewer's arrival. The two women have a similar upswept hairstyle, ornamented with flowers. Both turn their faces to look out at the audience, perhaps even fixing their eyes on the same approaching figure. In this image the line between audience and performer is blurred, as was typical in vaudeville performances. The woman onstage and the woman in the crowd emphasize the vaudeville community of spectacle through their joint focus beyond the painting, which draws the viewer into a drama of seeing and being seen.

Degas's pastel drawing *Le Café—Concert des Ambassadeurs* (fig. 71.1) evokes a different experience. Here, as in *Outdoor Theatre*, the viewer is situated in the audience, looking up at the performers onstage, yet while various audience members and musicians appear to be interacting with each other, no one directly meets the viewer's gaze. Although the performer closest to the audience, a woman in a red dress, looks off into the distance and extends one arm toward the crowd before her, it is not clear that she is addressing anyone in particular. Through dramatic perspectives and juxtapositions of the various elements of the theater crowd, the picture emphasizes the voyeurism and spectacle of French theatricals. Indeed, audience and performers seem somewhat isolated from each other; the women onstage interact primarily with one another, and the figures in the audience seem to look across the crowd rather than directing their attention to the stage.

In *Outdoor Theatre*, Shinn directly involves the viewer in both the performance and the spectatorship of it, creating a direct connection between the viewer, the figure on the stage, and the painted audience. Degas's large, vibrant groupings of performers and spectators suggest a far more public, impersonal experience. Positioning the viewer amid the audience is, for Degas, a formal innovation; perspective alone situates the viewer in the crowd. For Shinn, this formal strategy is evocative of the experience of urban spectacle. Shinn's interest in the interaction between performers and audiences was noted by contemporary viewers. In 1903 Helen Henderson, a Philadelphia art critic who admired the "modern" quality of Shinn's portrayals of the "artificial life of the folk at the cheaper theatres and concert halls," found the relationship he created between performers and

spectators to be a defining feature of his work. She noted: "of this novel view of the stage and its relation to the audience Mr. Shinn has made a special study."[16]

In addition to evoking the audience engagement common to vaudeville, the female spectator in *Outdoor Theatre* would have had other connotations for contemporary viewers. In the 1860s, as dramatic theater became an increasingly respectable entertainment and women began to dominate theater audiences, men sought new forms of entertainment, such as "leg shows," burlesques, and sporting events. Although vaudeville theaters did not revive the permissive attitude toward prostitution common to the early days of theater, vaudeville performances did encourage the spirited interaction between audience and performers that was no longer acceptable in dramatic theater.[17] By the 1870s the gallery and the orchestra pit, which had long been the areas of the theater reserved for the solicitation of prostitutes, became seating areas for respectable women escorted by men. The only member of the audience visible in Shinn's *Outdoor Theatre*—the solitary woman in the foreground—may be seated in the pit. Although she could be waiting for an escort—or even the viewer—she is pictured alone. Women could attend the theater unescorted for matinee performances, but it was uncommon to see them alone at evening performances, especially seated so close to the stage.[18] This woman's unusual position and the boldness with which she turns to face the viewer would likely have evoked both the disreputable undertones of the French theater experience and the licentious early days of American theatergoing.

Connotations of the disrepute and glamorous slumming many Americans associated with French theater were actively encouraged by theater promoters at the turn of the century. American outdoor theaters, in particular—which were often based on Parisian models—strove to cultivate an experience of elegant squalor. Oscar Hammerstein's Paradise Roof Garden, which opened in New York in 1899, was built of used materials to create a makeshift, secondhand appearance and to allow audiences to imagine that they were slumming in a run-down theater.[19] Shinn's blending of distinctive elements from French and American theater surely contributed to the popularity of his work, as it permitted viewers to extend the fantasy of a worldly, yet protected, encounter with the "artificial life of the folk at the cheaper theaters and concert halls," which made theatergoing an alluring pastime in the early twentieth century.

[AG]

72. ROBERT HENRI, *Lady in Black with Spanish Scarf (O in Black with Scarf)*

FROM SENSE AND SENSIBILITY
TO SEX AND SENSUALITY

Wouldn't it jar you to think you were sailing with an eligible party, (first having invested in a becoming steamer-rug, a sea-shore bang and scented soda-mints) and then be confronted with a golden-haired bride, just as the gang-plank creaked its good-byes to the gaping crowds? FLOSSIE SHINN[1]

Lady in Black with Spanish Scarf (1910) is a painting of Robert Henri's wife, Marjorie Organ, whom he affectionately called "O."[2] One of New York's leading artists, Henri (1865–1929) made annual study trips to Europe with his students most summers; and in 1908, just before embarking for Spain on one of those trips, the artist, then a young widower of forty-two, met Marjorie. Organ was a twenty-one-year-old cartoonist for the *New York Journal* and a caricaturist of theater personalities for the *New York World*.[3] Her friend the artist Walt Kuhn, also at the time a cartoonist for the *World*, had encouraged Organ to attend Henri's lectures, where the two met. After a brief two-month courtship they were secretly married, which shocked (and galled) many people, as the introductory epigraph relates.[4]

Organ's participation in New York's cultural and intellectual elite was well suited to Henri's temperament and his role as one of the leading avant-garde artists in revolt against the constraints of the established art institutions. In 1910 he was instrumental in organizing the Independents Exhibition, the first major exhibition of American art to be shown without the sanction of a jury.[5] This portrait of his young, sensuous wife was among the works featured in that exhibition.[6]

Henri was born Robert Henry Cozad in Cincinnati, Ohio, at the close of the Civil War and grew up on the frontier as the son of a riverboat gambler. When his father shot and killed a cowboy, the family fled to Philadelphia, where his parents resumed life in disguise under the name John

and Theresa Lee. Robert latinized his middle name to become Robert Henri (pronounced "Hen-rye").[7]

Henri began his artistic career by studying at the Pennsylvania Academy of the Fine Arts from 1886 to 1888, just as Thomas Anshutz (1851–1912) was replacing Thomas Eakins (1844–1916) as director of painting at that institution. Anshutz expanded Eakins's interest in Realism, encouraging his students to portray subjects in a manner unvarnished by classicizing idealism. As part of the academy's philosophy, Henri also received highly disciplined training in anatomy and drawing from life. However, during a trip to Europe in 1895, Henri discovered a related antecedent for his works in seventeenth-century realist painters, especially the old master portraits of Frans Hals (after 1580–1666), Rembrandt van Rijn (1606–1669), Francisco de Goya (1746–1828), and Diego Velázquez (1599–1660) that he saw in Holland, at the Musée du Louvre, and at the Museo del Prado.[8] He adopted their loose brushstrokes, dark palette, and love of laboring-class individuals in opposition to the prevailing preference for the fractured paint handling, bright hues, and bourgeois subjects of Impressionism.

As the Spanish scarf of the title suggests, the influence of Spain, in particular, remained a powerful component in Henri's work when he returned from Europe in 1900 to set up a studio and to teach in New York City.[9] From 1902 to 1908 he became an increasingly important artist and voice of the avant-garde community that was working in a manner opposed to, and rejected by, the National Academy of

72. Robert Henri (1865–1929), *Lady in Black with Spanish Scarf (O in Black with Scarf)*, 1910. Oil on canvas, 77¼ × 37 in. (196.2 × 94 cm) Gift of the de Young Museum Society, purchased from funds donated by the Charles E. Merrill Trust, 66.27

Design in New York.[10] The closest American institution in spirit to the European salons, especially the Paris Salon, the academy preferred impressionist and academically derived painting, exerting its considerable control over artistic production in the United States through prizes and its formidable influence on the art market. As a member of the 1907 jury at the academy's annual exhibition, Henri was disgusted by the attitudes and decisions handed down by that body. In a highly public protest, he resigned his position and gathered together a group of eight artists who had been trained in drawing and were largely working as illustrators for major journals and newspapers.[11] In 1908 they staged a group exhibition at the Macbeth Galleries in New York, becoming known as the Eight and quickly establishing themselves as the voice of the American avant-garde.[12]

Henri and other members of the Eight created a visual vocabulary that reflected their commitment to the gritty, real-life portrayals of urban life represented in paintings such as John Sloan's *The Hairdresser's Window* (fig. 72.1), which occasioned heated debates over the suitability of its subject matter for a serious work of art.[13] Such subject matter has also earned the members of this group the somewhat misleading moniker of the Ashcan School, although they never used that term to describe themselves.[14] Coined in 1915 in reference to the next generation of urban Realists, the term became common in historical discussions during the 1930s when the art critics Holger Cahill and Alfred Barr used it to characterize the negative perception of earlier writers who had objected to the focus by these artists on the lives of the lower classes in the city.[15]

Henri's portrait of Organ is consistent with his search for a vocabulary that would allow him to represent a more commonly lived experience than that of a society preoccupied with decorum. In fact, Henri's depiction of Organ visually argues with the traditional conventions of society portraiture and challenges the assumptions about the type of family experience that was communicated in the previous era's portraits, such as John Singer Sargent's *Caroline de Bassano, Marquise d'Espeuilles* (pl. 53). Typical of the society portrait, Organ stands isolated against an indistinct ground, her neck and face crowning the length of an elegant gown. However, although she strikes that genre's usual pose of regal formality with a direct, confrontational gaze, Henri invests her with a strong sexual register that contrasts dramatically with the established conventions for a woman of cultured society. In place of the expected depiction of extravagance and privilege, Henri employs a vocabulary of psychological realism to represent his elegant young wife as

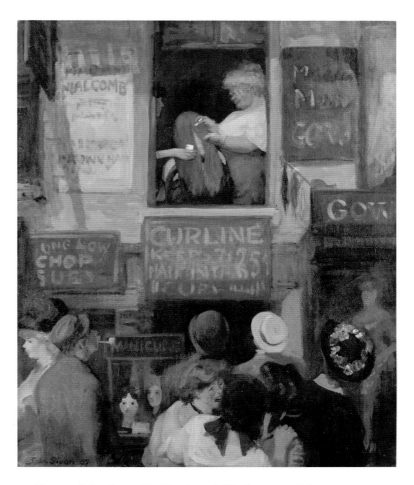

Fig. 72.1. John Sloan, *The Hairdresser's Window*, 1907. Oil on canvas, 31⅞ × 26 in. (81 × 66 cm). Wadsworth Atheneum, Hartford, Connecticut. The Ella Gallup Sumner and Mary Catlin Sumner Collection Fund, 1947.240

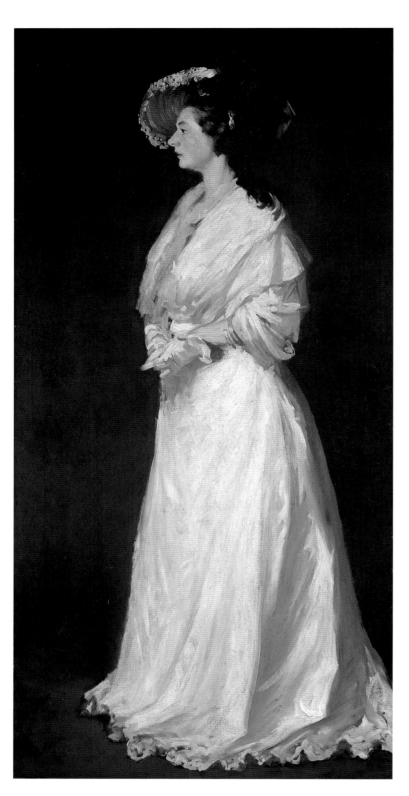

Fig. 72.2. Robert Henri (1865–1929), *Young Woman in White*, 1904. Oil on canvas, 78¼ × 38⅛ in. (198.8 × 96.8 cm). National Gallery of Art, Washington, D.C. Gift of Violet Organ, 1949.9.1

the self-possessed, assured, and liberated woman that was the feminist ideal of the day.

At the end of the nineteenth century, progressive women in Europe and America participated in what became known as the Reform Dress Movement. The constraint of the female body through bustles, whalebone corsets, and tight lacings was condemned both medically for their abuse of a woman's biological functions and socially for the restrictions they placed on a woman's freedom of movement. Designed to coerce a woman's body into assuming the hourglass silhouette that emphasized a full, matronly bosom, pinched waist, and ample, structured derriere, such clothing limited her activities to the drawing room.[16] In its place, the ideal figure of the "New Woman" displayed "the more flexible serpentine curvature of the modern body."[17] Such reforms in dress reflect a shift from clothing as a sign of class or an indicator of vocation to a more expressive measure of personality.

As a measure of the previous fashion conventions, the conservatively dressed figure Henri depicts in *Young Woman in White* (fig. 72.2) stands formally erect, shaped by her costume. In contrast, Organ's slightly turned pose emphasizes the natural outline of her body, which shapes her flowing gown into the desired serpentine curves that were the hallmark of the new independent woman. The loose, sketchy brushwork that Henri adopted from his study of the baroque old masters creates a sense of painterly movement that reinforces the ideal of physical movement and liberation. His remarkable portrait of Organ is the perfect foil for the decorous style of representation that Henri and his avant-garde peers rejected. She personifies the culturally empowered woman of the modern era who is free from social conventions, befitting her status as her husband's intellectual and artistic equal.

While Henri's painting is infused with the attitude of an artist deeply in love with his wife's emancipated, modern persona, his homage to her beauty is also encoded with a darker sexuality that the Symbolists had found earlier in Freudian models of desire.[18] In Victorian England, the writers Algernon Charles Swinburne (1837–1909) and Walter Pater (1839–1894) had explored the erotics of sexual expression and gender, especially transgressive desires that ruptured traditional social roles, anticipating the language of psychoanalysis in developing the image of the femme fatale (French for "disastrous woman").[19] Evoking this image, Organ's dangerous allure, based in crossing the boundaries of libidinal decorum, links the power of insatiable

sexual appetite to the terror and fascination of the artistic sublime. The warm tones of the dark brown background and the coupling of her black dress with her flaming auburn hair and red pouting mouth signal the forbidden pleasures and temptations inherent in the sublimated sexual drives that dominated the discourse of the new discipline of psychology.

However, Henri has replaced the menacing image of the femme fatale with a more open though no less insistent sensuality. Organ stares directly at the viewer, confident in her alluring beauty and her sexual identity, which she controls. Nevertheless, it is a confidence rooted in her sensuality and passion rather than unvarnished lust. In place of the femme fatale's insincerity, duplicity, and deceit, Henri represents Organ as frank, candid, and honest, a woman in charge of her own life. Yet she is equally confident in her role as Henri's wife, overtly indicated by the gleaming flash of yellow that represents her wedding ring.[20] In the language of sexual politics, she disallows the mastering gaze that psychoanalytic models associate with male viewers and their visual prerogatives, asserting her own look and claiming the erotic power of her body and its image.[21]

Although it might seem surprising that Henri would represent his beloved wife in such overtly sexual terms, her portrait is consistent with the goals of urban Realists at the turn of the century. They were determined to replace what they believed to be superficial and decorative Impressionism with works of art that conveyed strong, visual effects. Henri's portrait masterfully delineates the double register of apprehension and pleasure implicit in the psychoanalytic model of desire. By attending to each half of Organ's face, the viewer can clearly see how the artist collapses these two separate sensibilities symbolized by the New Woman, the destructively carnal and the self-confidently sensual. The left half of her face (on the viewer's right) is painted according to the ideal conventions of objectified feminine beauty associated with the male gaze, whereas the right half (on the viewer's left) is painted as a penetrating and calculating gaze. On the left he portrays the lovely image of an ingenue; on the right the more resolute personality beneath her surface appearance. Organ's beauty is explicitly not naturalized as innocent, naïve, or dependent. Rather, Henri's portrait goes beyond superficial appearances, capturing the strong, internal social and psychological forces underlying the impact that Organ's fully embodied spirit has on his life.

[DC]

73. CHILDE HASSAM, *Seaweed and Surf, Appledore, at Sunset*

"LANDSCAPE WITH SEA"

On a late summer day in 1894, the body of Celia Laighton Thaxter was laid to rest in the family plot on Appledore Island, the largest of Maine's Isles of Shoals and a Laighton possession for sixty-five years. A poet, essayist, and painter, Mrs. Thaxter's sudden death at fifty-nine was lamented by the many writers and artists whom she had invited to share in the island's beauty and quietude over the years at her family's hotel.[1] Among her pallbearers was the painter Childe Hassam (1859–1935), a frequent guest at these summer salons and a close friend of the deceased. It might seem surprising that Hassam would return following the death of Mrs. Thaxter, given that it became "a place of ghosts and memories" for the artist.[2] Yet he did continue to visit—and paint—the island until 1913. The more than four hundred paintings of Appledore in Hassam's oeuvre are an evocative record of a unique place as one man experienced it over time.

Nathaniel Hawthorne said of Appledore, "it seems as if some of the materials of the world remained superfluous, after the Creator had finished, and were carelessly thrown down here, where the millionth part of them emerge from the sea, and in the course of thousands of years, have got partially bestrewn with a little soil."[3] When Celia Laighton was four years old, in 1839, her father bought the island and assumed the post of lighthouse keeper; eight years later he and his business partner and future son-in-law, Levi Thaxter, built the Appledore House hotel. The establishment would host many luminaries over the years, artists and writers whose early influence contributed to the success of Celia's own literary career. Later Thaxter herself would be the draw that brought New England's erudite elite to the island, Childe Hassam among them.[4]

Hassam was a leading figure in the American impressionist movement at the end of the nineteenth century and was considered by an art critic for the *New York Times* as among the "true followers of the modern French Impressionists" in America.[5] His artistic career began in 1876, when he was apprenticed to a Boston wood engraver at the age of seventeen; the following year he began to work as an illustrator at Little, Brown and Company, and to take formal art instruction at the Boston Art Club.[6] A visit to Europe in 1883 whetted his appetite for all the Continent had to offer an aspiring artist, and in 1886 Hassam and his wife, Maude, left New England for a three-year stay in Paris, where he studied briefly at the Académie Julian. Entries in the Paris Salons of 1887 and 1888 and a bronze medal at the 1889 Exposition Universelle testify to his European success; more important than the accolades, however, was Hassam's exposure to French Impressionism, particularly that of Claude Monet. On his return to America in 1889, Hassam brought Impressionism with him, and his work ever after spoke with a French accent.

Hassam had unintentionally been preparing himself for work in the impressionist mode for some time. In the early 1880s, as Monet and his followers painted on the banks of the Seine, Hassam was known for venturing outdoors to paint cityscapes of Boston.[7] These early landscapes are characterized by a subdued palette and tight brushwork. While in France, his brushstrokes began to fracture and his colors to lighten, and once back in the United States in the 1890s Hassam's Impressionism flourished.[8] Like his French predecessors, he explored the effects of light and atmospheric changes in his paintings and now employed loose brushstrokes and uneven, at times extremely thick, paint

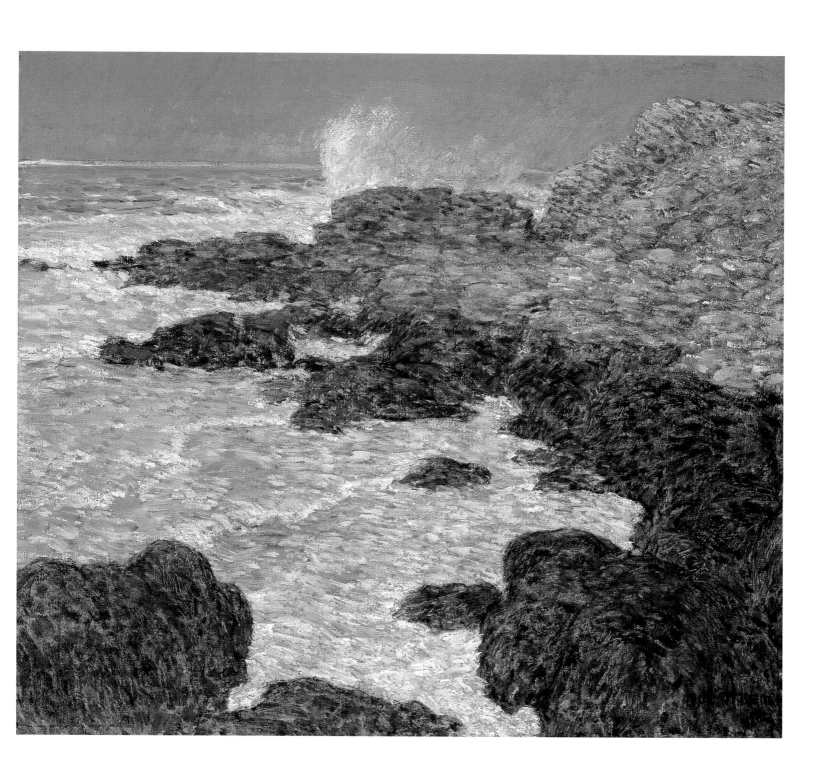

73. Childe Hassam (1859–1935), *Seaweed and
 Surf, Appledore, at Sunset*, 1912. Oil on
 canvas, 25½ × 27¼ in. (64.8 × 69.2 cm)
 Gift of the Charles E. Merrill Trust with matching
 funds from the de Young Museum Society, 67.23.2

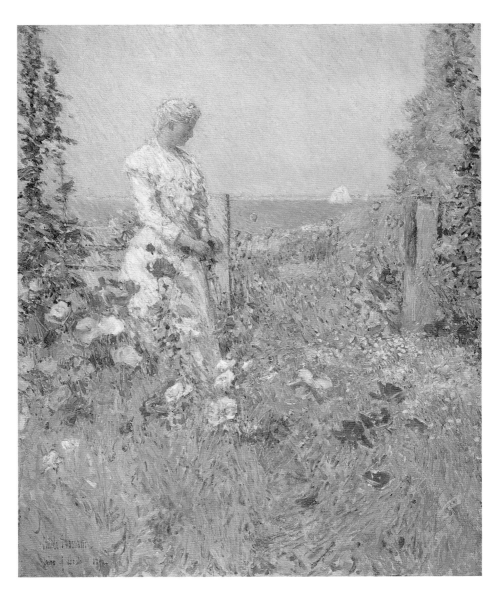

Fig. 73.1. Childe Hassam (1859–1935), *In the Garden (Celia Thaxter in Her Garden)*, 1892. Oil on canvas, 22⅛ × 18⅛ in. (56.2 × 46 cm). Smithsonian American Art Museum, Washington, D.C. Gift of John Gellatly, 1929.6.52

surfaces. During this period, in 1892, Hassam was commissioned to illustrate *An Island Garden,* by his friend Celia Thaxter, a meditation on her garden, its cultivation, and its meaning. Mrs. Thaxter's celebrated garden was the product of many years' loving cultivation, an oasis of calm and beauty on wild and treeless Appledore. The garden was carefully planned and tended to give the effect of spontaneous, organic proliferation and riotous color—a marked contrast both to the rather stuffy formal gardens then popular and to the barren rockiness of the island landscape.[9]

The volume was a genuine collaboration between author and artist, from the pair of poppy petals featured on the title page to the single pink chrysanthemum serving as a coda beneath the final sentence of text.[10]

An Island Garden's frontispiece, *In the Garden (Celia Thaxter in Her Garden)* (fig. 73.1), is characteristic of Hassam's scores of Appledore paintings from the early 1890s. Thaxter, in a white dress matching her white hair, stands introspectively by an open gate in her garden. A low vantage point eliminates the rocky shoreline and allows the lower

two-thirds of the canvas to be filled with loosely worked, but still identifiable, flowers, notably the red Iceland poppies that are a recurring motif in the book. More foliage reaches up both sides of the composition to the very top, so that Thaxter is surrounded by her horticultural handiwork, framed against a backdrop of light blue sea and lighter blue sky. The ground on which she stands is not visible, so that she, too, appears to be sprouting out of the earth. The very surface of the canvas appears overgrown—a profusion of thickly applied brushstrokes, a riot of color. Thaxter is depicted with more controlled strokes and a limited palette of whites and flesh tones, a visually quiet focal point amid the bright and active foliage clamoring for the viewer's attention. An even greater contrast to the active brushwork and heavy impasto of the garden is provided by the seascape in the background, where a very thin, flat layer of paint is applied in more regular strokes. Thaxter is one with her garden, Hassam's favored subject at this time.

The color and light of Thaxter's garden disappear from Hassam's canvases following her death. His later Appledore paintings take his Impressionism into a new realm, one of darker tones and even freer execution. During the summer of 1912, his penultimate one on the island, he painted *Seaweed and Surf, Appledore, at Sunset*, an excellent example of his changed personal vision and artistic expression. We are beyond the cultivated confines of the garden, at the very edge of the island, where craggy stone and spuming surf meet. A high vantage point tilts the picture plane up and toward us, denying the viewer a spot on which to stand and creating a sense of vertiginous vulnerability. The architectonic cliffs are constructed of short, powerful strokes of thick pigment in a range of earth tones, which contrast sharply with the frothy white and blue of the foreground ocean. In the far distance the sea darkens to a narrow strip of deep blue, which matches the band of sky above; the application of paint similarly shifts from choppy, thick, and active in the foreground, capturing the action of water

striking land, to smooth, controlled, and thinly applied as the surf gives way to open ocean, horizon, and sky. And what a horizon! As the sun sets, casting all but the upper reaches of the cliffs into crepuscular shadow, a brilliant flash of color—red, orange, yellow, white—delineates the horizon line. This razor edge of sunset, which does not even span the entire width of the painting, imparts a geometric steadiness to the flattened upper zone, an anchoring counterpoint to the energetic organic irregularity of the monumental cliffs and raging ocean that occupy most of the canvas.[11] Here is the wild coast we expect of Maine and which, in Hassam's later years on Appledore, was the landscape most expressive of his relationship with the island.

For such a small and isolated bit of rock, Appledore Island played a large role in Childe Hassam's life. Even before his first meeting with Celia Thaxter in 1883, he knew of the island as the place where his cousin William Morris Hunt had ended his life. By contrast, Hassam's own early experiences there were positive; he considered the island to have had a significant and positive influence on his artistic development and he even met his first buyer there.[12] His relationship with the island changed dramatically, however, with Thaxter's death; Hassam now saw a different landscape, one of desolation and danger rather than life and light, but equally inspiring as a subject and equally instrumental in the development of his powerful impressionist style. *Seaweed and Surf* speaks to the sense of melancholy that shadowed the artist during his later visits to the island, the setting sun a token of time lapsed, and the inexorably crashing surf a reminder that the world continues on its way heedless of personal experience. In 1927 Hassam referred to his later Isles of Shoals works as paintings of "The rocks and sea, landscape; if you care to call them that. Landscape[s] with sea."[13] *Seaweed and Surf*, and the many paintings like it, are also internal landscapes, expressing the artist's own experience of the island. [EL]

74. CHIURA OBATA, *Mother Earth*

NATURE WITHOUT NATIONALITY

In the San Francisco Bay Area, Chiura Obata (1885–1975) was the most prominent practitioner of the modern *nihonga* (Japanese painting) movement, which sought to reconcile the practices of traditional Japanese and contemporary European schools of art. Accompanied by his wife, Haruko Kohashi (1892–1989), who helped to introduce *ikebana* (the art of flower arrangement) to the Bay Area, Obata gave hundreds of public lectures and demonstrations that introduced audiences to Japanese art and aesthetics.[1] His mastery of *sumi-e* (brush and ink painting) contributed to the evolution of the California Watercolor School and helped to elevate the status of the watercolor medium in the art world.

As a revered professor of art at the University of California at Berkeley from 1932 to 1942 and again from 1945 to 1954, Obata introduced thousands of students to Asian culture and to Buddhist philosophies of respect for nature, selflessness, and pacifism. The East West Art Society, co-founded by Obata in 1921, promoted his belief that art could provide the common ground necessary to break down the barriers of nationalism and racism. Like the synthetic *nihonga* style of art, the society's stated goal was "finding the way to a highest Idealism where the East unites with the West."[2]

Obata remained faithful to the credo of the East West Art Society even during World War II, when he and his family, along with 110,000 other Japanese Americans, were sent to internment camps. While interned, Obata founded an art school and created works in which his vision of "Great Nature" (*Dai Shizen*) transcended the physically and psychologically trying circumstances of camp life. After the war, he and his wife conducted tours of Japan, hoping to promote cross-cultural understanding by introducing Americans to Japanese art, architecture, and landscape gardening.

Zoroku (Chiura) Obata was born in Okayama-ken and raised in the city of Sendai on the island of Honshu in northern Japan. His artistic interests were nurtured by his older brother Rokuichi Obata, an established artist whose style fused Japanese, Chinese, and European art traditions. At age seven, Obata began his art studies with the Sendai painter Chikusen Moniwa: for two years his practice was limited to making circles and vertical and horizontal lines. Obata also worked exclusively in monochrome for seven years, developing his sensitivity to the subtle tones and values in *sumi*, the traditional Japanese black ink that he used throughout his career.[3]

In 1899 Obata went to Tokyo, where he enrolled in Kakuzo Okakura's Nihon Bijutsuin (Japan Fine Arts Academy), a *nihonga* school that revived historical Japanese art styles but also encouraged the selective use of European naturalism, modeling, and perspective. Obata's principal teachers were Tanryō Murata, who favored Japanese literary and historical subjects, and Gaho Hashimoto, who fused traditional Chinese painting techniques with Pre-Raphaelite realism.[4] During his apprenticeship, Obata traveled throughout Japan, painting landscapes, viewing famous artworks, learning about the traditional arts of the tea ceremony, landscape gardening, and flower arrangement, and informally studying the principles of Zen Buddhism.

In 1900 he joined the Kensei-kai, a group of young artists whose exhibitions and publications promoted the *nihonga* movement throughout Japan. Two years later, Obata won a prestigious bronze medal at Tokyo's annual spring art exhibition for his painting *Hatsu Haru* (*Early Spring* or *New*

74. Chiura Obata (1885–1975), *Mother Earth*, 1912/1922/1928
Ink and color on silk, 87¾ × 58⅝ in. (222.9 × 148.9 cm)
Gift of the Obata Family, 2000.71.2

Fig. 74.1. Gottardo Piazzoni (1872–1945), *Lux Aeterna*, 1914. Oil on canvas, 42½ × 60½ in. (108 × 153.7 cm). Fine Arts Museums of San Francisco. Gift of Ethel A. Voorsanger by her friends through the Patrons of Art and Music, 1981.90

Year). Despite his precocious success, in 1903 he left Japan for the United States, seeking greater artistic challenges.

Obata's arrival in San Francisco in 1903 coincided with a period of xenophobic racism that particularly targeted Asian American immigrants. Presented in the guise of nationalism but usually motivated by a desire to protect Euro-American economic prerogatives, anti-Asian agitation by San Francisco's newspapers, unions, and the Asiatic Exclusion League (later known as the Japanese Exclusion League) created a hostile environment in which Obata frequently was subjected to verbal and physical assaults. Ironically, as an artist, he simultaneously benefited from the increasing popularity of Japonisme—the vogue for Asian and Asian-influenced art and decorative arts—which was

given renewed cultural cachet by California's Arts and Crafts movement. Japonisme was marketed as a cultural commodity in such San Francisco department stores as Gump's, the Emporium, and the City of Paris, which commissioned Obata to decorate their "Oriental," "Japanese," and "Chinese" salesrooms.[5]

Obata's scroll painting *Mother Earth* (1912/1922/1928) was begun in 1912 as a nude portrait of his wife, Haruko. Although European and American artists had previously painted life-size nudes, they were a relatively recent development in Japanese art, and the subject is unique in Obata's oeuvre. However, this painting was inspired by singular personal circumstances, his wife's announcement that she was pregnant with their first child, Kimio.[6] The painting also

reflects Obata's perception of all Japanese women as embodying a powerful life force: "I believe women have enormous power. . . . On the one hand they work, on the other hand they have to encourage others, and they have to lead the atmosphere from the dark to the light. They have an enormous amount of patience. That kind of patience is really strong. In this sense the Japanese women demonstrate a great power."[7]

In 1922 Obata added the background forest scene to his portrait of Haruko, utilizing his recent sketches of redwood trees in Alma, California. Obata's title for this second state of the painting, *Dusk in the High Sierra* (*Kure Yuku High Sierra*), emphasized the passage of time and a reflective, end-of-day mood.[8] In 1928 Obata reworked the painting again, thickening the female figure's hair and adding the small flowers below and the overhanging branches at the left.[9] He exhibited the finished work at the East West Art Society Gallery in San Francisco in 1928 with its final title, *Mother Earth*.

Obata's self-conscious change of the work's title from the poetic *Dusk in the High Sierra* to the symbolic *Mother Earth* reveals his intention to endow his subject with greater resonance. The solitary female figure thus serves as a universal personification of nature, fertility, and maternity, as well as of the cycles of the seasons and of life itself. With its aura of spiritual reverence and quietude, Obata's *Mother Earth* is reminiscent of symbolist works by the California artist Gottardo Piazzoni, such as his *Lux Aeterna* (fig. 74.1), which depicts a solitary female figure kneeling in prayer in a California landscape.[10] Although Obata's subject is Japanese, the more universal title—*Mother Earth*—reflects his global perspective regarding the relation of nature and nationality:

> I believe you have heard many times our words *Ten-Chi-Jin. Ten* means heaven, *Chi* means earth, *Jin* means human. These are one great unit in the universe. The idea *Ten-Chi-Jin* is nothing other than "Go with Nature." It explains simply and strongly that we humans, without knowing the rhythmical activities of heaven and earth, can not live our harmonious life. Get in closer contact with Mother Earth! By which I mean we all together,

young or old, rich or poor, no matter what kind of occupation. Above the border line of nationality everybody must feel a deep appreciation toward Mother Earth.[11]

Obata's nude subject stands in profile in the shade of a primeval forest, flanked by three massive centenarian redwood trees and surrounded by delicate seasonal flowers that blossom at her feet.[12] In the background, a screen of silhouetted pine trees follows the curve of the landscape and marks the dividing line between the sunlit earth and sun-suffused sky. Horizontal rays of pigment mixed with metallic powder capture the raking, golden light of the setting sun, while touches of blue-gray amid the tree trunks suggest the imminent arrival of the evening fog, which begins to blur the outlines of the trees.

Obata's reverence for his favored subject—Great Nature—is embodied not only by the human figure of *Mother Earth* but also by the giant trees, which Obata viewed in anthropomorphic terms. In an anecdote that reveals nature not just as a source of artistic inspiration but also as a source of spiritual instruction, Obata recounted the experience of a giant sequoia tree "speaking" to him on the subject of the material and the immaterial: "'No human can claim true possession of any materials forever. All materials in this world are the production of nature. Sooner or later you must return them to Mother Earth. Of course, you can use them if you understand how they are to be used; but, you have one precious possession, that truly belongs to you: that is, a sense of feeling based on deep appreciation.'"[13]

Obata's detailed naturalism obscures the contrived nature of his subject—a solitary nude woman serenely standing in a High Sierra forest—as well as the surreal aspects of his style, in which the female figure makes no physical impression on the forest floor. Even the theme of *Mother Earth* seems at odds with the prevailing realities of early-twentieth-century American life, which was characterized by unchecked urbanization, industrialization, and the economic exploitation of natural resources. In contrast, Obata's timeless vision of nature, rooted in the traditions of Zen Buddhism but successfully transplanted to American soil, reaffirms humankind's perennial ties to nature, even—or especially—in an increasingly technological age. [TAB]

GREAT NATURE AS SPIRITUAL SOURCE

Chiura Obata's art practice was shaped by his personal beliefs regarding "Great Nature" (*Dai Shizen*). His lifelong reverence for nature may be traced in part to the status of his native Japan as an agrarian island nation, deeply attuned to the natural cycles of the seasons and protective of its precious natural resources. He also was influenced by the respect accorded to nature by Buddhism, which was practiced by his parents, and by ancient Japanese traditions that associated elements of nature with deities. For Obata (1885–1975), Great Nature provided important philosophical lessons regarding permanence and impermanence, and also served as a source of spiritual sustenance. Although he never practiced any organized religion, Obata observed, "when I enter into the bosom of Great Nature I believe in the blessing of nature as a kind of God to me."[1]

The great turning point of Obata's career as an artist occurred in the summer of 1927, when Worth Ryder, an art professor at the University of California at Berkeley, invited Obata to join him and fellow artist Robert Boardman Howard on a hiking and camping expedition to the Yosemite Valley and the High Sierra. Obata's perceptions of the American landscape during this trip were influenced by the writings of his hero, the naturalist and environmentalist John Muir, who "had a very serious, sincere belief towards the land like our Japanese ancestors."[2] Obata created more than 150 artworks during this six-week trip and wrote, "this experience was the greatest harvest for my whole life and future in painting. The variety of expression from Great Nature is immeasurable."[3]

Among the works Obata created during this pivotal trip was *Lake Basin in the High Sierra* (fig. 75.1), a small painting on paper that depicts a lake in a valley beneath Johnson Peak, south of Tuolumne Meadows. Obata described the scene in terms that capture his exceptional sensitivity to nature: "For just two months in the year the nameless lake nestling at the foot of Johnson Peak in the High Sierra comes to life from its wintery slumber. Rocks and five needle pines along the shore cling to each other tightly. Countless streams run down the frozen mountainside, lending a sublime melody. Man's very soul and body seem to melt away into the singular silence and tranquility of the surrounding air."[4]

Obata's first large-scale version of *Lake Basin in the High Sierra* (fig. 75.2), painted on silk and measuring three by four feet, was created during the fall and winter of 1927–28.[5] The compressed composition emphasizes the enclosed nature of the lake, partially hidden by the foreground hill and protected by the massive, sheer cliff wall. This painting was exhibited at the East West Art Gallery in the San Francisco Western Women's Club in March 1928 and then at the annual exhibition of the Western Arts Association in Los Angeles in April.[6] *Lake Basin in the High Sierra* was purchased by one of Obata's longtime friends, Setsuo Aratani, who took the painting to Japan and offered it as a gift in honor of Emperor Hirohito's coronation in 1928.[7] Echoing the aspirations of the East West Art Society that he cofounded in 1921, Obata observed, "The subject is occidental, the work is oriental, the whole is a mixture of East and West. The significance of the presentation of California, the Occident, to the Emperor, the Orient, is the fusion of the East and the West."[8]

Obata's *Lake Basin in the High Sierra, Johnson Peak, High Sierra, U.S.A.* (fig. 75.3), copied almost exactly from his original painting on paper of 1927, served as the first print created for his *World Landscape Series: "America"* (1930).[9] This portfolio of thirty-five color woodblock prints

75. Chiura Obata (1885–1975), *Lake Basin in the High Sierra*, ca. 1930. Ink and color on silk, 71 × 104⅝ in. (180.3 × 265.8 cm) Museum purchase, Dr. Leland A. Barber and Gladys K. Barber Fund, 2000.71.1

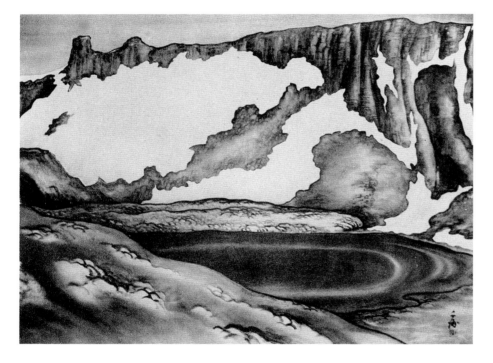

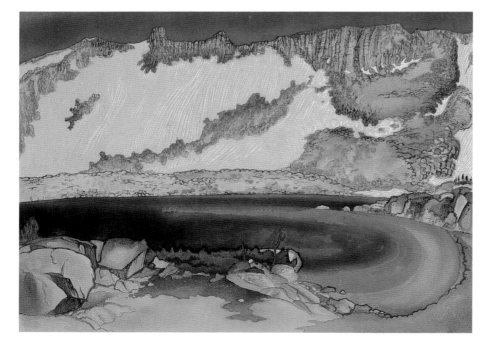

Fig. 75.1 [top]. Chiura Obata
(1885–1975), *Lake Basin in the High Sierra*,
1927. Ink and color on paper, 11 × 15½ in.
(27.9 × 39.4 cm). Private collection

Fig. 75.2 [center]. Chiura Obata
(1885–1975), *Lake Basin in the
High Sierra*, 1928. Ink and color
on silk, 36 × 48 in. (91.4 × 121.9 cm).
Imperial Collection, Tokyo, Japan

Fig. 75.3 [left]. Chiura Obata
(1885–1975), *Lake Basin in the High Sierra,
Johnson Peak, High Sierra, U.S.A.*,
1930, from the *World Landscape Series:
"America."* Color woodblock print, 11 × 15¾ in.
(27.9 × 40 cm). Printed by Tadeo Takamizawa,
Takamizawa Print Works, Tokyo. Fine Arts
Museums of San Francisco, Achenbach
Foundation for Graphic Arts, 1963.30.3126.23

was created during an extended visit in 1928–30 to Tokyo after the death of his older brother, Rokuichi. Although thirty-four of the prints depicted California scenes (one print was a portrait of the opera singer Thalia Sabanieva), Obata's "America" subtitle conveyed his global view of nature. In contrast to the painting given to Emperor Hirohito, the print version of *Lake Basin in the High Sierra* expands horizontally to emphasize the craterlike curvature of the surrounding cliff. The *Lake Basin in the High Sierra* print required more than one hundred progressive proofs to replicate accurately Obata's original painting on paper and won a first-prize silver cup at the annual Japan Art Exhibition in Tokyo in 1928.[10]

Obata's creation of a second large-scale version of *Lake Basin in the High Sierra* (pl. 75), painted on silk and measuring nearly six by nine feet, no doubt was inspired in part by the imperial and art world honors accorded his earlier versions of the composition. It probably was painted after Obata's return to San Francisco in the fall of 1930 for inclusion in a two-man exhibition in 1931 at the California Palace of the Legion of Honor that presented his work with that of his recently deceased brother, Rokuichi.[11] This work straightens the distinctive curve of the lakeshore and cliff that appears in the print version, enhancing the lake's monumentality by suggesting that it continues beyond the cropped composition. More significantly, it deepens and darkens the tone of the painting, evoking dusk, when the colors emanate from the rocks, earth, snow, and water, rather than from sunlight falling on them.[12]

Although Obata's composition is based on his experience of a specific site, the generic title—*Lake Basin in the High Sierra*—reveals his intention to evoke poetically, rather than depict topographically, the experience of a High Sierra lake. Fusing memory and imagination, Obata sought the essential truths and eternal themes of Great Nature, believing that "the aim of the Japanese painting should be brought out and felt directly from one's soul. Just to imitate or depict an object or some part of nature is not enough, because such an imitative idea without the creative soul cannot bring forth any beauty or humanity."[13] Instead, Obata developed a harmonious synthesis of naturalism and abstraction, incorporating stylized calligraphic delineation, large areas of subtly modulated color, and a fusion of Japanese and European perspective systems. Rather than choosing sides in the contemporary art world debate between naturalism and abstraction, Obata argued for their peaceful coexistence, observing that "if there is no reality, there is no abstraction."[14]

Lake Basin in the High Sierra is one of the most monumental of Obata's landscapes, yet it retains an intimate sense of enclosure and sanctuary. The luminous, deep blue lake, painted with sparkling lapis lazuli, perfectly reflects Obata's Zen-influenced philosophy of art: "In training and producing art, our mind must be as peaceful and tranquil as the surface of a calm, undisturbed lake. Let not a shadow be cast on it with the slightest thought of self-conceit or Egotism, but philosophically undertake the task with perfect composure and frankness. Only thus can a genuine art, overflowing in deep praise and abounding in inspiration, be produced."[15] The translucent melting snow, tinted by the underlying rocks, recalls Obata's admonition to his art students to carry their minds, not cluttered like a newspaper, but "white as snow" and open to nature's varied impressions.[16]

Unlike many earlier artists who depicted the High Sierra, Obata omits any trace of human spectators or intermediaries. Instead, he offers a direct encounter and communion with Great Nature, a vision grounded in the Buddhist philosophy that accepts the insignificance of human affairs in relation to the timeless forces of nature. *Lake Basin in the High Sierra* embodies Obata's guiding principles of *wa*, *kei*, *sei*, and *jyaku* (harmony, respect, purity, and serenity), which are associated with the traditional Japanese tea ceremony. This philosophy shaped Obata's fundamental beliefs regarding both nature and art: "when faced with such serene beauty, the soul and mind of man are lost, the possibility of petty thought vanished."[17]

Obata's vision of Great Nature as a common ground shared by all cultures, and a precious physical and spiritual resource deserving of protection and reverence, seems ever more prescient with the passage of time. *Lake Basin in the High Sierra*, a subject to which he returned repeatedly, epitomizes this vision and captures Obata's belief in the restorative powers of nature, which could provide spiritual sustenance to sensitive viewers—and listeners.

> Well, you can learn from many things: some people teach by speeches, some by talking, but I think it is important that you are taught by silence. . . . So, when you see these things, not only the big, rich and abundant Great Nature in America, but also if you look at the land very carefully and see the many different details, you will find it embraces a very gentle and refined nature. . . . Immerse yourself in nature, listen to what nature tries to tell you in its quietness, so that you can learn and grow.[18]

[TAB]

76. ALBERT BLOCH, *Nacht I*

THE ROAD NOT TAKEN

Albert Bloch, the only non-European member of the avant-garde art group Der Blaue Reiter (The Blue Rider), played an important role in the evolution of modernism. Although he believed that art should be rooted in tradition, Bloch shared his colleagues' conception of new art as a language that could spiritually transform receptive viewers. While retaining recognizable subjects, Bloch employed abstracted, expressionist forms and a vocabulary of resonant symbols to convey his belief that the purpose of art *"has always been and must always remain the deepening of the human perception and consciousness ... to give to the human race some sense of the dependence ... of our life here on earth, upon a state of being higher than our present one: to bring to us a profounder feeling of our inextricable union with the Infinite."*[1]

Albert Bloch (1882–1961) was born in St. Louis, Missouri, and studied art from 1898 to 1900 and again in 1905–6 at the St. Louis School of Fine Arts with Dawson Dawson-Watson, Halsey C. Ives, and Edmund Wuerpel. In 1905 he was hired as an illustrator for the *Mirror*, a St. Louis literary and political weekly published by William Marion Reedy, who recognized Bloch's talent and funded the young artist's first trip to Europe in 1908.[2] In 1909 Bloch and his family settled in Munich, where he studied informally with Leo Samberger and Hans Volkert and continued his career as an illustrator.[3] Bloch's paintings from this early period reveal his progressive assimilation of contemporary French and German modernism, reinforced by a trip to Paris in 1910–11.[4]

The turning point of Bloch's career occurred in 1911, when he first contacted the Russian modernist Wassily Kandinsky, who paid a studio visit with fellow artist Franz Marc.

The two artists encouraged Bloch to submit his work to the Neue Künstlervereinigung München (New Artists' Union of Munich) in the fall of 1911, but it was rejected. When the union subsequently rejected an abstract painting by Kandinsky, he and Marc resigned and formed The Blue Rider group with Gabriele Münter, August Macke, Heinrich Campendonk, and Bloch. The first Blue Rider exhibition, a major landmark in the history of modernism, was held at the Thannhauser Gallery in Munich in December 1911. Bloch exhibited six paintings—two religious subjects, two scenes from the commedia dell'arte, and two cityscapes.[5]

Nacht I (1913), a nocturnal cityscape, is the first of seven paintings Bloch created between 1913 and 1924 that address the theme of night.[6] The composition is divided vertically by a leafless tree whose trunk is rooted at the bottom, while its animated branches ascend in graceful, sinuous arcs. The scene is divided horizontally by a bridge, which appears to be supported at the left by a round arch and a Gothic window, and at the right by the triangular fulcrum of a peaked roof. Beneath the dividing line of the bridge, several human figures and a house are cast into darkness. Above, the glowing windows of a building and two brilliant constellations of lights illuminate the surface of the bridge and the surrounding night sky.[7]

The first owner of *Nacht I* was Arthur Jerome Eddy, a pioneering collector of European and American modernism.[8] In his book *Cubists and Post-Impressionism*, Eddy wrote, *"'Night I'* is almost a pure creation of the imagination as well as a beautiful composition of line and color. It is, as a matter of fact, a synthesis of Bloch's impressions of Munich by night, a summary of things he saw and felt during his wanderings about the city; it is vision on vision,

76. Albert Bloch (1882–1961), *Nacht I*, 1913

Oil on canvas mounted on hardboard panel,

33¼ × 41¼ in. (84.5 × 104.8 cm)

Museum purchase, American Art Trust Fund, 2001.124

Fig. 76.1 [top]. Albert Bloch (1882–1961), *Nacht IV*, 1915–16.
Oil on canvas, 23½ × 24 in. (59.7 × 61 cm). Private collection

Fig. 76.2 [above]. Albert Bloch (1882–1961), *Nacht V*, 1917.
Oil on canvas, 27½ × 39¾ in. (69.9 × 101 cm). Collection
of Dr. Horst Kollman, Weitenau, Germany

dream on dream, a composite of a hundred glimpses, the
fusion of a hundred impressions; it represents no part of
the city, but it *is* the city by night."[9] Eddy's emphasis on vi-
sions and dreams rather than specific urban topography ac-
curately reflected Bloch's stated goal of achieving "a total
spiritualization of the object" through pictorial means.[10]

Characteristically, Bloch endows his multivalent im-
agery with spiritual resonances while avoiding explicit reli-
gious references. Thus, the rainbow-hued constellations of
lights might be viewed as electric lights, but they also evoke
associations with suns, moons, and stars, or perhaps even
the falling stars of St. John's apocalyptic Revelation.[11] The
Gothic rose window form at the left is balanced by an ab-
stract triangle at the right, a form that traditionally symbol-
izes the Christian Trinity, but one that Kandinsky often
used to represent a more universal aspiration to achieve a
higher state of spiritual development.[12] Similarly, Bloch's
dividing bridge recalls Kandinsky's metaphor of the bridge
as a symbol of the senses, which link the artist's and the
viewer's immaterial emotions to the material work of art.[13]
Bloch's conception of the tree as a symbolic link between
the terrestrial underworld and a celestial, spiritual realm is
apparent in his painting *The Blue Bough* (1952), in which a
blue tree limb points the way for a pilgrim climbing a steep
mountain path toward a roadside crucifix. Similarly, Bloch
described blue, the predominant color in *Nacht I*, as a color
associated with spiritual transformation:

> Ah Blue! My only pigment not of earth,
> how you bring all these others swift to birth!
> Fetched out of heaven, from beyond the deep
> you came to rouse these earth-clods from their sleep.
> How you reveal their pent profounder value
> through your own spirit, deepest Blue![14]

In keeping with Bloch's perception of the artist as a lone
prophet whose purpose is to convey higher spiritual truths,
Nacht I presents a vision of spiritual enlightenment as a
choice that confronts all human beings. Tellingly, the shad-
owy, hunched-shoulder human figures that trudge up the
diagonal embankment look downward and seem oblivious
to the spectacular array of lights above. Metaphorically,
these individuals—at least two of whom are top-hatted
bourgeoisie—are focused on the material world and are
thus spiritually barren. Only the figure at the rear appears to
pause and stand upright. He is physically separated from his
companions by the arcing ray of light descending from the

sky above.[15] Like the biblical figure of Saul, who is struck down by "a light from heaven" and converted to Christianity (Acts 9:1–19), this chosen one appears to be on the verge of receiving spiritual enlightenment.[16]

Bloch's theme is reminiscent of the Italian Futurist Umberto Boccioni's triptych of 1911, *States of Mind I: The Farewells*; *States of Mind II: Those Who Go*; *States of Mind III: Those Who Stay* (The Museum of Modern Art, New York). This work, which also uses form and color to evoke psychological states, was shown in the spring of 1912 in Berlin at Der Sturm Gallery, where Bloch also exhibited.[17] Boccioni's ostensible subject, passengers departing from a train station, is a pretext for a metaphoric and metaphysical conception of his voyagers, who either are energized and spiritualized by the dynamism of modern life or are left behind.

Bloch's utopian vision of spiritual enlightenment was shattered by the horrors of World War I, especially the battlefield death in 1916 of Franz Marc, his closest artist friend and kindred spirit. Bloch's shifting worldview is apparent in *Nacht IV* of 1915–16 (fig. 76.1), a wartime work whose composition recalls the cityscape and lights of *Nacht I*. However, the city buildings are now surmounted by a menacing dragon, a motif that Kandinsky had appropriated from the legend of St. George and the Dragon to symbolize evil. At the upper right, a solitary figure who has committed suicide by hanging almost certainly represents the prophetic but alienated artist, a recurring theme in Bloch's writing.[18] Ten dark, top-hatted bourgeois figures turn their backs on this sad scene, suggesting indifference, if not culpability.

In *Nacht V* of 1917 (fig. 76.2), the lights glowing through a smoky, hellish red haze resemble bursting artillery shells rather than stars, and the earlier vibrant cityscapes have been replaced by a barren landscape of blasted trees that resembles the infamous no-man's-land between the opposing trenches of World War I battlefields. On 11 November 1918, the day of the armistice, Bloch wrote to Marc's widow: "Somehow all of this must have a meaning—but I am not able to find it. Faith in mankind, once and for all, is gone. . . . I torment and torture myself, break head and heart in a search for the sense of this horror; for sense it must have, there must somehow be one. This belief I clutch as firmly as the drowning man his straw, otherwise one could end by despairing of God himself."[19]

Despite Bloch's early success in Europe and in the United States, where he was given a one-person exhibition at the Art Institute of Chicago in 1915, by the time he returned to the United States in 1921, he was deeply disillusioned. During his tenure as a professor at the University of Kansas at Lawrence (1923–47), Bloch downplayed his role in the Blue Rider, exhibited only reluctantly, and destroyed many of his early works. He thus is a dramatic representative of the pre–World War I generation of young artists whose utopian ideals perished on the battlefields of Europe. However, *Nacht I* serves as an eloquent testament to a crucial prewar period in which avant-garde American artists such as Bloch, working in harmony with their European colleagues, sought to transform the world through their art. [TAB]

77. ERNEST LAWSON, *Harlem River at High Bridge*

"THE BEAUTIFUL IN UNLOOKED-FOR PLACES"[1]

From 1848 until 1917, water was brought into New York City from the north via the Croton Aqueduct System.[2] Originating in the farmlands of Westchester County, water traveled forty miles through a pastoral landscape, finally crossing the Harlem River to reach the island of Manhattan for the last stage of its journey to 42nd Street. The aqueduct spanned the Harlem by means of a viaduct, constructed between 1839 and 1848, known as High Bridge.[3] Designed by James Renwick Jr., who would go on to such projects as St. Patrick's Cathedral, High Bridge cost more than one million dollars to erect. More than 100 feet above the river and 1,450 feet long, it is a soaring series of fifteen granite arches, reminding one, as surely it was intended to do, of the great Roman aqueducts such as that at Nîmes, France. Despite its prosaic function, following its construction High Bridge was, by virtue of its impressive dimensions and aesthetically pleasing form, a landmark of note and a destination for tourists and day-trippers alike, who thrilled to the pedestrian walkway on its top and enjoyed the rustic forests, rocky bluffs, and farmlands all around. The addition of a tall water tower in 1872 made the scene even more picturesque.

Difficult though it is to imagine today, at that time the northern reaches of Manhattan were largely uninhabited and considered a world away from civilization. The area is described in William Cullen Bryant's 1874 opus, *Picturesque America*:

> At Harlem River, which forms the northern boundary of the island, there is a change. The banks of the river are high and well wooded. It is crossed by several bridges,

and by a viaduct for the waters of the Croton, which are here brought into the town from the rural districts above for the use of the citizens, and which is known by the somewhat incorrect and very prosaic designation of High Bridge. It is a handsome structure, however, of high granite piers and graceful arches, and shows from different points of view, through vistas of trees, from the open river, from distant hills, with singular and even lofty beauty. The tall tower . . . is for the elevation of the Croton to an altitude sufficient to give it force for the supply of residences on the high banks in the upper part of the city. Tower and bridge make a fine effect.[4]

A quarter century later the area had undergone a transformation. Rail, road, and shipping traffic had increased dramatically. The metropolis of New York had moved north of Central Park, creating the still semirural suburbs of Harlem and Washington Heights. Some of the unpleasant corollaries of urban life that congregated at the fringe of all large cities moved north as well; a small shantytown sprang up by the tracks, and the open space near the viaduct was frequently used to dump garbage, as it was far enough from the suburban residences to be out of sight (and smell) yet close enough for convenience. The northern edge of the island, though, was still rustic and full of undeveloped land; some farms remained, and a park was established in 1867 for the use and enjoyment of the city dwellers who flocked to the banks of the Harlem for fresh air and communion with nature.[5] In this neighborhood, where the suburbs met the countryside and the dross of the city

77. Ernest Lawson (1873–1939), *Harlem River at High Bridge*,
ca. 1915. Oil on canvas, 25¼ × 30 in. (64.1 × 76.2 cm)
Gift of Harry William and Diana Vernon Hind, 78.63.2

found a home in the natural environment, the artist Ernest Lawson and his family settled in 1898.[6] Lawson would paint the Washington Heights area, and High Bridge in particular, many times during his career, returning frequently even after moving south to Greenwich Village in 1906.[7]

In *Harlem River at High Bridge*, once the painted surface resolves itself into recognizable forms, we look obliquely from the Bronx across the Harlem River to Manhattan and the buildings of Washington Heights. It is winter, and the bare trees of the foreground afford an unobstructed view of the icy river and railroad below. A rail line cuts a diagonal across the lower left, and High Bridge itself creates a crisp, though truncated, near horizontal at center left; these linear elements intersect out of sight beyond the left edge of the canvas. Combined with the vertical of the water tower, which breaks the high horizon line at the center, these straight-edged symbols of modern technology provide an orthogonal structure to the painting. Houses, railroad cars, steamboats—all of the man-made elements are blocky, contrasting with the curves of color that make up the hillsides, the undulating strokes of the river, and the scumbled sky that occupy most of the composition. Forms are built up from small, variegated patches of contrasting hues, some of the paint appearing to have come directly from the tube.[8] All are unified by the consistent texture of Lawson's signature impasto, his "almost prodigal use of pigment."[9] *Harlem River* bears Lawson's distinct "look," which he developed early in his career and from which, with few exceptions, he never departed.

Lawson's mentor was the American Impressionist John Twachtman, with whom he studied in 1891 at the Art Students League and the following year at the art school that Twachtman and John Alden Weir had established in Cos Cob, Connecticut.[10] There Lawson was schooled in the tradition of the French Impressionists, embracing their interest in the changing effects of light and atmosphere and developing an approach based on broken strokes of variegated color, creating a "deep fabric of pigment which lies on the surface of the canvas."[11] Lawson's idiosyncratic style incorporated Twachtman's heavy impasto, decorative surface patterning, and a predilection for near-monochromatic winter scenes. He always painted *en plein air*, directly onto the canvas and without preliminary studies, though he often reworked paintings in the studio afterward. In 1893 he

left for France to study Impressionism at its source, hoping, he wrote to a cousin, "to keep my individuality and at the same time get as much of the best French influence as will be consistent with it."[12] In Paris he enrolled at the Académie Julian, where he undertook a traditional curriculum of life drawing in the mornings and studio painting in the afternoons. During the summer he painted outdoors in the south of France and in Moret-sur-Loing, near Paris.[13]

Returning to the United States, Lawson sought to apply his impressionist training to the modern landscape of New York City, painting the same scenes over and over under differing conditions during the first decades of the twentieth century. In his many High Bridge paintings, Lawson's goal, and his gift, was to "bring beauty out of a region infested with squalid cabins, desolate trees, dumping grounds and all the other important familiarities of any suburban wilderness."[14] High Bridge, Brooklyn Bridge, the Flatiron Building, Washington Square with its classical marble arch—although fewer than 4 percent of his paintings are figural, the human presence is manifest in the man-made objects he takes as his subjects.[15] Not everyone shared his enthusiasm for the subject. When he exhibited with the Eight in 1908 he was accused of going out of his way to discover the ugliest scenes possible to paint.[16] His favorite landscapes were those that had, in the words of the artist and critic Guy Pène du Bois, "been arranged by man, remade, given a human touch."[17]

In Washington Heights Lawson found an ideal locale, where modern structures and commercial activity could be made to appear beautiful in an environment that was still quite natural despite their presence. High Bridge itself presented a similar duality; a symbol of New York's modern urban infrastructure, it intentionally references similar European viaducts more than two thousand years old.[18] *Harlem River at High Bridge* is a study in contrasts: New World innovation and Old World ruins; solid man-made objects and swirling organic forms; the gritty urban scene of the American Realists and the charming countryside of the French Impressionists; passages of bare canvas with sculptural impasto. All come together in the art of Ernest Lawson who had, in the words of the critic Frederic Fairchild Sherman, "that rare gift of art of seeing the beautiful in unlooked-for places and of re-creating it upon his canvases so that others see it as well."[19] [EL]

AN OUTSIDE VIEW

Why, why was everything wonderfully made, perfectly made, and I given the power,
above many, to appreciate this wonder and perfection? And yet denied the one thing
which would perfect me, truly? CHARLES DEMUTH, *The Voyage Was Almost Over* [1]

As one of the key artists associated with New York's avant-garde, first with the Daniel Gallery and then Alfred Stieglitz's circle, Charles Demuth (1883–1935) received recognition early in his career and has consistently retained his reputation as one of America's most significant painters.[2] Demuth's work was championed by some of the most adventurous collectors of early-twentieth-century avant-garde European art, including Albert Barnes, Ferdinand Howald, and Abby Aldrich Rockefeller, ensuring that it would be exhibited and purchased during his lifetime by the Whitney Museum of American Art and the Museum of Modern Art, both in New York. The famous early historian of American art Lloyd Goodrich called Demuth "the most sophisticated American artist of his time," largely due to his successful translation of European Cubism into an American idiom through a style that has become known as Cubist-Realist.[3] Henry McBride succinctly expressed Demuth's contribution by declaring that he "may be said to have translated Cubism 'into American.'"[4] Artists working in this style retained recognizable subject matter while embracing the compositional and spatial experiments of the European avant-garde that so shocked most Americans at the Armory Show of 1913.[5]

Later identified as Precisionists, American artists such as Charles Sheeler, Preston Dickinson, Ralston Crawford, Niles Spencer, Elsie Driggs, and Demuth created an entirely new approach to painting meant to be analogous to the emotional experience of living in the modern world, which was characterized by fragmented and dynamic per-

ceptions that felt simultaneously highly structured and detached.[6] Demuth's first one-person exhibition at the Daniel Gallery in 1914 made him one of the group's leading figures.

The work's title, *From the Garden of the Château*, is something of a displacement. Rather than referring to the painting's depicted scene, the newly opened, modern laundry in Lancaster, Pennsylvania, it references the artist's vantage point, the Demuth family home across the street at 118 East King Street.[7] The family had colonial roots, settling in Lancaster in 1736, and Demuth maintained his second-floor studio in the rear of the eighteenth-century homestead, overlooking the Lancaster Laundry.[8] A close friend of Marcel Duchamp and the most ardent defender of his infamous work *Fountain* (1917), an upended urinal,[9] Demuth employs a similar ironic humor; he aggrandizes the commonplace by referring to his family's residence in the industrial town of Lancaster as "the château," as if it were a French country estate belonging to an old-world European ancestral family. Not incidentally, his mother's extensive backyard gardens were laid out in the formal manner associated with such aristocratic properties.[10] However, like Duchamp, Demuth was interested in more than a witty inversion based on linguistic play. His title recontextualizes the object in his painting, suggesting that the signs of power and prestige in America were to be found in the industrial landscape, linking modern technology to the symbolic garden with its edenic echoes.

Several scholars have noted that Demuth often relied on

78. Charles Demuth (1883–1935), *From the Garden of the Château*,
 1921 (reworked 1925). Oil on canvas, 25 × 20 in. (63.5 × 50.8 cm)
 Museum purchase, Roscoe and Margaret Oakes Income Fund, Ednah Root,
 and the Walter H. and Phyllis J. Shorenstein Foundation Fund, 1990.4

the Dadaist device of creating an "ironic dissonance be-tween object and title" as a strategy to disrupt the symbolic relationships on which conventional associations rely and to construct an alternative understanding of reality.[11] It also throws the significance of his visual signs into a more per-sonal realm, leading to a wide range of speculations about their meaning.[12] One tempting conjecture arises from the obvious contrast between the suave sophistication asso-ciated with a Paris château and the unrefined pragmatism associated with urban life in the United States, especially in the industrial town of Lancaster. However, as Jonathan Weinberg writes, "One of the clichés of Demuth criticism is to see him as a decadent prisoner of an almost chaste provincial town."[13] In point of fact, Demuth's letters written from Paris during the fall of 1921, the year he painted *From the Garden of the Château*, often chronicle his ambivalence about both France and the United States. In a letter to Al-fred Stieglitz, he quotes his friends and artistic allies Mar-cel Duchamp and Albert Gleizes, who disparage Europe with "Oh! Paris. New York is the place, —there are the mod-ern ideas. Europe is finished."[14] In another letter to Stieg-litz, he complains: "The Autumn Salon was dead, —about five years dead."[15] He writes to his mother after attending the Paris opera that "it was quite grand, but ours is really better."[16]

On the other hand, he confesses that he feels " 'In' Amer-ica—even though its insides are empty," and goes on to write "Maybe I can help fill them."[17] To his close friend and confidant William Carlos Williams he writes that the French have embraced American art, but then he immedi-ately registers a sardonic note in the self-deprecating phrase that follows: "France thinks a great deal of our art. Of course, it all seems strange, never knowing we had one!"[18] In response to Stieglitz's letter after he has returned from Paris, Demuth says, "Your letter made me glad to be home, and I will see you soon in New York. It was all very wonder-ful,—but I must work, here."[19] This theme of working as a modern artist in the United States is most famously sum-marized in his resigned comment to Stieglitz: "What work I do will be done here; terrible as it is to work in this 'our land of the free.' "[20]

Demuth adopted the persona of the alienated, modern artist whether in Paris or Lancaster. Yet this position as an outsider went beyond the aesthetic concerns of the avant-garde as he formulated a visual vocabulary to express his own frustrations surrounding health, sexuality, and gender,

especially as a closeted gay man subject to social expecta-tions.[21] The artist used the title and the language of Preci-sionism to explore both his personal experience and the social implications of modern industrial life in America.

From the Garden of the Château is one of a number of enigmatically titled paintings Demuth made between 1920 and 1933 that focus on the industrial architecture of Lan-caster.[22] The irony of the landscape reference in Demuth's title serves to intensify the visual impact of his scene's compressed space; the sky is depicted more like a series of architectural planes than open air. Bright, blue-toned electrical insulators on the side of the building in the immediate foreground, repeated on the telephone pole in the background, signal the powerful charge that Demuth makes visible through his dynamic rendering of the site. Conjoining electrical wires, rays of sunshine, and the play of light and shadow formed by the juxtaposition of build-ings, Demuth structures a web of signs that makes no dis-tinction between actual and metaphoric force lines. He captures, literally and symbolically, the sense of technolog-ical progress that characterized the early twentieth century, especially that resulting from the industrial applications of electrical power.[23]

Demuth had studied at the Pennsylvania Academy of the Fine Arts under Thomas Anshutz (1851–1912), who be-lieved that artists should represent the details of everyday life, no matter how gritty, and inspired the New York group of painters popularly known as the Ashcan School.[24] As the name implies, the members of this group set about to cap-ture common and usually overlooked aspects of urban experience, such as garbage containers in back alleys and other emblems of city living. Focusing on the crowded neighborhoods of the slums, home to the immigrants who provided the necessary factory workforce, paintings of the Ashcan School featured fire escapes and rickety stairways strewn with laundry hung out to dry. Such familiar motifs simultaneously symbolized poverty and the social life of these communities.

Electricity not only transformed heavy industry such as manufacturing and transportation; it dramatically changed the nature of cities. One of the most significant changes re-sulted from the introduction of the washing machine. In contrast to the ubiquitous clotheslines of the slums, the electric laundry symbolized an entirely different economic and social order. It offered those with financial means the opportunity to escape a centuries-old domestic drudgery,

and it represented the promise of a sanitary, technological future that would liberate urban populations from unpleasant and unhealthy conditions.

For Demuth, such a symbol would have had special resonance as he was painting *From the Garden of the Château*. In 1920 he was diagnosed with the diabetes that would debilitate him until taking his life fifteen years later. In 1921 he underwent a complicated and painful medical regime, which was new and still highly experimental, involving starvation treatments and injections.[25] During the next year he spent extended periods as one of the first patients at a sanitarium for diabetics in Morristown, New Jersey, which was the first institution in the country to use insulin. The emphasis on cleansing his body to combat his disease would have given special significance to the laundry that Demuth viewed every day from his studio window. It would have been a small step for the artist to appropriate the laundry as a sign of purity, linking his own health and the transformation of urban space in a double portrait.[26]

The language of purity raised by that portrait also touches on Demuth's sexuality. To whatever degree Demuth biographers believe that he acted on his gay desire, they all agree that he was deeply conflicted about its influence. An astute critic has speculated that the artist used his own ambivalence as a creative stimulant in both his lifestyle and his painting. For Demuth "this meant simultaneously savoring the flagrant and cultivated sexual inclinations which he viewed as personal weaknesses, and making those weaknesses the most dependable sources of his creative strength."[27] He adopted the persona of the epicurean dandy, modeled on aesthetes from the previous era, notably Oscar Wilde, Aubrey Beardsley, Joris-Karl Huysmans, and Marcel Proust.[28] This cultivation of effete dandyism, which prized experiences of extreme sensation, provided him with an elaborately coded self-presentation on which his friends and contemporaries often remarked.

In Precisionism's stylized representation of industrial and mechanical forms, which sought to present the dynamic sensations of modern, urban life, Demuth fashioned a visual language that echoed his personal life. In addition, the subject of the modern laundry provided an iconography that allowed him to express his identity, remaining in the closet without entirely concealing his homosexuality, through the metaphoric implications of corruption and purity, which in turn suggested connections between his artistic vocabulary and the era's social values. *From the Garden of the Château*, an homage to the technological advances of the modern industrial landscape, is more than ironic. Demuth found a symbol of the new urban promise in the laundry and transformed it into a sign of the marginalized position, both physical and psychic, that characterized his life as an artist, a diabetic, and a closeted gay man. The painting offers an analogue for his attempt through the language of Precisionism to transform his vantage point as an outsider looking at the modern world, cloistered in his studio, limited by his illness, and closeted in his personal life. [DC]

AESTHETICIZATION AND ALIENATION

In a 1917 issue of *Soil*, a short-lived avant-garde magazine published in New York, the editor Robert Coady exhorted American artists to find their subjects in what he saw as the unique urban and industrial landscape of modern America. "Our art is, as yet, outside of our art world," he stated. "It is in the spirit of the Panama Canal . . . the skyscraper, the bridges and Docks . . . the Electric Signs, the factories and Mills—this is American Art. It is not an illustration to a theory, it is an expression of life—a complex life—American life."[1] Painters responded to the counsel of Coady and other like-minded critics and intellectuals, and by the early 1920s a new artistic idiom had emerged, today known as Precisionism. The Precisionist artists—whose name is derived from the word "precise," used by critics in the 1920s to characterize the painting style—most often rendered American skyscrapers, bridges, and industrial subjects in a linear, crisp, and abstracting style.[2] Among the earliest and most promising practitioners of this modernist style was George Ault, whose 1923 painting *The Mill Room* both typifies the precisionist style and conveys complexities of the machine age often elided by other Precisionist painters.

George Copeland Ault (1891–1948) was born in Cleveland, Ohio, where he grew up in a prosperous but conservative family.[3] His introduction to art came from his father, Charles Henry Ault, an amateur painter, an acquaintance of William Merritt Chase, and an active supporter of the arts who served as president of the Western Art Union and was a founder of the Saint Louis Museum and School of Fine Arts. The family moved to London in 1899, when the senior Ault was appointed European representative to his cousin's ink manufacturing firm. Once in London, George Ault's artistic talents were encouraged; he was enrolled in University College School, the Slade School of Fine Arts, and St. John's Wood Art School, where, in 1908, he first publicly exhibited his work. Three years later the family returned to the United States, at which time his father opened the Jaenecke-Ault Printing Ink Company in Hillside, New Jersey, a suburb of New York. George, now in his twenties, worked for a time in the plant but devoted himself to painting, executing rural landscapes in the conservative impressionist style he had learned in London—paintings he later disparagingly called "the 'winter brook and birch tree' subjects of the National Academicians."[4]

About 1920 Ault's painting style changed. He turned his attention to urban subjects, which he increasingly rendered in a flat, planar style. In 1922 he moved to New York City and soon established his reputation as one of the nation's leading painters. By the late 1920s his work was being exhibited at such progressive galleries as the Downtown Gallery, run by Edith Halpert. Halpert's stable of artists included Georgia O'Keeffe, Arthur Dove, Charles Demuth, and Stuart Davis. In a review of a 1928 exhibit of Ault's work, one critic praised his modernist abstractions, saying, "The artist, like many of our young modernists, has had a decided flair for the abstract, building up his design in somber tones with architectural precision of structure."[5] A second critic singled out Ault as one of the period's most important painters: "Ault may be called one of the true American artists. . . . The American school of painting which is now in a fertile period of development . . . has in this artist a strong and important contributor, with an individual approach and a very personal sense of the relation of form and color."[6] Unfortunately, Ault's success did not last. Toward the end of the decade, he had become reclusive and prone

79. George C. Ault (1891–1948), *The Mill Room*, 1923
 Oil on canvas, 21⅜ × 15¾ in. (54.2 × 40 cm)
 Gift of Max Rosenberg to the California
 Palace of the Legion of Honor, 1931.26

to excessive drinking. The death of his father from cancer in 1929, the stock market crash, and the suicide deaths of his two brothers further undermined his mental stability, and he alienated his art dealers, artist friends, and wife. During the 1930s he continued to paint, but his unsound personality isolated him from the mainstream art world. In an unsuccessful effort to improve his mental health, in 1937 he moved to Woodstock, New York, where he lived until 1948, the year he committed suicide.

The Mill Room (1923) depicts an industrial interior painted in Ault's mature, precisionist style. Framed by shadowy darkness, a solitary worker monitors a mill, its red cylindrical rollers turned by a belt stretching down from a driveshaft along the ceiling. In the foreground, two red-topped cylinders lead our eye from the lower right corner of the painting to the red roller of the mill. In the background, multicolor barrels rest against the walls, while beyond the arched doorway and window we glimpse the rest of the manufacturing plant.

The title of the work and the subject depicted suggest Ault based this painting on observations he made of his family's ink manufacturing business, which may have used similar mills, known as roll mills, to process ink for use in printing presses.[7] Although the scene is based on reality, Ault has simplified and abstracted the worker, the machinery, and the architecture, rendering each with a minimum of detail and modeling and a consistent, flat application of paint. As a result, the scene appears composed of a series of interlocking geometric shapes and evinces a fixed stillness and a silence that are characteristics of precisionist painting.

Ault and the other Precisionist painters generally did not incorporate figures in their paintings, and the laborer here creates an unexpected tension. By rendering the industrial machinery and architecture as a composition of crisply painted geometric shapes, Ault aestheticizes and glorifies modern manufacturing. The real heroes of the machine age, as represented by Ault and his fellow Precisionists, are the mills, power plants, factories, and skyscrapers, which almost appear to have manufactured themselves. The solitary figure in this painting, whose body has been reduced to a black silhouette and whose face is devoid of an individualized physiognomy, reminds us of the very human cost of

industrialization, namely, the worker's alienation. As Karl Marx stated, "Alienation manifests itself not only in the result, but in the *act of production*, in the *producing activity* itself."[8]

Although Ault's *The Mill Room* does not represent an assembly line, the worker's contribution to the manufacturing process consists solely of observing and monitoring the "work" the mill does—work that, a century earlier, would have been done by the labor of men. This figure's abstracted body and features reduce him to a generic unit, one that can be replaced with a similar unit should the need arise, just as worn-out rollers on the mill can be taken out and replaced with new ones. Furthermore, the belt's figure eight, Möbius-strip form is suggestive of infinity and, by extension, the monotony of industrial labor. Thus, even as the painting celebrates the machine age, it also reminds us of the potential human cost of modernization and industrialization, in which the worker controls neither the mode of production nor the product of his labor.

This rare inclusion of a human figure in a precisionist painting renders its content potentially critical. Yet, the ambivalent relationship between modern manufacturing and individual labor expressed in *The Mill Room* may reflect the artist's personal relationship to the subject of the painting. The industrial space depicted in this painting was, it is thought, based on Ault's observations of the workers, machinery, and architecture of the Jaenecke-Ault Printing Ink Company, the business run by his father.[9] The profits of this business had enabled Ault to become a successful painter. Indeed, he had been able to move to New York in 1922 with the help of a small stipend from his father.[10] Yet, his father disapproved of the modernist style in which his son painted. As Ault's second wife later recalled, "Because George wouldn't paint the way his father wanted him to, the father gave him little to live on. . . . George suffered terribly."[11] The subject of *The Mill Room* may thus be seen as representing an industrial space that was, for all intents and purposes, an extension of the artist's father, to whom he was indebted for his artistic education and financial support. But the style in which *The Mill Room* is painted had alienated George from his father. Thus, the son's ambivalent relationship with his father may in some ways parallel the worker's alienation on the shop floor. [KM]

A SILENT REQUIEM

Edwin Dickinson is an artist who doesn't fit into any neat classification. He is a representational painter who uses reality with the utmost freedom, a traditionalist who is entirely unacademic, an imaginative creator who embodies his visions in naturalistic imagery. A complete individualist, he has evolved his highly personal art without regard to trends of the moment.[1] LLOYD GOODRICH

Edwin Dickinson (1891–1978) was twelve when his mother died of tuberculosis in 1903, an event that would reverberate throughout his life and career.[2] The youngest of four children, he was close to his sister and brothers, particularly his brother Burgess. During his childhood, it was assumed that he would follow in his father's footsteps and become a Presbyterian minister; at Burgess's suggestion, however, Dickinson settled on a career in the navy. After failing the math portion of the Annapolis entrance exam twice—fortuitously, as it turned out—he decided to become a painter instead. In the fall of 1910 he entered the Pratt Institute in Brooklyn and took up residence with his brothers; Howard was then an attorney, and Burgess was attempting to make a living as a composer.

The following years were exhilarating for Dickinson, who thrived on the vitality of the city, his brothers' company, and his art studies at Pratt, the Art Students League, and the National Academy of Design. "[I was] bursting out of my shell joyfully into a life that I hadn't known before.... I was just completely taken up with the joy of being an art student and knowing what I was going to do."[3] During his summer break in 1912 he escaped the city heat by attending Charles Hawthorne's art classes in Provincetown, Massachusetts, and was profoundly influenced by both the lessons and the locale. This idyllic period ended abruptly the following winter, when Dickinson's adored brother Burgess, prone to episodes of depression, committed suicide by leaping from Edwin's sixth-floor window. Distraught,

Dickinson determined to spend another summer in Provincetown; when autumn came, he stayed on, one of three artists to do so.[4]

Provincetown was to be Dickinson's home on and off for many years. That first winter of 1913 he rented a bare, unheated studio, yet he claimed that he "lived more luxuriously than J. P. Morgan ever thought of."[5] He did not manage to sell many of the paintings that came out of his spartan studio (nor would he for many years), and his funds eventually dwindled to the point that he took a temporary job as an art instructor in Buffalo in 1916, the first of dozens of teaching positions he would hold over the years.[6] America's entry into World War I imposed an eighteen-month hiatus on any painting, however, as Dickinson enlisted in the naval reserve, serving as a radio operator on ships plying the New England coast until July 1919.[7] When he was discharged, he returned to his family in upstate New York for an extended visit, then set off for a six-month European sojourn. When Dickinson arrived in Provincetown after an absence of two and a half years, he immediately settled down to work.

The large canvas for *An Anniversary* (fig. 80.1) was stretched just two weeks after Dickinson's return and occupied him for more than a year. The scene is crowded with individuals—young women, fishermen, artists—and various objects such as shells, bowls, and sheet music lying scattered on the floor. Despite the sense of festivity imparted by the bustling, colorful arrangement, however, each figure is

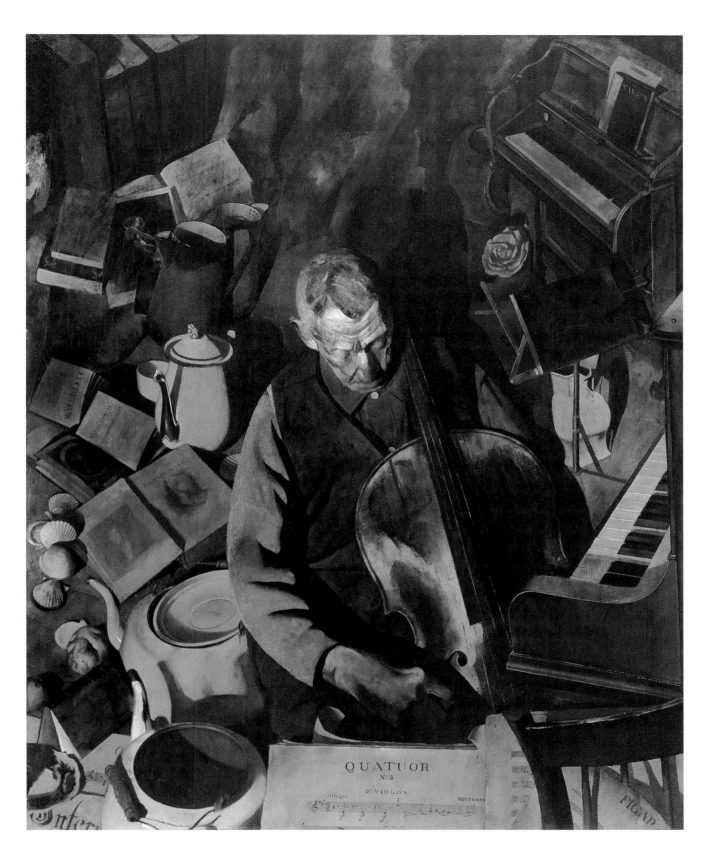

80. Edwin W. Dickinson (1891–1978), *The 'Cello
 Player*, 1924–26. Oil on canvas, 60¼ × 48½ in.
 (153 × 123.2 cm). Museum purchase, Roscoe
 and Margaret Oakes Income Fund, 1988.5

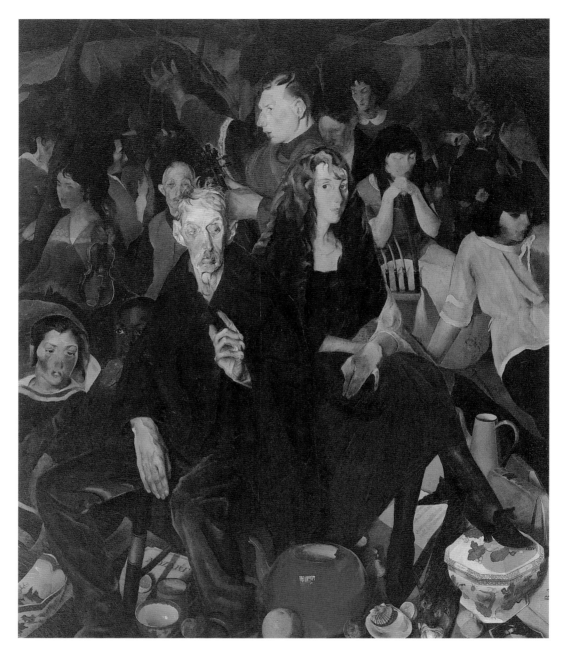

Fig. 80.1. Edwin W. Dickinson (1891–1978), *An Anniversary*, 1920–21.
Oil on canvas, 72 × 60 in. (182.9 × 152.4 cm). Albright-Knox Art Gallery,
Buffalo, New York. Gift of Mr. and Mrs. Ansley W. Sawyer, 1927.29

utterly disconnected from the others and from the barely discernible landscape in the background. The foundation of the composition is a pyramid created by the three brightly lit figures in the foreground. A young woman and an old man, both dressed in black, sit so closely back to back that it is hard to tell where one body ends and the other begins, yet they display no awareness of one another. Behind them a man stands holding a cello, his face accentuated by his red shirt. Dickinson asserted that the painting did not depict a specific event, saying, "I named the picture after it was painted, as I've done with all my canvases.... The name of the picture makes no difference whatsoever."[8] What Dickinson had labored over for a year was not the significance of these figures and objects but their formal

arrangement on the canvas. "While he was always happy to identify objects in his paintings, tell where he found them, or from whom he borrowed them, he considered questions about 'meaning' or 'symbolism' to be entirely beside the point."[9]

At five by four feet, *The 'Cello Player* is smaller than *An Anniversary* but took much longer to complete. "It was commenced on 4 March 1924 and completed on 27 August 1926.... It occupied 290 execution-sittings (half days)."[10] For years the painting was known as *The Cello Player*, but, according to Dickinson's daughter, "My father always wrote this painting's title *The 'Cello Player*, thinking of *'cello* as a shortening of *violincello* [*sic*]."[11] At first the painting appears to be monochromatic, a study in gray. Upon perusal, however, muted colors reveal themselves: pinks, browns, greens, purples, blues.

At the center an older man is seated, apparently deep in thought, a cello cradled against his left side. His right arm and the cello create the diagonals of the composition's strong pyramidal foundation. He holds no bow; the cello is silent. Objects surround the musician, filling the room in which he sits as well as the picture space at which we gaze.[12] We see the room from above, looking down into what Dickinson described as the "bowl" in which his subject sits.[13] The perspective shifts, however, for we see the cellist himself frontally; scale shifts as well, for the teakettle just behind his right elbow appears enormous.[14] So precipitous is the tilt within the picture space that the kettle and other furnishings give the impression of floating freely around the musician.

Though each item is depicted with precision, their arrangement is a purely formal concern; according to Dickinson, "the still life was not put in for itself ... but to carry out [a] compositional plan."[15] This densely packed, spatially complex scene is structurally grounded by the deployment of text around its edges: at center left, the book titles "Lucretius," "Works," and "Robert Burns" appear; sheet music—"Inter[mezzo]," "Quatuor," and "Figaro"— borders the bottom; and the book "Nansen" is propped on the organ.[16] The limited palette and the reorganization of pictorial space in the service of surface patterning call to mind Analytic Cubism, which Dickinson has adapted to his own idiosyncratic ends.[17] According to the *New York Times*, "Edwin W. Dickinson in 'The 'Cello Player' undertakes the impossible task of suggesting the movement of music by the rhythms of design.... If architecture is frozen music, this kind of painting is fluid music."[18]

Dickinson steadfastly denied that *The 'Cello Player* contained any narrative or symbolic meaning. Some art historians have proposed, however, that the painting expresses the profound sense of loss and mourning that Dickinson had suffered ever since Burgess's death more than ten years before. The somber palette certainly invites an elegiac interpretation, as does the fact that the man, head bowed, seems lost in thought. Due to the placement of objects, the room defies all efforts to read it as a coherent, inhabitable space; the cellist almost seems to be seated in a dreamscape, surrounded by his memories.

Many of the items Dickinson selected for the painting held personal significance. The piano, for instance, had been his sister's, and the trilobite fossil was a souvenir of the artist's childhood, when he delighted in fossil hunting.[19] In fact, all of the objects in the painting can be considered fossils—traces of past activity in the room, accumulating over time. One of the teapots particularly signals the passage of time, for it was supposedly used to serve tea to General Sherman, a fact that delighted Dickinson.[20] According to the artist's daughter, "*The 'Cello* Player is packed full of things Father cared about, even passionately loved."[21]

The 'Cello Player is a portrait of a musician, the calling to which Burgess had been so committed.[22] While Burgess was at the Yale School of Music, his classmates had taken to calling him "Beethoven," a nickname that clung to him until his death. Dickinson identified the sheet music at the bottom center of the painting—the object that appears closest to the viewer—as Beethoven's "quatuor 18 #3, 2nd violin, Allegro," a selection he could not have made without thoughts of Burgess.[23] This simple piece of paper conjures a palpable sense of loss, for a cellist is only one of four musicians required to play the composition; the other three are conspicuous in their absence. Moreover, the portion of the quartet pictured is that for the second violin, a poignant trace of a musician no longer present. Edwin Dickinson is himself no longer present, and the objects he so carefully selected and composed for *The 'Cello Player* have taken on further meaning as relics of his long life and far-reaching career. [EL]

81. GEORGIA O'KEEFFE, *Petunias*

BIG ENOUGH

Everyone has many associations with a flower. You put out your hand to touch it, or lean forward to smell it, or maybe touch it with your lips almost without thinking, or give it to someone to please them. But one rarely takes the time to really see a flower. I have painted what each flower is to me and I have painted it big enough so that others would see what I see. GEORGIA O'KEEFFE[1]

Georgia O'Keeffe's *Petunias* (1925) is one of a series of paintings based on a patch of flowers that the artist planted at the extended-family summer home of her husband, Alfred Stieglitz, near Lake George in upstate New York, the year that they were married. It is the most complex of the dozen works she would paint inspired by such plants over the next two years.[2] Several large blossoms fill the canvas, pushed to the picture plane and cropped as in a photograph so that they seem to spill out of the frame and crowd the viewer's space. There is no room for a signature, which O'Keeffe usually placed on the back of her works, believing it not to be part of the painting.[3] Subtle tonalities create the naturalistic effects of modeling, and the modulated range of intense purples gives the petals a velvety appearance that reflects the delicate sensuousness of an actual flower.

Yet, in spite of providing these realist clues, O'Keeffe resists a realist effect through her use of abstract principles. The sharply delineated forms and the broad planes of saturated color flatten the perspective and visually reduce the flowers to a pattern of lines and shapes. Further isolated from any context except the viewer's space, the flowers float against an indeterminate ground, anchored to the earth by only the tiniest sprig of green, which is dislocatingly positioned at the top of the painting. The effect, then, is at once abstract and real, resulting in a painting that carries the ineffable emotional experience of a flower. Rather than an objectively realized description of the natural world, O'Keeffe's monumentalized, abstract petunias function as a metaphor of sensuous experience, presenting nature as

beautiful and even ravishing. The painting transcends visual imitation, offering instead the register of strong feelings that is the foundation of O'Keeffe's reputation.

As *Petunias* demonstrates, O'Keeffe's paintings suspend viewers between representational and abstract imagery in a manner that reflects her training in the 1910s under Arthur Wesley Dow (1857–1922). Dow, a champion of Asian art, introduced her to an aesthetic that emphasized simplified arrangements and organic forms, principles he found in Chinese and Japanese art that he believed could reinvent and revitalize Western art traditions.[4] He advocated shifting the focus of representation away from an illusionism that sought to imitate the viewer's perceptual experience, the focus of Western art's visual language since the Renaissance, to an apprehension of abstract formal relations.

In 1946, the year of her retrospective at the Museum of Modern Art, New York, the institution's first one-woman show, O'Keeffe (1887–1986) was already guaranteed a place in American art history.[5] With the opening of the Georgia O'Keeffe Museum in Santa Fe in 1997, the artist joined the pantheon of select creative talents whose status has become larger than life. Although it is not surprising that the word *legend* is often associated with O'Keeffe, given her popularity and hold on the American imagination, her artistic importance is easily obscured by such an ahistorical designation. Certainly it contributes to facile understandings that attempt to define her through a single lens as a romantic visionary, a feminist muse, or a heroic iconoclast.

Not only was O'Keeffe a gifted artist, but she and Alfred

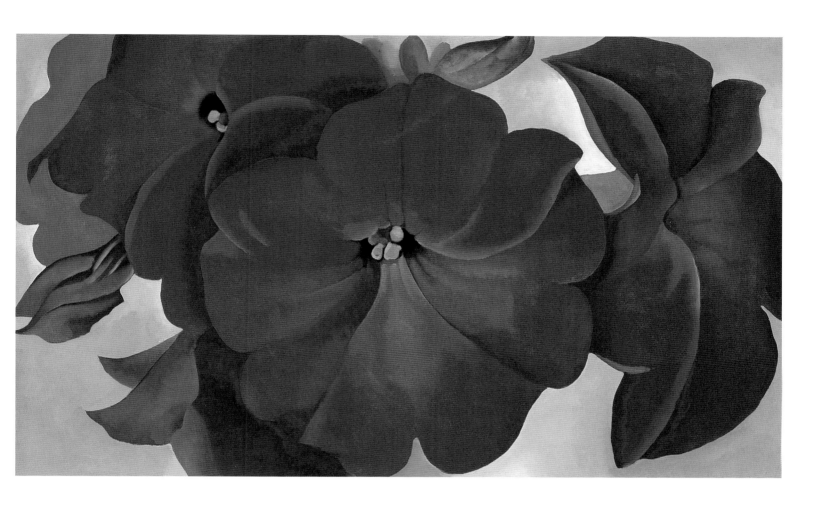

81. Georgia O'Keeffe (1887–1986), *Petunias*, 1925
 Oil on hardboard panel, 18 × 30 in. (45.7 × 76.2 cm)
 Gift of the M. H. de Young Family to the
 Fine Arts Museums of San Francisco, 1990.55

Fig. 81.1. Alfred Stieglitz (1864–1946), *Georgia O'Keeffe*, 1919. Palladium print, 9⅝ × 7⅝ in. (24.5 × 19.4 cm). The Metropolitan Museum of Art. Gift of Georgia O'Keeffe through the generosity of The Georgia O'Keeffe Foundation and Jennifer and Joseph Duke, 1997.61.23

Stieglitz (1864–1946) collaborated in an intense relationship of mutual inspiration and creative production, first as lovers and then as wife and husband, generating a dual celebrity that seemed the epitome of avant-garde art in the United States. The best-known result of this artistic relationship was a series of strikingly modern, nude photographs that rendered O'Keeffe's body in the fragmented, formalist vocabulary of avant-garde abstraction (fig. 81.1). O'Keeffe employed a similar language in her paintings.

A photographer and art impresario, Stieglitz introduced the principles of modern European abstraction to the American public through his journal *Camera Work* (1903–17) and his gallery, called 291 (1905–17), after its address on Fifth Avenue. By the time he opened the Intimate Gallery (1925–29) and An American Place (1929–47), O'Keeffe was working with him as the principal manager and exhibition installer.[6] Although O'Keeffe is inevitably linked to Stieglitz, who first exhibited her work in Gallery 291 in 1916

and subsequently featured it in twenty-nine yearly solo shows until his death in 1946, she was an accomplished artist and teacher before meeting him at the age of twenty-nine.[7] She attended the Art Institute of Chicago from 1905 to 1906; the Art Students League, New York, from 1907 to 1908; the University of Virginia, Charlottesville, in 1912; and Columbia Teachers College, New York, from 1914 to 1915, where she studied with Dow.[8]

In 1915 O'Keeffe began teaching at Columbia College, South Carolina, and in the following year she secured a faculty position at West Texas State Normal College, Canyon, where she taught until 1918.[9] It was during this time that Stieglitz was introduced to her work through her friend from Teachers College, Anita Pollitzer.[10] O'Keeffe's early work from 1915 to 1918 makes it clear that, before coming under Stieglitz's influence, she had already found her own style and vision, combining personal expression and organic abstraction, a rhetoric that strongly appealed to the modern idiom of the circle of artists he was promoting.[11] Moving to New York to live with Stieglitz in 1918, O'Keeffe worked principally there until 1949.[12]

However, in 1929 she also began spending summers in Taos, New Mexico, under the patronage of Mabel Dodge Luhan. In the Southwest O'Keeffe took up an interest in bones, which became a central motif of her painting, along with flowers, trees, architecture, and desert landscape.[13] In spite of a relationship that became strained over the years, largely due to O'Keeffe's need for solitude and the clash of two strong personalities, Stieglitz named her the sole heir and executrix of his will when he died in 1946, a project that she undertook with great care and that required three years to complete.[14] Having settled his estate, in 1949 she moved permanently to the Abiquiu area of New Mexico, where she remained for the rest of her life, painting the desert images that define the second half of her creative life as strongly as the flowers do the first.[15]

As emblems of beauty, domesticity, femininity, and transience, flowers function as tropes that resonate with sexual connotations. Not only are flowers literally the sexual organs of plants, but they are also central objects of the rituals of love and romance. That they are delicate and intimate has served to reinforce as many cultural assumptions about women as it has about flowers. However, O'Keeffe's flowers revolutionized their conventional associations through a vocabulary of modern abstraction, as is evident in *Petunias*.[16] These flowers are not the carefully arranged household objects, set within a domestic frame, that characterize traditional still-life painting. Their setting resists association with the usual indoor space by suggesting the natural world of sky and clouds that is the theater of landscape painting. Unfolding on a monumental scale, the purple petals resemble silken tongues, and the expansive blooms are transformed into a looming presence that recalls a devouring mouth and swallowing throat.

In addition, with their apparent genital reference, such overt figures of erotic sexuality were bound to raise eyebrows, and since the first exhibition of these paintings in 1923 people have speculated about what O'Keeffe's painted flowers reveal about her personal life. Nevertheless, it would be a mistake to limit the interpretation of these petunias to metaphoric symbols of protofeminist sexual ecstasy. From the beginning O'Keeffe resisted any associations based on female identity that made her work a trope for female genitalia, intuition, or instinctual creativity.[17] She particularly welcomed Henry McBride's review of her 1927 exhibition, in which he wrote of her flowers: "To overload them with Freudian implication is not particularly necessary."[18] In a statement published with her 1939 exhibition of oils at An American Place, O'Keeffe wrote to her critics in response to just such Freudian speculations: "I made you take time to look at what I saw and when you took time to really notice my flower you hung all your own associations with flowers on my flower and you write about my flower as if I think and see what you think and see of the flower—and I don't."[19] Stieglitz himself had contributed to the critics' view, which O'Keeffe believed to be reductive, by casting her as the symbolist muse and artistic product of his own creative power.[20] That O'Keeffe found this role increasingly stifling is indicated by her long visits to, and ultimate resettlement in, New Mexico, far from the influences of Stieglitz and his New York circle.

While O'Keeffe's paintings are not merely symbolic icons of female sexuality, they do carry a physical charge that resonates with her own involvement in the social and political changes experienced by women during the 1920s. She participated actively in the National Women's Party, having joined in 1914 during the suffrage campaign,[21] and remained an energetic member of the party throughout her life, lending her efforts for an Equal Rights Amendment.[22] In 1926 she spoke at the party's convention in Washington, D.C., calling on women to cultivate their talents as a way to free themselves from dependency on men.[23]

In 1927, when she served on the jury for the Opportunity Gallery in New York City, which was founded to provide space for emerging artists without a place to exhibit their works, O'Keeffe overwhelmingly selected women to showcase.[24]

This unmistakable support for women to lead lives of independence suggests her commitment to women's experience. However, in place of the feminist political statements often attributed to O'Keeffe's flowers as symbols of emancipated womanhood, their understanding can be amplified by consideration of the larger philosophical concerns of the still life's visual vocabulary that is her chosen sphere of meaning. Through her stylization, O'Keeffe separates the blooms in *Petunias* from their natural environment, yet resists domesticating them in a vase. She enlarges them, emphasizing their smooth, sculptural forms and bold, solid colors, distilling them into an abstract pattern of swelling shapes that burst open with obvious energy. They signify nature as a force rather than as a passive backdrop to human culture or a decorative flourish.

In the traditional language of gendered representations, women are identified with nature and men with culture, but O'Keeffe's monumental flowers challenge any such easy division of the world. Conflating still life and landscape through the magnification of blooming flowers, she presents both genres as meditations on abstract space. O'Keeffe's simple transformation suggests a reversal of nature and culture that collapses their customary opposition and opens both realms to women and men equally. Rather than being reduced to direct analogues for feminine genitalia and sexuality, the bodily references in *Petunias* offer signs of ineffable sensations that belong to both women and men.[25] They are multivalent images of the emotional power available to both sexes when we allow the world to become "big enough." [DC]

SPIRIT OF THE SEA

When Arthur Dove arrived at the doorstep of Alfred Stieglitz's gallery in 1910 with examples of his recent work in hand, he was an artistic unknown. The thirty-year-old Dove (1880–1946) had been born and raised in an unremarkable middle-class family in western New York State.[1] While at Cornell University, he studied to be a lawyer, following his father's wishes, but he much preferred his art classes. As a form of compromise between the financial security of law and his passion for art, Dove settled on a career as an illustrator and after graduation moved to New York City, an important publishing center. He soon became disillusioned with the commercial nature of illustration work, however, and began to study painting in earnest. In 1908 he embarked on a yearlong trip to Europe, where he was exposed to recent trends in avant-garde painting, and it was on his return that he brought his work to Stieglitz, the well-known photographer, art dealer, and champion of American modernism. Stieglitz immediately recognized Dove's potential. He encouraged Dove to paint in a modernist style and included him in the elite group of painters he represented, eventually putting Dove in the company of such American artists as John Marin (1870–1953), Charles Demuth (1883–1935), Marsden Hartley (1877–1943), and Georgia O'Keeffe (1887–1986).

Stieglitz's importance for Dove cannot be overestimated. He was the artist's promoter, friend, and, after Dove's own father rejected him because of his choice of career, surrogate father. Stieglitz was especially important to Dove because he maintained his faith in the artist even though Dove's paintings were not strong sellers and were unpopular with most critics. As the artist once reflected: "I do not think I could have existed as a painter without that super-encouragement and the battle he has fought day by day for twenty-five years. He is without a doubt the one who has done the most for art in America."[2] Still, it was clearly the originality and force of Dove's paintings that Stieglitz recognized, including *Sea Gull Motive* (1928), which Stieglitz acquired for his private art collection.

Sea Gull Motive was first shown publicly in New York in April 1929 at Stieglitz's the Intimate Gallery, in a one-man exhibition of Dove's recent work. On that occasion, Stieglitz produced a pamphlet listing the paintings on view and a short text, "Notes by Arthur G. Dove." As the title suggests, the text was a selection of informal notes written by the artist, their diaristic nature emphasized by the fact that month and day designations precede each entry. Throughout his life, Dove was reluctant to explain his works, but these "notes" can help us elucidate his artistic intentions.[3] Reading the pamphlet, we learn that "Anybody should be able to feel a certain state and express it in terms of paint or music. . . . [F]or instance, to feel the power of the ground or sea, and to play or paint it with that in mind, letting spirit hold what you do together rather than continuous objective form."[4] In this passage, Dove asserts that an artist should learn to represent the emotional experience of nature—he uses the word "power" — in such a way that the "spirit" of the experience structures the representation. In other words, the artist should render the raw emotional experience of nature as he actually felt it, using a personal—not academic—set of artistic conventions. Yet Dove was uninterested in pure abstraction, unlike so many early-twentieth-century artists who believed arrangements of color and line constituted a universal language. In the same "Notes" we find Dove boldly proclaiming: "THERE IS NO

82. Arthur G. Dove (1880–1946), *Sea Gull Motive* (*Sea Thunder* or
The Wave), 1928. Oil on wood panel, 26 × 20 in. (66 × 50.8 cm)
Museum purchase, Richard B. Gump Trust Fund, the Museum
Society Auxiliary, Museum Acquisition Fund, Peter and
Kirsten Bedford, Mrs. George Hopper Fitch, Art Trust
Fund, and by exchange of Foundation objects, 1990.19

SUCH THING AS ABSTRACTION."[5] Thus, the artist sought to steer a middle course between academic illusionism and modernist abstraction, and instead render an emotional experience of place in an altogether new, but recognizable, formal language.

The title of this painting, *Sea Gull Motive*, is an important clue to understanding Dove's working method and his intentions. The artist inscribed the title on the back of the painting, but when Stieglitz exhibited it, he called it *Seagull Motif*.[6] *Webster's Dictionary* defines "motive" as "in art, literature, and music, a motif," and it defines "motif" as "a main theme or subject to be elaborated on or developed" or "a repeated figure in a design."[7] For Dove, motive or motif meant all of this and more. At a time when European and American modernist painters took their design vocabulary from industrial forms, Dove did the opposite and turned to nature, in part because he disliked mechanized society but also because he saw a correlation between art and nature.[8] In a 1913 letter he explained: "One of the principles which seemed most evident [in art] was the choice of the simple motif. This same law held in nature, a few forms and a few colors sufficed for the creation of an object."[9]

For Dove, nature could be reduced to a vocabulary of simple forms and a handful of colors. Throughout his life he searched out these laws of nature and used them as the principles, which he also called "motives" or "motifs," to compose his paintings.[10] That he should use the same word for the forms and colors in nature and those in his paintings can be explained through his equation of the latter with the former.[11] In "Notes by Arthur G. Dove," the artist provided a more concrete example of the relationship between artistic motifs and the subject matter of his paintings when he wrote that "two or three motifs," each consisting of specific colors and types of lines, could render the theme of "ruggedness."[12] He did not elaborate what a painting whose subject was "ruggedness" would actually look like, but his comment underscores that his paintings represent an emotion, not an illusionistic rendition of the visible world.

Arthur Dove's *Sea Gull Motive* is thus an economical representation of the artist's nature-induced emotions distilled into a few colors—plum, white, blue, and black—and two simple forms—rounded masses and arcing lines. Dark mounds emerge from the lower right corner of the composition and spread across the panel. Deep plum in color, their contours are illuminated so that they look like a bubbling or roiling mass. In the upper left-hand corner, alternating arcing bands of pastel blue and white flow toward the plum-colored mounds. As the light-colored bands descend toward the dark mass, they edge nearer to one another, suggesting a deep spatial recession, like that of a distant horizon. Finally, from near the lower left corner, a black, double-arced form stretches diagonally across this cloud-streaked "sky," silhouetted against its wispy bands of white. Seen this way, Dove's painting calls to mind a seagull wheeling toward the earth's horizon. Alternatively, we could read the painting as projecting into a downward, rather than outward, space, if we see the dark mass as pushing against the white bands, which respond by spreading out like ripples on a pond. In this orientation, we are looking down on a gull as it swoops over waves that wash against a rocky shore, its "wings" echoing the shape of the waves as well as a similar double curvature of the rocks. In making a painting that can be read simultaneously in two different ways, Dove was able to move beyond rendering solid forms and instead convey the sensation of their movement. By creating a visually dynamic composition from basic forms and a limited palette, the artist depicted the profound power of nature at the ocean's edge, where wind and water and flight come together. [KM]

83. DIEGO RIVERA, *Two Women and a Child*

A MURAL IN MINIATURE

Diego Rivera is the best known of the Mexican muralists who rose to international prominence in the 1920s and 1930s. Working in the medium of fresco, a wall and ceiling painting technique with roots in both ancient Europe and ancient Central America, Rivera formulated a unique style of modernist painting that fused historic and avant-garde idioms. A tireless worker—his entire oeuvre covers an astonishing 7,200 square yards—Rivera was also a champion of the working class.[1] He celebrated the fortitude, power, and historical significance of the laboring classes by making them the primary subject of his paintings, a move he understood to be revolutionary. As he explained it, "Mexican muralism—for the first time in the history of monumental painting—ceased to use gods, kings, chiefs of state, heroic generals, etc., as central heroes.... Mexican mural painting made the masses the hero of monumental art."[2] Rivera's Marxist politics also engendered controversy, most famously in the case of his Rockefeller Center mural, *Man at the Crossroads* (1932–33), which Nelson Rockefeller ordered destroyed when the artist refused to paint over a portrait of Vladimir Ilyich Lenin.[3] In most cases, however, even the most contentious debates about the content of the artist's murals eventually subsided, leaving to posterity his eloquent and powerful testimonials to the power of the people.

José Diego María Rivera (1886–1957) was a precocious child who learned to draw at the age of three. He spent the first decades of his life experimenting with a myriad of artistic styles, first as a student at the San Carlos Academy of Fine Arts in Mexico City and later in Spain and Paris, where he studied the works of the old masters as well as Europe's most avant-garde modernists.[4] While in Paris,

Rivera was contacted by a member of Mexico's new post-revolutionary government interested in reviving the indigenous tradition of wall painting in Mexico.[5] Rivera was advised to travel to Italy to study early Renaissance frescoes, and he subsequently made some three hundred sketches of frescoes by Italian masters, including Giotto.[6] Rivera was deeply inspired by these colorful wall paintings, but he did not have a true artistic epiphany until he returned to Mexico in 1921. According to the artist, "My homecoming produced an aesthetic exhilaration which is impossible to describe.... From then on, I worked confidently and contentedly. Gone was the doubt and inner conflict which had tormented me in Europe. I painted as naturally as I breathed, spoke, or perspired. My style was born as children are born, in a moment, except the birth had come after a torturous pregnancy of thirty-five years."[7] Buoyed by his newfound artistic confidence and enthusiasm for his native country, Rivera painted bold and dramatic murals, which secured his reputation in Mexico and north of the Rio Grande and earned him many prestigious commissions.

While completing his mural commissions in Mexico, Rivera also painted a number of easel paintings, including *Two Women and a Child* (1926), which was acquired by the San Francisco businessman and art patron Albert M. Bender the year it was painted.[8] Bender's interest in Rivera may have been inspired by two contemporary San Francisco artists, the sculptor Ralph Stackpole and the painter Ray Boynton, who had traveled to Mexico to see Rivera's recent work and returned with such vivid descriptions that they sparked the interest of local art patrons.[9] Unfortunately, because Rivera's murals adorned walls of buildings in Mexico, few of his paintings were to be seen in San Francisco. Thus

83. Diego Rivera (1886–1957), *Two Women and
a Child*, 1926. Oil on canvas, 29¼ × 31½ in.
(74.3 × 80 cm). Gift of Albert M. Bender, 1926.122

Fig. 83.1 [top]. Giotto di Bondone (ca. 1267–1337), *The Lamentation*, 1305–6. Fresco. Arena Chapel, Padua, Italy

Fig. 83.2 [bottom]. *Kneeling Female*, Jalisco, Mexico, 200 B.C.–A.D. 300. Ceramic (Amica Grey), 15½ × 9¼ × 8¼ in. (39.4 × 23.5 × 21 cm). Fine Arts Museums of San Francisco, L1994.3.14. Lent by the Land Collection

in 1926 Bender purchased a number of easel paintings from the artist, including *Two Women and a Child*.[10] Bender's acquisition of this painting fit his program of cultivating a regional art scene in San Francisco since, although Rivera was a Mexican artist, California has always had strong historical, cultural, and artistic ties with Mexico. Bender's purchases also enabled him to see examples of Rivera's mural style without actually traveling to Mexico.[11]

The subject of *Two Women and a Child* corresponds to Rivera's declared interest in representing the working-class people of Mexico. Two women, one cradling an infant, sit across from each other in a moment of subdued conversation. The woman to the left, dressed in a pale purple dress, sits crosslegged and turns her back to the viewer. This posture focuses our attention on the two braids of thick black hair that cascade down her back and on the tiny hand of the child she cradles on her lap. The woman opposite her, wearing a pale blue skirt and blouse, sits facing the viewer with her legs tucked beneath her and her hands clasped in her lap. She looks intently and attentively in the direction of the other woman. The sparse setting consists of a mat, an ambigious blue and white background, and an unadorned ceramic bowl in which the artist signed his name and dated the painting.[12] The women's warm brown skin, jet black hair, broad faces, peasant-style clothing, and the spartan setting are all intended to invoke a scene of rural Mexico.

This painting lacks the spatial depth and detail of academic easel paintings and instead looks like an early Italian Renaissance fresco. Rivera painted his murals in a technique known as *buon fresco*, which he learned from his study of Italian Renaissance precedents.[13] This technique, also known as "true fresco," involves painting water-based pigments on a damp plaster surface. The drying plaster adheres the pigment to the wall permanently through a chemical process. Because the fresco artist must cover a large area before the plaster dries, there is no time to render the figure or setting in great detail. Therefore, the artist's drafting skills are at a premium if he or she is to create direct and bold compositions that will grab and hold the viewer's attention. Also, because the water-based pigments are quickly absorbed by the porous plaster surface, they cannot be blended as can oil paints, and therefore the artist is unable to render subtle textures and reflections. Thus, fresco painting requires the artist to model figures and objects with broad strokes of paint, which often impart a greater solidity to the subject than is possible with oil paint.

If we compare Rivera's *Two Women and a Child* to

Giotto's famous *The Lamentation* (1305–6) from the Arena Chapel (fig. 83.1), we can see just how much Rivera mirrored the attributes of fresco painting even while painting in oils. Both artists created compositions in which figures dominate and the setting has been reduced to a minimum. Like Giotto before him, Rivera also modeled light falling on drapery using broad, smooth brushstrokes that define the mass and volume of bodies underneath rather than the superficial texture of the cloth. In addition, the woman to the left seems to be a direct quotation of the seated figure turning her back to us in the foreground of Giotto's *Lamentation*.[14] At the same time, the figure on the right with her legs tucked beneath her also calls to mind pre-Columbian seated ceramic figures from western Mexico (fig. 83.2).[15] By invoking both fourteenth-century fresco paintings and this indigenous Mexican art form, Rivera linked these women, assumed to be contemporary, with a premodern past.

More important, by painting *Two Women and a Child* to look like a fresco, Rivera gave these women a historical weight that corresponded with his vision of the significance of the laboring peasantry in world history. Unlike Giotto's fresco, Rivera's painting lacks a narrative, and therefore the theme of his painting is largely symbolic. To this end, the women appear as generic types, lacking individualized physiognomies or clothes. They also are larger than life.

They occupy nearly the entire compositional space and, because no other objects or scale referents are visible (other than the small, unadorned bowl in the right foreground), they dominate the canvas in truly monumental fashion. By forcing us to focus on these figures, Rivera makes us aware of the pyramidal massing of their seated bodies, which, when combined with Rivera's technique of modeling the figures with broad strokes, imparts a solidity that anchors each of them to the earth. As a result, these women appear as iconic Earth Mother types who possess within them the natural processes of creation and nourishment, a theme underscored by the infant in the woman's lap and the empty bowl in the foreground.

Although *Two Woman and a Child* is an oil painting, it nevertheless provided Bender with an approximation of Rivera's mural style. Curiously, Bender gave the work to the Legion of Honor the same year he acquired it, 1926. It was not that he disliked the painting. Indeed, with the advantage of hindsight, we know now that by giving Rivera's painting to the museum, Bender helped cultivate a public taste for the work of Diego Rivera, who eventually came to San Francisco to paint the much-loved murals at the Pacific Stock Exchange, the California School of the Fine Arts (now the San Francisco Art Institute), and Treasure Island (now relocated to City College of San Francisco).[16] [KM]

84. REGINALD MARSH, *The Limited*

ON THE WRONG SIDE OF THE TRACKS

Reginald Marsh was among the American Scene artists who gained prominence between the two world wars for their depictions of contemporary American life. Marsh spent most of his career in New York, "the greatest and most magnificent of all cities," and his works capture New York's kinetic compression and expansion of architectural, technological, and human energy.[1] Although he celebrated the city's built environment, Marsh's true protagonists were the city's inhabitants, who brought the urban stage to life and provided an unending source of drama. An extraordinary visual diarist, Marsh mastered the depiction of human physiognomy, physiology, and character in order to explore the urban human condition, capturing the realities of life in depression-era New York.[2]

Reginald Marsh (1898–1954) was born in Paris, France, to a painter of New York City, Fred Dana Marsh, and a miniaturist, Alice Randall. The family returned to America in 1900 and lived first in Nutley, New Jersey, and later in the New York City suburb of New Rochelle. Marsh's brief introduction to studio art while attending Yale University (1916–20) was followed by sporadic studies at the Art Students League in New York (1920–24, 1927–28) with the Ashcan School artists John Sloan and George Luks, as well as with George Bridgman and his lifelong mentor, Kenneth Hayes Miller. Like his Ashcan School teachers, Marsh honed his reportorial drawing style as a newspaper illustrator, covering vaudeville revues, nightclubs, and court trials as a staff artist for the *New York Daily News* (1922–25).[3] Subsequently, his newspaper and magazine illustrations revealed a strong social conscience, most memorably in a political cartoon from 1934 of a little girl being lifted above a crowd for a better view by her parents, who explain to a bystander, "This is her first lynching."[4]

Returning to Europe as an adult in 1925–26, Marsh described his visit to the Musée du Louvre in Paris as "so awe-inspiring that I thought I must throw the greatest energy into the study of art."[5] He later claimed to have made "some kind of copy in pen and ink of almost every great picture in the European cities I began visiting in 1926."[6] Upon his return, Marsh drew inspiration from the figurative works of old masters such as Michelangelo and Peter Paul Rubens, endowing his New Yorkers with a muscular monumentality and baroque exuberance that captured the dynamism of modern urban life.

Marsh's *The Limited* depicts one the most famous trains of the era, either the 20th Century Limited operated by the New York Central Lines or its archrival, the Pennsylvania Railroad's Broadway Limited, running at full steam on the New York–Chicago route.[7] These luxurious railroad company flagships were powered by enormous engines and comprised a baggage car, a lounge-buffet-smoker car, Pullman sleepers, a dining car, and an observation lounge car. Although the Limited trains often lost money, they generated publicity and clients for the company's more lucrative freight business. Viewed as a uniquely American symbol, the 20th Century Limited was promoted as "An expression of American life today, of its virility, of its force, of its unending demand for speed, precision, comfort."[8]

Marsh evokes the defining characteristic of *The Limited* —speed—through his use of "freight train perspective" to render the rapidly receding utility poles. Aboard the 20th Century Limited in 1930, Marsh's wife, Betty Burroughs, described how the train altered her perceptions of space and time, writing, "Here is a real sensation of speed. We race with the sun. Flat—flat—just whizzed by a great number of steam engines parked in a formidable train. . . .

84. Reginald Marsh (1898–1954), *The Limited*, 1931
 Egg tempera on canvas mounted on hardboard
 panel, 24 × 48 in. (61 × 121.9 cm)
 Bequest of Felicia Meyer Marsh, 1980.84

Fig. 84.1 [top]. John Sloan (1871–1951), *Sixth Avenue Elevated at Third Street*, 1928. Oil on canvas, 30 × 40 in. (76.2 × 101.6 cm). Whitney Museum of American Art, New York. Purchase, 36.154

Fig. 84.2 [bottom]. Charles Sheeler (1883–1965), *Rolling Power*, 1939. Oil on canvas, 15 × 30 in. (38.1 × 76.2 cm). Smith College Museum of Art, Northampton, Massachusetts. Purchased with the Drayton Hillyer Fund, 1940.18

What impresses me is the movie-like, or ant-like nature of man. . . . We've just gone through South Bend [Indiana]. Thee'd adore it—assorted chimneys—black factories—black watertowers. It's more thy meat than I can say. And it will be more fun for thee to see for thyself than to hear about."9

Historically, the train has been one of the most culturally resonant American symbols.10 In works by Marsh's Ashcan School teachers, such as John Sloan's *Sixth Avenue Elevated at Third Street* of 1928 (fig. 84.1), the train typically epitomizes the dynamism and democratization of urban life and is an integral part of the urban landscape, inseparable from the inhabitants who bring it to life. Precisionist artists such as Charles Sheeler viewed the train as an ideal symbol of modernity, characterized by speed, new technology, and a design in which form follows function. Sheeler's *Rolling Power* of 1939 (fig. 84.2), which focuses exclusively on the wheels and pistons of a 20th Century Limited locomotive, depicts the train in complete isolation from less perfect humans, celebrating the beauty of technology and its power as ends in themselves.

The critic Jo Ranson perceptively linked Marsh's train paintings to their era, writing, "His pictures convey the meaning of this age—the age of machines, engines, and the turmoil of the present day. . . . Trains, some artists may argue, are not pretty things, and therefore should not be placed upon canvas. But there are others who see in trains and railroad yards the spirit of this age, and Reginald Marsh is one of these."11

However, Marsh's own lifelong admiration for trains was often mitigated in practice by his empathy for their human counterparts. One of Marsh's friends recalled that the artist's fascination with the hoboes who rode the rails dated to his childhood in New Jersey, where he "would look out from his windows at these tramps, wondering what sort of men they were and what lives they led. I think he went on wondering all his life."12 His drawing *Death Ave.* (1927), published in *The New Yorker*, contrasts the inexorable strength and power of the passing locomotive with the physically and psychically exhausted men on the adjacent New York street corner.13 Four years later in *The Limited*, Marsh juxtaposed one of America's greatest technological marvels with three anonymous hoboes to reveal the deep divisions that characterized depression-era America. Hoboes had been riding the rails since the post–Civil War era, but their numbers swelled to an estimated two million during the 1930s.14 While some hoboes were motivated by wanderlust, most were unemployed laborers in search of temporary work, prompting the famous quip, "The hobo works and wanders, the tramp drinks and wanders, and the bum just drinks."

Because of their unconventional lifestyle, hoboes often were perceived as a threat to mainstream American ideals and values. They were not only socially ostracized but also physically marginalized in the most undesirable city neighborhoods or in hobo camps, called "jungles," on the outskirts of urban centers.15 Thousands perished in train accidents or were beaten and robbed by railroad company detectives, or "bulls"—guards hired to keep hoboes off the trains.16 Jimmie Rodgers, a former hobo who became famous as the Singing Brakeman, captured the sorrow of the hobo life in the song "Waiting for a Train" (1928): "Nobody seems to want me / Nor to lend me a helping hand / I'm on my way from Frisco / Going back to Dixieland / My pocketbook is empty / My heart is full of pain / I'm a thousand miles away from home / Just waiting for a train."

Marsh's unemployed hoboes, waiting to catch a slow-moving freight train, watch passively as the Limited rockets by, symbolically cutting them off from the distant grain mill, a poignant symbol of potential employment and abundance. The alienation of such men draws attention to one of the paradoxes of modern travel technology, which ostensibly draws people together but often accentuates the distance between the haves and the have-nots. Marsh's disenfranchised hoboes bear silent witness to the failures of capitalism and, given their lack of options, might also be described as "the limited."17 Conversely, the limited few who can afford to ride America's premier train are insulated from the realities of the depression, including the hoboes, who will recede from the passengers' view as quickly as the telephone poles. Adopting a reportorial perspective that is neither that of a privileged passenger nor of a hapless hobo, Marsh nonetheless offers a pointed editorial on behalf of those who have been left behind by America's economic engine. [TAB]

85. JOHN MARIN, *Study, New York*

BRIDGING THE PAST,
PRESENT, AND FUTURE

John Marin's prints, watercolors, and paintings of New York City, the mountains of the Northeast, the deserts of the Southwest, and the coast of Maine earned him a critical reputation as the most important American artist of his generation.[1] Through his close association with his influential art dealer and critic Alfred Stieglitz, Marin played a key role in introducing the theories and techniques of European modernism to American art. Employing a visual vocabulary of personal signs, symbols, and metaphors, Marin's cityscapes, landscapes, and seascapes oscillated between naturalism and abstraction, but they consistently resonated with a strong sense of animism and spirituality.

John Currey Marin (1870–1953) was born in Rutherford, New Jersey, and studied mechanical engineering at the Stevens Institute of Technology in Hoboken before pursuing a career as a draftsman and architect. Marin commenced his art studies at Philadelphia's Pennsylvania Academy of the Fine Arts, where he studied from 1899 to 1901 with Thomas Anshutz (1851–1912) and Hugh Breckenridge. In 1902 he enrolled in New York's Art Students League, where he studied for a year with Frank Vincent Dumond. However, Marin's extensive travels through the art capitals and museums of France, Germany, Italy, and Holland from 1905 to 1910 played a greater role in shaping his artistic evolution.

Marin's extended stay in Paris coincided with a renewed interest among artists in the work of Paul Cézanne, and with the rise of the avant-garde art movements of Fauvism, Cubism, and Orphism. These three movements greatly impacted his subsequent evolution as an artist. In Paris, Marin studied briefly at the Decluse Academy and the Académie Julian, and joined with Edward Steichen, Alfred Maurer, and Max Weber in the secessionist group the New Society of American Artists in Paris.[2] Steichen arranged for a 1909 exhibition of Marin's watercolors at 291—Stieglitz's New York gallery—and Marin subsequently became a prominent figure in the Stieglitz circle.

In 1910 Marin returned to New York City, which had been transformed during his absence into a dynamic, modern metropolis dominated by soaring steel-frame skyscrapers, the world's tallest buildings. Among these, completed or under construction, were the Singer Building (1908), the Metropolitan Life Insurance Company Tower (1909), and the Woolworth Building (1913). For Marin, New York's geometric architecture and kinetic street life epitomized the abstract principles of the European avant-garde art movements and the transformative power of modernism.

Marin's vantage point in *Study, New York* (1934), looking from Brooklyn across the East River toward lower Manhattan, was popular with artists who could thus juxtapose the nineteenth-century Brooklyn Bridge with New York's twentieth-century skyscrapers.[3] Although the earlier Ashcan School artists had embraced modern New York City subjects, their works focused on the social interactions of the city's inhabitants. In contrast, Marin's New York works boldly declared that every element of the urban landscape is spiritually animated—even sentient:

> Thus the whole city is alive—buildings, people, all are
> alive—and the more they move me the more I feel them

85. John Marin (1870–1953), *Study, New York*, 1934
Oil on canvas, 22 × 28 in. (55.9 × 71.1 cm)
Museum purchase, Roscoe and Margaret Oakes
Income Fund, American Art Trust Fund, 2002.139

Fig. 85.1. John Marin (1870–1953), Panel from *Four Studies: New York City Abstraction with Figures*. Oil on hardboard panel, 10 × 12 in. (25.4 × 30.5 cm). Private collection, courtesy of Owings-Dewey Fine Art, Santa Fe, New Mexico

to be alive. . . . I see great forces at work; great movements; the large buildings and the small buildings; the warring of the great and the small; influences of one mass on another greater or smaller mass. Feelings are aroused which give me the desire to express the reaction of these pull forces, those influences which play with one another; great masses pulling smaller masses, each subject in some degree to the other's power. In life all things come under the magnetic influence of other things; the bigger assert themselves strongly, the smaller not so much, but still assert themselves, and though hidden they strive to be seen and in so doing change their bent and direction. While these powers are at work pushing, pulling, sideways, downwards, upwards, I can hear the sound of their strife and there is great music being played. And so I try to express graphically what a great city is doing.[4]

Characteristically, both Marin's title—*Study, New York*—and his watercolor-inflected technique suggest that this work is a mutable impression, rather than a definitive statement. This aesthetic approach is also evident in a small oil study for this painting (fig. 85.1), which Marin framed with three other New York subjects.[5] He entitled the group *Four Studies: New York City Abstraction with Figures*, thus suggesting that each painting is only one "study" in a constantly evolving portrait of New York.[6]

Marin's intuitive understanding of architectural form is apparent in *Study, New York*, which is constructed with geometric building blocks and planes that resemble interlocking puzzle pieces. Throughout the composition, physical forms are deconstructed or even dematerialized, while line, color, and scale are liberated from naturalistic representation. Each pictorial element jostles its neighbors with a force field of energy that implicitly extends beyond its

physical form onto Marin's faux-painted frame, or even beyond the painting's actual frame.[7] Yet the whirlpool form at the lower center of the painting, which resembles the yin/yang symbol, suggests that these powerful forces are held in a dynamic balance.[8] As Marin observed, "I can have things that clash. I can have a jolly good fight going on. There is always a fight going on where there are living things. But I must be able to control this fight at will with a Blessed Equilibrium."[9]

The left side of *Study, New York* is dominated by the portal-like tower of the Brooklyn Bridge (1883), one of New York's most famous architectural icons and a personal landmark in Marin's early work.[10] Immediately to the right is a smaller sail-like suspension bridge—perhaps the Williamsburg (1903) or Manhattan (1909)—as well as warehouses and piers lining the banks of the East River. Marin's ongoing artistic exploration of the Brooklyn Bridge was inspired in part by the French artist Robert Delaunay's orphist images of the Eiffel Tower. Both men depicted their urban landmarks as receivers and transmitters of energy that transformed the viewer's experience of the surrounding cityscape.[11] The Brooklyn Bridge's striking marriage of neo-Gothic masonry architecture and modern steel technology also inspired spiritual associations among modernist artists and writers, most famously Hart Crane in his poem "To Brooklyn Bridge" (1930):

> O Sleepless as the river under thee,
> Vaulting the sea, the prairies' dreaming sod,
> Unto us lowliest sometime sweep, descend
> And of the curveship lend a myth to God.[12]

Marin's use of a prominent five-pointed star in *Study, New York* recalls a similar motif on the church steeple in his painting *Related to St. Paul's, New York* (1928). Yet such traditional religious associations were being transformed in New York, where neo-Gothic skyscrapers such as the Woolworth Building were being described as modern "cathedrals of commerce" in which capitalism transcended spirituality.[13] Painted at the height of the Great Depression, Marin's vibrant red star also evokes associations with utopian socialism, not unlike Lyonel Feininger's use of the star in *The Cathedral of Socialism* (1919), created for the German Bauhaus manifesto.[14] However, rather than promoting a particular religious or political view, Marin's harbinger star marks the modern American city as the locus for a new spiritual order of the future.[15]

Marin's *Study, New York* also has foundations in America's past. The Native American step motif and muted desert colors of Marin's faux-frame border derive from his travels to Taos, New Mexico, in 1929 and 1930.[16] The origins of the step motif in the geometric patterns of Navajo blankets and in the profiles of pueblo adobe architecture are made explicit in Marin's watercolor *Taos Indian Rabbit Hunt* of 1929 (University of Maine at Machias Art Galleries).[17] The step motif also had a modern incarnation in New York City, where a setback zoning ordinance required high-rise buildings to step or taper progressively inward.[18] Marin's *Study, New York*, like George Bellows's famous painting *Cliff Dwellers* of 1913 (Los Angeles County Museum of Art), suggested that New Yorkers were the contemporary counterparts of ancient American cliff dwellers. This cross-cultural analogy also shaped Marin's depiction of the New York skyline, in which individual skyscrapers and buildings have been subsumed within a monolithic, pueblo-like structure with a single door. Immediately to the left, two parallel diagonal lines evoke not only a modern skyscraper airshaft with windows but also a traditional pueblo ladder.

Like his fellow Stieglitz circle artists Marsden Hartley (1877–1943) and Georgia O'Keeffe (1887–1986), Marin perceived Native American art as validating modernism's experimentation with abstract forms. Dismissing the lessons of the old masters, he wrote: "I would rather base [my work] —on those archaic peoples and our own American Indians in their concept of what an art work must possess which is mostly an imprinting of their concepts on flat surfaces."[19] However, Marin also described a Native American dance that he attended as "my greatest human Experience," and he perceived these cultural traditions as providing indigenous, communal, and spiritual continuity in an increasingly technological age.[20] Through his dynamic triangulation of the pueblo, the Brooklyn Bridge, and the star in *Study, New York*, Marin bridged America's past, present, and future to suggest the continuity of its culture. [TAB]

86. GRANT WOOD, *Dinner for Threshers*

THE REGIONALIST RENAISSANCE

Grant Wood of Iowa, like his colleagues John Steuart Curry (1897–1946) of Kansas and Thomas Hart Benton (1889–1975) of Missouri, was among the American regionalists who gained prominence in the 1930s. Although famous works such as *American Gothic* (1930) and *Daughters of Revolution* (1932) adopted a satirical stance similar to that in the writings of H. L. Mencken and Sinclair Lewis, Wood was widely perceived as an artistic "flag-waver" for the landscape, inhabitants, and lifestyles of America's midwestern Grain Belt.[1] In his regionalist manifesto, "Revolt against the City" (1935), Wood rejected European-derived modernism and argued instead for the creation of regional schools of American art that embraced realism, indigenous subjects, and a populist sensibility.[2] Recalling his own artistic transformation, Wood observed, "I lived in Paris a couple of years myself and grew a very spectacular beard that didn't match my face or my hair, and read Mencken and was convinced that the Middle West was inhibited and barren. But I came back because I learned that French painting is very fine for French people and not necessarily for us, and because I started to analyze what it was I really knew. I found out. It's Iowa."[3]

Grant DeVolson Wood (1891–1942) grew up on a farm near Anamosa, Iowa, before the death of his father in 1901 compelled his family to move to Cedar Rapids. He studied art at the Minneapolis School of Design and Handicraft and Normal Art (1910–11), the University of Iowa (1911–12), and the Art Institute of Chicago (1913–16) and taught art (1919–25) in the Cedar Rapids public school system. Wood made four influential trips (1920, 1923–24, 1926, 1928) to Europe and studied briefly at the Académie Julian in Paris. His

revelatory discovery of Flemish and German Renaissance artists such as Hans Memling, Albrecht Dürer, and Hans Holbein in Munich's Alte Pinakothek in 1928 inspired him to paint indigenous Iowa subjects in a neo-Flemish style.[4] Wood pursued his populist approach to art as director of the Stone City Colony and Art School (1932–33) in Stone City, Iowa, as state director (1934) of the Iowa Federal Public Works Project, and as a professor of art (1934–42) at the University of Iowa in Iowa City.

Dinner for Threshers was inspired by Wood's 1933 visit to the "Johnson Farm" outside Cedar Rapids during the annual threshing ritual, one of the most important economic and social events for farming families.[5] In late July or early August, neighboring farmers joined in a communal "threshing ring" to harvest the winter oat or wheat crop. Harvester machines cut and bound the crop, which was then fed into a threshing machine to separate the grain kernels from the straw stalks and chaff.[6] While men and boys worked in the fields, women and girls worked in the kitchen, preparing dinner for the threshing crew. Taking this dinner as his primary subject, Wood created at least three meticulous studies (figs. 86.1, 86.2, and 86.3) for the final tripartite composition.[7]

However, internal evidence reveals that *Dinner for Threshers* is set in the past, not in the 1930s. Few depression-era farms still relied exclusively on windmills, horses, kerosene lamps, hand pumps, and wood-burning stoves. In 1934 women would have worn their dresses, not floor-length, but between the ankle and the knee. We also have Wood's own declarative statement that "'Dinner for Threshers' is from my own life. It includes my family and

86. Grant Wood (1891–1942), *Dinner for Threshers*, 1934
 Oil on hardboard panel, 20 × 80 in. (50.8 × 203.2 cm)
 Gift of Mr. and Mrs. John D. Rockefeller 3rd, 1979.7.105

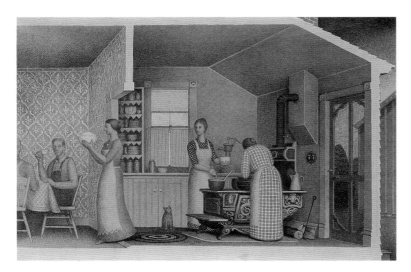

Fig. 86.1 [top]. Grant Wood (1891–1942), Study for *Dinner for Threshers* (left section), 1933. Graphite and gouache on paper, 17¾ × 26¾ in. (45.1 × 67.9 cm). Whitney Museum of American Art, New York. Purchase, 33.79

Fig. 86.2 [bottom]. Grant Wood (1891–1942), Study for *Dinner for Threshers* (right section), 1933. Graphite and gouache on paper, 17¾ × 26¾ in. (45.1 × 67.9 cm). Whitney Museum of American Art, New York. Purchase, 33.80

Fig. 86.3 [facing]. Grant Wood (1891–1942), Study for *Dinner for Threshers*, 1934. Graphite on paper, 18 × 72 in. (45.7 × 182.9 cm). Private collection

our neighbors, our tablecloths, our chairs and our hens."[8] Wood dated the scene to 1900, which suggests that this threshing dinner evokes the last one on the family farm, before his father's death in March 1901.[9]

The left third of *Dinner for Threshers* depicts a farmyard with a classic red barn, its hayloft door inscribed "1892," the year that Wood mistakenly thought to be his birth year.[10] Peeking like a rising sun from behind the barn is a windmill, which pumped water on farms that lacked electricity.[11] Similarly, the two horses tethered to the empty hay wagon recall the era when horsepower was real, rather than the measure of a machine.[12] Four white chickens look in the same direction, like folk-art weathervanes facing into the wind.[13] Three men—one carrying a bucket of water, one washing his face in a basin, and one combing his wet hair—represent the three stages of the washing-up process. As sons or hired hands, they will have to wait for a second sitting at the long dinner table.

Wood's centerpiece is composed of fourteen threshers enjoying their hard-earned noon meal. The threshers' nearly identical denim overalls, sunburned necks, and pale foreheads (protected from the sun by hats when outdoors) attest to their solidarity as a working team in the fields.[14] Wood accentuated the scene's authenticity by including details such as the ornamental stopper in the stovepipe hole (stoves often were removed from living areas during the summer months) and a Windsor chair and a piano stool brought in from another room. Wood identified the twelve matching chairs and red-checked tablecloth as a nostalgic reminiscence of his childhood home and described the barely visible china as his mother's "Haviland china with a moss rose pattern."[15]

Conversely, Wood exaggerated formal compositional elements, such as the X diagonals of the farmers' overall straps (which echo the diagonal pattern of the wallpaper) and the mirror images of the men at the heads of the table lifting their arms to eat and drink.[16] The standing woman and seated man on the far side of the table may be married, or courting, a common occurrence at threshing dinners.[17] The relationship of the couple is wittily mirrored twice, first by the framed print on the wall behind them, which depicts two wild horses in a storm, and again by the pair of docile workhorses in the barnyard.[18]

The right third of the painting depicts three women who, mirroring the three male farm workers at the opposite end of the painting, represent three stages of food preparation—cooking, dishing up, and serving. Leaving her

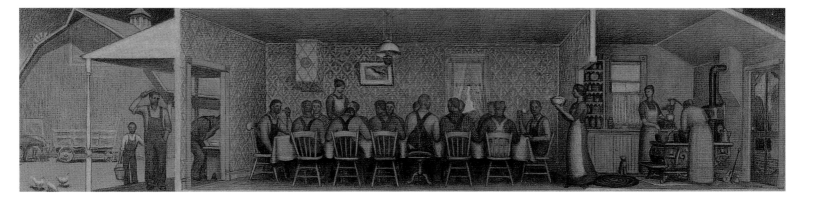

gendered sphere of work, one woman glides into the central communal space, carrying a large bowl of mashed potatoes in her upraised hands like a ritual offering. Wood's attention to detail is again apparent in the metal match holder from the wall of his childhood home, the jar of pickles on the kitchen counter, the blue cabinet that Wood built for his mother, one of his mother's handmade rag rugs, and a well-fed cat waiting expectantly for a stray scrap of food.[19]

Wood's convincing brand of realism lured viewers to critique such details as the identical attire of the threshers and the placement of the hens' shadows. In a humorous riposte, Wood reminded his critics, "It was painted with my paint and my brushes on my own time. It is of and by me and readers have no right to force upon me their families, their clothing, their hens, or their screen doors."[20] To the woman who complained that the absence of a screen door at the left would allow flies to enter the house, he replied in exasperation, "Why allow me, without comment, to bisect an entire house and then quibble about a screen door?"[21]

Pictorial inconsistencies such as the finished face of the bisected farmhouse (which does not reveal any internal construction), the lack of a unifying one-point perspective, the discrepancy between the full- and half-door frames in the dining room, and the absence of a door to the barnyard porch are not errors by Wood, who was a talented amateur architect, but rather are subtle tributes to Renaissance precedents.[22] The painting's tripartite composition replicates the format of an early Renaissance triptych, while the painting's elongated proportions recall a religious altarpiece's lower predella panels, which typically presented a sequential narrative.[23] Wood's appropriations from Renaissance art did not go unobserved by art critics, who variously likened *Dinner for Threshers* to works by the Italian artists Fra Angelico, Sandro Botticelli, and Giotto.[24]

Wood's appropriation of European Renaissance art may be viewed as part of a trend among American artists who rejected European modernism but sought to endow their contemporary American subjects with some of the more universal and timeless cultural resonance that they perceived in works by the European old masters.[25] In *Dinner for Threshers*, which Wood had hoped to enlarge into a large-scale mural, he borrowed not only formal elements but also the content, which is reminiscent of Renaissance murals that depict the biblical Last Supper.[26] This startling connection endows Wood's farmers, participants in the ancient community ritual of harvest communion, with the dignity of the biblical disciples partaking of a sacramental meal.[27] It also enables Wood's painting, which is already set in the past (i.e., 1900), to further transcend the temporal concerns of the Great Depression, which included one of the most prolonged dust bowl droughts in American history, and farm foreclosures that ran as high as 25 percent in some parts of Iowa in 1931 and 1932.[28]

Wood, however, does not focus on the religious beliefs of his farmers but instead suggests that his subjects are emblematic of Jeffersonian democracy—America's de facto religion.[29] In his *Notes on Virginia*, Thomas Jefferson elevated the American farmer to the status of a secular saint, declaring, "Those who labor in the earth are the chosen people of God, if ever he had a chosen people, whose breasts he has made his peculiar deposit for substantial and genuine virtue. It is the focus in which he keeps alive that sacred fire, which otherwise might escape from the face of the earth."[30] One hundred fifty years later, in *Dinner for Threshers*, Wood fanned the flames of that sacred fire, reassuring depression-era viewers that America's agrarian foundation myth continued to yield a rich harvest. [TAB]

87. AARON DOUGLAS, *Aspiration*

UP FROM SLAVERY

Aaron Douglas (1899–1979) was the most influential artist associated with the Harlem Renaissance and was credited with being the first African American to incorporate both European modernism and traditional African art subjects into his work. As an "Africanist," Douglas argued that although it would be "absurd to take African sculpture and literally transplant it and inject it into Negro American life, we can go to African life and get a certain amount of understanding, form and color and use this knowledge in development of an expression which interprets our life."[1] Douglas's unique Afro-Egyptian style of symbolic abstraction, combined with his message of pan-African cultural and political nationalism, strongly influenced a younger generation of artists, including Jacob Lawrence and Romare Bearden.[2]

Aaron Douglas was born in Topeka, Kansas, and studied art at the University of Nebraska at Lincoln (1918–22) and the University of Minnesota at Minneapolis (1918).[3] In 1924 he moved from Kansas City to New York, where he studied art (1925–27) with Winold Reiss, who encouraged Douglas to study African art.[4] Douglas's reputation was secured through his first major commission—illustrations for Alain Locke's *The New Negro: An Interpretation* (1925), the famous literary anthology that defined many of the major themes of the progressive New Negro movement and the Harlem Renaissance.[5] Locke's influential essay "The Legacy of the Ancestral Arts" urged African American artists to embrace their African art heritage as a source of cultural pride and artistic inspiration.[6] Locke's message was reinforced during Douglas's fellowship (1928) at the Barnes Foundation outside Philadelphia, where African artworks were accorded equal respect with works by European modernists such as Paul Cézanne, Vincent van Gogh, Henri Matisse, and Pablo Picasso.[7]

Douglas is best known for major mural cycles depicting African and African American themes, including *Symbolic Negro History* (1930) at Fisk University, Nashville, Tennessee (where Douglas taught from 1937 to 1966); *Harriet Tubman* (1930) at Bennett College for Women in Greensboro, North Carolina; *Aspects of Negro Life* (1934) at the Countee Cullen branch of the New York Public Library; and *Evolution of Negro Dance* (1935) for Harlem's 135th Street YMCA.

Aspiration and *Into Bondage* (fig. 87.1) are the two extant paintings from a four-part mural cycle that Douglas created for the Hall of Negro Life at the Texas Centennial Exposition of 1936 in Dallas.[8] Overcoming local opposition, African American community leaders obtained federal funding for an exposition building that housed exhibits "depicting the story of the Negro and his progress."[9] The Hall of Negro Life opened to the public on Juneteenth (June 19), an African American holiday that commemorated the end of slavery in Texas.[10] Douglas's four mural paintings, installed in the octagonal lobby, depicted "the chronological transition of Negroes from the days of slavery up to the present time."[11] The four subjects included a scene with Estevanico, a slave of African descent who "discovered" Texas with the Spanish conquistador Cabeza de Vaca (unlocated); *Into Bondage*; *The Negro's Gift to America* (unlocated); and *Aspiration*.[12]

Aspiration synthesizes several major themes, including African Americans' shared Egyptian African heritage as a source of nationalism and cultural pride, the tragic legacy of slavery, and the promise of education and industry to

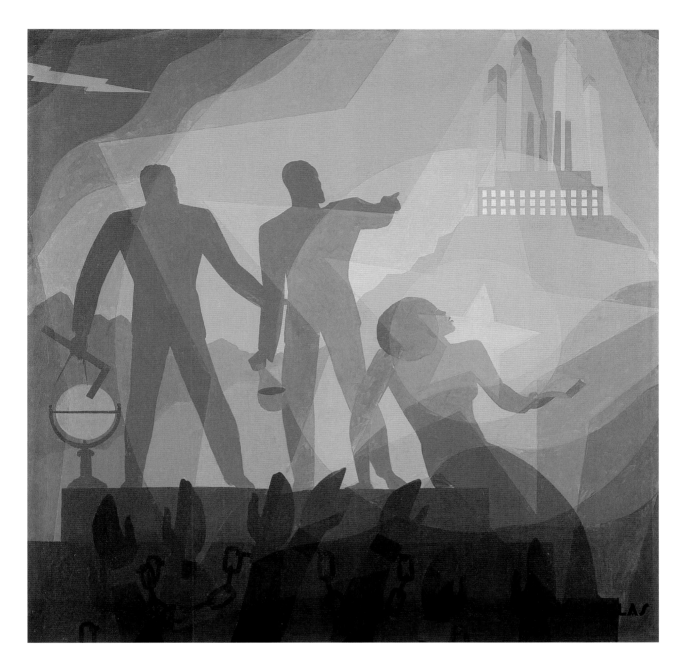

87. Aaron Douglas (1899–1979), *Aspiration*, 1936. Oil on canvas, 60 × 60 in. (152.4 × 152.4 cm)
Museum purchase, the estate of Thurlow E. Tibbs Jr., the Museum Society Auxiliary,
American Art Trust Fund, Unrestricted Art Trust Fund, partial gift of Dr. Ernest A. Bates,
Sharon Bell, Jo-Ann Beverly, Barbara Carleton, Dr. and Mrs. Arthur H. Coleman, Dr. and
Mrs. Coyness Ennix Jr., Nicole Y. Ennix, Mr. and Mrs. Gary Francois, Dennis L. Franklin,
Mr. and Mrs. Maxwell C. Gillette, Mr. and Mrs. Richard Goodyear, Zuretti L. Goosby,
Marion E. Greene, Mrs. Vivian S. W. Hambrick, Laurie Gibbs Harris, Arlene Hollis,
Louis A. and Letha Jeanpierre, Daniel and Jackie Johnson Jr., Stephen L. Johnson,
Mr. and Mrs. Arthur Lathan, Lewis & Ribbs Mortuary Garden Chapel, Mr. and Mrs.
Gary Love, Glenn R. Nance, Mr. and Mrs. Harry S. Parker III, Mr. and Mrs. Carr T. Preston,
Fannie Preston, Pamela R. Ransom, Dr. and Mrs. Benjamin F. Reed, San Francisco Black
Chamber of Commerce, San Francisco Chapter of Links, Inc., San Francisco Chapter of
the N.A.A.C.P., Sigma Pi Phi Fraternity, Dr. Ella Mae Simmons, Mr. Calvin R. Swinson,
Joseph B. Williams, Mr. and Mrs. Alfred S. Wilsey, and the people of the Bay Area, 1997.84

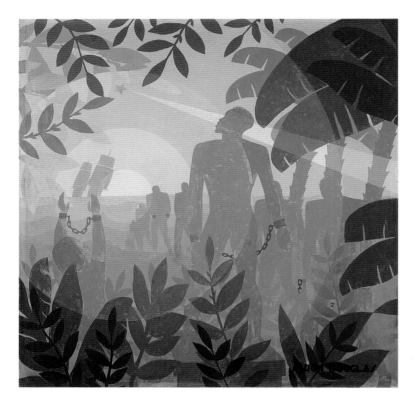

Fig. 87.1. Aaron Douglas (1899–1979), *Into Bondage*, 1936. Oil on canvas, 60⅜ × 60½ in. (153.4 × 153.7 cm). Corcoran Gallery of Art, Museum purchase and partial gift from Thurlow Evans Tibbs Jr., The Evans Tibbs Collection, 1996.9

lead African Americans out of physical and intellectual bondage. In the lower register, the shackled arms of enslaved Africans, enveloped by undulating, wavelike curves, recall the sick slaves who were thrown overboard by slave traders during the infamous transatlantic Middle Passage of slave ships. These anonymous hands reach upward, as if seeking both physical liberation and spiritual salvation from a higher authority.

Seated on the upper step of the architectural plinth and looking up toward the distant city on a hill is a female figure who appears to be wearing an ancient Egyptian wig. Her purple attire, a color that pervades the painting and is traditionally associated with royalty, serves as a reminder that Egypt was a kingdom of pharaohs and nobility. Her position on the stone steps recalls the fusion of figure and architecture often found in Egyptian sculpture, while her figural style—a flat silhouette seen simultaneously in profile and three-quarter views—is reminiscent of Egyptian wall reliefs and paintings.[13] This figure holds an open book that signifies the contributions of Egyptian civilization, including papyrus books and hieroglyphic writing.

The waves washing over the seated figure's legs recall the siting of temples along the Nile River, as at Abu Simbel in ancient Nubia, and the annual spring flood of the Nile, a major focus of Egyptian religion and culture. However, rivers also figured prominently in African American culture, where they served both as geographic symbols of the journey from slavery to freedom and as metaphors for spiritual salvation.[14] In "The Negro Speaks of Rivers" (1922), Langston Hughes explicitly linked the Euphrates, Congo, Nile, and Mississippi rivers in a continuum of the African experience of diaspora.[15]

Douglas's Mother Egypt–Africa figure, who offers her open book of knowledge as a means of intellectual liberation, shares a subtle kinship with two nineteenth-century liberators whose names were inscribed in the lobby of the Hall of Negro Life—Sojourner Truth and Harriet Tubman. The pose of Douglas's figure resembles that of Michelangelo's famous Sistine Chapel Sibyls and thus indirectly invokes the persona of the famous abolitionist Sojourner Truth, who was known as the "Libyan Sibyl."[16] Douglas had depicted Tubman, wearing a similar Egyptian-style wig, in his earlier *Harriet Tubman* (1930) mural at Bennett College for Women in Greensboro, North Carolina.[17] Tubman was known as the "Moses" of her people for personally leading more than two hundred slaves out of "Egypt" (slavery in the South) to freedom in the North.[18]

The three-tiered plinth in *Aspiration*, which may symbolize the Old, Middle, and New Kingdoms of Egypt, resembles the early step pyramids that antedated the more familiar triangular pyramids. The three major pyramids at Giza are also present, their silhouettes formed by the triangular spaces between the two lowest points of the concentric five-pointed stars that radiate through the composition. The cupped slave hands at the far right that cradle the smallest pyramid not only serve as a reminder of the slave labor that supposedly constructed these monuments but also symbolize an Egyptian cultural legacy to be passed on to future generations.

On the plinth stand two powerful African American men in suits who appear to embody Booker T. Washington's philosophy of self-improvement through an education in applied trades, W. E. B. Du Bois's conception of a new elite black intelligentsia known as the "talented tenth," and Alain Locke's vision of a newly self-educated and self-empowered "New Negro."[19] The figure at the left, standing by a globe that signifies geography and/or astronomy and holding a carpenter's angle and a compass that signifies architecture, recalls the pioneering astronomer, mathematician, and surveyor Benjamin Banneker. His companion holds a glass beaker signifying chemistry, reminiscent of the agricultural chemist George Washington Carver, who prepared a "scientific agricultural exhibit" for the Texas Centennial Exposition.[20] Both men's names were inscribed on the lobby wall beneath Douglas's murals.[21]

Douglas described the distinctive pyramidal torsos of his two male protagonists as a form of "spiritualized revitalization" that linked them to their collective African Egyptian past.[22] Their elevation above their enslaved ancestors may be seen as a visual counterpart to the scientist-educator Booker T. Washington's famous autobiography *Up from Slavery* (1901). Like the contemporary African Americans Jesse Owens, Joe Louis, and Paul Robeson—international stars in their respective fields—Douglas's dynamic duo stands tall upon the three-tiered plinth, transforming the slave auction block of the pre-Emancipation period into a symbolic stepping stone to higher achievement.[23]

Douglas's protagonists gaze at and point upward to a metropolis whose skyscrapers, contemporary equivalents of the pyramids, soar heavenward as the ultimate symbol of modern human aspiration.[24] Significantly, Douglas's white-collar skyscrapers are built on the foundation of a blue-collar factory, whose smokestacks resemble the columns of ancient Egyptian architecture. This idealized

Fig. 87.2. Texas Centennial Exposition, *Cavalcade of Texas Souvenir Program*, Dallas, Texas, 1936. Collection of the American Art Department, de Young

vision of economic opportunity and prosperity may be a personal recollection of Douglas's experience in 1917, when he moved from Topeka north to Detroit—"the money Mecca of every young Negro youth who yearned to escape the oppressive conditions of his life"—and worked in the Fisher Body and Cadillac automobile factories.[25]

Douglas's vision of *Aspiration* is unified by his distinctive use of concentric five-pointed stars.[26] In the context of the Texas Centennial Exposition, most viewers would have interpreted these stars as patriotic symbols of the Lone Star State. However, African American visitors may have viewed these multivalent stars as the North Star that guided African American slaves from the South to freedom in the North.[27] These guiding stars, which inevitably recall the Star of Bethlehem, also may be seen as references to Christian salvation, especially in conjunction with the heavenly city on the hill, which recalls the famous biblical quote: "Ye are the light of the world. A city that is set upon a hill cannot be hid. Neither do men light a candle, and put it under a bushel, but on a candlestick; and it giveth light unto all that are in the house" (Matt. 5:14–15).[28] Douglas's stars appear to dissipate the storm and lightning at the upper left and to illuminate the jagged mountains and valleys, common religious symbols for human trials and tribulations. Finally, in the mid-1930s, a period when Douglas openly embraced Marxism, the stars may have covertly suggested that socialism provided an alternative means of political salvation for African Americans.[29]

Aspiration is, in part, a visual metaphor for shared black experience of the diaspora spanning time and place—from ancient Africa to modern America, and from the American South to the North. The flow of imagery from the bottom of the painting to the top suggests historical progression from the slavery of the past to the emancipated, educated, and empowered New Negro of the present, and finally to an idealized future achieved through self-determination. *Aspiration* also suggests a geographic progression from the agrarian slave, sharecropper, and migrant labor of the rural South to the industrial free labor of the urban North, recalling the great exodus of two million African Americans between the world wars. [30]

Aspiration also forges a bond between African Egyptian and African American culture, thus promoting a shared heritage of pan-African nationalism. Douglas reclaimed Egypt, which had traditionally been appropriated by Europeans as the historical foundation for their own cultural heritage, for both Africans and African Americans. This legacy, symbolized by the small pyramid proffered by the upraised hands, emanates outward from the figure of Mother Egypt–Africa in the form of the concentric pyramids, stars, and circles that Douglas likened to radio waves, which carried African American jazz and blues around the globe.[31] However, in the Hall of Negro Life, situated in the city of Dallas, in the Jim Crow South, *Aspiration* appropriated and subverted the official imagery and message of the Texas Centennial (fig. 87.2) to picture an alternative African American history.[32] In this context, Douglas's *Aspiration* would have been viewed by African Americans as a visual equivalent of Langston Hughes's famous essay "The Negro Artist and the Racial Mountain" (1926), in which he defiantly declared:

> Let . . . Aaron Douglas drawing strange black fantasies cause the smug Negro middle class to turn from their white, respectable, ordinary books and papers to catch a glimmer of their own beauty. We younger Negro artists who create now intend to express our individual dark-skinned selves without fear or shame. If white people are pleased we are glad. If they are not, it doesn't matter. We know we are beautiful. And ugly too. The tom-tom cries and the tom-tom laughs. If colored people are pleased we are glad. If they are not, their displeasure doesn't matter either. We build our temples for tomorrow, strong as we know how, and we stand on top of the mountain, free within ourselves.[33]

[TAB]

88. JOHN STEUART CURRY, *Self-Portrait*

A QUIET MAN SPEAKS

John Steuart Curry (1897–1946) was not one for chitchat. Born and raised on a farm in Kansas, he was stereotypically laconic. His friend and colleague Thomas Hart Benton (1889–1975) remembered, "Like a farmer John was a slow and clumsy talker. It took a good many months to know him and understand what was in his mind."[1] Although he was a large, powerfully built man, others found Curry "gentle and soft-spoken," although they too admitted, "Easy conversation was not his forte."[2] Self-doubting by nature, Curry was sensitive to criticism. Benton recalled, "When the critics yapped, 'He can't paint,' John went by himself and wept."[3] The artist Reginald Marsh (1898–1954) suggested that Curry's painting of a large bull, *Ajax* (1936–37, Forbes Magazine Collection, New York), was actually a self-portrait, and it is possible to see a resemblance between the massive animal, horns pointing safely downward, placidly eating grass while two little birds rest on his back, and Curry, with his imposing frame and sensitive nature.[4]

Curry, Benton, and Grant Wood (1892–1941) were the central figures in American midwestern regionalist art. Yet Curry confessed, "I learned that I belonged to the regional school of art long after I had done the work as I pleased, without giving a thought as to what 'school' it might fit."[5] The art critic Thomas Craven wrote about Regionalism with a strident, antimodernist tone, tapping into a deep vein of American isolationism. Given his taciturn manner, it is perhaps not surprising that Curry stayed out of the ideological skirmishes between supporters of regionalist art and proponents of the abstract art being created in Europe.

Curry had no objections to the work of the School of Paris. He did, however, object to American imitations of it. Curry, like his Regionalist colleagues, valued art rooted in

subject. He declared, "The artist ought to paint people doing things. . . . The use of life as an excuse for clever arrangements of color or other pictorial elements ends where it begins."[6] The reformed modernist Benton summarized the three men's efforts, "We stood for an art whose forms and meanings would have direct and easily comprehended relevance to the American culture of which we were by blood and daily life a part. . . . We hope to build our 'universals' out of the particularities of our own times and our own places."[7] So Curry turned to the people and sights of his native Kansas for his subjects, painting farmyard baptisms, rural funerals, state fairs, religious revivals, manhunts, tornadoes, and rainstorms over fields of corn.

In 1936 the University of Wisconsin invited Curry to be the artist-in-residence at its Madison campus. Curry was not required to teach art. Rather, his brief was to mingle with students of the agricultural school, helping them to develop an appreciation for art. He would serve as "a living museum" and "an artistic hub for the state," working and residing in a barnlike studio constructed especially for him.[8] Five months after he began his residency in Wisconsin, Curry painted this self-portrait. In it, he wears a green corduroy jacket and a white shirt, the unbuttoned collar slightly askew. He is smoking a pipe and holds brushes and a paint-stained cloth in his hand. Curry has positioned a sculpture of a bird of prey, its wings outspread, and a painting behind him. The painting, which shows a woman in a pink costume standing with a horse, is a reference to a series of circus pictures that Curry painted while traveling with the Ringling Brothers Barnum & Bailey in 1932. The frame of the mirror Curry looked into as he worked runs down the right side of the canvas, doubled in the

88. John Steuart Curry (1897–1946), *Self-Portrait*, 1937
Oil and tempera on canvas, 30 × 24 in. (76.2 × 61 cm)
Gift of Mr. and Mrs. J. Burgess Jamieson, 1996.129

"reflection." Curry used a similar device in an earlier self-portrait (1927–29, Spencer Museum of Art, University of Kansas, Lawrence), creating in both instances reminders of his doubled role as author and subject.

Benton might compare him to a farmer, Curry might plead ignorance of the various, competing schools of art, buckle when sniped at by the urban art press, and paint frankly heroic images of stockmen and farmers, but he was no rube. Instead of the usual grain and feed calendars, Curry's childhood home was decorated with reproductions of art by Peter Paul Rubens, Jean-François Millet, and Giovanni Bellini, which his parents had bought on their European honeymoon. He studied art in Chicago and drawing in Paris, and he lived for a while in Manhattan's Greenwich Village.

Curry demonstrates his art historical knowledge in the self-portrait. The rough jacket and white shirt, the three-quarter view of the head, and the pipe clenched between teeth recall Vincent van Gogh's *Self-Portrait with Pipe* (1886, Van Gogh Museum, Amsterdam) and *Self-Portrait with Bandaged Ear and Pipe* (1889, Leigh B. Block, Chicago). Curry used conventional devices of Renaissance portraiture to show his allegiances and claim his authority as an artist: the heraldic bird (perhaps the Kansas mascot, the fictitious jayhawk) and the circus painting, included to demonstrate his ability to depict both people and animals. The crossed brushes are reminiscent of the crossed flail (used for threshing) and crook (used for shepherding) carried by the Egyptian god of agriculture, Osiris—a witty reference to his new relationship with the agricultural school at the University of Wisconsin.[9]

Curry entered his tenure at Wisconsin at the height of his career: his work had been acquired by the Whitney Museum of American Art and the Metropolitan Museum of Art, both in New York, and it had been exhibited at the Corcoran Gallery of Art, in Washington, D.C., and at the Pennsylvania Academy of the Fine Arts, in Philadelphia. He had been profiled in the first issue of *Life* magazine. In the painting, Curry's gaze is steady and firm, his wide shoulders and the crossed brushes suggesting a man ready to defend himself. When asked around this time about those people who questioned whether his paintings of Kansan scenes were art, Curry retorted with uncharacteristic confidence, "To hell with them."[10]

In 1937 Curry was nominated for membership in the National Academy of Design. To qualify for membership, nominees had to present a painting to the academy's council. Curry intended the FAMSF self-portrait to serve as his qualifying painting, but his dealer at the time sent it for exhibition elsewhere. Curry pledged to provide the academy with another painting. In the meantime, the academy council, in a rare if not unprecedented move, accepted him on the basis of the painting's reproduction on the cover of the 15 January 1938 issue of *Art Digest*.[11]

The self-portrait, therefore, was intended to represent Curry to the art establishment of the metropolitan East, a fact that helps explain the painting's slightly defensive tone. For those distant viewers who did not know him or who doubted his abilities, the bird of prey, the circus painting, and the symbolic reference to agriculture demonstrated Curry's regional affiliations, while the technical accomplishment of the painting (emphasized by the painted mirror frame) and the art historical references established his credentials as an artist. The painting had another audience, however, quite different from the council of the National Academy of Design. When Curry accepted the position of artist-in-residence at the University of Wisconsin, he committed to showing all his new work in Wisconsin first. Exhibited early in Curry's tenure at Madison, the self-portrait introduced the established, widely known artist to the university's agricultural students and to the state's population as a whole. To that audience Curry presented himself as informal and accessible, committed to the Midwest and familiar subjects, yet also accomplished, confident.

On his arrival in Wisconsin Curry declared, "Any influence I may exert will be because of my work itself, not because of anything I may say or write."[12] In his self-portrait, this taciturn man found a way to communicate to the disparate members of his audience—be they sophisticated urban academicians or untutored rural viewers—who he was and where he came from. [IB]

GEOMETRY AND CRAFT

Charles Sheeler (1883–1965) is best known as a Precisionist, a term most often used to describe artists who in the 1920s and 1930s represented scenes of modern urbanism and industrialism in an abstracting, linear, and hard-edged style.[1] Sheeler set the standard for the precisionist aesthetic with his iconic paintings and photographs of the Ford Motor Company plant at River Rouge, Michigan. However, the artist also successfully employed this artistic idiom in paintings of more vernacular and intimate subjects, including barns and domestic interiors in Pennsylvania and New York.[2] This range reveals that Sheeler's aesthetic transcended the particularities of subject matter. Indeed, describing his goals as an artist Sheeler once stated, "All nature *has* an underlying abstract structure and it is within the province of the artist to search for it and to select and rearrange the forms for the enhancement of his design."[3] For Sheeler, the way to search for and find nature's "abstract structure" was through photography, a medium in which he excelled; he often turned his lens on the built environment to collect data in preparation for his paintings.[4] By utilizing photographs in this way, Sheeler was able to render a scene with an uncanny clarity, fixing and intensifying vision to reveal the unseen geometries that order the material world.

Sheeler was born, raised, and educated in Philadelphia.[5] After high school, he opted for a practical education and enrolled in the School of Industrial Design. After three years of creating patterns for wallpaper and carpeting, however, he decided pursue his true passion, painting. He transferred to the Pennsylvania Academy of the Fine Arts and learned to paint in the loose, brushy style of his teacher, William Merritt Chase. Then, in 1909, he was jolted by

the exciting new work of European Fauves and Cubists, which he saw while visiting Paris. Inspired, he returned to Philadelphia and began to paint in the manner of Paul Cézanne. Sheeler's early Cézannesque paintings were included in the Armory Show (1913), but as he could not support himself by painting, he took up commercial photography. This was a fortuitous decision. Not only did it pay Sheeler's bills, but it also further tuned his eye to see the geometries in everyday life. His first assignments documented the work of Philadelphia-area architects, but he was soon in New York, photographing art for collectors and dealers and frequenting the salon of the vanguard collectors Walter and Louise Arensberg, where he met some of the period's leading artists and authors, including Marcel Duchamp and William Carlos Williams.

In 1919 Sheeler moved to New York, where he eventually made a name for himself as both a photographer and a painter. In 1920 he and the photographer Paul Strand co-produced a six-minute film entitled *Manhatta*. Significantly, Sheeler employed stills from this film as studies for paintings that represented the urban environment as abstract, interlocking planes.[6] During this time, however, the artist continued to support himself with commercial photographic assignments, although his paintings, drawings, and photographs were increasingly garnering critical attention. Then in 1927 he was commissioned by the Ford Motor Company to create a photographic portfolio of its plant in River Rouge, Michigan. The success of these photographs, and of the paintings Sheeler made after them, solidified his reputation as one of the nation's premier artists. In the 1930s he was able to spend more time painting, but he continued to make photographs and received important

89. Charles Sheeler (1883–1965), *Kitchen, Williamsburg*, 1937
 Oil on hardboard panel, 10 × 14 in. (25.4 × 35.6 cm)
 Gift of Mr. and Mrs. John D. Rockefeller 3rd, 1993.35.24

Fig. 89.1. Charles Sheeler (1883–1905), *Colonial Williamsburg Kitchen*, 1935–36.
Gelatin silver print. © The Lane Collection. Courtesy Museum of Fine Arts, Boston

commissions, including the one in 1935 from Abby Aldrich Rockefeller to document in a photographic essay the recently restored Colonial Williamsburg in Virginia.[7] During this decade, Sheeler's paintings were closest in style to his photographs; by the 1940s and 1950s they became more abstract, even though still based on photographic images.

In *Kitchen, Williamsburg* (1937), Sheeler depicts a spartan corner of a colonial kitchen at Williamsburg in the meticulous, linear style for which he is well known. In the corner of the room, nestled in a nook, stands a small table on which rests a cake mold and a large, two-handled bowl. On the shelves above, additional molds, kettles, roasters, and utensils are stored, while ladles, skimmers, and graters of different shapes and sizes hang from nearby moldings. A William and Mary side chair, a table, and an unembellished cabinet are pushed against the wall to the

left. A bread bowl, with dough in it, and a grouping of tubers on the table are illuminated by light streaming through the window just out of sight along the left-hand side of the painting. The cabinet in the left foreground is likewise cropped by the edge of the canvas. The right side of the painting is dominated by the opening of the hearth, also cropped, from which hangs a black kettle on a swing crane. A brass pot rests in front of the hearth's opening, and to its left various fire tools lean against a spice box. Above the box hang various metals skewers, as do a shovel and a copper pot.

Although Sheeler based this painting on a photograph (fig. 89.1), a comparison reveals the unique qualities of the painting. Both share the same composition, although in the painting Sheeler has eliminated the sprig of herbs that hangs beside the window, and he has extended the scene on

either side, thereby subtly emphasizing the horizontality of the composition via the furniture surfaces, the moldings, and the shelves. More obvious is the fact that the photograph presents the scene in shades of black and white, while the painting presents it in color. However, Sheeler limited his palette to brown, yellow, and red hues and used only a restricted range of values. As a result, none of the objects disappears into the shadows as they do in the photograph, such as the pots and utensils on the upper shelf. Nor do particular items, the mold on the table for instance, catch our attention in the painting as they do in the photograph, owing to that medium's starker contrast of values. Thus Sheeler renders each object clearly, precisely, and uniformly. This uniformity comes across even more emphatically because Sheeler has rendered the entire painting in meticulous brushwork. There are no painterly flourishes to call our attention to any one part of the painting. The result is a painting that allows us to become acutely aware of the geometric form and mass of each object, from the circular copper pan hanging on the wall to the rectilinear spice box below it. In turn, we are led to consider the geometry that organizes all of these objects, an invisible grid composed of horizontal and verticals that crisscross the canvas.[8] Because a photograph served as a basis for the painting, we know this composition is not one invented by the artist. Instead, through his meticulous rendering of the scene on an intimate scale—the painting measures a mere ten by fourteen inches—Sheeler makes us see an ordering of the world that in all likelihood we would otherwise fail to observe.

For the artist and his contemporaries, *Kitchen, Williams-burg* connected the past to the present. For Sheeler, the subject and execution of the painting dovetailed with his admiration for early American craftsmanship. An avid collector of Shaker furniture, Sheeler saw himself as a craftsman, seeking to paint "with the utmost clarity by means of a craftsmanship so adequate as to be unobtrusive."[9] In this painting, Sheeler focuses on the kind of ordinary household items early American craftsmen lovingly created and, like those artisans who effaced themselves from their finished product, so Sheeler avoids any impastoed touches of paint that might remind us of the painting's creator. Sheeler and his contemporaries admired the colonial past in large part because they believed it represented a time when the values associated with workmanship and labor remained firm, as yet uncorrupted by the Industrial Revolution.

The underlying geometry of *Kitchen, Williamsburg* could also link the colonial past to the modern present for Sheeler's peers.[10] The art critic Jerome Klein, for example, writing for the *New York Post* in 1939, observed that Sheeler "interprets a vast industrial complex like the Ford plant as a study in pure pattern. Its 'clean lines' appeal to him, as do the simple contours and plain surfaces in the historic early American kitchen at Williamsburg, Va., which he has also painted."[11] Sheeler, a craftsman of pattern, geometry, and the basic structure of the environments we build for life and work, thus established himself and his pictures as a bridge between the industrial America of his modern world and the premodern, colonial past of his forebears—and thereby masked the inherent tension between the two.

[KM]

ABSTRACTING NATURE'S STRUCTURE

Charles Biederman's uncompromising commitment to modernist abstraction in the 1930s put him in the vanguard of American art. However, unlike many artists for whom abstraction was a means to transcend the real world and thus represent the spiritual or the unconscious, Biederman believed abstraction was best suited to rendering the natural, material world. In 1933 he wrote, "I believe, if a man could live long enough painting abstractions, he would finally end up with nature (I mean realism). He would eventually be forced back to nature, to study nature which gives the painter, I think a more complete understanding of abstraction."[1] That is, for Biederman, abstraction ultimately led to nature, and nature in turn provided the ultimate source of abstraction. However, Biederman was never interested in representing a recognizable image of nature, either on a macro- or a microscopic level. Instead, over the course of his life, he sought to create an abstract art that enabled the viewer to experience the very structure of nature.

Born and raised in Cleveland, Ohio, Karel (Charles) Joseph Biederman (1906–2004) apprenticed in a commercial art studio before attending the Art Institute of Chicago School (1926–29), where, in addition to enrolling in studio classes, he studied the museum's impressive collection of modern European art.[2] Inspired by the post-impressionist paintings of Paul Cézanne, and with the guidance of his painting instructor John Norton, Biederman set out to represent what he called "the different forms of structural expression."[3] At a time when realist and expressionist styles prevailed, Biederman experimented with abstraction, and, in so doing, often incurred the scorn of his fellow students. Nonetheless, he persisted, at first executing Cézannesque still lifes and then, after moving to New York in 1934, graduating to the style of those European modernists who had

built on the achievements of Cézanne. As a result, by the mid-1930s Biederman had absorbed the lessons of the most accomplished abstract painters of the previous decades, including Pablo Picasso, Georges Braque, Joan Miró, Fernand Léger, and Piet Mondrian. A number of his abstract paintings were included in an important exhibition in 1936 at A. E. Gallatin's Gallery of Living Art called *Five Contemporary American Concretionists: Biederman, Calder, Ferren, Morris, Shaw*, which showcased the work of these most advanced American modernists.[4]

That same year, Biederman visited the *Cubism and Abstract Art* exhibition at the Museum of Modern Art and was inspired to travel to Paris, where he believed he would find a vibrant center of modern art. There he met the artists whose work he had studied, including Mondrian, Léger, and Miró, as well as Jean Arp, Constantin Brancusi, and Antoine Pevsner. In Paris, Biederman continued his quest for a form of abstraction that would satisfactorily render the structure of nature, but he soon concluded that the art scene in Paris was ill-suited for him to achieve his much desired breakthrough. Significantly, before he returned to the United States, he attended the 1937 Paris World's Fair, where he found himself more interested in the technology displays than the art exhibitions—a personal insight that led him to abandon painting altogether because, as he put it, "the old methods of painting and sculpting have reached the end of their usefulness."[5] He returned to New York City, then moved back to Chicago, but in neither location did he find a supportive art community. In 1942 he settled permanently in Red Wing, Minnesota, where, for the rest of his long life he made relief sculptures in a style he called Structurism and published dense theoretic texts explaining his art.[6]

Paris 140, January 14, 1937 (1937), with its title taken from

90. Charles Biederman (1906–2004), *Paris 140, January 14, 1937*, 1937
Oil on canvas, 45¾ × 35 in. (116.2 × 88.9 cm)
The Harriet and Maurice Gregg Collection
of American Abstract Art, 2005.58

the place and date of its creation, is of interest for having been executed just months before Biederman renounced painting entirely. In it, the artist marshals a variable vocabulary of biomorphic forms, geometric shapes, and rectilinear planes of color. In the lower left corner of the painting, three blue, twisted lozenges float one above the other. From there, our eye is drawn upward by silver-metallic-colored filaments that extend toward the top of the canvas. At the upper left corner, a blue stripe begins a diagonal descent, alternately turning white and red as it flutters over two red biomorphic crescent forms before snapping apart. The broken stripe continues in blue to the painting's bottom edge. The right side of the composition is dominated by a prismatic or crystalline form and a single sphere. Biederman has made his forms appear volumetric by modeling them with light and shadow, and thus they seem to hover against the background of evenly painted, monochromatic planes of white, black, and yellow.

Biederman identified *Paris 140, January 14, 1937* as one of a series of paintings that served at the time as "a reconsideration of various subject and/or structural modes of expression I had explored since 1934."[7] The biomorphic forms recall both his paintings of a few years earlier, when Biederman was under the influence of Surrealism, and those he made slightly later, immediately before he left for Paris, which also featured forms of biological origin. In these paintings, Biederman tells us, he "tried to eliminate figurative subject matter by simply using the particular formative method of nature's structuring."[8] By "formative method" he seems to mean the kind of shapes he imagined could be found in immature plants and animals or at the subcellular level.

In the case of *Paris 140, January 14, 1937*, the spiky red form, blue lozenges, and silver-gray filaments do indeed invoke the reproductive organs of a plant or subcellular growth structures. Geometric forms, such as the pointed crystal and the sphere, recall Biederman's earlier attempt to use geometric forms rather than organic shapes "as the solution for expressive structuring."[9] But the crystal and the sphere on the right side of the canvas, like the biomorphic forms on the left, also connote the "formative method of nature's structuring," in this case drops of water falling from the sky and mineral and geologic formations rising from beneath the earth's crust. By juxtaposing the organic and the inorganic on the two sides of the composition, Biederman suggests that nature can be created or constructed by very different processes that nonetheless coexist symbiotically.

The palette Biederman used to paint *Paris 140, January*

14, 1937 and its flat, rectilinear planes of color also call to mind the work of Mondrian. While in Paris, Biederman met the Dutch artist and increasingly came under the influence of the principles of De Stijl, an informal collaboration between Dutch artists, architects, and designers that originated in the late 1910s and had its roots in the philosophical principles articulated by M. H. J. Schoenmaekers.[10] In *The New Image of the World* (1915), Schoenmaekers attributed primary significance to horizontal and vertical lines and the primary colors yellow, blue, and red. He stated, "the two fundamental complete contraries which shape our earth are: the horizontal line of power, that is the course of the earth around the sun and the vertical, profoundly spatial movement of rays that originates in the centre of the sun."[11] When it came to color, he wrote: "The principal colours are essentially yellow, blue and red. They are the only colours existing.... Yellow is the movement of the ray.... Blue is the contrasting colour to yellow.... As a colour, blue is the firmament, it is line, horizontality. Red is the mating of yellow and blue.... Yellow 'radiates,' blue 'recedes,' and red 'floats.'"[12] Mondrian translated these principles into *de nieuwe beelding*, often called Neoplasticism, but best translated as "the new structuring or forming."[13] By employing a vocabulary of yellow, blue, red, white, and black rectilinear shapes, Mondrian and other artists associated with De Stijl sought to create paintings that were "the equivalence of reality," without relying on age-old techniques of illusionism.[14]

Although Mondrian intended his abstract paintings to possess spiritual content, and therefore were not exactly the kind of model Biederman was searching for, the principles of De Stijl did offer the American artist potential tools from which to formulate a new art, one that invoked the structure of nature. In *Paris 140, January 14, 1937* we can see him working with these tools. The background of flat planes of pure color create emphatic verticals and horizontals, which could be interpreted as suggesting the primary vectors that organize the universe, just as here they create the backdrop that organizes Biederman's universal forms. By using a palette consisting of only yellow, blue, red, white, and black, the primary colors and values, Biederman is also able to suggest the foundations of all colors, since from the primary colors and the values of black and white all hues can be created. Nevertheless, soon after completing *January 14, 1937*, Biederman relinquished painting for the creation of relief constructions that projected his new vision into three dimensions. [KM]

THE NAKED TRUTH

Thomas Hart Benton was the most famous of the American Scene and Regionalist artists who gained prominence between the two world wars.[1] Rejecting European modernism as a form of "aesthetic colonialism," Benton argued for the creation of a national school of American art, one that embraced realism, indigenous subjects, and a populist sensibility.[2] Benton's panoramic mural compositions, characterized by an almost cinematic complexity and kinetic energy, captured "a picture of America in its entirety . . . north and south and from New York to Hollywood and back and forth in legend and history."[3] His "people's history" focused on ordinary Americans who were rendered memorable by their roles in the evolution of America's history and culture.[4] Benton's large-scale mural cycles, *America Today* (1930), *The Arts of Life in America* (1932), *A Social History of Indiana* (1933), and *The Social History of Missouri* (1936), helped to secure a prominent place for the populist public mural in American life and for vernacular subjects in American art.

Thomas Hart Benton (1889–1975), the namesake of a famous United States senator, was born in Neosho, Missouri. He began his art career as a newspaper illustrator for the Joplin, Missouri, *American* and studied at the Chicago Art Institute with Allen E. Philbrick and Frederick C. Oswald from 1907 to 1909. During his extended residency in Paris (1908–11), Benton attended classes at the Académie Julian and the Académie Colarossi; studied the old masters at the Musée du Louvre; and absorbed the lessons of Impressionism, Fauvism, and Cubism. Benton returned to the United States in 1912 and settled in New York, where he created abstract paintings that initially placed him among the most avant-garde American artists.

Benton's artistic evolution from modernism to representation began while he served as a draftsman for the United States Navy (1918–19).[5] Benton's contemporaneous study of Jesse Ames Spencer's illustrated *History of the United States* inspired the subsequent creation of his first major painting cycle, *The American Historical Epic* (1919–26).[6] Benton's extensive travels throughout the rural South and Midwest in the late 1920s provided a wealth of additional subjects for the murals that later made him famous and led to his identification in an influential *Time* magazine article of 1934 as a "U.S. Scene" or Regionalist artist.[7] In 1935 Benton embraced his new Regionalist identity by publicly denouncing the New York City art world before leaving to teach at the Kansas City Art Institute in Missouri.[8]

Benton's *Susanna and the Elders* (1938), a religious subject atypical for the artist, is derived from the Bible story (Dan. 13:1–64) in which Susanna, the beautiful wife of Joachim, was trapped while bathing by two elders.[9] When she refuses their sexual advances, the elders accuse her of adultery. Susanna's life is spared only when the young prophet Daniel discovers discrepancies in the accounts of her accusers, who are then sentenced to death. Benton's Susanna, however, is a contemporary midwestern woman with red marceled hair, a hairclip, bright red nail polish, and a gold wedding band. She has shed her red dress, high-heeled shoes, and cloche hat and sits on a stream bank, grasping a bare branch with her right hand while tentatively dipping her left foot into the water.[10] Benton later described his model as "that delightful hillbilly girl (*a true Ozark product, gone wrong*), who became the motif for Susanna—my boy—what a skin, what a blood pulsing skin,—just enough

91. Thomas Hart Benton (1889–1975), *Susanna and the Elders*, 1938. Oil and tempera on canvas mounted on wood panel, 60⅛ × 42⅛ in. (152.7 × 107 cm) Anonymous gift, 1940.104

yellow in the belly to make the 'tits' look pink—We don't find models like that anymore."[11] Benton saw no contradiction in depicting Susanna as a contemporary woman, in keeping with his observation that

> The great painters of the Renaissance in the service of the Church built their pictures around names of religious significance. They started out with a name; and suggestion, in so far as religious meaning was concerned, finished the job. Actually the real subject matter of these paintings was given by the life, character, and environment of the period. Depending upon the painter's habitation, Mary, the mother of God, was a Roman, a Venetian, or a Flemish belle, and the Holy City was architecturally consistent with the local type. The saints were perfectly good people; the feminine characters—generally mistresses of the moment—more or less good; and even the grass and the sky and the landscape revealed local characteristics. The religious art of the Renaissance pictured the life of the Renaissance.[12]

As in the Bible, Benton's Susanna is spied on by two older men, one of whom (with a mustache) resembles the artist.[13] Benton stages the scene to maximize the viewer's complicity in this act of voyeurism, as the viewer has a more direct view of Susanna than the two elders. In the distance, an outdated Ford Model T captures the conservative and frugal nature of its owners, while the white clapboard church signifies the presence of piety—or at least the pretense of it. Benton's contemporary *Susanna and the Elders* transforms the biblical parable into a critique of the religious hypocrisy and repressed sexuality fostered by some Bible Belt religions. As Benton observed during his travels in rural America,

> The religious furies of the southern poor are blinding. The rich believe on Sundays and with a proper respect for the "things that are Caesar's and for the physical things that are the devil's, though they take the latter with a snicker, but the poor believe all the time. They know nothing about Caesar's things and they easily confuse the devil's urges with the "will of the Lord," or, when they are too flagrantly not of "His will," as objects for gorgeous and exciting testimonial penance: "And I seen that woman a-washin' herself in the brush, brother, with her paps a-stickin' up, and the devil bein' in me—"[14]

Susanna and the Elders may be viewed as one of three major paintings by Benton that address the subject of nudity—and hypocrisy—in American art and life. Benton's

earlier *Hollywood* (fig. 91.1) of about 1937 depicts an elaborate movie set that revolves around, and is focused on, the worship of an idol—a screen goddess whose two-piece bathing suit reveals as much as it conceals. Benton cynically observed that he "wanted to give the idea that the machinery of the industry, cameras, carpenters, big generators, high voltage wires, etc., is directed mainly toward what young ladies have under their clothes."[15]

Benton's later *Persephone* (fig. 91.2), of about 1938, which depicts the mythological Greek goddess who was raped and carried to the underworld by Pluto (a self-portrait of an aged Benton), serves as a profane counterpart to the sacred Susanna.[16] Persephone's ripe beauty, mirrored in the colorful, fertile landscape of wheat fields, grapevines, and daylilies, contrasts dramatically with the lean angularity of Susanna, her bare branch, and her monochrome surroundings. As a reporter for the *Indianapolis Star* tartly opined, "*Susanna* would not be 'Miss America' at Atlantic City. She wouldn't even be 'Miss Missouri.' Her arms are lean. She's a bit raw-boned."[17] Benton's pointed pairing suggests that while the pinup Persephone might merit a beauty title, for the dour Susanna, virtue is its own—and only—reward.

The critical and popular reception of *Susanna and the Elders* and *Persephone* focused almost exclusively on their controversial nudity. To be sure, Benton's nude Susanna had art historical antecedents in works by old masters such as Titian, Tintoretto, and Rembrandt, whose *Susanna and the Elders* (ca. 1634, Mauritshuis, The Hague) also depicted the protagonist as a contemporary woman.[18] Benton made these art historical roots even more explicit in *Persephone*, whose pose is directly derived from Correggio's *Venus and Love Discovered by a Satyr* (ca. 1524–27, Musée du Louvre, Paris).[19] However, unlike earlier famous American nudes, such as John Vanderlyn's *Ariadne Asleep on the Island of Naxos* (1809–14, Pennsylvania Academy of the Fine Arts, Philadelphia) and Hiram Powers's *Greek Slave* (1844, private collection), which were cloaked in propriety by complicit viewers, Benton's Susanna stripped away the pretense of any mythological, religious, or historical cover story to reveal an unadulterated contemporary female nude.

Indeed, Benton's "pornographic" Susanna drew explicit attention to an anatomical convention so pervasive that it typically went unobserved (or at least unspoken)—the absence of pubic hair in fine art nudes.[20] This convention even applied to pinup nudes such as George Petty's "Petty Girls" for *Esquire* magazine (1933–41), which were characterized by all-American models rendered with streamlined, airbrushed perfection.[21] Reacting to Benton's seemingly

Fig. 91.1 [above]. Thomas Hart Benton (1889–1975), *Hollywood*, ca. 1937. Oil on canvas, 56 × 84 in. (142.2 × 213.4 cm). The Nelson-Atkins Museum of Art, Kansas City, Missouri. Bequest of Thomas Hart Benton, F75-21/12

Fig. 91.2 [right]. Thomas Hart Benton (1889–1975), *Persephone*, ca. 1938. Egg tempera and oil on canvas mounted on wood panel, 72 × 56 in. (182.9 × 142.2 cm). The Nelson-Atkins Museum of Art, Kansas City, Missouri. Purchase, acquired through the Yellow Freight Foundation Art Acquisition Fund and the generosity of Mrs. Herbert O. Peet, Richard J. Stern, the Doris Jones Stein Foundation, the Jacob L. and Ella C. Loose Foundation, Mr. and Mrs. Richard M. Levin, and Mr. and Mrs. Marvin Rich, F86-57

gauche break with convention, Meyric R. Rogers, director of the City Art Museum in St. Louis, Missouri, critiqued Susanna as "very nude" and initially prohibited the painting from being exhibited.[22] After the painting was installed, the evangelist Mary H. Ellis demanded its removal, protesting, "The nude is stark naked. It's lewd, immoral, obscene, lascivious, degrading, an insult to womanhood and the lowest expression of pure filth. It leaves nothing to the imagination."[23] While Benton's Susanna leaves little to the imagination, the painting does expose some of the subtle contradictions that lie behind its provocative subject. As part of a sequential triptych composed of *Hollywood* (1937), *Susanna and the Elders* (1938), and *Persephone* (1939), respectively drawn from the realms of modern life, biblical scripture, and ancient mythology, it consciously blurs the traditional distinctions between fine art and popular art, the sacred and the profane, and the nude and the naked, thus challenging the voyeuristic viewer to define his or her terms. [TAB]

92. AGNES PELTON, *Challenge*

TRANSCENDENT MODERNISM

A pioneering American modernist and honorary president of the American Transcendental Painting Group (founded 1938), Agnes Pelton nurtured the evolution of abstraction in America during the crucial decade of the 1930s, when realism was ascendant. Yet Pelton never embraced abstract art as an end in itself—her subjects are three-dimensional rather than two-dimensional, organic rather than purely geometric, and spiritual rather than intellectual. Often cosmic in their scope, her abstractions seek to illuminate universal truths in nature, including the eternal cycles of birth, growth, transformation, death, and rebirth. Pelton's "symbolic abstractions" are distinguished by her belief that "artistic creation is the metamorphosis of the external aspects of a thing into a self-sustaining spiritual reality."[1]

Born in Stuttgart, Germany, to American parents and raised in New York, Agnes Pelton (1881–1961) studied art at Brooklyn's Pratt Institute with Arthur Wesley Dow from 1895 to 1900. In his influential book of art theory entitled *Composition* (1899), Dow rejected the academic tradition of representation, declaring realism to be "the death of art."[2] Focusing instead on the aesthetic relationships of line, tone, and color, he emphasized their power to convey meaning metaphorically rather than descriptively. Dow also exhorted his students to cultivate a personal artistic vision, a philosophy that especially resonated with Pelton.

In 1900, after working as a teaching assistant at Dow's Summer School of Art in Ipswich, Massachusetts, Pelton suffered a psychological crisis that prompted her to stop painting for seven years. Resuming her art career in 1907, Pelton honed her sensitivity to light and color, although she rejected the impressionist practice of plein-air sketching in favor of "studies from memory of the natural effects and the significance of lights."[3] The turning point in Pelton's artistic evolution occurred during a yearlong trip (1910–11) in Italy, where she studied life drawing at the British Academy in Rome and viewed the great masterpieces of Renaissance and baroque art.[4]

Soon after her return to the United States, Pelton created her first "Imaginative Paintings," which she described as "interpretations of moods of nature symbolically expressed."[5] These symbolist works typically depict solitary, ethereal female figures in shallow, stagelike settings, living in harmony with, or serving as allegorical representations of, nature. The "Imaginative Paintings," which partake of a romantic tradition represented by the works of such artists as William Blake, Elihu Vedder, and her contemporary Arthur B. Davies, reveal Pelton's search for an artistic style empathetic to her evolving inner vision.

In 1921 Pelton left New York City for Water Mill, near Southampton, Long Island. There, in 1926, she painted the first of her "Symbolic Abstractions." Inspired by the example of the English romantic poets John Keats, Percy Bysshe Shelley, and William Wordsworth, these works were based on her close observation of terrestrial and celestial phenomena. Relinquishing her earlier reliance on the human figure as a surrogate viewer of nature, Pelton now sought to evoke the organic forms and forces of nature itself. The resulting artworks are not pictorial records of Pelton's encounters with nature but are evocative equivalents for these emotional experiences.[6] As she wrote in 1929, "These pictures are like little windows, opening to the view of a region not yet much visited consciously or by intention—an inner realm rather than an outer landscape."[7]

In addition, Pelton's "Symbolic Abstractions" reveal the

92. Agnes Pelton (1881–1961), *Challenge*, 1940
 Oil on canvas, 32 × 26 in. (81.3 × 66 cm)
 The Harriet and Maurice Gregg Collection of American
 Abstract Art, museum purchase, Harriet and Maurice
 Gregg Fund for American Abstract Art, 2000.134

influence of the Russian avant-garde artist Wassily Kandinsky. In his famous treatise *Concerning the Spiritual in Art* (1911), Kandinsky advocated the development of a new language of art, one that utilized nonrepresentational form and color to create visual equivalents, not only for physical objects but also for emotions or even sounds. He also encouraged artists to embrace subconscious thoughts as essential components of the creative process and to perceive both animate and inanimate objects as endowed with a spiritual force.[8] Kandinsky did not promote abstraction as an end in itself, but as a liberating means of achieving greater artistic expression.

In 1932 Pelton moved to the desert community of Cathedral City near Palm Springs, California, and developed an increasingly transcendent style of abstraction. Acknowledging her pioneering role as an abstract artist, Raymond Jonson invited Pelton to join the Transcendental Painting Group, founded in 1938 in Santa Fe, New Mexico. Members created abstract works that often were inspired by natural and organic forms, and aspired to capture spiritual essences and truths. Their stated goal was to create an "Art vitally rooted in the spiritual need of these times" that would "carry painting beyond the appearance of the physical world, through new concepts of space, color, light, and design, to imaginative realms that are idealistic and spiritual."[9]

Challenge (1940), perhaps the most abstract of Pelton's "Symbolic Abstractions," may have been inspired in part by the spectacular natural environment surrounding her Cathedral City studio.[10] The pyramidal arrows at the lower left, surrounded by curvilinear, cloudlike forms, may serve as shorthand notation for nearby Mount Jacinto or Mount San Gorgonio and the spectacular weather phenomena these mountains engender. Similarly, the crystalline purity of Pelton's luminous palette appears to capture the transitional moment of dawn or dusk as it dissolves into the luminous glow of daybreak or sundown on the desert horizon.

Pelton was a habitual stargazer and wrote that this pastime conveyed a feeling of "great depth & beauty, serenity & completeness."[11] Describing the emotions triggered by such nocturnal experiences, Pelton wrote ecstatically, "Lately the stars have been nearer again, such nights! Such relationships, such qualities—movements—sounds? I apprehend them dimly—[my] receiving apparatus being so rudimentary, at least consciously. The lovely resonances or whatever they are [make] the stars seem personal like real beings—as no doubt they are."[12]

Pelton's poetic perception of stars as "real beings" reveals the pitfalls of any attempt to identify specific geography or astronomy in *Challenge*. She had explored similar mountain and star themes in works she made before moving to California such as *Star Gazer* (1929) and *Illumination* (1930), which also endowed these ostensibly inanimate subjects with sentient spiritual qualities. In a description of *Illumination* that might equally apply to the principal elements of *Challenge*, Pelton wrote: "The radiant star as a messenger is a symbol of the sudden descent of transcendent light, answering through darkness the rising peaks of aspiration."[13]

"Transcendent light," symbolized by the stars, is the dominant and defining feature of *Challenge*, in which elements are not passively illuminated but are actively giving off light.[14] The conjoined yellow and blue-purple stars may symbolize the planet Venus, which, known as the Morning Star and the Evening Star, is a cyclical harbinger of both day and night. Similarly, the vertical light blue and yellow S curves at the center of *Challenge*, which resemble elongated musical clefs or the sound holes of stringed instruments, also separate light from dark. Pelton wrote that "all my abstractions have to do with light, for light is really all life," while she described color as "a real force, like light itself, and beneficent, as light is."[15]

Pelton's perception of duality in nature is apparent from her use of conjoined double silhouettes for the arrows, stars, and S curves, thus creating a metaphor for the resonant coexistence of physical substance and its spectral or spiritual shadow.[16] The theme of duality also is evocative of replication or of reproductive processes, and the translucent embryonic, spermatozoid, or cellular forms above, beneath, and next to the conjoined stars in *Challenge* recall the more explicit womb and egg imagery in Pelton's symbolic portrait of her mother entitled *Mother of Silence* (1933). In this context, the erect crimson arrow form at the lower left is suggestive both of a phallus and, with its blue-speckled, reptilian surface, of a snake—a related symbol of regeneration and rebirth.[17] This rising male principle is counterbalanced by the adjacent descending stars, which almost certainly represent (as in *Stargazer*) Venus, a female symbol. The serpentine line rising at the lower right, crisscrossed by a diagonal zigzag line that Pelton likened to an oscillating weaving shuttle, may evoke the theosophic "golden thread" of life itself.[18]

Pelton expressed concern that her works, like those of her contemporary (and fellow Arthur Wesley Dow student)

Georgia O'Keeffe, would be subjected to reductive interpretations based on the identification of specific anatomy or biological processes. Acknowledging that occasionally her "visions for paintings develop apparent sex symbols," she wrote, "when a form appears to have a phallic resemblance *use the force it represents without the form*."[19] In *Challenge* Pelton sublimated the primal forms and forces of physical creation within the broader themes of cosmic creation and spiritual enlightenment, thus linking the microcosm with the macrocosm. The arrows at the lower left, the S curves at the center, and the serpentine lines at the lower right connect the terrestrial and the celestial spheres and convey a sensation of ascension. Pelton offers a vision of transcendent spiritual rebirth to viewers who aspire to a higher spiritual state and who are receptive to the challenge. [TAB]

93. CLAUDE CLARK, *Guttersnipe*

THE MAN IN THE STREET

Claude Clark's lifelong commitment to racial and economic equality derived from the hardships of his early life, which prompted him to observe, "as a son of a tenant farmer, I decided early to help in some small way to alleviate the sufferings of humanity."[1] Clark pursued this goal through both personal political activism and his genre paintings of working-class African Americans. Clark's belief that his artwork could be a powerful catalyst for social change is evident in works such as *Guttersnipe* (1942), in which he fused African and African American art traditions to confront the discrepancy between American ideals and the realities he observed in the streets.

Claude Clark (1915–2001) was born in Rockingham, Georgia, where his father worked as a sharecropper. In 1929 Clark's family joined the Great Migration, in which more than two million African Americans sought to escape poverty and racism by migrating from the South to the North between the world wars. Settled in Philadelphia, Clark studied art at the Pennsylvania Museum School of Industrial Art with Earl Horter, Henry Pitz, and Franklin Watkins (1935–39). After graduating, Clark supported himself by working as a printmaker for the Federal Art Project of the Works Progress Administration (1939–42). Also in 1939 Clark began attending classes in art history and aesthetic philosophy at the Barnes Foundation in the Philadelphia suburb of Merion. The founder, Dr. Albert C. Barnes, was best known for his pioneering collection of art by such European modernists as Paul Cézanne, Vincent van Gogh, Henri Matisse, and Pablo Picasso, but he also was among the first Americans to champion the aesthetic value of African art.[2] The Barnes Foundation, which had previously supported such African American artists as Horace Pippin and Aaron Douglas, provided Clark with a fellowship that enabled him to paint full-time (1942–44).

Clark's early paintings, among them *Guttersnipe*, were strongly influenced by his socialist politics and typically focused on working-class men and women.[3] Although *Guttersnipe* was not modeled on a specific individual, the painting's title suggests that it depicts a teenage denizen of Philadelphia's streets.[4] The close-cropped composition, swift execution (the painting was completed in a single session), prominent inclusion of a smoking cigarette, and the subject's diverted gaze convincingly convey the impression of a momentary street encounter. Clark painted *Guttersnipe* on the verso of a carved woodblock that had been salvaged from his W.P.A. print studio and utilized the natural wood color to render the warm skin tones of his subject.[5]

According to Clark, *Guttersnipe* owes its greatest artistic debt to African Baule masks (fig. 93.1), which provided a source for the subject's facial features. Visual similarities include the distinctive depiction of the nose and eyebrows with a single, continuous line, as well as the almond-shaped eyes, prominent mouth, pointed chin, and incised hair (which Clark scratched into the wet pigment with the handle of his brush). While still a high school student in the early 1930s, Clark had sketched the African objects on display at the University of Pennsylvania Museum of Archaeology and Anthropology.[6] After a friend photographed some of these objects, he gave several of the prints to Clark, who later used them when he painted *Guttersnipe*.[7]

Clark's early interest in African art was reinforced by his studies at the Barnes Foundation, where African and European art were accorded equal respect, both in the permanent collection galleries and in the classroom curriculum.[8]

93. Claude Clark (1915–2001), *Guttersnipe*, 1942
 Oil on wood panel, 19⅝ × 16¼ in. (49.9 × 41.3 cm)
 Museum purchase, American Art Trust Fund, 2000.21

Fig. 93.1. Unidentified Baule artist, Ivory Coast, *Kpan Mask*, 20th century. Wood and pigment, 12¾ × 5½ × 5½ in. (32.4 × 14 × 14 cm). Fine Arts Museums of San Francisco. Bequest of Dean C. Barnlund, 1994.28.10

Clark admired Barnes for the high regard in which he held African art, noting, "he was the first collector, to my knowledge, to place the art of Black Africa in an art gallery and not in an ethnic museum. He also placed the paintings of Pablo Picasso side by side with Congo sculpture to document the sources of some of the elements in the paintings of the internationally known Spanish artist."[9]

These didactic juxtapositions, still visible in the Barnes Foundation galleries (fig. 93.2), include Picasso's *Head of a Woman* (1907) and *Head of a Man* (1907), which hang next to wall-mounted African objects and above a glass display case containing additional African objects, including five Baule works.[10] The two Picasso heads demonstrate the Spanish artist's appropriation of African art while working on *Les Demoiselles d'Avignon* (1907) and may have provided additional inspiration for Clark's use of the conjoined nose-and-eyebrow motif, as well as his expressionistic brushwork.[11]

Unlike many modernists, Clark's interest in African art was deeply rooted in issues of cultural identity, an approach shared by a family friend, the African American philosopher Alain Locke.[12] Locke would have seen Clark's use of African art in *Guttersnipe* as a validation of the philosophy he published in his famous anthology, *The New Negro: An Interpretation* (1925), the defining text of the Harlem Renaissance. Locke's influential essay in this book, "The Legacy of the Ancestral Arts," illustrated with reproductions of African art at the Barnes Foundation, urged African American artists to embrace their African art heritage as a source of cultural pride and artistic inspiration.[13]

Locke's message of intellectual, social, and cultural aspiration was influenced by the writings and example of the author, educator, and civil rights leader W. E. B. Du Bois, the first African American to be graduated from Harvard University with a doctorate. In his famous essay "The Talented Tenth" (1903), Du Bois argued that "the Negro race, like all other races, is going to be saved by its exceptional men," the most "talented tenth" of its population. Locke's own stature as Harvard's first African American Rhodes Scholar and a prominent exemplar of "the talented tenth" —a new elite black intelligentsia—shaped his response to Clark's paintings. Viewing a recently completed painting in Clark's studio, Locke exclaimed, "That looks just like a guttersnipe!"—a descriptive promptly adopted by the artist as accurately identifying his subject.[14] As the pejorative connotations of Locke's appellation suggest, *Guttersnipe*

Fig. 93.2. Wall ensemble from Gallery Room XXII, South Wall, Barnes Foundation.

appears to depict a real, rather than ideal, youth—one who projects a strong sense of street style and self-awareness.

Guttersnipe reveals an important shift in Clark's work, from cultural pride to political engagement, by overtly introducing the issue of economic class, a subject that intersected that of race in nearly every aspect of African American life.[15] Clark later summarized the evolution of the African American artist's political consciousness, explaining, "during the Negro Renaissance of the 1920s our Black Image came sharply into focus. During the 1930s the African American artist was engulfed by Social Realism— stating his case about racism, lynching, unemployment and living conditions."[16]

By the time Clark painted *Guttersnipe* in 1942, many Americans had been lifted out of the Great Depression by the economic boom associated with World War II. In stark contrast, poor or unemployed African Americans continued to suffer severe economic hardship that was compounded by racism and discrimination. While Clark shared many of the cultural ideals of Alain Locke, his political perspective was shaped by the realities of working-class African American experience. Clark's *Guttersnipe* thus is less the offspring of Locke, who named the painting, than of the writer Langston Hughes, who articulated the class problem the painting confronts.

In his influential essay "The Negro Artist and the Racial Mountain" (1926), Hughes readily acknowledged the pervasiveness of racism, whether covert, overt, or patronizing. However, he also critically contrasted the "smug, contented, respectable" Negro middle class and its aspiration

to assimilate into American society with the "low-down folks, the so-called common element."[17] As Hughes observed, these working-class African Americans

[f]urnish a wealth of colorful, distinctive material for any artist because they still hold their own individuality in the face of American standardizations. And perhaps the common people will give to the world its first truly great Negro artist, the one who is not afraid to be himself. Whereas the better-class Negro would tell the artist what to do, the people at least let him alone when he does appear. And they are not ashamed of him—if they know he exists at all. And they accept what beauty is their own without hesitation.[18]

Wearing the proud face of an ancestral African mask, Clark's *Guttersnipe* not only challenged middle-class conformity and complacency but also unmasked the discrepancy between America's ideals of equality and economic opportunity and the realities for working-class African Americans.[19] Clark took his messenger—a "guttersnipe"

who embodied both his historical African heritage and his contemporary African American experience—from the streets and introduced him into the realm of the fine arts, where he could confront "the talented tenth" face-to-face. Clark's *Guttersnipe* served as a powerful reminder that this, too, was the face of America, and the visual embodiment of the resounding declaration with which Langston Hughes closed "The Negro and the Racial Mountain":

We younger Negro artists who create now intend to express our individual dark-skinned selves without fear or shame. If white people are pleased we are glad. If they are not, it doesn't matter. We know we are beautiful. And ugly, too. The tom-tom cries and the tom-tom laughs. If the colored people are pleased we are glad. If they are not, their displeasure doesn't matter either. We build our temples for tomorrow, strong as we know how, and we stand on top of the mountain, free within ourselves.[20]

[TAB]

BEHOLD THE MAN

Horace Pippin was one of the most famous American artists to work in the style commonly described as folk art. Unlike many of his African American contemporaries, who sought to break down the barriers of racism by embracing European or Euro-American academic or modernist styles, Pippin remained true to a vision that was deeply rooted in personal and collective African American experiences. Pippin's discovery by the mainstream art world in 1937 coincided with a peaking interest in American folk culture. In the years following World War I, "primitive" or "naïve" folk art had been embraced by artists such as the sculptor Elie Nadelman (an important folk art collector), who appropriated the distilled abstractions of folk art for their own artistic innovations, and by influential collectors such as Juliana Force, Abby Aldrich Rockefeller, and William Edgar and Bernice Chrysler Garbisch.[1]

Pippin's critical success was facilitated by American nationalism, which prompted some critics to reject European modernism in favor of homegrown artists and subjects; and by the perception that folk art represented a handmade, and predominantly rural antithesis—or antidote—to elite urban modernism and the mass-produced products of capitalism. However, Pippin's African American identity elicited commentary that mingled patronizing praise with racist stereotypes. The famous illustrator N. C. Wyeth believed that Pippin's work had "a basic African quality; the jungle is in it. It is some of the purest expression I have seen in a long time, and I would give my soul to be as naïve as he is."[2] Dr. Albert C. Barnes, director of the Barnes Foundation who collected European modernist art and provided fellowships for African American artists, wrote that Pippin's works "have their musical counterparts in the Spirituals of

the American Negro."[3] Pippin's own perception of his work provides a pithy counterpoint to these imposed interpretations: "I don't do what these white guys do. I don't go around here making up a whole lot of stuff. I paint it exactly the way it is and exactly the way I see it."[4]

Horace Pippin (1888–1946) was born in West Chester, Pennsylvania, and grew up in the village of Goshen, New York. His first art experience occurred in 1898, when he made a series of religious drawings with art materials that he won by copying a drawing for an art contest sponsored by a magazine.[5] At the age of fourteen, Pippin left school to help support his family, working variously as a hotel porter, a moving company packer, and an iron molder. Motivated by patriotism, he enlisted in the United States Army in 1917 and served in a segregated African American regiment during World War I. Wounded by a German sniper's bullet in 1918, Pippin returned in 1920 to his native West Chester, where he married and lived until his death. Although he made some sketches during his army service, Pippin did not create his first painting until 1928. In 1937 the Pennsylvania critic, collector, and art dealer Christian Brinton discovered Pippin's work and successfully promoted it to influential critics, curators, and collectors.[6]

Horace Pippin's John Brown trilogy (1942), perhaps his most famous series of works, was inspired by his mother's eyewitness oral account of the famous abolitionist martyr being taken to his hanging in Charles Town, Virginia, on 2 December 1859.[7] On the previous 16 October, Brown and twenty-one followers had seized the federal arsenal at Harper's Ferry, Virginia (now West Virginia), hoping to inspire a general rebellion among enslaved African Americans. As the raid unraveled, Brown and six survivors made

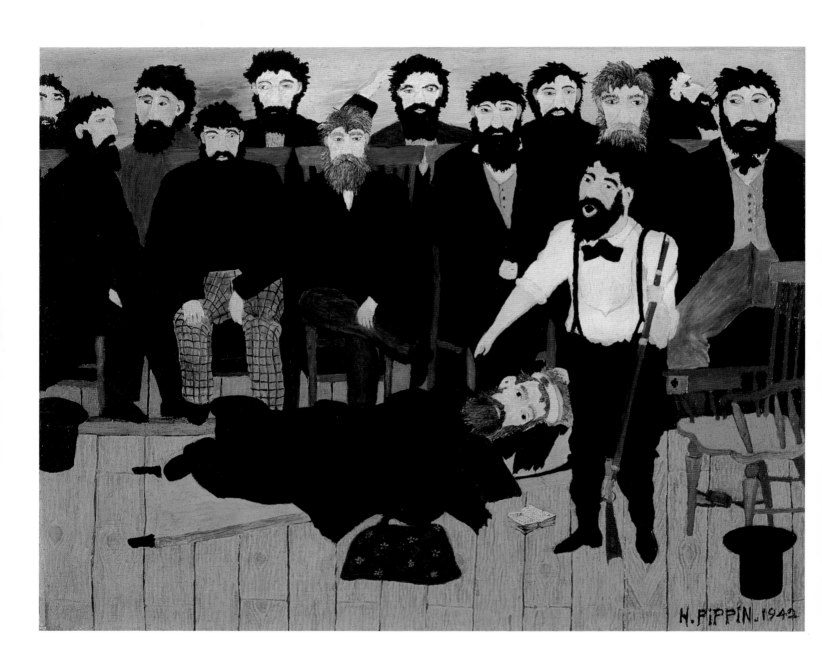

94. Horace Pippin (1888–1946), *The Trial of John Brown*, 1942

Oil on canvas, 16½ × 20⅛ in. (41.9 × 51.1 cm)

Gift of Mr. and Mrs. John D. Rockefeller 3rd, 1979.7.82

a last stand before being captured by U.S. troops commanded by Colonel Robert E. Lee. Revealingly, Pippin's John Brown trilogy does not depict the climactic moment of John Brown's armed uprising but rather its prelude and its aftermath. By focusing on Brown's spiritual calling and his ultimate sacrifice, Pippin's sequential narrative evokes a religious narrative in which a martyr's preordained fate must be stoically enacted.

Pippin's *John Brown Reading His Bible* (fig. 94.1) introduces the protagonist and sets the stage for the ensuing drama. Brown sits bolt upright, his steely gaze directed downward to his open Bible, as if absorbing a scriptural revelation. The strong horizontals (cabin logs and table planks) and verticals (cabin door and window curtain) seem to mirror the righteous rectitude of Brown and his biblically inspired mission. The single candle, representing determination in Pippin's later painting *Lincoln's First Book* (1944), here also symbolizes spiritual enlightenment.

John Brown Going to His Hanging (fig. 94.2), the largest canvas of Pippin's trilogy, depicts the fulfillment of Brown's destiny to serve as a martyr for the abolitionist cause. Like the slaves whom he sought to free, Brown, seated on his pine coffin and with his arms bound, will find liberation only in death. The bleak winter scene, framed by three oak trees with withered leaves, accurately conveys this nadir of the abolitionist cause. The viewer's perspective is that of a spectator in the crowd, shoulder to shoulder with the two jeering men at the left, who are complicit in the proceedings. In the right foreground, just above Pippin's signature, an African American woman—no doubt Pippin's mother—turns her back on the sad spectacle and confronts the viewer. The only African American eyewitness in the John Brown series, she looks apprehensively to her left, perhaps toward the hanging scaffold.

The Trial of John Brown (1942) depicts the Northern abolitionist's judgment in a Southern court of law, where he was indicted on 26 October 1859, placed on trial the next day, and sentenced to death by hanging on 2 November. Brown, who suffered a head wound when he was captured, is accurately depicted as being tried while lying on a stretcher.[8] The open Bible that played a prophetic role in the first scene of the trilogy lies beside him, as does a carpetbag filled with incriminating correspondence between Brown and his supporters.[9] The bearded prosecutor, who has risen from his armchair, holds Brown's rifle in his left hand, while pointing an accusing finger at the supine Brown with his right hand.[10] The implacable jury, composed of twelve

Fig. 94.1 [top]. Horace Pippin (1888–1946), *John Brown Reading His Bible*, 1942. Oil on canvas board, 16 × 20 in. (40.6 × 50.8 cm). Formerly the Crispo Collection, Charleston, South Carolina

Fig. 94.2 [above]. Horace Pippin (1888–1946), *John Brown Going to His Hanging*, 1942. Oil on fabric, 24 × 30 in. (61 × 76.2 cm). Pennsylvania Academy of the Fine Arts, Philadelphia. John Lambert Fund, 1943.11

nearly identical, bearded white men, confronts the viewer as they sit in judgment. The juror at the far right, whispering in the ear of his shifty-eyed colleague, reinforces the viewer's sense of collusion in this trial, whose guilty verdict was a foregone conclusion.

A comparison of Horace Pippin's *The Trial of John Brown* (1942) with Thomas Hovenden's *The Last Moments of John Brown* (pl. 52), of 1884, reveals the defining role of artists and their intended audiences in the creation and interpretation of artworks. Although both paintings utilize Christ imagery, they differ fundamentally in their treatment of similar subjects. Hovenden's composition resembles traditional depictions of Christ presented to the people, an association reinforced by the crucifix form behind Brown's head, made of the vertical barrel of a gun and the horizontal belt on the left and the dark red brick on the right. Pippin's John Brown, wearing a bloody bandage around his head, resembles the artist's earlier image of the suffering *Christ Crowned with Thorns* (1938).[11] In addition, Pippin's first biographer noted the resemblance of Brown's bearded jury and prosecutor to traditional depictions of Christ's twelve apostles and the solitary traitor, Judas.[12]

While Hovenden's John Brown is a triumphant, larger-than-life martyr calmly going to his execution, Pippin's John Brown is a diminutive, wounded man at the mercy of a morally corrupt society that condoned slavery. Hovenden's iconic image resembles the central painting in a large religious altarpiece, while Pippin's John Brown trilogy recalls early Renaissance predella panels that often depict the life of an ordinary man or woman before their martyrdom and beatification.

Pippin's twentieth-century image of John Brown, a nineteenth-century martyr for African American civil liberties and rights, had contemporary resonance. Despite John Brown's sacrifice (1859), the Civil War (1861–65), and Abraham Lincoln's emancipation of enslaved African Americans (1863), institutionalized Jim Crow racism proliferated in the decades following the Civil War. Volunteering to defend democracy in World War I, Pippin was compelled to serve in a segregated unit, the famous 369th Infantry "Harlem Hellfighters" Regiment.[13] In 1942 Pippin's image of a Southern jury composed of twelve white men told a truth that had ongoing relevance for African Americans, perhaps most famously for the Scottsboro Boys, who were repeatedly convicted in the 1930s for a crime they had not committed.[14]

It is not a question of determining which image of John Brown is more "true," but rather of acknowledging that these images reveal different truths for different audiences. Twenty-five years after Brown's death, Hovenden depicted an empowered John Brown whose prophecy of freedom supposedly had been vindicated by, and for, many of the painting's Reconstruction-era viewers. Nearly a hundred years after Brown's death, Pippin's downtrodden freedom fighter, faithful to God and to the cause of African American liberation but helpless in the hands of his enemies, presented a picture that was all too familiar to many of Pippin's contemporaries. [TAB]

THE MYSTERY AND
MELANCHOLY OF A STREET

Ben Shahn (1898–1969) was one of the most politically engaged Social Realist artists who rose to prominence during the Great Depression of the 1930s. Seeking to create a populist "art of and for the people," Shahn fought for political and social justice through his empathetic depictions of immigrants and workers.[1] His extensive travels as a government photographer through the South and Midwest in the mid-1930s inspired a gradual shift in his work "from what is called 'social realism' into a sort of personal realism."[2] A decade later, the horrors of World War II, the Holocaust, and the atomic bomb triggered a final shift to symbolic works in which he sought "to tap some sort of universal experience, to create symbols that will have some such universal quality."[3]

Shahn's realism drew inspiration from the simplicity, sincerity, and storytelling power of early Italian Renaissance artists such as Giotto, and from the reportorial directness of contemporary newspaper and documentary photographs.[4] Shahn observed that "the concern, the compassion for suffering—feeling it, formulating it—has been the constant intention of my work since I first picked up a brush,"[5] and his protagonists often are characterized by a sense of physical isolation and emotional introspection. Shahn channeled his compassion into his belief that "the work of art is a product of the human spirit and that, conversely, the function of the work of art is to broaden and enrich the human spirit."[6]

Benjamin Hirsch Shahn was born in the city of Kovno (Kaunas) and grew up in the small town of Vilkomir, both within the "Pale of Settlement" to which Jews were relegated by law in Russian Lithuania. Shahn's childhood experience of both anti-Semitism and religious orthodoxy instilled a lifelong resistance to injustice in any form.[7] His father, an anti-czarist socialist who was exiled to Siberia, eventually immigrated to New York, where his family joined him in 1906. Shahn's nascent art skills were honed by his apprenticeship (1913–17) as a commercial lithographic engraver. However, despite his studies at New York University (1919–20), City College (1920–22), and the National Academy of Design (1921), as well as trips to Europe and North Africa (1925 and 1928–29), Shahn did not find his true artistic calling until after he returned to America in 1929.

Shahn first gained fame in 1932 with the exhibition of *The Passion of Sacco and Vanzetti* (1931–32), a series of gouaches that critiqued the controversial trial and execution of the Italian immigrant anarchists Nicola Sacco and Bartolomeo Vanzetti.[8] An ardent supporter of President Roosevelt, Shahn worked as a graphic designer and photographer for several depression-era New Deal agencies, including the Public Works of Art Project, the Federal Art Project, the Resettlement Administration, and the Farm Security Administration. He also implemented his populist vision of art through public mural commissions for the Jersey Homesteads (1937–38) in Roosevelt, New Jersey; the Bronx Central Annex Post Office (1938); and the Social Security Building (1940–42) in Washington, D.C.

Ohio Magic (1945), one of the World War II–era works in which Shahn sought "to tap some sort of universal experience," had more prosaic origins in several of his own

95. Ben Shahn (1898–1969), *Ohio Magic*, 1945
 Tempera on paperboard mounted on hardboard panel, 26¾ × 39⅜ in.
 (68 × 100 cm). Mildred Anna Williams Collection, 1948.14

earlier photographs.[9] The street scene is adapted from a trompe l'oeil painting (fig. 95.1) on a brick wall adjoining a SOHIO gas station in downtown Warren, Ohio.[10] Shahn made several changes in the painting, narrowing the street, altering some of the buildings, and replacing the vertical SOHIO sign with a window. Shahn also replaced the pickup truck with a hand-cranked, pre–World War I yellow passenger bus that he appropriated from a New York sideshow banner (fig. 95.2).[11] The trompe l'oeil painting of a flower basket is derived from a storefront window at 100 Walton Street in Brooklyn (fig. 95.3), near Shahn's childhood home at 111 Walton Street.[12] Finally, the image of the young boy in the window is derived from a portrait of Shahn's son Ezra (fig. 95.4), whom he also photographed on Walton Street.

At first glance, Shahn's *Ohio Magic* appears to be a pictorial ode to Main Street America—the communal heart of every large town or small city.[13] Yet this main street is eerily empty, devoid of building signs and numbers, traffic lights and stop signs, passenger cars and commercial trucks, or even pedestrians. So many major elements are omitted that the absence of any doors on the left side of the street seems but a minor detail. The only human presence is confined to a pre–World War I hand-cranked bus, a technological dinosaur that appears to be magically frozen in time in the surrealistic brick wall.[14] Like the mythical "Main Street, U.S.A.," this trompe l'oeil scene seems to exist as much in memory—or in the imagination—as in reality.

However, Shahn's view of a desolate street had European precedents, most notably in the proto-surrealist metaphysical paintings by the Italian modernist artist Giorgio de Chirico. Works such as *Mystery and Melancholy of a Street* (1914, private collection), which depicts a solitary girl rolling a toy hoop down a narrow street flanked by two arcaded buildings, suggested that even inanimate architecture or objects could preserve memories and project a psychological mood. Shahn especially admired de Chirico for his ability to bridge the personal and collective unconscious through such imagery, stating, "In art, the symbol which has universality may be some figure drawn from the most remote and inward recesses of consciousness; for it is here that we are unique and sovereign and most wholly aware. . . . I think of a Chirico figure, lonely in a lonely street haunted by shadows, its loneliness speaking to all human loneliness."[15]

Although the trompe l'oeil street mural in Warren, Ohio, existed, Shahn must have been struck by its visual kinship with de Chirico's enigmatic, stagelike street

Fig. 95.1 [top]. Ben Shahn (1899–1969), *Untitled (Warren, Ohio)*, 1937. Gelatin silver print, 7⅜ × 9½ in. (18.8 × 24.2 cm). Ben Shahn Papers, Archives of American Art, Smithsonian Institution, Washington, D.C.

Fig. 95.2 [above]. Ben Shahn (1899–1969), *Untitled (Eighth Avenue and Forty-second Street, New York City)*, 1932–35. Gelatin silver print, 5⅞ × 9 in. (14.9 × 22.9 cm). Courtesy of the Fogg Art Museum, Harvard University Art Museums. Gift of Bernarda Bryson Shahn, P1970.3038

Fig. 95.3 [top]. Ben Shahn (1899–1969), *Untitled (Walton Street, Brooklyn, New York City)*, Fall 1936–Spring 1937. Gelatin silver print, 6¾ × 9½ in. (17 × 24.3 cm). Ben Shahn Papers, Archives of American Art, Smithsonian Institution, Washington, D.C.

Fig. 95.4 [above]. Ben Shahn (1899–1969), *Untitled (Ezra Shahn, Walton Street, Brooklyn, New York City)*, Fall 1936–Spring 1937. Digital positive from original 35 mm negative. Fogg Art Museum, Harvard University Art Museums. Gift of Bernarda Bryson Shahn, P1970.4378.1

scenes.[16] As an artist who drew pictorial inspiration from ancient Rome and the Italian Renaissance, de Chirico embodied the continuity of Italian culture that had been endangered by World War II. Shahn noted that Italy came to symbolize all of Europe in his wartime works, which drew on documentary photographs he viewed while working for the U.S. Office of War Information in 1942–43: "There were the blurred pictures of bombed-out places, so many of which I knew well and cherished. There were the churches destroyed, the villages, the monasteries—Monte Cassino and Ravenna. At that time I painted only one theme, 'Europa,' you might call it. Particularly I painted Italy as I lamented it, or feared that it might have become."[17]

The melancholy air of *Ohio Magic* is reinforced by the trompe l'oeil floral arrangement on the painted-out shop window, a personal memorial that is projected into the public realm. The Italian inscription, "Riuniti nel nome di Gesu" (reunited with the Lord), visible above the floral arrangement in one of Shahn's original source photographs of the Walton Street shop window, confirms its funereal context.[18] This image may have had deep personal associations for Shahn, since the Italian family who rented the ground floor of the Shahn house on Walton Street had asked Shahn's woodcarver father to carve a memorial altarpiece for a son who had drowned. Shahn's mother blamed the artist for the accidental drowning of his brother in 1926, and her death in 1944 may have revived those sad memories.[19]

In 1945, as Allied troops continued on the offensive on both the Pacific and the European fronts, floral tributes to the war dead became a familiar sight across the United States. As the painting's title and the American flags on the bus suggest, *Ohio Magic* is ostensibly an American subject, but it is suffused with the inescapable undercurrent of the war in Europe, which pervaded Main Streets across the country.[20] Describing the impact of the war on the small town of Bedford, Virginia, which lost twenty-three men, one resident recalled, "Bedford after the war was the calmest, quietest little town there was. It was sad. Everything just looked so sad. You take a small town like this. . . . Everything seemed so still, like going to a church funeral. How quiet the streets were."[21]

Shahn's street-level basket of cut flowers is contrasted with the second-story window box, which holds a living ivy vine, a symbol of immortality often associated with the dead. Two seed packets identify the new plants that will eventually grow.[22] The young boy, whose likeness is derived

from Shahn's photograph of his son, also resembles Shahn's self-portrait in *Portrait of Myself When Young* (1943) and may be seen as an autobiographical surrogate.[23] Children play key roles in Shahn's World War II paintings, such as *Cherubs and Children* (Whitney Museum of American Art, New York, 1944), in which the four children sprawled on the ground in a blasted European urban landscape are innocent victims of adult violence.[24] In *Liberation* (Museum of Modern Art, New York, 1945), three children frantically swinging from a pole near a bomb-blasted building are resilient survivors, clinging to life amid the ruins of war.[25] In *Ohio Magic*, Shahn's solitary child surrogate appears to be suspended between a miragelike past, represented by the flag-bedecked bus, and an uncertain future, represented by the empty blue void around the corner.

Recalling the evolution of his World War II–era works, Shahn noted, "A symbolism which I might once have considered cryptic now became the only means by which I could formulate the sense of emptiness and waste that the war gave me, and the sense of littleness of people trying to live on through the enormity of the war."[26] Also implicit is the incomprehensible horror of the Holocaust, which destroyed the lives of six million men, women, and children, emptied entire towns and villages, and subverted morality, justice, and even the foundations of faith itself.[27] In this context, Shahn's poetic description of an earlier painting might equally be applied to the empty street in *Ohio Magic*: "It's an emptiness of something that was there before."[28]

[TAB]

TRAVELING THE LANDSCAPE
OF SMALL-TOWN AMERICA

Edward Hopper (1882–1967) worked as a commercial illustrator in New York City for nearly two decades before establishing a successful career as a painter.[1] His years in illustration were not always easy. As he explained during a 1955 interview, "Illustrating was a depressing experience. And I didn't often get very good prices because I didn't often do what they wanted."[2] Hopper, who became known for his haunting urban landscapes and quiet views of small-town America, found it difficult to produce the exuberant images favored by editors and advertising executives. In 1935, ten years after abandoning illustration work, he recalled, "I was always interested in architecture, but the editors wanted people waving their arms."[3] In contrast, the urban scenes presented in his paintings and etchings rarely contain more than one or two somber, isolated figures. Architecture, rather than human narrative, was the evocative focus of Hopper's creative vision, serving as a dynamic setting in which to project mood.

Hopper's spare and often desolate views of modern American life led many critics to group him with such Regionalist artists as Thomas Hart Benton (1889–1975), John Steuart Curry (1897–1946), and others commonly referred to as "American Scene" painters, due to their interest in rural motifs and characteristically American subject matter. Hopper noted his objection to this grouping in an interview with the art critic Brian O'Doherty: "I never tried to do the American scene as Benton and Curry and the Midwestern painters did. I think the American scene painters caricatured America. I always wanted to do myself.... The American quality is in a painter. He doesn't have to strive for it."[4]

In his own turn as critic, Hopper wrote an assessment of his fellow artist Charles Burchfield—who also painted everyday American subjects—which stands as a fitting description of the views of America Hopper himself captured:

> From what is to the mediocre artist and unseeing layman the boredom of everyday existence in a provincial community he has extracted a quality that we may call poetic, romantic, lyric, or what you will. By sympathy with the particular he has made it epic and universal. No mood has been so mean as to seem unworthy of interpretation; the look of an asphalt road as it lies in the broiling sun at noon, cars and locomotives lying in God-forsaken railway yards, the steaming summer rain that can fill us with such hopeless boredom, the blank concrete walls and steel constructions of modern industry, midsummer streets with the acid green of close cut lawns, the dusty Fords and gilded movies—all the sweltering tawdry life of the American small town, and behind all, the sad desolation of our suburban landscape. He derives daily stimulus from these that others flee from or pass with indifference.[5]

In these words, as in his art, Hopper transforms the desolate landscape of suburban life as he describes it. Like Burchfield, he does not simply flee or pass scenes of everyday existence; instead, they become the focus of his attention. In paintings such as *Portrait of Orleans* he presents the suburban landscape from a very American vantage point, as seen from a passing automobile.

When Hopper painted *Portrait of Orleans* in 1950, thirty years after widespread use of motor vehicles began, the

96. Edward Hopper (1882–1967), *Portrait of Orleans*, 1950
 Oil on canvas, 26 × 40 in. (66 × 101.6 cm)
 Gift of Jerrold and June Kingsley, 1991.32

automobile was firmly established as a characteristic and prevalent feature of American life. In 1945 almost twenty-six million cars were registered in the United States. That year Americans drove more than two hundred fifty billion miles and owned more than 75 percent of all cars and trucks in the world.[6] Increased use of automobiles fostered a new relationship with roadside scenery. Car travel made it possible to stop, start, or change the sequence of passing images through the touch of a pedal or the turn of a wheel and structured the landscape in terms of movement and obstacles. The vantage point of the motorist—predetermined by the height of the automobile, its position in the street, and the dimensions of the windshield and window glass—was entirely different from that offered by earlier forms of transportation.[7] By the time Hopper painted *Portrait of Orleans*, the motorist's view of the passing scenery was no longer the novelty it had been during the first boom in car travel in the 1920s; instead, it had become yet another aspect of the "sweltering tawdry life of the American small town" that he associated with Burchfield's work and sought to capture in his own.

One of the first major purchases made by Edward Hopper and his wife, Jo—who was also a painter—was the secondhand Dodge they acquired in 1927, three years after their marriage.[8] The two frequently took road trips, visiting both famous attractions and ordinary places in New England, the South, the Far West, and Mexico. Hopper found driving inspirational, and on long trips he often sketched from the backseat of the car. When Hopper purchased another secondhand automobile—this time a 1954 Buick —in the mid-1950s, he paid $160 to have its green-tinted glass windshield and windows replaced with clear glass, suggesting careful attention to the particularities of the view offered from the vehicle.[9] In several of his works, including *Haskell's House* (1924), *Street Scene, Gloucester* (1934), *East Wind over Weehawken* (1934), *Rooms for Tourists* (1945), and *Portrait of Orleans*, the motorist's specific orientation from the street is a primary element of the composition.[10]

Hopper was particularly fond of traveling by car through rural New England, and he often drew subjects for his paintings from the roadside architecture and small towns he and Jo encountered on their drives.[11] The couple began summering on Cape Cod in 1930, and in 1933 they designed and started to build a house of their own in Truro (it was completed in 1934). The Hoppers chose the Cape because it stayed warm longer than Maine or Cape Ann, and they generally remained there until the end of October, when they returned to their apartment in New York City.[12] The Hoppers were among many artists who established homes in coastal Massachusetts, further enhancing the area's tourist appeal. Two maps of the area drawn by Jo suggest the frequency with which Hopper painted the rural New England landscape surrounding their home during their summers at the Cape. According to the notations on the maps, most of Hopper's subjects were drawn from sites between Orleans and Provincetown, concentrated especially in the area around South Truro.[13]

The Hoppers built their home in Truro at a time when automotive travel was profoundly changing the New England landscape. In the 1920s and 1930s recreational motoring began to be promoted in guidebooks, and in 1935 the Bourne and Sagamore Bridges were constructed, facilitating the entrance of cars to the Cape.[14] Cars allowed vacationers to tour the entire region rather than staying at a single resort hotel or summer colony, and they quickly became a popular mode of travel for tourists. In response to an increase in vehicular traffic on the Cape in the early twentieth century, the state highway, Route Six, was paved with tar in 1913. By the 1930s, when the Hoppers built their home in Truro, planning had begun for an additional divided highway down the middle of the Cape (the Mid Cape Highway), which would spread development inward from the shoreline and speed travel to the outer Cape for both vacationers and residents.[15] In the 1950s the growth and expansion ushered in by the new highway prompted preservation efforts, which led to the designation of historic districts and the passage of a bill in 1961 that created the Cape Cod National Seashore.[16]

By the time the preservation movement began, the spread of car culture had already brought dramatic changes to New England roadside scenery. As in other regions, New England highways were increasingly lined with roadside signs and billboards and the boldly self-promotional architecture of nationally franchised enterprises. Oil companies were among the first businesses to align their corporate identity with consistent and recognizable signage and architectural styles. In the late nineteenth century, gas was sold with relative anonymity through existing outlets such as carriage, feed, hardware, and grocery stores. By World War I roadside pumps associated with specific companies had become common, and in the early 1920s, oil companies began building pattern book service stations that presented a unified corporate identity throughout their sales regions.[17]

Fig. 96.1. Edward Hopper (1882–1967), *Gas*, 1940. Oil on canvas, 26¼ × 40¼ in. (66.7 × 102.2 cm). The Museum of Modern Art, New York. Mrs. Simon Guggenheim Fund, 577.1943

Hopper's most sustained exploration of service station architecture is his painting *Gas*, completed in 1940 (fig. 96.1). In a letter written to Hopper's sister, Marion, in September of that year, Jo explained, "Ed is about to start a canvas—an effect of night on a gasoline station. He wanted to do one for years."[18] The painting depicts a rural service station at late twilight. Its distinctive "Mobilgas" sign is lit from above, and light cast by bulbs on the pumps and from the windows and doorway of the boxy, houselike service station building—a structure typical of the 1930s and 1940s before self-service stations began to appear—casts shadows across the pavement.[19] A lone attendant stands beside one of the pumps, easily overlooked as the eye is drawn past the service station—though it seems initially to be the painting's subject—toward the darkened, vanishing highway in the distance.

Hopper later told the art historian Lloyd Goodrich that he had had something particular in mind for the painting and had not been able to find a filling station like it to study. As a result, he made one up out of parts of several,

composing the painting in his studio and often referring back to "the fact," by consulting various studies he had made of actual pumps and gas station architecture.[20] In another letter to Marion, Jo explained that one of the greatest difficulties with the painting was finding the proper lighting: "He's doing a filling station—a twilight, with the lights over the pumps lit. And when we go to look at them—around here, they aren't lit at all. They're not wasting Elec. til it's pitch dark, later than Ed wants." As a result, he had taken to "painting in the studio entirely now."[21]

Since the 1930s, Hopper had frequently worked from memory in his studio rather than directly from his subject. The difficulty of matching an actual scene with the picture in his mind that he wished to paint increasingly led him to develop composite scenes. By the time *Gas* was painted, this had become standard practice, and he used this method in composing *Portrait of Orleans* as well.[22] On 15 August 1950 Jo noted in her diary that Hopper had settled on a subject for the painting: "the main street intersection in Orleans with A&P Market outside, dress shop, etc." Two

days later, she recorded that he had "the corner of Route 6 & the Main St. of Orleans . . . down in blue paint!"[23]

The architecture in the picture seems to have been recorded with relative fidelity to the actual streetscape of Orleans, a small town in southeastern Massachusetts, situated at the elbow of Cape Cod. Originally known as South Parish of Eastham when it was settled in 1644, Orleans became incorporated in 1797. In the middle of the twentieth century, the town's population increased dramatically, nearly doubling between 1940 and 1960. In 1950, when *Portrait of Orleans* was completed, the population of Orleans hovered at nearly two thousand residents, a number that rose substantially during the summer months, when an influx of tourists visited the town, stopping there or passing through on the way to the Outer Cape.[24]

Although Orleans was an important nineteenth-century center for fishing and salt mining, by the time Hopper began painting there, its economy focused on tourism. The town provided services for passing travelers and offered a glimpse of historic New England architecture and vanishing small-town life. It was this romantic idea of Orleans as a part of vanishing New England that led to Hopper's interest in the town. He completed seven extant sketches (in private collections) in preparation for *Portrait of Orleans*, but the effect of the scene was developed back in his studio, formulated to match a picture of the town that existed in Hopper's mind. As Jo noted on 7 September, "E. has given up finding an evening sky in Orleans, so faked one of his own. Brings picture together to get a sky." A few days later the couple traveled the Cape by car in search of an evening sky to study, "riding about enough for E. to decide there wasn't going to be any sky he wanted for his canvas."[25]

Although Hopper carefully studied the architecture along Main Street in preparation for the painting, only one of the businesses along the intersection can be identified: the Esso station, announced by its prominent sign at the right of the canvas. The town is quiet. Two cars are parked in the distance, and another appears poised to round a corner and approach the intersection at the foreground of the painting. A single woman in a green dress walks along the sidewalk, her back to the viewer. A clock on the building ahead of her reads seven o'clock. While Jo's notes about Hopper's work on the painting suggest that it is a late summer evening, the emptiness and silence of the streets are reminiscent of Hopper's *Early Sunday Morning* (Whitney Museum of American Art, New York, 1930).

The scene is painted from the vantage point of an automobile at the intersection—perhaps about to turn and pass the Esso station at the right—and emphasizes the filling station as a landscape element of particular importance for passing motorists. Motoring motifs such as signs, gas stations, cars, and road directions had been of interest to artists since the 1920s, when the use of cars first became widespread. The Parisian Surrealist Louis Aragon wrote half seriously and half ironically of the quasi-religious nature of roadside "idols" in *Le Paysan de Paris* (1926), and in the 1920s and 1930s Stuart Davis (1894–1964) frequently included signs as both design elements and rebuslike guides to meaning in his paintings.[26] For Hopper, however, the emphasis on the Esso sign—rendered here far more clearly and prominently than the station sign pictured in *Gas*— seems to have more to do with creating a sense of place and evoking the motorist's fleeting experience of a particular landscape. In this he was in sympathy with Ben Shahn (1898–1969), who described hand-lettered signs as "a folk art of great quality, and one that was extremely amusing as well. . . . I loved using these signs as parts of paintings. Not only is there a certain structural character in letters—any letters—but there is also a flavor and sense of place."[27]

Filling stations bearing the name Esso—an acronym for Eastern States Standard Oil and also the phonetic spelling of "SO," the original shorthand for John D. Rockefeller's oil refining organization, Standard Oil—were among the most prominent features of the motorist experience along the eastern seaboard in the mid–twentieth century. (Standard Oil was broken into several separate companies—including Esso—under the Sherman Antitrust Act in 1911. Esso later became known as Standard Oil of New Jersey and, ultimately, Exxon Mobil.[28]) The corporatization and homogenization of small-town America, signified by the bold presence of corporate franchises such as Esso, were among the conditions of American life Hopper was most interested in painting. He recognized that the American landscape was changing, and in *Portrait of Orleans* he documented the transformation of a quaint New England streetscape from the wistful, vanishing viewpoint of a passing motorist. As a 1956 profile of the artist published in *Time* explained, "In Hopper's quiet canvases, blemishes and blessing balance. . . . He presents common denominators, taken from everyday experiences, in a formal, somehow final, way. The results can have astonishing poignancy, as if they were familiar scenes witnessed for the very last time. 'To me,' says Hopper, 'the important thing is the sense of going on. You know how beautiful things are when you are traveling.'"[29]

[AG]

MYSTERIOUS ANCESTOR

Charles Howard garnered national and international acclaim in the 1930s and 1940s for his surrealist-inspired abstract paintings. Surrealism, originally a literary and artistic movement founded in France in the mid-1920s devoted to investigating and representing the unconscious, inspired artists on both sides of the Atlantic to take an interest in the psychoanalytical writings of Sigmund Freud and Carl Jung, the latter especially popular among artists in the United States. Although Howard did not state any particular allegiance to Jung's theories of the collective unconscious, he believed that by fusing the radical content of Surrealism and time-honored methods of composing and executing paintings, he could create powerful abstractions that held a universal meaning. "I am dealing with material which is the possession of all people," he explained in an article he published in 1946, "presenting it with the fundamental anonymity of a human being on the face of the earth. I make pictures with shapes common to man anywhere, of any race, of any generation, regardless of time."[1]

Charles Houghton Howard (1899–1978) did not set out to become a modern painter. He grew up in Berkeley, California, where his father, a professor of architecture and architect-in-charge at the University of California, and his mother, a former art student, instilled in him and his siblings a love of literature and the visual arts.[2] Howard studied journalism as an undergraduate, followed by graduate course work in English. In 1924 he traveled to Europe, where he experienced a career-changing epiphany. While journeying by train from Venice to Milan, he stopped at a picturesque village to see a painting of the Madonna by the Italian Renaissance master Giorgione. Howard later recalled that Giorgione's synthesis of "the somber, analytical, philosophical approach of the Florentine painters" and the

"free, warm, romantic fervor" of the Venetians came as such a revelation that it made him "violently ill."[3] From that day on, Howard devoted himself to becoming a painter who, like Giorgione, brought together the two great impulses in art: the rational and the romantic.

In 1926 Howard moved to New York City, where he lived for seven years before moving to London in 1933 with his wife, the English painter Madge Knight.[4] During the 1930s his abstract paintings were praised by critics, art dealers, and museum curators, and his works were included in a number of important exhibitions on both sides of the Atlantic.[5] With a war being fought in Europe, in 1940 he and Knight moved back to the United States, settling in San Francisco, where they were welcomed into a vibrant art scene that, at least according to one contemporary, surpassed that of New York.[6] In 1946, after the war ended, the couple returned to England and eventually moved to Italy.

The Progenitors (1947) is a painting of biomorphic and spiky forms rendered in a flat, hard-edged style. Looking very closely, one sees a primitive life form silhouetted against the work's steely blue ground and surrounded by jagged shards of light and shadow. A purple-and-black insectile head, sprouting black ribbonlike antennae and kinky black feelers, appears at the top center of the painting. This head rests atop a thin neck composed of a pair of calligraphic black lines that descend, swell, and separate to become the two halves of a skeletal torso. Bladelike shoulders, connected internally by three irregularly shaped ribs, narrow to form a wasp waist. Below, red-and-white propeller or insect wing shapes balloon out to reveal a puckered orifice, its opening crisscrossed by twisted filaments forming a filter through which we see a blue void. Around the edges of the propeller/wing forms, black spiky fins line up,

97. Charles Houghton Howard (1899–1978), *The Progenitors*, 1947
Oil on canvas, 24⅜ × 34½ in. (62 × 87.7 cm)
Mildred Anna Williams Collection, 1948.13

their leading edges oriented toward the orifice, the focal point of the composition.

The imagery of *The Progenitors* originated in the artist's study of both nature and the man-made environment. For Howard, making a painting was a process that began with "many small drawings, automatic and otherwise. I make a lot of these drawings in my head. It isn't a question of copying, *but of remembering*."[7] He discovered the subjects for these drawings everywhere, but rather than focus on the obvious, Howard trained himself to pick out the minuscule and the marginal, in his words, the "waste things, the amiable objects that people throw away, the shapes left over after the fine, neat arbitrary palaces of our civilization have been made."[8] Thus, we can imagine that the insect imagery, the biomorphic shapes, and the orifice in *The Progenitors* came from the artist's informal but passionate interest in insect and mammalian physiology, from which he selected forms that are either so small we do not usually notice them or those that remain out of sight.[9] On the other hand, the cool metallic colors, the propeller shapes, the irregular beams of light, and the flat, spiky forms—which evoke the scraps of sheet metal that might litter the floor of a machine shop—may have had their origins in the shipbuilding yard where Howard worked during World War II.[10]

Needless to say, Howard did not represent the objects and forms in *The Progenitors* exactly as he saw them or as he remembered them. Nor did he represent them in a context remotely similar to the ones in which he must have encountered them. Instead, he was able to distill from particular objects their salient forms by pursuing a multistep process. Howard did not sit down and deliberately start a painting; rather, the idea for one came to him in the form of "a tiny spark, a flash, [or] a momentary passion" in which the many different forms he had seen and remembered coalesced into a meaningful composition.[11] With his composition in mind, he then made "literally hundreds" of preparatory drawings, in which "every line, shape, color, gradation is screened and caressed."[12] Only after he had a blueprint for the finished painting in hand did he apply paint to canvas, employing the meticulous, hard-edged style we see here. Precisely because he employed a process in which the forms he had observed in nature and the man-made world came together intuitively, and because he edited and massaged his imagery until he approved of it, did he succeed in breaking the normative associations we have with specific forms and reconfigured them within a new and, for Howard, more meaningful visual syntax.

This working method drew on surrealist techniques, yet it enabled Howard to create paintings with more universal themes than his Surrealist counterparts. One of the major objectives of Surrealism was to represent the unconscious, and European Surrealist painters sought to achieve this goal by employing a form of automatism, which often led to abstract paintings, as seen, for example, in the work of André Masson. Other painters, most famously Salvador Dalí, worked in a highly illusionistic style and represented familiar objects in unfamiliar or illogical compositions. In Howard's view, when these techniques were the sole means used to create a painting, the resulting work was "merely the presentation of illustrative notes or disparate objects in a precalculated fashion" and could, at best, only represent something that is "strange but not mysterious."[13] Howard made use of automatic drawings, and he represented objects found in everyday life, but unlike his European Surrealist counterparts, he subordinated and subsumed both to what he called "the natural problems of pure painting."[14] The result, he explained, was that "the objects (which are too abstract to be regarded as literally as objects), as such, become secondary, as I paint, and serve only as a departure. The painting itself becomes of primary importance."[15] In the case of *The Progenitors*, familiar objects have been abstracted and resolved into something entirely new, creating an image that does indeed appear mysterious.

Howard once stated that the title of one of his paintings was meant to be "allusive, not descriptive," and the same could be said of the title of this painting.[16] *Webster's Dictionary* defines a "progenitor" as "an ancestor in the direct line; a forefather" and notes that the modern word stems from the Latin *progignere*, "to beget."[17] The painting's title thus implies and confirms that we are seeing a primordial life form—with its insect's head, primitive skeletal frame, and finlike shoulders. The evolutionary lineage implicit in the painting's title is visualized by its birth imagery. The propeller-like blades project toward us from the dark to reveal a rudimentary birth canal through which we can see the dimensionless void of the distant past, but through which we also sense the present that has been born. Painted just two years after the United States dropped atomic bombs on the Japanese cities of Hiroshima and Nagasaki in an effort to end World War II, at a time when traditional beliefs were called into question and existentialism was on the rise, Howard's *Progenitors* posits a new, if not ambivalent, take on an age-old subject in the history of Western art, the subject of creation itself.[18] [KM]

98. YVES TANGUY, *From One Night to Another*

MIND OVER MATTER

Tanguy . . . seems more than any other Surrealist painter to embody the spirit of Surrealism—
not in the parochial 1920s sense of the term, but in the fecund, open sense in which it can still
be said to animate the most advanced art being done today. JOHN ASHBERY[1]

Yves Tanguy (1900–1955) was one of the predominant members of a group of artists in Paris gathered around André Breton and the founders of Surrealism. Breton articulated the principles of this artistic movement in 1924 in his *Manifesto of Surrealism*, the group's first of many published theoretical statements.[2] He and his followers joined the political philosophy of Karl Marx with the psychoanalytic theories of Sigmund Freud. By creating a space of imaginative freedom and intellectual play unencumbered by economic and social conditions, they sought to challenge the hegemony of bourgeois capitalism, which they believed was based in repression, alienation, and dissociation.[3]

Breton promoted visual, literary, and other artistic modes that could directly express the actual process of thought, which the Surrealists believed was driven by chance rather than any logical or orderly system. Tanguy, in fact, was the inventor of the Surrealists' most famous drawing game based on chance, *le cadavre exquis* (the exquisite corpse), in which blind juxtapositions are used to create a series of connected but random drawings that reveal arbitrary associations (fig. 98.1).[4] Surrealists argued that only by banishing reason—as in modes of experience such as *le cadavre exquis*, dreams, seances, automatic writing, and other unconscious or blind processes—could the sources of creativity be explored and liberated for artistic innovation and social progress. This faith in the unconscious and distrust of reason mirrored the disillusionment with rational processes felt by many intellectuals and artists after World War I. Having witnessed the war's brutality and inhumanity, they were searching for alternative ways of thinking that could

provide the means to a more benevolent society. As a utopian project, Surrealism linked the world of avant-garde artistic experimentation to the European social and political movements that sought progressive change in the first half of the twentieth century.[5]

Standard discussions of Surrealism oppose its illusionist and abstract formulations, suggesting that artists were primarily interested in either the encoded meanings of symbolic imagery or the generative possibilities of painterly forms. Tanguy's paintings resist this opposition, conjuring hallucinatory worlds through carefully realized yet bizarre objects set within fantastic landscapes. *From One Night to Another* (1947) depicts the alien terrain that characterizes Tanguy's signature pictorial spaces. The topography of his painting invokes the unconscious world of dreams and visions. The play of light and shadow suggests an undulating plane that is simultaneously hard and soft. It rolls into the distance and disappears, merging almost imperceptibly into an atmospheric haze rather than ending at its implied horizon line. The smoothly applied paint contributes to a feeling of liquefaction, which is countered by the pyramidal forms that sit solidly on this indeterminate surface.

In contrast to the uncertain landscape, the objects that inhabit this strange world are not represented as indistinct phantoms but with the vivid clarity of trompe l'oeil perspective.[6] They appear to inhabit the scene as monumental totems, an impression heightened by the low horizon and the way these figures occupy the foreground, casting strong shadows and towering above the diminutive pyramidal shapes. Typical of Tanguy's forms, they embody

98. Yves Tanguy (1900–1955), *From One Night to Another*, 1947
 Oil on canvas, 45 × 36 in. (114.3 × 91.4 cm)
 Mildred Anna Williams Collection, 1948.15

Fig. 98.1. Yves Tanguy, André Breton, Marcel Duhamel, and Max Morise, *Cadavre exquis*, ca. 1920–40. Colored pencil on paper, 10⅝ × 8¼ in. (27 × 21 cm). Private collection

contradictory states of being: fluid and solid, biomorphic and mechanical, vegetable and mineral, internal and external, flesh and bone. As fantastic, animated creatures, they rise up impossibly like a disjointed jumble of unconnected fragments yet stand solidly and ominously, as if heroic combatants or threatening giants. Through this referential ambiguity Tanguy suspends viewers in a visionary realm, where descriptive details are inadequate, requiring them to rely on the associations of the unconscious to construct meaning out of the painting's imagery.

Americans had been introduced to Surrealism by the 1931 exhibition *Newer Super Realism*, which opened at the Wadsworth Atheneum in Hartford, Connecticut, and traveled to the Julien Levy Gallery in New York. Levy's gallery, along with Pierre Matisse Gallery in New York, regularly began showing the work of prominent European Surrealists, including Joan Miró, André Masson, Max Ernst, René Magritte, Giorgio de Chirico, Salvador Dalí, and Tanguy. By 1936 the movement had become so prominent that Alfred H. Barr Jr. organized an exhibition at the Museum of Modern Art, New York, entitled *Fantastic Art: Dada and Surrealism*, predicting that Surrealism would replace geometric abstraction as the most significant artistic development in the country. Not surprisingly, the rise of dictatorial regimes and the inevitable world war they presaged sent many of these European artists to the United States beginning in 1939. In Manhattan they formed a colony of expatriates around the Julien Levy Gallery and Peggy Guggenheim's gallery, Art of This Century (now the Guggenheim Museum), which became an important meeting place for these European Surrealists and emerging American artists.[7] In 1942 the two groups banded together for a seminal group exhibition called *The First Papers of Surrealism* organized at the Whitelaw Reid Mansion on Madison Avenue.[8]

Tanguy and his new wife, fellow Surrealist Kay Sage, moved to the United States as part of this émigré group. Once here, they took up residence on a farm in Woodbury, Connecticut, an easy drive from New York City. As a central figure in Breton's Paris circle, Tanguy was an important contributor to the ongoing development of Surrealism after its artistic center moved to New York, evident in his influence on Roberto Matta Echaurren and Arshile Gorky.[9] Tanguy participated in all the notable exhibitions that brought critical acclaim to the Surrealists working in the United States, including the pivotal *Artists in Exile* at Pierre Matisse Gallery (1942); *Abstract and Surrealist Art in America*, based on the book by Sidney Janis, at the San Francisco

Museum of Art (1944); and *European Artists in America* at the Whitney Museum of American Art (1945).[10] This alliance between Europe's most avant-garde artists living in exile and the American institutions and artists most committed to radical experimentation shifted the global center of the art world from the capital cities of Europe to New York.[11]

Although working in several different styles, the Surrealists shared a belief that logic should be rejected in favor of unconscious associations represented by the hallucinatory, the uncanny, and the fantastic. Tanguy, along with Dalí and Magritte, worked in the most illusionist of these styles, relying on the tradition of the uncanny derived from de Chirico's hauntingly imprecise symbolism (fig. 98.2). In a frequently repeated incident, in 1923 Tanguy was so startled by a de Chirico painting in the window of Galerie Paul Guillaume in Paris that he jumped off a bus for a closer look, which resulted in a religiouslike conversion to painting. The experience changed Tanguy's life, introducing him to Surrealism and Breton, from whom the painting was on loan.[12] De Chirico is usually credited with originating the "metaphysical painting" style, which emphasizes the unseen reality behind ordinary phenomena. It removes common objects from their usual context, juxtaposing them within mysterious scenes to create new associations laden with disturbing and enigmatic possibilities.

The Surrealists saw de Chirico's dreamscapes and narratives of implied neurosis as precursors to their own works, and Tanguy's paintings remained firmly rooted in this sensibility even as other Surrealists moved toward a more expressive abstraction. Tanguy freights his landscape in *From One Night to Another* with a sense of the primordial and its chaotic forces, which the Surrealists believed were accessible through the unconscious, providing a way to escape the stultifying order of habitual existence that was thought to have destroyed creativity. He thinned his paint until it was nearly liquid, permitting him to depict cool gray and white tonalities whose misty gradations ambiguously suggest a barren desert, a lunar surface, or a floating sea.

Tanguy had spent his youth in Brittany, frequently visiting its rocky coast. According to a scholar for the artist's 1983 retrospective, organized by the Georges Pompidou Cultural Center in Paris, these experiences "kept alive in him his preoccupation with the elements and stored in him a desire to use elemental forms as the syllables of a new language."[13] During his visits to Brittany Tanguy also would have encountered the mysteriously haunting sites that had been venerated by the area's ancient Celtic inhabitants,

Fig. 98.2. Giorgio de Chirico, *Nostalgia of the Infinite*, ca. 1913–14. Oil on canvas, 53¼ × 25½ in. (135.3 × 64.6 cm). The Museum of Modern Art, New York. Purchase, 87.1936

Fig. 98.3. Carnac, Brittany, France, prehistoric megaliths, ca. 2000 B.C., *The Celtic Monuments at Carnac*. Copper engraving, original coloring. From Bertuch, *Bilderbuch fuer Kinder* (Weimar: Landes-Industrie-Comptoir, 1809[?]), no. 90. Coll. Archiv f. Kunst & Geschichte

who conducted rituals now lost to us. These sites consist of single standing stones (menhirs) and multistone clusters (dolmens), which were hewn from local granite and now sit worn by time and weather, covered with white lichen (fig. 98.3).[14] The esoteric nature of these structures and their close affiliation with the mythic life of an earlier civilization, which Tanguy understood as primitive and unbound by modern rationalism, made them the perfect vehicles for his experiments in visual forms.

Although Tanguy's painting seems to be characterized by an affinity with ancient rituals, it also invites speculation about the future. The hybrid nature of the players in this surreal drama suggests a synthesis of the mechanical and the biological. The middle figure, especially, reveals brightly colored red, yellow, and orange components that can be read as organs, and the gray and white forms seem clothed in a substance that could be likened to skin, plastic, bone, metal, or some combination of these materials. They represent the biomorphic potential of a fabricated future where reality and artifice are indistinguishable. Although the Surrealists often created arbitrary titles for their works, *From One Night to Another* seems to suggest an inversion of the usual marking of time from one day to another.[15] It makes nighttime, with its access to the unconscious during sleep, the basis of a movement into the future, possibly symbolized by the three figures who march toward the front of the picture plane, casting long shadows behind them.

Tanguy invented a painterly language that becomes increasingly cryptic the more precisely it seems to depict his visionary mindscapes. By combining the lucid with the enigmatic, he created a surrealist practice that held illusionist and abstract modes of painting in dynamic tension at a time when most of his fellow artists were abandoning the radical potential of symbolic forms for the more personal explorations of expressive gestures. [DC]

LIGHTING THE WAY

Rothko was about to mourn the death of the figure and to celebrate the survival of the subject as an act of freedom. BERNICE ROSE[1]

It is easy to lose sight of how important the San Francisco Bay Area was to the artists who were developing Abstract Expressionism in America. Art historians have tended to focus on a coterie of well-known critics, dealers, and painters working in New York City during the 1940s and 1950s.[2] However, Clyfford Still had made the California School of Fine Arts (now the San Francisco Art Institute) an intellectual center for artists who were exploring how to reference subjectivity without representing the figure. Through his friendship with Still, Mark Rothko (1903–1970) was also destined to play an important role in the story of that exploration, as evidenced by the Fine Arts Museums' painting *Untitled*[3] (1949). It is a major work from Rothko's pivotal years from 1947 to 1949, a time of transition for his painterly language and the period of his greatest influence on West Coast artists.

Rothko met Still while visiting Berkeley, California, in 1943, and the two artists quickly became friends and advocates of each other's work.[4] In 1947 and 1949 Still used his position in the Paintings Department at the California School of Fine Arts to secure Rothko a position on the school's summer faculty. In addition, Still's own paintings from this period, composed of raggedly abstract forms and thickly layered paint surfaces, were influential in Rothko's mature abstract style.[5]

The year 1949 saw Rothko's critical artistic breakthrough, in which he made the final transition from the biomorphic forms that had characterized his earlier surrealist work to their dissolution, which he had been exploring since 1947 in his "multiform" paintings. These paintings anticipate and lead directly to his signature style and compositions, with their characteristic single color grounds, radiant, rectilinear shapes, and painted edges. Included in the 1961 retrospective of Rothko's work at the Museum of Modern Art, New York, which traveled internationally, the Fine Arts Museums' painting offers an ideal summation of the visual vocabulary and transcendent themes of this crucial turning point in Rothko's development.[6]

Rothko (born Marcus Rothkowitz) immigrated to Portland, Oregon, from Russia in 1913 at the age of ten, speaking only Russian and Hebrew. He grew up sensitive to the political and social turmoil of pre–World War I Europe, especially the gathering working-class unrest that culminated in the overthrow of Czar Nicholas during the October Revolution of 1917. After a brief two years studying the natural sciences at Yale University (1921–23), Rothko moved to New York City and by 1924 was studying at the Art Students League, a bastion of American Scene and other realist painting traditions.[7]

In the years before 1949, Rothko experimented with two distinct painting styles: realism and Surrealism. Rothko's early work, created between 1925 to 1939, was rooted in politically progressive, realist depictions of Manhattan's modern, urban life and its isolating conditions. Max Weber, with his emphasis on expressive interpretations of the nude, most influenced Rothko in these years, when he concentrated on the figure in city settings, including his famous subway series from the end of this period.[8] In 1935 Rothko joined with Adolph Gottlieb to form the Ten, a group of expressionist painters who banded together for support, exhibited as a group and held monthly meetings, which were known for passionate discussions about the relationship

99. Mark Rothko (1903–1970), *Untitled*, 1949
 Oil on canvas, 68 × 34⅜ in. (172.7 × 87.3 cm)
 Bequest of Josephine Morris, 2003.25.5

between artistic issues and world events. Over the next ten years, members of the group championed the infusion of emotional content into abstract painting as they sought more individualistic explorations of meaning. During this period, Rothko began the search for a visual language that would incorporate universal experiences of spirituality, leading him, as it did other modernists, to an interest in the myths and symbols of archaic societies.[9]

Beginning in 1940, Rothko abruptly shifted to a surrealist visual language. The Ten had closely followed the surrealist exhibitions at Julien Levy's gallery and the *Fantastic Art: Dada and Surrealism* exhibition at the Museum of Modern Art in 1936. Rothko, especially, was attracted to the ability of these avant-garde artists, who worked abstractly but still referenced consciousness through mythological and primitive themes expressed in animated and ambiguous biomorphic forms. As did many artists who rejected geometric abstraction, they relied on the universal symbols of the collective and individual unconscious posited in the psychological theories of Carl Jung. This interest continued to inform Rothko's paintings even after he developed the abstract expressionist language of intense color as a primary subject.

In a June 1943 review of the Federation of Modern Painters and Sculptors exhibition in New York, the critic Edward Alden Jewell acknowledged his "befuddlement" when viewing the paintings of Rothko and Gottlieb, inviting the artists to use his column to explain their work. In response, they joined with Barnett Newman and issued a statement that declared: "There is no such thing as good painting about nothing. We assert that the subject is crucial and only that subject-matter is valid which is tragic and timeless. That is why we profess spiritual kinship with primitive and archaic art."[10] Rothko and his fellow artists were committed to working in a visual language that expressed, in Robert Rosenblum's words, the "heroic effort to convey the ultimates of life, death, and faith."[11]

This decidedly humanist sensibility led Rothko to explore moral rather than purely aesthetic concerns. Neither realism nor Surrealism had created an artistic language that could respond effectively to the politics of destruction and the philosophical defeat of humanism represented in the global depression, the rise of totalitarian governments, and World War II.[12] In 1947 Rothko abandoned the mythic and symbolic figures that had populated his surrealist works, explaining his decision in the short-lived art publication

Possibilities. His text, a manifesto really, advocated a modern revision of Romanticism, in which art provided viewers with transcendental experiences. Rothko declared: "The most important tool the artist fashions through constant practice is faith in his ability to produce miracles when they are needed."[13] From 1947 to 1949 Rothko experimented with a visual vocabulary that could accomplish the goals contained in his manifesto. He moved from the biomorphic shapes of Surrealism to the monumental color blocks that would become the recognizable signature of his classic works of the 1950s.

In the paintings from this transitional period, Rothko organized his canvases into so-called multiforms, abstracting animate and inanimate objects through indeterminate, colorful shapes set within a single field. By evacuating figurative representations from his works, Rothko freed the subject from drawing, referencing its presence through color alone. His break with drawing was triggered when he saw the work of Pierre Bonnard in a New York exhibition during the winter of 1946–47. Rothko returned to his studio from the exhibition and translated Bonnard's *Interior at Le Cannet* (1938) (fig. 99.1) into a series of color patches based on his memory of the painting (fig. 99.2).[14] The resulting work was an abstract arrangement of forms that serve as shifting signs as they delineate objects, define space, and depict material relationships based not on specific representations but on the artist's emotional and psychological experience.[15]

In *Untitled*, Rothko transforms the canvas into a visionary space that has been freed from its need to represent objects. In place of anything recognizable, he substitutes diffuse, rectilinear forms built up of nearly translucent scrims of thinly applied paint. The painting's overall palette of yellow and orange hues, which register with the warm glow of early morning or evening, quite possibly reflects his experience with the saturated yet translucent quality of light that characterizes those times in the San Francisco Bay Area. Squares and columns are arranged on a soft, peach-tinted yellow ground that defines the field of the painting. Three stacked squares float mysteriously in the bottom right quadrant of this field. This arrangement anticipates Rothko's further simplification during this same year, when he began to pare down his compositions to two or three monumental forms on a single ground. The prominent green square suggests possible associations with nature, spring, or new life. Its semi-transparency—yellow

hues radiate through the darker green—gives the appearance of an object hovering and covering, yet not quite concealing, what lies beneath it. This quality of simultaneously covering yet revealing extends to all the forms in the painting. It evokes an impression of the transcendent, heightening the painting's phenomenological presence through an emphasis on unseen forces and the limits of human understanding.

It has often been observed that Rothko did not withdraw from objects in order to explore color relationships or optics alone.[16] In his 1947 manifesto he wrote: "I think of my pictures as dramas."[17] And as Peter Selz noted in his essay for the 1961 retrospective, Rothko "is concerned with his art not esthetically, but as a humanist and a moralist."[18] From his multiform translations of Bonnard and other artists, it is clear that the drama has moved away from the emblematic actors that populated his earlier works. Not incidently, these are also the first paintings Rothko exhibited without frames. The dramatic action no longer takes place on the canvas but rather in the space between the canvas and the spectator, as characterizes the operation of the sublime. It is written in the intangible register of the ineffable emotions that define spiritual experience.

Rothko never gave up on this attempt to create paintings that placed narrative at the service of metaphysical purposes, a quest that culminated in the Rothko Chapel in Houston (1965). It led him to paint works that set up a psychological confrontation with viewers based more on what they project onto the surface of the canvas than what is represented within it. In his multiform paintings, Rothko invented the vocabulary for which he became famous. In place of a specific scene for viewers to contemplate, he used the imagery of light, on which spiritual rhetoric so often relies, to create the conditions of meditation itself. [DC]

Fig. 99.1 [top left]. Pierre Bonnard (1867–1947), *Interior at Le Cannet*, 1938. Oil on canvas, 49¾ × 49¼ in. (126.4 × 125.1 cm). Yale University Art Gallery. The Katharine Ordway Collection, 1980.12.19

Fig. 99.2 [bottom left]. Mark Rothko (1903–1970), *Untitled* [recto], 1947. Oil on canvas, 53½ × 39⅝ in. (135.9 × 100.5 cm). Collection of Christopher Rothko, estate number 3008.47

FACING THE DARK

Elegy black black
Black with blood coagulated black
With the white lime of bones outlining forms.
RAFAEL ALBERTI[1]

The use of black is a primary vocabulary of Abstract Expressionism. An exhibition in 1979 titled *Black and White Are Colors* traced the significance of this palette in the development of the New York School artists, whose post–World War II artworks had dictated the leading aesthetic of the international avant-garde.[2] Robert Motherwell's *At Five in the Afternoon* (1950) is a summary expression of the theme, and, as the first and earliest catalogue entry in that exhibition, it paid homage to an artist who was an articulate advocate of black and white throughout his career.[3] Undoubtedly among Motherwell's most important works, the painting represents one of the first two major explorations of the signature motif that was to develop into his famous series *Elegies to the Spanish Republic*, which depicts an emblematic imagery that secured his place as a foremost member of the New York School.[4]

Although they comprise only a small percentage of his entire output, the more than 140 *Elegies* are the most recognizable and celebrated of Motherwell's painting series, ranging in scale from this modest, easel-sized canvas to monumental, mural-scaled versions. Indeed, many people know none of his other work.[5] The power of these paintings was expressed by Motherwell's good friend the literary critic Mary Ann Caws when she wrote: "Were he never to have painted anything else, these *Elegies* would ensure his lasting presence among us."[6] The motif that characterizes the series began in 1948 as an intimate pen-and-ink sketch on paper to accompany Harold Rosenberg's poem "The Bird for Every Bird," which was created for the unpublished second issue of the surrealist, avant-garde magazine *Possibilities* (fig. 100.1).[7]

Motherwell (1915–1991), typical of the first-generation Abstract Expressionists, began as a Surrealist painter, and he developed the motif for Rosenberg's poem according to that movement's artistic philosophy.[8] Using automatic drawing as a device to tap the unconscious, Motherwell started with a random doodle that he improvised while copying out the poem in his own hand. Returning to his arbitrary marks, he built up the composition by emphasizing the linear and curving suggestions that he perceived to be emerging in his original scribbled drawing. This dialectic between chance occurrence and deliberate manipulation lies at the heart of surrealist method.

During his 1941 summer break from studies with the philosopher and art historian Meyer Schapiro at Columbia University, Motherwell traveled to Taxco, Mexico, with Roberto Matta Echaurren, the charismatic Chilean artist who was electrifying New York's surrealist circles at the time. Matta introduced him to "psychic automatism," a technique of inscribing through free association that became the central principle underlying all of Motherwell's work.[9] The experience was so exhilarating that Motherwell abandoned academic study to devote himself to painting when he returned to New York City in the winter of 1942.

Surrealism was the intellectual product of the French avant-garde, invented by Guillaume Apollinaire in 1917 and articulated by the writer and critic André Breton in 1924, forging close links between literary and visual artists. When

100. Robert Motherwell (1915–1991), *At Five in the Afternoon*, 1950
 Oil on hardboard panel, 36 × 48 in. (91.4 × 121.9 cm)
 Bequest of Josephine Morris, 2003.25.4

Hitler's rise to power in Europe during the 1930s forced many intellectuals to flee Europe, New York City's Greenwich Village became the center of an international circle of Surrealist writers and artists. Motherwell had come to the visual arts through his theoretical interests, earning a bachelor's degree in philosophy from Stanford University in 1937 and beginning graduate studies in the subject at Harvard in 1937–38, before transferring to Columbia. This background, along with his lifelong appreciation of literature, led Motherwell to embrace the Surrealists, who created a nexus of literary, musical, and visual arts based on their interest in psychoanalysis, especially its explorations of the unconscious through dreams, trances, and other altered mental states.

Motherwell was especially attracted to poetry because it functioned for him in relation to prose as abstraction does to representation.[10] He often quoted poets such as Charles Baudelaire, Stéphane Mallarmé, Federico García Lorca, T. S. Eliot, Frank O'Hara, and Rafael Alberti, writers who resonated with his commitment to the expression of powerful feelings through intellectual abstraction. In many of his paintings Motherwell paid homage to such writers: *Mallarmé's Swan* (1944–47), *Ulysses* (1979), *The Face of Night (For Octavio Paz)* (1981), and *The Hollow Men (from T. S. Eliot)* (1983), which he claimed as "one of the best paintings I ever did."[11]

However, the artist has said that his abstract compositions should not be read as descriptive of the poems they often reference. Consistent with surrealist theories, he maintained that the expression exists prior to the cognitive relationships, emerging from his unconscious associations.[12] In this instance, what began as Motherwell's unconscious response to Rosenberg's poem became a visual metaphor for García Lorca's poem "Lament for Ignacio Sánchez Mejías," with its insistently repeating refrain, "At five in the afternoon." Rather than an illustration, therefore, his painted elegy *At Five in the Afternoon* is "the visual equivalent of the poem."[13]

Three black vertical bars appear to hang from the top edge of the painting, one on each side and the third a massive form hanging just left of center. A single black ovoid appears to be squeezed between the left and center verticals. Two more ovoids are suspended between the center and right verticals. Thick black brushstrokes characterize all the forms, which have irregular edges. Typical of Motherwell's paintings, the paint is scored and scratched, its heavy black impasto punctuated with vigorous cuts. A horizontal

Fig. 100.1. Robert Motherwell (1915–1991), *Elegy to the Spanish Republic, No. 1*, 1948. India ink on rag paper, 10¾ × 8½ in. (27.3 × 21.6 cm). The Museum of Modern Art, New York. Gift of the artist, 639.1987

framelike image along the top right edge interrupts the strong vertical energy of the painting. Outlined by a cut in the surface so severe that it feels carved, the frame implies interior space but reads ambiguously as either the edge of a window or a picture.

Through this motif, consisting of strong verticals alternating with ovoids in black against a white ground, Motherwell fashions a subjective symbol of modern Spain. Its heroic and ultimately tragic history made Spain a powerful metaphor of Western civilization for artists and intellectuals of the mid–twentieth century. The era's ideological contests over freedom, conformity, social responsibility, and national ambition seemed to be played out in the failure of the Spanish Republic, which ended in the civil war (1936–39) that brought about the fascist dictatorship of General Francisco Franco. The intelligentsia of Western culture appeared to take up the cause of the Spanish Republic as a measure of its psychological health, philosophical stability, social conscience, and political will. Motherwell said that in spite of distrusting collective movements, his involvement with the Spanish civil war "was unique because Liberal intellectuals felt about it as one man, throughout the world."14

Motherwell links the formal tensions within his painting to these conflicts through an artistic vision of dualities. The flat, thickly painted, black-and-white surfaces emphasize the starkness of opposing forces, and the vertical and ovoid forms are organized into a matrix of contradictory impressions: expansion and compression, attraction and repulsion, thrusting and pulling, movement and stasis, unity and disorder, organization and chaos, harmony and dissonance, freedom and repression, night and day, and, ultimately, life and death. In this way Motherwell simultaneously activates the universal themes of the century's public conflicts and articulates the highly personal and subjective existential experiences of individuals.

Ultimately, Motherwell's painting does not resolve but rather animates these tensions. For all the verticality of the forms, they read horizontally as a series of suspended moments, almost as if musical notes. The title of the painting and the original title of the motif, *At Five in the Afternoon*, references the hour of the famous Spanish matador's death in García Lorca's poem. Both the poem and Motherwell's painting draw a symbolic portrait of Spain that conflates universal themes and individual incidence within an existential moment, recalling the philosophy of Søren Kierkegaard, whose thought informed Motherwell's own theoretical writings.15 By transforming the title of his series to *Elegies to the Spanish Republic*, Motherwell shifts his focus from the particulars of the poem and the death of a specific individual to his symbolic idiom with its dynamic allusions to the human condition.

Motherwell liked to joke that he changed the title of his motif because he grew tired of having to explain that it was not a reference to the fashionable hour for cocktails.16 However, the change more likely suggests the artist's desire to use the language of Abstract Expressionism to create a highly flexible symbol of an individual's feelings, especially anxiety, which weighed heavily on the collective unconsciousness of Western culture at the time. His work truly is an "elegy," a poetic and musical lament for the loss of potential and hope embodied in a lost cause that nevertheless contains a tribute to the indomitable spirit of life. It finds consolation in an artistic act that dares to find the joy of creation in the midst of despair. Motherwell's affinity for music and poetry may also have played a larger role in creating his initial motif than even he recognized. The vertical bars and ovoid forms mark the syncopated stresses of anapestic tetrameter in both Rosenberg's and García Lorca's poems.

By 1950 Abstract Expressionism had entered its mature phase, and the central importance of black was established within its visual economy. Black was central to the expressive idiom of the group of artists who became known as the New York School, including Jackson Pollock, Willem de Kooning, and Franz Kline.17 De Kooning's revolutionary black-and-white paintings of 1948 reinvented the relation between space and line. Kline used large brushes to create bold, slashing strokes of black paint on white canvases to trace the movement of his arm as he worked. Many of Pollock's monumental drip paintings rely on an overall network of black lines to give them compositional structure. Motherwell's training in philosophy made him the group's most erudite apologist for both their use of black and their rejection of recognizable subject matter as merely surface depiction. *At Five in the Afternoon* demonstrates his elegant ability to capture abstract concepts and impressions through metaphors of invented meaning rather than familiar descriptions of the world at hand. The painting is a black lament that faces the dark, inviting its viewers to face the weight of its presence and comprehend the unknowable.

[DC]

101. RICHARD DIEBENKORN, *Berkeley No. 3*

THE EMBODIMENT OF ABSTRACTION

Richard Diebenkorn (1922–1993) perceived himself as working in a modernist tradition that included Paul Cézanne, Henri Matisse, and Piet Mondrian, the artists whose paintings had the most enduring influence on his work.[1] His career encompassed several major stylistic phases, including Abstract Expressionism (ca. 1947–55); a figurative mode (ca. 1955–67) of landscapes, interiors, still lifes, and figures; and a return to abstraction (ca. 1967–93) that centered on the renowned *Ocean Park* series of paintings and drawings. Diebenkorn's profound and ongoing dialogue between realism and abstraction, and between figure and ground, led critics to describe him as an abstract painter who also painted landscapes and figures, a characterization the artist accepted with reservations, observing:

> all paintings start out of a mood, out of a relationship with things or people, out of a complete visual impression. To call this expression abstract seems to me often to confuse the issue. Abstract means literally to draw from or separate. In this sense every artist is abstract . . . a realistic or non-objective approach makes no difference. The result is what counts.[2]

Richard Clifford Diebenkorn Jr. was born in Portland, Oregon, and moved with his family to San Francisco in 1924. He commenced his formal art studies at Stanford University (1940–43) with Victor Arnautoff and David Mendelowitz, whose admiration for the works of Edward Hopper (1882–1967) was shared by his student.[3] At the University of California, Berkeley (1943–44), Diebenkorn studied with Worth Ryder, Eugen Neuhaus, and Erle Loran.[4] Diebenkorn's studies were interrupted by his service in the U.S. Marines (1943–45), but he continued a self-described

form of "art school" by viewing major modernist paintings at museums in Washington, D.C., Baltimore, Philadelphia, and New York, while stationed at Quantico, Virginia.[5]

After World War II, Diebenkorn continued his studies in 1946–47 at the California School of Fine Arts with David Park (1911–1960), Edward Corbett, Clay Spohn, John Grillo, and Douglas MacAgy; and at the University of New Mexico, Albuquerque, 1950–51, where he obtained his master of fine arts degree. Diebenkorn's precocious talent led to early teaching positions at the California School of Fine Arts (1947–49) and the University of Illinois at Urbana (1952–53). During this period, Diebenkorn embraced Abstract Expressionism and developed his own abstract vocabulary in the *Albuquerque* (1950–52), *Urbana* (1952–53), and *Berkeley* (1953–55) series of paintings.

The approximately fifty-six paintings in Diebenkorn's *Berkeley* series, created during a two-year period after the artist moved with his family to the San Francisco Bay area in the fall of 1953, represent the culmination of his first extended exploration of abstraction.[6] The titles of the individual paintings (e.g., *Berkeley No. 3*), composed of the place of their production and their sequential number in the series, accentuate the artist's perception of the works as part of a creative continuum and suggest the scope of his enterprise. The omission of descriptive titles may reflect the Abstract Expressionists' aversion to overt narrative content in works that were supposed to be viewed primarily in terms of their formal elements.[7] However, Diebenkorn's use of geographic series titles such as *Albuquerque*, *Urbana*, and *Berkeley* suggests that the surrounding environment played an important role in shaping his work.

Berkeley No. 3, one of the earliest in this series,

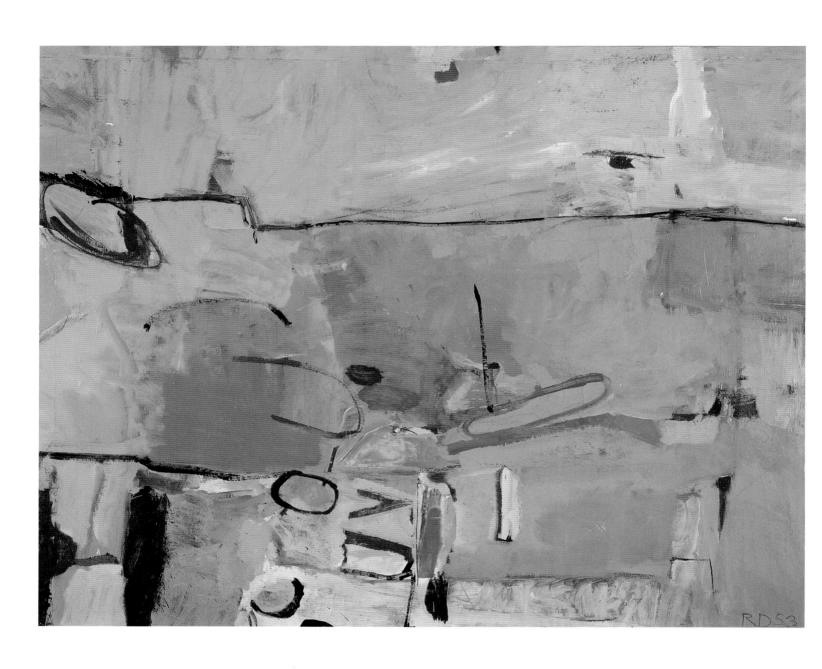

101. Richard Diebenkorn (1922–1993), *Berkeley No. 3*, 1953
Oil on canvas, 54⅛ × 68 in. (137.5 × 172.7 cm)
Bequest of Josephine Morris, 2003.25.3

resembles a form of topographic mapping in which the landscape is tilted up until it appears to be contiguous with the picture plane.[8] Cézanne, whose works Diebenkorn had first studied intensively as a student in Berkeley ten years earlier, had utilized this compositional device both in his landscape views and in his tabletop still lifes. Matisse further distilled Cézanne's planar perspective, reducing three-dimensional objects to two-dimensional silhouettes or calligraphic outlines. Diebenkorn's interest in the potential of planar perspective was reinforced by airplane flights that he took between San Francisco and Albuquerque in 1951.[9]

Berkeley No. 3 appears to have been painted over an earlier *Albuquerque* or *Urbana* painting, and the stepped horizon line has been interpreted as a recurring reminiscence of a distinctive landscape mesa that was visible from Diebenkorn's house in Albuquerque.[10] The horizontal format of the composition, which includes a green and brown horizon line delineating the upper third of the composition and a partially obscured black line demarcating the lower third of the canvas, inevitably reinforces this landscape association. Diebenkorn's tripartite division of the landscape is a defining characteristic both of Albuquerque, which is framed by the desert, distant mesas/mountains, and the sky, and of the hillside community of Berkeley, which looks down on a flat shoreline, across San Francisco Bay, and up to a horizon formed by distant hills meeting the sky.[11] Acknowledging the pervasive presence of the landscape in his early abstractions, Diebenkorn recalled, "It was impossible to imagine doing a picture without it being a landscape; to try to make a painting space, a pure painting space, but always end up with a figure against a ground."[12]

However, Diebenkorn's interest in tripartite compositions dated back to an indelible childhood memory of a European souvenir that he received as a gift—a set of eighty cards illustrating the famous Bayeux Tapestry (ca. 1066), an icon of medieval history and culture. The central band of this horizontal embroidery depicts a linear narrative of the events surrounding the Battle of Hastings in 1066, but it is flanked at the top and bottom by parallel pictorial borders that alternately comment on or diverge from the main story line. For Diebenkorn, the Bayeux Tapestry provided a medieval precedent for the modernist interest in the simultaneous representation of multiple visual spaces and narrative times.[13]

Berkeley No. 3 is suffused with interlocking and overlapping fields of luminous, atmospheric color. The warm gold, orange, and ocher tones evoke sun-drenched earth and a pervasive, humidity-laden atmosphere. Subtle modulations in these colors make them appear to advance or to recede and help to create a sense of palpable, three-dimensional space. Describing his use of color in the *Berkeley* paintings, Diebenkorn noted that he incorporated "every hue and every variation into the picture. With six basic hues, and at least one variant for each—that's twelve—plus black and white and grays, I would get the ball rolling. I would ask, how much farther can I go, what further break in the color system can I make?" He concluded, "It wasn't fun unless all the colors, all the characters, were present."[14]

Diebenkorn's description of colors as "characters" suggests that he perceived colors as active protagonists in his compositions. The term might equally be applied to his calligraphic marks, which range from the gestural to the geometric and are superimposed over the field of floating colors.[15] Diebenkorn described the resulting visual effect as that "of objects totally clear of a deep space behind them."[16] This disengagement of drawing from color is reminiscent of the works of the New York Abstract Expressionists Willem de Kooning and Arshile Gorky. Diebenkorn had been impressed by reproductions of paintings by de Kooning published in 1948 and was deeply moved by the Gorky memorial exhibition, which he viewed at the San Francisco Museum of Art in 1951.[17] Gorky's *Golden Brown Painting* (fig. 101.1), which was included in the exhibition, not only offers formal parallels to *Berkeley No. 3* but also incorporates figurative imagery that has been integrated completely within the surrounding landscape.[18] Despite their differences, Gorky and de Kooning both infused their abstract biomorphic or landscape forms with powerful emotional and erotic charges that were enhanced by their sublimation.

Just as Diebenkorn's early attempts to create a "pure painting space" often resulted in a landscape, his abstract imagery often gravitated toward figuration: "I thought I was being non-objective—absolutely non-figurative—and I would spoil so many canvases because I found a representational fragment . . . back it would go to be redone."[19] However, figurative imagery is apparent in *The Green Huntsman* (fig. 101.2) of 1952, in which it is possible to perceive a recumbent figure in profile that resembles a dead knight from the Bayeux Tapestry or a medieval tomb.[20] A biomorphic appendage that thrusts upward from this recumbent figure introduces the possibility of symbolic sexual forces.[21]

In *Berkeley No. 3*, it is possible to discern a similar semi-reclining figure, composed of a dark green and blue oval head at the upper left, two black and gray curvilinear breasts

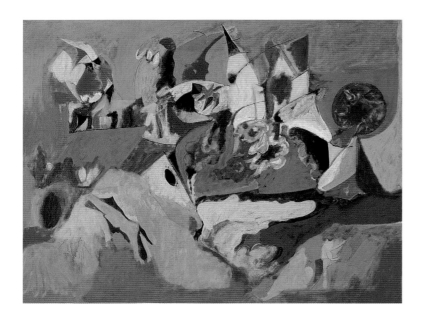

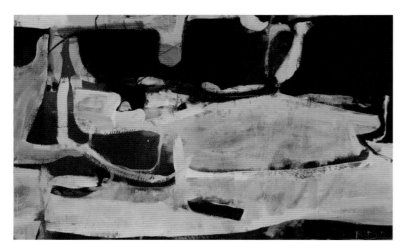

Fig. 101.1 [top]. Arshile Gorky (1904–1948), *Golden Brown Painting*, 1943–44. Oil on canvas, 43¹³⁄₁₆ × 55⁹⁄₁₆ in. (111.3 × 141.1 cm). Mildred Lane Kemper Art Museum, Washington University in St. Louis. University purchase, Bixby Fund, 1953

Fig. 101.2 [above]. Richard Diebenkorn (1922–1993), *The Green Huntsman*, 1952. Oil on canvas, 42½ × 69¼ in. (108 × 175.9 cm). Private collection

below, and an oblong blue phallic shape at the right center. Yet these same forms also might be viewed as a large rock, two curved hills, and a sailboat with a vertical mast. The dense accumulation of geometric symbols in the center foreground alternately might be interpreted as ideograms for objects on a tabletop next to the reclining figure or for man-made elements in a suburban Berkeley landscape.

As Diebenkorn noted, he did not consciously seek to depict representational imagery, and when it inadvertently appeared and became too overt, he attempted to conceal its presence. This process of concealment obscured any obvious surface connection between Diebenkorn's anatomical and landscape topography but enabled viewers to sense the submerged resonances of the imagery. Diebenkorn's abstractions also concealed his conception of landscape as a living, biomorphic vehicle for the expression of his own emotions. Discussing his Albuquerque paintings he said, "Temperamentally, perhaps, I had always been a landscape painter, but I was fighting the landscape.... In Albuquerque I relaxed and began to think of natural forms in relation to my own feelings."[22]

These feelings, eloquently embodied in a living landscape, but not explicitly articulated for the viewer, are the defining elements of the *Berkeley* series, disrupting their tectonic planes and tracing seismographic paths across the surface. As the series drew to a close in 1955, Diebenkorn brought the landscape and the figure to the surface but subdued the emotional content, recalling, "I came to mistrust my desire to explode the picture and supercharge it in some way. At one time the common device of using the super emotional to get 'in gear' with a painting used to serve me for access to painting, but I mistrust that now. I think that what is more important is a feeling of strength in reserve — tension beneath calm."[23] [TAB]

A PURE PAINTING SPACE

Richard Diebenkorn's *Ocean Park* series (1967–88) of approximately 143 paintings represents one of the most ambitious and sustained explorations of abstraction in the history of American art.[1] Diebenkorn (1922–1993) first gained national renown as an abstract artist with his *Albuquerque* (1950–52), *Urbana* (1952–53), and *Berkeley* (1953–55) paintings. However, in 1955 he turned to figuration because "it was almost as though I could do too much, too easily. There was nothing hard to come up against. And suddenly the figure painting furnished a lot of this."[2] By the mid-1960s Diebenkorn sensed that he was preparing for a shift back to abstraction: "At about this time the figure thing was running its course. It was getting tougher and tougher. Things really started to flatten out in the representational [paintings]. . . . And the painting I did here [in Los Angeles] really flattened out, and so it was as if I was preparing to go back to abstract painting, though I didn't know it."[3]

As Diebenkorn observed, this change in his work is often linked with his move in the fall of 1966 from the San Francisco Bay community of Berkeley to Los Angeles, where he took a teaching position at the University of California. Diebenkorn settled with his family in Santa Monica Canyon and maintained a studio in the Ocean Park section of Los Angeles, just south of Santa Monica. He initially worked in a small, windowless studio, his paintings becoming increasingly reductive and planar, until he moved into Sam Francis's vacated studio on the top floor of the same building, where he commenced the *Ocean Park* series at the end of 1967.[4]

Like Claude Monet's series of paintings depicting Rouen Cathedral or Paul Cézanne's numerous views of Mont Sainte-Victoire, Diebenkorn's *Ocean Park* images, as variations on a theme, conferred enormous advantages: "I wanted to get away from having to follow all the obligations, so to speak, that were carried by a given subject. . . . In brief, I suppose I just wanted more freedom."[5] The *Ocean Park* designation, no doubt originally coined by real estate developers, seems to contain a contradiction—how can anything be both an ocean and a park? Yet this enigmatic title poetically captures the dynamic interaction of seeming opposites that is one of the defining characteristics of the series—ocean and park, nature and culture, natural and intellectual forces.[6]

The origins of the series are as numerous and multilayered as the *Ocean Park* paintings themselves. Diebenkorn's new environment played an important role, as his close friend William Brice observed, "I don't know of any artist who was more responsive to his physical environment than Dick. If he moves down the block, it changes everything. He absorbed the aura of a place."[7] Diebenkorn's encounters with the changeable color, light, and atmospheric effects that characterize the Southern California seascape, landscape, and cityscape contributed important elements to the *Ocean Park* series.[8]

The evolution of the *Ocean Park* series also was influenced by Diebenkorn's artistic involvement with a U.S. Department of the Interior water reclamation project at Salt River Canyon, Arizona, in 1970. After seeing the geometric fields and irrigation channels from an airplane, Diebenkorn recalled, "We were supposed to do documentary drawings, but mine came out like abstract interpretations. I think the many paths, or pathlike bands, in my paintings may have something to do with this experience, especially in that wherever there was agriculture going on you could

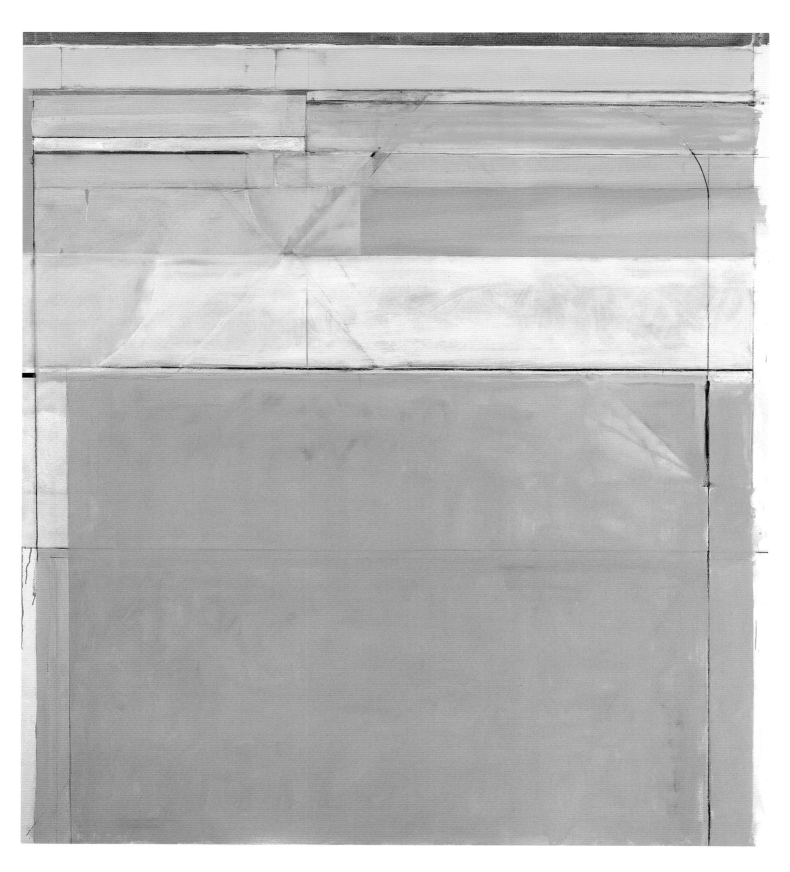

102. Richard Diebenkorn (1922–1993), *Ocean Park 116*, 1979
Oil on canvas, 82 × 72 in. (208.3 × 182.9 cm)
Museum purchase, gift of Mrs. Paul L. Wattis, 2000.20

see process—ghosts of former tilled fields, patches of land being eroded."[9]

However, the origins of the *Ocean Park* paintings may be traced as well to Diebenkorn's interest in Henri Matisse, whose works Diebenkorn first viewed in the collection of Sarah and Michael Stein while attending Stanford University (1940–43).[10] As a U.S. Marine stationed at Quantico, Virginia (1943–45), Diebenkorn frequently visited the Phillips Collection in Washington, D.C., and was particularly impressed by Matisse's *Studio, Quai St. Michel* (1916). Recalling his first impression of this work, which depicts a room interior with a reclining nude and a window view of a Paris cityscape, Diebenkorn focused on how Matisse balanced three-dimensional space with two-dimensional design: "I noticed its spatial amplitude; one saw a marvelous hollow or room yet the surface is right there . . . right up front."[11]

Diebenkorn's ongoing interest in Matisse peaked with a retrospective exhibition that he saw at U.C.L.A. in 1966, shortly before he commenced the *Ocean Park* series.[12] Among the exhibited works, *View of Notre Dame* (fig. 102.1) of 1914 pushed representation to the edge of abstraction, distilling the image of the famous Gothic cathedral to a geometric silhouette. This silhouette, repeated several times in different scales, floats ambiguously on the picture plane, alternately receding into space or projecting outward. Similarly, the recession of the Seine River and its adjoining quay, schematically suggested by diagonal vectors, is undermined by vertical and horizontal lines that relate more strongly to the surface geometry of the canvas. Matisse's translucent and transparent blue brushstrokes create a tangible, enveloping light and atmosphere that heighten the spatial ambiguity of the composition. Unlike most of Diebenkorn's

Fig. 102.1 [top right]. Henri Matisse (1869–1954), *View of Notre Dame*, 1914. Oil on canvas, 58 × 37⅛ in. (147.3 × 94.3 cm). The Museum of Modern Art, New York. Acquired through the Lillie P. Bliss Bequest and the Henry Ittleson, A. Conger Goodyear, Mr. and Mrs. Robert Sinclair Funds, and the Anna Erikson Levene Bequest given in memory of her husband, Dr. Phoebus Aaron Theodor Levene, 116.1975

Fig. 102.2 [bottom right]. Henri Matisse (1869–1954), *Artist and Goldfish*, 1914. Oil on canvas, 57¾ × 44¼ in. (146.7 × 112.4 cm). The Museum of Modern Art, New York. Gift and bequest of Florence M. Schoenborn and Samuel A. Marx, 507.1964

contemporaries, who perceived the choice between representation and abstraction as a moral imperative, fifty years earlier Matisse identified the conflict between these two modes as potentially more productive than its resolution.[13] Diebenkorn's *Ocean Park* paintings explore and extend many of Matisse's formal pictorial concerns.

The composition of *Ocean Park 116* is slightly more vertical than square, which counterbalances the effect of compression created by the horizontal color bands in the upper register. These bands are offset by the rectilinear elements at the left and right edges, which resemble vertical posts supporting a lintel above an open door. The intersecting and overlapping planes of opaque, translucent, and transparent color create a sense of three-dimensional space and atmosphere. These color planes are delineated or crossed by skeins of vertical, horizontal, diagonal, and curvilinear lines that emphasize the two-dimensional picture plane. These subtle lines weave in and out of the color bands and fields, confounding the viewer's attempts to construct a single-point perspective of advancing and receding planes.

Diebenkorn's black line underdrawing and overdrawing, reminiscent of that found in the finished work of Matisse and the unfinished work of Piet Mondrian, provides an architectonic framework for the overall composition. However, this internal support structure is simultaneously subverted by numerous modifications and erasures. Wayne Thiebaud recalled, "Dick discussed 'crudities' with me. This is something like 'ineptitudes' or 'awkwardnesses,' which are retained in one's work in order to avoid the slick, the ingratiating. It is a redirection to avoid getting easy . . . Diebenkorn retains the stumbling . . . it becomes crucial to the character of his work."[14] Diebenkorn's reluctance to fix a definitive image or statement, a quality that he appreciated in Matisse's work, served to reaffirm his belief in painting as a contingent process rather than a finished product.[15]

As Thiebaud observed, "There's a systematic skepticism inherent in his paintings—they always seem complete, but never finished."[16]

Diebenkorn's emphasis on formal concerns does not preclude the presence of content. Without being literal or explicit, the *Ocean Park* paintings, like the mature abstractions of Mark Rothko, are also evocative of nature and the elemental encounter of earth, sea, and sky—as well as the play of light and shadow on sand, stucco, and streets. They thus confirm Diebenkorn's observation about his earlier abstract paintings: "It was impossible to imagine doing a picture without it being a landscape; to try to make a painting space, a pure painting space, but always end up with a figure against a ground."[17]

Although the human figure is never overtly depicted in the *Ocean Park* paintings, its presence is sensed both on and beneath the surface. As in Leonardo's famous drawing of the ideal "Vitruvian Man," who is depicted both at rest and with his limbs fully extended, the scale of Diebenkorn's paintings is derived from, and relates to, the scale of the human body.[18] William Brice observed, "He chose a scale that embodied his own extension. *That means something.*"[19]

Matisse's *Artist and Goldfish* (fig. 102.2) of 1914, in which the French artist painted over a self-portrait, leaving only the traces of a hand and palette, also prefigures the *Ocean Park* series, most obviously in its abstract elements but as well in its figuration. The vestigial presence of the artist, even more than a complete self-image, serves as a striking reminder that the artist's hand, body, and emotional identity are present in every painting—even when they are not visible on the surface. This fundamental principle is embodied in the *Ocean Park* paintings, which epitomize Diebenkorn's belief that "if what a person makes is completely and profoundly right according to his lights, then this work contains the whole man."[20] [TAB]

103. DAVID SMITH, *Ovals on Stilts*

THE SHAPE OF WORK

*[B]efore knowing what art was and before going to art school, as a factory worker
I was acquainted with steel and the machines used in forging it.* DAVID SMITH[1]

David Smith (1906–1965) is the preeminent sculptor linked to the Abstract Expressionists of the New York School. Most often discussed as working to uncover the link between visual signs and the unconscious mind, these artists explored the pure constraints of their chosen medium and its unique potential for subjective discovery.[2] Because much Abstract Expressionism is tied philosophically so closely to its medium, most discussions focus on the determining effects of the flat surface and the physical properties of paint. Or, when sculpture is considered, the focus becomes the specific requirements of fashioning materials and the volumetric experience of objects in space. Artists are seen as existential protagonists, pursuing individual freedom in the creation of works that express their identity as they overcome the apparent dictates of a medium.[3]

Smith, however, who began as a painter, resisted the specificity of medium and rhetoric of purity common to other Abstract Expressionists, most evident in his insistence that it was critics who artificially imposed the supposed distinction between the two- and three-dimensional languages of painting and sculpture, respectively. As he asserted in his journal, "sculpture can be painting and painting can be sculpture and no authority can overrule the artist in his declaration."[4] The artist invented a process that allowed him to move fluidly between the requirements of working in two and three dimensions. Like Jackson Pollock, he developed a technique of composing on the floor, discovering his subject through the manipulation of his materials and their physical properties, whether he was painting or sculpting.[5] Therefore, although he is most well known for his metal sculptures, Smith could write: "I belong with

painters.... Some of the greatest contributions to sculpture of the twentieth century are by painters.... Painting and Sculpture aren't very far apart."[6]

Smith's work began with the languages of Cubism and Surrealism, and especially with collage, which he studied at the Art Students League, New York, under Jan Matulka, whose teaching there from 1929 to 1931 was instrumental in introducing the works of the European avant-garde to American artists.[7] In particular, Smith adopted the additive and improvisational method that aligns collage with the playful associations of constructivist assemblage. Smith's procedure, whether in drawing, painting, or sculpture, relied on making art objects based in actual materials rather than using those materials to create works that reference something else. Some of his earliest experiments with collage were photomontages that he fashioned by sandwiching multiple negatives into a single, composite composition (fig. 103.1).[8] They reflect cubist and surrealist notions of removing objects from a recognizable or functional context in order to invent startling juxtapositions and mobilize unconscious associations. This emphasis on combining existing objects into new arrangements is the key to Smith's visual language in all media. During the late 1950s and early 1960s, it led him to develop an innovative vocabulary of abstraction that was closely aligned in two bodies of work—his *Zig* series of painted, steel sculptures (fig. 103.2) and his enamel spray paintings.

Ovals on Stilts (1959), one of Smith's most important spray paintings, dates from the period of the artist's emerging prominence within the international art world.[9] As in the other works from this series, Smith ingeniously

103. David Smith (1906–1965), *Ovals on Stilts*, 1959
 Spray paint on canvas, 106 × 50 in. (269.2 × 127 cm)
 Gift of Diane B. Wilsey in honor of Harry S. Parker III, 2000.138

Fig. 103.1. David Smith (1906–1965), *Untitled*, ca. 1932–35. Gelatin silver print, 3½ × 4¾ in. (8.9 × 12.1 cm). Fine Arts Museums of San Francisco. Museum purchase, with funds from the Harriet Ames Charitable Trust and the Photography Committee, 98.28.4

references sculpture and painting simultaneously. The canvas support with its spray-painted enamel surface remains resolutely two-dimensional, and its emphasis on the relationship of figure to ground reiterates one of the most important themes in the history of modern painting. Smith created the composition by placing the canvas on the floor and laying three-dimensional objects on top of it as stencils. He used cutout scraps of metal, wood, cardboard, paper, and even fruits and vegetables, creating these stencils out of the materials at hand, much as he constructed his welded assemblage sculptures.[10] He then sprayed enamel paint on the canvas, working quickly and shifting the templates. The indistinct, blurred, white silhouettes that remain, contrasting with the areas of colored paint, constitute a physical record of the three-dimensional objects and their movement. Smith's painting thus combines the gestural registers of abstract expressionist painting with the linear structure and solid geometric shapes that resemble his own welded, abstract sculptures, a relationship reinforced by the artist's

periodic use of this spray technique to produce preliminary sketches for some of his metal assemblages.[11]

Given Smith's background in Cubism and Surrealism, one is tempted to look for anthropomorphic or zoological imagery in his abstract shapes. Such references are signaled in the descriptive titles he gave many of his landmark early works and in the figural implications of two of his most important series, the *Tanktotems* and *Sentinels*.[12] However, although vertical, *Ovals on Stilts* resists being read as an organization of forms around a primary spinal element, which is how Smith most often indicated a figure. Rosalind Krauss, one of Smith's most important interpreters, has argued that his primary ambition during the 1950s was to transform the notion of line as a support for figurative associations into a more fully abstract reference.[13] She further maintains that in this period, especially with the *Tanktotem* series, Smith began creating works whose meaning is entirely coexistent with their surfaces.[14]

Smith's interest in surface began during the 1940s and

Fig. 103.2. David Smith (1906–1965), *Zig V*, 1961. Painted steel, 111 × 85 × 44 in. (281.9 × 215.9 × 111.8 cm). Fine Arts Museums of San Francisco. Museum purchase, gift of Mrs. Paul L. Wattis, 1999.66

1950s when he originated the use of metal line to create open works that encouraged viewers to think of his sculptures as transparent rather than solid objects, contrary to sculpture's traditional interpretation. In *Ovals on Stilts*, he uses the tension between figure and ground in the painted surface to illustrate this sculptural tension between inside and outside. The obvious layering of imagery, which results from the stencil technique, may suggest that the *on* in the title refers to the building up of objects (and paint) on the surface. It counters the more pictorial meaning, which implies that this collection of forms depicts a group of ovals balanced on stilts. In other words, the viewer is led to read this canvas, on which objects have left signs of their physical presence, in terms of the depth and dimensionality that belong to the vocabulary of sculpture. It is a painted contradiction, simultaneously literal in its reference to actual objects and abstract in its visual representation. It demonstrates Smith's lifelong interest in collapsing the purity of practice in painting and sculpture that the period's most influential critics, such as Clement Greenberg and Harold Rosenberg, insisted was the hallmark of Abstract Expressionism.

Nevertheless, in one major respect Smith shared the rhetoric of the Abstract Expressionists, emphasizing his art as a manifestation of physical exertion and bodily experience. He always insisted on the close associations between his own methods and working-class labor. Industry played an important role in Smith's life from an early age. Born in 1906 in Decatur, Indiana, he grew up in a small-town milieu of railroads and factories. In the summer of 1925, while still a teenager, Smith learned welding at the South Bend, Indiana, Studebaker factory.[15] During World War II he worked as a machinist in Glens Falls, New York, and from 1942 to 1944 for the American Locomotive Company in Schenectady, New York, where he refined his skills in arc welding, which became his primary method of sculpting.[16]

Ovals on Stilts demonstrates just how much Smith drew on his industrial background in his artistic innovations. The enamel paint, which Smith also used on his metal *Zig* sculptures, recalls his youthful experience in an auto factory. But it is in arc welding that Smith's sculptural and painting techniques converge most suggestively. Fabricating a join through arc welding requires a high degree of skill in a complex electrical process, during which a spray of sparks is emitted. This spray has a parallel in the splattering of paint used to produce the tactile surface of his paintings.

Smith's self-proclaimed identification with working-class labor also informs the subject matter of *Ovals on Stilts*. With its square field of white shapes, alternating stripes, and predominantly blue and white palette, the painting is likely to remind viewers of the American flag. However, the substitution of orange for the expected red intervenes in the composition, suggesting an alternative affiliation reflected in Smith's often-voiced leftist sentiments.[17] For instance, Smith wrote in his journal: "By choice I identify myself with workingmen and still belong to Local 2054 United Steelworkers of America. I belong by craft—yet my subject of aesthetics introduces a breach. I suppose that is because I believe in a workingman's society in the future and in that society I hope to find a place."[18] He even rejected the term *studio* for his workplace in Bolton Landing, New York, because he identified his method with manual labor and factory work, preferring to call it Terminal Iron Works after the actual ironworks in Brooklyn where he made sculpture in the 1930s.[19] The orange and reddish brown hues in the painting may signify an additional reference to both industrial manufacturing and Smith's metal sculptures through their association with rust or the color of metal primer.

Ultimately, *Ovals on Stilts* uses the visible marks of the painting's process as a record of its physical and intellectual creation. It calls attention to Smith's own preoccupation with the dialectic strategies of both painting and sculpture, perceptively using each medium to comment on the other's spatial relationships: figure to ground, negative to positive, and horizontal to vertical. In this way, his painting serves as a metaphor of sculpture. The relationship between figure and ground on which painting relies for illusionistic effect is subverted by an actual trace of the objects depicted; however, the painting references those objects without describing them. Similarly, Smith reverses the viewer's usual experience of positive space in painting, using the absence created by the stencils to emphasize the role of background and context in defining the ghostly figures. And laying objects that would typically be experienced vertically onto a horizontal field reminds viewers how the surface of painting not only flattens the three-dimensional world but also transforms it into a linear realm. At the same time, because the work is displayed upright, it evokes Smith's sculptural appropriation of painting's more linear and planar vocabulary.

Through this series of relational reversals in his enamel spray paintings, Smith uses the materials of one medium to represent another. Not incidentally, this is how the rhetoric of Surrealism operates, generating multilayered associations that open onto surprising revelations. It is this exploration of relationships rather than any particular imagery that connects Smith's earlier work based in collage and assemblage to his mature abstract expressionist works of the 1950s and 1960s. In its commitment to the physical materiality of industrial methods, Smith's *Ovals on Stilts* links sculpture and painting, labor and intellect, collage and anarchy, and, ultimately, working-class politics and artistic practice. [DC]

FACING REALITY

David Park (1911–1960) was the most influential of the artists associated with the San Francisco Bay Area Figurative movement, which challenged the cultural dominance of Abstract Expressionism in the 1950s. The origins of the perceived schism between these two art movements in the Bay Area usually are ascribed to Park, who took most of his nonobjective paintings to the Berkeley city dump in 1949.[1] This legendary act of destruction and renewal symbolically prefigured the seismic shift in the cultural landscape engendered by Park's subsequent exhibition of the figurative painting *Kids on Bikes* (1950, private collection) in 1951.[2] Park's return to figuration was widely interpreted as a rejection of Abstract Expressionism, rather than as the natural evolution of the San Francisco school.[3] Commenting on his self-defined shift from nonobjective "paintings" to representational "pictures," Park observed, "As you grow older, it dawns on you that you are yourself—that your job is not to force yourself into a style, but to do what you want."[4]

Recent scholarship has adopted a more nuanced approach to the history of these art movements, acknowledging the complex interchange of personal, regional, and national factors that shaped their development.[5] Park's figurative work, for example, represented, not a complete rejection of Abstract Expressionism, but an ongoing dialogue with its philosophical principles, psychological insights, and pictorial innovations. While often retaining the Abstract Expressionists' gestural paint surfaces, sensitivity to the autonomy of the two-dimensional picture plane, and even their interest in existential universality, Park's choice of figurative subjects infused his late work with a new degree of emotional engagement and grounded them within a broad humanism. Park's late works increasingly captured not actual human experience but rather the human condition:

> I think of painting—in fact all the arts—as a sort of extension of human life. The very same things that we value most, the ideals of humanity, are the properties of the arts. The words that come to mind are many—energy, wisdom, courage, delight, humor, sympathy, gentleness, honesty, peace, freedom—I believe most artists are goaded by a vision of making their work vivid and alive with such qualities. I believe this is the undercurrent of the artist's energy.[6]

David Park was born in Boston, Massachusetts, and his precocious art aspirations were encouraged by his parents, who built their teenage son a studio at their summer home in Peterborough, New Hampshire.[7] Although Park briefly studied art with Vaclav Vytlacil in 1928 at the Otis Art Institute in Los Angeles and assisted the sculptor Ralph Stackpole in 1929 with his Pacific Coast Stock Exchange commission in San Francisco, he was essentially self-taught. During the Great Depression, Park worked for the Federal Art Project of the Works Project Administration painting murals, designing tapestries, and documenting W.P.A. labor projects. An influential instructor, Park taught art at the Winsor School in Boston (1936–41), at the California School of Fine Arts (1944–52), and at the University of California at Berkeley (1955–60).[8]

Over the course of his career, Park's subjects evolved from American Scene genre images influenced by the Mexican muralist Diego Rivera (1886–1957) in the 1930s; to

104. David Park (1911–1960), *Couple*, 1959
 Oil on canvas, 25¾ × 48 in. (65.4 × 121.9 cm)
 Partial gift of the Morgan Flagg Family Foundation, 1995.21.6

Fig. 104.1. Imogen Cunningham (1883–1976), *David Park with "Portrait of Lydia,"*
October 16, 1956. Copyright © Imogen Cunningham Trust, all rights reserved

figural abstractions influenced by Pablo Picasso's Cubism and Joan Miró's Surrealism in the early 1940s; to the abstract works of the late 1940s. The figurative works of Park's final decade evolved from anecdotal genre scenes of social interaction to increasingly iconic and timeless figures isolated from any temporal context.[9] These late works incorporate monumental figures, bold brushstrokes, lush pigments, and vivid colors. Park employed radical visual perspectives and physical manipulations of painted space to foster a mood and to amplify the viewer's emotional response. Although painted from memory, rather than from a model, these works convey an extraordinary sense of immediacy and humanity.[10]

Park's *Couple* (1959), one of his most compelling late works, fuses figural subjects with abstract expressionist brushwork, thus reconciling the competing demands of representation and abstraction. The painting depicts two emphatically frontal human figures, abruptly cropped at the shoulders so as to create the illusion that their bustlike heads are resting on the bottom of the picture plane. The figures' shoulders overlap, suggesting familiarity or intimacy, and they present a unified front to the viewer. The tight cropping of the composition, the unifying orange-red ground, and the lack of conventional perspective accentuate the ambiguous, indeterminate nature of the space, isolate the figures from any anecdotal context, and heighten the sense of direct confrontation.

Park's use of bravura brushwork and arbitrary color in *Couple*, most notably the yellow stripe representing the left figure's nose, reveals the influence of the fauve paintings of Henri Matisse, such as *Madame Matisse (The Green Line)* (1905, Statens Museum for Kunst, Copenhagen), or *Femme au chapeau* (1905), which was owned by one of Park's patrons, Elise S. Haas.[11] *Couple* reveals Park's fascination with raw, earthy oil pigment, not merely as a means of replicating life but as an organic life substance in its own right. As

Richard Diebenkorn recalled, "He was also in *love* with oil paint and its potential to become *merde* which he manipulated with frank relish, creating from it his powerful and loving statements affirming the possibilities of a densely loaded and vigorously articulated canvas—plus humanity as he perceived it."[12]

Park had previously explored the theme of the couple in numerous works. In the cubist-influenced painting *Encounter* (1945, Oakland Museum of California), he activated the interstitial space between two profile heads that confront each other eye to eye, thus seeming to create a third entity.[13] In *Bathers on the Beach* (1956, private collection) and *Two Female Figures* (1957, Los Angeles County Museum of Art), which owe a pictorial debt to works by Matisse and Picasso, Park used two full-length female nude bathers—or one bather posed in two positions—to explore issues of sameness and difference.[14] In *Two Heads* (1959, private collection), whose format resembles that of *Couple*, the frontal head on the left confronts the viewer, while the proximate figure on the right is depicted in pure profile, as if whispering intimately in the first figure's ear.

In *Couple*, Park's crude brushstrokes and impastoed pigment manifest the abstract expressionist nature of his work but also conceal a complex underlying structure. The two figures nearly mirror each other, the strong highlights and deep shadows of each complementing those of the other. Both figures share dark brown outlines and touches of vivid red on their mouths. However, the smaller head on the left is slightly more vertical and ovoid and rests on larger shoulders, while the larger head on the right is rounder and rests on smaller shoulders. The warm yellow nose of the left figure, shaped like an inverted keyhole, reads as a highlight falling on a solid, while the similarly shaped dark brown nose of the right figure reads as a dark void. In Park's bipolar composition, the two figures evoke counterbalancing weights on a visual scale, or positive and negative battery terminals that together complete a charged circuit.

Although the gender of the figures in *Couple* is not clear, the relative widths of their shoulders and necks suggest that the left figure might be male and the right one might be female. On a personal level, Park's theme of the couple undoubtedly was grounded in the context of his strong and supportive relationship with his wife. Lydia Park was her husband's favorite model (fig. 104.1) and the source of the "Lydia Park Fellowship" (i.e., her salary) that enabled the artist to pursue his figurative work without financial

Fig. 104.2. *Portrait of a Bearded Man*, Roman, Egypt, Faiyûm, ca. A.D. 250. Encaustic on panel, 18⅛ × 7¹⁵⁄₁₆ in. (46 × 20.2 cm). Courtesy of the Arthur M. Sackler Museum, Harvard University Art Museums. Gift of Dr. Denman W. Ross, 1923.59

constraint in the early 1950s. Yet, ultimately, Park's theme is not personal biography but the coexistence of universal opposites—representation and abstraction, positive and negative space, light and darkness, male and female, the self and the other—in a state of balanced tension.

Park suggests that to be part of a couple is to be located relationally in the world, to be a unique individual, but also to be mirrored by another human being through shared experience. Park's universal theme and generic title evoke the presence of a primordial couple. These archetypal personages, unidentified yet not unfamiliar, fix the viewer with an intense wide-eyed stare that conveys a heightened state of sentient awareness. Incapable of speech, their open mouths accentuate their desire for communication. Simultaneously materializing out of, and dematerializing into, their paint ground, these figures seem to oscillate eternally between materiality and spirituality. Their bust-length forms recall the tender couples of Etruscan and Roman sarcophagi relief portraits, or the wide-eyed encaustic mummy portraits (fig. 104.2) painted by Greek and Roman artists for tombs in the Faiyûm district of Egypt. What *Couple* shares with these commemorative portraits is not the fixing of temporal identities, but the eloquent emotional force of their humanity, preserved for posterity. [TAB]

105. MEL RAMOS, *Superman*

THE MYTHOLOGY OF POP ART

Mel Ramos (b. 1935) is a pioneer of the Pop art movement that breached the traditional barriers separating popular culture and high art.[1] Between 1961 and 1963 Ramos created his first Pop art paintings—a series of portraits of superheroes and superheroines drawn from the pages of classic comic books. In subsequent paintings, which juxtaposed an oversized consumer product and trademark logo with a pinup-style nude, Ramos fused the cool Pop art aesthetic of appropriation with an explicitly erotic subject. These works revealed a striking kinship between the imaging, marketing, and consumption of animate and inanimate objects of desire. In a series entitled *A Salute to Art History*, Ramos launched a full-frontal assault on conventional perceptions of the nude in art, rendering contemporary female pinups in the guise of famous nudes by Diego Velázquez, J.-A.-D. Ingres, and Edouard Manet, thus recovering the original sexual charge of the earlier paintings.

Ramos was born in Sacramento and attended Sacramento Junior (now City) College (1954–55), San Jose State College (now University, 1955–56), and Sacramento State College (1956–58), where he received his B.A. and M.A. degrees. He initially experimented with Abstract Expressionism, but in the late 1950s his work evolved toward a style of painterly figuration under the influence of Bay Area artists David Park (1911–1960), Richard Diebenkorn (1922–1993), Elmer Bischoff (1916–1991), and Nathan Oliveira. However, Ramos's mature work was most influenced by his teacher at Sacramento Junior College, Wayne Thiebaud (b. 1920), whose knowledge of art history, interest in popular culture, and sensual use of oil paint shaped Ramos's own aesthetic.[2]

Recalling the difficulty inherent in challenging the dominant abstract expressionist style with figuration in the late 1950s, Ramos noted that new forms of popular media suddenly seemed to provide equally viable—and perhaps more relevant—artistic alternatives: "When I began painting the human figure during the nineteen fifties, conventional wisdom in the world of art seemed to discourage this work. . . . This may well have been justified at the time because television seemed to provide the best 'figuration' of that culture."[3]

In the early 1960s television both mirrored and projected the increasingly commercial values of American society and played a prominent role in the evolution of American Pop art. Artists were among the first to observe—and to embrace—a phenomenon in which the production, dissemination, and consumption of images seemed to have a cultural impact nearly coequal with the objects depicted. In this new culture characterized by images of images, the mass media's homogeneous reproduction of fine art and popular culture revealed previously unobserved parallels. Ramos was among the Pop artists who did not perceive a diminution of art but rather an exciting expansion of its field of vision: "The whole point about my work is that art grows out of art. That is central, no matter whether it is high art, low art, popular art or what. Comic books, girlie magazines, magazine ads, billboards are all art to me."[4]

California, a major locus for the entertainment industry and for the proliferation of commercial, corporate, and media culture, seemed to epitomize many of the Pop artists' favored themes (consumerism, celebrity) and also provided many of the movement's iconic images (Hollywood stars, Disney cartoons). As Ramos has observed, while East Coast Pop artists typically adopted a detached and ironic stance in relation to their subjects, West Coast artists often

105. Mel Ramos (b. 1935), *Superman*, 1962
 Oil on canvas, 40 × 30 in. (101.6 × 76.2 cm)
 Museum purchase, Dr. Leland A.
 and Gladys K. Barber Fund and
 American Art Trust Fund, 2004.2

embraced their subjects with open affection: "To me Pop Art itself was very much about nostalgia.... My paintings are affirmative. They're not negative criticisms of anything. And that's very important to me—my aim is affirmation."[5]

Superman (1962), Ramos's first Pop art painting, depicts one of America's most iconic and universally recognized cultural icons. The creation of writer Jerry Siegel and artist Joe Shuster, Superman first appeared in print in *Action Comics* in 1938 and, beginning in 1940, in his own eponymously titled comic book. A larger-than-life figure from Ramos's childhood, Superman represented a depression-era fantasy in which even an ordinary man such as Clark Kent could be transformed into a superhero. A twentieth-century counterpart to the nineteenth-century cowboy, Superman also seemed to embody America's belief in the ultimate triumph of good over evil and its self-perceived role as the definer and defender of that good.

Ramos's nostalgia for the golden age of comic books may have reflected the seemingly simpler times, values, and pleasures of the pre–World War II era, in which moral certainties were not yet mitigated by the complexities of the Holocaust, the atomic bomb, the cold war, the Korean War, and McCarthyism. Even comic books did not emerge unscathed from this transformed cultural landscape. The psychiatrist Frederick Wertham's *Seduction of the Innocent* (1954) attacked comic books for corrupting the morals of America's unsuspecting youth with images of violence and lust—and led to the creation of the Comics Code Authority, which censored comic book content.[6]

By 1962, when Ramos appropriated Superman for his first Pop art painting, the 1930s superhero seemed to provide a subversive, popular culture antidote to the serious pretensions of contemporary art:

> I got my Master's Degree in painting in 1958 and it was about 1959 or so that I realized that I had reached a dead end. I felt like a hanger-on since everybody seemed to already be doing the same stuff and I was just making more of what they were making. So I came to the conclusion that "high art" probably wasn't for me and that I should attend to subject matter that really interested me. As a young person I had been fascinated with comic books. Having already shifted to representational figures at this point, one day I decided to put a Superman costume onto one of them. So I painted Superman in the same style in which I was doing those figurative paintings.[7]

Ramos's *Superman* is representative of a seeming contradiction in Pop art in which preexisting, mass-produced

Fig 105.1. Diego Velázquez (1599–1660), *Portrait of Jester Pablo de Valladolid*, 1632. Oil on canvas, 82¼ × 48⅜ in. (208.9 × 122.9 cm). Museo del Prado, Madrid

images are often personalized through their selection, manipulation, and rendering.[8] While the immediate source for this painting was the cover of a contemporaneous Superman comic book, Ramos omitted the central drama, in which a three-person tribunal representing "The Legion of Super-Villains" condemns the powerless superhero to death.[9] The saturated primary colors replicate the comic book's palette, but Ramos's lush paint application is at odds with the flat colors of commercial printing. On the contrary, Ramos's rendering of the representational figure and its abstract ground with the same technique seems to address the contemporary conflict between figurative artists who valued the three-dimensional illusion of space and the Abstract Expressionists who valued an emphatically two-dimensional paint surface.[10]

Indeed, Ramos's *Superman* owes as much of a pictorial debt to fine art as to popular art.[11] Superman's odd shadow and the painting's monochrome, indeterminate space, which lacks a clear ground line, resemble art historical antecedents in such old master works as Edouard Manet's *The Fifer* (1866, Musée d'Orsay, Paris) or Diego Velázquez's *Portrait of Jester Pablo de Valladolid* (fig. 105.1) of 1632.[12] The halation around the figure of Superman—thin lines of vivid magenta, yellow, blue, and orange pigment that Ramos termed the "nasty little line"—were derived from another painterly artist, the Spaniard Joaquín Sorolla y Bastida, whose work he admired in San Francisco and New York in 1956.[13]

Reflecting on his inclusive view of art history, Ramos has observed, "One of the central issues of my work has been the notion that art grows from art. I've been fascinated by the myths, iconography, and clichés that have perpetuated themselves throughout the history of art in various forms and idioms."[14] Ramos thus perceived no inherent contradiction in creating "a series of heroic portraits of the comic book gods and goddesses, exacted I had hoped, with all the splendor of Modigliani, de Kooning, and the others."[15] Perceiving Ramos's intended parallels with classical mythology, the art critic Barbara Rose wrote: "And which of us, able to recite the myths of Captain Marvel and Wonder Woman as unfalteringly as Homer sang of the gods, can fail to experience the shock of recognition upon seeing Mel Ramos's lurid, grinning 'Joker'?"[16]

Ramos's *Superman*, posed with his legs planted firmly and his fists clenched, appears prepared to tackle an unseen foe or Herculean task. Isolated for contemplation, he appears ennobled—a secular hero to be emulated or, like an archaic Greek kouros statue, an enigmatic deity worthy of worship. Yet, for a "faster-than-a-speeding-bullet" superhero who embodies the speed that characterizes American society, Superman is surprisingly inert.[17] The freeze-frame isolation of this solitary figure, divorced from the display of his superpowers or the pursuit of his foes, renders the traditionally virile figure of Superman poignantly mortal. Stripped of a temporal context and lacking a motivating narrative, he becomes truly timeless—a modern mythological hero standing—and waiting—on an existential stage.

[TAB]

106. STUART DAVIS, *Night Life*

THE ART OF JAZZ

Stuart Davis combined American subjects with the pictorial vocabularies of the European avant-garde to forge a uniquely American brand of modernism. Despite the distinctive American accent of his works, whose subjects encompassed rural New England and urban New York, Davis denounced the nationalistic tenor of the art movement known as American Regionalism. Davis instead proclaimed art's autonomy from political or cultural agendas, arguing that the act of making art—even abstract art—is itself a political act that benefits society.[1] In his essay "The Cube Root" (1943), Davis enumerated his diverse sources of inspiration, which bridged America and Europe, the past and the present, and the canonical and the vernacular:

> Some of the things which have made me want to paint, outside other paintings, are: American wood and iron works of the past; Civil War and skyscraper architecture; the brilliant colors on gasoline stations, chainstore fronts and taxicabs; the music of Bach; synthetic chemistry; the poetry of Rimbaud; fast travel by train, auto and aeroplane which brought new and multiple perspectives; electric signs; the landscape and boats of Gloucester, Mass.; 5 & 10 cent store kitchen utensils; movies and radio; Earl Hines' hot piano and Negro jazz music in general, etc.[2]

Edward Stuart Davis (1892–1964) was born in Philadelphia to parents who were artists.[3] In 1909 he left high school in New Jersey to study art with Robert Henri (1865–1929) in New York City. One year earlier, Henri had joined with John Sloan, William Glackens (1870–1938), George Luks, Everett Shinn (1876–1953), George Bellows, Arthur B. Davies, and Maurice Prendergast (1859–1924) to hold the first exhibition of the Eight, a group later known as the Ashcan School. Davis's early paintings, along with his illustrations for the populist periodical the *Masses*, emulated this group's controversial working-class subjects. However, New York's infamous Armory Show of 1913, the first large-scale exhibition in America of works by European avant-garde artists, made the Ashcan School's works appear provincial. In an analogy that was prescient for his later work, Davis linked this seminal exhibition with his love of jazz: "It gave me the same kind of excitement I got from the numerical precisions of the Negro piano players in the Negro saloons, and I resolved that I would quite definitely have to become a 'Modern' artist."[4]

Davis's early interest in jazz is documented in a 1915 article entitled "Night Life in Newark," which was illustrated by Davis and Glenn O. Coleman.[5] The article recounts a nocturnal tour of working-class jazz clubs, with Davis, the tour guide, extolling the improvisations of an African American pianist.[6] However, Davis's jazz subjects from this period, including *Barrel House—Newark* (1913, private collection) and *The Back Room* (1913, Whitney Museum of American Art), are rendered in characteristic Ashcan School style.[7] Davis's transformation of jazz from a literal subject into a metaphoric sensibility did not begin until his trip to Paris in 1928–29, when he was introduced to the music of the jazz pianist Earl "Fatha" Hines.[8] In a letter of 1940 to the jazz impresario and critic John Hammond, Davis recalled this revelatory event:

> Earl Hines' piano playing has served me as a proof that art can exist, since 1928, when I heard his playing in a Louis Armstrong record, "Save it pretty mama." . . . Earl

106. Stuart Davis (1892–1964), *Night Life*, 1962
Oil on canvas, 24 × 32 in. (61 × 81.3 cm)
Gift of Mrs. Paul L. Wattis and Bequest
of the Phyllis C. Wattis 1991 Trust from
Paul L. Wattis Jr. and Carol W. Casey, 1996.75

Hines represented to me the achievement of an abstract art of real order. His ability to take an anecdotal or sentimental song and turn it into a series of musical intervals of enormous variety has played an important part in helping me to formulate my own aspirations in painting.[9]

Davis believed that jazz—a uniquely American art form—could provide a model for American artists seeking to establish an indigenous modernist tradition independent of that of Europe. Following his return from Paris in 1929, Davis gradually assimilated jazz aesthetics, theories, and vocabularies in abstract paintings such as *American Painting* (1932–51, Joslyn Art Museum), which includes the phrase "It don't mean a thing if it ain't got that swing"; *Swing Landscape* (1938, Indiana University Art Museum); *Hot Still-Scape in Six Colors—7th Avenue Style* (1940, Museum of Fine Arts, Boston); *New York under Gaslight* (1941, The Israel Museum), which includes the phrase, "DIG THIS FINE ART JIVE"; *For Internal Use Only* (fig. 106.1); *The Mellow Pad* (1945–51, private collection); and *Night Life* (1962). In 1943 Davis's exhibition at the Downtown Gallery in New York opened with an extraordinary all-day jam session that included Duke Ellington, Red Norvo, W. C. Handy, Mildred Bailey, George Wettling, and Pete Johnson.[10] Davis described the symbiotic relationship between his art and jazz later, in 1957:

> I have always liked hot music. There's something wrong with any American who doesn't. But I never realized that it was influencing my work until one day I put on a favorite record and listened to it while I was looking at a painting I had just finished. Then I got a funny feeling. If I looked, or if I listened, there was no shifting of attention. It seemed to amount to the same thing—like twins, a kinship. After that, for a long time, I played records while I painted.[11]

Painted nearly fifty years after the Armory Show, and two years before Davis's death, *Night Life* is the culmination of the artist's belief in the centrality of jazz to the development of American abstract art. Composed of emphatically flat forms that have been fitted together like interlocking puzzle pieces, *Night Life* reveals the influence of two other jazz-inspired works—Piet Mondrian's *Broadway Boogie Woogie* (1942–43, The Museum of Modern Art, New York) and Henri Matisse's *Jazz* portfolio (1943).[12] Davis likened the minimal palette of late works such as *Night Life* to

Fig. 106.1. Stuart Davis (1892–1964), *For Internal Use Only*, 1944–45. Oil on canvas, 45 × 28 in. (114.3 × 71.1 cm). Reynolda House Museum of Art, Winston-Salem, North Carolina

Fig. 106.2 [top]. Stuart Davis at the piano. Photogaph. Collection of Earl Davis, courtesy of Salander-O'Reilly Galleries, New York

Fig. 106.3 [bottom]. [Man with still], unidentified newspaper clipping, Stuart Davis Papers

"notes on a scale that can produce whatever melody he wants with no need for half-tones."[13]

Davis's title, *Night Life*, provides a clue to the ostensible subject of the painting—an African American musician, viewed in profile, wearing a broad-brimmed hat and playing an upright piano.[14] In this context, the black X's and straight lines in the white square at the lower right are visual referents for piano keys. The three short appendages of the musician's left hand evoke the heavier beat of a base line, while the tangled lines of the right hand suggest a faster-paced melody.[15] The subject and its treatment recall Davis's *For Internal Use Only* (fig. 106.1), a posthumous homage to the Dutch expatriate Mondrian—a fellow jazz aficionado. Davis described this earlier painting as a tribute to their shared experiences listening to jazz, and pointed to the abstracted black face and spotted bow tie of one of Mondrian's favorite boogie-woogie pianists, as well as piano keys and the abstracted marquee of a New York jazz club.[16]

Archival photographs of Davis, an accomplished jazz pianist, playing the piano (fig. 106.2) raise the possibility that *Night Life* is also a self-portrait of the artist. Davis's dual identities as a musician and an artist are suggested by the superimposition of the musician's extended right hand against the left half of the composition, as if making a brushstroke on a vertical painting propped on an easel. Similarly, his left hand is juxtaposed with the white square and black lines, which resemble an artist's palette and pigments.[17]

The composition of *Night Life* is divided vertically into predominantly abstract and representative halves, which are mirrored by the horizontal s and vertical DAVIS of the signature. Although Davis's fascination with this type of split vision dates back to *House and Street* (1931), the direct source for the bifurcated composition of *Night Life* is a newspaper photograph that appears to show a man operating a liquor still (fig. 106.3).[18] The appropriation and transformation of this mass-media image reveals the breadth of Davis's sources and the fluidity of his imagery, which he distilled to its essential components. The seemingly disparate halves of *Night Life*, which are unified by the superimposed word STYLE, may serve as metaphors for the fragmentary, disjunctive experiences of modern life—and modern art—and the artist's unique ability to reconcile these forces.

In *Night Life*, whose title recalls the early "Night Life in Newark" article of 1915, Davis looks back over a career extending from the realism of the pre–World War I Ashcan School to post–World War II abstraction. As Rudi Blesh explained in 1960, Davis's late work summarized the essence of his art.

Now, as always, he [Davis] paints from a memory whose elbow nudges invention, but now that memory is a rich storehouse of images, colors, moving forms, and of sounds too: Basie's blockbuster brass; Dixieland jazz at old Reisenweber's the long-ago year we entered the first World War; Bessie Smith, tawny and tragic, chanting the lowdown blues; and far, far away the lost magic tinkle of ragtime. He weaves it all together—American documents, ever more and more complex and yet ever more distilled.... American yet universal—a local dialect that all men may read and understand.[19]

As an artist, Davis self-consciously identified with the African American jazz musician as a fellow creator and performer who continually improvised variations on his themes through the use of composition, color, tone, syncopation, and harmony. *Night Life* is a pictorial summation of Davis's distinctive artistic style, which mediated the forces of representation and abstraction but consistently affirmed his belief in the primacy of form, space, and color as the true subjects of art. [TAB]

1 O 7 . J E S S , *If All The World Were Paper And All The Water Sink*

APOCALYPTIC ALCHEMY

Jess (1923–2004) was a key figure in the extended community of artists associated with the post–World War II collage and assemblage movements. Drawing inspiration from the public domain of art, literature, history, mythology, and religion and from a private realm of biography, memory, fantasy, and the unconscious, Jess created a parallel mythopoetic world with its own multivalent language of allegory, metaphor, and symbolism as well as riddles, puzzles, and puns. Inspired by the Dada precedent of appropriating a preexisting found object or image that could be recontextualized in an artistic context, Jess's work is a testament to the power of art to recalibrate viewers' perceptions of the world.[1]

Burgess ("Jess") Franklin Collins was born in Long Beach, California, and began his career as a chemist, studying (1942, 1946–48) at the California Institute of Technology in Pasadena. In 1943 he was drafted into the U.S. Army and stationed at Oak Ridge, Tennessee, where he worked for the infamous Manhattan Project that developed the world's first atomic bombs. On 6 August 1945, Jess's twenty-second birthday, the United States dropped one of these bombs on Hiroshima, Japan. Three days later, a second bomb was dropped on the city of Nagasaki. These two bombs killed or wounded more than two hundred thousand people and led to Japan's surrender, ending World War II. Soon after, Jess and his fellow atomic researchers viewed a top-secret film that showed the destroyed Japanese cities, the dead, and the disfigured survivors. Overwhelmed with horror and guilt, Jess staggered to the door, vomited, and then fainted.[2]

Discharged from the army in 1946, Jess returned to school in Pasadena and then worked (1948–49) as a chemist

at the Hanford Atomic Energy Project in Richland, Washington. In 1949, troubled by his role in the creation of atomic weapons and his work on the H-bomb, Jess had a disturbing dream that the world would come to an apocalyptic end in twenty-five years, and he abandoned his scientific career.[3] Two months later, he enrolled at the California School of Fine Arts (now the San Francisco Art Institute), where he studied (1949–51) with Clyfford Still, Edward Corbett, Ad Reinhardt, Hassel Smith, Elmer Bischoff, David Park, and Clay Spohn.[4] Jess's transformation from scientist to artist was facilitated by his symbiotic personal and professional partnership with the poet Robert Duncan, an influential figure in San Francisco's gay community.

Jess's *If All The World Were Paper And All The Water Sink* (1962) is one of several works that address personal and collective responsibility for the creation and use of the atomic bomb. Jess's collagelike composition, a technique that he described as "flux-image," suspends conventional conceptions of reality to combine simultaneous and multivalent images, narratives, and spaces, not unlike early Renaissance painting.[5] The focal point of the composition is the detonation of an atomic bomb, whose characteristic mushroom cloud glows hot yellow-white and trails flames to the left. The atomic burst, illuminated by an artificially triggered nuclear chain reaction, resembles or even rivals the sun, which is naturally fueled by nuclear fusion. Alternately, and ironically, it may be viewed as a glowing light bulb, the classic cartoon convention for a theoretically "bright idea."

The blue Greek letter Ω (omega), which encircles the atomic mushroom cloud and signifies the end, implicitly introduces its counterpart, the Greek letter A (alpha), which signifies the beginning.[6] This pairing occurs most

107. Jess (1923–2004), *If All The World Were Paper And All The Water Sink*, 1962
Oil on canvas, 38 × 56 in. (96.5 × 142.2 cm). Museum purchase, Roscoe
and Margaret Oakes Income Fund, the Museum Society Auxiliary,
Mr. and Mrs. John N. Rosekrans Jr., Walter and Phyllis J. Shorenstein
Foundation Fund, Mrs. Paul L. Wattis, Bobbie and Mike Wilsey,
Mr. and Mrs. Steven MacGregor Read, Mr. and Mrs. Gorham B. Knowles,
Mrs. Edward T. Harrison, Mrs. Nan Tucker McEvoy, Harry and Ellen
Parker in honor of Steve Nash, Catharine Doyle Spann, Mr. and Mrs.
William E. Steen, Mr. and Mrs. Leonard E. Kingsley, George Hopper Fitch,
Princess Ranieri di San Faustino, and Mr. and Mrs. Richard Madden, 1994.31

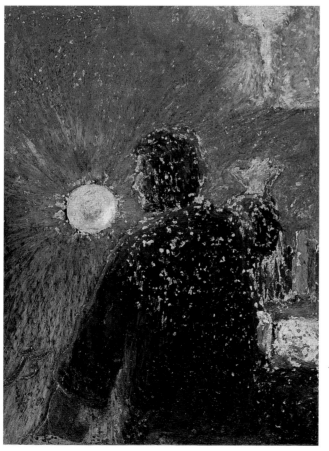

famously in Christ's statement in the biblical Apocalypse, "I am the Alpha and the Omega, the beginning and the end, the first and the last" (Revelation 22:13). This religious association is augmented by the pale blue and brown form that appears at the upper left side of the composition. A nearly identical form that is clearly a vertical angel with a horizontal wing appears in Jess's "... *When We Will Tempt the Frailty of Our Powers* ...": *Salvages IV* (1952–54, 1972–74, private collection).[7] Both images recall Renaissance Annunciations, in which the Archangel Gabriel flies in and announces to the Virgin Mary that she is pregnant with the Christ Child. However, in Jess's vision, these overlapping associations simultaneously invoke biblical and nuclear creation ("let there be light") but also biblical and nuclear apocalypse, announced by an angel of death.[8]

To the right of the mushroom cloud, an owl, linked by the ancient Greeks to Athena, goddess of wisdom, but perceived by the Romans as a bad omen, is swallowed headfirst by a parrot, whose mimicking of nature makes it a symbol of folly. The owl, a bird of prey, appears to be flying away from the atomic blast, not unlike the planes that dropped the bombs on Hiroshima and Nagasaki.[9] The owl's symbolic role as a messenger of death is reinforced by the skeleton key clutched in its talons. This key, in conjunction with the keyhole-shaped blue omega, has unlocked one of the secrets of the universe but also has opened the mythological Pandora's box of evil, unleashing nuclear destruction upon the earth.[10]

The radioactive fallout generated by the nuclear explosion resembles candy-colored confetti and rains down upon a group of eight unsuspecting children holding hands and dancing in a circle.[11] This image of dancing children appears both in Robert Duncan's poem "Often I Am Permitted to Return to a Meadow" and on Jess's cover (fig. 107.1) for the book in which the poem was first published in 1960.[12] Duncan's poem, a bittersweet meditation on the cycles of innocence and knowledge and of life and death, includes the lines, "It is only a dream of the grass blowing/

Fig. 107.1 [top left]. Jess (1923–2004), Cover for Robert Duncan, *The Opening of the Field* (New York: Grove Press, 1960). Bancroft Library, University of California, Berkeley

Fig. 107.2 [bottom left]. Jess (1923–2004), *LXXI. Qui Auget Scientiam Auget Dolorem*, 1959. Wax crayon on paper, 10 × 7 in. (25.4 × 17.8 cm). Collection of Nancy and Roger Boas, San Francisco

east against the source of the sun / in an hour before the sun's going down / whose secret we see in a children's game / of ring a round of roses told."

Like Duncan's poem and Jess's painting, the childhood nursery rhyme "Ring around the Rosy" is double-edged. While the singsong lyrics evoke child's play, the rhyme originated with the bubonic plague or black death. "Ring around the roses" referred to the characteristic swollen lymphatic glands that afflicted plague victims; "A pocket full of posies" alluded to the scented flowers used to block out the stench of decaying bodies; and "Ashes! Ashes! We all fall down!" referred to the overwhelming numbers of dead.[13]

Similarly, the shadows of Jess's dancing children are eerily reminiscent of the silhouettes of victims burned into the pavement by the heat from the atomic bomb blasts in Hiroshima and Nagasaki. Indeed, the head of a little boy ("Little Boy" was the name given to the bomb dropped on Hiroshima) has just burst into yellow flame, either from the atomic blast above or from what appears to be a flame-throwing tank at the left center of the scene.[14] The heavily impastoed red button on this machine of destruction inevitably evokes associations with the doomsday button that would launch a massive nuclear attack.

The passive observer of this horrific scene, cast into symbolic darkness and viewed in profile at the left, is the Olympic decathlon champion Bob Mathias.[15] Mathias, a California teenager who won the Olympic decathlon in 1948 and 1952, seemed to embody America's highest ideals.[16] Like Mathias, this figure wears a U.S.A. Olympic team warm-up jacket, a reminder of the pervasive American nationalism that influenced Cold War–era sports as well as politics, the arms race, the space race, and even art. The conspicuous absence or obliteration of the letter "A" on the warm-up jacket leaves the letters "US," a pointed reminder of the "us" and "them" mentality that made the use of the atomic bomb conceivable.[17]

However, the Bob Mathias figure also resembles the youthful Jess, and he may serve as a surrogate self-portrait of the artist as a member of the U.S. team that created the atomic bomb — and watched the films of its devastation. He holds a deck of cards, traditionally associated with chance, gambling, and fortune-telling. The card-holding hands, copied from a *Life* magazine photograph of a "card shark,"

suggest that the use of the atomic bomb undermined the fair-play ideals represented by Mathias.[18] The hourglass on the cards is a traditional symbol for "hour" in alchemy and early chemistry and may refer to time running out before a nuclear holocaust engulfs humanity.[19] The alchemical associations of the hourglass make it an appropriate symbol for the transformation of matter into nuclear energy, and it also recalls the hubris that led medieval alchemists to search for the philosopher's stone that would enable them to turn base metals into gold.

If All The World Were Paper And All The Water Sink serves as a personal and collective indictment of the creation and use of the atomic bomb. Jess's surrogate appears to be looking down on the curved surface of the earth, a seemingly omniscient creator blinded by his creation — the atomic bomb. As suggested by the name of the first atomic test, "Trinity," this figure may be "playing God." Jess explored this theme three years earlier in the drawing *LXXI. Qui Auget Scientiam Auget Dolorem* (fig. 107.2), in which he stares into a brilliant sun at the left and points downward with his darkened left hand, as if consigning the sun to obsolescence. With his illuminated right hand he points upward to a bright nuclear mushroom cloud on the horizon, as if signaling the dawn of a new nuclear era. The glass beakers on the counter at the right recall Jess's role as a nuclear chemist, and the Latin title may be translated as "he who spreads science spreads suffering." In both the drawing and the painting, as Jess successfully transforms matter into energy to create a false sun (or "Son"), he simultaneously unleashes a nuclear apocalypse that subverts traditional conceptions of religious creation, judgment, and destruction.

Jess's seemingly nonsensical title, which refers to a child's nursery rhyme, "If all the world were paper, / And all the sea were ink, / If all the trees were bread and cheese, / What should we have to drink?" describes an irrational world in which the natural order has been dangerously subverted by the machinations of man.[20] However, Jess's nightmarish vision also documents his personal transformation from a nuclear chemist who contributed to a chain reaction of nuclear proliferation into an artist who attempts to halt it with a prophetic revelation.[21] [TAB]

108. WAYNE THIEBAUD, *Three Machines*

THE REAL IDEAL

Wayne Thiebaud first gained critical fame in 1962 with a New York exhibition of paintings that depicted a particularly—and peculiarly—American cornucopia. His images of delicatessen counters stocked with preserved meat and processed cheese and of bakery and cafeteria displays of artificially colored and flavored cakes, pies, and confections challenged viewers to decide whether these prosaic subjects were worthy of admiration, criticism, or even consideration. Thiebaud later recalled, "I didn't quite know why, but it seemed to me that there are certain objects that contain telltale evidence of what we're about. But I wasn't interested in trying to explain or give answers so much as trying to present these objects so that they might be evocative in an existential sense."[1]

Morton Wayne Thiebaud (b. 1920) was born in Mesa, Arizona, and grew up in Long Beach, California. Thiebaud's evolution as an artist began long before he studied art and art history at San Jose State College (now San Jose State University) and at California State College (now California State University) in Sacramento, where he received his B.A. (1951) and M.A. (1953) degrees. His experience as a stagehand for high school theatrical productions may have influenced the "staged" aspect of his later still-life and figure paintings. As a cartoon animator for Disney Productions on films including *Pinocchio* (1940), Thiebaud mastered the art of caricature and its ability to capture the distilled essence—and humor—of a given subject.[2] His characteristic compositional clarity may be traced in part to his work as a commercial magazine artist in New York and Los Angeles.

Like most artists of his generation, Thiebaud initially attempted to integrate his evolving personal style with the dominant abstract expressionist style. He rejected this uncomfortable accommodation after a revelatory trip in 1956–57 to New York, where he met the prominent Abstract Expressionists Franz Kline, Willem de Kooning, and Barnett Newman:

> It was shocking to hear someone like Franz Kline talk about Vermeer, until you thought about his work. And it was shocking to know how much de Kooning liked Fairfield Porter, for instance. It was interesting to hear Barnett Newman extol and be so ecstatic over the *Mona Lisa*, and what he would say about it! . . . I had been painting cigar counters and windows and shoes and pinball machines, but they were all kind of articulated and hyped up with Abstract Expressionist brushstrokes—sort of hidden. So that when I came back to California I determined, "Well, I'm going to see if I can't just present something as clear as I can."[3]

Thiebaud's *Three Machines* (1963) depicts three life-size gumball machines arrayed in a row on a shelf or counter. Ironically, the clarity of Thiebaud's composition obscures its artifice—most notably the improbability of encountering three seemingly identical, perfectly aligned gumball machines, each filled to capacity with the same contents and isolated from their usual supermarket or store context. In fact, Thiebaud's gumball machines were painted from memory, and it is his intensely personal interpretation of realism that elevates them to the realm of art: "The interesting problem with realism was that it seemed alternately the most magical alchemy on the one hand, and on the other the most abstract construct intellectually. Somehow the two had to merge. You can't depend, for instance, on a

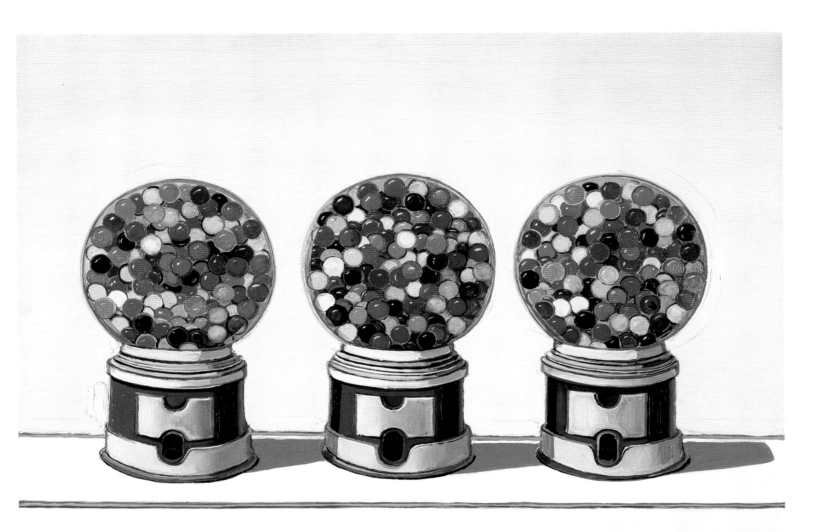

108. Wayne Thiebaud (b. 1920), *Three Machines*, 1963
Oil on canvas, 30 × 36½ in. (76.2 × 92.7 cm)
Museum purchase, Walter H. and Phyllis J. Shorenstein
Foundation Fund and the Roscoe and Margaret Oakes
Income Fund, with additional funds from Claire E. Flagg,
the Museum Society Auxiliary, Mr. and Mrs. George R. Roberts,
Mr. and Mrs. John N. Rosekrans Jr., Mr. and Mrs. Robert
Bransten, Mr. and Mrs. Steven MacGregor Read, and Bobbie
and Mike Wilsey, from the Morgan Flagg Collection, 1993.18

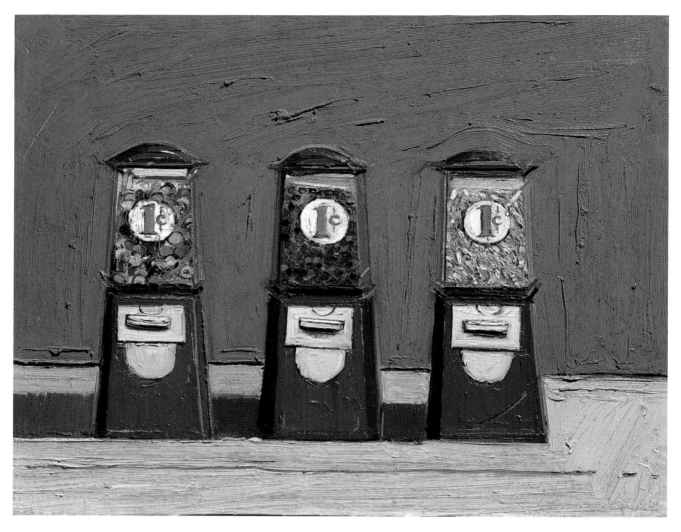

Fig. 108.1. Wayne Thiebaud (b. 1920), *Penny Machines*, 1961. Oil on canvas, 23¾ × 29¾ in. (60.3 × 75.6 cm). Collection of Gretchen and John Berggruen, San Francisco

singular view of an object, at least I didn't feel I could, to dignify its presence or make it manifestly important unless it does something other than be a kind of replication, or simple visual recording."[4]

Thiebaud's composition acknowledges the conventions of traditional still-life painting but subverts them by introducing seemingly irreconcilable contradictions. Thus, *Three Machines* resembles a tabletop still life painted in Thiebaud's studio—not unlike those created by his idol, Giorgio Morandi—but the gumball machines also appear to be illuminated by the full force of the sun. The illusion of a uniform, enveloping white light is undermined by the horizontal painterly brushstroke that becomes vertical after it collides with the base of the gumball machine at the left.[5]

The gumball machines cast blue shadows, but their trapezoidal shapes are inconsistent with objects composed of a cylinder and a sphere. Finally, although gumball machines are ostensibly inanimate objects, the thick impasto halo that surrounds each globe playfully recalls the shorthand convention for movement that Thiebaud would have employed as a cartoonist.

Thiebaud's feats of legerdemain confirm that his real subject is art and the alchemical process that transforms his raw oil medium into a convincing image.[6] While the spherical gumballs have white surface highlights, the much larger glass globes lack the bright highlights one would expect with a strong light source, giving the impression that the gumballs are not physically contained but are merely

434

circumscribed and are defying gravity. Only three thin horizontal lines of colored pigment appear to differentiate the shelf from the wall behind the shelf and to keep the machines from crashing to the ground. The absence of handles on the three machines, along with the usual "1¢" price markings that are included in *Penny Machines* of 1961 (fig. 108.1) removes Thiebaud's subjects ever further from the realm of reality and heightens their iconic, existential appearance.

Three Machines offers an elementary primer in artistic representation and visual perception and reveals a subtle but insistent interplay between repetition and individuation. For example, the gumball machines appear equidistant from each other, but the two at the right are actually closer together. Similarly, the three globes are identical in diameter, but their bases become progressively smaller from left to right. Each gumball dispenser is slightly different, but none is actually large enough to permit the passage of the gumballs (with their colorful, concrete halos) from the spheres above. Thiebaud has confirmed his fascination with such subtle distinctions, which often reveal larger truths:

> And you can see a pie in Pasadena, or Madison Avenue in New York, or Madison, Wisconsin and it's the same damn pie. . . . It interests me because of the consciousness of simultaneity—of how much alike we are, how close we are to one another and how rare it is to come across distinctions of any sort. It is one of the ways I think about art. It has the capacity to build alternatives in a peculiar way—it is full of little discriminations and little insights which are terribly important and only a very few individuals ever think about them.[7]

Three Machines reveals Thiebaud's talent for transforming prosaic objects of American popular culture into evocative, sociological, or even surreal still lifes.[8] The stagelike composition, isolated objects, spotlight effects, oscillating halation, and deep shadows all suggest the lasting influence of Thiebaud's early experience with stage design.[9] The artist has described his supposedly inanimate still-life objects functioning "like small landscapes, buildings or characters in a play with costumes," and his comments on

Morandi's enigmatic still lifes might equally be applied to his own work: "On his simple 'stages' objects are cast in various roles. Tableaux and friezes in scene after scene infer arresting little dramas. . . . Are they real, surreal, concrete, abstract or, finally, an evaporating sensual daydream?"[10]

From a personal perspective, gumball machines evoke childhood nostalgia for Thiebaud, who has vivid memories of purchasing candy in a neighborhood candy store and in Woolworth's.[11] However, in a broader context, gumballs are the cheapest form of American fast food and were the common denominator of penny candy—a sort of atomic particle of American consumer culture. They provide almost every American child's first experience of longing for a nonessential commodity and, parents willing, their first entry-level purchase as a consumer. Gumballs also offer a lesson in the persuasive power of marketing. While offering consumers the illusion of a choice of colors or flavors, they are, at their core, identical orbs of sugar-sweetened gum.

Given that one could buy all the gumballs for a few dollars, they provide a perfect metaphor for American plenitude and self-gratification, despite, or because of, their lack of nutritional value.[12] But gumballs also represent, in microcosm, a cyclical trope of American consumerism, which traces an arc from the desire for an imagined ideal, to the gratifying pleasure of possession, to a state of diminishing returns, and finally to the melancholy associated with loss—until the cycle is restarted by memory. Thiebaud, who selects subjects that are emphatically of their time but renders them timeless in the realm of art, perceives these rituals as particularly American:

> But then there is another aspect to foodstuffs, one which interests me a great deal. Food as a ritualistic offering—that is—making food seem like it is something more than it is—dressing it up and making it very special. It has something to do with our preoccupation for wanting more than we have. Or a little something more than we know. It's perfectly logical, if there wasn't that continual yearning for a little something more then man would never have left the cave. It doesn't matter how much you have—you can have everything—you still yearn for more.[13]

[TAB]

435

INCLINED TOWARD REALITY

*[P]ainting is a kind of X ray of visual experience: it should re-form the
perceptual world, condensing it, encapsulating it.* WAYNE THIEBAUD[1]

It does not diminish the importance or power of Wayne Thiebaud's work to observe that his earliest jobs were as a freelance cartoonist, a commercial illustrator, and a set designer. In fact, Thiebaud (b. 1920) proudly claims this background, evident in his statement, "I had, and continue to have, a great regard for commercial artists."[2] When he was only sixteen years old he had an apprenticeship with Walt Disney Studios, although it was short-lived owing to his pro-union activity.[3] From 1942 to 1945 the Special Services Department of the United States Air Force deployed Thiebaud as a cartoonist and cartographer.[4] His early training in illustration and his long-standing interest in art history, as both student and teacher, have fostered a lifelong concern for the vocabulary of representational art. It has also led him to embrace subject matter that remains firmly within the recognizable conventions of the traditional genres, namely still life, figure, and landscape.

Diagonal Freeway (1993) continues the series of urban landscapes that Thiebaud began in the early 1970s when he moved to San Francisco's Potrero Hill neighborhood, with its vertiginous topography bordered by freeways.[5] It also connects his cityscapes to his landscape paintings of the 1960s, particularly *Diagonal Ridge* (1968), which explores a similar compositional structure, challenging the viewer's expectations about the horizon and perspective (fig. 109.1).[6]

From the beginning, Thiebaud has explored spatial incongruities that ordinary vision ignores, creating ambiguity about the relationships in his represented scene. These works are subtle examinations of color, form, and light, employing recognizable shapes that are rendered mysterious by an incoherent logic. They are representational without being photographic and summarize the concerns of traditional painting without relying on conventional perspective.[7]

Diagonal Freeway juxtaposes nature, buildings, and streets in a manner that collapses the viewer's usual impressions of their separateness. Cut off from the steep cliff and vertical skyscrapers by the prominent diagonal of roadway that divides the composition into two nearly equal triangles, the viewer is stranded in the no-man's-land indicated by the blue-gray field of the lower section of the canvas. The strategy is reminiscent of Edgar Degas, whom Thiebaud has identified as an important influence on his design sense.[8] The resulting pictorial dissonance sets up a visual impression that the viewer feels as much as sees.

The painting's strong geometry recalls simultaneously Renaissance orthogonal composition and modern Constructivism, precedents with a shared interest in the use of linear elements to define the relationship between the flat canvas and three-dimensional space.[9] Thiebaud manipulates the spatial experience of the scene by exploiting the conventions of traditional perspective. The "diagonal freeway" of the title suspends the viewer between two possible perceptions, depending on whether the expanse lined with light poles is read as a bird's-eye aerial view or a more standard eye-level ground view. At first glance, the shadows of the light poles and vehicles indicate a flattened surface: one seems to be looking down on a single concrete roadway that cuts through the middle of the picture plane. However, a closer inspection reveals that the freeway is divided; its opposite directions exist on two separate levels, and the vehicles are bounded by guard rails. Thiebaud has

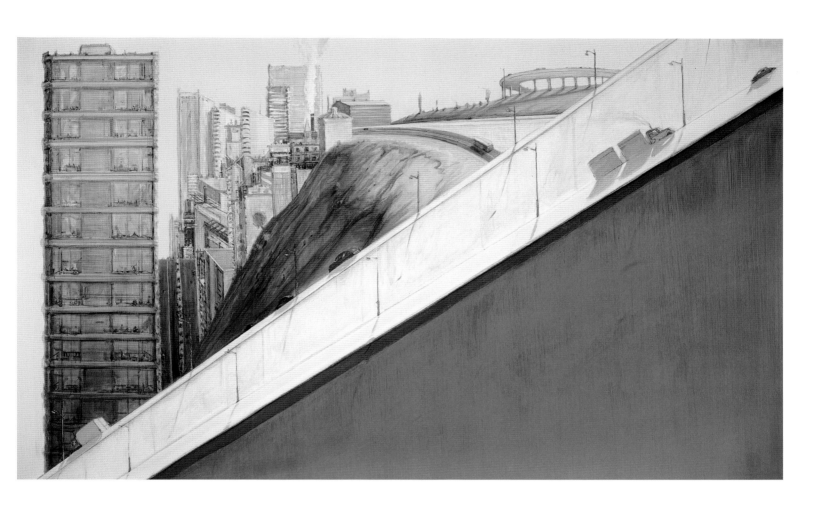

109. Wayne Thiebaud (b. 1920), *Diagonal Freeway*, 1993
 Acrylic on canvas, 36 × 60 in. (91.4 × 152.4 cm)
 Partial gift of Morgan Flagg in memory
 of his son Lawrence J. Flagg, 1998.186

Fig. 109.1 [above]. Wayne Thiebaud (b. 1920), *Diagonal Ridge*, 1968. Acrylic on canvas, 77¾ × 84 in. (197.5 × 213.4 cm). Private collection, Courtesy of Allan Stone Gallery, New York

Fig. 109.2 [left]. Wayne Thiebaud (b. 1920), *Caged Pie*, 1962. Oil on linen, 20⅛ × 28⅛ in. (51.1 × 71.4 cm). San Diego Museum of Art. Museum purchase with the Earle W. Grant Acquisition Fund, 1977:109

explained that such apparent confusion is deliberate. "The ambiguity is as important as specificity. It becomes a beautiful dialogue, a tightrope walk, between abstraction and representation."[10]

The large, blue-gray triangle at the bottom, solid and insistent as if in a color-field painting, can be read as both a flattened horizontal surface and a vertical wall that parallels the picture plane.[11] In either case, an abstract expanse stands between the viewer and the colorful cityscape in the painting's background. However, here too Thiebaud manipulates visual expectations about perspective in the nearly sheer cliff off of which the city's buildings seem to hang and the impossibly steep street that appears to rise vertically alongside the skyscraper dominating the left edge of the painting. Once again the artist creates a visual conundrum that requires the viewer to confront the imaginary construction of space on a flat surface.

Although Thiebaud's interest in the rhetoric of spatial representation dominates the experience of this painting, he is equally concerned with capturing the emotional tenor of San Francisco represented in this scene. The city is renowned for its hills, featured prominently in the central, plunging bluff, which has a swirling on-ramp above it and a vertical street rising perpendicularly from its base. Linked visually by the foreground's steeply inclined diagonal freeway, these roadways create an impression of San Francisco's roller-coaster topography that registers somatically and psychologically as well as pictorially. This is a personally poetic appreciation of the childlike joy offered by living in a crowded city of dizzying ups and downs. He also captures the inevitable urban opposition between the city's crowded vitality and its isolating loneliness. The press of buildings squeezed into a triangle of space in the top left corner of the canvas contrasts dramatically with nearly empty streets. One writer, comparing the overall experience of Thiebaud's cityscapes to the romanticized jumble of buildings in a view of ancient Rome by the eighteenth-century Italian artist Giovanni Battista Piranesi, writes that viewers are "thrown into an almost Piranesian world, where ordinary streets turned into vertical planes and skyscrapers nestled together like people hugging (happily) for dear life before the downslope on a roller-coaster."[12]

Thiebaud's personal attachment to these icons of San Francisco's urban life distinguishes his commitment to rendering their emotional tenor from the impersonal, ironic detachment with which other artists concerned with popular culture often represent such objects.[13] Although Thiebaud is not a Pop artist, he shares Pop's interest in elevating the quotidian object to iconic status (fig. 109.2).[14] He accomplishes this transformation of the commonplace things that constitute American mass society partly through a strategy known as *halation*, in which rainbows of pure color outline the objects in his paintings. He uses this strategy to define the freeway, edging its diagonal lines with his characteristic halo silhouettes in a manner that not only delineates its contours but also isolates it as a rarefied object. This effect has been described as giving "to his pictures not just a sense of the shiver of light in a particular place but also the sense that the scene has the interior life and unnatural emphases of something recalled from memory."[15] Rather than playing across the white strip that signifies the painting's freeway, the light seems to emanate from the prismatic mix of colors that make up the band of white itself.

Mirroring the operations of our own cognition, Thiebaud converts the ordinary into the extraordinary by virtue of the attention he pays it. The critic Adam Gopnik links him to the American tradition of "empirical painters," whose focus on the details that give objects their emotional resonance produces a mode of realism that registers as "unnatural" yet produces instantly recognizable perceptions.[16] Ultimately, it is this focus on the emotional truth of things that makes Thiebaud's painting profoundly American in spite of his lifelong status outside the dominant, twin movements of Abstract Expressionism and Pop art that define American artists of his generation. His figurative compositions have reclaimed the expressive possibilities of art —which Abstract Expressionist painters had appropriated for themselves—and placed it in the service of describing reality. [DC]

A PSYCHEDELIC PERSPECTIVE
ON LOCAL COLOR

I'm not just interested in the pictorial aspects of the landscape—see a pretty place and try to paint it
—but in some way to manage it, manipulate it, or see what I can turn it into. WAYNE THIEBAUD[1]

In his seventy-seventh year, Wayne Thiebaud exhibited a major new body of work at a gallery in San Francisco. Most completed within the previous two years, the forty landscapes he unveiled at the Campbell-Thiebaud Gallery in November 1997 came at a time in his life when most artists are no longer producing substantial numbers of new paintings, let alone embarking on a new direction.[2] Thiebaud had extended his uniquely realist vocabulary into landscapes as early as 1963, just one year after his breakthrough exhibition in New York at the Allan Stone Gallery, which introduced his signature cafeteria, delicatessen, and drugstore still lifes painted with an economical, formal language based in the simplified forms of caricature.[3] By the mid-1960s he was regularly painting the natural terrain of the Sacramento Valley, where he lived. Beginning with landscapes such as *Coloma Ridge* (fig. 110.1) and continuing through his recent *Ponds and Streams* (2001), Thiebaud exploits the traditional conventions of landscape painting to explore the tension between realistic depiction and exaggerated artifice that epitomizes his visual rhetoric.

Thiebaud's desire to mine the relation between abstraction and figurative representation, which lies at the heart of his realist vision, is already evident in an early work like *Coloma Ridge*. It demonstrates the artist's love of distorted perspective and conflated points of view that will come to dominate his rural and urban scenes. The cliff falls precipitously, the cartoonish trees, fence, and gold-colored hills wrapping over the ridge in an impossible scene that moves diagonally from corner to corner on the canvas. The trees

remain inexplicably upright, and the ridge appears to be sliced open, revealing its geological interior as abstract skeins of poured paint that has reminded critics of Morris Louis's *Veil* paintings.[4] In *Ponds and Streams*, as in the other works from Thiebaud's late series of Sacramento River Valley landscapes, the pictorial and compositional strategies he introduced in the 1960s culminate in an innovative synthesis.

Whereas his earlier still-life subjects and human figures were rendered with the thick impasto associated with the dominant post–World War II school of Abstract Expressionism, Thiebaud's landscapes demonstrate a shift toward thinly painted and layered stains more closely aligned with Color-Field painting. Thiebaud has said that before he found his mature style he was trying to copy the superficial signs of Abstract Expressionism by disguising his subject matter underneath heavily paint-laden brushstrokes.[5] Although he rejected such stylistic mannerisms, the artist committed himself to balancing the depicted subject matter and the formal composition, paying as much attention to the details of topography as to abstract issues of line and color. Typical of the late landscapes, *Ponds and Streams* represents a bird's-eye view with a high horizon line that positions the viewer above the scene looking down but also below it looking up. By pushing the horizon to the extreme top edge of the canvas, the scene is flattened and tipped toward the painting's surface so that it appears to rise up vertically, confronting the viewer even as the diminishing scale and rows of crops suggest perspectival distance.

110. Wayne Thiebaud (b. 1920), *Ponds and Streams*, 2001
 Oil on canvas, 72 × 60 in. (182.9 × 152.4 cm)
 Museum purchase, gift of Dick Goldman, 2001.168

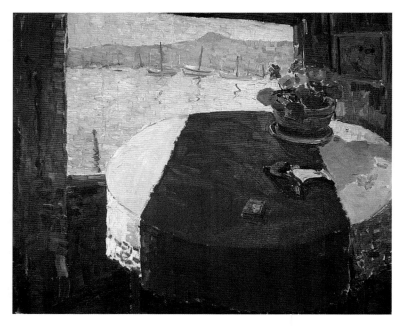

Fig. 110.1 [top]. Wayne Thiebaud (b. 1920), *Coloma Ridge*, 1967–68. Acrylic, pastel, and charcoal on canvas, 74 × 75⅞ in. (188 × 192.7 cm). Paul LeBaron Thiebaud collection

Fig. 110.2 [bottom]. Selden Connor Gile (1877–1947), *The Red Tablecloth*, ca. 1927. Oil on canvas, 30 × 36 in. (76.2 × 91.4 cm). Private collection

Yet the apparently straightforward use of perspective turns out to be a deception. Each plot of crops obeys its own orthogonal logic, creating a series of incongruous views held together by the strong rationale of the composition. It is easy to see evidence of Thiebaud's early training as a cartoonist and commercial artist versed in layout and design. As Kathan Brown, the artist's printmaking collaborator at Crown Point Press, observes, "'That perspective thing,' in all of Thiebaud's work is oddly askew though it seems oddly correct."[6] Viewing this painting, one understands Thiebaud's comment about the continuing influence of caricature in his work: "Caricature to me means specific formal changes in size, scale, et cetera: in relationships that combine the perceptual with the conceptual."[7]

One of the most notable conceptual gambits in this painting is the vacant space at its center formed by the shape of a large pond. Violating one of the primary principles of design, Thiebaud has pushed the recognizable subject matter to the sides of the canvas, almost as if he had decided to forgo depicting the scene in favor of ornamenting the frame. But of course the pond is central to the work, literally and theoretically. The vacant center calls attention all the more strongly to the radically cropped nature of the landscape, as one's eye follows the cultivated rows to the painting's edge. By organizing his composition around a pond rendered in bright whites, Thiebaud sets himself a formidable formal challenge. He must contrast the white of the pond with the strong colors of the surrounding fields without having it read as an empty hole in the composition. He accomplishes this through the complex tonalities that make up the white pond and give it substance, appropriating the luminous color handling found in Color-Field painting and coincidentally revealing its origins in the tradition of landscape. It is as if the light that infuses the brightly colored painting emanates from the middle of the pond.[8]

This sense of highly keyed color and light connects Thiebaud to the Society of Six, California's important group of landscape painters active in the 1920s and 1930s. He has commented on their paintings, especially their use of color for both expressive and formal purposes, calling them "pictures that create their own sense of light."[9] Of Selden Gile's *The Red Tablecloth* (fig. 110.2), Thiebaud notes, "The painting uses color as a dominant light theme. It creates a light because of its juxtaposition of strengths."[10] Although he eschews Gile's paint-laden brushstrokes and heavy impasto, Thiebaud accomplishes similar light effects

in *Ponds and Streams* through juxtapositions of pure color that define and intensify the visual energy within the composition. He has said, "I realized that you can't mix colors that look like one thing or another; they have to be enlivened by a structural phenomenon of some kind if they are to come alive."[11] The bold color scheme of the painting is tightly organized, and each bounded plot of land has its own pattern and palette, a multiseasonal display of possibilities collapsed into a single moment. Thiebaud turns the ordinary farmlands of California into a psychedelic vision rooted in the region's radiant light.

This pond, with its artificially rectilinear contour, also serves to remind viewers of the human presence that has imposed its will on the natural topography of the Sacramento River Valley, turning it into an immense agricultural resource. Thiebaud has repeatedly warned against reading too much symbolic meaning into the subject matter of his paintings, preferring to emphasize formal concerns. "The symbolic aspect of my work is always confusing to me — it's never been clear in my mind. . . . I tend to view the subject matter without trying to be too opaque with respect to its symbolic reference, mostly from the standpoint of problematic attractions — what certain aspects of form offer."[12] Nevertheless, what may be an unintended irony exists in the contrast between the abundant promise represented by the crops and the empty space of the pond, a reminder of how dependent such agricultural riches are on

an ever-dwindling water supply. The same concern with common household commodities that informs Thiebaud's early images of cakes, pies, and candy continues in the more industrial commodities of agriculture shown here. The painting also presents an affectionate vision of farming life in transition from the family operation to agribusiness, with its increasingly large, monolithic tracts of land managed by corporations.

Such political and social issues are bound to find their way into Thiebaud's paintings by virtue of his commitment to a realist tradition. His concerns may be formal, focused on depicting the look and feel of things, but the very attention to ordinary life that is the hallmark of realism freights his paintings with the weight of the historical present. The late landscape paintings such as *Ponds and Streams* embody an unexpected burst of creativity at the close of a long career. Thiebaud compels viewers to take a second look at what is most familiar so that the world again might become wonderfully strange and a source of pleasure. He has said: "I continue to have an interest in caricature and its effect on stylization — for instance, the many ways color, light, space, and shapes can be caricatured. Styles in painting are based upon distorting various elements in order to move them away from the ordinary to the extraordinary."[13] Attending to the ordinary is an unnatural discipline, and Thiebaud has spent a lifetime developing a representational vocabulary of artifice to explore what and how we see. [DC]

111. JACK LEVINE, *Birmingham '63*

"WE SHALL NOT BE MOVED"

Jack Levine (b. 1915), one of the foremost Social Realist artists of his generation, has been a major proponent of representational form and moral content in American art. He consciously embodies a living link to the traditions of the European old masters, an artistic debt openly acknowledged in his painting *Six Masters: A Devotion* (1963, private collection), which depicts Francisco de Goya, Diego Velázquez, Rembrandt Harmensz van Rijn, Titian, Peter Paul Rubens, and El Greco.[1] Drawing inspiration from Goya as well as from Honoré Daumier and George Grosz, Levine also has been a perceptive critic and satirist, recording societal ills and human foibles and failings with uncompromising candor. Addressing the pessimistic perspective that characterizes many of his works, Levine has observed: "I am primarily concerned with the condition of man. The satirical direction I have chosen is an indication of my disappointment in man, which is the opposite way of saying that I have high expectations of the human race."[2]

An artistic prodigy, Levine was still a teenager in Boston when he studied art with Harold Zimmerman and the Harvard University art professor Denman Waldo Ross, who introduced Levine to the old master paintings in Harvard's Fogg Art Museum. During the Great Depression, Levine worked from 1935 to 1939 for the Federal Art Project of the Works Project Administration, an experience that reinforced his socialist politics and humanist stance. Levine earned a national reputation as an artist in 1937, when his painting *The Feast of Pure Reason* (1937) was acquired by the Museum of Modern Art in New York. A depiction of cynical collusion between a police officer, a political boss, and a wealthy businessman, this scathing portrayal of contemporary fiscal and moral corruption set the standard for

subsequent works such as *Welcome Home* (1946, Brooklyn Museum of Art), *Gangster Funeral* (1952–53, Whitney Museum of American Art), *The Trial* (1953–54, The Art Institute of Chicago), and *The Spanish Prison* (1959–62, private collection).[3]

Levine's *Birmingham '63* (1963) commemorates famous events that occurred during the civil rights struggle in Birmingham, Alabama, in the spring of 1963. Birmingham, located deep in the heart of the segregationist South, was colloquially known as Bombingham, because of eighteen unsolved bombings by racists who had targeted black neighborhoods between 1957 and 1963. The city had already been the focus of national outrage in 1961, when civil rights activists known as Freedom Riders were savagely beaten by a mob of white segregationists. In 1962 the Birmingham city government closed sixty-eight parks, thirty-eight playgrounds, six swimming pools, and four golf courses to avoid complying with a federal court order to desegregate these public facilities.[4]

In April 1963 Dr. Martin Luther King Jr. and other civil rights activists initiated an economic boycott and a series of marches, picket lines, and sit-ins intended to end segregation in Birmingham's commercial businesses and public facilities. Because many potential adult marchers feared retribution from their employers for participating, the protest organizers made the pivotal decision to include teenage children. Although they practiced tactics of nonviolence and passive resistance, on 2 May 959 of these teenagers were taken to Birmingham jails. When new marchers appeared on 3 May, Birmingham's commissioner of public safety, Theophilius Eugene "Bull" Connor, a notorious racist, ordered the city police and fire departments

444

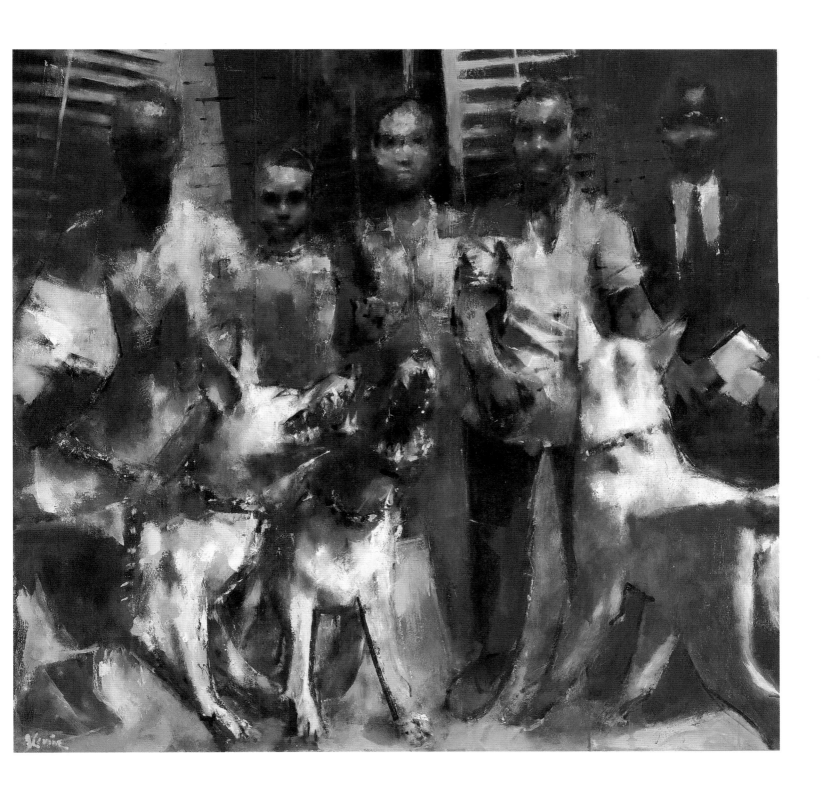

111. Jack Levine (b. 1915), *Birmingham '63*, 1963
 Oil on canvas, 71 × 75 in. (180.3 × 190.5 cm)
 Museum purchase, Dr. Leland A. and
 Gladys K. Barber Fund, American Art
 Trust Fund, and Mildred Anna Williams
 Collection, by exchange, 1999.69

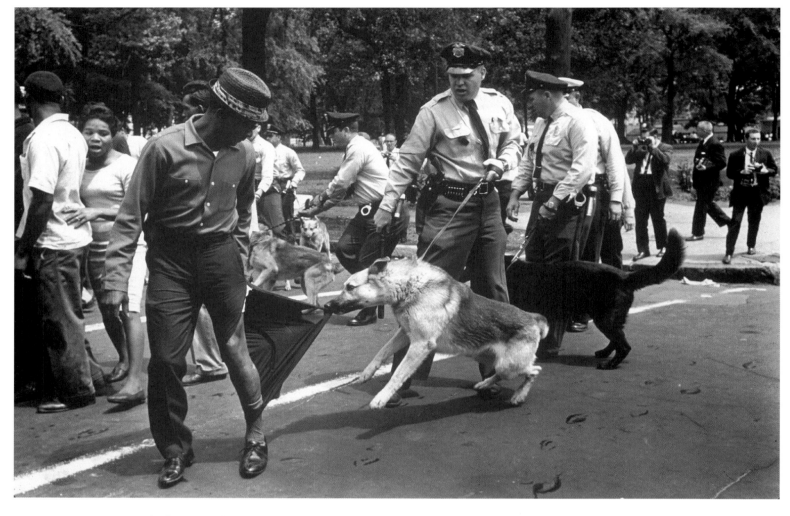

Fig. 111.1. Charles Moore (b. 1931), *Civil Rights Protestors, Birmingham, Alabama,* 1963, published in *Life,* 17 May 1963, with the caption "The Dogs' Attack is Negroes' Reward"

to use attack dogs and powerful fire hoses on the men, women, and children protesters.[5] The resulting violence and injuries, captured by television and newsprint cameras, sparked national outrage and confirmed the power of television to shape public opinion. These events provoked the collective conscience of mainstream American society and marked a major turning point in the modern civil rights movement.[6]

Appalled by the events in Birmingham, Levine eventually tackled the subject, although when first prodded by a friend to paint this subject, the artist replied, "Mind your own business. Art, as Wordsworth once said, is pure emotion recollected in tranquility. I'll do it if and when I feel like it."[7] Charles Moore's famous photographs of police dogs attacking the Birmingham protestors (fig. 111.1) were merely a point of departure for *Birmingham '63,* reflecting Levine's

philosophy that "in painting, I don't document anything. I use conjecture and improvisation—more like what they did during the Renaissance. After all, none of those artists were at the Crucifixion."[8] Instead, he consciously emulated the grand history painting tradition exemplified by the European old masters, who often transformed current events into timeless, more universal truths.

Levine's *Birmingham '63* depicts a group of five African American protestors who are threatened by lunging, snarling dogs, one of which already has blood on its fangs.[9] Levine initially depicted the figure on the right as a minister, but deleted the white collar when his wife, the artist Ruth Gikow, convinced him not to introduce religion as an overt subject.[10] However, the second figure from the left accurately reflects the inclusion of adolescents in the Birmingham protest marches. Standing tall and arrayed

shoulder to shoulder, their individual identities subsumed within a common cause, the five stoic African American protestors seem to embody the famous civil rights anthem "We Shall Overcome." Levine's composition and palette subtly evoke famous art historical precedents for the depiction of injustice and martyrdom, including Goya's *The Third of May, 1808 in Madrid* (1814, Museo del Prado) and Edouard Manet's *The Execution of the Emperor Maximilian* (1867, Staatliche Kunsthalle, Manheim).

The dogs at the left, collectively depicted with three heads but only four feet, evoke the multiheaded Cerberus who guards the entrance to Hades—the underworld—in Greek mythology. At the right, the shadowy silhouette of a dog's head that is cast on the shirt of the fourth protestor increases the sense of menace. These dogs block the progress of the protestors and attempt to turn them back toward the dark portal in the background. Levine's tenebrous palette of black, white, and brown accentuates the stark, nightmarish aspect of this confrontation, and also carries powerful associations with racial identity.[11] Levine's use of white attack dogs, whose leashes are held by unseen persons beyond the boundaries of the painting, implicitly implicates complacent white viewers in this brutal act of aggression against black Americans. It also raises the question of whose actions are more animalistic—the dogs' or their handlers'. As Levine noted, he made the dogs white "to remind us of ourselves . . . and what I thought of as ourselves menacing them."[12]

The aura of menace that permeates *Birmingham '63* is compounded by the painting's compressed, claustrophobic composition. The door, framed by green wood shutters, recalls the French-influenced architecture prevalent in the Gulf States but also serves as a metaphor for the insular, shuttered character of much of the Deep South, a society that celebrated its antebellum legacy and defended institutionalized segregation.[13] The fragile house-of-cards aspect of this society—built on the flawed foundation of slavery, propped up by Jim Crow segregation and violence, and subject to inevitable collapse—is suggested by the off-kilter orientation of the shutters and door. Yet, only one year before the Birmingham protests, Governor George Wallace of Alabama publicly defended segregation in his defiant inaugural speech of 14 January 1963:

It is very appropriate that from this cradle of the Confederacy, this very heart of the great Anglo-Saxon Southland, that today we sound the drum for freedom as have our generations of forebears before us time and again down through history. Let us rise to the call for freedom-loving blood that is in us and send our answer to the tyranny that clanks its chains upon the South. In the name of the greatest people that have ever trod this earth, I draw the line in the dust and toss the gauntlet before the feet of tyranny, and I say segregation now, segregation tomorrow, segregation forever.[14]

Levine's depiction of the five protestors standing before a doorway also had particular resonance, as open, closed, or separate doors had served as both physical and symbolic barriers to African Americans during the long struggle to obtain equal access to private institutions and public facilities. On 11 June 1963 Governor Wallace personally attempted to prevent the integration of the University of Alabama at Tuscaloosa by two African American students. Standing in the door to Foster Auditorium, Wallace gave his famous "Schoolhouse Door" speech, which invoked "states' rights" as coded language for Alabama's right to preserve its segregationist laws and policies.[15]

That same night President John F. Kennedy gave a televised speech in which he declared civil rights a "moral issue" and publicly announced his administration's support for civil rights legislation.[16] Kennedy's announcement was followed in August by the March on Washington, D.C., and Martin Luther King Jr.'s famous "I Have a Dream" speech, symbolically delivered from the steps of the Lincoln Memorial. In Birmingham, local politicians and businessmen were compelled by the economic boycott and public pressure to desegregate the city. Within a year, Congress had passed the Civil Rights Act (1964), which barred discrimination in public housing; authorized the attorney general to institute lawsuits to desegregate schools and other public facilities; outlawed employment discrimination on the basis of race, color, religion, sex, or national origin; and strengthened voting rights. Levine's *Birmingham '63* bears witness to the collective courage of civil rights activists in one city during one year, but it also serves as a timeless testament to the universal struggle for freedom. [TAB]

ARTISTIC ANCESTRY

Joan Brown, with David Park (1911–1960), Elmer Bischoff (1916–1991), and Richard Diebenkorn (1922–1993), was among the most talented of the painters associated with the San Francisco Bay Area Figurative Art movement that flourished in the 1950s and 1960s. Like the works by her triumvirate of artist heroes—Rembrandt, Velázquez, and Goya—Brown's paintings of domestic life often view the universal human condition through the lens of personal experience.[1] Her favored subjects—herself, family, friends, and animals—often were arranged in stagelike tableaux, enacting private dramas in the public realm. Brown's deeply personal works mingle memory, experience, and imagination, prompting her to observe, "I feel most of my work, if not all of it, is like keeping a diary."[2]

Born Joan Vivien Beatty and raised in San Francisco, Joan Brown (1938–1990) studied with Bischoff and Frank Lobdell at the California School of Fine Arts (now the San Francisco Art Institute), where she received a B.F.A. (1959) and an M.F.A. (1960). An extraordinarily precocious painter, Brown's inclusion in the Whitney Museum of American Art's *Young America* exhibition in 1960 earned her an early reputation as one of the best-known women artists in the United States. Brown, however, resisted attempts to elevate her as a feminist icon, observing, "And if people say, 'Are you a feminist?' I'd say, 'No, I'm a humanist,' hopefully."[3]

Brown's *Noel and Bob* (1964) was created at the culmination of the Bay Area Figurative Art movement, just before she abandoned the bravura brushwork and luscious impasto that had earned her critical and financial success.[4] Consistent with Brown's unconventional approach, the painting was created using commercial house paints,

which Park, Bischoff, and Brown liked for their buttery textures and brilliant colors.[5] Brown, renowned in her student days for being perennially covered in paint, applied her medium directly to the canvas, thus unifying drawing and painting into a single process: "I tend to be somewhat of an extremist—to go overboard. But I really dug painting, and I loved the application as well as the look of the paint, right out of the gallon can. I loved what happened when I was using the trowel, the physical exuberance of just whipping through it with a big, giant brush."[6]

Brown occasionally incorporated crumpled fabric into her paint surfaces, and *Noel and Bob*, whose surface is more than one inch thick in places, resembles a sculpture in low relief.[7] This sculptural aesthetic was shaped in part by a symbiotic relationship with her second husband, Manuel Neri, in which he painted portions of her paintings and she painted parts of his sculptures.[8] Brown, however, strongly believed that her technique was not an end in itself but an expressionistic equivalent for her intensely emotional vision: "There's always a connection to the way I'm describing something, which is basically an expressionistic belief."[9]

The human protagonist of *Noel and Bob* is Brown's son with Manuel Neri—Noel Elmer Manuel Neri—who was born in August 1962. Noel's birth, "an awesome experience" in Brown's life, compelled the artist to move her studio into their home: "As usual I painted what I saw around me, Noel being my main subject, of course."[10] Often inspired by Noel's baby book, an album of family photographs augmented by her drawings, Brown painted a series of domestic subjects including *Noel's First Christmas* (1963, Collection of Noel Neri), *Noel on a Pony with Cloud* (1963, Phoenix Art Museum), *Noel at Table with Vegetables*

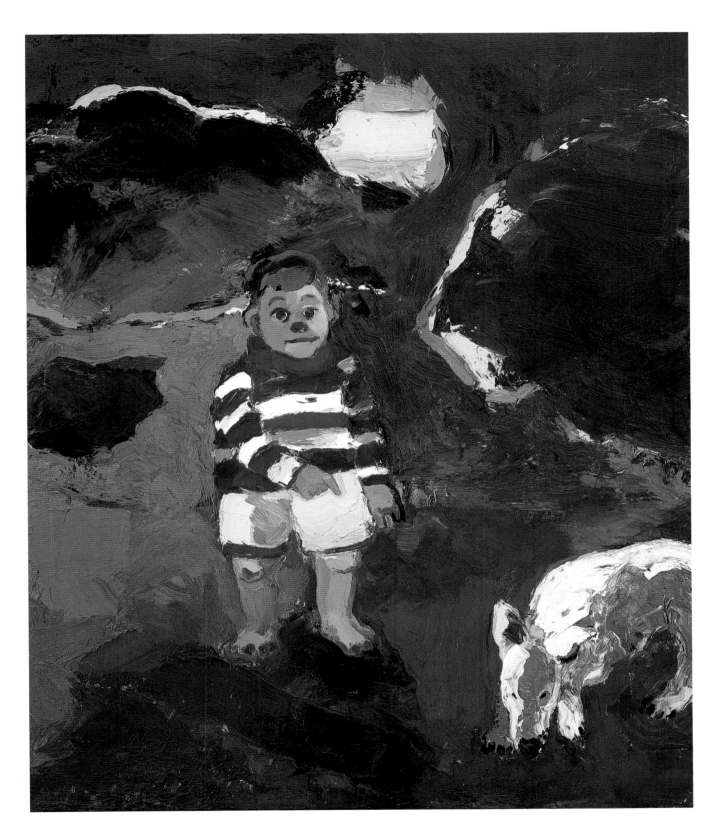

112. Joan Brown (1938–1990), *Noel and Bob*, 1964
Oil on canvas, 72 × 60¼ in. (182.9 × 153 cm)
Museum purchase, American Art Trust Fund,
Mr. and Mrs. Alec J. Merriam Fund, and
Morgan and Betty Flagg Fund, 2003.67

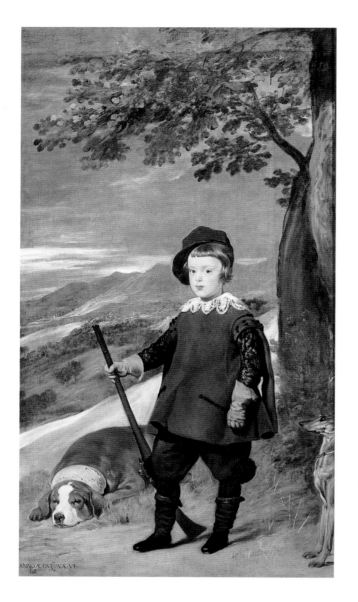

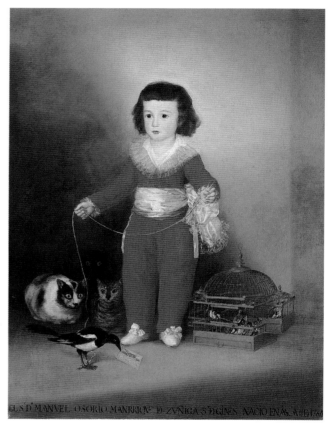

Fig. 112.1 [above left]. Diego Velázquez (1599–1660), *Prince Don Baltasar Carlos as a Hunter*, 1635. Oil on canvas, 75¼ × 40½ in. (191 × 103 cm). Museo del Prado, Madrid

Fig. 112.2 [above right]. Francisco de Goya y Lucientes (1746–1828), *Don Manuel Osorio Manrique de Zuñiga*, 1784–92. Oil on canvas, 50 × 40 in. (127 × 101.6 cm). The Metropolitan Museum of Art. The Jules Bache Collection, 1949.7.41

(1963, Whitney Museum of American Art), *Noel at the Table with a Large Bowl of Fruit* (1963, private collection), *Noel on Halloween* (ca. 1964, private collection), and *Noel in the Kitchen* (ca. 1964, San Francisco Museum of Modern Art).

In *Noel and Bob*, two-year-old Noel, with a sweet doll-like expression and button eyes, stands on chubby legs and points to the family dog.[11] Noel's canine companion, given equal billing by name, is a bull terrier, well known in the San Francisco art community as Bob the Dog.[12] Viewed from slightly above, his massive head lowered to sniff the ground beneath his paws, Bob serves as a diligent forward scout for his younger companion.[13] Brown frequently used dogs and other animals as human surrogates in her paintings, alternately accentuating their instinctual animal natures or their sentient human qualities. Brown also blurred the distinctions between nonhuman animals and their human counterparts—one supposedly wild and the other supposedly civilized, commenting, "Sure, I see human characteristics in animals. But maybe more to the point is that I see the animal characteristics in people. . . . And this kind of duality, this kind of exchange of the animal nature and human nature, of the connection and psychic response that the animal picks up from the person, is something that continues to fascinate me."[14]

Brown greatly admired the Spanish master Diego Velázquez's paintings of people posed with their pets, and *Noel and Bob* clearly owes a debt to such works as *Prince Don Baltasar Carlos as a Hunter* (fig. 112.1) of 1635, in which a diminutive child poses for a portrait while his canine companion remains oblivious to the process. Commenting on Velázquez's portraits of aristocrats posing with their dogs, Brown observed, "There's no interaction, or there is an interaction, and often there's a crazy kind of size relationship. There's a tremendous humanity. . . . there's a sympathy and connection to these people and very much so to the animals."[15] Brown's choice of Velázquez as an artist ancestor for her portrait of Noel is revealing, as she consciously linked her first encounter with the works of Velázquez and Francisco de Goya in 1961 to the experience of her son's birth one year later. Describing her visit to the Museo del Prado in Madrid, Brown recalled: "I experienced just a knock-out experience seeing those Goyas and the Velazquez'. And the only other comparable experience I've had after that was when my child was born, for which I was totally awake and conscious. And it was that kind of enlightening change, that dramatic type of experience."[16]

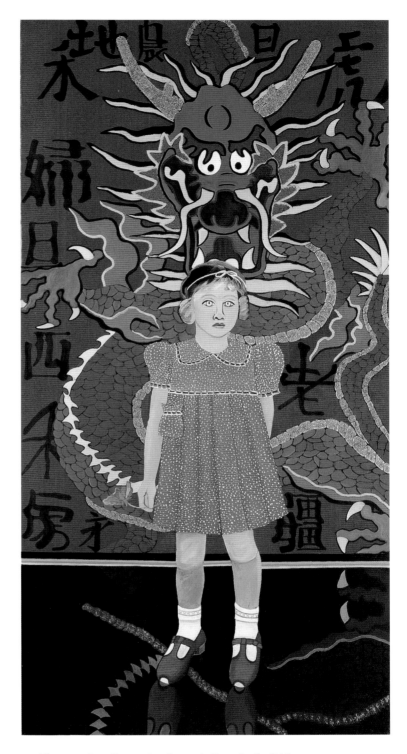

Fig. 112.3. Joan Brown (1938–1990), *Portrait of a Girl*, 1971. Oil enamel and glitter on masonite, 96¼ × 48 in. (244.5 × 121.9 cm). Estate of Joan Brown; Collection of Michael Hebel and Noel Neri, San Francisco. Courtesy of George Adams Gallery, New York; Gallery Paule Anglim, San Francisco; and Koplin Gallery, Los Angeles

Thematically, *Noel and Bob* appears to share kinship with works such as Vincent van Gogh's *First Steps* (1890, The Metropolitan Museum of Art, New York), in which a young child takes its first tentative steps outside the safe haven of the home.[17] However, the exuberance of Brown's saturated colors cannot conceal the dark undertone that pervades her painting. Noel appears as a parentless child, cast adrift in a vast landscape that is vaguely foreboding. The identity of the looming solar or lunar form at the top of the painting remains ambiguous.[18] Certainly a potential pun between "sun" and "son" is operative, especially given Brown's childhood fascination with the Egyptian pharaoh Akhnaton—Son of the Sun—and her admiration for "the sensitivity, the immediacy and spontaneity of the animal paintings and sculptures of his reign."[19] Equally unclear is the identity of the two dark, amorphous shapes that bracket the celestial form and press in on Noel: they may be viewed as clouds, hills, bushes—or voids. This sense of dislocation and vulnerability is accentuated by the dog, which serves as a cautious sentinel, scouting the world beyond the boundaries of the painting.

Brown's dark vision of childhood is reminiscent of Goya's portrait *Don Manuel Osorio Manrique de Zuñiga* (fig. 112.2) of the 1790s. In this work, Don Manuel's pet bird, tethered on a leash and menaced by three wide-eyed cats, may be seen as an allegory of youthful innocence threatened by worldly experience.[20] The perception of childhood as an ambiguous state, one filled with uncertainty and fear,

may reflect Brown's own experience as a child, living in a cramped three-room apartment with an elderly, bedridden grandmother, an alcoholic father, and an epileptic, depressive mother who periodically threatened to commit suicide. Brown later described her house as "black, dark, scary, like a Dracula house to me, and I would never be alone in it."[21] She added that her childhood "was dark, I mean dark in the psychological way, and it was crazy. . . . So all I wanted to do was grow up and get the hell out of there."[22]

In Brown's *Portrait of a Girl* (fig. 112.3) of 1971, painted two years after the death of her father and the suicide of her mother, the solitary and perplexed young Brown stands on a black void and is menaced from behind by a huge fang-bearing Chinese dragon.[23] Although the painting was inspired in part by childhood photographs in which Brown holds a rose in her right hand and a doll in her left, in the painting she implicitly holds the doll protectively behind her back, symbolically becoming the protective mother she lacked as a child.[24] Generically titled *Portrait of a Girl*—rather than *Self-Portrait*—this cathartic painting reprises the theme of childhood innocence and experience explored by Goya and provides insight into the vision of childhood depicted in Brown's portrait of her son.[25] While Brown's *Noel and Bob* does not dispel the demons of her own childhood, it does embody the power of art to capture these primal emotions and, ultimately, in *Portrait of a Girl*, to exorcise them in the crucible of artistic creation.[26] [TAB]

THE FOG OF WAR

Frank Lobdell (b. 1921) is one of the most influential artists associated with the evolution of Abstract Expressionism in California during the post–World War II period.[1] Like other artists who were veterans, Lobdell was compelled to consider the existential question of whether art retained any relevance in a world that had been irrevocably transformed by the war, the Holocaust, and Hiroshima and Nagasaki. Inspired by Clyfford Still's near-religious commitment to art as a calling, Lobdell gradually confronted the disasters of the war and resurrected the figure as the natural locus of a humanity that seemed to have perished during the conflict.[2]

Lobdell's work, which often explores the realm between abstraction and representation, is unified by the artist's ongoing study of the human condition and his strong social conscience. Equating art and life on a fundamental level, his works emphasize painting as a process, recording the progressive physical and psychic traces of the artist's mind and hand as he searches for meaning. Lobdell has observed that painting "is a kind of conversation with myself. The painting represents that conversation. If the dialogue is important enough, others will listen in."[3]

Frank Irving Lobdell was born in Kansas City, Missouri, and began his art studies at the St. Paul School of Fine Arts (1939) with the Regionalist painter Cameron Booth before serving (1942–46) in the U.S. Army during World War II. As a G.I. Bill student (1947–50) at the California School of Fine Arts (now the San Francisco Art Institute), and as an influential teacher at the C.S.F.A. (1957–65) and at Stanford University (1965–91), Lobdell contributed to the evolution of a new abstract expressionist visual vocabulary

—abstract, elemental, and mythic—that resonated with his existential postwar perspective.[4]

Lobdell's *Summer 1967 (In Memory of James Budd Dixon)* (1967) is a monumental antiwar statement that summarizes many of his thematic and stylistic concerns from the previous decades' work.[5] The origins of the painting may be traced to 1940, when he viewed the Museum of Modern Art's Pablo Picasso retrospective at the Art Institute of Chicago. The exhibition centerpiece was Picasso's monumental Spanish Civil War painting *Guernica* (fig. 113.1) of 1937, and Lobdell spent an entire day studying this apocalyptic vision of innocence and evil, of life and death.[6] Lobdell's strong response to *Guernica* was heightened by Picasso's scathing political indictment of Nazi Germany and fascist Spain for the bombing of Guernica and the murder of its civilians.[7] Lobdell later described this transformative experience as a revelation, recalling, "I felt the power of painting to really move. I wanted that power, the power to stir emotions as strongly as I was feeling the work I was looking at."[8]

In April 1945, five years after viewing Picasso's *Guernica*, Lieutenant Frank Lobdell confronted the harsh realities of war in Gardelegen, Germany, where German soldiers had forced more than one thousand concentration camp prisoners into an enormous barn, which was then set ablaze. When American troops arrived the next day, they found over three hundred smoldering corpses in the barn and more than seven hundred bodies buried in an adjacent mass grave. This horrific scene of "charcoal corpses" contorted by fear and by fire, their blackened and skeletal hands futilely grasping for escape, was indelibly seared into

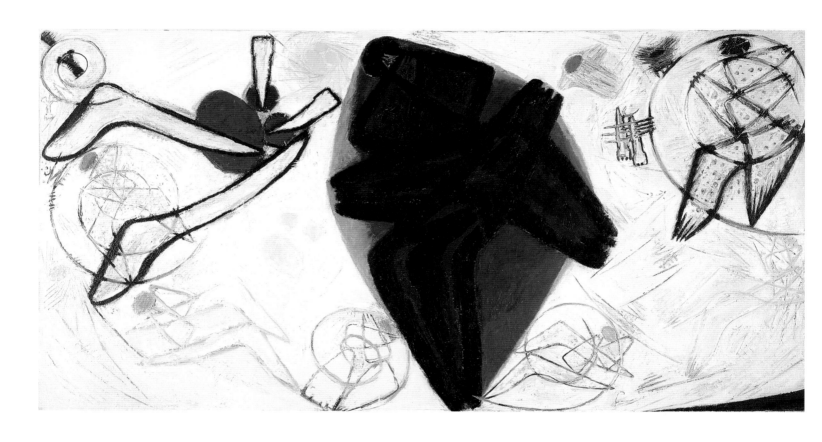

113. Frank Lobdell (b. 1921), *Summer 1967 (In Memory of James Budd
 Dixon)*, 1967. Oil on canvas, 90½ × 173½ (229.9 × 440.7 cm)
 Gift of Judson, Heather, and Charlotte Lobdell, 2002.150

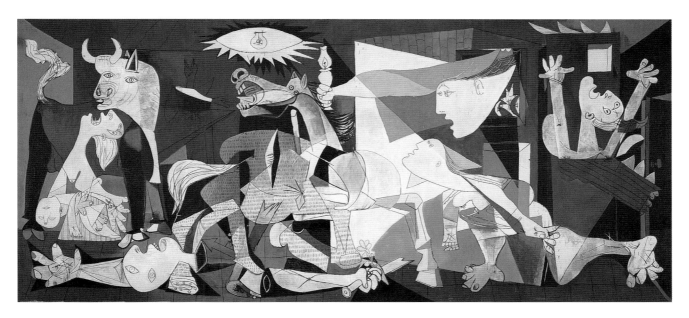

Fig. 113.1. Pablo Picasso (1881–1973), *Guernica*, 1937. Oil on canvas, 137⅜ × 305½ in.
(349 × 776 cm). Museo Nacional Centro de Arte Reina Sofía, Madrid

Lobdell's memory.[9] Of his World War II experiences, he recalled:

> My identity was shaken by that experience, as I think everyone's was. . . . Somewhere in *All Quiet on the Western Front*, [Erich Maria Remarque] remarks that there are no survivors. I think he's absolutely right. No one who has been involved in one of these wars truly survives. It'll haunt you for the rest of your life. . . . I painted my way out of a lot of this. Fortunately I had the talent to do this. I couldn't say that I came to grips with myself except that I was no longer as anxious about a lot of experiences. Somehow the anxiety had maybe gone into the paintings. A bit therapeutic, an unloading on the canvas.[10]

Lobdell's *Summer 1967*, along with his subsequent *Dance* (1969–71) series, represents the culmination of the artist's cathartic "unloading on the canvas."[11] Like Picasso's numerous studies for *Guernica*, many of Lobdell's earlier works, including a suite of thirty-three prints created the previous summer, may be seen as individual pages that coalesce within these penultimate antiwar statements.[12] Lobdell also consciously mirrored *Guernica*, not only through the large scale and panoramic proportions of *Summer 1967* but also through his use of a tripartite composition, which evokes a traditional religious triptych or altarpiece, such as

a crucifixion or a martyrdom. His protagonists seem to have been created from a series of permutations on the cruciform, including one at the upper center right that is pierced with needlelike forms evocative of stigmata and suffering.

The large, dismembered figure at the upper left appears to be composed of body parts that have been pinned back together.[13] Lobdell's female figure resembles a composite of two figures at the right in *Guernica*—the victim with upstretched arms in the burning building and the witness stumbling upon this scene of horror. The torso of Lobdell's floating figure is made up of a blue, egg-shaped belly and circular breasts, which also may be viewed as an abstracted open mouth and eyes. These ovoid forms are mirrored twice—by a ghostly image below and by three yellow circles above that resemble both a head with hair and a blazing sun with spiraling rays.

Lobdell has identified the ominous central figure, enveloped in a dark cocoon of ultramarine blue, as having been inspired by one of Goya's famous "Black Paintings"—*Saturn Devouring His Son* (fig. 113.2) of 1820–22.[14] Goya's subject is derived from the Greek myth of Kronos (Saturn), who castrated his father with a sickle and assumed his throne. Fearing that one day he would be usurped by his own children, he swallowed them whole at birth. Only Zeus escaped, eventually liberating his five previously devoured siblings and overthrowing his father. However,

Fig. 113.2. Francisco de Goya y Lucientes (1746–1828), *Saturno devorando a un hijo (Saturn Devouring His Son)*, ca. 1820–22. Mural painted with oil paints, mounted on canvas, 56¼ × 31⅞ in. (142.8 × 80.9 cm). Museo del Prado, Madrid

Goya's painting envisions the bloody dismemberment and carnivorous consumption of Saturn's children, thus precluding their later regurgitation. Lobdell's Saturn, a malevolent figure composed of boomerang-like legs and blood red hands, one of which bears a child's face, echoes Goya's gory conception of the myth. Unlike his airborne companions, he appears to be dragged downward by the weight of his dark deed.

The smaller, childlike figure with button eyes and mouth at the upper right, seated on a cosmic spiral as if on a swing, looks on blankly as his siblings are consumed. This figure has been drained of color and is covered with diseaselike spots or holes that Lobdell termed "wounds."[15] The entire ivory white ground of the painting is littered with such ghostly figures, some composed of limbs and others resembling mere ideograms of figures. They appear to have been caught up in this spiral of violence and death, devoured and then cast off as lifeless, skeletal husks, slowly fading from view. The curved black wedge at the bottom right suggests the cosmological nature of this life-and-death struggle and hints at a black void of oblivion beyond—a fate worse than death, which at least is symbiotically tied to life.

Lobdell's Oedipal trinity of mother, father, and child suggests a narrative in which the mother figure at the left—who raises her arms in desperation and cries out in protest—attempts to stop the central Saturn father figure from devouring their children, while the uncomprehending child at the right suffers a loss of innocence. In the context of the Vietnam War era, the Saturn myth was an appropriate metaphor for young American soldiers, including Lobdell's own son and some of his former Stanford students, who were drafted and then physically and psychically devoured by the war. Describing the influence of Goya's *Saturn Devouring His Son*, Lobdell observed, "That painting has always impressed me. I used it in the Dancer series. During the Vietnam War it was very clear that we were devouring our young."[16]

Lobdell's use of mythological and cosmological imagery in *Summer 1967* introduces several metaphorical associations relevant to the theme of war. For example, the mother figure, with her blazing sun head and disjointed limbs, recalls the myth of Icarus, in which Daedalus and his son Icarus escape from the labyrinth Daedalus had created for King Minos on Crete by fashioning wings made of feathers and wax. Despite his father's warning, Icarus foolishly flies too close to the sun, which melts the wax and sends him plummeting to his death. This desire to fly in the face of reality has since served as a metaphor for hubris, a character

flaw frequently ascribed to the United States government during its intervention in Vietnam, which increasingly resembled a maze without exit. Similarly, the numerous spiral forms in *Summer 1967* may be seen as metaphors for the United States' escalating involvement in a conflict that spiraled out of control.[17] Observing the cyclical nature of war, Lobdell has noted with bitter irony, "My father was in the First World War, I was in the Second, [my son] Frankie in Vietnam. This whole century's been nothing but wars."[18]

Despite his initial eagerness to fight fascism, Lobdell was deeply ambivalent about his World War II service. Describing his horrific experience at Gardelegen, Lobdell pointedly noted that the Allied troops expressed outrage over the atrocities committed at the barn but demonstrated indifference toward the dead German civilians they had seen in the town.[19] Lobdell came to see war as inherently dehumanizing and stated that victory by any means did not necessarily confer moral righteousness:

> Fascism had been defeated in a war that a lot of people felt was a worthwhile war, without, of course, realizing the other side. By the time we'd conquered Germany and Japan, we'd been reduced to using the same means. I felt that at the time. An uneasiness about a lot of this. Say, the bombing of Dresden, and the atomic bomb at Hiroshima. Mixed feelings. . . . If this had been the enemy, why we had defeated ourselves.[20]

The floating figures in *Summer 1967* subtly recall Lobdell's unease with the aerial death-dealing that characterized twentieth-century warfare, including the saturation bombing of Guernica, the firebombing of Dresden, the atomic bombs dropped on Hiroshima and Nagasaki, and the use of chemical weapons in Korea and Vietnam.[21] The disproportionate impact of these weapons of mass destruction upon civilian populations inevitably introduced serious moral issues regarding not only the use of such weapons but also the act of war making itself.

Like Picasso's *Guernica*, Lobdell's *Summer 1967* transcends its temporal origins to depict a universal battle between the forces of life and death, light and darkness, reason and madness, and fate and free will, thus serving as a condemnation of all wars.[22] Lobdell's nightmarish vision fatalistically acknowledges the endless cycle of human violence and suggests that morality is inevitably the first victim of the "fog of war." However, *Summer 1967* also proclaims the act of artistic creation to be inherently life-affirming and thus a powerful political protest in its own right.[23] Confronting the dark forces of war, Lobdell offers moral clarity regarding the only sensible solution, which he articulated at the inauguration of his retrospective exhibition at the Fine Arts Museums of San Francisco in 2003. Invited to speak, Lobdell hesitated and then pronounced to his audience a two-word exhortation — "No War!" [TAB]

114. ELMER BISCHOFF, *Yellow Lampshade*

THE UNTOLD STORY

Elmer Bischoff (1916–1991) was a Bay Area native, born in Berkeley.[1] He entered the University of California there in 1934 with a major in architecture, but the requisite art courses proved far more to his liking. When he graduated with a master's degree in 1939, Bischoff found a job teaching ceramics and jewelry at a high school in Sacramento; his painting suffered from lack of time to devote to his own art and, frustrated, he joined the Air Force Intelligence Section in 1941 and was deployed to England. Not surprisingly, life as an intelligence officer left as little time for artistic pursuits as teaching adolescents had. "It was a matter of my art interest being in abeyance for that stretch of time. I did very, very little," Bischoff later recalled.[2] He returned to the Bay Area in 1945 and soon heard of a faculty opening at the California School of Fine Arts in San Francisco. As he told it, he interviewed with C.S.F.A.'s new director, Douglas MacAgy, one day and was in the classroom the next.[3]

Restlessness was endemic during the postwar years, and the students and faculty at C.S.F.A., many of them veterans like Bischoff, felt what he termed a "hunger," making them receptive to new approaches to art that were emerging in New York.[4] "These ideas were just there, they were in the air and they infiltrated and took hold. . . . A lot of names were current . . . Pollock of course; we'd see their work reproduced in magazines," he told the critic Thomas Albright.[5] Clyfford Still was hired at C.S.F.A. shortly after Bischoff, and Mark Rothko was a summer session instructor in 1947 and 1949.[6] Bischoff joined his colleagues in exploring the new style and held a one-man show of abstract expressionist paintings that same year. A change of administration at C.S.F.A. led to the dismissal or resignation of much of the faculty, including Bischoff, who took a job driving trucks rather than continue at the school. He even-

tually found a teaching position at Yuba College in Marysville, which allowed him time to paint, but he chafed at being isolated from the vibrant Bay Area art scene. He threw himself into his work, for, as he put it, "I knew I'd never get out of Marysville if I didn't paint my way out."[7] Eventually he did just that, accepting faculty positions at C.S.F.A. (1956–63) and his alma mater, U.C. Berkeley (1963 until his retirement in 1985). During his four-year hiatus from C.S.F.A., Bischoff had begun to move away from abstraction, reintroducing the figure to his paintings. His friends — and former colleagues — David Park (1911–1960) and Hassel Smith were making the same transition, and the three pioneered what would soon come to be called Bay Area Figurative painting.[8] Feeling that Abstract Expressionism was "playing itself dry," Bischoff applied its characteristic action painting to representational subjects. He "relied in part on accident, filling up his paintbrush with globs of unmixed pigments, blending colors on the canvas as he went along."[9] As he later explained,

> A "unity of feeling" is the principal end. What you present in a painting is something that is immediate. If it makes a total impact, people are not going to pull it apart for anecdotal references. They're going to be hit — engulfed — to experience this world of the painting. What is most desired in the final outcome is a condition of form which dissolves all tangible facts into intangibles of feeling.[10]

Yellow Lampshade dates from the latter part of Bischoff's two-decade figurative period.[11] It is one of many moody, evocative paintings in which he was, in the words of Donald Kuspit, "determined to make the paint articulate what is emotionally fundamental to human being: the feeling of

458

114. Elmer Bischoff (1916–1991), *Yellow Lampshade*, 1969
Oil on canvas, 70 × 80 in. (177.8 × 203.2 cm)
Gift of Nan Tucker McEvoy in memory of
her mother, Phyllis de Young Tucker, 1992.10

being alone."[12] The total impact has been achieved, for the viewer is able to instantly grasp, though not fully understand, the palpable psychological tension of the image.[13] A man and a woman face each other across the living room of an upper-floor apartment. The light of the setting sun streams in from the window at left, creating a rosy glow in the room even as the San Francisco cityscape outside is falling into the deep blue shadow of evening. The space is sparsely furnished—a shadowy easy chair sits between the viewer and the couple, a small cabinet bearing the eponymous lamp stands beneath the central window, three green curtains are pulled to the far edges of the window, and a white light fixture hangs over the man's head. Both figures appear to be wearing white, though his suit radiates the red-orange of the sunset while hers shimmers with twilight blue.[14] His face is turned from us, hers is a blank patch of pigment; his hands are in his pockets, she rests one on the cabinet and holds the other behind her back. Bischoff has denied us facial expression or dramatic gesture to avoid endowing the scene with specificity, narrative, or—worst of all—sentimentality.[15] His neutral title further deflects emphasis from the taut emotions that are arguably the painting's subject, yet his evocative composition allows us to read the tension suffusing the room.

Though only yards apart, the figures impress the viewer as distant and alone. They stand at opposite ends of the composition, facing one another across the almost empty room. The man is associated with the warm colors of the floor, walls, and ceiling, his pink-orange face blending into the vertical support at the concave corner of the room. The woman is in blue, the chromatic opposite of orange, and her face is framed against the blue night outside. He is surrounded by empty space, free to move should he so choose, but she is pinned against the vertical support at the room's convex corner, in the lee of the small cabinet. Though we know that nothing lies spatially between the two figures, the forms of the cabinet and chair visually barricade her from him (and us). We also perceive the lampshade of the painting's title as standing between the figures; glowing yellow, it is essentially the only object in the painting that is not part of the high-contrast pink-orange-blue-green color scheme polarizing the image.[16] By abstracting the woman's face into a passage of paint, Bischoff not only removed the narrative prop of expression but also denied the couple the communion of a gaze, further estranging them. Each face—we assume his to be as featureless as hers—points directly at its counterpart, but without the woman's eyes to provide the expected locus of reception and reciprocation, the link

of the gaze is rebuffed. Outside the window, the urban canyon of a skyscraper-lined street emphasizes the physical and emotional divide separating the pair.

Not only are the two isolated one from the other, but also each vibrates with a more universal sense of aloneness. Relative to the room in which they stand, the figures seem disproportionately small and thus vulnerable.[17] They are rounded, organic forms in a sea of lines and angles, each compartmentalized at the edge of an enormous, sharply rectangular window, through which the blocky urban landscape is cold and unwelcoming: no other people are in sight, no windows illuminated.[18] Bischoff contrasts the vast panorama of the impersonal city with the intensely personal emotions of his protagonists, a reminder that the dispassionate metropolis is a tapestry of such small human moments.[19] One cannot help but think of Edward Hopper's (1882–1967) paintings of alienated urbanites from the 1930s and 1940s, which included paintings of couples, faces obscured, coexisting but not communicating. Bischoff vehemently denied any such influence, but the correspondence of both subject and mood between *Yellow Lampshade* and Hopper's *Room in New York* (1932, Sheldon Memorial Art Gallery and Sculpture Garden, University of Nebraska), for example, are too striking to overlook.[20]

Bischoff's interest in aloneness, particularly that oxymoronic state of being profoundly alone with someone else, may have developed soon after his graduation from Berkeley in 1939. His first job took him to Sacramento, seventy-five miles and a world away. Military service followed, including three years abroad, a period of "imprisonment" during which Bischoff felt "an increasing sense of estrangement."[21] On his return to the Bay Area, he met Mark Rothko (1903–1970):

> My own big influence was Mark Rothko.... Rothko voiced the hope of breaking through solitude. He saw man in our society as being immersed in solitude, a solitude that cannot be overcome by ordinary means and he spoke, poetically, of this solitude gathering on beaches and streets and in parks and forming a living tableau of human incommunicability.[22]

He took these ideas with him to Marysville and another period of isolation, during which he moved from abstraction to figuration as the most effective vehicle for expression. Years later, in a style far removed from that taught to him by Rothko, Bischoff created just such a "living tableau of human incommunicability" in *Yellow Lampshade*. [EL]

115. WILLEM DE KOONING, *Untitled XX*

THE ANATOMY OF A LANDSCAPE

Willem de Kooning (1904–1997) was widely recognized as the most influential member of the New York School and as the greatest American figurative artist of his generation. Drawing inspiration from European Surrealism, psychological theories of unconscious creation, and existentialist philosophical thought, de Kooning helped to pioneer Abstract Expressionism in the late 1940s. The movement emphasized artistic innovation over convention, process over completion, and intuitive actions over rational thought. The artworks often revealed the physical and psychic traces of the artist's creative struggle, combining visual problems, solutions, erasures, and corrections in a continuous cycle of creation, destruction, and rebirth.

Dutch by birth, de Kooning, along with the Armenian Vosdanik Adoian (Arshile Gorky) and the Russian Marcus Rothkowitz (Mark Rothko [1903–1970]), helped to shape one of the quintessential American art movements. Unlike the American Jackson Pollock, who studied with the Missouri Regionalist Thomas Hart Benton (1889–1975), these immigrant artists never felt compelled to address American Scene painting of the 1930s. Instead, de Kooning's European academic training, deep knowledge of art history, and art world stature enabled him to embrace traditional subjects—particularly the human figure and landscape—while simultaneously advancing the evolution of American abstract art.[1]

Willem de Kooning was born in Rotterdam, the Netherlands, where he studied at the Rotterdam Academy of Fine Arts and Techniques (1916–24/25). In 1924 he studied at the Académie Royale des Beaux-Arts in Brussels and at the Van Schelling Design School in Antwerp. De Kooning immigrated to the United States in 1926, settling in New York City the following year. Like many Depression-era artists, he found temporary financial support by working for the mural division of the Federal Arts Project of the Works Progress Administration (1935–36).

De Kooning's career progressed through several distinct periods: tentative experiments with biomorphic abstraction in the early to mid-1930s; stylized figurative works strongly influenced by Pablo Picasso in the late 1930s to mid-1940s; the breakthrough semiabstract "Woman" paintings of the late 1940s and early 1950s, famous for their frenetic deconstruction of the female figure; the majesterial abstract expressionist figurative and landscape works of the 1950s, which became increasingly pastoral in the 1960s; nearly pure abstractions during the 1970s; and, finally, the increasingly reductive paintings of the 1980s with their long, sinuous ribbons of color floating on a luminous white ground.

Untitled XX is from a series of untitled late paintings in which de Kooning explored the anatomy of the nude figure and the topography of the surrounding interior/exterior landscape. The initial inspiration for *Untitled XX* was almost certainly de Kooning's favorite subject—the female nude. Although several parallel brushstrokes in the lower left corner of the canvas resemble his typical shorthand notation for a human hand or foot, neither the nude figure nor its gender is delineated by defined anatomy. Rather, this figure's presence is evoked by the sensual and curvilinear rose, pink, and flesh pigments that fill the left half of the composition. The sensuousness of this painted flesh recalls de Kooning's celebrated comment that "flesh was the reason oil painting was invented."[2]

The female figure, usually nude, was the subject of de Kooning's iconic "Woman" paintings of the late 1940s and early 1950s. This conventional artistic subject carried traditional associations with goddesses, fertility, Madonnas,

461

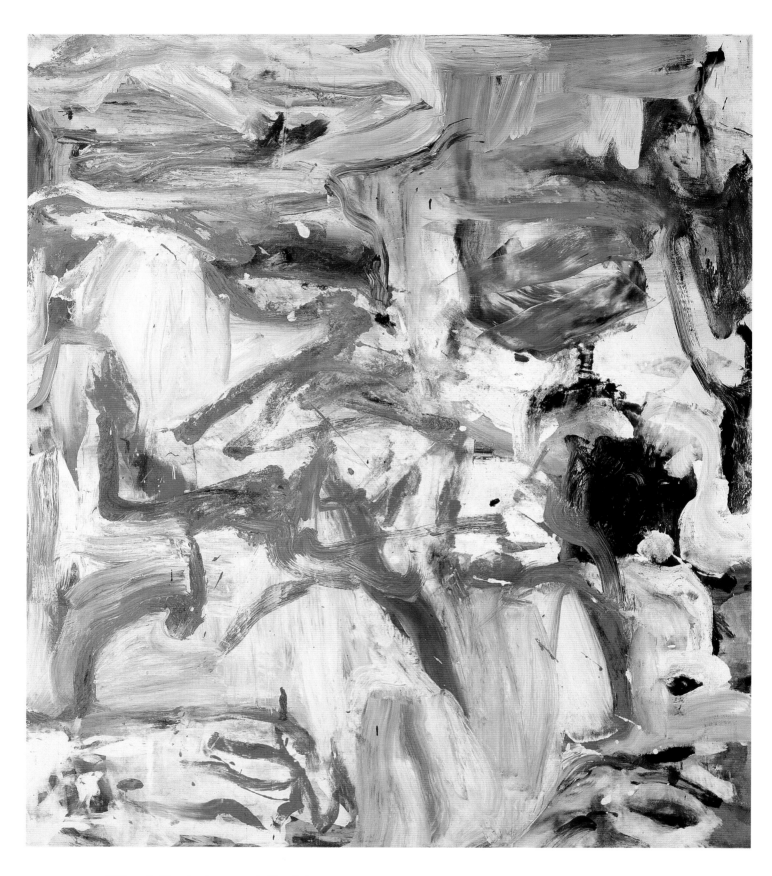

115. Willem de Kooning (1904–1997), *Untitled XX*, 1977
Oil on canvas, 80 × 70 in. (203.2 × 177.8 cm)
Museum purchase, gift of Nan Tucker McEvoy, 2002.1

maternity, and sexuality. As de Kooning recalled, "I began with women, because it's like a tradition, like the Venus, like Olympia, like Manet made *Olympia*."[3] However, de Kooning added, "There seems to be no time element, no period, in painting for me," and his nudes also drew inspiration from modern newspaper and magazine reproductions and often incorporated contemporary gender signifiers, including lipstick, high-heeled shoes, dresses, bathing suits, and nail polish.[4] These cultural hybrids thus fused the past and the present, high and low culture, and the ideal and the real.[5]

The salient characteristics of the "Woman" paintings, which persisted until the end of de Kooning's career, are already present in early works such as *Woman* (fig. 115.1) of about 1944. The subject, a woman whose upper torso is seen frontally and whose legs and arms are seen in three-quarter view, is seated in an indeterminate space against a backdrop of rectilinear forms that may be windows, doors, or paintings. Despite her exaggerated sexuality and gender markers such as the pink lipstick, bodice, and nail polish, she is essentially composed and contained.

Although its ostensible subject is identical to that of *Woman*, artistic and societal conventions of restraint and propriety have been stripped from de Kooning's primal *Woman I* (fig. 115.2) of 1950–52, which was included in his controversial 1953 exhibition *Paintings on the Theme of the Woman*.[6] These feral fertility figures have been subjected to interpretations ranging from mythological goddesses to "the new American woman," but the most interesting interpretation is that of the artist, who discerned a fluid duality of gender and in 1956 speculated, "Maybe in that earlier phase I was painting the woman in *me*."[7]

In contrast to these early female nudes, which he subsequently described as "satiric and monstrous, like sibyls," in 1967 de Kooning stated that "the women I paint now are

Fig. 115.1 [top right]. Willem de Kooning (1904–1997), *Woman*, ca. 1944. Oil and charcoal on canvas, 46 × 32 in. (116.8 × 81.3 cm). The Metropolitan Museum of Art. From the Collection of Thomas B. Hess, jointly owned by The Metropolitan Museum of Art and the heirs of Thomas B. Hess, 1984.613.2

Fig. 115.2 [bottom right]. Willem de Kooning (1904–1997), *Woman I*, 1950–52. Oil on canvas, 75⅞ × 58 in. (192.7 × 147.3 cm). The Museum of Modern Art, New York. Purchase, 478.53

very friendly and pastoral, like my landscapes, and not so aggressive. Women are the symbol of civilization, like the Venus of Willendorf."[8] De Kooning's reference to the Paleolithic Venus of Willendorf (ca. 24,000–22,000 B.C., Naturhistorisches Museum, Vienna) as an archetypal idol and prototype for his own nudes (most obviously *Woman I*) is revealing, as this famous Stone Age carving, distinguished by its exaggerated sexuality, is usually interpreted as a powerful fertility goddess.

Like the overtly sexual portraits Picasso made of his mistress Marie-Thérèse Walter in the 1930s, de Kooning's female nudes of the 1970s may be perceived as artistic equivalents for the act of making love, palpably pulsing and flowing with life and sexual energy. Inspired in part by the older artist's passionate affair with the much younger Emilie Kilgore, these paintings convey the sensual physicality of the female form, not just observed and objectified, but actually felt and internalized through painterly means.[9] This theme of all-encompassing sensuality, in which individual female and male identities are joined in an act of protean creation, dovetails with de Kooning's perception of a gender duality in his paintings of women.

The nude in *Untitled XX* also appears to be inextricably fused with de Kooning's other favorite subject—the landscape. He attributed his lifelong fascination with the meeting of the earth, sky, and water to his childhood in the port city of Rotterdam, stating, "There is something about being in touch with the sea that makes me feel good. That's where most of my paintings come from, even when I made them in New York."[10] In 1963, after almost four decades in New York City, de Kooning returned to the Atlantic coast and moved into a large, light-filled studio in the rural hamlet of Springs, East Hampton, Long Island. This new pastoral environment provided fertile ground for de Kooning's perception that his paintings and his environment were not discrete entities but were instead part of a continuum.[11]

Within the energetic flurry of seemingly abstract brushwork in *Untitled XX*, one can discern elements that are reminiscent of those in de Kooning's earlier landscape paintings. The vertical blue rectangle at the upper right may be viewed as an architectonic window or door framing a view of blue water, while the horizontal yellow rectangle at the upper left evokes a sun-suffused sky. Defying gravity, the sinuous blue brushstroke appears to flow like water into the room; it is depicted with the same animated sensuality evident in his rendering of his nude female form. De Kooning metaphorically connected water to Emilie Kilgore, comparing the back of her neck to the beach, the beginnings of her hair to the shore grass, and the fall of her hair to the meeting of sea and sand.[12]

De Kooning's perception of the fluidity and mutability of both animate and inanimate form can be linked to his conception of "no environment," of which Thomas Hess wrote,

> The window-outdoors-indoors-mirror-painting-rectangle is its embodiment.... One of the decisions many New York artists made in the 1940s was to have their painting mean anything and everything. From this it followed that the studio should be everywhere and anywhere. The painting and the studio, the streets outside, the drive through the country that led away from and back to the easel, all merged into the painting—especially de Kooning's, who played a key role in this decision.[13]

De Kooning's placement of the nude in a transitional space that is neither pure domestic interior nor pure landscape recalls Henri Matisse's simultaneous depiction of interior and exterior views as metaphors for the interior, imaginary realm of artistic creation, and for the exterior world of observed experience.[14] In *Untitled XX*, de Kooning dissolves the traditional boundaries between studio and non-studio, figure and ground, representation and abstraction, and animate and inanimate.[15] Like Picasso's late expressionist works of the previous decade, *Untitled XX* is the creation of a twentieth-century old master at the height of his expressive powers as a painter. De Kooning himself recognized this power, remarking of his *Untitled* series, "I made those paintings one after the other, no trouble at all. I couldn't miss. It's a nice feeling. It's strange. It's like a man at a gambling table [who] feels that he can't lose. But when he walks away with all the dough, he knows he can't do that again. Because then it gets self-conscious. I wasn't self-conscious. I just did it."[16] [TAB]

116. ED RUSCHA, *A Particular Kind of Heaven*

HEAVEN ON EARTH

Ed Ruscha's interest in the intersection of texts and images as meaningful subjects for art initially caused critics to link his work with the Pop art movement of the 1960s. In such early works as *Standard Station, Amarillo, Texas* (1963, Hood Museum, Dartmouth College, Hanover, N.H.) and *Noise, Pencil, Broken Pencil, Cheap Western* (1963, private collection), Ruscha appropriated the vocabulary and aesthetics of commercial advertising to create seemingly transparent representations of some of the most prosaic aspects of contemporary popular culture. However, viewers who accept Ruscha's work at face value will miss its considerable artifice, which includes the enigmatic juxtaposition of seemingly disparate subjects and their subtly expressive rendering, which often subverts conventional conceptions of realism.

Removed from their familiar contexts and projected into the realm of art, Ruscha's enigmatic texts and images create a form of visual and mental collage that draws attention to the poetic possibilities—and the prosaic limitations—of written, visual, and verbal communication. Viewers are invited to follow a stream-of-consciousness path of free association that can either lead to multivalent interpretations or end somewhere in the disjunction between subjects and their meanings. Acknowledging the coexistence of the real and the surreal in his work, Ruscha has observed, "sometimes I feel like I'm doing book covers for mysterious stories."[1]

Edward Joseph Ruscha (b. 1937) was born in Omaha, Nebraska, and raised in Oklahoma City, Oklahoma. In 1956 he moved to Los Angeles, where he studied commercial art at the Chouinard Art Institute (now the California Institute of the Arts) with Robert Irwin and Emerson Woelf-fer until 1960. During these student years, Ruscha mastered the fundamentals of illustration, lettering, and layout, and worked as a sign painter. He also took a printmaking class and apprenticed at Plantin Press, an art book publisher. On graduation, Ruscha briefly worked for advertising agencies before deciding in 1961 to pursue a serious art career. He soon became associated with Los Angeles's Ferus Gallery, which exhibited works by such artists as Jay DeFeo, Richard Diebenkorn (1922–1993), John Altoon, George Herms, and his former teacher Robert Irwin. Ruscha vividly recalled that his contemporaries were "almost priestlike in their commitment to their art and commitment to working. I decided I had to commit myself, in this way, to painting."[2]

Like most young artists of his generation, Ruscha initially was influenced by Abstract Expressionism: "When I was in school, I painted just like an Abstract Expressionist—it was a uniform. Except you didn't really have to wear it, you just aped it. It was so seductive: the act of facing a blank canvas with a palette. I liked painting that way, but there seemed no reason to push it any further. But I began to see that the only thing to do would be a preconceived image. It was an enormous freedom to be premeditated about my art."[3] By selecting preexisting subjects and by depicting them with a style associated with commercial art, Ruscha shifted the focus from the primordial artist-creator trope embraced by the Abstract Expressionists to the perception and interpretation of a uniquely American vernacular vocabulary.

A Particular Kind of Heaven (1983) is one of a series of works in which words and phrases are projected against the sky, like typographic skywriting. The large-scale, panoramic format and spectacular chromatic effects of Ruscha's

116. Ed Ruscha (b. 1937), *A Particular Kind of Heaven*, 1983
Oil on canvas, 90 × 136 in. (228.6 × 345.4 cm)
Museum purchase, Mrs. Paul L. Wattis Fund, 2001.85

Fig. 116.1. Ed Ruscha (b. 1937), *A Certain Form of Hell*, 1983.
Oil on canvas, 64 × 64 in. (162.6 × 162.6 cm). Private collection

painting vaguely recall the transcendental abstractions of Mark Rothko (1903–1970), but they have even older antecedents in the western landscapes of such Hudson River School artists as Albert Bierstadt (1830–1902). These nineteenth-century artists perceived the American landscape as a metaphor for the new nation and Euro-Americans as ordained to fulfill their Manifest Destiny to settle the continent from the Atlantic to the Pacific. Ruscha's interest in this problematic intersection of politics and religion is apparent in the contemporaneous word painting *Lost Empires, Living Tribes* (1984, private collection) and in a later painting of a western covered-wagon train, *The Uncertain Trail* (1986, private collection).[4] Characteristically, Ruscha's texts do not reveal whether they refer to Native American or European "lost empires" and "living tribes," or what makes the course of the American empire "uncertain."

The five white words that constitute Ruscha's title—*A Particular Kind of Heaven*—are arranged on three descending lines, the first aligned to the left, the second nearly so, and the third to the center of the composition. The letters may be viewed as opaque and superimposed on the sky or as stencil cutouts that leave a void in the image. These emphatically flat letters, which assert the two-dimensional picture plane and counterbalance the subtle suggestion of a recessive space, recall the Cubists' similar use of typography as a compositional device. Ruscha has described his characteristic lettering as "a type of typography that I call 'Boy Scout Utility Modern.' It's not about the history of typography. It's the kind of thing a carpenter might apply to making a letter form. I like it for just that reason."[5]

However, Ruscha's generic letters resemble a specific carpenter's prototype—the wood letters of the famous

HOLLYWOOD sign that has become an icon not only of Los Angeles, California, and the United States but also of the artist's work. This implicit reference to America's movie capital is apt; Ruscha has described his canvases as "a flat screen" and has stated that "my paintings have a closer relation to movies than to painting. . . . I guess you could say I am interested in the possibilities that remain in a time which tends to favor the moving image."[6] As a lifelong aficionado of films and the director of his own films, *Premium* (1970) and *Miracle* (1975), Ruscha frequently employs cinematic vocabularies in his otherwise "still" paintings, drawings, prints, and photographs.

In *A Particular Kind of Heaven*, the three lines of bright white text resemble a film title projected on a movie screen and are evocative of a compressed drama enacted on a vast landscape stage.[7] Although Ruscha's painted words cannot move physically, the enigmatic nature of his text creates a mental afterimage that continues to resonate with the viewer, not unlike a film title as it fades from the screen. Similarly, although Ruscha has experienced the "big sky country" of the American West in Oklahoma and at his house in the Mojave Desert, the painting's low horizon, Panavision format, and Technicolor palette all evoke the vocabulary of classic American film westerns, particularly their clichéd images of an opening sunrise or a closing sunset.[8]

The luminous Hollywood letters and California landscape of *A Particular Kind of Heaven* implicitly introduce the historical perception of California as a mythical El Dorado or a biblical Eden. In 1956, a generation after the "Okie Exodus" described in John Steinbeck's *The Grapes of Wrath* (1940), Ruscha migrated from Oklahoma across the desert to Los Angeles, which he described as "a Garden of Eden compared to Oklahoma."[9] Conversely, he described Oklahoma as a barren wasteland of religious hypocrites: "I began to realize that I was living a hypocritical life, and was so glad that I had gotten away from the Bible Belt and all those people. Because there was just no room for poetry, no room for a poet there. An artist would starve to death there."[10] Ruscha later commemorated his pilgrimage route between Oklahoma and Los Angeles and the "stations" along the road in his book *Twentysix Gasoline Stations* (1963).[11]

Although not a pendant to *A Particular Kind of Heaven* per se, the luridly colored *A Certain Form of Hell* (fig. 116.1) employs both text and image to offer an ironic counterpoint to the larger painting.[12] Thus, the expansive panoramic format has been replaced by a confining square format; the grounded juncture of heaven and earth has been replaced by an amorphous flame red space; and the lighter-than-air words hovering over the horizon have been replaced by a ponderous, staircaselike descent of words down the canvas.[13] More subtle contrasts are suggested by the multiple meanings of "certain" (i.e., sure or definite) and "form" (i.e., a mold, fixed procedure, proper manners, etc.) versus "particular" (i.e., specific or unique) and "kind" (i.e., compassionate). Ruscha's words are as real as words can be, but, because they represent abstract concepts, viewers with preconceived ideas of heaven and hell—especially those inspired by art-historical precedents—may find the artist's conceptions strangely lacking.

Ruscha's relativism, in which meaning is contingent rather than certain, may be seen in part as an individualistic and iconoclastic response to the religious dogma he encountered during his youth: "I think that I got distorted feelings about morality, maybe, and things that were put upon me by the Catholic Church. . . . Then I learned more about the Church and it seemed even more hypocritical, to the point where I just had to say adios."[14] Ruscha's "particular" or personal vision of heaven is pointedly grounded in his experience of the California landscape, a more accessible form of heaven on earth. It also suggests that everyone is free to perceive, or to create, his or her personal vision of heaven and hell, with or without people.

Viewed together, *A Particular Kind of Heaven* and *A Certain Form of Hell* capture Ruscha's ongoing interest in the dualities of texts and images, both within and between artworks, and encompass his existential philosophical perspective:

> I have a—what do you call it—positive negativism, or negative positivism. It's pessimism about the state of the world. I respond to all these things and I generally take a pessimistic attitude about them. That probably makes me a cynic. . . . So many opposing conditions in the world makes for no sense, and I'm constantly wondering why I get up and do what I do, and everybody else, why they wake up and do what they do. . . . That's the only thing that's left, is to make your work, and that's the way to escape this world as it is. I love it, don't get me wrong.[15]

[TAB]

THE UNFOLDING DRAMA OF AIDS

Having spent his first twenty-five years in his native Japan, the second twenty-five years as a resident alien in Los Angeles, and the ensuing years as a citizen of the United States, Masami Teraoka is acutely aware of his dual cultural identities. His artworks, which draw on nineteenth-century Japanese prints, twentieth-century American Pop art, and European Renaissance art, focus a perceptive, almost anthropological gaze on some of the most resonant social, political, and cultural issues confronting contemporary society. Especially prominent themes are the proliferation of America's corporate and consumer culture, the HIV/AIDS pandemic, the pervasive and pernicious influence of new technology and media, the culture wars, and the moral hypocrisy of powerful institutions and individuals.

Masami Teraoka (b. 1936) was born in Onomichi, Japan, where he studied watercolor painting for two years with Moemon Sugihara. Teraoka also studied art history and literature at Kwansei Gakuin University in Kobe, receiving a B.A. in aesthetics in 1959. In 1961 he came to the United States and settled in Los Angeles, studying at the Otis Art Institute (1964–68). Drawn to the works of the contemporary Pop artists Claes Oldenburg and Tom Wesselman, Teraoka perceived striking affinities between their works and those of the nineteenth-century Japanese artists Katsushika Hokusai and Utagawa Kunisada. Similarities included subjects drawn from popular culture; flattened or isometric perspective; calligraphic, often caricatured outlines; subtly modulated color planes; and interplay between the image and superimposed texts. Fusing these two genres to create a new cultural hybrid, Teraoka explored the complex cultural interaction of America and Japan in his well-known series *McDonald's Hamburgers Invading Japan* (1974–82) and *31 Flavors Invading Japan* (1975–79).

Teraoka's *American Kabuki/Oishiiwa* (1986), a *sumi* ink and watercolor painting on a four-panel *byobu*, or folding screen, seamlessly fuses elements of Japanese and American culture to capture the fear and fury associated with the global HIV/AIDS crisis. The title explicitly references Kabuki theater, which arose during Japan's Edo period (1615–1868) and provided middle-class patrons with an accessible alternative to the arcane Noh theater associated with the aristocracy. Because Kabuki plays often incorporated overt eroticism and covert political content, performances were restricted to the urban pleasure quarters, or "floating world" (*ukiyo*), and were strictly regulated by government censors.

Teraoka has observed that the Kabuki tradition plays an important role in his artworks, which also fuse eroticism with political commentary: "I look at my paintings as Kabuki plays, the ancient Japanese equivalent to movies. I am the director, and I have to be careful casting each actress and actor because the strength of each work depends on how I script, draw, and paint each one. I call my work 'Masami-za' or 'Masami-theater.'"[1]

American Kabuki/Oishiiwa also draws on the vocabulary of Japanese color woodblock prints known as *ukiyo-e*, or "pictures of the floating world." *Ukiyo-e* typically depict scenes drawn from Kabuki theater or everyday life and favor themes of satire, love, eroticism, sex, violence, and death. While celebrating the panorama of pleasure and pain inherent in human experience, *ukiyo-e* prints also implicitly reflect one of Buddhism's central tenets—the acceptance of the ephemeral nature of life.

American Kabuki/Oishiiwa, Teraoka's first and most famous work dealing with HIV/AIDS, was inspired by the news that a friend's newborn child had contracted HIV from a

117. Masami Teraoka (b. 1936), *American Kabuki/Oishiiwa*, 1986
Watercolor and *sumi* ink on paper, mounted on a
four-panel folding screen, 77½ × 155 in. (196.9 × 393.7 cm)
Museum purchase, American Art Trust Fund
and gift of Brian Pawlowski and Aki Ueno, 2002.4

Fig. 117.1. Katsushika Hokusai (1760–1849), *Cresting Wave off the Coast of Kanagawa*, from the series *Thirty-six Views of Mount Fuji*, ca. 1831–34. Color woodcut, 9⅞ × 14⅜ in. (25 × 36.6 cm). Fine Arts Museums of San Francisco. Museum purchase, Achenbach Foundation for Graphic Arts Endowment Fund, 1969.32.6

blood transfusion.[2] Although Teraoka later created more elaborate works that addressed the HIV/AIDS theme, *American Kabuki/Oishiiwa* retains the power and clarity of a first revelation. Teraoka's Edo-style calligraphic inscription reads, "In the evening, the clouds are very turbulent, storm-bearing. The sound of the waves is loud, and black clouds are beginning to spread over the shoreline. As the evening wears on, the full moon is revealed when the clouds part. Suddenly a cry is heard, 'Help us, help us!' It is so faint that the audience is uncertain whether they have heard a voice, or if it is only the sound of the waves."[3]

The source of the faint cry, a ghostlike woman wearing a red kimono, surges forward on the crest of a wave with windblown brown hair and a hollow-eyed stare. Only gradually does the viewer perceive the infant clutched protectively to her left shoulder.[4] The characteristic lesions of Kaposi's sarcoma on the mother's forehead and right forearm reveal that she is already suffering from the symptoms of AIDS. The goggles dangling unused from her wrist are a poignant vestige of recreational swimming in calmer waters. The black frigate bird at the right, a species notorious for stealing food from the mouths of other birds, serves as a metaphor for HIV/AIDS stealing life, even within the protective womb of a mother.[5]

The mother's anguish is echoed by the forces of nature, the ominous black-gray clouds above and the stormy, teal blue sea below. The cresting wave, inspired by Hokusai's most famous color woodblock print, *Cresting Wave off the Coast of Kanagawa* (fig. 117.1), suggests that the HIV/AIDS pandemic is a tsunami, or tidal wave, that threatens the entire earth with its destructive power. The white wave crests, metaphorically described by Teraoka as "creeping fingers," evoke the skeletal fingers of Death, grasping at the mother's kimono and threatening to pull her beneath the surface. The solitary mother's precarious position, deluged with no sign of salvation in sight, evokes the social ostracism that often stigmatizes people living with HIV/AIDS.

Teraoka has described the full moon, whose eternal cycles suggest the continuity of life, as a protective symbol of hope, but the billowing black clouds threaten to cast the entire scene into darkness.[6] Scattered across the night sky are five flamelike forms, appropriated from nineteenth-century *ukiyo-e* prints (fig. 117.2), that here represent the ghostly souls or spirits of people who have died of AIDS-related illnesses. These red and blue flames appear to plummet like comets toward the waves below, where they would be permanently extinguished.[7] The visual similarity between these fiery souls and the mother's flamelike hair suggests that she ultimately may share their fate.

The unmitigated celebration of sexuality that characterized many of Teraoka's earlier works has been compromised in *American Kabuki/Oishiiwa* by the advent of HIV/AIDS.[8] The subtitle, *Oishiiwa*, derived from a contraction of *oishi*, "delicious," and *wa*, which adds a feminine connotation,

Fig. 117.2. Utagawa Kunisada (1786–1864), *The Actors Kataoka Gado II and Bando Hikosaburo V as Tamiya Iemon and the Ghost of Oiwa*, 1861. Color woodcut, 14¼ × 19¼ in. (36.1 × 49 cm). Fine Arts Museums of San Francisco. Museum purchase, Achenbach Foundation for Graphic Arts Endowment Fund, 1984.1.86

evokes associations of female beauty and erotic pleasure.[9] However, Teraoka's angst-ridden mother quickly throws cold water on the erotic visions conjured by this sensual subtitle. Instead, she serves as a pointed warning or memento mori regarding the new physical and psychic dangers that have complicated natural human sexual desires. Reinforcing this theme, the predatory frigate bird, whose black color has connotations of death and mourning, turns menacingly toward the oblivious pair of red snappers that are mating in the water below his rock perch.

Teraoka's subtitle, *Oishiiwa*, also refers to Oiwa, the female ghost protagonist in the Kabuki play *Tokaido Yotsuya Kaidan* (*The Ghost Story of Yotsuya*) by Tsuruya Nanboku IV. First performed at the Nakamura Theater in Edo in 1825, *Yotsuya Kaidan* soon became the most famous ghost story in Japan and was depicted by the two artists most admired by Teraoka, Hokusai and Kunisada. The tragedy commences when Oiwa's husband, Tamiya Iemon, falls in love with his neighbor's daughter, O-Ume, and abuses Oiwa, hoping to force her to leave him. When this course of action fails, O-Ume's father gives Oiwa a poison that, although failing to kill her, causes severe disfiguration. In despair from her husband's rejection and suffering from her poisoning, Oiwa commits suicide. Tamiya Iemon then kills Oiwa's faithful servant Kohei (a witness to his mistress's abuse), ties

both of their bodies to a door, and has the door thrown into a river.

On the day of Tamiya Iemon's marriage to O-Ume, Oiwa returns from the grave, her blue-tinted face connoting her ghost state, to exact her revenge. She causes Tamiya Iemon to mistake O-Ume for the ghost of Oiwa, and O-Ume's father for the ghost of Kohei, and he kills them both. Tamiya Iemon then flees to the river, where the door bearing the grisly corpses of Oiwa and Kohei floats to the surface (fig. 117.2). Unable to push the door permanently beneath the water, Tamiya Iemon throws himself in the river and drowns. In keeping with the dramatic precedent set by Oiwa, Teraoka has observed, "Ghosts haunt my AIDS series as vestiges of envy, longing, revenge, and death."[10]

By invoking Japanese *ukiyo-e* prints and the Kabuki play *Tokaido Yotsuya Kaidan*, Teraoka's *American Kabuki/Oishiiwa* links Japanese and American culture and history, both of the past and the present. The painting gives a face to the unfolding drama of HIV/AIDS and its unbearable human suffering and bereavement. *American Kabuki/Oishiiwa* also appeals to the viewer's conscience, serving as an eloquent indictment of collective inaction and perhaps as a warning of righteous retribution if viewers fail to embrace people living with HIV/AIDS, to remember those who have died, and to protect future generations. [TAB]

KEY TO ABBREVIATIONS:

AAA/SI = Archives of American Art/Smithsonian Institution

AAD/DEY/FAMSF = American Art Department,
de Young, Fine Arts Museums of San Francisco

1. FREAKE-GIBBS LIMNER,
David, Joanna, and Abigail Mason

1. While scholars have not been able to identify the painter by name, they have noted similarities between the paintings of the Mason family and those of the Freake and the Gibbs families, which strongly suggest they were painted by the same hand. As is the case with some other colonial painters whose names have been lost, the artist is now identified by the family or families whose members sat for him. In addition to this painting of David, Joanna, and Abigail Mason, portraits of Mary Mason (1668) and Alice Mason (1670), both at the Adams National Historic Park, Quincy, Massachusetts, are also thought to have been executed by the Freake-Gibbs Limner.

2. E. P. Richardson to John D. Rockefeller 3rd, North Haven, Maine, 16 August 1973, object file, AAD/DEY/FAMSF.

3. For a discussion of the assize, see William G. Panschar, *Baking in America: Economic Development*, 2 vols. (Evanston, Ill.: Northwestern University Press, 1956). For information about Arthur Mason as a baker, see Arthur W. Brayley, *Bakers and Baking in Massachusetts: Including the Flour, Baking Supply and Kindred Interests: From 1620 to 1909* (Boston: Master Bakers Association of Massachusetts, 1909).

4. Lillian B. Miller, "The Puritan Portrait: Its Function in Old and New England," in *Seventeenth-Century New England*, ed. David D. Hall and David Grayson Allen (Boston: Colonial Society of Massachusetts, 1984), 157.

5. Ibid., 154. Thanks to Dr. John L. Strother of the University of California, Berkeley, for his identification of the flower.

6. Alicia M. Annas, "The Elegant Art of Movement," in *An Elegant Art: Fashion and Fantasy in the Eighteenth Century* (New York: Harry N. Abrams, in association with the Los Angeles County Museum of Art, 1983), 48. See *Mrs. Daniel Sargent* (pl. 5) for the depiction of a similar gesture.

7. Unidentified English correspondent to Governor Winthrop, 1637, quoted in Louisa Dresser, *Seventeenth-Century Painting in New England* (Worcester, Mass.: Worcester Art Museum, 1935), 21.

8. Karin Calvert, "Children in American Family Portraiture, 1670–1810," *William and Mary Quarterly* 39, no. 1 (January 1982): 87–113. Calvert writes, "[The Mason children's costumes] suggest a social system in which the sexes and classes were clearly differentiated but age groups were not." The distinctions drawn through costume became more varied and nuanced in the course of the eighteenth century.

9. J. Freake, *Agrippa's Occult Philos*, quoted in Abby Hansen, "Coral in Children's Portraits: A Charm against the Evil Eye," *Antiques* 120, no. 6 (December 1981): 1424.

10. David Mason lived from 1661 to 1724; Joanna, 1664 to before 1725; Abigail was baptized in 1666 and lived long enough to marry Captain Benjamin Gillman. It was not uncommon for artists to include the age of sitters in paintings. See, for example, John Smibert's *John Nelson* (see pl. 2).

11. Anne Bradstreet, "On my Dear Grand-Child Simon Bradstreet, who Dyed on 16. Novemb. 1669. Being But A Moneth, and One Day Old," in *The Complete Works of Anne Bradstreet*, ed. Joseph R. McElrath Jr. and Allen P. Robb (Boston: Twayne Publishers, 1981), 188.

12. Boys usually adopted adult clothing at about seven years old. Calvert, "Children in American Family Portraiture," 89.

13. John Dutton, quoted in Brayley, *Bakers and Baking*, 72.

14. Quoted in Martha Hutson, "An Interview with John D. Rockefeller 3rd," *American Art Review* 3, no. 4 (July–August 1976): 93–94.

15. Anders Greenspan, *Creating Colonial Williamsburg* (Washington, D.C.: Smithsonian Institution Press, 2002), 91, 98.

2. JOHN SMIBERT, *John Nelson*

1. This pattern of attribution may have begun with Henry Wilder Foote who was the first art historian to publish a full-length biography of Smibert. *John Smibert, Painter* (Cambridge, Mass.: Harvard University Press, 1950), 172.

2. William H. Whitmore, *Elements of Heraldry* (Boston: Lee and Shepard, 1866), 75.

3. William Armstrong Crozier, ed., *Crozier's General Armory: A Registry of American Families Entitled to Coat Armor* (New York: Fox, Duffield & Company, 1904), vi–vii.

4. Smibert painted at least one other portrait that included a coat of arms. *Sir John Rushout* (1726, Yale Center for British Art, Paul Mellon

Collection, New Haven) includes a small coat of arms wedged in the top left corner.

5. A Steenkirk is a long tie, often with fringed ends, which hangs down outside the coat. It became fashionable after the Battle of Steenkirk in 1692, during which French noblemen went into battle in such haste that they did not pause to knot their ties. In Boston in the 1730s older men still favored the style, while younger men preferred ruffles. Many of Smibert's older male sitters wear Steenkirk ties, and before the discovery of Smibert's notebooks, it was a useful aid in dating portraits.

6. Quoted in Foote, *John Smibert*, 103. Vertue, an associate of many London artists, kept notebooks for forty years documenting their activities. *Note Books*, 6 vols. (Oxford: Printed for the Walpole Society at the University Press, 1930–47).

7. The academy was run, at one point, by the acclaimed portraitist Sir Godfrey Kneller (1646–1723).

8. It is virtually impossible to determine with any reasonable precision what 40 guineas would be worth today. According to one scholar, forty guineas of British currency in 1732 would have the "purchase power" of 4,672.50 pounds sterling today, or about $8,700. John J. McCusker, "Comparing the Purchasing Power of Money in Great Britain from 1264 to Any Other Year Including the Present," Economic History Services, 2001, http://www.eh.net/hmit/ppowerbp/. However, as Ron Michener discusses in his online article "Money in the American Colonies," colonial currency was not equivalent to British currency, even though the denominations were similarly named; Michener, "Money in the American Colonies," EH.Net Encyclopedia, ed. Robert Whaples, 9 June 2003, http://www.eh.net/encyclopedia/contents/michener.american.colonies.money.php. To further complicate the equation, each colony established its own laws, coin ratings, and conventions and each issued its own currency. Therefore, Massachusetts guineas were not equivalent to those of Virginia, for instance. Monetary systems in the colonies were in constant and at times dramatic evolution.

9. Advertisement quoted in Foote, *John Smibert*, 86. Foote cites two entries in the account book of Andrew Belcher (Massachusetts Historical Society) for linseed oil and paints purchased from Smibert, which he used to paint warehouses and fences.

10. John Trumbull, *Autobiography: Reminiscences and Letters of John Trumbull, from 1756 to 1841* (New York: Wiley and Putnam, 1841), 49–50.

11. In a letter now in the collection of the Newport Historical Society dated Boston, 22 September 1735, Smibert lists a number of items that he is shipping to a Rhode Island man named Sueton Grant and their value, among them "the coat of arms 3-0-0, a gold frame for ditto 3-10-0, a glass for ditto 0-10-0." Letter reproduced in Richard H. Saunders, *John Smibert: Colonial America's First Portrait Painter* (New Haven: Yale University Press, 1995), 256.

12. Charles Knowles Bolton, *The Founders: Portraits of Persons Born Abroad Who Came to the Colonies in North America before the Year 1701* (Boston: Boston Athenaeum, 1919), 3:797–798.

13. Despite the assertions of art historians, the coat of arms in Nelson's portrait bears a greater resemblance to the arms of a branch of the Nelson family than it does to a branch of the Temple family. Anonymous notes and research, object file, AAD/DEY/FAMSF.

14. Henry Wilder Foote, *Annals of King's Chapel: From the Puritan Age of New England to the Present Day* (Boston: Little, Brown & Co., 1882), 1:180–181. A slightly different version of this story is given in Bolton, *Founders*, 3:797–798.

3. DE PEYSTER PAINTER, *Maria Maytilda Winkler*

1. Mary Maytilda Winkler's life dates are not known. However, her parents were married 21 May 1719 on Curaçao. Her husband, Nicholas Gouverneur (1713–1786/87), seems to have married his second wife, Sara Cryer, in 1755.

2. My thanks to Dr. John L. Strother of the University of California, Berkeley, for his expertise in identifying—or in this case, not identifying—flowers. Scholars have attempted to identify eighteenth-century artists and to attribute specific paintings to them, but with little certain success. See James Thomas Flexner, *American Painting: First Flowers of Our Wilderness* (Boston: Houghton Mifflin Company, 1947), 69–76, and "Pieter Vanderlyn, Come Home," *Antiques* 75 (June 1959): 546–549, 580; also Mary Black, "Contributions toward a History of Early Eighteenth-Century New York Portraiture: Identification of the Aetatis Suae and Wendell Limners," *American Art Journal* 12, no. 4 (Autumn 1980): 5–6. For the time being, similarities in style and handling serve to group portraits together that seem to be the work of the same artist. In the case of *Maria Maytilda Winkler*, that artist has been dubbed "the De Peyster Painter."

3. Mary Black has attributed the portrait of Jacomina to Gerardus Duyckinck, but that attribution is not universally accepted.

4. Russell Shorto, *The Island at the Center of the World: The Epic Story of Dutch Manhattan and the Forgotten Colony That Shaped America* (New York: Doubleday, 2004), 304.

4. ROBERT FEKE, *Mrs. Charles Apthorp*

1. They had eighteen children in all; three had predeceased their father.

2. The three columns of numbers represent pounds, shillings, and pence. Twelve pence made up a shilling, twenty shillings, a pound.

3. Assuming the value given on the list is divided equally among the six paintings, each would be worth about five pounds eight shillings five pence, while the tables are listed at five pounds four shillings for all three.

4. John Nelson paid John Smibert forty guineas for a smaller portrait in 1732, and John Singleton Copley charged twenty guineas for a fifty-by-forty-inch portrait in New York in 1771. However, see John Smibert's *John Nelson* (cat. 2 n. 8), which discusses the variations in colonial currency.

5. The exception being prints after portraits of particularly revered leaders and ministers. As suggested by the value given to the three glazed pictures in the Apthorps' parlor, however, those prints were not expensive items.

6. The paintings of Charles and Grizzell *mère* by Feke are signed and dated 1748; the portrait of Grizzell *fils* is generally assigned the same date by scholars. Blackburn's painting of Susan Apthorp is signed and dated 1757. *Charles Apthorp* by Robert Feke is in the collection of the Cleveland Museum of Art; *Mrs. Barlow Trecothick (Grizzell Apthorp Trecothick)* is in the collection of the Wichita Art Museum; Joseph Blackburn's portraits of Charles and Grizzell Eastwick Apthorp are in a private collection; and his portrait *Susan Apthorp (Mrs. Thomas Bulfinch)* is in the collection of the Museum of Fine Arts, Boston.

7. Square portraits are unusual at this time, and this one is unique in Feke's known oeuvre. Perhaps its shape was designed to fit on a particular wall or to hang above a specific piece of furniture or fireplace.

8. Ralph Peter Mooz, referring to the work of Waldron Phoenix Belknap, has stated that the mezzotint source for Feke's portrait of Mrs. Apthorp is a print of Catherine of Braganza from 1705 ("The Art of Robert Feke" [Ph.D. diss., University of Pennsylvania, 1970]). However, the

significant differences between the two images (Catherine of Braganza has a small dog on her lap and dabbles one hand in a fountain; most significantly, her body is oriented in the opposite direction) suggests that there is another source for the Feke portrait. The print of Catherine of Braganza is actually more similar to Blackburn's portrait of Mrs. Apthorp. The younger Grizzell's portrait is based on a 1735 mezzotint by A. Van Haecken after J. Van Haecken of Catherine Clive, and Charles Apthorp's portrait by Feke is based in part on a mezzotint by John Smith from 1693 after Sir Godfrey Kneller's portrait of Charles Montagu. Waldron Phoenix Belknap, *American Colonial Painting: Materials for a History* (Cambridge, Mass.: Belknap Press of Harvard University Press, 1959), 297, 284. Belknap does not mention Feke's portrait of Mrs. Apthorp.

9. Henry Wilder Foote, *Robert Feke: Colonial Portrait Painter* (Cambridge, Mass.: Harvard University Press, 1930), 17.

10. Among the items in his home, for instance, was a large mahogany and oak chest with mirrored doors, made in London ca. 1740–50. Now in the collection of the Museum of Fine Arts, Boston, it originally stood either in Apthorp's "great Parlour" or a "Dining Room up Stairs." The inventory lists a mahogany bureau valued at thirty-two pounds in the former, and a mahogany chest valued at thirty pounds in the latter.

11. Henry Wilder Foote, *Annals of King's Chapel: From the Puritan Age of New England to the Present Day*, 2 vols. (Boston: Little, Brown & Co., 1896), 2:146.

12. Kevin J. Hayes, *A Colonial Woman's Bookshelf* (Knoxville: University of Tennessee Press, 1996), 37–38, 72.

13. John Milton, *Paradise Lost*, ed. Merritt Y. Hughes (New York: Odyssey Press, 1962), 227, lines 896–916, quoted in Marc Simpson, "Robert Feke," in Simpson, Sally Mills, and Jennifer Saville, *The American Canvas: Paintings from the Collection of The Fine Arts Museums of San Francisco* (New York: Hudson Hills Press, in association with The Fine Arts Museums of San Francisco, 1989), 26.

14. Grizzell married Barlow Trecothick, her father's business partner, on 2 March 1747, and Susan married Thomas Bulfinch (their son was the architect Charles Bulfinch) on either 13 September 1759 (Foote, *Annals*, 2:368) or 8 October 1754 (ibid., 2:143). Mrs. Apthorp's obituary, quoted in ibid., 2:147.

5. JOHN SINGLETON COPLEY, *Mrs. Daniel Sargent*

1. Quoted in William Dunlap, *A History of the Rise and Progress of the Arts of Design in the United States*, 2nd ed., 3 vols. (Boston: C. W. Goodspeed & Co., 1918), 1:143–144.

2. P. Rameau, *The Dancing Master*, trans. Cyril W. Beaumont from the original edition published in Paris, 1725 (London: C. W. Beaumont, 1931), 1.

3. Ibid., 2, 31.

4. Kellom Tomlinson, *The Art of Dancing* (London, 1735), 3, as quoted in Alicia M. Annas, "The Elegant Art of Movement," in *An Elegant Art: Fashion and Fantasy in the Eighteenth Century* (New York: Harry N. Abrams, in association with the Los Angeles County Museum of Art, 1983), 40.

5. One eighteenth-century British commentator remarked, "Few unmarried women appear abroad in robes or sacques; and as few married ones would be thought genteel in anything else." Frances Seymour, duchess of Somerset, quoted in Margaretta M. Lovell, "Mrs. Sargent, Mr. Copley, and the Empirical Eye," *Winterthur Portfolio* 33, no. 1 (Spring 1998): 11.

6. The circumstances surrounding this offering of advice are discussed in more detail in John Singleton Copley, *William Vassall and His Son Leonard* (pl. 6).

7. West to Copley, 4 August 1766, *Letters and Papers of John Singleton Copley and Henry Pelham, 1739–1776*, ed. Guernsey Jones (Boston: Massachusetts Historical Society, 1914), 44–45.

8. Copley to Captain R. G. Bruce, 17 January 1768, in ibid., 70.

9. One professional model complained that Copley "would make her sit a longer time than she could well bear . . . she had resolved not to go to him any more"; quoted in Lovell, "Mrs. Sargent," 37. In Copley's defense, unlike his British colleagues, he did not have the benefit of subcontractors who could paint background landscapes or drapery for him while he attended to the faces and hands of his sitters, although his younger half brother, Henry Pelham, may have served as a studio assistant at times. Some of the delay in delivering portraits may have been due to the press of other projects.

10. C. R. Leslie, quoted in Dunlap, *A History*, 144.

11. He painted eleven members of the extended Sargent family, for instance. Jules Prown, *John Singleton Copley in America, 1738–1774* (Cambridge, Mass.: Harvard University Press, 1966), 190.

12. Copley to Henry Pelham, 6 November 1771, in *Letters and Papers*, 174.

13. Lovell, "Mrs. Sargent," 34–36. For a discussion of the political valences of fabric during the Revolution, see Isabel Breskin, "'On the Periphery of a Greater World': John Singleton Copley's *Turquerie* Portraits," *Winterthur Portfolio* 36, nos. 2–3 (Summer/Autumn 2001): 97–123.

14. For instance, at roughly the same time that he was painting these three portraits, Copley also painted *Mrs. John Amory (Katherine Greene)*, 1763, Museum of Fine Arts, Boston; *Mrs. Daniel Hubbard (Mary Greene)*, 1764, The Art Institute of Chicago; and *Mrs. John Murray (Lucretia Chandler)*, 1763, Worcester Art Museum. These portraits are all based on a mezzotint by John Faber Jr. after a portrait by Thomas Hudson of the Right Honorable Mary Viscountess Andover, 1746. The women adopt the same pose and wear virtually identical dresses. For a full discussion, see Lovell, "Mrs. Sargent," 21–29.

15. Mrs. Warren wears ten pounds' worth of lace in a portrait that cost less than ten pounds. Ibid., 34.

16. Ibid., 32–34. Lovell discusses in detail the connections between these women and their families.

17. Sally Mills, "John Singleton Copley," in Marc Simpson, Mills, and Jennifer Saville, *The American Canvas: Paintings from the Collection of The Fine Arts Museums of San Francisco* (New York: Hudson Hills Press, in association with The Fine Arts Museums of San Francisco, 1989), 34; Lovell, "Mrs. Sargent," 7.

6. JOHN SINGLETON COPLEY, *William Vassall and His Son Leonard*

1. Captain R. G. Bruce to Copley, 4 August 1766, in *Letters and Papers of John Singleton Copley and Henry Pelham, 1739–1776*, ed. Guernsey Jones (Boston: Massachusetts Historical Society, 1914), 42.

2. West to Copley, 4 August 1766, in ibid., 44–45.

3. Copley to West, 12 November 1766, in ibid., 50–52. Copley did send a single-figure painting in 1767, *Young Lady with Bird and Dog* (Toledo Museum of Art). It was not well received.

4. Sally Mills, "John Singleton Copley," in Marc Simpson, Mills, and Jennifer Saville, *The American Canvas: Paintings from the Collection of The Fine Arts Museums of San Francisco* (New York: Hudson Hills Press,

in association with The Fine Arts Museums of San Francisco, 1989), 34. Leonard bears a strong resemblance to Henry Pelham in Copley's *Boy with a Squirrel*; perhaps Copley's arduous posing schedule was too much for a young boy, and the artist had to resort to a model of another youth—his painting of his half brother—to complete the portrait.

5. Carrie Rebora, "William Vassall and His Son Leonard," in Rebora et al., *John Singleton Copley in America* (New York: The Metropolitan Museum of Art, 1995), 282. Copley used a similar pose for his portraits of Thomas Boylston II (1767, Harvard University Portrait Collection) and Ezekial Goldthwaite (1770–71, Museum of Fine Arts, Boston), but in both the right side of the canvas is empty.

6. Quoted in Clifford K. Shipton, *Biographical Sketches of Those Who Attended Harvard College in the Classes 1731–1735 with Bibliographical and Other Notes* (Boston: Massachusetts Historical Society, 1956), 356.

7. Rebora suggests that Vassall turned to Copley to improve his standing in an increasingly hostile community and had his son included as the primary means to do so; "William Vassall," 283.

8. Jules Prown provides illuminating statistics on the political inclinations of Copley's subjects. Copley painted more Tories early in his career (72% of his sitters in the period 1753–61). While Whigs were in the majority in 1762–64 and 1768–70 (56%), the latter period was particularly high in radical Whigs. "Copley's Tory sitters, often identified with the ruling establishment, were more consistently on a level of political or social prominence that seems to have called for portraiture. Whigs seem to have been painted as and when they came in prominence. . . . " Jules Prown, *John Singleton Copley in America, 1738–1774* (Cambridge, Mass.: Harvard University Press, 1966), 13.

9. Rebora, "William Vassall," 282.

10. Leonard was the fifteenth of Vassall's sixteen children, few of whom survived to adulthood. Leonard, however, lived to be ninety-six.

11. Jay Fliegelman, *Prodigals and Pilgrims: The American Revolution against Patriarchal Authority, 1750–1800* (Cambridge: Cambridge University Press, 1982), 3.

12. Mills, "John Singleton Copley," 34. Portraits of other fathers and sons during this period also show a Lockean sensibility. See, for instance, Matthew Pratt, *Cadwallader Colden and His Grandson Warren DeLancey* (ca. 1772, The Metropolitan Museum of Art, New York).

13. Copley to West, 24 November 1770, in *Letters and Papers*, 98.

7. CHARLES WILLSON PEALE, *Mordecai Gist*

1. Sir Joshua Reynolds, "Discourses on Art" (1771), in *Nineteenth-Century Theories of Art*, ed. Joshua C. Taylor (Berkeley and Los Angeles: University of California Press, 1987), 22.

2. In addition to being a painter, Peale was a saddler, watchmaker, silversmith, sculptor, portrait miniaturist, and engraver. William Dunlap, *A History of the Rise and Progress of the Arts of Design in the United States*, 2nd ed., 3 vols. (1834; reprint, Boston: C. E. Goodspeed & Co., 1918), 1:158.

3. E. P. Richardson, *American Art: A Narrative and Critical Catalogue* (San Francisco: The Fine Arts Museums of San Francisco, 1976), 42.

4. The standard explanation is that he was frustrated by the whistling that accompanied his speech after losing his teeth and set out to find a solution.

5. William Wilson, *Los Angeles Times Book of California Museums* (New York: Harry N. Abrams, 1984), 65.

6. This dynasty was the subject of a major exhibition: *The Peale Family: Creation of a Legacy, 1770–1870*, ed. Lillian B. Miller (New York: Abbeville Press, in association with the Trust for Museum Exhibitions and the National Portrait Gallery, Smithsonian Institution, 1997).

7. The two artists were confused because of their similar "directness of vision and homeliness of mood." They are usually now distinguished by pointing to Peale's "delicacy of color and simple, unaffected grace." James Thomas Flexner, "250 Years of Painting in Maryland," *Magazine of Art* 38 (December 1945): 292.

8. A good discussion of the training Peale received at the Royal Academy is in Miller, *The Peale Family*, 42.

9. This was in contrast to French portraiture of the period, which "characteristically conveyed a sense of the physical presence of a particular individual, resulting in greater potential for psychological penetration than the English tradition provided." Lois Marie Fink, *American Art at the Nineteenth-Century Paris Salons* (Cambridge, U.K.: Cambridge University Press; Washington, D.C.: National Museum of American Art, Smithsonian Institution, 1990), 10. Sir Joshua Reynolds was elected president of the Royal Academy in 1768.

10. Information on Mordecai Gist comes primarily from Katherine Walton Blakeslee, *Mordecai Gist and His American Progenitors* (Baltimore: Daughters of the American Revolution, 1923). See also G. Johnston, "Gist Family of Baltimore County," *Maryland Historical Magazine* 8 (1913): 380; and *Dictionary of American Biography*, ed. Allen Johnson and Dumas Malone, rev. ed. (New York: Charles Scribner's Sons, 1960), 4:324–325.

11. That Gist was considered handsome and cut a dashing figure is evident in a journal entry from a young Quaker girl, who wrote: "He's very pretty, a charming person; his eyes are exceptional; and he so rolls them about that mine always fall under them." Quoted in Caspar Wistar, ed., "Journal of Miss Sally Wister," *Pennsylvania Magazine of History and Biography* 9 (1885): 95.

12. Reynolds delivered a series of fifteen discourses from January 1769 to December 1790, which were published individually after their presentation. The first edition of the collected *Discourses on Art* was published in 1797.

13. Reynolds, "Discourses on Art" (1771), in Taylor, *Nineteenth-Century Theories of Art*, 13.

14. Jules Prown, in memo on visit of 12 February 1985, Charles Willson Peale *Modecai Gist* object file, AAD/DEY/FAMSF.

15. The similarity of Peale's portrait of Gist as a merchant captain to Reynolds's of Admiral Kingsmill as a military aristocrat is pointed up by an 1837 copy of the former by Luther Terry (Maryland Historical Society, Baltimore). In painting a military tribute to Gist, Terry reproduces Peale's composition, merely changing the costume into that of a Revolutionary solider and replacing the divider with a scabbard.

16. He moved to Philadelphia in 1776 after making a name for himself with five family portraits for John Cadwalader, one of Philadelphia's most prosperous merchants. Painted between 1770 and 1772, they were commissioned for Cadwalader's newly acquired house on Second Street near Pine Street, one of the city's grandest and most fashionable residences. All five portraits are in the collection of the Philadelphia Museum of Art.

17. For a discussion of the Washington portrait, which was copied many times, and Peale's "Gallery of Great Men," see Edgar P. Richardson,

Brooke Hindle, and Lillian B. Miller, *Charles Willson Peale and His World* (New York: Harry N. Abrams, 1983), 58–67.

18. For a discussion of Peale's Philadelphia Museum and his educational principles, as well as the class and racial assumptions on which his enterprise depended, see David R. Brigham, *Public Culture in the Early Republic: Peale's Museum and Its Audience* (Washington, D.C.: Smithsonian Institution Press, 1995).

19. Ellen Sacco, "Racial Theory, Museum Practice: The Colored World of Charles Willson Peale," *Museum Anthropology* 20, no. 2 (1996): 1–8.

20. Sally Mills has established that the other portrait, not this one as previously supposed, is the pendant to the portrait of Gist's first wife, Elizabeth McCluer, from whom he had been recently widowed. For a summary of Mills's research notes, see Marc Simpson, Mills, and Jennifer Saville, *American Canvas: Paintings from the Collection of The Fine Arts Museums of San Francisco* (New York: Hudson Hills Press, in association with The Fine Arts Museums of San Francisco, 1989), 38. The portrait of Elizabeth McCluer, who died in 1769, is in the collection of the Milwaukee Art Museum. The other portrait of Gist is in a private collection. He was remarried in 1778 to Mary Sterrett.

21. He was commissioned second major in 1776, and promoted to colonel in 1777 and brigadier-general in 1779.

22. The other was the Delaware Regiment.

8. CHARLES WILLSON PEALE, *Self-Portrait*

1. *The Selected Papers of Charles Willson Peale and His Family*, vol. 5, *The Autobiography of Charles Willson Peale*, ed. Lillian B. Miller and Sidney Hart (New Haven: Yale University Press, 2000), 15. Peale wrote his autobiography in the third person.

2. Ibid., 21.

3. Peale painted this self-portrait in 1808; it is unlocated. Charles Willson Peale to Rembrandt Peale, 26 June 1808, quoted in Charles Coleman Sellers, *Portraits and Miniatures by Charles Willson Peale* (Philadelphia: American Philosophical Society, 1952), 160.

4. Peale's grandson said he saw Peale painting enlarged replicas of other small paintings made during the Revolution. Ibid., 159.

5. Angelica was named after the Swiss painter Angelica Kauffman (1741–1807). We cannot grant Peale special prescience in his choice of names, however, as he named many of his children after famous painters.

6. The autobiography gave Peale the opportunity to reflect on his life and to impart his accumulated wisdom to younger generations. It also, like the portraits, gave him the chance to shape his public image, emphasizing events that he considered particularly important. David C. Ward, "Celebration of Self: The Portrait of Charles Willson Peale and Rembrandt Peale, 1822–27," *American Art* 7, no. 1 (Winter 1993): 10. Ward and the editors of Peale's autobiography remark that he does not engage in the level of self-creation that Benjamin Franklin does in his autobiography. Both remark, however, that Peale was, in the words of the Peale editors, "not above making events serve his purposes," and Ward notes that "it doubtless occurred to him that an autobiography would allow him to fashion and control the image he presented to the public and to ultimately shape memory." Ward, 10, and Peale, *Autobiography*, xxii.

7. Sellers, *Portraits*, 158.

8. She was a favorite among Peale's children (he had seventeen chil-

dren by his three wives, eleven of whom survived to adulthood), and family legend has it that she alone was able to influence Peale in omitting events from his autobiography that might cause offense or distress. Peale, *Autobiography*, xxii.

9. The last recorded location of the painting was the collection of Lester Hoadly Sellers, Radnor, Pa. Ibid., 160.

10. Peter Hastings Falk, ed., *The Annual Exhibition Record of the Pennsylvania Academy of the Fine Arts, 1807–1870* (Madison, Conn.: Soundview Press, 1988), 163.

11. Sellers, *Portraits*, 160.

12. Painted in 1823, the *Staircase Self-Portrait* is unlocated but probably was destroyed by fire while exhibited at P. T. Barnum's American Museum in New York City. Ibid., 162.

13. Peale, *Autobiography*, 327.

9. JOSEPH WRIGHT, *John Coats Browne*

1. Margaretta Lovell suggests that Wright's color choices in this portrait are evidence of "an active interest in color theory and curiosity about the action of color on the retina," in *American Painting, 1730–1960: A Selection from the Collection of Mr. and Mrs. John D. Rockefeller 3rd* (Tokyo: National Museum of Western Art, in association with the Fine Arts Museums of San Francisco, 1982), 13. Contrarily, Monroe H. Fabian, *Joseph Wright, American Artist, 1756–1793* (Washington, D.C.: Smithsonian Institution Press, 1985), 79, states that the daring use of color in the portrait of Browne is unique in Wright's oeuvre.

2. For Patience Wright's biography, see Charles Coleman Sellers, *Patience Wright: American Artist and Spy in George III's London* (Middletown, Conn.: Weslyan University Press, 1976).

3. Fabian, *Joseph Wright*, provides a complete catalogue of Wright's oeuvre including the many versions of his portraits of Franklin and Washington.

4. For a description of schoolboys' attire, see Edward Warwick, Henry C. Pitz, and Alexander Wyckoff, *Early American Dress: The Colonial and Revolutionary Periods* (New York: Benjamin Blom, 1965), 252. Wright painted other schoolboys in almost identical costume—white shirt with wide, open collar, a long jacket, and a vest and breeches in matching color. See, for example, his posthumous portrait *Marcus Camillus Knox* (1791, State of Maine Bureau of Parks and Recreation). Further confirming his identification as a student, Knox is shown holding an open book, and two other volumes are on the table in front of him.

5. For Browne's biography, see Frank Willing Leach, "Old Philadelphia Families, 148: Browne," *North American* (Philadelphia), 2 February 1913.

6. Both John Hayes, *Gainsborough: Paintings and Drawings* (New York: Phaidon, 1975), 215, and Jonathon Norton Leonard, *The World of Gainsborough, 1727–1788* (New York: Time Life Books, 1969), 83, discuss the Van Dyck derivation of *Blue Boy* posture; Leonard mentions the Villiers brothers specifically.

7. Fabian, *Joseph Wright*, 114, proposes this as the explanation of how Wright knew Gainsborough's painting. In an interesting note, Wright's fellow Royal Academy student, friend, and eventual brother-in-law John Hoppner acquired *Blue Boy* in 1802 for 65 guineas. Perhaps the two young students visited the Buttall home together and both were moved and impressed by the portrait.

8. Wright's mother modeled West in wax and West later wrote a letter of recommendation for Wright to M. Pierre, a professor at the French Royal Academy in Paris. Dorinda Evans, *Benjamin West and His American Students* (Washington, D.C.: Smithsonian Institution Press, 1980), 51.

10. BENJAMIN WEST, *Genius Calling Forth the Fine Arts to Adorn Manufactures and Commerce*

1. Raphael Lamar West and Benjamin West, *Letter from the Sons of Benjamin West, Deceased, Late President of the Royal Academy of London, Offering to Sell to the Government of the United States Sundry Paintings of That Artist*, doc. 8, 19th Congress, 2nd session (Washington, D.C.: Printed by Gales & Seaton, 1826), 3–4.

2. Lists of works executed by West for George III, drawn up at the king's request, do not entirely agree with the description in the *Windsor Guide*. Even though the information in those lists may have been provided by West himself, they were compiled many years after the works' completion and therefore are less likely to be accurate than the contemporary guide. See Helmut von Erffa and Allen Staley, *The Paintings of Benjamin West* (New Haven: Yale University Press, 1986), 410–411.

3. These four scenes are *Husbandry Aided by Arts and Commerce* (1789, Mint Museum of Art, Charlotte, N.C.), *Manufactory Giving Support to Industry* (ca. 1789–91, The Cleveland Museum of Art), *The Four Quarters of the Globe Bringing Treasures to Britannia* (ca. 1787–91, location unknown), and *Marine and Inland Navigation Enriching Britannia* (ca. 1788–89, Davis Museum and Cultural Center, Wellesley College).

4. Helmut von Erffa, "Benjamin West at the Height of His Career," *American Art Journal* 1, no. 1 (Spring 1969): 20–21.

5. Description of iconography drawn from von Erffa and Staley, *The Paintings of Benjamin West*, 410, and from Jennifer Saville, "Benjamin West," in Marc Simpson, Sally Mills, and Saville, *The American Canvas: Paintings from the Collection of The Fine Arts Museums of San Francisco* (New York: Hudson Hills Press, in association with The Fine Arts Museums of San Francisco, 1989), 36.

6. Robert Huish, *Public and Private Life of His late Excellent and most Gracious Majesty, George the Third, Embracing its Most Memorable Incidents, as They were Displayed in the Important Relation of Son, Husband, Father, Friend, and Sovereign* (London: Thomas Kelly, 1821), 480.

7. From "Account of Pictures painted by Benjamin West for His Majesty, by his Gracious Commands, from 1768 to 1780. A True Copy from Mr. West's Account Books, with their several Charges and Dates," reproduced in John Dillenberger, *Benjamin West: The Context of His Life's Work with Particular Attention to Paintings with Religious Subject Matter* (San Antonio, Tex.: Trinity University Press, 1977), 134.

8. *Genius Calling Forth the Fine Arts to Adorn Manufactures and Commerce* and *Husbandry Aided by Arts and Commerce* were exhibited in 1790; *Manufactory Giving Support to Industry* and *The Four Quarters of the Globe Bringing Treasures to Britannia* in 1791. *Marine and Inland Navigation Enriching Britannia* is the only one of the five main scenes that West did not exhibit at the Royal Academy. He did make an oil painting that appears unfinished. Von Erffa and Staley (*The Paintings of Benjamin West*, 413) hypothesize that West was dissatisfied with the design, which would explain why he neither finished nor exhibited it. With its enthroned central figure and symmetrical flanking figures, it would have made an imposing central panel for the ceiling, and, indeed, some descriptions of the ceiling program do place it at the center. Queen Charlotte disliked the ceiling. She had it removed shortly after it was installed while King George was incapacitated by illness (he ordered it reinstalled when he recovered). Perhaps she objected to another woman, albeit an allegorical one, so prominently depicted on a throne. If that was the case, West may have decided later not to display the painting publicly out of deference to royal feelings and to preserve his good standing at court.

11. JOSHUA JOHNSON, *Letitia Grace McCurdy*

1. J. Hall Pleasants, "Joshua Johnston, the First American Negro Portrait Painter," *Maryland Historical Magazine* 38 (June 1942): 121. Confusion has always surrounded the spelling of Johnson's name. In 1987 Carolyn J. Weekley argued for spelling it without a *t*, since that was more common in period sources. See Weekley, "Who Was Joshua Johnson?" in Weekley and Stiles Tuttle Colwill, with Leroy Graham and Mary Ellen Hayward, *Joshua Johnson: Freeman and Early American Portrait Painter* (Baltimore: Maryland Historical Society in association with The Abby Aldrich Rockefeller Folk Art Center, Colonial Williamsburg, 1987), 42. Even in the manumission records, Johnson is spelled both ways, but "Johnson" has become the preferred spelling.

2. Johnson's manumission record is included in the earliest of three volumes of Baltimore County Court chattel records, which were donated to the Maryland Historical Society in July 1994 by M. Peter Moser. See Jennifer Bryan and Robert Torchia, "The Mysterious Portraitist: Joshua Johnson," *Archives of American Art Journal* 36 (1996): 2–7.

3. See Pleasants, "Joshua Johnson." Pleasants has been discussed in every subsequent study on Johnson. See especially Weekley and Colwill, *Joshua Johnson*.

4. For a thoughtful discussion of the controversy surrounding Johnson's racial identity, see Romare Bearden and Harry Henderson, "The Late Eighteenth and Early Nineteenth Centuries: The Question of Joshua Johnston," in Bearden and Henderson, *A History of African-American Artists from 1792 to the Present* (New York: Pantheon Books, 1993), 3–17.

5. Weekley, "Who Was Joshua Johnson?" 47–49.

6. Bryan and Torchia, "Mysterious Portraitist," 3.

7. "Portrait Painting," *Baltimore Intelligencer*, 19 December 1798.

8. Pleasants was the first to note a stylistic similarity between Johnson and the Peales. See esp. Weekley, "Who Was Joshua Johnson?" 39–51. For a thoughtful discussion of the possibility of a connection between Johnson and the Peale family—and especially Charles Peale Polk—see Lynda Roscoe Hartigan, "Joshua Johnson," in *Sharing Traditions: Five Black Artists in Nineteenth-Century America* (Washington, D.C.: Smithsonian Institution Press, for the National Museum of American Art, 1985), 39–50.

9. Weekley, "Who Was Joshua Johnson?" 49–51.

10. On Polk, see Linda Crocker Simmons, *Charles Peale Polk (1767–1822): A Limner and His Likenesses* (Washington, D.C.: Corcoran Gallery of Art, 1982).

11. Johnson's manumission record has been microfilmed by the Archives of American Art. See Bryan and Torchia, "Mysterious Portraitist," for a discussion of its contents.

12. See http://www.askart.com/auctionrecords (accessed November 2004).

13. Hartigan discusses Johnson's patrons, "Joshua Johnson," 42. See Weekley, "Who Was Joshua Johnson?" 13, for discussion of the number of children's portraits attributed to Johnson.

14. Pleasants, "Joshua Johnston," 140–141.

15. See Weekley and Colwill, *Joshua Johnson*, 107–110, 136, cats. 10, 41.

16. For a discussion of French influence on American fashion of this period, see Clare Rose, *Children's Clothes since 1750* (New York: Drama Book Publishers, 1989), 38–39; and Aileen Ribeiro, *Fashion in the French Revolution* (London: B. T. Batsford, 1988), 118–119. For discussion of this specific dress style, see Katherine Morris Lester and Rose Netzorg Kerr, *Historic Costume*, 7th ed. (Peoria, Ill.: Chas. A. Bennett Co., 1977) 186–187; and Estelle Ansley Worrell, *Children's Costume in America, 1607–1910* (New York: Charles Scribner's Sons, 1980), 53.

17. Worrell, *Children's Costume in America*, 53.

18. For an overview of the history of the Pomeranian, see Lee Weston, "The Pomeranian: From Sled Dog to Fluff," http://www.barkbytes.com/history/pomran.htm (accessed November 2004). The royal family's influence on the popularity of dogs is discussed in James Breig, "The Eighteenth Century Goes to the Dogs," *Colonial Williamsburg Online Journal*, Autumn 2004. An ad for a missing Pomeranian that appeared in the *Virginia Gazette* in 1777, cited by Breig, suggests the breed's popularity in early America.

19. See Stanley Coren, *The Pawprints of History: Dogs and the Course of Human Events* (New York: Free Press, 2002); and Robert L. McGrath, *Canines and Felines: Dogs and Cats in American Art* (Sandwich, Mass.: Heritage Plantation of Sandwich, 1988), 6. For dogs in portraiture, see Catherine Wills, "Canines on Canvas," *Country Life*, 25 April 1991, 72–73.

20. Breig, "Eighteenth Century Goes to the Dogs."

21. Paul Staiti, "Character and Class," in Carrie Rebora, Staiti, et al., *John Singleton Copley in America* (New York: The Metropolitan Museum of Art, 1995), esp. 62–65, 76 n. 40.

22. For discussion of children's portraits in relation to changing conceptions of childhood in the eighteenth and nineteenth centuries, see Sandra Brant and Elissa Cullman, *Small Folk: A Celebration of Childhood in America* (New York: E. P. Dutton, in association with the Museum of American Folk Art, 1980); and Sara Holdsworth and Joan Crossley, *Innocence and Experience: Images of Children in British Art from 1600 to the Present* (Manchester, U.K.: Pale Green Press, in association with Manchester City Art Galleries, 1992).

12. JOHN VANDERLYN,
Caius Marius Amid the Ruins of Carthage

1. Quoted from Vanderlyn's Paris journal, in Kevin J. Avery and Peter L. Fodera, *John Vanderlyn's Panoramic View of the Palace and Gardens of Versailles* (New York: The Metropolitan Museum of Art, 1988), 33.

2. Kenneth C. Lindsay, *The Works of John Vanderlyn: From Tammany to the Capital* (Binghamton, N.Y.: University Art Gallery, State University of New York, 1970), 5.

3. His grandfather, a colonial American limner, never anglicized his name, continuing to use the even older Dutch Pieter Van de Lyn his entire life. See John D. Hatch, "What's in a Name?" (1988), MS in John Vanderlyn artist file, AAD/DEY/FAMSF.

4. This apprenticeship would surface years later when Vanderlyn used Stuart's famous portrait of George Washington as the model for his own portrait, which was commissioned for the Washington centennial in 1832.

5. Vanderlyn also benefited from William McClure's patronage from 1805 to 1807. Avery and Fodera, *John Vanderlyn's Panoramic View*, 12–13. In addition to his portraits of Aaron Burr (1802–3 and 1809), Vanderlyn painted many of the early republic's important politicians, including Roger Strong (1802–3), James Monroe (ca. 1816), James Madison (1816), Martin Van Buren (n.d.), Zachary Taylor (1850), and George Washington (1832–34), his most successful and well-known portrait, painted for the Washington centennial. The fullest discussion of Vanderlyn's portraits remains Lindsay, *The Works of John Vanderlyn*, 24–53.

6. For a fuller account of West's visit, see Lois Marie Fink, *American Art at the Nineteenth-Century Paris Salons* (Cambridge, U.K.: Cambridge University Press; Washington, D.C.: National Museum of American Art, Smithsonian Institution, 1990), 13–15.

7. Ibid., 14.

8. "When the Salon of 1800 opened under the calendar of the Republic on the fifteenth of Fructidore (September 5) in the year VIII, a twenty-five-year-old painter from Kingston, New York, John Vanderlyn, was entered as an exhibitor, becoming the first American artist to exhibit at a Salon." Ibid., 10.

9. There were three classes of gold medal. Vanderlyn was awarded the lowest class.

10. A letter from Vanderlyn recounts how a fox was startled out of its hiding place at the ruins of Roma Vecchia, which inspired the work's setting. William Kip, "Recollections of John Vanderlyn," *Atlantic Monthly* 19 (February 1867): 231.

11. A full account of Burr's bizarre life is available in the introduction to his papers, published in Mary-Jo Kline and Joanne W. Ryan, eds., *Political Correspondence and Papers of Aaron Burr*, 2 vols. (Princeton: Princeton University Press, 1982). For additional details concerning Burr's political triumphs and disappointments with a comparison to the rise and exile of Caius Marius, see William T. Oedel, "John Vanderlyn: French Neoclassicism and the Search for an American Art" (Ph.D. diss., University of Delaware, 1981), 301–305.

12. Although not completed until 1814, David began working on *Leonidas at Thermopylae* in 1800, making it more contemporaneous with Vanderlyn's painting than the later date suggests.

13. Napoleon was apparently uncomfortable with this painting, perceiving in David's subject too many possibilities for parallels between his own situation and that of Leonidas. Abigail Solomon-Godeau, *Male Trouble: A Crisis in Representation* (London: Thames and Hudson, 1997), 64.

14. Diana Strazdes, "John Vanderlyn," in Theodore E. Stebbins Jr., *The Lure of Italy: American Artists and the Italian Experience, 1760–1914* (Boston: Museum of Fine Arts; New York: Harry N. Abrams, 1992), 164.

15. In addition, both Vanderlyn's Marius and David's Leonidas display the late neoclassical image of uncompromisingly virile masculinity that nevertheless flirts with homoeroticism through the open display of desirable and passive male bodies, reflecting the instability of the gendered system on which their images rely. The bodies of both generals exhibit dual characteristics that establish a relation to gender and nation: they are forcefully active individuals whose strength is submissive to the needs of the state.

16. One of the earliest and most influential expressions of this argument was presented in a BBC television series that was later published as John Berger, *Ways of Seeing* (London: British Broadcasting Corporation; Middlesex: Penguin Books, 1972), 45–64.

17. *Ariadne* takes its inspiration from Vanderlyn's skillful copy of *Antiope* (1809) after Correggio's painting.

18. Lindsay, *The Works of John Vanderlyn*, xi.

19. Vanderlyn completed one final major history painting, *The Land-*

ing of Columbus (1839–46), which was commissioned by the U.S. Congress for a panel in the Capitol Rotunda. In it he avoided the display of the body that characterized his other three major history paintings.

20. Vanderlyn's restored *Panorama* went on permanent display in the new American Wing of the Metropolitan Museum of Art, New York, in 1980. It measures 165 feet in circumference and is twelve feet high. For an account of its restoration and conservation, see Avery and Fodera, *John Vanderlyn's Panoramic View*, 35–39.

21. Ibid., 25. Earlier in his career, Vanderlyn had attempted a more American subject through engravings of Niagara Falls, but this project also was a financial failure.

13. JOHN WESLEY JARVIS, *Philip Hone*

1. Many historians report that Jarvis was under the care of his uncle John Wesley, the founder of Methodism, during these early years. While the rich irony that a child who would become such a dissipated man lived under the roof of such a well-known preacher is hard to pass up, it appears that Wesley was actually Jarvis's great-great-uncle and that while his esteemed relative may have sent money, Jarvis lived with his mother. Harold E. Dickson, *John Wesley Jarvis: American Painter, 1780–1840* (New York: The New-York Historical Society, 1949), 5.

2. Quoted in Theodore Bolton and George C. Groce Jr., "John Wesley Jarvis: An Account of His Life and the First Catalogue of His Work," *Art Quarterly* 1, no. 4 (Autumn 1938): 304.

3. Henry T. Tuckerman, *Book of the Artists: American Artist Life Comprising Biographical and Critical Sketches of American Artists* (New York: G. P. Putnam & Son, 1867; New York: James F. Carr, 1967), 59.

4. In 1814 Jarvis took over a commission from the Corporation of the City of New York that Gilbert Stuart (1755–1828) had begun but abandoned. Jarvis apparently completed the likenesses of Captain Isaac Hill and Commodore William Bainbridge that Stuart had left unfinished and then painted four other full-length portraits. There is no documentary proof that Jarvis completed Stuart's canvases rather than beginning afresh, but William H. Gerdts makes a convincing argument for such a course of events in "Natural Aristocrats in a Democracy: 1810–1870," in Michael Quick, Marvin Sadik, and Gerdts, *American Portraiture in the Grand Manner: 1720–1920* (Los Angeles: Los Angeles County Museum of Art, 1981), 39–40.

5. The notice read in part, "Believing many persons are prevented from having Likenesses from not knowing where to apply, or at what price they can have them done, I make this statement of the several manners, prices, and sizes, in which I paint them." Quoted in Dickson, *John Wesley Jarvis*, 131.

6. Gerdts, "Natural Aristocrats," 38.

7. William Dunlap, *A History of the Rise and Progress of the Arts of Design in the United States*, rev. ed., 3 vols. (Boston: C. E. Goodspeed & Co., 1918), 219.

8. *The Diary of Philip Hone: 1828–1851*, ed. Allan Nevins, 2 vols. (New York: Dodd, Mead and Company, 1927), 2:92.

9. The story, from John James Audubon's "An Original Artist," in *An Ornithological Biography*, is sometimes quoted as purely factual. As Dickson, *John Wesley Jarvis*, 238, reports, however, "Audubon was not one to restrict his fancies when effective results might be obtained through fictional embellishments of the truth. His own journal effectively refutes the ac-

count in 'The Original Painter' of his first meeting with [Jarvis]." He adds, "[The story] is an altogether delightful, if humorously overdrawn, sketch of Jarvis."

10. John W. Francis, *Old New York,: or, Reminiscences of the Past Sixty Years* (New York: W. J. Widdleton, 1865), 297.

11. Ibid., 294–295.

12. *Dictionary of American Biography*, ed. Dumas Malone (New York: Charles Scribner's Sons, 1932), 192.

13. Gerdts, "Natural Aristocrats," 39.

14. Quoted in Dell Upton, "Inventing the Metropolis: Civilization and Urbanity in Antebellum New York," in *Art and the Empire City: New York, 1825–1861*, ed. Catherine Hoover Voorsanger and John K. Howat (New Haven: Yale University Press, 2000), 3 and 4.

14. ROBERT SALMON, *British Merchantman in the River Mersey off Liverpool*

1. Correspondence and comment sheets, object file, AAD/DEY/FAMSF.

2. Notes from a 7 May 1986 visit to FAMSF by Karl Kortum, Curator, National Maritime Museum, San Francisco; letter from D. J. Lyon, 20 May 1986, Head of Naval Ordnance, Department of Ships & Antiquities, National Maritime Museum, London; letter from A. S. Davidson, 20 June 1986, Hon. Curator of Marine Paintings, Merseyside Maritime Museum. All in object file.

3. John Wilmerding, *Robert Salmon: Painter of Ship and Shore* (Salem, Mass.: Peabody Museum; Boston: Boston Public Library, 1971), 61, 62.

4. Lyon and Davidson letters.

5. Salmon kept a numbered record of his output. Unfortunately, early in his career (which is when he painted *British Merchantman*) he simply recorded the number of paintings he produced in each year. Later he added more detail to his lengthening list, noting how long he spent on each painting, to whom he sold it, where, and for how much. The list is reproduced in Wilmerding, *Robert Salmon*.

6. Ibid., 10.

7. Ibid., 40. Salmon noted in his painting record that some of his paintings had been traded to a sailmaker and others to a boatbuilder. In "Janewerey 1831" he noted that his paintings nos. 703 and 704 were given to Mr. Perkins "in pay for a boat." Ibid., 92.

8. John Wilmerding, *A History of American Marine Painting* (Boston: Little, Brown & Co.; Salem, Mass.: Peabody Museum of Salem, 1968), 137.

9. All information about Liverpool is from correspondence with Davidson. The painting is signed and dated at lower right "R. S. 1809."

10. A. S. Davidson, *Marine Art and Liverpool: Painters, Places and Flag Codes, 1760–1960* (Albrighton, Wolverhampton: Waine Research Publications, 1986), 35.

11. Margaretta Lovell, in *American Painting 1730–1960: A Selection from the Collection of Mr. and Mrs. John D. Rockefeller 3rd* (Tokyo: National Museum of Western Art, in association with the The Fine Arts Museums of San Francisco, 1982), 18.

12. Henry Hitching, report to the Bostonian Society in 1894, quoted in Wilmerding, *Robert Salmon*, 10.

15. THOMAS BIRCH, *The Narrows, New York Bay*

1. Rev. Abel C. Thomas, "Obituary of Artists: Sketch of Thomas Birch," *Phildelphia Art Union Reporter* 1, no. 1 (January 1851): 22.

2. John Wilmerding, *A History of American Marine Painting* (Boston: Little, Brown & Co.; Salem, Mass.: Peabody Museum, 1968), 113. Wilmerding describes this pattern of areas of dark and light occurring in Birch's work of the late 1820s and 1830s, although it is clearly in evidence in this earlier painting.

3. Correspondence with Steven Miller, Senior Curator, Museum of the City of New York, 12 September 1986, and Barnet Shepherd, Executive Director, Staten Island Historical Society, 18 August 1989, object file, AAD/DEY/FAMSF. The tall structure on the right looks more like a lighthouse than a steeple, which would lend support to the theory that the island it stands on is Staten Island, not Manhattan.

4. Sally Mills, "Thomas Birch," in Marc Simpson, Mills, and Jennifer Saville, *The American Canvas: Paintings from the Collection of The Fine Arts Museums of San Francisco* (New York: Hudson Hills Press, in association with The Fine Arts Museums of San Francisco, 1989), 60.

5. Unnamed critic quoted in Thomas, "Obituary," 23.

6. They were *Engagement between the Constitution and Guerriere, Engagement between the Wasp and the Frolic, Engagement between the Constitution and Java, Engagement between the Frigates United States and Macedonian,* and *Engagement between the Hornet and Peacock.*

16. RAPHAELLE PEALE, *Blackberries*

1. For further discussion of the museum and Raphaelle's involvement with it, see Linda Bantel, "Raphaelle Peale in Philadelphia," in Nicolai Cikovsky Jr., *Raphaelle Peale Still Lifes* (Washington, D.C.: National Gallery of Art, 1988), 16–18. Phoebe Lloyd and Gordon Bendersky have suggested that Raphaelle's work as a taxidermist was the cause of his chronic illness and untimely death. Others have attributed his demise to alcoholism and gout. See Lloyd and Bendersky, "Arsenic, an Old Case: The Chronic Heavy Metal Poisoning of Raphaelle Peale," *Perspectives in Biology and Medicine* 36 (Summer 1993): 654–665.

2. The names of Peale's children are a favorite bit of Peale family lore first recorded by the art historian William Dunlap in 1834 and frequently reported by later scholars. Raphaelle, the first child of Rachel and Charles Willson Peale to survive infancy, was also the first to be named after a famous artist. Peale's teacher, Benjamin West, had also named a son Raphaelle. Later children were named Rembrandt, Rubens, Titian, and Angelica Kauffman. See Nicolai Cikovsky Jr., "Democratic Illusions," *Raphaelle Peale Still Lifes*, 31.

3. Ibid., 33–34.

4. Quoted in William H. Gerdts, *Painters of the Humble Truth: Masterpieces of American Still Life, 1801–1939* (Columbia: University of Missouri Press, 1981), 51. The *Port Folio* review is quoted at length in Bantel, "Raphaelle Peale in Philadelphia," 24–25.

5. David C. Ward and Sidney Hart, "Subversion and Illusion in the Life and Art of Raphaelle Peale," *American Art* 8 (Summer/Fall 1994): 107.

6. Raphaelle's paintings of fruit, vegetables, and other foods seem to have been popular with collectors, yet he struggled financially throughout his career. *Blackberries* was owned by Charles Graff of Philadelphia, who, at the time of his estate auction in 1856, owned five of the artist's "fruit pieces." For further discussion of Raphaelle's patrons and the Philadelphia art market, see Cikovsky, "Democratic Illusions," 65.

7. For a comprehensive discussion of Dutch and Flemish still lifes in Philadelphia at the turn of the nineteenth century, see Carol Eaton Soltis, "Rembrandt Peale's *Rubens Peale with a Geranium*: A Possible Source in David Teniers the Younger," *American Art Journal* 33 (2002): 8. I am grateful to Tim Burgard for bringing this article to my attention.

8. William H. Gerdts, in particular, has discussed the work of Sánchez Cotán in relation to Raphaelle's fruit and vegetable still lifes. See "On the Tabletop: Europe and America," *Art in America* 60 (September–October 1972): 62–69; and *Painters of the Humble Truth,* 56–57.

9. For discussion of James Peale and the similarities and differences between his still lifes and those of Raphaelle, see Gerdts, *Painters of the Humble Truth,* 61–64.

10. Bantel, "Raphaelle Peale in Philadelphia," 13–14. For further information about the museum, see David R. Brigham, *Public Culture in the Early Republic: Peale's Museum and Its Audience* (Washington, D.C.: Smithsonian Institution Press, 1995).

11. However, Raphaelle's paintings of fruit, despite their intricacy, do not approach the level of detail expected of botanical drawings and could not, for example, be used to identify the specific variety of fruit pictured. In a review of the catalogue for the exhibition *The Peale Family: Creation of a Legacy,* Phoebe Lloyd asserts that the fruit in *Blackberries* is *Mysore Ras (Rubus niveus),* a berry found in India that may have been housed in William Hamilton's renowned Philadelphia greenhouse. Phoebe Lloyd, "Essay Exhibit and Book Review," *Pennsylvania History* 64 (Summer 1997): 429. In a letter to Patricia Junker, former Associate Curator of American Art at the de Young Museum, Thomas F. Daniel, Curator of the Department of Botany at the California Academy of Sciences, refutes Lloyd's identification of the berry and further states, "Many of the morphological characters used to classify species of *Rubus* [the genus that includes raspberries and blackberries] are not evident in the painting." Letter from Daniel to Junker, 12 March 1997, Raphaelle Peale *Blackberries* object file, AAD/DEY/FAMSF.

12. Blackberries typically flower for a three-month period, which means that both flowers and more or less ripe fruit can be found on the plant at the same time. Berries of various degrees of ripeness appearing on the same branch therefore may not be extraordinary, yet this feature is unusual to find represented in a still-life painting. Gunther Liebster, *The Macmillan Book of Berry Gardening* (New York: Collins Macmillan, 1986), 74. In 1815 Peale completed a picture entitled *Peaches and Unripe Grapes* (private collection); he seems to have had an interest in depicting fruit at various stages of ripeness and maturity rather than exclusively selecting subjects that were ready for the table.

13. Gordon Dunthorne, *Flower and Fruit Prints of the Eighteenth and Early Nineteenth Centuries: Their History, Makers, and Uses, with a Catalogue Raisonné of the Works in Which They Are Found* (New York: Da Capo Press, 1970), 52. Dunthorne's catalogue raisonné indicates that botanical illustrations of blackberries were extremely rare in this period; he identifies two (pp. 214 and 223). In contrast, he notes thirteen illustrations of raspberries and fifteen of strawberries.

14. For a comprehensive nineteenth-century discussion of blackberries, see L. H. Bailey, *Sketch of the Evolution of Our Native Fruits* (1898; 3rd ed., New York: The Macmillan Co., 1911), 298–329. Bailey quotes Card at length; this passage appears on 299.

15. Thomas Budd includes blackberries on his list of "Fruits that grow naturall" in his *A True Account of the Country . . . Pennsilvania and New*

Jersey; in which there was Good Order Established (1685), quoted in Ann Leighton, *American Gardens of the Eighteenth Century: "For Use or for Delight"* (Boston: Houghton Mifflin Co., 1976), 46. In 1785 blackberries were mentioned in Humphrey Marshall's *Arbustrum Americanum: The American Grove* as a "wild fruit"; quoted in H. Frederic Janson, *Pomona's Harvest: An Illustrated Chronicle of Antiquarian Fruit Literature* (Portland, Ore.: Timber Press, 1996), 191. For discussion of the blackberry in the nineteenth century, see Bailey, *Evolution of Our Native Fruits*, 301–304.

16. The author consulted both editions of M'Mahon's *American Gardener's Calendar, Adapted to the Climates and Seasons of the United States* on microfiche. For discussion of M'Mahon, see Joel T. Fry, "An International Catalogue of North American Trees and Shrubs: The Bartram Broadside, 1783," *Journal of Garden History* 16 (Spring 1996): 56.

17. Bailey, *Evolution of Our Native Fruits*, 303.

18. Most recently, the vitality of Peale's still lifes—and *Blackberries*, in particular—has been noted by Alexander Nemerov in *The Body of Raphaelle Peale: Still Life and Selfhood, 1812–1824* (Berkeley and Los Angeles: University of California Press, 2001). Nemerov writes: "The objects in *Blackberries* are very lively—too lively. They give credence to Lillian B. Miller's contention that Raphaelle 'could endow inanimate objects with an animation occasionally missing from his life portraits' "; 15–16.

19. This advertisement is reproduced in Cikovsky, *Raphaelle Peale Still Lifes*, 65.

20. Charles Coleman Sellers, *Raphaelle Peale* (Milwaukee, Wis.: Milwaukee Art Center, 1959), 7.

21. Quoted in Bantel, "Peale in Philadelphia," 16.

17. GILBERT STUART, *William Rufus Gray*

1. Quoted in James Thomas Flexner, *America's Old Masters*, rev. ed. (Garden City, N.Y.: Doubleday & Co., 1980), 301.

2. Quoted in ibid., 270.

3. Quoted in ibid., 268.

4. Ibid., 271.

5. Benjamin West's comment was reported in a letter from William Temple Franklin to Benjamin Franklin, 9 November 1784, quoted in Eleanor Pearson DeLorme, "Gilbert Stuart: Portrait of an Artist," *Winterthur Portfolio* 14, no. 4 (Winter 1979): 51.

6. Flexner, *Old Masters*, 302, describes Stuart's working method.

7. Biographical information comes from *Dictionary of American Biography*, ed. Allen Johnson and Dumas Malone (New York: Charles Scribner's Sons, 1935), 4:523–524.

8. S., "The Old Masters as Portraits Painters, and the Modern.—Copley and Stuart.—Staigg's Portrait of General Stevenson," *Dwight's Journal of Music* 24, no. 21 (7 January 1865): 371.

9. Quoted in Henry T. Tuckerman, *Book of the Artists: American Artist Life Comprising Biographical and Critical Sketches of American Artists* (1867; New York: James F. Carr, 1967), 111.

10. George Walter Chamberlain, *History of Weymouth, Massachusetts, in Four Volumes*, vol. 3 (Weymouth, Mass.: Weymouth Historical Society, 1923), unpaginated, on website www.usigs.org/library/books/ma/Weymouth1923. Joshua Bates entered "the counting house of William Rufus Gray" in 1805 when he was fifteen and Gray was twenty. His son was born on 11 July 1815.

18. THOMAS COLE, *View near the Village of Catskill*

1. Cole's patron Philip Hone wrote, "I think every American is bound to prove his love of country by admiring Cole"; *The Diary of Philip Hone*, ed. Allan Nevins, 2 vols. (New York: Library Editions, 1970), 1:92–93. Ironically, the English-born Cole did not take legal steps to become a U.S. citizen until 1834. See Ellwood C. Parry III, *The Art of Thomas Cole: Ambition and Imagination* (Newark: University of Delaware Press; London and Toronto: Associated University Presses, 1988), 26.

2. For Cole's early years in the United States, see Louis Legrand Noble, *The Life and Works of Thomas Cole*, ed. Elliot S. Vesell (Cambridge, Mass.: The Belknap Press of Harvard University Press, 1964), 3–31.

3. Parry, *Art of Thomas Cole*, 23.

4. Ibid., 24–26.

5. George Washington Greene, *Biographical Studies* (New York: G. P. Putnam, 1860), 92.

6. Alf Evers, *The Catskills: From Wilderness to Woodstock* (Woodstock, N.Y.: The Overlook Press, 1972), 318–325.

7. Kenneth Myers, *The Catskills: Painters, Writers, and Tourists in the Mountains, 1820–1895* (Yonkers, N.Y.: The Hudson River Museum of Westchester, 1987), 34–35. See also ibid., 359–360.

8. Myers, *The Catskills*, 31–32.

9. Ibid., 36–38.

10. Ibid., 38.

11. Cole's Catskill Mountain images were preceded by two of the twenty engravings published in William Guy Wall's *Hudson River Portfolio* (1821–25), which provided pictorial proof of the region's spectacular scenery. Myers, *The Catskills*, 188–190.

12. Bruce W. Chambers, *American Paintings V* (New York: Berry-Hill Galleries, 1988), 14. The companion piece to this painting was *Falls of the Katterskill* (1827), reproduced in Myers, *The Catskills*, 47.

13. Myers, *The Catskills*, 49. Cole's Catskill paintings may have served as pictorial surrogates for their real-life counterparts, which the artist believed possessed restorative powers, especially for the urban viewer seeking to escape the city's turmoil: "He who looks on nature with a 'loving eye,' cannot move from his dwelling without the salutation of beauty; even in the city the deep blue sky and the drifting clouds appeal to him. And if to escape its turmoil—if only to obtain a free horizon, land and water in the play of light and shadow yields delight—let him be transported to those favored regions, where the features of the earth are more varied, or yet add the sunset, that wreath of glory daily bound around the world, and he, indeed, drinks from pleasure's cup. The delight such a man experiences is not merely sensual, or selfish, that passes with the occasion leaving no trace behind; but in gazing upon the pure creations of the Almighty, he feels a calm religious tone steal through his mind, and when he has turned to mingle with his fellow men, the chords which have been struck in that sweet communion cease not to vibrate." Thomas Cole, "Essay on American Scenery," *The American Monthly Magazine* 7 (January 1836): 1–12.

14. Alan Wallach lists nine other versions of this subject: *Sunset in the Catskills* (1831, Museum of Fine Arts, Boston); *Sunset View on Catskill Creek* (1833, New-York Historical Society); *View on the Catskill Creek, N.Y.* (1834, New-York Historical Society); *View on the Catskill—Early Autumn* (1837, The Metropolitan Museum of Art); *North Mountain and Catskill Creek* (1838, Yale University Art Gallery); *River in the Catskills* (1843, Museum of Fine Arts, Boston); *Catskill Creek, New York* (1845, New-York Historical Society); *Distant View of Round Top* (n.d., Albany Institute of

History and Art); and *Catskill Scene* (n.d., private collection). Wallach, "Thomas Cole's River in the Catskills as Antipastoral," *Art Bulletin* 84, no. 2 (June 2002): 334, 348 n. 2.

15. Parry, *Art of Thomas Cole*, 374; and Howard S. Merritt, *Thomas Cole* (Rochester, N.Y.: Memorial Art Gallery of the University of Rochester, 1969), 23.

16. During his European trip of 1829–32, Cole wrote, "Claude, to me, is the greatest of all landscape painters, and indeed I should rank him with Raphael or Michel Angelo." Quoted in William Dunlap, *The History of the Rise and Progress of the Arts of Design in the United States*, 2 vols. (New York: George P. Scott, 1834), 2:365.

17. Cole continues, "These are circumstances productive of great variety and picturesqueness—green umbrageous masses—lofty and scathed trunks—contorted branches thrust athwart the sky—the mouldering dead below, shrouded in moss of every hue and texture, form richer combinations than can be found in the trimmed and planted grove. It is true that the thinned and cultivated wood offers less obstruction to the feet, and the trees throw out their branches more horizontally and are consequently more umbrageous when taken singly; but the true lover of the picturesque is seldom fatigued—and trees that grow widely apart are often heavy in form, and resemble each other too much for picturesqueness." Cole, "Essay," 9.

18. Quoted in Noble, *Life and Works*, 8.

19. Cole, "Essay," 6.

20. Ibid., 8. Cole also observed that "the Catskills, although not broken into abrupt angles like the most picturesque mountains of Italy, have varied, undulating, and exceedingly beautiful outlines—they heave from the valley of the Hudson like the subsiding billows of the ocean after a storm." Ibid., 5.

21. No signs are evident of the substantial industry already operating in the Catskills, including the tanning mills that cut down thousands of acres of hemlock trees and polluted streams and rivers. See Evers, *From Wilderness to Woodstock*, 326–350; and Myers, *The Catskills*, 39–40. The dead trees in Cole's *Lake with Dead Trees* (1825) may have been drowned by Silas Scribner's man-made dam, which powered the sawmill that provided the lumber for the Catskill Mountain House. Ibid., 41.

22. In contrast to Cole's *View near the Village of Catskill*, which emphasizes the beautiful and picturesque characteristics of the landscape below the Catskill Mountain House, William Cullen Bryant described the hotel and surrounding landscape in more sublime terms in *The American Landscape* (1830): "For my own part, however, I am not sure that it does not heighten the effect of the scene when viewed from below, to know, that on that little point, scarce visible from the heart of the mountain, the beautiful and the gay are met and the sounds of mirth and music arise, while for leagues around the mountain torrents are dashing, and the eagle is uttering his shriek, unheard by human ears." Quoted in Evers, *From Wilderness to Woodstock*, 379. In *Catskill, A Journal of the Grand and the Glorious* (1828), Grenville Mellen described himself and companions as "pilgrims," while Willis Gaylord Clark compared ascent with a pilgrimage, the Mountain House with the heavenly Jerusalem, and the hotel guest book with the heavenly book of the elect; Myers, *The Catskills*, 51.

23. Cole, "Essay," 6.

24. Describing America as a Garden of Eden, Cole admonished his contemporaries, "I will now conclude, in the hope that, though feebly urged, the importance of cultivating a taste for scenery will not be forgotten. Nature has spread for us a rich and delightful banquet. Shall we turn from it? We are still in Eden; the wall that shuts us out of the garden is our own ignorance and folly." Cole, "Essay," 12.

25. Ibid., 11–12. Compare Cole's comment that "the Rhine has its castled crags, its vine-clad hills, and ancient villages; the Hudson has its wooded mountains, its rugged precipices, its green undulating shores—a natural majesty, and an unbounded capacity for improvement by art. Its shores are not besprinkled with venerated ruins, or the palaces of princes; but there are flourishing towns, and neat villas, and the hand of taste has already been at work. Without any great stretch of the imagination we may anticipate the time when the ample waters shall reflect temple, and tower, and dome, in every variety of picturesqueness and magnificence." Ibid., 9.

19. THOMAS COLE, *Prometheus Bound*

1. Letter from Church to the artist's son, Theodore Cole, dated Mexico, 19 March 1859, quoted in Howard S. Merritt, *Thomas Cole* (Rochester, N.Y.: University of Rochester, 1969), 43.

2. Letter to Paul T. Sellers from John C. Bagley, legal advisor to the granddaughter of Thomas Cole, Florence H. Cole Vincent, who owned *Prometheus Bound* (1847) before its 1964 auction. Copy in Thomas Cole *Prometheus Bound* object file, AAD/DEY/FAMSF.

3. The tragedy is attributed to Aeschylus in the fifth century B.C. Additional texts include those by the Greek writers Hesiod, Apollodorus, Pausanias, and Plato, and the Roman writer Ovid.

4. For the various accounts of Prometheus, see *Bulfinch's Mythology* (New York: Avenel Books, 1979), 12–13, 16–18.

5. A facsimile copy of the statement exists in the Thomas Cole artist file, AAD/DEY/FAMSF.

6. A full discussion of the implications of *The Course of Empire* and Luman Reed's patronage is recounted in Alan Wallach, "Thomas Cole and the Aristocracy," in *Reading American Art*, ed. Marianne Doezema and Elizabeth Milroy (New Haven: Yale University Press, 1998), 79–108.

7. The original leg of the canal connecting Lake Erie to the Hudson River opened in 1825. Cole began recording his ideas for *The Course of Empire* in 1829. Timothy Anglin Burgard, "Thomas Cole: *The Course of Empire*, 1833–36," in Ella M. Foshay, *Mr. Luman Reed's Picture Gallery: A Pioneer Collection of American Art* (New York: Harry N. Abrams, in association with the New-York Historical Society, 1990), 130.

8. The relationship between Reed and Cole has been described as "a situation in which a self-made merchant paid a small fortune to a self-taught artist for paintings that elaborately mourn the passing of an aristocracy to which both merchant and artist aspired and to which neither could ever belong." Wallach, "Thomas Cole and the Aristocracy," 103.

9. Cited in William H. Treuttner and Alan Wallach, eds., *Thomas Cole: Landscape into History* (Washington, D.C.: National Museum of American Art, 1974), 73.

10. Alan Wallach has speculated that the ceremonies represent President Andrew Jackson in antique garb. This would be especially fitting since Jackson's populist demagoguery was seen by the Federalists as a dangerous threat to the political and moral order of the nation. Wallach, "Thomas Cole and the Aristocracy," 90.

11. This cyclical view of history drove Federalist ideology and policy. See ibid., 91–92.

12. For a discussion of Freemasonry in American culture and politics,

see Gordon S. Wood, *The Radicalism of the American Revolution* (New York: Alfred A. Knopf, 1992), 222–224.

13. Document in the Thomas Cole *Prometheus Bound* object file, AAD/DEY/FAMSF. William Gerdts argues that the visual associations with Christ's Crucifixion were meant to make the subject matter more acceptable, but the connections to Freemasonry would have been sufficient. See William H. Gerdts, *The Great American Nude: A History in Art* (New York: Praeger, 1974), 48.

14. Patricia Junker, "Thomas Cole's *Prometheus Bound*: An Allegory for the 1840s," *American Art Journal* 31, nos. 1–2 (2000): 37, 49–50.

15. Junker argues that Cole's Prometheus was his response to Hiram Powers's *The Greek Slave* (1846), which was touring internationally to great acclaim and even frenzy as a symbol of slavery in America. Ibid., 47–48.

16. Michael Kimmelman has written rather harshly, "*Prometheus Bound* resembles a lumpy sunbather on holiday in the Alps checking his tan." "Thomas Cole, Early American Pessimist," *New York Times*, 19 June 1994, A1.

17. Gerdts, *The Great American Nude*, 48.

18. Truettner and Wallach, *Thomas Cole*, 79.

19. Ibid.

20. For this definition and a full discussion of the impact of the sublime on American landscape painting, see the seminal study by Barbara Novak, *Nature and Culture: American Landscape and Painting, 1825–1875* (New York: Oxford University Press, 1980), 34–44.

21. Church, quoted in Merritt, *Thomas Cole*, 43.

22. This sense was clearly understood by Cole's contemporaries, as his biographer Louis Legrand Nobel attests in writing that the painting's light "bursts in through the spotless, awful space, and smites with fire the icy peaks." Louis Legrand Nobel, *The Life and Works of Thomas Cole*, ed. Elliot S. Vesell (Cambridge, Mass.: Belknap Press of Harvard University Press, 1964), 289.

23. The leading role of sublime landscape (as opposed to the figure) in Cole's work began with his 1827 works illustrating James Fenimore Cooper's *Last of the Mohicans*. Truettner and Wallach, *Thomas Cole*, 79.

20. GUSTAV GRUNEWALD, *Niagara Falls Diptych*

1. Thomas Moore, writing in 1853, quoted in Charles Mason Dow, *Anthology and Bibliography of Niagara Falls*, vol. 1 (Albany, N.Y.: State of New York, 1921), 131.

2. Angela Miller, *Landscape Representation and American Cultural Politics, 1825–1875* (Ithaca and London: Cornell University Press, 1993), 217.

3. Elizabeth McKinsey, "An American Icon," in Jeremy Elwell Adamson, *Niagara: Two Centuries of Changing Attitudes, 1697–1901* (Washington, D.C.: The Corcoran Gallery of Art, 1985), 87.

4. Ibid., 91–92.

5. The painters who have been identified as belonging to the Hudson River School did not band together in a school as such. Its admitted founder, Thomas Cole, only tutored a single student, Frederic Edwin Church. Critics gave the artists this designation retrospectively later in the century. David Bjelajac, *American Art: A Cultural History* (New York: Harry N. Abrams, 2001), 192.

6. The dating of the paintings ca. 1832 is suggested by the inclusion in the scene of a second enclosed staircase that was built on the Canadian side during the summer of 1832 and by the absence of the Terrapin Tower, which was constructed in 1833.

7. Andrew Wilton, "The Sublime in the Old World and the New," in *American Sublime: Landscape Painting in the United States, 1820–1880* (London: Tate Publishing, 2001), 11–12.

8. Edmund Burke, quoted in Malcolm Andrews, *Landscape and Western Art* (New York: Oxford University Press, 1999), 134.

9. Quoted in Dow, *Anthology and Bibliography of Niagara Falls*, 127.

10. The best-known painting of Niagara Falls is Church's *Niagara* (1857) in the collection of the Corcoran Gallery of Art. It is a monumental oil on canvas (42½ × 90½ in.) that stretches the falls along the edge of a dramatically elongated horizon and simultaneously suspends the viewer above the nearer precipice in the foreground. The painting was exhibited at the 1867 Exposition Universelle in Paris, where "it represented not only the most grandiose scene on the American continent but the triumph of a mature American art," placing the country and its culture on a level that rivaled those of Europe. See McKinsey, "An American Icon," 97. In 1808 John Trumbull used the panorama format to emphasize the spectator's experience of the horizon in two painted studies: *Niagara Falls from Two Miles below Chippawa* and *Niagara Falls from under Table Rock* (both oil on canvas, 29 × 168 in., New-York Historical Society). However, Trumbull was unable to find a business partner to finance full-scale versions of his panorama because the two works represented two different points of view and therefore could not be joined in the continuous circle necessary for an illusionistic scene. Adamson, *Niagara*, 33.

11. About the same time, 1832–33, Grunewald painted another, smaller diptych of Niagara Falls from the same vantage points but using a landscape format: the works measure 28 × 34¼ in. and 25¼ × 34¼ in. Peter Blume included this pair of paintings in his important retrospective of Grunewald. Blume, *Gustav Grunewald* (Allentown, Pa.: Allentown Art Museum, 1992), 10, 13.

12. Andrews, *Landscape and Western Art*, 147.

13. Previously John Davis Hatch attributed the paintings to John Vanderlyn in his paper "John Vanderlyn's Views of Niagara," presented at the symposium "American Paintings before 1900: New Perspectives," University of Delaware, 12 April 1985. However, Blume's discovery of a smaller pair of paintings in Hong Kong that are remarkably similar except for their horizontal orientation makes the attribution of Grunewald the more likely. Additionally, during a 2003 research trip to Allentown and Bethlehem, Pennsylvania, Tony Rockwell, Associate Conservator for the Fine Arts Museums of San Francisco, and the author examined a large percentage of Grunewald's paintings and sketches. The rendering of close values that characterizes Grunewald's oeuvre in general makes it nearly certain that the Niagara Falls diptych is the work of his hand. Also, the painterly vocabulary corresponds to that of his signed and dated painting *Niagara Falls* (fig. 20.1; 1834, Allentown Art Museum), evident in the treatment of sky and clouds, the tonalities of the water, the chevronlike treatment of the falls, and the sfumato of the billowing vapors. I would especially like to thank Christine I. Oaklander, Curator of Collections and Exhibitions at the Allentown Art Museum, Dave Leidich, Director of the Moravian College Museum, and Barbara Schafer, Curator of the Kemerer Museum, for their helpful and informative discussions and access to materials during this research visit. Relevant correspondence and notes from Hatch, Blume, Cornell, and Rockwell are located in the curatorial files, AAD/DEY/FAMSF.

14. Grunewald studied from 1820 to 1823 under Caspar David Friedrich at the Dresden Art Academy, where he absorbed the German romantic

school's radically subjective aesthetic so well suited to the language of the sublime. Blume, *Grunewald*, 2.

15. Ibid., 8. The FAMSF diptych is painted after the views in the 1832 sketches.

16. William C. Reichel, *A History of the Moravian Seminary for Young Ladies, at Bethlehem, Pennsylvania*, rev. 4th ed. (1858; Lancaster, Pa.: New Era Printing Company, 1901), 246.

17. Blume, *Grunewald*, 2.

18. In 1827 Captain Basil Hall wrote: "The scenery in the neighborhood of Niagara has, in itself, little or no interest, and has been rendered still less attractive by the erection of hotels, paper manufactories, saw-mills, and numerous other raw, staring, wooden edifices." In 1838 Mrs. A. B. M. Jameson wrote of the disfiguring "horrid red brick houses, and other unacceptable, unseasonable sights and signs of sordid industry." Both quoted in Dow, *Anthology and Bibliography of Niagara Falls*, 165, 217.

19. Reichel, *A History of the Moravian Seminary*, 229, 332.

21. JASPER FRANCIS CROPSEY, *View of Greenwood Lake, New Jersey*

1. Jasper Francis Cropsey, "Natural Art," speech delivered to the New-York Art Reunion, on 24 August 1845. Typescript in the Newington-Cropsey Foundation papers, Hastings-on-Hundson, N.Y., quoted in William Nathaniel Banks, "Ever Rest, Jasper Francis Cropsey's House in Hastings-on-Hudson, New York," *Antiques* 130 (November 1986): 1000.

2. *Knickerbocker Magazine* 23, no. 6 (June 1844): 596, quoted in William S. Talbot, "Jasper F. Cropsey, 1823–1900" (Ph.D. diss., New York University, 1972), 27.

3. "The Fine Arts," *Literary World* 1, no. 15 (15 May 1847): 348.

4. William S. Talbot, *Jasper F. Cropsey, 1823–1900* (Washington, D.C.: Smithsonian Institution, 1970), 15.

5. Ibid., 16.

6. "Fine Arts," 348.

7. From a review of an exhibition by Cropsey that appeared in the *Times of London*, quoted in Henry T. Tuckerman, *Book of the Artists: American Artist Life Comprising Biographical and Critical Sketches of American Artists* (New York: G. P. Putnam, 1867; New York: James F. Carr, 1967), 533.

8. Talbot, "Jasper F. Cropsey," 27.

9. Talbot, *Jasper F. Cropsey*, 69.

10. For a discussion of how the nineteenth century's geological debates were expressed in painting, see Barbara Novak, *Nature and Culture: American Landscape and Painting, 1825–1875* (New York: Oxford University Press, 1980), 49ff.

11. *Appleton's Illustrated Hand-Book of American Travel* (New York: D. Appleton & Co., 1857), 179.

22. EDWARD HICKS, *The Peaceable Kingdom*

1. The de Young's *Peaceable Kingdom* was given to a member of the Goose Creek Meeting, Daniel Janney, although it was not painted until the mid-1840s. Hicks and Janney may have remained in contact, or Hicks may have visited Goose Creek again at a later date. Patricia Junker, "Edward Hicks and His Peaceable Kingdom," *Triptych*, no. 70 (July–September 1994): 16.

2. Alice Ford, *Edward Hicks: Painter of the Peaceable Kingdom* (Philadelphia: University of Pennsylvania Press, 1952), 85.

3. David Tatham, "Edward Hicks, Elias Hicks, and John Comly: Perspectives on the Peaceable Kingdom Theme," *American Art Journal* 13, no. 2 (Spring 1981): 39.

4. Biographical information was drawn from many sources, including Ford, *Edward Hicks*; Junker, "His Peaceable Kingdom"; Tatham, "Perspectives"; and Scott W. Nolley and Carolyn J. Weekley, "The Nature of Edward Hicks's Painting," *Antiques* 155, no. 2 (February 1999). See also Carolyn J. Weekley, *The Kingdoms of Edward Hicks* (New York: Harry N. Abrams, 1999).

5. One of his products was "Hicks Alphabet Blocks" for children; Ford, *Edward Hicks*, 92.

6. Junker, "His Peaceable Kingdom," 15.

7. The frames of Hicks's *Peaceable Kingdoms* were embellished with several lines of verse from a poem he composed paraphrasing the Isaiah passage, exemplifying the Hicksite "unwillingness to treat the Scriptures as Holy Writ." Tatham, "Perspectives," 41–44.

8. Ibid., 41.

9. Ibid., 46.

10. Each wild animal represented one of the traditional humors of man: wolf = melancholic, leopard = sanguine, bear = phlegmatic, lion = choleric. Ford, *Edward Hicks*, 86.

11. Junker, "His Peaceable Kingdom," 17; Eleanore Price Mather et al., *Edward Hicks: His "Peaceable Kingdoms" and Other Paintings* (Newark: University of Delaware Press, 1983), 130. This figure began appearing in the *Peaceable Kingdoms* in the mid-1830s.

12. Eleanore Price Mather, introduction to *Edward Hicks: A Peaceable Season* (Princeton: The Pyne Press, 1973). See also Tatham, "Perspectives," 44.

13. In his *Memoirs* Hicks rarely mentions his paintings or even the fact that he is a painter; Tatham, "Perspectives," 40. In response to his inner turmoil and pressure from the community, Hicks left his painting business briefly in 1815; he returned the following year after an unsuccessful attempt at farming. Timothy Anglin Burgard, "The Kingdoms of Edward Hicks," *Fine Arts* 13 (Fall/Winter 2000): 5.

14. In addition to the *Peaceable Kingdoms*, Hicks painted landscape "portraits" of farms and popular historical subjects; he relied heavily on print sources for images such as the Signing of the Declaration of Independence (derived from John Trumbull), Washington Crossing the Delaware (derived from Thomas Sully), and, of course, Penn's Treaty with the Indians (derived from Benjamin West). Junker, "His Peaceable Kingdom," 16; Nolley and Weekley, "Nature," 283. Some of his *Peaceable Kingdoms* and history paintings include recognizable natural features, such as the Delaware Water Gap and Virginia's Natural Bridge, emphasizing the potential for God's kingdom in America. Mather, introduction to *A Peaceable Season*, 3.

15. Edward Hicks, *Memoirs of the Life and Religious Labors of Edward Hicks, Late of Newtown, Bucks County, Pennsylvania, Written by Himself* (Philadelphia: Merrihew & Thompson, 1851), 12. Hicks also wrote, "If the Christian world was in the real spirit of Christ, I do not believe there would be such a thing as a fine painter in Christendom. It appears clearly, to me, to be one of those trifling, insignificant arts, which has never been of any substantial advantage to mankind. . . . But there is something of importance in the example of the primitive Christians and primitive Quakers, to mind their callings or business, and work with their own hands at such business as they are capable of, avoiding idleness and fanaticism." Ibid., 71.

16. Quoted in Tatham, "Perspectives," 47–48. Years earlier, Comly had said that Hicks possessed a "genius and a taste for imitation, which, if the Divine law had not prohibited, might have rivalled Peale or West." John

Comly to Isaac Hicks, 12 August 1817, quoted in Junker, "His Peaceable Kingdom," 15.

17. Hicks's success was praised in a letter to the artist: "Your historical paintings are useful. They are like an open book from which all read and imbibe the right sort of national feeling." S. P. Lee to Edward Hicks, 25 June 1841, quoted in Ford, *Edward Hicks*, 91. Margaretta Lovell reckoned Hicks a history painter of sorts, for "His images are based on verbal texts, they contain visual quotations, they are intended to be read and interpreted, and they are intended to plead a case, to ameliorate the state of mankind." Lovell, *American Painting, 1730–1960: A Selection from the Collection of Mr. And Mrs. John D. Rockefeller 3rd* (Tokyo: National Museum of Western Art, in association with the Fine Arts Museums of San Francisco, 1982), 28. See also Tatham, "Perspectives," 48.

18. Tatham, "Perspectives," 37.

19. Junker, "His Peaceable Kingdom," 18. See also Tatham, "Perspectives," 39.

20. Hicks frequently gave his paintings away; when he sold them, it was for a very modest sum: "I send thee by my son one of the best paintings I ever done (and it may be my last). The price as agreed upon is twenty dollars, with the additional sum of one dollar 75 cents which I give Edward Trego for the fraim." Edward Hicks to Joseph Brey, 23 September 1844, quoted in Ford, *Edward Hicks*, 93. According to David Tatham, Hicks's "goal was to have no reputation as a fine artist"; Tatham, "Perspectives," 37.

23. GEORGE CALEB BINGHAM,
Boatmen on the Missouri

1. Amount cited in David E. Schob, "Woodhawks and Cordwood," *Journal of Forest History* 21, no. 3 (July 1977): 126. There were hundreds of steamboats on western rivers in the middle of the nineteenth century, making dozens of trips up- and downriver. Therefore, the total amount of fuelwood consumed was enormous. The historian Michael Williams has calculated that in 1840 alone some 863,353 cords of wood were sold in the counties that abutted the Mississippi and Ohio rivers and that most of this wood was used as fuelwood for steamboats; see Williams, "Products of the Forest: Mapping the Census of 1840," *Journal of Forest History* 24, no. 1 (January 1980): 9.

2. Williams, "Products of the Forest," 10.

3. A concise and comprehensive discussion of woodhawks and woodyards is Schob, "Woodhawks and Cordwood," 124–132. In 1849 Bingham painted a scene of a woodyard, now unlocated. However, a contemporary description of the painting does exist; see E. Maurice Bloch, *The Paintings of George Caleb Bingham: A Catalogue Raisonné* (Columbia: University of Missouri Press, 1986), 180–181.

4. Johann Georg Kohl, *Reisen im Nordwesten der Vereinigten Staaten* (New York, 1857), 176–177, translated and quoted in Schob, "Woodhawks and Cordwood," 131.

5. The amount of money spent on fuelwood was not insignificant. Williams estimates that steamboat companies spent $1.2 million on fuelwood in 1829. Although he does not include figures for later years, this amount increased as the number of steamboats operating on western rivers multiplied and larger steamboats were built. By the 1840s the average annual cost for fuel per steamboat was $12,594, a figure that represents 26.7% of the boat's annual operating costs; see Williams, "Products of the Forest," 9–10. The price of fuelwood varied according to the location, season, and quality. However, on the eve of the Civil War, it cost between $1.25 and $6.00 a cord; see Schob, "Woodhawks and Cordwood," 124.

6. Bingham later (1872) recalled: "The wonder and delight with which his [Harding's] works filled my mind infused them indelibly upon my then unburthened memory." Bingham to J. Colvin Randall, 25 December 1872, quoted in Bloch, *Paintings*, 9. Bingham did not become a painter immediately after Harding's visit to Franklin because Bingham's father died the next year and Bingham needed to work to help his destitute mother. In the following years Bingham apprenticed as a cabinetmaker, and it was not until he encountered another itinerant portrait painter sometime in the late 1820s that he decided to pursue a career as a portraitist; see ibid., 272.

7. In 1837 Bingham wrote his friend James S. Rollins: "There is no honourable sacrifice which I would not make to attain eminence in the art to which I have devoted myself. I am aware of the difficulties in my way, and am cheered by the thought that they are not greater [than] those which impeded the course of Harding and [Thomas] Sully, and many others, it is by combatting that we can overthrow them and by determined perseverance, I expect to be successful." Bingham to Rollins, 6 May 1837, quoted in ibid., 9–10. The "difficulties" Bingham refers to may be the fact that he was self-taught, as was Harding. He may also be acknowledging that he was embarking on a career as a painter far from the eastern art centers, where training, resources, and patrons were more plentiful.

8. Curiously, this trip stimulated Bingham to paint his first genre scene of life along a western river (unfortunately now lost), which he exhibited at the Apollo Gallery in New York, a forerunner of the American Art-Union; see ibid., 10. Perhaps it was only by going east that Bingham came to realize the suitability of western subjects for his more ambitious paintings.

9. The American Art-Union (AA-U) was formed to support American artists, educate ordinary citizens about the arts, and encourage patronage of American artists. To achieve these ends, the organization solicited yearly subscriptions from individuals living all over the country. These subscribers received an engraving and a chance to win an original work of art. The AA-U purchased paintings directly from American artists, which were exhibited in New York and then distributed to individual members by way of a lottery. Bingham's dealings with the AA-U are concisely and insightfully analyzed in ibid., 11–15.

10. See ibid., 176.

11. See *St. Louis Daily Missouri Republican*, 17 April 1849; and *Bulletin of the American Art-Union* 2, no. 6 (September 1849): 10.

12. Thomas Hamilton, *Men and Manners in America*, 2 vols. (Edinburgh, 1833), 2:187–188, quoted in Schob, "Woodhawks and Cordwood," 127; and Matilda Houstoun, *Hesperos: or, Travels in the West*, 2 vols. (London, 1850), 2:49, quoted in ibid., 129. Anthony Trollope was one traveler, and there were others, who did not find woodmen suspect; see ibid., 128–129.

13. The reputation of boatmen may have derived in large part from the legends of Mike Fink, a real boatman who was mythologized in humorous adventure tales published in the first half of the nineteenth century. For an account of the historical and folklorish aspect of Mike Fink, with a collection of Mike Fink stories, see *Half Horse Half Alligator: The Growth of the Mike Fink Legend*, ed. Walter Blair and Franklin J. Meine (Chicago: University of Chicago Press, 1956).

14. Bingham's preparatory drawings are discussed in E. Maurice Bloch, *The Drawings of George Caleb Bingham, with a Catalogue Raisonné* (Columbia: University of Missouri Press, 1975), 11–14. Nancy Rash has suggested the seated figure in *Boatmen on the Missouri* is based on the seated river god in Marcantonio Raimondi's engraving after Raphael's *Judgment*

of Paris. She also notes that the stooping figure in the center of Bingham's composition "recalls and reverses Michelangelo's digging Noah in the Sistine Ceiling"; see Rash, *The Paintings and Politics of George Caleb Bingham* (New Haven: Yale University Press, 1991), 82. Even though Bingham did not depict real woodmen, the men he did represent are dressed in the appropriate clothing. In her 1850 account of her travels in the West, Houstoun noted that woodmen generally dressed in "an old broad brimmed hat, with the crown half out, and boots of untanned leather, with the pantaloons tucked down inside of them." Houstoun, quoted in Schob, "Woodhawks and Cordwood," 129.

15. Steamboat captains also enticed able-bodied male passengers to assist in loading fuelwood by offering them reduced fares for passage; see ibid., 131–132.

16. On the myth of the West as a place of easy profits, see Patricia Nelson Limerick, *The Legacy of Conquest: The Unbroken Past of the American West* (New York: W. W. Norton, 1987), 97–133. The woodman disappeared after the Civil War, when steamboats converted to coal-burning boilers. The shift from wood to coal was motivated by the costliness and bulkiness of wood, but also by a growing concern over the depletion of timber sources; see Schob, "Woodhawks and Cordwood," 124. Mark Twain lamented the disappearance of the woodman in his *Life on the Mississippi* (1884): "He [the woodman] used to fringe the river all the way; his close-ranked merchandise stretched from the one city to the other, along the banks, and he sold uncountable cords of it every year for cash on the nail; but all the scattering boats that are left burn coal now, and the seldomest spectacle on the Mississippi to-day is a wood-pile. Where now is the once wood-yard man?" See Mark Twain, *Life on Mississippi* (1884; reprint, New York: Oxford University Press, 1996), 257.

24. GEORGE CALEB BINGHAM, *Country Politician*

1. The most thorough account of Bingham's political career and its relationship to his paintings is Nancy Rash, *The Paintings and Politics of George Caleb Bingham* (New Haven: Yale University Press, 1991).

2. On the artist's political banners, see E. Maurice Bloch, "Art in Politics," *Art in America* 33, no. 2 (April 1945): 93–100; Bloch, *The Paintings of George Caleb Bingham: A Catalogue Raisonné* (Columbia: University of Missouri Press, 1986), 159, 166–167.

3. For a comprehensive history of the Whig Party, see Michael F. Holt, *The Rise and Fall of the American Whig Party: Jacksonian Politics and the Onset of the Civil War* (New York: Oxford University Press, 1999).

4. According to one historian: "While residing temporarily in Natchez, Mississippi, he [Bingham] found his money tied up in a local bank by the Specie Circular. Bingham had been painting portraits in Natchez for $40 to $60 each and the checks received in payment became worthless when the local banks closed because of the demand for specie by the Federal Treasury." See Keith L. Bryant, "The Artist as Whig Politician," *Missouri Historical Review* 59 (October 1964–July 1965): 450. Bingham described Whigs as "freemen, and not like [Democrats] bound to model their thoughts to correspond with the wishes of a Master. We differ . . . but are a unit in opposition to the men who would dare deprive us of the *right* to do so and I trust we shall never fail to exercise this privilege for which we have been so long contending against the dictation of an unscrupulous party." Bingham to James S. Rollins, quoted in Barbara Groseclose, "Painting, Politics, and George Caleb Bingham," *American Art Journal*, November 1978, 7 n. 12.

5. Bingham continued to be active in politics in the 1850s and 1860s,

serving as Missouri state treasurer during the Civil War; see Rash, *Paintings and Politics*, 185–215.

6. Preparatory drawings for *Country Politician* are illustrated and discussed in E. Maurice Bloch, *The Drawings of George Caleb Bingham, with a Catalogue Raisonné* (Columbia: University of Missouri Press, 1975), 99–113. The artist reused some of these figures in his 1852 *Canvassing for the Vote* (The Nelson-Atkins Museum of Art, Kansas City, Mo.), suggesting that he may have employed his drawings as a kind of pattern book; see ibid., 14.

7. For a historiographic account of phrenology, see Roger Cooter, *The Cultural Meaning of Popular Science: Phrenology and the Organization of Consent in Nineteenth-Century Britain* (Cambridge: Cambridge University Press, 1984), 15–35. For a discussion of the relationship between phrenology and the legibility of the social order in the nineteenth century, see ibid., 107–133.

8. Bingham may have derived the composition of *Country Politician* from William Sidney Mount's 1837 *The Long Story* (The Corcoran Gallery of Art, Washington, D.C.), which he could have known through an engraving; see E. Maurice Bloch, "A Bingham Discovery," *American Art Review* 1, no. 1 (September–October 1973): 24.

9. The Mabie Circus performed throughout rural Missouri in the 1840s; ibid., 24–26.

10. *Daily St. Louis Missouri Republican*, 17 April 1849, 2-1, quoted in Bloch, *Paintings*. Bingham exhibited two other paintings in St. Louis, presently unlocated, but described by the reporter from the *Daily Missouri Republican*; see Bloch, *Paintings*, 180–181. Given the specificity with which the reporter described the painting, Rash has plausibly suggested that Bingham explained the subject to the reporter; see Rash, *Paintings and Politics*, 109.

11. A thorough discussion of the Wilmot Proviso is Chaplain W. Morrison, *Democratic Politics and Sectionalism: The Wilmot Proviso Controversy* (Chapel Hill: University of North Carolina Press, 1967). On the Wilmot Proviso and Bingham, see Rash, *Paintings and Politics*, 94–119.

12. For a concise account of the "Jackson Resolutions" and its aftermath, including a tally of votes for and against, see A. J. Conant et al., *Switzler's Illustrated History of Missouri, from 1541 to 1881* (St. Louis: C. R. Barns, 1881), 264–270. See also Rash, *Paintings and Politics*, 103–106.

13. Jackson Resolutions, quoted in Conant, *Switzler's Illustrated History*, 266.

14. Ibid., 269.

15. Rash, *Paintings and Politics*, 109.

16. Bloch, *Paintings*, 180. On the American Art-Union, see ibid., 11–15.

17. Mary Barlett Cowdrey, *American Academy of Fine Arts and American Art-Union Exhibition Record, 1816–1852* (New York: The New-York Historical Society, 1953), 22.

18. Alexis de Tocqueville, *Democracy in America*, abridged Sanford Kessler, trans. Stephen D. Grant (Indianapolis: Hackett Publishing, 2000), 99. Bingham undoubtedly intended *Country Politician* to have a broad national appeal because by this time in his career he was painting his genre subjects primarily with the American Art-Union in mind; any controversial political content would be reason for the Art-Union to decline his work.

19. In 1867 Henry Tuckerman acknowledged the popularity of Bingham's depiction of regional subjects when he wrote: "Such representations also of border life and history as Bingham made popular, though boasting no special grasp or refinement in execution, fostered a taste for

primitive scenes and subjects which accounts for the interest once excited in cities and still prevalent at [sic] the West in such pictures as 'The Jolly Flat-Boatman.'" See Henry T. Tuckerman, *Book of the Artist: American Artist Life, Comprising Biographical and Critical Sketches of American Artists: Preceded by an Historical Account of the Rise and Progress of Art* (New York: G. P. Putnam, 1867), 494. An insightful discussion of Bingham's regionalism is Angela Miller, "The Mechanisms of the Market and the Invention of Western Regionalism: The Example of George Caleb Bingham," *Oxford Art Journal* 15, no. 1 (1992): 3–20.

25. CHARLES CHRISTIAN NAHL, *Peter Quivey and the Mountain Lion*

1. For Nahl's biography, see Moreland L. Stevens, *Charles Christian Nahl: Artist of the Gold Rush, 1818–1878* (Sacramento, Calif.: E. B. Crocker Art Gallery, 1976).

2. Anthony Kirk, "'As Jolly as a Clam at High Water': The Rise of Art in Gold Rush California," *California History* 79, no. 2 (Summer 2000): 185.

3. Nahl and Wenderoth advertised as "daguerreotype artists," and Nahl developed a method for using glass photographic negatives to create clichés-verre that he called Nahlotypes. See Stevens, *Nahl*, 53, 61, 66–67.

4. Arthur Nahl to his uncle Wilhelm, 2 April 1858, San Francisco, Nahl Papers, The Bancroft Library, University of California, Berkeley, quoted in ibid., 51.

5. For Peter Quivey's biography, see Frederic Hall, *The History of San Jose and Surroundings with Biographical Sketches of Early Settlers* (San Francisco: A. L. Bancroft and Company, 1871), 141, 206, 375–376; Horace S. Foote, ed., *Pen Pictures from the Garden of the World; or, Santa Clara County California* (Chicago: The Lewis Publishing Company, 1888), 62, 71, 349–350; and *Northwest Missouri Genealogical Society Journal* 16, no. 1 (March 1996): 19–20.

6. "Notes of a Trip of the S.F.B.D. [San Francisco Board of Directors] Agricultural Visiting Committee," *Daily Alta California*, 14 August 1860, 1. In a letter to his parents, Nahl wrote, "Presently I am painting a settler with a dead lion which he had killed with his revolver (six-shooter type pistol). The lion measures from the tip of its tail to his snout 9 feet. The same man has so far killed five of these lions." Nahl to his parents, ca. 1856, Bancroft Library, University of California, Berkeley, MSS 68152c, translated from the German by Hermann Friedlander.

7. The Artist, "Photography," *Crayon* 1, no. 11 (14 March 1855): 170.

8. Rembrandt Peale, "Portraiture," *Crayon* 4, pt. 2 (February 1857): 44.

9. B. P. Avery, "Art Beginnings on the Pacific," pt. 1, *Overland Monthly*, o.s., 1 (July 1868): 32.

10. Nahl was an exceptional animalier, and exhibited Nahlotype prints of a "California Lion" and "Grizzly Bear" in 1858. See Stevens, *Nahl*, 61.

11. The identifications of the Bowie knife and the Colt revolver were confirmed by the arms and armor authority Greg Martin of San Francisco. Although San Francisco was renowned for its high-quality Bowie knives, the tapered clip-point on the blade makes it more likely that Quivey acquired his knife during his westward migration. These multipurpose knives typically were used for skinning, butchering, and self-protection. Martin notes that Quivey's .44 caliber Colt Model Dragoon revolver was the largest handgun available in 1857 and an appropriate choice for a professional hunter who might need to use it at close range. See Martin to the

author, 19 November 1998, Charles Christian Nahl *Peter Quivey and the Mountain Lion* object file, AAD/DEY/FAMSF.

12. Another possible precedent for Nahl's portrait of Peter Quivey is the San Francisco artist E. Hall Martin's now-lost painting (ca. 1850) of the gold-rush folk character known as Mountain Jack, who was depicted "loading his rifle, with his dog, panting on one side, and a dying antelope on the other." See Janice T. Driesbach and Harvey L. Jones, "First in the Field: Thomas A. Ayres and E. Hall Martin," in Driesbach, Jones, and Catharine Church Holland, *Art of the Gold Rush* (Oakland: Oakland Museum of California; Berkeley and Los Angeles: University of California Press, 1998), 14.

13. For William Smith Jewett's *The Promised Land—the Grayson Family* (1850) and its exhibition at the First Industrial Exhibition of the Mechanics Institute in 1857, see Janice T. Driesbach, "Portrait Painter to the Elite," in Driesbach, Jones, and Holland, *Art of the Gold Rush*, 38–39 and 44. For Quivey's westward travel with Andrew Jackson Grayson in 1846, see Foote, *Pen Pictures*, 349.

14. The same or a similar painting, entitled *The Hunter*, was exhibited at the 1856 California State Fair in San Jose and confirms that Nahl's subject could function both as a specific portrait and as a more generic genre scene. See Stevens, *Nahl*, 60. Although Nahl's *Peter Quivey and the Mountain Lion* is signed and dated "C. Nahl 1857," it may have been exhibited in an earlier state at the State Fair in San Jose, where Quivey lived.

26. GEORGE HENRY DURRIE, *Winter in the Country*

1. E. P. Richardson called Durrie "a modest, unaffected painter of New England landscapes and farm scenes [that] have become part of our folk memories of rural America." Accession notes, George Henry Durrie, *Winter in the Country* object file, AAD/DEY/FAMSF.

2. For a discussion of the development of winter landscape painting in America, see Martha Hutson, "The American Winter Landscape, 1830–1870," *American Art Review* 2, no. 1 (January–February 1975): 60–78.

3. The most thorough discussion of Durrie's life and work is Martha Young Hutson, *George Henry Durrie (1820–1863)* (Santa Barbara: Santa Barbara Museum of Art and American Review, 1977).

4. Mary Clarissa Durrie, "George Henry Durrie: Artist," *Antiques* 24, no. 1 (July 1933): 14.

5. The Hudson River School artists generally took the traditional view that the four seasons paralleled the four periods of a man's life. For artists seeking to depict the full majesty and grandeur of landscape, winter—associated with old age, passivity, and decline—had undesirable associations. There were also the practical difficulties of making sketches and studies outside in ice and snow. Hutson, "American Winter Landscape," 60, offers a full discussion of the Hudson River School painters' aversion to winter landscapes.

6. Advertisement reproduced in Hutson, *Durrie*, 90.

7. Durrie painted *Winter in the Country* during that year in New York. Marc Simpson argues that the extremely high level of detail in the painting is a result of Durrie's misguided effort to impress a sophisticated New York audience. Simpson, Sally Mills, and Jennifer Saville, *The American Canvas: Paintings from the Collection of The Fine Arts Museums of San Francisco* (New York: Hudson Hills Press, in association with The Fine Arts Museums of San Francisco, 1989), 94.

8. Hutson, *Durrie*, 166.

9. Quoted in Roger B. Stein, "After the War: Constructing a Rural Past," in *Picturing Old New England: Image and Memory*, ed. William H. Truettner and Stein (Washington, D.C.: National Museum of American Art, Smithsonian Institution, 1999), 17. By 1867 *Snow-Bound* had sold 28,000 copies.

10. Hutson, *Durrie*, 27.

11. Ibid., 49.

27. JAMES BARD, *The Steamship "Syracuse"*

1. *Gibbons v. Ogden*. Aaron Ogden claimed that he had a license from the New York legislature for exclusive right to navigate state waters by steamboat. He wanted to block Thomas Gibbons from running steam passenger service between New York and New Jersey. State courts ruled in his favor, but the Supreme Court overturned the decision, saying that Congress had the right to regulate commerce between the states and that the New York monopoly was not in the national interest.

2. For biographical details about the Bard brothers, as well as information about patrons and techniques, see A. J. Peluso Jr., *J. & J. Bard: Picture Painters* (New York: Hudson River Press, 1977).

3. "James Bard Obituary," *Seaboard Magazine*, 1 April 1897, quoted in ibid., 85.

4. Peluso provides a list of extant works by the Bards and a list of "Sightings of Bard Work." Ibid., 112–129.

5. "James Bard Obituary," quoted in ibid., 86. Bard depicted the *Robert L. Stevens* (1835, Mariners Museum, Newport News, Va.) in winter.

6. Ibid. Given the high level of detail in Bard's paintings, it might seem possible that he worked from ships' plans. Peluso doubts this, however. The cross sections and cutaways would have been of little use to Bard, and the plans themselves would have been too important to give away. In addition, there are anecdotes of Bard measuring the actual ships.

7. Bard's technique is described by Harold Sniffen and Alexander Brown, "James and John Bard, Painters of Steamboat Portraits," *Art in America* 37, no. 2 (April 1949): 51–66.

8. Peluso, *J. & J. Bard*, 88.

9. In *The Steamship "Syracuse"* the raised areas include the spray at the boat's bow and side wheel, the gold tops to the flagpoles and masts, the two gold birds perched on and near the wheelhouse, the stair railings, and the walking beam.

10. *Nautical Gazette*, 16 September 1871, quoted in Peluso, *J. & J. Bard*, 133 n. 65.

11. This practice sometimes results in multiple paintings of the same vessel. There are, for instance, five known paintings of the *Syracuse*.

12. Peluso, *J. & J. Bard*, 86.

13. For instance, Bard showed the *Illinois* (1837, Mariners Museum) steaming to the right.

28. FREDERIC EDWIN CHURCH, *Twilight*

1. Quoted in Andrew Wilton and Tim Barringer, *American Sublime: Landscape Painting in the United States, 1820–1880* (London: Tate Publishing, 2002), 130.

2. Franklin Kelly had speculated an earlier date of 1856 based on an inscription to Erastus Dow Palmer on the back of the canvas. Kelly, *Frederic Edwin Church and the National Landscape* (Washington, D.C.: Smithsonian Institution, 1988), 84. However, a date of 1858 has been discovered on the painting, and a small study of the composition exists in the bottom left corner of a sketch dated 1858 in Church's notebook for his painting *Heart of the Andes* (1859, The Metropolitan Museum of Art). See "'Three Sketches for *The Heart of the Andes*; House on a Precipice, 1858," in Gerald L. Carr, *Frederic Edwin Church: Catalogue Raisonné of Works of Art at Olana State Historic Site*, vol. 2, plates (Cambridge: Cambridge University Press, 1994), no. 390v. The sky, however, is taken from an earlier sketch. See "Maine Twilight, ca. 1856," in ibid., no. 369. Kelly provides a good summary of the earlier confusion caused by the painting's exhibition under the titles *Twilight* and *Sunset* with another painting entitled *Twilight (Sunset)* (1856). See Kelly, *Church and the National Landscape*, 153 n. 22.

3. Mathew Baigell, *Dictionary of American Art* (New York: John Murray, 1979), 68.

4. E. P. Richardson, *American Art: A Narrative and Critical Catalogue* (San Francisco: The Fine Arts Museums of San Francisco, 1976), 116.

5. An early painting by Church pays homage to that founding: *Hooker and Company Journeying through the Wilderness from Plymouth to Hartford in 1636* (1846).

6. The painting for which Church was elected to the National Academy was *West Rock, New Haven* (1849). He was elected to full member in 1850. Theodore E. Stebbins Jr. et al., *A New World: Masterpieces of American Painting, 1760–1910* (Boston: Museum of Fine Arts, 1983), 238.

7. Church's first major tour of his painting *Niagara* received high praise when it traveled to London. Graham C. Boettcher, "Biographies of the Artists," in Wilton and Barringer, *American Sublime*, 258.

8. Franklin Kelly, "Frederic Church and the Enterprise of Landscape Painting," *Antiques* (November 1989): 1114.

9. Ibid.

10. Calvert Vaux was the architect for Olana.

11. Kelly, "Frederic Church and the Enterprise of Landscape Painting," 1116.

12. Ibid., 1118–1119.

13. Kevin J. Avery, *Church's Great Picture: The Heart of the Andes* (New York: The Metropolitan Museum of Art, 1993), 34. Avery's monograph is the most thorough discussion of the painting's history, including its production, display, reception, and tour.

14. *National Academy of Design Exhibition Record, 1826–1860*, vol. 1 (New York: The New-York Historical Society, 1943), 81.

15. Artists working in this vein were sometimes called "Luminists," but it is important to remember that there was no "luminist" school or self-identified group who practiced this style of painting. Rather, it is a descriptive term used by art historians to refer to American realist landscape painters who were striving for particular light effects. Important discussions of this work as "luminist" include John Wilmerding, *American Light: The Luminist Movement, 1850–1875: Paintings, Drawings, Photographs* (Washington, D.C.: National Gallery of Art, 1980), 16; and Barbara Novak, *Nature and Culture: American Landscape and Painting, 1825–1875* (New York: Oxford University Press, 1980), 43. For a rebuttal of the term, see Andrew Wilton, "The Sublime in the Old World and the New," in Wilton and Barringer, *American Sublime*, 24–25.

16. Franklin Kelly, *Frederic Edwin Church* (Washington, D.C.: National Gallery of Art, 1989), 53.

17. Novak, *Nature and Culture*, 80–89.

18. In fact, Church had Cole's *Prometheus Bound* (pl. 19) in his studio while he was working on *Twilight*. *The Crayon* 3 (January 1856): 30.

19. Kelly, *Frederic Edwin Church*, 53.

20. This structure has been read variously as a trapper's cabin, a clapboard house, and a timber mill, each with its own iconographic implications for the historical moment.

21. Malcolm Andrews, *Landscape and Western Art* (Oxford: Oxford University Press, 1999), 149.

29. FREDERIC EDWIN CHURCH,
Rainy Season in the Tropics

1. Henry T. Tuckerman, *Book of the Artists: American Artist Life* (New York: G. P. Putnam & Son, 1867), 383.

2. "American Studio Talk," *International Studio Supplement* 11, no. 43 (September 1900): xiii, xiv.

3. What happened to the painting in the intervening years is not exactly clear. A grandson of Henry Sturges recalled the arrival of the painting, which the family called "The Rainbow," in Connecticut. Only one wall was large enough to accommodate it. Thomas Cole's *The Notch of the White Mountains (Crawford Notch)* (1839) hung on that wall, but since the family preferred "The Rainbow," the Cole went into the cellar. One night during World War II the family was playing bridge in an adjoining room when they heard a crash. They discovered that "The Rainbow" had fallen out of its frame and was badly torn. The painting was indifferently restored. Meanwhile, the banished Cole was sold to a "peddler" who said he would have to cut it up into pieces to sell it—no one had houses big enough for that size of painting. Luckily, he did not cut it up, and *The Notch of the White Mountains* is now in the National Gallery of Art in Washington, D.C. These stories help explain how *Rainy Season in the Tropics* ended up in an outbuilding. Its image marred by a ghastly rip, the once-favorite painting was probably shunted aside and forgotten. See the letter from Henry S. Bullard to Hugh Latham, 26 January 1988, object file, AAD/DEY/FAMSF.

4. A number of slightly different versions of Middendorf's discovery can be found in the object files in AAD/DEY/FAMSF: for instance, in Marc Simpson, "Memo of Record, Meeting with Mr. and Mrs. Robert Vose, Jr.," 6 February 1985; letter from F. Lanier Graham, then FAMSF Chief Curator, to Alfred Frankenstein, 24 March 1972; letter from Graham to Charles H. Morgan, 6 June 1973.

5. "American Studio Talk," xiii.

6. Eleanor Jones Harvey, *The Painted Sketch: American Impressions from Nature, 1830–1880* (Dallas: Dallas Museum of Art, 1998), 71.

7. See *Palm Trees*, *Wild Philodendron on a Tree Trunk*, and *Trumpet Tree* (all 1865, Cooper-Hewitt, National Design Museum). These sketches are reproduced in Theodore E. Stebbins Jr., *Close Observation: Selected Oil Sketches by Frederic E. Church* (Washington, D.C.: Smithsonian Institution, 1978), 78, 79.

8. Stephen Jay Gould, "Church, Humboldt, and Darwin: The Tension and Harmony of Art and Science," in Franklin Kelly, *Frederic Edwin Church* (Washington, D.C.: National Gallery of Art, 1989), 94–107.

9. Quoted in ibid., 97.

10. Gerald L. Carr, *Frederic Edwin Church: Catalogue Raisonné of the Works of Art at Olana State Historic Site* (Cambridge, U.K.: Cambridge University Press, 1994), 287.

11. See, for instance, Robert Hughes, *American Visions: The Epic History of Art in America* (New York: Alfred A. Knopf, 1997), 164.

12. David C. Huntington, *The Landscapes of Frederic Edwin Church: Vision of an American Era* (New York: George Braziller, 1966), 56. Carr has

discovered what appears to be a preliminary sketch for *Rainy Season in the Tropics*, including the double rainbow, on a letter dated January 1863. He argues, therefore, that Church did not conceive of the painting as a celebration of war's end (it was in one of its bloodiest periods) or as a memorial to his children (his daughter would not be born until the following year). Carr, *Catalogue Raisonné*, 286–287.

13. Quoted in Gould, "Church, Humboldt, and Darwin," 98.

14. Ibid., 104–107.

15. Quoted in ibid., 104.

30. ALBERT BIERSTADT,
Roman Fish Market, Arch of Octavius

1. George Stillman Hillard, *Six Months in Italy* (Boston: Ticknor, Reed, and Fields, 1853), 2: 21. Quoted in Paul Manoguerra, "Anti-Catholicism in Albert Bierstadt's *Roman Fish Market, Arch of Octavius*," *Nineteenth-Century Art Worldwide* 2, no. 1 (Winter 2003). Viewed at www.19thc-artworldwide/winter_03/articles/mano.html.

2. Antony married Octavia in 40 B.C. to solidify a pact with Augustus (then still known as Octavian), but he returned almost immediately to Egypt and Cleopatra, with whom he had become enamored two years before. Antony divorced Octavia in 32 B.C., triggering a declaration of war from Octavian. Defeated by Octavian at Actium in 31 B.C., Antony and Cleopatra fled to Alexandria, where they committed suicide the following year.

3. The Portico of Metellus and its Temple of Jupiter Strator were erected in 146 B.C. by the general Quintus Caecilius Metellus Macedonius. The Temple of Juno Regina was some thirty-three years older. The Portico of Octavia retained those temples and also contained a library, a curia (meeting hall), and many artworks. Samuel Bell Platner and Thomas Ashby, *A Topographical Dictionary of Ancient Rome* (London: Oxford University Press, 1929), 427. Augustus boasted, "I found Rome built of bricks; I leave her clothed in marble." Suetonius, *The Twelve Caesars*, trans. Robert Graves (London: Penguin Books, 1957), 69, quoted in Manoguerra, "Anti-Catholicism." Information on the Portico of Octavia, the Pescheria, and the Ghetto was also drawn from sources including Augustus J. C. Hare, *Walks in Rome*, 2nd American ed. (New York: George Routledge & Sons, 1872), 163–165; and Richard Krautheimer, *Rome: Profile of a City*, 312–1308 (Princeton: Princeton University Press, 2000), passim.

4. Platner and Ashby, *Topographical Dictionary*, 427.

5. This was the fate of much of the Colosseum.

6. This neighborhood had already been home to Rome's Jewish population since the second century B.C., but before the later Middle Ages they enjoyed great freedom and prosperity. Still, it was one of the most undesirable areas of the city, prone to routine flooding of the Tiber; the close quarters in the Ghetto—the population averaged more than four thousand—made living conditions unhealthy at best. From 1584 until 1848 the Jewish residents were forced to attend a weekly Catholic service at Sant'Angelo. Carol Shapiro, "Jewish Ghetto in Rome," www.audiowalks.com/read-a-walk/rome_ghetto.html.

7. Margaret R. Scherer, *Marvels of Ancient Rome* (New York: Phaidon Press, 1956), 30. According to some, many of the fishmongers were Jewish, though this would have been contrary to the papal decree forbidding them to traffic in anything but secondhand goods. David Downie, "Rome's Jewish Culinary Heritage," *Jewish Journal of Greater Los Angeles*, 16 January 2004, Life Style section; see also Shapiro, "Jewish Ghetto."

8. John Murray, *Handbook of Rome and Its Environs; Forming Part II of the Handbook for Travellers in Central Italy*, 5th ed. (London: John Murray, 1858), 80. The sculptor William Wetmore Story described the Portico in 1862: "The splendour of imperial Rome has given place to the Pescheria—the fish market. Step under this arch and look up that narrow, dirty, but picturesque street on the left—that is the Pescheria. Stone slabs, broken and grappled by iron hooks, stretch out on either side into the street, and usurp it so as to leave no carriageable way between them. If it be market-day you will see them covered with every kind of fishes. Green crusty lobsters, squirming crawfish all alive, heaps of red mullet, baskets of little shining sardines. . . . Great dark holes open into the houses behind, begrimed with dirt and smoke. Above stretches an arch supported by black beams." William Wetmore Story, *Roba di Roma*, 7th ed. (London: Chapman and Hall, 1876), 408, quoted in Manoguerra, "Anti-Catholicism."

9. Manoguerra, "Anti-Catholicism." In the mid–nineteenth century, Catholics represented only 5 percent of the population of the United States. "The U.S. Catholic Church," Archdiocesan Archives, Archdiocese of St. Louis. Viewed at www.archstl.org/archives/about/cathhist.htm.

10. Diana Strazdes, "The Arch of Octavius (Roman Fish Market), 1858," in Theodore E. Stebbins Jr., *The Lure of Italy: American Artists and the Italian Experience, 1760–1914* (Boston: Museum of Fine Arts; New York: Harry N. Abrams, 1992), 214.

11. Gordon Hendricks, *Albert Bierstadt: Painter of the American West* (New York: Harry N. Abrams, in association with the Amon Carter Museum, 1974), 57.

12. Apparently, this dog is a portrait of Bierstadt's own. *New Bedford Daily Mercury*, 16 July 1858, quoted in ibid., 58.

13. The guidebook has been identified as Murray's *Handbook of Rome and Its Environs*, which describes the ruins of the portico: "The [remaining] 2 pillars and pilasters in the front, and the 2 pillars and 1 pilaster in the inner row, towards the portico, are sufficient to show the magnificence of the original building." Murray, *Handbook of Rome*, 80, quoted in Manoguerra, "Anti-Catholicism."

14. In 1858 Nathaniel Hawthorne described a similar market scene in the Piazza Navonna: "Women and men sit with these things for sale, or carry them about in trays or on boards, on their heads, crying them with shrill and hard voices. There is a shabby crowd, and much babble; very little picturesqueness of costume or figure, however. . . . A few of the men have the peasant costume: a short jacket and breeches of a light blue cloth, and white stockings—the ugliest dress I ever saw. The women go bareheaded and seem fond of scarlet and other bright colors, but are homely, and clumsy in build. The Piazza is dingy in its general aspect, and very dirty, being strewn with straw, vegetable tops, and the rubbish of a week's marketing; but there is more life in it than one sees elsewhere in Rome." Hawthorne, "Roman Journal," 1 May 1858, quoted in *Travelers in Arcadia: American Artists in Italy, 1830–1875* (Detroit: The Detroit Institute of Arts, 1951), 16–17.

15. A portion of an inscription remains embedded in a wall of the fish market; it was apparently used for centuries as a measuring stick for fish, based on how many letters the specimen stretched. Platner and Ashby, *Topographical Dictionary*, 427.

16. Hillard, *Six Months in Italy*, 1:291, quoted in Strazdes, "The Arch of Octavius," 214.

17. Platner and Ashby, *Topographical Dictionary*, 427.

18. Published as *Veduta interna dell'Atrio del Portico di Ottavia*, in Giovanni Battista Piranesi, *Vedute di Roma* (Rome: Presso l'Antore, ca. 1750–ca. 1778).

19. This archway replaced two columns that were damaged by fire; it was originally clad in white marble to match the rest of the portico.

20. To see Bierstadt's view, one would need to walk under the pediment into the center of the atrium and then turn ninety degrees to the left.

21. In 1870 the portico was described as "one of the most memorable ruins of Rome; it offers one of those piquant contrasts between the past and the present that are a perpetual delight to the imagination in this city of contrasts. . . . The site is made for a water colour." Jean-Jacques Ampère, *L'empire romain à Rome* (Paris: Lévy Frères, 1867), quoted in Scherer, *Marvels*, pl. 48.

22. Strazdes, "The Arch of Octavius," 214.

31. ALBERT BIERSTADT, *Sunlight and Shadow*

1. Andreas Blühm and Louise Lippincott, *Light! The Industrial Age, 1750–1900: Art and Science, Technology and Society* (London: Thames and Hudson, 2000), 144.

2. Barry Gray, "Bierstadt, the Artist," *New York Leader* 9 (17 January 1863): 1. Worthington Whittredge writes about Bierstadt that it was this "picture that gave him more fame than anything he had ever painted." *The Autobiography of Worthington Whittredge, 1820–1910*, ed. John I. H. Baur (1942; rev. ed., New York: Arno Press, 1969), 27. For critical reviews, see Gordon Hendricks, *Albert Bierstadt: Painter of the American West* (New York: Harry N. Abrams, in association with the Amon Carter Museum, 1974), 104.

3. "Fine Art Items," *Watson's Weekly Art Journal* 2 (5 November 1864): 20. Bierstadt eventually gave the painting to his sister, Eliza Bierstadt, who lent it to the First Annual Exhibition of the Yale School of Fine Arts, 1867. Albert Bierstadt *Sunlight and Shadow* object file, AAD/DEY/FAMSF.

4. "Fine Art Items," 20. The chromolithograph (22½ × 19½ in.) was published in Berlin by Storch and Kramer (1864) and is reproduced in Nancy K. Anderson and Linda S. Ferber, *Albert Bierstadt: Art and Enterprise* (New York: Hudson Hills Press, in association with the Brooklyn Museum of Art, 1990), 289.

5. Anderson and Ferber, *Albert Bierstadt*, 271.

6. In this process, multiple layers of ink were applied by printing a canvas with successive stones, creating a surface whose appearance resembled that of an actual oil painting. In Germany the process was called *oleography*. Janet Altic Flint and Joseph Goddie, *Creation and Craft: Three Centuries of American Prints* (New York: Hirschl and Adler Galleries, 1990), 52.

7. Bierstadt principally studied in the studio of fellow American Worthington Whittredge, with whom he also traveled on several sketching tours throughout the countryside. E. P. Richardson, *American Art: A Narrative and Critical Catalogue* (San Francisco: The Fine Arts Museums of San Francisco, 1976), 106.

8. When Bierstadt returned to the United States, he took a studio in the Tenth Street Studio Building in New York, joining friends from his Düsseldorf days—Emanuel Leutze, Worthington Whittredge, Sanford Robinson Gifford, and William Stanley Haseltine—artists who played a central role in the Hudson River School of landscape painting. Anderson and Ferber, *Albert Bierstadt*, 140.

9. Bierstadt's first sketching trip in 1855, after two years of study in Düsseldorf, was to the mountains of Westphalia, followed in the summer of

1856 by a trip to the Rhineland, Switzerland, and Italy. Brucia Witthoft, *American Artists in Düsseldorf: 1840–1865* (Danforth, N.H.: Danforth Museum, 1982), 18.

10. After visiting the Löwenburg chapel, William H. Gerdts has pointed out the discrepancies between the actual site, the sketch, and the final composition. Gerdts and Mark Thistlethwaite, *Grand Illusions: History Painting in America* (Fort Worth, Tex.: Amon Carter Museum, 1988), 146. Further implications posed by these differences, especially the re-creation of a pre-Reformation building for a Protestant royal family, are discussed in his letter to Jennifer Saville, 30 June 1987, in Albert Bierstadt *Sunlight and Shadow* object file, AAD/DEY/FAMSF.

11. This is a sensibility that is carried over from the Hudson River School painting tradition, principally begun by Thomas Cole and Asher B. Durand.

12. John Alan Walker in a letter to Marc Simpson, 25 May 1991, in Albert Bierstadt *Sunlight and Shadow* object file, AAD/DEY/FAMSF.

13. George Ferguson, *Signs and Symbols in Christian Art* (London: Oxford University Press, 1973), 35.

14. Blühm and Lippincott, *Light! The Industrial Age, 1750–1900*, 144.

32. ALBERT BIERSTADT, *View of Donner Lake, California*

1. Fifteen hundred was more than six times the number who had made the overland journey the previous year and far outstripped the fifty-three emigrants who had reached California in 1844. John D. Unruh Jr., *The Plains Across* (Champaign: University of Illinois Press, 1982), 84. This wave of emigrants effectively tripled the white American residents of Mexican California, from eight hundred to twenty-three hundred. "Facts about the West during 1846," a companion to the copy of Hastings's *Guide* found at xroads.virginia.edu/~HYPER/IGUIDE/or-facts.htm. Information about the emigrants of 1846 was drawn from several sources, including Margaret C. S. Christman, *1846: Portrait of a Nation* (Washington, D.C.: Smithsonian Institution Press, 1996), 95–110. Sources of information regarding the Donner Party are countless; a recent and extremely accessible one is Ric Burns's "The Donner Party," a documentary produced for PBS's *American Experience* (1997). A transcript is available at www.pbs.org/wgbh/amex/donner/. The magazine articles and books on the Donners published during the nineteenth century tend toward the lurid and often contain exaggerations and errors. See, for example, "The Donner Party," *Overland Monthly* 5 (July 1870): 38–43.

2. Emigrants came together to form wagon trains by placing newspaper advertisements. Grayson's, which ran in the *St. Louis Reveille* on 20 February 1846, began, "Ho for California! At the suggestion and desire of a number of my friends, who propose emigrating with me to California, and deeming it actually necessary that some one should take the lead, whereby we may be able to organize an expedition and preserve good order while on the route, I have consented to take the charge upon myself, and pledge my life to the safe conduct of those who are disposed to join us in our journey to that country." George and Jacob Donner placed their advertisement in the *Sagamo Journal* of Springfield, Missouri, on 26 March 1846. Their copy read, "Westward, ho! For Oregon and California! Who wants to go to California without costing them anything? As many as eight young men, of good character, who can drive an ox team, will be accommodated by gentlemen who will leave this vicinity about the first of April. Come, boys! You can have as much land as you want without costing you any thing. The government of California gives large tracts of land to per-

sons who have to move there." Dale Morgan, *Overland in 1846: Diaries and Letters of the California–Oregon Trail* (Georgetown, Calif.: Talisman Press, 1963), 1:480, 491.

3. Unfortunately, Hastings had not actually tried his "shortcut" before publishing it, and the trek through a nigh-impassable canyon and then across eighty miles of salt desert was in fact 125 miles longer and far more arduous than the old trail.

4. The tale of the Donner tragedy quickly spread across the country and was the subject of countless articles and books. The publicity was largely responsible for the number of California emigrants dropping back below five hundred in 1847 and 1848. The year 1849, of course, brought the gold rush, and the rest is history. Unruh, *The Plains Across*, 84.

5. Apparently, though, at Fort Laramie Grayson had "quarreled with all his companions, and every one who could raise a horse had left him." Morgan, *Overland in 1846*, 2:623. After making his fortune during the gold rush, Grayson was able to pursue his true love—natural history, particularly ornithology. He was called the "Audubon of the West" and produced *Birds of the Pacific Slope*, a lavish illustrated series, between 1853 and 1869, though it was not published for more than one hundred years. "Beyond Audubon: Rediscovering Andrew Jackson Grayson, Louisiana's Forgotten Artist," Louisiana State Archives, found at www.sec.state.la.us/archives/grayson/grayson-index.htm.

6. Elliot Evans, "The Promised Land," *Quarterly of the Society of California Pioneers* 36 (November 1957): 4.

7. The lake was not the only landmark renamed after 1846; Stephens Pass, the emigrant route over the summit, was rechristened Donner Pass.

8. Also known as Tunnel #6, the Summit Tunnel is the longest on the route at 1,659 feet. It passes 124 feet below the surface at its deepest. Progress on the tunnel, which entailed blasting through solid granite, averaged two feet every twenty-four hours. John R. Gilliss, "Tunnels of the Pacific Railroad," *Van Nostrand's Eclectic Engineering Magazine* 2 (1870): 418–423. The Bierstadts rode in a Silver Palace luxury sleeper car, used on the CPRR until 1883, when it was replaced by the Pullman car. Lucius Beebe, *Mr. Pullman's Elegant Palace Car* (New York: Doubleday & Co., 1961), 114–117.

9. The names of the Big Four live on in California's Stanford University; storied Mark Hopkins hotel; Huntington Library, Art Collections, and Botanical Gardens (the estate of Collis's nephew and heir, Henry, who ended up with not only his uncle's money but his wife as well); and Crocker Museum (the former home of Charles Crocker's brother Edwin, a prominent judge and art collector, and the legal counsel for the Central Pacific).

10. According to a San Francisco paper, "Our California railroad magnates are all gathering collections of paintings." *San Francisco Daily Evening Bulletin*, 18 September 1871.

11. Many excellent sources on the history of the CPRR are available. One of the most interesting and enjoyable is the California State Railroad Museum, located in Old Sacramento just yards from the Huntington, Hopkins & Co. hardware store, where two of the Big Four started out.

12. *Overland Monthly* 10 (March 1873): 286. In 1870 another *Overland Monthly* reporter had said of Donner Lake, "Of all the waters gathered in the lofty basins of the Sierra Nevada, Donner Lake is, perhaps, the most beautiful in itself, as well as the most picturesque in its surroundings." *Overland Monthly* 5 (March 1870): 38.

13. Gordon Hendricks, "The First Three Western Journeys of Albert Bierstadt," *Art Bulletin* 46, no. 3 (September 1964): 348.

14. D. O'C. Townley, "Living American Artists, No. III," *Scribner's Monthly* 3, no. 5 (March 1872): 608.

15. *Donner Lake from the Summit* is in the collection of the New-York Historical Society. "The members and patrons of the San Francisco Art Association will be glad to know that Mr. Bierstadt will . . . place on exhibition in the Gallery his great picture of *Donner Lake from the Summit.* Bierstadt has been engaged on this work for more than a year. He has made a great many elaborate studies for it during numerous excursions to the summit, and has aimed to make a careful transcript of an actual scene." *San Francisco Daily Evening Bulletin,* 9 November 1872.

16. Seven tunnels were located in the two miles just east of the summit. Lucius Beebe, *The Central Pacific & the Southern Pacific Railroads* (Berkeley: Howell-North, 1963), 24. See also Gilliss, "Tunnels." Apparently, William Cullen Bryant's *Picturesque America,* published in 1874, complained that the snowsheds obscured the view. Amy Ellis, "View of *Donner Lake, California,* 1871–72," in Elizabeth Johns et al., *New Worlds from Old: Nineteenth-Century Australian and American Landscapes* (Canberra: National Gallery of Australia, 1998), 70.

17. *Overland Monthly* 10 (March 1873): 287.

18. This cross does not appear in the final version of the painting, nor does any evidence exist that a cross was ever at the site; perhaps Bierstadt thought the cross was necessary to call up the desired associations but decided that including "Donner Lake" in the title was reference enough. Interestingly, the name of the painting was reported to be *Sunrise in the Sierras* while it was under way in 1872 but was titled *Donner Lake from the Summit* when first exhibited in January 1873. Nancy K. Anderson, "'Wondrously Full of Invention': The Western Landscapes of Albert Bierstadt," in Anderson and Linda S. Ferber, *Albert Bierstadt: Art and Enterprise* (New York: Hudson Hills Press, in association with the Brooklyn Museum of Art, 1990), 96.

19. Bierstadt insured the painting for $25,000. Gordon Hendricks, *Albert Bierstadt: Painter of the American West* (New York: Harry N. Abrams, in association with the Amon Carter Museum, 1974), 228.

20. A contemporary travel guide said of traversing Donner Pass by train: "As we look down from the beautiful cars, with every want supplied and every wish anticipated, upon that historic and picturesque spot in the summer, where those poor emigrants suffered all that humanity could suffer, and died in such a heart-sickening way, we could not release ourselves from the sad impression which this most terrible item in the history of those times made upon the mind." Quoted in Susan Danly Walther, *The Railroad in the American Landscape: 1850–1950* (Wellesley: The Wellesley College Museum, 1981), 48.

33. ALBERT BIERSTADT, *California Spring*

1. Heath Schenker, ed., *Picturing California's Other Landscape: The Great Central Valley* (Berkeley: Heyday Books; Stockton, Calif.: The Haggin Museum, 1999), 15.

2. The title of this painting has caused some confusion with another painting, *Sacramento Valley in Spring* (ca. 1878, also called *Sunset in the Sacramento Valley*), which Bierstadt gave to the Montreal Museum of Fine Arts in 1878 (deaccessioned and sold in 1945). For a time, FAMSF's *California Spring* (1875) was also known by the Montreal painting's title because it was purchased for the city and county of San Francisco as *Sacramento Valley in Spring* and listed as such in Gordon Hendricks, *Albert Bierstadt: Painter of the American West* (New York: Harry N. Abrams, in association with the Amon Carter Museum, 1974), 255–256. Hendricks's book was the principal research publication on the artist before the exhibition catalogue by Nancy K. Anderson and Linda S. Ferber, *Albert Bierstadt: Art and Enterprise* (New York: Hudson Hills Press, in association with the Brooklyn Museum of Art, 1990). Anderson and Ferber correctly identify the FAMSF painting, *California Spring,* as the work Bierstadt exhibited and published under that title in the 1875 National Academy of Design catalogue (no. 228). This also identifies it as the painting that was exhibited at the 1876 Centennial Exhibition in Philadelphia and listed in its catalogue under the title *California Spring.* A description of the painting at the National Academy of Design confirms that the FAMSF painting is the work exhibited under that title. See the description in "The National Academy of Design," *Art Journal* 1 (April 1875): 125. Allan Pringle also corroborates these findings based on the measurements of the two paintings in his "Albert Bierstadt in Canada," *American Art Journal* 17 (Winter 1985): 4, 26.

3. Maria Naylor, ed., *The National Academy of Design Exhibition Record, 1861–1900,* vol. 1 (New York: Kennedy Galleries, 1973), 59.

4. Linda Ferber argues that Bierstadt's success in Vienna may have hurt his reputation in the United States because he violated a boycott of the exposition by other American artists who were protesting the limited space the country had been allotted. Anderson and Ferber, *Albert Bierstadt,* 58–60.

5. *San Francisco Chronicle* (12 January 1873); *California Art Gallery* (February 1873). Nancy Anderson points out that early on there was a critical divide over Bierstadt's sublime western landscapes, which became especially heated with the exhibition of his monumental canvas *The Domes of Yosemite* (1867, 9 ft. 8 in. × 15 ft.), painted after his second trip west. Anderson and Ferber, *Albert Bierstadt,* 91–92.

6. By the time of his death in 1902, Bierstadt's devolution was so complete that a contemporary painter could state, "I did not know he was alive until I saw he had died." Quoted in Anderson and Ferber, *Albert Bierstadt,* 11. Even as early as the 1876 Centennial, the public was already becoming critical of the works Bierstadt exhibited, calling them old-fashioned and out of step with the new painting styles. Hendricks, *Albert Bierstadt: Painter of the American West,* 247. John Ferguson Weir, director of the Yale University School of Fine Arts and one of the fair's judges, wrote that Bierstadt's work at the Centennial represented "a lapse into sensational and meretricious effect, and a loss of true artistic aim." Quoted in Anderson and Ferber, *Albert Bierstadt,* 59.

7. Anderson and Ferber, *Albert Bierstadt,* 70. For a discussion of Manifest Destiny and the Hudson River School painters, see Tim Barringer, "The Course of Empires: Landscape and Identity in America and Britain, 1820–1880," in Andrew Wilton and Barringer, *American Sublime: Landscape Painting in the United States, 1820–1880* (London: Tate Publishing, 2002), esp. 57–62.

8. The principal conflict created by Manifest Destiny is reiterated in Richard White, *"It's Your Misfortune and None of My Own": A New History of the American West* (Norman: University of Oklahoma Press, 1991).

9. Bierstadt helped establish the New Bedford, Massachusetts, photographic studio of his older brothers, Charles and Edward, in 1859, who published their own photographs of the Civil War in addition to Bierstadt's western photographs. Hendricks, *Albert Bierstadt,* 93.

10. Not everyone was pleased with this constructed conflation of

European style and American idiom, and Mark Twain was among the most critical. Stephanie Foster Rahill, *The American West: Out of Myth, Into Reality*, ed. Peter H. Hassrick (Washington, D.C.: Trust for Museum Exhibitions, 2000), 69.

11. "Letter from the Rocky Mountains," dated 10 July 1859, *Crayon* (September 1859): 287. For a discussion of the European sublime, Hudson River School painting, and Bierstadt, see Andrew Wilton, "The Sublime in the Old World and the New," in Wilton and Barringer, *American Sublime*, 11–20, 31–37.

12. Marc Simpson, "Albert Bierstadt: Art and Enterprise," *Triptych* (June/July/August 1991): 13.

13. Anderson and Ferber, *Albert Bierstadt*, 140.

14. The first Rocky Mountain painting Bierstadt exhibited at the National Academy of Design was *Base of the Rocky Mountains, Laramie Peak* (1860), which was described by the *New York Tribune* as the "piece de resistance" in the landscape section. Quoted in Anderson and Ferber, *Albert Bierstadt*, 146. The painting made Bierstadt an "artistic superstar." Later sold to James McHenry, a wealthy English railroad businessman, for $25,000, it established Bierstadt as the foremost painter of the American West. Brian J. Wolf, "How the West Was Hung, Or, When I Hear the Word 'Culture' I Take Out My Checkbook," *American Quarterly* 44 (September 1992): 435.

15. Anderson and Ferber, *Albert Bierstadt*, 78. His sketches for the *Atlantic Monthly* were later collected as *The Heart of the Continent* (1870).

16. Ibid., 105.

17. Heath Schenker, "Picturing the Central Valley," *Landscape* 52, no. 2 (1994): 3.

18. Sally Mills has pointed out that Bierstadt's "view is taken from hills that could not exist in this location, just as the seventeenth-century Dutch artists invented high vantage points from which to survey their flat homeland." Sally Mills in Marc Simpson, Mills, and Jennifer Saville, *The American Canvas: Paintings from the Collection of The Fine Arts Museums of San Francisco* (New York: Hudson Hills Press, in association with The Fine Arts Museums of San Francisco, 1989), 124.

19. Mills credits Marc Simpson with this observation in ibid.

20. The painting is a testament to Bierstadt's willingness to finesse his landscapes so that they would flatter the Gilded Age sensibilities of his patron. Missing from the painting is any visual cue to Huntington's Washington ties and corruption. The Central Pacific Railroad budgeted $500,000 annually from 1875 to 1885 for bribes. Huntington is quoted, "If you have to pay money to have the right thing done, it is only just and fair to do it." Quoted in Peter N. Carroll and David W. Noble, *The Free and the Unfree: A New History of the United States*, 2nd ed. (New York: Penguin Books, 1988), 288.

21. It should be noted, however, that this was a promise that already appeared suspect in 1875, in light of Gilded Age extravagance and the financial instabilities of the Reconstruction economy that supported it. The 1870s were a time of especially devastating economic crisis and labor unrest. "The crisis was built into a system which was chaotic in its nature, in which only the very rich were secure. It was a system of periodic crisis . . . that wiped out small businesses and brought cold, hunger, and death to working people while the fortunes of the Astors, Vanderbilts, Rockefellers, Morgans, kept growing through war and peace, crisis and recovery." Howard Zinn, *A People's History of the United States, 1492–Present*, rev. ed. (New York: Harper Perennial, 1995), 237.

34. JOHN FREDERICK KENSETT, *Sunrise among the Rocks of Paradise at Newport*

1. In "Critics, Collectors, and the Nineteenth-Century Taste for the Paintings of John Frederick Kensett" (Ph.D. diss., University of California, Berkeley, 2003), Melissa Geisler Trafton discusses Kensett's Newport paintings in the context of the history and development of the area. She makes the argument that this site would not have been readily recognized by viewers of the painting. See chapter 3, "Pictures of Newport: Views 'hardly known to the ordinary summer visitor,'" 181–243.

2. Benjamin Champney to John F. Kensett, 3 September 1854, Morgan Papers, quoted in ibid., 186.

3. Kensett biography drawn from ibid., Appendix A.

4. Henry T. Tuckerman, *Book of the Artists: American Artist Life Comprising Biographical and Critical Sketches of American Artists* (New York: G. P. Putnam & Son, 1867; reprint, New York: James F. Carr, 1967), 514; Kelly Eberling, "John F. Kensett and Newport, Rhode Island: A Study in Patronage," manuscript intended for *Triptych*, John Frederick Kensett *Sunrise among the Rocks of Paradise at Newport* object file, AAD/DEY/FAMSF.

5. Trafton, "Critics, Collectors," 186–187.

6. Ibid., 185.

7. Tuckerman, *Book of the Artists*, 512.

8. Trafton, "Critics, Collectors," 212.

9. Robert G. Workman, *The Eden of America: Rhode Island Landscapes, 1820–1920* (Providence: Museum of Art, Rhode Island School of Design, 1986), 28.

10. Henry James, "Art," *Atlantic Monthly* 38 (August 1876): 251, quoted in Trafton, "Critics, Collectors," 212.

11. Trafton, "Critics, Collectors," 212–213.

12. Trafton discusses the changing concept of "refinement" throughout the nineteenth century in ibid. For a discussion of how that concept particularly pertains to Newport, see 227–232.

13. *Newport Mercury*, 8 July 1871, quoted in ibid., 205.

35. SANFORD ROBINSON GIFFORD, *Windsor Castle*

1. See *A Memorial Catalogue of the Paintings of Sanford Robinson Gifford, N.A.* (New York: The Metropolitan Museum of Art, 1881). The catalogue includes six entries related to Windsor Castle; three are described as sketches, the others are listed as paintings. The version of 1860 is the final and largest painting of Windsor Castle. Gifford frequently revisited the same subject over a period of several years, in a series of sketches and larger paintings. For a useful overview of his working methods, see Eleanor Jones Harvey, "Tastes in Transition: Gifford's Patrons," in Kevin J. Avery and Franklin Kelly, eds., *Hudson River School Visions: The Landscapes of Sanford R. Gifford* (New York: The Metropolitan Museum of Art, in association with Yale University Press, 2004), 76. For a contemporary discussion of Gifford's process, see George W. Sheldon, "How One Landscape Painter Paints," *Art Journal* 3 (1877): 234–235.

2. Whereas the grand tour became common among Americans in the nineteenth century, Europeans had begun touring major cultural and artistic sites in Italy and France much earlier, in the late sixteenth century. For a useful discussion of European tourism, see James Buzard, *The Beaten Track: European Tourism, Literature, and the Ways to Culture, 1800–1918* (Oxford: Clarendon Press, 1993).

3. Gifford traveled with a copy of *Black's Picturesque Tourist and Road*

and *Railway Guidebook through England and Wales* (Edinburgh: Adam and Charles Black, 1862). Adam and Charles Black were the official publishers to the queen at this time, and this association made their guidebooks especially popular. For an overview of the firm, see *Adam and Charles Black, 1807–1957, Some Chapters in the History of a Publishing House* (London: Adam and Charles Black, 1957). Karl Baedeker, a German publisher who produced many popular guidebooks to Europe in the nineteenth century, did not publish an English edition of his guide to London and its environs until 1879, perhaps because of the primacy of Black's guidebooks to that region. For an overview of the many travel accounts published in the nineteenth century by American visitors to England, see Walter Allen, *Transatlantic Crossing: American Visitors to Britain and British Visitors to America in the Nineteenth Century* (New York: William Morrow & Co., 1971); and Allison Lockwood, *Passionate Pilgrims: The American Traveler in Great Britain, 1800–1914* (New York: Cornwall Books, 1981). For an analysis of Anglo-American relations in the period, see Fred M. Leventhal and Roland Quinalt, eds., *Anglo-American Attitudes: From Revolution to Partnership* (Aldershot, U.K.: Ashgate Publishing, 2000). Without fail, Windsor Castle was included in guidebooks to England and was also featured in popular illustrated travel narratives such as Bayard Taylor's *Picturesque Europe* (New York: D. Appleton and Co., 1875). Taylor's earlier account of European travel, *Views-a-Foot; or Europe Seen with Knapsack and Staff* (1855; New York: G. P. Putnam, 1862), seems to have been particularly influential for Gifford in planning his itinerary. For a discussion of Gifford as a traveler, see Heidi Applegate, "A Traveler by Instinct," in Avery and Kelly, *Hudson River School Visions*, 53–74; and Monica Anke Koenig, *America and the Grand Tour: Sanford Robinson Gifford at Home and Abroad* (Poughkeepsie, N.Y.: Vassar College Museum of Art, 1991).

4. The most comprehensive discussion of American attitudes toward England in this period is Elisa Tamarkin, "American Anglophilia: Deference, Devotion, and National Culture, 1820–1865" (Ph.D. diss., Stanford University, 2000). See also Lockwood, *Passionate Pilgrims*.

5. "Travel in Europe," *North American Review*, April 1861, 550, quoted in Tamarkin, "American Anglophilia," 82.

6. Nathaniel Parker Willis, "English Aristocracy," from his *Pencillings by the Way* (1836), excerpted in Allen, *Transatlantic Crossing*, 31.

7. Ralph Waldo Emerson, from the journals, January 1849, excerpted in Allen, *Transatlantic Crossing*, 80.

8. James Fenimore Cooper, "Windsor," from his *England* (1837), excerpted in Allen, *Transatlantic Crossing*, 46.

9. For an overview of the castle's history, see Christopher Hibbert, *The Court at Windsor: A Domestic History* (1964; London: Penguin Books, 1977).

10. Walter L. Arnstein, "Queen Victoria and the United States," in Leventhal and Quinault, *Anglo-American Attitudes*, 91–106; and see Tamarkin, "American Anglophilia," Chap. 1, "American Anglophilia; or How the Prince of Wales Saved the Union," 10–70.

11. "The Prince of Wales in New York—Splendid Military Display—Vast Concourse of People—Immense Enthusiasm," *Frank Leslie's Illustrated Newspaper*, 20 October 1860, quoted in Tamarkin, "American Anglophilia," 22–23.

12. Gifford notes that he arrived in Windsor at four o'clock, "too late to visit the 'State Apartments,' for which I had obtained a card in London," and goes on to describe St. George's Chapel, commenting at length on the tomb of Princess Charlotte, which was noted as a "particularly fine" feature in the guide he brought with him, *Black's Picturesque Tourist and Road and Railway Guidebook*. That evening he made his first sketch of the castle and drew inspiration from Shakespeare, noting in his journal that he had sketched the castle "from 'Datchett Mead' in the home park. 'Datchett Mead' you remember was the place where the Merry Wives of Windsor got Fallstaff [*sic*] a ducking." The next day Gifford sketched the castle from the Thames, and once again related his experience to his reading, citing "the history of the town I picked up here" to explain the connection between the river's winding path through Windsor and the Saxon origins of the town's name. Gifford, "European Letters," vol. 1, AAA/SI, microfilm reel D21, 45. Windsor Castle is discussed in *Black's* on 89–90. The guidebook advises: "The state-rooms are fitted up in a very superb style, and the different apartments are adorned by a great number of painting of the most eminent masters. These can be seen by anyone possessing an order, which is easily procurable in London, at the shop of Messrs. Colnaghie, print sellers, Pall-Mall, East." Ila Weiss has characterized portions of Gifford's travel through England as a "literary pilgrimage." See Weiss, *Sanford Robinson Gifford (1823–1880)* (Ph.D. diss., Columbia University, 1968; New York: Garland Publishing, 1982), 131–140; and Weiss, *Poetic Landscape: The Art and Experience of Sanford R. Gifford* (Newark: University of Delaware Press, 1987).

13. Gifford, "European Letters," vol. 1, typescript, 45–46.

14. During Victoria's reign there was always a flag flying at Windsor Castle from sunrise to sunset. When the queen was in residence, the Royal Standard was used; at all other times the Union Jack was flown from the tower. The fact that Gifford was able to secure a card to visit the State Apartments (see n. 12) suggests that the queen was away at the time that he visited. According to period guidebooks this was typically only allowed when the castle was unoccupied. See, for example, "To the Visitor," in *The Royal Windsor Guide* (Windsor: J. B. Brown, 1843), 2.

15. H. Perry Smith, ed., *History of the City of Buffalo and Erie County* (Syracuse, N.Y.: D. Mason and Co., 1884), 473–474; biographical section, 77–79. Rogers served as district attorney from 1837 to 1843 and as collector of the Port of Buffalo from 1845 to 1849, an appointment he received from President Polk. After his term expired, he continued to work as a lawyer in Buffalo until retiring to Ann Arbor, Michigan, in 1863. His firm represented local mining interests, and he may have been acquainted with Gifford's father, Elihu, who owned an iron foundry in Hudson, New York. For a discussion of Elihu Gifford's career, see Kevin Avery, "Gifford and the Catskills," in Avery and Kelly, *Hudson River School Visions*, 26–27.

36. MARTIN JOHNSON HEADE,
Singing Beach, Manchester

1. Information regarding Heade's early travels was drawn from Theodore E. Stebbins Jr., *Martin Johnson Heade* (College Park: University of Maryland, 1969).

2. Theodore E. Stebbins Jr., *The Life and Works of Martin Johnson Heade* (New Haven: Yale University Press, 1975), 67.

3. Although dated no more precisely than "1863," *Singing Beach, Manchester* was likely painted in the spring of that year, as Heade's Providence dealer and supplier, Seth Vose, sold him a frame exactly the same dimensions as this painting on 23 April for $20. Such frames—to say nothing of canvases, paints, and brushes—are the reason he netted only $400 of the

$992 generated through the sale of his paintings. Stebbins, *Life and Works*, 41 and 71–73. Vose's enterprise lives on as the Vose Galleries of Boston.

4. See, for instance, Margaretta Lovell, *American Painting 1730–1960: A Selection from the Collection of Mr. and Mrs. John D. Rockefeller 3rd* (Tokyo: National Museum of Western Art, in association with The Fine Arts Museums of San Francisco, 1982), 35.

5. Sarah Cash, "Singing Beach, Manchester: Four Newly Identified Paintings of the North Shore of Massachusetts by Martin Johnson Heade," *American Art Journal* 27, nos. 1 and 2 (1995–96): passim. An extremely thorough and convincing case for Singing Beach as the site of the painting, Cash's article does not question its interpretation (and titling) as a twilight view.

6. Though at first glance a single rocky point appears to emerge from behind Eagle Head at the left, careful examination reveals three different landmasses; since they overlap, are all the same color, and are partially obscured by the haze at the horizon line, they are difficult to distinguish from one another. Thus, on the left side of the painting, moving away from the viewer's position, we begin with Eagle Head. The easternmost portion of Graves Island lies behind, blending almost imperceptibly into Coolidge Point. The flattened section at the far right of the very end of the landmasses is the tip of Magnolia Point. All names are those that were in use in 1994. Cash, "Singing Beach," passim.

7. Stebbins, *Martin Johnson Heade*, 4.

8. Stebbins, *Life and Works*, 42.

9. Martin Johnson Heade *Singing Beach, Manchester* object file, AAD/DEY/FAMSF. The painting was in the possession of the art conservator Gustav D. Klimann, who placed it with Vose for sale. How or when Klimann came to own it is not known. Theodore Stebbins was the purchaser, in turn selling the painting to John D. Rockefeller 3rd and his wife, Blanchette, in 1967.

10. Four extant paintings feature slightly different versions of this same beach. In the mid-1960s the art dealer Victor Frank christened one of them *Spouting Rock Beech*, determining it to be Heade's "Spouting Rock Beach" listed in an 1861 exhibition catalogue. Stebbins recognized that his painting had the same subject and narrowed his identification to Spouting Rock Beach as well. This assumption was sound, since the painting was already associated with Newport, where Heade was known to have spent a good deal of time; Newport was also convenient to the nineteenth-century Vose base of operations in Providence. Cash, "Singing Beach," 96 n. 4.

11. Ibid., 96 n. 5. Rhode Island paintings were exhibited at the National Academy of Design in 1859, 1867, and 1868; at the Boston Athenaeum in 1857, 1859, 1863, and 1873; at the Brooklyn Art Association in 1868; and at the Pennsylvania Academy of the Fine Arts in 1857, 1861, and 1868. See also Sarah Cash, *Ominous Hush: The Thunderstorm Paintings of Martin Johnson Heade* (Fort Worth: Amon Carter Museum, 1994).

12. John Collins, *The Spouting Rock*, tinted lithograph, 1857, printed by T. Sinclair, Philadelphia, from Collins, *The City and Scenery of Newport, Rhode Island* (Burlington, N.J.: [J. Collins], 1857). Viewed at www.webcom.com/frost/spoutingrock.html. The lack of islands was noted by Sarah Cash in a letter to curators Marc Simpson and Patricia Junker, 31 January 1994, Martin Johnson Heade *Singing Beach, Manchester* object file, AAD/DEY/FAMSF.

13. At the time, Sarah Cash was assistant curator of the Amon Carter Museum in Fort Worth; she is currently Bechhoefer Curator of American Art at the Corcoran Gallery of Art in Washington, D.C.

14. Heade was also known to have worked in Newburyport, some twenty-five miles farther up the coast from Manchester, during the 1860s. Cash, "Singing Beach," 84.

15. The photographer was Anna D. Shaw. Cash outlines the process whereby she made the identification in her letter of 31 January 1994, Martin Johnson Heade *Singing Beach, Manchester* object file, AAD/DEY/FAMSF.

16. In the 1860s Rock Dundy was known as Little Egg Rock. Cash, "Singing Beach," 90.

17. Ibid.

18. See Barbara Novak, "Spouting Rock, Newport," in *The Thyssen-Bornemisza Collection: Nineteenth-Century American Painting* (New York: Vendome Press, 1986), 35; Lovell, *American Painting*, 34–35; and Elizabeth M. Thompson, "Spatial Definition in the Paintings of Martin Johnson Heade," *Rutgers Art Review* 4 (January 1983): 62–63.

19. One such example is Caspar David Friedrich's 1823–24 *Eismeer (Sea of Ice)*, also known as *The Wreck of the Hope*.

37. MARTIN JOHNSON HEADE, *The Great Swamp*

1. Memo dated 11 March 1994, artist file, AAD/DEY/FAMSF.

2. Theodore Stebbins Jr., *Martin Johnson Heade* (Boston: Museum of Fine Arts, 1999), 31. There is rarely contemporaneous documentation for the titles of Heade's paintings, and the provenance for *The Great Swamp* is sketchy and incomplete. At times in its past, the painting was identified as *Great Marshes*, for instance on an unidentified exhibition label (typewritten, probably from the early or mid–twentieth century) and a Sloan & Roman dealer's label affixed to the back of the painting. In an invoice from 1970, however, Sloan & Roman identify the painting as *The Great Swamp*. No explanation for the name change, and the change in state—Great Swamp is in Rhode Island, Great Marshes is in Massachusetts—is mentioned. Whether *Great Marshes* or *The Great Swamp* or some other name is the accurate one is unknown. Great Marshes is located in West Barnstable County on Cape Cod, and Heade lived in Boston in the early 1860s. However, by 1868 he had moved to New York and was frequenting marshes more convenient to that city. Given that Heade painted (and definitively identified) Narragansett Bay in the same year he painted this work, and given the bay's proximity to the Great Swamp, it is reasonable to retain this title until further research confirms or disproves its validity.

3. Quoted in Neil G. Dunay, Norma LaSalle, and R. Darrell McIntire, *Smith's Castle at Cocumscussoc: Four Centuries of Rhode Island History* (Wickford, R.I.: Cocumscussoc Association, 2003), 18. The booklet provides a detailed discussion of the events leading up to the attack.

4. Ibid., 17, note the visual connection between the haystacks and the wigwams of the Narragansett.

5. In *The Life and Works of Martin Johnson Heade* (New Haven: Yale University Press, 1975), 43, Theodore E. Stebbins Jr. writes, "In painting [the marshes] he was in fact painting himself."

6. Stebbins, *Martin Johnson Heade*, 54.

38. MARTIN JOHNSON HEADE, *Orchid and Hummingbird*

1. General information regarding Heade's biography and travels was drawn from Theodore E. Stebbins Jr., *The Life and Works of Martin Johnson Heade* (New Haven: Yale University Press, 1975). The "Gems of Brazil" series is described in Rebecca Solnit, "Looking West: American Paintings from the Manoogian Collection and the M. H. de Young Museum of Art,"

Antiques and Fine Art 7, no. 1 (December 1989): 109. Heade published several articles on hummingbirds in *Forest and Stream* under the pen name "Didymus." In one he asserted, "From early boyhood I have been almost a monomaniac on the hummingbirds, and there is probably very little regarding their habits that I do not know." "Didymus," "Taming Hummingbirds," *Forest and Stream* 38, no. 15 (14 April 1892): 348.

2. Stebbins, *Life and Works*, 131.

3. In 1867 it was reported, "During a sojourn in South America he made a fine collection of tropical birds and butterflies, which have served him for authentic and elaborate studies." Henry T. Tuckerman, *Book of the Artists: American Artist Life Comprising Biographical and Critical Sketches of American Artists* (New York: G. P. Putnam & Son, 1867), 542.

4. Heade may also have decided that John Gould's mammoth *Monograph of the Trochilidae*, published just three years before, effectively saturated the market for illustrated hummingbird books. Gould's opus featured more than four hundred species of hummingbirds in its five volumes, complete with 360 chromolithographed plates. Theodore E. Stebbins Jr., *Martin Johnson Heade* (College Park: University of Maryland, 1969).

5. That he painted hummingbirds from firsthand experience was a point of pride for Heade, and he disparaged Gould for never having "set his foot on South American soil, the habitat of this large family of birds." Ella M. Foshay, "Nineteenth-Century American Flower Painting and the Botanical Sciences" (Ph.D. diss., Columbia University, 1979), 290.

6. Ibid., 300. The manuscript "Introduction to the Gems of Brazil" is available on microfilm in the Heade Papers and Notebooks, AAA/SI.

7. The year he died, Heade said, "I have been acquainted with many ornithologists—Gould among the number—and I have fed and tamed hummingbirds for more than fifty years, so I think myself capable of speaking with authority." *Forest and Stream* 63 (6 August 1904): 111.

8. Briefly stated, Darwin proposed that species arose and continue to develop by means of evolution; living organisms are thus in a constant state of change. This change is brought about by the two-step process of natural selection: (1) every species contains considerable variation within its members, and (2) only those members whose variations best equip them to survive in their environment will be able to reproduce. This statement is, of course, an extreme simplification of Darwinian theory. The complete title of Darwin's opus is *On the Origin of Species by Means of Natural Selection; or, The Preservation of Favoured Races in the Struggle for Life*. Ella Foshay, "Charles Darwin and the Development of American Flower Imagery," *Winterthur Portfolio* 15, no. 4 (Winter 1980): 301.

9. Foshay, "Charles Darwin," 310.

10. Foshay, *Reflections of Nature: Flowers in American* Art (New York: Alfred A. Knopf, 1984), 56.

11. Charles Darwin, *On the Various Contrivances by Which British and Foreign Orchids Are Fertilised by Insects and the Good Effects of Intercrossing* (London: J. Murray, 1862), quoted in Foshay, "Charles Darwin," 314.

12. The "orchid and hummingbird" paintings date from 1871 to 1901, three years before Heade's death.

13. Heade's "Jamaica Sketchbook" contains studies of orchids; Stebbins, *Life and Works*, 139.

14. By 1867, four years before the first orchid and hummingbird painting, Heade had already "become identified with tropical landscapes" and was known "as an accurate and graceful illustrator of natural history." Tuckerman, *Book of the Artists*, 542.

15. In fact, he reused many sketches and studies over time so that iden-tical orchids appear in multiple paintings. William H. Gerdts, *Painters of the Humble Truth: Masterpieces of American Still Life, 1801–1939* (Columbia: University of Missouri Press, 1981), 126.

16. Jennifer Saville, "Martin Johnson Heade," in Marc Simpson, Sally Mills, and Saville, *The American Canvas: Paintings from the Collection of The Fine Arts Museums of San Francisco* (New York: Hudson Hills Press, in association with The Fine Arts Museums of San Francisco, 1989), 92. The de Young's example dates from the middle of the series, after Heade had moved to tropical climes—St. Augustine, Florida—in 1883. There he had a studio at the Hotel Ponce de Leon, whose owner, Henry M. Flagler, acquired this painting from the artist. It remained in the Flagler family until 1969, when it was purchased by John D. Rockefeller 3rd and his wife, Blanchette; Martin Johnson Heade *Orchid and Hummingbird* object file, AAD/DEY/FAMSF. For more on Flagler, the Ponce de Leon, and the artists' studios there, see Sandra Barghini, *A Society of Painters: Flagler's St. Augustine Art Colony* (Palm Beach, Fla.: Henry Morrison Flagler Museum, 1998). During his twenty years in Florida, Heade also painted flowers native to that state, such as the Cherokee rose and magnolia. Gerdts, *Painters of the Humble Truth*, 130.

17. Heade's paintings, however, are "flower paintings with landscape backgrounds, rather than landscape paintings with flowers in the foreground," as is the case with Church's *Heart of the Andes*. Foshay, "Charles Darwin," 309.

18. Foshay, *Reflections of Nature*, 310.

19. Traditionally, scientific illustrations had isolated specimens against a white background for maximum clarity. John James Audubon provided rather minimalist settings for his avian subjects but confessed, "The flowers, plants, or portions of trees which are attached to the principal objects, have been chosen from amongst those found in the vicinity of which the birds were found, and are not, as some persons have thought, the trees or plants upon which they always feed or perch." John James Audubon, *Ornithological Biography; or, An Account of the Habits of the Birds of the United States of America; Accompanied by Descriptions of the Objects Represented in the Work Entitled The Birds of America, and Interspersed with Delineations of American Scenery and Manners*, 5 vols. (Edinburgh: Adam Black, 1831–39), 1:xii–xiii.

20. Foshay, "American Flower Painting," 304. Insects actually bear most of the responsibility for orchid pollination, though hummingbirds perform the task for certain species. Ibid., 310.

21. Stebbins, *Life and Works*, 143.

22. Heade himself rarely mentioned them during the three decades he worked on them. Ibid., 137.

23. Ibid., 138–139. Orchids were exhibited at the Massachusetts Horticultural Society in the 1830s. Foshay, "American Flower Painting," 302.

24. The association of the flowers with sexual activity was widespread. Dioscorides, writing in the first century A.D., reported that eating orchids can influence the gender of one's children; a seventeenth-century Jesuit, Athanasius Kircher, believed that orchids grew where animals had copulated. Stebbins, *Life and Works*, 138.

25. The reproductive structures of the orchid might have been particularly disquieting to a nineteenth-century audience, as the flower is hermaphroditic, the male stamen and female pistil fused into a single stalk. Ibid., 143.

26. Ibid., 131. Stebbins also quotes an ornithologist who asserts that hummingbirds "take their females by storm."

39. EASTMAN JOHNSON, *Sugaring Off*

1. "American Painters: Their Errors as Regards Nationality," *Cosmopolitan Art Journal* 1 (June 1857): 116. The journal represented the Cosmopolitan Art Association, which was the American Art-Union's main competitor. Quoted in Patricia Hills, "Images of Rural America in the Works of Eastman Johnson, Winslow Homer, and Their Contemporaries," in *The Rural Vision: France and America in the Late Nineteenth Century*, ed. Hollister Sturges (Omaha: University of Nebraska Press and the Joslyn Art Museum, 1982), 64–65.

2. For a large part of its history, this painting was known by the title *A Different Sugaring Off*, to distinguish it from a similar painting that was also part of Johnson's maple sugar painting campaign. Because this designation was a convenience used in executing the work's sale and not a title given to it by Johnson, Marc Simpson, when publishing the Rockefeller Collection catalogue, restored the descriptive title Johnson used for all the works in this campaign more generally as a more accurate reflection of the artist's intentions. See Marc Simpson with Patricia Junker, *The Rockefeller Collection of American Art at The Fine Arts Museums of San Francisco* (San Francisco: The Fine Arts Museums of San Francisco, in association with Harry N. Abrams, New York, 1994), 169.

3. Patricia Hills, "Painting Race: Eastman Johnson's Pictures of Slaves, Ex-Slaves, and Freedmen," in Teresa A. Carbone and Hills, *Eastman Johnson: Painting America* (New York: Rizzoli, in association with the Brooklyn Museum of Art, 1999), 126. Johnson was elected an associate at the National Academy of Design in 1859 and a full academician in 1860.

4. Robert A. di Curcio, *Art on Nantucket* (Nantucket, Mass.: Nantucket Historical Association, 1982), 126.

5. Trinkett Clark, "Mead Art Museum," *American Art Review*, Special Issue: The Western Massachusetts Art Trail, 16 (May–June 2004): 141. The arguments are summarized in John Davis, "Eastman Johnson's *Negro Life at the South* and Urban Slavery in Washington, D.C.," *Art Bulletin* 80 (March 1998): 67–70.

6. Nancy Heller and Julia Williams, "Eastman Johnson: A Nostalgic View of the Old South," *American Artist* 40 (January 1976): 65. More recently Patricia Hills has argued that while Johnson's painting appealed to many Southerners in its depiction of life under slavery, it is also more nuanced, reflecting the contradictions of slavery and the range of opinions about African Americans even among New York Republicans. See her "Painting Race," 126–131.

7. From 1858 until his death, Johnson maintained a winter studio in New York City but also spent much of his time away from the city, first in his hometown of Fryeburg and then after 1870 chiefly on Nantucket during the summer. Richard Koke, *American Landscape and Genre Paintings in The New-York Historical Society* (Boston: G. K. Hall and Co., 1982), 232.

8. Davis, "Eastman Johnson's *Negro Life at the South*," 68.

9. "The *crayon portrait* was popular in the mid-nineteenth century. It was larger than a miniature, less costly than an oil, and less taxing upon the sitter's time and patience than a painting." E. P. Richardson, *American Art: An Exhibition from the Collection of Mr. and Mrs. John D. Rockefeller 3rd* (San Francisco: The Fine Arts Museums of San Francisco, 1976), 78.

10. Teresa A. Carbone, "From Crayon to Brush: The Education of Eastman Johnson, 1840–1858," in Carbone and Hills, *Eastman Johnson: Painting America*, 12–13.

11. Ibid., 13–15.

12. The French firm of Goupil, Vibert and Co. produced the engraving. Ibid., 18.

13. Di Curcio, *Art on Nantucket*, 130. In 1899 Johnson emphasized the importance of his youthful study in The Hague and the influence of Rembrandt's painting on his own work when he created a self-portrait in a Dutch seventeenth-century burgher costume.

14. Albert Boime, *Thomas Couture and the Eclectic Vision* (New Haven: Yale University Press, 1980), 596–597. Boime goes on to claim that Johnson's first painting of renown, *Negro Life at the South*, not only is indebted to Couture's color sensibility and facture but also borrows Couture's compositional structure from his painting *Enrollment*. Teresa Carbone rejects Boime's claim, arguing that Johnson had begun developing the stylistic manner associated with Couture while still in The Hague. See her "From Crayon to Brush," in Carbone and Hills, *Eastman Johnson: Painting America*, 32.

15. Johnson produced more paintings, finished sketches, and a greater diversity of subjects for his maple sugar campaign than for any other project, including his recognized masterwork, *The Cranberry Harvest* (1880). The unfinished canvas intended for his final painting is probably the version of *Sugaring Off* (ca. 1865) in the Museum of Art, Rhode Island School of Design, Providence. Brian T. Allen, *Sugaring Off: The Maple Sugar Paintings of Eastman Johnson* (Williamstown, Mass.: Sterling and Francine Clark Art Institute, 2004), 19. However, Johnson never found a patron to support a finished version, 47.

16. Ibid., 33–35. The method depicted in *Sugaring Off* was called the "Fryeburg method" (named after Johnson's boyhood town) and dated from 1820.

17. Anne C. Rose, "Eastman Johnson and the Culture of American Individualism," in Carbone and Hills, *Eastman Johnson: Painting America*, 216.

18. Allen, *Sugaring Off*, 29–32.

19. Although never enlisting, Johnson painted Union troops in battle, contributed works to several auctions for the war effort, and painted the widely used propagandistic image of a wounded drummer boy. Ibid., 39.

20. Southerners praised the painting as proof of the benign effects of slavery under the plantation system. However, in an important revisionist essay, John Davis points out that the painting's actual urban setting of Washington, D.C. — which was central to Johnson's engagement with the issue of slavery in the nation's capital — was overlooked in their assessment. Davis, "Eastman Johnson's *Negro Life at the South*," 67–92.

21. An analysis of Johnson's *Christmas Tree* (1864) carries the important caveat that the painting's support of black emancipation "does so only under an overarching paternalism, in which even the most liberal attitudes were couched at the time." Carbone, "From Crayon to Brush," in Carbone and Hills, *Eastman Johnson: Painting America*, 64.

22. Quoted in Allen, *Sugaring Off*, 37.

23. Ibid., 42. Johnson's other major painting that addresses slavery is his *A Ride for Liberty—The Fugitive Slaves* (ca. 1863) in the Brooklyn Museum, New York.

40. EASTMAN JOHNSON, *Portraits (The Brown Family)*

1. "National Academy of Design," *Appleton's Journal* 1 (June 5, 1869): 309.

2. Johnson trained in Düsseldorf at the Düsseldorf Academy and then in the atelier of Emanuel Leutze (1849–51) before moving to The Hague to study seventeenth-century Dutch paintings for four years (1851–55). Stephen May, "America's Chronicler," *Art and Antiques* (April 2000): 89–90.

3. Patricia Hills, "Painting Race: Eastman Johnson's Pictures of Slaves, Ex-Slaves, and Freedmen," in Teresa A. Carbone and Hills, *Eastman Johnson: Painting America* (New York: Rizzoli, in association with the Brooklyn Museum of Art, 1999), 126.

4. In her discussion of the development of the European conversation-piece portrait, Patricia Hills remarks that during his training in The Hague, Johnson would have become familiar with conversation pieces by Gillis van Tilborch (ca. 1625–1678), Gonzales Coques (1614/18–1684), Gabriel Metsu (1629–1667), Adriaen van Ostade (1610–1685), and Pieter Codde (1599–1678). Patricia Hills, *The Genre Painting of Eastman Johnson: The Sources and Development of His Style and Themes* (New York and London: Garland Publishing, 1977), 114.

5. William Hogarth popularized the conversation piece through a series of paintings and engravings, such as *The Rake's Progress* (ca. 1735) and *Mariage à la Mode* (ca. 1743), that were visual morality tales for England's emerging middle classes.

6. Michael Rosenthal, *The Art of Thomas Gainsborough: "a little business for the eye"* (New Haven: Yale University Press for the Paul Mellon Center for Studies in British Art, 1999), 86.

7. For a discussion of American adaptations of European grand manner portraiture, see Daniell Cornell, *Visual Culture as History: American Accents, Masterworks from the Fine Arts Museums of San Francisco* (San Francisco: Fine Arts Museums of San Francisco, 2002), 15–18.

8. Christopher Flint, "The Family Piece: Oliver Goldsmith and the Politics of the Everyday in Eighteenth-century Domestic Portraiture," *Eighteenth-Century Studies* 29 (Winter 1995–96): 127–152.

9. *The Gilded Age: A Tale of Today* (1873) depicts the post–Civil War economic boom years and their driving spirit of acquisitiveness through a story about land speculation, financial profiteering, Washington corruption, murder, sensational courtroom spectacle, and illusory hope. The central characters, Colonel Beriah Sellers and Senator Abner Delworthy, are united by a government railroad bribery scheme that reveals the corruption and scandal on which the appearance of American promise and prosperity is based. "Gilded Age" refers to Greece's "Golden Age," with the implication that nineteenth-century America is a mere surface imitation of the classical world's genuine splendor.

10. Alexander Brown, James Brown's father, emigrated from England to found the first U.S. branch of the family's business in 1800 as Alexander Brown and Sons. James, the fourth son, became a full partner in 1811. The firm had branches in London, Philadelphia, Boston, and Baltimore. Frank R. Kent, *The Story of Alexander Brown and Sons* (Baltimore: Private printing, 1925), 183–185, 215.

11. James Brown married his first wife, Louisa Kirland Benedict, in 1817. He married Eliza in 1831.

12. S. S. Conant, "Fine Arts: The National Academy of Design," *Putnam's Magazine of Literature, Science, Art and National Interests* 3 (June 1869): 747.

13. Jane Weiss, "Home-Loving Sentiments: Domestic Contexts for Eastman Johnson's Paintings," in Carbone and Hills, *Eastman Johnson: Painting America*, 174.

14. For an account of gendered spheres in the Gilded Age, see Linda Nicholson, *Gender and History: The Limits of Social Theory in the Age of the Family* (New York: Columbia University Press, 1986). A comprehensive review of the historical approaches to gendered spheres is available in Linda Kerber, "Separate Spheres, Female Worlds, Woman's Place: The Rhetoric of Women's History," *Journal of American History* 75 (June 1988):

9–39. For an updated discussion on the relationship between gender and separate spheres on male subjects, see R. W. Connell, *Masculinities: Knowledge, Power, and Social Change* (Berkeley and Los Angeles: University of California Press, 1995), esp. 185–199. For a recent discussion of the relationships among nineteenth-century religious ethics, gender, and separate spheres, see Kathy Rudy, *Sex and the Church: Gender, Homosexuality, and the Transformation of Christian Ethics* (Boston: Beacon Press, 1997), 15–44.

15. John Davis, "Children in the Parlor: Eastman Johnson's *Brown Family* and the Post–Civil War Luxury Interior," *American Art* (Summer 1996): 52.

16. Although significant during the first half of the nineteenth century, the firm's wealth greatly increased during the Civil War, largely because of the thoroughly industrialized nature of that conflict, which initiated modern notions of combat and provided the investment opportunities James and John Brown exploited. John commissioned this portrait to celebrate his financial successes and his role in securing the legacy of the family company that he inherited from his father.

17. The Brown family had the means to commission Léon Marcotte in 1846, before he moved from France to New York in 1854, "followed by boatloads of 'showy furniture.'" He specialized in marquetry, butterfly motifs, and inlaid mother-of-pearl stars. Marshall B. Davidson, ed., *The American Heritage History of American Antiques, From the Revolution to the Civil War* (New York: American Heritage, 1968), 213.

18. John Crosby Brown commissioned a second, smaller version of the painting that focuses more tightly on the family grouping; it was sent to a nephew in London. Also called *The Brown Family* (1869, oil on paper mounted on canvas, 23⅝ × 28½ in.), the painting is now in the collection of the National Gallery of Art, Washington, D.C.

19. The critic goes on to write: "What conscience has been expended on the chandelier. It looks as if made up of the artist's crystallized tears of vexation at having to waste his time over the tasteless thing. What quiet skill has given the mantelpiece, though it must have hung like a millstone round his neck in the doing. And how skillfully he has wrought the whole discordant upholstery mess into a harmony which, while it allows nothing to escape, makes it easy to forget all the incongruous detail." "The Fine Arts: The National Academy of Design," *New-York Daily Tribune*, 22 May 1869.

20. For an extended discussion of the relationship between seventeenth-century Dutch realism and bourgeois society, see Svetlana Alpers, *The Art of Describing: Dutch Art in the Seventeenth Century* (Chicago: University of Chicago Press, 1983), passim.

21. Several pieces, including the fireplace, mirror, and sconces, had belonged to the Browns and been incorporated into their house at 21 University Place in 1846. Brady and Johnson were commissioned to record the Brown's drawing room in preparation for moving it from University Place to their new home on Park Avenue. Elsabeth Donaghy Garrett, "The American Home, Part IV: The Dining Room," *Antiques* 126 (October 1984): 918.

22. Davis, "Children in the Parlor," 54.

41. WINSLOW HOMER, *The Bright Side*

1. Homer also exhibited *Pitching Quoits* (1865, Fogg Art Museum, Harvard University) and *The Initials* (1864, private collection).

2. "National Academy of Design. Fortieth Annual Exhibition. Concluding Article," *Evening Post*, 31 May 1865, quoted in Marc Simpson,

Winslow Homer: Paintings of the Civil War (San Francisco: The Fine Arts Museums of San Francisco and Bedford Arts, 1988), 206.

3. For example, the critic for the *Albion* noted: "Good drawing and a broad sense of humour characterize this production." "Fine Arts. The National Academy of Design. Third Notice," *Albion* 43, no. 21 (27 May 1865): 249, quoted in ibid., 206.

4. Homer's mother, an accomplished watercolorist, was undoubtedly instrumental in his early artistic development, and although he would later produce stunning watercolors, early in his career Homer focused on mastering his draftsmanship. His father was a businessman, but he too encouraged young Winslow by presenting him with a gift of a drawing manual and later arranging for him to apprentice with a Boston lithographer. Nicolai Cikovsky addresses Homer's early artistic training and the significance of his Civil War experiences in his artistic development in Nicolai Cikovsky Jr. and Franklin Kelly, *Winslow Homer* (Washington, D.C.: National Gallery of Art, 1995), 17–37. For a year-by-year chronology of Homer's life, see ibid., 391–406. For a detailed chronology of Homer's life during the Civil War, see Simpson, *Homer: Paintings*, 16–23.

5. Homer's merit and future potential did not go unnoticed in the spring of 1865. A critic for the *New-York Daily Tribune* observed, "If he [Homer] shall paint every picture with the loyalty to nature and the faithful study that marks this little square of canvas, he will become one of the men we must have crowned when the Academy gets officers that have a right to bestow crowns. Meanwhile, the public crowns the best chronicler of the war, so far, with smiling eye and silent applause." "National Academy of Design," *New-York Daily Tribune*, 3 July 1865, quoted in ibid., 206. In addition, Homer was elected a full academician in the National Academy of Design in May 1865, no doubt in large part based on the artistic merit of *The Bright Side*; ibid., 47.

6. In 1863 General Order No. 6 sought to recruit blacks in the Union Army; ibid., 60 n. 29.

7. Oliver Wilcox Norton, "14 July, 1861," in *Army Letters, 1861–1865: Being Extracts from Private Letters to Relatives and Friends from a Soldier in the Field during the Late Civil War, with an Appendix Containing Copies of Some Official Documents, Papers and Addresses of Later Date* (Chicago: O. L. Dening, 1903), 355. From *The American Civil War: Letters and Diaries*, Alexander Street Press, http://www.alexanderstreet2.com/CWLDlive/index.html (accessed 30 October 2004).

8. In an 1866 article, T. B. Aldrich stated that Homer attempted to recruit an African American who lived near his studio to model for him. According to Aldrich, this man mistakenly thought the artist was an army surgeon intent on operating on him and thus ran from Homer's studio. T. B. Aldrich, "Among the Studios," *Our Young Folks: An Illustrated Magazine for Boys and Girls* 2, no. 6 (July 1866): 396–397. Extant sketches and preparatory paintings for *The Bright Side* are illustrated in Simpson, *Homer: Paintings*, 200, 202, 204.

9. "National Academy of Design. Seventh Article," *Watson's Weekly Art Journal* 3, no. 10 (1 July 1865): 148–149, quoted in Simpson, *Homer: Paintings*, 206. For an assessment of the humor attributed to Homer's painting, see Marc Simpson, "The Bright Side: 'Humorously Conceived and Truthfully Executed,'" in ibid., 47–63.

10. Michael D. Harris, *Colored Pictures: Race and Visual Representation* (Chapel Hill: University of North Carolina Press, 2003), 15.

11. See Elizabeth Johns, *American Genre Painting: The Politics of Everyday Life* (New Haven: Yale University Press, 1991), 33–38.

12. Harris, *Colored Pictures*, 40.

13. For a discussion of black soldiers assigned excessive work detail, see Keith P. Wilson, *Campfires of Freedom: The Camp Life of Black Soldiers During the Civil War* (Kent, Ohio: Kent State University Press, 2002), 38–44. On issues of equal pay for black soldiers, see ibid., 44–58.

42. JOHN GEORGE BROWN, *On the Hudson*

1. "The Painter of the Street Arabs," *Art Amateur* 31, no. 6 (November 1894): 125.

2. Martha J. Hoppin, *Country Paths and City Sidewalks: The Art of J. G. Brown* (Springfield, Mass.: George Walter Vincent Smith Art Museum, 1989), 15.

3. *Curling;—a Scottish Game, at Central Park* (1863, Lady Eden) and *Claiming the Shot: After the Hunt in the Adirondacks* (1865, The Detroit Institute of Arts).

4. The following investigation into the painting's commissioning depends entirely on the research of Sally Mills, then of the Fine Arts Museums of San Francisco, and Martha J. Hoppin, of the George Walter Vincent Smith Art Museum. Their correspondence on Brown can be found in the John George Brown *On the Hudson* object file, AAD/DEY/FAMSF.

5. Biographical and steamboat information from J. M. Van Valen, *History of Bergen County, New Jersey* (New York: New Jersey Publishing and Engraving Company, 1900), 504–505.

6. "Mr. John G. Brown, Artist, Dies of Pneumonia at 81," *New York Herald*, 9 February 1913, quoted in Sally Mills, "John George Brown," in Marc Simpson, Mills, and Jennifer Saville, *The American Canvas: Paintings from the Collection of The Fine Arts Museums of San Francisco* (New York: Hudson Hills Press, in association with The Fine Arts Museums of San Francisco, 1989), 128.

43. WORTHINGTON WHITTREDGE, *On the Cache la Poudre River, Colorado*

1. "Colorado," *Art Journal*, n.s., 2 (1876): 97.

2. Ibid., 99.

3. Worthington Whittredge, *The Autobiography of Worthington Whittredge*, ed. John I. H. Baur (reprint, New York: Arno Press, 1969), 45, 46.

4. Ibid., 32.

5. In his autobiography, Whittredge describes seeing the painting by Durand at the New-York Historical Society. However, there is no record of an exhibition of a Durand painting at the society when Whittredge returned from Europe. It seems likely that, recording the experience many years later, Whittredge was mistaken in either venue or the artist. However factually imperfect, the anecdote provides a strong idea of Whittredge's mind-set as he returned to his native country after ten years overseas. See Anthony F. Janson, *Worthington Whittredge* (Cambridge: Cambridge University Press, 1989), 70–71.

6. Whittredge, *Autobiography*, 41, 42.

7. Quoted in Janson, *Worthington Whittredge*, 215.

8. The painting is signed and dated 1868 on the reverse. Given that Whittredge fairly regularly redated his pictures, scholars accept the article in the *Greeley Tribune* that describes Whittredge at work on a study of a cottonwood tree as sufficient evidence to assign a date of 1871.

9. K. Hoermann, "Incoming Condition Report," 22 August 1986, object file, AAD/DEY/FAMSF.

10. The larger painting, also entitled *On the Cache la Poudre River* (1876, Amon Carter Museum, Fort Worth), is very similar to the Fine Arts

Museums' painting. There are differences in color, in the number and position of the deer, and in the placement of plants and foliage.

44. WILLIAM MORRIS HUNT, Governor's Creek, Florida

1. Elihu Vedder, *Digressions of V* (Boston and New York: Houghton Mifflin, 1910), 257, quoted in Theodore E. Stebbins Jr., introduction to Martha J. Hoppin and Henry Adams, *William Morris Hunt: A Memorial Exhibition* (Boston: Museum of Fine Arts, 1979), 7.

2. Martha J. Hoppin has been particularly attentive to recent misreadings of Hunt's career and to the critical reception of his work during his lifetime. See her "The Sources and Development of William Morris Hunt's Painting," in Hoppin and Adams, *William Morris Hunt*, 9–19; and Hoppin, "William Morris Hunt and His Critics," *American Art Review* 2 (September–October 1975): 79–91. In addition to the Hoppin and Adams catalogue, the most comprehensive treatments of Hunt's work include Marchal E. Landgren, *The Late Landscapes of William Morris Hunt* (College Park: University of Maryland Department of Art, 1975); and Sally Webster, *William Morris Hunt* (New York: Cambridge University Press, 1991).

3. Maybelle Mann, *Art in Florida, 1564–1945* (Sarasota, Fla.: Pineapple Press, 1999), 3.

4. T. Addison Richards, "The Landscape of the South," *Harper's New Monthly Magazine* 6 (May 1853): 721–733. In 1870 *Appleton's Journal* published an article titled "St. John's and Oklawaha Rivers, Florida," which was later included in *Picturesque America* (1872–74), a two-volume illustrated series of travel sketches edited by the poet William Cullen Bryant. Bryant's own report on Florida appeared in the *New York Evening Post* in 1873, the same year *Scribner's* ran a series of essays on the area by Edward King. King's essays, illustrated by James Wells Champney, were later compiled with other sketches by the same writer-illustrator team in the popular collection *The Great South* (1875). For more information, see Mann, *Art in Florida*, 53–55, 59. Angela Miller has suggested that before the Civil War northern artists avoided the South because of "distaste for southern slavery and an undeveloped market for southern views in the North." Miller, *The Empire of the Eye: Landscape Representation and American Cultural Politics, 1825–1875* (Ithaca, N.Y.: Cornell University Press, 1993), 238. For conditions specific to Florida, see Roberta Smith Favis, "Who Will Paint Florida?" in Favis, *Martin Johnson Heade in Florida* (Gainesville: University Press of Florida, 2003), 1–16.

5. Mann, *Art in Florda*, 62–63.

6. Harriet Beecher Stowe, *Palmetto Leaves* (Boston: James R. Osgood and Co., 1873), 36.

7. Ibid. David C. Miller's groundbreaking study *Dark Eden: The Swamp in Nineteenth-Century American Culture* (New York: Cambridge University Press, 1990) documents a growing interest in swamps, jungles, and wastelands in American literature of the mid–nineteenth century. Miller suggests that this new interest was related to shifting attitudes about nature and responses to change brought on by urbanism and technological advancement. There is something less gothic, however, about Stowe's enthusiastic and lively evocation of the Florida swamps. Perhaps this can be attributed to the fact that Stowe, a Florida resident, did not consider the swamps the dark unknown.

8. Landgren, *Late Landscapes*, 32, 70. See also Martha Shannon, *Boston Days of William Morris Hunt* (Boston: Marshall Jones Co., 1923), 123–124.

9. Landgren, *Late Landscapes*, 70.

10. Quoted in Helen Knowlton, *Art-Life of William Morris Hunt* (Boston: Little, Brown & Co., 1899), 106. Knowlton, a favorite student and frequent companion of Hunt's, was also the compiler of his lectures and art critiques, published as *W. M. Hunt's Talks on Art* (Boston: Houghton & Mifflin & Co., 1875).

11. Stowe, *Palmetto Leaves*, 28.

12. Hunt traveled to Florida again the following spring, this time by way of Havana, and the next year he visited Mexico. From 1875 to 1878 he continued making landscape sketches in the Northeast, traveling through New York and Massachusetts in a painter's wagon. See Knowlton, *Art-Life*, 109, for a discussion of the painter's wagon. For Hunt's influence on Homer, see Hoppin and Adams, *William Morris Hunt*, 31–33, and esp. n. 64. Patricia Junker has suggested that Homer would have been aware of Hunt's work and teachings through his published lectures and through Homer's good friend John La Farge, who had been Hunt's student. See Patricia Junker with Sarah Burns, *Winslow Homer: Artist and Angler* (Fort Worth: Amon Carter Museum; San Francisco: Fine Arts Museums of San Francisco, 2002), 39. In the same volume, see also Junker, "Fishing on the St. John's and Homosassa Rivers: Winslow Homer's Florida," 162–183. For a discussion of Hunt's influence on Heade, see Smith, *Martin Johnson Heade*.

13. For a useful discussion of Hunt's use of charcoals, see Hoppin, "William Morris Hunt and His Critics," 82–83.

14. See Landgren, *Late Landscapes*; and Webster, "Years of Recovery and Renewal: 1873–1878," chap. 4 in *William Morris Hunt*, for further discussion of Hunt's late landscapes.

15. The drawing, *Governor's Creek, Florida*, is reproduced in Landgren, *Late Landscapes*, no. 30, fig. 36, and in Webster, *William Morris Hunt*, fig. 100. The smaller painted version is reproduced in Landgren, *Late Landscapes*, no. 9, fig. 24. At the time Landgren's study was published in 1976, the painting was owned by Mrs. Harry S. Forbes of Milton, Massachusetts.

45. THOMAS EAKINS, The Courtship

1. Quotation recorded in the Thomas Eakins artist file, AAD/DEY/FAMSF.

2. The complete, official title was the Centennial International Exhibition of Arts, Manufactures and Products of the Soil and Mine.

3. The previous year, the National Academy of Design in New York accepted the first painting by Eakins, *Rail Shooting on the Delaware* (1876), for its 1877 exhibition. *William Rush Carving His Allegorical Figure of Schuylkill River* (1876–77), Eakins's first major history painting, is the breakthrough work that launched his artistic career. This painting is also significant for its anti-Victorian representation of an artist working directly from a nude model, the heart of Eakins's artistic philosophy and the principle that would embroil him in controversy. The society exhibited his *The Gross Clinic* (1875) the following year in 1879. The painting won numerous awards, including a gold medal at the Louisiana Purchase Exposition in Saint Louis in 1904. However, Eakins resigned from the society in 1892 after they rejected his paintings for its annual exhibition three years in a row, including *The Agnew Clinic* (1889), which he considered one of his most significant works. In 1893 it was exhibited to the public for the first time in any large exhibition at the Chicago World's Columbian Exposition, where it won a bronze medal. Lloyd Goodrich, *Thomas Eakins: His Life and Work* (New York: Whitney Museum of American Art, 1983), 168, 180.

4. Kathleen Brown, "Chronology," in *Thomas Eakins*, ed. Darrel Sewell (Philadelphia: Philadelphia Museum of Art, 2001), xxiv.

5. Beginning in 1868 Eakins also received instruction in sculpture from Augustin-Alexandre Dumont. Ibid., xxvi.

6. He assisted Dr. Samuel David Gross in surgery, and Dr. Joseph Pancoast with anatomy lectures.

7. Eakins first began his career at the Philadelphia Academy of the Fine Arts in 1863 as a volunteer "teacher" and was admitted to drawing classes with Peter F. Rothermel and Christian Schussele the same year. In 1866 he is listed as a "writing teacher." Brown, "Chronology," xxiv. Eakins became director of the schools and professor of painting at the Pennsylvania Academy in 1882. In 1886 he was dismissed for using nude models in his coeducational drawing classes. The first recorded protest of his use of nude models for life-drawing classes came from the mother of one of his students in 1882.

8. Reliefs, these sculptures were rejected for exhibition by the Society of American Artists in 1884. For a full discussion, see Kathleen A. Foster, *Thomas Eakins Rediscovered: Charles Bregler's Thomas Eakins Collection at the Pennsylvania Academy of the Fine Arts* (Philadelphia: Pennsylvania Academy of the Fine Arts; New Haven: Yale University Press, 1997), 408–410.

9. Eakins first demonstrated his uses for photography at the 5 December 1883 meeting of the Photographic Society of Philadelphia. See Robert S. Redfield, "Society Gossip: Photographic Society of Philadelphia," *Philadelphia Photographer* 21 (January 1884): 15. An account of Eakins's use of photographs in his paintings is offered in Mark Tucker and Nica Gutman, "Photographs and the Making of Paintings," in Sewell, *Thomas Eakins*, 225–238. His use of photography as an artistic medium is recounted in W. Douglass Paschall, "The Camera Artist," in ibid., 239–255.

10. The first of these exhibitions was organized by Gordon Hendricks. See his *Thomas Eakins: His Photographic Works* (Philadelphia: Pennsylvania Academy of the Fine Arts, 1969). In addition, Eakins was closely aligned with Eadweard Muybridge, who showed his photographs of animal locomotion during lectures at the Pennsylvania Academy on 12 and 16 February 1883. The school made its facilities available for Muybridge's experimental project in August 1883. In 1884 Eakins was one of nine commission members appointed by the Pennsylvania Academy to oversee the project. The University of Pennsylvania published Muybridge's *Animal Locomotion* plates in 1887.

11. The earliest and best overview of the case and responses to it remains Lloyd Goodrich, *Thomas Eakins* (Cambridge, Mass.: Harvard University Press, 1982), vol. 1, 281–295. Excerpts from contemporary letters and papers are included in the account by Kathleen A. Foster and Cheryl Leibold, *Writing about Eakins: The Manuscripts in Charles Bregler's Thomas Eakins Collection* (Philadelphia: University of Pennsylvania Press, 1989), 69–79. See also the exchange of letters between academy board president Edward H. Coates and Eakins in this same volume, 214–218.

12. This was an advanced idea at the time. It would be decades before women in Europe would have access to nude male models in their study. Kathleen A. Foster, "Eakins and the Academy," in Sewell, *Thomas Eakins*, 103.

13. A return to conservative morality and the crusade against perceived licentiousness was evident in Victorian culture. Anthony Comstock had already initiated his regressive campaign against vice in New York in the 1870s.

14. The controversy was fueled by the exhibition of *Swimming* (1884–85, Amon Carter Museum, Fort Worth), which clearly demonstrated in its depiction of the naked bodies of his easily identifiable students that Eakins had continued his use of students as nude models and even had taken them on off-campus outings where they posed nude.

15. Foster, "Eakins and the Academy," 104. Foster goes on to point out that this was only the first of at least four confrontational scandals involving charges of sexual impropriety that resulted from Eakins's insistence on progressive teaching methods.

16. The rehabilitation of Eakins's reputation is evident in his works being regularly accepted for exhibition at the Pennsylvania Academy after 1894 and in his often serving on its annual exhibition jury from 1901 until his death in 1916. Additionally, beginning in 1899 he regularly served on the jury for the Carnegie Institute's annual exhibitions. Perhaps most gratifying of all, in 1904 *The Gross Clinic* (1875) was awarded a gold medal at the Louisiana Purchase Exposition in Saint Louis.

17. These works are discussed in Marc Simpson, "Eakins's Vision of the Past and the Building of a Reputation," in Sewell, *Thomas Eakins*, 211–223. Simpson points out that from 1877 to 1883 Eakins produced fifty works that portrayed figures in historical costume, 211.

18. For an account of the Colonial Revival, see William H. Truettner and Roger B. Stein, eds., *Picturing Old New England: Image and Memory* (New Haven: Yale University Press; Washington, D.C.: National Museum of American Art, Smithsonian Institution, 1999).

19. Goodrich, *Thomas Eakins*, vol. 1, 59.

20. Eakins's Spanish notebook and discussion of *The Fable of Arachne* (1657) is transcribed in ibid., 61–62. The quote is in French: "le plus beau morceau de peinture que j'ai vu de ma vie." The title appears in the Museo del Prado's inventory of 1664.

21. *Bulfinch's Mythology, Illustrated* (New York: Avenel Books, 1974), 8.

46. THOMAS EAKINS, *Frank Jay St. John*

1. John Wilmerding discusses how the emotional impact of Eakins's forced resignation manifested in his work and life in "The Tensions of Biography and Art in Thomas Eakins," in *Thomas Eakins*, ed. Wilmerding (Washington, D.C.: Smithsonian Institution Press, 1993), 27.

2. Kathleen A. Foster discusses Eakins's withdrawal from the established academy and creation of a personal academy in "Portraits of Teachers and Thinkers," in *Thomas Eakins*, ed. Darrel Sewell (Philadelphia: Philadelphia Museum of Art, 2001), 307.

3. Thomas Eakins to Henry Rowland, 28 August 1897, Pennsylvania Academy of the Fine Arts archives, quoted in Brian Wolf, in Wilmerding, *Thomas Eakins*, 129.

4. *Specifications and Drawings of Patents Issued from the United States Patent Office for March, 1894* (Washington, D.C.: Government Printing Office, 1894), part 1, 189.

5. Margaretta Lovell, *American Painting, 1730–1960: A Selection from the Collection of Mr. and Mrs. John D. Rockefeller 3rd* (Tokyo: National Museum of Western Art, in association with the Fine Arts Museums of San Francisco, 1982), 57.

6. Kathleen A. Foster, *Thomas Eakins Rediscovered: Charles Bregler's Thomas Eakins Collection at the Pennsylvania Academy of the Fine Arts* (Philadelphia: Pennsylvania Academy of the Fine Arts; New Haven: Yale University Press, 1997), 212.

7. Lovell, *American Painting*, 57.

8. Foster, "Portraits," 315.

9. While I come to somewhat different conclusions than Wolf, I am drawing on his insightful reading of the Rowland portrait in Wilmerding, *Thomas Eakins*, 129–132. Foster, "Portraits," 313–314, also discusses the connection between thinking and doing.

10. Review of 1882, quoted in Foster, "Portraits," 312.

47. JAMES MCNEILL WHISTLER,
The Gold Scab: Eruption in Frilthy Lucre (The Creditor)

1. Frank A. Hadley, "Whistler, the Man, as Told in Anecdote," *Brush and Pencil* 12 (August 1903): 351.

2. Linda Merrill, *The Peacock Room: A Cultural Biography* (Washington, D.C.: Freer Gallery of Art, Smithsonian Institution, in association with Yale University Press, 1998), provides the most comprehensive discussion of this period in Whistler's career. In spite of Whistler's efforts to cast Leyland as a villainous creditor, Merrill notes that Leyland was among the majority who voted to spare Whistler the indignity of bankruptcy (which would have continued until all of his debts were paid or discharged by the court) and instead agreed to liquidate his assets and settle his debts by arrangement. Merrill, 279–281. On *The Gold Scab*, see Kirk Savage, "'A Forcible Piece of Weird Decoration': Whistler and *The Gold Scab*," *Smithsonian Studies in American Art* 4 (Spring 1990): 41–53.

3. The other two works, *The Loves of Lobsters* (1879) and *Mount Ararat* (1879), are unlocated. See Andrew McLaren Young, Margaret MacDonald, Robin Spencer, and Hamish Miles, *The Paintings of James McNeill Whistler* (New Haven: Yale University Press for the Paul Mellon Centre for Studies in British Art, 1980), vol. 1, 121–122, nos. 209, 210. Descriptions of the two paintings are drawn from Elizabeth Robins Pennell and Joseph Pennell, *The Life of James McNeill Whistler*, 2 vols. (London and Philadelphia: W. Heinemann and J. B. Lippincott, 1908). *The Gold Scab* was the largest of the three paintings.

4. Leyland's peacock features, including the spur and aggressive talons, are in keeping—though somewhat exaggerated—with the depiction of peacocks in Japanese prints and in the murals in the Peacock Room. For discussion of Whistler's knowledge of peacocks in Japanese art, see Merrill, *Peacock Room*.

5. "A Whistlerian Derangement," 19 September 1879, unidentified newspaper clipping in Whistler's autograph letters to Walter and C. M. Dowdeswell 2/50a, Library of Congress, Washington, D.C., Lessing J. Rosenwald Collection; and [Godwin], "Notes on Current Events," *British Architect* 14 (6 January 1882): 2. Both quoted in Merrill, *Peacock Room*, 288.

6. Whistler mockingly referred to Leyland's frills on the back of a letter from his patron during the negotiations over the Peacock Room: "Whom the gods intend to make ridiculous they furnish with a frill." Letter, dated 22 July 1877, University of Glasgow Library. Quoted in David Park Curry, *James McNeill Whistler at the Freer Gallery of Art* (New York: W. W. Norton and Co., 1984), 93. Also notable are two caricatures Whistler completed of Leyland: *F.R.L.—frill—of Liverpool / begins to be uncertain about the White House!* ca. 1879, pen and ink on paper, 5½ × 4⅜ in. (17.6 × 11 cm), Ashmolean Museum, Oxford; and *It occurs to F.R.L. frill that he will keep / an eye on the assets of the White House*, ca. 1879, pen and ink on paper, Hunterian Art Gallery, University of Glasgow, Birnie Philip Bequest. In both drawings, Leyland wears a prominent frilled collar. See Merrill, *Peacock Room*, 281, figs. 6.29, 6.30.

7. "A Whistlerian Derangement," in Merrill, *Peacock Room*, 288.

8. See Merrill, *Peacock Room*, and Curry, *Whistler at the Freer*, for further discussion of the Peacock Room. For an additional account of the relationship between Whistler and the Leyland family, see Susan Grace Galassi, "Whistler and Aesthetic Dress: Mrs. Frances Leyland," in Margaret F. MacDonald, Galassi, and Aileen Ribiero, *Whistler, Women and Fashion* (New York: The Frick Collection, in association with Yale University Press, 2003), 92–115. See also M. Susan Duval, "F. R. Leyland, a Maecenas from Liverpool," *Apollo* (August 1986): 110–115.

9. Both Merrill and Curry discuss this mural, alternately referred to as *Fighting Peacocks* and, simply, southeast wall of *Harmony in Blue and Gold: The Peacock Room*. There has been significant debate over whether the mural was designed before or after the quarrel between Whistler and Leyland, and especially when the silver accents were added. See Merrill, *Peacock Room*, 244–245, and Curry, "Artist and Architect," in *Whistler at the Freer*, 53–69. Curry suggests that the mural was always part of Whistler's conception for the Peacock Room and predates the quarrel with Leyland, while Merrill argues that the entire mural was produced after the dispute, and that the silver accents, rather than being added later to alter the meaning of the mural, were always a part of the design.

10. *The Three Girls* was dismembered by Whistler, and only one panel of it has been located (*Girl with Cherry Blossoms*, private collection, London; see Young et al., *Paintings of Whistler*, no. 90). For a discussion of *The Three Girls*, see ibid., 50–52, no. 88.

11. Ira M. Horowitz, "Whistler's Frames," *Art Journal* 39 (Winter 1979–80): 124–131.

12. Merrill, *Peacock Room*, 142–143. The musical excerpt was identified by Horowitz as the opening bars of Franz Schubert's *Moments Musicaux*, 1823, op. 94, no. 3.

13. It has been suggested that Whistler included *Moments Musicaux* on the frame because someone—perhaps Leyland himself—had played the piece in Whistler's studio while he was at work on *The Three Girls*. Horowitz ("Whistler's Frames") draws on this story, while Merrill (*Peacock Room*) reminds us that it has "no basis in fact." She notes (142–143), however, that Horace Jee, a musician and society figure who knew both Whistler and the Leylands, was often known to play the piano in Whistler's studio. The fact that Leyland was an accomplished amateur musician is undisputed. The announcement of the sheriff's sale of Whistler's property at the White House states that there was a "brilliant toned cottage pianoforte in walnut case" among his studio furnishings. (For an original proof of the poster, see the *Whistler Journal*, Pennell Collection, Library of Congress.) Whistler was notoriously unmusical, but his father was accomplished at both the piano and the violin. For further discussion of Whistler and the piano, see Richard Dorment, "At the Piano," in Dorment and Margaret F. McDonald, *Whistler* (London: Tate Gallery Publications, 1994), 71–73, cat. 11.

14. For a comprehensive discussion of the painting's provenance, see Merrill, *Peacock Room*, 288–289.

15. For discussion of the gender dynamics of piano playing in the nineteenth century, see Craig H. Roell, "The Place of Music in the Victorian Frame of Mind," in *The Piano in America, 1890–1940* (Chapel Hill: University of North Carolina Press, 1989), 1–27; and Richard Leppert, "Sexual Identity, Death, and the Family Piano," *Nineteenth-Century Music* 16 (Autumn 1992): 105–128. Mary Burgan offers an insightful analysis of the gendered conception of the piano as revealed in nineteenth-century litera-

ture: Burgan, "Heroines at the Piano: Women and Music in Nineteenth-Century Fiction," *Nineteenth-Century Studies* 30 (Fall 1986): 51–76. Most studies of nineteenth-century musical practice draw on the model set forth by English and German culture. For Leyland (an Englishman) and Whistler (an artist who spent the majority of his professional life in England), the British model was particularly relevant.

16. Burgan, "Heroines at the Piano," 59. James Paraskilas, "Austen and the Domestic Life of the Piano," in *Piano Roles: Three Hundred Years of Life with the Piano*, ed. Paraskilas (New Haven: Yale University Press, 1999), 96–103. There has been relatively little work on this subject in relation to visual art, perhaps because it was typically the province of genre painters, who are less frequently the focus of scholarship. A notable exception to this is Charlotte N. Eyerman, "Piano Playing in Nineteenth-Century French Visual Culture," in Paraskilas, *Piano Roles*, 216–235.

17. Eyerman, "Piano Playing," 216. Eyerman suggests that the appearance of women at the piano in French art has broader implications and relates to the use and meaning of pianos in America, since Americans looked to Paris as an influential visual and musical capital in the nineteenth century. European models found in French visual culture and British examples such as Hunt's painting would have been particularly relevant for Whistler, who spent time in Paris and lived abroad. Whistler himself interpreted the woman-at-the-piano motif in his *At the Piano* (1858–59). This painting of his half sister and her daughter at the family piano escapes the sentimentality of many piano paintings. It was reproduced in the first serious American article about Whistler in 1879, the same year as *The Gold Scab*, and continued to be included in accounts of his "greatest" and "most famous" paintings even after he had become better known for his more atmospheric and decorative later works. *At the Piano* is a relatively minor deviation from the woman-at-the-piano motif in comparison to *The Gold Scab*. Viewers' knowledge of *At The Piano* would likely have made Whistler's subsequent departure from the representational conventions of piano pictures particularly shocking. See "Whistler in Painting and Etching," *Scribner's Monthly* 18 (August 1879): 481–495; William F. Losee, "James McNeill Whistler," *Brush and Pencil* 12 (August 1903): 319–333; and J. Walker McSpadden, "James A. McNeill Whistler; Painter of Protest," in *Famous Painters of America* (New York: Dodd, Mead and Co., 1916), 221–271. For discussion of *At the Piano*, see Kenneth Paul Bendiner, "Whistler's *At the Piano*," *Apollo* 128 (December 1988): 399–401; and Bendiner, "James Abbott McNeill Whistler: *At the Piano*," in *The Taft Museum: Its History and Collection* (New York: Hudson Hills Press, 1995), vol. 1, 217–219.

18. See Caroline Arscott, "Employer, Husband, Spectator: Thomas Fairbarn's Commission of *The Awakening Conscience*," *The Culture of Capital: Art, Power, and the Nineteenth-Century Middle Class*, ed. Janet Wolff and John Seed (Manchester, U.K.: Manchester University Press, 1988), 159–190; Kate Flint, "Reading *The Awakening Conscience* Rightly," in *Pre-Raphaelites Re-viewed*, ed. Marcia Pointon (Manchester, U.K.: Manchester University Press, 1989), 45–65; and Michael Hancher, "Hunt's Awakening Conscience," *Journal of Pre-Raphaelite Studies* 4 (Fall 1995): 27–43. It is unclear whether Whistler knew Hunt, but he was a friend and neighbor to Hunt's fellow Pre-Raphaelite artist Dante Gabriel Rossetti, and it was Rossetti who introduced Whistler to Leyland in 1867. Duval, "Leyland," 111.

19. Joanna Meacock, "Signatures," Center for Whistler Studies/History of Art Department, University of Glasgow, http://www.mr-whistlers-

art.info. See also the discussion of Whistler's butterflies in *The Gentle Art of Making Enemies* in Curry, *Whistler at the Freer*, 280–281. In 1903 the butterflies became the subject of a lighthearted magazine article: Annie Nathan Meyer, "Whistler's Butterflies," *Critic* 43 (September 1903): 254–256, which analyzes their appearance in *The Gentle Art of Making Enemies*.

20. Val Prinsep, "James A. McNeill Whistler, 1834–1903; Personal Recollections," *Magazine of Art* 26 (November 1903): 580.

48. ELIHU VEDDER, *The Sphinx of the Seashore*

1. William Howe Downes, "Elihu Vedder's Pictures," *Atlantic Monthly* 59 (June 1887): 843.

2. Regina Soria identifies the use of "Vedderesque" in "Elihu Vedder: An American Visionary Artist," *American Art and Antiques* 2 (July–August 1979): 38.

3. The most comprehensive study of Vedder's life and career is Regina Soria, *Elihu Vedder: American Visionary Artist in Rome* (Rutherford, N.J.: Fairleigh Dickinson University Press, 1970). Soria has also written useful articles about the artist: "Elihu Vedder's Mythical Creatures," *Art Quarterly* 26 (Summer 1963): 181–193; and "Elihu Vedder: An American Visionary Artist," 38–45. See also *Perceptions and Evocations: The Art of Elihu Vedder* (Washington, D.C.: Smithsonian Institution Press for the National Collection of Fine Arts, 1979), which includes an introduction by Soria and several other essays.

4. "Exhibition of Paintings at the Athenaeum Gallery, Boston," *Watson's Art Journal* 9 (15 August 1868): 212.

5. For a comprehensive discussion of the influence of Egyptomania on Western art and culture in the nineteenth century, see Jean-Marcel Humbert, Michael Pantazzi, and Christiane Ziegler, *Egyptomania: Egypt in Western Art, 1730–1930* (Ottawa: National Gallery of Canada, in association with the Réunion des Musées Nationaux/Musée du Louvre, Paris, and the Kunsthistorisches Museum, Vienna, 1994).

6. Ibid., 22, 312, 331, 450.

7. See Peter A. Clayton, *The Rediscovery of Ancient Egypt: Artists and Travelers in the Nineteenth Century* (London: Thames and Hudson, 1982); and Clayton, *Explorers and Artists in the Valley of the Kings* (Cairo: American University in Cairo, 2001). Over the course of the nineteenth century, Americans increasingly had access to Egyptian artifacts in their own cities. The Metropolitan Museum of Art in New York City, founded in 1870, began collecting Egyptian artifacts in 1874. In 1881 Cleopatra's Needle, an obelisk presented by the Egyptian government, was erected in Central Park behind the museum. Neil Harris, "Four Stages of Cultural Growth: The American City," in *Cultural Excursions: Marketing Appetites and Cultural Tastes in Modern America* (Chicago: University of Chicago Press, 1990), 20; and Lisa Small, "Western Eyes, Eastern Visions," in *A Distant Muse: Orientalist Works from the Dahesh Museum of Art* (New York: Dahesh Museum of Art, 2000), 20.

8. Paul Jordan, *Riddles of the Sphinx* (Phoenix Mill, Gloucestershire, U.K.: Sutton Publishing, 1998), 21, 112.

9. Ibid., 97, discusses the clearing of sand. The problem of sand was also discussed in period guidebooks. See, for example, *A Handbook for Travelers in Egypt* (London: John Murray, 1875).

10. Jordan, *Riddles*, xvii.

11. Vedder to an admirer, 7 September 1884, quoted in Marjorie Reich, "The Imagination of Elihu Vedder—as Revealed in His Book Illustra-

tions," *American Art Journal* (May 1974): 40. The original letter is in the Century Collection, New York Public Library. (Also available in microfilm in Vedder Papers, AAA/SI, microfilm reel 8, frames 936–939.)

12. Elihu Vedder, *The Digressions of V* (Boston and New York: Houghton Mifflin Co., 1911), 451.

13. Vedder to his wife, Carrie, 12 January 1890, quoted in Soria, *Elihu Vedder*, 203.

14. Vedder, *Digressions*, 454.

15. Bishop's article was the most comprehensive treatment of Vedder to appear during the artist's lifetime: W. H. Bishop, "Elihu Vedder," *American Art Review* 1 (1879–80): 325–329, 369–373, quotation on 325. The making of the *American Art Review* profile is discussed in David Tatham, "Elihu Vedder's Lair of the Sea Serpent," *American Art Journal* (Spring 1985): 33–47.

16. Bishop, "Vedder," 326.

17. F. D. Millet, "Elihu Vedder's Pictures," *Atlantic Monthly* 45 (June 1880): 846–847. While Vedder's dark themes had some detractors, many critics praised them and found a gothic taste in art to be a characteristic of American culture, especially in the years immediately following the Civil War. A critic for *Watson's Weekly Art Journal* wrote in 1865: "[Vedder] treats the weird, the wild, and the gloomy. The creatures of his imagination flit along the boundary line of day and night, or reason and unreason, of hope and despair.... Creations such as his have a powerful fascination for the mind; they seize upon the imagination; they suggest thought; but they do not elevate the soul.... It is a noteworthy fact that we Americans, whose antecedents and education would seem to be most averse to the indulgence of a frame of mind delighting in the terrible—the weird, should nevertheless show so marked an inclination thereto. Is it because we feel that it is preeminently our duty as a nation to grapple with the powers of darkness, to subdue those monster evils that stalk along the twilight of feudal hierarchism and the new civilization? Or is it the force of the undisaplined [*sic*] imagination of youth, eager to explore new realms of thought, to lay open the yet untrodden wildernesses of existence?" *Watson's Weekly Art Journal* 3 (24 June 1865): 131. The fullest discussion of this gothic taste is Sarah Burns, *Painting the Dark Side: Art and the Gothic Imagination in Nineteenth-Century America* (Berkeley and Los Angeles: University of California Press, 2004).

18. David Tatham's essay on Vedder's *Lair of the Sea Serpent* is the first comprehensive discussion of possible sources for one of Vedder's allegorical works. Tatham argues that the painting relates to the local lore surrounding a sea serpent off the New England coast. Vedder's relationship with contemporary mythologies of sirens, mermaids, and other dangerous female figures is less well established. Bram Dijkstra, *Idols of Perversity: Fantasies of Feminine Evil in Fin-de-Siecle Culture* (New York: Oxford University Press, 1986), discusses the femme fatale figure in art at the turn of the century, but there have been few studies of the uses of the type in this earlier moment. Carter Ratcliff, "The Gender of Mystery: Elihu Vedder," *Art in America* 67 (November 1979): 84–92, at 92, offers another way of thinking about female figures in Vedder's work: "Vedder's art implies an unresolvable drama of unknowing—of, in his terms, male consciousness entranced and stymied by the secrets of nature, history, destiny, and all those other powers whose resistance to rational analysis makes them female. Yet Vedder is more accessible in our time if this sexual polarity is dropped—if, that is, we see his subject as consciousness, male or female, losing and finding itself in an awareness of the limits to understanding set

by gender-free ultimates." Ratliff further argues that Vedder's work suppressed "any sense of sexuality as the medium of ultimate mysteries" and notes that his depictions of women at this time were "relentlessly genteel," 91. Sarah Burns offers a different reading of Vedder's images of women; see her "Mental Monsters," in *Painting the Dark Side*, 158–187, in which she charts "Vedder's pictorial discourse of female monstrosity," 185.

19. Unidentified review from the *Boston Evening Transcript*, 20 January 1900, Vedder Papers, AAA/SI, microfilm reel 528, frame 1101.

20. See *Handbook for Travelers in Egypt*.

21. Soria, *Elihu Vedder*, 15–16. Vedder discusses the dream as well in his *Digressions*, 112–113. An additional inspiration may have been *Ozymandias* (1818), the famous poem on the Egyptian ruins by Percy Bysshe Shelley: "I met a traveller from an antique land, / Who said—'Two vast and trunkless legs of stone / Stand in the desert.... Near them, on the sand, / Half suck a shattered visage lies, whose frown, / And wrinkled lip, and sneer of cold command, / Tell that its sculptor well those passions read / Which yet survive, stamped on these lifeless things, / The hand that mocked them, and the heart that fed; / And on the pedestal, these words appear: / My name is Ozymandias, King of Kings, / Look on my Works, ye Mighty, and despair! / Nothing beside remains. Round the decay / Of that colossal Wreck, boundless and bare / The lone and level stands stretch far away.'" *The Norton Anthology of English Literature*, 6th ed. (New York: W. W. Norton and Co., 1993), vol. 2, 672.

22. For discussion of Vedder's illustrations for the *Rubáiyát*, see Jane Dillenberger, "Between Faith and Doubt: Subjects for Meditation," in *Perceptions and Evocations*, 146; and Andrew Wilton and Robert Upstone, eds., *The Age of Rossetti, Burne-Jones, and Watts: Symbolism in Britain, 1870–1910* (London: Tate Gallery Publishing, 1997), 185. See also Reich, "The Imagination of Elihu Vedder," for a general discussion of Vedder's illustrations. Charles Eldredge has also related *The Sphinx of the Seashore* to a poem Vedder wrote about sirens on an empty beach. See Eldredge, "Wet Paint: Herman Melville, Elihu Vedder, and Artists Undersea," *American Art* 2 (Summer 1997): 130. Interestingly, Vedder did not copyright *The Sphinx of the Seashore* until 1899, perhaps as a result of the increased attention his work received after the success of his illustrations for the *Rubáiyát*.

23. Quoted in Soria, "Vedder's Mythical Creatures," 188.

49. FRANK DUVENECK, *Study for "Guard of the Harem"*

1. Sargent's statement, invariably cited in studies of Duveneck, was allegedly made at a dinner party in London in the early 1890s. The origins of the quote are unclear, but it was returned to circulation when it was printed in Norbert Heermann, *Frank Duveneck* (Boston: Houghton Mifflin Co., 1918), 1. Since then, numerous stories have circulated about the story. In Heermann's version, Sargent "spoke at a dinner given at London in the early nineties, in a discussion of the merits of such eminent men as Carolus Duran and others." Heermann's book, published the year before the artist's death, was the earliest study of Duveneck's life and career. Other useful sources on Duveneck include the biography written by his daughter-in-law, Josephine Whitney Duveneck, *Frank Duveneck: Painter—Teacher* (San Francisco: John Howell Books, 1970); Walter H. Siple, *Exhibition of the Work of Frank Duveneck* (Cincinnati: Cincinnati Art Museum, 1936); Michael Quick, *An American Painter Abroad: Frank Duveneck's European Years* (Cincinnati: Cincinnati Art Museum, 1987); Robert Neuhaus, *Unsuspected Genius: The Art and Life of Frank Duveneck*

(San Francisco: Bedford Press, 1987); and Jan Newstrom Thompson, *Duveneck: Lost Paintings Found* (Santa Clara, Calif.: Triton Museum of Art, 1987).

2. Quick, *American Painter Abroad*, 11, 12. A useful chronology of Duveneck's career is included in Duveneck, *Frank Duveneck*, 165–166. For further discussion of Duveneck's activities in the art community of Cincinnati, see *Cincinnati Painters of the Nineteenth Century Represented in the Cincinnati Art Museum* (Cincinnati: Cincinnati Art Museum, 1979).

3. Neuhaus, *Unsuspected Genius*, 6–7.

4. Thompson, *Duveneck: Lost Paintings Found*, 6–7. Courbet visited Munich in 1869, when his work was included in the First International Art Exposition there.

5. Quick, *American Painter Abroad*, 24.

6. Neuhaus, *Unsuspected Genius*, 36.

7. Henry James, "Arts," *Nation* 20 (3 June 1875): 376.

8. Ibid., 377.

9. Thompson, *Duveneck: Lost Paintings Found*, 9.

10. For a discussion of Orientalism in the nineteenth century, see Lisa Small, "Western Eyes, Eastern Visions," in *A Distant Muse: Orientalist Works from the Dahesh Museum of Art* (New York: Dahesh Museum of Art, 2000). Orientalist works were primarily a French phenomenon and began to appear in great numbers at the beginning of the nineteenth century after Napoleon's expedition to Egypt. Whereas avant-garde artists turned to the Orient and Japan for formal innovations, orientalist painters focused on capturing an imaginary construct of the Near East. If French Orientalism depicted the East as a feminized and exotic region, American Orientalism was less blatantly erotic, and American artists described the Orient as a mysterious and desirable region. For Americans, Orientalism was a context for art making rather than "an imperialistic, voyeuristic, or even ethnographic exercise." See Holly Edwards et al., *Noble Dreams, Wicked Pleasures: Orientalism in America, 1870–1930* (Princeton, N.J.: Princeton University Press in association with the Sterling and Francine Clark Art Institute, 2000), 13, 25. Edwards describes Chase, who never actually traveled to the Orient, as a "studio orientalist" who "imbued his personal spaces with the entrepreneurial exotic." For Chase, Orientalism was about pleasing details and surfaces, not deeper knowledge of Eastern cultures. Edwards, 175.

11. "Art," *Atlantic Monthly* 39 (May 1877): 641–642. This passage is cited in Theodore E. Stebbins Jr. et al., *A New World: Masterpieces of American Painting, 1760–1910* (Boston: Museum of Fine Arts, 1983), 296. For a discussion of Chase's *The Turkish Page* (1876), see Quick, *American Painter Abroad*, 38–39. The painting is owned by the Cincinnati Art Museum.

12. "Culture and Progress," *Scribner's Monthly* 14 (June 1877): 263.

13. George McLaughlin, "Cincinnati Artists of the Munich School," *American Art Review* 2 (1881): 4.

14. The earliest source on Near Eastern history and culture that was widely available to artists was *The Description of Egypt* (first published in Paris and then translated, 1809–28), the study produced by the artists, archaeologists, and scholars Napoleon brought to Egypt. John G. Wilkinson's *Manners and Customs of the Ancient Egyptians* (London, 1837) formed the basis of popular knowledge of ancient Egypt for much of the nineteenth century. The book, researched during twelve years of excavations, reproduced texts, furnishings, wall reliefs, and other previously undocumented details, which provided valuable source material for artists. For those interested in contemporary Egypt, Edward William Lane's *An*

Account of the Manners and Customs of Modern Egyptians (London, 1836) was a valuable source for information about the Egyptian material environment and habits of daily life. These works are discussed in Small, "Western Eyes, Eastern Visions,"17–20.

15. McLaughlin, "Cincinnati Artists," 4.

16. Quick, *American Painter Abroad*, 48.

17. Ibid., 47–48.

18. Thompson, *Duveneck: Lost Paintings Found*, 12.

19. The study remained in the Duveneck family until 1990, whereas the unfinished painting was given by the artist to the Cincinnati Art Museum in 1915.

20. Hals and Velázquez were admired by many students and instructors at the Munich Academy. Duveneck often attempted to copy the works of these masters, bringing his own paintings to the Pinakothek in Munich to compare them to the originals. He was particularly fond of Hals, whose work had recently been rediscovered. Thompson, *Duveneck: Lost Paintings Found*, 7.

21. Elizabeth Boott's letters are often cited in studies of Duveneck. They were first published in Duveneck, *Frank Duveneck* (1970). Duveneck's book is still the most complete and comprehensive source for Boott's letters. For this excerpt, see 77.

50. WILLIAM BRADFORD, *Scene in the Arctic*

1. "Art in San Francisco—New Pictures," *San Francisco Daily Evening Bulletin*, 5 August 1876.

2. The most comprehensive studies of Bradford's life and career are Richard C. Kugler, ed., *William Bradford: Sailing Ships and Arctic Seas* (Seattle: University of Washington Press, in association with the New Bedford Whaling Museum, 2003); and John Wilmerding, *William Bradford: Artist of the Arctic* (Lincoln, Mass.: DeCordova Museum, in association with the Whaling Museum of New Bedford, 1969). For the Bradford quote, see Kugler, *Bradford: Sailing Ships*, 28.

3. Wilmerding, *Bradford*, 11. Kugler, *Bradford: Sailing Ships*, 13–14.

4. Kugler, *Bradford: Sailing Ships*, 7–8.

5. For connections between Bradford and Bierstadt, see ibid., 7, 10–12. It is also likely that Bierstadt was instrumental in introducing Bradford to important patrons, and in encouraging Bradford to establish a studio in San Francisco. See ibid., 26, 34.

6. On Church's *The Icebergs*, see Gerald Carr, *Frederic Edwin Church: The Icebergs* (Dallas: Dallas Museum of Fine Arts, 1980); and Eleanor Jones Harvey, *The Voyage of the "Icebergs"* (Dallas: Dallas Museum of Art, in association with Yale University Press, 2002). Two of Bradford's most important patrons were the Boston physician John C. Sharp, who financed his expedition in 1861, and LeGrand Lockwood, an early supporter of Bradford's work who financed his most ambitious voyage, in 1869. Kugler, *Bradford: Sailing Ships*, 14, 26.

7. Kugler, *Bradford: Sailing Ships*, 2–3.

8. Ibid.

9. For further background, see John Wilmerding, *A History of American Marine Paintings* (Boston: Little, Brown & Co.; Salem, Mass.: Peabody Museum of Salem, 1968); Lewis A. Shepard, *American Painters of the Arctic* (Amherst, Mass.: Mead Art Gallery, Amherst College, 1975); and Roger B. Stein, *Seascape and the American Imagination* (New York: Whitney Museum of American Art, 1975). Gerald Carr also provides useful context for the popularity of Arctic paintings in his *Church: The Icebergs*.

10. Shepard, *American Painters of the Arctic*, 2; Carr, *Church: The Icebergs*, 10–11.

11. See Carr, *Church: The Icebergs*, 39–54, and Kugler, *Bradford: Sailing Ships*, 16.

12. Kugler, *Bradford: Sailing Ships*, 16–17. Although Church revisited Arctic subjects in *Aurora Borealis* (1865) and *The Iceberg* (1891), he did not become as closely associated with the region as Bradford later did. See Harvey, *The Voyage of the "Icebergs"*; Carr, *Church: The Icebergs*; and William H. Truettner, "The Genesis of Frederic Edwin Church's *Aurora Borealis*," *Art Quarterly* 31 (Autumn 1968): 267–283.

13. Bradford traveled with the Boston photographers William H. Pierce, George Critcherson, and J. L. Dunmore. Critcherson and Dunmore, of the firm James Wallace Black, accompanied him on his final expedition in 1869 and assisted with the production of the photographs in *Arctic Regions*. Dunmore published a short account of the voyage later that year: Dunmore, "The Camera among the Icebergs," *Philadelphia Photographer* 6 (December 1869): 412–413. The *Philadelphia Photographer* published several articles about Bradford's use of photography in the following decades. Isaac I. Hayes, a noted polar explorer who served as a paid adviser to the expedition, published his own account, which is illustrated by engravings after the photographs produced in the Arctic: Hayes, *The Land of Desolation: Being a Personal Narrative of Observation and Adventure in Greenland* (New York: Harper and Bros., 1872). Bradford's *Arctic Regions* was available by subscription, and fewer than 300 copies were produced. Hayes's account was likely better known to many readers.

14. "The Arctic Regions," *Art Journal* (London), 25 (1873): 255.

15. "The Paintings of Mr. William Bradford, New York," *Philadelphia Photographer* 31 (January 1884): 7.

16. William Bradford, *The Arctic Regions, Illustrated with Photographs Taken on an Art Expedition to Greenland, with Descriptive Narrative by the Artist* (London: S. Low, Marston, Low, and Searle, 1873). For a discussion of Bradford's photographs in relation to nineteenth-century attitudes toward photography, see Frank Horsch, "Photographs and Paintings by William Bradford," *American Art Journal* 5 (November 1973): 61–70. Recent scholars have devoted greater attention to the role played by the professional photographers who accompanied Bradford. See Sandra Phillips, "The Arctic Voyage of William Bradford: Photographs by John Dunmore and George Critcherson, under the Direction of William Bradford," *Aperture* 90 (1983): 16–27. The most comprehensive discussion of Bradford's use of photography is Adam Greenhalgh, "The Not so Truthful Lens: William Bradford's *The Arctic Regions*," 72–86, in Kugler, *Bradford: Sailing Ships*.

17. Bradford's late style is discussed at greatest length by John Wilmerding. See his *Bradford*, 34–35, and Wilmerding, ed., *American Light: The Luminist Movement, 1850–1875* (Washington, D.C.: National Gallery of Art, 1980), 123–128. More recent studies such as the catalogue edited by Richard Kugler have focused on earlier moments in Bradford's career.

18. Greenhalgh, "The Not so Truthful Lens," 79.

19. The painting is in the collection of Maurice Tempelsman. It is reproduced in Kugler, *Bradford: Sailing Ships*, 138, cat. 52.

51. THOMAS POLLOCK ANSHUTZ,
The Ironworkers' Noontime

1. Francis J. Ziegler, "An Unassuming Painter—Thomas P. Anshutz," *Brush and Pencil* 4 (September 1899): 280.

2. Randall C. Griffin, *Thomas Anshutz: Artist and Teacher* (Seattle: University of Washington Press, in association with the Heckscher Museum, 1994), 38.

3. Ibid., 37.

4. Ibid., 42.

5. Other images of foundry work, especially those in popular illustration, often relied on the discourse of horror used by Dante and gothic writers, who portrayed it as an underworld of the supernatural, infernal, and demonic. Ibid., 40.

6. Anshutz titled the painting *The Ironworkers* and then *Dinner Time*. When Thomas B. Clarke, an important early collector of American art, purchased the painting from Anshutz in 1883, he changed the title to *The Ironworkers' Noontime*. Ibid., 118 n. 59.

7. See, for instance, Edward Lucie-Smith, *American Realism* (New York: Harry N. Abrams, 1994), 63.

8. *Man at Work* (Denver: Schleier Gallery, Denver Art Museum, 1952), 15. In one of the earliest monographs to establish the importance of American art, the painting is praised for its attention to the working class: "A painter has at last endeavored to incorporate the millions into his work." Jerome Mellquist, *The Emergence of an American Art* (New York: Charles Scribner's Sons, 1942), 80. The most complete discussion of *The Ironworkers' Noontime* as an unvarnished depiction of changing labor conditions brought about by industry is in Griffin, *Thomas Anshutz: Artist and Teacher*, 37–45.

9. "There are troubles between employers and their workmen in the United States as elsewhere: but the case of the men is so much more in their own hands there than where labour superabounds, that strikes are of a very short duration.... [T]he wages of labour are so good that there is less cause for discontent on the part of workmen than elsewhere." *Life in America: A Special Loan Exhibition of Paintings Held during the Period of the New York World's Fair* (New York: The Metropolitan Museum of Art, 1939), 206. Similiarly, the first major exhibition catalogue to include the painting states merely: "At the stroke of noon the toilers at forges and furnaces emerge into the cinderous outer precincts of the foundry, for a brief respite from labor, and refreshment against labor yet to come. Utter weariness and the robust strength of abundant manhood are seen in contrast." Thomas B. Clarke, *Catalogue of the Thomas B. Clarke Collection of American Pictures* (Philadelphia: Pennsylvania Academy of the Fine Arts, 1891), 7. Most recently, Thomas H. Pauly emphasizes the celebratory aspects of this painting, asserting that it is "not criticizing industrialization or its effect upon labor; such concerns are ones our age has read into Anshutz's unusual painting." Pauly, "American Art and Labor: The Case of Anshutz's *The Ironworkers' Noontime*," *American Quarterly* 40 (September 1988): 333–358.

10. "The rough play of boys, the only interaction in the composition, is a poignant reminder of the extensive use of child labor in American industry." Judith Ayre Schomer, "New Workers in a New World: Painting American Labor, 1830–1913," *Labor's Heritage* 3 (January 1991): 46. The major exception to this generalizing is Randall Griffin's explanation of the specific work of "puddling" that would have occupied the ironworkers in this painting. See Griffin, *Thomas Anshutz: Artist and Teacher*, 42.

11. *Thomas Anshutz: 1851–1912* (Philadelphia: Pennsylvania Academy of the Fine Arts, 1973), 8.

12. Anshutz's interest in the avant-garde is evident in the list of students he influenced, including Robert Henri, Hugh Breckenridge, Arthur B. Carles, William J. Glackens, John Marin, H. Lyman Sayen, Charles Sheeler, and Morton Schamberg. William H. Gerdts, "The American

Fauves: 1907–1918," in *The Color of Modernism: The American Fauves* (New York: Hollis Taggart Galleries, 1997), 27.

13. Wayne Craven, *American Art: History and Culture* (Madison, Wisc.: Brown and Benchmark, 1994), 342.

14. The Ashcan School emerged out of a group of artists who exhibited together as the Eight in 1908 at Macbeth Galleries in New York City. The exhibition included Arthur B. Davies, William J. Glackens, Robert Henri, Ernest Lawson, George Luks, Maurice B. Prendergast, Everett Shinn, and John Sloan. For a discussion of all eight artists and the exhibition, see Bernard B. Perlman, *The Immortal Eight: American Painting from Eakins to the Armory Show, 1870–1913* (Cincinnati: North Light Publishers, 1979).

15. Writing about *The Ironworkers' Noontime*, Patricia Hills comments, "the nineteenth century witnessed an intensification of the struggles between labor and capital as industrialization became firmly established in the nation. A new subject entered into art: the urban proletariat. Many artists and writers sympathized with the hopes and goals of this urban proletariat, and were attracted to various socialist groups that advocated reforms and/or the overthrow of the economic and social system of capitalism." Hills, *The Working American* (Washington, D.C.: Smithsonian Institution, 1979), 8.

16. Griffin, *Thomas Anshutz: Artist and Teacher*, 38–39. Studies include fifteen drawings, two oil sketches, and a number of perspective sketches, 46.

17. Randall Griffin has identified the probable source for the poses of the two most prominent figures as Lord Elgin's Parthenon fragments, which Anshutz would have studied through a cast version at the Pennsylvania Academy. Ibid., 43.

18. Melissa Dabakis writes about the painting: "Positioned as if on a stage set, these workers appear to place their exposed arms, shoulders, and upper torsos deliberately on display for middle-class consumption." See "Douglas Tilden's Mechanics Fountain: Labor and the Crisis of Masculinity in the 1890s," *American Quarterly* 47 (June 1995): 204.

19. For a description of this work, see David Montgomery, *The Fall of the House of Labor: The Workplace, the State, and American Labor Activism, 1865–1925* (Cambridge, U.K.: Cambridge University Press, 1987), 14–16.

20. The sketch is *Factory—Study for "The Ironworkers' Noontime"* (1880, oil on paperboard, 8½ × 12⅞ in. Hirshhorn Museum and Sculpture Garden, Smithsonian Institution. Gift of Joseph H. Hirshhorn, 1966).

21. For an account of the cultural implications of the 1876 Centennial International Exhibition in Philadelphia as well as the 1877 strike, with special attention to the Pennsylvania Railroad in Pittsburgh and Philadelphia, see Herbert G. Gutman, director, and Stephen Brier, ed., *Who Built America: Working People and the Nation's Economy, Politics, Culture and Society*, vol. 2, *From the Gilded Age to the Present* (New York: American Social History Project and Pantheon Books, 1992), xvii–xxviii.

52. THOMAS HOVENDEN, *Last Moments of John Brown*

1. See Anne Gregory Terhune, "Thomas Hovenden, Images of Heritage and Hope," 29–30, and Sylvia Yount, "A Pennsylvania Artist: Thomas Hovenden and the Philadelphia Art World," 52–54, in Terhune, Yount, and Naurice Frank Woods Jr., *Thomas Hovenden (1840–1895): American Painter of Hearth and Homeland* (Philadelphia: Woodmere Art Museum, 1995).

2. Hovenden may have been especially receptive to the subject, as his wife's parents had been ardent abolitionists, and his studio on their family farm in Plymouth Meeting, Pennsylvania, had been used as a way station on the Underground Railroad. See Amy Seville Wolff, "Life and Work of Hovenden," *Philadelphia Times*, 18 August 1895, 24.

3. Attacked as a fanatical revolutionary in the South, Brown was praised as a Christian martyr in the North, where his death solidified support for the abolitionist movement. Widely perceived as a harbinger of the approaching Civil War, Brown was memorialized by Herman Melville as "the meteor of the war," while Frederick Douglass wrote, "John Brown began the war that ended American slavery and made this a free republic." See Melville, "The Portent" (1859), in *Battle-Pieces and Aspects of the War* (New York: Harper & Brothers, 1866; reprint, Gainesville, Fla.: Scholars' Facsimiles and Reprints, 1960), xi; and Douglass, quoted in Ken Chowder, "The Father of American Terrorism," *American Heritage* 51, no. 1 (February–March 2000): 87. Brown's final prophetic proclamation seemed to predict the Civil War: "Charlestown, Va. Dec. 2, 1859. I, John Brown, am now quite *certain* that the crimes of this *guilty land* will never be purged away but with *Blood*. I had, as I now think, *vainly* flattered myself that without *very much* bloodshed it might be done." Ibid., 81.

4. The noose was not placed around Brown's neck until he was on the hanging scaffold, and Hovenden was criticized for this historical inaccuracy, but he maintained that his version of these events was correct. See *New York Evening Post*, 16 May and 19 May 1884, cited in Natalie Spassky et al., *American Paintings in the Metropolitan Museum of Art*, vol. 2, *A Catalogue of Works by Artists Born between 1816 and 1845* (New York: The Metropolitan Museum of Art, 1985), 542.

5. In his final speech to the Charles Town court before being hanged, Brown himself made the bondage analogy, noting that the Bible "teaches me further to remember them that are in bonds as bound with them." See *The Life, Trial and Execution of Captain John Brown Known as "Old Brown of Ossawatomie," with a Full Account of the Attempted Insurrection at Harper's Ferry. Compiled from Official and Authentic Sources. Including Cooke's Confession, and All the Incidents of the Execution* (New York: Robert M. De Witt, 1859), 94.

6. It is possible that the African American man at the left side of the painting is holding an old Revolutionary War–era tricorne hat, which would accentuate the irony of slavery persisting in a country founded on the principles of liberty and democracy. The connection between the American Revolution and John Brown was made by J. Sella Martin, pastor of the Joy Street Baptist Church in Boston, at a public rally on 2 December 1859 after Brown's hanging. See Benjamin Quarles, *Allies for Freedom: Blacks and John Brown* (New York: Oxford University Press, 1974), 125–126. On 5 March 1860 in Boston, John S. Rock of Boston linked Brown to an African American martyr from the Boston Massacre of the American Revolution: "The John Brown of the second Revolution is but the Crispus Attucks of the first." Ibid., 120.

7. See, for example, Rembrandt's drypoint print *Christ Presented to the People* (1655). See *Hollstein's Dutch and Flemish Etchings, Engravings and Woodcuts*, vol. 17, Rembrandt van Rijn, comp. Christopher White and Karel G. Boon (Amsterdam: A. L. van Gendt & Co., 1969, 41–42). For a reproduction of the final state (VII), see 19:70.

8. Ralph Waldo Emerson, quoted in Chowder, "The Father of American Terrorism," 87.

9. Henry David Thoreau, quoted in ibid., 82.

10. Perhaps in preparation for Battell's commission, Hovenden ex-

plored the John Brown subject in several minor related works. For a reproduction of *John Brown in Prison* (oil on canvas, 12½ × 20 in.), see Lee M. Edwards, "Noble Domesticity: The Paintings of Thomas Hovenden," *American Art Journal* 19, no. 1 (1987): 19. See also *John Brown at Harper's Ferry* (n.d., oil *en grisaille* on canvas laid down on masonite, 12½ × 20 in.), reproduced in Christie's East, New York, *American Paintings and Sculpture*, 1 October 1998, lot 27. Two John Brown drawings attributed to Hovenden are known. *John Brown Being Led to His Execution* (n.d., ink over pencil on board, 9 × 9 in.), with Marilyn Pink Prints and Drawings, Los Angeles, as of 1986; and *Study for "John Brown"* (n.d., pencil and wash on paper, ca. 13 × 17 in.), reproduced in *Kennedy Quarterly* 3, no. 1 (April 1962): 11. Battell was so pleased with Hovenden's final painting that he paid $2,000 more than the previously agreed price of $4,000. See Spassky et al., *American Paintings in the Metropolitan*, 542.

11. Although Brown's jail had been destroyed during the Civil War, Hovenden ascertained its original appearance and also that the north-facing door meant that the abolitionist's final exit had taken place in shadow, rather than sunlight. He also talked to John Avis, Brown's jailer, and to some of his surviving guards, carefully recording the details of their military uniforms. Hovenden even learned that Brown wore carpet slippers (made by an admirer) to the gallows. For Brown's likeness, Hovenden borrowed several photographs, including one that belonged to Horace Howard Furness, a prominent Unitarian minister in Philadelphia. For Hovenden's research, see Edgar Preston Richardson to John D. Rockefeller 3rd, 13 June 1974, photocopy in Thomas Hovenden *Last Moments of John Brown* object file, AAD/DEY/FAMSF. See also Helen Corson Livesey, "The Life and Work of Thomas Hovenden," AAA/SI, microfilm reel P52, frames 565–566; and Spassky et al., *American Paintings in the Metropolitan*, 542.

12. For the two Currier & Ives prints (1863 and 1870) that reproduced Louis Ransom's now unlocated *John Brown on His Way to Execution*, see Frederic A. Conningham and Colin Simkin, *Currier & Ives Prints* (New York: Crown Publishers, 1970), 149, no. 3253; and *Currier & Ives: A Catalogue Raisonné* (Detroit: Gale Research Company, 1984), vol. 1, xxvii–xxviii and 366, no. 3514.

13. See Spassky et al., *American Paintings in the Metropolitan*, 541–542. See also Robbins Battell to Thomas Hovenden, 22 June 1882, enclosing an extract from the *New-York Daily Tribune* article of 5 December 1859 describing Brown's kissing of the African American baby, in Scrapbook of Mrs. Livingston Corson, Plymouth Meeting, Pa., AAA/SI, microfilm reel P13, frame 230.

14. "Incidents Connected with the Execution," *New-York Daily Tribune*, 5 December 1859, 8.

15. The poem was first published in the *New York Independent*, 22 December 1859. See *The Complete Poetical Works of John Greenleaf Whittier* (Boston: James R. Osgood & Co., 1876), 258. See also Lydia Maria Child, *The Freedmen's Book* (Boston: Ticknor and Fields, 1865), 141–142, for her poem "John Brown and the Colored Child."

16. Responding to the sacking of the antislavery town of Lawrence, Kansas, by proslavery forces in May 1856, Brown led a bloody raid on Pottawatomie, Kansas, on the night of 23–24 May 1856, in which five proslavery settlers were executed by being hacked to death with sabers. See Chowder, "The Father of American Terrorism," 84.

17. "Mr. [John] Avis who was the jailer at the time and had Brown in charge. He told him [Hovenden] that no such thing occurred and further told him that there was not a negro in 100 yards of the jail at the time." See *Page News*, 1 August 1890, in Scrapbook of Mrs. Livingston Corson, Plymouth Meeting, Pa., in AAA/SI, microfilm reel P13, frame 11. See also R. Green, letter published in the *Baltimore Sun*, 21 May 1884, which states that he was a member of the Richmond Howitzers on duty in Charles Town and that the kissing of the child did not take place. See also Jules Abels, *Man of Fire: John Brown and the Cause of Liberty* (New York: Macmillan, 1971), 367–368.

18. See Quarles, *Allies for Freedom*, 120–121.

19. Booth later recalled, "I looked at the traitor and terrorizer with unlimited, undeniable contempt." John Wilkes Booth, quoted in Chowder, "The Father of American Terrorism," 82.

20. As one critic aptly observed, "The touching incident is too well established to be invalidated by the doubts which Southern papers have lately tried to cast upon it. If their endeavors should succeed, the fact that so popular a legend has been created and has gained a foothold within our generation, would only go to show that the mythopoetic process which, according to Mr. J. Addington Symonds, is necessary to the creation of works of art, is still at work." See *Magazine of Art*, July 1884, quoted in "The Last Moments of John Brown," print publication prospectus (Philadelphia: George Gebbie, 1885), 9–11, photocopy in Thomas Hovenden *The Last Moments of John Brown* object file, AAD/DEY/FAMSF.

21. A critic for the *New York Times* described *The Last Moments of John Brown* as "the crowning work of several essays on the same subject" and "the most significant and striking historical work of art ever executed in the republic." R., "Men, Women, and Pictures," *New York Times*, 18 May 1884, 6, quoted in "The Last Moments of John Brown," print publication prospectus, 11–12. See also *Philadelphia Press*, 25 May 1884, in ibid., 15. The success of Hovenden's painting may be attributed in part to the abolitionist's saintlike characteristics of self-denial and self-sacrifice, which resonated strongly with Gilded Age viewers like Robbins Battell, who were living in an increasingly materialistic age. One critic who praised Hovenden's *The Last Moments of John Brown* contrasted it with works "which serve only to tickle the senses and minister to luxury," although he unconvincingly placed these paintings and their patrons in the pre–Civil War generation, rather than in his own: "to coming generations, whether of the North or of the South, it will be a visible token of the fact that their ancestors, however deeply immersed they may have been in materialism of the grossest kind, had yet the power to go to death calmly for the sake of that which they held to be just and true." *New York Mail and Express*, 20 May 1884, quoted in "The Last Moments of John Brown," print publication prospectus, 12–13.

22. *The Last Moments of John Brown* was reproduced as a wood engraving by Frederick Juengling in *Harper's Weekly* 29 (31 January 1885): 72–73, and as an etching (1885) published by George Gebbie of Philadelphia. Edgar Preston Richardson, an art historian who advised John D. Rockefeller on his art acquisitions, stated that Battell allowed Hovenden to copyright the image, which guaranteed the artist additional income from the sale of reproduction rights. See Richardson to John D. Rockefeller 3rd, 13 June 1974, photocopy in Thomas Hovenden *Last Moments of John Brown* object file, AAD/DEY/FAMSF.

23. *The Last Moments of John Brown* is one of a group of Reconstruction-era works that depicted paternalistic or patronizing white men, such as Abraham Lincoln and John Brown, rather than African American counterparts such as Frederick Douglass, as the effective agents of abolition.

See, for example, John Rogers's *The Fugitive's Story* (1869), which depicts the famous abolitionists William Lloyd Garrison, Henry Ward Beecher, and John Greenleaf Whittier listening to an escaped slave telling her story, and Thomas Ball's *Lincoln Emancipation Group* (1875), which depicts Abraham Lincoln standing next to a kneeling slave. David H. Wallace, *John Rogers: The People's Sculptor* (Middletown, Conn.: Wesleyan University Press, 1967), 221–223; and Thomas Ball, *My Fourscore Years: Autobiography by Sculptor Thomas Ball (1819–1911)* (Los Angeles: Trecavalli Press, 1993), 94–95.

24. Many of these viewers probably missed the irony that Brown was captured by U.S. federal troops sent by President James Buchanan and was not condemned and hung by the Confederacy, which did not yet exist, but by a Virginia National Guard unit wearing "Union" blue and bearing the name—"Jefferson"—of the author of the Declaration of Independence.

53. JOHN SINGER SARGENT,
Caroline de Bassano, Marquise d'Espeuilles

1. Quoted in Lucia Miller, "John Singer Sargent in the Diaries of Lucia Fairchild, 1890 and 1891," *Archives of American Art Journal* 26, no. 4 (1986): 7.

2. Caroline Marie Eugénie Philippe Ghislaine de Bassano, marquise d'Espeuilles (1847–1938), was the daughter of Napoléon-Joseph-Hugues Maret, 2nd duc de Bassano, a diplomat, senator, and grand chamberlain du palais to Napoleon III. Her mother, Pauline-Marie-Ghislaine van der Linden d'Hoogworth, was a lady of honor to the Empress Eugénie. On 7 September 1871 Caroline was married to Marie-Louis Antonin Viel de Lunas, marquis d'Espeuilles, descendant of titled nobility from Nièvre in central France, who distinguished himself in the Franco-Prussian War of 1870–71, became Inspector General of Cavalry and in 1878 was elected a senator with Bonapartist loyalties to the conservative majority party. E. P. Richardson, *American Art: An Exhibition from the Collection of Mr. and Mrs. John D. Rockefeller 3rd* (San Francisco: The Fine Arts Museums of San Francisco, 1976), 210. For further biographical information on the Maret family and the duc de Bassano, see Roman d'Amat, ed., *Dictionnaire de biographie française* (Paris: Librairie Letouzey et Ané, 1968), 741–745.

3. Adam Gopnik, "Sargent's Pearls," *New Yorker*, 15 February 1999, 66.

4. Richard Ormond has argued that Sargent, like other young, experimentally modern artists—such as Gustave Courbet and Edouard Manet, with whom Carolus-Duran was friends—contributed to numerous exhibitions both inside and outside the Salon. Elaine Kilmurray and Richard Ormond, eds., *John Singer Sargent* (London: Tate Gallery Publishing, 1998), 25.

5. Ibid., 12. For an extensive discussion of his years with Carolus-Duran, see H. Barbara Weinberg, "Sargent and Carolus-Duran," in *Uncanny Spectacle: The Public Career of the Young John Singer Sargent*, ed. Marc Simpson (Williamstown, Mass.: Sterling and Francine Clark Art Institute; New Haven: Yale University Press, 1997), 5–29.

6. James F. Cooper, "John Singer Sargent: The Last Conservative," *American Arts Quarterly* (Winter 1987): 7.

7. Albert Boime, "Sargent in Paris and London: A Portrait of the Artist as Dorian Gray," in *John Singer Sargent*, ed. Patricia Hills (New York: Whitney Museum of American Art, in association with Harry N. Abrams, 1986), 82.

8. This painting technique is also known as "wet on wet." Manuela

Hoelterhoff, "Painter of the Edwardian Elite," *Wall Street Journal*, 15 October 1986, 30.

9. Kilmurray and Ormond, *John Singer Sargent*, 83. Ormond quotes Carolus-Duran as admonishing his students, "Velasquez, Velasquez, Velasquez, ceaselessly study Velasquez," 23.

10. Cooper, "John Singer Sargent: The Last Conservative," 9.

11. Boime, "Sargent in Paris and London," 79.

12. Ibid., 88.

13. Ibid., 91.

14. A full discussion of the controversy with contemporary commentaries is available in Richard Ormond and Elaine Kilmurray, eds., *John Singer Sargent: Complete Paintings*, vol. 1, *The Early Portraits* (New Haven: Yale University Press, 1998), 113–115. Also see Simpson, *Uncanny Spectacle*, 140–141. For a discussion of the economic and social conditions that were transforming French society and the 1882 crash of the Union générale bank, see Albert Boime, "Sargent in Paris and London," 86–96.

15. Ibid., 89.

16. For a discussion of Sargent's swagger portraits, see Edmund Swinglehurst, *John Singer Sargent* (San Diego: Thunder Bay Press, 2001), 62–101.

17. Quoted in Simpson, *Uncanny Spectacle*, 3.

18. Marion Hepworth Dixon, "Mr. John S. Sargent as a Portrait-Painter," *Magazine of Art* 23 (January 1899): 119.

54. JOHN SINGER SARGENT, *Le verre de porto*

1. Adam Gopnik, "Sargent's Pearls," *New Yorker*, 15 February 1999, 66.

2. Elaine Kilmurray and Richard Ormond, eds., *John Singer Sargent* (London: Tate Gallery Publishing, 1998), 11.

3. These include his remarkable series of street scenes depicting working-class Venetian figures painted from 1880 to 1882. See Linda Ayers, "Sargent in Venice," in *John Singer Sargent*, ed. Patricia Hills (New York: Whitney Museum of American Art, in association with Harry N. Abrams, 1986), 49–73.

4. Gopnik, "Sargent's Pearls," 70.

5. Sargent's first visit to the United States was in 1876; he visited the Centennial Exhibition in Philadelphia and Niagara Falls. Stanley Olson, *John Singer Sargent. His Portrait* (New York: St. Martin's Press, 1986), 51.

6. Kilmurray and Ormond, *John Singer Sargent*, 16. Stanford White solicited Sargent for the Boston Library murals after meeting him thirteen years earlier in Paris, where the young artist was working on the ceiling decorations for the Palais du Luxembourg under the tutelage of Carolus-Duran. In that same year, 1877, Sargent's career had received an important early boost when Carolus-Duran also introduced him to Augustus Saint-Gaudens, who selected Sargent to be a member of the jury for the newly founded Society of American Artists. For an account of Sargent and White, and the Boston mural project, see Olson, *John Singer Sargent*, 163–167.

7. Kilmurray and Ormond, *John Singer Sargent*, 18.

8. For a full discussion of the controversy, see Albert Boime, "Sargent in Paris and London: A Portrait of the Artist as Dorian Gray," in Hills, *John Singer Sargent*, 86–96.

9. The variant titles are a reflection of Sargent's dual interests in French and English painting at the time. *Le verre de porto* is the title Sargent first used when exhibiting the painting and indicates his desire to be accepted at the Paris Salon. A *Dinner Table at Night* is a descriptive

title that reflects the genre elements that are derived from the tradition of conversation-piece portraits. *Mr. and Mrs. Albert Vickers* is the title in the catalogue raisonné, which consistently uses the society-portrait convention of naming the sitters when known and acknowledges his commission by an English family.

10. Kilmurray and Ormond, *John Singer Sargent*, 105; and Richard Ormond and Elaine Kilmurray, eds., *John Singer Sargent: Complete Paintings*, vol. 1, *The Early Portraits* (New Haven: Yale University Press, 1998), 11.

11. *Uncanny Spectacle: The Public Career of the Young John Singer Sargent*, ed. Marc Simpson (Williamstown, Mass.: Sterling and Francine Clark Art Institute; New Haven: Yale University Press, 1997), 124. See also Stanley Olson et al., *Sargent at Broadway: The Impressionist Years* (New York and London: Universe Coe Kerr Gallery and John Murray, 1986), 38.

12. Simpson, *Uncanny Spectacle*, 38.

13. Albert Boime notes specifically that the Aesthetes were preoccupied with decor and red interiors. Boime, "Sargent in Paris and London," 86.

14. Ibid., 97.

15. Ormond and Kilmurray, *John Singer Sargent: The Early Portraits*, 133.

16. During this visit to England in 1884, Sargent produced numerous sketches and painted an entire group of portraits of the Vickers family, which include *The Misses Vickers, Mrs. Thomas Edward Vickers, Ronald Vickers, Mrs. Albert Vickers, Garden Study of the Vickers Children,* and *Edward Vickers*, to which he added *Dorothy Vickers* during his 1885–86 trip. For a discussion of all these paintings, see Ormond and Kilmurray, *John Singer Sargent: The Early Portraits*, 129–137.

17. Helen Valentine, ed., *Art in the Age of Queen Victoria: Treasures from the Royal Academy of Arts Permanent Collection* (London: Royal Academy of Arts, 1999), 163. Sargent, who was in London at the time, would have been aware of the painting, and it is highly probable that he would have seen it at the Royal Academy.

18. Stephen Kern, *Eyes of Love: The Gaze in English and French Paintings and Novels, 1840–1900* (London: Reaktion Books, 1996), 217.

19. An interesting comparison can be made to Sargent's own painting of his sister, *The Breakfast Table (Violet Sargent)* (ca. 1883, Fogg Art Museum, Cambridge, Mass.). In this work the morning light plays off an elegant table service that dominates the painting's foreground while Violet, sitting at the table in her dark dress, recedes into the black of the background's open doorway.

20. Carter Ratcliff, *John Singer Sargent* (New York: Abbeville Press, 1982), 89.

21. Simpson, *Uncanny Spectacle*, 124.

55. JOHN SINGER SARGENT, *Trout Stream in the Tyrol*

1. Edmund Gosse, quoted in Erica E. Hirshler, "'Huge Skies Do Not Tempt Me': John Singer Sargent and Landscape Painting," in Hilliard T. Goldfarb, Hirshler, and T. J. Jackson Lears, *Sargent: The Late Landscapes* (Boston: Isabella Stewart Gardner Museum, 1999), 57.

2. Gosse, quoted in ibid.

3. Ibid.

4. Ibid., 53.

5. Adrian Stokes, "John Singer Sargent, R.A., R.W.S.," *Old Water-Colour Society's Club: 1925–1926* 3 (1926): 54.

6. The model for the angler was probably Nicolo d'Inverno. There were few, if any, other people who could have posed for Sargent. On the same trip, Adrian Stokes's wife's maid was pressed into modeling service. In addition, photographs of d'Inverno show him to have the same dark hair, thick mustache, prominent nose, and high cheekbones as the man in the painting.

7. Hirshler, "Huge Skies," 57–58.

8. Stokes, "John Singer Sargent," 60, and Hirshler, "Huge Skies," 62.

9. Hirshler, "Huge Skies," 65–68, discusses the possible influences on Sargent's abstracted landscapes. In addition to Monet, she points to photography and Sargent's work researching two-dimensional ornament for his mural commissions.

10. Richard Ormond, "In the Alps," in Warren Adelson et al., *Sargent Abroad: Figures and Landscapes* (New York: Abbeville Press, 1997), 73.

11. Sally Mills, "John Singer Sargent," in Marc Simpson, Mills, and Jennifer Saville, *The American Canvas: Paintings from the Collection of The Fine Arts Museums of San Francisco* (New York: Hudson Hills Press, in association with The Fine Arts Museums of San Francisco, 1989), 178.

56. DENNIS MILLER BUNKER, *A Bohemian*

1. Alfred Trumble, "Art's Summer Outings," *Quarterly Illustrator* 2 (1894): 406, quoted in Sarah Burns, *Inventing the Modern Artist: Art and Culture in Gilded Age America* (New Haven: Yale University Press, 1996), 23. Burns's invaluable study is the definitive work on the construction of artistic identity in the late nineteenth century. Trumble was well known to nineteenth-century audiences as the author of *Representative Works of Contemporary American Artists* (1887; reprint, New York: Garland Publishing Company, 1978).

2. For background on bohemianism, see Marilyn R. Brown, *Gypsies and Other Bohemians: The Myth of the Artist in Nineteenth-Century France* (Ann Arbor, Mich.: University Microfilms International Press, 1985); and Jerrold Seigel, *Bohemian Paris: Culture, Politics, and the Boundaries of Bourgeois Life, 1830–1930* (New York: Viking Penguin, 1986). Burns, *Inventing the Modern Artist*, discusses popular representations of the bohemian artist in chap. 8, "Performing Bohemia."

3. The connection between bohemianism and youth is discussed in Burns, *Inventing the Modern Artist*, 247–251, and Seigel, *Bohemian Paris*, 19. The first history of American bohemianism was Albert Parry, *Garrets and Pretenders: A History of Bohemianism in America* (1933; reprint, New York: Dover Publications, 1960). Parry, 3, defines *bohemian* as a "sentimental term applied to a man of art and of unconventional or wandering disposition." The idea of bohemian life seems to have been increasingly sentimentalized after the turn of the century.

4. Burns, *Inventing the Modern Artist*, 150. For further discussion of studios and artist self-presentation, see Annette Blaugrund, *The Tenth Street Studio Building: Artist-Entrepreneurs from the Hudson River School to the American Impressionists* (Southampton, N.Y.: Parrish Art Museum, 1997).

5. Burns, *Inventing the Modern Artist*, 266.

6. See Blaugrund, *Tenth Street Studio Building*, chap. 3, "William Merritt Chase's Studio: The Ultimate Marketing Tool."

7. Quoted in Barbara Dayer Gallati, *William Merritt Chase* (New York: Harry N. Abrams, in association with the National Museum of American Art, Smithsonian Institution, 1995), 42. The limp, lifeless body of the swan on Chase's wall makes an interesting comparison with the bird in Alexander Pope's *The Trumpeter Swan* (pl. 65), with its massive and powerfully ex-

tended wings. While Pope's bird is arranged as a hunting trophy or ornithological specimen, Chase's bird—with its fashionable feathers—is simply one of many artful touches used to decorate his studio.

8. Jared I. Edwards, "Dennis Miller Bunker Rediscovered," *Nineteenth Century* 4 (Spring 1978): 74.

9. The most comprehensive study of Bunker's life and career is Erica E. Hirshler, *Dennis Miller Bunker: American Impressionist* (Boston: Museum of Fine Arts, 1994). See also Hirshler, *Dennis Miller Bunker and His Circle* (Boston: Isabella Stewart Gardner Museum, 1995); and Charles B. Ferguson, *Dennis Miller Bunker Rediscovered* (New Britain, Conn.: New Britain Museum of American Art, 1978).

10. For a discussion of the popularity of Spanish subjects at the French Salons, see Lois Marie Fink, *American Art at Nineteenth-Century Paris Salons* (Washington, D.C.: Smithsonian American Art Museum, in association with Cambridge University Press, 1990). For further discussion of *El Jaleo*, see Mary Crawford Volk, *John Singer Sargent's El Jaleo* (Washington, D.C.: National Gallery of Art, 1992).

11. *Manet, 1832–1883* (New York: The Metropolitan Museum of Art, 1983). For discussion of both the painting and the etching of *The Spanish Singer*, see 63–70. For Manet's exhibition history, see 536–539. On Pearce, see Mary Lublin, *A Rare Elegance: The Paintings of Charles Sprague Pearce* (New York: The Jordan-Volpe Gallery, 1993). See especially 24–25 for discussion of *Prelude!* I am grateful to Mary Lublin for her insightful suggestions about the relationship between *A Bohemian* and the work of Manet, Sargent, and Pearce.

12. Clarence Cook, "Some Old-Fashioned Things Worth Reviving," *Scribner's Monthly* 22 (May 1881): 147–149, quoted in Ronald G. Pisano, *Idle Hours: Americans at Leisure, 1865–1914* (Boston: Little, Brown & Co., for the New York Graphic Society, 1988), 33.

13. Useful sources on guitars in nineteenth-century America include Tom Evans and Mary Anne Evans, *Guitars: Music, History, Construction, and Players: From the Renaissance to Rock* (New York: Paddington Press, 1977); and Darcy Kuronen, *Dangerous Curves: The Art of the Guitar* (Boston: MFA Publications, 2001).

14. "Sixtieth Academy," *Critic* 6 (April 11, 1885): 174.

15. William A. Coffin, "The Artist Bunker," *Century Illustrated Monthly Magazine* 41 (February 1891): 637–638.

16. Celia Betsky, "American Musical Paintings, 1865–1910," 64, describes the painting as a self-portrait; excerpted in Marc Simpson with Patricia Junker, *The Rockefeller Collection of American Art at The Fine Arts Museums of San Francisco* (San Francisco: The Fine Arts Museums of San Francisco, in association with Harry N. Abrams, New York, 1994), 224. For further discussion of the painting's relationship to contemporary ideas of bohemianism, see David Park Curry, "Reconstructing Bunker," in Hirshler, *Dennis Miller Bunker*, 90–116.

17. Bunker to Joe Evans, 24–25 November 1885, Dennis Miller Bunker Papers, AAA/SI, quoted in Curry, "Reconstructing Bunker," 104.

18. Undated letter from Bunker to Gardner (late August 1890), Gardner Papers, Isabella Stewart Gardner Museum, Boston. The papers, on microfilm, are also available in the AAA/SI, quoted in Erica E. Hirshler, "Dennis Miller Bunker and His Circle of Friends," *Antiques* 147 (January 1995): 193.

57. WILLIAM MICHAEL HARNETT, *After the Hunt*

1. "Queer Art Illusions," *New York World*, n.d., n.p. This article is one of many unidentified press clippings in a scrapbook kept by William A. Blemly, whose father worked with Harnett in the early years of his career as a silver engraver at Wood and Hughes in New York. The Blemly Scrapbook is in the Alfred Frankenstein Papers, AAA/SI. This article is quoted at length in James W. Cook, "Queer Art Illusions," chap. 5 in *The Arts of Deception: Playing with Fraud in the Age of Barnum* (Cambridge, Mass.: Harvard University Press, 2001), 254. A lengthy quote of the article also appears in a biography of Theodore Stewart, the owner of the fourth version of *After the Hunt*, published a year after Stewart's death in 1887. [Theodore D. Rich], *Theodore Stewart* (New York: L'Artiste Publishing Co., 1888), 23–28.

2. The relationship between Harnett's paintings and nineteenth-century collecting and consumerism has been a popular theme in recent scholarship. See, for example, David M. Lubin, "Masculinity, Nostalgia, and the Trompe l'Oeil Still-Life Paintings of William Michael Harnett," chap. 6 in *Picturing a Nation: Art and Social Change in Nineteenth-Century America* (New Haven: Yale University Press, 1994), 273–319; and Sylvia Yount, "Commodified Displays: The Bric-a-Brac Still Lifes," in *William M. Harnet*, ed. Doreen Bolger, Marc Simpson, and John Wilmerding (New York: Harry N. Abrams, in assocation with The Metropolitan Museum of Art and the Amon Carter Museum, 1992), 243–251.

3. William H. Gerdts, "William Michael Harnett and Illusionism," chap. 8 in *Painters of the Humble Truth: Masterpieces of American Still Life, 1801–1939* (Columbia: University of Missouri Press, 1981), 153–156.

4. Yount, "Commodified Displays," 243. For further discussion of the Aesthetic Movement, see Doreen Bolger Burke et al., *In Pursuit of Beauty: Americans and the Aesthetic Movement* (New York: The Metropolitan Museum of Art, 1986).

5. Yount, "Commodified Displays," 243. For a discussion of the appeal Harnett's paintings of objects may have held for collectors, see Gerdts, "Harnett and Illusionism," 153–154. For a more extensive discussion of Harnett's patrons, see Doreen Bolger, "The Patrons of the Artist: Emblems of Commerce and Culture," in Bolger, Simpson, and Wilmerding, *William M. Harnett*, 73–85.

6. "Still Life," *Aldine* 9 (1 December 1878): 18.

7. In 1891 Harnett joined the Old Curiosity Club, a group of amateur collectors who held weekly meetings in an antiques store in New York. Yount, "Commodified Displays," 243, 247.

8. Douglas R. Nickel, "Harnett and Photography," in Bolger, Simpson, and Wilmerding, *William M. Harnett*, 179; Gerdts, "Harnett and Illusionism," 158.

9. Nickel, "Harnett and Photography," 179.

10. William H. Gerdts and Russell Burke, *American Still-Life Painting* (New York: Praeger Publishers, 1971), 250–256. For a discussion of the artistic niche filled by Harnett in Munich, see Michael Quick and Eberhard Ruhmer, *Munich and American Realism in the Nineteenth Century* (Sacramento, Calif.: E. B. Crocker Art Gallery, 1978), 34.

11. For a useful discussion of art training in Munich, see Robert Neuhaus, "Munich: Duveneck's Rise in the *Leiblkreis*," in *Unsuspected Genius: The Art and Life of Frank Duveneck* (San Francisco: Bedford Press, 1987), 7–27. See especially 17–19 for discussion of the importance of museum visits to German academic training.

12. Quick and Ruhmer, *Munich and American Realism*, 33; Elizabeth Jane Connell, "After the Hunt," in Bolger, Simpson, and Wilmerding, *William M. Harnett*, 278.

13. Connell, "After the Hunt," 278. Although Neal settled in Munich permanently after completing his training at the academy, he was well

known in America and was included in S. G. W. Benjamin's *Our American Artists* (Boston: D. Lothrop and Co., 1879), n.p.

14. Alfred Frankenstein was the first to posit a connection between Braun's photographs and Harnett's paintings; Frankenstein, *After the Hunt: William Harnett and Other American Still-Life Painters* (Berkeley and Los Angeles: University of California Press, 1953), 66–67. Frankenstein's workbook remains an essential source on American trompe l'oeil. More recently, Braun's influence on Harnett has been discussed extensively by Nickel, "Harnett and Photography," 77–84. For further discussion of Braun, see *Image and Enterprise: The Photographs of Adolphe Braun*, ed. Maureen C. O'Brien and Mary Bergstein (Providence: Rhode Island School of Design, 2000).

15. Nickel, "Harnett and Photography," 179. It has been suggested that Harnett viewed Braun's work as a technical challenge and was encouraged by the photographs to re-create a similar level of illusionism in his paintings. Nickel, "Harnett and Photography," 182. The distinguished artistic heritage of gaming subjects was probably also a factor in Harnett's decision to paint a hunt series. Even before leaving for Europe he demonstrated an interest in reinterpreting and adapting art historical precedents. In the 1870s he revived the *vanitas*, a seventeenth-century Dutch form of still-life painting that includes a human skull. While abroad he adopted the miniaturistic scale of many Dutch still lifes, often painting the same composition in both miniature and life-size versions, perhaps as a show of skill. For discussion of Harnett's *vanitas* still lifes, see Chad Mandeles, "Harnett and Vanitas," in Bolger, Simpson, and Wilmerding, *William M. Harnett*, 253–564. Gerdts credits Harnett with the revival of the form and discusses his use of a miniaturistic format in "Harnett and Illusionism," 157, 159.

16. Connell, "After the Hunt," 280–281.

17. Nickel, "Harnett and Photography," 179. Maureen O'Brien notes that while the reception of Braun's *After the Hunt* series is difficult to reconstruct, his eight compositions remained listed in the Braun and Cie catalogue for twenty years. See O'Brien, "The Influence of Contemporary French Painting," in O'Brien and Bergstein, *Image and Enterprise*, 84.

18. Comment by Harnett in an unidentified newspaper clipping, reprinted in Hermann W. Williams Jr., "Notes on William M. Harnett," *Antiques* 43 (June 1943): 261. The clipping is also available in the Blemly Scrapbook, Alfred Frankenstein Papers, AAA/SI.

19. The histories of the objects Harnett used as props were often well known to him. Extensive descriptions of his studio furnishings are offered in the catalogue of his estate, which was auctioned in 1893. The catalogue identifies and describes many props used in *After the Hunt*, such as the "very rare" old sword, the "ancient fire-lock of the fifteenth century" from a collection in Stuttgart, the "antique brass hunter's horn," the sixteenth-century iron key, and the "old powder horn" described as "a relic of the Revolution." *The William Michael Harnett Collection: His Own Reserved Paintings, Models, and Studio Furnishings*, sale cat., Stan V. Henkels at Thos. Birch's Sons, Auctioneers, Philadelphia, 23–24 February 1893.

20. Elizabeth Jane Connell discusses the key in her essay on *After the Hunt*, which addresses the possible symbolism of many elements of the painting. Connell, "After the Hunt," 285.

21. For a discussion of the art typically displayed in saloons, see Gerald Carson, "The Saloon," *American Heritage* 14 (April 1963): 24–31, 103–107; and George Ade, *The Old-Time Saloon: Not Wet—Not Dry, Just History* (New York: Ray Long and Richard R. Smith, 1931), 31–33. By all accounts, Stewart's was not a typical working-class saloon but rather "one of those luxurious barrooms that make a special feature of art." "A Fine Still-Life Painting," *Springfield Republican*, 7 November 1887. For a discussion of Stewart's exceptional saloon and art gallery, see [Rich], *Theodore Stewart*.

58. MARY CASSATT,
Mrs. Robert S. Cassatt, the Artist's Mother

1. Louisine Havemeyer, from a 1930 reminiscence, quoted in *Cassatt: A Retrospective*, ed. Nancy Mowll Mathews (New York: Hugh Lauter Levin Associates, 1996), 85. The quotation continues: "Even in my day, when she was no longer young, she was still powerfully intelligent, executive and masterful and yet with that sense of duty, that tender sympathy that she had transmitted to her daughter Mary."

2. Nancy Mowll Mathews, *Mary Cassatt: A Life* (New Haven: Yale University Press, 1994), 322.

3. The artists were designated by numerous names, including Independents, Impressionists, Intransigents, phalangists, and radicals. Charles S. Moffett, ed., *The New Painting: Impressionism, 1874–1886* (San Francisco: The Fine Arts Museums of San Francisco, 1986), 17–18.

4. In 1893 philanthropist Bertha Honoré Palmer selected Cassatt to paint a mural on the theme of the Modern Women in the Woman's Pavilion at the exposition. The mural was not a success with the American public, which was still largely hostile to "the new painting" in France that Cassatt represented. Judith A. Barter, in *Mary Cassatt: Modern Woman*, ed. Barter (New York: Harry N. Abrams, in association with the Art Institute of Chicago, 1998), 87–96. William H. Gerdts notes that due to Cassatt's advice to Louisine Havermeyer that she purchase Degas's *Ballet Rehearsal* (1874, The Metropolitan Museum of Art), the painting became the first French impressionist work to be exhibited in the United States. See his "American Art and the French Experience," in D. Scott Atkinson, *Lasting Impressions: American Painters in France, 1865–1915* (Giverny, France: Musée Américain, 1992), 43.

5. Mathews, *Mary Cassatt: A Life*, 325.

6. Ibid., 4–7. Cassatt was born in Allegheny City, now a suburb of Pittsburgh.

7. Ibid., 10–13.

8. Ibid., 15.

9. Ibid.

10. Ibid., 31–32.

11. Jochen Wierich, "Mary Cassatt," in Atkinson, *Lasting Impressions*, 248.

12. She studied there with the two most famous French genre painters of the time, Pierre-Edouard Frère and Paul-Constant Soyer. Mathews, *Mary Cassatt: A Life*, 43.

13. Cassatt exhibited this painting under the name Mary Stevenson. Adelyn Dohme Breeskin, ed., *Mary Cassatt: A Catalogue Raisonné of the Oils, Pastels, Watercolors, and Drawings* (Washington, D.C.: Smithsonian Institution Press, 1970), 34.

14. Debra N. Mancoff, *Mary Cassatt: Reflections of Women's Lives* (London: Frances Lincoln, 1998), 10–11.

15. Except for brief visits to the United States in 1898 and 1908, Cassatt remained in the vicinity of Paris, keeping a studio at 19 rue de Laval in the city and living from 1894 until her death in the château de Beaufresne at Mesnil-Théribus, Oise. Nancy Mowll Mathews, ed., *Cassatt and Her Circle: Selected Letters* (New York: Abbeville Press, 1984), 131.

16. The 1877 impressionist exhibition that Cassatt was invited to join was canceled. All the paintings listed in the catalogue are illustrated in Ruth Berson, ed., *The New Painting, Impressionism, 1874–1886;*

Documentation, vol. 2, *Exhibited Works* (San Francisco: Fine Arts Museums of San Francisco, 1996), 126–127, 161–162, 189, and 257–258.

17. Robert Cassatt to Alexander Cassatt, in Mathews, *Cassatt and Her Circle*, 144. See also 135 for a quote from an American newspaper in Paris.

18. In 1886 Durand-Ruel held his first impressionist exhibition in New York City, which began "the flood of Impressionist art to the United States." He gave Cassatt her first solo exhibitions in Paris in 1891 and 1893, and in New York in 1895. Mathews, *Cassatt and Her Circle*, 136, 205.

19. Ronald Pickvance, "Contemporary Popularity and Posthumous Neglect," in Moffett, *The New Painting*, 256. Lydia was Cassatt's most frequent model, often represented reading or knitting with concentration and solitary contentment. Mancoff, *Mary Cassatt: Reflections of Women's Lives*, 41.

20. Richard H. Love, *Cassatt: The Independent* (Chicago: Milton H. Kreines, 1980), 82.

21. The other known oil portraits include *Miss Cassatt's Mother in a Lacy Blouse* (1873); *Reading "Le Figaro"* (ca. 1878); and *Mrs. Cassatt Reading to Her Grandchildren* (1880), all in private collections.

22. Griselda Pollock, *Mary Cassatt* (New York: Harper and Row, 1980), 96.

23. Barter, *Mary Cassatt: Modern Woman*, 58.

24. For a discussion of Cassatt's suite of prints, see ibid., 82–84.

25. This comparison, suggested by Timothy Anglin Burgard, is not listed among the numerous paintings discussed as tributes to, or influenced by, Whistler's painting in Linda Merrill et al., *After Whistler: The Artist and His Influence on American Painting* (New Haven: Yale University Press and the High Museum of Art, 2003).

26. Barter, *Mary Cassatt: Modern Woman*, 50–51.

27. Alexander Cassatt later commissioned Whistler to paint a portrait of his wife, Lois: *Arrangement in Black, No. 8: Portrait of Mrs. Cassatt* (1883–85). Mary Cassatt had visited Whistler's studio during 1883 in an attempt to secure the release of the painting for her brother, which she recounts was unfinished at the time of her visit. "Mary Cassatt to Alexander Cassatt" (14 October 1883), in Mathews, *Cassatt and Her Circle*, 172. It is also likely that Cassatt viewed Whistler's painting of his mother when it was exhibited at the 1883 Paris Salon.

28. Whistler himself implied such a comparison during his visit to the Hals Museum in Haarlem. See Richard Dorment, "Portraits of the 1870s," in Dorment and Margaret F. MacDonald, *James McNeill Whistler* (London: Tate Gallery Publications, 1994), 140.

29. "In her work, the act of touching between adult females and children seems to suggest enormous emotional and physical satisfaction." Barter, *Mary Cassatt: Modern Woman*, 76.

30. "Phenomenological space is not orchestrated for sight alone but by means of visual cues refers to other sensations and relations of bodies and objects in a lived world." Griselda Pollock, *Vision and Difference: Femininity, Feminism and Histories of Art* (London and New York: Routledge, 1988), 65.

31. Gill Perry, ed., *Gender and Art* (New Haven: Yale University Press, 1999), 209.

32. Edgar Richardson, "Sophisticates and Innocents Abroad," *Art News* (April 1954): 62.

59. WILLIAM J. MCCLOSKEY, *Oranges in Tissue Paper*

1. The first stanza of Kipling's "The Conundrum of the Workshops" reads, "When the flush of a new-born sun fell first on Eden's green and gold, / Our father Adam sat under the Tree and scratched with a stick in the mould; / And the first rude sketch that the world had seen was joy to his mighty heart, / Till the Devil whispered behind the leaves, 'It's pretty, but is it Art?'" Rudyard Kipling, *Rudyard Kipling's Verse*, inclusive edition, *1885–1926* (New York: Doubleday, Doran & Co., 1929), 388.

2. Alice M. Van Natta, "Noted Painter Exhibits Work at Siskiyou Camp—William McCloskey Visits Daughter at Community House in Southern Oregon and Displays Pictures," *Oregonian*, 26 July 1925, quoted in John McGuigan Jr., 'Wonderful Realism': The Wrapped Orange Still-Life Paintings of William J. McCloskey" (M.A. thesis, University of Denver, 1997), 33.

3. McGuigan, "Wonderful Realism," 33–34.

4. Charles M. Kurtz, *National Academy Notes* (New York: Cassell & Co., 1888), 119, quoted in ibid., 14.

5. For McCloskey's early history, see ibid., 3–6.

6. "The Centennial Exhibition," *Art Journal*, n.s., 2 (1876): 162, 284, quoted in ibid., 4.

7. Including, of course, the still lifes of Raphaelle Peale, such as *Blackberries* (pl. 16).

8. Maria Chamberlin-Hellman, "Thomas Eakins as a Teacher" (Ph.D. diss., Columbia University, 1981), 266, quoted in ibid., 7.

9. Charles Bregler, "Thomas Eakins as a Teacher: With Quotations and Notes from Lectures," *Arts Magazine* 17–18 (March–April 1931).

10. Margaretta Lovell, *American Painting 1730–1960: A Selection from the Collection of Mr. and Mrs. John D. Rockefeller 3rd* (Tokyo: National Museum of Western Art, in association with the Fine Arts Museums of San Francisco, 1982), 46.

11. Will Wallace Harney, "Orange Culture," *Southern Bivouac: A Literary and Historical Magazine*, n.s., no. 5 (October 1886): 272–278, quoted in McGuigan, "Wonderful Realism," 1.

12. Although oranges were only cultivated in the sunny climes of Florida and Southern California (as well as in Mexico), over the years McCloskey painted them in New York, California, Pennsylvania, and perhaps Colorado. He also produced at least one orange painting while living in France, but his models for this effort were almost certainly the product of Spain or the eastern Mediterranean.

13. As recently as the 1870s oranges were still rare delicacies, as depicted in numerous popular sources including Laura Ingalls Wilder's *Little House* series of books for young adults. To this day many families still place an orange in each Christmas stocking, a tradition dating back to times when the fruit, though available, was costly enough to enjoy only as a holiday treat.

60. JEFFERSON DAVID CHALFANT, *Bouguereau's Atelier at the Académie Julian, Paris*

1. Henry James, "John Singer Sargent," *Harper's*, October 1887, reprinted with emendations in *Picture and Text* (1893); reprinted in *The Painter's Eye: Notes and Essays on the Pictorial Arts by Henry James*, ed. John L. Sweeney (London, 1956), 216. Quoted in H. Barbara Weinberg, "'When to-day we look for "American art" we find it mainly in Paris': The Training of American Painters in France and the Influence of French Art on American Painting," in *America: The New World in Nineteenth-Century American Painting*, ed. Stephan Koja (Munich: Prestel, 1999), 223.

2. For discussion of the art tariff of 1883 and subsequent tariffs on imported art, see Kimberly Orcutt, "Buy American? The Debate over the Art Tariff," *American Art* 16 (Fall 2002): 82–91. For discussion of the

investigation conducted by the French government, see Weinberg, "American Art," 222.

3. Weinberg, "American Art," 222. According to Weinberg, French art was especially popular in Philadelphia and New York City.

4. The most comprehensive study of Chalfant is Joan H. Gorman, *Jefferson David Chalfant, 1856–1931* (Philadelphia: Consolidated/Drake Press for the Brandywine River Museum, 1979).

5. Ibid., 17.

6. H. Barbara Weinberg, "The Académie Julian," in *The Lure of Paris: Nineteenth-Century American Painters and Their French Teachers* (New York: Abbeville Press, 1991), 221–222.

7. Ibid., 227.

8. H. Barbara Weinberg, "Cosmopolitan Attitudes: The Coming of Age of American Art," in *Paris 1889: American Artists at the Universal Exposition,* ed. Annette Blaugrund (New York: Harry N. Abrams, in association with the Pennsylvania Academy of the Fine Arts, Philadelphia, 1989), 47.

9. Ibid.

10. Weinberg, "Académie Julian," 226.

11. Weinberg, "Cosmopolitan Attitudes," 47.

12. Daisy Brown, "Experiences at the Julian School," *Corcoran Art Journal* 1 (April 1893): 6; quoted in Weinberg, "Académie Julian," 222.

13. M. Riccardo Nobili, "The Académie Julian," *Cosmopolitan* 8 (April 1890): 747–748. Life study opportunities developed earlier in America than in Europe, where the Académie Julian's women's classes were unique. Life-drawing classes for women began to be offered at the Pennsylvania Academy of the Fine Arts in 1868, the National Academy of Design in 1871, the Art Students League in 1875, and the school at Boston's Museum of Fine Arts in 1877. See Weinberg, "Académie Julian," 226–227. For further discussion of the academy tradition in America, see Derrick Cartwright, *The Studied Figure: Tradition and Innovation in American Art Academies, 1865–1915* (San Francisco: The Fine Arts Museums of San Francisco, 1988); David B. Cass, *In the Studio: The Making of Art in Nineteenth-Century France* (Williamstown, Mass.: Sterling and Francine Clark Art Institute, 1981); and Lois Marie Fink and Joshua C. Taylor, *Academy: The Academic Tradition in American Art* (Washington, D.C.: Smithsonian Institution Press for the National Collection of Fine Arts, 1975).

14. Weinberg, "Académie Julian," 250.

15. Ibid., 253. Bouguereau's American students included Cecilia Beaux, Robert Henri, Thomas Anshutz, and Louis Eilshemius. Other well-known Americans who studied at the academy under other teachers included William Paxton, Edward Steichen, Maurice Prendergast, Thomas Wilmer Dewing, and Kenyon Cox. Fronia E. Wissman, *Bouguereau* (San Francisco: Pomegranate, 1996), 110.

16. Gorman, *Jefferson David Chalfant*, 18.

17. Gorman, ibid., discusses Chalfant's transfer technique on 20 and his use of photographs as the basis for portraits on 35. Emily Shapiro characterizes Chalfant's technique as a "highly reproductive image making process that rivaled mechanical means of reproduction." For further analysis of the cultural implications of this practice, see Shapiro, "An Artist in the Factory: Cultural Contradictions in Jefferson David Chalfant's *The Clock Maker,*" in "Machine Crafted: The Image of the Artisan in American Genre Painting, 1877–1906" (Ph.D. diss., Stanford University, 2003).

18. I am grateful to Debra Evans, Head of Paper Conservation, Fine Arts Museums of San Francisco, for examining the pencil study and confirming that the charcoal present on the back of the drawing is consistent with Chalfant's method of charcoal transfer.

19. Edmund Wuerpel autobiography, St. Louis Art Museum Archives, in Betty Grossman, *Edmund Wuerpel Retrospective Exhibition* (St. Louis: St. Louis Artists' Guild, 1988), 1, quoted in Weinberg, "Académie Julian," 227.

20. Cecilia Beaux, *Background with Figures* (Boston and New York: Houghton Mifflin, 1930), 124, quoted in Weinberg, "Académie Julian," 257.

21. Nobili, "Académie Julian," 750.

22. Henry Ossawa Tanner, "The Story of an Artist's Life, II: Recognition," *World's Work* 18 (June 1909): 11770, quoted in Weinberg, "Académie Julian," 227.

23. Nobili, "Académie Julian," 748.

24. Caroline Rudolph, "J. D. Chalfant," *Every Evening*, women's edition, 13 April 1895.

25. Unidentified clipping, Chalfant Papers, AAA/si, microfilm reel 2427, frame 571.

26. See Shapiro, "An Artist in the Factory," for further analysis of Chalfant's precise drawing and painting style.

27. Gorman was the first to identify the figure at the far right as Chalfant. See Gorman, *Jefferson David Chalfant*, 18. Gorman's assessment was seconded in *American Paintings and Historical Prints from the Mittendorf Collection* (New York: The Metropolitan Museum of Art, 1967), 72. Comparison of the figure at the far right with period photographs of the artist reinforces the plausibility of this identification. For additional analysis of the significance of this self-portrait, see Shapiro, "An Artist in the Factory," 41.

28. For discussion of the photographs and the contents of Chalfant's studio, see Rudolph, "J. D. Chalfant," and the passage from the *Morning News* quoted in Gorman, *Jefferson David Chalfant*, 32. The photographs are also reproduced in Gorman, figs. 8 and 9; 31, 33.

29. Gorman, *Jefferson David Chalfant*, 28. According to Rudolph, Chalfant was twice forced to return to decorating railroad cars in order to support his family.

61. JOHN FREDERICK PETO, *Job Lot Cheap*

1. Alfred Frankenstein, *The Reality of Appearance: The Trompe l'Oeil Tradition in American Painting* (New York: New York Graphic Society; Berkeley: University Art Museum, 1970), 100.

2. For a discussion of the confusion caused by forgers attempting to pass off Peto's works as those by Harnett, see Stuart P. Feld, "The Nineteenth-Century Artist and His Posthumous Public," in *The Shaping of Art and Architecture in Nineteenth-Century America* (New York: The Metropolitan Museum of Art, 1972), 121–122. See also the review of the first Peto retrospective, on the occasion of discovering his works. Belle Krasne, "Peto's Harnetts and Peto's Petos," *Art Digest* 24 (1 May 1950): 13. For the story of Alfred Frankenstein's discovery of the misattribution of a majority of Peto's works to Harnett and the disentangling of the two oeuvres, see Frederick A. Sweet, "Two Americans Paint a Still Life," *Art Institute of Chicago Quarterly* 52 (1 December 1958): 95–99; and Olive Bragazzi, "The Story behind the Rediscovery of William Harnett and John Peto by Edith Halpert and Alfred Frankenstein," *American Art Journal* 16 (Spring 1984): 51–65.

3. Frankenstein, *The Reality of Appearance*, 56.

4. Sanford Schwartz, "The Art World: The Rookie," *New Yorker*, 15 August 1983, 80.

5. Alfred Frankenstein, *After the Hunt: William Harnett and Other*

American Still Life Painters, 1870–1900, rev. ed. (Berkeley and Los Angeles: University of California Press, 1969), 101.

6. For a discussion of *Venus Rising from the Sea* (ca. 1822), see *The Peale Family: Creation of a Legacy, 1770–1870*, ed. Lillian B. Miller (New York: Abbeville Press; Washington, D.C.: Trust for Museum Exhibitions, 1997), 91. For a comparison of the painting with Charles Willson Peale's famous trompe l'oeil painting *"The Staircase Group": Raphaelle and Titian Ramsay Peale* (1795), see Brandon Brame Fortune, "A Delicate Balance: Raphaelle Peale's Still-Life Paintings and the Ideal of Temperance," in Miller, *The Peale Family*, 139–140.

7. In his discussion of Harnett's painting, Alfred Frankenstein writes, "it is easy to see why, when Harnett was revived by the Down-town Gallery in 1939, the press treated him as if he were a modern artist who had somehow strayed into the nineteenth century and remained there." See his *The Reality of Appearance*, 62. Frankenstein is also on record as speculating that the painting is "a kind of requiem for Harnett." Quoted in Marc Simpson with Patricia Junker, *The Rockefeller Collection of American Art at the Fine Arts Museums of San Francisco* (San Francisco: Fine Arts Museums of San Francisco, in association with Harry N. Abrams, 1994), 252.

8. John Wilmerding, *Important Information Inside: The Art of John F. Peto and the Idea of Still-Life Painting in Nineteenth-Century America* (Washington, D.C.: National Gallery of Art, 1983), 111.

9. William H. Gerdts has written of Peto's paintings, "His still lifes are the most pessimistic in American art." See his *Painters of the Humble Truth: Masterpieces of American Still Life, 1808–1939* (Columbia: University of Missouri Press, 1981), 185.

10. John Ashbery, "Peto's Treasures of Trash," *Newsweek* 101 (14 March 1983): 79.

11. The peddler was being replaced by department-store retailers who marketed to modern consumers who were more interested in being entertained than enlightened. Andrew Walker, "Job Lot Cheap," in *William M. Harnett*, ed. Doreen Bolger, Marc Simpson, and John Wilmerding (New York: Harry N. Abrams, in association with the Metropolitan Museum of Art and the Amon Carter Museum, 1992), 236.

12. Wilmerding, *The Art of John F. Peto*, 106.

13. R[egina] S[oria], "John F. Peto's Studio," *Journal of the Archives of American Art* 4 (January 1964): 8.

14. Gabriel P. Weisberg, "The Sleight-of-Hand Man," *Art News* (May 1983): 91.

62. JOHN FREDERICK PETO, *The Cup We All Race 4*

1. R[egina] S[oria], "John F. Peto's Studio," *Journal of the Archives of American Art* 4 (January 1964): 8.

2. Alfred Frankenstein, *After the Hunt: William Harnett and Other American Still Life Painters, 1870–1900*, rev. ed. (Berkeley and Los Angeles: University of California Press, 1969), 107.

3. Most of those years Peto maintained his studio on Chestnut Street in the city's principal art district. In 1887 he married Christine Pearle Smith and began visiting Island Heights with her before building a house and moving there permanently in 1889. John Wilmerding, *Important Information Inside: The Art of John F. Peto and the Idea of Still-Life Painting in Nineteenth-Century America* (Washington, D.C.: National Gallery of Art, 1983), 15–16.

4. Ibid., 17.

5. Ibid., 141.

6. Ibid., 17.

7. This anxiety was expressed in the obvious psychic protest of religious revivalism by fundamentalists and evangelicals that characterized Methodism. However, the High Church movement and Anglo-Catholicism played an equally important role in this transformation of society. See T. J. Jackson Lears, *No Place of Grace: Antimodernism and the Transformation of American Culture, 1880–1920* (New York: Panetheon Books, 1981), 183–215. The opposing religious critiques of late-nineteenth-century materialism in Methodism and Anglo-Catholicism are effectively dramatized in Harold Frederic's *The Damnation of Theron Ware* (1896).

8. Norbert Schneider, *The Art of the Still Life: Still Life Painting in the Early Modern Period* (Cologne: Taschen, 1990), 7–8.

9. John Wilmerding, *American Views: Essays on American Art* (Princeton: Princeton University Press, 1991), 278.

10. Ibid., 177–178.

11. Nicolai Cikovsky Jr., " 'Sordid Mechanics' and 'Monkey-Talents': The Illusionistic Tradition," in *William M. Harnett*, ed. Doreen Bolger, Marc Simpson, and John Wilmerding (New York: Harry N. Abrams, in association with the Metropolitan Museum of Art and the Amon Carter Museum, 1992), 20.

12. Lears, *No Place of Grace*, 5.

13. John Wilmerding, *Signs of the Artist: Signatures and Self-Expression in American Paintings* (New Haven: Yale University Press, 2003), 110.

14. This "must be one of the earliest paintings, American or European, to make use of a graffito." Sanford Schwartz, "The Art World: The Rookie," *New Yorker*, 15 August 1983, 87.

15. Stephan Koja, ed., *America: The New World in Nineteenth-Century Painting* (Munich: Prestel, 1999), 139.

16. John Yau, "Target Jasper Johns," *Artforum* 24 (December 1985): 83.

17. Schwartz, "The Art World: The Rookie," 87.

18. King James Version, Hebrews 12:1 and Philippians 3:14.

19. Gabriel P. Weisberg, "The Sleight-of-Hand Man," *Art News* (May 1983): 90.

20. Wilmerding, *Important Information Inside*, 12.

63. THOMAS WILMER DEWING, *Elizabeth Platt Jencks*

1. *New-York Daily Tribune*, 11 August 1907, quoted in *A Circle of Friends: Art Colonies of Cornish and Dublin* (Durham: University Art Galleries, University of New Hampshire, 1985), 39–40.

2. Susan A. Hobbs, *The Art of Thomas Wilmer Dewing: Beauty Reconfigured* (Brooklyn: The Brooklyn Museum, in association with Smithsonian Institution Press, 1996), 19–20. The photograph (private collection) is reproduced on 20. It is inscribed on the back by Oakey, "Mrs. TWD and Miss L."

3. Dewing to Freer, letters 64 and 66, Freer Gallery of Art, Smithsonian Institution, Washington, D.C.; Freer Gallery Papers, AAA/SI, microfilm reel 453.

4. The dress appears in *In White* (1895, Freer Gallery of Art) and *Portrait of a Young Girl* (1896, Smithsonian American Art Museum). See Hobbs, *The Art of Thomas Wilmer Dewing*, 124.

5. For a discussion of Gainsborough's painting, see cat. 9.

6. Bunker to Eleanor Hardy, letter 123, Dennis Miller Bunker Papers, AAA/SI, microfilm reel 2773.

7. Details of Jencks's biography from Hobbs, *The Art of Thomas Wilmer Dewing*, 124–125.

8. Sadakichi Hartmann, *A History of American Art*, 2 vols. (Boston: L. C. Page and Company, 1902), 1:301–302, quoted in Marc Simpson, "Thomas Wilmer Dewing," in Simpson, Sally Mills, and Jennifer Saville, *The American Canvas: Paintings from the Collection of The Fine Arts Museums of San Francisco* (New York: Hudson Hills Press, in association with The Fine Arts Museums of San Francisco, 1989), 162.

9. William Adair, "Stanford White's Frames," *Antiques* 151, no. 3 (March 1997): 449.

64. EDMUND C. TARBELL, *The Blue Veil*

1. Charles H. Caffin, "The Art of Edmund C. Tarbell," *Harper's Monthly Magazine* 117, no. 697 (June 1908): 65.

2. Ibid., 71.

3. Tarbell, quoted in Erica E. Hirshler, "'Good and Beautiful Work': Edmund C. Tarbell and the Arts and Crafts Movement," in *Impressionism Transformed: The Paintings of Edmund C. Tarbell* (Manchester, N.H.: The Currier Gallery of Art, 2001), 74 and 103.

4. For a full discussion of the influence of the Arts and Crafts Movement on Tarbell, see Hirshler, "Good and Beautiful Work."

5. The desk, which Tarbell owned, appears in *Mary and Mother* (1922, National Gallery of Art, Washington, D.C.).

6. See, for example, Kenyon Cox, "The Recent Work of Edmund C. Tarbell," *Burlington Magazine* 14 (October 1908–March 1909): 259.

7. Linda J. Docherty, "The Making of an Artist: Edmund C. Tarbell's Early Influences and Career," in *Impressionism Transformed*, 56.

8. Bernice Kramer Leader, "Antifeminism in the Paintings of the Boston School," *Arts Magazine* 56 (January 1982): 118.

9. Josephine Tarbell Ferrell, "My Idea of My Father, Edmund C. Tarbell," quoted in Susan Strickler, "A Life that is Art: Edmund C. Tarbell in New Castle," in *Impressionism Transformed*, 127.

10. Linda J. Docherty, "Model-Families: The Domesticated Studio Pictures of William Merritt Chase and Edmund C. Tarbell," in *Not at Home: The Suppression of Domesticity in Modern Art and Architecture*, ed. Christopher Reed (London: Thames and Hudson, 1996), 48–64.

11. Cox, "Recent Work," 254.

12. William Germain Tooley in the Boston *Transcript*, quoted in "Tarbell," *Art Digest* 12, no. 20 (1 September 1938): 17.

65. ALEXANDER POPE, *The Wild Swan*

1. *Boston Sunday Post*, 2 November 1902, quoted in *American Paintings and Historical Prints from the Middendorf Collection* (New York: The Metropolitan Museum of Art, 1967), 60. The painting has frequently been referred to as *The Trumpeter Swan*, but early reviews and a letter written by Pope in 1910 suggest that *The Wild Swan* is a more accurate title. See Alexander Pope to George Washington Stevens, 12 May 1910: "'The Wild Swan.' This picture was exhibited in a great many places and is pretty well known in the principal cities of the country," G. W. Stevens Papers, AAA/SI, microfilm reel D34, frame 485.

2. Alfred Frankenstein revived interest in Pope with his landmark study, *After the Hunt: William Harnett and Other American Still Life Painters, 1870–1900* (Berkeley and Los Angeles: University of California Press, 1953), see esp. 139–140. The most comprehensive study on Pope to date is Donelson F. Hoopes, "Alexander Pope, Painter of Characteristic

Pieces," *Brooklyn Museum Annual* 8 (1966–67): 129–146. For contemporary discussion of the artist, see Howard J. Cave, "Alexander Pope, Painter of Animals," *Brush and Pencil* 8 (May 1901): 105–112; and Frank T. Robinson, "An American Landseer," *New England Magazine*, n.s., 3 (January 1891): 631–641.

3. Note the title of Robinson's article, "An American Landseer." On Landseer, see Richard Ormond, *Sir Edwin Landseer* (Philadelphia: Philadelphia Museum of Art, 1981); and W. J. Loftie, *Landseer and Animal Painting in England, with Practical Hints for Drawing and Painting Animals* (London: Blackie and Son, 1891).

4. See *Call of the Wild: A Sportsman's Life* (New York: Hirschl and Adler Galleries, 1994), for a discussion of Tait and the popularity of animal and sporting pictures at the turn of the century.

5. Cave, "Pope, Painter of Animals," 105. For further discussion of animal painting in America and for a comparison of Pope and Landseer, see Mary Sayre Haverstock, "An American Bestiary," *Art in America* 58 (July–August 1970): 38–71.

6. "Alexander Pope's Realistic Paintings," *Boston Sunday Globe*, 26 December 1909.

7. Robinson, "American Landseer," 639.

8. Pope's use of the term "characteristic pieces" is discussed in Cave, "Pope, Painter of Animals." When Hoopes's "Pope, Painter of Characteristic Pieces" was published, he speculated that Pope had painted about ten trompe l'oeil pictures. That number has since been raised to twelve.

9. For a nuanced and perceptive discussion of nineteenth-century attitudes toward deception and the reception of trompe l'oeil paintings, see James W. Cook, *The Arts of Deception: Playing with Fraud in the Age of Barnum* (Cambridge, Mass.: Harvard University Press, 2001); and Michael Leja, *Looking Askance: Skepticism and American Art from Eakins to Duchamp* (Berkeley and Los Angeles: University of California Press, 2004).

10. Cave, "Pope, Painter of Animals," 112.

11. Alexander Pope to George Washington Stevens, 12 May 1910, G. W. Stevens Papers, AAA/SI, microfilm reel D34, frame 485.

12. Winston E. Banko, "The Trumpeter Swan: Its History, Habits, and Population in the United States," *North American Fauna*, 63 (Washington D.C.: U.S. Fish and Wildlife Service, 1960), 1–214.

13. John Wilmerding has discussed a second version of *The Trumpeter Swan*, painted eleven years later, which includes vines of ivy and a hanging shotgun. Wilmerding, "Winslow Homer's *Right and Left*," *Studies in the History of Art* 9 (1980): 74.

14. See William T. Hornaday, *Taxidermy and Zoological Collecting* (New York: Charles Scribner's Sons, 1894); and *Ladies' Manual of Art, or, Profit and Pastime, a Self-Teacher in All Branches of Decorative Art. . . .* (Chicago: Donohue, Henneberry and Co., 1890).

15. Audubon, his interest in trumpeter swans, and his use of wire armatures are discussed in Lindsay A. Price, *Swans of the World in Nature, History, Myth, and Art* (Tulsa, Okla.: Council Oak Books, 1994), 141–154. Other useful sources on the artist include Alice Ford, ed., *Audubon by Himself* (Garden City, N.Y.: Natural History Press for the American Museum of Natural History, 1969); Annette Blaugrund and Theodore E. Stebbins Jr., eds., *John James Audubon: The Watercolors for Birds of America* (New York: Villard Books, Random House, for the New-York Historical Society, 1993); and *John James Audubon: Writings and Drawings*, selected by Christopher Irmscher (New York: Library of America, 1999).

16. Audubon was especially captivated by trumpeter swans. His *Ornithological Biography* included extensive discussions of their behaviors and the difficulties—and pleasures—of hunting them. The movement of the swans' necks receives particular attention. See *John James Audubon: Writings and Drawings*, 508–514. While living in Henderson, Kentucky, conducting his survey work for *Birds of America*, he kept an injured trumpeter swan for two years as a pet. Ford, *Audubon by Himself*, 72.

17. It is unclear when ownership of the painting passed to the Massachusetts Society for the Prevention of Cruelty to Animals, but Frankenstein (*After the Hunt*, 140) suggests that it was not the original owner of the painting: "Many years later the owner of this work, tired of its sorcery, presented it to the most inappropriate institution he could find—the Massachusetts Society for the Prevention of Cruelty to Animals—which somewhat shamefacedly trots it out today when it is asked to do so." That the society may have been embarrassed by the painting's subject (rather than proud of its antihunting sentiment) suggests caution about imputing such a message to the work.

18. Both Banko, "Trumpeter Swan," 165–188, and Price, *Swans of the World*, 127–138, discuss the near extinction of the trumpeter swan in great detail.

19. Price, *Swans of the World*, 146–147.

20. Robinson, "American Landseer," 17.

21. For a comprehensive discussion of nineteenth-century artists' studios and of Chase's studio in particular, see Sarah Burns, *Inventing the Modern Artist: Art and Culture in Gilded Age America* (New Haven: Yale University Press, 1996). In one of Chase's many paintings of his studio, *The Tenth Street Studio* (begun ca. 1881, Carnegie Museum of Art), a trumpeter swan is included—to much different effect—among the many props pictured in the space.

66. WILLIAM GLACKENS, *May Day in Central Park*

1. A well-illustrated and comprehensive account of Glackens's life and work is William H. Gerdts, *William H. Glackens* (Fort Lauderdale, Fla.: Fort Lauderdale Museum of Art, 1996).

2. Glackens's experience working as an artist-reporter was crucial for the development of his artistic skills. His co-worker, friend, and artistic peer Everett Shinn later recalled, "The Art department of a newspaper of 1900 was a school far more important in the initial training of the mind for quick perception than the combined instruction of the nation's art schools." Shinn, "Life on the Press," *Philadelphia Museum Bulletin* 41, no. 207 (November 1945): 9. Shinn also noted that Glackens developed an economic style of sketching, one that enabled him to make drawings "done with lightning speed and repeated many times, until he had become so familiar with his subjects he could place them in his pictures without even referring to the sketches." Shinn, "William Glackens as an Illustrator," *American Artist* 9 (November 1945): 22.

3. According to John Sloan, "Robert Henri had that magic ability as a teacher which inspires and provokes his followers into action. He was a catalyst; he was an emancipator, liberating American art from its youthful academic conformity, and liberating the individual artist from repressions that held back his natural creative ability." Sloan, quoted in William Inness Homer, *Robert Henri and His Circle* (Ithaca, N.Y.: Cornell University Press, 1969), 76. For a discussion of the impact of Henri's ideas on Glackens and his peers during this time, see ibid., 75–79.

4. Glackens, Henri, Shinn, Luks, Sloan, Maurice Prendergast, Ernest Lawson, and Arthur B. Davies are remembered as the Eight based on their participation in a controversial exhibition at New York's Macbeth Gallery in 1908; see Elizabeth Milroy, *Painters of a New Century: The Eight and American Art* (Milwaukee: Milwaukee Art Museum, 1991). The label "Ashcan School" was coined in the 1930s to describe the work of these artists and that of George Bellows, see ibid., 15–16. Glackens's *May Day in Central Park* was included in the exhibition tour of the paintings of the Eight in 1908 and 1909; see Judith Zilczer, "The Eight on Tour, 1908–09," *American Art Journal* 26, no. 3 (Summer 1984): 44–45.

5. Robert Henri, "The New York Exhibition of Independent Artists," *Craftsman* 18 (May 1910): 167, quoted in H. Barbara Weinberg, Doreen Bolger, and David Park Curry, *American Impressionism and Realism: The Painting of Modern Life, 1885–1915* (New York: The Metropolitan Museum of Art, 1994), 14. Henri further articulated his ideas about art in Henri, *The Art Spirit: Notes, Articles, Fragments of Letters and Talks to Students, Bearing on the Concept and Technique of Picture Making, the Study of Art Generally, and On Appreciation*, comp. Margery Ryerson (Philadelphia: J. B. Lippincott Company, 1923).

6. For a discussion of Glackens's travels to Europe and the work he produced there, see Gerdts, *Glackens*, 15–23.

7. Gerdts nicely summarizes Glackens's incredibly prolific output during these years; see ibid., 27–35.

8. Walter Pach, "Manet and Modern American Art," *Craftsman* 17 (February 1910): 483, quoted in ibid., 68.

9. Margaret Steel Anderson, *The Study of Modern Painting* (New York: Century Co., 1914), 19, quoted in ibid., 68.

10. For a brief discussion of Manet's reputation in New York art circles in the first years of the twentieth century, see Milroy, *Painters of a New Century*, 37–38.

11. See David Glassberg, "Restoring a 'Forgotten Childhood': American Play and the Progressive Era's Elizabethan Past," *American Quarterly* 32, no. 4 (1980): 351–368.

12. On May Day as a workers' holiday, see Philip S. Foner, *May Day: A Short History of the International Workers' Holiday, 1886–1986* (New York: International Publishers, 1986), 56–81.

13. Reformers were forced to turn to Elizabethan England because the Puritan past was devoid of play traditions. In the early 1600s, when a settler named Thomas Morton erected a Maypole in the village of Merrymount and organized community celebrations around it, William Bradford, the Puritan governor of Plymouth Plantation, had it taken down because he felt it encouraged immoral and unchristian behavior. See William Bradford, *Of Plymouth Plantation* (New York: The Modern Library, 1981), 226–232.

14. For example, see "Happy Youngsters Celebrate May Day," *World*, 2 May 1903. Maypole and other folk dances were considered especially suitable for girls and young women because they were not allowed to participate in organized athletics; see Glassberg, "Restoring a 'Forgotten Childhood,'" 358. General background information on May Day can be found in Ruth Hutchinson and Ruth Adams, *Every Day's a Holiday* (New York: Harper's Brothers Publishers, 1951), 94–97.

67. MAURICE PRENDERGAST, *The Holiday*

1. Charles Hovey Pepper, "Is Drawing to Disappear in Artistic Individuality? A Sketch of the Work of Maurice Prendergast," *World Today* 19 (July 1910): 716. Pepper and Prendergast had taken part in a joint exhibi-

tion, along with Charles Hopkinson, at the Kimball Gallery, Boston, in 1905. "Maurice Brazil Prendergast," *Dictionary of American Biography*, ed. Allen Johnson and Dumas Malone (New York: Charles Scribner's Sons, 1928–36), 8:186.

2. Pepper, "Is Drawing to Disappear?" 719.

3. Duncan Phillips, "Maurice Prendergast," *Arts* 5 (March 1924): 127.

4. See Cynthia Zaitzevsky, *Frederick Law Olmsted and the Boston Park System* (Cambridge, Mass.: The Belknap Press of Harvard University Press, 1982).

5. "City Ownership of Seaside Parks," *Cosmopolitan* 33 (August 1902): 426.

6. Milton W. Brown, "Maurice B. Prendergast," in *Maurice Brazil Prendergast, Charles Prendergast: A Catalogue Raisonné*, ed. Carol Clark, Nancy Mowll Mathews, and Gwendolyn Owens (Munich: Prestel, in association with Williams College Museum of Art, 1990), 16. Carol Clark, "Modern Women in Maurice Prendergast's Boston of the 1890s," in *Catalogue Raisonné*, 33. For further discussion of paintings of leisure in the nineteenth and early twentieth century, see Ronald G. Pisano, *Idle Hours: Americans at Leisure, 1865–1914* (Boston: Little, Brown & Co., 1988); H. Barbara Weinberg, Doreen Bolger, and David Park Curry, *American Impressionism and Realism: The Painting of Modern Life, 1885–1915* (New York: The Metropolitan Museum of Art, 1994); and Nancy Mowll Mathews, *The Art of Leisure: Maurice Prendergast in the Williams College Museum of Art* (Williamstown, Mass.: Williams College Museum of Art, 1999), 21–23.

7. Eleanor Green, "Maurice Prendergast, Myth and Reality," *American Art Review* 4 (July 1977): 89–103.

8. Pamela A. Ivinski discusses the recurrence of Japanese parasols in *Maurice Prendergast: Paintings of America* (New York: Adelson Galleries, 2003), 65. According to Ivinski, the turkey red umbrella was so popular at the turn of the century that it was the subject of parody in Elizabeth Stuart Phelp's short story "The Madonna of the Tubs," published in *Harper's New Monthly Magazine* in 1885.

9. Ivinski has also cited "street furniture like lamps, flag poles, and park benches" as common elements in Prendergast's work. Drawing on Mathews, *Art of Leisure*, Ivinski suggests that Prendergast's interest in park benches was related to worries about the democratic nature of the public benches in Central Park. See Ivinski, *Prendergast: Paintings of America*, 49.

10. Amy Goldin, "The Brothers Prendergast," *Art in America* 64 (March–April 1976): 93.

11. Hedley Howell Rhys, *Maurice Prendergast, 1859–1924* (Cambridge, Mass.: Harvard University Press, 1960), 42.

12. Clark, "Modern Women," 33.

13. Doreen Bolger discusses the frequency with which Prendergast's work was likened to decorative media in her essay "Modern Mural Decoration: Prendergast and His Circle," one of the few studies that address Prendergast's relationship to broader trends in decorative art and design. See W. Anthony Gengarelly and Carol Derby, *The Prendergasts and the Arts and Crafts Movement: The Art of American Decoration and Design, 1890–1920* (Williamstown, Mass.: Williams College Museum of Art, 1989), 52–63. For contemporary discussion of Prendergast's work as tapestry-like, see "Boston Art Club—Figures and Portraits—Second Article," *Boston Evening Transcript*, 11 January 1906, 14; "Works of Contemporary American Landscape Painters Shown at the National Arts Club," *New York Times*, 6 February 1910, magazine sec., 14.

14. C[harles] de K[ay], "Eight Man Show at Macbeth's," *New York Evening Post*, 7 February 1908, 5, quoted in Bolger, "Modern Mural Decoration," 54.

15. Quoted in Richard J. Wattenmaker, "Maurice Prendergast at the Whitney," *New Criterion*, November 1990, 36. No contemporary citation is given.

16. Brown, "Prendergast," 17.

17. For a discussion of Prendergast's influences, see Cecily Langdale, "Maurice Prendergast: An American Post-Impressionist," *Connoisseur* 202 (December 1979): 250. Richard J. Wattenmaker was the first to comprehensively discuss the possibility of a connection between Prendergast and Puvis. He considers Puvis particularly significant to the work Prendergast produced after 1913, when he had the opportunity for further study of Puvis's work at the Armory Show. See Wattenmaker, *Puvis de Chavannes and the Modern Tradition* (Toronto: Art Gallery of Ontario, 1975). For a critique of Wattenmaker's arguments, see Goldin, "The Brothers Prendergast," and the sequel to that article, Goldin, "How Are the Prendergasts Modern?" *Art in America* 64 (September–October 1976): 60–67. For discussion of the Nabis, see Claire Frèches-Thory and Antoine Terrasse, *The Nabis: Bonnard, Vuillard, and Their Circle* (New York: Rizzoli, 2003).

18. On the Nabis, see Thory and Terrasse, *Nabis*. For a discussion of Prendergast, graphic design, and the Arts and Crafts Movement, see Gengarelly and Derby, *The Prendergasts and the Arts and Crafts Movement*.

19. Thory and Terrasse, *Nabis*, 175.

20. Cited in ibid., 177.

21. George Leland Hunter, *Decorative Textiles* (Philadelphia and London: J. B. Lippincott and Co., 1918), x–xi.

22. Thory and Terrasse discuss Nabi tapestry, *Nabis*, 176–190.

23. Green, "Prendergast, Myth and Reality," 98.

68. ROCKWELL KENT, *Afternoon on the Sea, Monhegan*

1. As quoted in David Traxel, *An American Saga* (New York: Harper & Row, 1980), 49.

2. Most of the information in this biographical sketch is drawn from Richard V. West, *"An Enkindled Eye": The Paintings of Rockwell Kent, a Retrospective Exhibition* (Santa Barbara: Santa Barbara Museum of Art, 1985), 15–16.

3. Rockwell Kent, *It's Me O Lord: The Autobiography of Rockwell Kent* (New York: Dodd, Mead & Company, 1955), 76.

4. Thayer introduced Kent to Icelandic sagas, sparking an interest in the far north that must have been further kindled by the exploits of Arctic explorers such as Roald Amundsen and Robert Peary just a few years later. Eventually, Kent would enjoy friendships with Knud Rasmussen and other later explorers. Constance Martin, *Distant Shores: The Odyssey of Rockwell Kent* (Berkeley and Los Angeles: University of California Press, 2000), 18–19.

5. Bruce Robertson, *Reckoning with Winslow Homer: His Late Paintings and Their Influence* (Cleveland: The Cleveland Museum of Art in cooperation with Indiana University Press, 1990), 103.

6. The year-round community was quite small, consisting only of twenty-five or so houses clustered at the harbor. Kent was probably introduced to the locals through the baseball games in which all males on the island apparently participated each afternoon. Traxel, *American Saga*, 31.

7. Kent, *It's Me*, 122.

8. Kent knew next to nothing about building a house when he set out,

but he was a sufficiently successful autodidact that he was able to support himself through construction and carpentry once his house was complete. On one occasion, he hired a workman—William Moody—from the mainland as an assistant, and Monhegan saw its first black person. Moody was such a popular addition to the community that his temporary residence was a subject of interest for decades. Traxel, *American Saga*, 34.

9. Kent, *It's Me*, 137.

10. Robertson, *Reckoning with Homer*, 103. Kent was also stridently opposed to Cubism and abstract art, calling them "meaningless," an opinion from which he never wavered. Martin, *Distant Shores*, 18.

11. As quoted in Traxel, *American Saga*, 50. The artist Jamie Wyeth considers Kent "the only artist who worked on Monhegan who got the true sense of the place. The island has a primeval quality, and he's the one who really caught the mood." Quoted in Edgar Allen Beem, "Monhegan Island Love Affair," *Yankee* 64 (January 2000), 119.

12. Kent later recalled the exhibition: "The critics gave columns to it. The pictures were all for sale and were all low priced. Nobody bought one. Nearly all these pictures are now in museums or important private collections. A lot of money was paid for them—but not to me. In a time of great distress several years later, I sold them all, including their costly gold frames, for the sum of $38.46 apiece." Kent sold this lot of paintings to the dealer William Macbeth in 1911 to raise money for medical bills, thus beginning *Afternoon on the Sea*'s journey to San Francisco. Kent, quoted in Don Roberts, *Rockwell Kent: The Art of the Bookplate* (San Francisco: Fair Oaks Press, 2003), 13. Also see Scott Ferris and Ellen Pearce, *Rockwell Kent's Forgotten Landscapes* (Camden, Me.: Down East Books, 1998), 75.

13. Robertson, *Reckoning with Homer*, 103.

14. Ibid., 104.

15. In the words of Bruce Robertson, "To an almost frightening degree, Kent carried out the mythic quest of isolating himself in a forbidding landscape, to confront nature on her terms, a quest exemplified in Homer's art (if not quite in his life)." Ibid., 106.

16. Martin, *Distant Shores*, 18. Just days before his first wedding anniversary, Kent wrote a letter to his hero Jack London, requesting any information he might have about Pitcairn Island, one of the remotest spots on earth, as he hoped to journey there shortly. Financial straits, exacerbated by the birth of Kent's son in September (perhaps the catalyst for his urge to be elsewhere), prevented the trip, but he must have made an impression on the author; in 1910, when Kent launched the Monhegan Summer School of Art (forming his own version of the artists' colony he rejected in 1905), one of his first students was a close friend of London who came all the way from California. Traxel, *American Saga*, 49.

69. MARSDEN HARTLEY,
The Summer Camp, Blue Mountain

1. Letter to Norma Berger, 13 November 1933, quoted in Marsden Hartley, *Somehow a Past*, ed. Susan Elizabeth Ryan (Cambridge, Mass.: MIT Press, 1998), App. 2, 170.

2. Hartley, in ibid.

3. Ibid., 118–121.

4. Patricia McDonnell, "Marsden Hartley: Painting, Number 5, 1914–15," in *Frames of Reference: Looking at American Art, 1900–1950*, ed. Beth Venn and Adam D. Weinberg (New York: Whitney Museum of American Art, 1999), 211.

5. The most complete study of this subject remains Jonathan Weinberg, *Speaking for Vice: Homosexuality in the Art of Charles Demuth, Marsden Hartley, and the First American Avant-Garde* (New Haven: Yale University Press, 1993). Weinberg also discusses Hartley's homoerotic figurative paintings of the late 1930s and early 1940s based on religious images of Christ and his tributes to the virile sons of the Mason family in Nova Scotia, 171–193.

6. Elizabeth Mankin Kornhauser, "Marsden Hartley: Gaunt Eagle from the Hills of Maine," in *Marsden Hartley*, ed. Kornhauser (New Haven: Yale University Press, in association with the Wadsworth Atheneum, 2002), 15.

7. Hartley identifies the Segantini painting as *Ploughing in the Engadine*. Hartley, *Somehow a Past*, 106.

8. Ibid., 187.

9. Hartley was given a copy of Emerson's *Essays*, which he describes as a kind of "holy script," by his art teacher Nina Waldeck. Hartley wrote that after reading "Emerson then assiduously to the neglect of all else," he went on to become similarly obsessed with reading Henry David Thoreau. See ibid., 181.

10. Jonathan Weinberg, "Marsden Hartley: Writing on Painting," in Kornhauser, *Marsden Hartley*, 124.

11. Amy Ellis, in ibid., 289. Technically, his first one-person exhibition occurred at the home of Mrs. Ole Bull, which was adjacent to the Green Acre complex. Gail R. Scott, *Marsden Hartley* (New York: Abbeville Press, 1988), 15.

12. This episode is recounted in Gail Levin, "Marsden Hartley and Mysticism," *Arts* 60 (November 1985): 16–21.

13. For an account of Theosophy, see Joy Mills, *100 Years of Theosophy: A History of the Theosophical Society in America* (Wheaton, Ill.: Theosophical Publishing House, 1987).

14. For a discussion of equivalency as a mode of artistic production and its relation to modern linguistic theory, see Daniell Cornell, *Alfred Stieglitz and the Equivalent: Reinventing the Nature of Photography* (New Haven: Yale University Art Gallery, 1999), esp. 9–10.

15. Marc Simpson, "Marsden Hartley," in Simpson, Sally Mills, and Jennifer Saville, *The American Canvas: Paintings from the Collection of The Fine Arts Museums of San Francisco* (New York: Hudson Hills Press, in association with The Fine Arts Museums of San Francisco, 1989), 210.

70. MARSDEN HARTLEY,
A Bermuda Window in a Semi-Tropic Character

1. From Hartley's *Dissertation on Modern Painting* (1921), quoted in Marsden Hartley, *Somehow a Past*, ed. Susan Elizabeth Ryan (Cambridge, Mass.: MIT Press, 1998), 24.

2. Barbara Haskell, *Marsden Hartley* (New York: Whitney Museum of American Art, in association with New York University Press, 1980), 17. The Eight were a group of artists formed by Robert Henri for an exhibition in 1907 at Macbeth Gallery after his ideological and stylistic break with the National Academy of Design. In addition to Henri, the group included George Luks, William J. Glackens, John Sloan, Everett Shinn, Ernest Lawson, Arthur B. Davies, and Maurice Prendergast.

3. Hartley recounts the 1921 auction of 117 works that was arranged by Alfred Stieglitz at the Anderson Galleries to keep Hartley from going further into debt and to provide a modest sum so he could continue to spend his time painting instead of working for money. Hartley, *Somehow a Past*, 102–104.

4. Jonathan Weinberg, "Marsden Hartley: Writing on Painting," in *Marsden Hartley*, ed. Elizabeth Mankin Kornhauser (New Haven: Yale University Press, in association with the Wadsworth Atheneum, 2002), 123.

5. Hartley was appointed its first secretary on 4 May 1920.

6. The collection was purchased by Ferdinand Howald, a wealthy investor. Hartley, *Somehow a Past*, 105.

7. Hartley saw Picasso's exhibit of Rose Period Harlequin, proto-cubist, and analytical cubist paintings at Gallery 291 during spring 1911. He saw Cézanne's paintings during the winter of 1911, when Arthur B. Davies arranged a visit to the collection of Mr. and Mrs. Horace O. Havemeyer in New York. Gail R. Scott, *Marsden Hartley* (New York: Abbeville Press, 1988), 32, 34.

8. For an example and discussion of Hartley's "Segantini stitch" style of painting, see cat. 69 in this volume.

9. Bruce Weber, *The Heart of the Matter: The Still Lifes of Marsden Hartley* (New York: Berry-Hill Galleries, 2003), 22.

10. Peter Sheldon, "First Step Homeward Taken: Marsden Hartley in Bermuda, 1916–17 and 1935," *Heritage Magazine* (1986): 139.

11. Two of the paintings that Hartley completed while on this trip were exhibited at the 1913 Armory Show. Weber, *The Heart of the Matter*, 21.

12. Haskell, *Marsden Hartley*, 17–18. During travels in 1913 Hartley met Wassily Kandinsky and Gabriel Münter in Paris and Franz Marc and Albert Bloch in Munich. Kandinsky's *On the Spiritual in Art* had been an important influence on Hartley from the time Stieglitz first showed it to him.

13. Hartley, *Somehow a Past*, 90.

14. Ibid., 87.

15. Peter Gay, "Marsden Hartley: *Painting, Number 5* (1914–15)," in *Frames of Reference: Looking at American Art, 1900–1950*, ed. Beth Venn and Adam D. Weinberg (New York: Whitney Museum of American Art, 1999), 206; Patricia McDonnell, "Marsden Hartley: *Painting, Number 5* (1914–15)," in ibid., 213.

16. Karl von Freyburg was killed on 7 October 1914.

17. See, for instance, Haskell, *Marsden Hartley*, 55.

18. Marc Simpson, "Marsden Hartley," in Simpson, Sally Mills, and Jennifer Saville, *The American Canvas: Paintings from the Collection of The Fine Arts Museums of San Francisco* (New York: Hudson Hills Press, in association with The Fine Arts Museums of San Francisco, 1989), 212.

19. Paul Rosefeld wrote in a 1921 article in the *Dial*: "a cold and ferocious sensuality seeks to satisfy itself in the still-lives, with their heavy stiff golden bananas, their dark luscious figs, their erectile pears and enormous breast-like peaches." Quoted in Haskell, *Marsden Hartley*, 56.

20. Bruce Weber points out that Hartley created a series of still-life paintings that featured gardenias. Weber, *The Heart of the Matter*, 13.

71. EVERETT SHINN, *Outdoor Theatre*

1. Caroline Caffin, *Vaudeville* (New York: Mitchell Kennerly, 1914), 15.

2. Shinn had a lifelong interest in the theater. As a boy in Woodstown, New Jersey, he designed posters for the local opera house, and during the early years of his career in Philadelphia he became involved with the amateur theatricals held at artist Robert Henri's studio. In 1907, more than a decade after establishing himself in New York, Shinn built a studio behind his house on Waverly Place, which, according to an article on New York studios published in 1910, contained "tiny models of stages set with scenery and fully equipped with electric lights no bigger than peas—for Mr. Shinn designs many theatrical effects." By 1912 Shinn's studio included a fifty-

five-seat theater with a proscenium stage and crimson curtains that was used to stage burlesque melodramas which he wrote, directed, and produced. Shinn noted in "Recollections of the Eight," an essay published in an exhibition catalogue in 1943, that "his interest in the theater went deeper than merely drawing its action. He never meant to be a playwright, yet emerged from his own studio theater with three vaudeville acts, two having played eighteen years, one in six different languages." Although Shinn's amateur theatricals came to an end shortly after his divorce from his first wife in 1912, his involvement in the world of the stage was extended in 1917, when he began a second career as an art director for motion pictures. The most comprehensive study of Shinn's life and career is Edith DeShazo, *Everett Shinn, 1876–1953: A Figure in His Time* (New York: Clarkson N. Potter, 1974). For discussion of Shinn's theater subjects, see Linda S. Ferber, "Stagestruck: The Theater Subjects of Everett Shinn," *Studies in the History of Art* 37 (1990): 51–67; Janay Wong, *Everett Shinn: The Spectacle of Life* (New York: Berry-Hill Galleries, 2000); Sylvia L. Yount, "Consuming Drama: Everett Shinn and the Spectacular City," *American Art* 6 (Fall 1992): 86–109; and Yount, "Everett Shinn and the Intimate Spectacle of Vaudeville," in *On the Edge of Your Seat: Popular Theater and Film in Early Twentieth-Century American Art*, ed. Patricia McDonnell (New Haven: Yale University Press, 2002), 157–174. Shinn's studio theater is described by Walter Pritchard Eaton, "The Latin Quarter of New York," *Metropolitan Magazine*, May 1901, 166–167, cited in Ferber, 64. Shinn's "Recollections of the Eight" appears in *The Eight* (New York: Brooklyn Museum and the Brooklyn Institute of Arts and Sciences, 1943), 11–22.

3. Yount, "Shinn and the Intimate Spectacle," 161; Wong, *Shinn: The Spectacle of Life*, 40.

4. Ferber, "Stagestruck," 53–54.

5. "Everett Shinn's Work," *New York Times*, 12 March 1904, cited in ibid., 55.

6. Albert E. Gallatin, "Studio-Talk," *Studio* 39 (October 1906): 84–85.

7. Wong, *Shinn: The Spectacle of Life*, 41.

8. Patricia McDonnell, "American Early Modern Artists, Vaudeville, and Film," in McDonnell, *On the Edge of Your Seat*, 13.

9. Richard Butsch, *The Making of American Audiences: From Stage to Television, 1750–1990* (Cambridge, U.K.: Cambridge University Press, 2000), 115–188. See also Butsch, "Bowery B'hoys and Matinee Ladies: The Re-Gendering of Nineteenth-Century American Theater Audiences," *American Quarterly* 46 (September 1994): 374–405.

10. Butsch, *Making of American Audiences*, 118. Caffin (*Vaudeville*, 226–227) reminded her readers of the peculiar power of vaudeville audiences: "[it] . . . is YOUR show. It is there because it is what is wanted by the average of you. If you want it different you only have to make the demand loud enough. For these figures you see on the stage are but a reflection of what YOU, their creators want. . . . We have put our entertainers behind the frame of a proscenium arch and let down a curtain to mark the division between actor and audience. But the actor is still the reflection of his audience."

11. Caffin, *Vaudeville*, 16.

12. Butsch, *Making of American Audiences*, 108–114.

13. For a discussion of electric lighting and American theater, see McDonnell, "American Early Modern Artists," 19; and David Nasaw, "It Begins with the Lights: Electrification and the Rise of Public Entertainment," in McDonnell, *On the Edge of Your Seat*, 45–60.

14. McDonnell, "American Early Modern Artists," 20–21, discusses Shinn's relationship with Belasco.

15. The painting is in a private collection. It is reproduced in McDonnell, *On the Edge of Your Seat*, Fig. 8.4, 160.

16. Helen Henderson, "Philadelphia Artists Exhibit in New York," *Philadelphia North American*, 11 March 1903, cited in Yount, "Intimate Spectacle," 165–166.

17. Butsch, *Making of American Audiences*, 108–114.

18. Butsch, "Bowery B'hoys," 391–394.

19. H. Barbara Weinberg, Doreen Bolger, and David Park Curry, *American Impressionism and Realism: The Painting of Modern Life, 1885–1915* (New York: The Metropolitan Museum of Art, 1994), 210. The authors also point out that theatrical subjects were avoided by American Impressionists, perhaps because of disreputable connotations of French theaters. It was left to Realists such as Everett Shinn and fellow members of the Eight—noted for their depictions of the seamier side of urban life—to focus attention on vaudeville. See ibid., 208–210.

72. ROBERT HENRI, *Lady in Black with Spanish Scarf (O in Black with Scarf)*

1. Flossie Shinn in a letter to Edith Glackens, quoted in *William Glackens and the Ashcan Group: The Emergence of Realism in American Art*, ed. Ira Glackens (New York: Crown, 1957), 110.

2. Although the work has been variously titled, including the FAMSF's previous *Marjorie Henri* and *O in Black with Scarf (Marjorie Organ Henri)*, Henri's diary of 5 January 1910 lists the current title along with a notation for the Independents Exhibition, 27 April. Robert Henri, AAA/SI, microfilm reel 886, frame 293.

3. Marjorie Organ joined the *Journal*'s art staff at seventeen years of age and was its only woman. Her popular comic strip "Reggie and the Heavenly Twins" ran for three years. Other famous cartoons of hers included "The Man Hater's Club" and "Strange What a Difference a Mere Man Makes." Pamela M. Davis, *City Life Illustrated, 1890–1940: Sloan, Glackens, Luks, Shinn—Their Friends and Followers* (Wilmington: Delaware Art Museum, 1980), 55. She also executed a series of expressive drawings entitled *Soul Pictures of Famous Artists* (ca. 1908), an example of which is illustrated in Judith Zilczer, "Arthur B. Davies: The Artist as Patron," *American Art Journal* 19, no. 3 (1987).

4. Henri had first married Linda Craig, a student, in 1898. She died in 1905. Mahonri Sharp Young, *The Eight: The Realist Revolt in American Painting* (New York: Watson-Guptill, 1973), 23–24 and 33–34. The announcement for the marriage of Robert Henri and Marjorie Organ appears in the *New York Times*, 7 June 1908.

5. The artists who participated in organizing the exhibition were Robert Henri, John Sloan, Walt Kuhn, Scott Stafford, William J. Glackens, Arthur B. Davies, Guy Pène du Bois, Ben Ali Haggin, Glenn O. Coleman, Dorothy Rice, and Clara Tice. Review in *Craftsman* (May 1910): 160–172.

6. For the artist's statement on this exhibition, see Robert Henri, "The New York Exhibition of Independent Artsts," in ibid.

7. Elizabeth Milroy, *Painters of a New Century: The Eight and American Art* (Milwaukee: Milwaukee Art Museum, 1991), 109.

8. In 1896 Henri also traveled to London to view the Edouard Manet exhibition and to Paris for the Manet retrospective, observing how that celebrated artist had imbibed the lessons of these same old masters. Valerie

Ann Leeds, *My People: The Portraits of Robert Henri* (Orlando, Fla.: Orlando Museum of Art, 1994), 16–17. While in Paris from 1888 to 1891 he had furthered his training in studio figure drawing with William-Adolphe Bouguereau and Tony Robert-Fleury at the Académie Julian. Milroy, *Painters of a New Century*, 109.

9. Invited by William Merritt Chase, Henri taught on the faculty of the New York School of Art from 1902 to 1908. In 1909 he left to start the Henri School of Art, where he taught until 1912. Leeds, *My People*, 113–114.

10. For an overview of the controversies generated by the Eight, see Elizabeth Hutton Turner, *Men of the Rebellion: The Eight and Their Associates at The Phillips Collection* (Washington, D.C.: The Phillips Collection, 1990), 6–25.

11. For a discussion of Henri's protest and his public challenge to the National Academy of Design, see Milroy, *Painters of a New Century*, 21–23.

12. A complete facsimile of the exhibition catalogue is reproduced in Bennard B. Perlman, *The Immortal Eight: American Painting from Eakins to the Armory Show, 1870–1913* (Cincinnati: North Light Publishers, 1979), 157–173.

13. In one review, Charles De Kay wrote: "Vulgarity smites one in the face at this exhibition, and I defy you to find anyone in a healthy frame of mind who, for instance wants to hang Luks's posteriors of pigs, or Glackens's *At Mouquin's* or John Sloan's *Hairdresser's Window* in his living rooms or gallery, and not get disgusted two days later," quoted in Perlman, *The Immortal Eight*, 179–180.

14. The Eight consisted of Robert Henri, John Sloan, Arthur B. Davies, Ernest Lawson, William Glackens, George Luks, Maurice Prendergast, and Everett Shinn.

15. Holger Cahill and Alfred H. Barr Jr., *Art in America: A Complete Survey* (New York: Reynal and Hitchcock, 1934), 89. They point out that the Eight were also vilified as "The Revolutionary Black Gang." The designation "Ashcan School" was derived from a newspaper article accompanying George Bellows's drawing *Disappointments of the Ash Can*, published in the *Masses*, 5 February 1914. For a discussion of the second-generation Ashcan artists (principally George Bellows, Stuart Davis, Guy Pène du Bois, Glenn Coleman, Edward Hopper, Rockwell Kent, Carl Sprinchorn, and Rex Slinkard) and the genesis of the term in relation to this later group of urban realists, who were trained under the Eight, see Robert Hunter, "The Rewards and Disappointments of the Ashcan School: The Early Career of Stuart Davis," in Lowery Stokes Sims, *Stuart Davis: American Painter* (New York: The Metropolitan Museum of Art and Harry N. Abrams, 1992), 31–41.

16. This painting depicts Eugenie Stein, who was a professional model Henri painted often. Leeds, *My People*, 21.

17. Whitney Chadwick, *Women, Art and Society*, 2nd rev. ed. (London: Thames and Hudson, 1996), 143.

18. Sigmund Freud's German edition of *Studies in Hysteria*, his clinical study of female sexuality, was first published in Leipzig and Vienna in 1895. The English translation was published in 1909, the year before Henri's painting of Organ.

19. The femme fatale especially appealed to Victorian writers interested in the erotics of queer desire. Charles Swinburne was a masochist and a flagellant, possibly as a result of his frequent punishments while at Eton, from which he eventually was dismissed. He is known to have frequented the flagellation brothels of London, particularly an establishment named Verbena Lodge. He was fascinated by lesbianism and

bisexuality, for both their erotics and their use as tools of social and cultural rebellion. James Najarian, "Algernon Charles Swinburne," in *The Gay and Lesbian Literary Heritage: A Reader's Companion to the Writers and Their Works, from Antiquity to the Present*, ed. Claude J. Summers (New York: Henry Holt and Co., 1995), 691. Walter Pater's stylistic elegance and his dangerous ideas about art's autonomy from morality, combined with rumors of homosexuality at Oxford, where he taught, made his name virtually synonymous with gay sensibility during the late nineteenth century. Scott McLemee, "Walter Pater," in *The Gay and Lesbian Literary Heritage*, 539–541. By the time of Henri's portrait, the earlier lesbian subtext of the femme fatale had been generalized to signal the exclusion of masculine power from the calculus of desire within both heterosexual and homosexual contexts.

20. Sally Mills sees this detail as further evidence that Henri was interested in portraying real life. See Mills, "Robert Henri," in Marc Simpson, Mills, and Jennifer Saville, *The American Canvas: Paintings from the Collection of The Fine Arts Museums of San Francisco* (New York: Hudson Hills Press, in association with The Fine Arts Museums of San Francisco, 1989), 194.

21. A summary of the female body and the male gaze in art history is available in Norma Broude and Mary D. Garrard, eds., *The Expanding Discourse: Feminism and Art History* (New York: Harper Collins, 1992), 7–12.

73. CHILDE HASSAM, *Seaweed and Surf, Appledore, at Sunset*

1. Adeline Adams, *Childe Hassam* (New York: American Academy of Arts and Letters, 1938), 81–84.

2. Jay E. Cantor, "Hassam's Twentieth-Century Work," in Warren Adelson, Cantor, and William H. Gerdts, *Childe Hassam: Impressionist* (New York: Abbeville Press, 1999), 84.

3. Nathaniel Hawthorne, *Passages from the American Notebooks of Nathaniel Hawthorne* (Boston: Ticknor and Fields, 1868).

4. Appledore House visitors over the years included the writers John Greenleaf Whittier, Nathaniel Hawthorne, and Sarah Orne Jewett (whose short story *White Heron* may have been inspired by Celia). The painter William Morris Hunt, a cousin of Hassam, summered on Appledore in 1879 to recuperate from a long struggle with poor health and depressed spirits; Hunt committed suicide there in July.

5. Hassam was accorded this status, along with Robert Reid and John Henry Twachtman, in an 1899 review of the exhibition by the Ten American Painters. Kenneth Coy Haley, "The Ten American Painters: Definition and Reassessment" (Ph.D. diss., State University of New York, Binghamton, 1975), 153.

6. Material for this biographical sketch was drawn from H. Barbara Weinberg, *Child Hassam, American Impressionist* (New York: The Metropolitan Museum of Art, 2004).

7. Doreen Bolger Burke, "Childe Hassam," in *American Paintings in the Metropolitan Museum of Art*, Vol. 3, *A Catalogue of Works by Artists Born between 1846 and 1864* (New York: The Metropolitan Museum of Art, 1980), 351–352.

8. Despite his reputation as the closest American follower of the Impressionists, Hassam himself thought little of the label, downplayed any French influence, and considered himself a landscapist in the English style of Joseph Mallord William Turner and John Constable.

9. Robert Hughes, *American Visions: The Epic History of Art in America* (New York: Alfred A. Knopf, 1997), 265.

10. Celia Thaxter, *An Island Garden* (Boston: Houghton, Mifflin & Co., 1895).

11. The horizontality of space and diffuse quality of light in the distance of many of Hassam's paintings—both early and late in his career—are sometimes attributed to the earlier American landscape traditions of the Hudson River School. J. Gray Sweeney, *Themes in American Painting* (Grand Rapids, Mich.: The Grand Rapids Art Museum, 1977), 63.

12. George Chadwick, a composer and regular at Thaxter's summer gatherings, bought the first painting Hassam ever put up for sale. Donelson F. Hoopes, *Childe Hassam* (New York: Watson-Guptill Publications, 1979).

13. Childe Hassam, interview by De Witt McClellan Lockman, 31 January 1927, AAA/SI, microfilm reel 503.

74. CHIURA OBATA, *Mother Earth*

1. Obata dazzled audiences with his bravura brushwork and with his ability to create a finished composition from a random brushmark made on a piece of paper by a spectator. See R. M. D., "S.F. Admirers Inspired by Chiura Art. Obata Exhibition at Art School Hall Draws Crowds," *San Francisco Japanese American*, 23 February 1931, Chiura Obata Scrapbook, Obata Family Collection, photocopy in Chiura Obata artist file, AAA/DEY/FAMSF. See also *San Francisco Chronicle*, 18 March 1928, D7, cited in Gene Hailey, ed., "Chiura Obata: Biography and Works," *California Art Research* 20, pt. 2, 1st ser. (San Francisco: Works Project Administration, 1937), 137–138.

2. *Catalogue of Second Free Jury Exhibition of the Work by Members of East West Art Society in San Francisco Museum of Art* (San Francisco: San Francisco Museum of Art, 1922), n.p.

3. For Obata's biography, see Hailey, "Obata: Biography and Works," 120–160; Masuji Fujii, "Chiura Obata: An Oral History," Japanese American History Project, The University of California at Los Angeles Special Collections Library, ca. 1965, transcript, Obata Family Collection, photocopy in Chiura Obata artist file, AAA/DEY/FAMSF; Janice T. Driesbach and Susan Landauer, *Obata's Yosemite: The Art and Letters of Chiura Obata from His Trip to the High Sierra in 1927* (Yosemite National Park, Calif.: Yosemite Association, 1993); Kimi Kodani Hill, Timothy Anglin Burgard, and Ruth Asawa, *Topaz Moon: Chiura Obata's Art of the Internment* (Berkeley: Heyday Books, 2000); and Tetsuro Shimojima, *A Samurai in California: A Life of Chiura Obata, Japanese Painter* (Tokyo: Shogakukan, 2000).

4. Breaking with the tradition of adopting a teacher's name, Obata selected as his artist name "Chiura," a contraction of *chiga-no-ura*, or "Thousand Bays," a reference to the shoreline near his Sendai home. See Susan Landauer, "Obata of the Thousand Bays," in Driesbach and Landauer, *Obata's Yosemite*, 18.

5. See Fujii, "Obata: An Oral History," n.p. Cf. Hailey, "Obata: Biography and Works," 130.

6. Haruko Obata later recounted, "I was four months pregnant and papa [Obata] wanted to paint me in [the] nude. I was so upset and didn't want to pose in [the] nude. He insisted as my body would change after I bore a child. He said every artist's wife becomes his model so you must pose in the nude. We argued back and forth—finally I said I would do a short while—just a short time. He drew the tree from imagination. It was a big

painting and first he sketched me in while it was hanging vertically. Then he painted the rest on the floor. From time to time he hung it up to look at proportions. It took a long time to finish as he did detail on grass and flowers. None of our friends saw it in progress as the back room was used as a studio and I closed the door when guests came. No one knew and he painted all the time." See "Haruko Obata, Oral History," tape 7, side 2, 28 March 1986, transcript, Obata Family Collection, photocopy in Chiura Obata *Mother Earth* object file, AAA/DEY/FAMSF.

7. Fujii, "Obata: An Oral History," n.p.

8. A critic reviewing Obata's works at the East West Art Society exhibition in San Francisco in 1928 observed, "Obata is at home among trees. He has even painted redwoods that are so unlike the redwoods rejected by art juries that one must pause to give them reverence. Misty trees, beautifully spaced, suggestions of trees and bigness of outdoors." H. L. Dungan, *Oakland Tribune*, 11 March 1928, clipping in Chiura Obata Scrapbook, Obata Family Collection, photocopy in Chiura Obata artist file, AAA/DEY/FAMSF.

9. For Obata's reworking of *Mother Earth*, see Shimojima, *A Samurai in California*, 167–169. For an image of the painting before the addition of the hair, flowers, and branches, see "Japanese Artist Takes His Work as Solemn Ceremony. Paints on Silk, Using Three Brushes Simultaneously to Get Results," *San Francisco Chronicle*, 12 March 1928, 12, newspaper clipping, Chiura Obata Scrapbook, Obata Family Collection, photocopy in Chiura Obata *Mother Earth* object file, AAA/DEY/FAMSF.

10. Piazzoni observed, "In every canvas I produce, whether it is a landscape, a symbolic painting, or figure work, it is always the spirit of California that I am endeavoring to express." See Scott A. Shields, "Eternal Light: Visions of Gottardo Piazzoni," *California History* 80, nos. 2–3 (Summer/Fall 2001): 123. When an interviewer asked Piazzoni what religion he practiced, he replied, "I think it is California." See ibid., 106.

11. Chiura Obata, "Natural Rhythm and Its Harmony," lecture typescript, 1933, Obata Family Collection, photocopy in Chiura Obata artist file, AAA/DEY/FAMSF.

12. On the subject of painting trees, Obata wrote: "When you draw a tree, the most important matter you have to take into your consideration is the recognition of the vital relationship between the tree and the soil from which it is getting its nourishment; the relation is vital therefore most impressive. It is impossible to have colorful flowers, green leaves, etc., without getting proper nourishment from the soil. Before you start to draw a tree, therefore, you have to observe very carefully the sequence of the real facts, starting your observation with the soil, then the roots and the trunk, and then turn to the bough, leaves, flowers, and fruits. Thus from the subjective point of view, you will go far into the real nature of trees in relation to time and space, and you will be able to get in touch with the real life of the tree." See "Section II, No. 2. Trees," lecture typescript, Obata Family Collection, photocopy in Chiura Obata *Mother Earth* object file, AAA/DEY/FAMSF.

13. Obata, "Natural Rhythm and Its Harmony."

75. CHIURA OBATA, *Lake Basin in the High Sierra*

1. Masuji Fujii, "Chiura Obata: An Oral History," Japanese American History Project, The University of California at Los Angeles Special Collections Library, ca. 1965, transcript, Obata Family Collection, photocopy in Chiura Obata artist file, AAA/DEY/FAMSF.

2. Ibid. For Obata's great respect for John Muir, see Chiura Obata, "Nature of California As I See It," typescript, ca. 1928, Obata Family Collec-

tion, photocopy in Chiura Obata artist file, AAA/DEY/FAMSF; and a series of five articles published in an unidentified Japanese-language newspaper, ca. 1928, Obata Family Papers, photocopies in Chiura Obata artist file, AAA/DEY/FAMSF.

3. Fujii, "Obata: An Oral History," n.p. Cf. Janice T. Driesbach and Susan Landauer, *Obata's Yosemite: The Art and Letters of Chiura Obata from His Trip to the High Sierra in 1927* (Yosemite National Park, Calif.: Yosemite Association, 1993), 48.

4. Chiura Obata, ca. 1930, quoted in Driesbach and Landauer, *Obata's Yosemite*, 61. Obata later described the source for *Lake Basin in the High Sierra*: "Standing at the edge of the lake the indigo blue color is too deep to ever know the bottom. And then, far ahead was the perpetual snow covering all over as if it was the skin of a big white bear. And the strange thing was, while I was viewing at the edge of the lake I heard some music. I couldn't explain what it was; it sounded like the wind and it didn't sound like the wind. I didn't understand—what was this music and where did it come from? Also, the heart of the lake was still; not even a movement. Very quiet. All along the edge of the lake where I was [standing] grew tamarack [lodgepole] pines. High in the mountains the pines don't grow upwards, but sideways. The pine had started to have its new green like a chrysanthemum. In contrast, I could see the other side of the blue lake with the snow piled on the ground. There was this pink snow, and there was also blue snow. It was strange. And then, there was this sound. I didn't understand the sound. But looking towards the mountain I saw there were thousands of ten thousands of lines on the perpetual snow. That was the music. The music was the sound of the little streams created by the sun's heat melting the hard snow." See Fujii, "Obata: An Oral History," n.p.

5. Obata painted a contemporaneous vertical version of *Lake Basin in the High Sierra*, measuring approximately 30 × 20 in. This unlocated painting is visible in Kinso Ninomiya's photograph *"The Art Gallery," Kodani Family Guest House, Whaler's Cove, Point Lobos, Monterey, California*, ca. 1928, collection of Hisa Nitta, photocopy in Chiura Obata *Lake Basin in the High Sierra* object file, AAA/DEY/FAMSF.

6. The critic Jehanne Bietry Salinger wrote, "'Lake Basin in the High Sierra' is one of the most beautiful pictures included in the show. It is particularly beautiful in color. Its deep blue, deep green, terra-cotta and grey tones form a beautiful design of mountains and water." See "Chiura Obata," *San Francisco Examiner*, 11 March 1928, E10, Chiura Obata Scrapbook, Obata Family Collection, photocopy in Chiura Obata *Lake Basin in the High Sierra* object file, AAA/DEY/FAMSF.

7. "Obata Wins Imperial Honor," *Art Digest* 5, no. 9 (1 February 1931): 21.

8. *Oakland Tribune*, 8 March 1931, newspaper clipping, Chiura Obata Scrapbook, Obata Family Collection, photocopy in Chiura Obata *Lake Basin in the High Sierra* object file, AAA/DEY/FAMSF.

9. For the creation of the color woodblock print *Lake Basin in the High Sierra, Johnson Peak, High Sierra, U.S.A.*, see Driesbach and Landauer, *Obata's Yosemite*, 60–67. According to Obata, the *World Landscape Series*, published in an edition of one hundred by the Takamizawa Print Studio in Tokyo, required the skills of eight artists, thirty-two wood carvers, and forty printers, and took eighteen months to complete. See Miriam Dungan Cross, "A Delightful Day with the Achenbach Foundation Donors," *Oakland Tribune*, 19 June 1955, Chiura Obata Scrapbook, Obata Family Collection, photocopy in Chiura Obata artist file, AAA/DEY/FAMSF; and Fujii, "Obata: An Oral History," n.p. Each of the finished prints required between 120 and 205 separate hand printings, and some required fifteen to

twenty blocks just to replicate a single brushstroke. See H. L. Dungan, "Wood Block Prints of S.F. Artist Exhibited at U. of C.," newspaper clipping, Chiura Obata Scrapbook, Obata Family Collection, photocopy in Chiura Obata artist file, AAA/DEY/FAMSF. Cf. Nadia Lavrova, "Obata's Work Has Local Touch," *San Francisco Examiner*, 4 January 1931, E10, Chiura Obata Scrapbook, Obata Family Collection, photocopy in Chiura Obata artist file, AAA/DEY/FAMSF.

10. Fujii, "Obata: An Oral History," n.p.

11. Obata was photographed in a Legion of Honor gallery standing in front of this version of *Lake Basin in the High Sierra*. See Chiura Obata *Lake Basin in the High Sierra* object file, AAA/DEY/FAMSF.

12. The visual impact of the painting is heightened by Obata's use of extraordinary natural materials—especially hand-ground mineral pigments. According to contemporary accounts, the high-quality silk for a painting this size could cost up to one hundred dollars, while the blue pigment of the lake, made from ground lapis lazuli, cost sixty dollars—a considerable sum during the Great Depression. See H. L. Dungan, *Oakland Tribune*, 11 March 1928, Chiura Obata Scrapbook, Obata Family Collection. For Obata's materials, see Gene Hailey, "The Permanence of Japanese Pigments," *Argus* 3, no. 2 (May 1928): 11; William Frederick Calkins, "Portfolio: The Seasons at California," *California Monthly*, 1939, n.p.; Chiura Obata interview, *Voice of America* radio broadcast, Albuquerque, New Mexico, 1949, transcript; Obata Family Collection, photocopies in Chiura Obata artist file, AAA/DEY/FAMSF.

13. Chiura Obata, "Lecture on Japanese Painting," lecture typescript, Obata Family Collection, photocopy in Chiura Obata artist file, AAA/DEY/FAMSF.

14. Chiura Obata, cited in lecture notes by Beth Blake, Summer 1934, Obata Family Collection, photocopy in Chiura Obata artist file, AAA/DEY/FAMSF.

15. Chiura Obata, "Instruction Course 2A: Free Brush Work," typescript, Obata Family Collection, photocopy in Chiura Obata artist file, AAA/DEY/FAMSF.

16. Class notes by unidentified student, 28 June 1938, Obata Family Papers, photocopy in Chiura Obata artist file, AAA/DEY/FAMSF. See also Obata's comment, "An artist must bring to his work an unclouded mind like a canvas of purest white." Olivia Skinner, "Tranquil Artistry: Chiura Obata Paints Nature with Japanese Technique," *St. Louis Post-Dispatch*, 23 June 1968, Obata Family Collection, photocopy in Chiura Obata artist file, AAA/DEY/FAMSF.

17. Obata, "Instruction Course 2A: Free Brush Work," typescript, Obata Family Collection, photocopy in Chiura Obata artist file, AAA/DEY/FAMSF.

18. Obata, in Fujii, "Obata: An Oral History," n.p.

76. ALBERT BLOCH, *Nacht I*

1. Albert Bloch, "Lecture No. 1: General Introduction," typescript lecture notes for an art history course, University of Kansas at Lawrence, 1923–24, n.p., collection of Anna Bloch, quoted in David Cateforis, "Painter's Progress: The Later Work of Albert Bloch," in *Albert Bloch: The American Blue Rider*, ed. Henry Adams, Margaret C. Conrads, and Annegret Hoberg (Munich: Prestel, 1997), 79.

2. Ibid., 18–21.

3. For Bloch's Munich period, see Richard C. Green, "Albert Bloch: His Early Career: Munich and *Der Blaue Reiter*," *Pantheon* 39 (January–March 1981): 70–76; and Annegret Hoberg, "Albert Bloch in Munich, 1909–21," in Adams, Conrads, and Hoberg, *Bloch: The American Blue Rider*, 57–78.

4. For Bloch's own account of his art influences, see his letter to Dr. Edward A. Maser, 20 June 1955, in Adams, Conrads, and Hoberg, *Bloch: The American Blue Rider*, 205–207.

5. Ibid., 26.

6. See Mrs. Albert Bloch to the author, 17 August 1998, in Albert Bloch *Nacht I* object file, AAD/DEY/FAMSF.

7. For a related city composition, see the watercolor *Form and Color Study, No. 9: Railway Bridge* (1913), in Adams, Conrads, and Hoberg, *Bloch: The American Blue Rider*, pl. 53.

8. Kandinsky introduced Eddy to Bloch, and the Chicago collector eventually purchased at least twenty paintings from the American artist. See Wassily Kandinsky to Arthur Jerome Eddy, October 1913, quoted in Arthur Jerome Eddy, *Cubists and Post-Impressionists*, rev. ed. (Chicago: A. C. McClurg, 1919), 200. For Eddy's patronage of modern art, see Paul Kruty, "Arthur Jerome Eddy and His Collection: Prelude and Postscript to the Armory Show," *Arts Magazine* 61 (February 1987): 40–47.

9. Eddy, *Cubists and Post-Impressionists*, 201. Eddy went on: "Of this particular canvas a distinguished Japanese art-lover said, 'I would rather have it than any modern painting I have seen.'" The "distinguished Japanese art-lover" was almost certainly the German-Japanese American (Carl) Sadakichi Hartmann (1867–1944), a renowned writer and art-literary critic. Arthur Jerome Eddy's son, Jerome O. Eddy, who inherited *Nacht I*, later noted that it was his parents' favorite painting in their collection. See Jerome O. Eddy to Los Angeles art dealer Earl L. Stendhal, Stendhal Art Galleries, 12 April and 10 May 1935, Stendhal Art Galleries Papers, AAA/SI, microfilm reel 2717, frames 1007 and 1012.

10. Albert Bloch to Sidonie Nádherny, 10 June 1948, in Adams, Conrads, and Hoberg, *Bloch: The American Blue Rider*, 49. See Murray Sheehan, "The New Art: Apropos the Work of Albert Bloch," *St. Louis Mirror*, 11 April 1913, 5–6, in which Sheehan, following a studio visit, describes "Bloch's purely subjective canvases, those in which he tries to strip him [*sic*] of all flesh and blood, and present pure spirit."

11. Bloch's haloed spheres of light reflect contemporaneous theosophical theories that assert both animate and inanimate objects are sentient beings who emit spiritual auras visible only to perceptive viewers. See the popular theosophic text of 1901, Annie Besant and C. W. Leadbeater, *Thought Forms* (reprint, Wheaton, Ill.: Theosophical Publishing House, 1999). Bloch explicitly rendered this idea in his drawing *In the Beginning: For a Cycle of the Creation* (1922), which depicts a similar celestial sphere filled with embryonic human beings. See Adams, Conrads, and Hoberg, *Bloch: The American Blue Rider*, pl. 71.

12. Bloch later recalled Kandinsky's influence: "It is to be remembered, whatever my critical reservations regarding the actual *work* of Kandinsky, that never had I listened to such inspired and inspiring talk upon subjects which interested me most. He was bursting with ideas, and his work between 1909–14 showed this in every canvas, every scrap of paper. He had thought long and earnestly, often fruitfully, upon all aspects of the subject which had so long engaged my own thought. How could a receptive hearer, sixteen years younger, fail to learn from a man like that, who was not trying to teach?" Albert Bloch to Edward Maser, 20 June 1955, quoted in ibid., 206–207.

13. See Wassily Kandinsky, *Concerning the Spiritual in Art* (New York: Wittenborn, Schultz, 1947), 23.

14. Albert Bloch, "To My Palette," quoted in Maria Schucter, "Ro-

mantisches im Werk Albert Blochs," in *Albert Bloch: Artistic and Literary Perspectives*, ed. Frank Baron, Helmut Arntzen, and David Cateforis (Lawrence, Kans.: Max Kade Center for German-American Studies, in association with Prestel, 1997), 77. Bloch's poem echoes Kandinsky's conception of blue in his *Concerning the Spiritual in Art* (1912): "The deeper the blue becomes, the more strongly it calls man towards the infinite, awakening in him a desire for the pure and, finally, for the supernatural. It is the color of the heavens, the same color we picture to ourselves when we hear the sound of the word 'heaven.' Blue is the typically heavenly color." Wassily Kandinsky, *Concerning the Spiritual in Art*, quoted in David Cateforis, "Albert Bloch's Visionary Landscapes," in ibid., 127. See Besant and Leadbeater, *Thought Forms*, 23–24: "The different shades of blue all indicate religious feeling, and range through all hues from the dark brown-blue of selfish devotion, or the pallid blue-grey of fetish-worship tinged with fear, and up to the rich deep clear color of heartfelt adoration, and the beautiful pale azure of that highest form which implies self-renunciation and union with the divine; the devotional thought of an unselfish heart is very lovely in color, like the deep blue of a summer sky. Through such clouds of blue will often shine out golden stars of great brilliancy, darting upwards like a shower of sparks."

15. Although his parents were Jewish, Bloch painted Old and New Testament subjects throughout his career, kept a Bible by his bed, and even considered converting to Catholicism. See Reinhild Kauenhoven Janzen, "Albert Bloch's Images of Christ," in Baron, Arntzen, and Cateforis, *Bloch: Perspectives*, 55. Bloch would have known the Old Testament prophecy, "The people who walked in darkness have seen a great light; those who dwell in a land of deep darkness, on them the light has shined" (Isa. 9:2), which was fulfilled in the New Testament by Christ, who said, "I am the light of the world. Whoever follows me will never walk in darkness, but will have the light of life" (John 8:12). Bloch also referred to Christ as "Light unalloyed." See Janzen, 56. However, in *Nacht I*, darkness and light appear to serve as universal metaphors for the themes of the material and immaterial, the unenlightened and the enlightened.

16. Bloch's *Nacht II* (1914), in which a walking male figure lengthens his stride as he is progressively energized by spirit, appears to reprise the same theme. See Adams, Conrads, and Hoberg, *Bloch: The American Blue Rider*, pl. 24.

17. See Ester Coen, *Umberto Boccioni* (New York: The Metropolitan Museum of Art and Harry N. Abrams, 1988), 116–125.

18. See Bloch's "Prophecy," in which the visionary artist protagonist is "reviled and despised," and "Where is Sanctuary," in which the artist suffers in isolation, described in Adams, Conrads, and Hoberg, *Bloch: The American Blue Rider*, 24.

19. Albert Bloch to Maria Marc, 11 November 1918, quoted in ibid., 42.

77. ERNEST LAWSON, *Harlem River at High Bridge*

1. Frederic Fairchild Sherman, "The Landscape of Ernest Lawson," *Art in America* 8 (December 1919): 32.

2. Until the construction of the aqueduct, New York City was dependent on well water. One of the great public works projects of the nineteenth century, the Croton system was capable of bringing forty to fifty million gallons of water to the city each day. The two reservoirs that were the water's destination were located at the current sites of the New York Public Library and Central Park's Great Lawn. Historical and statistical information about the Croton Aqueduct and High Bridge Viaduct is drawn from http://www.nycroads.com/crossing/high.

3. The oldest standing bridge in New York City, it was closed in 1917 on the day the United States entered World War I; other sources of water had been developed, and the security threat was deemed too great. The walkway remained open until 1960, when misuse by vagrants and delinquent youth moved the parks department to bar access; a movement is under way to reopen it as part of an Old Croton Aqueduct State Park and Greenway. The High Bridge viaduct was listed on the National Register of Historic Places in 1972.

4. William Cullen Bryant, ed., *Picturesque America; or, The Land We Live In* (New York: D. Appleton and Co., 1874), 2:558. High Bridge is also featured in two illustrations—one a distant view of the entire span from the low vantage point of the river, the other a closer look from the bluffs adjacent to the viaduct on the Manhattan side.

5. High Bridge Park would be assembled piecemeal from these farms, beginning in 1867; land continued to be added to the park as it became available until the 1960s, when it reached its current size of 119 acres. New York City Department of Parks and Recreation.

6. Adeline Lee Karpiscak, *Ernest Lawson, 1873–1939: A Retrospective Exhibition of His Paintings Held at the University of Arizona Museum of Art* (Tucson: University of Arizona Museum of Art, 1979), 5.

7. Ibid., 6. Lawson painted High Bridge as late as the 1930s, working then in an almost photo-realist style. Ibid., 29.

8. FAMSF files. Lawson once remarked, "Color is my specialty in art. . . . It affects me like music affects some persons—emotionally. I like to play with colors like a composer playing with counterpoint music," quoted in Peter Morrin, Judith Zilczer, and William C. Agee, *The Advent of Modernism: Post-Impressionism and American Art, 1900–1918* (Atlanta: High Museum of Art, 1986), 109.

9. Sherman, "Landscape of Lawson," 33.

10. Jennifer Saville, "Ernest Lawson," in Marc Simpson, Sally Mills, and Saville, *The American Canvas: Paintings from the Collection of The Fine Arts Museums of San Francisco* (New York: Hudson Hills Press, in association with The Fine Arts Museums of San Francisco, 1989), 206. Before 1891 Lawson had briefly studied at an art school in Kansas City and had worked as a draftsman in Mexico. Lawson pursued art as a career despite the strong objections of his academically inclined family; his father considered working as an artist to be a "drifting, lazy position." Karpiscak, *Ernest Lawson*, 1. Lawson and his father first clashed over Ernest's artistic bent when, as a boy, he had tattooed an anchor and star of his own design onto his forearm. His furious father attempted to remove the tattoo with strong solvents but succeeded only in smearing the inks, leaving Ernest not only tattooed but poorly tattooed for the rest of his life. Everett Shinn, "Recollections of the Eight," in *The Eight* (New York: Brooklyn Museum and the Brooklyn Institute of Arts and Sciences, 1943), 12.

11. Bruce W. Chambers, *American Paintings in the High Museum of Art: A Bicentennial Catalogue* (Atlanta: High Museum of Art, 1975), 80. Lawson's technique was described by Duncan Phillips in 1917: "Briefly stated, his technique consists of applying a load of enamel paint to canvas and gradually working it with the help of glazes into a thick, rich and usually smooth impasto, frequently leaving parts of the canvas bare or very thinly covered, while on other parts the pigment is modeled into low relief." Phillips, "Ernest Lawson," *American Magazine of Art* 7, no. 7 (May 1917): 260.

12. Karpiscak, *Ernest Lawson*, 5.

13. Ibid., 4. Working at Moret-sur-Loing one day he encountered Alfred Sisley, a first-generation Impressionist whom Lawson greatly admired.

Accosting the older man, Lawson asked him to criticize the painting currently on his easel; Sisley, who disliked contact with other artists, simply advised him to "put more paint on your canvas and less on yourself." Lawson managed to get sufficient paint onto his canvases to have two paintings accepted for the 1894 Salon des Artistes Français. The titles of these paintings, *Soleil du soir* (Evening Sun) and *Matin* (Morning), make it clear that Lawson was following in the footsteps of both French and American Impressionists by exploring the effects of light at different times of day. He would maintain this interest throughout his career—for example, by painting the High Bridge area under varying conditions.

14. Phillips, "Ernest Lawson," 259.

15. Dennis R. Anderson, "Ernest Lawson's Vision," in *Ernest Lawson: Retrospective* (New York: ACA Gallery, 1976), 12.

16. Ibid., 16. Overall, however, his was a successful career, marked by critical acclaim, frequent acceptance into juried exhibitions, and strong sales. As early as 1894 William Merritt Chase had referred to Lawson as America's greatest landscape painter; at the Panama Pacific International Exposition in 1915 he had a room to himself in the Palace of Fine Arts and won a gold medal, not for any individual painting, but for the high quality of his exhibited works as a whole. Ibid., 6. One of the first three painting acquisitions of the Newark Museum of Art, in 1910, was one of Lawson's Harlem River scenes. William H. Gerdts, *American Impressionism* (New York: Abbeville Press, 1984). In 1916 A. E. Gallatin wrote, "Fame and success mean about as little to [Lawson] as they did to Degas"; one wonders if this would have been the case had Lawson not been so famous and successful. Gallatin, "Ernest Lawson," *International Studio* 59, no. 233 (July 1916): xiv.

17. Guy Pène du Bois, *Ernest Lawson*, American Artists Series (New York: Whitney Museum of American Art, 1932), 11.

18. The ancient Romans built aqueducts all over the empire. Viaducts are still standing in many locations and were the subject of many artistic renderings in the eighteenth and nineteenth centuries owing to their romantic ruined grandeur. The double-arched viaduct at Segovia is about the same height as High Bridge but twice as long; the triple-arched Pont du Gard at Nîmes is quite a bit shorter but some fifteen feet higher. All of Rome's eleven aqueducts were raised for some of their runs, which, in the case of the Anio Novus, was fifty-nine miles. Together they provided the city with more than 264 million gallons of water daily, more than Americans tend to use today. Aqueduct information is courtesy of http://www.inforoma.it.

19. Sherman, "Landscape of Lawson," 32.

78. CHARLES DEMUTH,
From the Garden of the Château

1. Quoted in Barbara Haskell, "Selected Writings," in *Charles Demuth* (New York: Whitney Museum of American Art, 1987), 47.

2. The Daniel Gallery promoted the group of artists known as the Immaculates, whose avant-garde aesthetic has also been called cubist-realist and precisionist. Other major Precisionists associated with the Daniel Gallery were Charles Sheeler, Preston Dickinson, Niles Spencer, and Elsie Driggs. Primary members of the Stieglitz circle, which Demuth joined in 1926, are Georgia O'Keeffe, Marsden Hartley, Charles Sheeler, Arthur Dove, John Marin, Joseph Stella, Alfred Maurer, Arthur B. Carles, Stanton Macdonald-Wright, and Max Weber.

3. Lloyd Goodrich, "Notes on Charles Demuth Exhibition," AAA/SI, microfilm reel 653, frame 28.

4. Henry McBride, "Demuth Memorial Exhibition," in *The Flow of Art: Essays and Criticism of Henry McBride*, ed. Daniel Catton Rich (New York: Atheneum Publishers, 1975), 356.

5. The 1913 International Exhibition of Modern Art is commonly referred to as the Armory Show after the 69th Regiment Armory building, located on Twenty-fifth Street in Manhattan's Gramercy Park district, where it took place. Arthur B. Davies organized the exhibition, which subsequently traveled to Boston and Chicago. The show famously included Marcel Duchamp's much maligned and mocked cubist painting *Nude Descending a Staircase No. 2* (1912).

6. The term *Precisionism* derives from Martin Friedman's pioneering 1960 exhibition *The Precisionist View in American Art*. Earlier terms have included Immaculates, New Classicists, and Cubist-Realists. Karen Tsujimoto, *Images of America: Precisionist Painting and Modern Photography* (San Francisco: San Francisco Museum of Modern Art, 1982), 22.

7. Jim Ruth, "Demuth sold for $1.4 million," *Lancaster Sunday News*, 11 February 1990, A4.

8. The house was next door to the family tobacco shop. Betsey Fahlman, *Pennsylvania Modern: Charles Demuth of Lancaster* (Philadelphia: Philadelphia Museum of Art, 1983), 15.

9. *Fountain* caused a scandal at the Society of Independent Artists in New York. Demuth had met Duchamp in 1915, just two years after *Nude Descending a Staircase* (1912) had been singled out for hostile criticism during the first Armory Show, in 1913, as evidence of the incomprehensible and decadent nature of modern avant-garde painting in Europe at the time. Especially targeted were the abstract movements identified with the School of Paris—notably Symbolism, Fauvism, Cubism, Orphism, and Dadaism.

10. Charles Demuth, *Letters of Charles Demuth: American Artist, 1883–1935*, ed. Bruce Kellner (Philadelphia: Temple University Press, 2000), 31.

11. Karal Ann Marling, "My Egypt," in *Frames of Reference: Looking at American Art, 1900–1950*, ed. Beth Venn and Adam D. Weinberg (New York: Whitney Museum of American Art, 1999), 160.

12. Maurice Berger has summarized the range of these speculations, along with their pitfalls, and his own theory that the pitfalls are exactly the point, in his essay on Demuth's painting *My Egypt* (1927), in ibid., 165–167.

13. Jonathan Weinberg, *Speaking for Vice: Homosexuality in the Art of Charles Demuth, Marsden Hartley, and the First American Avant-Garde* (New Haven: Yale University Press, 1993), 212.

14. Demuth, *Letters of Charles Demuth*, 30.

15. Ibid., 37.

16. Ibid., 33.

17. Ibid., 30.

18. Ibid., 32.

19. Ibid., 37.

20. Ibid., 38.

21. The most complete and convincing of these is Weinberg, *Speaking for Vice*. See especially his chapter "Charles Demuth and 'Some Unknown Thing,'" 43–60. Weinberg presents the evidence for a long-term, discreet affair between Demuth and Robert Locher, the man usually discussed in biographies as the artist's probable lover (46–47). For an alternative view that argues the two men were merely stylish confidants, see Demuth, *Letters of Charles Demuth*, 15.

22. Probably the most famous of these works are *Aucassin and Nicolette*

(1921), *My Egypt* (1927), and *And the Home of the Brave* (1931). For a complete list of architectural paintings, primarily in oil, see Barbara Haskell, *Charles Demuth* (New York: Whitney Museum of American Art, 1987).

23. Thomas A. Edison had demonstrated the industrial applications for electricity in 1880 at Menlo Park, New Jersey, but its force as a symbol of technological progress was created at the Exposition Universelle of 1900 in Paris through the demonstration of the electric dynamo in the Gallery of Machines. For a contemporary account, see Henry Adams, *The Education of Henry Adams: A Study of Twentieth-Century Multiplicity* (Private Printing 1907; Boston: The Massachusetts Historical Society, 1918; reprint, New York: Random House, Modern Library Edition, 1931), 382.

24. The principal members of the Ashcan School were those painters known as the Eight, after the number of artists associated with a groundbreaking exhibition in 1908 at Macbeth Gallery in New York City. They were Arthur B. Davies, William J. Glackens, Robert Henri, Ernest Lawson, George Luks, Maurice B. Prendergast, Everett Shinn, and John Sloan.

25. Emily Farnham, *Charles Demuth: Behind a Laughing Mask* (Norman: University of Oklahoma Press, 1971), 137–139.

26. This strategy is consistent with Demuth's poster portraits, a form he invented around the time of this painting, which collapsed the identity of people into objects. See Robin Jaffee Frank, *Charles Demuth Poster Portraits, 1923–1929* (New Haven: Yale University Press, 1994).

27. Kermit Champa, "'Charlie Was Like That,'" *ArtForum* 12 (March 1974): 54.

28. Demuth was profoundly influenced by reading J.-K. Huysmans's *À rebours*, which translates as *Against Nature*. Ibid., 55.

79. GEORGE C. AULT, *The Mill Room*

1. Robert Coady, *Soil* 1, no. 2 (January 1917): 55, quoted in Barbara Zabel, "The Machine as Metaphor, Model, and Microcosm: Technology and American Art, 1915–1930," *Arts Magazine* 57, no. 4 (December 1982): 103. For an analysis of artists, critics, and intellectuals who in the second decade of the twentieth century called for American artists to represent the urban and the industrial, see Wanda M. Corn, *The Great American Thing: Modern Art and National Identity, 1915–1935* (Berkeley and Los Angeles: University of California Press, 1999), 43–90. A well-illustrated survey of the machine aesthetic in art and design during the 1920s, 1930s, and 1940s is Richard Guy Wilson, Dianne H. Pilgrim, and Dickran Tashjian, *The Machine Age in America, 1918–1941* (Brooklyn: The Brooklyn Museum of Art, 1986).

2. Neither artists nor critics used the words *Precisionism* or *precisionist* in the 1920s to describe the paintings of Ault and his peers. For a history of these terms, see Gail Stavitsky, "Reordering Reality: Precisionist Directions in American Art, 1915–1941," in *Precisionism in America, 1915–1941: Reordering Reality* (Montclair, N.J.: Montclair Art Museum, 1994), 30–34. Surveys of Precisionist artists include ibid.; and Karen Tsujimoto, *Images of America: Precisionist Painting and Modern Photography* (San Francisco: San Francisco Museum of Modern Art, 1982).

3. The following biography of Ault is based on Susan Lubowsky, *George Ault* (New York: Whitney Museum of American Art, 1988), 7–45; and Jennifer Saville, "George C. Ault," in Marc Simpson, Sally Mills, and Saville, *The American Canvas: Paintings from the Collection of The Fine Arts Museums of San Francisco* (New York: Hudson Hills Press, in association with The Fine Arts Museums of San Francisco, 1989), 220.

4. Louise Ault, "Louise Ault Writings," 1, George Ault Papers, AAA/SI, quoted in Lubowsky, *Ault*, 8.

5. Unidentified source, review of exhibition at Downtown Gallery in 1928, Downtown Gallery Papers, AAA/SI, microfilm reel ND 1, frame 18, typescript copy in the George Ault artist file, AAD/DEY/FAMSF.

6. *Brooklyn Eagle*, 25 November 1928, from Downtown Gallery Papers, AAA/SI, microfilm reel ND 1, frame 22, typescript copy in the George Ault artist file, AAD/DEY/FAMSF.

7. Saville, "Ault," 220. For a brief discussion of the milling process in the manufacture of printing ink, see *Printing Ink Manual* (Cambridge, U.K.: W. Heffer and Sons, 1961), 601–605.

8. Karl Marx, "Alienated Labour," in *The Portable Karl Marx*, trans. and ed. Eugene Kamenka (New York, 1983), 136, quoted in Sharon Corwin, "Picturing Efficiency: Precisionism, Scientific Management, and the Effacement of Labor," *Representations* 84 (2004): 146, emphasis in original. My analysis of the representation of labor in Ault's painting is indebted to Corwin's insightful essay.

9. Saville, "Ault," 220.

10. Lubowsky, *Ault*, 11.

11. Louise Ault, "Writings," 17, quoted in ibid., 14–15.

80. EDWIN DICKINSON, *The 'Cello Player*

1. Lloyd Goodrich, *Edwin Dickinson* (New York: Whitney Museum of American Art, 1965), 5.

2. According to Dickinson, "A very important thing in conditioning my life was the loss of my mother in 1903." Quoted in John L. Ward, *Edwin Dickinson: A Critical History of His Paintings* (Newark: University of Delaware Press, 2003), 40. Most biographical material was drawn from this text. See also Helen Dickinson Baldwin, "Edwin Dickinson," *Provincetown Arts*, 1988; and Douglas Dreishpoon, *Edwin Dickinson: Dreams and Realities* (New York: Hudson Hills Press, 2002).

3. Quoted in Carol S. Gruber, "The Reminiscences of Edwin Dickinson" (MS, Oral History Research Office, Columbia University, New York, November 1957–January 1958), quoted in Baldwin, "Edwin Dickinson," 65.

4. In 1914 Frank Days, proprietor of Days Lumberyard in Provincetown, built above the lumber sheds ten artists' studios, primarily to take advantage of the summer influx of painters. In winter he rented them at "fifty dollars for the season, or as far into the winter as an artist could last." Baldwin, "Edwin Dickinson," 66.

5. Gruber, quoted in ibid., 66.

6. In Buffalo Dickinson became reacquainted with a classmate from his student days, Esther Hoyt Sawyer, who, along with her husband, Ansley, would become the foremost champion of his art. So fervently did the Sawyers believe in Dickinson's talent that in later years they provided him with a modest monthly stipend, purchased many of his paintings, and pursued venues for him to show and sell his work. The stipend of fifty dollars a month began in 1924. Dreishpoon, *Dreams and Realities*, 29.

7. Baldwin, "Edwin Dickinson," 67.

8. Dickinson continued, "The figures in the foreground were all painted from models, sometimes friends; those in the rear were either invented or done from drawings. The still life in the foreground was painted from nature—from objects I owned or had borrowed." Quoted in Katharine Kuh, *The Artist's Voice: Talks with Seventeen Artists* (New York: Harper & Row, 1960), 73. The painting was named in 1921 when Dickin-

son insured it for $1,000, perhaps because the insurance forms required a title. Ward, *A Critical History*, 75.

9. Baldwin, "Edwin Dickinson," 67.

10. Dickinson continued, "My age was 32–34. It began as a composition-portrait of Herman Kahler, painter, 'cellist, but Mr. Kahler's place was soon taken by John Cordes, a retired fisherman. Several heads of Mr. Cordes preceded the present one; they occupied a great deal of time. The first pieces of still-life were later substituted for by others. Everything in the piece was 'posed-for' by the objects present." Quoted in Goodrich, *Edwin Dickinson*, 7.

11. Helen Dickinson Baldwin to Derrick Cartwright, research assistant, American Paintings Department, M. H. de Young Memorial Museum, 18 June 1991. Baldwin's letter continues: "The apostrophe has not usually been noticed but if you want to be *absolutely* correct that is how it would be." The violoncello, commonly known today by the abbreviated form "cello," is a member of the violin family, pitched lower than the viola but higher than the double bass.

12. According to Dickinson, the painting contains "14 books; 2 potatoes; 2 saucers; 3 sheets of music (Intermezzo for Cavaliera [*sic*] Rusticana, Marriage of Figaro, LVB[eethoven] quatuor [*sic*] 18 #3, 2nd violin, Allegro); 2 china pitchers (Sherman); 1 photograph, 7 shells; 1 trilobite; 3 kettles; 1 rose; 1 music stand; 1 chair; 1 organ; 1 piano; 1 'cello; John Cordes. (45 [*sic*] pieces of still life)." Edwin Dickinson to Esther Hoyt Sawyer, 22 September 1924, Esther Hoyt Sawyer Papers, AAA/SI, microfilm reel 901, frame 730.

13. Goodrich, *Edwin Dickinson*, 7.

14. According to friend and patron Esther Hoyt Sawyer, "To Dickinson perspective is a guiding star which lures him ever on to more difficult compositions." Quoted in ibid., 16.

15. Gruber, quoted in Baldwin, "Edwin Dickinson," 67. According to Dickinson, "I've made [it] a rule all my life never to paint an object that has a normal posture in that posture . . . I always put something under an object . . . to give it a cant that will require me to look to see how much it is away from a position I might have assumed. . . . it may be a little livelier . . . to see things a little other than you've always seen them. I'd get pretty tired if I had to have things up and down [in a painting] because they had to be up and down in order to be used." Ibid., 168.

16. "Nansen" refers to Fridtjof Nansen, an Arctic explorer in whom Dickinson had a great interest. I am indebted to Timothy Anglin Burgard for the observation that "Figaro" may not only refer directly to Mozart but also be an indirect reference to the Parisian newspaper frequently employed as a design element in many cubist works, such Picasso's *Bottle of Vieux Marc, Glass, Guitar and Newspaper* of 1913.

17. James Schuyler called *The 'Cello Player* "much more abstract than it looks." The very solidity of the objects renders the final effect all the more surreal, as these "real" objects clearly exist in a fictive space. Schuyler, "U.S. Painters Today: No. 2, Edwin Dickinson," *Portfolio & Art News Annual*, no. 2 (1960): 101.

18. "American Section in Carnegie International," *New York Times*, 24 October 1926, sec. X, 11.

19. For the first few decades of his career Dickinson was perhaps best known as "the artist whose painting was hung sideways at the National Academy of Design." Indeed, in 1929 *The Fossil Hunters*, rotated ninety degrees from its intended orientation, won the second Altman Prize. The event was of sufficient interest to merit the front page of the *New York Times*. Over the caption, "Edwin W. Dickinson's painting is shown here as he intended it should be at the Winter show of the National Academy of Design," the painting is reproduced upside down. This anecdote is quoted widely, including in Schuyler, "U.S. Painters Today," 92.

20. "General Sherman drank tea from it in Atlanta en route to the sea." Edwin Dickinson to Esther Hoyt Sawyer, February 1926, Esther Hoyt Sawyer Papers, AAA/SI, microfilm reel 901, frame 751.

21. Quoted in Baldwin, "Edwin Dickinson," 67.

22. "Father came from a musically gifted family and music was always tightly woven into his life"; ibid.

23. Dickinson began the painting the year after seeing Beethoven memorabilia—a cup, saucer, letters, and sheet music—in New York. Edwin Dickinson to Esther Hoyt Sawyer, March 1927, Esther Hoyt Sawyer Papers, AAA/SI, microfilm reel 901, frame 782. On a later occasion he visited a vault at the New York Public Library to see one of Beethoven's pianos: "When my guide was not looking . . . I touched it. I felt compelled to. . . . There was no sound, but I had touched a key." Patricia B. Wilson, "Angle of Light on Dickinson's Art," *Christian Science Monitor*, 25 January 1966, 4, quoted in Ward, *A Critical History*, 96.

81. GEORGIA O'KEEFFE, *Petunias*

1. Statement from *Fifty Recent Paintings*, by Georgia O'Keeffe (New York: The Intimate Gallery, 1926), quoted in Barbara Buhler Lynes, *Georgia O'Keeffe: Catalogue Raisonné* (New Haven: Yale University Press, in association with the National Gallery of Art and the Georgia O'Keeffe Foundation, 1999), vol. 2, 1098.

2. Marc Simpson, "Georgia O'Keeffe's *Petunias,*" *Triptych* (April–May 1991): 21.

3. Elizabeth Montgomery, *Georgia O'Keeffe* (New York: Barnes and Noble, 1993), 13.

4. Dow was influenced by his teacher, Ernest Fenollosa, whose own study of Chinese and Japanese art led him to espouse Zen principles of self-discovery as a creative tool. Russell Bowman, in Barbara Buhler Lynes and Bowman, *O'Keeffe's O'Keeffes: The Artist's Collection* (New York: Thames & Hudson, in association with the Milwaukee Art Museum and the Georgia O'Keeffe Museum, 2001), 15.

5. Charles C. Eldredge, *Georgia O'Keeffe* (New York: Harry N. Abrams, in association with the National Museum of American Art, Smithsonian Institution, 1991), 11.

6. O'Keeffe oversaw the final exhibition at An American Place: it was of her own work.

7. The one exception was 1925, when he included her work in a group exhibition. The largest of these exhibitions, in 1923, included more than 100 works. Lynes, *Georgia O'Keeffe: Catalogue Raisonné*, 1:11, 13.

8. She studied figure drawing under John Vanderpoel at the Art Institute of Chicago, and portraiture and life drawing under William Merritt Chase and anatomy under Kenyon Cox at the Art Students League. Classes at the University of Virginia were taught by Alon Bement, a disciple of Arthur Wesley Dow. Montgomery, *Georgia O'Keeffe*, 8–9.

9. O'Keeffe's teaching position in South Carolina produced the humorous but telling incident in which Stieglitz infuriated her by inadvertently referring to her initially as Carolina O'Keeffe.

10. Pollitzer so believed in O'Keeffe's work that she first took a group of her charcoal drawings to Stieglitz in 1916 without the artist's permission.

11. It was the work from this period that Stieglitz first saw and admired

so much for its ability to "create abstract evocations of music and emotional states as advocated by Fenollosa and Kandinsky. These works represent some of the most advanced abstraction of the time, through their relative simplicity and their suggestions of a type of organic vitalism." Bowman, in Lynes and Bowman, *O'Keeffe's O'Keeffes*, 17.

12. Stieglitz left his wife, Emmeline Obermeyer, in 1918 to live with O'Keeffe when she moved to New York City. Stieglitz and O'Keeffe were married on 11 December 1924.

13. Her first exhibition of paintings with bones opened at Stieglitz's An American Place on 27 December 1931.

14. Stieglitz's estate included not only his own photographs, letters, and papers but his extensive collection of more than 850 works of art and thousands of photographs. Most of his collection was given to the Metropolitan Museum of Art, New York, which held two memorial exhibitions, one of his art collection and one of his own photographs. O'Keeffe also gifted a master set of Stieglitz's photographs (known as the key set) to the National Gallery of Art, Washington, D.C. Montgomery, *Georgia O'Keeffe*, 16–17.

15. In 1940 O'Keeffe bought her house at Ghost Ranch, near Abiquiu, New Mexico, which had been her summer home since 1936. In 1945 she purchased in Abiquiu a ruined *casa grande*, which she restored, principally with the help of her lifelong friend Maria Chabot. Beginning in 1949, she spent the winter and spring in Abiquiu and the summer and fall at Ghost Ranch, until health required her to move to Santa Fe in 1984.

16. Over her lifetime, O'Keeffe painted more than 200 flower works, the majority of them from 1918 to 1932. See Nicholas Callaway, "Afterword," *Georgia O'Keeffe: One Hundred Flowers* (New York: Alfred A. Knopf, 1989), n.p.

17. Anna Chave has summarized this view and critiqued it in light of contemporary feminist challenges to male constructions of women. See her "O'Keeffe and the Masculine Gaze," in *Reading American Art*, ed. Marianne Doezema and Elizabeth Milroy (New Haven: Yale University Press, 1998), 350–352.

18. Quoted in Eldredge, *Georgia O'Keeffe*, 82.

19. Statement from *Georgia O'Keeffe: Exhibition of Oils and Pastels* (New York: An American Place, 1939), n.p. Quoted in Lynes, *Georgia O'Keeffe: Catalogue Raisonné*, 2:1099.

20. Whitney Chadwick, *Women, Art, and Society*, rev. ed. (London: Thames and Hudson, 1996), 306.

21. O'Keeffe joined at the urging of her friend Anita Pollitzer. Eldredge, *Georgia O'Keeffe*, 15.

22. Barbara Buhler Lynes, *O'Keeffe, Stieglitz and the Critics, 1916–1929* (Ann Arbor, Mich.: UMI Research Press, 1989), 135.

23. Eldredge, *Georgia O'Keeffe*, 16.

24. Ibid., 15.

25. O'Keeffe's resistance in the face of her critics is discussed in Chadwick, *Women, Art, and Society*, 305–307.

82. ARTHUR G. DOVE, *Sea Gull Motive (Sea Thunder* or *The Wave)*

1. The most comprehensive biography of Arthur Dove is Ann Lee Morgan, *Arthur Dove: Life and Work, with a Catalogue Raisonné* (Newark: University of Delaware Press; London: Associated University Presses, 1984), 11–37.

2. Arthur G. Dove, "A Different One," in *America and Alfred Stieglitz:*

A Collective Portrait, ed. Waldo Frank et al. (1934; New York: Aperture, 1979), 245, quoted in Debra Bricker Balken, *Arthur Dove: A Retrospective* (Andover, Mass.: Addison Gallery of American Art, 1997), 20. Dove's second wife, Helen Torr Dove, herself an accomplished artist, also played a significant role in the development of his art and career.

3. Dove once stated: "As to going further and explaining what I felt, that would be quite as stupid as to play on an instrument before deaf persons. The deaf person is simply not sensitive to sound and cannot appreciate [it]; and a person who is not sensitive to form and color as such would be quite as helpless." Arthur Dove, in Arthur Eddy Jerome, *Cubists and Post-Impressionism* (Chicago: A. C. McClurg, 1914), 41, quoted in Balken, *Dove: A Retrospective*, 22.

4. Arthur Dove, "Notes by Arthur G. Dove," *Dove Exhibition* (New York: The Intimate Gallery, 1929), n.p.

5. Ibid.

6. See "List of Paintings," in ibid. The painting has also been known by other titles. In the 1930s it was twice reproduced as *Sea Thunder*; for example, see Elizabeth McCausland, "Water Color by Arthur G. Dove Presented Museum; Life and Work of a Fine American Abstractionist," *Springfield (Mass.) Sunday Union and Republican*, 21 May 1933. In the 1980s it was entitled *The Wave*; for example, see Morgan, *Dove: Life and Work*, 151–152. It may have been retitled because it was hung sideways, as if it were a landscape; see Marc Simpson, "Arthur G. Dove's *Sea Gull Motive*," *Tryptych* 53 (November–December 1990): 18–20.

7. *Webster's New Twentieth Century Dictionary*, 2nd ed., s.v., "motive" and "motif."

8. Dove's dislike of mechanized culture is noted by Balken, *Dove: A Retrospective*, 17. On Dove's artistic theories, see Morgan, *Dove: Life and Work*, 73–82; and esp. Sherrye Cohn, *Arthur Dove: Nature as Symbol* (Ann Arbor, Mich.: UMI Research Press, 1985).

9. Arthur Dove to Arthur Eddy Jerome, 1913, quoted in Cohn, *Dove: Nature as Symbol*, 12.

10. According to Dove's second wife, "when he returned [from Europe in 1908] he spent much time in the woods analyzing tree bark, flowers, butterflies, etc." Helen Torr Dove, "Notes," Dove Papers, AAA/SI, microfilm reel 4682, frame 63, quoted in Balken, *Dove: A Retrospective*, 20.

11. For an extended discussion of Dove's interest in nature, see Cohn, *Dove: Nature as Symbol*, 19–43.

12. Dove, "Notes," in *Dove Exhibition*.

83. DIEGO RIVERA, *Two Women and a Child*

1. The magnitude of Rivera's output is noted in Luís Cardoza y Aragón, "Diego Rivera's Murals in Mexico and the United States," in *Diego Rivera: A Retrospective* (Detroit: The Detroit Institute of Arts, 1986), 185. For a discussion of Rivera's political beliefs as they changed over his life and as he expressed them in his art, see David Craven, *Diego Rivera as Epic Modernist* (New York: G. K. Hall, 1997).

2. Rivera, quoted in Aragón, "Rivera's Murals," 187.

3. Rivera's Rockefeller Center murals are discussed in Laurance P. Hurlburt, *The Mexican Muralists in the United States* (Albuquerque: University of New Mexico Press, 1989), 159–174.

4. For an insightful account of the numerous styles Rivera experimented with during these years, see Craven, *Rivera as Epic Modernist*, 7–51.

5. The new government hoped mural painting would position Mexi-

can culture on the world stage and foster a sense of Mexican identity, especially among the illiterate populace. For a discussion of Rivera and the mural revival in Mexico, see ibid., 53–72.

6. Rivera also made sketches after frescoes by Ambrogio Lorenzetti, Mantegna, Uccello, Piero della Francesca, and Michelangelo; see ibid., 67.

7. Rivera, March 1960, quoted in Ellen Sharp, "Rivera as a Draftsman," in *Diego Rivera*, 203.

8. Albert Bender (1866–1941) was born in Dublin, Ireland. He immigrated to San Francisco in the early 1880s and by the 1920s had become insurance broker to the city's most important houses of business. He profited handsomely from the insurance business, but he neither indulged himself with a luxurious mansion nor surrounded himself with a munificent collection of imported objets d'art or old master paintings. Instead, this lifelong bachelor spent his money in support of local artists and artistic institutions. As a founding member of the Book Club of California he helped to promote regional authors, including Bret Harte and Joaquin Miller. Bender also purchased and donated rare books to local institutions of higher learning. When he turned his attention to the fine arts in the 1920s, he preferred to support local practitioners and institutions, which he did by purchasing an artist's work and then giving it to a local museum. Bender's life is most fully recounted in Oscar Lewis, *To Remember Albert M. Bender: Notes for a Biography* (n.p.: Oscar Lewis, 1973).

9. For a brief discussion of the growing interest in Rivera's work among San Franciscans, see Anthony W. Lee, *Painting on the Left: Diego Rivera, Radical Politics, and San Francisco's Public Murals* (Berkeley and Los Angeles: University of California Press, 1999), 41–42.

10. Bender's purchases were negotiated by Ralph Stackpole. *Two Women and a Child* was probably one of several paintings Rivera sent to Bender in the fall of 1926. See ibid., 233 n. 58. See also Diego Rivera to Ralph Stackpole, 13 October 1926, Ralph Stackpole Letters, Bancroft Library, University of California, Berkeley.

11. The role Rivera's easel paintings played in cultivating interest in his murals in the United States has been literally overshadowed by the scale and complexity of Rivera's murals. As a result, his easel paintings have received little scholarly attention, to the point that today they are often regarded only as a means by which the artist supplemented the meager income he was paid for his mural work. See *Diego Rivera*, 56.

12. The background of the painting can be read either as a blue and white painted wall or a sea extending to the horizon. Notice how the blue band changes height as it passes behind each of the women, a device that Rivera probably learned from his study of the paintings of Paul Cézanne and that subtly animates the composition.

13. *Buon fresco* and Rivera's mural technique are discussed in detail in Craven, *Rivera as Epic Modernist*, 89–93; and Hurlburt, *Mexican Muralists*, 253–256.

14. Bender and others in the San Francisco art world would have recognized Rivera's reference to Giotto because, as the painter Ray Boynton noted at the time, the present generation "worships at the shrine of Giotto." Boynton, "The True Nature of Mural Painting," *Argus*, n.d., quoted in Boynton, *California Art Research* 9 (San Francisco, 1937), 15.

15. Rivera was an avid collector of pre-Columbian art. See Barbara Braun, *Pre-Columbian Art and the Post-Columbian World: Ancient American Sources of Modern Art* (New York: Harry N. Abrams, 2000), 235–242. For a discussion of Rivera's use of pre-Columbian forms in his murals, see

ibid., 186–234. See also Betty Ann Brown, "The Past Idealized: Diego Rivera's Use of Pre-Columbian Imagery," in *Diego Rivera*, 139–155.

16. Bender played an instrumental role in bringing Rivera to San Francisco; see Lee, *Painting on the Left*, 47–56. For analyses of Rivera's San Francisco murals, see ibid., 57–114, 184–215; and Hurlburt, *Mexican Muralists*, 98–122.

84. REGINALD MARSH, *The Limited*

1. Describing his return from his trip to Europe in 1926, Marsh recalled, "I felt fortunate indeed to be a citizen of New York, the greatest and most magnificent of all cities in a new and vital country whose history had scarcely been recorded in art. . . . New York City was in a period of rapid growth, its skyscrapers thrilling by growing higher and higher. There was a wonderful waterfront with tugs and ships of all kinds and steam locomotives on the Jersey shore. In and around were dumps, docks and slums all wonderful to paint and in the city, subways, people and burlesque shows." Quoted in Lloyd Goodrich, *Reginald Marsh* (New York: Harry N. Abrams, 1972), 34.

2. Marsh's friend Thomas H. Garver estimated that Marsh filled more than 150 small, pocket-sized sketchbooks with some 20,000 images. See Garver, *Reginald Marsh: A Retrospective Exhibition* (Newport, R.I.: Newport Harbor Art Museum, 1973), n.p.

3. Augmenting his substantial reportorial skills, Marsh later used a portable 35mm Leica camera that functioned as a photographic sketchpad, capturing subjects for future reference in the studio and generating interesting compositions. See Douglas Dreishpoon, introduction to *Reginald Marsh (1898–1954): Works on Paper* (St. Louis, Mo.: The Greenberg Gallery; New York: Hirschl & Adler Galleries, 1986), 7. Cf. Goodrich, *Marsh*, 93–96.

4. See Goodrich, *Marsh*, 16 (illus.).

5. Quoted in Lloyd Goodrich and Rosalind Irvine, *Reginald Marsh* (New York: Whitney Museum of American Art, 1955), 7.

6. Reginald Marsh, "Let's Get Back to Painting," *Magazine of Art* 37 (December 1944): 296. Marsh deepened his understanding of the human figure by studying anatomy, including dissection, at the College of Physicians and Surgeons in New York in 1931 and at the Cornell University Medical College in New York in 1934. See Goodrich, *Marsh*, 296. Arguing that the past and the present were equally viable resources for the artist, Marsh urged his students to "Stare at Rembrandt's etchings, Dürer's, Mantegna's engravings. The modeling of forms, the lines, shadows, and reflected light show clearly in old engravings—more clearly than in paintings. Stare at Michelangelo casts. Go out into the street, stare at the people. Go into the subway. Stare at the people. Stare, stare, keep on staring. Go to your studio; stare at your pictures, yourself, everything." See Marsh, "Let's Get Back," 296.

7. Although Marsh titled the painting simply *The Limited*, his conception of the train's specific identity is confirmed by the nearly identical and contemporaneous print *20th Cent. Ltd.* (1931), in which the men are crossing the tracks, walking away from the passing train, while a maritime freighter takes the place of the grain mill at the far right. See Norman Sasowsky, *The Prints of Reginald Marsh: An Essay and Definitive Catalogue of His Linoleum Cuts, Etchings, Engravings, and Lithographs* (New York: Clarkson N. Potter, 1976), 168, no. 125 (illus.). Cf. the artist's entry in his calendar for 1 April 1931, which reads, "finish 20th cent. picture." See Reginald Marsh Papers, AAA/SI, microfilm reel NRM 2, frame 148. How-

ever, the engine number tag on the front of Marsh's steam engine more closely resembles that on the Pennsylvania Railroad's Broadway Limited. See Karl Zimmerman, *20th Century Limited* (St. Paul, Minn.: MBI Publishing Company, 2002), 142–145.

8. Edward Hungerford, *The Run of the Twentieth Century* (1930), quoted in Zimmerman, *20th Century Limited*, 58.

9. Burroughs included a small sketch of smokestacks seen in receding perspective. See Betty Burroughs to Reginald Marsh, 1930, Reginald Marsh Papers, AAA/SI, microfilm reel D308, frames 286–289.

10. For a discussion of the railroad's significance in American culture, see Leo Marx, *The Machine in the Garden: Technology and the Pastoral Ideal in America* (New York: Oxford University Press, 1964).

11. See Jo Ranson, "His Art Represents American Life and Manners," *Brooklyn Eagle Magazine*, 3 November 1929, 8.

12. See Edward Laning, *The Sketchbooks of Reginald Marsh* (Greenwich, Conn.: New York Graphic Society, 1973), 22.

13. See *New Yorker*, 5 November 1927, 10.

14. For a history of hoboes in the United States, see Todd DePastino, *Citizen Hobo: How a Century of Homelessness Shaped America* (Chicago: University of Chicago Press, 2003).

15. See, for example, Marsh's *East Tenth Street Jungle* (1934), in Goodrich, *Marsh*, 64 (illus.).

16. Marsh may have felt a special affinity with hoboes, given his personal experience being chased from railroad yards by railroad company detectives. See Ranson, "His Art Represents American Life and Manners," 8.

17. Marsh's sympathetic view of working-class Americans was not based on personal experience, as he came from a wealthy family. However, according to his friend Lloyd Goodrich, "Toward the upper class his attitude was that of one who belonged to it but was not of it. Its glamour interested him less than its foibles. He had a mocking eye for the fatigued aristocracy of the dowager and the old beau, the humors of opera and the Stork Club. But by and large he preferred the masses to the classes as subject matter. 'Well-bred people are no fun to paint,' was an oft-quoted statement that he denied but that still expressed his viewpoint. He did say: 'I'd rather paint an old suit of clothes than a new one, because an old one has character, reality is exposed and not disguised. People of wealth spend money to disguise themselves.'" See Goodrich and Irvine, *Reginald Marsh*, 10.

85. JOHN MARIN, *Study, New York*

1. In 1948 Marin was selected as the most important American artist in a survey of art critics and curators, prompting the critic Clement Greenberg to write: "He is certainly one of the best artists who ever handled a brush in this country. And if it is not beyond all doubt that he is the best painter alive in America at this moment, he assuredly has to be taken into consideration when we ask who is." See Greenberg, "Review of an Exhibition of John Marin," in *Clement Greenberg: The Collected Essays and Criticism*, ed. John O'Brian (Chicago: University of Chicago Press, 1986), 2:268.

2. Elizabeth A. McCausland, *A. H. Maurer* (New York: A. A. Wynn, 1951), 93.

3. Marin employed a similar perspective in early etchings such as *Brooklyn Bridge and Lower New York* of 1913 and *Brooklyn Bridge from Brooklyn (The Sun)* of 1915. See Ruth E. Fine, *John Marin* (Washington, D.C.: National Gallery of Art, 1990), 47–48 (illus.).

4. "Notes on '291,'" *Camera Work*, nos. 42–43 (April–July 1913): 18, reprinted in *The Selected Writings of John Marin*, ed. Dorothy Norman (New York: Pellegrini & Company, 1949), 4–5.

5. See Sheldon Reich, *John Marin: A Stylistic Analysis and Catalogue Raisonné*, 2 vols. (Tucson: The University of Arizona Press, 1970), 2:661, no. 34.7 (illus.).

6. Marin's conception of New York as a dynamic, constantly evolving city is reflected in his frequent use of the word *movement*. This word, which suggests both physical movement and musical composition and thus introduces the element of time, appears in the titles of at least 164 works. See Meredith Ward, *Movement: Marin* (New York: Richard York Gallery, 2001), 7.

7. For Marin's use of the frame motif, which originated with the beveled and inked edges of his early prints, see Fine, *Marin*, 46, 201, and 203–204.

8. For comments by Marin on the importance of a "balanced construction" in his New York works, see ibid., 151 and 153. Arthur Wesley Dow, who played a key role in introducing Asian art, aesthetics, and philosophy into the United States, was a professor at the Art Students League in New York while Marin was a student there (1902–3). See ibid., 28.

9. John Marin, 1928, quoted in *Letters of John Marin*, ed. Herbert J. Seligmann (New York: An American Place, 1931), n.p.

10. For Marin's early Brooklyn Bridge works, see Fine, *Marin*, 46–52.

11. For the influence of Robert Delaunay on Marin's work, see Reich, *Marin: A Stylistic Analysis*, 1:57–65; and Fine, *Marin*, 128.

12. *The Complete Poems and Selected Letters and Prose of Hart Crane*, ed. Brom Weber (Newcastle-upon-Tyne, U.K.: Bloodaxe Books, 1984), 63–64. Marin's dealer, Alfred Stieglitz, was a friend of Crane. See Fine, *Marin*, 105.

13. For the "Cathedral of Commerce" appellation, see Edwin A. Cochran, *The Cathedral of Commerce* (New York: Woolworth Building, 1916).

14. Hans Hess, *Lyonel Feininger* (New York: Harry N. Abrams, 1961), 88–89.

15. The star or comet traditionally appears as a portent of great religious or political events, most notably at Christ's Nativity.

16. For Marin's trips to New Mexico, see Ellen J. Landis and Sharyn Udall, *John Marin in New Mexico* (Albuquerque: The Albuquerque Museum, 1999); and Van Deren Coke, *Marin in New Mexico/1929 and 1930* (Allbuquerque: University Art Museum, University of New Mexico, 1968); and Fine, *Marin*, 217–225.

17. For Marin's purchase of two Indian blankets, see John Marin to Alfred Stieglitz and Georgia O'Keeffe, 9 October 1929, quoted in *Writings of John Marin*, 133–134.

18. New York buildings with setback profiles appear frequently in Marin's work. See the watercolor *Region Trinity Church, N.Y.C.* (1936) and the oil painting *Mid-Manhattan No. 2* (1932), reproduced in Fine, *Marin*, 151 and 155.

19. Quoted in *John Marin by John Marin*, ed. Cleve Gray (New York: Holt, Rinehart, and Winston, 1977), 136. In 1919, a decade before his first trip to New Mexico, Marin wrote "Now Mr. —— showed me some things made out of Mexican silver coins, made by the Hopi or Navajo tribe of Indians. You felt there was a symbolic expression, an abstract expression, a true expression of their personal sight of things existing in the world about

them, however abstractly treated, still gotten from those special things, from their own lives." See E. M. Benson, *John Marin: The Man and His Work* (Washington, D.C.: American Federation of Arts, 1935), 101.

20. *Marin by Marin*, 58.

86. GRANT WOOD, *Dinner for Threshers*

1. Wood later recalled, "Every week in the *Smart Set* and later, in the *American Mercury*, good old Mencken belabored my people as 'corn-fed boobs and peasants.'—and I ate it up." Quoted in Arthur Miller, "Bible Belt Booster," *Los Angeles Times Sunday Magazine*, 7 April 1940, 14. For the influence of H. L. Mencken, "who at that time was hilariously drubbing the yokels of the Bible Belt and the cornhuskers of the Middle West," see Thomas Craven, "Grant Wood," *Scribner's Magazine* 101 (June 1937): 19. For the parallels between Wood's work and that of Sinclair Lewis, see ibid., 21. Wood created nine illustrations (1935–37) for a limited edition of Sinclair Lewis's novel *Main Street* (1920). See Sinclair Lewis, *Main Street, with a Special Introduction by the Author, and Illustrations by Grant Wood* (Chicago: Printed for Members of the Limited Editions Club at the Lakeside Press, 1937); and Lea Rosson DeLong, *Grant Wood's Main Street* (Ames: Brunnier Art Museum, Iowa State University, 2004).

2. Grant Wood, "Revolt against the City," in James M. Dennis, *Grant Wood: A Study in American Art and Culture* (Iowa City: Clio Press, 1935; Columbia: University of Missouri Press, 1986), 229–235. The artist's sister, Nan Wood Graham, saw a copy of this essay inscribed by Frank Luther Mott, "I 'ghost-wrote' this for Grant." See Nan Wood Graham, with John Zug and Julie Jensen McDonald, *My Brother, Grant Wood* (Iowa City: State Historical Society of Iowa, 1993), 124.

3. Quoted in "Iowa Cows Give Grant Wood His Best Thoughts," *New York Herald Tribune*, 13 January 1936, newspaper clipping, photocopy in Grant Wood *Dinner for Threshers* object file, AAD/DEY/FAMSF.

4. For the influence of Flemish art on Wood's work, see Lincoln Kirstein, "An Iowa Memling," *Art Front* 1 (July 1935): 6, 8; and Darrell Garwood, *Artist in Iowa: A Life of Grant Wood* (New York: W. W. Norton & Co., 1944), 95–97. Correctly discerning Wood's artistic kindred spirits, George M. Moffett, one of the owners of *Dinner for Threshers*, hung the painting in his study with two Holbeins and a Rogier van der Weyden. Ibid., 167–168. For the possible influence of the Neue Sachlichkeit artists on Wood's mature style, see H. W. Janson, "The International Aspects of Regionalism," *College Art Journal* 2, no. 4 (May 1943): 110–115; and Brady M. Roberts, "The European Roots of Regionalism: Grant Wood's Stylistic Synthesis," in Roberts, James M. Dennis, James S. Horns, and Helen Mar Parkin, *Grant Wood: An American Master Revealed* (San Francisco: Pomegranate, 1995), 19–40. For the possible influence of the French artist Georges Seurat, see ibid., 1–19.

5. Wood's student Nellie M. Gebers recalled, "I went with a group of people and Grant Wood up to what was known as 'The Johnson Farm.' As it happened, they were threshing that day. Every farm belonged to a threshing ring and the day a particular farmer had his day to thresh all the farmers from that ring came with their wagons, teams and their 'women folk' who helped with the dinner. The host furnished all the food. This day G.W. showed me a place he thought I might like to paint and he sat down nearby under a tree and did his usual chain smoking. After awhile men began to come in for dinner. Grant said, 'Are you interested in the threshing scene?' I replied, 'Yes, I am, but I would rather paint the men in the house having dinner.' After a few minutes Grant said, 'That's a wonderful idea. Do you mind if I toy around with it?' I said, 'Of course not, I couldn't do it." Letter from Nellie M. Gebers (dictated to her daughter, Jeanne Gebers Bellefeuille) to Marc Simpson, Curator of American Paintings, 16 May 1991, in Grant Wood *Dinner for Threshers* object file, AAD/DEY/FAMSF.

6. Threshing continued into the 1930s, as many Depression-era farmers could not afford the new combine machines that both harvested and threshed crops. See J. Sanford Rikoon, *Threshing in the Midwest, 1820–1940: A Study of Traditional Culture and Technological Change* (Bloomington and Indianapolis: Indiana University Press, 1988).

7. The drawing of the entire composition, which already had been purchased from Ferargil Galleries by Stanley R. Resor, was reproduced in Edward Alden Jewell, "In the Realm of Art: The Nation Paints Its Walls," *New York Times*, 27 May 1934, sec. X, 7. The sketches for the left and right sections of *Dinner for Threshers*, which are nearly actual-size studies for the painting, were acquired in 1933 for the permanent collection of the Whitney Museum of American Art in New York. These two drawings include wallpaper with a fleur-de-lis pattern, which may have been intended as a witty reference to misguided midwestern pretensions to taste, including Wood's own years of study in France. Given the Italian Renaissance origins of Wood's composition, it is appropriate that these two sketches were included in the United States section of the International Exhibition of Art in Venice, Italy. "Grant Wood Wins Honor: Two Pencil Sketches Named for Italian Exhibit," unidentified newspaper clipping, photocopy in Grant Wood *Dinner for Threshers* object file, AAD/DEY/FAMSF. The completed *Dinner for Threshers* was exhibited at the 1934 Carnegie International Exhibition, where it was voted third-most-popular painting and was sold—sight unseen—to Stephen C. Clark, chairman of the acquisition committee for the Metropolitan Museum of Art, for $3,500. "The Popular Prize: The Public Chooses 'Tropic Seas' by Frederick J. Waugh," *Carnegie Magazine* 8 (December 1934): 196–197; and Garwood, *Artist in Iowa*, 171.

8. Quoted in "Letters: Art: How Threshers Eat," *Time* 2, no. 2 (21 January 1935): 4. In a variation on this comment, Wood would correct questioners with the rhyme "ITS MY FAMILY / ITS MY FRIENDS / ITS MY NEIGHBORS AND ITS MY HENS." Nan Wood Graham, comment on card RP.65.65, Davenport Art Museum, Davenport, Iowa, photocopy in Grant Wood *Dinner for Threshers* object file, AAD/DEY/FAMSF. Much of the specific imagery in *Dinner for Threshers* is described vividly in Wood's unpublished memoir, "Return from Bohemia: A Painter's Story" (1935), which was written by his secretary and friend, Park Rinard. Wanda Corn notes that Rinard submitted an earlier version of this memoir as his master's thesis for the Department of English at the University of Iowa in 1939. Wanda M. Corn, *Grant Wood: The Regionalist Vision* (New Haven: Yale University Press, 1983), 1, 151 n. 2; and Grant Wood and Park Rinard, "Return from Bohemia: A Painter's Story," AAA/SI, microfilm reel D24, frames 161–295. Included are references to the threshing dinner (frames 237–238, 242–243); the windmill (frames 242, 290); the two dappled horses (frames 169–170); the chickens (frames 171, 221–223); the bench and wash basin on the back stoop and the threshers combing their hair (frames 168, 242–243); the print of two horses in a thunderstorm (frame 292); the three dining-room tables arranged end to end and covered with a red checked tablecloth (frames 171–172, 242–243); the use of the mixed chairs and piano stool (fame 242); the full table requiring a second seating of the hired hands and

children (frame 243); the young women who served the food and flirted with the threshers (frame 243); the ironstone china in the kitchen cabinet (frame 242); the pickled vegetables in the kitchen (frame 238); and the wood-burning stove in the kitchen (frame 168). For Wood's entire description of the annual threshing event, see frames 209–210, 237–244. In his introduction (frame 166), Wood wrote, "More than thirty years have passed since I was a boy on an Iowa farm. Yet these early scenes and experiences remain clearer than any I have known since. . . . I want to set down here the record of these most vivid years."

9. Responding to a letter from a woman who objected to the farmers' having their sleeves rolled down at the dinner table, Wood wrote, "In 1900, tanned arms were considered a sign of the bucolic. The male forearm was denuded only during the washing-up process"; quoted in "How Threshers Eat," 4.

10. Graham, *My Brother*, 65.

11. Similar windmills are depicted in Wood's *Stone City* (1930), *Young Corn* (1931), *Fall Plowing* (1931), and *Spring Turning* (1936). By the 1930s, as electricity reached even remote farms, Wood worried that this traditional farm landmark was disappearing from the rural landscape, and he attempted to preserve its likeness in paintings such as *Self-Portrait* (1932–41), in which it serves as a symbolic attribute of his midwestern origins. Corn, *Grant Wood*, 126. Wood told his sister, "The Old Masters all had their trademarks, and mine will be the windmill. Wherever it is feasible to use it, I will." Graham, *My Brother*, 83.

12. Horse-drawn plows and wagons appear in Wood's *Fall Plowing* (1931), *Arbor Day* (1932), and *Spring Turning* (1936).

13. Chickens, Wood's favorite farm animals, play prominent roles in *Appraisal* (1931) and *Adolescence* (1940). See Wood and Rinard, microfilm reel D24, frames 171, 221–223; and Garwood, *Artist in Iowa*, 17–18.

14. The art critic Henry McBride perceived "a monotony in the *dramatis personae* that seems uncalled for. All the young-men threshers seem to be the same young man." McBride, "This Year's International," *American Magazine of Art* 27, no. 12 (December 1934): 659. Wood's respect for farmers and threshers derived in part from his own hard labor as a teenager, working to support his widowed mother: "Unconsciously, I learned to look at life from a workman's point of view. I had to—it was a matter of self-preservation." Quoted in Craven, "Grant Wood," 17. However, since he left the family farm as a boy in 1901, his only real experience with hard farm labor was a three-week summer stint working on the Woitishek farm as a teenager. Garwood, *Artist in Iowa*, 27–28.

15. Quoted in "How Threshers Eat," 4; and Wood and Rinard, "Return from Bohemia," microfilm reel D24, frame 242. See also Miller, "Bible Belt Booster," 14; and Garwood, *Artist in Iowa*, 170.

16. Discerning a discrepancy between Wood's ostensibly realist technique and the formal aspects of his paintings, Stuart Davis wrote, "This is the work of the men who, to quote *Time*, 'are destined to turn the tide of artistic taste in the United States.' They offer us, says *Time*, 'direct representation in place of introspective abstractions.' Is the well-fed farmhand under the New Deal, as painted by Grant Wood, a direct representation, or is it an introspective abstraction?" Davis, "The New York American Scene in Art," *Art Front*, February 1935, quoted in *Stuart Davis*, ed. Diane Kelder (New York: Praeger Publishers, 1971), 152.

17. Rikoon, *Threshing in the Midwest*, 121. Wood recalled in his memoir, "A half-dozen belles of the neighborhood had come in to serve for mother, and they fluttered about the table, replenishing serving dishes and carrying on shy flirtations over bowls of potatoes and platters of chicken"; Wood and Rinard, "Return from Bohemia," microfilm reel D24, frame 243.

18. Wood's sister recalled, "In Grant's youth, many farm homes exhibited a reproduction of a painting of horses in a storm. He hunted everywhere for one of these, but they seemed to be a thing of the past. Then Dr. McKeeby remembered that the mother of his dental assistant's boyfriend had one hanging in the parlor of her farm home. Before the dental assistant got around to borrowing it, she quarreled with her boyfriend, and Grant had to play peacemaker to secure the picture." Graham, *My Brother*, 113; see also Garwood, 169. In Grant Wood's complete drawing (fig. 86.3) for the painting, perhaps created before he located an example of this print, he depicted the white horse in front of the black horse. Although this print exists, the artist has not been identified.

19. Wood's sister recalled, "I arrived from Albuquerque in 1934 to find Grant hard at work in the sudio. *Dinner for Threshers* was nearing completion, and he had spared no details. The mashed potatoes had a dab of butter, and the wooden match holder that had been in the kitchen of our farm house was on the wall. The heads of the matches and the very warts on the pickles in a jar on the cupboard were visible. The painting includes a cat with distinct whiskers, the red checkered tablecloth, the piano stool one man sat on, and even the politeness on the men's faces as the women served them food." Graham, *My Brother*, 113; see also Garwood, *Artist in Iowa*, 167–172. The vertical white ironstone plate in the blue kitchen cupboard can be identified as the Tea Leaf pattern with a copper-luster leaf motif. See Julie Rich, *American Tea Leaf: Manufacturers, Potters and Decorators* (Springfield, Mo.: Tea Leaf Club International, 1992). Corn, *Grant Wood*, 48, notes that Wood collected Victorian ironstone china.

20. Quoted in "How Threshers Eat," 4.

21. Ibid.

22. Mr. and Mrs. Robert Armstrong of Cedar Rapids commissioned Wood and his contractor friend Bruce McKay to build them a "native" Iowa house in nineteenth-century pioneer Victorian style; Corn, *Grant Wood*, 37–38.

23. Wood joked regarding the panoramic format of *Dinner for Threshers*, "They put one of my pictures behind a door in Pittsburgh. They won't find a door big enough to hide this one." Wood was referring to his *Daughters of Revolution* (1932), which was exhibited at the Carnegie International Exhibition in Pittsburgh in 1932. Garwood, *Artist in Iowa*, 137 and 161; and Graham, *My Brother*, 95. The three-part narratives of the threshers carrying well water, washing up, and combing their hair and of the women cooking, dishing up, and serving recall a narrative technique found in early Renaissance altarpiece predella panels, which often show the same figure carrying out one or more sequential actions within the same panel.

24. Henry McBride wrote, "Mr. Wood's picture is a 'Dinner for Threshers,' stylized into a cleanliness that Fra Angelico might have envied for his saints"; McBride, "This Year's International," 659. M. M. wrote, "The well-known 'Dinner for Threshers' with its reminiscences of Leonardo da Vinci in the treatment of the table and of Botticelli's angels in the movement and rhythm of the waitresses, is the clearest illustration of this point"; M. M., "Exhibitions in New York: Grant Wood: Ferargil Galleries," *Art News* 33, no. 30 (27 April 1935): 13. Edward Alden Jewell wrote, "Its sensitive gravitation toward under rather than over statement assists in the establishment of a mood of monumental simplicity to parallel which we

might have to go back to Giotto. In my opinion, Grant Wood has here produced an American document that is tender, deep, reverent and altogether just; fine in its sympathy, its understanding; beautiful in its spaciousness and dignity and grave, unhurried poise." See Jewell, "In the Realm of Art," 7.

25. See, for example, Thomas Hart Benton's *Persephone* (1939; fig. 91.2) whose pose is derived from Correggio's *Venus and Love Discovered by a Satyr* (ca. 1524–27, Musée du Louvre, Paris). Wood may have been referring to this search for a more universal art when he resisted the limitations imposed by the regionalist label, commenting, "Regional sounds almost geographical, and there is nothing essentially geographical about the work"; quoted in "Grant Wood Spurns Role of Painters' Glamour Boy Bestowed by Art Critic," *Los Angeles Times*, undated newspaper clipping, photocopy in Grant Wood *Dinner for Threshers* object file, AAD/DEY/FAMSF.

26. Regarding *Dinner for Threshers*, Wood wrote, "The possibilities it has for a mural await only the proper place and circumstances"; quoted in Jewell, "In the Realm of Art," 7. Wood's hope of making a mural based on the composition may account for his inclusion of the copyright symbol after his signature and date; Garwood, *Artist in Iowa*, 171.

27. The woman entering the dining room holds her bowl of mashed potatoes as if it were an elevated host. James Dennis perceives a comparable analogy in the farmer on the barnyard porch, who "symbolically cleanses himself with the holy water of the barnyard before entering the sacred interior"; Dennis, *Grant Wood*, 218.

28. See Matthew Baigell, *The American Scene: American Painting in the 1930s* (New York: Praeger Publishers, 1974), 111. Wood was criticized for ignoring the Depression-era "dust storms and draughts, slaughtered pigs, unsown crops or crops plowed under"; Kirstein, "Iowa Memling," 8.

29. Despite Wood's appropriation of Renaissance precedents, one critic wrote that *Dinner for Threshers* bears "as genuine a U.S. stamp as a hotdog stand or baseball park"; "U.S. Scene," *Time*, 24 December 1934, 26.

30. Thomas Jefferson, *Notes on Virginia* (1785), quoted in Leo Marx, *The Machine in the Garden: Technology and the Pastoral Ideal in America* (New York: Oxford University Press, 1964), 120.

87. AARON DOUGLAS, *Aspiration*

1. Quoted in Amy Helene Kirschke, *Aaron Douglas: Art, Race, and the Harlem Renaissance* (Jackson: University Press of Mississippi, 1995), 47.

2. See Romare Bearden and Harry Henderson, *A History of African-American Artists from 1792 to the Present* (New York: Pantheon Books, 1993), 127.

3. Kirschke, *Aaron Douglas*, 6–7.

4. Ibid., 26–30. See also Bearden and Henderson, *History of African-American Artists*, 127–128.

5. For Douglas's illustrations, see Alain Locke, ed., *The New Negro: An Interpretation* (New York: Albert and Charles Boni, 1925; reprint, with preface by Robert Hayden, New York: Atheneum, 1969), 54, 56, 112, 128, 138, 152, 196, 198, 216, 228, and 270.

6. Alain Locke, "The Legacy of the Ancestral Arts," in ibid., 254–267.

7. Barnes Foundation funds enabled the Parisian art dealer Paul Guillaume and the Barnes Foundation teacher Thomas H. Munro to publish *Primitive Negro Sculpture* (1926), one of the earliest and most influential English texts on African art. See Richard M. Wattenmaker et al.,

Great French Paintings from the Barnes Foundation: Impressionist, Post-Impressionist, and Early Modern (New York: Alfred A. Knopf, in association with Lincoln University Press, 1993), 14. Douglas experienced French modernism firsthand in 1931 in Paris, where he studied at the Académie de la Grande Chaumière and at the Académie Scandinave with Charles Despiau, Henri de Waroquier, and Othon Frieze. Douglas was in Paris at the same time as Hale Woodruff, Augusta Savage, Palmer Hayden, Claude McKay, Countee Cullen, Langston Hughes, Alain Locke, and W. E. B. Du Bois, who were collectively known as the Negro Colony. Kirschke, *Aaron Douglas*, 118.

8. The official theme for this celebration of Texas statehood was "Empire on Parade," a historical interpretation reenacted daily in a theatrical production described as "the spectacle of an empire marching to its destiny through four hundred years. . . . This panoramic extravaganza is 'Calvacade of Texas,' written and produced as a living saga of the inexorable advance of civilization, by blood and iron and the enduring will of the white man, in what was once only the wild land of the naked savage." John Sirigo, *The Official Guide Book: Texas Centennial Exposition, June 6–Nov. 29, 1936* (Dallas: Texas Centennial Central Exposition, 1936), 63. For the "Empire on Parade" theme, see ibid., 5, 15.

9. Describing some of the prejudice encountered by African Americans at the Centennial Exposition, an editorial noted, "Hearts were filled and broken, souls were kindled and crushed, bodies were furbished and deadened, and minds were stimulated and insulted." I. M. Hunting, "Everyday," *Dallas Express*, 31 October 1936, 1. Overt racism is apparent in the article heading "History of Negro from Jungles to Now to Be Shown. Centennial to Be Turned Over to Darkies Juneteenth; Special Days," *Dallas Morning News*, 14 May 1936. The Hall of Negro Life was the only building demolished before the fair reopened the following year as the Greater Texas and Pan American Exposition. Jesse O. Thomas, *Negro Participation in the Texas Centennial Exposition* (Boston: Christopher Publishing House, 1938), 120; and "The Texas Centennial," *Dallas Express*, 6 February 1937, 8. Photocopies of the newspaper articles (some lacking full citations) cited in this essay are in Aaron Douglas *Aspiration* object file, AAD/DEY/FAMSF.

10. For the federal government's involvement in funding the Hall of Negro Life, see "Race Men on Centennial Job," *Dallas Express*, 4 April 1936, 1. For a description of the completed building, see Sirigo, *Official Guide Book*, 72–73 (illus.). For the inauguration of the building, see "Negro Exhibits Building to Be Dedicated Formerly [*sic*] on June 19th, Emancipation Day," *Dallas Morning News*, 7 June 1936, 10.

11. Thomas, *Negro Participation*, 25. Douglas's murals prompted many patronizing comments from white viewers, including one from a member of the Board of Education in Hawkins, Texas, who remarked, "You mean to say that Aaron Douglas was a Negro. He must have had a lot of white blood. These are the finest pieces of art I have ever seen." "83,000 Visit Negro Building. Comment on Exhibits. Proves Very Popular on Fair Grounds," *Dallas Express*, 25 July 1936, 1. Some of the themes and images in Douglas's mural cycle for the Texas Centennial Exposition had appeared earlier in the *Symbolic Negro History* (1930) mural for Fisk University that told "the story of the Negro's progress from central Africa to present day America." The imagery includes the Great Pyramids, "a long line of slaves, chained together" marched to waiting slave ships, "the rising star of freedom," an architect, and "truth—symbolized by a pyramid upon a hill with a star at its apex." Aaron Douglas, quoted in Jacqueline

Fonvielle Bontemps, "The Life and Works of Aaron Douglas: A Teaching Aid for the Study of Black Art" (M.A. thesis, Fisk University, 1971), 46–49. See also Kirschke, *Aaron Douglas*, 110–114.

12. The first painting in the four-part mural cycle depicted "a scene from the life of Estevanico, the Negro who was the first member of Cabeza de Vaca's party to set foot on Texas soil." The second painting was *Into Bondage*, in which "the Negro is being brought in chains to America where he was forced into servitude." The third, larger painting was *The Negro's Gift to America*, in which "'Human Labor' is the holder of the key to a true understanding of the Negro in a new world. Music, Art and Religion are all a part of the contribution. The agricultural workers on the left and the industrialists on the right bring their gifts to 'Labor.' The woman in the center of the composition with the babe in outstretched arms, symbolizes a plea for equal recognition. Heretofore, in all submerged social elements, the Negro woman has occupied the lowest position. Here, she is given a place of honor. The child is a sort of banner, a pledge of Negro determination to carry on and share the burden of humanity in its struggle toward truth and light. The cabin, in the midst of the towers, is the symbol of Negro evolution from a crude primitive pioneer life to the complicated existence in the great urban centers." Thomas, *Negro Participation*, 25–27, 128–130. A portion of *The Negro's Gift to America*, depicting a log cabin beneath a factory and skyscrapers, and two faces seen in profile, is illustrated on the cover of W. E. B. Du Bois's pamphlet *What the Negro Has Done for the United States and Texas* (Dallas: Texas Centennial Exposition, 1936). The section of this mural depicting the agricultural workers is visible behind Douglas in a contemporary newspaper photograph. "Creates Mural for Exposition," *Dallas Express*, 20 June 1936, 7.

13. Explaining how he used "the Egyptian form" in his works, Douglas noted, "The head was in a profile view, the body, shoulders down to the waist turned half way, the legs were also from the side." Quoted in Kirschke, *Aaron Douglas*, 77.

14. In Harriet Beecher Stowe's abolitionist novel, *Uncle Tom's Cabin; Or, Life Among the Lowly* (1852), the runaway slave Eliza Harris catches her first glimpse of the Ohio River, "which lay, like Jordan, between her and the Canaan of liberty on the other side." Stowe, *Uncle Tom's Cabin; Or, Life Among the Lowly*, ed. Ann Douglas (New York: Penguin Books, 1981), 107. Describing a religious service held by slaves, Stowe wrote that the spirituals "made incessant mention of 'Jordan's banks,' and 'Canaan's fields,' and the 'New Jerusalem.'" Ibid., 77–78.

15. Langston Hughes, *The Collected Poems of Langston Hughes*, ed. Arnold Rampersad and David Roessel (New York: Vintage Classics/Random House, 1994), 23.

16. Truth's appellation was coined, or at least publicized, by Harriet Beecher Stowe, who claimed that the abolitionist was the inspiration for William Wetmore Story's neoclassical sculpture, the *Libyan Sibyl* (1861). Stowe, "Sojourner Truth, the Libyan Sibyl," *Atlantic Monthly* 11 (April 1863): 473–481. For an analysis of Stowe's cultural construction of Sojourner Truth as the "Libyan Sibyl," see Nell Irvin Painter, *Sojourner Truth: A Life, a Symbol* (New York: W. W. Norton & Company, 1996), 151–163, 198, and 264. For Michelangelo's Libyan Sibyl, see Carlo Pietrangeli et al., *The Sistine Chapel: A Glorious Restoration* (New York: Harry N. Abrams, 1994), 154–155.

17. For the *Harriet Tubman* mural, see Aaron Douglas, cited in "The Aaron Douglas Fresco of Harriet Tubman," unidentified magazine clipping (January 1932), 449, Aaron Douglas Folder, Art and Artifacts Division,

Schomburg Center for Research in Black Culture, The New York Public Library; and Kirschke, *Aaron Douglas*, 116 and plate 74.

18. See Painter, *Sojurner Truth*, 201–203, for a description of Tubman as the "Moses" of her people and for a reproduction of Tubman wearing her characteristic head scarf. For the symbolic linkage of slavery with "Egypt," see Sojourner Truth's account of her name change: "'My name was Isabella, but when I left the house of bondage, I left everything behind. I wa'n't goin' to keep nothin' of Egypt on me, an' so I went to the Lord an' asked him to give me a new name. And the Lord gave me Sojourner.'" Quoted in Stowe, "Sojourner Truth, the Libyan Sibyl," 478.

19. Booker T. Washington, *Up from Slavery*, with an introduction by Ishmael Reed (New York: Signet Classic, 2000); W. E. B. Du Bois, "The Talented Tenth," in Booker T. Washington et al., *The Negro Problem: A Series of Articles by Representative Negroes of To-day* (New York: James Pott & Company, 1903); and Locke, *The New Negro*, 3–16.

20. See "Exhibit of Dr. Carver Is Assured," *Dallas Express*, 16 May 1936, 1.

21. "The names below the murals on a horizontal curvature serve both as a decoration and as a reminder of Negroes who started the ball of racial progress rolling. They are: Paul Lawrence Dunbar, the great American Negro poet; Benjamin Banneker, the inventor of the clock which strikes the hour and the Negro who had a part in laying out plans for the city of Washington, D.C.; Colonel Charles Young, the first Negro graduate from West Point Military Academy; Sojourner Truth, abolitionist lecturer; Frederick Douglass, a nationally known abolitionist; Harriet Tubman, a promoter of the Underground Railway; Wright Cuney, a Texas politician and statesman; Richard Allen, founder of the African Methodist Episcopal Church; Booker T. Washington, founder of the Tuskegee Institute, Alabama; Dr. Daniel T. Williams, a famous surgeon of Chicago; and Crispus Attucks, the first person to shed blood for American Independence during the Revolutionary War." Thomas, *Negro Participation*, 26–27.

22. Aaron Douglas, interview by David C. Driskell, quoted in *Black Art, Ancestral Legacy: The African Impulse in African American Art* (Dallas: Dallas Museum of Art, 1989), 136.

23. Jesse Owens, Joe Louis, and Paul Robeson all occupied prominent positions on the world stage, whether on the three-tiered Olympic medal platform, in the boxing ring, or on the theatrical stage. Owens's and Louis's defeat of Nazi athletes (and thus the theory of Aryan superiority) and Robeson's communist beliefs were compatible with Douglas's own socialist beliefs. For a famous description of a slave auction block, in which the slave mother Hagar is sold and separated from her son Albert, see Stowe, *Uncle Tom's Cabin*, 194–198. See also ibid., 475–479, in which Susan is sold and separated from her daughter Emmeline.

24. Langston Hughes explicitly linked the ancient pyramids with the modern skyscrapers in his poem "Negro": "I've been a worker / Under my hand the pyramids arose. / I made mortar for the Woolworth Building." Hughes, *Collected Poems*, 24.

25. Kirschke, *Aaron Douglas*, 5. The presence of the General Motors Auditorium, complete with new car displays, at the Texas Centennial Exposition would have reminded Douglas of his experience as a worker in automobile factories. Sirigo, *Official Guide Book*, 87–89 (illus.). The disproportionate impact of the Great Depression on African American workers prompted Douglas to embrace a Marxist view of industrial labor as offering both economic opportunity and the potential for exploitation. In an article written at the time Douglas's *Aspects of Negro Life* (1934)

was unveiled in New York, a reporter wrote of the artist, "He talked quite freely, too, of his present interest in Marx and the revolutionary movement and showed how this had influenced his recent work. The artist and his wife, Mrs. Alta Douglas, have joined a group of young intellectuals who are making a serious study of Marx and his theories. . . . There is nothing revolutionary about the library mural. . . . But there is a difference—a fundamental one. And for this Karl Marx is accountable." The reporter went on to describe the final panel of the *Aspects of Negro Life* mural: "The exodus North, the momentary happiness in Harlem and the final disillusion of the Negro worker are pictured in the last panel. . . . Disillusion is pictured at the left of the panel where the black figure, crushed, has been toppled to the ground as the hand of death and the smoke of industrialism reach out for his broken body. . . . Mr. Douglas is openly apologetic about the note of defeat upon which his mural ends. As a student of Marx and an artist who has been 'bolshevized by conditions,' he knows that he has not finished the picture. Had there been a fifth panel, he believes, he could not have escaped pointing to the way out for the Negro—to the one way outlined by Karl Marx and his disciples—the unity of black and white workers in the class struggle." T. R. Potson, "Murals and Marx: Aaron Douglas Moves to the Left with PWA Decoration," *New York Amsterdam News*, 24 November 1934, 9.

26. Much of the imagery in *Aspiration*, including the symbolic star, is prefigured in W. E. B. Du Bois's *The Star of Ethiopia* (1913), an elaborate theatrical pageant of black history. The production debuted in New York to commemorate the fiftieth anniversary of Emancipation and was later presented in Washington, D.C., Philadelphia, and Los Angeles. W. E. B. Du Bois, *The Souls of Black Folk*, with an introduction by John Edgar Wideman (New York: Vintage Books, 1990), 203. The pageant's second episode deals with "The Second Gift of black men to this world, the Gift of Civilization in the dark and splendid valley of the Nile," and includes the "gifts" of the Sphinx, Pyramid, the Obelisk, and the empty Throne of the Pharaoh drawn by oxen. The fourth episode deals with "The Fourth Gift of the Negro to the world, being a Gift of Humiliation. This gift shows how men can bear even the Hell of Christian slavery and live," and "how this race did suffer of Pain, of Death and Slavery and yet of this Humiliation did not die." It also includes "the chained and bowed forms of the slaves" and concludes with "the Dance of the Ocean, showing the transplantation of the Negro race overseas." The fifth episode deals with "The Fifth Gift of the Negro to the world, being a Gift of Struggle Toward Freedom. This picture tells of Alonzo, the Negro pilot of Columbus, of Stephen Dorantes [the Estevanico of Douglas's mural] who discovered New Mexico, of the brave Maroons and valiant Haytians, of Crispus Attucks, George Lisle and Nat Turner." The sixth episode deals with "the Sixth and Greatest Gift of black men to the world, the Gift of Freedom for the workers," and includes Sojourner Truth, as well as "symbolic figures of the Laborer, the Artisan, the Servant of Men, the Merchant, the Inventor, the Musician, the Actor, the Teacher, Law, Medicine and Ministry, the All-Mother, formerly the Veiled Woman, now unveiled in her chariot with her dancing brood, and the bust of Lincoln at her side." W. E. B. Du Bois, *The Oxford W. E. B. Du Bois Reader*, ed. Eric J. Sundquist (New York and Oxford, U.K.: Oxford University Press, 1996), 305–310.

27. Frederick Douglass titled his abolitionist newspaper the *North Star*. In *Uncle Tom's Cabin*, when George Harris is asked the location of his runaway wife, he replies, "Gone, sir, gone, with her child in her arms, the Lord only knows where;—gone after the north star; and when we ever meet, or whether we meet at all in this world, no creature can tell." Stowe, *Uncle Tom's Cabin*, 188. Describing the imminent escape of George and Eliza Harris and their son Harry to Canada, Stowe wrote, "Their night was now far spent, and the morning star of liberty rose fair before them!—electric word!" Ibid., 544. The stars in *Aspiration* may also represent the morning star, a biblical reference to Christ and salvation. In *Uncle Tom's Cabin*, Stowe wrote, "The solemn light of dawn—the angelic glory of the Morningstar—had looked in through the rude window of the shed where Tom was lying; and, as if descending on that star-beam, came the solemn words, 'I am the root and offspring of David, and the bright and morning star.'" Ibid., 538.

28. John Winthrop invoked this biblical passage at the founding of Plymouth Colony in 1620. Ironically, a Dallas newspaper editorial invoked the "city on a hill" analogy in proposing "that many of the usual Southern customs are modified, that inequalities are removed and that discrimination is stopped during the progress of the Big Show. . . . Dallas for the next few months is indeed a City set on a hill, and what it does, how it treats its guests, will be seen and commented upon. It cannot be hid." "A City on a Hill," *Dallas Express*, 9 May 1936, 6.

29. The overlapping political and religious associations of stars in African American culture are also reflected in James Weldon Johnson's lyrics for the second verse of "Lift Ev'ry Voice and Sing" (1900), widely known as "Negro National Hymn": "Stony the road we trod, / Bitter the chastening rod, / Felt in the days when hope / unborn had died; / Yet with a steady beat, / Have not our weary feet / Come to the place for which our fathers sighed? / We have come over a way that with tears has been watered, / We have come, treading our path through the blood of the slaughtered, / Out from the gloomy past, / Till now we stand at last / Where the white gleam of our bright star is cast." Locke quoted Johnson's "To America" (1917): "How would you have us, as we are? / Or sinking 'neath the load we bear, / Our eyes fixed forward on a star, / Or gazing empty at despair? / Rising or falling. Men or things? / With dragging pace or footsteps fleet? / Strong, willing sinews in your wings, / Or tightening chains about your feet?" Locke, *The New Negro*, 13. Douglas illustrated Johnson's *God's Trombones: Seven Negro Sermons in Verse* (1927). Kirschke, *Aaron Douglas*, 98–101.

30. Describing the *Song of the Towers* (1934) panel in his *Aspects of Negro Life* mural in the Countee Cullen branch of the New York Public Library, Douglas wrote, "A great migration, away from the clutching hand of serfdom in the South to the urban industrialized life of America, began during the First World War. And with it there was born the creative self-expression which quickly grew into the New Negro Movement of the 'twenties. At its peak, the Depression brought confusion, dejection, and frustration." Quoted in Samella Lewis, *African American Art and Artists* (Berkeley and Los Angeles: University of California Press, 1990), 62. Compare Jacob Lawrence's famous *Migration* (1941) series in Elizabeth Hutton Turner, ed., *Jacob Lawrence: The Migration Series* (Washington, D.C.: The Rappahannock Press, in association with the Phillips Collection, 1993).

31. Douglas, interview by Driskell, 136.

32. The cover image of the "Calvacade of Texas" program—a modern metropolis surrounded by oil derricks—reflected the perspective that "Where the Conquistadores once sought bright gold, black gold, oil, has gushed forth beyond the dreams of Midas." Sirigo, *Official Guide Book*, 12.

33. Langston Hughes, "The Negro Artist and the Racial Mountain,"

The Portable Harlem Renaissance Reader, ed. David Levering Lewis (New York: Penguin Books, 1994), 91–92, originally published in the Nation 122 (23 June 1926): 692. Hughes acknowledged his kinship with Douglas, inscribing a copy of his Fine Clothes to the Jew (1927), "For Aaron Douglas, who puts in line and color what I would put in words, these songs and poems, —Sincerely, Langston Hughes, Lincoln University, January 17, 1927." Aaron Douglas artist file, AAD/DEY/FAMSF.

88. JOHN STEUART CURRY, Self-Portrait

1. Thomas Hart Benton, "John Curry," University of Kansas City Review 13, no. 2 (Winter 1946), reprinted in Patricia Junker, John Steuart Curry: Inventing the Middle West (New York: Hudson Hills Press, in association with the Elvehjem Museum of Art, University of Wisconsin, 1998), 74.

2. Don Anderson, publisher of the Wisconsin State Journal, quoted in Theodore R. Wolff, "John Steuart Curry: A Critical Assessment," in Junker, John Steuart Curry, 83.

3. Benton, "John Curry," 74.

4. Charles C. Eldredge, "Prairie Prodigal: John Steuart Curry and Kansas," in Junker, John Steuart Curry, 105.

5. Curry, quoted in Wolff, "John Steuart Curry: A Critical Reassessment," in Junker, John Steuart Curry, 82.

6. John Steuart Curry, "Curry's View," Art Digest 9, no. 20 (September 1935): 29, quoted in Wolff, "Critical Reassessment," 85.

7. Benton, "John Curry," 76.

8. "Resident Artist: John Steuart Curry Takes Unique Post to Encourage Rural Painting," Literary Digest 122, no. 16 (17 October 1936): 22–24, and "Prairie Artist Finds New Soil," Milwaukee Journal, 6 December 1936, both reprinted in Patricia Junker, "The Life and Career of John Steuart Curry: An Annotated Chronology," in Junker, John Steuart Curry, 229.

9. Patricia Junker, "Twilight of Americanism's Golden Age: Curry's Wisconsin Years, 1936–46," in Junker, John Steuart Curry, 197.

10. "Resident Artist," in Junker, John Steuart Curry, 229.

11. John Curry to Jonas Lie, president, National Academy of Design, 16 February 1938, and David B. Dearinger, curator, National Academy of Design, to Patricia Junker, FAMSF, 10 February 1997; both in John Steuart Curry, Self Portrait object file, AAD/DEY/FAMSF.

12. "Curry Takes New Post on U.W. Campus," Milwaukee Sentinel, 5 December 1936, quoted in Junker, John Steuart Curry, 229.

89. CHARLES R. SHEELER, Kitchen, Williamsburg

1. Neither Sheeler nor his artistic peers identified themselves as "Precisionists," and critics of the time called them "Immaculates." For a history of the terms precisionist and Precisionism, see Gail Stavitsky, "Reordering Reality: Precisionist Directions in American Art, 1915–1941," in Precisionism in America, 1915–1941: Reordering Reality (Montclair, N.J.: Montclair Art Museum, 1994), 30–34.

2. Surveys of Precisionist artists include Precisionism in America, 1915–1941; and Karen Tsujimoto, Images of America: Precisionist Painting and Modern Photography (San Francisco: San Francisco Museum of Modern Art, 1982). For an insightful discussion of Sheeler's precisionist aesthetic, see Rick Stewart, "Charles Sheeler, William Carlos Williams, and Precisionism: A Redefinition," Arts Magazine 58, no. 3 (November 1983): 100–114. For Sheeler's interiors, see Susan Fillin-Yeh, Charles Sheeler: American Interiors (New Haven: Yale University Art Gallery, 1987). For a discussion of Sheeler's work and early-twentieth-century

industrial productions, see Sharon Corwin, "Picturing Efficiency: Precisionism, Scientific Management, and the Effacement of Labor," Representations 84 (2004): 139–165.

3. Charles Sheeler, Sheeler Papers, AAA/SI, microfilm reel NSh-1, frame 8, quoted in Tsujitmoto, Images of America, 80 (emphasis in original).

4. The relationship between Sheeler's photography and painting is discussed in Tsujimoto, Images of America, 79–85; Stewart, "Precisionism: A Redefinition," 101–110; and Ellen Handy, "The Idea and the Fact: Painting, Photography, Film, Precisionists, and the Real World," in Precisionism in America, 1915–1941, 40–51. For Sheeler's photographs, see Theodore E. Stebbins Jr. and Norman Keyes Jr., Charles Sheeler: The Photographs (New York: New York Graphic Society, 1987); and Carol Troyen, "Photography, Painting, and Charles Sheeler's 'View of New York,'" Art Bulletin 86, no. 4 (December 2004): 731–749.

5. This biographical account of Sheeler is based on Constance Rourke, Charles Sheeler: Artist in the American Tradition (New York: Harcourt, Brace and Company, 1938); Martin Friedman, Charles Sheeler (New York: Watson-Guptill Publications, 1975); Tsujimoto, Images of America, 73–85; and Carol Troyen and Erica E. Hirshler, Charles Sheeler: Paintings and Drawings (Boston: Museum of Fine Arts, 1987), 2–49.

6. See Tsujimoto, Images of America, 79.

7. See Stebbins and Keyes, Sheeler: The Photographs, 41. On the Rockefellers' role in the restoration of Williamsburg, see Carlisle H. Humelsine, Recollections of John D. Rockefeller Jr. in Williamsburg, 1926–1960 (Williamsburg, Va.: The Colonial Williamsburg Foundation, 1985).

8. Sheeler's approach to rendering his subject in Kitchen, Williamsburg can be traced back to his breakthrough work of 1929, the painting Upper Deck (Fogg Art Museum, Harvard University Art Museums, Cambridge, Mass.). Of this painting Sheeler later stated: "It was the first of a group of pictures which was to be still further intent upon precision of construction and execution, in the matter of the presentation of the subject seen in nature. I was also intent upon the development of craftsmanship which would further remove the evidence of painting as such from the painting in the final state, and to further realize a structural security." Charles Sheeler, manuscript autobiography, Charles Sheeler Papers, AAA/SI, microfilm reel NSH-1, frame 105, quoted in Stewart, "Precisionism: A Redefinition," 108.

9. Sheeler, quoted in Rourke, Sheeler, 98.

10. Wanda Corn has insightfully addressed the implications of Sheeler and his contemporaries' interests in early American material culture; see Corn, The Great American Thing: Modern Art and National Identity, 1915–1935 (Berkeley and Los Angeles: University of California Press, 1999), 293–338. Although Corn does not discuss Kitchen, Williamsburg, it fits into her argument that Sheeler and his peers preferred vernacular to high-style art objects.

11. Jerome Klein, "Modern Museum Show Sheeler's Pure Americana," New York Post, 7 October 1939, from Downtown Gallery Papers, Current Files (1958)—Chas. Sheeler—Catalogue and Clippings to 1939, AAA/SI, microfilm reel ND/40, frame 476.

90. CHARLES BIEDERMAN, Paris 140, January 14, 1937

1. Biederman, 1 November 1933, quoted in Leif Sjöberg, "Charles Biederman's Search for a New Art," in Charles Biederman: A Retrospective (Minneapolis: The Minneapolis Institute of Arts, 1976), 13.

2. The following biography of the artist is drawn from ibid., 11–20;

Charles Biederman: A Retrospective Exhibition with Especial Emphasis on the Structurist Works of 1936–69 (London: Arts Council of Great Britain, 1969), 14–17; and Neil Larsen, "Charles Biederman: A Brief History," at http://www.charlesbiederman.net/biography.html (accessed 9 December 2004).

3. Biederman, quoted in Sjöberg, "Biederman's Search," 13.

4. For a discussion of Biederman in the context of modernist abstract painting in America, see Susan C. Larsen, "Charles Biederman and American Abstract Modernism," in *Charles Biederman* (Minneapolis: Frederick R. Weisman Art Museum, 1999), 2–7. See also *Abstract Paintings and Sculpture in America, 1927–1944*, ed. John R. Lane and Susan C. Larsen (Pittsburgh: Museum of Art, Carnegie Institute, 1983). Incidentally, two of these five artists included in *Five Contemporary American Concretionists*, George L. K. Morris and Charles Shaw, became members of American Abstract Artists, a group formed in 1937 dedicated to promoting abstract art in the United States. On the American Abstract Artists, see Susan C. Larsen, "The Quest for an American Abstract Tradition, 1927–1941," in *Abstract Paintings and Sculpture*, 36–39.

5. Biederman, quoted in *Biederman* 1969, 15.

6. Discussions of Biederman's Structurism are included in Sjöberg, "Biederman's Search," 21–27; Jan van der Marck, "Landscapes by Whatever Name," in *Biederman* 1976, 57–65; Donald B. Kuspit, "Charles Biederman's Abstract Analogues for Nature," *Art in America* 65 (May–June 1977): 80–83. For Biederman's explanation of his approach to art making, see especially Biederman, *Art as the Evolution of Visual Knowledge* (Red Wing, Minn.: Charles Biederman, 1948). For a complete listing of Biederman's publications, see the artist's website, http://www.charlesbiederman.net (accessed 13 February 2005).

7. Biederman, in *Biederman* 1976, 51.

8. Ibid., 47.

9. Ibid., 46.

10. For a discussion of Biederman's interest in Mondrian and De Stijl, see Jan van der Marck, "Biederman and the Structurist Direction in Art," in *Biederman* 1969, 9–11. A concise history of De Stijl can be found in Paul Overy, *De Stijl* (London: Thames and Hudson, 1991). For the philosophical origins of De Stijl, see H. L. C. Jaffé, *De Stijl, 1917–1931: The Dutch Contribution to Modern Art* (Amsterdam: J. M. Meulenhoff, 1956), 53–62.

11. Schoenmaekers, quoted in Jaffé, *De Stijl*, 58.

12. Ibid., 60.

13. Noted in George Heard Hamilton, *19th and 20th Century Art: Painting, Sculpture, Architecture* (New York: Prentice-Hall and Harry N. Abrams, 1970), 240.

14. Mondrian, quoted in ibid.

91. THOMAS HART BENTON, *Susanna and the Elders*

1. Benton was the first artist to appear on the cover of *Time* magazine (24 December 1934). Although Regionalism was perceived as outdated, or even reactionary, after World War II, Benton's sophisticated art theories influenced his star pupil, Jackson Pollock, who later became the most famous of the Abstract Expressionists.

2. Quoted in Matthew Baigell, *Thomas Hart Benton* (New York: Harry N. Abrams, 1973), 105. For Benton's early interest in Marxism and his rejection of its principles by 1928, see Robert S. Gallagher, "Before the Colors Fade: An Artist in America, an Interview with Thomas Hart Benton," *American Heritage* 24, no. 4 (June 1973): 85–86.

3. Thomas Hart Benton, "American Regionalism: A Personal History

of the Movement," *University of Kansas City Review* 18, no. 1 (Autumn 1951), quoted in J. Richard Gruber, *Thomas Hart Benton and the American South* (Augusta, Ga.: Morris Museum of Art, 1998), 7.

4. Henry Adams, *Thomas Hart Benton: An American Original* (New York: Alfred A. Knopf, 1989), 129. Commenting on his mural *A Social History of Missouri* (1936), Benton declared, "In the development of Missouri, General Pershing was not as important as an ordinary old bucksaw and my granduncle, Senator Benton, was of far less importance than a common Missouri mule"; ibid., 272.

5. Benton later recalled that assignments to render the industrial landscape of the U.S. navy base at Norfolk, Virginia, "tore me away from my grooved habits, from my play with colored cubes and classic attenuations, from my aesthetic drivelings and morbid self-concerns. I left for good the art-for-art's-sake world in which I had hitherto lived." See ibid., 87.

6. Ibid., 87–88. See Jesse Ames Spencer, *History of the United States: From the Earliest Period to the Administration of James Buchanan*, 3 vols. (New York: Johnson, Fry & Company, 1858). Several revised and updated versions of this multivolume history were published.

7. See "U.S. Scene," *Time*, 24 December 1934, 24–27. For Benton's travels, see Adams, *Benton: An American Original*, 134–146. For the public construction of the American regionalist movement's identity by the art dealer Maynard Walker and others, see ibid., 216–221. For Benton's retrospective (1951) view of the regionalist movement, see Thomas Hart Benton, "What's Holding Back American Art?" in *A Thomas Hart Benton Miscellany: Selections from His Published Opinions, 1916–1960*, ed. Matthew Baigell (Lawrence: University Press of Kansas, 1971), 104–111.

8. Adams, *Benton: An American Original*, 240–243.

9. Asked why he occasionally painted religious subjects, Benton replied, "Yes, I'm an atheist, but not a militant one. When I go into a church or cathedral, I believe in what man has felt necessary to deify his creation. Yes—that I believe." See Polly Burroughs, *Thomas Hart Benton: A Portrait* (Garden City, N.Y.: Doubleday & Company, 1981), 195.

10. For some of Benton's studies for the figure of Susanna, see Karal Ann Marling, *Tom Benton and His Drawings: A Biographical Essay and a Collection of His Sketches, Studies, and Mural Cartoons* (Columbia: University of Missouri Press, 1985), 59, 66 (illus.), 144, 146 (illus.), 169, 170 (illus.), 171 (illus.). Although no model survives for *Susanna and the Elders*, Benton typically created clay dioramas of his compositions to work out spatial relations and lighting effects. See Adams, *Benton: An American Original*, 90.

11. See Thomas Hart Benton to Bert Granet, 1 November 1954, photocopy in Thomas Hart Benton *Susanna and the Elders* object file, AAD/DEY/FAMSF. For the oil study of the nude Susanna owned by Granet, see Sotheby's, New York, *Important American 18th-, 19th-, and 20th-Century Paintings, Drawings, and Sculpture*, 2 June 1983, lot 269. Benton noted that it took two months just to achieve the correct flesh tones for Susanna. See Adams, *Benton: An American Original*, 286.

12. See Thomas Hart Benton, "The Arts of Life in America" (1932), quoted in Baigell, *Benton Miscellany*, 22–23.

13. Adams, *Benton: An American Original*, 289. Benton had previously included a mischievous self-portrait in his *America Today* (1930) mural, in which he drinks bootleg whiskey with Alvin Pierson, director of the New School for Social Research in New York. See Gallagher, "Before the Colors Fade," 85.

14. Quoted in Marling, *Benton and His Drawings*, 58.

15. Thomas Hart Benton to Daniel Longwell, 8 February 1938, quoted

in Erika Doss, *Benton, Pollock, and the Politics of Modernism: From Regionalism to Abstract Expressionism* (Chicago: University of Chicago Press, 1991), 199. For Benton's work as a set designer for films in New York and New Jersey, and for the influence of film on his subsequent work, see Adams, *Benton: An American Original*, 72, 80, and 152–153.

16. Benton's son told his father regarding *Persephone*, "You know Dad, you're getting to look more and more like the bum in that painting." See Adams, *Benton: An American Original*, 289. Henry Adams has connected *Persephone*, which was originally titled *The Rape of Persephone*, with "Benton's early sexual traumas and his coming of age." See ibid., 289–290.

17. Ibid., 290.

18. As Benton disingenuously observed, *Susanna and the Elders* and *Persephone* "caused some controversy, although I'm not really sure why. I did the same thing as Giorgione's *Fête Champêtre*, in which the men have the costume of the day, although the women, of course, don't have any costumes at all." Benton, in Gallagher, "Before the Colors Fade," 89.

19. Adams, *Benton: An American Original*, 287.

20. For the description of Susanna as "pornographic," see D. B., "A Heralded and Popular Painter, Benton Seen in Retrospective," *Art News* 37, no. 32 (6 May 1939): 14. Benton was incensed when his friend Archie Musick described *Susanna and the Elders* in a review as a barroom nude: "Don't you know that bar-room nudes do not have hair on their pussys?" See Adams, *Benton: An American Original*, 286.

21. Pubic hair first appeared much later in the centerfolds of men's magazines such as *Penthouse* (April 1970) and *Playboy* (January 1971). Benton's longtime friend Rolf Armstrong was a specialist in pinup calendars. See Adams, *Benton: An American Original*, 27, 64, and 287. Benton dismissed pinup illustrations, writing, "I sometimes get thoroughly disgusted with the whole thing, especially when I see these half-witted talentless imbeciles who tickle up the vapid, simpering abortion called 'The American pretty girl.'" Ibid., 64.

22. *Susanna and the Elders* also was exhibited at San Francisco's Golden Gate International Exposition of 1939 and was purchased there for $7,200 (discounted from $9,000) by an anonymous buyer who donated it to the California Palace of the Legion of Honor. See Beatrice Judd Ryan, Manager of Art Sales, Golden Gate International Exposition, to Thomas Carr Howe, Director, California Palace of the Legion of Honor, 30 July 1940, in Thomas Hart Benton *Susanna and the Elders* object file, AAD/DEY/FAMSF.

23. Mary H. Ellis, quoted in Adams, *Benton: An American Original*, 290 and 292. The sculptor Haig Patigian, of the California Palace of the Legion of Honor's Committee on Gifts, critiqued *Susanna and the Elders* in similar terms: "I regret to say that I cannot recommend to the Trustees of the Palace of the Legion of Honor the acceptance of Benson's [*sic*] painting 'Suzanna [*sic*] and the Elders.' My main objection to the picture is that it borders on the 'vulgar'—it is not a nude in the artistic sense, but a naked every day woman which would shock most visitors to the museum accompanied by children or otherwise. The title, too, is quite farfetched—it doesn't mean anything." See Patigian, Member, Committee on Gifts, to Thomas Carr Howe, Director, California Palace of the Legion of Honor, 20 September 1940, in Thomas Hart Benton *Susanna and the Elders* object file, AAD/DEY/FAMSF. Howe wrote to another concerned member of the Committee on Gifts, "I personally do not feel that the picture in question 'borders on the vulgar,' nor do I find the nudity objectionable. It is to me rather the kind of 'naturalism' which is to be observed in the works of

certain 15th-century Flemish artists, with whom Benton may be compared by virtue of his unquestioned technical ability and his directness of approach." See Thomas Carr Howe, Director, California Palace of the Legion of Honor, to O. K. Cushing, Committee on Gifts, 28 September 1940, in Thomas Hart Benton *Susanna and the Elders* object file, AAD/DEY/FAMSF.

92. AGNES PELTON, *Challenge*

1. Margaret Stainer, Ed Garman, and Irving Sussman, *Agnes Pelton* (Fremont, Calif.: Ohlone College Art Gallery, 1989), 8. Pelton's natural spiritual inclinations were encouraged by her close friend Dane Rudhyar, a composer and astrologer who became her spiritual adviser regarding occult philosophies and religions. Although Pelton was raised in a Christian family, her artistic vision was informed by diverse spiritual influences that included Madame Helena Petrovena Blavatsky's Theosophy, Rudolf Steiner's Anthroposophy, the Agni Yoga promoted by the Russian expatriates Nicholas and Helena Roerich, and the teachings of Krishnamurti. See Michael Zakian, *Agnes Pelton: Poet of Nature* (Palm Springs, Calif.: Palm Springs Desert Museum, 1995), 64, 73, and 76.

2. See Arthur Wesley Dow, *Composition: A Series of Exercises in Art Structure for the Use of Students and Teachers* (Boston: Joseph Bowles, 1899; reprint, with an introduction by Joseph Masheck, Berkeley and Los Angeles: University of California Press, 1997).

3. Agnes Pelton, quoted in Zakian, *Agnes Pelton*, 18.

4. Aided by artist and critic Walter Pach's influential book *The Renaissance* (1873), which promoted a deeply subjective and emotional response to art, Pelton wrote that her Italian sojourn "liberated the creative impulse." See ibid., 19.

5. Quoted in ibid.

6. Pelton's desire to give form to immaterial thoughts and emotions was influenced by theosophical theories. See the popular theosophic text of 1901, Annie Besant and C. W. Leadbeater, *Thought Forms* (reprint, Wheaton, Ill.: Theosophical Publishing House, 1999).

7. Quoted in Zakian, *Agnes Pelton*, 53.

8. See Wassily Kandinsky, *Concerning the Spiritual in Art* (1912), trans. with an introduction by M. T. H. Sadler (New York: Dover Publications, 1977).

9. See Transcendental Painting Group, statement of purpose, Santa Fe, New Mexico, 1938; and Transcendental Painting Group, manifesto, Santa Fe, New Mexico, 1938, cited in Tiska Blankenship and Ed Garman, *Vision and Spirit: The Transcendental Painting Group* (Santa Fe: Jonson Gallery of the University of New Mexico Art Museum, 1997), 62.

10. Rudhyar also created a painting entitled *Challenge* (1948) that appears to address the interaction of cosmic forces. See Blankenship and Garman, *Vision and Spirit*, 25 (illus.).

11. Quoted in Zakian, *Agnes Pelton*, 53.

12. Ibid., 73.

13. Ibid., 56.

14. In an updated notebook entry, Pelton briefly referred to the subject of *Challenge* as "The dark and light stars in the pale sky." See Agnes Pelton Papers, Jonson Gallery, University of New Mexico, Albuquerque.

15. Ibid., 94, and Stainer, Garman, and Sussman, *Agnes Pelton*, 8.

16. The coexistence of oppositional forces and their resolution in a dynamic equilibrium was a primary interest of the Dutch artist Piet Mon-

drian, whose works and writings strongly influenced Pelton and the other artists in the Transcendental Painting Group. See Ed Garman, "The Ideals and the Art of the Transcendental Painters," in Blankenship and Garman, *Vision and Spirit*, 53.

17. The Transcendental Painting Group's logo, designed by Maryion and Emil Bisttram, was a butterfly that symbolized "metamorphosis," by which they meant "the constant renewal of forms toward a higher, freer, always transcendent life." Garman, "The Ideals and the Art of the Transcendental Painters," 52.

18. Zakian, *Agnes Pelton*, 94.

19. Quoted in ibid., 112.

93. CLAUDE CLARK, *Guttersnipe*

1. Quoted in David C. Driskell, *A Retrospective Exhibition, 1937–1971: Paintings by Claude Clark* (Nashville: The Carl Van Vechten Gallery of Fine Arts, Fisk University, 1972), n.p.

2. Barnes Foundation funds enabled the Parisian art dealer Paul Guillaume and the Barnes Foundation teacher Thomas H. Munro to publish *Primitive Negro Sculpture* (1926), one of the earliest and most influential English texts on African art. See Richard M. Wattenmaker et al., *Great French Paintings from the Barnes Foundation: Impressionist, Post-Impressionist, and Early Modern* (New York: Alfred A. Knopf, in association with Lincoln University Press, 1993), 14.

3. Clark's wife, Daima, recalled, "he joined the labor movement after his family moved to Philadelphia. Fact: he was a fellow traveler to the Communist Party, so much so that the F.B.I. followed us to Talladega College, where two agents tried to get him to name people in the Party, to no avail." Mrs. Claude (Daima M.) Clark to the author, 4 October 2000, Claude Clark *Guttersnipe* object file, AAD/DEY/FAMSF.

4. Dictionary definitions of *guttersnipe*, a hobo term that originally described a collector of cigar or cigarette butts (*snipe* is slang for a butt), include "a person of the gutter; a bum," "a child brought up in the gutter," and "a person of the lowest moral or economic station." The street urchin subject had been explored previously by Robert Henri in such portraits as *Willie Gee* (1904) and *Sylvester* (1914), which helped to introduce sympathetic depictions of urban African Americans into the realm of fine art. For reproductions of *Willie Gee* and *Sylvester*, see *Catalogue of a Memorial Exhibition of the Work of Robert Henri* (New York: The Metropolitan Museum of Art, 1931), pls. 28 and 58. In sharp contrast to Clark's street-smart *Guttersnipe*, Henri's children are depicted as idealized innocents— urban equivalents to the picturesque rural peasant subjects popular in late-nineteenth-century art.

5. Clark's lush palette-knife paint strokes reveal the influence of Vincent van Gogh's physically and emotionally expressive portraits, including *Joseph-Etienne Roulin* (1889) and *Man Smoking* (1889), both of which he had studied in the permanent collection of the Barnes Foundation. Van Gogh's working-class subjects were as influential as his technique, and Clark's wife, Daima, has noted that her husband "identified immeasurably with Van Gogh's use of subject matter and color." Mrs. Claude (Daima M.) Clark to the author, 26 May 2001, Claude Clark artist file, AAD/DEY/FAMSF.

6. See Claude Clark, *A Black Art Perspective: A Black Teacher's Guide to a Black Visual Art Curriculum* (Oakland, Calif.: privately published, 1969), 2. Clark's fascination with Africa dated to his childhood, when he had been entranced by African American Methodist Episcopal Church ministers who recounted their missionary experiences in "mother Africa." Ibid., 1.

7. Claude Clark, interviews by Steven L. Jones, summarized in Jones to the author, 9 January and 3 April 2000, Claude Clark *Guttersnipe* object file, AAD/DEY/FAMSF.

8. Paul-Philippe Cret's Barnes Foundation building (1922–25) also incorporated architectural elements inspired by African Baule and Senufo art. See the entrance to the Barnes Foundation building in Wattenmaker et al., *Great French Paintings*, 10–11.

9. Clark, *A Black Art Perspective*, 3.

10. According to Barnes Foundation records, this particular arrangement of the two Picasso paintings and the adjacent African art objects has remained unchanged since Barnes's death in 1951 and was probably present in identical or similar form during the period of Clark's Barnes Fellowship.

11. For Picasso's *Head of a Woman* and *Head of a Man*, see Wattenmaker et al., *Great French Paintings*, 204–207.

12. Alain Locke taught Clark's wife, Daima (Effie Mary Lockhart), while she was enrolled in a master's of philosophy program at Howard University (1938–41). Clark acquired Locke's book *The Negro in Art* (1941) in 1942, the same year Locke met Clark after Locke gave a lecture at Philadelphia's Pyramid Club. Locke subsequently visited the artist's Lombard Street studio, where he viewed *Guttersnipe*. See Steven L. Jones to the author, 9 January and 17 May 2000, Claude Clark *Guttersnipe* object file, AAD/DEY/FAMSF.

13. Alain Locke, "The Legacy of the Ancestral Arts," in *The New Negro: An Interpretation*, ed. Locke (New York: A. and C. Boni, 1925), reprinted as *The New Negro*, with a new preface by Robert Hayden (New York: Atheneum, 1969), 254–267.

14. Claude Clark, interviews by Steven L. Jones, summarized in Jones to the author, 9 January 2000, Claude Clark *Guttersnipe* object file, AAD/DEY/FAMSF.

15. In an early manifestation of his lifelong identification with the working class, as an aspiring writer in high school Clark had authored "The Pretzel Man," a moving portrait of a stoic street vendor struggling to survive the Great Depression. See Claude Clark, "The Pretzel Man," in Roxborough Junior/Senior High School *Wissahickon* (Philadelphia, ca. 1929–35), courtesy of Mrs. Claude (Daima M.) Clark. Copy in Claude Clark artist file, AAD/DEY/FAMSF. While Clark pursued his art career, his father supported the family by driving a garbage wagon in the streets of Philadelphia. Clark's street subject accrued new resonance during the Great Depression, when unprecedented numbers of unemployed Americans were forced to fend for themselves on the streets, dependent on itinerant labor, breadlines, soup kitchens, and handouts from sympathetic pedestrians.

16. Claude Clark to David C. Driskell, quoted in Driskell, *Paintings by Claude Clark*, n.p.

17. Langston Hughes, "The Negro Artist and the Racial Mountain," *Nation* 122 (23 June 1926): 692, reprinted in *The Portable Harlem Renaissance Reader*, ed. David Levering Lewis (New York: Penguin Books, 1994), 91–92.

18. Ibid.

19. For a similar conception of the discrepancies between African heritage and African American experience, see Langston Hughes's "Poem[1]. For the portrait of an African boy after the manner of Gauguin. / All the

tom-toms of the jungles beat in my blood, / And all the wild hot moons of the jungle shine in my / soul. / I am afraid of this civilization—/ So hard, / So strong, / So cold." See Arnold Rampersad and David Roessel, eds., *The Collected Poems of Langston Hughes* (New York: Vintage Books, 1995), 32.

20. Hughes, "The Negro Artist and the Racial Mountain," 95.

94. HORACE PIPPIN, *The Trial of John Brown*

1. For Elie Nadelman's interest in folk art, see "Nadelman as Collector," in Barbara Haskell, *Elie Nadelman: Sculptor of Modern Life* (New York: Whitney Museum of American Art and Harry N. Abrams, 2003), 150–155. Juliana Force, a pioneering collector of folk art and the first director of the Whitney Studio Club (later the Whitney Museum of American Art), acquired Pippin's *Buffalo Hunt* as the museum's first example of contemporary self-taught art. See Judith E. Stein, "An American Original," in Stein et al., *I Tell My Heart: The Art of Horace Pippin* (Philadelphia: Pennsylvania Academy of the Fine Arts, in association with Universe Publishing, 1993), 12. For the Abby Aldrich Rockefeller collection, see Beatrix T. Rumford and Carolyn J. Weekley, *Treasures of American Folk Art from the Abby Aldrich Rockefeller Folk Art Center* (Boston: Little, Brown & Co., 1989). For the Garbisch collection, see James J. Rorimer, John Walker, and Albert Ten Eyck Gardner, *101 Masterpieces of American Primitive Painting from the Collection of Edgar William and Bernice Chrysler Garbisch* (New York: American Federation of Arts, 1961).

2. Quoted in Stein, "An American Original," 11. Pippin's fellow artist and friend Claude Clark later recalled, "I feel that Pippin really was exploited to the hilt in many ways. . . . I don't think he was ever fully treated as a human being. . . . underneath [his appeal as a naive] . . . was this human being, who even though not the scholar that you might think of, he was certainly a thinker and he did more research than most people realize." See ibid., 32.

3. Ibid., 2. Barnes invited Pippin to the Barnes Foundation in the Philadelphia suburb of Merion, where Pippin viewed the permanent collection and attended art history lectures in the fall of 1939 and spring of 1940. For Barnes's relationship with Pippin, see ibid., 14–19. In the introduction to the catalogue for Pippin's 1940 exhibition at Robert Carlen's gallery in Philadelphia, Barnes wrote of the artist: "It is probably not too much to say that he is the first important Negro artist to appear on the American scene and that his work shares with that of John Kane the distinction of being the most individual and unadulterated painting authentically expressive of the American spirit that has been produced in our generation." See Selden Rodman, "Horace Pippin (1888–1946): Introduction," in *Four American Primitives* (New York: ACA Galleries, 1972), n.p.

4. Quoted in Stein, "An American Original," 16.

5. Ibid., 3.

6. For the complicated and contradictory accounts of Pippin's "discovery," see ibid., 5, 8.

7. Christine Pippin, who was twenty-nine years old in the year of Pippin's birth, was born the year of John Brown's death. Harriet Pippin, whom Pippin repeatedly named as his "mother" and identified as the witness to Brown being taken to his hanging, was fifty-three years old in the year of the artist's birth and would have been twenty-four in the year of Brown's death. It is possible that Christine was Pippin's birth mother, but that he was raised by Harriet Pippin, whom he therefore considered his true mother. See ibid., 2, 38 n. 1.

8. Brown's physical state during the trial provoked righteous indignation in an editorial in the Lawrence, Kansas, *Republican*: "We defy an in-

stance to be shown in a civilized community where a prisoner has been forced to trial for his life when so disabled by sickness or ghastly wounds as to be unable even to sit up during the proceedings, and compelled to be carried to the judgment hall upon a litter." See Rodman, "Horace Pippin: Introduction," 17.

9. Claude Clark later recalled: "When [Pippin] was doing the John Brown series he showed me the drawings [made] when he had gone to the courthouse of the period and noticed they had a desk where they had a compartment where they kept their scrolls. And he made detailed drawings of this." Claude Clark, quoted in Stein, "An American Original," 5. Compare Rodman, "Horace Pippin: Introduction," 17.

10. The prosecutor's stovepipe hat, on the floor just above Pippin's signature, is inevitably reminiscent of Abraham Lincoln's best-known trademark. Pippin painted *Abe Lincoln: The Great Emancipator* (1942), in which Lincoln wears a stovepipe hat, in the same year as his John Brown trilogy. The artist Romare Bearden noted the important linkage of these two abolitionist heroes among African Americans and recalled, "Lincoln and John Brown were as much a part of the actuality of the Afro-American experience, as were the domino games and the hoe cakes for Sunday morning breakfast. I vividly recall the yearly commemoratives for John Brown and see my grandfather reading Brown's last speech to the court, which was a regular part of the ceremony at Pittsburgh's Shiloh Baptist Church." See Romare Bearden, *Horace Pippin* (Washington, D.C.: The Phillips Collection, 1976), n.p.

11. See Richard J. Powell, "Biblical and Spiritual Motifs," in Stein et al., *I Tell My Heart*, 125 (illus.).

12. Rodman, "Horace Pippin: Introduction," 17.

13. The scheduled three-month training for Pippin's regiment was cut short at only two weeks after various members were harassed in the nearby town of Spartanburg, South Carolina. See Judith Wilson, "Scenes of War," 56–57, in Stein et al., *I Tell My Heart*. Pippin overtly addressed the persistence of racism in the U.S. military with the painting *Mr. Prejudice* (1943) in which the unity of black and white servicemen is threatened by the allegorical figure of "Mr. Prejudice," who threatens to drive a wedge between the two groups. See ibid., 61–65. The U.S. army was not desegregated until President Truman signed Executive Order 9981 in 1948.

14. For histories of the Scottsboro Boys, see Dan T. Carter, *Scottsboro: A Tragedy of the American South* (Baton Rouge: Louisiana State University Press, 1979); and James E. Goodman, *Stories of Scottsboro* (New York: Pantheon Books, 1995).

95. BEN SHAHN, *Ohio Magic*

1. Frances K. Pohl, *Ben Shahn: With Ben Shahn's Writings* (San Francisco: Pomegranate, 1993), 15. Shahn's political commitment continued after World War II through his support of political candidates such as Franklin Delano Roosevelt, Henry Wallace, Adlai Stevenson, and Eugene McCarthy, as well as the antinuclear, civil rights, and antiwar movements.

2. Ben Shahn, *The Shape of Content* (Cambridge, Mass.: Harvard University Press, 1957), 40.

3. Ibid., 45. Modifying his interest in Social Realism, Shahn observed, "I wanted to find some deeper source of meaning in art, a constant spring that would not run dry with the next change in political weather." Ibid., 43.

4. Shahn's early favorable impression of a painting by Taddeo Gaddi at the Metropolitan Museum of Art was reinforced by a trip to Italy in 1924; ibid., 108–109. Recalling his creation of "The Passion of Sacco and

Vanzetti" (1931–32) series, Shahn wrote, "I was not unmindful of Giotto, and of the simplicity with which he had been able to treat connected events—each complete in itself, yet all recreating the religious drama, so living a thing to Giotto." Ibid., 37–38. Shahn's wife recalled, "He thought deeply about Giotto, the simplicity and humanity that had made him so great. He said, 'I often longed to have lived in a time such as Giotto's, when the world was moved by some event as profound as the Crucifixion, when artists could put all their feelings into paint without fear of triviality.'" Bernarda Bryson Shahn, *Ben Shahn* (New York: Harry N. Abrams, 1972), 117. For Shahn's influential encounter with Gentile Bellini's *A Procession of Relics in the Piazza San Marco*, see Howard Greenfeld, *Ben Shahn: An Artist's Life* (New York: Random House, 1998), 40.

5. Ben Shahn, "Autobiography of Some Paintings," *Art in America* 51, no. 4 (August 1963): 101.

6. Quoted in "Some Questions," in *Ben Shahn*, ed. John D. Morse (New York: Praeger Publishers, 1972), 203.

7. Said Shahn; "I hate injustice. I guess that's about the only thing I really do hate." Quoted in John D. Morse, "Ben Shahn: An Interview," *Magazine of Art* 37, no. 4 (April 1944): 136.

8. Shahn commented, "I had seen all the right pictures and read all the right books—Vollard, Meier-Graefe, David Hume. But it still didn't add up to anything. 'Here am I,' I said to myself, 'thirty-two years old, the son of a carpenter. I like stories and people. The French school is not for me. If I am to be a painter I must show the world how it looks through my eyes, not theirs. Then I got to thinking about the Sacco-Vanzetti case. They'd been electrocuted in 1927, and in Europe of course I'd seen all the demonstrations against the trial—a lot more than there were over here. Ever since I could remember I'd wished that I'd been lucky enough to be alive at a great time—when something big was going on, like the Crucifixion. And suddenly realized I was! Here I was living through another crucifixion. Here was something to paint!'" Quoted in Greenfeld, *Artist's Life*, 72–73.

9. These photographs are reproduced and discussed in Deborah Martin Kao, Laura Katzman, and Jenna Webster, *Ben Shahn's New York: The Photography of Modern Times* (Cambridge, Mass.: Fogg University Art Museum; New Haven: Yale University Press, 2000), 204, 212–215.

10. Bernarda Bryson, who met Shahn in 1933 and eventually became his second wife, was from Athens, Ohio. Shahn and Bryson lived together in Columbus, Ohio, in 1938, when Shahn was photographing the state intensively for the Resettlement Administration, so Ohio had deep personal associations for the artist. Greenfeld, *Artist's Life*, 114–119, 145–151.

11. Describing his surreal use of the trompe l'oeil bus, Shahn observed, "The emotion conveyed by great symphonic music happens to be expressed in semimathematical acoustic intervals and this cannot be transposed in terms of ninety portraits or caricatures of performers. Just as, for example, the unrelatedness of a busload of travelers on a rural road in my picture 'Ohio Magic' seemed to me better conveyed by one of those 'primitive' renderings of the same scene on the brick wall of a filling station than in a realism divested of the overtones of unreality." Selden Rodman, *Ben Shahn: Portrait of the Artist as an American; A Biography with Pictures* (New York: Harper & Brothers Publishers, 1951), 27. Shahn also declared, "I expect more of the artist than a mere mechanical mirroring of his society.... I think the role of the artist is to transcend, you see. He must not only mirror his time, he must hold something beyond that." Pohl, *Ben Shahn*, 137.

12. Although the building at the left of *Ohio Magic* has two projecting bay windows on the second and third floors, it otherwise closely resembles the Shahn family brick rowhouse. Both buildings have three stories, three window bays, and a ground-floor arrangement of alternating doors and bay windows with an overhanging cornice. For a later photograph (ca. 1951) of the Shahn family home, see Rodman, *Portrait of the Artist*, 162.

13. Indeed, the transition from town to city may be contained within the painting; the right side of the street, including a church, resembles small-town architecture, while the left side of the street, including three buildings with vertical windows, resembles contemporary urban architecture.

14. Electrical ignition systems did not become standard in American cars until shortly before World War I.

15. Shahn, *Shape of Content*, 47.

16. Like de Chirico's paintings, Shahn's mature work, beginning appropriately with an Italian American subject—The Passion of Sacco and Vanzetti—owes a deep debt to early Italian Renaissance art. Shahn undoubtedly would have noticed the similarity of the trompe l'oeil street mural in Warren to Renaissance precedents such as Piero della Francesca's famous *View of an Ideal City* (ca. 1470, Galleria Nazionale, Urbino) a painting that helped to establish pictorial conventions for rendering cityscapes with one-point perspective.

17. Shahn, *Shape of Content*, 41–42.

18. Kao et al., *Shahn's New York*, 215, fig. 85, frame no. 5.

19. For more information about the Italian family who rented the ground floor of the Shahns' building, see Rodman, *Portrait of the Artist*, 159–161. Shahn had invited his younger brother, Hyman, to Truro on Cape Cod, where he was swept away by a receding tide. Shahn, his wife, and father accompanied Hyman's body back to the Shahn house on Walton Street, where his mother blamed him for her son's death. By all accounts, Shahn never fully recovered from this tragedy. Greenfeld, *Artist's Life*, 48–50.

20. Protesting a planned trip to nearby Trenton, New Jersey, Shahn's own children had protested, "But Dad, we can't go to Trenton! Isn't the war in Trenton?" Rodman, *Portrait of the Artist*, 61.

21. Elizabeth Teass, quoted in Richard Serrano, "The Town That Lost Its Sons," *George*, May 2000, 106.

22. Describing the use of specific details in his compositions, Shahn observed, "I always felt that the particular area of what I call intense reality had an aura that sort of spread over a larger area that might not have been equally well observed, and it would endow that surrounding area with the particular sense of intense reality." Ben Shahn, interview by Nadya Aisenberg, 1957, quoted in Morse, *Ben Shahn*, 48.

23. The self-portrait, which depicts the young Shahn standing in an empty lot watching a four-man band, is probably a reminiscence of the eight-year-old Shahn's first day in America in 1906, when he saw a brass band playing at the unveiling ceremony for a statue of George Washington in Williamsburg Bridge Plaza; Rodman, *Portrait of an Artist*, 170. The Shahn family's first apartment was in a new building surrounded by open lots on the outskirts of Williamsburg. Susan Chevlowe, "A Bull in a China Shop: An Introduction to Ben Shahn," in Chevlowe, Diana L. Linden, Stephen Polcari, and Frances K. Pohl, *Common Man, Mythic Vision: The Paintings of Ben Shahn* (New York: The Jewish Museum; Princeton: Princeton University Press, 1998), 6.

24. Ibid., 77 (illus.). Bernarda Bryson Shahn stated that this painting was a direct response to the Holocaust; Ziva Amishai-Maisels, *Depiction and Interpretation: The Influence of the Holocaust on the Visual Arts* (Oxford: Pergamon Press, 1993), 77.

25. See Pohl, *Ben Shahn*, 83 (illus.). Compare *Girl Skipping Rope* (1943), in which a girl and boy pursue a simple children's game next to a ruined building; ibid., 76 (illus.). In *Italian Landscape* (1943–44), in which a mother holding a child waits for a coffin borne by pallbearers; and in *Italian Landscape II: Europa* (1944), in which a mother holding a child walks precariously over a pile of building rubble, children have been rendered vulnerable by the absence or death of their fathers; ibid., 80–81 (illus.).

26. Shahn added, "I became most conscious then that the emotional image is not necessarily of that event in the outside world which prompts our feeling; the emotional image is rather made up of the inner vestiges of many events. It is of that company of phantoms which we all own and which have no other sense than the fear sense, or that of the ludicrous, or of the terribly beautiful; images that have the nostalgia of childhood with possibly none of the facts of our childhood; images which may be drawn only from the recollection of paint upon a surface, and yet that have given us great exaltation—such are the images to be sensed and formulated." Shahn, *Shape of Content*, 47–48.

27. Bernarda Bryson Shahn observed that "indirectly all Ben's war pictures . . . Italian, French, or even the later Japanese ones reflect the horrors of the Holocaust." Pohl, *Ben Shahn*, 21. For a work that explicitly addresses the Holocaust, see the drawing *Warsaw* (ca. 1952), which depicts a pair of upright, clenched fists and a Hebrew text that may be translated as "These I remember, and my soul melts with sorrow, for strangers have devoured us like unturned cakes, for in the days of the tyrant there was no reprieve for the martyrs murdered by the government"; ibid, 111 (illus.).

28. Quoted in Greenfeld, *Artist's Life*, 171. Shahn's description refers to his famous painting, *Vacant Lot* (1939); see Pohl, *Ben Shahn*, 64 (illus.).

96. EDWARD HOPPER, *Portrait of Orleans*

1. Gail Levin, *Edward Hopper: A Catalogue Raisonné* (New York: Whitney Museum of American Art, in association with W. W. Norton Co., 1995), 50. Hopper began work as a commercial illustrator in 1906; his earliest datable advertising illustration was published in 1908. His early career as a commercial artist was punctuated by three trips to Europe taken between 1906 and 1910. Other useful general sources on Hopper's life and career include Gail Levin, *Edward Hopper: The Art and the Artist* (New York: W. W. Norton Co., in association with the Whitney Museum of American Art, 1980); Gail Levin, *Edward Hopper* (New York: Crown Publishers, 1984); Robert Hobbs, *Edward Hopper* (New York: Harry N. Abrams, in association with the National Museum of American Art, Smithsonian Institution, 1987); Gail Levin, *Edward Hopper: An Intimate Biography* (New York: Alfred A. Knopf, 1995); and Ivo Kranzfelder, *Hopper: Vision of Reality* (Cologne: Taschen, 1995; English-language ed., trans. John William Gabriel, 2002).

2. Originally quoted in Suzanne Burrey, "Edward Hopper: The Emptying Spaces," *Art Digest* 1 April 1955, 9 and 33, quoted in Levin, *Catalogue Raisonné*, 55–56.

3. Originally quoted in Archer Winsten, "Wake of the News: Washington Square North Boasts Strangers Worth Talking To," *New York Post*, 26 November 1935, quoted in Levin, *The Art and the Artist*, 44.

4. Brian O'Doherty, *American Masters: The Voice and the Myth* (New York: Random House, 1973), 15. The essay on Hopper in this book is an abridged version of O'Doherty's "Portrait: Edward Hopper," *Art in America* 6 (1964): 68–81.

5. Quoted in O'Doherty, *American Masters*, 15.

6. Mark S. Foster, *A Nation on Wheels: The Automobile Culture in America since 1945* (Belmont, Calif.: Wadsworth/Thomson Learning, 2003), 2, 31. Hobbs discusses Hopper's work in relation to the automotive viewpoint; Hobbs, *Edward Hopper*, 14, 91.

7. Charles H. Liebs, *Main Street to Miracle Mile: American Roadside Architecture* (Boston: Little, Brown & Co., 1985), 4. For further discussion of the automotive viewpoint, see Hobbs, *Edward Hopper*, 16–20, 91–95.

8. Hobbs, *Edward Hopper*, 9.

9. "The Silent Witness," *Time*, 24 December 1956, 38–39, cover story.

10. Hobbs suggests additional paintings featuring this peculiar orientation to the street; *Edward Hopper*, 96.

11. Levin, *The Art and the Artist*.

12. Carl Little, *Edward Hopper's New England* (San Francisco: Pomegranate, 1993), 13–14; Levin, *Catalogue Raisonné*, 82; and Levin, *Hopper's Places* (Berkeley and Los Angeles: University of California Press, 1985), 77.

13. Levin, *Hopper's Places*, xii.

14. James C. O'Connell, *Becoming Cape Cod: Creating a Seaside Resort* (Lebanon, N.H.: University Press of New England, 2003), 47–48.

15. Ibid., 49, 97.

16. Ibid., 112.

17. Richard V. Francaviglia, *Main Street Revised: Time, Space, and Image Building in Small Town America* (Iowa City: University of Iowa Press, 1996), 57; Liebs, *Main Street to Miracle Mile*, 95, 97.

18. Quoted in Levin, *Catalogue Raisonné*, 278.

19. Liebs, *Main Street to Miracle Mile*, 108.

20. Lloyd Goodrich, *Edward Hopper* (New York: Harry N. Abrams, 1971), 129.

21. Quoted in Levin, *Catalogue Raisonné*, 278.

22. Little, *Hopper's New England*, 15.

23. Quoted in Levin, *An Intimate Biography*, 429.

24. "Population of Massachusetts Cities, Towns, and Counties: Census Counts, 1930–2000, with Land Area and Population Density in 2000," prepared by the Massachusetts Institute for Social and Economic Research (MISER)/Massachusetts State Data Center, University of Massachusetts, Amherst, 2001.

25. Quoted in Levin, *Catalogue Raisonné*, 332. See also Deborah Lyons, *Edward Hopper: A Journal of His Work* (New York: Whitney Museum of American Art, in association with W. W. Norton Co., 1997), 79. Information about the history of Orleans comes from the Town of Orleans's Web site, http://www.townorleans.ma.us.

26. Aragon wrote, "Great red gods, great yellow gods, great green gods have been erected on the margins of the speculative paths followed by the mind in pursuit of perfection, as it progresses from feeling to feeling, from a thought to its consequence. A strange sculpture has presided over the birth of these idols. Hardly ever before have humans found pleasure in such a barbaric aspect of fate and power. Little did the nameless sculptors who erected these metallic phantoms know that they were bowing to a tradition as vital as that which designed churches in the form of a cross. These idols share a kinship that is threatening. Brightly painted with English words and neologisms, with only a single, long, flexible arm, with their faceless illuminated head, their single foot and belly with rotating dial, the gas pumps sometimes have an air about them of Egyptian deities, or of the gods of cannibals who worship only war. O Texaco Motor Oil, Eco, Shell, grand inscriptions to human potential! Soon we shall make the sign of the cross at your fountains, and the youngest among us will perish, because they have seen their nymphs in naphtha." Quoted in Kranzfelder, *Vision*

of Reality, 144–145. For discussion of Stuart Davis's use of signs, see Lowery Stokes Sims, *Stuart Davis: American Painter* (New York: The Metropolitan Museum of Art, 1991).

27. Ben Shahn, "Love and Joy about Letters," in *Ben Shahn*, ed. John D. Morse (New York: Praeger Publishers, 1972), 147. I am grateful to Tim Burgard for bringing this quote to my attention.

28. Ruth Sheldon Knowles, *The First Pictorial History of the American Oil and Gas Industry, 1859–1983* (Athens: Ohio University Press, 1983).

29. "The Silent Witness," *Time*, 24 December 1956, 28.

97. CHARLES HOUGHTON HOWARD, *The Progenitors*

1. Charles Howard, "What Concerns Me," *Magazine of Art* 39, no. 2 (February 1946): 64. Howard's achievement, as well as that of other American painters like him who built on the innovations of European Surrealism but did not go on to paint in an abstract expressionist style, has been generally overlooked in the prevailing narratives of twentieth-century American art. For an overview of the many American painters working in surrealist-inspired styles, see Jeffrey Weschler, *Surrealism and American Art* (Camden, N.J.: Rutgers University Art Gallery, 1977). Two recent discussions on Howard in the context of his immediate artistic peer group include Susan M. Anderson, "Journey into the Sun: California Artists and Surrealism," in *On the Edge of America: California Modernist Art, 1900–1950*, ed. Paul J. Karlstrom (Berkeley and Los Angeles: University of California Press, 1996), 181–209; and Susan M. Anderson, *Pursuit of the Marvelous: Stanley William Hayter, Charles Howard, Gordon Onslow-Ford* (Laguna Beach, Calif.: Laguna Art Museum, 1990).

2. The artistic achievements of the Howard family are chronicled in Stacey Moss, *The Howards: First Family of Bay Area Modernism* (Oakland, Calif.: The Oakland Museum, 1988). Biographical accounts of Charles Howard include ibid., 52–56, 95–97; and Douglas Dreishpoon, "Some Thoughts on the Enigmatic Charles Howard," in *Charles Howard, 1899–1978: Drama of the Mind* (New York: Hirschl & Alder Galleries, 1993), 5–11. A partial biography, written at an early stage of the artist's career, is "Charles Houghton Howard," *California Art Research* 9 (1937): 40–53.

3. Howard, "What Concerns Me," 63.

4. The life and work of Madge Knight are briefly discussed in Moss, *The Howards*, 56–57, 105. While in London, Howard associated with a group of surrealist-inspired painters who called themselves Unit One. See Dreishpoon, "Some Thoughts," 6.

5. For example, *New Super Realism (Joseph Cornell, Charles Howard, and Man Ray)*, Julien Levy Gallery, New York, 1931–32; *International Surrealist Exhibition*, New Burlington Galleries, London, 1936; *Americans 1942*, The Museum of Modern Art, New York, 1942; *Abstract and Surrealist Art in the United States*, San Francisco Museum of Art, 1944; *Annual Exhibition*, Whitney Museum of American Art, 1944, 1945, 1946; *Abstract and Surreal American Art*, The Art Institute of Chicago, 1948; *Abstract Painting and Sculpture in America*, The Museum of Modern Art, New York, 1951. For a complete list of exhibitions, see Charles Howard Group Exhibitions, in Charles Howard artist file, AAD/DEY/FAMSF.

6. See "Abstraction Wins San Francisco Honor," *Art Digest* 15 (1 January 1941): 21.

7. Howard, "What Concerns Me," 63 (emphasis added).

8. Ibid.

9. While living in San Francisco, Howard pursued an informal study of biology by reading books on the life sciences; see Anderson, "Journey into the Sun," 194.

10. Anderson notes Howard worked in a shipyard and was inspired by scraps of metal cast off in the ship-building process; see ibid.

11. Howard, "What Concerns Me," 63.

12. Ibid., 63–64.

13. Charles Howard, quoted in *San Francisco News*, 4 May 1935, quoted in "Charles Houghton Howard," 48.

14. Ibid.

15. He concluded, "I suspect the Surrealists, such as Dali, Ernst, and Miro, would scorn me as still being a painter." See ibid.

16. Sidney Janis, *Abstract and Surrealist Art in America* (New York: Reynal and Hitchcock, 1944), 75. Two years earlier Howard stated, "The titles appended to these pictures are supplementary and allusive. They have no other function." See Charles Howard, in *Americans 1942*, ed. Dorothy C. Miller (New York: The Museum of Modern Art, 1942), 76.

17. *Webster's New Twentieth Century Dictionary*, 2nd ed., s.v., "progenitor."

18. In response to Howard's 1946 statement that he was "dealing with material which is in the possession of all people," Douglas MacAgy wrote, "I venture to suggest that the possessions he reveals, though they may haunt our innermost thoughts, are not ones we can name. The experience of elusiveness is not the sort that comes to an end, as the feeling of groping for a word dissolves the moment the word is discovered. Howard's form does not grope; it probes. It seems to reach into a realm of human drama where feelings have not yet been differentiated and circumscribed by a nomenclature." MacAgy, "Charles Howard," *Magazine of Art* 46, no. 4 (April 1953): 156.

98. YVES TANGUY, *From One Night to Another*

1. John Ashbery, "Tanguy—The Geometer of Dreams," in *Yves Tanguy* (New York: Acquavella Galleries, 1974), 9.

2. Guillaume Apollinaire coined the term *Surrealism* in his 1918 publication "L'Esprit nouveau et les poètes," his call for the avant-garde to abandon its reliance on the expressionism of German Romanticism and the devotion to order of French classicism. Apollinaire, "The New Spirit and the Poets," in *Art in Theory, 1900–1990: An Anthology of Changing Ideas*, ed. Charles Harrison and Paul Wood (Oxford, U.K.: Blackwell, 1992), 225–227.

3. The critique of existing political, social, and economic realities rooted in Marxist intellectual tradition was not limited to Surrealism and the circle of André Breton in France. It also formed the basis of critiques by writers skeptical of the revolutionary potential of Surrealism, such as Siegfried Kracauer, Walter Benjamin, Theodor Adorno, and Ernst Bloch in Germany; Meyer Schapiro, Clement Greenberg, and Harold Rosenberg in the United States; and Herbert Read in Great Britain.

4. Tanguy collaborated with André Masson in creating this drawing game.

5. Originally the Surrealists' commitment to political change was tied to the communist party, but they broke that alliance with the rise of Stalinism, which culminated in a statement by André Breton and Leo Trotsky in *Partisan Review* that sought to separate a Marxist commitment from Soviet communism under Stalin. Barbara Haskell, *The American Century: Art and Culture, 1900–1950* (New York: W. W. Norton and Co. and the Whitney Museum of American Art, 1999), 322.

6. The term *trompe l'oeil perspective* comes from Roland Penrose, *Yves Tanguy: A Retrospective* (New York: Solomon R. Guggenheim Museum, 1982), 7.

7. Gordon Onslow-Ford, Roberto Matta Echaurren, and Tanguy first went to New York in 1939, followed by André Masson, Kurt Seligmann, Man Ray, and André Breton. Paul Schimmel, "Images of Metamorphosis," in *The Interpretive Link: Abstract Surrealism into Abstract Expressionism, Works on Paper, 1938–1948* (Newport Beach, Calif.: Newport Harbor Art Museum, 1986), 17.

8. At the opening of Art of This Century in 1942, Peggy Guggenheim wore mismatched earrings, one by Alexander Calder and the other by Tanguy.

9. James Scarborough, "Yves Tanguy," in *The Interpretive Link*, 186. Gorky, who immigrated to the United States in 1920, had been readied for Surrealism along with other New York artists by John Graham, who came to his commitment to the artistic possibilities of the unconscious through the works of Pablo Picasso and the psychological theories of Carl Jung. See Haskell, *The American Century*, 329.

10. Schimmel, "Images of Metamorphosis," 18.

11. The émigré community of Surrealists was less homogeneous than such accounts often imply. Writing to Tristan Tzara in January 1946, Marcel Duchamp observed that "the group of exiles, compact in the beginning 3 years ago, rapidly turned into 'every man for himself' with the usual discord and rows." In *Affectionately Marcel: The Selected Correspondence of Marcel Duchamp*, ed. Francis M. Naumann and Hector Obalk, trans. Jill Taylor (Amsterdam: Ludion Press, 2000), 253.

12. Penrose, *Yves Tanguy: A Retrospective*, 5. The painting was Giorgio de Chirico, *Le Cerveau de l'enfant (The Child's Brain)*, 1914, oil on canvas, 31½ × 24¾ in. (80 × 63 cm), Moderna Museet, Stockholm.

13. Ibid., 7.

14. The most famous of these sites is at Carnac, France, where there are more than 3,000 prehistoric stones.

15. "The titles given to these paintings are in many cases baffling. According to surrealist practice they were invented after the picture was finished and in general it was not intended that they should explain its content. More often they form a poetic hiatus between picture and title as in the case of *Mama, Pap is Wounded!*, which was a phrase found by Breton and Tanguy in a book of psychiatric case-histories." Penrose, *Yves Tanguy*, 8.

99. MARK ROTHKO, *Untitled*

1. Bernice Rose writing about Rothko during his breakthrough year, 1949, in *Rothko: A Painter's Progress, The Year 1949* (New York: PaceWildenstein, 2004), 10.

2. Still's influence on the New York School of abstraction was firmly established by the seminal 1947 exhibition *Clyfford Still: The Ideographic Picture*. Organized by Barnett Newman for the Betty Parsons Gallery, it also included works by Newman, Hans Hofmann, Pietro Lazzari, Boris Margo, Ad Reinhardt, Mark Rothko, and Theodoros Stamos. In the catalogue essay, Newman insists that abstract art is not about eliminating content through abstract forms but rather using an abstract style to represent ideas. Newman compares the artists included in his exhibition to a Northwest Coast Indian artist who does not "in the name of a higher purity, renounce the living world for the meaningless materialism of design. The abstract shape he used, his entire plastic language, was directed by a ritualistic will towards metaphysical understanding." Newman, "The Ideographic Picture," in *Art in Theory, 1900–1990: An Anthology of Changing Ideas*, ed. Charles Harrison and Paul Wood (Oxford, U.K.: Blackwell, 1992), 566.

3. The titles of Rothko's paintings have been particularly vexing for

scholars. During his lifetime Rothko used numerous numbering systems, which cause some confusion when tracing the exhibition history and provenance of his paintings. He exhibited this work variously as *No. 7* (at Parsons in 1949), *No. 7A* (at the Whitney Museum of American Art in 1950), *Bild No. 7A* (at the Rathaus Schonberg, Berlin, in 1951), *No. 5* (at the Museum of Modern Art, New York, in 1961), and *Untitled* (at the Los Angeles County Museum of Art in 1964). As *Untitled* was the last designation used before his death in 1970, it seems likely that Rothko had settled on this title for the work. The full exhibition history, with the painting's various titles, is listed in David Anfam, *Mark Rothko: The Works on Canvas, Catalogue Raisonné* (New Haven: Yale University Press, 1998), 300–301; for a discussion of Rothko's competing numbering and titling systems, see 19–21 in the same volume.

4. Dore Ashton, *About Rothko* (New York: Oxford University Press, 1983), 92–95. When Still moved briefly to New York in 1945, Rothko introduced him to Peggy Guggenheim and wrote the catalogue essay for Still's first one-person show, which opened at her gallery Art of This Century in February 1946. In addition, Rothko's first large-scale museum exhibition, *Oils and Watercolors by Mark Rothko* (13 August–8 September 1946), was organized by the San Francisco Museum of Art (now the San Francisco Museum of Modern Art). Karen Tsujimoto, *Mark Rothko: 1949* (San Francisco: San Francisco Museum of Modern Art, 1983), 7–8.

5. Ashton, *About Rothko*, 95.

6. Peter Selz, *Mark Rothko* (New York: The Museum of Modern Art, 1961), 43. The painting is listed with an incorrect date as *No. 5, 1948*.

7. Rothko's leftist political sensibilities led him to be active in the Artist's Union during its fight against censorship, which was occasioned by the destruction of Diego Rivera's Rockefeller Center murals in 1934, but his concerns for social justice did not lead him to accept Social Realism. His work remained tied to the more progressive interest in expression. Ashton, *About Rothko*, 31–32.

8. Rothko first enrolled in George Bridgman's anatomy course and a sketching class in January 1924. In 1925 he enrolled in Weber's still-life and life-sketching classes. Ibid., 11. He began the subway series in 1937.

9. Rothko wrote: "Even the archaic artist, who had an uncanny virtuosity, found it necessary to create a group of intermediaries, monsters, hybrids, gods, and demigods. The difference is that, since the archaic artist was living in a more practical society than ours, the urgency for transcendent experience was understood, and given an official status." Quoted in Harrison and Wood, *Art in Theory, 1900–1990*, 564. The statement was originally published in the single-issue journal *Possibilities* (New York, 1947).

10. Quoted in Harrison and Wood, *Art in Theory, 1900–1990*, 563. The statement was originally published in the *New York Times*, 13 June 1943.

11. Robert Rosenblum, *Mark Rothko: Notes on Rothko's Surrealist Years* (New York: Pace Gallery, 1981), 9.

12. Robert Rosenblum writes of this period in Rothko's life: "to live in New York at that time was a strange amalgam of the mythical and the contemporary. The daily chronicle of evil reported in newspapers and on the radio, the living presence in the United States of growing numbers of refugees from hell were ample testimony to the actuality of the Nazis, of the war, of the atom bomb; yet the remoteness and monstrosity of these events in Europe and the Pacific could also give them an unreal, almost symbolic character that only an eye-witness observer could force into contemporary fact." Ibid., 6–7.

13. Quoted in Harrison and Wood, *Art in Theory, 1900–1990*, 563. The

statement was originally published in the single-issue journal *Possibilities* (New York, 1947).

14. Rothko's *Untitled* (1947) (Anfam, *Catalogue Raisonné*, no. 362) is a translation of Bonnard's *Interior at Cannet* (1938) into the language of multiforms; see Rose, *Rothko, A Painter's Progress*, 18–19. Rose goes on to examine the equally important lessons from Henri Matisse that Rothko incorporated into *No. 21* (1949), his similarly radical translation of Matisse's *The Red Studio* (1911, The Museum of Modern Art, New York) into the language of multiforms. Ibid., 21.

15. Anna C. Chave argues the opposite position, maintaining throughout her monograph on Rothko that his abstractions are rooted in specific representations. See her *Mark Rothko: Subjects in Abstraction* (New Haven: Yale University Press, 1989). My position is similar to that expressed by David Anfam, who argues that readings debating "whether figurative substrata populate the imagery of 1947–48 . . . tend to privilege prototypes over process." Anfam, *Catalogue Raisonné*, 59.

16. Selz, *Mark Rothko*, 9.

17. Quoted in Harrison and Wood, *Art in Theory, 1900–1990*, 563.

18. Selz, *Mark Rothko*, 10.

100. ROBERT MOTHERWELL, *At Five in the Afternoon*

1. Rafael Alberti, with illuminations by Robert Motherwell, *El Negro* (Mount Kisco, N.Y.: Tyler Graphics Ltd., 1983), 7.

2. Davis S. Rubin, *Black and White Are Colors: Paintings of the 1950s–1970s* (Claremont, Calif.: Pomona College, 1979), 31.

3. Barbara Haskell, *The American Century: Art and Culture 1900–1950* (New York: Whitney Museum of American Art, 1999), xx. There is some discrepancy in the record due to Motherwell's statements and Kynaston McShine's chronology in the catalogue for Motherwell's 1965 retrospective at the Museum of Modern Art, New York, where she records that *Granada* was the artist's first large-scale Spanish *Elegy*, painted in December 1948 and January 1949; Frank O'Hara, *Robert Motherwell* (New York: The Museum of Modern Art, 1965), 79. However, this would date *Granada* before Motherwell's small oil sketch titled *At Five in the Afternoon* (1949), which Motherwell identified as the first of his *Elegy* paintings. He experienced extreme grief when he lost that oil sketch in his 1971 divorce settlement with Helen Frankenthaler, which prompted him to paint a faithful (although larger) copy before giving it up. Motherwell said in a 1977 interview that he almost always retains the first version of a painting as "a lighthouse to return to if I get lost, a way to get back to the original impulse." Quoted in Jonathan Fineberg, "Death and Maternal Love: Psychological Speculations on Robert Motherwell's Art," *Artforum* (September 1978): 55. Motherwell is also quoted: "After I'd made Helen's (*At Five in the Afternoon*) I liked it so much better than Harold's [the illustration for Rosenberg's poem], I thought I'd 'make it even bigger.'" Quoted in E. A. Carmean Jr., "Robert Motherwell: The Elegies to the Spanish Republic," in Carmean and Eliza E. Rathbone, with Thomas B. Hess, *American Art at Mid-Century: The Subjects of the Artist* (Washington, D.C.: National Gallery of Art, 1978), 99. This comment clearly places the painting of *Granada* after the oil sketch titled *At Five in the Afternoon* (1949). It also appears that the first exhibition of *Granada* was in Kootz Gallery's *Black or White* exhibition of 1950. And finally, the two paintings entitled *At Five in the Afternoon* from 1949 and 1950 more closely approximate the compositional structure of each other than either does *Granada*. In spite of the attributed dates, it seems reasonable to assume that both the larger *At Five in the Afternoon* (1950, oil on masonite) and *Granada* (1949, oil on

paper) were painted at approximately the same time as the first two works of scale in the series known as *Elegy to the Spanish Republic*.

4. Stephen Polcari, *Abstract Expressionism and the Modern Experience* (Cambridge, U.K.: Cambridge University Press, 1991), 313.

5. Other equally important series in paint or collage include *Opens, Je t'aime, A la pintura, Iberia, Night Music, Lyric Suite*, and *Beside the Sea*.

6. Mary Ann Caws, *Robert Motherwell with Pen and Brush* (London: Reaktion Books, 2003), 147.

7. The first and only issue of *Possibilities (An Occasional Review)* was published in 1947 by Wittenborn and Schultz. See Carmean and Rathbone, *American Art at Mid-Century*, 95.

8. Motherwell noted: "Abstract expressionism should *never* have been coined—better 'abstract automatism.'" Quoted in *The Collected Writings of Robert Motherwell*, ed. Stephanie Terenzio (New York: Oxford University Press, 1992), 147.

9. Ibid., 4–5.

10. Interview with Robert Motherwell, in Mary Ann Caws, *Robert Motherwell: What Art Holds* (New York: Columbia University Press, 1996), 197.

11. Terenzio, *Collected Writings*, 182. Other works include *The Spanish Poet (José de Espronceda, 1808–42)* (1976), *Kafka's Room* (1944), his illustrations for Robert Desnos, *The Night of Loveless Nights* (1930), *Portrait of André Breton* (1979), *In Plato's Cave No. 1* (1972), *Tree of My Window (Robert Frost)* (1969), *Bloomsday* (1981–82), *James Joyce* (1979), and *Finnegans Wake VII, with Green* (1974). Motherwell also paid homage to modern musicians in *Monster (for Charles Ives)* (1959) and *Bust of Stravinsky* (ca. 1975).

12. Carmean and Rathbone, *American Art at Mid-Century*, 98.

13. Caws, *Robert Motherwell with Pen and Brush*, 148.

14. Quoted in Polcari, *Abstract Expressionism*, 315.

15. Motherwell's intellectual debt to Kierkegaard led him to paint his major canvas *Either/Or (for Kierkegaard)* (1990–91) in homage to the existential philosopher. The painting is owned by Knoedler and Company, New York. For a discussion of Motherwell and Kierkegaard, see Caws, *Robert Motherwell: What Art Holds*, 3–7.

16. Carmean and Rathbone, *American Art at Mid-Century*, 99.

17. Even Mark Rothko, known for his use of luminous and translucent color, experimented with black in his later works and most famously in his murals for the Rothko Chapel (1965) in Houston, Texas.

101. RICHARD DIEBENKORN, *Berkeley No. 3*

1. Jane Livingston, "The Art of Richard Diebenkorn," in Livingston, John Elderfield, and Ruth E. Fine, *The Art of Richard Diebenkorn* (New York: Whitney Museum of American Art, in association with University of California Press, 1997), 18. Although he significantly enriched the evolution of modernism, Diebenkorn declared, "I'm really a traditional painter, not avant-garde at all. I wanted to follow a tradition and extend it." See Maurice Tuchman, "Diebenkorn's Early Years," in Robert T. Buck, Linda L. Cathart, Gerald Nordland, and Tuchman, *Richard Diebenkorn: Paintings and Drawings, 1943–1976* (Buffalo, N.Y.: Albright-Knox Art Gallery, 1976), 13.

2. Quoted in Gerald Nordland, *Richard Diebenkorn* (New York: Rizzoli, 1987), 87.

3. Diebenkorn recalled, "I embraced Hopper completely. . . . It was his use of light and shade and the atmosphere, . . . kind of drenched, saturated with mood, and its kind of austerity. . . . It was the kind of work that just

seemed made for me. I looked at it and it was mine." Quoted in Livingston, "The Art of Richard Diebenkorn," 21.

4. A pioneering Cézanne scholar, Loran encouraged Diebenkorn to explore the French artist's innovative use of perspective, in which objects that receded into space were rendered on the canvas as being nearly contiguous with the picture plane. Ibid., 22.

5. Tuchman, "Diebenkorn's Early Years," 6.

6. Researchers for the Richard Diebenkorn catalogue raisonné have identified fifty-six paintings in the *Berkeley* series. See Andrea Liguori, research associate, Richard Diebenkorn catalogue raisonné, to the author, 13 April 2005, in Richard Diebenkorn *Berkeley No. 3* object file, AAD/DEY/FAMSF.

7. Diebenkorn commented, "I've been content to accept the label of an Abstract-Expressionist, because I do feel a kinship with the honest search of these painters." Quoted in Nordland, *Richard Diebenkorn*, 83.

8. Diebenkorn's topographic treatment of the landscape during the Berkeley period is most legible in *Urbana No. 5 (Beachtown)* of 1953. See ibid., 59 (illus.).

9. "The aerial view showed me a rich variety of ways of treating a flat plane—like flattened mud or paint. Forms operating in shallow depth reveal a huge range of possibilities available to the painter." Quoted in ibid., 43.

10. The upper edge of *Berkeley No. 3* appears to have been a tacking margin that the artist unfolded when the canvas was restretched, perhaps after moving from Urbana to Berkeley in the fall of 1953. The painting also has dried paint drips that run in the four directions parallel to the edges of the canvas and paint that appears to have been added by the artist over and into previously existing cracks that may have been created when the painting was rolled for transport. For Diebenkorn's depiction of the mesa in Albuquerque, see Tuchman, "Diebenkorn's Early Years," 16, 23. For *Albuquerque No. 11* (1951), which Tuchman describes as incorporating the same bluff, see ibid., 17. Discussing his Albuquerque paintings Diebenkorn remarked, "The flat line of the western mesa of Albuquerque . . . influenced my work." See Nordland, *Richard Diebenkorn*, 38.

11. This type of division, rendered more explicitly, appears frequently in Diebenkorn's paintings of the late 1950s and early 1960s that depict a lower foreground porch, an intermediary field of greater activity (e.g., a landscape or townscape), and an upper register composed of water and/or sky. See, for example, *Horizon—Ocean View* (1959), *Figure on a Porch* (1959), *View from the Porch* (1959), and *Yellow Porch* (1961) in Livingston et al., *The Art of Richard Diebenkorn*, 156–159 (illus.).

12. Quoted in Tuchman, "Diebenkorn's Early Years," 12. Despite this admission, Diebenkorn generally was resistant to perceptions of landscape in his abstract expressionist works: "What I paint often seems to pertain to landscape but I try to avoid any rationalization of this either in my painting or in later thinking about it. I'm not a landscape painter (at this time, at any rate) or I would paint landscape directly." Quoted in Livingston, "The Art of Richard Diebenkorn," 46. In Albuquerque, Diebenkorn "didn't have the color blue on [his] palette because it reminded [him] too much of the spatial qualities in conventional landscapes." See Frederick Wight, "Diebenkorn, Woelffer, Mullican: A Discussion," *Artforum* 1, no. 10 (April 1963): 26. However, Diebenkorn later confided to Kathan Brown, "When I was working abstractly, everything kept reducing itself to a horizon line." See Kathan Brown, "Richard Diebenkorn (1922–1993)," *Overview: Crown Point Press Newsletter*, Spring 1993, 1.

13. Describing his interest in the Bayeux tapestry, Diebenkorn observed, "the main events are central and in flanking panels above and below, there are dead men and devils and coats of arms—therefore, three dialogues paralleling one another, horizontally." Quoted in Tuchman, "Diebenkorn's Early Years," 16.

14. Quoted in ibid., 24.

15. Like de Kooning, Diebenkorn occasionally painted abstracted letters (including his own initials) on a blank canvas as a means of commencing a painting. Ibid., 15–16. Other marks may be viewed as visual equivalents for music. Diebenkorn recalled of the Berkeley period, "In the evenings I listened to lots and lots of music, mostly Mozart. And I felt that music was feeding right into the work." Quoted in Livingston, "The Art of Richard Diebenkorn," 46. Describing the *Berkeley* series he observed, "it seemed to me that things just flowed so freely, and it was kind of . . . *improvisation*, which was exciting." Quoted in ibid., 65. For Diebenkorn's love of both classical music and jazz, see ibid., 20, 28. The free association evident in Diebenkorn's mark making also may be seen as a form of surrealist-inflected "automatic writing" inspired by Joan Miró's biomorphic forms and by George Herriman's innovative Krazy Kat comic strip, which was set in a New Mexico landscape reminiscent of the country surrounding Albuquerque. Diebenkorn bought a Krazy Kat anthology while in Albuquerque. See Tuchman, "Diebenkorn's Early Years," 15. Diebenkorn's close friend and fellow artist Elmer Bischoff remembered, "Diebenkorn was keen about Krazy Kat cartoons, cultivating a deliberate awkwardness." Quoted in Nordland, *Richard Diebenkorn*, 34, 37–38.

16. Quoted in Tuchman, "Diebenkorn's Early Years," 23.

17. For the influence of the four reproductions of de Kooning paintings that were published in *Partisan Review* in April 1948, see Nordland, *Richard Diebenkorn*, 35. In Diebenkorn's opinion, de Kooning "had it all, could outpaint anybody, at least until the mid-sixties, when he began to lose it." Quoted in Livingston, "The Art of Richard Diebenkorn," 29. For the Gorky memorial exhibition, which was on view at the San Francisco Museum of Art from 9 May to 9 July 1951, see Nordland, 43; and *Arshile Gorky Memorial Exhibition* (New York: Whitney Museum of American Art, 1951).

18. Harry Rand has written, "*Golden Brown* depicts the countryside near where Gorky lived in the last years of his life in Sherman, Connecticut. . . . The great solar disk along the right edge floats tangential to a mountain. This peak rises from the river (probably the Housatonic) that flows along the painting's lower half and in the lower center breaks into a waterfall (the Housatonic Falls). The picture's lower left depicts the river's gorge and remnants of mill buildings that had utilized the Fall's waterpower. . . . In the upper left, sitting cross-legged and wearing a persimmon-colored robe (or caftan) and a tall inverted conical hat (a Kalpak), is a bearded man beside a torch. . . . Egg-shaped and self-contained, in the upper center of the painting is a neatly bordered, high-valued cartouche. Within this ovoid, at the same scale as the man in the upper left, is a woman dancing. She wears a black dress, closely fitted at the waist; perhaps to indicate another fabric, the bodice is blue. Her arms (or a second set of breasts) are thrown upward as she bends back toward the right; her hair descends from her head in three darkly tinged shapes (two of these may be arms)." See Harry Rand, "Golden Brown," Washington University Gallery of Art website, http://galleryofart.wustl.edu/art/imgLarge/78lg.html. For Gorky's *Golden Brown*, see *Arshile Gorky Memorial Exhibition*, 47, no. 54.

19. Quoted in Tuchman, "Diebenkorn's Early Years," 12.

20. Ibid., 17.

21. Diebenkorn's paintings of abstracted livestock often include sexual organs. See ibid., 14. In *Miller 22* (1951) an abstracted cow's udders also resemble human breasts. See Livingston et al., *The Art of Richard Diebenkorn*, 121, fig. 68.

22. Quoted in Nordland, *Richard Diebenkorn*, 38.

23. Quoted in Paul Mills, *Contemporary Bay Area Figurative Painting* (Oakland, Calif.: The Oakland Museum, 1957), 12.

102. RICHARD DIEBENKORN, *Ocean Park 116*

1. Researchers for the Richard Diebenkorn catalogue raisonné have identified approximately 143 paintings in the *Ocean Park* series. Diebenkorn may have created another eighteen paintings that were reworked or destroyed. See Andrea Liguouri, research associate, Richard Diebenkorn catalogue raisonné, to the author, 23 May 2005, in Richard Diebenkorn *Ocean Park 116* object file, AAD/DEY/FAMSF.

2. Quoted in Gerald Nordland, *Richard Diebenkorn* (New York: Rizzoli, 1987), 88.

3. Jane Livingston, "The Art of Richard Diebenkorn," in Livingston, John Elderfield, and Ruth E. Fine, *The Art of Richard Diebenkorn* (New York: Whitney Museum of American Art, in association with University of California Press, 1997), 58–59.

4. See Nordland, *Richard Diebenkorn*, 140; and Livingston, "The Art of Richard Diebenkorn," 60.

5. Quoted in Livingston, "The Art of Richard Diebenkorn," 65. Diebenkorn's interest in Cézanne was fostered while studying at Berkeley (1943–44) with the pioneering scholar Erle Loran. See Livingston, "The Art of Richard Diebenkorn," 22. From February to May 1978 Diebenkorn stayed in Aups, near Aix-en-Provence, where he created seventeen works on paper. The proximity of Cézanne's favored subjects may have loomed large, as Diebenkorn later reworked these drawings, claiming they were "too French." See ibid., 75.

6. See Jack Flam, *Richard Diebenkorn: Ocean Park* (New York: Rizzoli, 1992), 28–29.

7. Livingston, "The Art of Richard Diebenkorn," 75.

8. Diebenkorn's description of his strong emotional response to the works of Edward Hopper while at Stanford (1940–43) might equally be applied to the *Ocean Park* paintings: "I embraced Hopper completely. . . . It was his use of light and shade and the atmosphere, . . . kind of drenched, saturated with mood, and its kind of austerity. . . . It was the kind of work that just seemed made for me. I looked at it and it was mine." See Livingston, "The Art of Richard Diebenkorn," 21.

9. Flam, *Richard Diebenkorn: Ocean Park*, 21.

10. Livingston, "The Art of Richard Diebenkorn," 21.

11. Ibid., 23 (illus.). Diebenkorn also viewed Matisse's *Interior, Nice* (1918) in the Philadelphia Museum of Art and *Blue Window* (1913) in Museum of Modern Art, New York. See ibid., 23–24. Diebenkorn also saw numerous works by Matisse at a retrospective at the Los Angeles Municipal Gallery in 1952 and during a trip to the Soviet Union in 1964. For Diebenkorn's response to the Matisse retrospective, see ibid., 39. The planar, geometric background of Matisse's *Zorah on the Terrace* (1912), which Diebenkorn viewed at the Pushkin Museum in Moscow, may have provided a pictorial precedent for the *Ocean Park* series. See ibid., 57–58 (illus.).

12. Livingston, "The Art of Richard Diebenkorn," 63–64, 67 (illus.).

13. Diebenkorn recalled, "During the '50s, abstract painting was a religion, and it didn't admit any backsliding to representational imagery." Quoted in John Gruen, "Richard Diebenkorn: The Idea Is to Get Everything Right," *Artnews* 85 (November 1986): 85.

14. Nordland, *Richard Diebenkorn*, 199.

15. Describing his working process, Diebenkorn observed, "[A painting] came about by putting down what I felt in terms of some overall image at the moment today, and perhaps being terribly disappointed with it tomorrow, and trying to make it better and then despairing and destroying partially or wholly and getting back into it and just kind of frantically trying to pull something into this rectangle which made some sense to me." Quoted in ibid., 47.

16. Adam Gopnik, "The Art World: Diebenkorn Redux," *New Yorker*, 24 May 1993, 100.

17. Quoted in Nordland, *Richard Diebenkorn*, 26.

18. Jack Flam offers a slightly different perspective, writing, "Indeed, although the Ocean Park paintings may seem at first to have nothing at all to do with images such as Leonardo's celebrated *Study of Human Proportion in the Manner of Vitruvius*, Diebenkorn's ambitions are in many ways remarkably similar. In Diebenkorn's earlier abstractions, 'gross matter' was constantly implicit; in the representational works of 1955–1967 it had become explicit. Eventually too explicit. The Ocean Park paintings represent an important break with Diebenkorn's earlier work by the very extremeness of the ways in which they both impose an abstract order on, and distance themselves from, the material world." See Flam, *Richard Diebenkorn: Ocean Park*, 27.

19. Quoted in Livingston, "The Art of Richard Diebenkorn," 64.

20. Quoted in Gruen, "Richard Diebenkorn: The Idea," 82.

103. DAVID SMITH, *Ovals on Stilts*

1. Smith, writing about his job in the assembly department of the Studebaker Automotive plant. quoted in Rachel Kirby, "Biography," in *David Smith: Sculpture and Drawings*, ed. Jörn Merket (Munich: Prestel, 1986), 10.

2. Explaining Abstract Expressionism in 1946, Robert Motherwell wrote: "Like the cubists before them, the abstractionists felt a beautiful thing in perceiving how the medium can, of its own accord, carry one into the unknown, that is to the discovery of new structures. What an inspiration the medium is!" Quoted in E. A. Carmean Jr., *The Collages of Robert Motherwell* (Houston: Museum of Fine Arts, 1972), 91.

3. The logical corollary to such a belief became a rhetorical tool during the cold war. Through its associations with liberation, freedom, and the autonomous individual, Abstract Expressionism could be made to serve as a foil to collectivist ideologies, which were perceived as repressive and totalitarian. Ann Eden Gibson, *Abstract Expressionism: Other Politics* (New Haven: Yale University Press, 1997), 15–17. In another essay, Gibson writes even more explicitly that in *Hero* (1951) Smith created a sculptural self-portrait that identified his own artistic life with the mythic ideology of the heroic. Ann Gibson, "The Rhetoric of Abstract Expressionism," in *Abstract Expressionism: The Critical Developments*, ed. Michael Auping (New York: Harry N. Abrams, 1987), 71.

4. Quoted in *David Smith by David Smith: Sculpture and Writings*, ed. Cleve Gray (New York: Holt, Rinehart, and Winston, 1968), 34.

5. Robert Taplin, "David Smith: Toward Volume," *Art in America* (April 2002): 120. See also Carmean, *The Collages of Robert Motherwell*, 27.

6. Quoted in Gray, *David Smith by David Smith*, 106.

7. Smith said of Maltuka in autobiographical notes: "Maltuka was a guy I'd rather give more credit than anyone else." Smith was also introduced to European Surrealists, especially Julio González, through the Russian immigrant artist John Graham at Bolton Landing, New York, in 1929. See ibid., 24–25.

8. Maxwell L. Anderson, *Whitney: American Visionaries: Selections from the Whitney Museum of American Art* (New York: Whitney Museum of American Art, 2001), 288. A number of these photo collages were reproduced in Joan Pachner and Rosalind E. Krauss, *David Smith: Photographs, 1931–1965* (New York: Matthew Marks Gallery; San Francisco: Fraenkel Gallery, 1998), figs. 28–42.

9. In 1957 the Museum of Modern Art, New York, gave Smith his first major retrospective. In 1958 he represented the United States at the 29th Venice Biennale, and in 1959 his work was included in the 5th Bienal de São Paulo and Documenta II. In 1959 Anthony Caro visited Smith's studio, Terminal Iron Works, in Bolton Landing, New York, an event that is credited with dramatically altering the course of British sculpture. Kirby, "Biography," 15.

10. Hilton Kramer, "Stencils for Sculpture," *Art in America* (Winter 1962): 42.

11. Smith referred to them as "think pieces" or "starting-off points," and the most direct relationships are evident in his *Cubi* series from this same period. See Carmean, *The Collages of Robert Motherwell*, 25.

12. These titles include *Suspended Figure* (1935), *Table Torso* (1942), *The Rape* (1945), *Jurassic Bird* (1945), *Royal Bird* (1948), *Eagle's Lair* (1948), *Aftermath Figure* (1945), *Canopic Head* (1951), *Australia* (1951), *Hero* (1951–52), *Reclining Figure* (1953), *Raven II* (1955), and *Running Daughter* (1956–60).

13. Rosalind E. Krauss, *Terminal Iron Works: The Sculpture of David Smith* (Cambridge, Mass.: MIT Press, 1971), 98.

14. Ibid., 99.

15. Carmean, *The Collages of Robert Motherwell*, 19.

16. Kirby, "Biography," 13.

17. Smith's leftist politics can be seen in his work as early as his famous set of stridently antiwar medals in bronze called *Medals for Dishonor* (1939–40).

18. Quoted in Gray, *David Smith by David Smith*, 61.

19. Ibid., 39.

104. DAVID PARK, *Couple*

1. See Paul Mills, *The New Figurative Art of David Park* (Santa Barbara, Calif.: Capra Press, 1988), 34.

2. *Kids on Bikes* was exhibited at the San Francisco Art Association Annual in 1951 and won a major award. See Caroline A. Jones, *Bay Area Figurative Art, 1950–1965* (San Francisco: San Francisco Museum of Modern Art; Berkeley and Los Angeles: University of California Press, 1990), 12–16. Park's conversion had a catalytic effect on several leaders of the San Francisco school of Abstract Expressionism, including Elmer Bischoff, who turned to figuration in 1952, and Richard Diebenkorn, who began to incorporate overtly representational imagery in 1955.

3. This polarized view may be attributed in part to the charged political and cultural climate of the cold war era, in which New York critics proclaimed and promoted the regional New York school of Abstract Expressionism as a national style that represented "the main premises of Western art." See Clement Greenberg, "The Decline of Cubism," *Partisan Review* (March 1948), in *Clement Greenberg: The Collected Essays and Criticism*, ed. John O'Brian (Chicago: University of Chicago Press, 1986), 2:215. In the context of resurgent political and cultural nationalism in the 1950s, figurative art was widely condemned as a reactionary betrayal of Abstract Expressionism and was cited as proof of provincialism among its Bay Area adherents.

4. Mills, *New Figurative Art*, 36. Park recalled, "I was concerned with big abstract ideas like vitality, energy, profundity, warmth. They became my gods. They still are. I disciplined myself rigidly to work in ways I hoped might symbolize these ideals. I still hold these ideals today, but I realize that those paintings never, even vaguely, approximated any achievement of my aims. Quite the opposite; what the paintings told me was that I was a hard-working guy who was trying to be important." See ibid., 35, 111. Park also observed, "Art ought to be a troublesome thing, and one of my reasons for painting representationally is that it makes for much more troublesome pictures." See ibid., 30.

5. See Susan Landauer, *The San Francisco School of Abstract Expressionism* (Laguna Beach, Calif.: Laguna Beach Art Museum; Berkeley and Los Angeles: University of California Press, 1996); and Jones, *Bay Area Figurative Art*.

6. David Park, in *David Park* (San Francisco: M. H. de Young Memorial Museum, 1959), quoted in Mills, *New Figurative Art*, 34.

7. Richard Armstrong, *David Park* (New York: Whitney Museum of American Art, in association with University of California Press, 1988), 14.

8. Park's tenure at the California School of Fine Arts (now the San Francisco Art Institute) coincided with a period in which the dynamic director, Douglas MacAgy, hired such prominent artists as Clyfford Still, Mark Rothko, and Ad Reinhardt as well as younger artists like Diebenkorn and Bischoff.

9. Diebenkorn observed of Park's early figurative work, "There had to be a rationalization for the presence of the figure. The earlier bathers had to be doing something. They would be romping, playing ball, drying themselves with a towel; it was a kind of reason for the bather. At one point he was able to throw this off and his figures began to simply exist on the canvas. After the transition, the towel became much less important and the rationalization disappeared." Quoted in Mills, *New Figurative Art*, 99.

10. Ibid., 72–73.

11. Matisse's *Femme au chapeau* is now in the permanent collection of the San Francisco Museum of Modern Art.

12. Richard Diebenkorn, "David Park," in *David Park, 1911–1960: Paintings, Drawings, and Watercolors* (New York: Salander-O'Reilly Galleries, 1987), n.p.

13. For Park's *Encounter* (1945), see Mills, *New Figurative Art*, 44, fig. 19.

14. For Park's *Bathers on the Beach* (1957), see *David Park, 1911–1960*, pl. 7. For *Two Female Figures* (1957), see Mills, *New Figurative Art*, 68, pl. 82.

105. MEL RAMOS, *Superman*

1. Ramos does not perceive a meaningful distinction between popular culture and high art: "To me it's all the same. It all has to do with the media, whether drawing upon mass media or just some kind of an ocean that exists in the history of art." Quoted in Thomas Levy, ed., with contributions by Belinda Grace Gardner, *Mel Ramos: Heroines, Goddesses, Beauty Queens* (Bielefeld: Kerber Verlag, 2002), 216.

2. For Thiebaud's influence on Ramos, see Dan Tooker, "Mel Ramos: Interviewed by Dan Tooker," *Art International* 17, no. 9 (November 1973): 24. Ramos traveled with Thiebaud to New York several times to look at art and to find galleries that might exhibit his work. See Robert Rosenblum, *Mel Ramos* (Cologne: Taschen, 1997), 6, 8.

3. Mel Ramos, *Mel Ramos: Watercolors* (Berkeley: Lancaster-Miller Publishers, 1979), 6.

4. Quoted in Elizabeth Claridge, *The Girls of Mel Ramos* (Chicago: Playboy Press, 1975), 15.

5. Quoted in Levy, *Heroines, Goddesses, Beauty Queens*, 198. Ramos added, "To reveal, but not to criticize. Criticism has a negative implication. My paintings are not done for that purpose. Not to justify either—just to reveal, to expose." See ibid., 202.

6. Claridge, *The Girls of Mel Ramos*, 47.

7. Quoted in Levy, *Heroines, Goddesses, Beauty Queens*, 173.

8. Rejecting the realist label, Ramos declared: "I'm not interested in direct realism, empirical realism. I'm not interested in empiricism in any way. There's no question that you can tell whether a painting is painted from life or painted from a photograph. I'm not sure that it makes any difference. It's the end result that matters, and my end result is like my attitude toward most of the stuff I see around me—all is kind of artificial." Quoted in Tooker, "Ramos: Interviewed by Tooker," 25.

9. See DC/National Comics Publications, cover of *Superman*, no. 147 (August 1961).

10. Qualifying his classification as a Pop artist, Ramos observed: 'I'm just more of an Expressionist. I believe in the artist's hand—traces of the artist's hand have to be in the work." See Levy, *Heroines, Goddesses, Beauty Queens*, 245.

11. Ramos notes, "I have a deep interest in art history and it is the overwhelming motivation in my work." See Rosenblum, *Ramos*, 66.

12. Relating his interest in Velázquez to his paintings of comic book superheroes, Ramos recalled: "When I saw Velasquez's work for the first time in Madrid in 1960 I really learnt something about the right scale for the human figure. This scale is slightly smaller than life for the simple reason that if you make a figure exactly life-size it looks larger. It was very important to me that the costumed heroes should be on a human scale so that they would be believable, so that they should have life aside from what they were in comic books." Quoted in Claridge, *The Girls of Mel Ramos*, 28. Ramos has since stated that he first went to Europe in 1963, not 1960. Mel Ramos to the author, 19 July 2004, Mel Ramos *Superman* object file, AAD/DEY/FAMSF.

13. See Claridge, *The Girls of Mel Ramos*, 17.

14. Ramos, *Watercolors*, 5–6.

15. Ibid., 6.

16. Barbara Rose, "Dada Then and Now," *Art International* 7, no. 1 (25 January 1963): 24.

17. Superman's frozen pose is even more startling when compared with Ramos's *Man of Steel* (1962), in which Superman bursts through a steel plate and rushes toward the viewer. See Levy, *Heroines, Goddesses, Beauty Queens*, 176.

106. STUART DAVIS, *Night Life*

1. In 1941 Davis wrote: "The validity of a work of art stands in no direct proportionate relationship whatever to the cogency of its ideological content, and vice versa. If any care to call this viewpoint, 'art for Art's sake,' let them make the most of it. I call it art for society's sake. A society which cannot afford such an art is poor indeed." See Stuart Davis, "Abstract Art in the American Scene" (1941), quoted in *Stuart Davis: Documentary Monographs in Modern Art*, ed. Diane Kelder (New York: Praeger Publishers, 1971), 126.

2. Stuart Davis, "The Cube Root," *Art News* 41 (1 February 1943): 34.

3. Davis's mother, Helen Stuart Foulke Davis, was a sculptor, and Edward Wyatt Davis, his father, was an art editor for the *Philadelphia Press* who commissioned illustrations from John Sloan, William Glackens, George Luks, and Everett Shinn. See Karen Wilkin, *Stuart Davis* (New York: Abbeville Press, 1987), 14.

4. Quoted in ibid., 55.

5. "Davis, who is (to quote some Newarkians) SOME player of ragtime, admitted without hesitation that here was a master of syncopation. 'Listen to that, will you?' he enthused. 'Do you get that bass—SOME bass, believe me.' His enthusiasm reached the 'nth degree when he announced: 'And look how many times he changes his key! Four times in one chorus!'" See Emanuel Lewis, "Night Life in Newark," *New York Sunday Call*, 30 May 1915, magazine sec., clipping in the Stuart Davis Papers, AAA/SI, microfilm reel N584, frame 100.

6. For Davis's early love of jazz, see Stuart Davis, "Autobiography" (1945), quoted in Kelder, *Davis*, 21–22. Davis noted, "But the Spartan effort is always well repaid by the musicianship of such men as James P. Johnson, Pete Johnson, Vic Dickerson, Max Kaminsky, Frankie Newton, and a great many others. At one time or another, in darker mood, I have questioned the possibility of cultural advance in the United States, but on the evidence here presented I guess I must have been wrong."

7. See Patricia Hills, *Stuart Davis* (New York: Harry N. Abrams; Washington, D.C.: Smithsonian Institution, 1996), 8 (illus.) and 35 (illus.).

8. James Johnson Sweeney, *Stuart Davis* (New York: The Museum of Modern Art, 1945), 20.

9. Stuart Davis to John Hammond, 1940, quoted in Hills, *Davis*, 127.

10. Stuart Davis, "Memo on Mondrian" (1961), quoted in Kelder, *Davis*, 186. Davis noted that the jazz musicians were hired by the jazz impresario John Hammond and the *New Yorker* cartoonist Bill Steig. See Davis, "Autobiography" (1945), quoted in ibid., 28.

11. Quoted in John Lucas, "The Fine Art Jive of Stuart Davis," *Arts* 31 (September 1957): 33.

12. For the influence of Mondrian's *Broadway Boogie Woogie* on Davis's work, see John R. Lane, *Stuart Davis: Art and Art Theory* (Brooklyn: The Brooklyn Museum, 1978), 51–53. Wilkin, *Davis*, 216–217, notes that Matisse's *Jazz* portfolio was exhibited in Philadelphia and New York in 1948, while his *papiers collés* were included in exhibitions at the Pierre Matisse Gallery (1949) and the Museum of Modern Art (1951–52) in New York.

13. "Art: Blaring Harmony," *Time*, 18 May 1962, 67.

14. A similar figure in profile appears in Davis's *Rapt at Rappaport's* (1952, Hirshhorn Museum and Sculpture Garden, Washington, D.C.). See Hills, *Davis*, 132 (illus.). Although the African American pianist's face is stylized, it is not caricatured. Indeed, Davis publicly criticized Thomas Hart Benton's caricatures of African Americans, writing, "Are the gross caricatures of Negroes by Benton to be passed off as 'direct representation'? The only thing they directly represent is a third-rate vaudeville character cliché with the humor omitted. Had they a little more wit, they would automatically take their place in the body of propaganda which is constantly

being utilized to disenfranchise the Negro politically, socially, and economically." See Stuart Davis, "The New York American Scene in Art" (1935), quoted in Kelder, *Davis*, 152.

15. See Lane, *Davis: Art and Art Theory*, 51. These same motifs are included in Davis's *G & W* (1944), revealing the artist's fondness for reinterpreting his own works.

16. Ibid., 51–53.

17. For the possible influence of paintings by Picasso that explored the theme of the artist in the studio, see ibid., 29.

18. The newspaper clipping was rediscovered in Davis's papers by Ani Boyajian, editor of the Stuart Davis catalogue raisonné. See Boyajian to Daniell Cornell, 21 January 2003, Stuart Davis *Night Life* object file, AAA/DEY/FAMSF.

19. Rudi Blesh, *Stuart Davis* (New York: Grove Press, 1960), 61–62.

107. JESS, *If All The World Were Paper And All The Water Sink*

1. Arguing for the redemption of the commonplace image, Jess observed, "Our story as a human species is told with forgotten or neglected or scorned images of great sentiment, as well as the art of museums. The full story cannot be told in museums. The museum filters out a lot of the humor and the grotesque in the imaginative sense. That's much of what we're about." Quoted in Michael Auping, "Jess: A Grand Collage," in Auping, Robert J. Berthold, and Michael Palmer, *Jess: A Grand Collage* (Buffalo, N.Y.: Albright-Knox Art Gallery, 1993), 32.

2. Rebecca Solnit, *Secret Exhibition: Six California Artists of the Cold War Era* (San Francisco: City Lights Books, 1990), 31.

3. Michael Auping, "An Interview with Jess," in Auping, Berthold, and Palmer, *A Grand Collage*, 19; see also Solnit, *Secret Exhibition*, 31. Jess later recalled, "Art became an antidote to the scientific method. Even though I learned a great deal from my involvement with science, that type of objective thinking was not for me . . . the real truth—if there is such a thing— that you can learn from science is how little we know about reality. Art seemed to address this more openly. To me, art could be a very inwardly directed thing—which may be where science is going anyway—and that appealed to me. At the time I was very involved with nuclear energy, the direction it was going seemed questionable, nightmarish in many ways." Quoted in Auping, "A Grand Collage," 33. Jess's break with his problematic past was paralleled by a break from his conservative family, and he dropped his surname in favor of the eponymous "Jess." Solnit, *Secret Exhibition*, 30.

4. Although he was a favorite student of the Abstract Expressionist Clyfford Still, from whom he learned the "poetics of material," Jess "didn't see any reason to create a dichotomy between abstraction and representation." Auping, "Interview," 20, 24. Jess also rejected the prevailing call to cast off the artistic and literary traditions of Europe in order to create a distinctly American school of art.

5. Auping, "A Grand Collage," 48. Jess observed of his collage technique, "Collage was a way of coming to terms with getting a network of images, times, and spaces and freeze-framing them a bit." Ibid., 47. Jess also observed, "I see landscape, particularly in the early work, as a matrix for the imagination." Quoted in Auping, "Interview," 23.

6. Auping, "A Grand Collage," 46.

7. Auping, Berthold, and Palmer, *A Grand Collage*, 219 (illus.).

8. The *New York Times* science reporter William L. Laurence wrote, "One felt as though he had been privileged to witness the birth of the world—to be present at the moment of Creation when the Lord said: 'Let there be light.'" Stephane Groueff, *Manhattan Project: The Untold Story of the Making of the Atomic Bomb* (Boston: Little, Brown & Co., 1967), 355.

9. A brown butterfly wing with yellow and ivory spots appears to be grafted to the upper edge of the owl's wing. The extraordinary life cycle of the butterfly, in which a caterpillar becomes a chrysalis and then is transformed into a beautiful butterfly, is an ancient metaphor for the transformation of earthbound humans into immortal souls that ascend heavenward. For this reason, the Greeks used the same word—*psyche*—for both the butterfly and the soul. Jess may have viewed the ugly chrysalis state of the Little Boy and Fat Man atomic bombs and their spectacular airborne release/detonation as a perversion of the natural butterfly life cycle. Jess's partner, Robert Duncan, described the butterfly as "an emblem of the soul and of unconscious attention towards the light," but he also introduced a cautionary note regarding "the scientist-collector who wreaks havoc with the light through his tampering." Auping, "A Grand Collage," 60–61. The butterfly collector as a metaphor of the human aspiration for knowledge—and its unintended consequences—appears in Jess's *Will Wonders Never Cease: Translation #21* (1969); Auping, Berthold, and Palmer, *A Grand Collage*, 162–163 (illus.). Duncan noted that this theme has an ancient precedent in the myth of Icarus, who perishes when he flies too close to the sun and his wax wings melt; see Jess's *The Lament for Icarus: Translation #25* (1970) in Auping, "A Grand Collage," 60–61, and Auping, Berthold, and Palmer, *A Grand Collage*, 170–171 (illus.). It is possible to discern a similarly large horizontal wing at the upper left of *If All The World Were Paper And All The Water Sink*, and to see the central mushroom cloud as a head with streaming hair, as if Icarus has been depicted at the moment of his solar incineration.

10. The metaphor of the insatiable human desire for knowledge is echoed in the story in which Psyche is sent to retrieve a box of beauty from Persephone, queen of the underworld. Psyche obtains the box but, despite warnings that she cannot view immortal beauty, opens the box and dies. A key is the central symbol in George MacDonald's fairy tale *The Golden Key* (1867), in which the gold key unlocks the door to spiritual enlightenment and eternity. Jess and Duncan referred to the early 1950s as their "MacDonald period," and Jess's *The Forest of the Golden Key* (1958) was inspired by MacDonald's tale. Auping, "A Grand Collage," 41, 43. The key also appears in the Apocalypse, in which Christ holds "the keys of hell and of death" (Rev. 1:18). William L. Laurence used the key metaphor in the title of an article in which he wrote, "For atomic energy brings within sight the realization of the dream of the ages. He now has within his grasp a philosophers' stone that will not only transmute the elements and create wealth far greater in value than gold but will also provide him with the means for gaining a far deeper insight into the mysteries of living processes, leading to the postponement of old age and the prolongation of life." Laurence, "Is Atomic Energy the Key to Our Dreams?" *Saturday Evening Post*, 13 April 1946, 9–10, 36–37, 39, and 41.

11. Jess referred to such circle dances as a form of sun worship and engagement with the universe. Auping, "A Grand Collage," 46. The inclusion of children in this collagelike, "flux-image" composition recalls Jess's comment that "utilizing the image of the child can sometimes help me evoke that plane, that wondrous ability to infinitely connect images and stories without having to segregate everything." Ibid. The nuclear fallout, some of which is depicted as a circle within a square, may reference the ancient math conundrum of "squaring the circle," a theoretically impossible problem that became a metaphor for the futility of rational thought.

12. Robert Duncan, "Often I Am Permitted to Return to a Meadow," in *The Opening of the Field* (New York: Grove Press, 1960), 7. For a later example of the dancing children motif, see *Emblem #10* in John Yau, *Jess: Emblems for Robert Duncan* (San Jose, Calif.: San Jose Museum of Art, 1990), n.p.

13. This hidden meaning was referenced in a modern version of the rhyme popular in the late 1940s: "Ring-a-ring-o'-geranium, / A pocket full of uranium, / Hiro, shima, all fall down!"

14. Tanks equipped with flamethrowers were employed during World War II, especially against the Japanese entrenched on the Pacific islands of Iwo Jima and Okinawa. The flame-throwing tank and the atomic bomb both introduce the idea of death-dealing via technology, which isolates the perpetrators from their victims. In an analysis of Jess's painting *Ex. 4—Trinity's Trine: Translation # 5* (1964), whose title alludes to the first atomic bomb test—Trinity—and thus to the theme of playing god, Robert Duncan referred to the effects of the atomic bomb: "The nightmare gravity that colors Jess's canvases and unites his vision with that of the early de Chirico and Max Ernst's hallucinatory collages and paintings has not only its roots in the nightmare gravity that we all know in our childhood vision of the world but also it has its bitter root in the actuality of the grown-up nightmare which the workers in chemistry and physics have brooded in our time. Xibalba, the land of violent death, whose Lords cause bleeding in the road, vomiting of blood, running of pus from open sores, the terrors of revolution and of war, has been known by the artist not only in dreams but in actuality." Duncan, *Translations by Jess* (New York: Odyssia Gallery, 1971), viii.

15. Jess appropriated the image of Bob Mathias from a magazine photograph. Auping, "A Grand Collage," 46.

16. See Chris Terrence, *Bob Mathias: Across Fields of Gold, Tribute to an American Hero* (Lenexa, Kans.: Addax Publishing Group, 2000).

17. Jess also explored this theme in his contemporaneous assembly, *St. Nick* (1962), which subverts the traditional gift-giving associations of St. Nicholas (Santa Claus). Commencing with an antique papier-mâché St. Nicholas, Jess replaced the miniature Christmas tree normally held by such figures with an artist's paintbrush handle, topped by a gourd that resembles a nuclear mushroom cloud. The gourd's gnarly protuberances evoke the burns and scarring associated with radiation exposure. The identity of the "gift giver" is suggested by a "US" Army brass belt buckle and by industrial cast-iron gear, which identifies the military industrial complex as the creator of nuclear weapons. The delicate lace doily that protects the surface below the cast-iron gear exposes the veneer of acceptability applied to the deployment of atomic weapons and the absurdity of attempting to protect oneself from nuclear annihilation. *St. Nick* is now in the permanent collection of the Fine Arts Museums of San Francisco.

18. Auping, "A Grand Collage," 46.

19. Carl G. Liungman, *Thought Signs: The Semiotics of Symbols—Western Non-Pictorial Ideograms* (Amsterdam: IOS Press; Tokyo: Ohmsha, 1995), 308. The metaphor of time introduced by the hourglass is also appropriate given the existence, since 1947, of the "nuclear doomsday clock" maintained by the board of directors of the Bulletin of Atomic Scientists. Between 1960 and 1962 this symbolic clock was set at seven minutes to midnight. Many observers felt that the world came perilously close to the nightmare scenario of a nuclear holocaust during the Cuban missile crisis of October 1962.

20. One variation of the nursery rhyme says, "If all the world was apple-pie, / And all the sea was ink, / And all the trees were bread and cheese, /

What should we have to drink? / It's enough to make an old man / Scratch his head and think." A related text appears in the Jewish religious poem "Akdamut," which is read on the morning of Shavuot before the Torah reading: "Before I begin to read his Words (the Ten Commandments) / I will ask Permission / Of the One Whose Might is such that— / Even if all the heavens were parchment, / And all the reeds pens / And all the oceans ink, / And all the people were scribes, / It would be impossible to record / the Greatness of the Creator, / Who Created the World with a soft utterance, / And with a single letter, the letter 'heh,' / The lightest of the letters." In Aramaic, each line of the poem ends with the syllable *tah*, which consists of the last (*Tav*) and first (*Aleph*) letters of the *Aleph-Bet*, symbolizing that the Torah is without end.

21. The metaphor of transformation, which Jess experienced firsthand during his career as a nuclear chemist, also informed his subsequent conception of art. "I don't see much difference between the spiritual and the material. All matter is energy, and all matter and energy are infused with spirit." Auping, "Interview," 22.

108. WAYNE THIEBAUD, *Three Machines*

1. Wayne Thiebaud, "Wayne Thiebaud," in *Art of the Real: Nine American Figurative Painters*, ed. Mark Strand (New York: Clarkson N. Potter, 1983), 188–189. Thiebaud has not denied the possibility of content in his works: "Purely formal problems have always been what's most important to me, and I try to downplay subject matter because I'm afraid it limits how people think about pictures. True, I wouldn't have painted toys or pies if I didn't feel some emotional involvement with them." See Michael Kimmelman, "At the Met with Wayne Thiebaud: A Little Weirdness Can Help an Artist," *New York Times*, 23 August 1996, C25.

2. Thiebaud has commented, "Caricature to me means a specific characterization with a distinct formal aspect, as opposed to cartoon on the one hand, or taxidermy on the other. By taxidermy I mean the redundant visual recording of something, a dead image. The down side of realism is taxidermy." See Kimmelman, "At the Met with Wayne Thiebaud," C25. Thiebaud has likened caricature, with its exaggerated form, color, space, and perspective, to the reduction of a sauce in cooking, a process that "essentializes" an idea. See Wayne Thiebaud, cited in Kathan Brown, "Wayne Thiebaud," *Overview: Crown Point Press Newsletter*, Fall 2002, 3.

3. Stephen C. McGough, "An Interview with Wayne Thiebaud," in McGough, *Thiebaud Selects Thiebaud* (Sacramento, Calif.: Crocker Art Museum, 1996), 9–10.

4. Thiebaud, in Strand, *Art of the Real*, 189. On the issue of memory, Thiebaud recalled, "When I painted food products it is perhaps interesting to note that they were painted from memory. I did not have the objects in front of me; I made it a point to paint the pies, the gumball machines, the cakes, etc. as I remembered them. And this is perhaps what makes them seem like icons, in a sense; they're greatly conventionalized in many ways and yet they may allude to spatial and volumetric associations." Wayne Thiebaud, quoted in A. LeGrace G. Benson with David H. R. Shearer, "Documents—*Documents*: An Interview with Wayne Thiebaud," *Leonardo* 2, no. 1 (January 1969): 68.

5. Describing his uniformly colored backgrounds and their animated brushstrokes, Thiebaud wrote, "The space inference that I want is one of isolation. Ultraclear, bright, air conditioned atmosphere that might be sort of stirred up around the objects and echo their presence. For this reason uninterrupted single colored backgrounds are used and this allows the brushmarks to be seen more clearly and play their role. This back-

ground also suggests a kind of stainless steel, porcelain, enameled, plastic world that interests me now." See Wayne Thiebaud, "Is a Lollipop Tree Worth Painting," *San Francisco Sunday Chronicle: This World*, 15 July 1962, 29.

6. Thiebaud has observed, "you can enliven a construct of paint by doing any number of manipulations and additions to what one sees. This makes it possible for representational painting to be both abstract and real simultaneously." See Thiebaud, in Strand, *Art of the Real*, 192.

7. Quoted in John Coplans, "Wayne Thiebaud: An Interview," in *Wayne Thiebaud* (Pasadena, Calif.: Pasadena Art Museum, 1968), 26.

8. Acknowledging the complexities concealed within his seemingly simple imagery, Thiebaud has revealed, "The artist has always desired private sensual intercourse with our eyes in order to achieve intimacy with our hearts. Therefore the artist's work vacillates between obscurity and revelation creating a moment of anticipation for the spectator. He must be willing to wait for the picture to seep into him. Great pictures take a lifetime. Painting is a visual pause ... an erotic wait." Wayne Thiebaud, "A Painter's Personal View of Eroticism," *Polemic* 11, no. 1 (Winter 1966): 34.

9. For the influence of Thiebaud's early theater experience on his art, see Gene Cooper, "Thiebaud, Theatre, and Extremism," in *Wayne Thiebaud: Survey, 1947–1976* (Phoenix: Phoenix Art Museum, 1976), 11–29.

10. Quoted in Benson and Shearer, "Documents," 68; and Michael Kimmelman, "Even with 2 Shows, Far from the Usual Star," *New York Times*, 27 May 1994, C28. Commenting on the anthropomorphic qualities of his still lifes, Thiebaud wrote, "How alone these endless rows can be ... a kind of lonely togetherness ... each piece of pie has a heightened loneliness of its very own ... giving it uniqueness and specialness in spite of its regimentation. (None of us can escape our responsibility however totalitarian or utopian our world may be)." See Thiebaud, "Is a Lollipop Tree Worth Painting," 29.

11. Cooper, "Thiebaud, Theatre, and Extremism," 14–15. See also Karen Tsujimoto, *Wayne Thiebaud* (San Francisco: San Francisco Museum of Modern Art; Seattle: University of Washington Press, 1985), 52.

12. After viewing Thiebaud's first exhibition in New York, the Abstract Expressionist Barnett Newman commented, "You know the gumball machine is in a way the most surrealist object in the world, it promises things inside, it's like gift-wrapped elegance. All it supplies is something to chew on, but look at it with its brightest kind of colors plus the fact you put in the dirtiest, grimiest kind of copper money and out comes a beautiful magenta or yellow ball full of sweet promise." Quoted in Benson and Shearer, "Documents," 66. In 1993 Thiebaud mentioned that he had long wished to own, and had finally acquired, a Ford gumball machine, a brand used in the Sacramento area for charity fundraising. Unlike the type in *Three Machines*, this model has a chrome base. From a conversation with Steven A. Nash, Associate Director and Chief Curator, Fine Arts Museums of San Francisco, 6 April 1993, recorded in Wayne Thiebaud *Three Machines* object file, AAD/DEY/FAMSF.

13. Quoted in Coplans, "Thiebaud: An Interview," 24.

109. WAYNE THIEBAUD, *Diagonal Freeway*

1. Thiebaud, quoted in Michael Kimmelman, *Portraits: Talking with Artists at the Met, the Modern, the Louvre and Elsewhere* (New York: Random House, 1998), 168.

2. Wayne Thiebaud, in *Art of the Real: Nine American Figurative Painters*, ed. Mark Strand (New York: Clarkson N. Potter, 1983), 181. He goes on to say, "I thought I would be a designer, an art director, and was developing a career in that direction, but the more I got interested in layout and design, the more I was led to those examples in fine art from which they derived."

3. Steven A. Nash et al., *Wayne Thiebaud: A Paintings Retrospective* (San Francisco: Fine Arts Museums of San Francisco; New York and London: Thames and Hudson, 2000), 192.

4. Daphne Lane Beneke, *Fifteen Profiles: Distinguished California Modernists* (Fresno, Calif.: Fresno Art Museum, 1995), 39. Most biographies note that Thiebaud began his artistic career as layout director and cartoonist for the Rexall Drug Company in 1946.

5. Ibid., 41. Many of his early landscapes date from 1966 when he was still living in Sacramento. The earliest landscape in his 2000 retrospective is *Hillside* (1963).

6. Thiebaud makes this connection explicit by appearing in front of *Diagonal Ridge* in the photograph used in the biographical section of the 2004 catalogue for his exhibition of land- and cityscapes. Charles Lovell and Charles Strong, *Wayne Thiebaud: City/Country* (Albuquerque: The Harwood Museum of Art of the University of New Mexico, 2004), n.p.

7. Edward Leffingwell, "Wayne's World," *Art in America* (February 2002): 86.

8. Thiebaud, in Strand, *Art of the Real*, 181.

9. Kasimir Malevich, Piet Mondrian, and Bart van der Leck have been cited as important influences, for instance. Nash et al., *Wayne Thiebaud*, 20.

10. Thiebaud, quoted in Kimmelman, *Portraits*, 164.

11. This use of flat, thin color has often been compared to color-field painting. See Nash et al., *Wayne Thiebaud*, 30.

12. Adam Gopnik, "An American Painter," in ibid., 57. Gopnik later describes these cityscapes as "the orchestration of streets and towers together into a single vertiginous, falling-all-over, E-ride city," 60.

13. Nash, *Wayne Thiebaud*, 18–19. Although Thiebaud's tone is celebratory rather than ironic, as in Pop art, it would be difficult to deny a cultural critique in his work. He suggests the radical transformation brought about by freeways by the way he cancels the background city scene through the blank, triangular space and the wide strip of freeway, which operates as an emphatic line of erasure.

14. For Thiebaud's often misunderstood relation to Pop art, see Marco Livingstone, *Pop Art: A Continuing History* (New York: Harry N. Abrams, 1990), 71. Livingstone writes: "Even before he turned to a more traditionally realist conception of still life and landscape, Thiebaud occupied an ambivalent position in relation to Pop." See also Gopnik, "An American Painter," 55–57.

15. Adam Gopnik, "Window Gazing," *New Yorker*, 29 April 1991, 79.

16. Gopnik, "An American Painter," 41, 64.

110. WAYNE THIEBAUD, *Ponds and Streams*

1. Quoted in Gail Gordon, "Thiebaud Puts a Visual Feast on Canvas," *California Aggie*, 9 Feburary 1983, 2.

2. Adam Gopnik, "An American Painter," in Steven A. Nash et al., *Wayne Thiebaud: A Paintings Retrospective* (San Francisco: Fine Arts Museums of San Francisco; New York and London: Thames and Hudson, 2000), 62.

3. His mature style coincided with his 1960 appointment to the art faculty at the University of California, Davis. For a discussion of this period and his Allan Stone Gallery exhibition in 1962, see Karen Tsujimoto, *Wayne Thiebaud* (San Francisco: San Francisco Museum of Modern Art; Seattle: University of Washington Press, 1985), 35–41.

4. Nash et al., *Wayne Thiebaud*, 27; Tsujimoto, *Wayne Thiebaud*, 122–123.

5. He says, "I told myself, 'You shouldn't paint an object,' so I lavishly overlayered with all kinds of abstract expressionist brushstrokes." Wayne Thiebaud, in *Art of the Real: Nine American Figurative Painters*, ed. Mark Strand (New York: Clarkson N. Potter, 1983), 188.

6. Kathan Brown, "Wayne Thiebaud," *Overview: Crown Point Press Newsletter*, Fall 2002, 3.

7. Quoted in Michael Kimmelman, *Portraits: Talking with Artists at the Met, the Modern, the Louvre and Elsewhere* (New York: Random House, 1998), 158.

8. A painter with a more transcendental cast of mind would probably see in this image Emerson's conceit of the transparent eyeball, which Thoreau also applied to Walden Pond. But it is important to keep in mind Thiebaud's skepticism about turning real objects into something else and his resistance to metaphors.

9. Thiebaud, interviewed by Nancy Boas, in *The Society of Six: California Colorists* (San Francisco: Bedford Arts, 1988), 83.

10. Ibid., 111.

11. Thiebaud, in Strand, *Art of the Real*, 9.

12. Thiebaud, interviewed by Dan Tooker, in "Wayne Thiebaud," *Art International* 18 (November 1974): 22.

13. Quoted in Jan Greenberg and Sandra Jordan, *The Painter's Eye: Learning to Look at Contemporary American Art* (New York: Delacorte Press, 1991), 40.

111. JACK LEVINE, *Birmingham '63*

1. For Levine's *Six Masters: A Devotion* (1963), see Frank Getlein, *Jack Levine* (New York: Harry N. Abrams, 1966), pl. 160.

2. Quoted in Kenneth W. Prescott, *Jack Levine: Retrospective Exhibition; Paintings, Drawings, Graphics* (New York: The Jewish Museum, 1978), 9.

3. For Levine's biography, see Getlein, *Jack Levine*; Prescott, *Retrospective Exhibiton*; and Jack Levine, Milton W. Brown, and Stephen Robert Frankel, *Jack Levine* (New York: Rizzoli, 1989).

4. For a history of civil rights events in Birmingham, Alabama, before the protest marches in the spring of 1963, see Juan Williams et al., *Eyes on the Prize: America's Civil Rights Years, 1954–1965* (New York: Viking, 1987), 179–181.

5. Three of Charles Moore's now-famous photographs of police dogs attacking civil rights protestors were reproduced in *Life* magazine under the heading "The Dogs' Attack is Negroes' Reward." See "The Spectacle of Racial Turbulence in Birmingham: They Fight a Fire That Won't Go Out," *Life* 54, no. 20 (17 May 1963): 30–31.

6. For a history of the civil rights marches in Birmingham, Alabama, in the spring of 1963, see Williams et al., *Eyes on the Prize*, 179–194.

7. Quoted in *Jack Levine: Commitment and Ambivalence, Paintings and Prints, 1960–1975* (New York: DC Moore Gallery, 1998), n.p.

8. Ibid.

9. Levine recalled, "I had seen a picture in the newspapers of a dog snarling and snapping at a group of blacks, and I had an image like that in my mind when I began painting *Birmingham*." See Levine, Brown, and Frankel, *Levine*, 100.

10. *Jack Levine, Commitment and Ambivalence*, n.p.

11. Of his palette in *Birmingham '63*, Levine observed, "Bold color can be a deterrent to dramatic expression. In this case, the painting is near-monochrome, except for the inside of the dog's mouth. There's the possibility of red brick above the figures, but the color is withheld so it's almost not red. The green shutters are almost not green anymore. The idea is to hold back on that lushness—you can't indulge yourself with a subject like this." Ibid.

12. Quoted in Henry Freedman, "Jack Levine: Painter and Protestor" (Ph.D. diss., Johns Hopkins University, 1974), 84.

13. Levine later recalled, "I had seen the South when I was a soldier [during World War II], having been stationed in five southern states, and I was appalled by the conditions imposed by segregation. Which is not to say that the situation up North was all that great either." See Levine, Brown, and Frankel, *Levine*, 40.

14. See Bill Jones, *The Wallace Story* (Northport, Ala.: American Southern Publishing Company, 1966), 70.

15. See Dan T. Carter, *The Politics of Rage: George Wallace, the Origins of the New Conservatism, and the Transformation of American Politics* (Baton Rouge: Louisiana State University, 2000), 105–109, 133–155.

16. Underscoring the seriousness of the situation, later that same night the civil rights activist Medgar Evers was assassinated in Jackson, Mississippi.

112. JOAN BROWN, *Noel and Bob*

1. For Brown's fascination with the "tremendous sense of humanity" in Rembrandt, Velázquez, and Goya, see Joan Brown, interview by Paul J. Karlstrom, 1 July, 15 July, and 9 September 1975, AAA/SI, microfilm reel 3196, frames 1077, 1079–1080.

2. Quoted in Caroline A. Jones, *Bay Area Figurative Art, 1950–1965* (San Francisco: San Francisco Museum of Modern Art; Berkeley and Los Angeles: University of California Press, 1990), 153.

3. Brown interview, frame 1102.

4. Brown's husband, the sculptor Manuel Neri, noted that their colorful impasto technique was based on a misconception: "We'd look at those little black-and-white reproductions of de Kooning in the magazines, and we'd think that he was using really wild, crazy colors and sloshing them on in big, thick layers. So we started painting right out of the can and building up surfaces a half-inch thick. Finally, some real de Koonings were exhibited at one of the museums. Most of us were really disappointed—the paint was so thin, and the color was really dead. But the misinterpretation was a good thing." Quoted in Thomas Albright, *Art in the San Francisco Bay Area, 1945–1980* (Berkeley and Los Angeles: University of California Press, 1985), 72. For Brown's fascination with de Kooning's paint surfaces, see Brown interview, frame 1057.

5. Karen Tsujimoto, "Painting as a Visual Diary," in Tsujimoto and Jacquelyn Baas, *The Art of Joan Brown* (Berkeley and Los Angeles: University of California Press; Oakland: The Oakland Museum of California, 1998), 182 n. 102.

6. Ibid., 62.

7. Jones, *Bay Area Figurative Art*, 148.

8. Brown observed, "And Manuel and I always influenced each other

a great deal, way before we were ever together." Brown interview, frame 1076. For the symbiotic relationship between Brown and Neri, see Tsujimoto, "Painting as a Visual Diary," 58–59; and Charles Strong and Whitney Chadwick, *Working Together: Joan Brown and Manuel Neri, 1958–1964* (Belmont, Calif.: The Wiegand Gallery, College of Notre Dame, 1995).

9. Brown interview, frame 1052.

10. Quoted in Jones, *Bay Area Figurative Art*, 149, 153.

11. Brown connected Noel's sweet, gentle nature with her father: "There was a gentleness [in my father]—a natural, innate kind of gentleness that has been very impressive to me. I see it now in other people, I see it in my son—you see it in kids, but I especially see it in my son. Maybe it's inherited, I don't know. But it's something I'm very touched by." See Brown interview, frame 1009.

12. Tsujimoto, "Painting as a Visual Diary," 182 n. 111, notes that *Noel and Bob* was one of the last paintings to depict Bob the Dog, as Brown gave him away after he attacked Noel.

13. Brown's rendering of Bob the Dog was probably inspired by Francis Bacon's *Dog* (1952), which was included in the exhibition *Masters of British Painting, 1800–1850*, at the California Palace of the Legion of Honor, 3 March–12 May 1957. Brown still vividly recalled Bacon's painting twenty years later: "And there was a painting of that damn dog in that room. That funny perspective on four feet, front feet, spread out, just looking up. An aerial perspective just looking down, and a checkerboard floor. And that just knocked the hell out of me." See Brown interview, frame 1038.

14. Ibid., frames 1055–1056.

15. Ibid., frame 1041.

16. Ibid., frame 1043.

17. Van Gogh's *First Steps* (1890) is a reinterpretation of Jean-François Millet's earlier drawing, *First Steps* (ca. 1858, The Cleveland Museum of Art).

18. Tsujimoto, "Painting as a Visual Diary," 26, notes Brown's interest in light effects in such early works as *Fussing Around by the Light of the Moon* (1959) and *The Sun Blew Up in Salinas* (1960). In 1960 Brown wrote: "I'm on to something new in my light. I'm handling it more directly and a lot stronger, almost making it an image in itself." See Joan Brown to George Staempfli, quoted in ibid., 39.

19. See Moira Roth, ed., *Connecting Conversations: Interviews with 28 Bay Area Women Artists* (Oakland, Calif.: Eucalyptus Press and Mills College, 1988), 14–15.

20. Tsujimoto, "Painting as a Visual Diary," 65. A reproduction of Goya's *Don Manuel Osorio Manrique de Zuniga* was prominently displayed on the wall of Brown's Cameo Way studio by about 1974, if not earlier. See Brenda A. Richardson, *Joan Brown* (Berkeley: University Art Museum, 1974), 39.

21. Brown interview, frame 998.

22. Ibid., frames 990–991.

23. Tsujimoto, "Painting as a Visual Diary," 98, notes that the Chinese characters in *Portrait of a Girl* include those signifying "old" and "woman" and links the painting to the death of Brown's mother and to her "own maturity and new-found strength and vitality."

24. The three childhood photographs synthesized by Brown in *Portrait of a Girl* are reproduced in Jacquelyn Baas, "To Know This Place for the First Time: Interpreting the Art of Joan Brown," in Tsujimoto and Baas, *The Art of Joan Brown*, 197.

25. For interpretations of *Portrait of a Girl*, see Tsujimoto, "Painting as a Visual Diary," 98–99; and Baas, "To Know This Place," 195–198.

26. Brown acknowledged the diaristic and therapeutic elements in her art: "I keep my work around me; it's almost like a diary in a sense, a reminder of where I've been, where I want to go, where I am in the present. I never started out thinking of art as therapy, as 'Oh, gee, well now I'm going to do this and learn more about myself.' But believe me that happens. To take that one step further, I believe that one's art reflects what's going on with the person. That can be on many levels or on one level." Quoted in Claudia Steenberg-Majewski, "Joan Brown: One Stroke Ahead," *Artbeat* 1 (April 1981): 9.

113. FRANK LOBDELL, *Summer 1967*

1. In retrospect, it is possible that Lobdell has never painted a purely abstract painting. He once noted, "My stuff has never been abstract. There have always been associations I've had." Frank Lobdell, interview by Terry St. John, San Francisco, 8 April 1980, AAA/SI, photocopy, 33, in Frank Lobdell artist file, AAD/DEY/FAMSF.

2. Although Lobdell did not study with Clyfford Still at the California School of Fine Arts, he recalled that the older artist's exhibition at the California Palace of the Legion of Honor in San Francisco in 1947 "hit just as hard as the Picasso show." Quoted in Timothy Anglin Burgard, "Beyond Words: The Hand of Humanity," in Burgard et al., *Frank Lobdell: The Art of Making and Meaning* (San Francisco: Fine Arts Museums of San Francisco, in association with Hudson Hills Press, 2003), 2. Echoing Still's philosophy of art, Lobdell declared, "Painting for me is a way of life, not a means to a livelihood." Quoted in Caroline A. Jones, *Frank Lobdell: Works, 1947–1992* (Stanford, Calif.: Stanford University Museum of Art, 1993), 5.

3. Quoted in Leslie Weeden, "Art Professor with Major Show Pursues Anonymity," *Stanford Daily*, 23 February 1983, 5.

4. In 1949 Lobdell observed that the artist "can't be content with prettiness when a feeling of turmoil seems most characteristic of our times." [Judy Stone], "New Art Explained by Sausalitans," *San Rafael Daily Independent and Marin Journal*, 22 January 1949, quoted in Susan Landauer, *The San Francisco School of Abstract Expressionism* (Berkeley and Los Angeles: University of California Press, 1996), 142. In 1951 the advent of the Korean War motivated Lobdell to leave America for Paris, where he studied at the Académie de la Grande Chaumière. Lobdell interview, 27–28.

5. Although the painting is often interpreted as having been conceived as a memorial to Lobdell's friend the Abstract Expressionist James Budd Dixon, Lobdell stretched the canvas in the spring of 1966 and was nearly finished with the painting when Dixon died in 1967. Lobdell's parenthetical title was appended as a posthumous tribute to a friend of whom he recalled, "What I got from Bud was his great enthusiasm over a variety of things. Painting, of course, and everything from African drum music to South Sea Island chants. Budd read a bit but I don't recall that side as much as painting and music and films. Whatever was different or odd or strange, excited his curiosity." Ibid., 17–18.

6. The young artist was particularly struck by the installation of dozens of Picasso's related drawings and paintings and recalled, "You could read it like a book." Ibid., 9. Like predella panels in a Renaissance altarpiece, these independent works of art collectively augmented the visual and visceral impact of the larger painting.

7. As a teenager, Lobdell briefly considered enlisting in the famous

Lincoln Brigade of foreign volunteers to join the Spanish Republicans in their fight against Francisco Franco's fascists. Burgard, "Beyond Words," 2.

8. Lobdell interview, 7.

9. Childhood friend and fellow artist Walt Kuhlman recalled that Lobdell had recurring nightmares of "blood and guts spilling out of men" in the late 1940s. Quoted in Landauer, *San Francisco School*, 239 n. 69.

10. Lobdell interview, 35.

11. Describing the genesis of his eight-part *Dance* series (1969–71), Lobdell stated, "In developing these figures they were really a rage over that goddamn Vietnam War. This is one time the outside really did move in on me. It seemed to me that the manipulating of these figures in that kind of space, the various postures, well, there are visual booby traps throughout." Ibid., 58. For discussions about the *Dance* series, see Bruce Nixon, "A Wonderland of His Own," in Burgard et al., *The Art of Making and Meaning*, 115–129 (illus.).

12. For major paintings that prefigure the imagery in *Summer 1967*, see *Fall 1964* and *October 1965*, in ibid., 83–85 (illus.).

13. This floating figure's ponderous, swollen legs and outstretched arms have precedents in Picasso's *Bather with Beachball* (1932), in which a pneumatically voluptuous female bather, her belly and breasts accentuated, appears to levitate as she reaches up into the sky for a beach ball that doubles as the moon. William Stanley Rubin, ed., *Pablo Picasso: A Retrospective* (New York: The Museum of Modern Art, 1980), 295 (illus.).

14. Lobdell had encountered Goya's painting in the mid-1950s, and "it stayed with me." He did not consciously appropriate Goya's image until after the assassination of John F. Kennedy. Jones, *Frank Lobdell*, 14, 29 n. 39. Lobdell recalled, "It wasn't until later that the psychological and political implications of the Saturn paintings became apparent to me. At first it was the visual aspects—the power of the forms." Quoted in ibid., 14.

15. Ibid., 17, 29 n. 40.

16. Lobdell interview, 34.

17. About his lifelong fascination with spiral forms in relation to his painting *15 April 1962*, Lobdell observed, "There are other natural phenomena here. Whirlpools for example, or tornadoes, to say nothing of astronomical phenomena. That whirling, or spiraling, I see in nature all the time. Coming from the [Minnesota] lake and river country where you run into these eddies and whirlpools, they've always had a strong meaning for me." Ibid., 33.

18. Diane Roby and Anthony Torres, "Chronology," in Burgard et al., *The Art of Making and Meaning*, 326. Of his opposition to the Vietnam War, Lobdell recalled, "I read a few books about the French disaster. The Battle of Dien Bien Phu was one. To repeat that stupidity, which is precisely what we did, seemed to me almost incredible." Lobdell interview, 35.

19. Burgard, "Beyond Words," 5.

20. Lobdell interview, 26.

21. Lobdell's son Frank served on an aircraft flight crew in Vietnam in 1968. Author's telephone conversation with Lobdell's wife, Jinx Lobdell, 7 February 2005.

22. Lobdell's decision to critique war through metaphoric means was probably influenced by his own World War II experience of heavy-handed propaganda posters that demonized the Germans and Japanese: "Political art, those posters . . . it's so *sad*, it doesn't have the *intensity* of good art. Goya holds up because those are strong drawings, not because of the propaganda." Quoted in Jones, *Frank Lobdell*, 29 n. 41. Lobdell was also

disappointed in Picasso's heavy-handed *Massacre in Korea*, of which he commented, "I could hardly believe Picasso had done it." Ibid.

23. In the 1960s Lobdell gradually expanded the scale and scope of his figures, which actively asserted their humanity in opposition to the threat he perceived to be posed by the Vietnam War. During this period, working alongside his friends and colleagues Richard Diebenkorn, Elmer Bischoff, and Nathan Oliveira, Lobdell created a remarkable series of life drawings—primarily of female nudes—that captured the life-affirming potential of artistic and biological creation.

114. ELMER BISCHOFF, *Yellow Lampshade*

1. This biographical sketch is drawn from Kevin McGovern, "Elmer Bischoff," *Art of California* 4, no. 3 (May 1991): 11–15; and Robert M. Frash, ed., *Elmer Bischoff, 1947–1985* (Laguna Beach, Calif.: Laguna Art Museum, 1985), 11.

2. Quoted in McGovern, "Elmer Bischoff," 12.

3. Thomas Albright, "Elmer Bischoff: Bay Area Figurative," *Currânt* (Winter 1975–76): 38.

4. Elmer Bischoff, biographical statement written for the Oakland Museum, 7 October 1973; artist file, AAD/DEY/FAMSF.

5. Quoted in Albright, "Bay Area Figurative," 38.

6. According to Thomas Albright, "The standard myth is that Clyfford Still turned up in a long black overcoat one day . . . and . . . more or less single-handedly turned every artist in the Bay Area into an Abstract Expressionist." In actuality the process was far more complex and gradual. Ibid., 38.

7. Ibid., 40.

8. Erle Loran proclaimed a 1948 exhibition of abstract expressionist works by Bischoff, Park, and Smith "the most complete release from restraints of all kinds that had ever occurred"; their return to figurative painting just a few years later was an unexpected development. Frash, *Elmer Bischoff*, 12.

9. Brady Kahn, "Light and Accident," *East Bay Express*, 21 November 2001, Culture sec. Bischoff described his technique: "Throughout the figurative and the nonrepresentational work, all the mixing of paint takes place on the canvas. I want a play between soft, fused edges and sharp, hard edges . . . opaque paint and translucent paint . . . slowly applied paint and rapid brushwork . . . and paint put on with a wet rag, a knife or a hand as well as a brush." Quoted in Jan Butterfield, "Walking a Tightrope," in Frash, *Elmer Bischoff*, 39.

10. Quoted in Albright, "Bay Area Figurative," 40. On another occasion he described his desire to "bring off a fusion of your interest both in the subject and in the painting. It's like walking a tightrope. When you are too enamored of nature you lose touch with the demands of the painting. Conversely, with too little involvement with the subject, the painting can degenerate into a formal exercise. My aim has been to have the paint on the canvas play a double role—one as an alive, sensual thing in itself, and the other conveying a response to the subject. Between the two is this tightrope." Quoted in Butterfield, "Walking a Tightrope," 39.

11. Bischoff returned permanently to abstraction in 1972.

12. Donald Kuspit, *Elmer Bischoff: Paintings from the Figurative Period, 1954–1970* (San Francisco: John Berggruen Gallery, 1990), 9.

13. Bischoff himself resisted the presence of narrative in his figural paintings, despite the efforts of others to tease them out. In the case of *Yel-*

low *Lampshade* he liked to remark facetiously that the estranged couple seen in his earlier *Interior with Two Figures*, who "had a falling out because he wants to watch the fights and she wanted to watch something else," had now "patched up their differences and were in a better mood." He found such narratives simplifying and sentimental and did not want them to get in the way of the viewer's emotional response to his paintings. Susan Landauer, *Elmer Bischoff: The Ethics of Paint* (Berkeley and Los Angeles: University of California Press, 2002), 132–133.

14. Sunset carries with it implications of endings and melancholy; soon the shadow falling over the city will darken their aerie as well, and this moment will be lost forever.

15. In the words of Marcia Vetrocq, "In Bischoff's figural works we find a suppression of the idiosyncratic qualities and narrative potential usually associated with the human body." Vetrocq, "Elmer Bischoff: Against the Grain," *Art in America* 74 (October 1986): 148.

16. The white light fixture over the couple might also qualify, but it contains a fair amount of green.

17. Though both seem small for the room, the man is substantially larger than the woman. While this difference in size can be attributed to perspective (the man stands closer to the picture plane) or physiology (men tend to be larger than women), the resulting disparity implies a similarly uneven balance of power between the two, thereby increasing the tension perceived by the viewer.

18. The large picture windows resemble cityscapes hanging on the wall, bringing into question the reality of the outside world and the place of the couple in it. Thanks to Bischoff's fusion of subject and material, the viewer fluctuates between seeing people and patches of paint, further destabilizing the scene and adding to the anxiety that fuels the tension of the painting.

19. I am indebted to Tim Burgard for this observation.

20. Bischoff considered Hopper "cold." Landauer, *Ethics of Paint*, 130. *Room in New York* is a low-angle view through an apartment window. Only a portion of the living room is visible. A man sits in an overstuffed chair at the left, bent intently over the newspaper; on the opposite side of a round wooden table, a woman sits on a piano stool, her lower body facing the man but her torso and head twisted around toward the piano. She looks down at the keys much as her companion stares at his paper, their gazes and bodies completely closed off from one another. Both faces bear the merest suggestion of features. The couple are separated not only physically by the table but also visually by a large door in the rear wall that divides the room into two zones—his and hers. *Yellow Lampshade* is also reminiscent of some of the paintings of Edgar Degas, in which space is used to convey psychological tension. An example is the well-known *Intérieur (le Viol)* (*Interior [The Rape]*). Degas did not give it that title; he, like Bischoff, wanted the emotional impact of the image to arise directly from what is seen, unmediated by narrative cues.

21. Bischoff, Oakland Museum, 1.

22. Bischoff, quoted in Albright, "Bay Area Figurative," 38.

115. WILLEM DE KOONING, *Untitled XX*

1. When the influential critic Clement Greenberg commented in 1949 that it would be impossible for a contemporary artist to paint the human face and still be considered important, de Kooning replied, "That's right, and it's impossible not to." Quoted in Richard Shiff, "Water and Lipstick: de Kooning in Transition," in David Sylvester, Shiff, and Marla Prather,

Willem de Kooning: Paintings (Washington, D.C.: National Gallery of Art; New Haven: Yale University Press, 1994), 34.

2. Quoted in David Sylvester, "Flesh Was the Reason," in ibid., 16. De Kooning also commented, "At one time it was very daring to make a figure red or blue. I think now that it is just as daring to make it flesh-colored." Ibid., 24.

3. Quoted in Marla Prather, "Catalogue," in ibid., 127.

4. Ibid.

5. Richard Shiff wrote, "De Kooning's yoking of timeless Woman-in-art (elite culture), to fashionable woman-on-the-beach (bourgeois culture), to sexually stylized pinup-with-lipstick (mass culture) combined with conflicting features without pretending to mediate between them or transcend their differences. De Kooning worked toward all-inclusiveness, toward the pleasure of anarchic dissonance, not utopic harmony." Shiff, in "Water and Lipstick," 48–49.

6. Prather, "Catalogue," 127. The early stages of *Woman I* clearly reveal a woman seated in a chair with a door at the upper left and a window at the upper right. For six progressive states of *Woman I*, see Diane Waldman, *Willem de Kooning* (New York: Harry N. Abrams, in association with the National Museum of American Art, Smithsonian Institution, 1988), 88–89 (illus.).

7. Quoted in Prather, "Catalogue," 132. For the critical reception of de Kooning's "Woman" paintings, see ibid., 131–133.

8. Ibid., 132, 177.

9. For more about de Kooning's relationship with Emilie Kilgore, see Mark Stevens and Annalyn Swan, *de Kooning: An American Master* (New York: Alfred A. Knopf, 2004), 536–543, 551–554, and 559–560. David Sylvester has observed, "It is no secret that throughout this decade de Kooning was involved in a love affair that brought him great happiness. The paintings of this time that have to do with the figure—I mean the flesh, with skin and membrane of paler and darker shades of pink—blaze with desire and fulfillment. . . . De Kooning's paintings of the 1970s are an annihilation of distance. The close-ups are about closeness. These paintings are crystallizations of the experience and amazement of having body and mind dissolve into an other who is all delight." Sylvester, "Flesh Was the Reason," 30.

10. Quoted in Harold Rosenberg, "Interview with Willem de Kooning," *Artnews* 71, no. 5 (September 1972): 58.

11. Commenting on his move to Springs, de Kooning recalled, "When I came here I made the color of sand—a big pot of paint that was the color of sand. As if I picked up sand and mixed it. And the grey-green grass, the beach grass, and the ocean was all kind of steely grey most of the time. When the light hits the ocean there is a kind of grey light on the water. . . . I got into painting in the atmosphere I wanted to be in." Ibid., 58.

12. Stevens and Swan, *An American Master*, 560, 541.

13. Thomas B. Hess, *Willem de Kooning* (New York: George Braziller, 1959), 18.

14. In 1978 de Kooning considered painting a large studio interior with figures in the manner of Matisse. Prather, "Catalogue," 198.

15. De Kooning's perception of the mutability of form is apparent in titles such as *Woman, Wind, and Window I* (1950, Warner Communications), *Woman as a Landscape* (1954–55, private collection), and *Landscape of an Armchair* (1971, private collection).

16. Quoted in Prather, "Catalogue," 197.

116. ED RUSCHA, *A Particular Kind of Heaven*

1. Quoted in Suzanne Muchnic, "Getting a Read on Ed Ruscha," *Los Angeles Times*, 9 December 1990, 3.

2. Quoted in Bernard Blistène, "Conversation with Ed Ruscha," in Elbrig de Groot et al., *Edward Ruscha: Paintings* (Rotterdam: Museum Boymans-van Beuningen, 1990), 128.

3. Quoted in Fred Fehlau, "Ed Ruscha," *Flash Art* 138 (January–February 1998): 70–72, cited in Ed Ruscha, *Leave Any Information at the Signal: Writings, Interviews, Bits, Pages; Ed Ruscha*, ed. Alexandra Schwarts (Cambridge, Mass.: MIT Press, 2002), 262–263. Cf. "They wanted to collapse the whole art process into one act; I wanted to break it into stages, which is what I do now. First, whatever I'm going to do is *completely premeditated*, however off-the-wall it might be. Then it's executed, you know, fabricated. . . . *then* I decide if it's art." Quoted in Dave Hickey, "Available Light," in Hickey et al., *The Works of Edward Ruscha* (New York: Hudson Hills Press, in association with the San Francisco Museum of Modern Art, 1982), 27–28.

4. For Ruscha's *The Uncertain Trail* (1986), see de Groot et al., *Edward Ruscha*, 70–71 (illus.).

5. Quoted in Muchnic, "Getting a Read on Ed Ruscha," 96.

6. Quoted in Kathan Brown, "Ed Ruscha: Los Francisco San Angeles," *Overview: Crown Point Press Newsletter*, Summer 2001, 3; and de Groot et al., *Edward Ruscha*, 138. Cf. "With a painting you don't get a running story-line from beginning to end, you are confronted by something smack, face-on, something which doesn't move. . . . And yet movies . . . the screen . . . these have always been closely related to my work, and that's why I am so involved with them." Quoted in Blistène, "Conversations with Ed Ruscha," 136.

7. "If I'm influenced by movies, it's from way down underneath, not just on the surface. A lot of my paintings are anonymous backdrops for the drama of words. In a way they're words in front of the old Paramount mountain. You don't have to have the mountain back there—you could have a landscape, a farm. I have background, foreground. It's so simple. And the backgrounds are of no particular character. They're just meant to support the drama, like the 'Hollywood' sign being held up by sticks." Quoted in Bill Berkson, "Ed Ruscha," *Shift* 2, no. 4 (1988): 14–17, cited in Ruscha, *Leave Any Information at the Signal*, 278.

8. For Ruscha's house in the Mojave Desert, near Joshua Tree, see Ruscha, *Leave Any Information at the Signal*, 213. Describing the desert near Ruscha's house, Dave Hickey wrote, "After five miles or so I was in the grip of massive déjà vu. Then I realized that this country was the setting for every 'B' western I'd ever seen." See Hickey, "Available Light," 29. Among the films that inspired Ruscha's lifelong fascination with cinema was John Ford's *My Darling Clementine* (1946). See Hickey, *The Works of Ed Ruscha*, 157. Commenting on his interest in the panoramic and Panavision formats, Ruscha has observed, "Proportion is a lot more important to me than size . . . a large work will overpower you in a certain way that a small painting cannot. . . . most of my proportions are affected by the concept of the panorama. . . . like I say, I'm a victim of the horizontal line . . . and the landscape . . . which is almost one and the same to me. So I've eliminated a lot of unnecessary sky and unnecessary ground. I try to focus on where the sky meets the ground so that you have a stretched-out version, something panoramic . . . a panavision format." Quoted in Blistène, "Conversation with Ed Ruscha," 140.

9. Quoted in Brown, "Ed Ruscha," 1. Describing his migration to California, Ruscha said, "In the early 1950s I was awakened to the photographs of Walker Evans and the movies of John Ford, especially *Grapes of Wrath*, where the poor 'Okies' (mostly farmers whose land had dried up) go to California with mattresses on their cars rather than stay in Oklahoma and starve. I faced a sort of black-and-white cinematic emotional identity crisis myself in this respect—sort of a showdown with myself—a little like trading dust for oranges." Quoted in Bernard Brunon, "Interview with Ed Ruscha," in *Edward Ruscha* (Lyon: Musée Saint Pierre Art Contemporain, 1985), 89–97, cited in Ruscha, *Leave Any Information at the Signal*, 250. Recalling the popular lure of the California lifestyle, Ruscha stated, "I was attracted to the concept of Hollywood and the lifestyle here. . . . Real heaven for me was to drive somewhere and park right in front." Quoted in Muchnic, "Getting a Read on Ed Ruscha," 3.

10. Quoted in Paul J. Karlstrom, "Interview with Ed Ruscha in His Western Avenue Hollywood Studio," 29 October 1980, 25 March 1981, 16 July 1981, 2 October 1981, California Oral History Project, AAA/SI, cited in Ruscha, *Leave Any Information at the Signal*, 109.

11. David Bourdon, "Ruscha as Publisher [or All Booked Up]," *Art News* 71 (April 1972): 32–36, 68–69, cited in Ruscha, *Leave Any Information at the Signal*, 41. Ruscha has revealed that "There is a connection with my work and my experiences with religious icons: the Stations of the Cross and the Church." See Karlstrom, "Interview with Ed Ruscha," 99.

12. Ruscha reprised this theme in the two color aquatints, *Heaven* and *Hell*, of 1988. See Karin Breuer, *Acquisition of an Archive: The Graphic Works of Ed Ruscha* (San Francisco: Fine Arts Museums of San Francisco, 2001), n.p. (illus.). Describing his interest in subversive subjects, Ruscha has observed, "the quest for paradox has always gripped me as an artist. There has to be negative conflict. Disturbing things have an attraction to them. The idea of subversion is a powerful subject. It's not a question of making pretty pictures. That's not what art is all about." Quoted in Muchnic, "Getting a Read on Ed Ruscha," 3.

13. Commenting on the relationship between his images and texts, Ruscha has observed, "I find that the pictorial look of something almost always stays close to the word that represents it, such as 'sunset,' 'desert,' 'beach,' and then you can keep moving on and on." Quoted in Karlstrom, "Interview with Ed Ruscha," 150.

14. Ibid., 96. The lasting impression left by the Catholic Church is apparent in Ruscha's observation, "Like I did a drawing one time called *The Catholic Church* (1974). I could never say anything intelligent about it, except that just the power of those three words, 'The Catholic Church,' seems to contain its own potency protein." Quoted in Lewis MacAdams, "Catching Up with Ed Ruscha," *L.A. Weekly* 4, no. 34 (27 August–2 September 1982): 26–28, cited in Ruscha, *Leave Any Information at the Signal*, 238.

15. Quoted in Walter Hopps and Edward Ruscha, "A Conversation between Walter Hopps and Edward Ruscha, Who Have Known Each Other since the Early 1960s, Took Place on September 26, 1992," in Yve-Alain Bois, *Edward Ruscha: Romance with Liquids; Paintings, 1966–1969* (New York: Gagosian Gallery and Rizzoli, 1993), 103, 106.

117. MASAMI TERAOKA, *American Kabuki / Oishiiwa*

1. Masami Teraoka, "Notes on the *Hawaii Snorkel Series*," in *Masami Teraoka: Hawaii Snorkel Series* (Mount Kisco, N.Y.: Tyler Graphics, 1993), n.p.

2. James T. Ulak, Alexandra Munroe, and Masami Teraoka, with Linda

Hess, *Paintings by Masami Teraoka* (Washington, D.C.: Arthur M. Sackler Gallery, in association with Weatherhill, 1996), 62. For the related pair of *AIDS Series* works, *Mother and Child* (1990) and *Father and Son* (1990), see ibid., 74–75.

3. Howard A. Link, *Waves and Plagues: The Art of Masami Teraoka* (Honolulu: The Contemporary Museum; San Francisco: Chronicle Books, 1988), 55.

4. The woman clutching her child reappears as a white ghost drained of color in the *AIDS Series* work *Ghost of Kyoto Inn* (1987), where she comes in the middle of the night to threaten an American man and a Japanese courtesan. The same "ghost woman," without her child, is used in the *AIDS Series* study *Makiki Heights Disaster* (1988). See Link, *Waves and Plagues*, 70–72. A father holding a child is pictured in the *AIDS Series* work *Kyoto Inn: Ghost and Snake* (1987). See ibid., 56–57.

5. Ibid., 55.

6. Ibid.

7. Teraoka has said that these flamelike spirit forms (*hinotama*) traditionally are depicted hovering in midair. See Masami Teraoka to the author, 19 June 2002, Masami Teraoka *American Kabuki/Oishiiwa* object file, AAD/DEY/FAMSF.

8. This altered view of human sexuality is underscored by a comparison with the erotic works in Teraoka's earlier *Wave* series (inspired by Hokusai), in which an ecstatic woman swimmer clutching a facemask is ravished sexually by a giant octopus. See Link, *Waves and Plagues*, 23, 36–41.

9. Ibid., 54.

10. Quoted in Masami Teraoka and Lynda Hess, "Monitoring Our Times," in Ulak, Monroe, and Teraoka, *Paintings*, 53.

Abstract Expressionism, 397, 400, 409–13, 461; in California, 393, 453; influence of, 465; in New York, 397; practitioners of, 401, 403, 432, 458; rejection of, 414, 419, 432, 439, 458; technique of, 440

abstraction, 354, 362

Académie Colarossi, Paris, 357

Académie Julian, Paris, 219, 236–38, 237, 238, 288, 306, 334, 338, 357

Académie Royale, Paris, 188

Académie Royale des Beaux-Arts, Brussels, 461

Action Comics, 421

Acushnet (whaling ship), 193

Adams, John, 22

Adams, John Quincy, portrait of, 146

Adams, Samuel, 23

Administration: Farm Security, 375; Public Works, 338, 366, 375, 414, 444, 461; Resettlement, 375

Adoian, Vosdanik. *See* Gorky, Arshile

Aelst, Willem van, *Flowers in a Silver Vase*, 244, 246

Aeschylus, *Prometheus Unbound*, 70

Aesthetic Movement, 205, 211, 222, 231, 266

African art, 366, 368, 368

Albany (ship), 67

Albert, Prince, 134

Alberti, Rafael, 399

Albright, Thomas, 458

Aldine, The (periodical), 222

Alexander, John White, 192

Alexander III, czar of Russia, 255

Alison, Archibald, 65

Allan Stone Gallery, New York, 440

Allen, Brian, 149

Altoon, John, 465

American (newspaper), 357

American Art Review (periodical), 185, 191

American Art-Union, 88, 93, 94, 117, 129

American Locomotive Company, Schenectady, 412

American Scene painting, 330, 357, 380, 414, 461

An American Place (gallery), New York, 320

Anderson, Margaret, 261

Andrews, Malcolm, 109

Annett, George W., 161

Annett, Robert, 161

Anshutz, Thomas Pollock, 197–200, 283, 309, 334; **The Ironworkers' Noontime**, 197–200, *198*

Apollinaire, Guillaume, 397

Apthorp, Charles Ward, 12, 14

Apthorp, Grizzell (Mrs. Barlow Trecothick), 14, *14*, 15

Apthorp, Grizzell Eastwick (Mrs. Charles Apthorp), 12, 13, 15, 33

Apthorp, Susan (Mrs. Bulfinch), 14, 15

Aragon, Louis, *Le Paysan de Paris* (1926), 384

Aratani, Setsuo, 296

Arensberg, Walter and Louise, 350

Armenia (ship), 103

Armory Show, New York (1913), 307, 350, 423, 425

Arnautoff, Victor, 401

Arp, Jean, 354

Art Digest (periodical), 349

Art Institute of Chicago, 303, 321, 338, 354, 357; exhibitions at, 453

Art Journal (periodical), 183, 196, 232

Art of This Century gallery, New York, 390

Arts and Crafts Movement, 252, 266, 294

Art Students League, New York, 219, 306, 314, 321, 330, 334, 393, 409

Ashbery, John, 243

Ashcan School. *See* Eight, the

Asiatic (Japanese) Exclusion League, 294

assemblage, 409, 428

Atlantic Monthly (periodical), 127, 183, 190–91

Audubon, John James, 255, 258; *Birds of America* (1827–38), 255, 258; *Ornithological Biography* (1831–39), 258; *Trumpeter Swan (Cygnus Buccinator)*, 257, 258

Ault, Charles Henry, 311

Ault, George, 311–13; **The Mill Room**, 311, **312**, 313

Avegno, Virginie. *See* Gautreau, Madame Pierre

Avery, Benjamin P., 97

Avis, John, 201, 202, 203

Bacher, Otto, 192

Bailey, L. H., *Sketch of the Evolution of Our Native Fruits* (New York, 1898), 60

Bailey, Mildred, 425

Baldwin, Helen Dickinson, 317

Baltimore Intelligencer (newspaper), 39

Banneker, Benjamin, 345

Barberini Faun, 116

Barbizon School, 168, 227

Bard, James, 101–4; *C. Vanderbilt–Oregon Race*, 103–4; *The James Stevens*, 103; *The Steamship "Jay Gould,"* 103, *103*; **The Steamship "Syracuse,"** 101–4, **102**

Bard, John, 101

Barnes, Albert C., 274, 307, 366, 371

Barnes, Djuna, 274

Barnes Foundation, Merion, Pa., 342, 366, 368; installation view, 368, 369

Barr, Alfred H., Jr., 285, 390

Bartlett, William Henry, *The Nile Boat* (1853), 183

Bartow, Maria, 65

Bassano, Caroline de, marquise d'Espeuilles, 205, 206

Bates, William Rufus Gray, 64

Battell, Robbins, 203

Baudelaire, Charles, 399

Bauhaus, 337

Baule (Ivory Coast) mask, 366, 368

Bayeux Tapestry, 403

Bazille, Frédéric, 225

Beal, Gifford, 218

Bearden, Romare, 342

Beardsley, Aubrey, 310

Beaux, Cecilia, 239

Belasco, David, 281

Bellay, Charles, 227

Bellini, Giovanni, 349

Bellows, George, 269, 423; *Cliff Dwellers*, 337

Bender, Albert M., 326, 328, 329

Benjamin-Constant, Jean-Joseph, 239

Benton, Thomas Hart, 338, 347, 357–61, 380, 461; *America Today* (mural cycle), 357; *The American Historical Epic*, 357; *The Arts of Life in America* (mural cycle), 357; *Hollywood*, 359, 360, 361; *Persephone*, 359, 360, 361; *A Social History of Indiana* (mural cycle), 357; *The Social History of Missouri* (mural cycle), 357; **Susanna and the Elders**, 357–59, **358**, 361

Berger, Norma, 271

Berkeley, Dean George, 5

Biederman, Charles, 354–56; **Paris 140, January 14, 1937**, 354–56, **355**

Bierstadt, Albert, 113–28, 136, 164, 193, 196, 467; **California Spring**, 125–28, **126**; *Donner Lake from the Summit*, 123, 123, 125, 128; *The Rocky Mountains, Lander's Peak*, 127; **Roman Fish Market, Arch of Octavius**, 113–16, **115**; **Sunlight and Shadow**, 117–20, **118**, 125; *Sunlight and Shadow* (sketch), 117, 119; **View of Donner Lake, California**, **122**, 123–24

Bierstadt, Rosalie, 127

Bingham, George Caleb, 86–93; *Boatman: Study for "Boatmen on the Missouri,"* 88, 88; **Boatmen on the Missouri**, 86, 87–89; *Citizen*, 90, 92; **Country Politician**, 90–93, **91**

Bingham Resolutions, 93

Birch, Thomas, 54–56; **The Narrows, New York Bay**, 54–56, **55**; *View of a Bay*, 56; *View of Lemon Hill, the Seat of Henry Pratt, Esq.*, 56

Bischoff, Elmer, 419, 428, 448, 458–60; **Yellow Lampshade**, 458–60, **459**

Bishop, W. H., 185

Blackburn, Joseph, 14

Blake, William, 361, 362

Blennerhassett, Harman, 46

Blesh, Rudi, 426–27

Bloch, Albert, 300–303; *The Blue Bough*, 302; **Natch I**, 300–303, **301**; *Natch IV*, 302, 303; *Natch V*, 302, 303

Blodgett, William T., 107

Blue Rider. *See* Der Blaue Reiter

Boccioni, Umberto, *States of Mind* (triptych), 303

Boime, Albert, 205, 211

Bonaparte, Napoleon, 45, 183

Bonnard, Pierre, *Interior at Le Cannet*, 395, 396

Boone, Daniel, 86, 97

Booth, Cameron, 453

Booth, John Wilkes, 204

Boott, Elizabeth, 192

Boston Art Club, 188, 190, 288

Boston Evening Transcript (newspaper), 187

Boston Globe (newspaper), 255, 258

Boston Public Library, Sargent's murals for, 209

Boston Sunday Post (newspaper), 255

Boston Tea Party, 23

Botticelli, Sandro, 341

Bouguereau, William-Adolphe, 238

Boulanger, Gustave, 238

Bourdette, Stephen, 161

Bowie, Jim, 97

Boynton, Ray, 326

Bradford, William, 193–96; *The Panther among the Icebergs in Melville Bay*, 196; **Scene in the Arctic**, **194**, 195; *The Arctic Regions, Illustrated with Photographs Taken on an Art Expedition to Greenland* (1873), 193, 196

Bradford, Fuller, and Co., New Bedford, Mass., 193

Bradstreet, Anne, 4

Brady, Mathew (attrib.), *James and Eliza Brown in Their New York City Parlor* (photograph), 153, 154

Brancusi, Constantin, 354

Braque, Georges, 354

Braun, Adolphe, *Hare and Ducks* (photograph), 225, 225

Breckenridge, Hugh, 334

Bregler, Charles, 234

Breton, André, 391, 397; *Manifesto of Surrealism* (1924), 388; with Yves Tanguy et al., *Cadavre exquis*, 390

Brice, William, 405, 408

Bridgman, George, 330

Brinton, Christian, 371

Bronx Central Annex Post Office, New York, Shahn's murals for, 375

Brooklyn Art Association, 117

Browne, John Coats, 31, 32

Brown, Eliza Marie Coe, *151*, 152, 153

Brown, James, *151*, *152*, 153

Brown, Joan, 448–52; **Noel and Bob**, 448, **449**, 451–52; *Noel at Table with Vegetables*, 448; *Noel at the Table with a Large Bowl of Fruit*, 451; *Noel in the Kitchen*, 451; *Noel on a Pony with Cloud*, 448; *Noel on Halloween*, 451; *Noel's First Christmas*, 448; *Portrait of a Girl*, *451*, 452

Brown, John, 201–4, 202, 203, 371–73, *372*

Brown, John Crosby, 153

Brown, John George, 159–61; *Longshoremen's Noon*, 197, 199; **On the Hudson**, 159–61, **160**

Brown, Kathan, 442

Brown, William Adams, 151, 152

Brown Brothers and Company, New York, 152

Bryant, Louise, 277

Bryant, William Cullen, 65, 67; *Picturesque America* (New York, 1874), 304

Bunker, Dennis Miller, 216–21, 250; **A Bohemian**, 216, **217**, 219–20; *The Guitar Player. See* Bunker, Dennis Miller, *A Bohemian*

Burchfield, Charles, 380

Burke, Edmund, 65; *Philosophical Inquiry into the Origins of Our Ideas of the Sublime and the Beautiful* (1757), 73, 74

Burr, Aaron, 43, 45, 46

Burroughs, Betty, 330

Buttall, Jonathan, 33, *33*

Cabanel, Alexandre, 201

cadavre exquis, le (game), 388, 390

Caffin, Caroline, *Vaudeville* (1914), 278, 280

Cahill, Holger, 285

Calhoun, John, 74

California Art Gallery (periodical), 125

California Institute of Technology, Pasadena, 428

California Palace of the Legion of Honor, San Francisco, 299, 329

California School of Fine Arts, 393, 401, 414, 428, 448, 453, 458; Rivera's murals in, 329

California State College, Sacramento, 419, 432

California State University, Sacramento. *See* California State College

California Watercolor School, 292

Camera Work (periodical), 320

Campbell, Sheriff James W., 201, 202, 203

Campbell-Thiebaud Gallery, San Francisco, 440

Campendonk, Heinrich, 300

Canaletto, 51

Card, Fred Wallace, 60

Carnac, France, prehistoric site, 391–92, *391*

Carolus-Duran, 205, 209

Carver, George Washington, 345

Cash, Sarah, 136, 138

Cassatt, Alexander, 229, 231

Cassatt, Lydia, 229, *229*

Cassatt, Mary, 227–31; *The Child's Bath*, *230*, 231; *The Letter*, *230*, 231; *The Mandolin*, 227; **Mrs. Robert S. Cassatt, the Artist's Mother**, 227, **228**, 230, 231; *Woman in a Loge (Lydia in a Loge, Wearing a Pearl Necklace)*, 229, *229*

Cassatt, Robert, 227

Cassatt, Mrs. Robert S., 227, *228*, 230

Cave, Howard, 257

Caws, Mary Ann, 397

Cayuga (ship), 159, *160*

Centennial International Exhibition, Philadelphia (1876), 125, 169, 171, *172*, 200, 222, 232

Central High School, Philadelphia, 169, 259

Central Pacific Railroad, 121, 128

Century Association, 142

Century Magazine, 221

ceramics, pre-Columbian, *328*, 329

Cercle des arts libéraux, 209

Cézanne, Paul, 274, 342, 366, 405; as influence, 265, 274, 277, 334, 350, 354, 401, 403

Chalfant, Jefferson David, 236–39; **Bouguereau's Atelier at the Académie Julian**, **237**, 238–39; *Study for "Bouguereau's Atelier at the Académie Julian,"* 238, *238*

Chaplin, Charles, 227

Chardin, Jean-Siméon, 225

Charlotte, queen of England, 31, 42

Chase, William Merritt, 216, 311; in Munich, 190; studio of, 218–19, *218*, 258; as teacher, 191, 199, 219, 267, 273, 350; *Tenth Street Studio*, 218–19, *218*; *The Turkish Page*, 190

Cheere, Henry, 14

Chevreul, Eugène, 266

Chirico, Giorgio de, 377–78, 390, 391; *Mystery and Melancholy of a Street*, 377; *Nostalgia of the Infinite*, 391, *391*

Chouinard Art Institute (now the California Institute of the Arts), 465

Church, Frederic Edwin, 105–12, 168, 195; as critic, 73; as influence, 145; preeminence of, as landscapist, 65, 125, 136, 193; *Heart of the Andes*, 107, 109, 112; *The Icebergs*, *193*, 195; *Niagara*, 105, 107, *107*, 109; **Rainy Season in the Tropics**, 110–12, *111*, 145; *Twilight*, 105, *106*, 107, 108–9

City Art Museum, St. Louis, Missouri, 361

City College, New York, 375

City College, Sacramento. *See* Sacramento Junior College

City College of San Francisco, Rivera's murals in, 329

Civil Rights Act (1875), 204

Civil Rights Act (1964), 447

Civil War. *See* War, American Civil

Clark, Alfred Corning, 236

Clark, Claude, 366–70; **Guttersnipe**, 366, **367**, 368–70

Clarke, Richard, 23

Claude (Lorrain), 65, 68, 74, 127

Clay, Henry, 50

Cleveland School of Art, 271

Coady, Robert, 311

Cole, Thomas, 54, 65–73, 80, 100, 105, 168; *The Consummation of Empire*, 70, 72; *The Course of Empire* (series), 65, 70, 72; *The Cross and the World* (series), 73; *Essay on American Scenery* (1836), 68, 69; *Landscape with Figures: A Scene from "The Last of the Mohicans,"* 67, 68; **Prometheus Bound**, 70–73, **71**, 105; *View near the Village of Catskill*, 66, 67–69, *67* (detail); *The Voyage of Life* (series), 65, 73

Coleman, Glenn O., 423

collage, 409, 413, 428

Collins, Burgess ("Jess"). *See* Jess

Colonial Williamsburg Foundation, 4, 351, 352, *352*

Color-Field painting, 440

Colt, Samuel, 97

Columbia College, South Carolina, 321

Columbia Teachers College, New York, 321

Columbia University, New York, 267, 397

Columbus Museum of Art, 274

Comics Code Authority, 421

Comly, John, 85

Connor, Theophilus Eugene "Bull," 444

Constable, John, 65

Constructivism, 409, 436

Cook, Clarence, 220

Coolidge, Thomas Jefferson, 220

Cooper, James Fenimore, 67; *England* (1837), 134; *The Pioneers* (1823), 67

Cooper Union, New York, 222

Copley, John Singleton, 16–23, 24, 35, 42, 252; *Henry Pelham (Boy with a Squirrel)*, 20, 22; *Mrs. Benjamin Pickman (Mary Toppan)*, 18, 19; **Mrs. Daniel Sargent (Mary Turner)**, 16–19, **17**; *Mrs. James Warren (Mercy Otis)*, 18, 19; **William Vassall and His Son Leonard**, 20–23, **21**

Corbett, Edward, 401, 428

Corcoran Gallery of Art, Washington, D.C., 349

Corcoran School of Art, Washington, D.C., 252

Cork School of Design, Ireland, 201

Cornelius Vanderbilt (ship), 103

Correggio, Antonio Allegri, 229; *Venus and Love Discovered by a Satyr*, 359

Cosmopolitan Magazine, 263

Cotán, Juan Sánchez, 59

Courbet, Gustave, 188

Couture, Thomas, 148, 227

Coventry, Francis, *The History of Pompey the Little: or, The Life and Adventures of a Lap Dog*, 42

Cowles Art School, Boston, 219

Cozad, Robert Henry. *See* Henri, Robert

Crane, Hart, 274; "To Brooklyn Bridge" (poem), 337

Craven, Thomas, 347

Crawford, Ralston, 307

Crayon, The (periodical), 96–97

Critcherson, George. *See* Dunmore, John, and Crockett, Davy, 97

Cropsey, Jasper Francis, 78–81; *Autumn—On the Hudson*, 80; *View from Bald Mountain, Orange County, New York, October 3, 1843*, 80, 81; **View of Greenwood Lake, New Jersey**, 78, **79**, 81, 108

Croton Aqueduct System, New York, 304

Crown Point Press, San Francisco, 442

Cubism: in America, 307; anticipation of, 243; influence of, 334, 350, 357, 409, 411, 416; *see also* Realism, Cubist-; Synthetic Cubism

Cunningham, Imogen, *David Park with "Portrait of Lydia"* (photograph), 416

Currier and Ives, 98, 100, 225, 255

Curry, John Steuart, 338, 347–49, 380; *Ajax*, 347; **Self-Portrait**, **348**, 349; self-portrait (1927–29), 349

Dada, 309, 428

Dagett, Alfred, 129

Daily Alta California (newspaper), 96

Dai Shizen. *See* Great Nature

Dalí, Salvador, 387, 390, 391

Daniel Gallery, New York, 307

Darwin, Charles, 145; *On the Origin of Species by Means of Natural Selection* (1859), 81, 112, 143; *On the Various Contrivances by Which British and Foreign Orchids Are Fertilised by Insects* (1862), 143

Daumier, Honoré, 444

David, Jacques-Louis, 34, 45; *The Death of Socrates*, 46; *Leonidas at Thermopylae*, 46 (detail), 47; *Le Sacre de Napoléon Ier*, 62

Davies, Arthur B., 362, 423

Davis, Stuart, 311, 384, 423–27, *426*; "Cube Root, The" (essay, 1943), 423; *American Painting*, 425; *The Back Room*, 423; *Barrel House—Newark*, 423; *For Internal Use Only*, 425, *425*, 426; *Hot Still-Scape in Six Colors—7th Avenue Style*, 425; *House and Street*, 426; *The Mellow Pad*, 425; *New York under Gaslight*, 425; **Night Life, *424***, 425–27; *Swing Landscape*, 425

Dawson-Watson, Dawson, 300

DeCamp, Joseph, 192

Decluse Academy, Paris, 334

DeFeo, Jay, 465

Degas, Edgar, 209, 229, 278; as influence, 212, 259, 436; *Le Café—Concert des Ambassadeurs*, 280, 281

de Kooning, Willem, 400, 403, 422, 432, 461–64; **Untitled XX**, 461, *462*, 464; *Woman*, *463*, 463; *Woman I*, 463, *463*, 464; "Woman" paintings, 461, 463

Delaroche, Paul, 94

Delaunay, Robert, 337

Demuth, Charles, 274, 277, 307–10, 311, 323; **From the Garden of the Château**, 307, **308**, 309–10

De Peyster Painter, the, 8–11; (attrib.), **Maria Maytilda Winkler**, 8–11, *9*

Der Blaue Reiter (The Blue Rider), 276, 300, 303

Der Sturm Gallery, Berlin, 303

De Stijl, 356

Dewing, Thomas Wilmer, 248–51; **Elizabeth Platt Jencks**, 248–50, *249*; *The Lute*, 250, 251

Diaz de la Peña, Narcisse Virgile, 167

Dickinson, Burgess, 314, 317

Dickinson, Edwin, 314–17; *An Anniversary*, 314, 316–17, *316*; **The 'Cello Player, *315***, 317

Dickinson, Howard, 314

Dickinson, Preston, 274, 307

Didymus. *See* Heade, Martin Johnson

Diebenkorn, Richard, 405–8, 417, 419, 448, 465; *Albuquerque* (series), 401, 405; *Berkeley* (series), 401, 404, 405; **Berkeley No. 3**, 401–4, **402**; *The Green Huntsman*, 403, *404*; *Ocean Park* (series), 401, 405, 407, 408; **Ocean Park 116, *406***, 408; *Urbana* (series), 401, 405

Diez, Wilhelm, 188

Disney Productions, Inc., 432, 436

Divisionism, 271

Donner, George and Jacob, 121

Donner Party, 94, 121

Douglas, Aaron, 342–46, 366; *Aspects of Negro Life* (mural cycle), 342; **Aspiration**, 342–47, **343**; *Evolution of Negro Dance* (mural cycle), 342; *Harriet Tubman* (mural cycle), 342, 344; *Into Bondage*, 342, 344; *The Negro's Gift to America*, 342; *Symbolic Negro History* (mural cycle), 342

Dove, Arthur, 311, 323–25; **Sea Gull Motive (Sea Thunder or The Wave)**, 323, **324**, 325

Dow, Arthur Wesley, 273, 318, 321, 362, 364; *Composition* (Boston, 1899), 362

Downtown Gallery, New York, 311, 425

Dreier, Katherine, 274

Driggs, Elsie, 307

du Bois, Guy Pène, 306

Du Bois, W. E. B., 345, 368; "The Talented Tenth" (essay, 1903), 368

Duchamp, Marcel, 274, 309, 350; *Fountain*, 307

Dudley, Joseph, 139

Duhamel, Marcel, 390

Dumond, Frank Vincent, 334

Duncan, Robert, 428; "Often I Am Permitted to Return to a Meadow" (poem), 430–31; *The Opening of the Field* (New York, 1960), cover for, 430, *430*

Dunlap, William, 65

Dunmore, John, and George Critcherson, *The Steamer "Panther" Moored to the Ice in Melville Bay* (photograph), 195, 196

Durand, Asher B., 65, 164, 168

Durand-Ruel, Paul, 229

Dürer, Albrecht, 271, 338

Durrie, George Henry, 98–100; **Winter in the Country**, 98–100, **99**

Durrie, Mary Clarissa, 98

Düsseldorf Academy, 105, 113, 117, 119, 125, 146, 148, 162

Duveneck, Frank, 188–92; *Guard of the Harem*, *191*, 192; **Study for "Guard of the Harem,"** *189*, 192; *The Turkish Page*, 190–91, *190*, 192

Duveneck Boys, 191–92

Dyck, Anthony van, 31, 207; *George Villiers, 2nd Duke of Buckingham, and Lord Francis Villiers*, 31; *Marie Claire de Croy, Duchesse d'Havré, and Child*, 150, 152

Eakins, Thomas, 150, 169–77, *177*, 197, 201, 232, 234, 283; **The Courtship**, 169–73, **170**; *Figure Model*, 171; **Frank Jay St. John**, 174–77, **175**; *The Gross Clinic*, 169, 172; *In Grandmother's Time*, 169; *Professor Henry A. Rowland*, 174, 176, 177; *William Rush Carving His Allegorical Figure of the Schuylkill River*, 169

Earle's Galleries, Philadelphia, 204

East West Art Society, 292, 295, 296

Echaurren, Roberto Matto, 390, 397

Ecole des Beaux-Arts, Paris, 169, 201, 205, 209, 219, 220, 227, 236, 238

Eddy, Arthur Jerome, *Cubists and Post-Impressionism* (Chicago, 1919), 300, 302

Egypt, Afro-Egyptian style and, 344–46

Egyptomania, 183

Eibl, Ludwig, 224

Eight, the (Ashcan School), 199, 259, 274, 285, 309, 330, 333, 334, 423

El Greco, 444

Eliot, T. S., 399

Ellington, Duke, 425

Ellis, Mary H., 361

Emerson, Ralph Waldo, 74, 146, 203, 271, 273

Equal Rights Amendment, 321

Erie Canal, 101, 108

Ernst, Max, 390

Esquire magazine, 359

Evans, Joe, 221

Evening Post (newspaper), 155

exhibitions: *Abstract and Surrealist Art in America* (1944), 390; *American Artists at Home and in Europe* (1881), 231; *Artists in Exile* (1942), 390; *Black and White Are Colors* (1979), 397; *Cubism and Abstract Art* (1936), 354; *European Artists in America* (1945), 391; *Fantastic Art: Dada and Surrealism* (1936), 390, 395; *The First Papers of Surrealism* (1942), 390; *Five Contemporary American Concretionists: Biederman, Calder, Ferren, Morris, Shaw* (1936), 354; *Fortieth Annual Exhibition*, National Academy of Design (1865), 155; *Newer Super Realism* (1931), 390; *Paintings on the Theme of the Woman* (1953), 463; *Two Hundred Years of American Painting* (1946), 227; *Young America* (1960), 448

Exposition Universelle, Paris (1889), 204, 288

Fairfield, John, 146

Farmer, Sarah, 273

Fauvism, 199, 334, 350, 357, 416

Federation of Modern Painters and Sculptors, 395

Feininger, Lyonel, *The Cathedral of Socialism*, 337

Feke, Robert, 12–15; *Mrs. Barlow Trecothick*, *14*, 15; **Mrs. Charles Apthorp (Grizzell Eastwick Apthorp)**, 12–15, **13**

Ferus Gallery, Los Angeles, 465

figuration. *See* San Francisco Bay Area Figurative Art movement

Fine Arts Academy, Buffalo, 117

FitzGerald, Edward, *The Rubáiyát of Omar Khayyám*, 187

flux-image, 428

Fogg Art Museum, Harvard University, 444

folk art, 85, 371

Forain, Jean-Louis, 278

Forbes, John Murray, 167, 168

Force, Juliana, 371

Ford Motor Company, River Rouge, Mich.,
 photographic portfolio of, 350

Forepaugh, William, 41

Forest and Stream (periodical), 141, 143

Foshay, Ella, 143, 145

Fra Angelico, 341

frames, 181, 248, 251

Francis, Sam, 405

Franco, General Francisco, 400

Frankenstein, Alfred, 240, 244

Frank Leslie's Illustrated Newspaper, 135

Franklin, Benjamin, 31, 60

Franks, David, *10*

Franks, Phila, 8, *10*

Freake-Gibbs Limner, 2–4; **David, Joanna,
 and Abigail Mason,** 2–4, **3**

Freedom Riders, 444

Freemasons, 70, 72

Freer, Charles Lang, 248

Frémont, Colonel John C., 96

fresco, 271, 326, 328, *328*

Freud, Sigmund, 385, 388

Freyburg, Karl von, 271, 276, 277

Friedrich, Caspar David, 77

Furber, Robert, *Twelve Months of Fruit* (1738),
 60

Futurism, 303

Gage, General Thomas, 23

Gainsborough, Thomas, 150; *Jonathan Buttall
 (The Blue Boy),* 31, 33, 248

Galerie Georges Petit, Paris, 211

Galerie Paul Guillaume, Paris, 391

Gallatin, Albert E., 278, 354

Gallery 291, New York, 273, 274, 320, 334

Gallery of Living Art, 354

Gambier, James, 23

Garbisch, William Edgar and Bernice Chrysler,
 371

García Lorca, Federico, "Lament for Ignacio
 Sánchez Mejías" (poem), 399, 400

Gardner, Isabella Stewart, 220, 221

Gautreau, Madame Pierre (Virginie Avegno),
 205, 207, 209

Gay, Peter, 276

George, Heriot, 74

George III, king of England, 38, 42; as patron,
 31, 35

George IV, king of England, 37

Georges Pompidou Cultural Center, Paris, 391

Georgia O'Keeffe Museum, Santa Fe, 318

Gérôme, Jean-Léon, 169, 219, 227

Gifford, Sanford Robinson, 125, 132–35, 162;
 Study of Windsor Castle, 134, 135; **Windsor
 Castle,** 132–35, **133**

Gikow, Ruth, 446

Gilded Age, 150, 154, 201, 246

Gile, Selden, *The Red Tablecloth,* 442, *442*

Gilpin, William, 65

Giorgione, 385

Giotto di Bondone, 326, 341, 375; *The Lamenta-
 tion,* 328, 329

Gist, Mordecai, 24, 25, 27

Gist, Thomas, 24

Glackens, William, 259–62, 423; **May Day in
 Central Park, 260,** 261–62

Gleizes, Albert, 309

Gobelins Manufactory, Paris, 266

Godwin, E. W., 178

Goelet, Robert Walton, portrait of, 248

Gogh, Vincent van, 342, 366; *First Steps,* 452;
 Self-Portrait with Bandaged Ear and Pipe,
 349; *Self-Portrait with Pipe,* 349

Goodrich, Andrew T., *North American Tourist*
 (1839), 67

Goodrich, Lloyd, 307, 383, *383*

Gopnik, Adam, 209, 439

Gorky, Arshile, 390, 403, 461; *Golden Brown,*
 403, *404*

Gottlieb, Adolph, 393, 395

Goya, Francisco de, 283, 444, 448, 451; *Don
 Manuel Osorio Manrique de Zuñiga,* 450,
 452; *Saturn Devouring His Son,* 455–56, *456;*
 The Third of May, 1808 in Madrid, 447

Grant, William, 62

Gray, Thomas, 135

Gray, William, 64

Gray, William Rufus, 62–64, *63*

Grayson, Andrew Jackson, 96, 121, 124

Grayson, Frances, 96, 121

Grayson, Ned, 96, 121

Great Migration, 366

Great Nature (*Dai Shizen*), as belief, 292, 295,
 296, 299

Greeley (Colo.) Tribune (newspaper), 164

Greenberg, Clement, 412

Greene, George Washington, 65

Grillo, John, 401

Gross, Dr. Samuel David, 169, 172

Grosz, George, 444

Grunewald, Gustav, 74–77; *Niagara Falls,* 76,
 77; (attrib.) **Horseshoe Falls from below the
 High Bank,** 74, *75,* 76–77; **Niagara River at
 the Cataract,** 74, *75,* 76–77

Guggenheim, Peggy, 390

Guggenheim Museum, New York, 390

Gypsies, 216, 219

Haas, Elise S., 416

Haas (marmotintoist), 35

halation, 439

Hallgarten Prize, 219

Halpert, Edith, 311

Hals, Frans, 192, 230, 231, 259, 283; *The Regent-
 esses of the Old Men's Alms House,* 231

Hamilton, Alexander, 46

Hamilton, Mrs. Alexander, portrait of, 146

Hamilton, James, 195

Hammerstein, Oscar, 282

Hammond, John, 423

Hancock, John, 23

Handy, W. C., 425

Hanford Atomic Energy Project, Richland,
 Wash., 428

Harding, Chester, 86

Harlem Renaissance, 342, 368

Harnett, William Michael, 222–26, 232, 240, 244;
 After the Hunt, 222, **223,** 225–26, 257; *Job Lot
 Cheap,* 240, 242

Harper's New Monthly Magazine, 165

Harper's Weekly (periodical), 129, 155

Harris, Isaac, 28

Harris, Michael, 158

Hartley, Marsden, 271–77, 323, 337; **A Bermuda
 Window in a Semi-Tropic Character,** 274,
 275, 277; *Portrait of a German Officer,* 271,
 276; *Somehow a Past* (memoir, 1998), 271;
 The Summer Camp, Blue Mountain, 271,
 272, 273, 274

Haseltine, William Stanley, 125

Hashimoto, Gaho, 292

Hassam, Childe, 288–91; *In the Garden (Celia
 Thaxter in Her Garden),* 290–91, *290;* **Sea-
 weed and Surf, Appledore, at Sunset,** 289,
 291

Hassam, Maude, 288

Hastings, Lansford, *The Emigrants' Guide to
 Oregon and California* (Cincinnati, 1845), 121

Havemeyer, Henry O. and Louisine W., 227

Hawthorne, Charles, 314

Hawthorne, Nathaniel, 288; portrait of, 146

Hayes, Dr. Isaac, *The Open Polar Sea* (1855), 195

Heade, Martin Johnson, 136–45, 168; Didymus,
 as pseudonym, 141; *Breaking Waves, Newport.*
 See Heade, Martin Johnson, *Singing Beach,
 Manchester;* "Eagle Cliff" (sketch), 138; *Gems
 of Brazil* (lithographs), 143, 145; **The Great
 Swamp,** 139, **140,** 142; **Orchid and Humming-
 bird, 144,** 145; **Singing Beach, Manchester,**

136–38, **137**, 143; *Sunset on Lake Champlain*, 136; *Thunder Storm on Narragansett Bay*, 141–42, *141*; *Twilight, Spouting Rock Beach*. See Heade, Martin Johnson, *Singing Beach, Manchester*

Hébert, Antoine, 219

Henderson, Helen, 281

Henri, Robert, 259, 267, 283–87, 423; **Lady in Black with Spanish Scarf (O in Black with a Scarf)**, 283, **284**, 285–86; *Young Woman in White*, 286, *286*

Henry Clay (ship), 103

Herms, George, 465

Herschel, William, 38

Hicks, Edward, 82–85, 136; *A Little Present for Friends & Friendly People* (sermon), 82; *Memoirs* (Philadelphia, 1851), 85; *Peaceable Kingdom (with Rhymed Borders)* (1826–27), 84; *The Peaceable Kingdom* (ca. 1830–35), 84; **The Peaceable Kingdom** (ca. 1846), **83**, 84

Hicks, Elias, 82

High Bridge, New York, 304, 305

Hillard, George, 116

Hines, Earl "Fatha," 423

Hirohito, emperor of Japan, 296, 299

Hogarth, William, 150; *The Strode Family*, 150, 152

Hokusai, Katsushika, 469, 472; *Cresting Wave off the Coast of Kanagawa*, 471, *471*

Holbein, Hans, 338

Homer, Winslow, 150, 155–58, 168, 269–70; *The Bathe at Newport*, 129; **The Bright Side**, 155–58, **156**; *The Fog Warning*, 269, 270

Hone, Philip, 49, 50

Hopper, Edward, 380–84, 401, 460; *Early Sunday Morning*, 384; *East Wind over Weehawken*, 382; *Gas*, 383, *383*, 384; *Haskell's House*, 382; **Portrait of Orleans**, 380–84, *381*; *Room in New York*, 460; *Rooms for Tourists*, 382; *Street Scene, Gloucester*, 382

Hopper, Jo, 382

Hopper, Marion, 383

Horniday, William T., *Taxidermy and Zoological Collection* (1894), 258

Horter, Earl, 366

Hovenden, Thomas, 201–4; *Breaking Home Ties*, 201; **Last Moments of John Brown**, 201, **202**, 204, 374; *Last Moments of John Brown* (ca. 1884), 201, *203*, 204

Howald, Ferdinand, 307

Howard, Charles, 385–87; **The Progenitors**, 385–87, **386**

Howard, Luke, *Climate of London* (text), 107–8

Howard, Robert Boardman, 296

Hudson River School, 54, 78; development of,

65, 74, 80; influence of, 467; style of, 98, 100, 105, 112, 119, 125, 149

Hudson's Bay Company, Canada, 258

Hughes, Langston: "The Negro Artist and the Racial Mountain" (essay, 1926), 346, 369–70; "The Negro Speaks of Rivers" (1922), 344

Humboldt, Baron Alexander von, 112; *Cosmos*, 105

Huneker, James, 269

Hunt, William Holman, *The Awakening Conscience*, 181, *182*

Hunt, William Morris, 165–68, 291; *Governor's Creek, Florida* (1873), 167, *168*; **Governor's Creek, Florida** (1874), 165, **166**

Hunter, George Leland, *Decorative Textiles* (1918), 266

Huntington, Collis P., 121, 123, 124, 128

Huysmans, Joris-Karl, 310

ikebana, 292

Impressionism, 209, 229, 252, 288, 306, 357

Indianapolis Star (newspaper), 359

Ingres, J.-A.-D., 419

Inman, Henry, 50

Inness, George, 168

Intimate Gallery, New York, 320, 323

Inverno, Nicolo d', 213

Irving, Washington, 48, 67; "Rip van Winkle" (1819), 67

Irwin, Robert, 465

Ives, Halsey C., 300

Jackson, Andrew, 74, 90

Jackson, Claiborne, 92

Jackson Resolutions, 92, 93

Jacomb-Hood, George P., 182

Jaenecke-Ault Printing Ink Company, New York, 311, 313

James, Henry, 131, 190, 211, 236

Janis, Sidney, *Abstract and Surrealist Art in America* (New York, 1944), 390

Japan, art of, as influence, 230–31, 252, 254, 265, 469

Japan Art Exhibition, Tokyo (1928), 299

Japonisme, 294

Jarves, James Jackson, 109

Jarvis, John Wesley, 48–50; **Philip Hone**, 48–50, *49*

Jay, John, 62

jazz, as subject matter, 423, 425

Jeckyll, Thomas, 180

Jefferson, Thomas, 34, 46, 62; *Notes on Virginia* (1785), 341

Jefferson Guards (Virginia National Guard unit), 201, 202, 203

Jefferson Medical College, Philadelphia, 169

Jencks, Elizabeth Platt, 248, 249, 250–51

Jencks, Francis, 250–51

Jersey Homesteads, Roosevelt, N.J., Shahn's murals for, 375

Jess, 428–31; cover for Robert Duncan, *The Opening of the Field* (New York, 1960), 430, *430*; **If All The World Were Paper And All The Water Sink**, 428–31, **429**; *LXXI. Qui Auget Scientiam Auget Dolorem*, 430, 431; "... When We Will Tempt the Frailty of Our Powers ...": Salvages V, 430

Jewell, Edward Alden, 395

Jewett, William Smith, *The Promised Land— The Grayson Family*, 96, 97, 121, 124

Jocelyn, Nathaniel, 98

Johnson, Eastman, 139, 146–54; *The Cranberry Harvest*, 146; *Negro Life at the South (Old Kentucky Home)*, 146, 148, 149; *Old Kentucky Home. See* Johnson, Eastman, *Negro Life at the South; Portraits. See* Johnson, Eastman, *Portraits (The Brown Family)*; **Portraits (The Brown Family)**, 150–52, **151**, 154; **Sugaring Off**, 146, **147**, 148–49, 150

Johnson, George, 41

Johnson, Joshua, 39–42; *Grace Allison McCurdy (Mrs. Hugh McCurdy) and Her Daughters, Mary Jane and Letitia Grace*, 41, 42; **Letitia Grace McCurdy**, **40**, 42

Johnson, Pete, 425

Johnson, Philip, 146

Johnston, Joshua. *See* Johnson, Joshua

Jonson, Raymond, 364

Jugend (periodical), 271

Julian, Rodolphe, 236; *see also* Académie Julian

Julien Levy Gallery, New York, 390, 395

Jung, Carl, 385, 395

Junker, Patricia, 72

Kaaterskill (ship), 104

Kabuki theater, 469, 472

Kandinsky, Wassily, 273, 274, 300, 302, 303; *Concerning the Spiritual in Art* (treatise, 1911), 364

Kane, DeLancey Iselin, portrait of, 248

Kane, Elisha Kent, *Arctic Exploration in the Years 1853, 54, 55* (1856), 195

Kansas City Art Institute, Missouri, 357

Kassel Academy, Germany, 94

Kay, Charles de, 265

Keats, John, 362

Keith, William, *Donner Lake*, 124, *124*

Kelly, James P., 199

Kennedy, John F., 447

Kensei-kai (artists' group), 292

Kensett, John Frederick, 129–31, 162; **Sunrise**

among the Rocks of Paradise at Newport, 129–31, *130*

Kent, Rockwell, 267–70; ***Afternoon on the Sea, Monhegan,*** *268,* 269, 270; *The End,* 270, *270;* illustrations for Melville's *Moby-Dick* (1930) by, 267

Kierkegaard, Søren, 400

Kilgore, Emilie, 464

King, Martin Luther, Jr., 444, 447

Kipling, Rudyard, 232

Klein, Jerome, 353

Kline, Franz, 400, 432

Kneeling Female (pre-Columbian ceramic), 328, 329

Kneller, Godfrey, mezzotint after, *10,* 11

Knight, Madge, 385

Knox, General Henry, 62

Kohashi, Haruko, 292, 293, 294

Krauss, Rosalind, 411

Kuhn, Walt, 283

Kunisada, Utagawa, 469, 472; *The Actors Kataoka Gado II and Bando Hikosaburo V as Tamiya Iemon and the Ghost of Oiwa* (play), 471, *472*

Kurtz, Charles, 232

Kuspit, Donald, 458

Kwansei Gakuin University, Kobe, 469

Ladies Manual of Art, The (1890), 258

Lander, Frederick W., 125

Landseer, Sir Edwin, 255

Laurens, Jean-Paul, 239

Lawrence, Jacob, 342

Lawson, Ernest, 304–6; ***Harlem River at High Bridge,*** ***305,*** 306

Lazarus, Annie, 248

Lee, John and Theresa, 283

Lee, Colonel Robert E., 201, 373

Lefebvre, Jules-Joseph, 238, 239

Léger, Ferdinand, 354

Leibl, Wilhelm, 188

Lenin, Vladimir Ilyich, 326

Leonardo da Vinci: *Mona Lisa,* 432; "Vitruvian Man" (drawing), 408

Leutze, Emanuel, 117, 146; *Washington Crossing the Delaware,* 146

Levine, Jack, 444–47; ***Birmingham '63,*** 444–47, ***445;*** *The Feast of Pure Reason,* 444; *Gangster Funeral,* 444; *Six Masters: A Devotion,* 444; *The Spanish Prison,* 444; *The Trial,* 444; *Welcome Home,* 444

Levy, Julien, 390, 395

Lewis, Sinclair, 338

Leyland, Frederick Richards, 178, 180, 182

Life magazine, 349

L'Illustration (periodical), 205

Lincoln, Abraham, 204, 374

Little, Brown and Company, Boston, 288

Lobdell, Frank, 448, 453–57; *Dance* (series), 455, 456; ***Summer 1967 (In Memory of James Budd Dixon),*** 453, ***454,*** 456–57

Locke, Alain, 368, 369; *The New Negro: An Interpretation* (1925), 342, 345, 368

Locke, John, *Some Thoughts Concerning Education* (1693), 23

Longfellow, Henry Wadsworth, portrait of, 146

Long Island Star (newspaper), 48

Loran, Erle, 401

Louis, Joe, 345

Louis, Morris, *Veil* (series), 440

Löwenburg Castle, nr. Kassel, Germany, 117, *118, 119*

L. Prang and Co., Boston, 225

Ludlow, Fitz Hugh, *The Hasheesh Eater* (1857), 127

Luhan, Mabel Dodge, 274, 321

Luks, George, 259, 330, 423

Luminists, 142

MacAgy, Douglas, 401, 458

Macbeth Galleries, New York, 285

Macke, August, 300

MacMonnies, Frederick, 248

Madison, Dolley, portrait of, 146

Magritte, René, 390, 391

Malbone, Edward Greene, 50

Mallarmé, Stéphane, 399

Manet, Edouard, 227, 259, 261, 419; *The Execution of the Emperor Maximilian,* 447; *The Fifer,* 422; *Music in the Tuileries Gardens,* 261, *261,* 262; *Olympia,* 463; *The Spanish Singer,* 219, 220, 221

Manhatta (film), 350

Manhattan Project, 428

Manifest Destiny, 94, 97, 125, 468

Marc, Franz, 300, 303

Marcotte, Léon, 153–54

Marin, John, 274, 323, 334–37; *Four Studies: New York City Abstraction with Figures* (panel), 336, *336; Related to St. Paul's, New York,* 337; ***Study, New York,*** 334, ***335,*** 336–37; *Taos Indian Rabbit Hunt,* 337

Marsh, Fred Dana, 330

Marsh, Reginald, 330–33, 347; *Death Ave.,* 333; ***The Limited,*** 330, ***331,*** 333

Marx, Karl, 313, 388

Marxism, 346

Maryland Historical Magazine, 39

Masaccio, 271

Mason, Abigail, 2, 3

Mason, Arthur, 2

Mason, David, 2, 3, 4

Mason, Joanna, 2, 3

Mason, Joanna (Mrs. Arthur Mason), 2

Massachusetts Society for the Prevention of Cruelty to Animals, 258

Masses (periodical), 423

massiers, 238

Masson, André, 387, 390

Mathias, Bob, 431

Matisse, Henri, 274, 342, 366; as influence, 274, 277, 401, 407, 408, 416, 417, 425; *Artist and Goldfish,* 407, 408; *Femme au chapeau,* 416; *Jazz* (portfolio), 425; *Madame Matisse (The Green Line),* 416; *Studio, Quai St. Michel,* 407; *View of Notre Dame,* 407–8, *407*

Matteson, Tomkins H., 183

Matulka, Jan, 409

Maurer, Alfred, 334

Maurier, George de, *Trilby* (novel, 1894), 216

Maybury, Captain, 28

McAlmon, Robert, 274

McBride, Henry, 307, 321

McCloskey, Alice, 232

McCloskey, William, 232–35; ***Oranges in Tissue Paper,*** 232, ***233,*** 234–35; *Portrait of a Lady,* 232

McCurdy, Grace Allison, *41,* 42

McCurdy, Hugh, 42

McCurdy, Letitia Grace, *40, 41,* 42

McCurdy, Mary Jane, *41,* 42

McDonnell, Patricia, 276

McKim, Charles, 209

McKinsey, Elizabeth, 74

McLaughlin, George, 191

Melville, Herman, 193; *Moby-Dick* (1851), 193, 267; *Omoo* (1847), 193; *Typee* (1846), 193

Memling, Hans, 338

Mencken, H. L., 338

Mendelowitz, David, 401

Metcalf, Willard, 248

Methodism, 244

Metropolitan Museum of Art, New York, 110, 197, 227, 349

mezzotint, *10,* 11, 14, 20

Michelangelo, 330, 344

Middendorf, J. Wilhelm, II, 110

Miller, Kenneth Hayes, 330

Millet, Frank Davis, 186

Millet, Jean-François, 167, 168, 349

Milton, John, *Paradise Lost,* 15

Minneapolis School of Design and Handcraft and Normal Art, 338

Miró, Joan, 354, 390, 416

M'Mahon, Bernard, *American Gardener's Calendar* (treatise), 60

Modigliani, Amedeo, 422

Mondrian, Piet, 273, 354; as influence, 354, 356, 401, 408, 425, 426; *Broadway Boogie Woogie*, 425

Monet, Claude, 209, 211, 212, 225; as influence, 215, 288; John Singer Sargent and, 213; series by, 405

Moniwa, Chikusen, 292

Moore, Charles, *Civil Rights Protestors, Birmingham, Alabama, 1963* (photograph), 446, 446

Moore, Marianne, 274

Morandi, Giorgio, 434

Moravian religious community, 77

Moravian Seminary for Young Ladies, 77

Morise, Max, 390

Morisot, Berthe, 209

Morse, Samuel F. B., 50

Motherwell, Robert, 397–400; **At Five in the Afternoon**, 397, **398**, 399–400; *Elegies to the Spanish Republic* (series), 397; *Elegy to the Spanish Republic, No. 1*, 397, 399; *The Face of Night (for Octavio Paz)*, 399; *The Hollow Men (from T. S. Eliot)*, 399; *Mallarmé's Swan*, 399; *Ulysses*, 399

Mount, William Sydney, 139; *Farmers Nooning*, 157, 158

Muir, John, 296

multiforms, 395

Munich Art Academy, 188

Münter, Gabriele, 300

murals, 209, 227, 265, 281, 326, 329, 342, 357, 375

Murata, Tanryō, 292

Murger, Henri, *Scènes de la vie de bohème* (1851), 216

Murray, John, *Handbook of Rome and Its Environs* (London, 1858), 113

Murray, Samuel (possibly), *Thomas Eakins Painting a Portrait of Frank Jay St. John* (photograph), 176, 177

Museum of Fine Arts, Boston, Sargent's murals for, 209

Museum of Modern Art, New York, 318, 354, 444; exhibitions at, 307, 390, 393, 395, 453

Museum School, Boston, 252

Nabis, the, 265–66

Nadelman, Elie, 371

Nahl, Arthur, 94

Nahl, Charles Christian, 94–97; *The Hunter. See* Nahl, Charles Christian, *Peter Quivey and the Mountain Lion*; **Peter Quivey and the Mountain Lion**, **95**, 96–97

Nahl, Wilhelm, 94

Nanboku, Tsuruya, IV, 472

Narragansett tribe, 139, 141

Nation, The (periodical), 190

National Academy of Design, 283, 285; art training at, 117, 155, 201, 222, 273, 314, 375; exhibitions at, 81, 105, 125, 129, 146, 148, 154, 155, 161, 190, 219, 221, 232; membership in, 65, 78, 105, 142, 349

National Gallery of Art, Washington, D.C., 227

National Women's Party, 321

Native American art, as influence, 337

Neal, David, 224; *After the Hunt*, 224–25, 224

Neher, Michael, *The Fish Market at the Porticus Octaviae*, 116, 116

Nelson, John, 5, 6, 7, 33

Neoplasticism, 356

Neri, Manuel, 448

Neri, Noel Elmer Manuel, 448, 449

Neue Künstlervereinigung München (New Artists' Union, Munich), 300

Neuhaus, Eugen, 401

New England Magazine, 258

New English Art Club, 211

Newman, Barnett, 395, 432

New Negro movement, 342

New Society of American Artists, Paris, 334

New York Daily News (newspaper), 330

New-York Daily Tribune (newspaper), 154, 203, 204

New Yorker, The (periodical), 333

New York Evening Post (newspaper), 127, 265

New York Journal (newspaper), 283

New York Post (newspaper), 353

New York School, 267, 273, 397, 400, 461

New York Sun (newspaper), 269

New York Times (newspaper), 278, 288, 317

New York University, 375

New York World (newspaper), 222, 283

Nicholas, czar of Russia, 393

Nihon Bijutsuin (Japanese Fine Arts Academy), Tokyo, 292

nihonga (Japanese) painting, 292

Noble, Louis L., *After Icebergs with a Painter: A Summer Voyage to Labrador and Around Newfoundland* (1862), 195

Noble, Thomas Satterwhite, *John Brown's Blessing Just before His Execution*, 203, 203

North American Review (periodical), 132

Norton, John, 354

Norvo, Red, 425

Oakey, Maria Richards, 248

Obata, Chiura (Zoroku), 292–99; *Dusk in the High Sierra (Kure Yuki High Sierra)*, 295; *Hatsu Haru (Early Spring* or *New Year)*, 292; *Lake Basin in the High Sierra* (1927), 296,

298; *Lake Basin in the High Sierra* (1928), 296, 298, 299; **Lake Basin in the High Sierra** (ca. 1930), **297**, 299; *Lake Basin in the High Sierra, Johnson Peak, High Sierra, U.S.A.*, 296, 298, 299; **Mother Earth**, **293**, 294–95; *World Landscape Series: "America,"* 296, 298, 299

Obata, Kimio, 294

Obata, Rokuichi, 292, 299

O'Doherty, Brian, 380

O'Donnell, Eliza White, 42

Oedipus, 185

O'Hara, Frank, 399

Ohio Mechanics Institute, 190

Okakura, Kakuzo, 292

O'Keeffe, Georgia, 311, 318–22, 320, 323, 337, 365; **Petunias**, 318, **319**, 321, 322

Oldenburg, Claes, 414, 469

Oliveira, Nathan, 419

Olmsted, Frederick Law, 263

Opportunity Gallery, New York, 322

Orchardson, Sir William Quiller, *Mariage de Convenance*, 212

Oregon (ship), 103

Oregonian (newspaper), 232

Organ, Marjorie, 283, 284

Orphism, 334, 337

Oswald, Frederick C., 357

Otis Art Institute, Los Angeles, 414, 469

Oudry, Jean-Baptiste, 225

Overland Monthly (periodical), 123

Ovid, 173

Owens, Jesse, 345

Pach, Walter, 261

Pacific Stock Exchange, San Francisco, 414; Rivera's murals in, 329

Panther (ship), 195, 196

Paradise Roof Garden, New York, 282

Paris Peace Treaty (1873), 45

Paris World's Fair (1937), 354

Park, David, 401, 414–18, 416, 419, 428, 448, 458; *Bathers on the Beach*, 417; **Couple**, **415**, 416–18; *Encounter*, 417; *Kids on Bikes*, 414; *Two Female Figures*, 417; *Two Heads*, 417

Park, Lydia, 416, 417

Pater, Walter, 286

Paulding, James Kirke, *The New Mirror for Travellers; and Guide to the Springs* (1828), 67

Peale, Angelica, 28

Peale, Charles Willson, 24–30, 41, 57, 240; museum, 24, 27, 28, 30, 57, 61, 240; *The Artist in His Museum*, 30; **Mordecai Gist**, 24–27, **25**; self-portrait (1765), 28; self-portrait (1777–78), 28; self-portrait (ca. 1804), 30;

Self-Portrait (1822), **29**, 30; self-portrait (1822), 30; self-portrait with daughter Angelica, 28; "Staircase Group": Raphaelle and Titian Ramsay Peale, 240; *Staircase Self-Portrait*, 30

Peale, James, 59, 240

Peale, Margaretta, 240

Peale, Raphaelle, 41, 57–61, 240; ***Blackberries, 58***, 59–61, 240; *Venus Rising from the Sea— A Deception (After the Bath)*, 240, 242

Peale, Rembrandt, 41, 57, 97, 259

Peale, Rubens, 30, 240

Peale, Sarah Miriam, 240

Peale, Sophie, 30

Peale family, 232

Pearce, Charles Sprague, *Prelude! 219*, 220

Pedro II, Dom, emperor of Brazil, 143

Pelham, Henry, 20, 22

Pelham, Peter, 20

Pelton, Agnes, 362–65; ***Challenge, 363***, 364–65; *Illumination*, 364; *Mother of Silence*, 364; *Star Gazer*, 364

Pennsylvania Academy of the Fine Arts, 24; art training and, 169, 199–200, 199, 222, 227, 232, 240, 244, 259, 283, 309, 334, 350; exhibition at, 30, 54, 231, 349; faculty of, 197, 199, 201; Thomas Eakins and, 169, 171, 174, 197, 199, 201, 240, 283

Pennsylvania Museum School of Industrial Arts, 366

Pepper, Charles Hovey, 263

Perkins, Thomas Handasyd, 53

Peto, John Frederick, 232, 240–47; ***The Cup We All Race 4***, 244, **245**, 246–47; ***Job Lot Cheap***, 240, **241**, 243

Petty, George, 359

Pevsner, Antoine, 354

Philadelphia Art Union Reporter (periodical), 54

Philadelphia Museum of Art, 227

Philadelphia Photographer (periodical), 196

Philadelphia Record (newspaper), 267

Philbrick, Allen E., 357

Phillips, Duncan, 263

Phillips Collection, Washington, D.C., 407

photography, 96, 97, 104, 185, 196, 199–200, 201, 225, 238, 248, 320, 350, 366; Brady, Mathew (attrib.), *James and Eliza Brown in Their New York City Parlor*, 153, 154; Braun, Adolphe, *Hare and Ducks*, 225, 225; Cunningham, Imogen, *David Park with "Portrait of Lydia,"* 416; Dunmore, John, and George Critcherson, *The Steamer "Panther" Moored to the Ice in Melville Bay*, 195, 196; Eakins, Thomas, and, 171; Ford Motor Company, River Rouge, Mich., as subject, 350; [Man with still] (newspaper clipping), 426, 426; Moore,

Charles, *Civil Rights Protestors, Birmingham, Alabama, 1963*, 446, *446*; Murray, Samuel (possibly), *Thomas Eakins Painting a Portrait of Frank Jay St. John*, 176, 177; Shahn, Ben, *Untitled (Eighth Avenue and Forty-second Street, New York City)*, 377, *377*; *Untitled (Ezra Shahn, Walton Street, Brooklyn, New York City)*, 377, 378; *Untitled (Walton Street, Brooklyn, New York City)*, 377, 378; *Untitled (Warren, Ohio)*, 377, *377*; Sheeler, Charles, *Colonial Williamsburg Kitchen*, 352, 352; Stieglitz, Alfred, *Georgia O'Keeffe*, 320, 320; Tadd, J. Liberty, *Large Antique Class (#3)*, 199–200, 199; unknown photographer, *Stuart Davis at the piano*, 426, *426*

photomontage, 409, *411*

Piazzoni, Gottardo, *Lux Aeterna*, 294, 295

Picasso, Pablo, 274, 342, 366, 453, 464; as influence, 354, 368, 416, 417, 461; *Guernica*, 453, 455, *455*, 457; *Head of a Man*, 368, 369; *Head of a Woman*, 368, 369; *Les Demoiselles d'Avignon*, 368

Piero della Francesca, 271

Pierre Matisse Gallery, New York, 390

Piloty, Karl von, 224

Pinocchio (film), 432

Pippin, Horace, 366, 371–74; *Christ Crowned with Thorns*, 374; *John Brown Going to His Hanging*, 373, 373; *John Brown Reading His Bible*, 373, 373; *Lincoln's First Book*, 373; ***The Trial of John Brown, 372***, 373–74

Piranesi, Giovanni Battista, 439; *The Portico of Octavia: The Entrance Porch, Interior (Vedute interna dell'Atrio del portico de Ottavia)*, 116, *116*

Pittsburgh, bishop of, 229

Pitz, Henry, 366

Plantin Press, Los Angeles, 465

Platt, Charles, 248

Pleasants, J. Hall, 39

Plutarch, *Parallel Lives*, 45

Poe, Edgar Allan, 193

Polk, Bobby, 41

Polk, Charles Peale, 41

Pollitzer, Anita, 321

Pollock, Griselda, 230

Pollock, Jackson, 400, 409, 458, 461

Pop art, 419, 421, 439, 465, 469

Pope, Alexander, 255–58; *Celebrated Dogs of America* (lithograph collection, 1882), 255; *The Trumpeter Swan. See* Pope, Alexander, *The Wild Swan; Upland Game Birds and Waterfowl of the United States* (lithograph collection, 1878), 255; ***The Wild Swan***, 255, **256**, 257–58

Pope, General John, 162

Porter, Fairfield, 432

Port Folio (periodical), 57

Portico of Octavia (*Porticus Octaviae*), Rome, 113, 115, 116, *116*

Port Society of Boston, 53

Possibilities (periodical), 395, 397

Poulson's American Daily Advertiser (periodical), 61

Pound, Ezra, 243, 274

Powers, Hiram, *Greek Slave*, 359

Pratt, Matthew, 35

Pratt Institute, Brooklyn, 314, 362

Precisionism, 307, 310, 311, 313, 333, 350

Prendergast, Charles, 274

Prendergast, Maurice, 263–66, 273, 274, 423; ***The Holiday***, 263, **264**, 265–66

Price, Sir Uvedale, 65

prices, for artwork, 2, 41, 48, 88, 93, 107, 113, 182

prints, woodblock, 296, 298, 299

proto-Surrealism, 377

Proust, Marcel, 310

Puccini, Giacomo, *La Bohème* (opera), 216

Puvis de Chavannes, Pierre, 265

Quakers. *See* Religious Society of Friends

Quarterly Illustrator, The (periodical), 216

Quincy, Josiah, 62

Quivey, Peter, 94–96, 95

Rameau, P., 16

Ramos, Mel, 419–22; *A Salute to Art History* (series), 419; ***Superman, 420***, 421–22

Randall, Alice, 330

Ransom, Louis, *John Brown on His Way to Execution*, 203

Ranson, Jo, 333

Ray, Man, 274

Realism, 278, 283, 285, 287, 393; Cubist-, 307; *see also* Social Realism

Reed, John, 277

Reed, Luman, 70

Reedy, William Marion, 300

Reform Dress Movement, 286

Regiment: Maryland, 27; Massachusetts Fifty-fourth, 158; 369th Infantry "Harlem Hellfighters," 374

Regionalism, 338, 347, 357, 380, 423, 453, 461

Reinhardt, Ad, 428

Reiss, Winold, 342

Religious Society of Friends (Quakers), 82, 84, 85

Remarque, Erich Maria, *All Quiet on the Western Front* (London, 1929), 455

Rembrandt Harmensz van Rijn, 283, 444, 448; *Susanna and the Elders*, 359; *The Three Trees*, 127, 128, 129

Renoir, Pierre-Auguste, 209, 211

Renwick, James, Jr., 304

Revere, Paul, 23, 252

Reynolds, Sir Joshua, 20, 24, 43; *Admiral Sir Robert Kingsmill*, 24, 26, 26; *Discourses* (lectures, 1797), 24

Ribera, Jusepe de, 173

Richardson, Edgar P., 105, 231

Richmond Grays (militia), 204

Rimmer, William, 255

Ringling Brothers Barnum & Bailey, 347

Rivera, Diego, 326–29, 414; *Man at the Crossroads* (mural), 326; **Two Women and a Child,** 326, **327,** 328–29

Robert Annett (ship), 161

Robert-Fleury, Tony, 238

Roberts, Marshall O., 110

Robeson, Paul, 345

Robinson, Frank T., 255

Rockefeller, Abby Aldrich, 307, 352, 371

Rockefeller, John D., 3rd, 2, 4, 51, 384

Rockefeller, Nelson, 326

Rockefeller Center, New York, Rivera's murals in, 326

Rodgers, Jimmie, 333

Rodin, Auguste, 207

Roesen, Severin, 239

Rogers, Henry Wade, 135

Rogers, Meyric R., 361

Roosevelt, Franklin Delano, 251, 375

Rosa, Salvator, 65, 74

Rose, Barbara, 422

Rosenberg, Harold, 412; "The Bird for Every Bird" (poem), 397, 399, 400

Rosenblum, Robert, 395

Ross, Denman Waldo, 444

Rothko, Mark, 393–96, 408, 458, 460, 461, 467; **Untitled,** 393, **394,** 395–96; *Untitled* [recto] (1947), 395, 396

Rothko Chapel, Houston, 396

Rothkowitz, Marcus. *See* Rothko, Mark

Rotterdam Academy of Fine Arts and Techniques, 461

Rowland, Professor Henry A., 174, 176, 177

Royal Academy, Edinburgh, 159

Royal Academy, Munich, 224

Royal Academy of Arts, London, 31, 43, 45, 209, 231

Rubens, Peter Paul, 37, 207, 330, 349, 444

Ruisdael, Jacob Isaacksz van, *A Burst of Sunshine*, 127, 128

Ruscha, Ed, 465–68; *A Certain Form of Hell*, 467, 468; *Lost Empires, Living Tribes*, 467; *Miracle* (film), 468; *Noise, Pencil, Broken Pencil, Cheap Western*, 465; **A Particular Kind of Heaven,** 465–68, **466;** *Premium* (film), 468; *Standard Station, Amarillo, Texas*, 465; *Twentysix Gasoline Stations* (1963), 468; *The Uncertain Trail*, 467

Rush, Benjamin, 149

Ruskin, John, 178, 180, 182; *Modern Painters* (1843–56), 105

Ryder, Worth, 296, 401

Sabanieva, Thalia, 299

Sacco, Nicola, 375

Sacramento Junior College, 419

Sacramento State College, 410

Sage, Kay, 390

Saint-Gaudens, Augustus, 248

Saint Louis Museum, 311

Salmon, Robert, 51–53; **British Merchantman in the River Mersey off Liverpool,** 51–53, **53;** *British Warship in Liverpool Harbor. See* Salmon, Robert, *British Merchantman in the River Mersey off Liverpool*

Salon, Paris, 229, 238, 285; exhibition at, 43, 45, 205, 220, 226, 227, 288

Samberger, Leo, 300

San Carlos Academy of Fine Arts, Mexico City, 326

San Francisco Art Institute. *See* California School of Fine Arts

San Francisco Bay Area Figurative Art movement, 414, 419, 448, 458

San Francisco Chronicle (newspaper), 125, 240

San Francisco Daily Evening Bulletin (newspaper), 193

San Francisco Museum of Art, 390–91, 403

San Jose State College, 419, 432

San Jose University, Calif. *See* San Jose State College

Sargent, Dr. FitzWilliam, 209

Sargent, Daniel, 16

Sargent, Henry, 16

Sargent, John Singer, 188, 205–15, 236; **Caroline de Bassano, Marquise d'Espeuilles,** 205–8, **206,** 285; *El Jaleo*, 220; **Le verre de porto (A Dinner Table at Night),** 209–12, **210;** *Madame X (Madame Pierre Gautreau)*, 205, 207–8, 207, 209; *Madame Pierre Gautreau. See* Sargent, John Singer, *Madame X*; Mrs. Albert Vickers, 211, 211; **Trout Stream in the Tyrol,** 213–15, **214**

Sargent, Mary Newbold Singer, 209

Sargent, Mary Turner (Mrs. Daniel Sargent), 16, 17, 33

Savage, Edward, 48

Schapiro, Meyer, 397

Schoenmaekers, M. J. H., *The New Image of the World* (1915), 356

School of Industrial Design, Philadelphia, 350

School of Paris, 274, 347

Schubert, Franz, *Moments Musicaux*, 181

Schussele, Christian, 169, 232

Scottsboro Boys, 374

Scribner's Monthly (periodical), 191, 220

sculpture, 366, 368, 409, 412, 412

Segantini, Giovanni, 271, 274

Sellers, Charles Coleman, 61

Selz, Peter, 396

Shahn, Ben, 375–79, 384; *Cherubs and Children*, 379; *Liberation*, 379; **Ohio Magic,** 375–79, **376;** *The Passion of Sacco and Vanzetti* (series), 375; *Portrait of Myself When Young*, 379; *Untitled (Eighth Avenue and Forty-second Street, New York City)* (photograph), 377, 377; *Untitled (Ezra Shahn, Walton Street, Brooklyn, New York City)* (photograph), 377, 378; *Untitled (Walton Street, Brooklyn, New York City)* (photograph), 377, 378; *Untitled (Warren, Ohio)* (photograph), 377, 377

Shahn, Ezra, 377, 378

Shakespeare, William, 135

Sheeler, Charles, 307, 350–53; *Colonial Williamsburg Kitchen* (photograph), 352, 352; *Ford Motor Company, River Rouge, Mich.* (photographic portfolio), 350; **Kitchen, Williamsburg, 351,** 352–53; *Rolling Power*, 332, 333

Shelley, Percy Bysshe, 362

Sherman, Frederick Fairchild, 306

Sherman Antitrust Act (1911), 384

Shinn, Everett, 259, 278–82, 423; *Girl in Red on Stage*, 281; **Outdoor Theatre, 279,** 281–82

Shuster, Joe, 421

Sickert, Walter, 278

Siegel, Jerry, 421

Silberstein, Edith Cole, 70

Simpson, Marc, 211, 277

Sisley, Alfred, 225

Slade School of Fine Arts, London, 311

Sleeping Endymion, 116

Sloan, John, 259, 269, 330, 423; *The Hairdresser's Window*, 285, 285; *Sixth Avenue Elevated at Third Street*, 332, 333

Smibert, John, 5–7, 15; **John Nelson, 5–7, 6**

Smith, David, 409–13; **Ovals on Stilts, 409–13, 410;** *Sentinels* (series), 411; *Tanktotems* (series), 411; *Untitled* (photomontage), 409, 411; *Zig* (series), 409, 412, 412; *Zig V*, 412

Smith, Hassel, 428, 458

Smith, John, after Godfrey Kneller, *Portraits of Lord Villiers and Lady Mary Villiers*, 8, 10, 11

Smith, Mary Buchanan, 42

Social Realism, 375, 444; *see also* Realism

Social Security Building, Washington, D.C., 375

Société Anonyme, 227, 274

Society of American Artists, New York, 169, 254

Society of Six, 442

Soil (periodical), 311

Sorolla y Bastida, Joaquín, 422

Spain, civil war in, 399–400

Spencer, Jesse Ames, *History of the United States* (New York, 1858), 357

Spencer, Niles, 307

Spohn, Clay, 401, 428

Sprinchorn, Charles, 277

Stackpole, Ralph, 326, 414

Stanford University, 399, 401, 407, 453

Stebbins, Theodore E., Jr., 138

Steichen, Edward, 334

Stein, Gertrude, 274

Stein, John, 65

Stein, Sarah and Michael, 407

Steinbeck, John, *The Grapes of Wrath* (New York, 1940), 468

Stevens Institute of Technology, Hoboken, 334

Stewart, Theodore, 226

Stieglitz, Alfred, 273, 274, 309, 318, 320–21, 323, 325, 334; *Georgia O'Keeffe* (photograph), 320, 320

Stieglitz circle, 274, 277, 307, 334, 337

Still, Clyfford, 393, 428, 453, 458

still life, 59–60, 246, 246, 257, 434, 435

St. John, Frank Jay, 174–77, 175, 177

St. John's Wood Art School, London, 311

St. Louis School of Fine Arts, 300, 311

Stokes, Adrian, 213, 215

Stone City Colony and Art School, 338

Stowe, Harriet Beecher, 165; *Dred: A Tale of the Dismal Swamp* (1856), 165; *Palmetto Leaves* (1873), 165, 167; *Uncle Tom's Cabin* (1851–52), 165

St. Paul School of Fine Arts, Kansas City, 453

Strand, Paul, 274, 350

Structurism, 354

Stuart, Gilbert, 35, 43, 62–64; **William Rufus Gray**, 63–64

Sturges, Henry P., 110

Stuyvesant Theatre, New York, 281

Sugihara, Moemon, 469

sumi-e (brush and ink painting), 292

Summer School of Art, Ipswich, Mass., 362

Surrealism, 384, 385, 387, 397, 399; in America, 390–91, 393, 395, 397; anticipation of, 243; as influence, 399, 409, 411, 416, 461

Swinburne, Algernon Charles, 286

symbolism, 286, 295, 321, 362, 391

Synthetic Cubism, 277

Tadd, J. Liberty, *Large Antique Class (#3)* (photograph), 199–200, 199

Tait, Arthur Fitzwilliam., 225, 255

Tanguy, Yves, 388–92; **From One Night to Another**, 388–92, **389**; with André Breton, Marcel Duhamel, and Max Morise, *Cadavre exquis*, 390

Tanner, Henry Ossawa, 239

tapestry, 266, 403

Tarbell, Edmund C., 252–54; **The Blue Veil**, 252, **253**, 254

Tate Gallery, London, 227

Taylor, J. W., 35

Ten, the, 248, 254, 393, 395

Tenth Street Studio Building, New York, 125, 136, 142, 145, 159, 219, 248

Teraoka, Masami, 469–72; **American Kabuki/Oishiiwa**, 469–72, **470**; *McDonald's Hamburgers Invading Japan* (series), 469; *31 Flavors Invading Japan* (series), 469

Terminal Iron Works (studio), Bolton Landing, N.Y., 413

Texas Centennial Exposition (1936), 342, 345, 346; *Cavalcade of Texas Souvenir Program*, 345, 346

Thannhauser Gallery, Munich, 300

Thaxter, Celia Laighton, 288, 290, 290, 291; *An Island Garden* (Boston, 1895), 290

Thaxter, Levi, 288

Thayer, Abbott Handerson, 248, 267

theosophy, 273

Thiebaud, Wayne, 408, 419, 432–43; *Caged Pie*, 438; *Coloma Ridge*, 440, 442; **Diagonal Freeway**, 436, **437**, 439; *Diagonal Ridge*, 436, 438; *Penny Machines*, 434, 435; **Ponds and Streams**, 440–43, **441**; **Three Machines**, 432–35, **433**

Thomas E. Hulse (ship), 159, 160, 161

Thoreau, Henry David, 203, 271

Time magazine, 357, 384

Tintoretto, 359

Titian, 359, 444; *Rape of Europa*, 173

Tocqueville, Alexis de, *Democracy in America* (1835), 93

Tokaido Yotsuya Kaidan (The Ghost Story of Yotsuya) (play), 472

Tombs, the, New York, 183

Tomlinson, William and Henry, 82

Transcendentalism, 271, 273

Transcendental Painting Group, 362, 364

Traubel, Horace, 273

Traveler's Insurance Company, 98

trompe l'oeil, 240–42, 241, 242, 243, 245, 246, 247, 257, 337, 377

Trumble, Alfred, 216

Trumbull, John, 7, 64, 65

Truth, Sojourner, 344

Tubman, Harriet, 344

Tuckerman, Henry, 110

Turner, Frederick Jackson, 246

Turner, J. M. W., 65

Twachtman, John, 306

Twain, Mark, 150

ukiyo-e (prints), 469

unidentified artist: *Albion Brand Valencias* (lithograph), 234, 235; *The Celtic Monuments at Carnac* (engraving), 392; *David and Phila Franks*, 10; *Fruit Still Life*, 59, 59; *Kpan Mask* (Baule, Ivory Coast), 368; *Portrait of a Bearded Man* (Roman, Egypt), 417, 418

Union League, Chicago, 204

Union Pacific Railroad, 129

University College School, London, 311

University of Alabama, Tuscaloosa, 447

University of California, Berkeley, 296, 385, 401, 405, 414, 458

University of Illinois, Urbana, 401

University of Iowa, 338

University of Kansas, Lawrence, 303

University of Minnesota, Minneapolis, 342

University of Nebraska, Lincoln, 342

University of New Mexico, Albuquerque, 401

University of Pennsylvania Museum of Archaeology and Anthropology, 366

University of Virginia, Charlottesville, 321

University of Wisconsin, 347, 349

U.S. Air Force, 436, 458

U.S. Army, 428, 453

U.S. Department of the Interior, water reclamation project, Arizona, 405

U.S. Marines, 401, 407

U.S. Navy, 357

U.S. Office of War Information, 378

Van Beest, Albert, 193

Van Buren, Martin, 90

Vanderlyn, John, 43–47; *Ariadne Asleep on the Island of Naxos*, 47, 359; **Caius Marius Amid the Ruins of Carthage**, 43–47, **44**; *The Death of Jane McCrea*, 43; *Panoramic View of the Palace and Gardens of Versailles*, 47

Van Natta, Alice, 232

Van Schelling Design School, Antwerp, 461
Vanzetti, Bartolomeo, 375
Vassall, Leonard, 20, 21, 23
Vassall, William, 20, 21, 23–24
Veblen, Thorstein, *The Theory of the Leisure Class* (1899), 246
Vedder, Elihu, 165, 183–87, 362; *The Inevitable Fate*, 187; *The Lair of the Sea Serpent*, 183; *The Questioner of the Sphinx*, 183, 185, 186, 186, 187; **The Sphinx of the Seashore**, 183, *184*, 186–87
Velázquez, Diego, 419; as influence, 173, 192, 205, 231, 259, 283, 444, 448, 451; *The Fable of Arachne (The Spinners)*, *172*, 173; *Portrait of Jester Pablo de Valladolid*, 421, *422*; *Prince Don Baltasar Carlos as a Hunter*, 450, 451
Velde, Willem van de, the Younger, 51
Venus of Willendorf, 464
Vermeer, Jan, 254, 432
Vernet, Horace, 94
Vertue, George, 5
Vickers, Albert, 210, 211
Vickers, Edith (Lady Gibbs; Mrs. Albert Vickers), 210, 211, *211*
Vickers, Ltd., 211
Victoria, queen of England, 134
Vien, Joseph-Marie, 45
Vienna Exposition (1873), 125
Villiers, Lady Mary, 10
Villiers, Lord, 10
Vincent, François André, 43
Volkert, Hans, 300
Vose, Seth, 136
Vose Galleries, Providence, R.I., 138
Vytlacil, Vaclav, 414

Wadsworth Atheneum, Hartford, Conn., 390
Wales, George, Prince of, 135
Wallace, Governor George, 447
Walpole Society Notebook (periodical), 39
Walter, Marie-Thérèse, 464
War: American Civil, 149, 153, 155, 157, 158, 204, 374; of 1812, 56; Franco-Prussian, 229; Mexican-American, 96; Revolutionary (War of Independence), 27, 28, 45; Vietnam, 456, 457; World War I, 215, 276, 277, 303, 314, 371, 374, 388; World War II, 292, 379, 395, 401, 436, 453, 455, 458; *see also* Spain, civil war in
Warner, Charles Dudley, 150
Washington, Booker T., 345; *Up from Slavery* (autobiography, 1901), 345

Washington, General George, 74; portraits of, 27, 31
Washington Monument, 183
Watkins, Franklin, 366
Weber, Max, 273, 334, 393
Webster, Daniel, 50, 74
Weekley, Caroline J., 39
Weinberg, Jonathan, 309
Weir, John Alden, 306
Wenderoth, Frederick Augustus, 94
Wertham, Frederick, *Seduction of the Innocent* (1954), 421
Wesselman, Tom, 469
West, Benjamin, 18, 20, 23, 24, 33, 35–38, 62; *The Death of General Wolfe*, 43; *Death on the Pale Horse*, 45, *45*; *Design for a Monument to Lord Nelson*, 35; **Genius Calling Forth the Fine Arts to Adorn Manufactures and Commerce**, 35–38, *36*; *Landscape View of Windsor Castle, with the Royal Hunt*, 35; *Penn's Treaty with the Indians*, 84; *Procession of Queen Elizabeth to St. Paul's*, 35; sketch for *Genius Calling Forth the Fine Arts to Adorn Manufactures and Commerce*, *37*, 38
West, Benjamin, Jr., 35, 38
West, Raphael, 35, 38
Western Arts Association, Los Angeles, 296
Western Art Union, 311
West Texas State Normal College, 321
Wettling, George, 425
Wheeler, William, Sr., 41
Whistler, James McNeill, 178–82, 216, 227; as influence, 248, 265; *Arrangement in Gray and Black, No. 1: Portrait of the Painter's Mother*, 231; *Art and Money. See* Whistler, James McNeill, *Harmony in Blue and Gold; The Gentle Art of Making Enemies* (1890), 182; **The Gold Scab: Eruption in Frilthy Lucre (The Creditor)**, 178, *179*, 181–82; *Harmony in Blue and Gold: The Peacock Room*, 180–81, *180*; *La Princesse du pays de la porcelaine*, 180; *The Three Girls*, 180, *181*
White, Margaret Stuyvesant, 211
White, Stanford, 209, 248, 251
Whitelaw Reid Mansion, New York, 390
Whitman, Walt, 273
Whitney Museum of American Art, New York, 307, 349; exhibitions at, 391, 448
Whittier, John Greenleaf: "Brown of Ossawatomie" (poem), 204; *Snow-Bound* (poem), 100

Whittredge, Worthington, 125, 162–64; **On the Cache la Poudre River, Colorado**, *163*, 164
Wilde, Oscar, 310
Wilkinson, James, 46
Wilkinson, John Gardner, *A Handbook for Egypt* (1847), 183
Willem of Orange, 11
William, king of England, 7
William Clausen Galleries, New York, 269
Williams, Mary, 7
Williams, William Carlos, 274, 309, 350
Willis, Nathaniel Parker, *Pencillings by the Way* (1836), 132
Wilmans, Charles John Stricker, 42
Wilmerding, John, 240, 243, 247
Wilmot Proviso, 92, 93
Windsor Castle, England, 132–35, *133*, *134*
Winkler, Jacomina, 8
Winkler, Maria Maytilda, 8, *9*
Winsor School, Boston, 414
Wise, Governor Henry A., 204
Woelffer, Emerson, 465
Women's Civic League, Baltimore, 251
Wood, Enoch, *Plate "Pine Orchard House, Catskill Mountains,"* 67, *67*
Wood, Grant, 338–41, 347; "Revolt against the City" (manifesto, 1935), 338; *American Gothic*, 338; *Daughters of Revolution*, 338; **Dinner for Threshers**, 338–41, *339* (foldout); studies for *Dinner for Threshers*, 338, *340*, *341*
Wordsworth, William, 135, 362, 446
World's Columbian Exposition, Chicago (1893), 201, 227, 246
Wright, Joseph, 31–34; **John Coats Browne**, 31–34, **32**
Wright, Patience, 31
Wuerpel, Edmund, 238, 300
Wyeth, N. C., 371

Yale University, 393
Yau, John, 247
Yuba College, Marysville, Calif., 458

Zen Buddhism, 292, 295
Zimmerman, Harold, 444
Zurbarán, Francisco de, 59
Zusch, Justin Heinrich, 94

Unless otherwise noted, all works in the collection of the Fine Arts Museums of San Francisco were photographed by Joseph McDonald.

fig. 3.2: Courtesy, Winterthur Museum; fig. 5.2: Photograph © 2005 Museum of Fine Arts, Boston; fig. 6.1: Photograph © 2005 Museum of Fine Arts, Boston; fig. 7.1: © Tate Gallery, London / Art Resource, NY; fig. 12.1: Photograph © 1985 The Detroit Institute of Arts; fig. 12.2: Photograph © 1995 The Metropolitan Museum of Art; fig. 12.3: Erich Lessing / Art Resource, NY; fig. 18.3: Terra Foundation for American Art, Chicago / Art Resouce, NY; fig. 22.2: Richard Walker; fig. 23.1: Helga Photo Studio; fig. 25.1: Terra Foundation for American Art, Chicago / Art Resouce, NY; fig. 28.2: Photograph © 1979 The Metropolitan Museum of Art; fig. 30.1: Photograph © 2004 The Metropolitan Museum of Art; fig. 30.2: Martina Bienenstein; fig. 31.1: © The Newark Museum / Art Resource, NY; fig. 33.1: Erich Lessing / Art Resource, NY; fig. 33.2: Katya Kallsen; fig. 40.1: Tate Gallery, London / Art Resource, NY; fig. 40.3: Photo courtesy of John Davis; fig. 44.1: Photograph © 2005 Museum of Fine Arts, Boston; fig. 45.2: Scala / Art Resource, NY; fig. 46.1: Greg Heins; fig. 47.2: Tate Gallery, London / Art Resource, NY; fig. 48.1: Photograph © 2005 Museum of Fine Arts, Boston; fig. 52.1: Photograph © 1982 The Metropolitan Museum of Art; fig. 53.1: Photograph © 1997 The Metropolitan Museum of Art; fig. 54.1: Photo: Ron Jennings © Virginia Museum of Fine Arts; fig. 56.2: Photograph © 2002 The Metropolitan Museum of Art; fig. 56.3: Courtesy of Mary Lublin Fine Arts, Inc.; fig. 57.1: Photograph © 2005 Museum Associates / LACMA; fig. 57.2: Photograph © 1996 The Metropolitan Museum of Art; fig. 58.1: Lynn Rosenthal; fig. 58.2: Photography © The Art Institute of Chicago; fig. 58.3: Photograph © The Art Institute of Chicago; fig. 61.1: Robert Newcombe; fig. 65.1: Photo courtesy of Stanford University Libraries, Department of Special Collections; fig. 66.1: © The National Gallery, London; fig. 68.1: Photograph © 2005 Museum of Fine Arts, Boston; fig. 70.1: Photograph © 1986 The Metropolitan Museum of Art; fig. 71.1: © Studio Basset; fig. 81.1: Photography © 1996 The Metropolitan Museum of Art; fig. 83.1: CANALI PHOTOBANK, Italy; fig. 83.2: Jorge Bachman; fig. 84.1: © 1998: Whitney Museum of American Art, New York. Photograph by Sheldan C. Collins; fig. 86.1: © 1998: Whitney Museum of American Art, New York. Photograph by Sandak / Macmillan Pub-

lishing Co.; fig. 86.2: © 1998: Whitney Museum of American Art, New York. Photograph by Sandak / Macmillan Publishing Co.; fig. 89.1: Photograph © 2005 Museum of Fine Arts, Boston; fig. 91.1: Jamison Miller; fig. 91.2: Jamison Miller; fig. 93.2: Photograph © Reproduced with the permission of the Barnes Foundation™, All rights reserved; fig. 95.1: Image is courtesy of the Ben Shahn papers, 1879–1990 (bulk 1933–1970) in the Archives of American Art, Smithsonian Institution; fig. 95.2: David Mathews; fig. 95.4: Katya Kallsen; fig. 96.1: Digital Image © The Museum of Modern Art / Licensed by SCALA / Art Resource, NY; fig. 98.2: Digital Image © The Museum of Modern Art / Licensed by SCALA / Art Resource, NY; fig. 98.3: Photo: akg-images; fig. 99.2: Art Resource, NY; fig. 100.1: Digital Image © The Museum of Modern Art / Licensed by SCALA / Art Resource, NY; fig. 102.1: Digital Image © The Museum of Modern Art / Licensed by SCALA / Art Resource, NY; fig. 102.2: Digital Image © The Museum of Modern Art / Licensed by SCALA / Art Resource, NY; fig. 103.1: © 1998: Whitney Museum of American Art, New York. Photograph by Sheldan C. Collins; fig. 104.1: Photograph by Imogen Cunningham © The Imogen Cunningham Trust; fig. 104.2: Rick Stafford; fig. 105.1: SCALA / Art Resource, NY; fig. 106.3: Paul Waldman, Collection Earl Davis; fig. 110.2: Cecile Keefe; fig. 111.1: Charles Moore / Black Star; fig. 112.1: SCALA / Art Resource, NY; fig. 112.2: Photograph © 1994 The Metropolitan Museum of Art; fig. 112.3: Benjamin Blackwell; fig. 113.1: John Bigelow Taylor / Art Resource, NY; fig. 113.2: Erich Lessing / Art Resource, NY; fig. 115.1: Photograph © 1985 The Metropolitan Museum of Art; fig. 115.2: Digital Image © The Museum of Modern Art / Licensed by SCALA / Art Resource, NY

Permission to reproduce works was granted by the following:

Thomas Hart Benton: pl. 91, fig. 91.1, fig. 91.2 © T. H. Benton and R. P. Benton Testamentary Trusts / UMB Bank Trustee / Licensed by VAGA, New York, NY

Stuart Davis: pl. 106, fig. 106.1 © Estate of Stuart Davis / Licensed by VAGA, New York, NY

Giorgio de Chirico: 98.2 © 2005 Artists Rights Society (ARS), New York / SIAE, Rome

Willem de Kooning: pl. 115, fig. 115.1 © 2005 The Willem de Kooning Foundation / Artists Rights Society (ARS), New York

Arshile Gorky: fig. 101.1 © 2005 Artists Rights Society (ARS), New York

Jack Levine: pl. 111 © Jack Levine / Licensed by VAGA, New York, NY

John Marin: pl. 85, fig. 85.1 © 2005 Estate of John Marin / Artists Rights Society (ARS), New York

Reginald Marsh: pl. 84 © 2005 Estate of Reginald Marsh / Art Students League, New York / Artists Rights Society (ARS), New York

Henri Matisse: fig. 102.1, fig. 102.2 © 2005 Succession H. Matisse, Paris / Artists Rights Society (ARS), New York

Robert Motherwell: pl. 100, fig. 100.1 © Dedalus Foundation, Inc. / Licensed by VAGA, New York, NY

Georgia O'Keeffe: pl. 81: © 2005 The Georgia O'Keeffe Foundation / Artists Rights Society (ARS), New York

Pablo Picasso: fig. 113.1 © 2005 Estate of Pablo Picasso / Artists Rights Society (ARS), New York

Mel Ramos: pl. 105 © Mel Ramos / Licensed by VAGA, New York, NY

Mark Rothko: pl. 99, fig. 99.2: © 1998 Kate Rothko Prizel & Christopher Rothko / Artists Rights Society (ARS), New York

Ben Shahn: pl. 95, figs. 95.1–95.4 © Estate of Ben Shahn / Licensed by VAGA, New York, NY

David Smith: pl. 103, fig. 103.1, fig. 103.2 © Estate of David Smith / Licensed by VAGA, New York, NY

Yves Tanguy: pl. 98, fig. 98.1 © 2005 Estate of Yves Tanguy / Artists Rights Society (ARS), New York

Wayne Thiebaud: pl. 108, fig. 108.1, pl. 109, fig. 109.1, fig. 109.2, pl. 110, fig. 110.1 © Wayne Thiebaud / Licensed by VAGA, New York, NY

Grant Wood: pl. 86, figs. 86.1–86.3 © Estate of Grant Wood / Licensed by VAGA, New York, NY

Masterworks of American Painting at the de Young

WAS PRODUCED THROUGH THE PUBLICATIONS DEPARTMENT

OF THE FINE ARTS MUSEUMS OF SAN FRANCISCO:

Ann Heath Karlstrom DIRECTOR OF PUBLICATIONS

 AND GRAPHIC DESIGN

Elisa Urbanelli MANAGING EDITOR

Fronia W. Simpson BENNINGTON, VERMONT, MANUSCRIPT EDITOR

Produced by Wilsted & Taylor Publishing Services

PRODUCTION MANAGEMENT *Christine Taylor*

PRODUCTION ASSISTANCE *Andrew Patty and Jennifer Uhlich*

EDITORIAL ASSISTANCE *Melody Lacina*

DESIGN AND COMPOSITION *Jeff Clark*

 Text set in Electra, Bank Gothic, and Perpetua Italic

INDEXING *Frances Bowles*

COLOR SUPERVISION *Susan Schaefer*

COLOR SEPARATIONS *Bright Arts Graphics, Singapore*

PRINTING AND BINDING *Regal Printing Ltd., Hong Kong,*

 through Stacy Quinn of Quinnessentials Books and Printing, Inc.